American Art

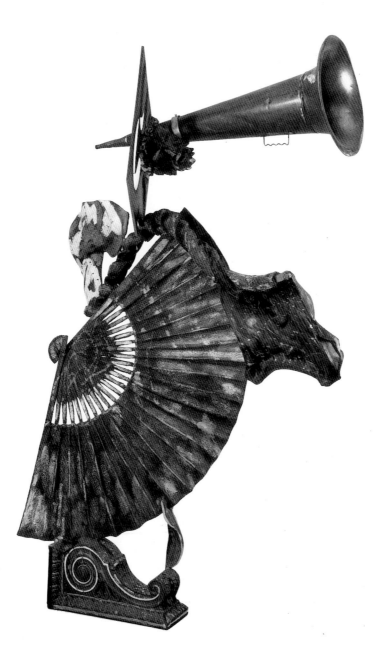

American Art
HISTORY AND CULTURE

WAYNE CRAVEN

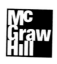

Boston, Massachusetts Burr Ridge, Illinois Dubuque, Iowa
Madison, Wisconsin New York, New York San Francisco, California St. Louis, Missouri

McGraw-Hill

A Division of The McGraw-Hill Companies

The credits section for this book begins on page 666 and is considered an extension of the copyright page.

Trade edition distributed by Harry N. Abrams, Inc., New York

Library of Congress Catalog Card Number: 93–71038

ISBN 0–697–16763–1

This book was designed and produced by
CALMANN & KING LTD
71 Great Russell Street, London WC1B 3BN

Designer *Karen Osborne*
Picture Researcher *Elizabeth Loving*

Typeset by Bookworm, Manchester, UK
Printed in USA by R.R. Donnelley & Sons

10 9 8 7 6 5 4 3 2

HALF TITLE:
Nancy Graves, *Synonymous with Ceremony*, Fig. 39.20. 1989. Mixed media, 81 × 53 × 31in (205.7 × 134.6 × 78.7cm). Private collection. George Mintz and Co., Inc., Morristown, N.J. © Nancy Graves/VAGA, New York, 1993.

FRONTISPIECE:
Charles Willson Peale, *The Artist in his Museum*, Fig. 10.14. 1822. Oil on canvas, 8ft 7¾in × 6ft 7⅞in (2.64 × 2.03m). Pennsylvania Academy of the Fine Arts, Philadelphia. Pennsylvania Academy purchase from the estate of Paul Beck, Jr.

PART OPENERS:
p. 15 John Singleton Copley, *Mr. and Mrs. Isaac Winslow (Jemima Debuke)*, Fig. 7.10. 1774. Oil on canvas, 3ft 4¼in × 4ft ¾in (1.02 × 1.24m). Museum of Fine Arts, Boston. Gift of Mr. and Mrs. Maxim Karolik for the M. and M. Karolik Collection of 18th-Century American Arts.

p. 109 William Rush, *Schuylkill Freed*, Fig. 12.10. c. 1828. Wood, height 3ft 6in (1.07m). Fairmount Park Commission, Philadelphia, Pa.

p. 171 Thomas Cole, *The Architect's Dream*, Fig. 15.6. 1840. Oil on canvas, 4ft 5in × 7ft ¹⁄₁₆in (1.35 × 2.14m). Toledo Museum of Art, Toledo, Ohio. Gift of Florence Scott Libbey.

p. 279 Richard Morris Hunt, Ballroom, Marble House, Newport, Rhode Island, Fig. 20.15. c. 1895. The Breakers and Marble House, Preservation Society of Newport County.

p. 391 Charles Sheeler, *Wheels*, Fig. 31.10. 1939. Gelatin-silver print, 6⅝ × 9⅝in (16.8 × 24.4cm). Collection, The Museum of Modern Art, New York. Given anonymously.

p. 499 Romare Bearden, *The Prevalence of Ritual: The Baptism*, Fig. 36.8. 1964. Collage (photomechanical reproduction, synthetic polymer, pencil) on paperboard, 9⅛ × 12in (23 × 30.5cm). Hirshhorn Museum and Sculpture Garden, Smithsonian Institution, Washington, D.C. Gift of Joseph H. Hirshhorn, 1966. Photo Lee Stalsworth.

To Lorna

CONTENTS

PREFACE

Art is important and fascinating for both aesthetic and expressive reasons. Understanding the art of our past helps us to understand our culture of the present. Through a course in American art, students may learn about the history of their own country. They may come to the realization that life in the present-day United States is part of a continuum of longstanding cultural traditions.

Primary themes emerge, such as the importance of materialism in our national psyche since the days of the nation's founding. One sees the power exerted by the middleclass in establishing a popular culture, and the "leveling" effect of the prevailing ideology—democracy—on the arts. Also of importance are the lives of the artists, where they have studied, and with whom. Artistic centers such as Paris, Rome, London, Canton, and Tokyo have exerted strong influences, as have the secular and spiritual motivations that have given direction to artistic creativity in America from its earliest manifestation around 1570 to the present.

While there are several ways in which to study American art, my own approach is essentially contextual—that is, the placement of the work of art in its cultural context. This context includes the social, economic, and religious ambience in which a work was created. It sets the political, philosophical, and technological scene. It describes scientific and literary postures of the moment. These areas give direction to the creative spirit of an age. During more than three decades of teaching American art, I have become increasingly aware that students being introduced to the subject need to have a cultural and historical framework established for them. Without such structure, they may take up the study of American art in something of a vacuum.

I have therefore begun each chapter with an introduction that sets the cultural stage upon which the art of the era is created. Within the confines of a one-volume study, the themes that introduce the chapters offer the reader or the teacher a point of departure from which to direct further discussion or enquiry. In some cases a book may be analyzed extensively because its theme or literary style helps to show the spirit of a movement in its fullest scope. In other cases I merely give a title or two with the idea that the reader or instructor may pick up on such references and expand on them at will.

On a related matter, I have written this book so that it can serve diverse methodologies. I believe that there is no single "correct" methodology, and I myself choose to employ a number of them as the situation warrants. It is my hope that those who prefer one or another analytical system—from analysis of material culture to popular culture, from Marxist to feminist interpretations, from psycho-sexual to formal analysis and connoisseurship—will be able to use this text as a point of departure. It seems to me that the more of these intellectual tools that the student of American art can master, the better an understanding will be gained.

I have chosen to include five areas of the arts in this study—architecture, decorative arts, painting, sculpture, and photography—because they are closely integrated and make up the basic core of the arts of America. There are, of course, other topics that might have been included, such as film or graphic arts. But within the scope of a single volume, and often with an eye to the timeframe of a single semester, time and space simply would not allow it.

In my book I have tried to be sensitive to the contributions of minorities and women, and I have introduced these throughout my text. Usually I have preferred to integrate these contributions within the narrative of the history of American art, for I believe that is the best way. However, occasionally I have made groupings, such as African-American Sculptors, for the purpose of emphasizing their creativity. Appreciation of the breadth, depth, and richness of American art is greatly increased by an understanding of its diversity.

Finally, throughout the text I use the term "the Americans." I am well aware that America has hosted a diverse culture throughout its history—that there is no one single group of Americans. The point of view of a white male Boston merchant of colonial times was different from that of an African-American slave woman of the antebellum period. The dreams and ambitions of pioneers moving West were different from those of the Native Americans into whose lands they moved. Newly arrived, penniless immigrants working in the Chicago packing houses saw America differently from the newly rich industrial and railroad barons of the Gilded Age. Similarly, Civil Rights activists of the 1960s found America to be quite unlike the world of the white, status-quo-oriented middleclass of that era. So, having recognized those differences, I use the word "America" to mean the guiding, determining force in the culture of this country—the one that causes art to take the form it does in any given era. Thus at one time, the millionaire society of late-nineteenth-century Newport may have been the guiding spirit behind architecture. At another time the streetlife of African-Americans in the Watts area of Los Angeles may have provided the creative impulses. The term "Americans" is not intended to indicate something monolithic, static, or élitist, but refers to any sector of American civilization that has given direction to the creation of art.

W. C.

ACKNOWLEDGMENTS

Special appreciation is expressed to a number of people at the University of Delaware: President David Roselle and Provost Byron Pipes, Dean Helen Gouldner and her successor Mary Richards for their encouragement to research and scholarly publication. My chairman, William Innes Homer, has through counsel and example provided a standard of excellence, as have my colleagues in the American field, Damie Stillman and George B. Tatum. I am also grateful to James Curtis, Director of the Winterthur Program in American Culture. The many graduate students of my seminars—from art history, history, the Winterthur Program, American Studies, and elsewhere—have been wonderfully intelligent soundingboards for the ideas contained in this book. My undergraduate students of thirty-three years have helped me define a methodology for informing college students about the arts of their own country and the values they express.

Curators and registrars at a great many museums and historical societies have been of enormous assistance. I would like to thank, among others, Mary Doherty of the Metropolitan Museum of Art, Anita Duquette of the Whitney Museum of American Art, Karol Schmiegel of Winterthur Museum, Graham Hood of Colonial Williamsburg, Elizabeth Broun, Director of the National Museum of American Art, Mary K. Woolever and Lieschen Potuznik of the Art Institute of Chicago, Thomas Grischkowsky and Richard Tooke of The Museum of Modern Art, and the entire staffs of the Rights and Reproductions Office and the Registrar's Office of the Museum of Fine Arts, Boston, and the New-York Historical Society.

A number of New York galleries have been especially helpful: Kennedy Galleries, Pace-MacGill, Castelli Galleries, M. Knoedler's, Berry-Hill Galleries, Robert Miller Galleries, Mary Boone Gallery, and Metro Gallery. My appreciation is also expressed to a number of private collectors who have generously allowed me to reproduce objects from their collections in this book. And several artists have been most helpful—among them Jerry Uelsmann, Duane Hanson, and Charles Parks.

Special thanks go to Regina Ryan, my literary agent. I am grateful as well to Deborah Reinbold of Brown & Benchmark, who has been a splendid liaison with the publishing house. And I am pleased to acknowledge the good efforts of my editor Ursula Sadie, the book's designer, Karen Osborne, and Judy Rasmussen, Production Director at Calmann & King, London, who have been marvelous throughout the process of publication.

Finally, although this book is dedicated to Lorna, my dear wife of forty years, I should like to mention here other members of my family who have shown the necessary patience and understanding during the long years of the writing of this book: my sister, Rebecca, and her wonderful family of Frank, Rachel, Frank E., and Sarah. My wife's sister, Nancy G. Breseke, deserves special thanks for increasing my sensitivity to the contributions of women to the arts and other areas.

PART 1

Colonial America

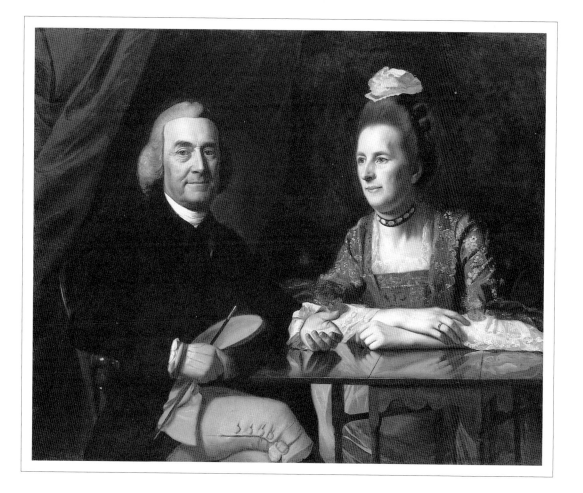

CHAPTER ONE

THE NEW WORLD AND NEW SPAIN

Sailing in the name of the Spanish monarchs Ferdinand and Isabella, Christopher Columbus discovered the New World in 1492, and the world began to change almost immediately. The new continents became safety valves—they allowed a release of the economic, religious, and political pressures that had reached explosive stages in Europe. The sequence that followed was essentially this: First came discovery, next exploration, then conquest. This was followed by colonization, either for exploitation or for permanent settlement. But it would be over one hundred years before successful and lasting colonies were established within the boundaries of today's continental United States.

It was the wealth of the New World that first brought Europeans across the Atlantic. By 1500, fishing fleets from several European countries were harvesting the cod fish in the waters off North America. Further south, the conquistadors came, advancing under the two banners of the pope of Rome and the king of Spain. Ponce de Leon, Spanish governor of Puerto Rico, discovered Florida in 1513 when he went searching for the Fountain of Youth and for the fabled Earthly Paradise where gold was abundant and jewels hung in trees. He found instead steamy swamps, impenetrable jungles, poisonous snakes, alligators, and fierce Native American warriors.

The conquistador Hernán Cortés completed his conquest of Mexico between 1519 and 1522, virtually destroying the high culture there. Ironically, the Aztec people, led by Montezuma, had hailed him as the god they had been expecting to arrive by sea. They were terrified specifically by two of the things Cortés's small band of soldiers brought with them—the cannon that left devastation in the wake of its explosion, and the spirited horses that made men seem like centaurs. Cortés razed the Aztec capital and built in its place Mexico City, from which the Spanish viceroys ruled the vast territory that stretched from the isthmus of Panama to the unknown desert expanses beyond the Rio Grande, as far west as the Pacific.

Always there was the expectation that goldmines or cities built of gold would be found. When that did not happen, the conquistadors contented themselves with melting down the treasures of the indigenous peoples, and sending heavily laden ships back to the mother country. About 1540, the Spanish explorer Francisco Coronado marched north from Mexico City in search of El Dorado, or the Cibola—the fabled Seven Cities of Gold that were believed to exist in New Mexico. What Coronado found, of course, was the sparse scattering of adobe huts that constituted the tribal villages of the Zuni people—Pueblo Native Americans who lived in large communal houses near the Zuni River.

Spain was not alone in its interest in the New World. In 1562 Jean Ribaut tried to plant a French Huguenot settlement near the site of present-day Beaufort, South Carolina. That ill-fated effort was the first attempt to relocate people in the New World who were fleeing religious persecution back home. In 1564 the French colonizer René Goulaine de Laudonnière established a fort near the mouth of St. Johns River in Florida. It was destroyed by the Spanish the next year—the same year the Spanish created the first permanent colonial settlement in the United States, at St. Augustine. Inevitably there was international warfare as French, Spanish, and English fought to assert their claims to the lands and the seas.

There were two primary reasons for conflict among European nations—one religious, the other economic. Spain and France remained staunchly Roman Catholic following the schism brought about by the Protestant revolution. Meanwhile England's King Henry VIII had expelled Catholic bishops and priests in the 1530s in order to establish the Church of England (or Anglican Church), and Holland had become wholly Protestant. Wherever the Spanish and French soldiers went, there too went Jesuit priests and Franciscan or Dominican friars, fired with the zeal of spiritual conquest. As to the economic issue, all European nations were agreed that the wealth of the New World was desirable. The conflict came when each tried to grab it all.

In 1588 the wrath of nature caused a decided shift in the balance of power, such as the kings of nations had not been able to accomplish—the Spanish Armada was destroyed in the English Channel by a raging storm. Thereafter, England held superiority at sea, challenged more by Dutch mercantile interests than by the Spanish or the French. England's trade vessels now had less to fear, and its merchant-adventurers could concentrate on exploiting the economic potential of new lands around the globe. Although Spain

held on to its lands in the New World, the expansion of the Spanish empire essentially came to a halt, except in undisputed areas like the American Southwest. In the early decades of the following century, English settlers would begin to colonize the New World along the Eastern Seaboard, commencing with Jamestown (1607) and Plymouth (1620).

IMAGES OF THE NEW WORLD

FIRST PICTURES

Jacques Le Moyne de Morgues (1533–88), a watercolorist and draftsman, accompanied René de Laudonnière on his 1564 expedition to Florida to document the journey. Two years earlier, Jean Ribaut had brought with him the materials to build a column that established the claim of the king of France. He erected it near the mouth of St. Johns River, in the vicinity of present-day Jacksonville. Le Moyne depicts the moment when the Native American chief Athore, of the Timucuan tribe, has escorted Laudonnière to the site of Ribaut's Column (Fig. 1.1). Pictures of the New World and of Native Americans were then, and long continued to be, presented from the viewpoint of the Europeans who drew or painted them. An inevitable bias or cultural perspective results.

Laudonnière is represented in the French portrait style of the Valois court, the most famous practitioner of which was Corneille de Lyons. Behind Laudonnière are several of his soldiers, and the artist has carefully rendered the details of the breastplate, helmets, and weapons. No less meticulously did he record the fantastic costume and bodypainting or tattooing of the native chieftain, who gestures respectfully toward the monument. Before it a number of Native Americans kneel in worshipful postures, as if it had become an idol. Athore displays his friendship by placing one arm around the French commander. The chief was described by the artist as handsome, wise, grave, and majestic. His image is the first representation of the Native American as the

1.1 Jacques Le Moyne de Morgues, *René de Laudonnière and the Indian Chief Athore visit Ribaut's Column*, c. 1570. Gouache on parchment, 7 × 10¼in (17.7 × 26cm). New York Public Library.

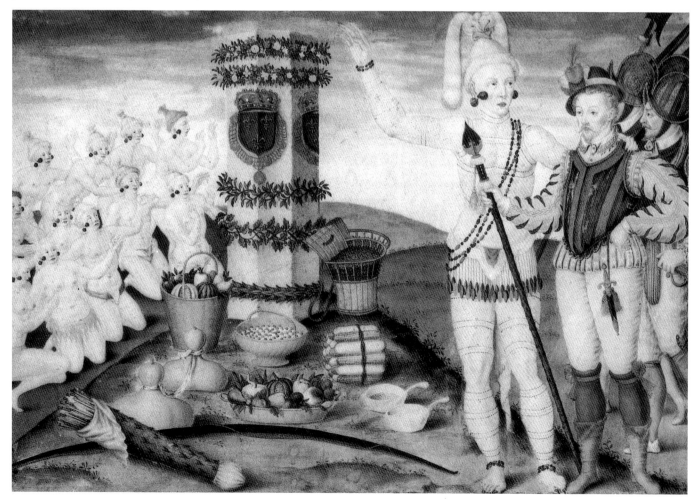

"noble savage"—an image ennobled even further, in European eyes, by being drawn in the form of an Apollo.

The column bears the emblem of the Valois kings of France, with a crown surmounting a shield adorned with three fleurs-de-lis. In the foreground are offerings that have been placed before the idol-monument—a bow with a quiver of arrows, corn, fruit in baskets, squashes, and other produce that would fascinate the wondering eyes of Europeans back home.

Le Moyne's smallscale gouache on parchment was not painted on location. It was executed after his return to France, probably in the early 1570s, from sketches made in the New World. Its representation shows various cultural inaccuracies—the Native Americans are depicted with pale pink skin, and most of the women to the left have blonde hair. Neither of these features was characteristic of the race. Furthermore, some of the fruit on display did not exist in Florida. Otherwise, Le Moyne's details agree with evidence obtained from the writings of later eyewitnesses or from archeological excavations. Although Le Moyne painted a number of watercolors that derive from the trip of 1564–5, only this one original has survived. Others are known from engravings that were made as illustrations for Théodore de Bry's publication *America* (1590). About 1580 Le Moyne left France—possibly for religious reasons, as he was a Calvinist—to live in England. There he was soon employed by the English adventurer Sir Walter Raleigh, who had developed a passionate interest in exploiting the riches of the New World.

SCENES FROM ROANOKE

In 1585, Raleigh sent a company of settlers to Roanoke Island, off the coast of present-day North Carolina. Among them were John White (active 1575–93) and Thomas Hariot. White's role, like Le Moyne's, was to create pictures of the people, and also of the flora and fauna of the region. Hariot was to observe and record scientific data concerning natural history and ethnology. Little is known of White's earlier life or training, except that he knew Le Moyne and made copies of at least two of the latter's Native American studies. But the sixty-three watercolors (now preserved in the British Museum) that resulted from White's visit to Roanoke testify to his skill as a draftsman. Some depict life in a Native American village. The plan of the site, the architectural forms, and the daily customs, ceremonies, and agricultural pursuits of the people are all carefully logged (Fig. 1.2). Hariot's description accompanying De Bry's engraved plate of this scene reads as follows:

> They have groves of trees where they hunt deer, and fields where they sow their corn. In the cornfields they set up a little hut on a scaffold, where a watchman is stationed. He makes a continual noise to keep off birds and beasts which would otherwise soon devour all the corn.... They also have a large plot where they meet with neighbors to celebrate solemn feasts, and a place where they make merry when the feast is ended. In the round plot they assemble to pray. The large building holds the tombs of their kings and princes. In the garden on the right they sow pumpkins.... These people live happily together without envy or greed.[1]

Some of White's watercolors represent painted warriors, while others show women caring for children. Turtles and Caribbean flamingos caught the eye of the observant artist, as did a special plant, previously unknown in England. In Hariot's words:

> There is an herb called *uppowoc*, which ... the Spanish call *tobacco*. Its leaves are dried, made into powder, and then smoked by being sucked through clay pipes into the stomach and head. The fumes purge superfluous phlegm and gross humors from the body.[2]

1.2 John White, *Indian Village of Secoton*, c. 1585. Watercolor, 12¾ × 7¾in (32.4 × 19.7cm). British Museum, London.

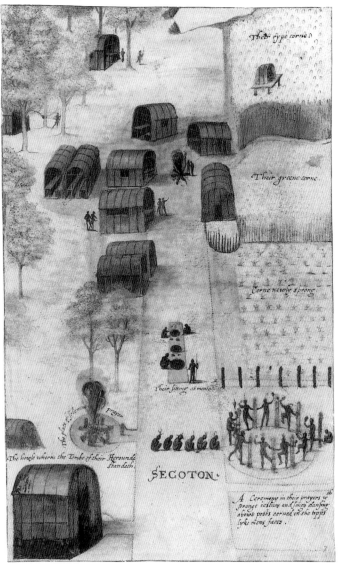

Map of America

MARYLAND inset:
New Castle, Wilmington, DELAWARE, Dover, Annapolis, Chesapeake Bay, Delaware Bay, MARYLAND, Antietam, Towson, Baltimore, DC, Washington, Potomac

NEW JERSEY inset:
Hoboken, Jersey City, West Orange, Newark, Long Branch, Princeton, Trenton, Delaware, NEW JERSEY

MASSACHUSETTS / CONNECTICUT / RHODE ISLAND inset:
Newburyport, Ipswich, Gloucester, Lawrence, Charlestown, Concord, Cambridge, Hingham, Boston, Worcester, Plymouth, Provincetown, Cape Cod, New Bedford, Bristol, Newport, Providence, RI, MASSACHUSETTS, Lenox, Holyoke, Chicopee, Simsbury, Hartford, CONNECTICUT, Connecticut, New Haven, Old Lyme, New Canaan, Long Island Sound, Narragansett Bay

NEW YORK inset:
Adirondack Mountains, Bolton's Landing, Saratoga Springs, Rochester, Utica, Syracuse, Seneca Falls, Oneonta, Catskill Mountains, Troy, Albany, Buffalo, Warsaw, Lake Ontario, Newburgh, Tarrytown, Bronx, Brooklyn, Staten Island, Hudson, Stony Brook, Oyster Bay, Long Island, New York, East Hampton

Main map:
CANADA
MEXICO
ATLANTIC OCEAN
PACIFIC OCEAN
Gulf of Mexico
Gulf of California
ROCKY MOUNTAINS
APPALACHIAN MOUNTAINS
Sierra Nevada
Mojave Desert

MAINE — Bangor, Augusta, Bath, Brunswick, Prout's Neck, Kennebunk, Fryeburg
NH — Portland, Concord, Montpelier, VT, Burlington
MA — Boston, Providence, CT, RI, Hartford, Albany, NEW YORK
Lake Ontario, Lake Erie, Lake Huron, Lake Superior, Lake Michigan
Oswego, Allegheny
PENNSYLVANIA — Wilkes-Barre, Harrisburg, Pittsburg, Gettysburg, Lancaster, Bethlehem, New Hope, Philadelphia, West Chester
NJ, Dover, DE, MD, Washington, DC, VA, Alexandria, Fredericksburg, Richmond, Williamsburg, Hampton, Kitty Hawk, Roanoke Island, Jamestown, Appomattox, Newport Parish (Smithfield), Charlottesville
WV, Wheeling, Salem, Marietta, Athens, Charleston, Frankfort, Louisville, New Harmony
OHIO — Cleveland, Columbus, Cincinnati, Columbus
Columbia, Asheville, Greensboro, Raleigh, NORTH CAROLINA
SOUTH CAROLINA — Florence, Columbia, Charleston, Beaufort
GEORGIA — Atlanta, Savannah, Montgomery
FLORIDA — St. Augustine, St. Johns, Tallahassee
ALABAMA — Selma, Montgomery
KENTUCKY — Nashville
TENNESSEE
MISSISSIPPI — Vicksburg, Jackson, Natchez
LOUISIANA — Baton Rouge, White Castle, New Orleans
Bay St. Louis
MICHIGAN — Lansing, Detroit
INDIANA — Lafayette, Urbana, Indianapolis, New Castle, Columbus
ILLINOIS — Chicago, Highland Park, Oak Park, Kewanee, Racine, Springfield, Bloomington, Centralia, St. Louis
WISCONSIN — Spring Green, Madison, Milwaukee
MINNESOTA — Minneapolis, St. Paul
IOWA — Dubuque, Iowa City, Des Moines
MISSOURI — St. Joseph, Kansas City, Jefferson City
ARKANSAS — Little Rock
Ohio, Mississippi rivers
NORTH DAKOTA — Bismarck
SOUTH DAKOTA — Pierre, Missouri
NEBRASKA — Omaha, Lincoln, Platte
KANSAS — Topeka, Wichita
OKLAHOMA — Oklahoma City
TEXAS — Fort Worth, Dallas, Austin, Houston, San Antonio
MONTANA — Helena
WYOMING — Cody, Cheyenne
COLORADO — Denver, Pueblo, Promontory Point
NEW MEXICO — Taos, Santa Fe, Laguna, Acoma, Quemado, Rio Grande, Grand Canyon
IDAHO — Boise, Snake
UTAH — Salt Lake City, Great Salt Lake, Rifle Gap
ARIZONA — Phoenix, Scottsdale, Tempe, Tucson, Colorado
NEVADA — Carson City
WASHINGTON — Seattle, Olympia, Aberdeen, Columbia
OREGON — Portland, Salem
CALIFORNIA — Sacramento, Berkeley, San Francisco, Palo Alto, Fresno, Yosemite Valley, Santa Barbara, Los Angeles, Palm Springs, La Jolla, San Diego, Eureka

300 miles
400 km

CT CONNECTICUT
DE DELAWARE
DC DISTRICT OF COLUMBIA
MD MARYLAND
MA MASSACHUSETTS
NH NEW HAMPSHIRE
NJ NEW JERSEY
PA PENNSYLVANIA
RI RHODE ISLAND
VA VIRGINIA
VT VERMONT
WV WEST VIRGINIA

The space, composition, and activities of the Native Americans are laid out diagrammatically in White's illustrations. The insertion of labels and inscriptions further contributes to the educational effect. Although some knowledge of Renaissance **perspective** is demonstrated in the village scene, in his figure studies White used the English Elizabethan style. Here form is defined primarily with line. Linear decoration is emphasized wherever appropriate—as in costumes or painted designs on the body—and shading is timid. The pictures are clearly book illustrations rather than paintings made to adorn a wall.

But Roanoke Colony was destined not to survive. White, Hariot, and the other members of the group returned to London in 1586 aboard a ship commanded by Sir Francis Drake, the first English circumnavigator. The next year, White returned as governor of the colony, but this venture, too, was abandoned.

In England and Continental Europe, scientists, politicians, merchant-entrepreneurs and armchair-travelers were fascinated by pictures of the New World. De Bry's books were published in several languages in response to this interest in images and accounts of the wondrous land of America.

ARCHITECTURE IN NEW SPAIN, 1500–1700

By 1511, a Spanish colony had been established in Cuba. It became the regional governor's residence, the home port for the Spanish treasure fleets in the Americas, and the base from which other areas were explored.

FORTIFICATIONS

The continual struggle for domination of the region made fortifications essential. The Castillo de San Marcos is the primary monument to the Spanish era that still stands in Florida (Fig. 1.3). There had been wooden forts on or near the site since its establishment in 1565—St. Augustine was the oldest city in America. The present structure dates from 1672–87. St. Augustine was the anchor of Spanish claims and security in that part of the New World. There had been a devastating raid on the city by the English pirate John Davis (alias Robert Searles) in 1669, and the following year an English colony had been established at Charleston, South

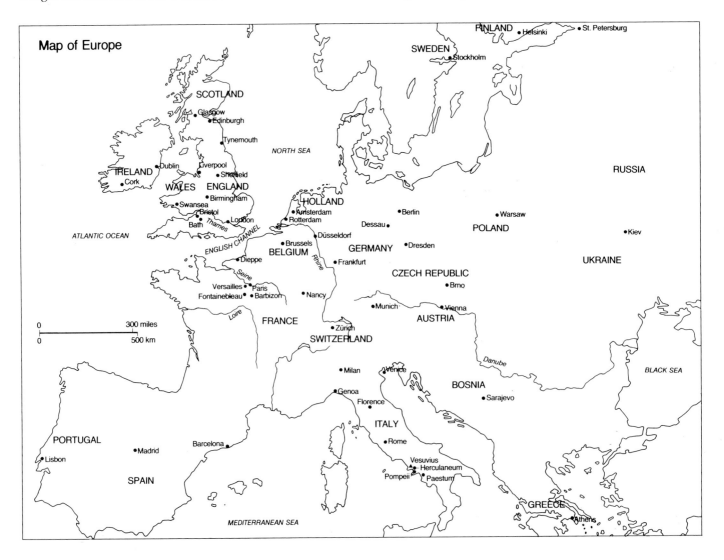

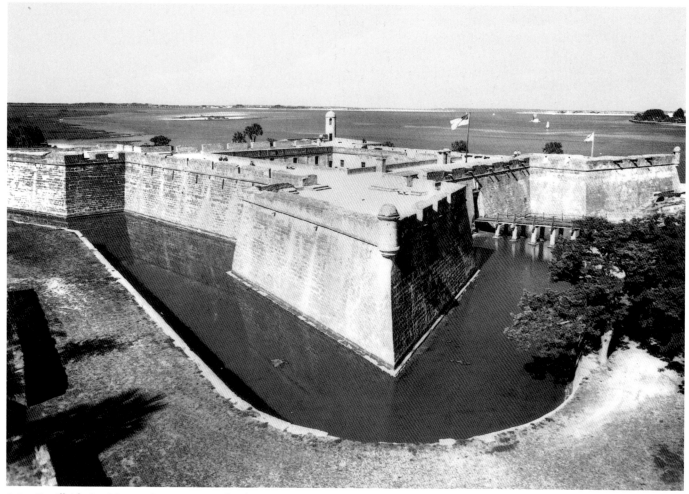

1.3 Castillo'de San Marcos, St. Augustine, Florida, 1672–87.

Carolina, only about 200 miles (322 km) up the coast. No doubt these factors had much to do with the decision to erect a major stronghold. Ignacio Daza's design of the Castillo de San Marcos is typical of European fortifications from about 1500, when a new form of military installation had been devised in response to the firepower of cannon. In Europe this type of fort replaced the medieval castle.

The basic plan at St. Augustine is a square about 200 feet (61 m) across with an enclosed courtyard and projecting triangular bastions at each corner. While the walls were generally lower than those of the old castles, they were much thicker, in order to withstand bombardment from artillery. The fort was erected by Native American and convict labor. It was constructed of *coquina*, or shell-limestone, which is virtually indestructible—it absorbs cannonballs, whereas other types of stone shatter upon impact.

The Castillo faces the Atlantic Ocean to the east, and the other three sides are encircled by a moat crossed by a drawbridge. The battlements are 25 feet (7.6 m) high and 12 feet (3.7 m) thick at the base, with sloping outer walls that reduce to a depth of 7 feet (2.1 m) at the top. Cannon could be moved about on the upper level, to fire through parapet

openings. Within the massive bastions were the governmental offices, barracks, and storage rooms. The effectiveness of the fort is borne out by the fact that the Spanish were able to maintain their presence in the area despite a series of English attacks until Florida was ceded to England in 1763.

THE PUEBLO TRADITION

Many buildings survive as reminders of the Spanish presence in the American Southwest, none more significantly than the mission churches. The conquest there was primarily aimed at spreading Catholicism among the Native American tribes. There was, in fact, virtually no economic incentive to settle the Southwest, once the dream of the Seven Cities of Gold was conceded to be unfounded. By 1580, Franciscan friars had already established a number of missions among the Pueblo peoples.

The Pueblo village of Taos was settled by the Spanish in the early seventeenth century as a center for trade with the Native Americans. The name Pueblo is synonymous with the unique native type of communal dwelling they built

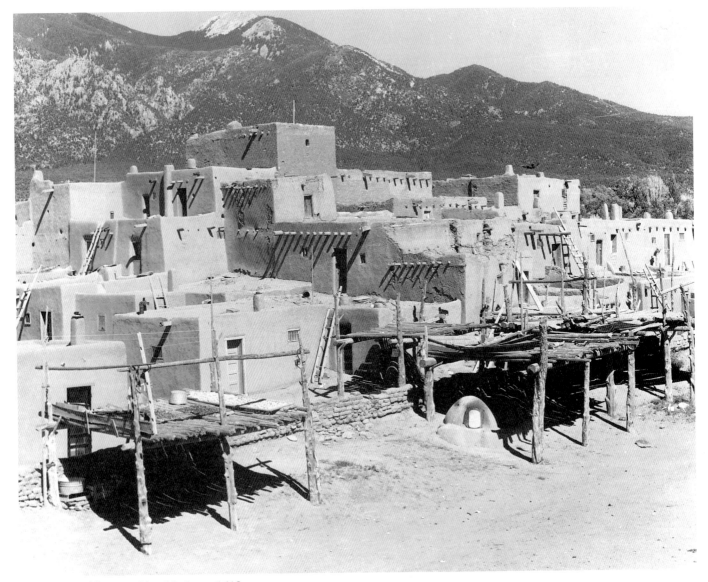

1.4 Taos Pueblo, Taos, New Mexico, c. 1610.

(Fig. 1.4). The pueblo was a large apartment complex often three to five stories high. Its massive blocklike forms grew irregularly at random with none of the order and symmetry that characterized European architecture. Walls were penetrated by only a few small windows. The total absence of applied decoration gave a bold, primitive simplicity to the form, and the whole was unified by the monotonality of the warm, sunburnt color of the earthen material.

Construction was of adobe—a mixture of clay, sand, and water—which was effective as an insulation against the heat of the desert. As the building material was taken from the site itself, the structure and the land upon which it was built seemed to become one. The Native American method of constructing walls—called puddling—was to apply successive layers by hand, each layer being allowed to dry before the next was added. The building was literally shaped by hand, which accounts for the soft edges and irregularities of the surfaces. The roofs were always flat but with a slight slant. They were made with pine logs, the ends of which protruded beyond the walls. Branches and brush were laid across these logs before the adobe was applied.

In terms of design and technology, the pueblo architectural tradition exerted a strong influence upon Spanish structures, for they were built by Native American labor. The situation was very different from that along the Eastern Seaboard. In the English colonies there, the architecture was not influenced by Native American motifs and techniques —it was purely European in form and construction.

Native laborers were employed in building the Spanish structures because they were the only labor force available. The influence of the pueblo tradition is seen in the Palace of the Governors at Santa Fe, erected soon after the Spanish established the site in 1609 as the governmental center for the territory (Fig. 1.5). Its blocklike mass, its thick, solid,

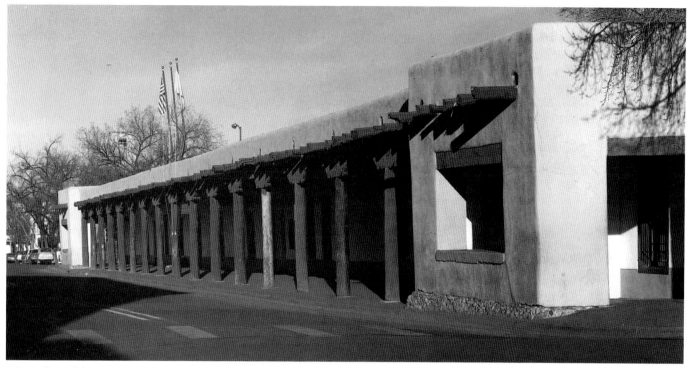

1.5 Palace of the Governors, Santa Fe, New Mexico, 1610–14.

unadorned, and generally unperforated walls, and its building material all recall the pueblo complex at Taos. However, here a Renaissance sense of architectural order and symmetry has been imposed upon the design. The Spanish introduced adobe bricks, which were formed in molds and baked in the sun. Bricks allowed for quicker construction than the puddling method and for straighter edges and more precise corners. Once the brick construction was finished, however, all walls were puddled with coats of mud, resulting in the handworked, uneven surfaces seen in pueblo complexes. Like the pueblo buildings, the Governors' Palace achieves an organic harmony with the land because it rises immediately from it. Land and building are of the same substance.

The covered porch is purely Spanish, for such a motif was unknown in Native American structures. Moreover, a Spanish element is found in the bracket **capital** atop each supporting post—the capital form was never used in native buildings. The pueblo influence reappears in the beams, which project from the walls, but their careful regularity further emphasizes the Europeans' sense of order.

MISSION CHURCHES

Governmental buildings such as the palace at Santa Fe or the occasional trading post were few in number compared to the many missions that were built. The task of converting the Native American population to Catholicism did not prove to be difficult. By 1628 some fifty churches had already been built in the territory, under the direction of

some two dozen friars. Missions were usually built at the site of Native American settlements, and they were more than just churches. Each one also included a school, a hospital, and a priest's house. There the Native Americans could learn farming techniques, reading, and writing.

The Spanish brought with them two animals that changed the way of life in the Southwest—the horse and the cow. Horses brought about a revolution in the way Native Americans hunted game, and they were also used as beasts of burden, which were previously unknown among the Native American peoples. Longhorn cattle became the breeding stock for the future great ranches of the region. So a way of life that had persisted for thousands of years—from spiritual beliefs to modes of acquiring food—changed dramatically with the arrival of the Spanish. Equally, Spanish ways were altered by both the land itself and the aboriginal people who lived there.

The simplicity and massive size of the pueblo complex assumed a monumental character when applied to the early mission churches such as San Estevan, at Acoma, New Mexico (Fig. 1.6). An ancient Pueblo habitat located dramatically atop a mesa (a plateau with steep sides) rising 350 feet (107 m) above the desert plain, the site became a mission center after the arrival of Fray Juan Ramirez in 1629. The viceroy in Mexico City had decreed that the government should provide every friar going out to establish a mission with the following tools and materials for building a church: 10 axes, 3 adzes, 3 spades, 10 hoes, 1 medium-size saw, 1 chisel, 2 augurs, 1 plane, 1 latch, 2 small locks, 1 dozen hinges, and 6000 nails. Beyond that assistance he was on

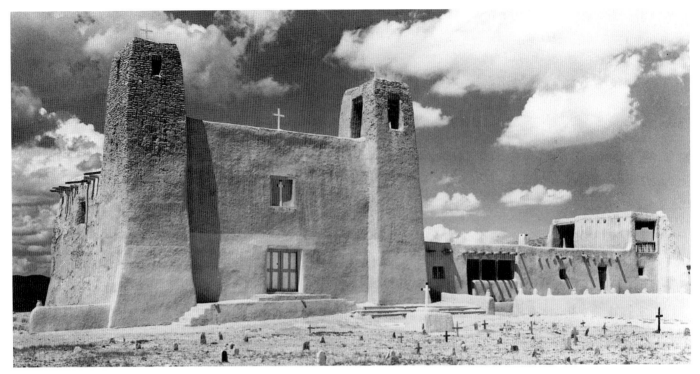

1.6 San Estevan, Acoma, New Mexico, 1629–42.

his own. Moreover, there is no evidence that any trained engineer or architect ever entered New Mexico in the seventeenth century.

Soon after his arrival, Fray Ramirez began the construction of a great church, employing Native American workers and using adobe. Among the Pueblo people, the building of walls by the puddling method had long been the work of women and girls, and it can only be assumed that this tradition was generally continued in the building of the mission structures. Here at Acoma, as at Santa Fe, the Pueblo were taught the southern European method of making bricks in wooden forms and drying them in the sun. All materials had to be carried up the narrow path to the top of the mesa.

The general plan of the church was of European origin, with a long **nave** that led to the sanctuary where the altar was placed (Fig. 1.7). The façade has a central **portal** and large bell towers at the corners, for Fray Ramirez was trying to imitate, in his own necessarily modest way, the great cathedral in Mexico City, Montezuma's former capital. That enormous church had been started in 1563. Its design was elaborate, with fine detail wrought by architects, masons, and sculptors who had been brought over from Spain especially for the purpose. It served as the primary "intermediary" between the splendid seventeenth-century Baroque churches of Spain and territorial outpost versions, such as San Estevan at Acoma.

In its structure San Estevan took on the character of pueblo architecture with its bold simplicity, virtually windowless walls, rough surfaces, and projecting beam poles.

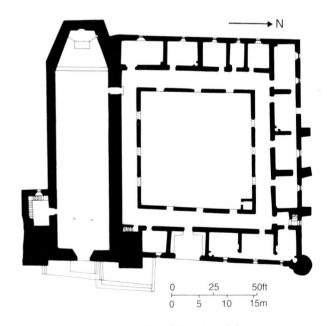

1.7 San Estevan, Acoma. Plan of church and cloister.

The flat roof was constructed of timber beams, across which brush was laid and spread with a thick layer of adobe. Wood, being scarce, was used sparingly as a building material. The European church design was thus modified by the building techniques and materials of Native American laborers to create the unique architectural form of the Spanish colonial mission church.

ARCHITECTURE IN THE SOUTHWEST: 1700S
STRUCTURE AND DECORATION

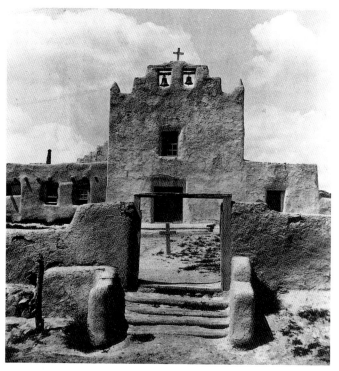

1.8 San José, Laguna, New Mexico, c. 1700.

1.9 San José, Laguna. Interior.

The church of San José at Laguna, New Mexico, built about 1700, possesses a similarly amalgamated form (Fig. 1.8). Under the guidance of Fray Miranda, it was constructed of **fieldstone** bound together with adobe. The entire surface was then plastered with adobe mud to give an effect identical to that of San Estevan. Native American laborers had no experience of quarrying stone or dressing it in a form for **ashlar** (squarehewn) **masonry**.

The façade has simple rectangular openings for the doorway and the single window, and the portal is typically undecorated. The doorway and the large window above it have large handhewn beams across the top. Arched openings are rare in early architecture in the Southwest, where the simple **post and lintel** system was used. This is because the indigenous workers, and probably the Franciscan brothers, did not know how to construct arches, either for doorways or for **vaults** over the nave. All edges and surfaces

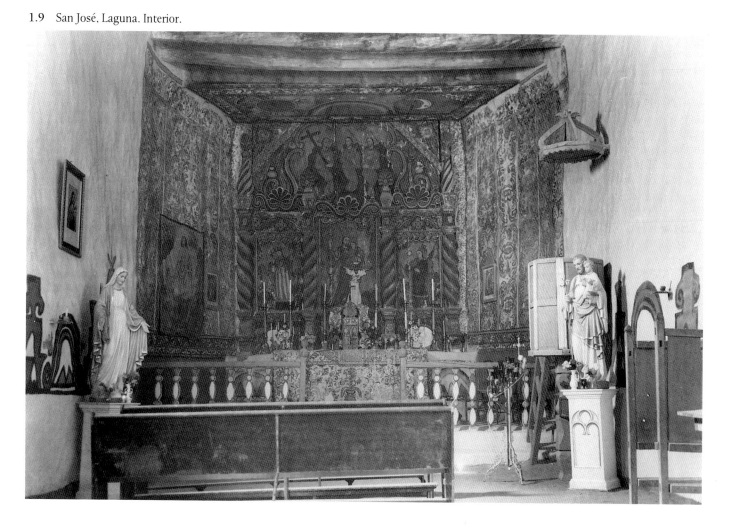

of the exterior are rounded, in the pueblo manner. Rising above the flat roof is an essentially triangular bellscreen, which attempts to imitate the ornate **stepped-gable** design of Spanish Baroque churches. At the corners are rough approximations of the turrets or scrolls often found on seventeenth-century Catholic churches. An idea of the appearance of the exterior of the **apse** end of a mission church may be gained from Paul Strand's famous photograph of the building at Ranchos de Taos, which dates from about 1780 (Fig. 31.11).

In the interior of San José one is immediately aware of exposed ceiling beams and windowless, uneven walls of pueblo construction (Fig. 1.9). The most pronounced indication of two distinct forms of cultural expression is found in the painted decorations. Along the side walls are the flat, simple, geometric, and abstract designs that were carried out by Native American artisans in their own style. These handsome symbols of corn, sun, rain, and thunder are bold and impressive. **Mural painting** in the pueblos existed as a native art well before the arrival of the Spanish—colorful wall decorations were commonplace.

At San José, the end wall is painted in an entirely different style, probably by a man of Spanish origins. These apse decorations are derived from the Spanish Baroque tradition, with typically Catholic imagery. The wall—the most important in the church, since it serves as a backdrop to the altar and the mass—is compartmentalized in the form of a **reredos** screen, with painted columns, capitals, and **entablatures**. All is exuberantly Baroque, creating compartments that contain the images of various saints and other religious figures. The style reveals an emphasis on human proportion, anatomy, and corporeality that was foreign to Native American artisans, who tended to reduce natural form to an abstraction.

The infusion of Spanish culture into the Southwest accelerated as the area became more widely colonized. The portal of San José y San Miguel de Aguayo, built in San Antonio, Texas, about 1770–5, is the work of a talented professional sculptor who was trained in Spain in the execution of elaborate Catholic iconography (Fig. 1.10). The style is known as Churrigueresque, taking its name from the sculptor José Benito Churriguera (1665–1725). His work epitomized Baroque sculpture in Spain, and his style was transported around the world to Spanish colonies.

The sculptor of the portal of San José is believed to be Pedro Huizar, who was trained in Spain in the Churrigueresque manner, and probably came to San Antonio by way of Mexico City. The imagery is what one would expect. Above the window is San José, patron of the mission, while below is the Virgin of Guadalupe, patroness of Mexico. On either side of the window are the saints Francis of Assisi and Dominic.

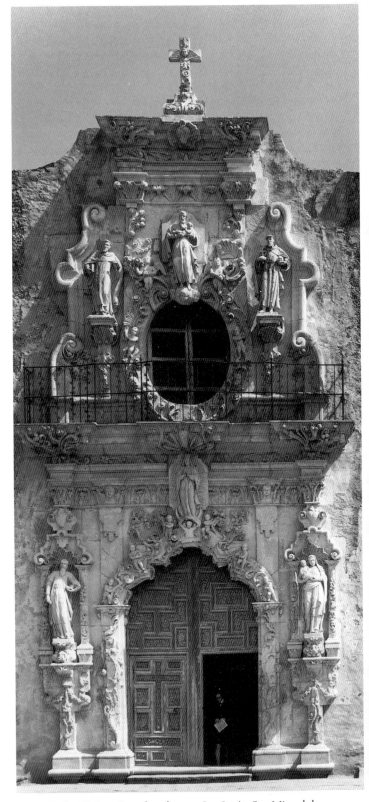

1.10　Pedro Huizar, Portal sculpture, San José y San Miguel de Aguayo, San Antonio, Texas, c. 1770–5.

PROVINCIAL BAROQUE

The American Revolution came and went with scant regard in the Southwest, which was still a land apart. At the grand *haciendas* of the great Spanish landowners, and especially in the churches of the region, there was a movement to create an environment resembling that of Old Spain. This can be seen in the Franciscan mission church of San Xavier del Bac, erected between 1784 and 1797 outside of present-day Tucson, Arizona (Fig. 1.11). Time and distance have placed this building out of its natural historical sequence. Its design largely ignores the advent of the Rococo and neoclassical movements in European architecture. It is still Baroque, long after that style had been superseded in Europe.

The architectural vocabulary, the bold masses, and the rich decorations are all thoroughly Baroque, even if they are not integrated in a sophisticated manner. Two towers dominate the façade, with an ornate portal between them. Although construction was of brick, which was covered with white-painted stucco, none of the handformed pueblo effects is seen here. Trained masons produced true and precise forms, straight lines, sharp edges and corners, and flat, smooth surfaces. High architectural skills were also needed to produce such sophisticated features as flying buttresses on the bell towers and round-headed arches. The plan of San Xavier is cruciform with shallow oval domes, whose construction required special knowledge and skill. They cover each of the two bays of the nave, the apse, the transept arms, and the crossing. Clearly, San Xavier del Bac is architecturally more ambitious than any church yet discussed. Because of its provincialisms, it would never be mistaken for a major, high-style Baroque church in Spain. Nevertheless, it was all that Spanish colonial church architecture aspired to in the American Southwest, and it may be considered the culmination of its type.

California experienced little European colonization until the 1770s. Once again, the first wave consisted of missionaries bent upon the conversion of Native American souls. Foremost among these was a Franciscan friar, Junipero Serra, who founded missions, taught such useful farming techniques as irrigation, and generally prepared the way for the next wave of colonials—the ranchers. Following his death in

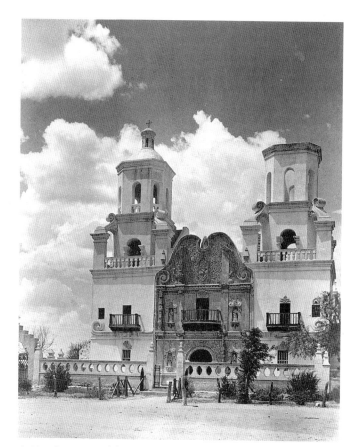

1.11 San Xavier del Bac, near Tucson, Arizona, 1784–97.

1784, a series of churches was erected on the site he had consecrated at Santa Barbara, until a devastating earthquake in 1812 required the building of an entirely new church. Work was begun on the church dedicated to Santa Barbara in 1815, based on a design by Father Antonio Ripoll, and it was consecrated five years later.

By 1850 nearly all of the land that is now Texas, New Mexico, Arizona, and California had become a part of the United States. Although a Spanish flavor has remained to this day, the influence of settlers arriving from the Eastern Seaboard began at once to change the formerly heterogeneous Spanish culture.

CHAPTER TWO

ARCHITECTURE AND DECORATIVE ARTS:

VIRGINIA, NEW ENGLAND, AND NEW NETHERLAND IN THE SEVENTEENTH CENTURY

The quest for religious freedom and the search for economic opportunities were the two primary reasons for which people came to the shores of the New World in the seventeenth century. Each was as potent an incentive as the other, and they proved by no means mutually exclusive. As the century opened, English merchant-adventurers were growing increasingly interested in the profit potential of the New World. By 1602 Bartholomew Gosnold was exploring the New England coast, and he became the first Englishman to set foot on Massachusetts soil. Then came the founding of Jamestown and the vast territory named Virginia in honor of the English "Virgin Queen," Elizabeth I (reigned 1558–1603).

About the same time a small group of dissenters broke with the Church of England and organized themselves into a congregation in Scrooby, Nottinghamshire. These "Pilgrims" wandered in search of religious freedom, to Leyden and Amsterdam in Protestant Holland, then back to England and, finally, in 1620, to a place in North America they called Plymouth Plantation. Meanwhile, the English sea captain Henry Hudson, under commission of the merchants of the Dutch East India Company, sailed the *Half Moon* into what is now New York harbor and up the broad river that bears his name. The Dutch soon established a fur-trading post on Manhattan Island, and by 1624 a group of Walloon (French-speaking Belgian) Protestants had settled Fort Orange, later renamed Albany. A fine natural harbor led to the establishment of Salem, Massachusetts, by 1628. Then in 1630 the Great Migration began, with the arrival in Boston harbor of Governor John Winthrop. He came from England with a fleet of eleven ships under the auspices of the Massachusetts Bay Company—its stockholders hoped that the colonists would make them rich.

Settlement of the New World proceeded rapidly. By 1631 the Dutch arrived in Delaware Bay, and in the following year Lord Baltimore received a royal charter from England's King Charles I. He was to establish a colony on Chesapeake Bay

which was named Maryland in honor of Charles's Catholic queen, Henrietta Maria. It was to be a religious haven where English Catholics would be free to practice their religion.

The Rev. Roger Williams had a similar motive in founding Rhode Island in 1636—there Baptists in particular, but also members of other denominations, could worship as they chose. By the 1650s, Quakers were beginning to arrive in Rhode Island, fleeing from Congregationalist Massachusetts. They had been warned they would be hanged if they returned—some did, and they were. In 1654, the first group of Jews arrived, seeking escape from persecution in Brazil. The colony of South Carolina was created on paper in 1670, and ten years later Charleston was settled. At first it was an economic venture, but later it became a refuge for Huguenot Protestants fleeing from France. With the founding of William Penn's Quaker colony in 1681, the great wave of establishing new colonies along the coast of America was complete.

To the north, the French had been attracted to the vast expanses of Canada by the richness of the fur trade. To the west, the French Jesuit missionary Jacques Marquette and the fur-traders Sieur de La Salle and Louis Joliet had explored the great Mississippi River region in the 1670s and 1680s.

Everywhere there was wilderness—a "howling wilderness," one New England minister called it. Settlements took root slowly, often painfully, but root they did. If the land was raw and untamed, it was also free of much of the restriction, privilege, and prejudice that had become knotted into the fabric of European society. The colonists naturally brought with them an array of cultural habits, but being remote from monarchical, ecclesiastical, and economic authority, this new land offered the opportunity for new patterns of life to develop.

In Virginia, for example, where land was plentiful and enormous estates evolved, one family could establish several plantations of hundreds or even thousands of acres for each

of its children. In England and Europe, very little land was available to commoners because it was already owned by either the aristocracy or the church. Furthermore, under the law of primogeniture, only the eldest son inherited the family estate, while siblings were essentially left out of the will and had to make their own way. The abundance of land in the New World made such a law unnecessary. In the patriarchal society that emerged, every white male colonist in Virginia had the opportunity of becoming a great land-owner, and land ownership symbolized power, authority, and wealth. That Native Americans actually owned the land was seldom either an ethical or a legal consideration—European settlers saw the land there for the taking.

The economic motive was strong in Virginia, and success gradually began to unfold. By 1612 the early Virginia planter John Rolfe had begun to cultivate tobacco, and two years later he sent the first shipment of it to England, thereby founding the economy upon which the southern plantation system would be based. Rolfe had married Pocahontas, daughter of a Native American chief, and in 1616 he took her to London, where she was presented at court. That same year a shipload of women was sent to Virginia where they were sold to planters, to become their wives, for 120 pounds (54 kg) of tobacco each. Another group of one hundred pauper children from London soon arrived to become apprentices in useful trades, and by 1619 slaves from the west coast of Africa were being imported to work the fields. At first the plantations were modest, even crude, but the incentive toward refinement of lifestyle seems to have arrived with the colonists, and it remained with them ever after.

New forms of government were created almost immediately. In them the seeds of the later Constitution, Bill of Rights, and systems of checks and balances can often be seen. In Virginia, the governor was appointed by the king and ruled with the advice of his council (a kind of "upper house"). But from the beginning there was also a form of "lower house" in the House of Burgesses, which was composed of men who were elected as representatives of their constituents. In New England, the Pilgrims had not yet disembarked when they signed the Mayflower Compact, in which they created their own new form of government—although they did pledge loyalty to the king. Here were people laying a foundation for governance with the consent and approval of the governed. This form of group decision-making also found strong expression in Congregationalism, the official religion of Massachusetts (as opposed to Anglicanism in Virginia). It united secular and religious authority, and its very name indicates that it was the congregation (that is, the people) who met to determine all things, from the selection of their minister to the allocation of common resources. This religious forum was the origin of the New England town-meeting type of government, where people could stand up and have their say, and, if franchised, cast a vote to decide an issue.

But if the new Americans eagerly discarded the useless or unworkable trappings of Old World governance and social stratification, they also retained much of the culture of their homelands. In the end, it would be English cultural patterns that dominated. By the end of the seventeenth century the Eastern Seaboard, from Maine to Georgia, was ruled by England.

ARCHITECTURE IN EARLY VIRGINIA

The first permanent English settlement was at Jamestown, Virginia. It was founded in 1607 by a motley group of wellborn gentlemen, pardoned prisoners, a few craftsmen, and a handful of soldiers, all sent out by the merchant-adventurers of the London Company. It would be hard to imagine a group less prepared to wage the fierce struggle with the wilderness, the climate, and the Native Americans, but survive they did. Their early period is chronicled in Captain John Smith's *General Historie of Virginia, New England, and the Summer Isles . . .* (1624).[1]

As ships from home brought more settlers and supplies, the little town grew. But towns were to be rare in the vast expanse of land known as Virginia, for farming was to prove more central to the economy than trade. The plantation houses of the great estates turned out to be the real hubs of activity and the centers from which English cultural patterns radiated. Tobacco—the source of the planters' wealth—was baled and loaded aboard ships that carried it to England. There it was exchanged for necessities and, increasingly, for refined English-made objects to grace the lifestyle of the Virginia plantation owners. The great plantation house in its most elegant form, however, was a creation of the second quarter of the eighteenth rather than of the seventeenth century. All evidence indicates that the homes erected during the first century of the colony's existence were little more than modest farmhouses.

ADAM THOROUGHGOOD HOUSE

Few structures survive intact from seventeenth-century Virginia, but those that do are all constructed of brick. This is misleading, for most of the houses were timberframe structures of the English Tudor type. The timberframe buildings were probably similar in plan to the Adam Thoroughgood House (Fig. 2.1), which was made of locally produced brick. The lime for the mortar was obtained from crushed oyster shells.

Adam Thoroughgood arrived in Virginia from England in 1621, prospered as a farmer, and by 1629 had become a member of the House of Burgesses. Before he died in 1640 he owned over 5000 acres (2000 ha) of land. His home has traditionally been dated about 1636, but some scholars believe the house now standing must have been built by his descendants, and assign it a date of about 1680.

The house has a simple plan of two rooms on each of the

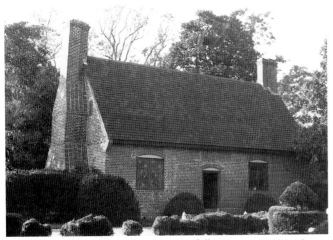

2.1 Adam Thoroughgood House, Norfolk, Virginia, 1636–40.

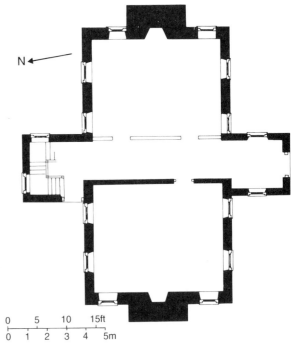

2.2 Bacon's Castle, Surrey County, Virginia, c. 1655.

2.3 Bacon's Castle. Plan.

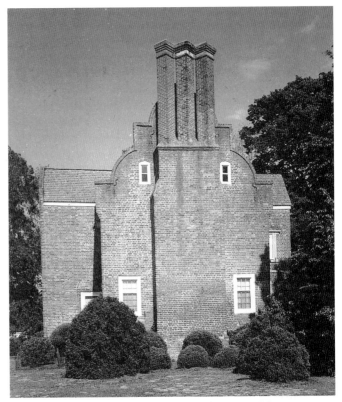

main and attic floors. The doorway is placed near the center of the façade, and leads into a small hall which also accommodates the stairway. Chimneys, which dominate each end, diminish twice before reaching the chimney stack. There is a fine geometric boldness and simplicity in this form, and a comparable design had been used in contemporary English farmhouses. Both the high rise of the compound chimney stack and the high pitch of the roof give a vertical accent to the design that reveals its medieval origins—or at least the Tudor survival of a medieval form. The windows, with their small diamond-shaped, leaded panes, further contribute to the medieval appearance.

The symmetry of the façade is only approximate, for the door is slightly to the left of center, and neither window is precisely in the middle of its half of the wall. There is neither an exacting application of a classical theory of proportions, nor any use of classical decorative motifs, despite the fact that the Renaissance-Baroque architectural tradition of classical inspiration had already been introduced into England through such works as Inigo Jones's Queen's House at Greenwich (1616–35) and his Banqueting Hall at Whitehall (1619). Jones (1573–1652) was an architect working in the service of court circles that readily embraced the current vogue of Continental Baroque high style and Palladian design.

The absence of the classical approach reflects the relatively low social status of the Virginia settlers. They would continue to cling to the old medieval-based Tudor style. Adam Thoroughgood, for example, had arrived there in 1621 an indentured servant, with roots in the yeoman class. He, therefore, erected the type of house that was known to that social group in England. The Thoroughgood House's unpretentiousness befits the social conditions of its owner.

BACON'S CASTLE

Bacon's Castle, also constructed of brick, is a grander type of house (Fig. 2.2). Built by the planter Arthur Allen about

1655, it acquired its name from being used as a bastion by the followers of Nathaniel Bacon during Bacon's Rebellion of 1676. This was an unsuccessful popular revolt against the royal governor when the latter failed to provide adequate defense on the frontier against Native American raids.

In plan, Bacon's Castle has one room on either side of a hall that runs through the center of the house. There is an entrance porch at the front, while a similar construction at the end of the hall axis contains the stairway (Fig. 2.3). In **elevation**, it is two-and-a-half stories high. The **gabled** porch or tower on each façade forms a central vertical axis that establishes the symmetry of the design. Seen from the front, the house is a rectangular block, with a **stringcourse** (a slightly projecting row of bricks) dividing first and second stories. At each level there are two windows on either side, aligned one above the other. The geometric scheme of the façade was clearly carefully thought out.

The most distinctive element of the design, however, is seen in the ends of the house. Here shaped gables and three chimney stacks, set diagonally, rise above the ridge line of the roof. The gable form had been imported into England from Holland or Flanders in the late sixteenth century, and had become a frequent component of late Tudor architecture. The juxtaposition of the three diamond stacks with the curves and angles of the gable provides a handsome decorative effect. It indicates a knowledge of high style that goes well beyond the vernacular style of the Thoroughgood House. These features are found in various English Tudor houses, such as Condover Hall, Shropshire, or Hatfield House, Hertfordshire, and also in the Dutch House at Kew Palace, Surrey, which was built in 1631. But as ambitious as Bacon's Castle was, it was still not of the size or grandeur that was to characterize the great plantation mansions of the eighteenth century. Nor was it wrought in the classical design of the late Baroque.

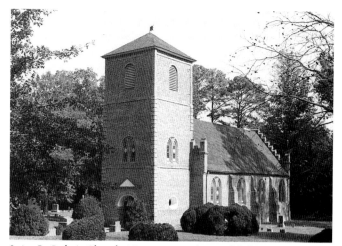

2.4 St. Luke's Church, Newport Parish, Smithfield, Virginia, 1632.

Medieval vestiges at St. Luke's are also seen in the **buttresses** of the nave, and in the windows between them with their pointed arches and **mullions**. Windows of similar design are found in the second level of the tower and in the **chancel** wall. The stepped gable reveals a Dutch influence. However, the **quoining** at the corners of the tower, the round-headed arch of the doorway, the triangular **pediment** naïvely worked into the wall above it, and the circular windows of the tower base suggest that the classical motifs of the Baroque had begun to intrude upon the medieval style.

CHURCHES

The powerful medieval heritage surviving in the architecture of the English middleclass is obvious in the one remaining seventeenth-century church in Virginia—St. Luke's, built in 1632 in Newport Parish, Smithfield (Fig. 2.4). This survival is not surprising, for few new churches had been built in England after King Henry VIII renounced Roman Catholicism and established the Church of England in 1534. Instead, the old church buildings had been appropriated and used throughout England until the 1660s, when the age of the great English architect Sir Christopher Wren (1632–1723) ushered in a new, Baroque style. Even thereafter, the medieval churches continued in use, despite the fact that they were stylistically out of date. Thus the parish architecture familiar to the settlers of Virginia was of English Gothic design. A typical small parish church had a nave with a squared-off eastern end for the altar and a large square tower at the west for the entrance—precisely the form seen in St. Luke's. As there were no towns in early Virginia other than Jamestown, the fifty or so churches that were erected in the seventeenth century were small and placed at locations convenient to the burgeoning plantations. Without any large centers of population, there was no need to erect large churches.

ARCHITECTURE IN NEW ENGLAND

New England architecture of the seventeenth century similarly reveals a medieval heritage. But for social, economic, and religious reasons it evolved in forms very different from those of Virginia. Many who came to Massachusetts were Puritans—nonconformists seeking religious freedom. There can be no doubt that the rocklike faith of these people had much to do with the success of the Massachusetts Bay Colony and had a great impact on the character of the settlements. But the immigrants came for other reasons, too. Almost all of them were from the ranks of England's middleclass and yeomanry, and many sought economic opportunities not available to them at home. Economic depressions in the seventeenth century left thousands destitute, and to the destitute even the howling wilderness seemed like a land of opportunity. The combined desire to worship according to one's conscience and to prosper economically forged an iron will that commands respect.

When the immigrants first came ashore, the initial concern was to erect temporary shelters. These probably took the form of bark huts, which Native Americans taught them to build. Others are likely to have been crude dugout sod

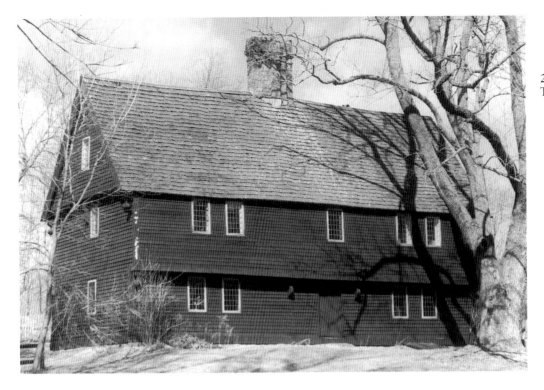

hovels copied from the fields or moors of England. The earliest permanent structures had a single-room plan with a large fireplace at one end. The door was set near the corner and gave access to a small entrance hall. Behind this was a stairway to the loft (Fig. 2.6a). The timber post and beam construction used horizontal planks for the exterior. As on many of the small farmhouses the settlers had known back home, the roof was thatched.

PARSON CAPEN HOUSE

The Parson Capen House was built at Topsfield, Massachusetts, in 1683. In plan, it consists of two "cottages" placed end to end (Fig. 2.5). Families often started out with a one-room cottage and then added another virtually identical section to one end (Fig. 2.6b). This accounts for the position of the chimney in the center of the house, and also explains why the doorway is slightly off center (as in the Adam Thoroughgood House, Fig. 2.1). The Capen House is two stories high, with one room on either side of the central fireplace on each floor. The door leads into a small entrance hall, which contains a steep, rather cramped stairway;

although sufficiently utilitarian, it is far from elegant.

There is a solemn dignity to the design and appearance of the Capen House, arising in large part from the simplicity of its form and from the minimal use of decoration. In style it is medieval, and it follows a form long used by the middleclass in England. The steep pitch of its roof gives it a decidedly Gothic verticality, and there are no classical architectural adornments.

The Capen House and others of its type were products of carpenter-craftsmen, rather than of architects who were versed in the Renaissance and Baroque theories of classical architecture. Artisans who raised such houses were applying the skills and practical knowledge inherited from generation upon generation of carpenters—people who had little or no knowledge of Vitruvius, Palladio, or Inigo Jones.

The typical seventeenth-century New England house was constructed of wood from the local forests (Fig. 2.6 a, b, c). A frame of heavy squared timbers was first erected, with angle braces at the corners. Vertical studs were then inserted to define the walls, and joists were laid to support the floors. The open spaces of the walls were filled with a mixture of clay and straw (daub and wattle) or with crude bricks, and

2.6 Plans, showing evolution of typical 17th-century New England houses: (a) cottage, (b) hall and parlor, and (c) hall and parlor with lean-to.

a

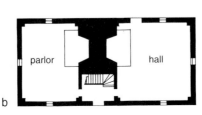

b

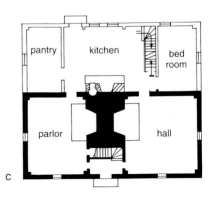

c

then the outer wall was covered with **clapboards**. Fireplaces and chimneys were constructed of brick or stone. Windows were few, relatively small, and made of small diamond-shaped panes that were leaded together, as they had been since the late Middle Ages. A more modern form of windows has replaced these in the Capen House. The door, like the windows, was always set within a simple casement frame, without decorative moldings, classical **pilasters**, or pediments. It was made of solid planks, adorned only by the pattern of the nails that held it together. In the typical house, an overhang resulted where the second story extended (for structural purposes) a little beyond the lower floor. The **pendant**, suspended from the corner of the overhang, was one of the few instances of architectural ornamentation.

There is, undeniably, a certain plainness about seventeenth-century New England houses of the Parson Capen type. But it should not be assumed that it resulted only from the austerity demanded by Puritan religion. In fact, Puritanism never made such demands. John Calvin—the great codifier of Puritan beliefs—advocated anything but a stern, harsh life for his followers. While Puritans were opposed to ostentation, austerity was demanded only by the rare fanatic. In addition, the house type is not an exclusively New World-Puritan creation, for it was used in England long before there were Puritans. It can hardly be understood as an expression of Puritanism, given that it served equally well for Catholics and members of the Church of England—the antagonists of the Puritans. Such houses should be seen as the homes of the middleclass in general. Their leanness of design is due more to economy and middleclass cultural traditions than to Puritanism. The Capen House was actually quite pleasant and comfortable for its day, sober though it may appear to later generations.

JOHN WARD HOUSE

The John Ward House in Salem was built in 1684, and was constructed in the same way as the Capen House. Its form was modified at attic level—two large gables were added (Fig. 2.7). The timber frame is covered with clapboards, enclosing two rooms on each floor, one on either side of the central fireplaces. The overhang, the asymmetrical arrangement of door and windows, the small diamond-shaped, leaded panes, and above all the steep pitch of the several gables reveal the medieval origins of the building.

2.7 John Ward House, Salem, Massachusetts, 1684.

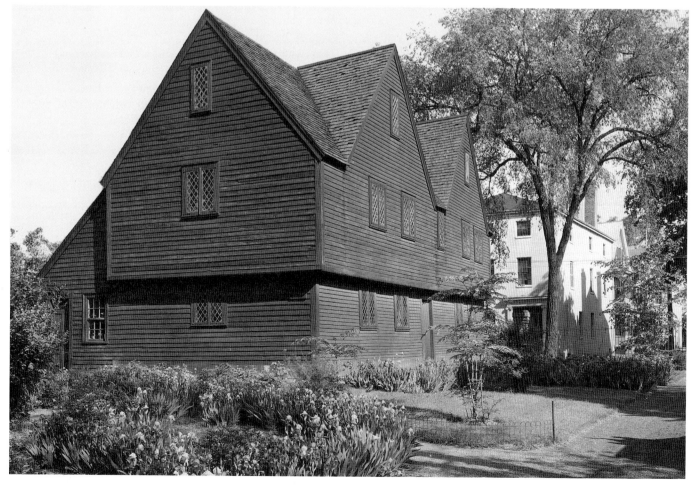

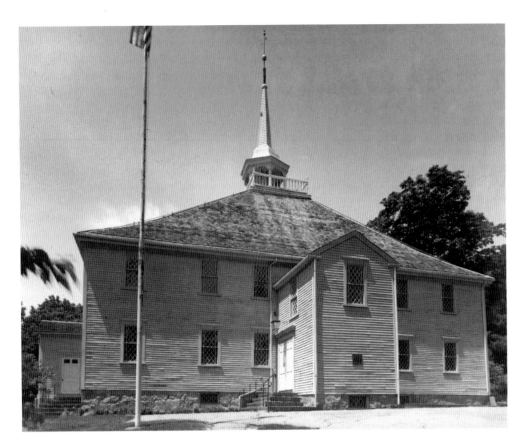

2.8 Old Ship Meetinghouse, Hingham, Massachusetts, 1681.

Another modification of the basic seventeenth-century New England house plan was the addition of a lean-to section at the back (Fig. 2.6c) to create the **saltbox form**. The extra roof could either continue in the same plane, as at the rear of the Ward House, or could be set at a different pitch. The lean-to section usually contained a kitchen with its own fireplace. Thus its addition removed much of the daily activity, clutter, and congestion from the hall.

MEETINGHOUSES

There were, of course, structures other than houses erected in seventeenth-century New England. Warehouses were built down by the wharves, and there was a need for shops and taverns. The Boston Town House of 1657 was a large public market and meeting place. Educational buildings were required too. Harvard College was founded in Cambridge in 1636, and Harvard Hall was built in 1674–7.

One example survives of a type of building central to the lives of New Englanders—the Congregational meeting-house. The Old Ship Meetinghouse was so-called because the curved struts of the roof supports resemble the framing of a ship's hull, turned upside-down. It was built at Hingham, Massachusetts, in 1681 (Fig. 2.8). Congregationalist Puritans detested Anglicanism almost as much as Catholicism, and they wanted nothing in their house of worship that reminded them of either the Church of Rome or the Church of England. Therefore, all earlier ecclesiastical forms were purged in favor of a simple, square construction. The aim was to leave the praise of God to the individual soul rather than to rely on glorious temples.

As it had no known prototype in the history of English church architecture, the meetinghouse must be seen as an original form that was developed in New England in response to deep-rooted religious convictions. And just as religion and civil matters were often integrated in the day-to-day events of life, the meetinghouse served as both a place of worship and the site of the famed New England town meetings. Hence, the Old Ship Meetinghouse looks as much like a secular as a religious structure.

Its original form was square with a **hipped roof** that had a large steeply pitched gable on each side, giving it more of a medieval appearance than it now has. The interior is consciously unelaborate, with enormous roughhewn wooden beams and struts left exposed in the vast open space. There is no longitudinal orientation toward a sanctuary, as is the norm in previous Christian church design. The pulpit is placed against one wall, and there is no altar. At this date, Protestants were absolutely opposed to any form of religious imagery, so this building is deprived of the carved and painted decorations and stained glass that enrich the interiors of Catholic churches. Throughout, the meeting-house's unpretentious plainness bespeaks the simple faith and strength that guided the lives of those who met within its walls.

NEW ENGLAND INTERIORS

On the inside as on the outside of New England houses there was not much in the way of architectural frills or applied decoration. Bedrooms were on the second and third stories, while two rooms of the ground level were typically a hall and a parlor. The word "hall" did not designate a hallway as the term is used today, but referred to a large living space in the medieval sense. While the parlor was used mainly upon formal occasions, the hall was the center of daily life. Food was cooked at the great fireplace, and meals were eaten at a nearby table. Candlemaking, spinning, sewing, and record-keeping were done in the hall, and it was there that the family gathered in the evening, often for the reading of Scripture or secular literature.

The rooms had low ceilings with exposed beams, plastered or occasionally paneled walls, and floors laid with broad planks. The usual complement of furnishings in the hall included a table, chairs and stools, a chest, a carved wooden Bible box, and possibly even a small bed. In addition there would be an assortment of cooking and eating utensils, as seen in the Oyster Bay Room at Winterthur Museum (Fig. 2.9). The parlor normally contained the best furniture in the house.

FURNITURE

New England furniture in the seventeenth century was basically late medieval in style, although occasionally a Renaissance or mannerist motif appeared. It was the work of local craftsmen who had mostly learned their cabinetry and joinery skills in England, where such furniture was used in middleclass homes. Made of oak or pine, it was characterized by heavy proportions. Geometric designs or abstractions of natural forms were incised in low relief as decoration. Some parts were turned on a lathe.

The great oak table of the type used in the hall is simple in design and construction, and sturdy in its turned legs of bold

2.9 Oyster Bay Room, 17th-century interior, as installed in Winterthur Museum, Winterthur, Delaware.

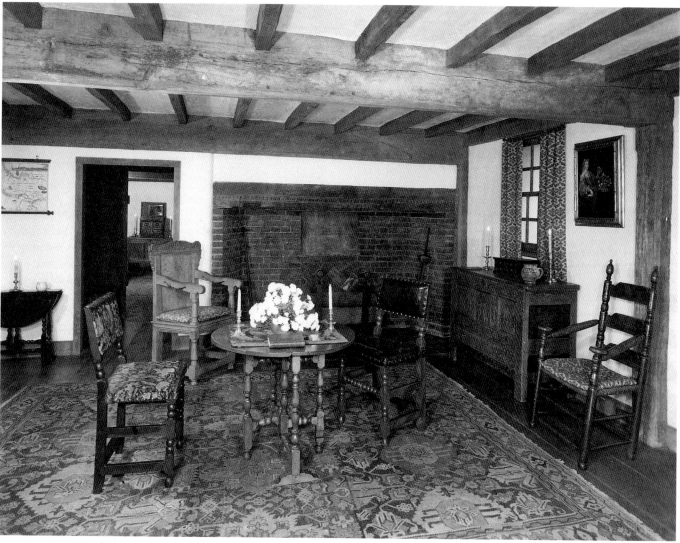

proportions (Fig. 2.14). While handsome, such a table was more serviceable than elegant, more sensible than elaborate or ornate. **Gateleg tables** with fine turnings, of the type seen in Figure 2.9, were popular because they could be folded up and set against the wall, as seen at the left of the illustration.

Chairs and Couches The master of the house or a special guest might sit in a Brewster chair, made entirely of lathe-turned parts (Fig. 2.10). This specific chair has established the generic term for chairs of its type, for it was once owned by the elder William Brewster of Plymouth Plantation. Its rectilinear severity is softened by the gentle curves of its turnings. Two examples of a type known as a side chair are

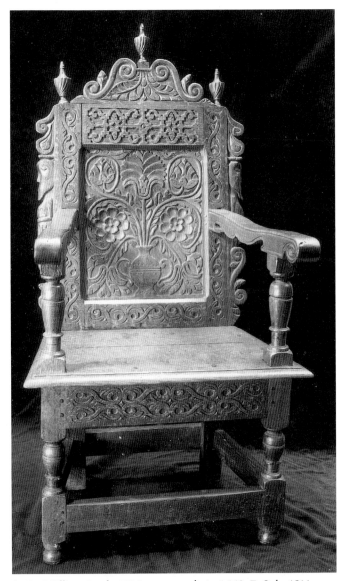

2.11 William Searle, Wainscot armchair, 1663–7. Oak, 48½ × 25½ × 15¼in (123.2 × 64.8 × 38.8cm). Bowdoin College Museum of Art, Brunswick, Maine.

2.10 Turned armchair, Brewster type, 1620–30. Ash, height 3ft 9in (1.14m). Pilgrim Hall, Plymouth, Massachusetts.

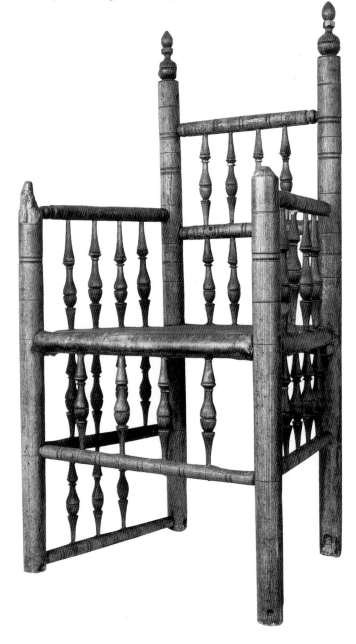

seen on either side of the table in Figure 2.9. At the left is a colorful Turkey-work chair, so-called because of its English-made upholstery fabric, which imitated Turkish carpeting. At the right is a Cromwellian chair, the leather of its seat and back held in place with brass tacks.

The most impressive and expensive type of chair, however, was a thronelike wainscot seat distinguished by ornately carved panels and applied decoration (Fig. 2.11). A great chair of this type is medieval in form. But the scroll and urns at the top, and the **strapwork** relief on the front skirt, indicate that late Renaissance motifs have entered the repertoire of its maker, William Searle (1634–67). Searle had been trained in joinery by his father in Devon, England, before he emigrated to Massachusetts around 1660, eventually settling there in Ipswich.

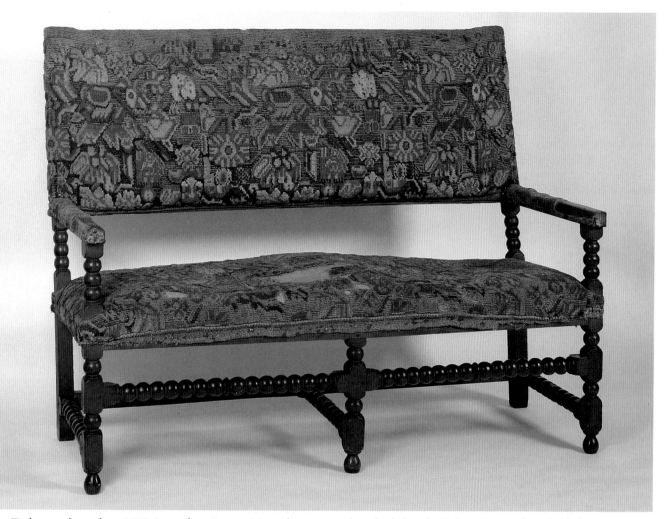

2.12 Turkey-work couch, c. 1698. Frame from Boston, Massachusetts, maple and oak, length 5ft (1.52m). Textile probably from Norwich, England, 1690–5. Essex Institute, Salem, Massachusetts.

A wealthy merchant of the period might have been able to afford an upholstered Turkey-work couch for his parlor. Its main feature would have been an imported knotted pile fabric of brilliant colors—such elaborate weaving was not done in the colonies (Fig. 2.12). The vibrant tones of this couch belie the notion that seventeenth-century New Englanders chose a drab, gray existence.

Chests and Cupboards

As closets were rare, clothing and other items were stored in chests. A particularly popular type was the **Hadley chest**, named after the town in western Massachusetts where many of them were produced (Fig. 2.13). Almost all of its parts were structural—that is, few pieces were applied purely for decorative purposes. The front is covered with low-relief strapwork embellishments (top and bottom **rails**) or floral abstractions (the three large panels).

The Renaissance strapwork motif had entered English art via Continental craftsmen who had gone to work in England during the late sixteenth century. It was also imported

2.13 Thomas Dennis, Hadley chest, 1676. Oak, maple, walnut, $31^{11}/_{16} \times 49^{5}/_{8} \times 22^{5}/_{8}$in (80.5 × 124.5 × 57.5cm). Courtesy Winterthur Museum, Winterthur, Delaware.

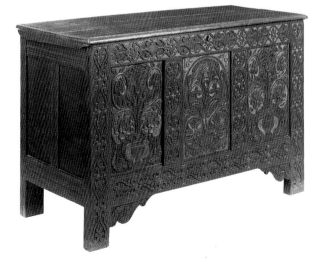

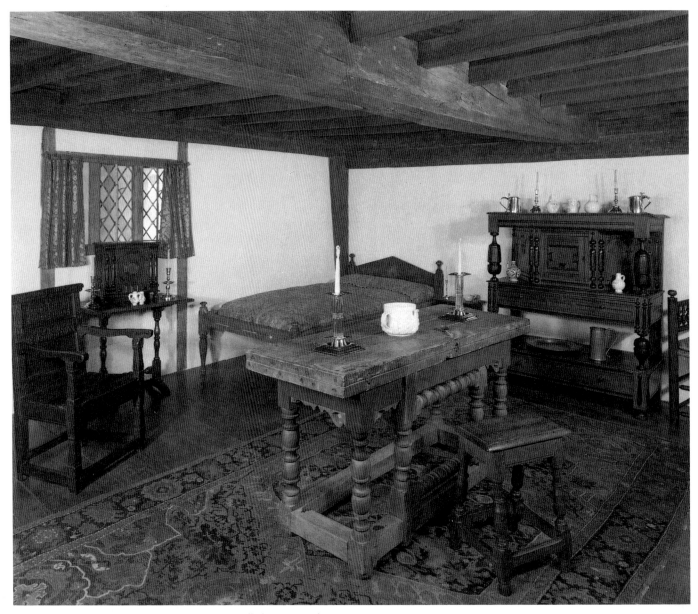

2.14 Hart Room, 17th-century interior, as installed in Winterthur Museum, Winterthur, Delaware.

through design books with engraved plates illustrating furniture styles from the Low Countries, Germany, and France.[2] This particular chest is attributed to Thomas Dennis (1638–1706) who, like Searle, had come to Ipswich from Devon and was an accomplished joiner. His work is similar to Searle's, as can be seen by comparing the carving on the chest with that on the great chair by Searle (Fig. 2.11).

In the division of the crafts of those days, people like Searle and Dennis were called joiners, that is, craftsmen who assembled furniture by means of **mortise-and-tenon joints**. The component parts were usually flat boards with incised or applied decoration. In contrast, a turner was someone who worked mainly with a lathe to produce rounded parts such as **balusters** and **spindles**, or legs and rungs, as seen in

Figure 2.10. Carpenters built houses or ships, while masons worked with stone or brick.

Thus the court cupboards to be found in the parlors of especially prosperous New Englanders would have been constructed by joiners and turners. A large, handsome one made by Thomas Dennis is seen against the wall at the right in Figure 2.14. Its bold, massive form is enlivened with intricate moldings, turned balusters, and turned spindles that have been split and applied to flat surfaces. Court cupboards were usually made of several different kinds of wood for decorative effect, and parts were often painted red, cream, and black. Again, this suggests the enjoyment of colorful domestic interiors. The family's silver plate, **pewter**, or any especially fine ceramic ware was displayed on the top and lower shelves.

METALWORK

The silversmith was a craftsman who was essential to seventeenth-century American communities. After about 1650, colonists tended to keep their wealth in the form of silver objects—solid silver that they called plate—for at that period there were no banks. Moreover, the silversmith's artistry not only brightened the interiors of colonists' homes, but also testified to their prosperity. For daily dining, pewter or wooden plates and bowls were used. Candlesticks were normally made of brass.

By mid-century, the earliest of the New England silversmiths—the partners John Hull (1624–83) and Robert Sanderson (1608–93)—had begun work. Both were born in England, and both immigrated in the mid-1630s. It was they who minted America's first coinage, the Pine Tree shilling, beginning in 1652.

Two of the earliest and finest of the native-born silversmiths, Jeremiah Dummer (1645–1718) and John Coney (1655/6–1722), are believed to have served their apprenticeships under Hull. Both then worked in Boston. An example of Dummer's skills is seen in a tankard which bears his mark, "ID," to the left of the handle, just beneath the lip (Fig. **2.15**). It was normal for a piece of silver to have both the initials of the silversmith and the family crest or some

2.15 Jeremiah Dummer, Tankard, 1690–1700. Silver, height 7¼in (18.4cm). Yale University Art Gallery, New Haven, Connecticut.

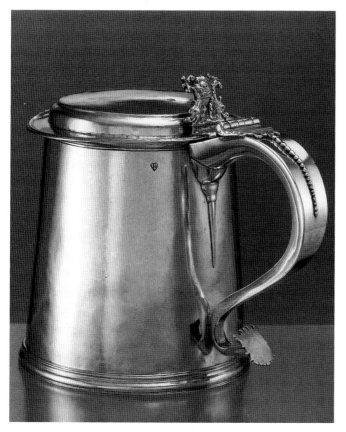

2.16 Edward Winslow, Sugar box, 1702. Silver, 7⅜ × 6³⁄₁₆in (17.8 × 15.7cm). Courtesy Winterthur Museum, Winterthur, Delaware.

other identifying mark of the owner stamped into it or engraved upon it. In form, the simplicity of the undecorated, tapering body of the tankard is relieved by the boldly swooping scroll of the handle and the cast dolphin and mask thumbpiece.

A sugar box (Fig. **2.16**) made by Edward Winslow (1669–1718) at the turn of the century is much more elaborate. Winslow was born in Boston and is thought to have served his apprenticeship under Dummer. His sugar box is a *tour de force* of design and craftsmanship, with nearly every surface richly decorated with Baroque motifs. Its style follows English examples, and there is even a little cast medallion of St. George (patron saint of England) and the dragon on the hasp in the center. Sugar was a valuable commodity in the seventeenth century, and sugar boxes were given or commissioned to celebrate a courtship, a marriage, or the birth of a child.

NEW NETHERLAND

Very little survives today from the seventeenth-century Dutch colony of New Netherland. The town of New Amsterdam (later to become New York) was settled in 1626 by a group sent over purely for trade by the Dutch West India Company. The colony's population did not increase as rapidly as that of New England, however, for there were not the same incentives to settle overseas. No Dutch people needed to flee Holland for fear of religious persecution, for their homeland was already Protestant. And the economic opportunities at home made it unnecessary to journey halfway around the world to a hostile wilderness to find prosperity.

2.17 Stadthuys, New Amsterdam, 1641–2. From a 19th-century lithograph by George Hayward of a sketch by A. Danckers. Courtesy The New-York Historical Society, New York City.

2.18 Winant-Winant (Hendrickson-Winant) House, Rossville, Staten Island, New York, 17th century.

THE STADTHUYS AND BRICK TOWNHOUSES

A **lithograph** taken from a sketch made by Adrian Danckers in 1679 (Fig. **2.17**) records the early development of New Amsterdam. In the center stands the Stadthuys, constructed of stone in 1641–2. Like all the other buildings except one, it has the crow-stepped gable that is typical of Dutch architecture. The houses surrounding it were built of brick—the Dutch had long excelled in brickwork. Unlike New England houses, which were each set in the middle of a lot, the Dutch townhouses abutted each other in tightly grouped rows, just as in the towns of the Netherlands.

DUTCH FARMHOUSE TRADITIONS

The Dutch farmhouse had a different form from the townhouse. The Hendrickson-Winant House at Rossville, on Staten Island, is a typical example (Fig. **2.18**). The four walls of the one-story rectangular block were built of stone, with chimneys encased within the end walls. Overhanging eaves extended the roofline beyond the walls. The style seems vernacular and provincial, and there is neither evidence of a knowledge of classical theory nor a use of classical motifs in its design. Inside, the rooms had low ceilings, and the walls were probably whitewashed.

Within a house such as this, one type of furniture that surely must have been present was the Dutch *kas*, a wardrobe used for storing clothes and linens (Fig. **2.19**). *Kasten* made in New Netherland closely followed the prototype form made in Holland. It is believed that the man who made and painted this one had developed his skills before emigrating. A large casepiece capped by a huge molded **cornice**, it has exterior surfaces handsomely painted with **grisaille** (monochrome) decorations. These are the earliest form of still life painting in the colonies. Furniture made of inferior or inelegant woods such as pine or gum was often painted. Artists in Holland excelled in the painting of flower and fruit pictures, and the decorations on the *kas* are fully in

2.19 *Kas*, 1700–35. Tulip wood, maple, paint, 69⅞ × 62¼ × 22⅝in (177.5 × 158.1 × 57.5 cm). Courtesy Winterthur Museum, Winterthur, Delaware.

the Baroque style, with no lingering reminiscences of medieval designs or techniques. Although this is a somewhat later example, pieces of this type did adorn seventeenth-century interiors in New Netherland. Such work, together with decorated tiles around the fireplace, would have brightened the interiors of colonial Dutch homes. New Amsterdam had become an English colony in 1664, but this piece testifies to the survival of Dutch traditions long after that date.

CHAPTER THREE

PAINTING AND SCULPTURE:

THE SEVENTEENTH CENTURY

Following the establishment of any colony, attention had to be focused on obtaining the necessities of life. Several hard decades would elapse before thoughts could be directed toward cultural luxuries. The settlers knew that they lived on the fringes of civilization, but as prosperity came, people emerged who cared about cultural development. They were anxious that their children should not grow up untutored, and so schools were established early—but mainly for boys, since girls of that period received little formal education in any part of the world.

In 1636 Harvard College was founded in Cambridge, Massachusetts—the first institution of higher education in America. Three years later, Boston got its own printing press, which initiated a remarkable flow of printed books and pamphlets to a highly literate population. The first book printed in America, *The Bay Psalm Book*, was published in 1640. By 1686, Boston could boast eight bookshops, and there can be no doubt that the printed word was a powerful vehicle for the circulation of ideas in New England.

By contrast, Governor William Berkeley of Virginia railed against such things in 1671 when he wrote, "I thank God that we have no free schools nor printing presses, and I hope we shall not have for a hundred years, for learning has brought disobedience and heresy... into the world; and printing has divulged them and libelled governments. God keep us from both."[1] Virginians tended to send their sons to England to be educated. The first institution of higher education in their colony—the College of William and Mary—was not founded until 1693. This was about the time that the *New England Primer*, that earliest of American schoolbooks, was first published in Boston. In the closing decades of the seventeenth century, New Englanders learned to enjoy music a little, and when they had their portraits painted, they wanted to be shown as stylish and prosperous.

Who were the people who appeared in these portraits? For the most part, in New England, they came from the urban merchant class. As it prospered, it created a kind of mercantile aristocracy at the tip of the social pyramid. These people were determined to succeed in the world, and possessed a powerful strain of materialism—something that seems to have become a part of the American character

virtually with the founding of the country. They listened to their ministers in the meetinghouse on the sabbath, but then devoted the rest of the week to profits in the countinghouse.

Neither they nor their ministers saw anything wrong with that. In fact John Calvin, the religious reformer they followed, had written in his *Institutes of Christian Religion* (1536), that it was a Christian duty to fulfill one's secular calling to the best of one's abilities. Obedience in this would please God, and would be rewarded with prosperity. This so-called "Puritan work ethic" was broader than Puritanism, for it applied to the middleclass generally. It proclaimed worldly effort to be a way of praising God. It was tailormade for the ambitious middleclass because it gave spiritual sanction to people's aggressive will to prosper. According to Marxist interpretation—which looks at society from a workingclass rather than an upper middleclass point of view—this philosophy of life was a misguided bourgeois fallacy. But it was a value-system that was subscribed to by people like the Freakes, whose portraits will soon be considered.

The earliest American paintings were exclusively portraits. As is the case with all art, their style expresses something of the society and culture from which they sprang—in this case, a middleclass, Protestant background. In the seventeenth century, the middleclass had an art of its own that was distinct from that patronized by royal courts and aristocratic circles. The type of portrait that Sir Peter Lely (1616–80), the court painter, created of King Charles II simply would not have done for a man of the merchant class. Thus, two strains of art evolved in England—one princely, the other middleclass. The purpose of the latter was not only to preserve a likeness in the portrait, but also to express deep-rooted secular and even religious values. The images of the men, women, and children of the so-called "Puritan century" were not always manifestations of Puritan gloom. Much more often they were icons that praised worldly prosperity and such secular virtues as industry and moderation.

Contrary to popular belief, the Puritans did not have any prejudice against art, except for the religious imagery of Catholicism. Portraiture was the main form of painting in

England, and such art was acceptable to New Englanders once they had established their settlements, obtained sufficient wealth to support such an art, and finally had someone in their midst who could produce it. All of this fell into place around 1665 to 1675.

NEW ENGLAND PORTRAITS

THE FREAKES

John Freake was a successful lawyer and merchant of Boston, and his wife Elizabeth Clarke Freake was the daughter of an equally prosperous merchant. They lived in one of the town's finest homes, which was probably similar to the Capen or Ward houses (Figs. 2.5 and 2.7). It was furnished with such niceties of living as could be obtained from local craftsmen or imported on one of John Freake's ships. Many would agree that the masterpieces of seventeenth-century painting in New England are the portraits of the Freakes and their baby daughter, Mary (Figs. 3.1 and 3.2). Elizabeth sits in a Turkey-work chair similar to the one in Figure 2.9—one of the finest types of chair known in New England homes. This is a subtle reference to the subject's wealth, which she must have been pleased to have

3.1 Anonymous, *John Freake*, c. 1671–4. Oil on canvas, 42½ × 36¾in (108 × 93.4cm). Worcester Art Museum, Worcester, Massachusetts.

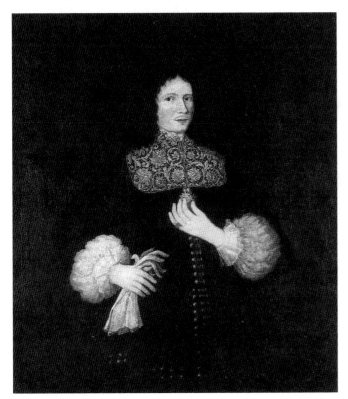

included in her portrait. The inventory of John's estate reveals that he owned over a dozen such chairs.

The Freakes wanted their portraits to include emblems of their prosperity which proved that they enjoyed God's blessing. In a supposedly classless community, one's position in society was measured by the extent of one's wealth. Mr. Freake, a stylish young man with shoulderlength, wavy hair and a neatly trimmed mustache, wears a handsome dark-brown velvet coat, which has a row of numerous silver buttons and embroidered buttonholes. His shirt sleeves are crenelated, and he holds a pair of gloves, an overt symbol of his gentleman's status. His left hand toys with a beautiful, ornate brooch, and he wears a lovely collar of imported Spanish or Italian lace.

His wife is equally well attired in her satin dress and red-orange petticoat trimmed with a rich brocade. Black and orange ribbons decorate her sleeves, and she, too, wears a beautiful lace collar. All the fabrics of her attire are expensive and imported. Moreover, she wears three strands of pearls around her neck, a garnet bracelet, and a gold ring. But, in spite of all the finery displayed in these portraits, the Freakes and their social contemporaries would have drawn a definite line between honorable prosperity and sinful ostentation. They would not—either in their lives or their portraits—have exceeded a known limit beyond which pride and vanity would have brought censure from their peers and from God.

The style of the Freake portraits had its origins in the neomedieval portraits of Elizabethan and Jacobean England. It had been formed in the sixteenth century in reaction to the sensuous, classical, illusionistic style that had spread out of Italy and across most of the Continent. It was recognized by the English as the true style of England. But when Charles I succeeded King James to the throne in 1625, the young monarch's tastes ran decidedly to the Renaissance and Baroque art of Italy, Spain, and France, which many of the English associated with Catholicism. In reaction to this, the conservative middleclass of his realm, especially the large Protestant segment, chose to cling to the old Elizabethan or Jacobean style, out of nationalistic pride and religious conviction.

The seventeenth-century middleclass English style is characterized by a flatness of forms and a lack of sensuousness in substances. Decorative patterning and linear definition of form are emphasized, and shading is used timidly. The dark neutral background probably came from Dutch art. It was acceptable to adopt features from Dutch painting, for Holland was a middleclass Protestant country. It was just this style that was introduced into New England around 1665–75, as seen in the Freake portraits.

ELIZABETH EGGINGTON

The image of Elizabeth Eggington (Fig. 3.3) is of the same generic style as that used by the Freake portraitist, or limner, but it is not by the same hand. It represents a girl who died at about age eight while her sea-captain father was

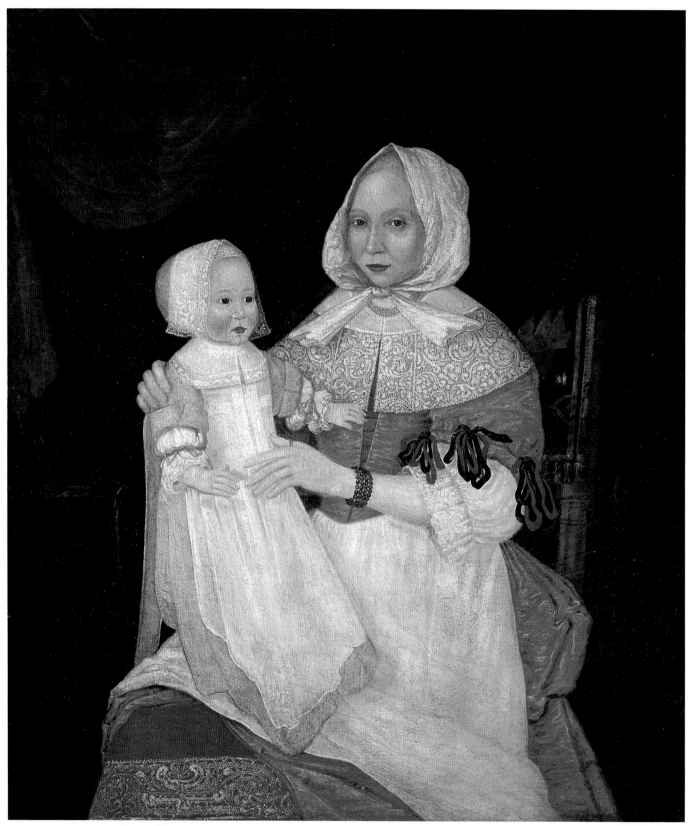

3.2 Anonymous, *Elizabeth Freake and Baby Mary*, c. 1671–4. Oil on canvas, 42½ × 36¾in (108 × 93.4cm). Worcester Art Museum, Worcester, Massachusetts.

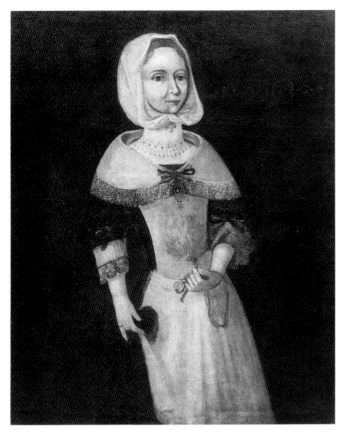

3.3 Anonymous, *Elizabeth Eggington*, 1664. Oil on canvas, 36¼ × 29½in (92.9 × 74.9cm). Wadsworth Atheneum, Hartford, Connecticut.

away. It may have been painted as a memorial for him. Her mother, the daughter of the Rev. John Cotton, had died soon after childbirth, and Elizabeth was raised by her widowed grandmother, who married the Rev. Richard Mather (Fig. **3.5**). This daughter of a merchant seaman thus lived at the center of both the mercantile and ministerial worlds of New England.

The richness of her attire testifies once again to the devotion of the merchant class to material pleasures, and the tolerance of the ministerial class as regards that passionate concern. Her dress is of a richly patterned fabric, trimmed with laces and bows. She wears an elaborate pearl and filigree necklace, while a drop pearl is seen below her chin. Beneath the ribbons that tie her collar together is a beautiful miniature, perhaps of her father, in a gold frame set with jewels, possibly rubies. In her left hand she holds a feather fan.

Anatomy is not fully mastered in the classical manner, and there is an absence of corporeal, or fleshly, form. Nor is space conceived in the Renaissance-Baroque manner. Rather, the human form is treated in a flattened decorative, non-corporeal way. Even the richest textiles are reduced to line, color, and pattern, and deprived of their sensuous, tactile qualities. There is none of the lush brushwork of a portrait by the English court painters Sir Anthony van Dyck

(1599–1641) and Sir Peter Lely. But charming works such as the Freake and Eggington portraits should not be dismissed for these reasons. They should be judged by the aesthetic criteria of their own Elizabethan-Jacobean survival style.

ELIZABETH PADDY WENSLEY

The final flowering of this middleclass, mercantile style is seen in the portrait of Elizabeth Paddy Wensley, painted about 1680 (Fig. **3.4**). The face is beautifully rendered and possesses a spark of life that animates the image. But her costume is the real glory of the picture, and again it shows how the accouterments of a portrait are used to elaborate upon the biography of the subject. The wife of a successful merchant, she wears a multicolored dress of rich and varied fabrics. It is adorned with lace, bows, and brocade, all stylishly fashioned. Her gold necklace, pearl earrings, and jeweled rings further tell of her wealth and position in society.

Shading is slight, forms are flattened, and linear decorative details are emphasized, as in the lace of her collar and the central band of her stomacher. Even the large bouquet of flowers at her side—a motif derived from Dutch art—is

3.4 Anonymous, *Elizabeth Paddy Wensley*, c. 1680. Oil on canvas, 41 × 33in (104.1 × 83.8cm). Pilgrim Society, Plymouth, Massachusetts.

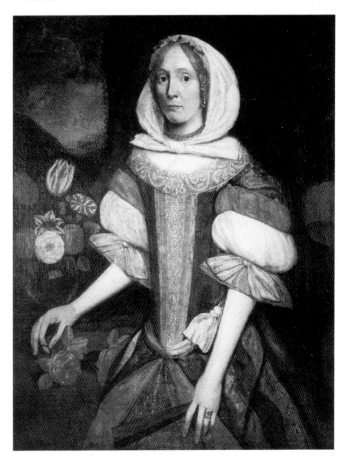

desensualized. But it still contributes to the lavishness of the image. Such a portrait clearly routs any theory of Puritan drabness.

Yet, until fairly recently, seventeenth-century New England portraits have been used to demonstrate the theory of Puritan gloom. This is the legacy of Nathaniel Hawthorne, author of *The Scarlet Letter* (1850) and *The House of Seven Gables* (1851). These doleful dramas about his seventeenth-century ancestors created such an indelible image of life in that period that his account of it became accepted as historical fact. The portraits of dour old men and ministers, and the innumerable skulls on gravestones, were cited as proof that life was indeed as he had described it. But Hawthorne was a nineteenth-century Romantic novelist writing fictional stories about just one or two aspects of life in early Salem. There was far more to Puritan existence than gloom and guilt.

EARLY PRINTS AND WOODCUTS: THE REV. RICHARD MATHER

The portraits of old men and ministers require careful analysis. The earliest known print produced in America is a small portrait of the Rev. Richard Mather (Fig. 3.5), Cotton Mather's grandfather (see p. 70). A Congregationalist minister, Mather had come to Massachusetts Bay from England in 1635 to escape persecution, and the next year he was called to the ministry at Dorchester, near Boston. As one of the founding fathers and a man of God, he was more committed to the religious purposes of the colony than were those who came to fulfill economic ambitions. The gravity of his image is appropriate for his profession. He is shown wearing a black ministerial robe with unadorned white collar, and he holds his eyeglasses in one hand and a book (probably either a Bible or the *Bay Psalm Book*) in the other.

The little **woodcut** of Mather was made by John Foster, one of Boston's first printers and since childhood a member of Mather's congregation. By the late 1660s Mather had become a venerable legend in his own time, and the woodcut may have been made as the frontispiece for *The Life and Death of that Reverend Man of God, Mr. Richard Mather* (Boston, 1670), written by his son, Increase Mather. Foster probably had little or no training in the graphic arts, but when circumstances called for a book illustration, he ventured to make one, using the rather flat, linear manner of the Tudor survival style.

DR. JOHN CLARK

A portrait of Dr. John Clark (Fig. 3.6), which was painted in 1664, is interesting because it demonstrates the presence in Boston of a painter who worked in a totally different manner from that of the Eggington limner. This artist practiced a fluid brushstroke, and attempted an illusionistic recreation of form, texture, and substance. He was bold in rendering

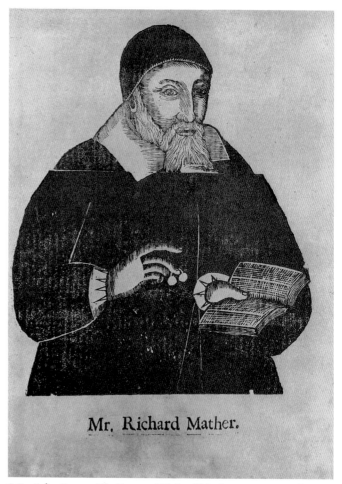

Mr. Richard Mather.

3.5 John Foster, *The Reverend Richard Mather*, 1670. Woodcut on paper, 6⅛ × 4⅞in (13.6 × 12.4cm). Massachusetts Historical Society, Boston.

light and shade, producing three-dimensional form within a believable space. The origins of this style lie in seventeenth-century Dutch portraiture rather than that of the English Elizabethan-Jacobean survival.

The Clark portrait also sheds further light on the presence of skulls in portraits. They have been understood as demonstrating the Puritan preoccupation with death, and of course skulls abound on the thousands of gravestones in early burial grounds (Fig. 3.13). In this portrait, however, the skull is a symbol of the subject's profession, as are the surgical instruments that are depicted. For Clark was well known for his operations on injured skulls.

SELFPORTRAIT OF THOMAS SMITH

The selfportrait of Thomas Smith (d. c. 1691) also includes a skull, and here it seems appropriate to interpret it as a symbol of death (Fig. 3.8). In 1690 Smith had already reached an age when he was contemplating death as a release from life's tribulations. The elegiac poem in the lower left of the painting reads: "Why why should I the World be

3.6 Anonymous, *Dr. John Clark*, 1664. Oil on canvas, 34 × 27in (86.4 × 68.6cm). Boston Medical Library, Francis A. Countway Library of Medicine.

ARISTOCRATIC COURT STYLE

By the last quarter of the seventeenth century there were signs that important changes were taking place in society and in art. A new element arose in New England society—men and women who saw themselves not as the heirs to the spiritual zeal of the founding fathers, but rather as the new leaders of the colonial élite and emerging mercantile aristocracy. These people sought an even higher lifestyle in their homes and their attire. The images they had painted of themselves reflected this new orientation. They rejected the old middleclass styles in favor of a modest version of the aristocratic court style of England (Fig. 3.7). Samuel Shrimpton was a wealthy Boston merchant and shipowner who resented the limits on his flamboyant lifestyle that the old-guard Congregationalists tried to impose. When he was in London on business in 1675, he had his portrait painted. In its Baroque richness and sensuousness it differs markedly from the Elizabethan-Jacobean survival style, resembling more the work of Sir Peter Lely than that of the Freake limner.

The Shrimpton portrait demonstrates that the middleclass was beginning to modify its lifestyle in emulation of that of the aristocracy, and so does the portrait of Maria Catherine Smith (Fig. 3.9). In the style of the hair and the revealing

3.7 Anonymous English painter, *Samuel Shrimpton*, 1675. Oil on canvas, 30 × 25in (76.2 × 63.5cm). Massachusetts Historical Society, Boston.

minding/therein a World of Evils, Finding/Then Farwell World: Farwell thy Jarres/thy Joies thy Toies thy wiles thy Warrs/Truth Sounds Retreat; I am not Sorye./The Eternall Drawes to him my heart/By Faith (which can thy Force Subvert)/To Crowne me (after Grace) with Glory." The poem is signed with the monogram TS. In old age and possibly afflicted with an illness, Smith intended the image to be a reflection of his anticipated departure from this life, when his soul would find its glory in heaven.

The style of Smith's selfportrait is basically Baroque in its rendering of solid, three-dimensional form in space, its treatment of light and shade, and its efforts to suggest textures. However, occasionally some lingering remnant of Jacobean painting appears, as in the decorative, detailed, and linear execution of the lace cravat. Smith is known to have been a mariner, and the view through the window probably depicts some event from his seafaring days. He had settled in Boston in 1650, and seems to have taken up portrait painting late in life, for several other portraits have been attributed to him.

3.8 Thomas Smith, *Selfportrait*, c. 1690. Oil on canvas, 24½ × 23¾in (62.2 × 60.3cm). Worcester Art Museum, Worcester, Massachusetts.

3.9 Anonymous, *Maria Catherine Smith*, c. 1690. Oil on canvas, 27½ × 25¼in (69.9 × 64.1cm). Courtesy American Antiquarian Society, Worcester, Massachusetts.

décolleté of the gown, the latter possesses a Restoration raffishness, a sensuality and fleshiness, and a devotion to current courtly fashions that are not found in the portrait of Mrs. Freake (Fig. **3.2**). There is also a bold, saucy expression on Smith's face. Her portrait was painted in the fluid brushstrokes of the style of Lely and his successor, Sir Godfrey Kneller (1645–1723).

While the colonial portrait stopped short of a total imitation of the aristocratic style, pictures such as *Samuel Shrimpton* and *Maria Catherine Smith* reveal the direction that painting in New England would take in the eighteenth century.

PORTRAITURE IN NEW NETHERLAND

Fewer paintings survive from seventeenth-century New Netherland than from New England. This is curious, considering the rich tradition in art that had permeated nearly every level of society in Holland. There had been a wide range of subjects which included not only portraiture but also still life, **genre** and interior scenes, and landscapes. Records indicate that there were some homes in New Amsterdam that had a number of such paintings adorning the rooms, all done, no doubt, in the fullness of the Dutch Baroque style. But precious few can be identified today as works that were either imported from home or created in New Netherland.

GOVERNOR PETER STUYVESANT

The portrait of Governor Peter Stuyvesant is one of the few paintings from seventeenth-century New Netherland to survive (Fig. **3.10**). It has been attributed to Henri Couturier, a Dutchman who had been admitted to the Leyden Guild of Painters—presumably as a fully trained, professional artist—before he emigrated to New Netherland in 1660. Before settling in New Amsterdam, Couturier spent a brief period in New Amstel (New Castle, Delaware) as a trader and public official. He was granted burgher rights in New Amsterdam in 1663 after painting the portraits of Governor Stuyvesant and his two sons. Little else is known about Couturier except that he left the colony in 1674 for London, where he died ten years later. In New Netherland, as in New England, nobody could make a living exclusively as a painter during the seventeenth century. There just was not that much demand for such work.

The Stuyvesant portrait is a competent if not brilliant characterization and display of painterly skills. It captures the stern, gruff personality of the subject while exhibiting the Dutch delight in **chiaroscuro** and textures within a

3.10 Attributed to Henri Couturier, *Governor Peter Stuyvesant*, c. 1663. Oil on wood panel, 21½ × 17½in (34.6 × 44.4cm). Courtesy The New-York Historical Society, New York City.

limited, low-key, Rembrandtesque palette. Its solid corporeal form, believable space, painterly brushwork, and bold use of light and shade distinguish it from the Elizabethan-Jacobean survival style that was first being used in New England at about the same time.

Soon after the portrait of Governor Stuyvesant was painted, New Netherland ceased to exist as a political entity. In 1664 Stuyvesant was forced to surrender the Dutch colony to the commander of an English fleet that sailed into New Amsterdam harbor. Thereafter, the colony was known as New York, and the cultural infusion came mainly from England. The Dutch colonists, however, long retained many of their traditions. They continued to use the Dutch language, they worshiped at Dutch Reformed churches, and they imported a few paintings from Holland. But there was little painting in the colony for several decades, until the rise of the Hudson Valley Patroon school around 1710.

PAINTING IN THE SOUTH

There was not much painting in the South during the seventeenth century, although several collections of family pictures were amassed to maintain the English custom of lining the walls of great houses with ancestral portraits. These are known from inventories and estate records in Virginia. There are also several portraits of Virginians which date from the 1690s. That of William Randolph, for example, is Baroque in style, with painterly brushwork, a subtle manipulation of light and shade, and a low-key palette (Fig. 3.11). It follows the current aristocratic English style that had been defined by Sir Godfrey Kneller. Even the pose follows one prescribed by Kneller for the portrayal of dignity and bearing.

Randolph was a man of intellectual pursuits, even while managing the affairs of his plantations and serving on the council of the royally appointed governor. Like most of the great planters, he was an Episcopalian who was as devoted to the high church as he was to the English monarchy. Such men took the English gentry as their role models, unlike the budding New England mercantile aristocracy, who tended to follow the ways of London's prosperous merchant class. In the great wig worn by Randolph, for example, the subject is seen following the high fashion of the English aristocracy. In contrast, the Boston merchant John Freake wears his own hair, neatly cropped to shoulder length (Fig. 3.1).

SCULPTURE

AN AUXILIARY CRAFT

Sculpture in seventeenth-century America was more a craft practiced by artisans than the fully developed artform that it later became. Moreover, it was usually subservient to some other form—furniture or architectural decoration, ship's carvings, or gravestones. It was virtually nonexistent as an independent work of art. Joiners or others in their woodworking shops carved ornate designs on the furniture they made—this was one of their auxiliary skills. Examples of such work are seen in the great chair and the Hadley chest discussed in chapter 2 (Figs. 2.11 and 2.13). This type of work was usually limited to shallow-relief carving. Its repertoire of motifs was derived from standard, stylized folk patterns of flowers or pinwheels, or from the numerous pattern books with engraved plates of late Renaissance or Baroque designs. In this decorative work the human figure was rarely attempted, for carvers had no experience with the classical ideal of an Apollo or a Venus. Also, their religion forbade the carving of religious figures. Indeed, neither the home, the garden, the public building, nor the town square had spaces specifically designed to receive statuary.

GRAVESTONE CARVERS

The one form of carving that touched the life of nearly everyone in the late seventeenth century was to do so after death. Many gravestones survive in New England burial grounds. Again, the carving is limited to low-relief designs cut shallowly into the plane. The technique was

3.11 Anonymous, *William Randolph*, c. 1695. Oil on canvas, 35 × 27in (88.9 × 68.6cm). Virginia Historical Society, Richmond.

uncomplicated, the iconography direct. If symbols of death abounded, so did motifs of salvation or rebirth. The gravestone offered one of the few opportunities for religious imagery in the Protestant world.

Prior to about 1670 most grave markers were made of wood, and these have long since disappeared. But in the decade that followed, several gifted stonecutters appeared in the Boston area. They began producing gravestones, principally in slate or sandstone, which imitated those found in English burial grounds.

Charlestown Stonecutter One of the early founders of this New England "school" of gravestone carvers was a man presently known only as the Charlestown Stonecutter. His masterpiece is the Joseph Tapping headstone of 1678 (Fig. 3.12). On it, the Protestant concepts of death and hope of resurrection are spelled out visually. In its own modest way, the program parallels the Last Judgment portal of a Gothic cathedral. The omnipresent Latin message to the viewer appears on the lower right panel: *Vive Memor Loethi* and *Fugit Hora* ("Live mindful of death," and "Time is fleeting").

A skull in the pediment starkly reminds the passer-by that death is certain, yet the wings attached to it give it a special meaning. It becomes at once the double symbol of death and the transmigration of the soul from earthly to eternal life. The hourglass resting on the skull reinforces the idea that death draws ever nearer. In the central panel below, the grim reaper holds an hourglass and helps a skeleton which is about to snuff out the light of life (the candle) of earthly existence (signified by the globe). A scythe, with which life is symbolically terminated, is seen behind the grim reaper. This complex motif was taken from an illustration in Francis Quarles's *Hieroglyphikes of the Life of Man*, a book published in London in 1638.

3.12 The Charlestown Stonecutter, Headstone of Joseph Tapping, 1678. Slate, width 28in (71.1cm). King's Chapel Burial Grounds, Boston, Massachusetts.

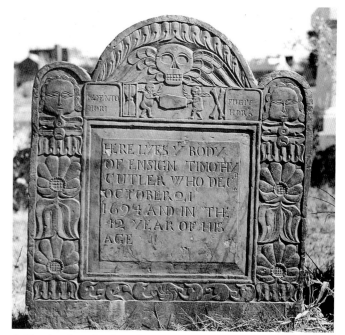

3.13 Attributed to Joseph Lamson, Headstone of Timothy Cutler, 1694. Slate, width 24in (61cm). Phipps Street Burial Grounds, Charlestown, Massachusetts.

Joseph Lamson The makers of most gravestones are anonymous, but for the Timothy Cutler headstone of 1694 the name of the craftsman and something about him are known (Fig. 3.13). Joseph Lamson (1658–1722) had a shop in Charlestown, Massachusetts. He may have been the apprentice of and successor to the Charlestown Stonecutter. On the Cutler stone, the winged skull again indicates death, but a death which the soul survives. Below it are the familiar inscriptions, exhorting the viewer to contemplate mortality. A coffin is carried by winged imps—another resurrection motif—while at the top of each side panel is an image of the cherubic being who will welcome Cutler into heaven. This sculpture reveals how inexperienced the stonecutter was in anatomical representation and in the depiction of the human figure in its classical-Renaissance-Baroque form. Still, from an expressive standpoint, they are effective images, for it was never the intention to portray the beauty of the nude human form here. The stylized plants and flowers in the borders are further symbols of regeneration and the hoped-for life in paradise.

CHAPTER FOUR

ARCHITECTURE AND DECORATIVE ARTS:

1700–50

Although its religious, economic, social, and cultural roots clearly lay in the seventeenth century, the eighteenth century had a very different character. A principal reason was that the population of the colonies increased considerably—from a quarter of a million in 1700 to nearly a million and a half by 1750. This was due largely to immigration, not only of English people but of Germans and Scottish-Irish as well. Opportunity beckoned, offering something Europe could not—land. There were places where a family could be given 50 acres (20 ha) just for agreeing to settle it, or buy 640 acres (259 ha) for a few shillings.

Expansion beyond the seaboard was by no means unlimited, though. Almost every advance into new lands brought bloody conflict with the native population. The Spanish checked movement to the south of present-day Georgia, and the French hemmed in the English colonies to the north and west. The French controlled Canada and the Great Lakes region, founded Detroit in 1701, and seventeen years later established New Orleans at the mouth of the Mississippi River. Their plan was to stop English expansion at the Allegheny Mountains and create a French empire in the mid-continent. This would stretch from Canada to the Gulf of Mexico, spanning the broad Mississippi Valley.

By the 1740s the French and Indian Wars had begun. A huge army had to be maintained to secure the frontiers, and Parliament held that the colonists should either provide such forces or pay for a standing British army. When the colonists did neither, Parliament imposed the hated Stamp Act in 1765, and the cry of taxation without representation went up.

But if thwarted by land to the north, south, and west, colonial expansion knew virtually no bounds as the merchant fleet took to the seas. From the prospering plantations of the South were shipped rice and indigo from South Carolina, tobacco from Virginia, and cattle from North Carolina. Wheat and corn were major exports from Maryland and Pennsylvania, while lumber, fish, and rum were sent out of New England.

This was the period when second- and third-generation Southerners created the great plantation houses and began in earnest to imitate the refined lifestyles of the English gentry. In the northern cities, merchants became rich beyond anything their seventeenth-century ancestors had known, and built fine townhouses in the stylish Wrenian or Georgian mode.

The colonies remained closely tied to England—much more so than to each other. The period around the turn of the century was known as the era of William and Mary, after the monarchs William of Orange and his wife Mary (d. 1694), daughter of King James II. Upon William's death in 1702, Mary's sister Anne became queen and ruled until 1714. At that date the first of the Georges, of the German house of Hanover, was brought to England, and the Georgian era began.

During this period the English monarchy and Parliament assumed a benign neglect of the colonies. Therefore, left for the most part to their own affairs, the colonists developed a spirit that approached selfrule. In the 1760s, when king and Parliament attempted to reassert their authority, conflict naturally ensued. In the course of this period, a slow but definite transformation of people's perceptions occurred—they moved from seeing themselves as English colonists to a new understanding that they were colonial Americans. Nevertheless, most colonists did think of themselves as English, and looked to their country of origin for cultural leadership. This affected clothing styles and manners, music and literature, architecture and painting, and the various forms of religion.

Orthodox, hardline Puritanism had already begun to decline before the new century opened, and even in New England religion was worn with more ease and grace than before. Anglicans tended to be more liberal than others in accepting cultural innovations. For example, the first imported organ was installed in King's Chapel, Boston, in 1714, while the first organ made in America was placed in New York's Trinity Church in 1737. Both edifices were Episcopal. The earliest public concert was held in 1731, in the great room of Mr. Peter Pelham, an Anglican. Four years later, the first opera performance—*Flora*—took place in Charleston, South Carolina, and by 1749 Philadelphia had its first theater building.

Printing presses had long existed in the Boston area (see p. 42), and by the 1720s they were being used in Philadelphia. One was set up in Charleston in 1731, and the first

newspaper in that colony, the *South Carolina Gazette*, went into publication the next year. Newspapers were usually rather small affairs of two to four pages. They proliferated— the *Boston Gazette* (1719) was followed by the *New England Courant* (1721), published by James, elder brother of Benjamin Franklin. The *New York Gazette* appeared in 1725, the *Maryland Gazette* in 1727, and Benjamin Franklin became owner and publisher of the *Pennsylvania Gazette* in 1729. These papers contributed to building up a wellinformed citizenry, for a wide variety of subjects was carried in their pages—from news of the day to scientific information, plus several forms of early American literature.

From the early years of the century, literature blossomed. Religious tracts continued to be published. The Rev. Cotton Mather, for example, was one of the most prolific writers of his day. Everything was considered, from the Salem witch trials to inoculation against smallpox. Secular works such as Robert Beverley's *History of Virginia* (London, 1705) appeared, and social treatises like Samuel Sewall's *The Selling of Joseph* (Boston, 1700)—a New Englander's attack on slavery. There were pure literary efforts like Ebenezer Cook's *The Sot-Weed Factor* (London, 1708), a story about a tobacco merchant. Hugh Jones's *The Present State of Virginia* of 1724 described the increased refinement of life among plantation society. And Benjamin Franklin's popular *Poor Richard's Almanac*, which appeared annually from 1732 to 1757, offered an amusing and sophisticated form of writing that arose from vernacular wit, philosophy, and common sense. By 1727 Franklin and several Philadelphians had

formed the Junto, a learned society which eventually became the American Philosophical Society, an institution that remains active to this day.

Clearly, the colonists possessed an ardent desire to grow intellectually and to lead a more cultivated lifestyle. This encouraged the patronage of painting and, inevitably, affected architecture and the decorative arts, as they were used to enhance the elegance of life. All along the Eastern Seaboard, Americans shed the last vestiges of styles that had retained medieval and Tudor features. Instead, the wealthy merchants of the North and the great planters of the South turned to a moderate form of the high style of the English aristocracy. Late Baroque, William and Mary, Queen Anne, and Early Georgian styles were adopted to express the new social and cultural ambitions and the new wealth of the emerging colonial aristocracy.

WREN'S INFLUENCE IN VIRGINIA

The architectural manifesto of the new style is first and most fully stated in several buildings erected at Williamsburg, Virginia, between 1695 and 1720. The College of William and Mary had been established in 1693 in Williamsburg, which six years later replaced Jamestown as the capital of the colony. Earlier public buildings throughout the colonies had been little more than modified and enlarged houses. But

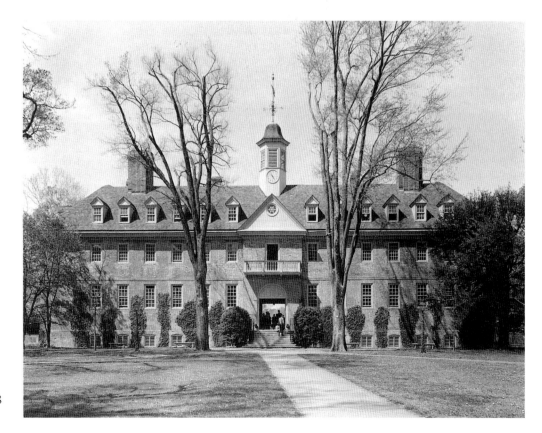

4.1 Wren Building, College of William and Mary, Williamsburg, Virginia, 1695–8 (restored 1931, 1968).

now a new style appeared in imitation of the English Baroque as defined by Sir Christopher Wren, whose designs for the rebuilding of London after the great fire of 1666 imposed a new look upon that city. Wren designed over fifty churches for London. The most famous is St. Paul's Cathedral, while among his best-known secular buildings are Chelsea Hospital, parts of Greenwich Hospital, and the garden façade at Hampton Court Palace.

Many of Wren's buildings were built of brick, with white trim of either wood or stone. Classical principles such as unity and symmetry prevailed, while classical components—pilasters, cornices, pediments—were used for adornment and articulation. The pitch of the roofline was usually lowered significantly or flattened altogether, presenting a classical horizontality as opposed to Gothic verticality. Much of a Wren building's beauty arises from the dignity of its design. The new architecture, as it rose throughout London, differed markedly from the old half-timber Tudor style, in both conception and detail.

WREN BUILDING

At the College of William and Mary the Wren Building—so named because it was once believed that Sir Christopher himself had designed it—introduced the new style into the colonies (Fig. 4.1). Seen from the façade, a simple rectangular horizontal block with a low hipped roof is symmetrically divided by a central pedimented pavilion, which has an open passage on the ground level. Stringcourse and cornice are continuous, uniting the three sections, and six rows of windows on each side line up vertically with dormers in the roof. A cupola completes the central axis. The Wren Building is constructed of red brick, which is set off by the light trim and the white of the window mullions and frames. The new form of the sash window replaced the old casement type, and the geometric grid of rectangular panes superseded the small leaded-diamond panes of the Tudor period. A comparison with the John Ward House or the Old Ship Meetinghouse (Figs. 2.7 and 2.8) shows the fundamental change of style that has occurred.

WILLIAMSBURG'S CAPITOL AND GOVERNOR'S PALACE

The new capital at Williamsburg was laid out in 1699 on a well organized grid plan. The Wren Building of the College stood at one end of a central axis (Duke of Gloucester Street) with the Capitol at the other, and the Governor's Palace was at the end of a perpendicular axis (the Palace Green). The royally approved plan was probably devised in London.

The present Capitol and Palace are both twentieth-century reconstructions, but they were based on archeological research and provide a good sense of the gracious dignity of the town as it appeared in the early eighteenth century. It is not known who designed either building, but

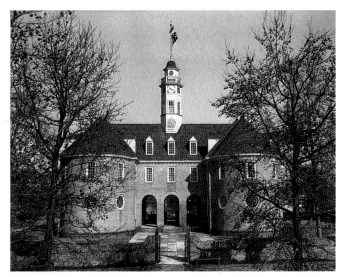

4.2 The Capitol, Williamsburg, Virginia, c. 1705 (rebuilt 1753, restored 1929). Colonial Williamsburg Foundation, Williamsburg, Virginia.

the overseer, or superintendent of construction, in each case was Henry Cary. He may well have contributed to the design of specific details.

The H-plan of the Capitol has two wings, one for the elected House of Burgesses, the other for the general court and the chamber of the Governor's Council (Fig. 4.2). Semicircular at one end, these sections were connected by a hyphen with an arcade below and a cupola above. Like the Wren Building, the Capitol was built of brick. It had eave cornices, sash windows, and dormers in the roof that were aligned with windows below. Handsome large oculus windows on the lower floor echoed the curves of the wings and arches of the hyphen. There was an aesthetically pleasing and intellectually satisfying massing of geometric forms and spaces, and a careful attention to architectural detailing rendered in a restrained classical English Baroque mode.

The Governor's Palace was an especially important building because of the new standard it established for domestic architecture in Virginia (Fig. 4.3). There had never before been anything so grand in the American colonies. Its elegant Wren-style form became the model for many of the wealthy planters. Most of them had served either on the Governor's Council or in the House of Burgesses, and so had seen the splendid new structures of Williamsburg during the periods when those groups met.

The Palace's block form and hipped roof, dormers, balusters at the ridge of the roof, cupola, and perfect symmetry give it great sophistication. While the Thoroughgood House (Fig. 2.1) was built on a plan that called for one room on either side of the entrance, the Governor's Palace effected a significant change by establishing the double-pile plan—that is, two rooms on either side of a large central hall. This became the favorite layout for eighteenth-century colonial homes, and follows the example set by fine English country houses such as Coleshill (1650) and Thorpe Hall (1655).

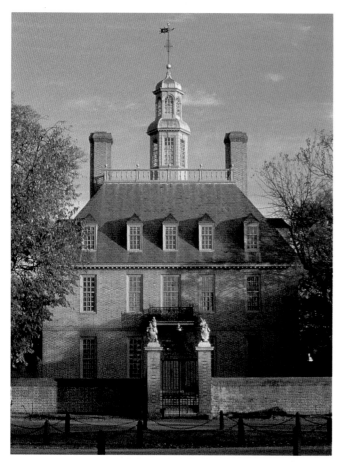

4.3 Governor's Palace, Williamsburg, Virginia, 1706–20 (restored 1930). Abby Aldrich Rockefeller Folk Art Center, Williamsburg, Virginia.

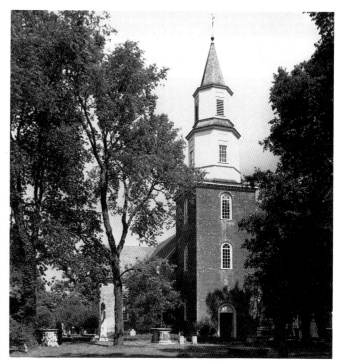

4.4 Bruton Parish Church, Williamsburg, Virginia, 1711–15, steeple 1769–70. Colonial Williamsburg Foundation, Williamsburg, Virginia.

OTHER WILLIAMSBURG BUILDINGS

Other buildings soon graced the new capital. At the College, a residence and classroom building for Native American boys called Brafferton Hall (1723) was erected. It flanked the Wren Building on one side, while the President's House (1732) was built on the other. Both echoed the style of the Wren Building.

Bruton Parish Church—a handsome, large, brick edifice—was erected between 1711 and 1715 as the showplace of Episcopalianism in America (Fig. 4.4). It is the first example in the colonies of the new Wren type of church that already dominated the London skyline. Its Baroque form, classical motifs, imposing scale, and carefully developed proportions were designed by Governor Alexander Spotswood (Fig. 5.14), the first of the gentleman-amateur architects of colonial America. At the western end of the cruciform plan is a large tower base, which had a steeple added much later—in 1770. Bruton Parish Church invites comparison with St. Luke's Church of 1632 (Fig. 2.4) and reveals that the medieval features of the earlier building have been purged from the new style.

Each of the buildings at Williamsburg in its own way

followed a design developed in England, with Wren as the guiding spirit. But in the process of transplantation, two characteristics set the American edifices apart from their English prototypes. Form and detail are simplified, and scale is reduced. Classical ornament, while often present, is not as rich. Windows are not recessed as deeply into the plane of the walls, so the walls are not as boldly three-dimensional, and plans and spaces are not as complex. These adaptations may have been the result of provinciality, or have been caused by workmen who were unfamiliar with the tasks required of them. Other possible reasons are the need for economy, or a reluctance to be showy, or any combination of these factors. But this simplification, in comparison to English counterparts, was to become part of the aesthetic taste of Americans throughout the rest of the colonial era.

PLANTATION HOUSES OF THE SOUTH

The time had arrived when wealthy planters were no longer content with the modest farmhouses their founding ancestors had built, and the great age of the splendid plantation houses was ushered in. The plantation was the social, economic, often even the judicial unit of the South. In place of towns, the South evolved plantations as nearly independent estates. Each had its own wheat, flax, and barley fields, its own orchards, herb gardens, and vineyards, and a variety

of livestock. In addition to the main house there were numerous other buildings—stables, kitchen, slave quarters, grist mill, tannery, cooperage, blacksmith and carpentry shops, and perhaps a school. Each plantation had its own craftspeople—either indentured servants from England or trained slaves.

Building materials were available locally. Bricks could be made from clay and baked in the plantation's kiln. Mortar was made from ground-up oyster shells, and timber was cut from the abundant forests. Plantation houses were almost always built on rivers because they were the means of communication and commerce with the world beyond. Tobacco was the money crop—at harvest time great bales of it were loaded aboard oceangoing ships at the plantation's own wharf for shipment to London. There it would be exchanged for silver plate, furniture, clothing, fancy fabrics, or any other items that could not be produced on the estate.

STRATFORD HALL

No doubt encouraged by what he saw at Williamsburg, Thomas Lee had Stratford Hall built as the focal point of his plantation. It is the earliest of the great houses (Fig. 4.5). Its H-plan (Fig. 4.6) is unusual, but there are earlier examples in England, and it was used at the Capitol in Williamsburg. There is a bold simplicity in the Baroque massing of the projecting blocks, and the basic massiveness is seldom disturbed by architectural ornament. Such decoration is limited to a stringcourse, and the pilasters and pediment of the doorway. All of these are merely continuous parts of the brickwork, in relief. A grand simplicity marks the great splayed staircase, and the white-trimmed sash windows on

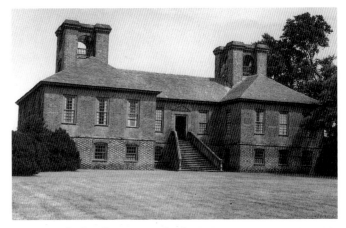

4.5 Stratford Hall, Westmoreland County, Virginia, 1725–30.

4.6 Stratford Hall, Westmoreland County, 1725–30. Plan.

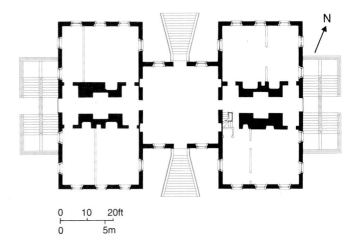

4.7 Stratford Hall, Westmoreland County, 1725–30. Interior, Great Hall.

the main floor are of noble scale. The roofline is low, and its forms and planes contribute to the geometric beauty of the structure.

Out of the roof rise the chimney blocks in which the four stacks are united into a single unit by graceful connecting arches. This particular compound chimney arrangement is unique in colonial American architecture, but it is found in several earlier English houses that were designed by Sir John Vanbrugh (1664–1726)—Blenheim Palace (1705–22), for example. The name of the person responsible for the design of Stratford Hall is unknown, although it may have been Lee himself.

If the exterior is characterized by a bold simplicity, the interior (Fig. 4.7) possesses a richness unsurpassed by any house then standing in America, except the Governor's Palace in Williamsburg. The grand stairway on the outside led into the Great Hall, a room that shows the new use of architectural spaces for specialized activities. The desire for a gracious environment for social entertainment saw that a large space (28 feet or 8.5 meters square and 18 feet or 5.5 meters high) was set aside which could be devoted to parties, balls, and concerts. This hall is one of the earliest examples of full-height paneling. A knowledge of the classical **Orders** is displayed in the elegant pilasters with their richly carved capitals, and a beautifully designed entablature crowns the whole.

WESTOVER

Westover (Fig. 4.8), on the banks of the James River, is of the late Baroque style and similar to the English country houses that William Byrd II (Fig. 5.13) saw during the many years that he lived in England. The central block dates from 1730–4, and the wings and hyphens were added later. In plan, Westover is a double-pile house with a large central entrance hall that contains a grand stairway. It is similar in form to the slightly earlier Brafferton Hall and the almost exactly contemporary President's House at the College of William and Mary in Williamsburg (see p. 54). (Byrd, as a member of the Governor's Council, knew both of these buildings well.)

A classical cornice and stone stringcourse give a horizontal emphasis to the façade. Locally produced red-orange brick is set off smartly by the white trim of the sash windows, and the whole façade is meticulously symmetrical, with a fine proportional relationship of window and wall spaces. Rectilinear severity is relieved by the slight but graceful curve at the top of the windows. But the most impressive feature is the classical marble doorway with its swan's-neck pediment and pineapple **finial** (a symbol of hospitality). No local stonecutter could have carved the **Composite** capitals and other fine details—Byrd imported the doorway from England.

4.8 William Byrd, Westover, Charles City County, Virginia, 1730–4. Colonial Williamsburg Foundation, Williamsburg, Virginia.

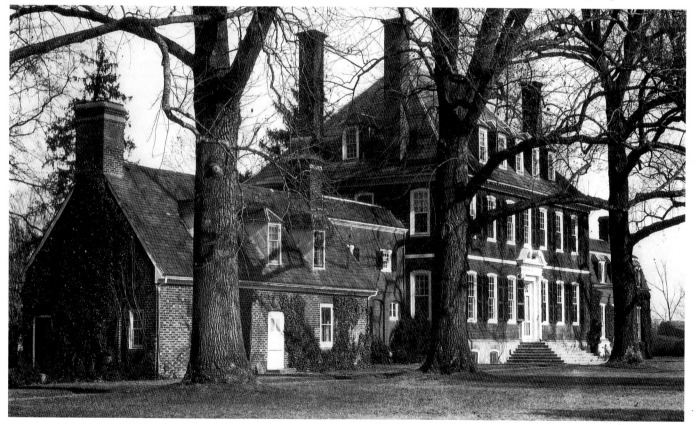

Plate XXVI

Compofite Order.

E. Hoppus Delin. J. Mundy f?

4.9 William Salmon, Plate 26 from *Palladio Londonensis* (London, 1734), design for a door in the Composite Order. Courtesy Winterthur Library: Printed Book and Periodical Collection, Winterthur, Delaware.

A well-educated eighteenth-century gentleman such as Byrd would have been knowledgeable in architectural design and theory. His library would have contained several pattern books with engraved plates, which were standard sources on both sides of the Atlantic. From Virginia, Byrd must have ordered his marble doorway from an English stonecutter, specifying that it be taken from a plate in William Salmon's *Palladio Londonensis* (published in 1734, the year Westover was completed) (Fig. 4.9).

DESIGN THROUGH PATTERN BOOKS

Pattern books such as Salmon's provided the means by which the contemporary fashions in architectural design crossed the Atlantic. They offered guidance to people wanting to build fine houses in the colonies in a slightly more modest form than the buildings then being erected in England. By the 1730s several such books were available, filled with engraved plates, essays on architectural theory, and practical advice on construction and materials. Architectural details could be assembled from the variety of choices

they offered. Late Baroque grandeur, Palladian elegance, and a classical architectural vocabulary were introduced into the colonies through such publications as Colin Campbell's *Vitruvius Britannicus* (5 vols., London, 1715), Giacomo Leoni's *Architecture of A. Palladio* (London, 1715), William Kent's *Designs of Inigo Jones* (London, 1727), James Gibbs's *Book of Architecture* (London, 1728), and Salmon's *Palladio Londonensis*.

DRAYTON HALL AND PALLADIANISM

In South Carolina, the colonists' desire for refined and substantial plantation houses attained its greatest fulfillment with Drayton Hall, built on the Ashley River near Charleston in 1738–42 (Fig. 4.10). John Drayton, master of Drayton Plantation, may have been responsible for its design. It features the earliest Palladian temple portico in the American colonies, which may have been inspired by Palladio's Villa Pisani in Montagnana, Italy. The designs of the celebrated Italian architect Andrea Palladio (1508–80) had been rediscovered in the early years of the eighteenth century. Through Lord Burlington's circle they had been transformed into a new mode known as English Palladianism, and had been circulated through various publications, including Leoni's English edition of *The Architecture of A. Palladio* (1715). Thereafter, Palladianism became one of the primary standards of taste in England, and as such it inevitably reached the American colonies.

Although it was begun in the same decade as Westover, Drayton Hall represents a more advanced fashion. For the Virginia house took its inspiration from the seventeenth-century mode of Sir Christopher Wren's architecture, while the house near Charleston derives its form from the eighteenth-century Palladian style.

The portico extends from a façade with a recessed central

4.10 Drayton Hall, Charleston, South Carolina, 1738–42. A property of the National Trust for Historic Preservation.

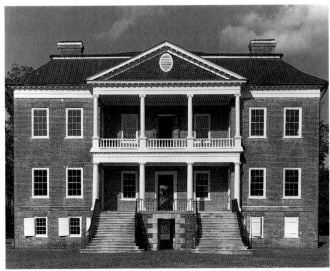

4.11 Drayton Hall, Charleston. Plan.

portion, which is unusual. More usual is the double-pile plan (Fig. 4.11), which includes a large entrance hall—the largest room in the house. A gracious center for entertaining, it has an elaborate chimneypiece taken from an engraved plate in William Kent's *Designs of Inigo Jones*. Jones had been among the first to introduce Palladianism into England, and his own work was greatly admired among Lord Burlington's followers during the 1720s. Thus, through two separate features, Drayton Hall demonstrates the sophisticated knowledge of architectural design and the prosperity of the planter class in the South by the 1730s.

MERCHANT ARCHITECTURE IN THE NORTH

In the North a similar pattern was followed, but the results were different. Even before the turn of the century wealthy merchants had begun to reject the medieval survival style of their ancestors (as found in the Parson Capen House, Fig. 2.5). They had turned instead to the current fashions of the English nobility. A similar social phenomenon was occurring among the great merchants of London, whose forebears had been content to live in rooms above the family shop or store. Now they chose to build fine houses in fashionable sections of the city, far removed from their places of business. New England seaport towns were growing and prospering, and

within them a mercantile aristocracy was ascending. Taste became increasingly sophisticated as the merchants called upon the arts to express and enhance their new mode of life.

DOUBLE-PILE HOUSES

The McPhedris-Warner House (1718–23) is one of the earliest surviving New England examples of the double-pile house in the new style (Fig. 4.12). Its symmetrical façade has a handsome doorway with pilasters, carved capitals, and a segmental-arch pediment. The roof is crowned with a balustrade and cupola. The end wall at the north is nicely articulated to incorporate the fireplaces, whose chimney-stacks rise well above the roofline. This form of the end wall, which became popular, is also found in the Royall House in Medford (Fig. 4.13). The design of the McPhedris-Warner House is a modest provincial version of a great English country house such as Coleshill.

ROYALL HOUSE

In the eighteenth century, with its commitment to classical principles and ornamentation, persons of taste insisted upon an architectural aesthetic based on unity, balance, harmony, and completeness. The decorative vocabulary was composed of the classical Orders. The conscious exercise of these principles is demonstrated in the Royall House (Fig. 4.13).

Isaac Royall, Sr., had already made a fortune in the sugar, rum, and slave trade in Antigua before he settled in Medford, near Boston, in 1732. There he acquired a 600 acre

4.12 McPhedris-Warner House, Portsmouth, New Hampshire, 1718–23.

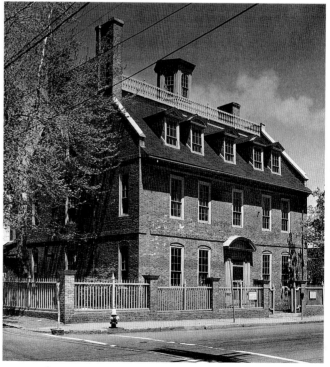

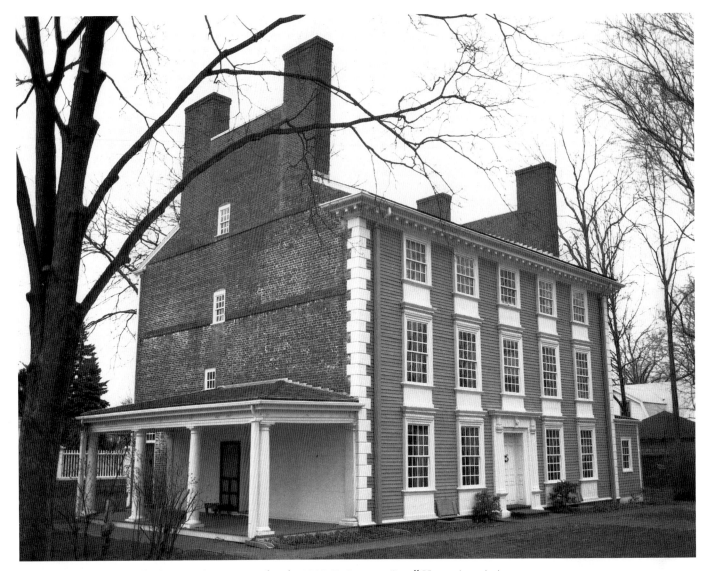

4.13 Royall House, Medford, Massachusetts, east façade, 1733–7. Courtesy Royall House Association.

(243 ha) estate that had on it an old seventeenth-century farmhouse. He immediately set about remodeling it. The east façade dates from 1733–7, but a few years after Royall's death, the west façade (1747–50) and most of the interior were remodeled by his son—Isaac, Jr., the young man seen in Feke's portrait (Fig. **5.7**).

On the east front a vertical unity was attained by inserting white spandrels between the sash windows, which are large and elegant. On the first two floors, each contains twenty-four lights (glass panes). The windowframes have elaborate moldings, and there is quoining at the corners. It is made of wood and painted white in imitation of the stone that was used on English houses. A welldeveloped classical cornice caps the façade, while the roof is barely visible. These features distinguish the upper portion markedly from the complex, medieval roof arrangement of, say, the Ward House (Fig. **2.7**). The centrally placed door is flanked by **Doric** pilasters and topped by a noble entablature.

WILLIAM AND MARY STYLE

Interiors of American homes took on a new appearance with the introduction of the William and Mary style of furniture, beginning in the last years of the seventeenth century and remaining in vogue until about 1725. The change had begun at the English court after 1660, when Charles II and his Portuguese queen, Catherine of Braganza, returned from exile in France and Flanders. The new modes were fashioned at the court by Dutch, Flemish, French, and Portuguese craftsmen whom the king encouraged to settle in England. Eventually they spread to the merchant class, and through it to the American colonies in the era of William and Mary. King William III (reigned 1689–1702) was of Holland's royal House of Orange, and under his rule Dutch fashions and craftsmen were naturally popular in England.

Kings and queens who had long lived on the Continent thus played a major role in redirecting English taste away

from the popular Tudor style. As religious refugees—such as the Protestant Huguenots fleeing Catholic France after the revocation of the Edict of Nantes in 1685—sought asylum in England and America, the crafts workers among them transplanted the new style wherever they settled.

WENTWORTH ROOM

The result of the change in interiors is seen in the Wentworth Room at Winterthur Museum, which is in the William and Mary style (Fig. 4.14). Fine paneling enhances the wall, and the furniture is of a very different style from that illustrated in Figures 2.9 and 2.14. The fireplace has been reduced in size since, in a parlor such as this, it is no longer the center of cooking, candlemaking, and other household chores. The heavy, roughhewn beam across the top of the fireplace that is visible in Figure 2.9 is here concealed by a wellcut molding that blends with the paneling of the wall. To the left is a built-in cabinet for the storage and display of the family's finer pieces of silver plate and ceramics. Fine porcelain, particularly that brought back from the Far East, was especially popular and began to replace pewter for daily use.

The distinctive features of the William and Mary style are seen in Figures 4.15 and 4.16. The turned parts of the chair and the high chest of drawers are more delicate than their counterparts illustrated in Figures 2.11 and 2.13. The armchair has rich floral and scroll carvings in the **crest rail** and **stretcher** that are boldly three-dimensional, in contrast to the earlier, rather timid, low-relief carvings.

Finer woods were used in the William and Mary style than in the earlier one. Maple, walnut, and imported mahogany replaced the pine and oak of most seventeenth-century furniture. Joiners and cabinetmakers had increased

4.14 Wentworth Room, early 18th-century interior, as installed in Winterthur Museum, Winterthur, Delaware.

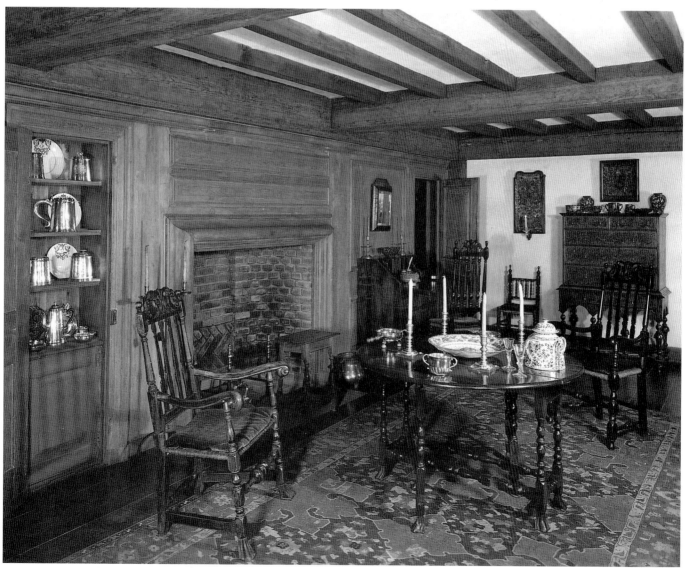

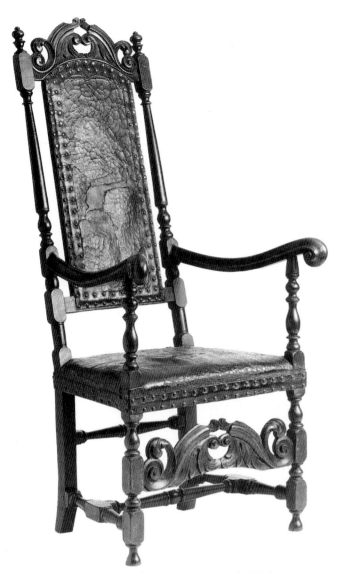

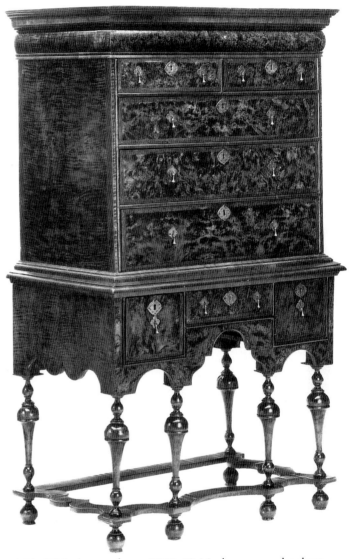

4.15 William and Mary chair, 1700–15. Beech, 53¼ × 24 × 27½in (135.3 × 61 × 69.9cm). Courtesy Winterthur Museum, Winterthur, Delaware.

4.16 High chest on frame, 1700–10. Maple veneer and walnut, 69⅜ × 41⅝ × 24⁵⁄₁₆in (176.2 × 105.7 × 61.8cm). Courtesy Winterthur Museum, Winterthur, Delaware.

their skills to include **veneering**—a thin layer of, say, curled maple was applied to a case and drawer fronts made of pine. This is seen here in the high chest. Glistening brass enhances the decorative scheme in the pulls and keyplates.

The proportions of both chair and high chest have become elongated, and the beautifully proportioned mass of the upper section of the chest hovers above the delicate forms of the turned "trumpet" legs and stretchers. Meanwhile the latter repeat the graceful curve-countercurve motif of the **apron**. Finally, the gateleg table seen in Figure 4.14 has a special feature—the "Spanish" or "paintbrush" foot—that is peculiar to the style.

The timespan of the William and Mary style was brief, for it was replaced by the Queen Anne style from about 1725. But it was an important movement, for it made the break with the old Tudor style in decorative art.

QUEEN ANNE STYLE

The furnishings of the fine homes built in the second quarter of the eighteenth century were of the fashionable new Queen Anne style, so-called after the English queen who ruled from 1702 to 1714. But it was not until a decade after her death that the Queen Anne style of furniture appeared in the American colonies. There it became so popular that it continued to be used through the reigns of George I and George II, until about 1760.

The movement toward ever more gracious living is evident in the Readbourne Parlor of about 1733. It was originally part of a home in Queen Anne's County, Maryland, but is now installed in Winterthur Museum (Fig. 4.17). Wall paneling, painted offwhite, shows off the handsome furnishings to great advantage. The room is lit by an

ornate chandelier and silver sconces flanking the tile-lined fireplace. But it is in the design of the furniture that the new style is most noticeable.

FURNITURE

If a William and Mary chair (Fig. 4.15) seems rectilinear and composed of a multitude of parts, a Queen Anne one is characterized by a harmonious unity founded upon gracefully curving forms (Fig. 4.18). The English painter and engraver William Hogarth (1697–1764) declared, in his *Analysis of Beauty* (London, 1753), that a flowing S-curve—which he called "the line of beauty"—was the essence of aesthetic perfection. The Queen Anne chair is a symphony of gentle, related curves in the back, the legs, and the rounded shape of the seat. These gracefully flowing forms dominate in the wingback chair seen in front of the window in the Readbourne Parlor, and in the settee.

Here the upholsterer's skills are united with those of the joiner (Fig. 4.19). On the knees of the settee, the decorative carving of the scallop shell—a favorite motif—is typical of the tasteful but sparing use of ornament in the Queen Anne style. It stands in marked contrast to the bold Baroque energy of the carvings on the William and Mary chair.

A delicate balance was achieved between curved and rectilinear forms in the Pimm high chest, made in Boston in

4.17 Readbourne Parlor, c. 1733. Courtesy Winterthur Museum, Winterthur, Delaware.

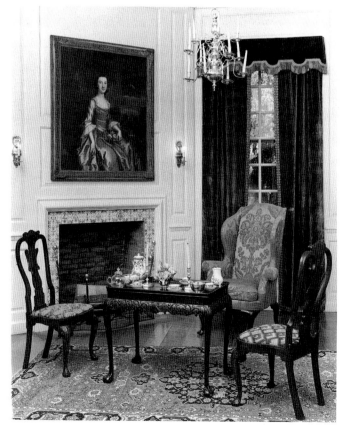

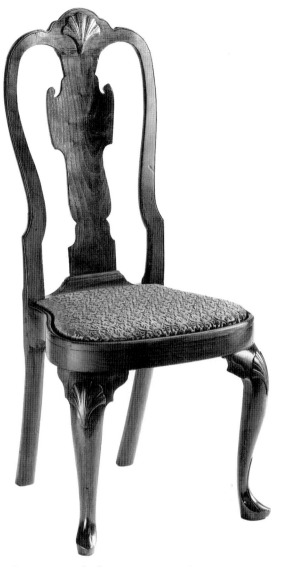

4.18 Queen Anne side chair, 1735–50. Walnut, 42⅝ × 20¼ × 20⅛ in (108.3 × 51.4 × 51.1cm). Courtesy Winterthur Museum, Winterthur, Delaware.

4.19 Queen Anne settee, c. 1740. Walnut frame, width 5ft 2in (1.57m). Metropolitan Museum of Art, New York City.

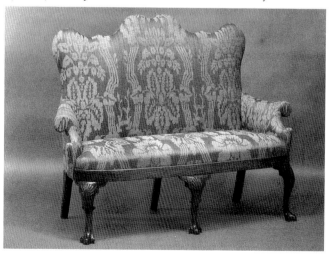

things Chinese that arose in late seventeenth- and early eighteenth-century Europe, when sea captains began bringing back exotic wonders from the Far East. The technique involved painting the exterior of the piece black, then building up designs in relief using a chalk-paste known as whiting. These were gilded with gold leaf, and finally the whole was coated with varnish in imitation of the rich, lustrous lacquerwork of Oriental objects. The japanner—probably Thomas Johnston (1708–67) of Boston—did not know the actual techniques of lacquering, but the simulated effect was satisfactory to his customers.

METALWORK

Silversmiths were also influenced by the newly introduced Oriental forms, although they continued to use western designs as well. Craftsmen like Peter van Dyck (1684–51) of New York and Jacob Hurd (1703–58) of Boston worked in the new style. Hurd had served his apprenticeship under either Edward Winslow or John Edwards (1671–1746)—probably the latter—and his son Nathaniel Hurd (1729/30–77) also became a silversmith. A portrait of Nathaniel Hurd by John Singleton Copley shows him with two books, John Guillim's *A Display of Heraldrie* (London, 1610) and Samuel Sympson's *A New Book of Cyphers* (London, 1726). These had undoubtedly belonged to his father as indispensable pattern books for the coats of arms and inscriptions he engraved on the silver pieces he made.

A teapot made by Jacob Hurd about 1735–45 shows an Oriental influence in its central bowl, while the spout and handle are Occidental in form (Fig. 4.21). Again, subtle curves dominate the design. Unlike the profuse, ornate decoration seen on the late Baroque sugar box (Fig. 2.16), the ornamentation on the Queen Anne teapot is sparing and selective, revealing a preference for the simplicity of curving forms and the intrinsic beauty of the silver itself.

4.20 John Pimm, japanned by Thomas Johnston, High chest, 1740–50. Maple and white pine, 95¾ × 42 × 24½in (243.2 × 106.7 × 62.2cm). Courtesy Winterthur Museum, Winterthur, Delaware.

4.21 Jacob Hurd, Teapot, 1735–45. Silver, wood, 6⅛ × 9⁵⁄₁₆in (15.6 × 23.7cm). Courtesy Winterthur Museum, Winterthur, Delaware.

the 1740s. The graceful curve of the pediment is echoed in the curve of the legs (Fig. 4.20). The cumbersome stretchers of the William and Mary high chest (Fig. 4.16) have been eliminated here, just as they were in the Queen Anne chair. Classical details were seldom used in William and Mary furniture, but here the pediment with its little brass urns presents a classical design that harmonized well with the classical architectural details that were then being applied to interiors. Decorative carvings adorn John Pimm's high chest in the central panels at the top and bottom—a shell motif is enhanced with swags.

But it is the **japanning** that truly distinguishes the piece, with its elaborate illustrations of Oriental fables. Japanning was part of the rage for **chinoiserie**. This was an imitation of

4.22 William Price, Christ Church (Old North Church), Boston, Massachusetts, 1723, spire 1741.

CHURCH DESIGN IN THE NORTH

In Bruton Parish Church (Fig. 4.4), a fundamentally new architectural form had emerged for the colonial American house of worship, patterned after London's Wren churches. But its model was seldom followed in the South. In New England, however, the new style appeared in Boston with Christ Church, Old North (1723), and Old South Meetinghouse (1729). The former was Anglican, the latter Congregational. If merchants were expressing their increasing prosperity in the fine homes they built, they also wanted their churches and public buildings to convey the rising level of refinement in the American provinces.

The Anglican community led the way with fashionable Christ Church, a rectangular (not cruciform) block with a double row of large, round-headed windows (Fig. 4.22). The whole architectural scheme is, typically, simplified in comparison with London churches—it expresses the colonial, mercantile restraint upon ostentatiousness. The form is altered from the meetinghouse plan by its longitudinal axis. There is also a semicircular apse on the eastern end, and a tower on the western end. Its tall spire—an English Baroque form adorned with classical components—was added in 1741.

The interior is logically organized, classically proportioned, and, unlike many earlier meetinghouses, fully finished. The slips (pew boxes) have paneled walls—this

indicates the careful attention given to every part of the design. A common practice was to "sell" slips to individual families, and, naturally, the most expensive pews were nearest the pulpit. Accordingly, the congregation mirrored the social order of secular life, organizing itself in order of prominence.

Christ Church was designed by William Price (1685–1771), a Boston print dealer and organist who probably knew the designs of the churches being erected in London through books of engravings. He was not a trained architect, for the professional architect did not exist as such in the American colonies.

PUBLIC BUILDINGS IN THE NORTH

Richard Munday (c. 1690–1739), who designed and built Trinity Church in Newport, Rhode Island, was merely a local builder who familiarized himself with the theory and forms then being circulated through architectural design books. A carpenter-architect, Munday was also responsible for the design of one of the handsomest public buildings of its day, the Old Colony House of 1739–41 in Newport, the capital of the province (Fig. 4.23). The building is constructed of brick and has the usual white trim. But the uninhibited freedom and inventiveness of the provincial builder are seen in his use of red sandstone for quoining at the corners and **rusticated** framing around the windows. A classical doorway with **Corinthian** pilasters establishes a central axis with the doorway and balcony above. It is surrounded by pilasters and a broken, scrolled pediment with a pineapple finial.

4.23 Richard Munday, Old Colony House, Newport, Rhode Island, 1739–41. Wayne Andrews/Esto.

The axis is completed by an attractive cupola. The tops of the windows have a gentle curve, and the dormers are capped by curved pediments. If the building has the appearance of being assembled from parts taken from the engraved pages of various architectural design books, it is because that is exactly what happened.

DESIGN OF THE QUAKER CITY

The colony of Pennsylvania was founded late, in 1681, when William Penn received a royal grant that enabled him to establish a place of refuge for Quakers and members of other denominations who were experiencing religious persecution. The colony grew rapidly. Philadelphia was laid out on a grid in 1682, and by the first quarter of the eighteenth century there were numerous small redbrick houses. These were similar to the surviving Letitia Street House (1713), standing in the vicinity of the port district. Of grander dimensions was the house built for James Logan, friend and adviser to William Penn. Stenton was erected in Germantown, outside Philadelphia, between 1723 and 1730 in the English Baroque manorhouse mode.

CHRIST CHURCH

Philadelphia also expressed its ambitions in its church and governmental architecture. Christ Church was begun in 1727 as the house of worship for the town's prosperous and fashion-conscious Anglican community. But building was still in progress in the 1740s, and the steeple was not added until 1754 (Fig. 4.24). The initial design was by English-born Dr. John Kearsley—a physician, scientist, and gentleman-amateur architect who settled in Philadelphia in 1717. His design was a Wren-type late Baroque church, longitudinal in plan with a large square tower at the western end. It was built of brick, with white trim—good clay for bricks was plentiful, even within the city limits. Along the sides, two rows of huge round-headed windows form a beautiful architectural cadence. The wall is articulated horizontally by a cornice and a stringcourse, and vertically by pilasters between the windows.

But Christ Church is a transitional edifice, for the balustrade above the cornice, the great steeple, and, above all, the large Palladian window in the eastern end all indicate the change from Baroque to Georgian design. Georgian was the architectural style in vogue during the reigns of George I, George II, and George III—in America, roughly the years 1725 to the outbreak of the Revolution in 1776. One of the greatest Early Georgian architects in England was James Gibbs (1682–1754). The influence on Christ Church of Gibbs's magnificent St. Martin-in-the-Fields (London, 1726) is unmistakable. As the Philadelphia church was being built, Gibbs's codification of the Early Georgian style was

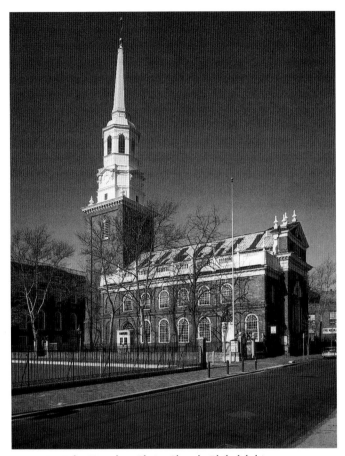

4.24 Dr. John Kearsley, Christ Church, Philadelphia, Pennsylvania, 1727, spire by Robert Smith, 1754.

becoming known in the colonies through the engraved plates of his *Book of Architecture* (London, 1728). The steeple at the western end is the work of one of Philadelphia's most capable carpenter-architects, Robert Smith.

The interior of Christ Church also reflects the influence of St. Martin's in London, especially in the enormous Palladian window above the altar. The arch of the central window beautifully repeats the arch above the chancel. Although St. Philip's (1711–23) in Charleston, South Carolina, was the first church in America to have a fully developed classical Order in its interior, Philadelphia's Christ Church was second, and its influence in later church design was considerable.

INDEPENDENCE HALL

The Pennsylvania State House, now better known as Independence Hall (Fig. 4.25), was begun in Philadelphia in 1731. It followed a design drawn up by the gentleman-architect Andrew Hamilton, a prominent attorney. That design was then executed by the carpenter-architect Edmund Woolley (c. 1695–1771). Hamilton and Kearsley were both members of the State House Building Committee, but Hamilton was ultimately in charge of the project.

There is a Wren-like reserve to his design, which is largely free of the potpourri of decorative features that would soon characterize the new style advocated by James Gibbs. Hamilton's concept is similar to a plate in Colin Campbell's *Vitruvius Britannicus*, representing Buckingham House in London, a building Hamilton could have seen when he visited London in 1726. There, too, are flanking dependencies, just as are found at the State House. Campbell's design book was available at Philadelphia's Library Company, although both Hamilton and Woolley may well have owned copies of it. The building may instead have been based on plate 64 of Gibbs's *Book of Architecture*, that publication which was so instrumental in transforming Wrenian Baroque into a lighter, more decorative Georgian style.

The State House is a long, two-story block, with upper and lower levels separated by two stringcourses. Between them rectangular marble panels line up vertically with the windows. Chimneys are in the end walls, and the low roof has a balustrade that runs the full length of the building. Entrance was by way of an unpretentious door placed in the center of the long walls.

This is the way the building stood until about 1750, when the brick tower was attached to the center of the south side to serve as an entrance hall and stairway. Above the tower rises a square wooden block with a balustrade.

This is surmounted by a smaller wooden block and bell tower, which is in turn capped by a cupola and spire. In fact, everything above the brick tower base was rebuilt in 1828 by William Strickland, a Philadelphia architect, but the original form was followed.

The earlier part of the building is of a late Baroque style. In contrast, the tower—with its pilasters, urns, and graceful transition from large base to diminutive cupola—is Georgian in design. On the southern face of the tower is a Palladian window with full entablature, which again testifies to the introduction of post-Baroque fashion. Inside, assembly and meeting rooms are richly paneled, with noble cornices at the ceilings.

The architecture studied in this chapter is very different from the Tudor, medieval survival style of the previous century. Colonial America made its own commitment to the new Baroque, Palladian, and classical forms of contemporary high style. In the decorative arts, the ancient folk traditions gave way to graceful and elegant new designs of the Queen Anne and Georgian modes. All of this sets the stage for the flowering of colonial architecture and furnishings that occurred in the decades preceding the American Revolution. But before considering that subject it is appropriate to turn to colonial American painting of the early eighteenth century.

4.25 Andrew Hamilton, Independence Hall, Philadelphia, 1731, steeple rebuilt by William Strickland in 1828, after original of 1753.

CHAPTER FIVE

PAINTING AND SCULPTURE:

1700–50

In the northern colonies, the merchants continued to assert themselves in the leadership role. More than any other group—farmers, crafts workers, ministers, or lawyers—they dominated in the dealing of such commodities as grain, lumber, and fish. Their ships took these cargoes across the Atlantic Ocean and brought back the fabrics and furnishings that the colonists wanted to ornament themselves and their fine new homes. They were land speculators, too, and their shrewd Yankee acumen made them wealthy.

While remaining devout, the merchants were anxious to rise in the world and shed the coarse ways of their humble origins. To this end they educated themselves and read numerous courtesy manuals—"how-to" books on the way to behave in polite society. Among the most popular were Richard Allestree's *The Gentleman's Calling* (London, 1664) and *The Ladies Calling* (Oxford, 1673), comparable to twentieth-century books by Emily Post or Amy Vanderbilt. More than any other social group, the merchants had their portraits painted, and in these portraits they are seen conforming precisely to the dicta of the courtesy manuals.

The colonists were well read generally. The Bible remained essential fare, but in addition they read popular literature. For example, an edition of the English novelist Samuel Richardson's *Pamela* was published by Benjamin Franklin in Philadelphia in 1744—it was the first novel printed in America. As a man of the Enlightenment, Franklin believed in knowledge as much as he believed in God, and many years earlier, in 1731, he had organized the first lending library in the colonies. In 1749 Franklin was one of the founders of the Academy in Philadelphia, which eventually became the University of Pennsylvania. By then other colleges had joined Harvard (see p. 42) and William and Mary (see p. 53) as centers for higher education. Yale was founded in 1701, and Princeton in 1746, and King's College (later renamed Columbia) would be established in 1754.

In the South, too, merchants carried on business to satisfy the ever-increasing demand for things that added to the materialistic refinement, stylishness, and comfort of life among the great plantation families. When the planters were not attending to the management of their vast estates, they enjoyed horseracing, foxhunting, gambling and card-playing, horticulture, and reading. They also loved their finery. An advertisement in the *South Carolina Gazette* (7 November 1740) suggests an emporium well stocked with just the sorts of clothing and assorted paraphernalia that reappear in the portraits of the planters and their families:

[Just arrived] in the *Minerva* from London and to be sold by William Stone ... a great variety of European and India Goods, viz. rich Brocade, English and India damasks, Ducapes, padusoys and tabbies [the last three are all types of silk], Calimantoes, worsted damasks and Camblets [a costly eastern fabric], shoes, hose, Gloves and Hatts of all sorts, hoopes, stays, scarlet Cloaks and Manteelets [short, sleeveless cloaks], Genoa's and other Velvet quilted baskets, black snale [chenille] and Lace, variety of English, Brussels and Flanders Lace, Gold and Silver Watches, and Plate, Glass, China and Earthen Ware, white and colored callicoes and fine chintz, ... fine green and Bohea Tea, Spices and Sago, all sorts of Linnen, Drapery, Cutlary, haberdashery, pewter, and ... sundry other goods, which will be sold cheap.

By 1739, wallpaper was being manufactured in Philadelphia to grace the rooms of the new Georgian mansions. Throughout the colonies, formal gardens replaced the earlier and more utilitarian kitchen gardens that supplied vegetables and herbs, at least at the grander houses. They were often ornately patterned, and their cultivation demanded much skill. And there was an increase in the number of portraits painted for the walls of stylish interiors.

FASHIONABLE PORTRAITS

From meager seventeenth-century beginnings, painting in America developed rapidly after 1700, as American-born talent rose and artists trained in Europe emigrated. Portraiture continued to be the primary subject. As with architecture and the decorative arts, there was a rejection of any lingering traces of earlier Elizabethan, Jacobean, or medieval styles. The preference was for the new high style, particularly that of the aristocratic portrait as defined by the work of Sir Godfrey Kneller, the celebrated portraitist of the English aristocracy.

5.1 Pierpont Limner, *Mrs. James Pierpont*, 1711. Oil on canvas, 31 × 25in (78.7 × 63.5cm). Yale University Art Gallery, New Haven, Connecticut.

COURT MODE

When Mary Hooker Pierpont (Fig. **5.1**) had her portrait painted in 1711, possibly in Boston, she was depicted in the manner of one of the ladies of Queen Anne's court. It was a style quite different from that of *Elizabeth Freake and Baby Mary* (Fig. **3.2**)—generically it was closer to that of *Maria Catherine Smith* (Fig. **3.9**).

Mrs. Pierpont was the wife of the Rev. James Pierpont, longtime minister of the Congregationalist church at New Haven, Connecticut. His portrait was painted as a pendant to hers. She was a granddaughter of the Rev. Thomas Hooker, one of the Puritan founders of the Massachusetts Bay Colony, and of Hartford, Connecticut.

The Pierponts' adoption of the court mode demonstrates that by the early eighteenth century the style had been accepted at the very core of the Congregationalist establishment. Nevertheless, the aristocratic style was tempered to suit the taste and social position of the middleclasses. Mrs. Pierpont's soft green gown is low cut and of the current mode, and her hair curls sensuously over one shoulder, as worn by Queen Anne. The brushwork is fluid and painterly, capturing the forms and textures of the subject and her attire, as well as demonstrating a mastery of light, shade, and space. As the identity of the artist is unknown, he is referred to as the Pierpont Limner.

PATROON PAINTERS

During the years 1710 to 1735, several limners were active in the Hudson Valley, from New York City to Albany, capturing the likenesses of members of the great patroon, or landowner families. The limners have accordingly been dubbed the Patroon Painters, since the identity of most of them is unknown. Native-born, and therefore without formal training in the European academies or from great masters, they relied heavily on mezzotint engravings of English nobility as their models. The mezzotints, imported into the colonies in great numbers, served as both an art school for the painters, and an art gallery for their patrons—the latter basing their concept of art almost totally upon them. In this way the style of Sir Godfrey Kneller was transmitted to the colonies, for the composition, pose, and details of the prints, and even the subjects' aristocratic bearing, were followed in the Patroon portraits.

The art of borrowing from a print source can be seen in a comparison of the portrait of young John van Cortlandt with a mezzotint by the famous London engraver John Smith (c. 1652–1742), after Kneller's painting of Lord Buckhurst and Lady Mary Sackville (Figs. **5.2** and **5.3**). The pose,

5.2 Anonymous, *John van Cortlandt*, c. 1731. Oil on canvas, 4ft 9⅛in × 3ft 5⅝in (1.45 × 1.06m). Brooklyn Museum.

5.3 John Smith, *Lord Buckhurst and Lady Sackville*, 1715–25, after Sir Godfrey Kneller. Mezzotint on paper, 16¾ × 10⅛ in (42.5 × 25.6cm). Courtesy Winterthur Museum, Winterthur, Delaware.

the architectural and landscape background, and the curved step in the foreground were taken from the mezzotint. Reportedly, the Van Cortlandt boy had a pet deer, which probably made the print an appropriate choice as the model for the portrait. The painting is but a provincial version of the original image, with the likeness of the American subject substituted for that of little Lord Buckhurst. Dozens of portraits of persons from prominent New York and Hudson Valley families exist, revealing similar borrowings from mezzotints.

PETER PELHAM

As word of the prosperity of the American colonies crossed the Atlantic, artists were inevitably attracted to them. Peter Pelham (1697–1751) was already a welltrained, competent mezzotint engraver when he left London for Boston in 1727.

Pelham had previously made over two dozen prints after portraits of English nobility and gentry. Once in Boston, he set to work to produce a mezzotint of that colony's most prominent citizen, the Rev. Cotton Mather (Fig. 5.4).

In London, Pelham, like all engravers, had copied portraits painted by someone else—there is no evidence he had any training in painting. In Boston, there were no painters who could make the painted portraits from which engravers worked, so Pelham had to do so himself, as seen in his labored image of the Rev. Mather (American Antiquarian Society, Worcester, Massachusetts).

But if the painted version of the Reverend is heavyhanded, the mezzotint—Pelham's specialty—is a beautiful specimen of engraving, with its subtle tones capturing the substance of flesh and fabric. Mather is shown wearing a great white wig, an object of fashion, which his grandfather, the Rev. Richard Mather, would have condemned as a sign of vanity. Comparison of Pelham's mezzotint of Cotton Mather with John Foster's woodcut of Richard Mather (Fig. 3.5) reveals how the graphic arts advanced with the arrival of the London-trained engraver. It also shows how even a member of the Puritan Mather clan succumbed to the pressures in colonial society to be fashionable.

Pelham produced thirteen more mezzotint portraits before he died. Most of these were taken from portraits painted by

5.4 Peter Pelham, *The Reverend Cotton Mather*, 1728. Mezzotint, 14 × 10in (35.6 × 25.4cm). Metropolitan Museum of Art, New York City.

John Smibert, who arrived from London two years after he did. Pelham, however, was unable to make a living from the meager sale of his prints. Leaving the graphic arts behind, he became a cultural entrepreneur and teacher.

JOHN SMIBERT

While Pelham was unable to make a career as an artist in America, John Smibert (1688–1751) was. Smibert was born in Scotland, and studied for three years in Italy before establishing his portrait studio in London in 1722, where he was fairly successful. Like almost every British painter of that day, he worked in the Baroque style of Sir Godfrey Kneller, who had developed a formula for depicting the sophisticated, idealized representation of the nobility. Smibert, however, was unhappy amid the keen competition of the London studios, and when Dean George Berkeley invited him to become the drawing instructor at the college he intended to found in Bermuda, the young artist accepted. The Berkeley group landed at Newport, Rhode Island, in 1728, there to await Parliament's approval of funds for the college. Smibert had already moved to Boston when news came that Parliament would not fund the college. He decided to remain in New England anyway, and became the portrait painter to its merchant society.

In his studio, Smibert proudly placed on display a large group portrait, the likes of which had never been seen in New England. It is known as the *Bermuda Group*, sometimes called the *Berkeley Entourage* (Fig. **5.6**). The Dean stands at the right, with his wife, who is holding their infant son, seated beside him. Next to her sits her companion, a Miss Hancock. Behind the two women stands John James, who, like Richard Dalton (second from the left), was a gentleman-adventurer who had accompanied the Berkeley group to America, primarily to see something of the country. The seated man, pen in hand, is John Wainwright, who commissioned the portrait before the group left England, but who did not actually make the trip himself. The artist himself looks out at us from the far left.

The figures are united around a table in a Baroque-style composition that is rhythmically interwoven by gestures and glances. It is typically Baroque, too, in the largeness of the figures, which are placed close to the **picture plane** and dominate the space, and in the colorscheme of rich oranges, browns, reds, golds, and blues. Rich textures abound in velvet and satin fabrics, and the Oriental carpet on the table. The people's attire shows them to be fashion-conscious members of élite society.

Smibert used the *Bermuda Group* to show New Englanders the skills he had to offer. Anxious to introduce as much English refinement as possible into their provincial lives, the mercantile class lost no time in commissioning images of themselves by the fashionable London painter. In what they believed to be the current mode, Smibert created family icons that conveyed the prosperity and lifestyle in which they took so much pride.

Smibert painted over 250 portraits before he retired in 1746—an artistic production and level of patronage previously unknown in the American colonies. He therefore can be said to have been the first successful professional artist in America. Moreover, Smibert was the first in the colonies to hold an art exhibition, which he did in Boston in 1730. Besides examples of Smibert's portraiture, the exhibition included several copies of paintings by Old Masters that he had made while in Italy, and a number of small plaster casts of ancient statues, as well as numerous mezzotint portraits. Smibert kept these things for reference and for sale. For the rest of his life, and long after his death, Smibert's studio was an art gallery and cultural center that did much to elevate New Englanders' knowledge of art.

Mrs. Nathaniel Cunningham is an excellent example of Smibert's portraits of women (Fig. **5.5**). Because she bears such a strong similarity to Mrs. Berkeley and Miss Hancock in the *Bermuda Group*, it is likely that Smibert had a preconceived ideal of feminine beauty, which he imposed upon the young women who sat for him. Here, the relative smallness of the head gives a monumentality to the rest of the figure, which suggests an imposing grandeur. The refined pose conveys a genteel decorum derived from a mezzotint by John Smith, taken from Kneller's portrait of the Countess of Ranelagh. Smibert's subject no doubt was greatly pleased to have her image cast in the mode of a

5.5 John Smibert, *Mrs. Nathaniel Cunningham*, 1730. Oil on canvas, 4ft 1⅞in × 3ft 4¼in (1.27 × 1.62m). Toledo Museum of Art, Toledo, Ohio.

celebrated beauty of the English nobility. The rich and fluid brushwork, seen especially in the gown, is evidence of the artist having been trained abroad. Later portraits by American-born artists, such as Robert Feke or John Singleton Copley, do not display Smibert's painterly dexterity, for they had had no instruction in such things.

Smibert's portraits of men tend not to be idealized. Demonstrating their mercantile pragmatism, the subjects valued truth and realism over aristocratic idealization. Smibert's American-born followers were to apply this characteristic to women as well, and it became a cardinal feature of the colonial New England style.

5.6 John Smibert, *The Bermuda Group—Dean George Berkeley and his Family*, 1729. Oil on canvas, 5ft 9½in × 7ft 9in (1.77 × 2.36m). Yale University Art Gallery, New Haven, Connecticut.

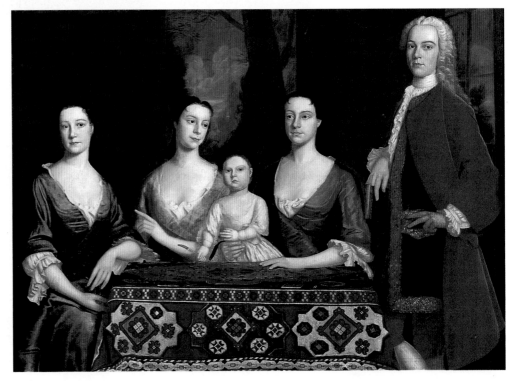

5.7 Robert Feke, *Isaac Royall and his Family*, 1741. Oil on canvas, 4ft 8in × 6ft 5in (1.42 × 1.98m). Harvard Law School Art Collection, Cambridge, Massachusetts.

ROBERT FEKE

In 1740–1 Smibert had an incapacitating illness. Although he recovered, he produced only a few portraits thereafter. His place was taken by the first of the great American-born painters, Robert Feke (1707–52), precursor to Copley, and the first to articulate the colonial style, as opposed to a foreign, imported style. Little is known of Feke's origins except that he was born in Oyster Bay, Long Island. There is no evidence that he had any formal training. His early exposure to art was probably limited to the study of some mezzotints, and sight of a few portraits by Smibert. With only these as models, however, Feke evolved an intuitive, native style that was clearly distinct from the English manner of painting.

Feke comes into historical focus in 1741, when he painted the large group portrait of Isaac Royall and his family (Fig. 5.7). Here we see, from the left, Royall's sister Penelope, his sister-in-law Mary Palmer, his infant daughter Elizabeth, his wife Elizabeth, and Royall himself. The wealthy twenty-two-year-old master of an estate in Medford with a fine house (Fig. 4.13) gave the commission to Feke because Smibert was debilitated.

It is obvious that either the patron, or the painter, or both, had Smibert's *Bermuda Group* in mind. Feke similarly arranged his figures around a carpet-covered table. The main figure stands at the right, and there is a landscape background. Like Berkeley, young Royall holds a book in his right hand. The resemblance between the two women in the earlier picture and the three in Feke's painting is also very close—as seen in the gestures of the hands, the turn of a head, the fashionable clothes they wear, and their idealized features. Smibert's rhythmically flowing, interwoven composition, however, has been replaced by an additive arrangement in the hands of a less experienced artist. Feke's figures, which seem to be added one by one, rather than being integrated, show a provincial lack of comprehension of the complexities of Baroque composition.

While the colors are those of the Baroque palette used by Smibert, there is a great difference in the way in which form is described in the two pictures. Smibert's deft brushstrokes built up form in the lush, painterly technique of the Van Dyck-Lely-Kneller tradition. Feke, totally untutored in that technique, defined form by crisply drawn contours, within which color was then smoothly and meticulously applied. Here, Smibert's fluid, painterly brushstrokes give way to a sharply focused realism.

Feke painted more from observation of the real world than from an aesthetic theory of painting, as developed in English and Continental studios. Lacking such training, he was forced to rely on his eyes for his knowledge and rendition of the material world. Because of this natural realism, Feke's art found favor among the pragmatic, materialistic mercantile folk, who had as little exposure as he to the sophisticated theories and techniques of European painting. In the end, Feke's style meshed better with the taste, values, and

character traits of colonial New Englanders than did Smibert's. In this way, *Isaac Royall and his Family* stands as a milestone in the history of American painting.

MERCANTILE HEROES

New England mustered a military force to send against the French at Louisbourg, Nova Scotia in 1745. When that force returned victorious, a grateful citizenry commissioned portraits of the three leaders of the expedition. Smibert painted two of these—*Sir William Pepperrell* and *Sir Peter Warren*. The third, *Brigadier General Samuel Waldo* (Fig. 5.8), was done by Feke.

Colonial America had previously recognized no heroes of military or civil affairs. Here was the first occasion to commemorate great men, which called for an official "state" portrait. Feke, however, like his fellow New Englanders, had

5.8 Robert Feke, *Brigadier General Samuel Waldo*, c. 1748. Oil on canvas, 8ft¾in × 5ft¼in (2.46 × 1.53m). Bowdoin College Museum of Art, Brunswick, Maine.

no concept of a hero or of a state portrait. As a result, he portrayed Waldo just as he represented prosperous merchants. In the middleground and on the far shore, fortifications and a cityscape allude to the site of the victory, and the subject holds a spyglass. Otherwise, this is a mercantile portrait of Feke's standard type, extolling prosperity and social position rather than conquest and heroism. The evolution of a state portrait would have to wait several decades—until Gilbert Stuart created the ultimate model in the Lansdowne *Washington* (Fig. 10.8).

The year 1751 is significant for painting in New England: John Smibert and Peter Pelham died that year, and Robert Feke left for Barbados, where he died in 1752, creating a temporary vacuum of artistic talent in the region.

PAINTING IN THE SOUTH
HENRIETTA JOHNSTON

Henrietta Johnston (d. 1728) is the first artist who worked in the South about whom something is known. In 1708, Johnston arrived from England or Ireland in Charleston,

South Carolina, the most cosmopolitan and prosperous town in the South. She accompanied her minister husband, who had been sent there by the bishop of London.

Several small pastel portraits of Irish subjects exist from before Johnston's emigration, suggesting she may have had some training in Ireland. In Charleston, she continued to do portraits in pastels for a few dollars each, evidently to supplement the family income. One such is *Mrs. Samuel Prioleau* (Fig. 5.9). Johnston may have been of French descent, which would have given her an *entrée* into the large Huguenot community in Charleston, of which Samuel Prioleau and his wife were members. Johnston's portraits have great charm. She has a special place in the history of American art as the first woman artist, and the first artist to work in pastels.

JUSTUS ENGELHARDT KÜHN

Farther north, the town of Annapolis had been settled in the mid-seventeenth century, and was made the capital of the colony of Maryland in 1694. Its prosperity attracted the German painter Justus Engelhardt Kühn (d. 1717), who

5.9 Henrietta Johnston, *Mrs. Samuel Prioleau*, 1715. Pastel on paper, 12 × 9in (30.5 × 22.9cm). Collection of the Museum of Early Southern Decorative Arts, Winston-Salem, North Carolina.

5.10 Justus Engelhardt Kühn, *Henry Darnall III*, c. 1710. Oil on canvas, 4ft 5in × 3ft 7in (1.35 × 1.09m). Collection of the Maryland Historical Society, Baltimore.

arrived in 1708 and lived there until his death. Fewer than a dozen portraits are attributed to Kühn, all of which were painted about 1710.

Kühn's full-length pictures of the children of Henry Darnall II are images meant to convey the social ambitions of one of the region's wealthiest landowners. *Henry Darnall III* shows a boy arrayed in great finery, attended by a young slave who wears a silver collar as the symbol of his servitude (Fig. **5.10**). Henry holds a bow and arrow—sporting toys frequently included in the portraits of sons of wealthy landowners—and his companion has retrieved a gamebird that has been shot.

The most wondrous features of the portrait, however, are the foreground setting and the background. The architectural segments suggest a monumental, palatial building, the likes of which did not exist anywhere in the American colonies. The elegant, formal garden, with its sculptured fountain, further contributes to a pretense of grandeur. The scene probably owes its inspiration to views of English or Continental manorhouses surrounded by formal gardens, such as those engraved by Johannes Kip (1653–1722) or Thomas Bladesdale (active 1705–20). A similar setting is found in the portrait of Henry's sister, Eleanor.

The figures in these pictures, as in others by Kühn, are stiff and doll-like. The small number of portraits attributed to Kühn, and the fact that he died in debt, indicate that the colony was not yet prepared to support a professional artist.

GUSTAVUS HESSELIUS

Three years after Kühn's death, Gustavus Hesselius (1682–1755) settled in Annapolis to try his fortune from 1720 to 1728, but with not much more success. Hesselius came from Sweden, and had probably had training as a painter before he arrived at the Swedish settlement of Christiana, later Wilmington, Delaware, in 1711. Soon after he moved to Philadelphia.

Two interesting paintings have been attributed to Hesselius—the *Bacchus and Ariadne* (Detroit Institute of Arts) and the *Bacchanalian Revel* (Pennsylvania Academy of the Fine Arts, Philadelphia). There was little demand for Italianate mythological pictures such as these in the colonies, however, and whether working in Pennsylvania or Maryland, Hesselius's commissions were almost all for portraits. In 1728, Hesselius left Annapolis to return to Philadelphia, where he spent the rest of his life.

Two portraits of chiefs of the Leni-Lenape tribe—*Lapowinsa* and *Tishcohan* (Fig. **5.11**)—are noteworthy as early records of Native Americans. Painted for John Penn, son of the founder of the colony, the portraits were admired for their accuracy. These were the first lifesize, bustlength images of Native Americans painted by a white artist in colonial America. Two years after they were painted, John Penn and his brother Thomas concluded a treaty with Tishcohan and Lapowinsa—the Walking Purchase Treaty—through which the Penns gained an enormous tract of

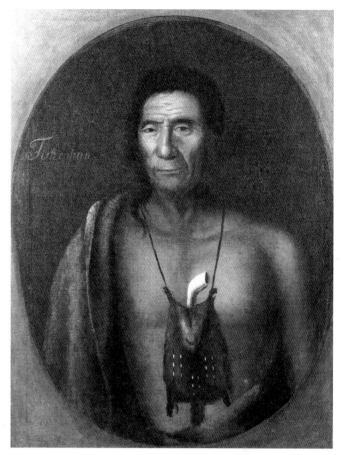

5.11 Gustavus Hesselius, *Tishcohan*, 1735. Oil on canvas, 33 × 25in (83.8 × 63.5cm). Historical Society of Pennsylvania, Philadelphia.

Native-American-owned land in eastern Pennsylvania.

Gustavus Hesselius also left a selfportrait and a pendant of his wife (Historical Society of Pennsylvania, Philadelphia). But even in Philadelphia, portrait commissions were so few that he had to find other means of livelihood. His son John, however, did become a successful professional portrait painter, as we shall see.

VIRGINIAN PORTRAITS

The number of portraits executed in Virginia between 1700 and 1750 was greater than in any other southern colony. The pattern, however, was always the same: a painter might visit the region briefly, or even take up residence for a few years, only to move on or turn to another profession. Because patronage was scattered among the distant plantation houses, the typical painter led an itinerant existence. Even Williamsburg did not entice professional portraitists to take up residence there in the way Boston had encouraged Smibert to establish a permanent studio. Nevertheless, Virginians had great appreciation for family portraits—they knew that the walls of the great English manorhouses they

5.12 Attributed to Nehemiah Partridge, *Edward Jaquelin, Jr.*, c. 1722. Oil on canvas, 31 × 26in (78.7 × 66cm). Virginia Museum of Fine Arts, Richmond. Lent by the Ambler family.

brushwork, rich and beautiful coloration, and the noble bearing of the figure make an attribution to Sir Godfrey Kneller plausible.

While in England, Byrd formed a collection of twenty or more portraits of his wife and daughter, and their many friends from London's élite social circles. He brought these back to Virginia, where they were hung at Westover (Fig. 4.8), the handsome new manorhouse built in about 1730. As a pendant to his own portrait, Byrd had one painted of his English wife, probably just before they left for Virginia in 1726. It equals his own in elegance, but it is by another artist.

William Byrd was also knowledgeable in the theory and techniques of painting, and his large private library contained several treatises on art, including Charles du Fresnoy's *The Art of Painting* (1695), Roger de Piles's book of the same title of 1706, and Lord Shaftesbury's *Characteristicks* (1711).

Byrd's southern collection, and the paintings that were on view in John Smibert's studio in Boston, mark, around 1730, the beginning of a new understanding of art in the American colonies.

5.13 School of Sir Godfrey Kneller, *William Byrd II*, c. 1704. Oil on canvas, 49 × 39in (124.5 × 99.1cm). Colonial Williamsburg Foundation, Williamsburg, Virginia.

admired and imitated were lined with icons that demonstrated a distinguished family lineage and high social position.

About 1722, Nehemiah Partridge (1683–c. 1729/37), a painter from the Hudson Valley, is believed to have visited Jamestown briefly. While there, he made several portraits of the Jaquelin and Brodnax families. One of these, representing young Edward Jaquelin, Jr. (Fig. 5.12), was typically based on an English mezzotint—this one by John Smith, after the portrait of the Hon. William Cecil. The boy is accompanied by his pet dog, and he gestures toward a parakeet, a bird then native to Virginia. The style is clearly that of the Hudson Valley Patroon painters, with marked, linear highlights cresting the folds of the fabrics, a somewhat stiff posture of the boy's figure, and an appealing, if self-conscious, facial expression. Partridge soon left, however, and Virginia was once again without a resident painter.

Perhaps one reason why such portraitists were neither successful nor remained long in the colony was because Virginians frequently had their likenesses taken in England, if business took them there, as it often did. William Byrd II, for example, who spent much of his early life in England, had his portrait painted there in about 1704. It is an elegant and aristocratic image (Fig. 5.13). The quintessence of English Baroque high-style portraiture, its exquisite

Charles Bridges (1670–1747) arrived in Virginia in 1735, as an agent of the Society for Promoting Christian Knowledge, and as a portrait painter in search of commissions. Bridges had been trained in England in a generally Knelleresque style. Almost immediately after arriving in Williamsburg, he was put to work painting portraits of William Byrd's young children. Byrd wrote to his friend Alexander Spotswood, former governor of the colony, recommending the artist to him. The *Governor Alexander Spotswood* portrait is therefore attributed to Bridges (Fig. 5.14).

It is a strong portrait, with its bright-red coat, rust-orange waistcoat with gold trim, and great white wig. The governor wears a sword, which, along with the castle and battle scene in the background, is a reference to Spotswood's military service under the Duke of Marlborough at the celebrated English victory at Blenheim. The scroll in his left hand probably at one time contained an architectural plan—now lost due to excessive cleaning—for the governor was well known as an amateur architect. As for Charles Bridges, he evidently longed to return to England, which he did in 1743 or 1744.

In the Williamsburg area, a cultural entrepreneur named

5.14 Attributed to Charles Bridges, *Alexander Spotswood*, c. 1735. Oil on canvas, 52 × 39in (132.1 × 99.1cm). Colonial Williamsburg Foundation, Williamsburg, Virginia.

William Dering (active 1735–50) took up portraiture to fill the gap created by Bridges's departure. Dering apparently had little or no training, but he had a portfolio full of English mezzotints. As he did not find sufficient commissions to allow him to become a fulltime portrait painter, Dering did other things, such as teach dancing, French, and music. About 1750 he moved to Charleston, and was heard of no more.

A few years earlier, Jeremiah Theus, a young man from Switzerland, had established a portrait studio in Charleston. As we shall see, Theus became the first professional portrait painter in the southern colonies, with a successful career spanning several decades.

THE CRAFT OF CARVING

During this period, sculpture, or more accurately carving, continued to be practiced in service to other forms of art, such as architecture and furniture, or as ornamentation for ships.

While gravestones still required images, a new occurrence was the frequent appearance of a little portrait of the deceased as he or she had looked while alive. The skull and crossbones continued as a favorite motif, accompanied by the familiar *memento mori* or *fugit hora*, as on seventeenth-century stones. But the smiling Mrs. Richard Owen (d. 1749) in fashionable attire indicates a shift to an eighteenth-century celebration of life (Fig. 5.15).

FIGURATIVE WOODCARVING

The stonecutter was not any more skilled in anatomy or in the rendering of fabrics than the woodcarver who made the *Little Admiral*, a shop sign for a tavern in Boston (Fig. 5.16). It is the earliest known example of a full-length carved figure in the American colonies. The stiffness of the figure reveals

5.15 Anonymous, Headstone of Mrs. Richard Owen, died 1749. Congregational Churchyard, Charleston, South Carolina.

that the carver was neither heir to the classical tradition, nor trained in the execution of the graceful forms of sculptors such as Jean-Baptiste Pigalle (1714–85) or Etienne Falconet (1716–91). Belonging to a folkcraft tradition, the *Little Admiral* marks the beginning of figurative woodcarving, which reached its fruition in the workshop of John and Simeon Skillin (Figs. 12.2 and 12.3) in the last quarter of the eighteenth century.

ARCHITECTURAL DECORATION

Carvers were increasingly called upon to make decorations for architecture. More and more colonial homes were based on eighteenth-century classical designs, which called for pilaster capitals, ornamented fireplaces, and the like. New fashions in furniture also required their skills—for example, the ornate, Baroque carvings for a William and Mary armchair, or the delicate shell-and-foot designs carved upon the legs of a Queen Anne settee (Figs. 4.15 and 4.19). The carver was, of course, following English styles, which were transmitted to the colonies through design books, imported furniture, and the immigration of carvers. Nevertheless, sculpture lagged well behind painting, and did not really become a fully developed, independent artform until after the Revolutionary War.

5.16 Anonymous, *The Little Admiral*, c. 1750. Wood, height 3ft 6in (1.07m). Courtesy Bostonian Society, Old State House, Boston.

CHAPTER SIX

ARCHITECTURE AND DECORATIVE ARTS:

1750–76

This was the golden age: Colonial America reached economic maturity, political independence, and its own intellectual and cultural identity. As the period opened, there was an ebullient feeling of prosperity among the towns and plantations of the seaboard colonies. The wealth created in the cities by merchants, shipowners, and land speculators was evident in the fashionable Georgian-style mansions they built, their handsome silver tea services, and the portraits they commissioned. Their ships, laden with the raw materials of the colonies, sailed to the West Indies and England, returning to port bearing exotic and useful goods from around the world. The southern planters bartered their tobacco, rice, indigo, wheat, and other grains for the goods they needed for their beautiful plantation houses. The merchants, farmers, planters, and craftsmen wanted nothing more than to concentrate on the very things that were providing their prosperity.

For all this prosperity, however, the period was a troubled one, beginning and ending with wars. As Englishmen crossed the Allegheny Mountains into Ohio, they inevitably confronted the French, who had formed an alliance with the Native Americans. The result was the Seven Years' War of 1757–63, which centered around Upstate New York and the Ohio-Pennsylvania frontier. The war ended with France ceding Canada and all of the land east of the Mississippi River to Britain. Westward expansion was now possible: In 1769 Daniel Boone began exploring Kentucky, and six years later he began cutting the Wilderness Road, which became the conduit for the settlement of Kentucky.

Many merchants and farmers prospered from wartime demand for their goods. But to pay for the war—defense of the frontiers and the presence of a standing British army —the king's ministers and Parliament, who admitted no colonial members, began to impose taxes on the colonies. The colonists decried this as taxation without representation.

The Seven Years' War had brought the colonies together and had planted the idea of the strength of unity. Also, victory over France, a great world power, had given them a new selfconfidence. Together, these emboldened the colonists in their resistance to the crown and Parliament. In turn, their newfound confidence in political, military, and economic arenas gave them a cultural identity, which was increasingly asserted through the arts.

English aristocrats and proprietors thought of the colonies as their personal property, to be exploited for their own gain. Americans, however, thought of their own interests. While they saw themselves as English, they also knew they were different from the homeland English. The concept of "the American" began to take form—they had gained experience in governing themselves, and they had learned to like it.

British interference and taxes brought a flood of pamphlets heatedly attacking the infringements of freedom, with Virginia and Massachusetts leading the way in civil disobedience. On 5 March 1770, English troops fired on a group of Bostonians, killing three and wounding others. Word spread among the colonies, and Committees of Correspondence were organized in an early step toward unity. On 13 December 1773, citizens disguised as "Indians" dumped a consignment of tea into Boston harbor to enforce an agreement of nonimportation of goods taxed by Parliament. When British soldiers marched on Lexington and Concord on 19 April 1775 to seize stores of ammunition, the "shots heard around the world" were fired. The end of the colonial phase in America had begun. In cultural matters such as architecture, however, colonial Americans were quite content to accept England as their guide and mentor.

GENTLEMAN-AMATEUR ARCHITECTS AND ARCHITECTURAL DESIGN BOOKS

Throughout the period 1750 to 1776, most Americans continued to see themselves as English. In England earlier in the century, Lord Burlington and his circle had led a revolution against the Wren-Baroque style, turning to the architectural designs of Inigo Jones (1573–1652) and Andrea Palladio (1508–80). This new spirit, which emerged

during the reign of King George I (reigned 1714–27), filtered through to the American colonies around 1740, leading to a golden age of Georgian splendor in the 1760s.

While retaining many of the traditions established before 1750, wealthy patrons sought even greater elegance in their homes, and exhibited a taste for elaborate, fashionable designs in their furniture. The craftsmen who created the houses and furnishings were often American-born, but the styles and motifs they used came straight from England, usually from a design book with engraved plates. Once the designs had crossed the Atlantic, they were modified to suit American tastes.

The rise of the gentleman-amateur architect and the increased availability and use of design books are two of the most important features in colonial American architecture of this era.

James Gibbs's *Book of Architecture* (1728), while retaining some English Baroque features, introduced the fashionable new Palladianism, providing details of classical capitals, pediments, the Orders, and so on. Colonial carpenters and their patrons could select, for example, a façade from Palladio, a pedimented doorway or window by William Kent (1684–1748), or the decorative details of a fireplace by Colin Campbell (d. 1729). The result was a montage of architectural "parts," tastefully, and often inventively, assembled. Thus the new American style was generally classical, with strong influences from Palladianism.

PETER HARRISON

Increasingly, taste in and knowledge of architectural design became a respected attribute in the eighteenth-century gentleman. This led to the rise of the gentleman-amateur architect, who was capable of designing public buildings— usually not for pay, but rather out of a sense of civic duty— or a house for a friend. Peter Harrison (1716–75) is an excellent example. Born in England, Harrison became a sea

6.2　Edward Hoppus *Andrea Palladio's Architecture* (Book IV, 1735), engraved plate, p.185. Courtesy Winterthur Library: Printed Book and Periodical Collection, Winterthur, Delaware.

captain and merchant, settling near Newport, Rhode Island, in about 1740. At the time of his death, his library contained twenty-seven architectural pattern books, which he put to use in designing several of the finest public buildings erected in New England between 1748 and 1770. His design for Newport's Redwood Library (Fig. 6.1), for example, is derived from a plate in Edward Hoppus's *Andrea Palladio's Architecture* (Fig. 6.2). It is one of the earliest Palladian temple porticos in America.

Harrison used the Doric Order, which he set upon a podium, in front of side wings that appear to form a low, second pediment behind it. Although the material is wood, in order to imitate the fine stone buildings being erected in England, the pine boards of the exterior walls were cut to look like rusticated masonry. The whole structure was painted light brown, the paint having sand mixed into it to further simulate stone. We can see a classical reserve and correctness of proportion, which Harrison derived from careful scrutiny of design books.

6.1　Peter Harrison, Redwood Library, Newport, Rhode Island, 1748–50.

6.3 Peter Harrison,
King's Chapel, Boston,
Massachusetts, 1749–54.
Interior. Courtesy Society for
the Preservation of New England
Antiquities, Boston.

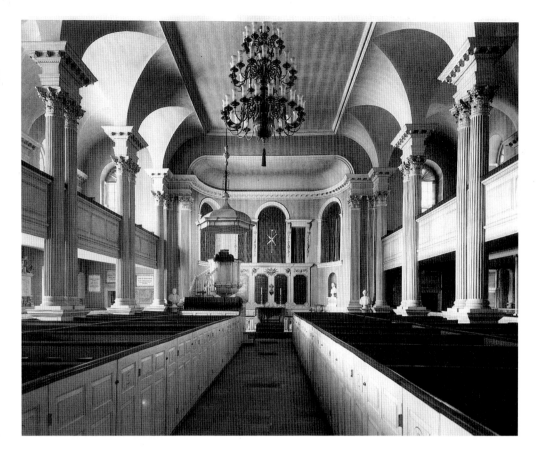

6.4 Peter Harrison,
Touro Synagogue, Newport,
Rhode Island, 1759–63. Interior.

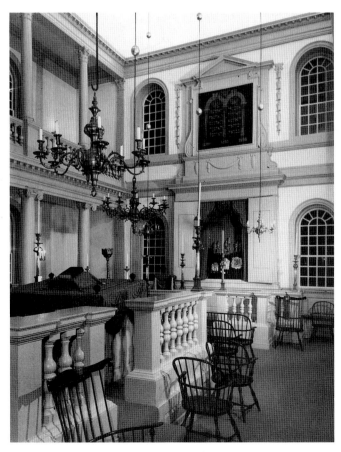

King's Chapel and Christ Church Harrison's reputation spread through his designs for two Anglican churches— King's Chapel (1749) in Boston and Christ Church (1760) in Cambridge. At King's Chapel, the largescale Ionic portico surrounding the tower followed Harrison's original scheme. In this way his design made the earliest use of the classical Order in the colonies. The spire was never built, but for its design Harrison turned to Gibbs's *Book of Architecture*, specifically to the spire of St. Martin-in-the-Fields. For the interior of King's Chapel, he again imitated St. Martin's, following another plate in Gibbs's book (Fig. 6.3).

Touro Synagogue Harrison's masterpiece of interior design is found in the Touro Synagogue (Fig. 6.4). In 1636, Roger Williams had founded the colony of Rhode Island on the principle of spiritual freedom. Twenty-two years later, escaping persecution in Europe, a group of Jews arrived in Newport. A century passed before they erected their own house of worship.

The first Jewish temple in America, Touro Synagogue has a plain exterior which masks the elegance within. Reportedly, the Jewish community did not want to flaunt their wealth or incur envy, so the exterior was left undecorated.

Since there was no prescribed form for a synagogue, Harrison needed only to provide for certain Jewish ceremonies and practices. Otherwise, he was free to organize the components of Georgian architecture as he wished. In the

center, surrounded by a balustrade, is a raised platform from which the cantor sang and the Law was read. At the eastern wall is a two-story tabernacle within which the Torah was kept. The twelve columns, with their beautifully carved capitals—Ionic below, Corinthian above—are symbolic of the twelve tribes of ancient Israel. While nearly every detail can be traced to the engraved plates of Harrison's several architectural pattern books, the sensitivity with which they were assembled is testimony to the refined skill of this gentleman-amateur.

Brick Market For Newport's Brick Market, Harrison found his model in Campbell's *Vitruvius Britannicus* (c. 1717), which illustrates the riverfront façade of London's Somerset House (Fig. 6.5). The lower floor consists of an arcade, which was originally open in the tradition of a public market. In the second and third stories, large windows with alternating triangular and segmental pediments have smaller square windows above them, in good Palladian manner. Pilasters flank each row of windows and are doubled at the corners.

In Harrison's use of the Ionic Order, instead of the Corinthian as at Somerset House, we find the colonial American penchant for simplifying architectural form, even when copying a specific building.

JOSEPH BROWN

Joseph Brown (1733–85), a merchant and, like Sir Christopher Wren, a mathematician and astronomer, designed the First Baptist Meetinghouse in Providence, Rhode Island (Fig. 6.6). Another gentleman-amateur architect, Brown also owned Gibbs's *Book of Architecture*, as well as Abraham Swan's *A Collection of Designs in Architecture* (London, 1757). The main body of the meetinghouse is a dignified but rather plain clapboard block, with round-headed windows in

6.5 Peter Harrison, Brick Market, Newport, Rhode Island, 1761–72.

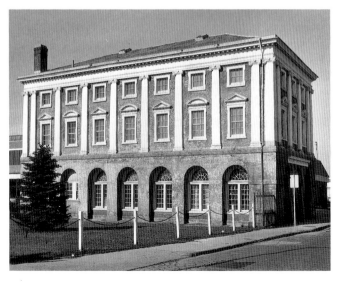

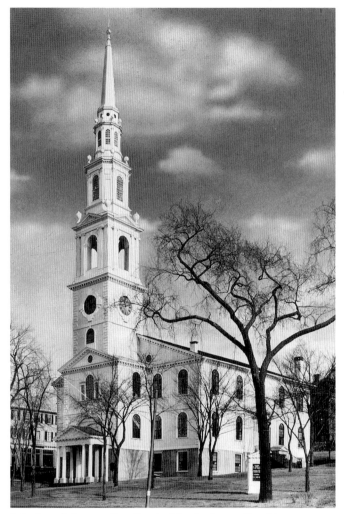

6.6 Joseph Brown, First Baptist Meetinghouse, Providence, Rhode Island, 1774–5.

the two upper levels. The chief glories of the building are the tower base and spire, which Brown designed from several plates in Gibbs. The little Doric portico was taken from the façade of St. Mary-le-Bone, London, and the spire is a replica of a rejected design for St. Martin-in-the-Fields. Brown was less successful in matters of scale and unity, for the portico and the Palladian window above seem much too small for the size of the building.

DESIGN BOOK GEORGIAN

Domestic architecture also consisted of parts from architectural source books. The Vassall-Longfellow House shows how the basic form of the American house has not changed much from that of the early eighteenth century—a horizontal, rectangular block with a hipped roof, constructed of wood with clapboard siding (Fig. 6.7). What is now a central pavilion, which projects slightly from the plane of the façade, is framed by two colossal Ionic pilasters and a pediment that reaches into the roofline. The great pilasters

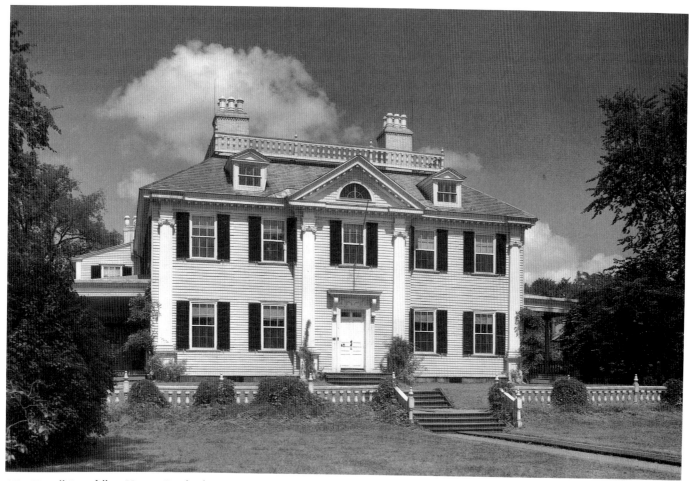

6.7 Vassall-Longfellow House, Cambridge, Massachusetts, 1759. Wayne Andrews/Esto.

are repeated at the corners, and a balustrade caps the roof. Architectural details gleaned from the design books have thus been applied to the surface of an old and familiar house form, ensuring that the edifice conforms to the new Georgian taste as defined by Gibbs, Kent, Swan, and other architect-authors.

ARCHITECTURE IN NEW YORK AND PHILADELPHIA

The survival of longstanding cultural and architectural traditions in the colony of New York can be seen in Van Cortlandt Manor, which shows the continuation of an older, Dutch farmhouse type long after the Georgian style had arrived in America (Fig. 6.8). Originally built as a modest, one-story stone house around 1700, the manor was remodeled in 1749, but it retained features found in the Hendrickson-Winant House (Fig. 2.18)—specifically, the prominent, steeply pitched roof, the sweeping extension of that roof at a flatter pitch, and the fullwidth verandah which the roof extension covers.

6.8 Van Cortlandt Manor, Croton-on-Hudson, New York, 1749. Courtesy Historic Hudson Valley, Tarrytown, New York.

Van Cortlandt Manor is a lovely house, but it is not design-book Georgian. It reminds us that such anachronisms do happen, usually as a result of enduring cultural forces—in this case, the continuing strength of Dutch traditions in the Hudson Valley.

6.9 Thomas McBean, St. Paul's Chapel, New York City, 1764–6, spire c. 1795. Wayne Andrews/Esto.

Handsome edifices in the Georgian style arose in the Morris-Jumel Mansion (1765) and St. Paul's Chapel in New York (Fig. 6.9). St. Paul's was designed by Thomas McBean, reportedly a student of James Gibbs. Both in its exterior and interior, the building follows closely the great church of St. Martin-in-the-Fields. The truly monumental Ionic portico and beautifully articulated spire were not added until about 1795, but in accordance with McBean's design. St. Paul's is constructed of ashlar brownstone, which has a slight mauvish tint.

PHILADELPHIA COUNTRY HOUSES

In the middle colonies, the foremost center of Georgian splendor was Philadelphia, which by the 1760s had become the largest and richest city in North America. Although often referred to as the "Quaker City," it is obvious that Quaker restraint and simplicity did not dominate the spirit of the town. Nor was the Society of Friends the only religious sect there. There were also Anglican, Presbyterian, and Methodist congregations, among others. Quakers, too, participated in the fervor for elegance, which was supported by mercantile prosperity.

Mount Pleasant was built as the country house of a Scottish sea captain. It shows the extent to which the decorative features of the Gibbsian-Georgian style could be carried (Fig. 6.10). The block form has a central pedimented pavilion and a hipped roof that carries a balustrade. Above the entrance, which is adorned with an applied Doric portico

6.10 Mount Pleasant, Fairmount Park, Philadelphia, Pennsylvania, 1761–2.

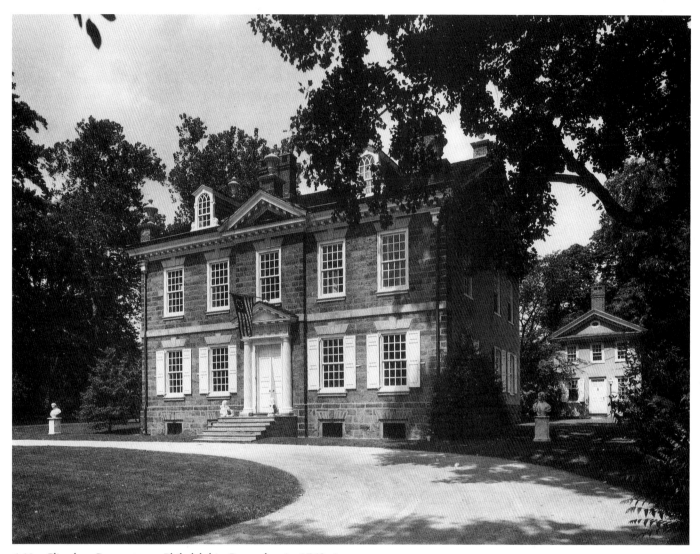

6.11 Cliveden, Germantown, Philadelphia, Pennsylvania, 1763–4.

that encloses an arch, is a Palladian window. There is little space left for the façade walls—constructed of rubble masonry and given a stucco surface—for the large windows, stringcourse, and corner quoining occupy much of the plane. Mount Pleasant may have been designed by Robert Smith (1722–77), a carpenter-architect who erected the steeple on Christ Church (Fig. 4.24).

Cliveden, built for Benjamin Chew according to his own designs, is of a similar form, but greater restraint was imposed in the decoration (Fig. 6.11). The central axis of its symmetrical stone façade is again marked by a pedimented pavilion, although the latter does not have a Palladian window, and the Doric doorway is not as elaborate; nor is there the bold quoining of Mount Pleasant. Cliveden, however, has its own special niceties, such as the scrolls applied to the sides of the dormers, and the urns—which were imported from England—that decorate the roof. Cliveden is double-pile, with a large, gracious entrance hall, beyond which is a stairhall (Fig. 6.12).

6.12 Cliveden, Germantown. Plan.

| 0 | 5 | 10 | 15 | 20ft |
| 0 | 1 | 2 | 3 | 4 | 5 | 6m |

PHILADELPHIA TOWNHOUSES

If Mount Pleasant and Cliveden represent the countryhouse type, the Powel House remains as a splendid example of the Philadelphia townhouse (Fig. 6.13). A typical townhouse was built of brick, was three or four stories high, had a narrow façade of three bays, or, less frequently, four, set immediately on the street, and ran on a long axis toward the rear of the lot. The red brick was smartly set off by the light-colored stone used for stringcourses and the keystones over the windows, while the wood of the shutters, doorway, and cornice was painted white. The sides of such houses often abutted neighboring houses, so only the façade was seen, except for houses on corner lots. The entrance of the Powel House is placed at one side, and leads to a hallway giving access to the rooms at the left. Some of the interior decorative architectural carving was done by Hercules Courtenay, an Irish-born, London-trained carver and gilder who arrived in Philadelphia in 1762. Courtenay was also employed by John Cadwalader and John Dickinson for similar work in their fine houses.

During a Grand Tour of Europe, Samuel Powel had seen the antiquities of Rome, met Voltaire, and been presented to King George III. While traveling he had observed architecture, and developed what the English at the time called "taste." Back in Philadelphia, as the last colonial mayor of that city, Powel and his wife entertained lavishly. The interior of the splendidly furnished house had to reflect the couple's taste and social position (Fig. 6.14). The very best craftsmen were employed for the paneling, cornices, fine moldings, and the decorative Georgian fireplace with its rich carvings. The Chinese wallpaper (as seen in the Metropolitan Museum of Art), while not actually used in the Powel House, is typical of the fascination with chinoiserie in the 1760s. The ornamental plasterwork on the ceiling was also not originally part of this particular room, but its pattern was taken from an adjoining room in the Powel House. The furniture is in the fashionable new Chippendale style, and a portrait by John Wollaston hangs above the fireplace.

CHIPPENDALE AND ENGLISH ROCOCO

Chippendale was an outgrowth of the Queen Anne style, with the basic forms and proportions made slightly more elaborate. Although the Queen Anne style continued to be used, Chippendale dominated interior furnishings in the 1760s and 1770s.

Thomas Chippendale (1718–79) was a London craftsman, who in 1754 published *The Gentleman and Cabinet-Maker's Director*. This contained numerous plates of current high-style furniture designs. While the S-curve remained an essential line in the forms, it became more vigorous than in Queen Anne. New motifs were also incorporated. The most

6.13 Powel House, Philadelphia, Pennsylvania, 1768.

important of these were Gothic, which was experiencing a revival at about this time, and French Rococo, which was restrained to suit English taste. Finegrained mahogany, imported from Central America or the West Indies, was the preferred wood. Its rich, reddish-brown tones were set off by polished brasses, elaborate carving, or elegant fabrics. In America, the craft of furnituremaking was developed to a high point—in Boston, Newport, New York, Charleston, and Savannah—but nowhere in the colonies was the glory of the Chippendale style more fully realized than in Philadelphia.

A comparison of a Chippendale chair (Fig. 6.15) with a Queen Anne (Fig. 4.18) illustrates the transformation that occurred. The earlier piece is characterized by a classic simplicity, gentle curves, and smooth surfaces. The later one, although following the same basic form, has more active lines, more intricate curves, and its surfaces are covered with elaborate carvings. The **splat**, or center support of the back, in the Queen Anne chair is an elegant but simple smooth plane, where its Chippendale counterpart is complex and perforated. The shape of the seat similarly varies from the simplicity of the one to the undulating curvatures of the other. The welldefined knees and front feet of the Queen Anne chair are replaced in the Chippendale chair by carved floral decorations and the claw-and-ball motif. Such elaborate carving, working so beautifully with the form it adorns, is one of the highest accomplishments of Philadelphia Chippendale furniture.

6.14 Powel House, Philadelphia. Interior, as installed in
Metropolitan Museum of Art, New York City.

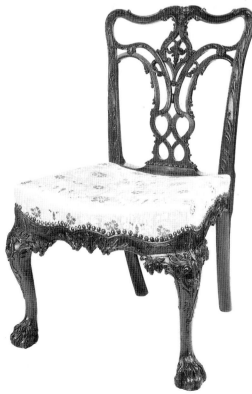

6.15 Thomas Affleck, Chippendale side chair, 1760–75.
Mahogany, 36⅞ × 23¾ × 23½in (93.7 × 60.3 × 59.7cm).
Courtesy Winterthur Museum, Winterthur, Delaware.

PHILADELPHIA CHIPPENDALE

One of the finest shops in Philadelphia was operated from
about 1765 to the Revolution by the cabinetmaker and
joiner Benjamin Randolph (1721–91). In addition to the
excellence of his workmanship, there were two other
reasons for Randolph's success: his conversion to the
fashionable new Chippendale mode, and the presence of
two carvers of extraordinary ability—John Pollard (1740–
87) and Hercules Courtenay (1744?–84). Both Pollard and
Courtenay had been trained in London and appear to have
worked for Randolph as journeymen (employees), not
apprentices, in the late 1760s to pay off the price of their
Atlantic crossing. By 1770, both had left Randolph to
establish their own shops, where they made elaborate
frames for mirrors and paintings, specialized carvings for
several of the city's cabinetmaking shops, and carved orna-
mentation for the interiors of many new houses.

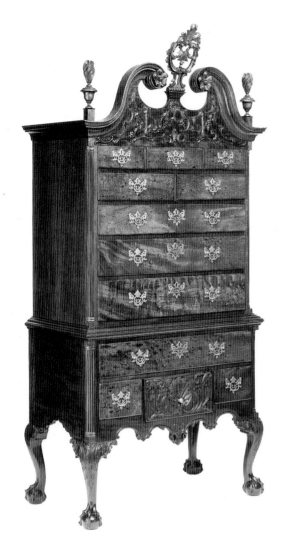

6.16 Chippendale high chest, 1765–80. Mahogany, 90¼ × 45⅝ × 25½in (229.2 × 115.9 × 64.8cm). Courtesy Winterthur Museum, Winterthur, Delaware.

The Quaker City was blessed with other gifted craftsmen. Among the best were the cabinetmaker Thomas Affleck (1740–95) and the carver James Reynolds (c. 1736–94). Affleck finished his apprenticeship in his native Scotland before going to London briefly, and arrived in Philadelphia in 1763. The side chair in Figure 6.15, made in Affleck's shop, is believed to be one of a matching set of at least thirteen, inspired by plate IX of the 1762 edition of Chippendale's *Director*. The exquisite carving was done by the shop of Bernard and Jugiez as a commission from John Cadwalader to adorn his new house.

Reynolds was trained in London in the most current manner, and emigrated in about 1765. The two may have collaborated to produce a beautiful set of cardtables for John Cadwalader. The corner of one is visible in Peale's portrait of the Cadwalader family (Fig. 7.17). Lavish carving became a major component in Philadelphia furniture and interiors, as seen in the parlor of the Powel House (Fig. 6.14)—on Chippendale chairs, sofa, piecrust teatables, the

grandfather clock, the pictureframe, fireplace ornamentation, and architectural decorations.

If the Chippendale high chest of drawers (Fig. 6.16) is compared with a Queen Anne piece (Fig. 4.20), we can see that the form is similar, but the decoration is quite different. The scrolled pediment is more active in the later example, and the two parts culminate in rosettes. A pedestal finial provides an intricately carved accent in between. More carving adorns the pediment, the central bottom drawer, the skirt, and the **cabriole** legs, all splendidly wrought in typically Rococo motifs. Similarly, the gleaming brasses are larger, of more intricate design, and are perforated more than those found on the Queen Anne chest. Whereas earlier casepieces were frequently painted to conceal inferior woods, the Chippendale high chest was typically made of fine woods—usually imported mahogany or native walnut—with the color and grain of the wood brought to a lustrous sheen by a high polish.

THE SILVERSMITH'S ART

In comparing a teakettle (Fig. 6.17) by the excellent Philadelphia silversmith Joseph Richardson (1711–84) with the simple, contained form of a Queen Anne teapot (Fig. 4.21) the same transformation from Queen Anne to English

6.17 Joseph Richardson, Teakettle on stand, 1745–55. Silver, height 11 1/16 in (28.1cm). Yale University Art Gallery, New Haven, Connecticut.

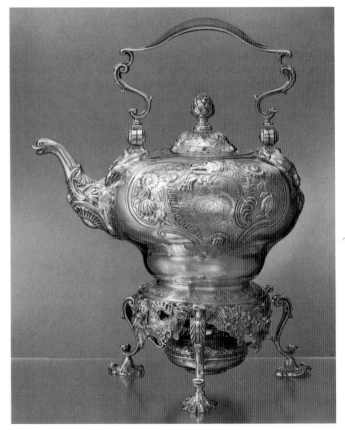

Rococo (Georgian) is observed. Richardson's teakettle—with its open, irregular form, the constant use of curve-countercurve motifs, and richly sculptured and asymmetrical reliefs—correlates well with the ornamental carving on the Chippendale side chair. Richardson's work comes close to specimens made in the best shops in London, and many consider his teakettle a high point in the silversmith's art in colonial America.

Probably the most famous early American silversmith was Paul Revere of Boston, whose work will be explored later. Revere's career is documented in a large *oeuvre*, and in John Singleton Copley's wellknown portrait that shows him working on a silver teapot (Fig. 7.9). Myer Myers (1723–95) was the foremost New York silversmith of the third quarter of the eighteenth century. He made a number of pieces for the synagogues in Newport, Philadelphia, and his native New York, but he made liturgical silver for Christian churches as well. Most of Myers's considerable production, however, was for domestic use, and splendid examples may be seen in the collections of Yale University and the New-York Historical Society.

ARCHITECTURE IN THE SOUTH

The South was equally eager to don the refining embellishments of the new architectural style. The wealth of the tobacco plantations in Virginia and Maryland and the rice and indigo plantations in South Carolina made it possible. The southern planters—who continued to see themselves as American counterparts to the English gentry—wanted their townhouses and plantation mansions, as well as their public buildings, to express their high level of culture.

CHURCHES

St. Michael's Church in Charleston (Fig. 6.18) possesses a dignity and nobility derived from its London model, Gibbs's St. Martin-in-the-Fields. The walls and tower of the church are brick covered with stucco, while the portico and steeple are wood. On the sides are two rows of round-headed windows, enframed by Ionic pilasters carrying a full entablature. The large, fully developed, freestanding Doric portico is the earliest example in colonial America. The square tower rises out of the main body—and is therefore unlike Christ Church, Philadelphia (Fig. 4.24) where it is added on to the end—before changing to an octagonal form in three decreasing stages, the uppermost of which is capped by a spire. The rich ornamentation is seen in the beautiful carvings of the capitals and entablature of the Composite Order in the chancel, which must be among the best such work of the colonial era (Fig. 6.19). A familiarity with classical design and a feeling for sculptural form are manifestly apparent here.

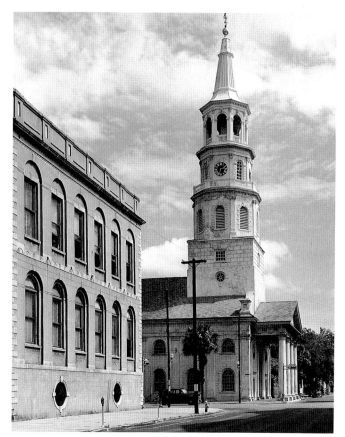

6.18 St. Michael's Church, Charleston, South Carolina, 1752–61. Wayne Andrews/Esto.
6.19 St. Michael's Church, Charleston. Chancel decorations.

HOUSES

Most domestic architecture in the South during this period follows the form of the Wren-Baroque house, which had been established in America during the second quarter of the eighteenth century. Several such houses were built in Virginia in the early 1750s—Kenmore, at Fredericksburg, for example, or Wilton, originally located on the James River but now removed to Richmond.

The Wythe House is typical of the conservative design that harks back to late seventeenth-century English architecture (Fig. 6.20). There is virtually no sign of the new Gibbsian style in its exterior. A simple block form constructed of brick, it has a hipped roof, a symmetrical façade, a stringcourse defining the two stories, and little classical ornamentation other than the cornice. The Wythe House is double-pile in plan, with two rooms on either side of a large central hall. The interior reflects the same penchant for simplicity as the exterior. It may have been designed by Richard Taliaferro (1705–79), who some scholars believe was a gentleman-amateur architect responsible for the design of several houses in that part of Virginia. Taliaferro is known to have been in charge of remodeling the Governor's Palace in the early 1750s. George Wythe—Williamsburg lawyer, tutor of the future chief justice John Marshall, and friend of the young Thomas Jefferson—married Taliaferro's daughter, and the newlyweds moved into the house.

Carter's Grove, on the James River, south of Williams-burg, is similarly reserved on the outside, but the rooms within provide a surprise. Carter's Grove was erected for Carter Burwell, grandson of the wealthy Robert "King" Carter. An English carpenter and carver, Richard Bayliss (active 1750–60), was commissioned to adorn its interiors. The entrance hall (Fig. 6.21), one of the finest rooms from the colonial period, has architectural decorations taken from William Salmon's *Palladio Londonensis* (London, 1734), a copy of which Burwell owned. In executing the beautifully carved Ionic pilasters, moldings, cornices, and panels, Bayliss created an interior that is resplendent in the new Georgian vocabulary of design.

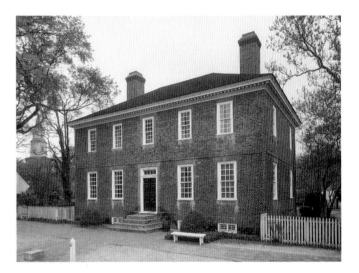

6.20 Attributed to Richard Taliaferro, George Wythe House, Williamsburg, Virginia, 1752–4. Colonial Williamsburg Foundation, Williamsburg, Virginia.

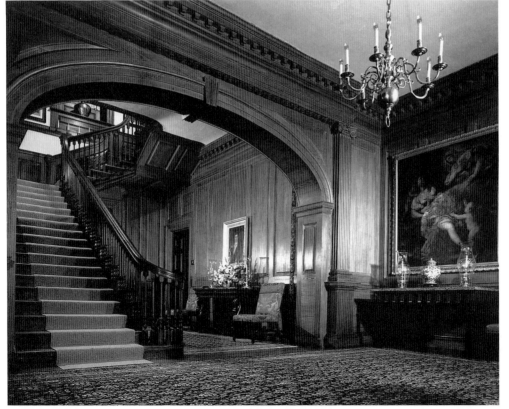

6.21 Carter's Grove, James City County, Virginia, 1750–3. Interior, entrance hall. Colonial Williamsburg Foundation, Williamsburg, Virginia.

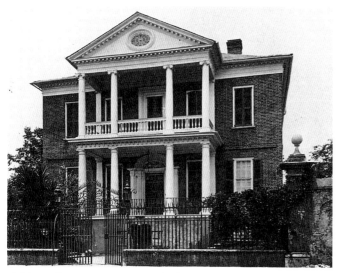

6.22 Miles Brewton House, Charleston, 1765–9.
Courtesy The Charleston Museum, Charleston, South Carolina.

6.23 Port Royal Parlor, 1760–80, as installed in Winterthur
Museum, Winterthur, Delaware.

GEORGIAN STYLE

A full commitment to the Georgian style is found in the Miles Brewton House (Fig. **6.22**). Here, the two-story portico was derived from Palladio's *Four Books on Architecture*, while the interiors show the influence of Inigo Jones and Colin Campbell. There is a dedication to the Palladian principles of rationally derived geometric proportions, while the Orders of the portico—Ionic above Doric—have a classical correctness and beauty of form. The width of the pediment is equal to the combined widths of the two halves of the façade flanking the portico, and its triangular form is enhanced with an oval oculus—all indications of the application of English Palladianism.

Palladianism of such purity was unusual in the South, and the Georgian style, as transmitted through the design books by Gibbs and Swan, had a broader appeal. Such influences are apparent in the fireplace and cornice of a parlor from a house built at Port Royal which is now installed in Winterthur Museum (Fig. **6.23**). After about 1760, the elegant and intricate Chippendale style dominated the furnishings of such rooms in the South, just as it did in the North.

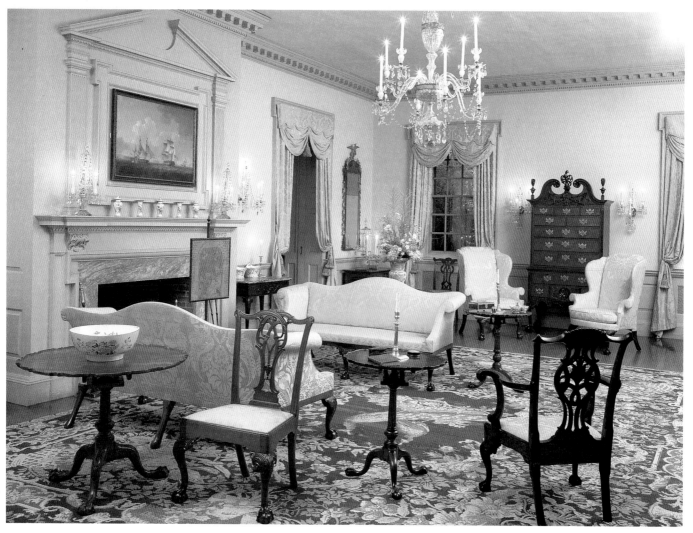

Charleston was the foremost furniture making center in the South. Among the leading craftsmen was Thomas Elfe (c. 1719–75), a London-trained cabinetmaker who worked in Charleston for three decades after emigrating in about 1745. In form, decoration, and construction, Elfe's work is among the closest of any made in the American colonies to the high-style pieces made in London shops. This was a characteristic that pleased South Carolinians because of the close cultural ties they maintained with England.

WILLIAM BUCKLAND

Gunston Hall on the Potomac River near Alexandria, Virginia, was built in 1755–9 for George Mason, a friend and neighbor of George Washington, and the man who wrote the Virginia Declaration of Rights. Mason himself drew up the plan for the house, and in 1755 William Buckland (1734–74), a London-trained joiner and carpenter, was brought over under an indenture to execute the interior woodwork and the porches of Gunston Hall. This exceptionally talented craftsman produced some of the finest architectural decorations of the colonial era, and eventually became an architect as well.

After completing his work—and his indenture—at Gunston Hall, William Buckland next went to Mount Airy in Richmond County, Virginia, where, around 1760, he again executed numerous architectural details. In 1772, he settled in Annapolis, the capital of colonial Maryland and a thriving town. The prosperous planters and merchants of the region were anxious to establish a tasteful and enlightened ambience within their province. With the William Paca House, the Brice House, Whitehall, and the Capitol—all of the 1760s—there is evidence that the great flowering had begun even before Buckland's arrival. But Buckland's Chase-Lloyd House (1771) and Hammond-Harwood House (1774) represent the crowning achievements.

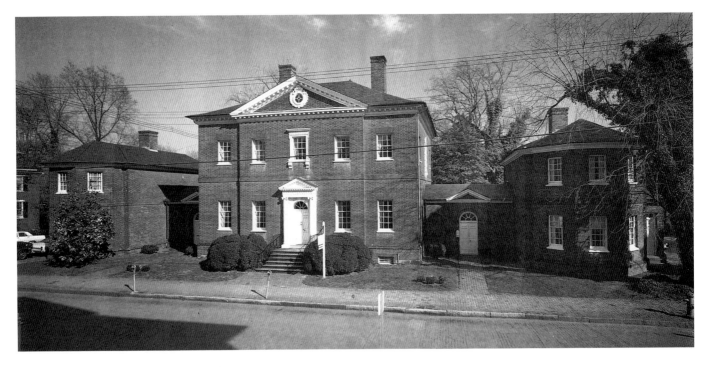

6.24 William Buckland, Hammond-Harwood House, Annapolis, Maryland, 1774.

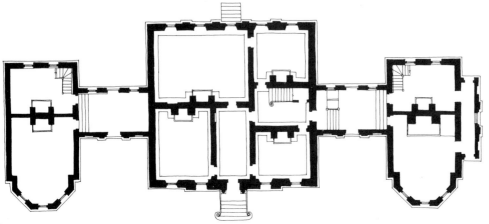

6.25 William Buckland, Hammond-Harwood House, Annapolis. Plan.

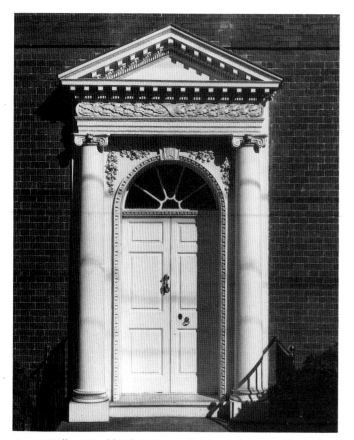

6.26 William Buckland, Hammond-Harwood House, Annapolis. Doorway.

The Hammond-Harwood House has a five-part plan, which was inspired by a plate from Robert Morris's *Select Architecture* (London, 1757), a copy of which Buckland owned (Figs. **6.24** and **6.25**). The large central block has a pedimented pavilion with a noble cornice. The central axis is emphasized by the oculus and the elaborate surround of the middle window, above an Ionic doorway that has some of the most beautiful and delicate carving produced in colonial America (Fig. **6.26**). Decoration is concentrated in the central axis of oculus, window, and doorway. Otherwise, a preference for sharpedged architectural simplicity prevails. Windows are cut cleanly into the façade, without the accent of molded surrounds. The stringcourse—of brick rather than

white marble—is more discreet than decorative. There is no fully developed entablature, only a dignified cornice. The house also follows the English Palladian style in its organization of multiple parts. The central two-story block is flanked by the low, one-story hyphens with pedimented pavilion entrances, while the two-story dependencies, set at right-angles to the hyphens, end in half-octagons. All reveals a sensitivity to the beauty of a bold interplay of architectural volumes and shapes.

Although America was moving inexorably toward rebellion against English rule, virtually every aspect of colonial culture remained firmly based upon English sources. Nowhere is this more apparent than in architecture and the decorative arts. If French Rococo and Oriental motifs appeared along the Atlantic Seaboard, these had been synthesized into an English mode before they arrived. Only occasionally—as in areas of longtime French influence such as Louisiana, or in enclaves of Dutch culture like the Hudson River Valley—were non-English forms an influence of consequence.

The gentleman-amateur architect Peter Harrison had been born and raised in England and was thoroughly familiar with contemporary English building design. William Buckland had grown up in England and was trained in London in the techniques and styles of English joinery and carpentry before he came to America. Thomas Elfe, the Charleston cabinetmaker, also brought with him a style that had been formed in England. American-born colonists turned to their copies of English design books to find their model of taste, and to imitate the forms of English Palladianism, Georgian classicism, anglicized Rococo, chinoiserie, and so on. Fireplaces to adorn interiors, urns to decorate rooflines, and furniture and silver were imported from England, further imposing an Englishness upon the colonial domestic scene.

However, there were forces at work which modified the English forms. In England, high style had been a reflection of the taste of aristocracy, whereas that style in America was tempered to suit the more conservative middleclass taste and purse of prosperous merchants and planters. The use of native materials in architecture, particularly wood instead of stone, also effected a difference, and native craftsmen, remote from the centers of style, naturally evolved their own provincial versions of English architecture and furniture.

CHAPTER SEVEN

PAINTING:

AFTER 1750

As with architecture and the decorative arts, the years 1750 to 1776 were a golden age for American painting. The ambience of colonial society was one in which the arts flourished. Many handsome towns now dotted the seaboard—Portsmouth, Salem, Newport, Providence, New York, Annapolis, Baltimore, Williamsburg, Charleston, and Savannah, for example. Philadelphia was the largest city in English North America, with a population of 18,700, and Boston was almost as large. Refinement accompanied the new wealth, as evident in the churches as in the homes of the merchants and planters. Throughout the colonies, there were candlelight concerts and elegant balls where the graceful minuet was danced, sometimes to the music of Haydn or Handel, sometimes to scores composed by a colonial musician. Theater, too, became a popular amusement.

In 1767, Thomas Godfrey's *The Prince of Parthia* was presented at Philadelphia's Southwark Theater, the first American drama to be performed on stage. A few years later, "The Rising Glory of America," a poem by Philip Freneau and Hugh Brackenridge, expressed the pride Americans felt in the new civilization they were creating. A young slave, Phillis Wheatley (Fig. 7.1), published a volume of her work, *Poems on Various Subjects*, in 1773, although that was extraordinary.[1] Wheatley, who was welleducated and familiar with classical traditions in literature, wrote on a fascinating range of subjects, for example the poem "To S. M., a Young African Painter, on Seeing his Works," dedicated to Scipio Morehead—a young black slave of the Rev. John Morehead of Boston.

Wheatley was freed in 1774, by John Wheatley, a Boston merchant, although she continued to work in his service. Her feelings about slavery and freedom were movingly expressed in two poems. One was addressed to the Earl of Dartmouth, British Secretary of State for North America:

> I, young in life, by seeming cruel fate
> Was snatch'd from Afric's fancy'd happy seat:
> What pangs excruciating must molest,
> What sorrows labour in my parent's breast?
> Steel'd was that soul and by no misery mov'd
> That from a father seiz'd his babe belov'd:
> Such, such my case. And can I then but pray
> Others may never feel tyrannic sway?

The other poem was titled "On Being Brought from Africa to America":

> 'Twas mercy brought me from my Pagan land,
> Taught my benighted soul to understand
> That there's a God, that there's a Saviour too:
> Once I redemption neither sought nor knew,
> Some view our sable race with scornful eye,
> "Their colour is a diabolic die."
> Remember, Christians, Negroes, black as Cain,
> May be refin'd, and join th' angelic train.

7.1 Anonymous, Phillis Wheatley, c. 1773. Engraved frontispiece from Phillis Wheatley, *Poems on Various Subjects* (London, 1773). Morris Library, University of Delaware, Newark, Delaware.

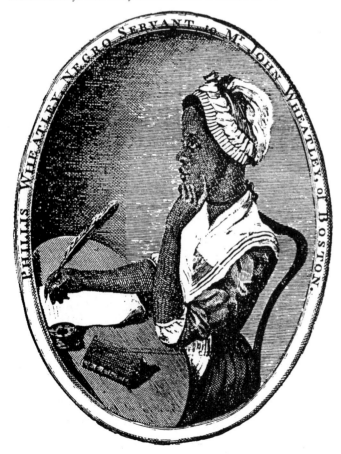

John Wheatley owned a number of books, including Homer's *Iliad* and *Odyssey*, nine volumes of Alexander Pope's works, John Milton's *Paradise Lost*, and Tobias Smollett's translation of *Don Quixote*. Americans generally were quite literate, had excellent personal libraries and several first-rate public libraries, and laid great stress on the value of education.

This was not, however, a great period for American *belles-lettres* or the development of a flowery literary style. The colonies had no Alexander Pope or John Dryden. Still, they had their wits, as well as an extraordinary American literature found in the more pragmatic genres of scientific and political writings. For example, John Bartram of Philadelphia wrote the internationally acclaimed *Observations on American Plants* in 1751, and in 1765 was named Royal Botanist by King George III. Benjamin Franklin's *Experiments and Observations on Electricity* (London, 1751) was praised in England by members of the Royal Society. Franklin's *Way to Wealth* (1758) was a philosophical but practical manifesto for the industrious and sober young American who wished to rise in society. Be alert, decorous, and useful to your community, Franklin advised, and worldly success is sure to follow in this land of opportunity—or, as Poor Richard said, "God gives all things to Industry," or, "He that has a Trade has an Office of Profit and Honour."

When it came to defining the rights of men and women, or attacking an injustice, Americans were especially brilliant. Thomas Paine (1737–1809) was an Englishman who arrived in America in 1774. His *Common Sense* (1776) provided a rationale for the justness and necessity of the "Declaration of Independence," written by Thomas Jefferson later that year. Such was the natural literary and rhetorical medium for Americans who had not yet warmed to fiction, fantasy, or fine arts.

Throughout the colonies ran powerful strains of pragmatism, utilitarianism, materialism, egalitarianism, and moderation. These are also the characteristics seen in the portraits of the period, and were strong determinants in the crystalization of the colonial painting style in the hands of such masters as John Singleton Copley (1738–1815) and Charles Willson Peale (1741–1827). Accordingly, there is elegance in the portraits, but seldom frivolity or foppishness. There is materialistic indulgence, but seldom ostentation. These traits—along with straightforwardness and selfconfidence—created a new kind of man and woman who was noticeably different from the Europeans.

IMMIGRANT PORTRAITISTS

By the 1750s, painting in the American colonies had entered a new phase. This was spawned by increased patronage, the arrival of several welltrained painters from abroad, and the rise of a considerable number of American-born artists. Painting continued to be limited almost exclusively to portraiture. The task of the painter was to capture both the likeness and the social position of the sitter, who was usually a merchant or planter. The latest London style was introduced by immigrant painters. American-born artists, after studying in England, or being exposed to English artists, developed a provincial but accomplished brand of Georgian painting. During the third quarter of the eighteenth century, the colonial American portrait reached its high point.

JOHN WOLLASTON

John Wollaston (c. 1710–75) had established a successful portrait studio in London by the time he emigrated to New York in 1749. Having learned the fashionable mannerisms of the day as practiced by Thomas Hudson (1701–79)—most notably the peculiar almond shape given to the subject's eyes—Wollaston imposed this characteristic upon all Americans who sat for him. It was enthusiastically accepted as the latest and most stylish mode, direct from London. Wollaston's paintings are not penetrating character studies of specific individuals, for he always applied his London-learned idealizations—that is, he sought an ideal more than the real.

The portrait of Mrs. John Dies is typical (Fig. 7.2). Most of the canvas is devoted to the lovely gown the subject wears, with its exquisite satins and laces splendidly painted, while

7.2 John Wollaston, *Mrs. John Dies*, c. 1750. Oil on canvas, 45 × 36in (114.3 × 91.4cm). Mead Art Museum, Amherst College, Amherst, Massachusetts.

her rather plain face is made elegant by the almond-shaped eyes. The color scheme of a Wollaston portrait was dominated by the new pastel hues of the Rococo style, as in the beautiful ice-blue of Mrs. Dies's dress.

Wherever Wollaston went, his fashionable style found favor among patrons. He exerted a strong influence on impressionable young American-born painters as well. Wollaston left New York for Philadelphia in 1752. The next year he was working in Annapolis, and then spent two years taking likenesses among the prominent plantation families of Virginia. In 1758, he returned to Philadelphia, but then went to the British West Indies before settling in Charleston for a while, ultimately departing for London in 1767.

JOSEPH BADGER AND JOHN GREENWOOD

In New England, the vacuum created by the death or departure of Smibert, Pelham, and Feke was soon filled. Both Joseph Badger and John Greenwood were American-born, and each was originally a signpainter. Both stepped forward to serve the community as portraitist when no other was available.

Born in Charlestown, Massachusetts, Joseph Badger (1708–65) moved to Boston in 1733 to work as a house- and signpainter. He took up portraiture—evidently with no training—about 1740. He probably knew John Smibert, and may have frequented his studio and color shop, which was near Badger's own house. Badger's unsophisticated style is redeemed by the simple, forthright charm of his images, as seen in the portrait of his grandson, James Badger (Fig. 7.3). Badger continued to paint portraits into the early 1760s, but faced formidable competition from John Singleton Copley.

John Greenwood (1727–92) was apprenticed to Thomas Johnston, an engraver and signpainter of Boston. An early work by Greenwood, of 1748, is the engraved portrait *Jersey Nanny*, in which he applied the skills learned from Johnston. Greenwood soon turned to painting portraits in oil, and he may have painted his large and complex group portrait, the *Greenwood-Lee Family* (1747; Museum of Fine Arts, Boston) to show potential patrons that his work could rival that of Smibert and Feke.

Greenwood's *Sarah Kilby* shows a greater gift for imbuing the subject with poise and animation than Badger possessed (Fig. 7.4). While it may have been based on an English mezzotint, it also reveals the influence of Feke. Although the figure possesses a monumentality, and there is a suggestion of material richness in the gown, the subject's plain face seems to contradict the elegance of her pose and attire.

7.3 Joseph Badger, *James Badger*, 1760. Oil on canvas, 42½ × 33⅛in (108 × 84cm). Metropolitan Museum of Art, New York City.

7.4 John Greenwood, *Sarah Kilby*, c. 1752. Oil on canvas, 4ft 1¹³⁄₁₆in × 3ft 4in (1.27 × 1.02m). Toledo Museum of Art, Toledo, Ohio.

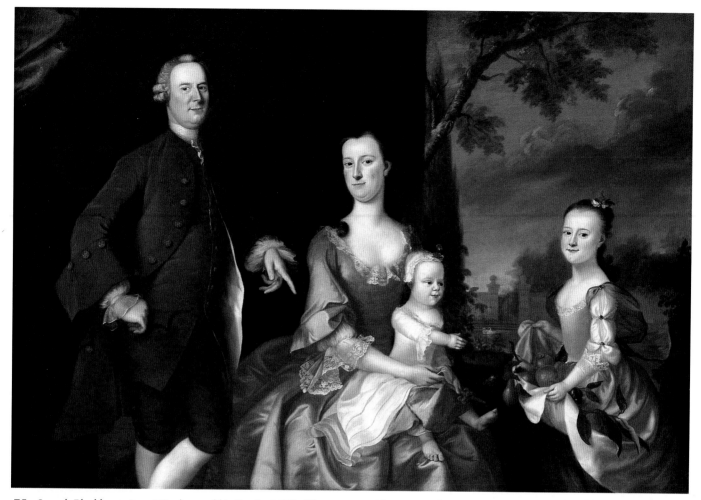

7.5 Joseph Blackburn, *Isaac Winslow and his Family*, 1755. Oil on canvas, 4ft 6½in × 6ft 7½in (1.38 × 2.02m). Museum of Fine Arts, Boston. Abraham Shuman Fund.

Greenwood did not remain in Boston, leaving in 1752 for the Dutch colony of Surinam, thence to Holland, and finally to London, where he became a picture dealer. His departure left Boston with no portrait painter but Badger.

JOSEPH BLACKBURN

Like Wollaston, Joseph Blackburn (active in America 1754–63) came from England, bringing the new Georgian Rococo style with him. Little is known of his origins, except that he spent two years in Bermuda painting portraits before arriving in Newport in 1754, settling in Boston the next year. Blackburn may have been a drapery-painter in a studio in London, and then decided to try his luck in the colonies, where he was welcomed in New England. During his nine years there he painted about 150 portraits, most of them in Boston or Portsmouth, New Hampshire.

Blackburn brought with him essentially the same style as Wollaston—portraits emphasizing high-fashion attire, in Rococo pastel hues, with lovely passages of lace, embroidery, flowers, or fruit—but with virtually no character in the pleasant but often vacuous faces. In *Isaac Winslow and his*

Family, Blackburn introduced the English conversation piece, a type of portrait that gained popularity in England in the 1740s through the work of Arthur Devis (c. 1715–87) and Thomas Hudson (Fig. 7.5).

Instead of arranging the figures around a table, as Smibert and Feke had done, Blackburn placed his group in an outdoor garden setting, arranging the figures as if they were engaged in a casual family gathering. Each subject is resplendent in velvets, satins, and laces, which were used to make a statement about the Winslows' social position, elegant lifestyle, and indulgence in material pleasures. The faces, however, while enlivened by the hint of a smile, portray the sitters as shy and selfconscious. It is, nevertheless, a lovely and gracious image, representing the prosperous Boston merchant with his wife Lucy (daughter of Samuel Waldo; see Fig. 5.8). She holds their daughter Hannah, while another daughter, Lucy, brings an apronfull of peaches and pears from the orchard.

Soon after this portrait was painted, young John Copley began to surpass Blackburn, and in 1763 the latter left New England to return to England, where he continued to paint portraits until about 1778.

7.6 John Singleton Copley, *Mary and Elizabeth Royall*, c. 1758. Oil on canvas, 4ft 9½in × 4ft (1.46 × 1.22m). Museum of Fine Arts, Boston. Julia Knight Fox Fund.

JOHN SINGLETON COPLEY

John Singleton Copley (1738–1815), the great genius of colonial painting, was introduced to art by watching his stepfather, Peter Pelham (see p. 70), engrave his mezzotint plates. One of young Copley's earliest efforts was the reworking of one of Pelham's plates into a print of the Rev. William Welsteed (1753). By then, his stepfather had died, Smibert, Feke, and Greenwood were gone, Blackburn had not yet arrived, and the only artist in residence was Joseph Badger. Living in Boston in the mid-1750s, the boy turned to whatever sources of instruction he could find—to mezzotints, to the little gallery run by Smibert's family, even to anatomical plates found in an encyclopedia, which he copied meticulously. When Blackburn arrived, for a brief period Copley's work was influenced by that of the Englishman's, as is obvious in Copley's portrait of Ann Tyng (1756, Museum of Fine Arts, Boston). Copley, however, quickly developed beyond the talents of Blackburn. In the end, his mature style was attained through an acute perception of the material world.

By 1758, only twenty years old, Copley was already amazingly accomplished. This is demonstrated by his portrait of Mary and Elizabeth Royall (Fig. 7.6), the daughters of Elizabeth and Isaac Royall, whose portrait had been painted by Feke (Fig. 5.7). Here, the vacuous faces of Blackburn's portraits give way to truly animated countenances—the two young girls seem enlivened with the spark of life, and look out at us with eyes that reveal the thinking person within. The faces are those of individuals, rather than a class ideal, as imposed by English immigrant painters like Blackburn or Wollaston. As if by magic, Copley's brush turns paint and canvas into flesh, satin, and lace, and miraculously gives life even to the pets—the hummingbird on Mary's finger, the little dog on Elizabeth's lap.

Copley scrutinized intensely everything before him. The result is more a recreation than a mere representation of the object. While Blackburn's handling of fabrics was often amorphous, Copley's folds are carefully constructed. The bold shading on each head, creating a solidity of form, suggests Copley was learning more from studying portraits by Feke than those by Blackburn. The Mary and Elizabeth Royall portrait signals that Copley's search for a personal style has ended. By the time he painted the portrait of Epes Sargent (1760, National Gallery of Art, Washington, D.C.), he had entered the mature phase of his colonial career.

A BOSTON GRANDE DAME

Copley's style found great favor among the wealthy merchant families of New England. The people he painted appreciated the rich materialism with which he filled his canvases, and the straightforward truthfulness of their likenesses. *Mrs. Thomas Boylston* is the ultimate realization of the image of colonial American mercantile aristocracy: the style is a perfect reflection of the taste and values of the subject (Fig. 7.7). The seventy-year-old Mrs. Boylston, seated in a snug corner of her Boston parlor, is the ultimate visualization of a *grande dame* of New England society. Her beautiful olive-tan satin dress, with black lace over a broad white collar, and the handsome gold damask Chippendale armchair in which she sits, testify to her prosperity and materialism.

It is the face of Mrs. Boylston that is the crowning glory of the picture. In it, Copley solved a problem that had vexed many foreign-born and -trained artists. Wollaston and Blackburn, for example, idealized the sitter's face, thereby creating a vapid expression and a lack of individuality. Or, if they tried to accommodate their sitters' request for truthfulness, the result was a face that was both unpleasant in its coarseness and at odds with the elegant surroundings. Copley, however, as a member of the same mercantile society as his sitters, could more easily perceive their unpretentious dignity. Although Mrs. Boylston's face is excruciatingly plain, he has made a virtue of that plainness, and imbued it with gentility.

With portraits like *Mrs. Boylston*, Copley's success was assured. Patrons flocked to his studio and paid well for his services. He made an excellent income from his art, married well, and built himself a fine home on Beacon Hill. This adjoined the residence of one of Boston's most affluent merchants, John Hancock, whom Copley painted sitting at his great ledger book. Nevertheless, Copley was discontented, for he knew there was a higher form of art than portraiture, and he yearned to test his skills against that most demanding type—history painting. He heard reports of the success of his fellow-American, Benjamin West (1738–1820; see p. 136), at what was for Copley the center of the art world: London. Copley also knew that study in Italy would develop his art beyond anything that local patronage could.

In 1765, Copley decided to submit a painting to the judgment of the London circle of painters and connoisseurs to see how it would fare. *Boy with a Squirrel* was sent to the annual exhibition of the Society of Artists, and Copley anxiously awaited the arrival of the ship that would bring news of its reception (Fig. 7.8). In sending a portrait, Copley worked from his strength, but here he added a touch of genre by showing the young boy—his stepbrother, Henry Pelham—lost in daydreams while playing with a pet squirrel. Copley summoned all his artistic powers, and the result is one of the great masterpieces of American art. Each detail of the sensitive face, the beautifully painted right hand, the glass and its reflection on the surface of the polished mahogany tabletop, and the magnificently painted little squirrel is a *tour de force* of painterly virtuosity. Copley was greatly pleased when he received a letter from Benjamin West reporting the very favorable response it had received in London. But it also threw Copley into a quandary, as the letter he wrote to a Captain Bruce indicates. In reply to West's suggestion that he should go to Italy to study for a year or two, Copley wrote:

7.7 John Singleton Copley, *Mrs. Thomas Boylston*, 1766. Oil on canvas, 4ft 3in × 3ft 6in (1.3 × 1.02m). Harvard University Portrait Collection, Cambridge, Massachusetts.

Copley was of one mind with his subjects in so many respects explains why he could portray them so perceptively. For the present, he decided not to gamble on a trip to Italy, or to move to London.

A CRAFTSMAN'S PORTRAIT

Paul Revere, the Boston silversmith, occasionally made silver frames for miniature portraits that Copley painted. It may have been to settle his account for such things with Revere that Copley painted the silversmith's portrait (Fig. 7.9).

Copley portrayed Revere in the familiar setting of his workplace, wearing his workclothes, engaged in the labor that made him a respected and useful citizen. Revere holds a silver teapot, and has laid aside the graver's tools in order to acknowledge the viewer, who has just entered his presence. He even holds his chin thoughtfully, as if he and the viewer are engaged in conversation.

The intimacy of direct social contact, which is present in many of Copley's portraits, lends a liveliness to the image, and accounts for much of its appeal. Arising from an egalitarian spirit, it excluded aristocratic aloofness, and allowed respectable citizens to meet each other on equal terms.

7.8 John Singleton Copley, *Henry Pelham (Boy with a Squirrel)*, 1765. Oil on canvas, 30¼ × 25in (76.8 × 63.5cm). Museum of Fine Arts, Boston. Gift of the artist's great-granddaughter.

What should I do at the end of that time (for prudence bids us to consider the future as well as the present)? Why I must either return to America and bury all my improvements among people entirely destitute of all just ideas of the arts, and without any addition of reputation ... or I should set down in London in a way perhaps less advantageous than what I am in at present, and I can not think of purchasing fame at so dear a rate.... I would gladly exchange my situation for the serene climate of Italy, or even England, but what would be the advantage of seeking improvement at such an outlay of time and money? I am now in as good business as the poverty of this place will admit ..., and three hundred guineas a year, my present income, is equal to nine hundred in London. With regard to reputation, you are sensible that fame cannot be durable where pictures are confined to sittingrooms, and regarded only for the resemblance they bear their originals. Were I sure of doing as well in Europe as here, I would not hesitate a moment in my choice, but I might in the experiment waste a thousand pounds and two years of my time, and have to return baffled to America.[2]

Copley was severe in his criticism of his patrons' level of taste in matters of art, but in the letter he also states that he, too, is a product of the mercantile society that weighs things prudently in terms of profit and loss. No doubt the fact that

7.9 John Singleton Copley, *Paul Revere*, c. 1769. Oil on canvas, 35 × 28½in (88.9 × 72.3cm). Museum of Fine Arts, Boston. Gift of Joseph W., William B., and Edward H. R. Revere.

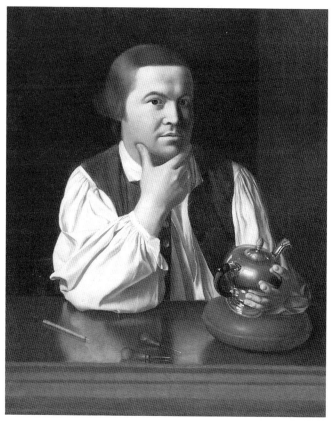

Paul Revere is the perfect visualization of the colonial American philosophy, as put into words by Benjamin Franklin, himself a native of Boston and the son of a craftsman. Success, Franklin wrote, in *Advice to a Young Tradesman* (1748), depends on two things: "Without Industry and Frugality nothing will do, and with them, everything. He that gets all he can honestly, and saves all he gets (necessary expenses excepted), will certainly become rich." Furthermore, as Franklin reported in his *Information to those who Would Remove to America* (1782):

> There is a continual demand for more artisans of all the necessary and useful kinds.... Tolerably good workmen in any of those mechanic arts are sure to find employ[ment], and to be well paid for their work.... If they are poor, they begin first as servants or journeymen; and if they are sober, industrious, and frugal, they soon become masters, establish themselves in business, marry, raise families, and become respectable citizens. Also, persons of moderate fortunes and capital, who, having a number of children to provide for, are desirous of bringing them up to industry... have opportunities of doing it in America, which Europe does not afford. There they may be taught and practice profitable mechanic arts, without incurring disgrace on that account, but on the contrary, acquiring respect by such abilities.

Here was a credo for the selfmade American merchant or craftsman who had earned his prosperity through the virtues of industry and diligence, who enjoyed God's blessing, and who enjoyed, too, the materialism that a land of opportunity offered.

PORTRAIT AND HISTORY PAINTER

Just before his departure from the colonies. Copley painted the portrait of Mr. and Mrs. Isaac Winslow. It is Copley at his best (Fig. 7.10). Mr. Winslow, by his glance and gesture, invites the viewer into the tasteful comfort of his home, with its finely crafted mahogany table and splendidly rendered reflections. Mr. Winslow's face is natural, confident, and friendly—in marked contrast to the portrait by Blackburn (Fig. 7.5). Moderation governs his attire, yet it is handsome and of the current style. Mrs. Winslow's face has a beauty and dignity that transcend its plainness, as in Copley's portrait of Mrs. Boylston. Copley here created a superbly integrated composition. His command of form and light and shade were not surpassed in any other portraits. He employed a sophisticated, reserved colorscheme, dominated by the black and cream suit of Mr. Winslow, the silver-blue of his wife's dress, and the dark red-brown of the table and the curtain.

Shortly before the Winslow portrait was painted, the Boston Tea Party occurred, boding unsettled times as rebellion approached. Now was the time, Copley concluded, to go abroad. He left America in the summer of 1774, never to return. After a year of study in Italy, Copley established himself in London and sent for his family to join him. He

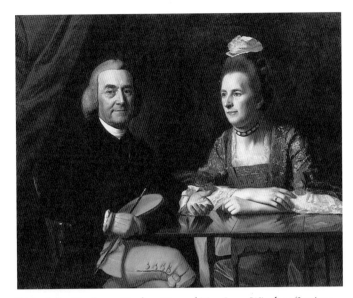

7.10 John Singleton Copley, *Mr. and Mrs. Isaac Winslow (Jemima Debuke)*, 1774. Oil on canvas, 3ft 4¼in × 4ft¾in (1.02 × 1.24m). Museum of Fine Arts, Boston. Gift of Mr. and Mrs. Maxim Karolik for the M. and M. Karolik Collection of 18th-Century American Arts.

was a success in England, both as a portraitist and as a **history painter**. Pictures such as *Watson and the Shark* (1778), *Death of the Earl of Chatham* (1718), and *Death of Major Peirson* (1784) brought him fortune as well as a reputation among the London circle of artists, led by Sir Joshua Reynolds (1723–92) and West.

In response to exposure to the art world of Italy and England, Copley's style changed dramatically. This can be seen in the *Copley Family* (National Gallery of Art, Washington, D.C.), in which Copley's tight, realistic style was replaced by a painterly brushstroke akin to that of Sir Joshua Reynolds and Thomas Gainsborough (1727–88), who were then at the height of their careers in England. The story of Copley's career after 1774 belongs more to the history of English painting than American. While in Boston, however, he had created the quintessential colonial mercantile portrait.

NEW YORK PORTRAITISTS

Unlike Boston, which provided ample and constant patronage for resident artists such as Smibert and Copley, New York was unable to attract and hold a major artistic talent on a permanent basis. There were, however, several portrait painters active in New York in the 1760s, for example, Lawrence Kilburn (1720–75), Abraham Delanoy (1742–95), and John Mare (1739–1802/3).

One of the most endearing New York pictures of this period is the *Rapalje Children* by John Durand (active 1765–82) (Fig. 7.11). Little is known of Durand's origins or training. He appears first in Virginia, to which he returned several times to make likenesses. He does not seem to have

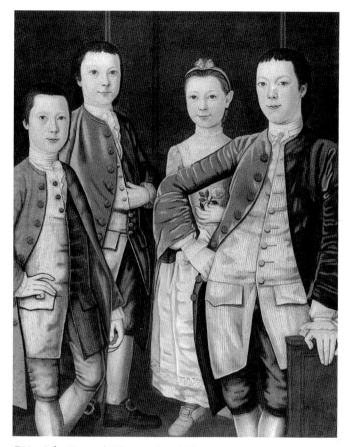

7.11 John Durand, *The Rapalje Children*, 1766. Oil on canvas, 4ft 2¾in × 3ft 6in (1.29 × 1.02m). Courtesy The New-York Historical Society, New York City.

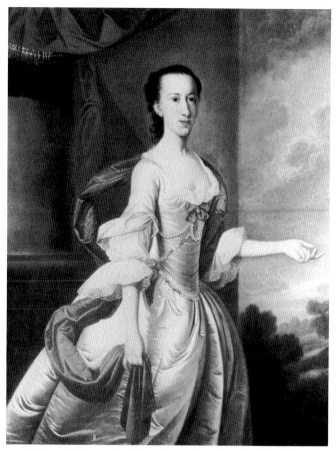

7.12 Jeremiah Theus, *Elizabeth Wragg Manigault*, 1757. Oil on canvas, 4ft 2in × 3ft 6in (1.27 × 1.02m). Courtesy The Charleston Museum, Charleston, South Carolina.

remained in New York long, but visited it between trips to Connecticut and Bermuda. Durand's style is one of great charm and naïveté. He used an attractive, bright palette, but shows a simplistic comprehension of color effects—his work would be the antithesis of, say, Gainsborough's impressionistic use of color and light. The shading is timid, and a dark outline defines most forms. Forced into itinerancy in order to make a living, Durand advertised that he also painted coats of arms, ciphers, and carriage wheels, and did gilding.

PORTRAITURE IN THE SOUTH

Mention has already been made of John Wollaston, but Jeremiah Theus, Henry Benbridge, and John Hesselius also became established fixtures in the social and cultural life of their regions.

JEREMIAH THEUS

The son of Swiss immigrants, Jeremiah Theus (1716–74) arrived in South Carolina in 1735. By 1740, he was advertising that he would take the likenesses of patrons, either in his Charleston studio or by calling at their plantation residences. Nothing is known about any training Theus might have had in Europe before coming to America, but even in his earliest works he demonstrates an awareness of the Rococo fashion portrait, which emphasized elegant attire and abundant lace. Strings of pearls, bows, and bouquets of flowers often decorate his portraits of women, as in *Elizabeth Wragg Manigault* (Fig. 7.12).

In this picture, Theus—like so many foreign-born artists who came to the colonies—had difficulty in balancing the elegance of the sitter's attire and the plainness of her face. This difficulty was often due to the sitter insisting upon a truthful representation of his or her features, yet desiring to be shown in refined clothing and surroundings. Theus's figures are often rigid and selfconscious, but his portraits generally are characterized by a charming persona.

HENRY BENBRIDGE

Theus retired about 1770, and Henry Benbridge (1743–1812) arrived in 1772, taking his place as portrait painter to Charleston's élite for the next twenty years. While observing John Wollaston painting a portrait in 1758, the

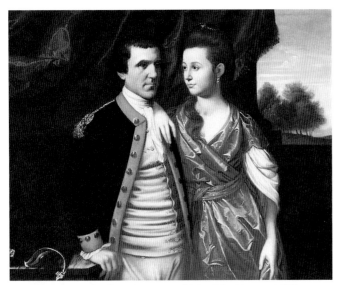

7.13 Henry Benbridge, *Captain and Mrs. John Purves*, 1775.
Oil on canvas, 3ft 3½in × 4ft 2in (1 × 1.27m).
Courtesy Winterthur Museum, Winterthur, Delaware.

Philadelphia-born Benbridge was ignited with a desire to become an artist. He left for Rome in 1765, remaining there for four years of study. He then went to London, where he studied briefly with Benjamin West, whose influence is seen in Benbridge's *Captain and Mrs. John Purves* of 1775 (Fig. 7.13). The subjects of the portrait were married in 1775, the same year John Purves received his appointment as captain, and the portrait is believed to commemorate these events.

While in London, Benbridge had been exposed to the popular new form of portraiture, the conversation piece. In South Carolina, he painted numerous group portraits of families informally gathered in outdoor settings. Although most of his Charleston work falls into the years of the Federal period, which followed the Revolutionary War, in style Benbridge's portraits belong to the colonial era, specifically to the third quarter of the eighteenth century.

JOHN HESSELIUS

John Hesselius (1728–78) probably received his first lessons in painting from his father, although he may also have been influenced by seeing the work of Robert Feke early in his career. The portraits by John Wollaston, however, had the greatest and most lasting effect on young Hesselius.

Working in several areas where Wollaston had visited, Hesselius had ample opportunity to observe the manner in which the English artist painted fashionable drapery in pastel shades, and he also adopted the mannerism of the almond-shaped eyes. Wollaston's influence is evident in Hesselius's portrait of little Charles Calvert attended by a young black slave (Fig. 7.14). This portrait, of a youthful scion of the family line of Lord Baltimore, follows the type used earlier in Kühn's *Henry Darnall III* (Fig. 5.10), but the style is Georgian Rococo instead of Baroque. The boy wears

7.14 John Hesselius, *Charles Calvert*, 1761. Oil on canvas, 4ft 2¼in × 3ft 3⅞in (1.28 × 1.01m). Baltimore Museum of Art.

a "Van Dyck" costume, which was then popular in England as a nostalgic reminiscence of the golden age of King Charles I, whose court was painted by Anthony van Dyck. The finely liveried slave attests to the high social position of the family.

Hesselius had painted briefly in Virginia as early as 1750, and in 1760 he took up residence in Annapolis, where, three years later, he married a wealthy widow and became a part of the plantation society that he painted during the remainder of his career.

CHARLES WILLSON PEALE

As a young man, Charles Willson Peale (1741–1827) had been a clocksmith, silversmith, and saddler in Annapolis before deciding to become a portrait painter in the mid-1760s. In fact, he "traded" John Hesselius a newly made saddle for some lessons in painting. Peale also traveled to New England to see Copley, who gave him advice on the art.

Peale soon concluded that a trip to England was necessary, and in 1767 he left for London, where he spent much of the next two years in the studio of Benjamin West. Peale avoided history painting, which had made West famous, realizing that his American patrons would want only portraits. Never happy in England, Peale was glad when he could return to his family in his native Maryland.

7.15 Charles Willson Peale,
The Peale Family, 1773 and 1808.
Oil on canvas, 4ft 8in × 7ft 6in
(1.42 × 2.29m). Courtesy
The New-York Historical Society,
New York City.

7.16 Charles Willson Peale,
The Edward Lloyd Family, 1771.
Oil on canvas, 4ft × 4ft 9½in
(1.22 × 1.46m). Courtesy
Winterthur Museum, Winterthur,
Delaware.

THE PEALE FAMILY

The joy of familial contentment is shown in the *Peale Family* (Fig. 7.15). The painting shows the group gathered around a table. Charles, standing at the left, gives brother Saint George, seated at the end of the table, a drawing lesson, while James—who became a miniaturist—looks on. Sister Margaret Jane stands behind Peale's wife, who sits in the center holding an infant. The family servant stands behind the group at the right, consisting of another sister, Elizabeth, and the artist's mother.

The picture is enriched by the lovely still life on the table, and the row of plaster busts—modeled by Peale—of himself and two friends from England, Benjamin West and a patron, Edmond Jenings. The canvas on the easel at the left is a sketch of a group representing *Concordia Animae*, or harmonious spirits, thereby establishing the congenial atmosphere of the group portrait. The artist was a warm, friendly, goodnatured person, and he seems to have brought out these characteristics in many of his sitters as well.

Peale firmly believed that anyone could become an artist simply by learning the fundamentals and applying him- or herself (he managed to convince two of his brothers and, later, several of his children to do so). Peale thus became an artist as much by sheer determination as by innate talent. He never became a master draftsman, and when drawing the figure he had a tendency to elongate the forms, noticeable in Saint George's torso and right arm. That Peale realized his limitations is evident in a letter he wrote to a friend in 1772:

> What little I do is by mere imitation of what is before me.... A good painter of either portrait or history must be well acquainted with the Greesian [*sic*] and Roman statues, to be able to draw them at pleasure by memory, and account for every beauty.... These are some of the requisites of a good painter.... These are more than I shall ever have time or opportunity to know, but as I have a variety of characters to paint, I must, as Rembrandt did, make these my antiques and improve myself as well as I can while I am providing for my support.[3]

THE EDWARD LLOYD FAMILY AND THE JOHN CADWALADER FAMILY

Soon after his return from England, Peale began to attract the patronage of Maryland gentry and Philadelphia merchants. Among the finest of his early portraits is the *Edward Lloyd Family* (Fig. 7.16). Lloyd was the master of Wye House on the Chesapeake Bay, Maryland, where this portrait hung for many years. The mansion house is seen on the horizon at the left. Although executed in Peale's provincial style of painting, the composition is reminiscent of some of the great group portraits by Benjamin West, such as that of the Arthur Middleton family (1770, private collection). The Lloyds are finely attired and grouped around an exquisite

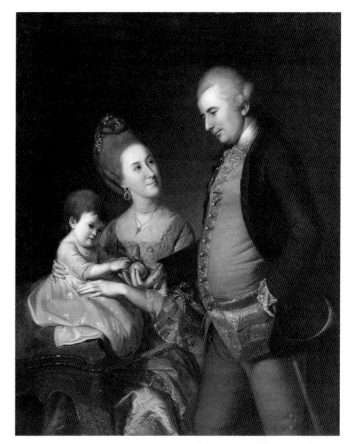

7.17 Charles Willson Peale, *General John Cadwalader, his First Wife, Elizabeth Lloyd, and their Daughter, Ann,* 1772. Oil on canvas, 4ft 3½in × 3ft 5¼in (1.31 × 1.05m). Philadelphia Museum of Art.

Chippendale sofa. It is clear they have made the art of music a part of their lives.

Even while living in Annapolis, Peale began to test the Philadelphia market in the early 1770s, and among the several excellent portraits he made there, the masterpiece is the *John Cadwalader Family* (Fig. 7.17). Here, Cadwalader strides in, bringing to his infant daughter a freshly picked peach, while his wife looks at him with affection. Husband and wife are richly attired, and the handsomely carved cardtable (made by Thomas Affleck and James Reynolds and discussed on p. 88) further testifies that the doctrine of prosperity was as respected among descendants of Quaker merchants as it was by New Englanders. The Cadwaladers, in fact, lived in one of Philadelphia's finest homes, filled with beautiful furnishings.

Peale took great pains to describe the richness of the gold brocade of the man's waistcoat, and the lace and silk of the woman's fashionable gown, as well as the stylishness of her hair and the beauty of several pieces of jewelry. However, for all the elaborate elegance of clothing and furniture, the faces are frankly plain. Neither painter nor patron felt any need to have the likenesses idealized.

GENERAL GEORGE WASHINGTON

Peale moved to Philadelphia just before the outbreak of the Revolutionary War, in which he served as an officer of the Continental Army, part of the time with General George Washington. The military and political struggles produced something the colonists had few of—American heroes. Late in 1778, Congress, meeting in Philadelphia, summoned its commander-in-chief for strategic planning sessions. During that period, Peale was commissioned by the Executive Council of Pennsylvania to paint a large portrait of the greatest American hero of all (Fig. 7.18).

The full-length portrait was meant to glorify George Washington and incite patriotic pride and fervor in the breast of all who saw it. Peale made studies of the battle-fields of Trenton and Princeton, where Washington had inflicted stinging defeats upon the British troops and captured over a thousand Hessians. The artist made specific reference to the Battle of Princeton in the background of his

7.18 Charles Willson Peale, *General George Washington before Princeton*, 1779. Oil on canvas, 7ft 10in × 4ft 10½in (2.39 × 1.49m). Pennsylvania Academy of the Fine Arts, Philadelphia.

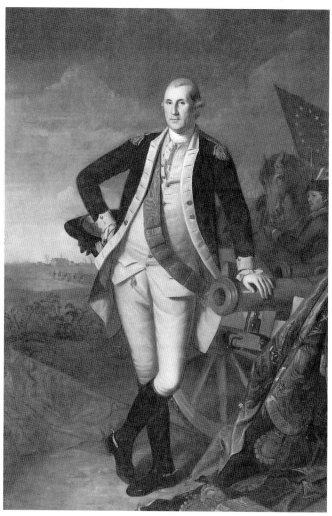

portrait by including the College's Nassau Hall on the horizon. Hessian flags are conspicuous among the trophies of war that surround the general.

Despite the opportunity his subject offered, Peale failed to create a truly grand state-type portrait—no American painter yet had experience in making such an heroic image. The accouterments notwithstanding, Peale's *Washington* does not achieve the heroic grandeur and dignity usually associated with the great man. George Washington was a tall man, to be sure, but Peale's tendency to attenuate the human figure, and the small size of Washington's head, cause him to appear gangly and lacking in refined proportions. Moreover, the pose in which he placed Washington is so casual, even awkward, that it precludes any feeling of greatness or of a dramatic moment. Even the face of Washington is unheroic. Be they commander-in-chief or merchant, Peale was incapable of idealizing his subjects—this produced an accurate likeness, but not an heroic ideal. Peale's *Washington* gives us a truthful representation of our first national hero, but tells us of his greatness through the collection of objects that surround him—just as colonial mercantile portraits relied on objects to convey the doctrine of prosperity—rather than through the man himself.

Soon after the Revolutionary War ended, Peale returned to peacetime pursuits in Philadelphia. He began to develop a portrait gallery of distinguished Americans, taking likenesses of celebrated people who visited the city. Peale was interested in many things, however, especially natural history. In 1795, he announced he would cease painting portraits in order to devote himself to the museum he had founded. A true spirit of the Enlightenment, Peale revelled in the excitement of learning. Through his museum, he shared the wonders of nature and science with the public (see chapter 10).

RALPH EARL

Ralph Earl (1751–1801) is a fitting painter with whom to close this section, for although the greater part of his American career dates from the period following the Revolution, he continued to work in a thoroughly colonial style. Earl's work is not so much a transition as a testimony to the strength of this colonial tradition. With the end of the Revolutionary War in 1783, America may have won its independence and embarked upon a new course of destiny, but the old colonial style of painting survived long after, for its essential features still expressed many deeprooted beliefs among Americans.

Earl was born in Worcester County, Massachusetts, and painted portraits in and around New Haven and along the Connecticut River Valley. There is no evidence that he received formal instruction. He comes into art-historical focus in 1775, when he painted the scenes of the Battles of Lexington and Concord, which were engraved by Amos Doolittle.

7.19 Ralph Earl, *Roger Sherman*, 1776. Oil on canvas, 5ft 4⅝in × 4ft 1⅝in (1.6 × 1.2m). Yale University Art Gallery, New Haven, Connecticut.

The next year, Earl painted the portrait of Roger Sherman, which many consider the archetypal image of a flinty Yankee—reserved, rockwilled, and highly individualistic (Fig. 7.19). Sherman—a Connecticut shoemaker, surveyor, and lawyer—became one of the signatories of the Declaration of Independence the year after his likeness was taken.

There is a starkness about the portrait that is probably due in part to the subject's conservative taste, and in part to Earl's inexperience as a painter, for this is his earliest known portrait. The setting is spartan, suggesting more the corner of an empty studio than the comfort of a New Haven parlor.

The cold emptiness of the room is hardly relieved by the inclusion of the conventional drape in the upper left. The only other object in the picture is the dark-green Windsor armchair, an inexpensive piece of country furniture. Earl's lack of understanding of perspective is seen in the lines of the floor and corner, which do not converge properly.

Sherman's posture is awkward. His face is solemn, and his rust-red suit is undecorated—as if he wanted his image to be one that was devoid of frivolity and vanity. One thinks of Benjamin Franklin's comment, "In order to secure my credit and character as a tradesman, I took care not only to be in *reality* industrious and frugal, but to avoid all appearances to the contrary. I dressed plainly."[4]

COLONIAL VALUES

Unsympathetic to the cause of the Revolution, Earl left for England in 1778, where he spent the next seven years. He painted some portraits there, and once showed his work at the annual exhibition of the Royal Academy, but exposure to British art had little permanent effect on his style.

After he returned in 1785, Earl continued to paint in a colonial style. The expressive content of his portraits was based on values long established during the colonial era. Virtually everything in Earl's portraits contributes to a visual ode to the doctrine of prosperity and the virtues of industry and diligence. The plainness of his faces is rendered with a simple, truthful naturalism—a style that was acceptable to the pragmatic merchants, who tended to define art as reality captured on canvas.

Such were the foundation-stones of colonial American painting, and in cultural backwaters like the Connecticut Valley, the colonial style persisted well into the nineteenth century, and often became the basis for a folk style. In the major cities the colonial style was displaced when Gilbert Stuart returned to America in 1793, bringing a new type of portrait—one that placed major emphasis on an idealized conception of a subject, rather than on an objective representation of his or her features, surrounded by the objects that told his or her story.

PART 2

The Federal Period

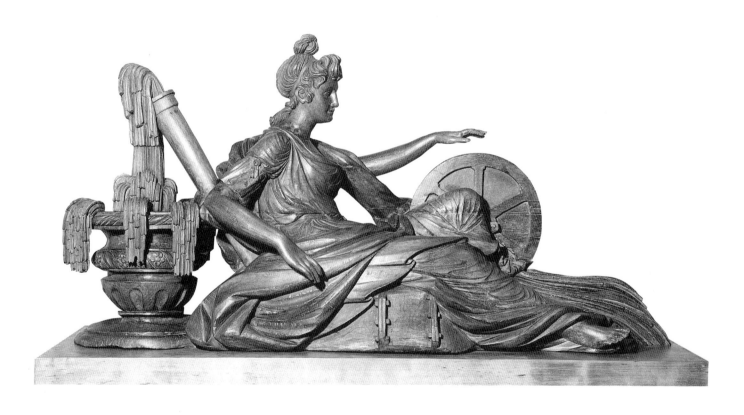

CHAPTER EIGHT

ARCHITECTURE:

1785–1830

After seven long, hard years of war, independence finally was won in 1783. All the world watched to see if the Americans could govern themselves justly and effectively, despite the diverse interests of the thirteen colonies that were now called "states."

At the end of the War, the government was in the hands of a quarreling Congress—which had no permanent home—operating under the Articles of Confederation. George Washington resigned as commander-in-chief of the army, and there was no navy to speak of.

The problem of a treasury that was not only empty but heavily indebted, with no guaranteed way of raising revenues, was surpassed only by disagreements over such divisive issues as states' rights, and the authority of a strong, central, federal government.

America, however, was also the home of a large number of exceptional men—George Washington, Thomas Jefferson, John Adams, James Madison, Benjamin Franklin, and Alexander Hamilton, to mention but a few. A Constitutional Convention was called to meet in Philadelphia in 1787 to transform the Articles of Confederation into a constitution. The result was the United States Constitution, one of the most original and effective political documents ever conceived. With its ratification in 1789, America had a government. The Bill of Rights was amended to that document in 1791. On 4 February 1789, the people chose George Washington as the first president of the United States.

Hardly had President Washington appointed his cabinet when dissension erupted. Washington, Adams, Chief Justice John Jay, and Hamilton advocated a central government of broad powers. Their views had been presented in essays in *The Federalist*, written mainly by Adams, Hamilton, and James Madison in 1787–8. Thomas Jefferson, who believed in more control of government by the people, headed the opposition Republican Party. Thus the two-party system came in with the birth of the new government itself.

Since the federal government had no permanent home, one of the first actions taken by Congress was to designate that the national capital should be located somewhere on the Potomac River, then a central site for the thirteen seaboard states. In 1790, they empowered President Washington to select a site for Federal City. Meanwhile, the government was to reside in Philadelphia.

On 18 September 1793, the president laid the cornerstone of the United States Capitol, and in 1800 the seat of government was transferred to Washington, D.C., named after the first president. A new federal government meant that new buildings were needed, and each of the states now had similar needs. A break with the past—with monarchy as a form of government—had been made. The question was, what style of architecture best expressed the new government, be it a republic or a democracy?

The War of Independence had been waged as much over commercial issues—taxation of goods and freedom of trade, for instance—as political ideology. After five years of postwar depression, a boom in commerce, industry, and agriculture began. In 1784, the first few hundred bales of American cotton were shipped to England. By 1830, the South was producing over 700,000 bales annually. By then, much of the cotton was going to American rather than English fabric mills. In 1793, Eli Whitney invented the cotton gin, and five years later perfected the manufacture of interchangeable parts for firearms. America took its first steps into the Industrial Revolution. Factories began to appear, at first waterpowered, and then steampowered.

On 22 February 1784, the *Empress of China* began her epoch-making voyage to Canton, commencing the American China trade. Before, Chinese goods came to America only through European, usually English middlemen. In 1785, Elias Hasket Derby sent his *Grand Turk* around the Cape of Good Hope to Canton. Soon after, the seaport town of Salem, Massachusetts, had many ships in the China trade. By 1806, it had over 130 ships in its merchant fleet. Much of the wealth brought back from the Orient went into the fine new houses erected by shipowners like Derby, as we will soon see.

During the Napoleonic Wars the United States fought its own war with England—the War of 1812. This arose over Britain's interference with American trade with France, and British impressment of seamen aboard American ships. In 1814, towards the end of the war, Francis Scott Key watched the bombardment of Fort McHenry in Baltimore harbor, and was moved to write *"The Star-Spangled Banner."*

About a month earlier, the British had landed at Washington, D.C., seized the capital, and burned such buildings as stood there, among them the new but unfinished Capitol, and the White House. With peace concluded a few weeks later, Americans returned to other pastimes—which included building and rebuilding. Architecture was used to express the political, social, and cultural ideals and ambitions of the new nation—a nation that was more unified than ever, and more aware of its strength and identity than before.

NEOCLASSICISM: AN INTERNATIONAL MOVEMENT

During the era following the Revolutionary War, inspiration no longer came from the works of Wren, Jones, Palladio, or Gibbs, but from Rome and Pompeii. Neoclassicism arose in the middle of the eighteenth century as a reawakening of interest in antiquity. It spread from Italy to other parts of the Continent, and to England. Excavations on the slopes of Mount Vesuvius at Pompeii and Herculaneum—buried by volcanic ash since A.D. 79—presented a view of the daily life of ancient Romans. The unearthed objects and buildings with their wall paintings were new sources of inspiration for architects, painters, sculptors, and decorative artists. Scholar-antiquarians such as Winckelmann wrote histories that considered not only Roman art, but that of Greece as well, finally recognizing the latter as the fountainhead of classical art.

Neoclassicism was an international movement from the beginning. Winckelmann was German, and the French architect Charles Louis Clérisseau (1721–1820) came from France to study the Roman ruins. The Italian Giovanni Battista Piranesi (1720–78) created exciting visions of Roman grandeur in his engravings. Two Englishmen—James Stuart (1713–88) and Nicholas Revett (1720–1804)—ventured from Rome to Greece to take measured drawings of the magnificent buildings there, such as the Parthenon and the Erechtheum, which they later published in *Antiquities of Athens* (London, 1762). The Scottish brothers James and Robert Adam also made the Grand Tour to Rome, where they imbibed the new spirit of classicism, which they carried back to England.

Among painters, the German Anton Raphael Mengs (1728–79) created idyllic scenes of Apollo amid the classical muses to decorate the rooms of Cardinal Albani's Roman villa. Benjamin West (1738–1820) and, later, the Frenchman Jacques-Louis David (1748–1825) absorbed the lessons antiquity offered in order to formulate new modes of history painting in London and Paris.

Antiquity struck a responsive chord for several reasons. Just as some sought to discover there the origins of western culture, others saw in Greco-Roman architecture the expression of republicanism and imperialism. The noble grandeur of antiquity offered an alternative to the lavish frivolity of the Rococo style that had emerged from the French court.

Neoclassicism was introduced into America mainly in two forms—the one, a purer brand, is found in Thomas Jefferson's design for the Virginia State Capitol; the other, a rather free interpretation of the Greco-Roman style, is exemplified by the Adamesque work of Charles Bulfinch. Neoclassicism took different forms according to whether it was imported via England or France.

THOMAS JEFFERSON: GENTLEMAN-ARCHITECT

Thomas Jefferson (1743–1826) represents the brilliant culmination of the gentleman-architect tradition in America. This remarkable man, who was the first to introduce neoclassical architecture into his native land, was also a lawyer, educator, scientist, and farmer. Jefferson was the author of the Declaration of Independence, minister to France, governor of Virginia, and, for two terms, the third president of the United States (1801–9). For Jefferson, architecture was a joy in itself, the carrier of all the things he held in the highest regard—taste, cultivation, and reason, the noblest aspirations of civilization, both past and present.

Jefferson's interest in architecture was aroused when he attended the College of William and Mary, where he began to acquire English design books, and became devoted to the theory of Palladio. From George Wythe he received not only his training in the law, but also in the Wythe House (Fig. 6.20) he undoubtedly met Wythe's father-in-law, Richard Taliaferro, one of the most gifted gentlemen-architects of colonial Virginia.

As Jefferson began his practice of law, he began to design a home for himself, choosing a mountaintop site near Charlottesville. He called it Monticello, and took the plan from an English design book, Robert Morris's *Select Architecture* (1755), while the elevation was based on a plate in Palladio's *Four Books on Architecture*. The house, erected between 1769 and 1782, was a provincial exercise. Before long, Jefferson rejected the eighteenth-century English style, and Palladio ceased to be his ultimate authority for the interpretation of classical architecture. Monticello was eventually thoroughly rebuilt, as a result of Jefferson's exposure to other sources during his travels in France.

NEOCLASSICAL INFLUENCES

During the Revolutionary War, Jefferson placed himself at the center of events. Afterwards, when he was appointed the American minister to France, in 1785 he went to live in Paris. A whole new world of culture and sophistication opened up to him. The buildings of his homeland seemed

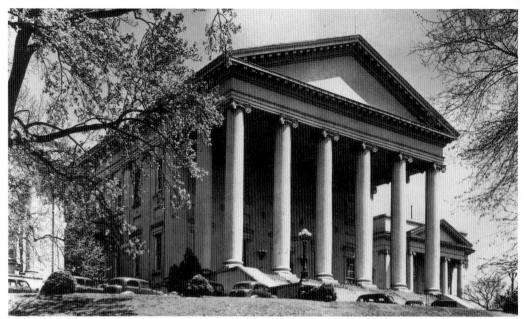

8.1 Thomas Jefferson, Virginia State Capitol, Richmond, Virginia, 1785–9.

provincial in contrast to the beautiful houses being erected in Paris—such as the Hôtel de Salm, or the elegant Hôtel de Langeac, designed by Jean François Chalgrin, which Jefferson rented as his embassy home.

The neoclassical interiors of these houses were planned for gracious living and entertaining. They tended to be single-story, with oval rooms and high, narrow French doors and windows—features that appeared when Jefferson returned home and redesigned Monticello.

While in Paris, Jefferson became friends with Charles Louis Clérisseau, the noted archeologist and architect who had been the mentor of the Adam brothers in Italy. Jefferson bought a copy of Clérisseau's *Antiquités de la France* (*Monuments de Nîmes*, 1778). The plates were of classical models, which he now much preferred over the English Georgian style. One of the most significant events of Jefferson's French sojourn was his visit to Nîmes, where he saw for the first time an original Roman building—the Maison Carrée, a beautiful little temple of the first century B.C. The impact upon Jefferson's mind and architectural aesthetic was powerful, and bore immediate fruit.

Virginia State Capitol When the Virginia legislature called upon Jefferson to procure a design for the new state capitol in Richmond, he characteristically produced one himself. Done in consultation with his friend Clérisseau, it was based on the Maison Carrée (Fig. 8.1). Of course, a man with Jefferson's creative mind did not slavishly copy his model. He changed the Order from Corinthian to Ionic, reduced the depth of the portico from three to two columns, and replaced the pilasters of the side walls with windows (the pilasters were later reinstated).

The Virginia State Capitol was the first volley announcing the arrival of Neoclassicism in the United States. To Jefferson and his contemporaries, the classical portico on the front of an American government building symbolized the democratic, republican, and humanistic values for which their new country stood.

Monticello: Final Form When Jefferson returned home in 1789, the Monticello he had left behind seemed provincial, amateurish, and oldfashioned. In the second phase of the construction of Monticello (1793–1809) the two-story elevation was reduced to what appears to be a single story *à la* fashionable Parisian houses, but the plan was enlarged (Figs. 8.2 and 8.3). A central axis is created by the entrance and gardenfront porticoes, which give access to the foyer and the drawing room. Over the latter rises a hexagonal drum, which supports a low saucer dome. This beautifully proportioned central section of fully developed portico—with its broad triangular pediment, the hexagonal drum with exquisitely scaled white-framed oculi, and the hemispherical

8.2 Thomas Jefferson, Monticello, near Charlottesville, Virginia, 1793–1809. Plan.

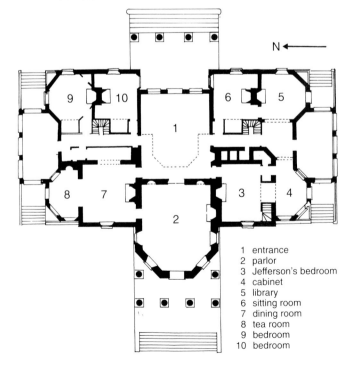

1 entrance
2 parlor
3 Jefferson's bedroom
4 cabinet
5 library
6 sitting room
7 dining room
8 tea room
9 bedroom
10 bedroom

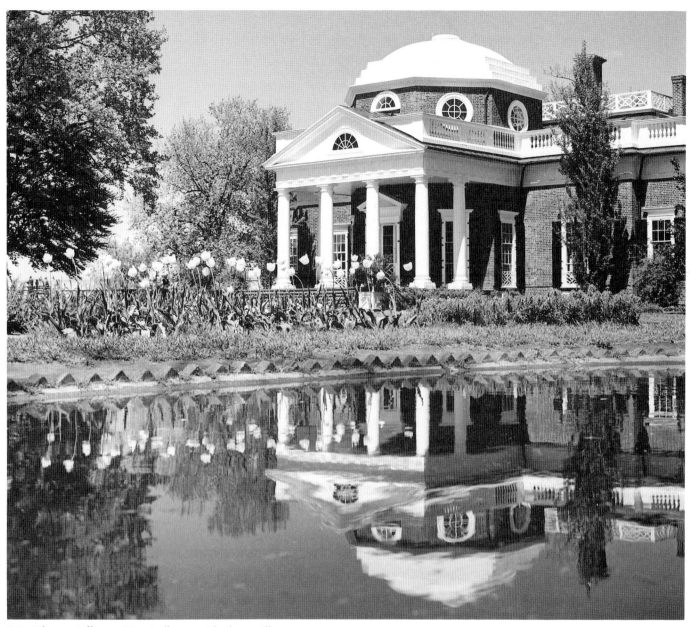

8.3 Thomas Jefferson, Monticello, near Charlottesville.

dome—testify to the reasoned geometry that pervaded Jefferson's architectural sensibilities, and the classical nature of his aesthetics.

The central axis is crossed by suites, which function for public or private activities. To one side are the dining room and the little six-sided tea room—a beautiful ambience for gracious entertaining. On the other side is Jefferson's private and very personalized suite, including his bedroom, cabinet, and library. All four corner rooms terminate in hemi-octagonal bays, but the interior shape of each is different. This love of variety in room spaces—thereby avoiding the boxlike uniformity of the rooms of Georgian houses—becomes characteristic of American Neoclassicism, and of the Federal style. Rooms are well lit by the elegant French doors and tall windows.

On the exterior, the complexity of the overall form is unified by the bold Doric entablature and balustrade, which run continuously around the building. The balustrade also serves to conceal the low, hipped roof. From the main

structure, long arms extend outward on the garden side, and then turn at right angles to form a large "U" with terminal pavilions, in one of which was Jefferson's law office. The "arms," kept low by sinking them partially below ground-level, contained support areas such as the kitchen, wine room, and beer room—all placed below the line of vision so as not to distract from the main edifice.

A NEOCLASSICAL UNIVERSITY

Before 1817, American colleges had developed more or less at random, with little coordination of the various buildings. Jefferson conceived a unified scheme for the University of Virginia that extolled order, reason, and diversity within harmony. The aim was to reflect the immutable natural laws and classical learning that were the linchpins of contemporary civilization. As the architect of the institution—the curriculum as well as the buildings—Jefferson believed that in a democracy, education was a responsibility. Only an

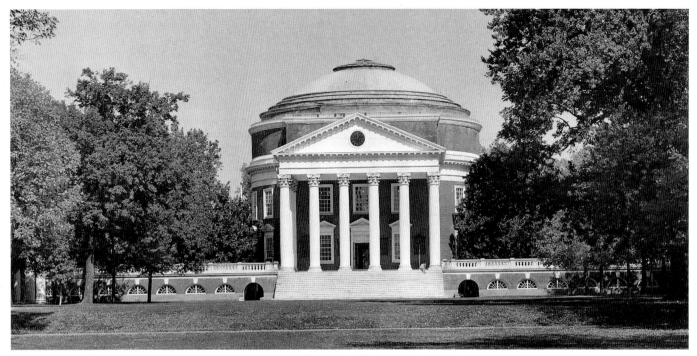

8.4 Thomas Jefferson, The Rotunda, University of Virginia, Charlottesville, Virginia, 1822–6.

enlightened citizenry should be entrusted to protect the rights and liberties established under the new ideology he had helped to found. Jefferson consciously rejected Oxford and Cambridge universities as models, for they carried connotations of Englishness and church-controlled education—and Jefferson disliked both. Naturally, he turned to a neoclassical solution.

In the center of Jefferson's plan was the beautiful temple of learning, the rotunda, based on the Pantheon in Rome, but scaled to half its size (Fig. 8.4). The library was housed in the dome room, and by its dominating position, Jefferson stressed the importance of the accumulated wisdom held in books. Like its Roman model, the rotunda has a Corinthian portico applied to a circular drum, capped with a low dome. Unlike its ancient counterpart, it has windows placed in the walls to admit light.

Arms extend from the rotunda, then turn at right angles and run parallel to create a broad central mall. Each parallel arm has five pavilions, between which are student dormitories. Each pavilion belonged to a professor of a given discipline, and contained a classroom below, with living quarters above. As Jefferson wanted the students to be aware of the special beauties of the several classical Orders, each pavilion was conceived in a different Order: Pavilion I is Doric, based on the Baths of Diocletian; Pavilion II is Ionic, based on the Temple of Fortuna Virilis in Rome; Pavilion III is Corinthian, and so on.

For Thomas Jefferson, being a gentleman entailed a study of all those disciplines of learning that combined to produce an intelligent and cultivated social being, including the art of architectural design and theory.

THE FEDERAL STYLE IN NEW ENGLAND

To trace the line of Neoclassicism that entered America through English, not French, sources, it is necessary to look to New England, where the style of London was transformed into the Federal style. French Neoclassicism will be encountered again in certain buildings or regions, but the British version had a much greater, and more widespread, influence.

ROBERT ADAM

The leading exponent of the new style in British architecture was the Scottish-born architect Robert Adam (1728–92). Adam's delicate Neoclassicism displaced the Georgian style, just as the neoclassical style in furniture designs by Thomas Sheraton (c. 1751–1806) and George Hepplewhite (d. 1786) replaced the Chippendale mode.

Robert Adam left his native Edinburgh in 1754 to embark on the Grand Tour. This ultimately took him to Italy, where he visited Pompeii and Herculaneum after settling in Rome. There, his friends included Piranesi and Clérisseau, the latter accompanying him to inspect the great Roman ruins at Spalatro on the Adriatic coast. The visit resulted in the publication of Adam's *Ruins of the Palace of the Emperor Diocletian at Spalatro in Dalmatia* (London, 1763). After further intensive study of antiquity—and Renaissance versions of it—Adam left Italy to settle in London in 1758 where, in collaboration with his brother James, he had

immediate and enormous success through his innovative interpretations of antique architectural forms and decorative motifs. English connoisseurs delighted in the new interior spaces and décors Adam created when he remodeled, for example, Syon House (1760–71), Kedleston Hall (1761–4), and Osterley Park (1765–85).

The rooms from Lansdowne House (1762–8), which have been installed at the Metropolitan Museum of Art and the Philadelphia Museum of Art, reveal Adam's brand of Neoclassicism to be elegant, decorative, and original interpretations—not austere, or pedantic imitations of antiquity. In the introduction to volume one of *The Works in Architecture of Robert and James Adam* (London, 1773), the Adam brothers wrote that they had attempted "to seize… the beautiful spirit of antiquity, and to transfer it, with novelty and variety."

Adam's rooms became circular, elliptical, rectangular, and apsidal. Classical proportions were consciously attenuated for the sake of elegance and delicacy, and classical Orders were willfully redesigned in the interest of originality. As interior space was more innovatively manipulated, wall surfaces became more two-dimensional. Classical simplicity and respect for basic form permitted greater emphasis on decorative elements such as swags and urns, which were inspired by antiquity. Such were the characteristics that were imported to the United States, beginning in the mid-1780s. Once there, they were transformed into the Federal style of architecture and interior design.

SAMUEL McINTIRE

Samuel McIntire (1757–1811) offers an excellent case for the study of the rise of Federal architecture in America, for in his work the transition from Georgian to Federal is easily observed. Born in Salem, where his father, grandfather, brothers, and uncles all worked as carpenters, McIntire rose from carpenter to architect. McIntire's hometown prospered greatly in the decades following the War of Independence, with shipping, shipbuilding, and worldwide trading activities providing the wealth with which many splendid new mercantile mansions were commissioned. New Englanders became wellinformed of the new modes of design, and wanted their dwellings to express their sophistication and taste.

The Peirce-Nichols House and the Gardner-Pingree House
The Peirce-Nichols House reveals the transition from Georgian to Federal. It was originally designed and built by McIntire in 1782 in an essentially Georgian manner (Fig. 8.5). The bold, fluted, corner pilasters, the massive cornice, balustrade, and pedimented Doric portico all seem to be an assemblage of parts from architectural design books. There are so many windows with shutters and projecting headers that the integrity of the façade is lost in a multitude of Georgian ornament. The house is woodframe with clapboard siding, which is associated with the colonial style. The

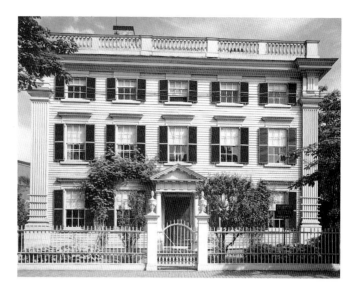

8.5 Samuel McIntire, Peirce-Nichols House, Salem, Massachusetts, 1782.

owners evidently found this oldfashioned, for in 1801 they had McIntire "modernize" the interior by applying decorative details inspired by the new Adamesque Neoclassicism.

That McIntire was capable of synthesizing Adamesque classicism into a mature expression of the Federal style is demonstrated in the Gardner-Pingree House (Fig. 8.6). In his design, McIntire was influenced by Charles Bulfinch's

8.6 Samuel McIntire, Gardner-Pingree House, Salem, Massachusetts, 1810.

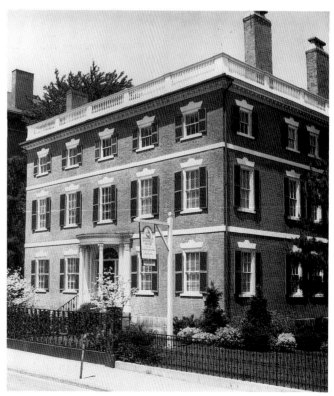

First Harrison Gray Otis House, Boston—one of the seminal buildings of the Federal style in New England (Fig. 8.10). The first thing one senses in the Salem house is its geometric beauty and simplicity, for decorative details have been reduced to delicate accents, which permit the wall plane to exist intact. Gone are the great corner pilasters. Instead we find the elegant beauty of one plane joining another to form a neat, crisp angle. The emphasis on delicacy is seen in the cornice, which is much smaller than the one on the Peirce-Nichols House. The integrity of the plane is retained by placing the stone window headers almost flush with the brick of the wall, whereas in the earlier house they had projected like three-dimensional hoods.

Instead of architectural ornamentation vying for the viewer's attention, simplicity prevails, and the eye focuses upon the exquisite classical detailing around the doorway. The portico is the only projection that is allowed to break the plane of the wall. In typical Adamesque fashion, its pilasters and columns have been attenuated, and the viewer is treated to a rich feast of elegant neoclassical embellishments in the capitals and around the top of the cornice. The elliptical form—frequently used in Adamesque and Federal design—is repeated in the fanlight above the door.

8.7 Samuel McIntire, Architectural elevation for the Ezekiel Hersey Derby House, Salem, Massachusetts, 1799.

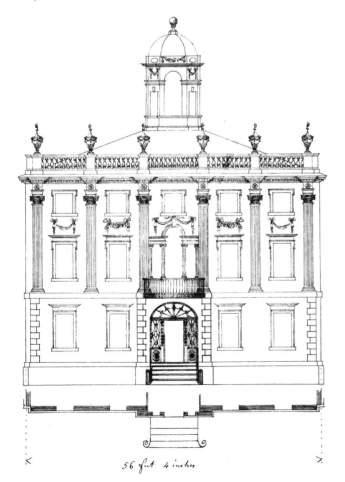

56 feet 4 inches

8.8 Samuel McIntire, Gardner-Pingree House, Salem, 1810. Mantel, front parlor.

The Gardner-Pingree House was commissioned by John Gardner, Jr., one of Salem's prospering merchants, who owned a dozen ships, including the *Hazard*, which made three voyages to India. The profits garnered from silks, spices, and other exotic commodities allowed the Gardners to build their fine house.

A drawing of the elevation of the Ezekiel Hersey Derby House shows how completely McIntire had mastered the Adamesque style and adapted it for American use (Fig. 8.7). The conception and details of the Derby House are thoroughly Adamesque—especially the use of urns, swags and garlands, the delicate pilasters, and the doorway with its elliptical fanlight. As always, lightness, variety, and delicacy are the guiding principles of Federal-style design.

The same characteristics are present in the interiors of McIntire houses. By the 1790s, he had begun to work oval rooms into his plans, following the example of Bulfinch's Joseph Barrell House of 1792–3. A typical McIntire interior was uniformly white or offwhite, or yellow with white trim, with decorative features restricted to a small ceiling cornice, and doorway and fireplace enframements.

In addition to being a carpenter and architect, McIntire was also a woodcarver of exceptional ability, and he often executed exquisite reliefs of garlands, baskets of flowers, cornucopias, and so on for the panels around his doorways and fireplaces, or for the furniture (Figs. 9.1–9.3) that this

talented and versatile man created. The front parlor of the Gardner-Pingree House has an excellent example of McIntire's carving in its fireplace reliefs (Fig. 8.8). Here is a specific instance of the Adamesque style being transmitted to America by way of a design book, for the fireplace is based on plate 16 of *Pain's British Palladio, or The Builder's General Assistant* (London, 1793) by William and James Pain.

FEDERAL MANSIONS

A dozen or more of McIntire's fine Federal mansions graced the streets of Salem. The new style was popular up and down the Eastern Seaboard—as in the John Brown House (1785) and the Thomas Poynton Ives House in Providence, Rhode Island; Homewood in Baltimore (1798–1801); Gore Place (1797–1804) in Waltham, Massachusetts; in the Woodlands (1788–9) and the William Bingham House (1789, destroyed) in Philadelphia; the Octagon in Washington, designed by William Thornton (1798–1800); and in Charleston, South Carolina, the Nathaniel Russell House (1809). In each of these, classical simplicity of plane and form rules, while architectural decoration is confined to specific areas, allowing the eye to focus upon the buildings' delicate beauty.

Boscobel (Fig. 8.9), now relocated in Garrison-on-Hudson, New York, is an especially good example of the Adamesque style in America. The decorations and attenuated columns of the porch are the epitome of English-style neoclassical elegance. An ancient precedent for slender, elongated columns of these proportions was set in Pompeiian wall paintings. Boscobel was begun by States Morris Dyckman in 1804, after he had returned from a four-year period in England, during which time he acquired a taste for the Adamesque style.

CHARLES BULFINCH

The American who best understood English Neoclassicism was Charles Bulfinch (1763–1844). He was America's first native-born professional architect, although he had no training, and emerged from the gentleman-amateur tradition. Born into a wealthy, cultivated Boston family, in his youth Bulfinch studied the architectural design books in his father's library. While attending Harvard College, he familiarized himself with Robert Adam's *Works in Architecture* and Stuart and Revett's *Antiquities of Athens*, two of the primary British conveyors of Neoclassicism.

8.9 Boscobel, Garrison-on-Hudson, New York, c. 1805.

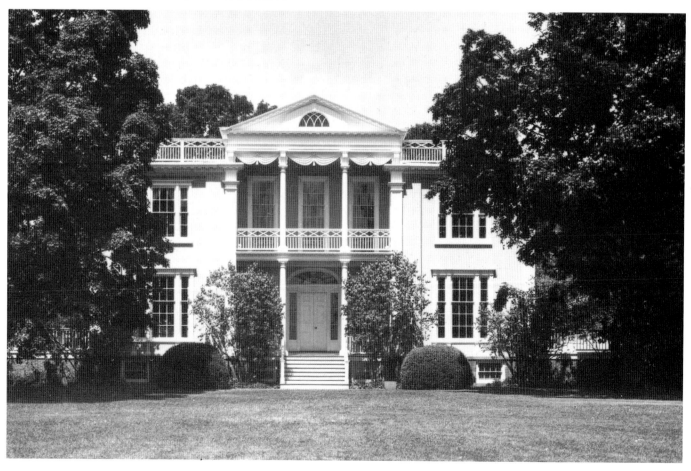

In 1785, Bulfinch embarked upon a European Grand Tour in order to complete his education as a gentleman. His chief interests in England, France, and Italy were in architecture, particularly in those examples of the new neoclassical design, rather than the ancient specimens from which they were derived. In London, Bulfinch studied the recently erected buildings by Robert Adam and William Chambers (1726–96). When he returned to Boston in 1787, he was a polished young man, wellinformed in architectural design.

At that time Bulfinch had no idea of becoming a professional architect. He went into public service, occasionally providing designs for friends or institutions as a sideline, in the old tradition of the gentleman-amateur architect. Among the most important of his early works was the Joseph Barrell House (1792–3, Somerville, Massachusetts, destroyed), which was one of the first buildings to introduce the Adamesque neoclassical design into New England. The main feature of the plan was a large oval salon, which, with the flanking sitting and dining rooms, formed an elegant suite for gracious entertainment.

HARRISON GRAY OTIS HOUSE

Harrison Gray Otis and his wife were among the leaders of Boston's élite. Bulfinch designed three houses for them, the first of which offers an excellent example of the new Federalist style (Fig. 8.10). Otis was a lawyer, mayor of Boston, and a member of Congress, who in 1817 helped to secure Bulfinch's appointment as architect of the Capitol.

In his design for the first Otis House (1795–6), Bulfinch was probably influenced by the William Bingham House (Fig. 8.14)—said to be the most elegant private home in

America—which Bulfinch had praised and sketched in Philadelphia in 1789. The façade is dominated by neoclassical simplicity and precision. The plane of the wall is respected, the corners are neat and crisp, symmetry prevails, and decoration is confined to specific areas, relying on exquisite refinement rather than overwhelming profusion.

The Otis House is built of brick, its three stories being clearly indicated by flush stone stringcourses. Stone window headers do not violate the flatness and unity of the plane. The cornice is reduced to a delicate enframement that leaves the eye free to concentrate on the other beauties of the façade—such as the central axis that, in contrast to the sharp rectilinearity of the rest of the scheme, is marked at all three levels by semicircular or elliptical forms: the fanlight on the first floor, the Palladian window of the second, and, finally, the glazed **lunette** with lithe mullions in a spoke-and-garland pattern. The attenuation of columns and pilasters of the doorway and Palladian window are direct reflections of Adamesque proportional relationships.

Bulfinch gave the town of Boston a new appearance. In designing Tontine Crescent—a row of sixteen townhouses set on a slight curve, facing a green, treelined sward—he hoped to establish a neoclassical precedent, following examples he had seen in England, specifically at Bath and Buxton. The Tontine venture, however, was a financial failure that nearly bankrupted him.

Among Bulfinch's commercial structures were two of the most important mercantile buildings of his day—India Wharf (1803–7) and the enlarged Faneuil Hall (1805–6). For Harvard College he designed Stoughton and University Halls (1804, 1814), and the New South Church (1814) in Boston and the Church of Christ (1818) in Lancaster, Massachusetts, were also of his design.

MASSACHUSETTS STATE HOUSE

During the designing and execution of the Connecticut State House (1793–6) in Hartford, Bulfinch honed his skills for the greatest challenge of his Boston period—the Massachusetts State House (Fig. 8.11). Typically, the design is based on examples of English Neoclassicism rather than on antique sources. For inspiration, Bulfinch looked to William Chambers's celebrated river façade of Somerset House (1778–86), which he probably saw when he was in London.

The State House is built of red brick, highlighted with marble trim. The columns, originally wooden, have Corinthian capitals that were carved in the shop of John (1746–1800) and Simeon Skillin (1756/7–1806). The central section of the State House rests on a simple, cleancut arcade. Above this rises a gallery with great Corinthian columns, which are paired at the corners and single in the middle. The wings have gracefully arched windows on the second story, the central one being of Palladian design recessed in a blind arch. At the third level, behind a pediment, towers the great dome, coated in gold leaf, and glistening below a handsome cupola, capped with a gilded pinecone.

8.10 Charles Bulfinch, First Harrison Gray Otis House, 1795–6, and Asher Benjamin, West Church, 1806. Boston, Massachusetts. Courtesy Society for the Preservation of New England Antiquities, Boston.

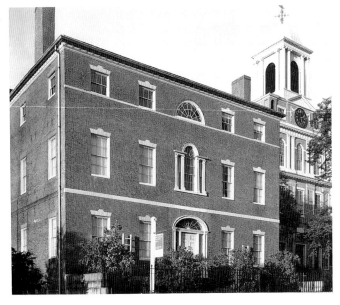

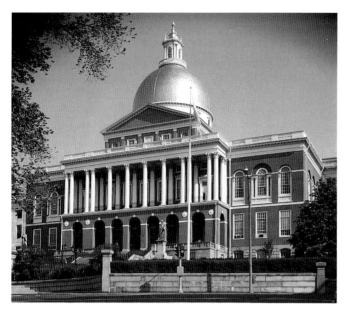

8.11 Charles Bulfinch, Massachusetts State House, Boston, 1795–8.

The interior of the State House, particularly Old Representatives' Hall, splendidly demonstrates Bulfinch's extraordinary mastery of Adamesque delicacy. The Senate Chamber has a flattened vault that is compartmentalized and adorned with elegant Adamesque stucco designs in low relief. When completed in 1796, Bulfinch's Massachusetts State House ranked with Jefferson's Virginia State Capitol as the finest examples of Neoclassicism in America. Bulfinch will be discussed again, for in 1818 he left Boston to assume his post as architect of the United States Capitol.

PUBLICATIONS OF ASHER BENJAMIN

The new style that Bulfinch introduced into New England was spread in part by the publications of a Yankee carpenter-turned-architect named Asher Benjamin (1773–1845). Benjamin's career began in the 1790s in the Connecticut Valley. In 1797 he published the first American architectural design book, the *Country Builder's Assistant*, which was based on William Pain's *Practical House Carpenter* (London, 1789). Its thirty plates provided plans for houses and a meetinghouse, and designs for mantels, cornices, moldings, and the like.

Benjamin settled in Boston in 1802, and soon after he published an even more influential volume, *The American Builder's Companion* (Boston, 1806). Again, this borrowed heavily from Pain's publications, but the classical forms and details were tempered with common sense by providing designs that carpenters could execute, and that were labor- and cost-effective. Bulfinch had by then altered the course of architectural design in New England, and Benjamin's book incorporates many of the innovations of the Adamesque Federal style. *The American Builder's Companion*

offered numerous plates, one of which shows the impact Bulfinch had on façade design, the use of curved interior walls, and neoclassical ornament (Fig. 8.12). One of the best examples of Benjamin's architecture is the West Church (1806) on Boston's Beacon Hill, next door to the Otis House, and not far from Bulfinch's State House. It is partially visible in Figure 8.10.

Altogether, Benjamin published seven books, most of which ran through several editions. Just as his earlier volumes had been instrumental in the spread of the Federal style, so those of the 1830s circulated the designs of the new Greek Revival. One need only look through the engraved plates of *The Practical House Carpenter* (1830), the *Practice of Architecture* (1833), and *The Builder's Guide* (1838) to understand how effective Benjamin's publications were in carrying new styles to the distant regions of the expanding nation, as well as all over New England. It has been estimated that over 35,000 copies of his books were sold.

8.12 Asher Benjamin, Engraving, plate 53, from *The American Builder's Companion, or, A New System of Architecture* (Boston, 1806, fourth edition 1820). Morris Library, University of Delaware, Newark, Delaware.

THE FEDERAL STYLE IN PHILADELPHIA

While the new Federal City on the Potomac was being readied, Philadelphia flourished, serving as the state capital until 1799, and as the national capital from 1790 to 1800. Its location on the Delaware River facilitated economic exchange, as well as an infusion of arts, objects, goods, and styles from Britain, Europe, and far-distant places of the world.

The Quaker City had some of the earliest and most influential examples of domestic architecture created in the Federal style. Woodlands, for example, was remodeled in 1788–9 according to the new Adamesque style, with square, circular, and elliptical rooms, and a large rectangular hall that has apsidal ends (Fig. 8.13). William Hamilton, the owner, may have brought the plans for remodeling the house back with him when he returned from England. In any

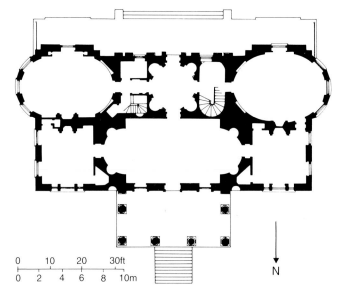

8.13 Woodlands, Philadelphia, Pennsylvania, 1788–9. Plan.

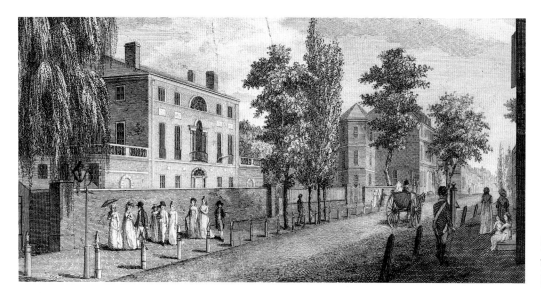

8.14 William Bingham House. Engraving, detail of plate 18, from William Birch, *The City of Philadelphia* (Philadelphia, 1800).

8.15 (below) Samuel Blodget, Jr., First Bank of the United States, Philadelphia, Pennsylvania, 1795–7.

event, Woodlands became the first full statement in America of the style of Robert Adam. On its façade, a grand, two-story, three-bay temple portico is the domestic equivalent of that which Jefferson applied to the front of the Virginia State Capitol, which was being built in the very same year.

In 1789, William Bingham, a wealthy banker, built his splendid townhouse in Philadelphia (Fig. 8.14). When he and his wife returned from several years in Europe, they brought with them crate upon crate of fashionable furnishings. They also brought the plan for their new house, which had been drawn up by John Plaw (c. 1745–1820), a London architect and builder, based on Manchester House in London. The Adamesque features of Bingham House so impressed Charles Bulfinch that he imitated them in his design for the Otis House in Boston.

Turning to commercial and governmental architecture, the First Bank of the United States in Philadelphia possesses

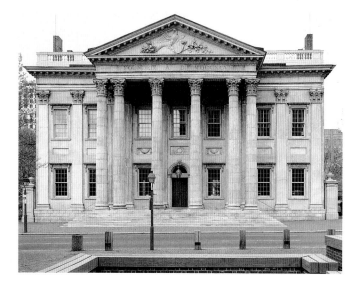

an imposing classical grandeur seldom known in America before it was erected (Fig. **8.15**). Its designer was Samuel Blodget, Jr. (1757–1814), a merchant. His source may have been an engraving of the Royal Exchange in Dublin, designed in 1769 by Thomas Cooley (1740–84). The great portico expresses republican ideals through the imitation of ancient Roman architectural forms, which were considered appropriate for governmental institutions. The portico, which recalls that of La Madeleine, begun in 1762 in Paris, was a harbinger of federal Romanism, which developed in the new national capital.

THE NEW FEDERAL CITY

Sitting in Philadelphia in the summer of 1790, Congress established a federal district on the banks of the Potomac River. The land was given by Virginia and Maryland, and Congress decreed that it was to be the permanent seat of the national government. The following year, President Washington appointed Pierre-Charles L'Enfant (1754–1825), a Frenchman and engineer, to draw up a plan for the new city (Fig. 8.16). The site was a raw wasteland, offering a rare opportunity to start from scratch—both in terms of city planning, and as an expression of political and ideological concepts. Whereas towns such as Boston had grown in a rambling manner, here was a chance to create a magnificent capital, unencumbered by the accidents and errors of previous urban expansion.

L'Enfant established two main focal points—the site of the Capitol near the center of the city, and the President's House in the northwest sector. From these, major avenues radiated, linking them with secondary squares or intersections. Pennsylvania Avenue created a connecting axis between these. Upon all of this, a rectilinear grid was imposed for the rest of the city, and splendid vistas and sites for great buildings and memorial monuments were established throughout. L'Enfant knew well the grand scheme of the palace and gardens of Versailles, and its influence is seen in his design for the national capital.

8.16 Pierre-Charles L'Enfant, Plan of the city of Washington, 1791. Library of Congress.

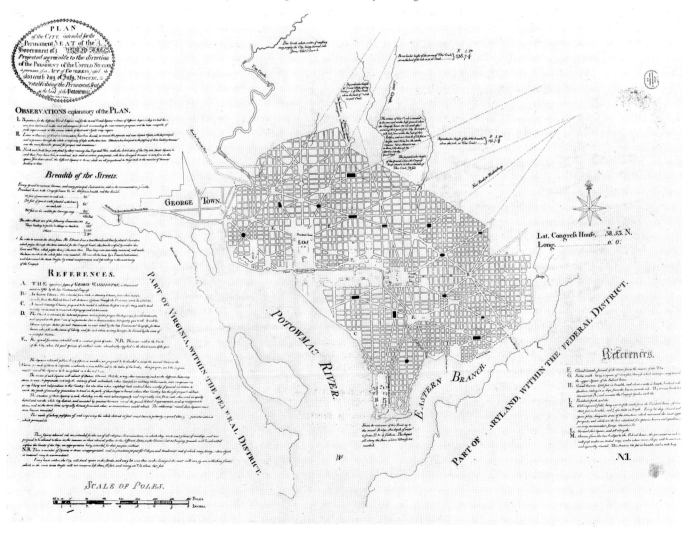

THE CAPITOL AND THE PRESIDENT'S HOUSE

Two buildings were required immediately: The Capitol—to house the legislative and judicial branches of the government—and the President's House, the residence of the chief executive. At the suggestion of Thomas Jefferson, then Secretary of State, a competition for designs of each building was held. Of the wide variety of entries, most were typically eighteenth-century in character. For the presidential residence, that submitted by James Hoban (1756–1821) was chosen.

Hoban was the first of a wave of professional architects who emigrated to America in the Federal period. He was already a practicing architect when he arrived in Philadelphia from Ireland in 1785, although his training had been in the Palladian mode, rather than in the newer Adamesque manner. Hoban's design for the President's House was based on James Gibbs's *Book of Architecture*, and on Leinster House (Dublin, c. 1745), which Hoban would have known. Both were archetypally eighteenth-century in style. Although Hoban's design was modified by Jefferson and Latrobe in the early nineteenth century, the end result was the building known today as the White House (Fig. 8.17). Its graceful Ionic pilasters, window surrounds, and alternating window pediments virtually cover the wall with applied decoration, which is typical of Georgian design, not neoclassical. But then, the Capitol also started out as an eighteenth-century building.

Of the numerous designs submitted in the Capitol competition, none was deemed entirely satisfactory. Then, a late entry was submitted by Dr. William Thornton (1759–1828), a young physician recently arrived from the Virgin Islands. Thornton was a typical gentlemen-amateur architect, who leafed through a few books containing plates, and from them assembled the components of his design. Thornton's entry had two wings that would house the House and Senate, with a central section fronted by a pedimented portico, which led to a rotunda capped by a low saucer dome (Fig. 8.18). Thornton's design looked backward rather than forward to a new style dominated by Neoclassicism. Although the central section bears a general similarity to the Pantheon in Rome, the wings are purely eighteenth-century in concept.

8.17 James Hoban, The White House, Washington, D.C., c. 1795.

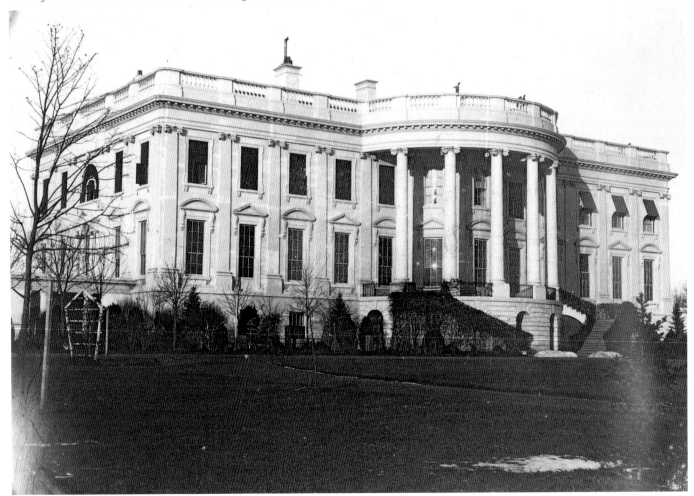

8.18 William Thornton, Design for the United States Capitol, Washington, D.C., 1792. Library of Congress.

LATROBE AND THE NEW CLASSICISM

It was at this moment that Benjamin Henry Latrobe (1764–1820) appeared upon the scene. Born in England to a mother from Pennsylvania, Latrobe was educated in Germany. He traveled extensively in France and Italy before returning to London in 1784, his interests in engineering and architecture already awakened. From the first, Latrobe was fascinated by the radical, abstract classicism of the progressive French architects Claude-Nicolas Ledoux (1736–1806) and Etienne Louis Boullée (1728–99), as well as the theory of the architectural critic Abbé Marc-Antoine Laugier (1713–69).

The greatest influence upon Latrobe, however, was the architecture of Sir John Soane (1753–1837), whose Bank of England (London, 1792–3) heralded the arrival of a new form of classicism that was very different from the Adamesque. Whereas Robert Adam had drawn mainly upon Roman prototypes, the new classicism was based more on Greek architecture and theory. Of special significance was the fact that the new brand featured a bold, almost primitive, purity of Greek forms. An austere simplicity, a severity of plane, edge, corner, and cubic form, and a poetry of geometry,

precision, and proportional relationships replaced the delicate and decorative character of Adamesque classicism.

After receiving his architectural training in the office of Samuel Pepys Cockerell (1754–1827), Latrobe established his own practice in London in 1791. He also mastered the theory and technique of masonry construction in vaulting, which was virtually unknown in America.

BANK OF PENNSYLVANIA

After the death of his wife, and the cessation of nearly all building projects in England because of the Napoleonic War, Latrobe decided to try his fortune in the United States, arriving in Virginia in 1796. Two years later, he settled in Philadelphia, where he was appointed architect of the Bank of Pennsylvania (Fig. 8.19).

Soane's Bank of England must have been in Latrobe's thoughts as he designed his Bank of Pennsylvania, for it shows an assertion of the new classicism. The building is in fact an architectural manifesto of the Greek Revival, for the porticoes on either end were inspired by the Greek Ionic temple on Ilissus. The porticoes, however, are raised on a podium in Roman manner, and the central block is capped by a Roman-type depressed dome.

The purity of the classicism in this building is not due to

8.19 Benjamin Henry Latrobe, *View of the Bank of Pennsylvania, Philadelphia*, 1798–1800. Watercolor on paper. Museum and Library of Maryland History, Maryland Historical Society, Baltimore.

its strict adherence to one or another Order, but rather to its absolute rationalism and logic, which governs everything from the overall basic form to the smallest detail. There is a geometric beauty in the simplicity of the central block, which is perfectly balanced by the two porches. Yet the whole is united into a single entity by a continuous entablature running all the way around.

Inside, the building was divided into three parts, with a great circular room in the center for conducting the daily business of the bank, and offices and meeting rooms in the end sections.

Latrobe's Neoclassicism forced Americans to make a considerable choice in their architectural tastes—between his bold, monumental, and often austere classicism, and that of Adamesque details, elegant decorations, and lithe proportions.

FAIRMOUNT WATERWORKS PUMP HOUSE

The next project Latrobe undertook tested his engineering as well as his architectural skills. Throughout Philadelphia, well-water was being polluted by drainage from privies. Latrobe proposed a scheme to raise fresh water from the Schuylkill River to a high point in the center of the city, by means of steampowered pumps, whence it was dispersed by gravity through wooden waterpipes. For one of the two

pumping stations, located on the present site of City Hall, Latrobe designed a structure that was radical in the severity of its classicism. The appearance of the pumping station is known from John Lewis Krimmel's painting of Center Square (Fig. 11.6). Geometric forms dominate in the lower cube, from which rises a cylinder crowned by a depressed dome. A recessed porch is of the Doric Order—the simplest, boldest, and most massive of all classical Orders. In this building, Latrobe demonstrated his comprehension of the fundamental theory that underlay classical architecture in its purest form. A comparison of Latrobe's Pump House with Ledoux's Portes de Paris (1784–9) confirms that the Frenchman's work was an influence on Latrobe's architecture.

A ROMAN CATHEDRAL

Latrobe's next major commission, awarded in 1804, was for a new cathedral in Baltimore. This was to be the first truly monumental Catholic cathedral built in America (Fig. 8.20). Latrobe supplied Bishop John Carroll with two designs—one in the Roman style, the other in the Gothic. The Roman was chosen. The result was a daring foray into domed and vaulted space, and an adventure in construction such as America had never known. The cathedral was built of stone on a Latin cross plan, with vaulted side aisles and a great dome (65 feet—20 m—in diameter) over the crossing of the nave and transepts. The entrance is through a colossal

8.20 Benjamin Henry Latrobe, *Baltimore Cathedral*, 1804–21. Watercolor on paper. Museum and Library of Maryland History, Maryland Historical Society, Baltimore.

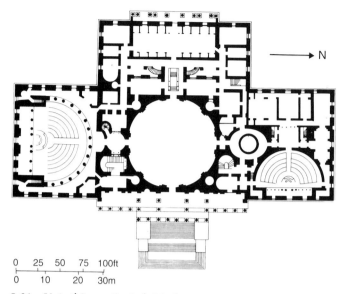

0 25 50 75 100ft

0 10 20 30m

8.21 United States Capitol, Washington, D.C., c. 1815. Plan.

Roman temple portico with handsome Ionic columns. The exterior walls emphasize the bold simplicity of the plain, geometric cubic form and cleancut edges, with decoration kept to a minimum.

In 1803, President Jefferson appointed Latrobe Surveyor of the Public Buildings for the United States. This gave Latrobe supervisory power over the completion of the two main buildings being erected in the national capital. To Hoban's design for the President's House Latrobe added an oval room and recommended a portico. He even assisted Dolley Madison with the interior furnishings. At the Capitol, he inherited Dr. Thornton's eighteenth-century scheme, arriving upon the scene as the two wings rose from their foundations. The plan shows the location of the large semicircular hall of the House of Representatives at the left, while the smaller Senate chamber is at the right, with the huge rotunda in the center (Fig. 8.21).

Latrobe had considerable freedom with the interior of the Capitol, where he exhibited his knowledge of Greek architecture, which he preferred over Roman, and certainly over eighteenth-century styles. In the Supreme Court area he used the powerful Doric Order in proportions similar to those found in the Greek temples at Paestum. The Ionic Order was used in the Senate chamber, and the Corinthian capitals of the House of Representatives (Fig. 10.20) were inspired by the famous Monument of Lysicrates (334 B.C., Athens, Greece).

AMERICAN NEOCLASSICISM

For all his devotion to the artistry of the ancient Greeks, Latrobe kept in mind that America was his patron. Accordingly, he Americanized his capitals in the classical mode. These are the famous corncob capitals, with cornstalks for the fluting of the shafts. In the vestibule of the Senate wing,

and for the Senate rotunda, Latrobe substituted the tobacco leaf for the acanthus in the capitals (Fig. 8.22). An important canon of the neoclassical creed demanded the modernization of classical forms, rather than a slavish imitation of them. In subscribing to this principle, Latrobe continually infused new life into an ancient architectural vocabulary.

Although senators and congressmen were delighted with his uniquely American capitals, Latrobe was often at odds with members of Congress, who knew little about the theory, history, and traditions of grand architecture. He was dismissed in 1811, but after the British burned the Capitol and President's House in 1814, as the War of 1812 came to a close, Latrobe was recalled to repair the buildings. Following yet another confrontation with the commission in charge, however, he resigned his post in 1817, and left Washington, D.C., for New Orleans, where he died a few years later.

Latrobe was succeeded as architect of the Capitol by Charles Bulfinch, whose primary task was completing the central section with its dome over the rotunda. The height of the dome was increased considerably, giving it a very different character from the low, saucer dome Latrobe had planned (Fig. 17.6). Bulfinch completed the Capitol building—for the time being, at least—and his reputation soared as a result of his work.

By the time Bulfinch left the capital in 1830, he, along with Latrobe even earlier, had established the professional standing of the architect. Before these men there had been only gentlemen-amateurs or craftsmen-builders, all of whom worked from eighteenth-century design books. Now, there were professional architects, who became the final authorities in architectural design and structural methods.

8.22 Tobacco Leaf Capital, designed by Benjamin Henry Latrobe for the United States Capitol, Washington, D.C., c. 1815.

THE FEDERAL STYLE IN NEW YORK CITY

Like Boston and Philadelphia, New York City had flourished during the 1790s and the first decade of the nineteenth century. Pierre-Charles L'Enfant had designed a Federal-style Federal Hall (1788) for use while the seat of national government was temporarily located in the City, and the spire of St. Paul's Chapel (1790–5, Fig. 6.9) and John McComb's St. John's Chapel (1803–7) soon graced the skyline.

The town's chief glory was its new City Hall (1802–12), a collaborative effort by Joseph-François Mangin (d. after 1818) and John McComb, Jr. (1763–1853). Mangin, a French *émigré*, first appears in New York City in 1794, already trained as an architect and engineer. McComb had made a name for himself in the city as designer of a number of houses in the Adamesque style, and it was actually he who supervised the building of City Hall (Fig. 8.23). The decidedly French flavor in the exterior design of the building is no doubt attributable to Mangin. New York City also had a strong Francophile faction, which frequently expressed itself in matters of art.

Mangin's design recalls specific French models such as Alexandre Théodore Brongniart's Hôtel de Monaco (c. 1774) or Jacques-Denis Antoine's Hôtel des Monnaies (c. 1770), both in Paris. It possesses something of the decorative delicacy of seventeenth- and eighteenth-century French architecture before it became bold and ponderous under the spell of a monumental Roman classicism. The pavilion design—with arched windows, scrolled keystones, pilasters with finely cut capitals, and other rich adornment—reminds one more of the Garden Façade of the Palace at Versailles than of the severe, planar, and austere contemporary work of Latrobe. A handsome cupola crowns the exterior. Inside, where McComb was in charge, the French influence gave way to Adamesque classicism, particularly noticeable in the assortment of variously shaped rooms.

THE FEDERAL STYLE IN THE SOUTH

The South, too, had its architectural flowering during the Federal era, and many fine houses were erected from the Carolinas to Louisiana. The Thomas Fuller House (also

8.23 Joseph-François Mangin and John McComb, Jr., City Hall, New York City, 1811. Shown here in John Hill, *City Hall*, 1826. Handcolored aquatint on paper, 17 × 28in (43.2 × 71.1cm). National Museum of American Art, Smithsonian Institution, Washington, D.C.

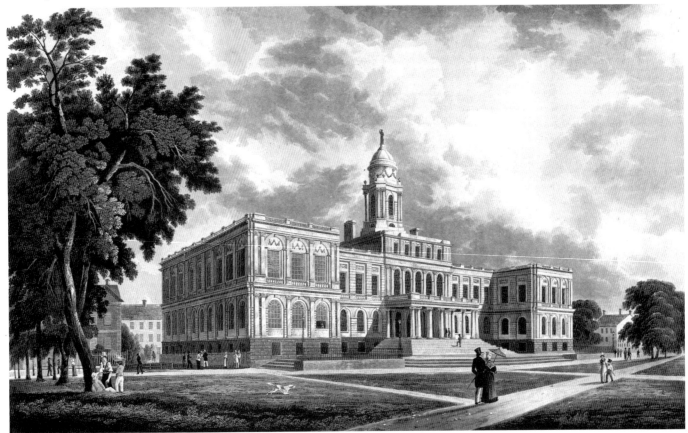

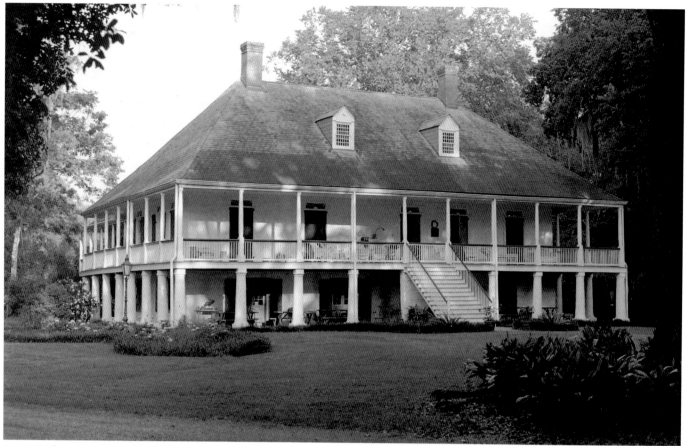

8.24 Parlange, near New Roads, Louisiana, c. 1785–95.

called the Tabby Manse because of the material of its construction) in Beaufort, South Carolina, is an early example of Adamesque Neoclassicism, for it was built in 1786. Its façade has the temple portico with attenuated columns and delicate cornice, and the flat, largely undecorated walls with plain, sharp corners that are typical of the new style. The Maxey House (c. 1813), also in Beaufort, has double galleries along one side, as frequently found in southern townhouses of this period.

At Parlange (c. 1790), in the bayou country of Louisiana, there are French and Caribbean influences (Fig. 8.24). A double gallery surrounds the house, the lower floor being a raised basement with the main living quarters above it. Its builder, the Marquis Claude Vincent de Ternant, came to Louisiana from France to establish an indigo plantation. He probably brought some notion of French Neoclassicism with him, but the main influence at Parlange is a type of galleried house devised in the islands to cope with the heat. The galleries serve as the hallways for the house, with each room opening on to them. Windows and doors, the full height of the high-ceilinged rooms, were also designed for ventilation.

Although political independence had been won with the end of the Revolutionary War, cultural infusions continued to cross the Atlantic. Latrobe offered one form of Neoclassicism, while another variation came from France. Nevertheless, the architecture of the Federal period was unified by its commitment to classicism. It was to be more than a century before such homogeneity was again achieved, for succeeding decades employed a wide array of styles to suit their romantic inclinations, from Egyptian to Gothic, and from Renaissance to Oriental.

CHAPTER NINE

DECORATIVE ARTS:

1785–1830

During the Federal period the decorative arts continued to be handcrafted, even as the era of the Industrial Revolution began to open in the United States. Paul Revere produced the first coldrolled copper in 1801. Four years earlier, the cast-iron plow had been invented and patented. In 1805, Robert Fulton's steamboat, the *Clermont*, made its historic trip up the Hudson River. By 1816, steamboats were working the Mississippi River and the Great Lakes. In 1818, the *Savannah* left Georgia for Liverpool on the first transatlantic crossing made mostly under steam.

Machine-driven looms in factory towns like Waltham and Lowell, Massachusetts, were producing fabrics that earlier had been handmade on home looms. A woodworking machine was perfected for planing boards and cutting them with tongue-and-groove edges—an important development in the costeffective production of clapboarding for houses. By 1816, Baltimore had illuminated its streets after dark with gas lighting, the first city in the United States to do so.

One of the effects of the Industrial Revolution was the increasing specialization of labor, and the transition from the individual handcrafted object to massproduction that was marketed for massconsumption. This phenomenon will be observed even in connection with handmade furniture, silver, and other items of the Federal period.

ADAMESQUE INFLUENCES

During the years 1785 to 1830, the single most important influence on furnishings was the new, classically inspired designs of Robert Adam and his brother James. The Adamesque mode was known in America through the Adams' book of engraved plates, *Works in Architecture* (London, 1773–9), which contained interior and furniture designs as well as architectural plans and elevations. Even Thomas Chippendale—the quintessential Georgian—succumbed, and produced chairs, chests, sofas, and so on in the popular Adamesque style.

The straight, slender, tapering leg replaced the S-curve of the cabriole, and there was delicate inlay instead of lavish carving. Subtle curves took the place of the more dynamic curves of sofa backs, while simplified, tapered feet supplanted the claw-and-ball. Proportions became lithe and delicate, and simple planes replaced richly sculptured surfaces. Robert Adam's inspiration stemmed from objects excavated at Pompeii and Herculaneum. The classical forms of these objects made them suited to the Federal period, which had philosophically a close affinity with ancient, republican Rome. The classical urn, swag or festoon, cornucopia, shield, and eagle became favorite decorative motifs, and were wrought in shapes that underscored the essential quality of the Adamesque style—elegance.

PRACTITIONERS AND SOURCES OF THE FEDERAL STYLE

By the 1780s, most of the cabinetmakers in London had switched to the new designs. Among them were George Hepplewhite and Thomas Sheraton, whose names have become synonymous with Federal-style furniture in America. They did not invent the style, but were craftsmenpractitioners of it. Their greatest significance is in the books of engraved plates which they published: Hepplewhite's *The Cabinet-Maker and Upholsterer's Guide* was published in London in 1788, and Sheraton's *The Cabinet-Maker and Upholsterer's Drawing-Book* appeared in 1791–3. Both publications carried the new style to America. The only essential differences between their designs was that Hepplewhite included subtle curves and low-relief carvings, while Sheraton preferred rectilinear forms and painted surfaces or inlay.

The term "Federal" refers to a period in American history, and it encompasses several European styles or movements in the arts. Adamesque, Hepplewhite, and Sheraton have been mentioned, but others should be identified as well.

In French history and furniture style, Directoire refers to the era between the French Revolution and the crowning of Napoleon as emperor, or 1789 to 1804. There was an influx of French influences into America during the Federal period. Empire, the next period in France, began with Napoleon's ascension as emperor in 1804, and continued until his defeat at Waterloo in 1815. (The neoclassical furniture of this period is discussed in chapter 14.) The English counterpart to Empire was Regency, which takes its name from the

years 1811–20, when King George III was mentally incompetent, and regents ruled in the name of the Prince of Wales (the future George IV). These styles, brought together in the United States under the umbrella term "Federal," were unified in their commitment to classical sources as the basis of their design.

SAMUEL McINTIRE

The work of Samuel McIntire is a convenient starting point for the study of Federal decorative arts, as his shop, in Salem, Massachusetts, was one of the first to produce furniture in the new classical style. The design of a chair McIntire made (Fig. 9.1) is taken directly from Hepplewhite's *Cabinet-Maker's Guide*. It has a shieldshaped back with carved swags, and a classical urn for a splat. Throughout, the proportions of the wooden members are slender and graceful, and the tapered, straight front legs terminate in what are called spade feet. The delicate, low-relief carvings of shafts of wheat, bunches of grapes, and ribbons are exquisite examples of McIntire's skill as a carver—a skill already encountered in his interiors (Fig. 8.8). Typically, the carved reliefs on the legs of the chair are quite unlike the rich ornamentation of, say, the knee of the cabriole leg on the Chippendale chair seen in Figure 6.15.

Furnishings from the McIntire shop were produced for Salem's ever prospering merchants, whose ships carried on trade with nearly every corner of the earth. Elias Hasket Derby, for example, kept numerous Salem craftsworkers busy with his commissions for the finest pieces they could make. The similarity between this chair and McIntire's design for the Ezekiel Hersey Derby House (Fig. 8.7) is clear, with a fine continuity existing between exterior, interior, and furnishings.

LEMON CHEST

McIntire was also associated with the production of one of the great masterpieces of American furniture—the chest-on-chest, made in the Salem shop of either William Lemon or of Charles or John Lemon in 1796 for Elizabeth Derby West, daughter of the famous merchant (Fig. 9.2). The overall

9.2 Central figure probably carved by Simeon Skillin, Jr., or John Skillin; design and carving traditionally ascribed to Samuel McIntire; cabinet work to William Lemon, Chest-on-chest, 1796. Mahogany, veneer on pine, 102½ × 46¾ × 23in (260.4 × 118.7 × 58.4cm). Museum of Fine Arts, Boston. M. and M. Karolik Collection.

9.1 Attributed to Samuel McIntire, Armchair, 1796–1800. Mahogany, 38 × 22 × 18⅜in (96.5 × 55.9 × 46.7cm). Courtesy Winterthur Museum, Winterthur, Delaware.

9.3 Samuel McIntire, Detail of carvings for the chest-on-chest in Fig. 9.2.
Museum of Fine Arts, Boston. M. and M. Karolik Collection.

form of the case is transitional, for in its massiveness and in
the shape of the feet it recalls the Chippendale style. But the
pediment, of small, discreet size and straight lines, is typical
of the Federal period. Most exemplary of all is the beautifully
carved decorative work supplied by McIntire. On the **cham-
fered** corners of the lower chest, classical cornucopias spill
out the abundance of America, while elegant Ionic columns
with beautifully carved capitals adorn the corners of the
upper chest. The true glory of this type of ornamentation is
found in the graceful figure of Liberty (an Americanized per-
sonification of a republican Roman goddess-type), the ex-
quisite freestanding and low-relief urns derived from Adam-
esque origins, the classically inspired vignettes of **putti**
with garlands, and the central motif of the basket of fruit.

A comparison of the carved details (Fig. 9.3) with
McIntire's ornamentations on the fireplace in the Gardner-
Pingree House (Fig. 8.8) again reveals the continuity be-
tween interiors and furnishings. The rich mahogany of the
Lemon chest is enhanced by the double row of lion-headed
pulls, which were probably imported from England or
France, and which reveal the preference for Roman motifs
over the Chippendale-style brasses seen in Figure 6.16.

FEDERAL-STYLE CASEPIECES

In contrast to the transitional form of the Lemon chest, a
more thoroughly Federal-style casepiece is the lady's cabinet
and writing table, made in Baltimore, which flourished
during the Federal period (Fig. 9.4). A desk of this type was
created expressly for women, and placed in the drawing
room or *boudoir*. It is made of mahogany with satinwood
veneer. Its design is based on plate 50 of Sheraton's *Drawing
Book*.

Straight lines with cleancut edges and smooth planes are
relieved by the oval shapes—favored in this period—of the
mirror and the glass panels. These panels have lovely
goddesses painted on them, very much in the manner of
Adamesque interpretation of figures from Pompeiian wall
paintings. Inlay satinwood banding trims the edges of the
drawers and the doors, as well as the slender, tapering legs.
The three small crowning urns are derived from classical
sources. The use of different woods, giving a range of natural
colors, distinguishes such work from a Chippendale piece,

which was normally of a single type of wood with uniform coloration. The reverse painting on the backs of glass panels is called *églomise*, a term derived from the name of Jean-Baptiste Glomy (d. 1786), a French artisan who perfected the technique. It was frequently used in Baltimore case-pieces.

DU PONT DINING ROOM

Individual pieces of furniture such as these were integral components of domestic interiors, which took on a specific and unified character, as seen in the Du Pont Dining Room at Winterthur Museum (Fig. 9.5). The set of Sheraton-type chairs was made in New York City about 1800 for Victor Marie du Pont. On the sideboard at the left, also the product of a New York shop, are two urn-shaped knife boxes that once belonged to Elias Hasket Derby, and six silver tankards made by Paul Revere. The mahogany dining table, made in Baltimore, has oval inlays encircling the American eagle—a favorite Federal decorative motif and the national emblem since 1782. The table is set with Chinese export porcelain, more of which is seen through the glass doors of the breakfront secretary that stands against the far wall. The carpet was woven in Aubusson, France.

9.4 Lady's cabinet and writing table, 1795–1810. Mahogany, satinwood, red cedar, 62⅛ × 30⅞ × 22¼in (157.8 × 78.4 × 56.5cm). Courtesy Winterthur Museum, Winterthur, Delaware.

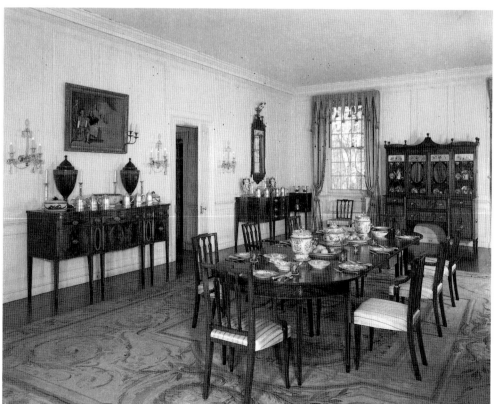

9.5 The Du Pont Dining Room, c. 1800–10. Courtesy Winterthur Museum, Winterthur, Delaware.

DUNCAN PHYFE

CUSTOMMADE TO READYMADE

American economic expansion during the Federal period meant an increased demand for goods. Cabinetry ceased to be the production of a small shop with a master, a couple of journeyman cabinetmakers, and an apprentice or two. Instead, it became a large business with dozens of artisans, warehouses, and advertisements.

Probably the bestknown of the furnituremakers of this period, Duncan Phyfe (1768–1854), became more a business manager and merchant-entrepreneur than a craftsman. His work involved the supervision of the daily production of a great many specialists working within his manufactory. Once his business reached its greatest success, Phyfe seldom touched the hundreds of pieces that issued annually from his establishment. The great furnituremakers soon began to keep wellstocked warehouses, and "readymade" replaced the custommade. Here was the transitional phase between the colonial craft tradition and the massproduction of the Industrial Revolution of the mid- and later nineteenth century.

At age fifteen, young Duncan Phyfe emigrated with his parents from his native Scotland. Settling first in Albany, New York, where he may have served an apprenticeship in cabinetmaking, by 1792 he had moved to New York City, where, three years later, he opened his own shop. Phyfe was soon making furniture in the new Adamesque, Sheraton, and Hepplewhite designs for the leading citizenry of New York and other major cities. A consummate designer and craftsman, Phyfe was said by many to have improved on the designs he borrowed from Sheraton's *Drawing Book*, and his pieces were praised especially for their elegance.

Figure 9.6 shows an assemblage of Phyfe pieces in which characteristics of the Federal style are present, as well as a

9.6 The Duncan Phyfe Room, c. 1810–15. Courtesy Winterthur Museum, Winterthur, Delaware.

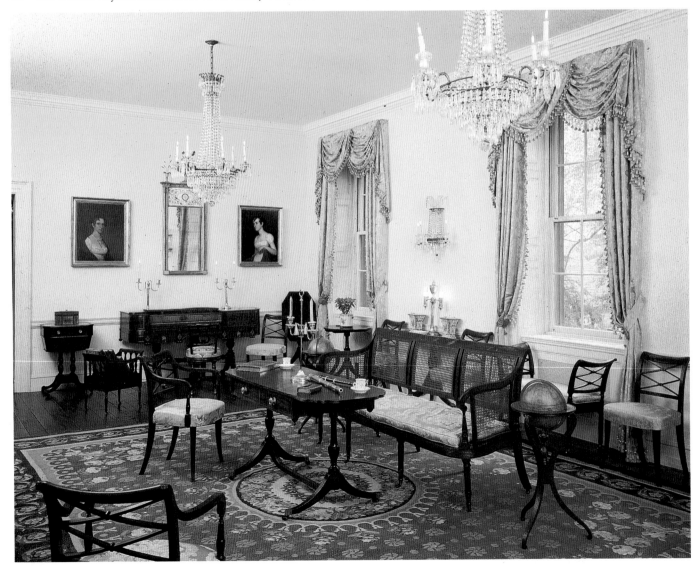

few additional features. Phyfe was particularly fond of caning and reeding, both of which are found in the settee. Caning was admired because it was light and linear, both essential qualities of the Federal mode, and reeding (the cutting of parallel grooves on the surface of the wood) provided a handsome linear attractiveness to rails, stiles, and legs. Against the far wall is a piano in a case produced by the Phyfe workshop. Chinese export porcelain is appropriately placed here and there as adornment.

TOWARD THE INDUSTRIAL REVOLUTION

Phyfe's career extended over half a century, until his retirement in 1847. During the second and third decades of the nineteenth century, Phyfe was the leading American interpreter of the Regency style. He operated what a contemporary described as the largest and most fashionable shop in America. To keep up with demand, he installed the newest industrial equipment, such as mortise-making machines and powered bandsaws, and he purchased vast quantities of veneer, cut in thin sheets by steam- or waterpowered saws.

In addition to the wide assortment of readymade furniture Phyfe kept on display at his large warehouse on Fulton Street, he exported furniture—speculatively, not on commission—to Savannah, Georgia, and St. Croix and Guadeloupe in the West Indies. After about 1820, Phyfe's shop produced furniture in a variety of revival styles—Greek and Gothic, for example—as those styles came into vogue. The Grecian-inspired lyreback side chair is perhaps his bestknown type.

SILVER AND PORCELAIN

PAUL REVERE

Many of the characteristics noted in Federal-style furniture are also to be found in silver. Paul Revere learned his craft from his father, and when the latter died in 1754, he became master of the shop, which he operated successfully until the Revolution. During the war, he learned much about metallurgy, building mills, and the process of coldrolling copper. With the end of the conflict and independence, he returned to activities connected with metalcrafting. With his son, Revere operated a foundry that produced bronze bells and cannons, and his mill produced the sheaths of copper used to cover the dome of Bulfinch's State House (Fig. 8.11).

Through all of these often very profitable activities, Paul Revere continued to create beautifully designed silver pieces in the Federal style. The teapot of 1796 (Fig. 9.7) is very different in form from the Georgian example shown in Copley's portrait (1769) of the Boston silversmith (Fig. 7.9), or from the one made by Jacob Hurd of 1735–45 (Fig. 4.21). It has the then-favored oval shape, with fluted sides that are smooth except for the delicate swag-and-ribbon design

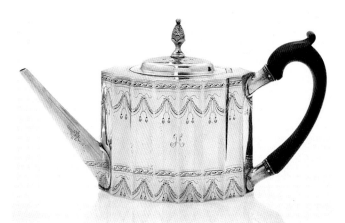

9.7 Paul Revere, Teapot, 1796. Silver, height 5⅞in (14.9cm) including finial, depth of base 3¼in (8.3cm). Museum of Fine Arts, Boston. Pauline Revere Thayer Collection.

engraved at the top and bottom. The spout is a tapering form with straight lines, and there is a pinecone finial on the shallow-domed top.

Rolled Silver American silversmiths now had access to large sheets of rolled silver, obtainable from commercial refineries. This was quite unlike earlier periods, when each silversmith melted down and refined his own silver. Rolled silver facilitated production, and even led to a certain standardizing of forms. Again we perceive a harbinger of the Industrial Revolution, when silver objects would be stamped out by machines. Firms in Sheffield and Birmingham, England, had, in fact, already begun shipping manufactured silver objects to the United States by this period, but in the United States, silver items were still handmade by craftsmen like Revere.

THE CHINA TRADE AND DESIGN

Porcelain was often included within the Federal interior, as we see in Figures 9.5 and 9.6. Most porcelain was imported from China or England, while France and Germany also offered an exquisite selection. Chinese export porcelain was made for the purpose of being exported to Europe and America. The main center in the eighteenth century was at Ching-te-Chen, where the pieces were produced before being sent to Canton to be decorated. At Canton were the *hongs*, or factory/warehouses of the foreigners, lined up along the docks, each proudly displaying its national flag. A glimpse of this scene is given in a large punchbowl, which depicts the *hongs*, and which is itself an example of Chinese export porcelain (Fig. 9.8). Brightly colored and beautifully detailed, it offers a view of the foreign sector rendered in a Chinese style; one of the *hongs* flies an American flag.

Americans entered the direct mercantile trade with China just as the Federal period got underway. In 1784, the *Empress of China* sailed out of New York harbor bound for

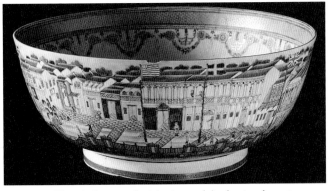

9.8 Punchbowl, decorated with views of the foreign factories at Canton, China, 1800–10. Porcelain hardpaste, 5½ × 14⅜in (14 × 36.5cm). Courtesy Winterthur Museum, Winterthur, Delaware.

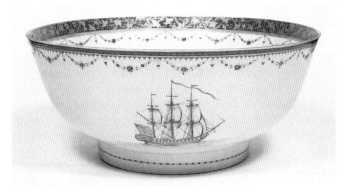

9.9 Punchbowl, decorated with American merchant vessel, made in Canton, c. 1794. Porcelain hardpaste, 6½ × 16in (16.5 × 40.6cm). Courtesy Winterthur Museum, Winterthur, Delaware.

Canton, and the next year Elias Hasket Derby sent his *Grand Turk* around the Cape of Good Hope, across the Indian Ocean, to the *hongs* on the Canton River. The Americans traded ginseng root to the Chinese in exchange for tea, silk, spices, lacquer, and porcelain. Soon the Chinese were decorating porcelain expressly for the American market, as seen in another punchbowl that was made for Henry Smith, a merchant of Providence, Rhode Island (Fig. 9.9). The swag border along the upper edge is a typical Federal period motif—English Adamesque, wrought in China, for an American home. The other decorations show they were done personally for Smith. They represent his monogram, a portrait of the *George Washington*, the ship that brought the bowl to Providence, and the Rhode Island state seal and the great seal of the United States.

Willow Pattern and Transfer Prints Only wealthy Americans would have had personalized porcelain. The Chinese produced other types by the thousands, if not millions, of pieces for broader consumption. One of the most popular is known as the willow pattern. Originally designed in England in about 1780 by Thomas Minton, it represents a landscape with a Chinese temple, trees, figures crossing a bridge, a boat, and two birds, or variations of these, all done in a blue glaze with a light background. At first this pattern was produced at Caughley in Staffordshire, England, in an outright imitation of the Chinese style that reflects the

popularity of the Oriental mode. But eventually, and ironically, this English version of a Chinese type began to be made in Canton for export to England and America.

England continued to be a major source for porcelain, and foremost among the centers were the "Potteries," several towns in Staffordshire where an excellent type of clay was available. Other centers were Liverpool, Swansea, Worcester, Bristol, and Chelsea. One particularly popular kind of Englishware was decorated with transfer prints. For the United States market these designs often represented American cities or scenic spots along American rivers, mountain ranges, or other recognizable places. The transfer-print process involved printing a scene or design from an engraved copper plate on to a sheet of paper. While the ink was still wet, it was transferred to the plate, saucer, or bowl. The piece was then fired in the kiln, and the design became a permanent part of the object.

The architecture, interiors, and decorative arts that were wrought in the Federal mode represent the first style of a young nation. Neoclassicism seemed an appropriate means of declaring both the republican ideals of a new country, and a separation from styles associated with monarchy. If political independence was achieved, however, cultural and artistic independence was not, and Americans continued to look abroad for guidance. This situation prevailed generally in the arts of painting and sculpture as well.

CHAPTER TEN

PAINTING:

THE TRADITION OF THE
GRAND MANNER,
1785–1830

During the Federal period, a number of ways were found to celebrate the new republic and its leading citizens—in song, poem, and image. Institutions, often based on European models, were established for the promotion of learning, science, and the arts—an important step in the cultural development of the nation. The spirit of intellectual and scientific enquiry personified by Benjamin Franklin was institutionalized in the Franklin Institute, founded in Philadelphia in 1824. And the Academy of Natural Sciences had been established in 1812, also in the Quaker City. Of special interest for the arts were the founding of the Pennsylvania Academy of the Fine Arts in Philadelphia in 1805, and the American Academy of Fine Arts in New York City in 1802. Museums began to appear as well, and none was more famous than the one Charles Willson Peale opened in Philadelphia in 1794—the Peale Museum—for the popularization of science and natural history.

Literature continued to follow longstanding European literary traditions, but also often explored new and characteristically American themes. Philip Freneau (1752–1832) was one of the leading poets of the day. "On the First American Ship" (1784), an ode to the *Empress of China's* daring voyage to the Orient, is filled with nationalism, resentment against Britain, and excitement over the newly won freedom of the seas:

1 With clearance from Bellona won
 She spreads her wings to meet the Sun,
 Whose golden regions to explore
 Where George forbade to sail before.

4 To that old track no more confined,
 By Britain's jealous court assigned,
 She round the Stormy Cape shall sail,
 And, eastward, catch the odorous gale.

5 To countries placed in burning climes
 And islands of remotest times
 She now her eager course explores,
 And soon shall greet Chinesian shores.

6 From thence their fragrant teas to bring
 Without the leave of Britain's king:
 And Porcelain ware, enchased in gold,
 The product of that finer mould.

7 Thus commerce to our world conveys
 All that the varying taste can please;
 For us, the Indian looms are free,
 And Java strips her spicy tree.

8 Great pile proceed!—and o'er the brine
 May every prosperous gale be thine,
 'Till freighted deep with Asia's stores,
 You reach again your native shores.[1]

Freneau also wrote about American heroes and Native Americans, and he turned his pen to political issues as well in support of Jefferson and republicanism. Thoroughly American, too, were Washington Irving's (1783–1859) *Knickerbocker's History* (1809) and the *Sketch Book* (1820). The former took its inspiration from Dutch folktales of the Hudson River Valley and from legends of the Catskill Mountains. The arts of America now had a past full of heroes, globecircling adventures, Native American lore, and local legends. Such themes were increasingly used by poets, writers, and painters.

Some authors preferred to work in a European literary style that had been passed on to the vigorous New World. For them, the American culture was a continuum of, rather than a break with, Old World traditions, even though American themes might be their subjects. Joel Barlow (1754–1812), for example, left his native country to live in Paris, surrounded by the Old World culture which had a great impact on his writings. His long epic poem, *The Columbiad* (1807), is European high style in form, even though its subject treats the history of America from the time of Columbus's discovery of it. The story of a young American girl, Jane McCrea (Lucinda), appears in book VI. During the Revolutionary War she was murdered by Mohawks who were in the pay of Britain (Albion):

One deed shall tell what fame great Albion draws
From these auxilliars in her barbarous cause,
Lucinda's fate; the tale, ye nations, hear;
Eternal ages, trace it with a tear. (615–18)

The fair one too, of every aid forlorn,
Had raved and wander'd, till officious morn
Awakened the Mohawks from their short repose
To glean the plunder ere their comrades arose.
Two Mohawks met the maid,—historian, hold!—
Poor human nature, must thy shame be told? (649–54)

She starts, with eyes upturn'd and fleeting breath,
In their raised axes views her instant death,
Spreads her white hands to heaven in frantic prayer,
Then runs to grasp their knees and crouches there.
(661–4)

Does all this eloquence suspend the knife?
Does no superior bribe contest her life?
There does: the scalps by British gold are paid;
A long-hair'd scalp adorns that heavenly head;
And comes the sacred spoil from friend or foe,
No marks distinguish and no man can know.
 With calculating pause and demon grin,
They seize her hands and thro' her face divine
Drive the descending ax (669–77)[2]

The American painter Washington Allston (1779–1843) also wrote poetry, most of which was consciously set in the European tradition. Allston wrote poems dedicated to the great masters of the Old World—Rembrandt, Raphael, Michelangelo, Rubens—and was more devoted by far to the lofty European culture they represented than he was to American democratic ideals.

Most of the artists discussed in this chapter chose the European Grand Manner of painting—as defined by Greco-Roman antiquity and the European Old Masters—as the source for their own art. Their intention was to transplant that great tradition to the United States, rather than to create a generic American art, which arose from the people of the nation.

The art of painting made enormous strides in America during this period. Before the Revolutionary War it had been limited almost totally to portraits. Now, painting burst forth in great richness and variety. As the colonial era came to an end, John Adams voiced the old utilitarian attitude that art was an extravagant frill of the idle Old World aristocracy: "It is not indeed the fine arts which our country requires; the useful, the mechanic arts are those we have occasion for in a young country."[3] However, the cultural tide of the Federal period proved Adams wrong.

AMERICAN HISTORY PAINTING

Possessing a didactic quality through which moral, ethical, religious, and nationalistic lessons could be taught, or the great deeds of noble persons eulogized, history painting had long been heralded as the loftiest branch of the art. It also offered by far the greatest challenge to the painter's abilities—far more so than landscape, portraiture, still life, or genre. If successful, however, it earned him the highest acclaim—as well as offering the viewer an ennobling, enriching experience.

America was changing from an assortment of provincial colonies on the periphery of civilization to a unified nation taking its position near the center of the world stage. Now a country with heroes and international figures, there was need of painters who could tell of its greatness, its victories, its ideologies. An art limited to portraits of merchants and planters was no longer adequate. Just as a monumental architecture arose to express the new spirit of America, might a comparable school of painting emerge? While the effort was certainly made, in the end America turned to a pictorial art that was less grand, and less rooted in European traditions.

BENJAMIN WEST

The story of this phase of American painting begins with Benjamin West (1738–1820), who achieved great fame as the preeminent history painter of the English-speaking world.

Born in Swarthmore, Pennsylvania, West began to paint portraits in and around Philadelphia in the mid-1750s. There was at the time no place where a young artist could study in America—no art school, no established master with an active studio, no great collections of paintings or of ancient statues, no great palaces or churches to decorate. The Old World had these things, however, and so in 1759 West went to Rome, where he spent three years studying the Renaissance and Baroque masters, and ancient masterpieces such as the Apollo Belvedere and the Ara Pacis (Altar of Peace). In 1763, he left Rome for London.

The year 1768 saw West admitted into the inner circle of England's most acclaimed artists. He was a founding member of the Royal Academy, and obtained the patronage of King George III. Most importantly, he became the recognized leader in the field of history painting, with *Agrippina Landing at Brundisium with the Ashes of Germanicus* (Fig. 10.1). The moving story, as reported by the ancient Roman historian Tacitus, tells of the widow of Germanicus, a noble general. He had been poisoned in Syria because the Emperor Tiberius had feared him as a rival, and his widow arrived at Brundisium in Italy carrying the funerary urn containing the ashes of her husband. She is accompanied by her two

10.1 Benjamin West, *Agrippina Landing at Brundisium with the Ashes of Germanicus* (after restoration), 1767. Oil on canvas, 5ft 4in × 7ft 10in (1.63 × 2.39m). Yale University Art Gallery, New Haven, Connecticut.

children, Caligula, the future emperor, and little Agrippina who would one day become the mother of the Emperor Nero.

The central group of the picture is based on an ancient Roman relief from the Ara Pacis, which West had sketched in Rome. The background is based on Robert Adam's *Ruins of the Palace of the Emperor Diocletian at Spalatro* (1764). In an age still euphoric over the rediscovery of antiquity at Pompeii and Herculaneum, archeological accuracy was of great importance. West's picture was conceived and executed with all the grandeur of the greatest of Baroque classicists, Nicolas Poussin (1594–1665). It therefore claimed an ancestry of ancient and modern masters, revitalizing the Baroque as a means for contemporary history painting. When George III saw West's picture, he immediately commissioned him to paint two similarly grand themes from Roman history. Thus began the longlasting friendship between the king of England and the young artist from Swarthmore, Pennsylvania.

A NEW THEME IN HISTORY PAINTING

West's next triumph was the *Death of General Wolfe*, which introduced near contemporary events into the acceptable repertoire of history painting (Fig. 10.2). The event—the British victory over the French at Quebec in 1758—shows the mortally wounded general dying. The moral lesson of the picture is that great men sacrifice their lives for causes such as duty, honor, and patriotism. Many, however—including Sir Joshua Reynolds—cautioned West that great deeds could not be successfully represented if the figures were shown in contemporary attire—they must be dressed in the nobler, timeless garb of ancient Greeks or Romans. West refused to agree, and eventually even Sir Joshua admitted that West had succeeded in creating a revolutionary new type of history painting.

West, however, did not separate himself totally from tradition. Turning again to Baroque models, his central group recalls scenes of the Deposition, the Lamentation, and

10.2 Benjamin West, *The Death of General Wolfe*, 1770. Oil on canvas, 5ft½in × 7ft (1.54 × 2.13m). National Gallery of Canada, Ottawa.

the Descent from the Cross, particularly those painted by masters such as Rubens or Van Dyck. The coloration, dramatic lighting, and turbulence of the elements suggest painterly Baroque traditions.

HIGH ART OF THE GRAND MANNER

West's success continued unabated with pictures such as *William Penn's Treaty with the Indians* (1771, Pennsylvania Academy of the Fine Arts, Philadelphia). In 1792, he was elected by his fellow artists to succeed the late Sir Joshua Reynolds as president of the Royal Academy. He was also a constant inspiration to the next generation of young American painters, who looked to him for leadership, instruction, and assistance in their own careers. The list of those who studied under his guidance is impressive: Charles Willson Peale, Gilbert Stuart, Ralph Earl, John Trumbull, Washington Allston, Rembrandt Peale, Charles Bird King, Thomas Sully, and Samuel F. B. Morse, to mention only the more prominent. Although West never returned to his native

land, he maintained a lifelong affection for it, and several examples of his late work were sent to the United States in an effort to implant the high art of the Grand Manner.

Perhaps most impressive of all of West's late works is *Death on a Pale Horse, or the Opening of the First Five Seals* (Fig. 10.3). Its subject is from the Book of Revelations. The ghastly specter of Death is seen riding triumphant in the center of the picture, while his henchmen—War, Famine, and Pestilence—ride out to destroy humanity, assisted by the unleashed demons and furies of Hell and the savagery of wild beasts. The painting possesses a powerful romanticism, and what was known as *terribilità*, in imagery informed with the mystical, visionary zeal of seers and prophets. The dynamic, explosive force of the composition is the antithesis of the calm Baroque classicism of West's earlier pictures, revealing the extraordinary breadth of his imaginative powers and artistic genius. Such work by West inspired a whole corps of young American painters to test their abilities against the glorious literary and artistic traditions of the Grand Manner.

10.3 Benjamin West, *Death on a Pale Horse, or the Opening of the First Five Seals*, 1817. Oil on canvas, 14ft 8in × 25ft 1in (4.47 × 7.65m). Pennsylvania Academy of the Fine Arts, Philadelphia.

JOHN TRUMBULL

John Trumbull (1756–1843) was one of the most gifted—and the most frustrated—of the American artists to follow West's lead. The son of a prominent Connecticut family, he attended Harvard College, and about the same time began painting portraits that suggest the influence of the work of Copley. In Boston, Trumbull rented the studio of John Smibert, which was still partially intact. During the Revolution, young Lieutenant-Colonel Trumbull served as an aide-de-camp to General Washington until, piqued when his promotion to general did not come through on time, he resigned. In 1780 Trumbull went to England to study with Benjamin West.

THE REVOLUTIONARY WAR SERIES

In London, and in close contact with West, Trumbull executed the best work of his career between 1786 and 1789. His series depicting the major events of the Revolutionary War has a brilliant, coloristic fire, virtuosity of brushwork, and inventiveness of composition that place it among the masterpieces of that day. One of the best of these is the *Death of General Montgomery in the Attack on Quebec* (Fig. 10.4), which reminds one of West's great success, the *Death of General Wolfe*, but also of the jewel-like color and

dynamic composition of the celebrated Flemish master Peter Paul Rubens (1577–1640).

The pictures of the series were painted on a relatively small scale because they were to serve as models for fine quality, steelplate engravings. Trumbull, however, ran into difficulty in getting them engraved to his high standards. When he attempted to raise a list of subscribers, he met with an apathetic response from his countrymen, as the role of patron was unknown. The project therefore ended in failure, and was only one of the many disappointments Trumbull was destined to endure.

IN THE GRAND MANNER

If Americans were not interested in great moments of their history, perhaps the English would offer more encouragement, or so Trumbull hoped when he painted *Sortie made by the British Garrison at Gibraltar* (Fig. 10.5). Here again, coloristic excitement is displayed, as are the didactic lessons of history painting. Trumbull associated the picture with the traditions of the Grand Manner by basing the figure of the moribund Spanish officer on the wellknown Hellenistic statue of the *Dying Gaul*. The British response, however, was not much warmer than that of the Americans to the Revolutionary War series. Greatly disappointed, Trumbull returned to America in 1789 to paint portraits—the only

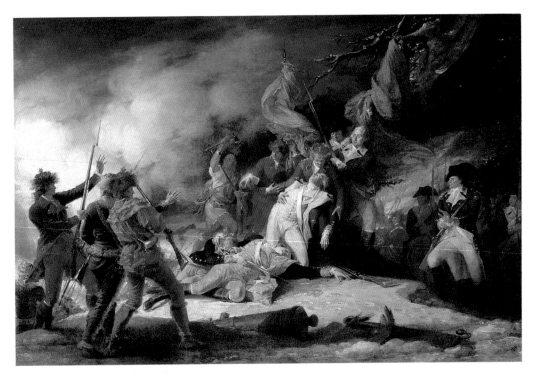

10.4 John Trumbull, *The Death of General Montgomery in the Attack on Quebec*, 1786. Oil on canvas, 24⅝ × 37in (62.5 × 94cm). Yale University Art Gallery, New Haven, Connecticut.

10.5 John Trumbull, *Sortie made by the British Garrison at Gibraltar*, 1789. Oil on canvas, 5ft 10½in × 8ft 10in (1.79 × 2.69m). Metropolitan Museum of Art, New York City.

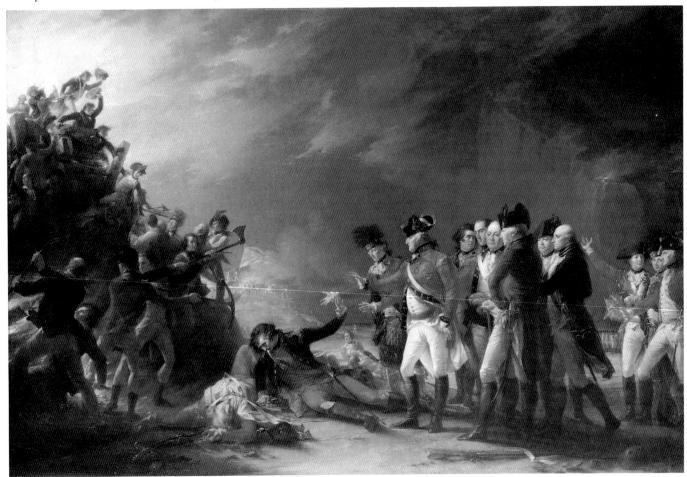

type of work, it seemed to him, at which an artist could make a living.

THE HISTORICAL PORTRAIT

Working in the early 1790s in New York City, John Trumbull was the finest portrait painter in the United States, and remained unrivalled until Gilbert Stuart returned from abroad in 1793. When Trumbull arrived, New York City was the temporary seat of the federal government. His full-length portraits of George Washington and George Clinton for New York City Hall, painted in 1790–1, establish a new type, and a high standard for the public, or state, portrait in America. To this group also belongs the exquisite image of Alexander Hamilton (1792, private collection).

Not receiving commissions for history paintings, Trumbull tried infusing portrait commissions with the stuff from which Grand Manner paintings were made. In 1792, when the grand portrait of George Washington was painted in

10.6 John Trumbull, *General George Washington at the Battle of Trenton*, 1792. Oil on canvas, 7ft 8½in × 5ft 3in (2.35 × 1.6m). Yale University Art Gallery, New Haven, Connecticut.

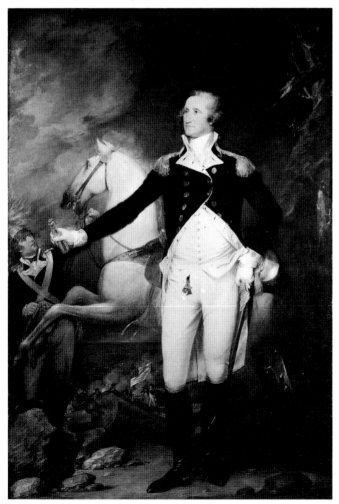

Philadelphia, Washington had been president for only three years (Fig. 10.6). Trumbull, like others, remembered him as the commanding general who led the Continental Army to victory in the War of Independence. The artist created a military image of Washington, in perfect command as all around him the battle of Trenton erupts—Washington crossed the Delaware by night on Christmas Eve, 1776, to inflict a stinging defeat upon the vastly superior number of Hessian troops in one of his first victories of the war. Charles Willson Peale had undertaken a similar portrayal of Washington thirteen years earlier (Fig. 7.18), but his seems less heroic, and his subject less romanticized. In Trumbull's picture we see a typological reduction of *Sortie made by the British Garrison at Gibraltar* into a state portrait of a great man.

It was Trumbull's lifelong curse to feel he never received the acclaim or recognition that was his due, and in 1794 he gave up painting altogether. He accepted the post of secretary to John Jay in London, remaining there a decade before returning to New York City—and to portrait painting. By 1808 he was again in London, painting, and did not return to America until 1816, a bitter old man of sixty, whose brilliant artistic genius of earlier years had all but withered away. Trumbull became president of the American Academy of Fine Arts in New York City, a kind of gentleman's art club, with little regard for artists or their needs.

Soon after his return, in 1817 Trumbull received an enormous commission from the federal government to paint four large pictures for the rotunda of the new Capitol. Thirty years earlier, this would have been an opportunity that Trumbull would have seized with enthusiasm, and executed with painterly brilliance. But Trumbull's talent had by now dried up, and the rotunda pictures are pedantic, academic exercises, in contrast to the beautiful, smaller pictures of 1786–7.

GILBERT STUART AND THE FEDERAL STYLE

Another extraordinary talent was Gilbert Stuart (1755–1828), who was born and grew up in Rhode Island. In about 1770, Stuart met Cosimo Alexander (c. 1724–72), who became his first teacher and took him to Scotland in 1772. Alexander promptly died, leaving young Stuart stranded. Only with difficulty could he make his way back to Newport, where he painted portraits in a provincial style. Realizing the need for training that was unavailable in America, Stuart embarked in 1777 for London, where he spent several destitute years before Benjamin West learned of his plight and took him into his own studio. Stuart quickly mastered the style, especially the painterly brushwork of the leading English portraitist Sir Joshua Reynolds. Stuart soon left West to set up his own studio, which became one of the most successful in London. During those

years, the American group included Benjamin West, John Singleton Copley, John Trumbull, and Stuart—an impressive contingent of artistic talent. Unlike West and Trumbull, Stuart liked painting portraits because they could be completed quickly, and they were lucrative. Stuart, who had developed a taste for elegant high living, was always in need of money.

It was *The Skater* (National Gallery of Art, Washington, D.C.) that established Stuart's reputation in London, and brought great critical acclaim when it was exhibited at the Royal Academy in 1782. All traces of provincialism have been replaced by the feathery, impressionistic brushstrokes of masters such as Reynolds, George Romney (1734–1802), and Gainsborough. But despite numerous commissions, Stuart's extravagant lifestyle carried him ever deeper into debt, until his only recourse was flight to Ireland. There he worked from 1787 to 1792, achieving comparable success and acclaim, but again accruing such debts that it was once more necessary to flee or go to prison—and so he returned to America in 1793.

MRS. RICHARD YATES IN NEW YORK

Soon after Stuart settled in New York City, he painted Mrs. Richard Yates—a superb specimen of masterly brushwork (Fig. 10.7). Stuart, a splendid colorist, here sets the beautiful, cool, silvery tones of Mrs. Yates's dress against the

10.7 Gilbert Stuart, *Mrs. Richard Yates*, 1793–4. Oil on canvas, 30¼ × 25in (77 × 63cm). National Gallery of Art, Washington, D.C.

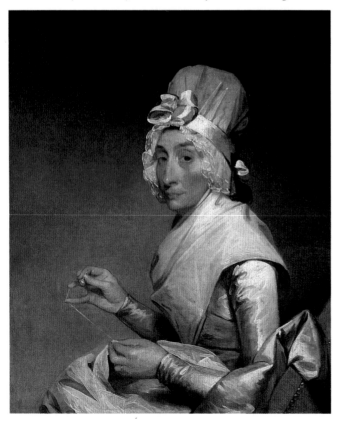

warm, ruddy hue of her face—and a marvelous face it is in its animation and personality. Mrs. Yates, comfortably engaged in sewing, seems to look up to take note of our presence. The detail of the hand keeping the thread taut is a brilliant passage. Such portraits soon brought Stuart all the work he could handle, but, ambitious to establish a practice among the new governmental leadership of the young republic, he moved to Philadelphia in 1794.

THREE PORTRAITS OF WASHINGTON

Stuart's first portrait of Washington—the Vaughan[4] type—was painted in Philadelphia in the spring of 1795. It shows the subject, extremely sober and aloof, turned obliquely to the viewer's right. Dissatisfied, Stuart sought another sitting from the president in 1796. The result was the creation of two portraits that have ever since been the

10.8 Gilbert Stuart, *George Washington (The Lansdowne Portrait)*, 1796. Oil on canvas, laid to wood, 8ft¼in × 5ft¼in (2.45 × 1.53m). Pennsylvania Academy of the Fine Arts, Philadelphia.

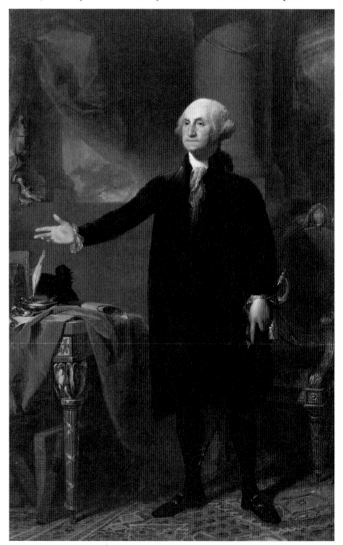

accepted image of the great man. The bustlength Athenaeum type shows the head turned to our left. The original unfinished portrait, now owned by the National Portrait Gallery, Stuart kept in his studio throughout his life, and from it produced well over one hundred replicas. For many years, the original was owned by the Boston Athenaeum, hence its name.

The third type—the Lansdowne—is a full-length state portrait for which Stuart used the Athenaeum image for painting the head (Fig. 10.8). To simplify his task, and to associate his image with the Grand Manner, Stuart based this portrait on an engraving by Pierre Drevet (1663–1738) of a late seventeenth-century picture of Bishop Bossuet by Hyacinthe Rigaud (1659–1743). Nearly every detail of the setting was copied or derived from that print. Here, finally, was a portrait of Washington that equaled the adulation and hero-worship that had by then enveloped him. In fact, Stuart's image of Washington has often been criticized, beginning with Martha Washington, for not capturing an accurate likeness of the man. What it did capture, however, was an image that expressed what admirers over the centuries wished to think him—dignified, solemn, and stately, a statesman of international stature. Although Peale's may present a more accurate likeness, Stuart's portrait surpasses Peale's image (Fig. 7.18) in its idealization.

STUART'S STYLE

In 1803, Stuart once again followed the federal government to its new and permanent home in Washington, D.C. While he remained in great demand as a portraitist, his undisciplined lifestyle often left commissions unfulfilled. Stuart never had the patience for a carefully delineated and detailed drawing as the first stage of a portrait, and commenced painting directly on to the canvas in a sketchy fashion, completing the face in a single sitting or two of perhaps an hour each. The slashing strokes of a loaded brush by this brilliant master instantly created, or at least convincingly suggested, the desired form. This technique permitted Stuart to produce a prodigious number of portraits within a minimum of time.

Stuart painted most of the great names of the social and political scene assembled in Washington, D.C., during the two years he spent there. His style has been called neoclassical, but it remained essentially the late-eighteenth-century style of the English school of Reynolds and Romney. The classical element, seen in portraits such as *Thomas Jefferson*, is found in the artist's concentration on those character traits that contemporary America admired most: dignity, nobility of bearing, reserve, composure, and inspired vision—rather than the pride in and display of materialism that is found in colonial portraits (Fig. 10.9). Stuart's Neoclassicism concerns more the spirit in which the subject is portrayed than the style of execution.

The colorscheme, here of red, black, gray, and white, is also typical of neoclassical restraint. Jefferson, in the first of

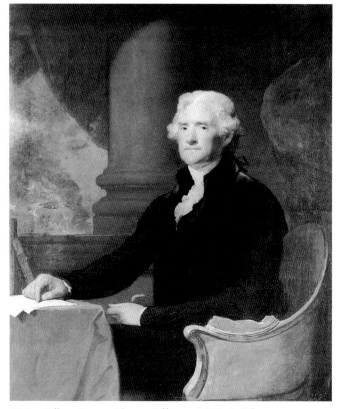

10.9 Gilbert Stuart, *Thomas Jefferson*, 1805–7. Oil on canvas, 4ft⅜in × 3ft 3¾in (1.23 × 1.01m). Bowdoin College Museum of Art, Brunswick, Maine.

two terms as president when this picture was painted, possesses a composed, dignified bearing. He is surrounded with indications of monumental architecture and a great swag of drapery, standard attributes in European portraits executed in the Grand Manner.

In 1805, Stuart suddenly left Washington, D.C., and moved to Boston, where he reigned as the preeminent portrait painter until his death in 1828. Trumbull had returned to America several years before Stuart, bearing a rich, fluidly painted type of portrait. It was actually Stuart, however, who effected the change from the late, post-colonial style to the Federal style, and a host of young American painters were strongly influenced by his manner.

THOMAS SULLY AND THE ROMANTIC PORTRAIT

Next to Stuart, the most popular portrait painter of the Federal period was Thomas Sully (1783–1872). Sully was the foremost portraitist working in Philadelphia for over half a century after he settled there in 1808. The legacy that Stuart had left behind in the Quaker City appears in the earliest of Sully's portraits. In 1809 the young painter went

10.10 Thomas Sully, *Robert Gilmor, Jr.*, 1823. Oil on canvas, 29⅜ × 24¾in (74.6 × 62.9cm). Baltimore Museum of Art. Hendler Fund, by exchange.

10.11 Thomas Sully, *Lady with a Harp: Eliza Ridgely*, 1818. Oil on canvas, 7ft⅜in × 4ft 8⅛in (2.15 × 1.43m). National Gallery of Art, Washington, D.C.

to England, where he studied for a year under the tutelage of the aging Benjamin West. In London he saw portraits by Henry Raeburn and Thomas Lawrence, and he copied pictures that were in West's collection.

When Sully returned to Philadelphia, he had mastered a painterly style that was distinguished from Stuart's by its tinge of Romanticism—by 1810, Romantic elements in English painting had already begun to rival neoclassical features. The Romantic factor of contemporary English and Scottish portraiture is seen in Sully's handsome, dashing portrait of Robert Gilmor, Jr., the wealthy Baltimore patron of the arts (Fig. 10.10). Gilmor did not pose for Sully, but commissioned him to make a copy of a portrait painted by Thomas Lawrence when Gilmor visited England in 1818. In the portrait, Gilmor's hair is tousled in a carefree, Romantic manner. Portraying another Romantic characteristic, the subject looks dreamily off into space, as a man more of sensibilities than of studied rationalism should.

ROMANTIC IDEALISM

If portraits of men were idealized as handsome and dashing, images of women were idealized in the sweet, peaches-and-cream concept of feminine loveliness and elegance. An example of this type of portrait is seen in Sully's *Eliza*

Ridgely (Fig. 10.11). This is an early nineteenth-century American vision of the ancient Greek poetess Sappho, but related, too, to the contemporary portraits of aristocratic English ladies as painted by Sir Thomas Lawrence (1769–1850). There is a wistful, innocent quality about Miss Ridgely. She wears a fashionable Empire-style organdie gown, and, being a young woman of artistic abilities and musical talent, she strums lightly on the strings of a harp. It would seem that Sully never depicted a man who was not handsome, or a woman who was not beautiful.

One of Sully's finest portraits is of the wealthy merchant prince of Boston, Thomas Handasyd Perkins (Fig. 10.12). A noted philanthropist, statesman, financier, and entrepreneur, Perkins had made much of his wealth in the China trade, and the large Oriental pitcher in the lower left is a reference to that fact. It also reflects the subject's interests in the fine arts, as does the portfolio of engravings or drawings that leans against the pitcher. The towering Roman arch contributes monumentality, providing a grand patrician

setting. Perkins is Romantically portrayed as a man of vision, staring off into space as though lost in reverie. His head is given an animated tilt to suggest a vigorous, dynamic personality, and his hair is tousled and windblown. Sully's brushwork contributes to the spontaneity and excitement of the picture.

DEMOCRATIC INFLUENCES

John Neagle (1796–1865), Sully's son-in-law, worked in a style generally similar to the older Philadelphia artist. His bestknown work is *Pat Lyon at the Forge* (Fig. 10.13). This was commissioned by the subject with the specification that he be shown with his sleeves rolled up, wearing the great leather apron of the blacksmith, standing at his forge—Lyon wanted this to be a tribute to the American democratic

10.12 Thomas Sully, *Thomas Handasyd Perkins*, 1831–2. Oil on canvas, 7ft 10in × 4ft 10in (2.39 × 1.47m). Library of the Boston Athenaeum.

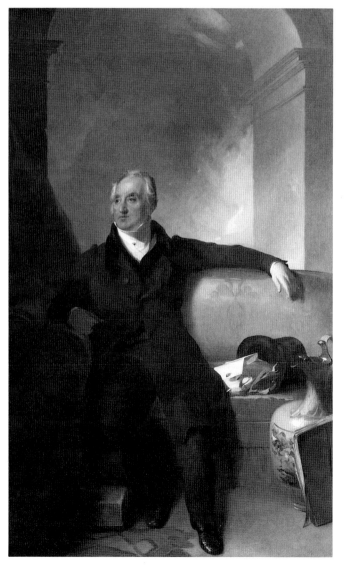

10.13 John Neagle, *Pat Lyon at the Forge*, 1826–7. Oil on canvas, 7ft 9in × 5ft 8in (2.36 × 1.73m). Museum of Fine Arts, Boston. Henry H. and Zoë Oliver Sherman Fund.

system, which allowed a young man who started life penniless to rise to wealth and position in his community. He purposely did not want to be represented as a member of Philadelphia's social élite, whom he distrusted as a group. They had caused him to be imprisoned in his youth on a groundless charge of bank robbery—the cupola at the left is that of the Walnut Street Jail, where he had been incarcerated. This image shows how democratic influences could affect monumental portraiture in America, redirecting it from the traditional Grand Manner portrait of European derivation.

PEALE'S *ARTIST IN HIS MUSEUM*

Charles Willson Peale's early career as a colonial portrait painter was discussed in chapter 7. He is further considered now in connection with his large selfportrait, *The Artist in his Museum*, an autobiographical reminiscence of one of the most remarkable lives America has ever known (Fig. 10.14). The portrait was commissioned by the board of trustees of the Pennsylvania Academy, in recognition of the many

10.14 Charles Willson Peale, *The Artist in his Museum*, 1822. Oil on canvas, 8ft 7¾in × 6ft 7⅞in (2.64 × 2.03cm). Pennsylvania Academy of the Fine Arts, Philadelphia.

contributions Peale had made to the intellectual and artistic life of Philadelphia.

Painted only four years before Peale's death, the picture shows the artist raising a curtain, gesturing to the viewer to step into his museum, and to learn from it about art, history, and the natural world. Some of the 240 portraits Peale painted for his gallery of distinguished persons are seen above the shadowboxes that contain stuffed specimens of American birds. An avid disciple of the famous Swedish botanist Linnaeus, Peale knew the ornithologists Alexander Wilson and John James Audubon, the naturalist William Bartram, and the German scientist Alexander von Humboldt as well as the leading savants of Philadelphia, then the most learned city in the United States. In the lower left is an American turkey, and beside it the tools of taxidermy (the skills of which Peale had mastered). At the right are the painter's palette and brushes, and an assembled skeleton of the great mastodon that Peale himself had excavated.

Symbols of art, science, patriotism, and politics abound. The didactic purpose of the museum is accentuated by the visitors who are in it. A father instructs his young son who holds a book; a woman raises both hands in wonder as she looks at the mastodon skeleton; a man at the far end of the room stands in rapt concentration. The room itself is probably the one Peale rented in Independence Hall (Fig 4.25).

JOHN VANDERLYN AND THE GRAND MANNER

A group of talented young American painters, led by John Vanderlyn, Washington Allston, and Samuel F. B. Morse, followed Benjamin West's lead in seeking instruction abroad. They spent years in Paris, London, and/or Rome studying the masterworks there, embracing the lofty artistic tradition of European high culture known as the Grand Manner. Indeed, they had a high mission: Through their efforts, they gave to their native land an art that was an extension of European culture, helping to establish America as the cultural successor to Athens, Rome, Versailles, and London. To them, American art was not to rise naturally out of the country itself, but was to be a continuation of—and thoroughly based in—European art.

John Vanderlyn (1775–1852) had had only a little instruction from Gilbert Stuart before he left New York City to go to Paris in 1796. In the galleries of the Louvre, Vanderlyn found great collections of ancient statues, from which he drew constantly, and masterpieces of painting. Several of these he copied in order to learn the techniques—the coloration, composition, and lighting—of the Old Masters, so that he could incorporate their ways into his own work.

NEOCLASSICISM AND EUROPEAN INFLUENCES

The result of this commitment is seen in Vanderlyn's first important, original work, *Death of Jane McCrea* (Fig. 10.15), painted as a model to be engraved as an illustration for Joel Barlow's epic poem, *The Columbiad*, which recounts the story of the discovery and settlement of America. Frantically searching for her sweetheart, who is seen in the distance arriving too late to save her, the heroine is captured outside the fort in the North American wilderness, and carried off by two Mohawks who, after quarreling over who shall have this prize, savagely murder her—as related in the extract on page 136. The story is thoroughly American, but the artistic means are thoroughly European, and of the Grand Manner. The figure of Jane is reminiscent of an ancient Greek statue of a Niobid, while each of the Mohawks is based on a Hellenistic marble statue of the first century B.C. that Vanderlyn had studied at the Louvre. The picture was conceived and wrought in the European neoclassical style of that day, in the manner of Jacques-Louis David.

Vanderlyn's most famous painting—which was not associated in any way with America—was *Ariadne Asleep on the Island of Naxos* (Fig. 10.16). Its story was taken from ancient Greek mythology. It tells a lover's tale about Ariadne, the daughter of King Minos of Crete, who helped the Athenian hero Theseus slay the Minotaur, only to be deserted by him while she lay sleeping on the Aegean island of Naxos. At the far right Theseus is seen gathering his men into his boat in preparation for his secret departure. The picture was painted

10.15 John Vanderlyn, *The Death of Jane McCrea*, 1804. Oil on canvas, 32½ × 26½in (82.6 × 67.3cm). Wadsworth Atheneum, Hartford, Connecticut.

as a demonstration piece to establish Vanderlyn's credentials within the tradition of the Grand Manner. The image of Ariadne belongs to that long line of heroic nude females that commences in antiquity, and claims representatives in the work of Giorgione (c. 1476/8–1510), Titian (c. 1487/90–1576), Poussin, and Van Dyck.

The picture brought Vanderlyn high acclaim when he exhibited it at the annual Salon in Paris, but there was no place back home for art such as this. Its subject matter and style of painting were foreign to most Americans, who, unlike European connoisseurs, had not learned to cope with a nude image set boldly before them. Vanderlyn's *Ariadne* is beautifully and delicately painted, but that was not sufficient to gain acceptance in America.

A CLASSICAL TEMPLE

Vanderlyn returned to America in 1815 and attempted to set himself up in a little classical-style temple of painting on a site near City Hall in New York City. There he showed his *Jane McCrea*, the *Ariadne*, and another of his history paintings, *Marius amid the Ruins of Carthage*, painted in Rome in 1807. On the walls of his rotunda he exhibited his panorama of the Palace of Versailles, which the curious paid to see in smaller numbers than Vanderlyn had hoped. In the end, he lost his rotunda to the City, and there were no commissions except for portraits, which Vanderlyn detested painting. Finally, in 1837 he was awarded the commission for the large picture *The Landing of Columbus*, which is installed in

10.16 John Vanderlyn, *Ariadne Asleep on the Island of Naxos*, 1814. Oil on canvas, 5ft 8½in × 7ft 3in (1.74 × 2.21m). Pennsylvania Academy of the Fine Arts, Philadelphia.

the rotunda of the Capitol. But, as with Trumbull, whose four large pictures hang nearby, this patronage came too late, for the bitter, aging artist's talents were all but burnt out.

WASHINGTON ALLSTON

Washington Allston's (1779–1843) career ran a similar course. From a prominent South Carolinian family, Allston was sent to Harvard to be educated. While there he began painting pictures with literary themes, sometimes of a bizarre nature. His Romantic spirit revelled in Gothic novels and poetic visions.

In 1801, Allston left for England to study at the Royal Academy and with Benjamin West, from whom he learned the theories of the Grand Manner. Three years later, Allston set off for the Continent, passing through Paris, and then on to Italy by way of the Swiss Alps. The Alps made a profound impression on him, and when he got to Rome he began a large canvas depicting an Alpine scene—*Diana in the Chase* (1805, Fogg Art Museum, Harvard University).

ROMAN INFLUENCES

Samuel Taylor Coleridge, the English Romantic author who wrote *Kubla Khan* and *The Rime of the Ancient Mariner*, became Allston's intimate and constant companion in Rome, and admired the *Diana* picture greatly. They were two kindred spirits: the Englishman and the American, both devoted to poetry and poetic visions, thrilling to strolls amid the ruins of the Colosseum and other ancient edifices by moonlight, reinforcing each other's fascination with the mysterious and the supernatural. Allston was captivated by both ancient Rome and Renaissance and Baroque Rome, and his pictures from this period reveal the influence of the classicism of Raphael (1483–1520) and Poussin, whose works he studied there.

Allston returned to America in 1808, spending the next three years in Boston before going again to England, this time accompanied by his young bride and his young pupil, Samuel F. B. Morse. During the following years, it seemed to many that Allston was destined to succeed the aging West as the leading history painter of the English school. Perhaps to establish his qualifications to do so, Allston began a large and important canvas: *Dead Man Restored to Life by Touching the Bones of the Prophet Elisha* (Fig. 10.17).

A technique of the Grand Manner, as described in Sir Joshua Reynolds's *Discourses*, was for an artist to choose a work by a recognized Old Master, and paint an original composition in competition with it. Allston chose Sebastiano del Piombo's *Raising of Lazarus* (1517–19, National Gallery, London), which had recently been acquired by an English collector. The subject came from the Old Testament, offered a grand theme, and presented the artist with the opportunity to treat a supernatural event—the miraculous restoration of life to a dead man.

The scene is a mysterious, gloomy grotto, and the figures' reactions vary from shocked disbelief to terrified horror. In all of this one finds Allston indulging rapturously in Romantic excitation of the emotions and sensations. To align his art with that of the Old Masters, he employed a Rembrandt-esque chiaroscuro, a Michelangelesque **contrapposto** in the figures, a Poussinesque quality in the gestures, and, finally, based the figure of the reviving dead man on the celebrated ancient statue of the *Dying Gaul*. Anchored to tradition, Allston's *Dead Man Restored* was hailed as a resounding success.

LANDSCAPES

When not working on one of his grand figural compositions, Allston painted landscapes. His vision of landscape was exceptional, for he refused to use the objective clarity and detachment of the eighteenth-century Enlightenment. Instead he infused his paintings with mood, poetry, and Romantic sentiment. Because landscape—as a view of a specific place, pure and simple—was considered a low form of art, Allston inhabited his pictures with heroic literary or historical figures.

Elijah in the Desert is essentially a landscape, and a powerful one at that—beautiful yet austere in its starkness and barrenness, inhospitable to human existence, making Elijah's survival in it all the more miraculous and super-natural (Fig. 10.18). Elijah, the sole human inhabitant in this vast space, is fed by two enormous black ravens, one of them perched on the branch of a tormented and gnarled tree, which contributes to the awesomeness of the

10.17 (opposite) Washington Allston, *The Dead Man Restored to Life by Touching the Bones of the Prophet Elisha*, 1811–13. Oil on canvas, 13ft × 11ft (3.96 × 3.35m). Pennsylvania Academy of the Fine Arts, Philadelphia.

10.18 (right) Washington Allston, *Elijah in the Desert*, 1818. Oil on canvas, 4ft¾in × 6ft½in (1.24 × 1.84m). Museum of Fine Arts, Boston. Gift of Mrs. Samuel Hooper and Miss Alice Hooper.

10.19 Washington Allston, *Belshazzar's Feast*, 1817–43. Oil on canvas, 12ft⅛in × 16ft⅛in (3.66 × 4.88m). Detroit Institute of Arts.

landscape. The picture displays Allston's interest in the "carnival colors" of the northern Italian painters of the Renaissance, such as Titian, Tintoretto (1518–94), and Veronese (1528–88), and his fascination with glazes, for which he was acclaimed by his contemporaries. Numerous landscapes followed. Always, there is a poetic, lyrical, or supernatural quality about them. In good Romantic fashion, nature is represented with human emotions impressed upon her.

BELSHAZZAR'S FEAST

At the very height of his career in England, Allston inexplicably decided to go home to America. It was, as with Vanderlyn, a mistake. Once done, in 1818, he remained there in semi-isolation for the remainder of his life. Allston established himself in Cambridgeport just outside of Boston, and set up on his easel an enormous canvas that he had

begun in London. *Belshazzar's Feast* was to be a great work, but one that would haunt and frustrate him the rest of his days (Fig. 10.19). Daniel stands triumphant in its center, a splendid visualization of an Old Testament prophetic personage. He interprets the mysterious handwriting on the wall, which had confounded the court seers and magicians who are present at the right. King Belshazzar, son of Nebuchadnezzar, shrinks and cowers before Daniel's prophecy of the impending doom of his empire and the great city of Babylon.

Allston clearly hoped to sustain his commitment to the Grand Manner even while working in America, where only a privileged few—cultured connoisseurs who had traveled in Europe, literati, and intellectuals—could identify with that tradition. But Cambridgeport, even Boston, could not provide the artistic atmosphere conducive to bringing his great picture to a satisfactory conclusion.

When not working on the *Belshazzar*—which was often left rolled up in a corner of the studio for years at a time—Allston painted delicate, wistful little fantasies like the *Spanish Girl in Reverie* (1831, Metropolitan Museum of Art). These usually found buyers, but if he ever dreamed of seeing the Grand Manner transplanted to America, Allston was disappointed. He died a virtual recluse, all but forgotten by the London art world in which he had once been a well-known figure, the man who more than any other introduced Romantic sentiments into American painting.

SAMUEL F. B. MORSE

Allston's influence on American art was considerable, if indirect. It was he, for example, who led young Samuel Finley Breese Morse (1791–1872) along the path of the Grand Manner. Morse, the son of a Connecticut minister and noted geographer, had begun painting little portraits of his classmates at Yale for cigar money. He came to the attention of Allston when the latter was on a return visit to Boston, and when the older artist sailed for England in 1811, he took his young protégé with him.

Morse studied in London for four years, absorbing the theories and practices of the Grand Manner through the regular criticisms his work received from both West and Allston. One of his major pictures of this time was *The Dying Hercules* (Yale University Art Gallery), which he painted from a sculptured model he made. Both the sculpture and the painting were based on a famous statue from antiquity, the Farnese Hercules, now in the National Museum, Naples.

A PORTRAYAL OF AMERICAN DEMOCRACY

Family and financial pressures forced Morse to return home in 1815, full of ambitions and dreams of the role he would play in implanting the Grand Manner in America. In this aim, he would be as frustrated as Trumbull, Vanderlyn, or Allston. Morse became a successful portrait painter in order to support his more cherished work on large subject pieces. Even the latter, however, reveal that Morse was trying to make a compromise with the great wave of democratic spirit that was then sweeping the country. In 1822 he painted a picture that praised the American democratic system, *The Old House of Representatives* (Fig. 10.20). There is no spectacular debate to give focus to the scene; in fact, the Congressmen and their aides are shown milling about, or in quiet informal discussions. The most action occurs in the center,

10.20 Samuel F. B. Morse, *The Old House of Representatives*, 1822. Oil on canvas, 7ft 2in × 10ft 11in (2.18 × 3.33m). Corcoran Gallery of Art, Washington, D.C.

10.21 (above) Samuel F. B. Morse, *Marquis de Lafayette*, 1826. Oil on canvas, 8ft × 5ft 4in (2.44 × 1.63m). City Hall, New York City.

where a functionary lights the lamps of the great chandelier that has been lowered for that purpose—hardly an event of consequence. One of the chief glories of the picture is the room itself, completed only a few years earlier under Latrobe's direction. Soon after the painting was finished, Morse took it on tour to several American cities, hoping through admission fees to finance a return trip to Europe. Unfortunately, even a picture of this type, so much more directly related to America than an *Ariadne* or a *Hercules*, attracted less attention than the artist wished.

Morse's continued commitment to the Grand Manner is evident in the portrait he painted of the Marquis de Lafayette, a commission awarded by the City of New York in 1824 on the occasion of the old Revolutionary War hero's return visit to America (Fig. 10.21). Grand and dynamic in its conception, and thoroughly Venetian in its coloration, it shows that Morse remembered well the lessons he had learned from Allston, especially in the use of glazing to achieve dazzling effects of light, shadow, and color. At the left are Houdon's sculptured busts of Washington and Franklin, Lafayette's old friends of earlier years. A third pedestal stands empty, awaiting Lafayette's own image. At the right, a sunflower—symbol of unwavering devotion—grows from an urn. Stylistically, this magnificent picture is similar to a later portrait by Morse of his daughter, *Susan Walker Morse as a Muse* (1835–7, Metropolitan Museum of Art). The two paintings represent a highpoint for American portraiture in the early nineteenth century.

GODS OF THE GRAND MANNER

Morse returned to Europe in 1829, spending three years there. One of his main projects was the painting *Gallery of*

10.22 Samuel F. B. Morse, *Gallery of the Louvre*, 1831–3. Oil on canvas, 6ft 1¾in × 9ft (1.87 × 2.74m). Terra Museum of American Art, Chicago, Illinois.

10.23 Rembrandt Peale, *The Court of Death*, 1820. Oil on canvas, 11ft 6in × 23ft 5in (3.51 × 7.14m). Detroit Institute of Arts.

the Louvre (Fig. **10.22**). On this canvas he assembled into one gallery the greatest masterpieces housed throughout the Louvre, meticulously copied in miniature. These are pictures by Raphael, Leonardo da Vinci, Titian, Correggio, Poussin, Rubens, Van Dyck, Claude, Ter Borch, and Murillo, among others. The group of figures at the left represents the novelist James Fenimore Cooper with his wife and daughter, the latter in the process of copying a painting by one of the Little Dutch Masters. Morse took his finished picture back to America, where he went on tour with it in the hope that those who had not been able to travel abroad would flock to see it. Unfortunately, this was no more successful financially than the *Old House of Representatives*.

By this time, much of Morse's energy was channeled into the affairs of the National Academy of Design, founded in New York in 1826 with Morse as its first president. It was to be an academy that functioned primarily for the benefit of the growing corps of artists in New York. It was to provide for them a school that had rooms for study, exhibition space so their work could be shown regularly to potential collectors, and a central meeting place. Morse deserves much of the credit for the survival of the infant institution. When he resigned the presidency in 1845, the Academy was permanently established and flourishing, with very successful annual exhibitions. For the artists, it was exactly what Colonel Trumbull had never allowed the American Academy to become.

Since the mid-1830s, Morse's interests had been directed away from art by a fascination with gadgets. It was he who brought the **daguerreotype** with him when he returned from France in 1839. (More will be said about this in chapter 17 in connection with the rise of photography in the United States.) About this same time, Morse became absorbed with the invention of the telegraph. It was this that finally caused him to forsake his career as a painter, which, all things considered, had been a rather frustrating affair.

There were others who similarly tried to present the tradition of the Grand Manner to their countrymen and -women, and there is the occasional success story, as with *Court of Death*, painted in 1820 by Rembrandt Peale (1778–1860), son of Charles Willson Peale (Fig. **10.23**). As with West's *Death on a Pale Horse* (Fig. **10.3**), with which it must be compared, its religious and moral content appealed to Americans. Set in a gloomy cavern, the scene presents as its central figure the specter of death. A court filled with tormented personifications of greed, murder, suicide, war, and the like is presided over by death, with the reminder that even the virtuous must eventually come before this harsh judge. Ministers urged their flocks to go and see this huge, dramatic tableau, and to reflect upon its moral message. The *Court of Death* was financially a roadshow success. In general, however, Americans wanted something other than art of the Grand Manner, and it is to that subject that attention is now turned.

CHAPTER ELEVEN

PAINTING:

STILL LIFE, GENRE, LANDSCAPE, AND NATURAL HISTORY, 1785–1830

America expanded greatly during the Federal period, enlarging from the thirteen seaboard states at the end of the Revolutionary War to nearly half a continent. Most of this new territory was accrued when President Jefferson negotiated the Louisiana Purchase in 1803 with Napoleon. The next year, he sent Meriwether Lewis and William Clark on a two-year expedition to explore what it was he had acquired from France. The Louisiana Purchase led to the establishment of the territories of Ohio, Indiana, Michigan, Illinois, Louisiana, Alabama, and Missouri, and eventually others. Cincinnati, on the Ohio River, had been settled in 1788, while Detroit and St. Louis, established much earlier by the French, began to grow as immigrants and American-born migrants began to pour into the new lands. In 1803, Fort Dearborn was founded, and the site was later renamed Chicago.

Cultural growth followed upon the heels of geographical expansion. The first newspaper west of the Allegheny Mountains was the *Pittsburgh Gazette*, beginning publication in 1786. Gilbert Imlay's novel *The Emigrants* (1793) was a romance set in the Pittsburgh frontier. By 1808, the *Missouri Gazette* was the first newspaper to appear west of the Mississippi River. In 1804, the "coon-skin library" was formed in Marietta, Ohio, when a shipment of raccoon skins was sent to Boston to be exchanged for books. Ohio University was founded in a town named Athens that same year.

Nationalism became one of the main themes in literature and art, as in life. The first American comedy ever produced, Royall Tyler's *The Contrast*, was a plea for the rejection of foreign ways. It advocated "native themes" and "homespun arts," in which the true American character was to be found. Ever more chauvinistically aware of their separateness from the English, Americans defended their manners and customs by declaring they were based on honesty, straightforwardness, a respect for learning, and the principle of liberty. *The Contrast*—called a spiritual Declaration of Independence,

because of its emphasis on patriotism and praise of the federal union of the states—was first staged in New York City in 1787, the year of the Constitutional Convention. A novel by Royall Tyler, *The Algerine Captive* (1799), encouraged Americans to learn about themselves, rather than devote themselves to studying and imitating European cultures. Tyler calls for a truly American literature, and again praises American manners, homespun though they may be.

Natural history was an intellectual passion among Americans, which resulted in several extraordinary projects. William Bartram's *Travels through North and South Carolina, Georgia, East and West Florida* (1791) gained international respect for its author. By 1808, Alexander Wilson had published volume one of his greatly admired *American Ornithology*, with handcolored plates handsomely engraved by Alexander Lawson. Between 1808 and 1820, John James Audubon roamed the forests of Kentucky and elsewhere to make studies for his celebrated *Birds of America*, the first folio of which appeared in 1828. All of these manifestations of a fascination with things American were but another form of nationalism, as Americans discovered themselves and their land.

In the fine arts, too, there was a rising swell of nationalism and a call for the depiction of American themes in an American style, divorced from European subjects and modes. This ran contrary to the Grand Manner, and in the end American nationalism triumphed. But it was a slow, faltering process. Americans were filled with selfdoubt, as demonstrated in a quote from a letter Gulian Verplanck wrote from London to his brother Samuel in New York in 1773: "Do not laugh at my Connoisseurship as I am not at the profession...."[1] Verplanck, in apologizing for his inexperience with the fine arts, was expressing the sentiments of the majority of Americans. They were eager to learn, however, and they were particularly anxious to foster a truly American art that rose from their own people, their own culture, and their own land.

THE PEALES: A FAMILY OF PAINTERS

MINIATURES AND STILL LIFES

The remarkable family of Charles Willson Peale practiced nearly every aspect of painting that was known in the late eighteenth and early nineteenth centuries. James (1749–1831), the second seated person from the left in Figure 7.15, received his first lessons from his older brother. Following the Revolutionary War, James began painting miniatures on ivory, and when Charles Willson retired from portrait painting in 1795 he turned over all miniature business to James. But working constantly in small detail eventually caused James's eyesight to begin to fail, and about 1820 he turned to still life painting.

These are simple tabletop still lifes, with the edge of the table brought close to the picture plane and placed parallel to it, creating an uncomplicated composition, with a neutral-colored wall cutting off the space immediately behind the objects. Within this intimate space, as in *Still Life: Apples, Grapes, Pear*, an abundance of fruit fills the area, often spilling over from a Chinese export porcelain bowl (Fig. 11.1). The unwithered leaves on the grapevine suggest the freshness of the luscious grapes, but the apple resting on the table in the center shows signs of overripeness. It is typical of James's still lifes to have just such a gamut of conditions, which seems to add to their sensory appeal. Each morsel and object is carefully painted, and the subtle color and harmonies are characteristic. Historical precedent for this type of composition exists in the art of the seventeenth-century French painter Louise Moillon.

Charles Willson Peale's oldest son, Raphaelle (1774–1825), also specialized in still lifes—usually small pieces, meticulously painted, with a lovely, soft tonal quality. They

11.1 James Peale, *Still Life: Apples, Grapes, Pear*, c. 1822–5. Oil on wood, 18³⁄₁₆ × 26³⁄₈in (46.2 × 66cm). Munson-Williams-Proctor Institute, Museum of Art, Utica, New York.

11.2 Raphaelle Peale, *Venus Rising from the Sea—A Deception (After the Bath)*, c. 1822. Oil on canvas, 29¼ × 24⅛in (74.3 × 61.3cm). Nelson-Atkins Museum of Art, Kansas City, Missouri.

tend to be more tightly rendered than those by James, and less sensuous. Raphaelle learned to paint from his father, and at first was a miniaturist, turning to still life around 1815 at a time when his health began to fail. But personal problems compounded by alcoholism plagued Raphaelle and curtailed a career that might well have accomplished more.

Probably his most famous picture is the *trompe l'oeil* (or trick of the eye) *After the Bath*, supposedly a joke to make the viewer think the hanging towel is real and conceals a painting of a female nude, one bare arm and a foot of which are exposed (Fig. 11.2). There are several known instances in the nineteenth century of a nude painting being kept covered for propriety's sake: A. B. Durand, for example, did so when he owned Vanderlyn's *Ariadne*.

REMBRANDT PEALE

Rembrandt Peale (1778–1860) was the most successful of Charles's children who became artists. He, too, was trained by his father, who launched him on his career by arranging to have President George Washington pose for the lad—a mere seventeen—in 1795 in Philadelphia. During his early years, Rembrandt assisted his father with his museum,

helping, for instance, to assemble the two mastodon skeletons which the elder Peale had acquired.

Rembrandt's younger brother Rubens (1784–1865) shared his father's interest in natural history, and one of Rembrandt's best portraits is *Rubens Peale with a Geranium*, showing the thoughtful, studious youth with what was reportedly the first geranium brought to America (Fig. 11.3). The Peale fascination with the natural world is stated forthrightly here, as the human subject clearly shares the spotlight with an exotic plant. Rubens maintained a museum of natural history in Baltimore, although late in life he, too, turned to painting still lifes.

Soon after the portrait with the geranium was painted, Charles Willson Peale sent Rembrandt and Rubens to England, in charge of one of the mastodon skeletons, which they were to exhibit there. For a brief period after he arrived in London in 1802 Rembrandt studied with Benjamin West, thirty-five years after his father had. Rembrandt later visited Paris, in 1808 and 1809–10. He was therefore more familiar with contemporary movements in painting, and the great European collections, than the other artists of his family. Rembrandt's portrait style was influenced by the cool palette and severe linearity of French Neoclassicism—then under the domination of Jacques-Louis David—and he painted a number of fine portraits while in Paris.

Rembrandt Peale set himself up as a portrait painter in Philadelphia, where his studio was in a portion of the space allotted to his father's museum in Independence Hall. He was at the peak of his powers as a painter from about 1804 to 1820. From this period date such excellent portraits as *Thomas Jefferson* (1804, New-York Historical Society), painted in Washington, D.C., while Jefferson was president, and the series of military portraits of the heroes who had defended Baltimore in the waning days of the War of 1812.

Through his study with West, and his years spent in London and Paris, Rembrandt Peale became acquainted with the tradition of the Grand Manner, as seen, for example, in his *Court of Death* (Fig. 10.23) of 1820. He made other forays as well—from the *Roman Daughter* (National Museum of American Art, Washington, D.C.), to an equestrian *Napoleon* (destroyed).

Beginning about 1823, Rembrandt became absorbed with the idea of painting the ultimate and standard portrait of George Washington, based on his own early portrait and the one by his father painted at the same time. This was intended to replace Stuart's likeness as the accepted image by which Washington should be remembered. The result was the "Porthole" *Washington*, so named because, in an effort to make the picture monumental, the artist painted a great stone enframement, with Washington's bust in the oval opening. Peale sold a number of these, but the vision of the Father of his Country was rather raw and unsophisticated, and to this day Stuart's portrait is generally preferred.

SARAH MIRIAM PEALE

Many others of the Peale family either became artists or were in some way associated with art. Titian Ramsay Peale (1799–1885) was an artist-naturalist who was more an illustrator of natural phenomena than a practicing fine artist. He was the artist-naturalist who made the visual record of

11.3 Rembrandt Peale, *Rubens Peale with a Geranium*, 1801. Oil on canvas, 28¼ × 24in (71.7 × 61cm). National Gallery of Art, Washington, D.C.

11.4 Sarah Miriam Peale, *A Slice of Watermelon*, 1825. Oil on canvas, 17 × 21¹³⁄₁₆in (43.2 × 55.4cm). Wadsworth Atheneum, Hartford, Connecticut.

Stephen H. Long's expedition to the Rocky Mountains in 1818–21. Sarah Miriam Peale (1800–85) was the youngest daughter of James Peale, from whom she learned to paint portraits, and also still lifes such as *Slice of Watermelon* (Fig. 11.4). This may be the still life that was owned by Robert Gilmor, Jr. (Fig. 10.10), the Baltimore collector. It was painted in 1825, and from 1820 to 1829 Sarah Miriam Peale lived and painted in Baltimore. In 1824 she and her sister Anna were elected to membership in the Pennsylvania Academy of the Fine Arts, an exceptional honor for a woman in those days. She also worked in Washington, D.C., and, for thirty years, in St. Louis, before returning to Philadelphia in 1877. Sarah's brand of still life was a simple, tabletop type, which, like those by her father, was composed of only a few objects in uncomplicated arrangements. Her still lifes claim no obscure secondary meaning, nor do they indulge in any deeply symbolic message.

SYMBOLIC STILL LIFE

Charles Bird King (1785–1862) painted still life of a very different type from that of James and Sarah Miriam Peale. Based on a European tradition, it was packed with symbolism, and bespoke a biting social commentary, as in *Poor Artist's Cupboard* of about 1815 (Fig. 11.5).

MESSAGE ON A CANVAS

King, a native of Newport, Rhode Island, had studied with Benjamin West in London between 1805 and 1812, and had worked in Philadelphia and Baltimore before settling permanently in Washington, D.C. While in London, he had learned of the Grand Manner, and of the theory that great art must be more than just pleasing to the eye, but should have the capability to convey an edifying, didactic message.

Although mainly a portraitist, King painted two remarkable still lifes: *Vanity of an Artist's Dream* (1830, Fogg Art Museum, Cambridge, Massachusetts) and *Poor Artist's Cupboard*. The latter is executed in conformity to a European tradition that reaches back to seventeenth-century Dutch still life painting, an example of which is the *Vanitas* of 1668 by Maria van Oosterwyck (Kunsthistorisches Museum, Vienna).

Living in Philadelphia from 1812 to 1816, when he painted *Poor Artist's Cupboard*, King made his painting a scourging indictment of a society that would not support its artists, and the picture is indeed autobiographical. In the upper left is a notice of a sheriff's sale of an artist's property, presumably because he could not pay his debts. The bread and glass of water make reference to a meager diet, while cynical humor is injected by books titled *Advantages of Poverty* and Thomas Campbell's *Pleasures of Hope* (1799). Allusion to the painter's profession is made with the copy of Giorgio Vasari's *Lives of the Great Painters*, which relates how the great artists of the Renaissance were rewarded and

11.5 Charles Bird King, *The Poor Artist's Cupboard*, c. 1815. Oil on panel, 30 × 28in (76.2 × 71.1cm). Corcoran Gallery of Art, Washington, D.C.

esteemed by generous patrons. The book on the bottom is sarcastically labeled *Choice of Criticism on the Exhibitions at Philadelphia*.

In its affiliation with a wellknown European tradition and its powerful didactic character, *Poor Artist's Cupboard* belongs in a modest way more to the Grand Manner than to the still life tradition of the Peales, which King certainly would have known while he was living in Philadelphia and Baltimore.

PORTRAITS OF NATIVE AMERICANS

King's other claim to fame lies in a series of portraits of Native Americans who visited Washington, D.C., commissioned by the Bureau of Indian Affairs, a branch of the federal government that was established in 1824. Unfortunately, many of these handsome portraits were lost in a fire at the Smithsonian Institution.

The art life of Philadelphia was not as bad as King would have us believe, for by 1815 the Pennsylvania Academy of the Fine Arts flourished, with its own Roman-style building that housed its permanent collection. After 1811, the Society of Artists, an organization of professional artists, held annual exhibitions of contemporary work in galleries provided by the Academy. Philadelphia was a lively place, and as much of a center of intellectual, scientific, and artistic activity as then existed in the United States.

GENRE AND LANDSCAPE PAINTING

SCENES OF DAILY LIFE

In a little picture painted only a few years before King's caustic and critical still life, John Lewis Krimmel (1786–1821) left us a glimpse of life in the Quaker City. With *Fourth of July in Center Square, Philadelphia*, the German-born Krimmel, who had emigrated to America in 1810, commenced the tradition of genre painting—scenes of ordinary people doing ordinary things—in this country (Fig. 11.6). Here, gentlemen strut in their Beau Brummell finery, ladies parade in their Empire fashions, children play with pets or with each other, a few men enjoy their stein of stout drink, purchased from an old woman who has set up a concession table amid this holiday ambience. A sociable citizenry is welldressed and happy, celebrating Independence Day in the parklike area that is now occupied by City Hall, but which then contained several examples of their ingenuity. First, Benjamin Henry Latrobe's little classical temple houses a marvel of engineering, which pumps fresh, clean water from the Schuylkill River. Both the edifice and the mechanism are extraordinary achievements. In the middle of the picture is one of the earliest examples of outdoor public sculpture of the Early Republic, and one of sculptor William Rush's best efforts—the wooden image of the *Water Nymph and Bittern* (Fig. 12.9) that serves as the centerpiece for the attractive fountain. Several finely dressed black men and women are among those admiring the statue, seen in the middleground just to the left of center.

Americans enjoyed scenes of their environments and the ordinary daily activities of common people—views of the

11.6 John Lewis Krimmel, *Fourth of July in Center Square, Philadelphia*, 1810–12. Oil on canvas, 23 × 29in (58.4 × 73.7cm). Pennsylvania Academy of the Fine Arts, Philadelphia.

11.7 Francis Guy, *Winter Scene in Brooklyn*, 1817–20. Oil on canvas, 4ft 10¾in × 6ft 3in (1.49 × 1.91m). Brooklyn Museum.

11.8 (below) William Winstanley, Meeting of the Waters, 1795. Oil on canvas, 35 × 49¼in (88.9 × 125.1cm). Munson-Williams-Proctor Institute, Museum of Art, Utica, New York.

sort seen in Francis Guy's *Winter Scene in Brooklyn* (Fig. 11.7). A varied array of commonplace vignettes is played out before a backdrop of the borough of Brooklyn as it appeared about 1820. Two men stop to chat, another saws firewood, another feeds chickens, and another falls on the ice. A boy pumps water at the public pump, a man rests on a shovel beside a pile of coal, a family is drawn along the snowy streets in a onehorse sleigh. Guy (c. 1760–1820), an Englishman who had come to America about 1795, specialized in such kaleidoscopic scenes of commonplace America. Another favorite picture is his *Tontine Coffee House* (1797, New-York Historical Society), in which the passing scene of lower Manhattan is described in meticulous detail.

RURAL SCENES

Americans were also becoming fascinated with the special character of their rural areas. While the American school of landscape painting did not take form until after the Federal period, there were numerous efforts in that line in the 1790s and the first quarter of the nineteenth century.

The way was led by English artists who brought the eighteenth-century topographic view to America, along with a style that showed a love of nature in her gentler, "improved" aspects. Francis Guy painted a number of rural scenes, as did fellow-Englishmen George Beck (1748?–1812), William Groombridge (1748–1811), and William Winstanley (active 1793–1806), all of whom arrived in

America in the 1790s. Typical of the lyrical, poetic, picturesque tradition—the eighteenth-century English transformation of the style of the seventeenth-century French landscapist Claude Lorraine (1600–82) by way of Richard Wilson (1714–82)—is Winstanley's *Meeting of the Waters* (Fig. 11.8). This painting possesses something of the Romantic adulation of nature that was expressed in William Wordsworth's *Lyrical Ballads*. Published in 1798, the ballads were written while the poet lived in the Lake District of northern England, at about the same time that Winstanley painted this picture.

11.9 Joshua Shaw,
Landscape with Cattle, 1818.
Oil on canvas, 31 × 41in
(78.7 × 104.1cm).
Butler Institute of American
Art, Youngstown, Ohio.

Notions about the mood and mystery of nature are thus beginning to stir, and many scholars have seen the *Lyrical Ballads*, written in the midst of the neoclassical period, as the overture to Romanticism. President George Washington, who called Winstanley a celebrated landscape painter, purchased four of his views, two of which may still be seen at Mount Vernon.

Joshua Shaw (c. 1777–1860) left England and arrived in Philadelphia in 1817, already a welltrained artist. The next year, he painted *Landscape with Cattle*, a lovely, domesticated scene in subtle earthen tones, which, although painted in America, depicts the rolling countryside near Bath, England (Fig. 11.9). Shaw also painted a series of American views at this time, which were then engraved by another English immigrant, John Hill (1770–1850), and published in *Picturesque Views of American Scenery* (Philadelphia, 1820). Hill was the progenitor of many such books, and a major influence in arousing interest in scenes of the American landscape.

William Guy Wall (1792–after 1863) came to New York City from his native Dublin in 1818, and soon after executed a number of watercolors of views along the Hudson River. In 1820 the first of five issues of the famous *Hudson River Portfolio* appeared, each issue containing four handcolored **aquatints**, most of which had been engraved by John Hill. *View near Hudson* depicts the lovely river valley with its roads, fences, and sailboats, all indications of a peaceful and harmonious coexistence of men and women with glorious

nature (Fig. 11.10). These plates were in such demand that they were published in a single volume in 1828. The interminable, untamed wilderness that inspired Thomas Cole about this same time still lay beyond the mountain range that we see on the horizon in *View near Hudson*. Wall was concerned with the "improved" landscape—the cleared fields, the farmhouse here and there, perhaps a church steeple or a school, all signs of civilization rather than wilderness.

11.10 William Guy Wall, *View near Hudson, New York*, c. 1820. Aquatint, from *Hudson River Portfolio*, 18 × 24in (45.7 × 61cm). Courtesy The New-York Historical Society, New York City.

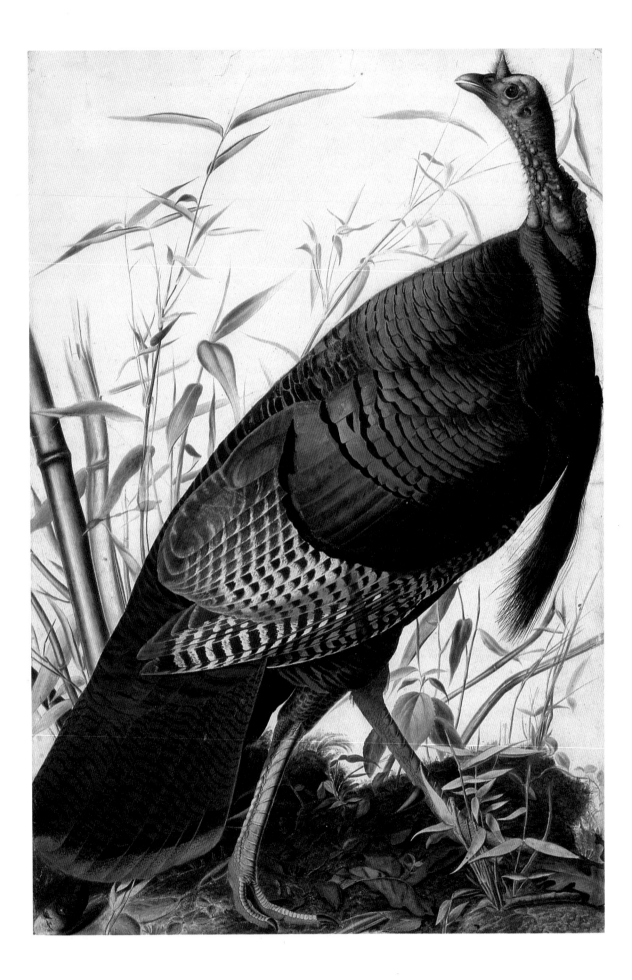

WILSON AND AUDUBON: AMERICAN ORNITHOLOGISTS

America's interest in its natural world took many forms, often effecting a merging of artistic talent and scientific genius. Then, as now, within the sphere of natural history few subjects were more fascinating to Americans than the study of their native birds. This phenomenon began with Mark Catesby's work of the early eighteenth century, and a similar fascination with ornithology gripped an impoverished Scottish-born weaver, Alexander Wilson (1766–1813), who came to Philadelphia in 1794. With the encouragement of the famed naturalist William Bartram, Wilson began to collect specimens of birds, and learned how to draw them in careful, accurate detail. He set about preparing *American Ornithology*, the first volume of which appeared in 1808, with six more by 1813. The handcolored plates were engraved by a fellow-immigrant Scotsman, Alexander Lawson (Fig. **11.12**). In his commentary for each plate, Wilson frequently made reference to the specimen in Peale's Museum, and gave Peale's number for it, as when he wrote "Clark's Crow... Peale's Museum, No. 1371... was drawn with particular care, after a minute examination and measurement of the only preserved skin... which is now deposited in Mr. Peale's Museum."[2] Wilson's work has been praised for its accuracy, the illustrations having an attractive simplicity about them. Like most of Catesby's plates, Wilson's birds are shown isolated from their natural setting, surrounded simply by the whiteness of the paper upon which they are printed.

BIRDS OF AMERICA: A WORK OF ART

Not long after Wilson's death, John James Audubon (1785–1851) appeared upon the scene. Born in Haiti and raised in France, Audubon claimed to have had a few lessons in drawing from Jacques-Louis David before coming to America in 1803 at age eighteen, settling first near Philadelphia. Audubon's interest in birds had begun while he was a boy, and he took to drawing them—not sketching them in the wild, but setting up dead specimens on a table indoors. Audubon's fascination with this kind of work continued after he with his young bride moved to Kentucky, where he was a shopkeeper and then a mill operator.

The failure of the mill in 1819 left him free to devote himself to his great project, the painting of the large watercolors in preparation for publication of his *Birds of America*. Of the 435 watercolors that served as models for the engraved plates, 432 are preserved at the New-York Historical Society. One of the most popular of these is the *Wild Turkey* (Fig. **11.11**). It was probably painted in 1822 when Audubon was in Louisiana on a trek through the eastern states, sketching specimens as he went.

His bird studies, like the wild turkey, were done lifesize, so he could be absolutely certain of the measurements and proportions. Unlike Wilson, Audubon created natural backdrops, often collecting specimens of trees or grasses from which to paint accurate habitats. In the beginning, Audubon usually made a single bird in profile within a relatively simple composition—but he sometimes introduced the drama that he observed in nature, for example, a great snake attacking a nest of mockingbirds, or a hawk pouncing on a covey of quail.

Finding insufficient patronage in Philadelphia to have his collection published there, Audubon took his project to London in 1826. There his pictures were beautifully engraved in aquatint, most of them by Robert Havel, Jr. (1793–1878), lifesize, which necessitated publication as a

11.12 Alexander Wilson, *Louisiana Tanager, Clark's Crow, and Lewis's Woodpecker*, colored engraving by Alexander Lawson, plate 20, from Wilson's *American Ornithology*, vol. 3 (Philadelphia, 1811). 14 × 10in (35.6 × 25.4cm). Morris Library, University of Delaware, Newark, Delaware.

11.11 (opposite) John James Audubon, *Wild Turkey*, 1822. Watercolor on paper, 36 × 25in (91.4 × 63.5cm). Courtesy The New-York Historical Society, New York City.

huge elephant-folio—about 40 × 26 inches (102 × 66cm). Each impression, or plate, was painstakingly handcolored under Audubon's close supervision.

Issued in eighty-seven parts between 1828 and 1838, *Birds of America* made Audubon instantly famous. In London he was elected to the Linnaean and Royal societies. In America, even Wilson's loyal followers had to admit that comparing Wilson's work to Audubon's was like comparing "the Falls of Trenton to Niagara Falls." Wilson's birds are scientific ornithological studies, while Audubon's are lovely works of art, which are also ornithologically accurate.

The range of American painting broadened considerably during the Federal period, from portraiture in the colonial era, to history painting, still life, landscape, genre themes, naturalists' studies, and, as always, portraits. American art grew in that period, as patrons emerged, and collections of paintings were first formed. Art institutions arose, such as the American Academy of Fine Arts and the National Academy of Design in New York City, the Pennsylvania Academy of the Fine Arts in Philadelphia, the Boston Athenaeum, and the South Carolina Art Association in Charleston.

Several painters made a noble effort to bestow upon their native land the lofty art of the Grand Manner, but Americans preferred scenes of America itself—its land, cities, people, and abundance. The cultural tug-of-war between European tradition and expression of the American spirit ended in favor of the latter. Just as the nation had forged a new political system by which men and women would live and govern themselves, so America began to assert its cultural independence in the paintings it produced.

CHAPTER TWELVE

SCULPTURE:

1785–1830

As the Federal period opened, three major problems confronted the art of sculpture. First, it was relatively expensive. Sculpture in marble—or even wood—is a time-consuming and costly art, especially in a land that has considerable debt, and few persons of great wealth. Second, there were few places for its use and display. Third, sculpture was little known except in the forms of shopsigns or ships' figureheads. Painting had been known in America for over a century, albeit through the limited range of portraiture. The public, however, was largely unfamiliar with sculpture as an artform. On 16 May 1783, Benjamin Franklin wrote to a European friend in reply to the latter's query about the advisability of a sculptor-acquaintance of his going to America to find patronage. Franklin was not encouraging:

> ...I hardly think it can be worth his while at present to go to America in Expectation of being employ'd there. Private persons are not rich enough to encourage sufficiently the fine Arts.... And the Public being burden'd by its War Debts, will certainly think of paying them before it goes into the Expense of Marble Monuments.[1]

Few structures in colonial America had a place for figurative sculpture—such as broad pediments or large niches especially designed for statues or busts. Private homes almost never had spaces specifically for sculpture. There were also the practical problems. No marble quarries had been discovered, there were no trained artisans to assist in the laborious process of transferring the clay model into plaster and then into marble, no great collections of ancient statues to study, and no group of professional nude models. All of these were available in Europe, and most young Americans who aspired to become sculptors found it necessary to go abroad. Some of them never returned.

The Federal period of American sculpture was a transitional phase between the colonial era of craftsmen-woodcarvers or artisan-stonecutters, and the rise of a school of American-born sculptors who went to Italy. Some of these attained remarkable success within the first generation—men such as Horatio Greenough, Hiram Powers, and Thomas Crawford (see chapter 18). During the Federal period, woodcarvers like Samuel McIntire, the Skillins, and William Rush continued the older traditions. Those traditions, however,

were modified by several factors—the introduction of the Adamesque style, Neoclassicism, the arrival of several famous pieces of sculpture from European studios, and the immigration of a host of European sculptors and stonecutters. The latter were induced to try their fortunes in the new nation by the large numbers of new, monumental buildings being built, many of which required sculptural adornment, or at least architectural decoration in the classical mode.

SAMUEL McINTIRE AND THE SKILLINS

PROVINCIAL CHARM

Several examples of Samuel McIntire's carving have already been seen in the interior of the Gardner-Pingree House (Fig. 8.8) and on an armchair and a chest-on-chest (Figs. 9.1 and 9.3).

McIntire did not do much figurative carving, but in the versatile manner of the master of an artisan-carver's shop, he did a variety of things that fell within his skills. An example is *Governor John Winthrop*, which he executed for the Rev. William Bentley, from a miniature portrait provided by Bentley (Fig. 12.1). The bust shows an uncertainty in the carving of the human figure—here, McIntire was untrained and had practically no examples from which to learn. His translation from a two-dimensional model—the miniature—to a three-dimensional bust is naïve and simplistic in terms of sculptural form, as well as in its suggestion of textures, such as flesh, hair, and fabrics.

That sculptures executed in the provincial woodcarver's style could have vigor and charm is demonstrated in the work of the brothers John and Simeon Skillin (see p. 118). The two maintained a large and prolific shop in Boston near the wharves, where they, too, supplied a variety of carved objects, including shopsigns, ships' figureheads, garden ornaments, and decorative pieces for furniture and architecture. Many of the stylistic features found in McIntire's *Winthrop* are also present in the Skillins' work, for example, their wooden statue of *Hope*, which was painted light

12.1 Samuel McIntire, *Governor John Winthrop*, 1798. Wood, height 16in (40.6cm). American Antiquarian Society, Worcester, Massachusetts.

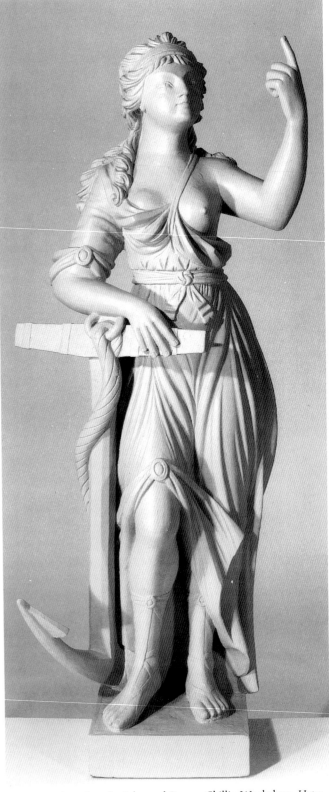

12.2 Attributed to the John and Simeon Skillin Workshop, *Hope*, 1790–1806. White pine, height 4ft 6in (1.37m). Courtesy Winterthur Museum, Winterthur, Delaware.

gray in imitation of marble neoclassical statues in Europe (Fig. 12.2).

In their representation of Hope, the Skillins followed traditional symbolism by showing a goddess pointing heavenward while leaning on an anchor. The style has an artisan naïveté, but there is a truthful woodenness about it, indicating a symbiosis between the craftsman, his tools, and his medium.

12.3 Attributed to the John and Simeon Skillin Workshop, *Agriculture, Liberty, and Plenty*, on a chest-on-chest made by Stephen Badlam, 1791. Mahogany, pine, 101½ × 51½ × 23⅜in (257.8 × 130.8 × 59.4cm). Yale University Art Gallery, New Haven, Connecticut.

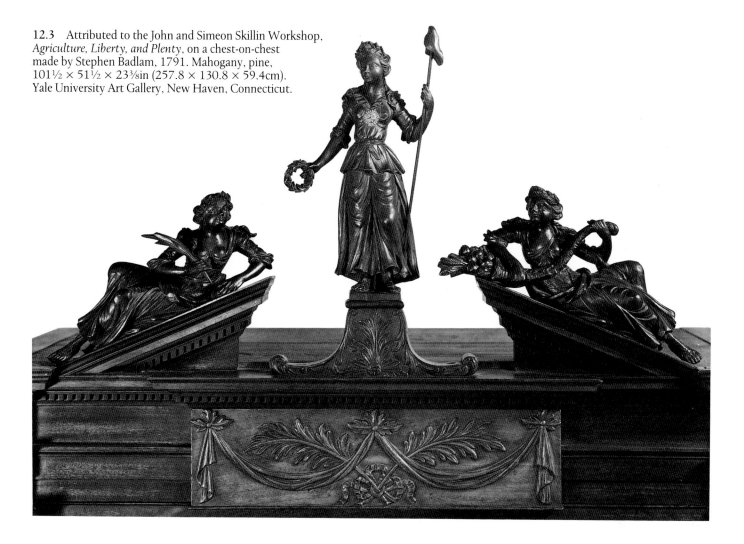

FIGURAL SCULPTURE

One place where the new figural sculptures began to appear was in the formal gardens of the fine homes built during the Federal period. These followed the precedent of statuary in Italian, French, and English gardens. The Salem merchant Elias Hasket Derby had the Skillins carve several figures for his summer house in Danvers. Among these was a *Reaper*, a *Shepherdess*, a *Pomona*, and also a *Hermit*.

Similar in style to the *Hope* are the figures of Agriculture, Liberty, and Plenty that the Skillins carved for a chest-on-chest made by Stephen Badlam for Elias Hasket Derby (Fig. 12.3). The central figure resembles a standard representation of Virtue, with a sunburst on her chest and a wreath in her hair. But she also carries a laurel wreath, symbol of victory, and a staff with a Phrygian "freedom" cap on it, transforming her into a personification of America. The reclining figure at the left holds a palm branch, traditional symbol of peace, while her counterpart at the right, with a wreath of wheat or corn in her hair and a cornucopia in her hands, is an image of abundance.

At the same time they were supplying the decorations for this handsome piece of furniture, the Skillins were also carving a masthead, quarter rails, tailboards, and other ornamentations for one of Derby's new merchant ships. Also around this time, on commission from Charles Bulfinch the Skillin shop carved thirty-two elaborate Corinthian capitals for the new State House (Fig. 8.11) being erected in Boston.

SCULPTURE IN NEOCLASSICAL PHILADELPHIA

The new type of neoclassical architecture being erected in Philadelphia created a demand for sculptural enrichment. This is seen in the beautifully carved Corinthian capitals and the pediment of the First Bank of the United States (Fig. 8.15). The pedimental relief shows an American eagle with shield, laurel branch, and arrows, plus an oak bough and a cornucopia. Carved of wood and painted light gray, in imitation of stone, it was executed by Clodius F. Legrand and Sons, who had a woodcarving and stonecutting shop in Philadelphia. The central motif is derived from the Great Seal of the United States, while the horn-of-plenty refers to American abundance, and the oak tree is a symbol of American strength.

SCULPTORS FROM EUROPE

JEAN ANTOINE HOUDON

The potential for sculpture that the Federal period created soon attracted the attention of a great number of French, English, and Italian sculptors. Jean Antoine Houdon (1741–1828)—the most famous sculptor in Europe, who had produced handsome busts of Jefferson and Benjamin Franklin—left his busy Paris atelier in 1785 in order to model the likeness of George Washington, who was by then an international celebrity. Through Jefferson's recommendation, Houdon had been commissioned to make a marble statue of Washington for the rotunda of the new Virginia State Capitol in Richmond (Fig. 8.1). Houdon spent two weeks at Mount Vernon modeling a bust and making notations about Washington's physical form before returning to Paris, where the statue was completed (Fig. 12.4). The Washington statue is a sophisticated blending of Houdon's Rococo elegance with the dignity of the new Neoclassicism.

Washington preferred to be represented in his uniform rather than in a toga—as was then common practice—but the symbolism of the piece is nevertheless neoclassical. Washington's hand rests on a walking stick, not his sword, which has been hung on the side of the fasces (the bundle of thirteen rods which, though individually weak, become strong when joined together—a wellknown Roman form). Behind the figure is a plow. This symbol compares Washington to Cincinnatus (active in the fifth century B.C.), a Roman soldier who gave up his military command to return to the peaceful pursuits of his farm. Just under Washington's waistcoat is the badge of the Society of the Cincinnati, a fraternal order founded in 1783 by the officers of the Continental Army, who were disbanding to return to their peacetime occupations. It is typical they should choose a hero of ancient republican Rome as their model.

GIUSEPPE CERACCHI AND ITALIAN INFLUENCE

With Giuseppe Ceracchi (1751–1802), who came to America in 1791, began an influx of Italian sculptors. Their work here greatly increased both the total amount of sculpture in

12.4 Jean Antoine Houdon, *George Washington*, 1788. Marble, lifesize. Virginia State Capitol, Richmond.

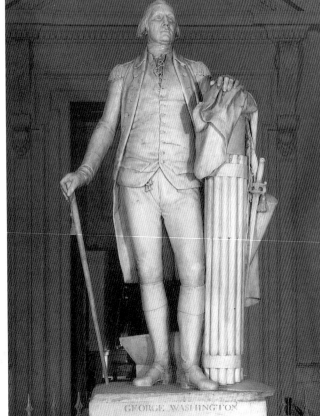

12.5 Giuseppe Ceracchi, *George Clinton*, c. 1792. Terracotta, height 27½in (69.9cm). Courtesy The New-York Historical Society, New York City.

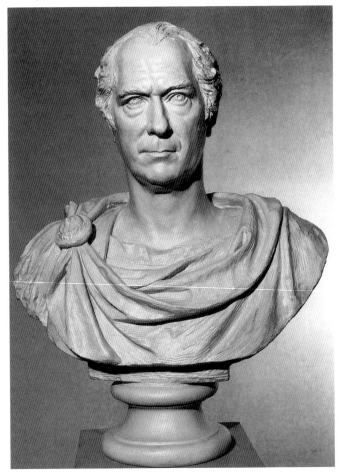

America and Americans' awareness of it as an artform. Ceracchi was trained in Rome and then worked in London for a while, executing sculptural designs for the architects Robert Adam and William Chambers. That he was a gifted sculptor is evident in his portrait of *George Clinton* (Fig. **12.5**). Equally evident is the neoclassical style. Ceracchi represented Clinton in the attire of a noble Roman, with the naturalism of ancient Roman portraiture. The modeling is rich, bold, and confident. A comparison with McIntire's little wooden bust of Winthrop (Fig. **12.1**) reveals the differences between the work of a sculptor trained in Europe, and the efforts of an American artisan-carver. Although Ceracchi returned to Europe in 1795, a host of his fellow-countrymen followed him to America to work at the new Capitol in the District of Columbia.

Benjamin Henry Latrobe, the architect of the Capitol, imported two Italian stonecarvers, Giuseppe Franzoni (d. 1815) and Giovanni Andrea (1770–1824), to execute the ornamental work on the building—capitals, cornice moldings, and the like. It was during Latrobe's tenure that another Italian sculptor, Francesco Iardella (1793–1831), carved the famous tobacco leaf capitals, around 1815 (Fig. **8.22**).

By about 1825, when Charles Bulfinch was serving as architect, there was a need for sculptors who could supply the stone figures for the interior and exterior of the Capitol. For the central pediment of the east façade, Luigi Persico (1791–1860), who had arrived from Naples in 1818, created the group of three goddesses. America is seen in the middle with her spear and shield resting on a pedestal inscribed 4 July 1776, while an eagle stands vigilant at her side. Justice, at the left, holds the scales and a scroll that reads "Constitution, 17 September 1787." Hope is on the right with her anchor (Fig. **12.6**). Persico also executed the figures representing War and Peace (1829–35), which stand in niches just beyond the great central portico, and the Discovery Group (1844) shown on the left blocking in Figure **12.6**, which has long been consigned to storage.

12.6 Luigi Persico, Pedimental group of Justice, America, and Hope, 1828; Luigi Persico, Discovery Group on left blocking, 1844; Horatio Greenough, Rescue Group on right blocking, 1837–52. Central pavilion, East Front, United States Capitol, Washington, D.C.

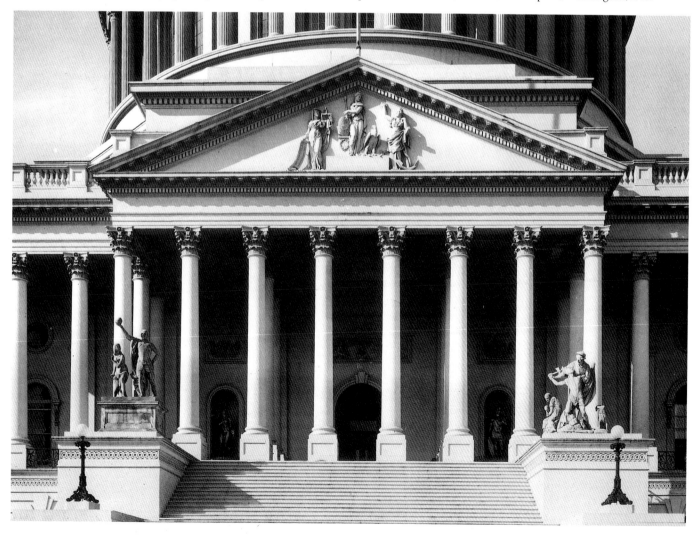

12.7 Enrico Causici, *Liberty*, 1825. Plaster. Executed for the Old House of Representatives, United States Capitol, Washington, D.C.

Inside the Capitol, another Italian immigrant sculptor, Enrico Causici (active 1822–32), made the ponderous and archetypally neoclassical image of Liberty in the form of Athena. Liberty is valiantly guarded by a powerful eagle, while a serpent protects the fasces, symbolizing the union of the States (Fig. 12.7). This figure stands above the cornice over the spot where the Speaker presided in the old House of Representatives (now Statuary Hall), and the lower portion of it may be seen in Morse's painting of that chamber (Fig. 10.20). Watching these and other neoclassical sculptures taking their places on the new Capitol and other federal buildings, Americans became increasingly aware of the art of sculpture—and how different it is from the craft of carving.

WILLIAM RUSH

The impact that this continuing importation of foreign sculpture and sculptors had on American art is seen in the work of an American-born woodcarver of the craft tradition, William Rush (1756–1833).

Rush was trained in the use of mallet and chisel by his father, a ship's carpenter in Philadelphia. After serving as an officer in the American army during the Revolution, Rush established his own carver's shop in the Quaker City. He was particularly successful as a maker of ships' figureheads. Soon after the turn of the century, Rush showed an interest in art of a higher form than that of the artisan tradition. In 1805, for example, he was one of the founders of the Pennsylvania Academy of the Fine Arts, joining with Charles Willson Peale and others to do so. He comes into focus in about 1808 through his earliest surviving work.

OUTDOOR PUBLIC SCULPTURE

Latrobe had just designed the New Theater on Chestnut Street in Philadelphia. For the niches of its façade he commissioned William Rush to carve statues representing theatrical personifications of *Comedy* and *Tragedy* (Fig. 12.8).

The face of *Tragedy* shows an expression of anguish, as she is about to drink from the cup of poison she holds. But while her figure has a Baroque grandeur and monumentality, there remains something of the form of a ship's figurehead about her. There is a vigor in her form and the sculpted folds of her drapery that seems antithetical to the restraint usually associated with Neoclassicism. In *Tragedy* and *Comedy*, however, Rush demonstrated he could make the transition from a craftsman-woodcarver to high-style sculptor.

Rush's *Water Nymph and Bittern*, executed for another of Latrobe's Philadelphia projects, was also created as a piece of outdoor public sculpture—something that was new to Americans (Fig. 12.9). Like *Tragedy*, it was carved in wood, and painted white in imitation of the marble used by Italian neoclassical sculptors. The original of the *Water Nymph and Bittern* was placed in the center of a fountain, as seen in Krimmel's painting *Fourth of July in Center Square, Philadelphia* (Fig. 11.6). Unfortunately, the constant spray of water soon caused the wood to rot, and the statue survives only in a bronze cast that was made in the mid-nineteenth century.

The figure of Rush's *Nymph* is animated, and her gown clings to her form in a revealing manner—a bit too revealing, in fact, for some, who were shocked and critical of the effect. It, too, represents an American-born woodcarver's response to Neoclassicism, and in the end it belongs partly to the provincial craft tradition, and partly to the international neoclassical style.

12.8 (opposite) William Rush, *Tragedy*, 1808. Pine, 8ft 5½in × 3ft 5½in (2.58 × 1.05m). Philadelphia Museum of Art.

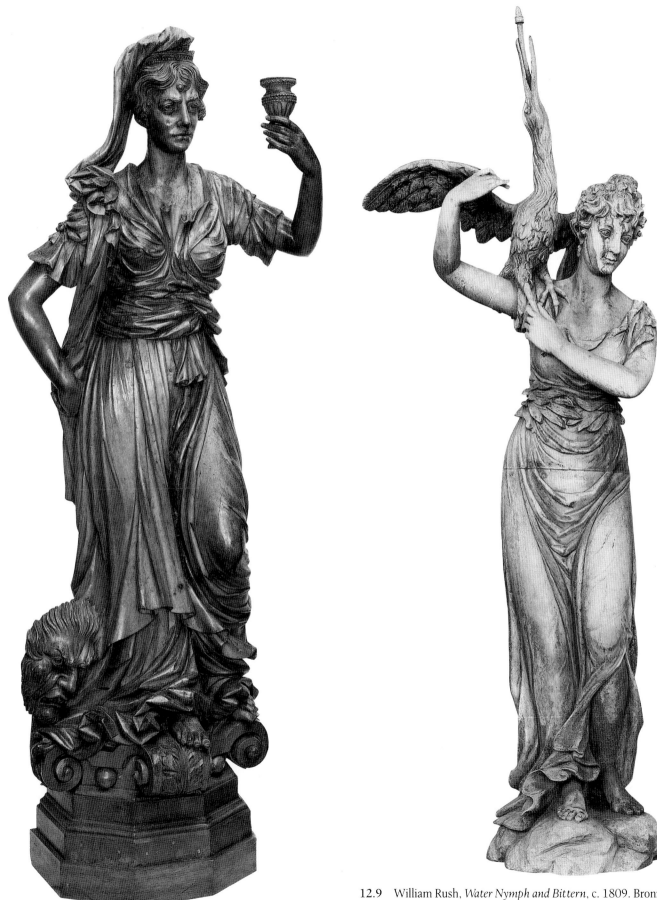

12.9 William Rush, *Water Nymph and Bittern*, c. 1809. Bronze replica of wooden original, height 7ft 7in (2.31m).

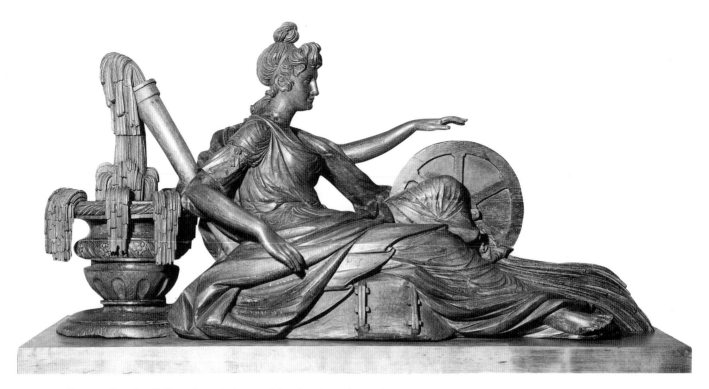

12.10 William Rush, *Schuylkill Freed*, c. 1828. Wood, height 3ft 6in (1.07m).

A CARVER BECOME SCULPTOR

By 1828, Rush, then seventy-four but still active as a sculptor, was a fully accepted member of the community of artists in Philadelphia. One significant factor that distinguished him from artisan-woodcarvers was modeling in clay, a technique unknown to the craftsmen who carved ships' figureheads and the like. In that pliable material Rush produced a number of excellent portrait busts. In 1828 he created two of his finest and most original public sculptures, for the Fairmount Water Works—the *Schuylkill Chained* and *Schuylkill Freed* (Fig. 12.10). These are allegorical figures in the mode of an ancient river god and goddess, respectively, but retaining something of the woodcarver's style. The *Schuylkill Freed*, with her lovely neoclassical profile, reminds one of Canova's *Pauline Bonaparte Borghese* (1807, Galleria Borghese, Rome). It is a classical personification that proclaims America's potential for the future. She commemorates the harnessing of a natural force—the Schuylkill River—by means of a pumping system (see p. 124).

The next generation of sculptors, led by Greenough, Powers, and Crawford, carried American sculpture well beyond the woodcarver tradition that still informed even Rush's late works like the *Schuylkill Freed*. They sought both a native mode of artistic expression and an accommodation with classical and other historic styles in order to express the forces that shaped America in the mid-nineteenth century.

Sculpture became a major artform in the Federal period. It emerged from its artisan-craftsman beginnings among stonecutters and woodcarvers, while drawing upon the talents of a host of European sculptors, who arrived to create images of the new nation's ideals and heroes. Their influence was great and longlasting. Their work gave American patrons and aspiring young sculptors their first real understanding of sculpture as artistic expression. Following the impetus of the Federal era, there emerged what may be called the first American school of sculpture (see chapter 18).

PART 3

The Romantic Period

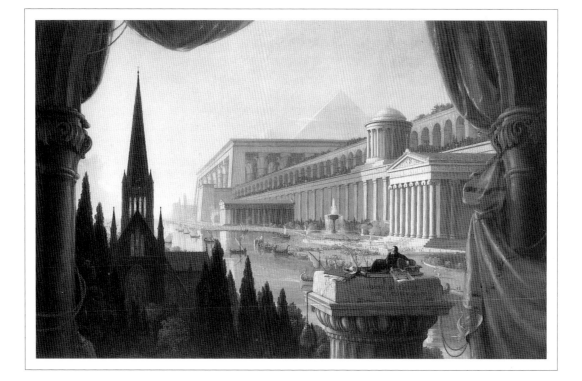

CHAPTER THIRTEEN

ARCHITECTURE:

THE AGE OF ROMANTICISM
AND ECLECTICISM, 1825-70

In the United States, the decades between 1830 and 1870 were dominated by four forces: The Industrial Revolution, the expansion westward to the Pacific Ocean, the rise of the common people, and the social, political, and economic factors that culminated in the Civil War. The emergence of "King Cotton," the growth of the railroads, immigration, and such social issues as women's rights, slavery, and the treatment of Native Americans were all part of these. It was a time of energy, invention, creativity, and accomplishment. The continent was spanned—by annexation, telegraph lines, railroads, wagontrains, and goldrushers. It was a time of hope for the hundreds of thousands of immigrants who fled Europe to come to the fabled Land of Opportunity.

It was also a time of trouble for the established order. Within a few years of each other, Marx's and Engels's *Communist Manifesto* (1848), Thoreau's *Civil Disobedience* (1849), and Darwin's *Origin of Species* (1859) appeared, all of which were read and debated in the United States.

Water and steam were harnessed to power the Industrial Revolution, so-called because of the complete change from hand production to factory manufacture. The factories were worked by laborers—men, women, and children. Now that they were being paid wages, they could afford to buy more goods than previously. Railroads carried those massproduced goods to virtually all parts of the country, and returned loaded with the fruits of an enormous harvest.

In the 1830s, the power knitting machine was perfected, and Erastus Bigelow invented the power loom for weaving carpets. In 1845, Lawrence, Massachusetts, was founded by a group of Boston capitalists. From the beginning, it was laid out as an industrial "company" town for the production of woolen goods. The Bostonians built not only the mills and the dams for power, but also workers' housing. The number of bales of cotton the plantations of the South shipped out increased to two million by 1850. Within a decade that amount had doubled to feed the machine-driven looms of Europe and America. In 1846, Elias Howe patented the sewing machine, which revolutionized sewing in the home as well as in the factory, especially with the improvements made by Isaac Merritt Singer in his versions in the years that

followed. In 1868, the typewriter was patented, and five years later the patent was sold to Philo Remington, who began producing typewriters in the factory where his father had manufactured firearms.

By 1839, Charles Goodyear had developed a process for vulcanizing rubber, and a few years later Stuart Perry invented the gasoline engine. Drilling a well in western Pennsylvania in 1859, Edwin L. Drake struck oil instead of water, and the modern petroleum industry began. By 1865, John D. Rockefeller had begun to organize an oil-refining company in Cleveland, which eventually became Standard Oil.

In 1848, a penniless boy of thirteen arrived in America from Scotland. Andrew Carnegie was to leave a public benefaction of $350,000,000, and establish nearly 3000 public libraries. In his lifetime his mills produced one-quarter of all the steel manufactured in America, and his company later became the foundation of United States Steel. The Bessemer process for converting iron into steel, first developed in Britain in 1856, was in use in America within a few years. American foundries were soon turning out an almost endless supply of iron rails for the railroads that were crisscrossing the expanding nation.

The railroads started modestly in the 1830s and 1840s, but by 1846 the Pennsylvania Railroad had been chartered, and five years later the Erie Railroad ran from New York City to Lake Erie. Also in 1851, Philadelphia was connected with Pittsburgh, and within a year there was a through train from the East Coast to Chicago. In 1856, the Iron Horse nosed across the Mississippi River, and a year later St. Louis and New York City markets were united by rail. Giants of the railroad industry made enormous fortunes with their entrepreneurship, their capital, and their inventions. George M. Pullman invented the sleepingcar in 1858, and later created a whole town, Pullman, outside Chicago, as a model industrial community for his factory workers. In 1868, improvements in refrigeration meant that meats butchered at the Chicago stockyards could be shipped to the markets of the East Coast. That same year, too, Philip D. Armour began packaging meats in Chicago. By then, Cornelius

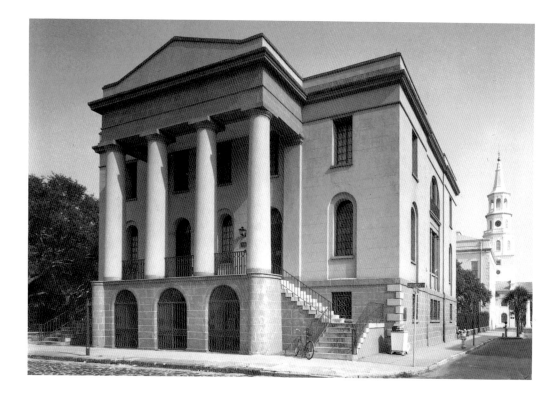

13.1 Robert Mills, County Records Building (Fireproof Building), Charleston, South Carolina, 1821–7.

Vanderbilt had gained control of the several railroad lines that connected New York City with Albany and Buffalo, forming the core of the New York Central system. Soon after, the great transcontinental railroad got underway. The Central Pacific joined the Union Pacific on 10 May 1869, at Promontory Point, Utah. The East and West Coasts—and the continent in between—were united (Fig. 25.1).

The nation was united in another way, too. In the days of the California goldrush, beginning in 1849, it took a minimum of eighty-nine days to make the trip by boat from New York City to San Francisco. The circuitous route went around Cape Horn at the lower tip of South America. But by 1861, a message could be flashed across the continent in hours, if not minutes, thanks to Samuel F. B. Morse's telegraph. He patented it in 1840 (Fig. 17.8), and within the decade, New York City and Chicago were connected by wire. By 1866 the Western Union Telegraph Company (organized in 1856) had over 75,000 miles (120,000 km) of line in operation, and was America's first big monopoly.

It was also an exciting and inventive period for the arts, which reflected or reacted against the mind-boggling changes happening in the nation. The period 1825 to 1870 produced an architecture that can only be described as romantic and eclectic. It was romantic in its search for historic styles that expressed national aspirations and in its use of picturesque forms to escape the harsh realities of the Industrial Revolution. It was eclectic in refusing to be restricted to a single style. With typically unbounded energy, a spectrum of **revival styles** was drawn forth, a notion that is given contemporary visualization in Thomas Cole's *The Architect's Dream* (Fig. 15.6). Architects adapted Greek, Roman, Gothic, Oriental, and Egyptian styles to suit American ambition, ideology, or institutions, as well as nationalistic, religious, or moral sentiments. The range reached from austere classicism to picturesque **Victorian**

"gingerbread." New technologies and materials—such as cast iron—were forced into old forms, as in the Romanlike dome of the enlarged U.S. Capitol (Fig. 13.13).

MILLS AND STRICKLAND: GREEK REVIVAL AND ROMAN GRANDEUR

Robert Mills (1781–1855), a native of South Carolina, went to Washington, D.C., in search of a career as an architect. There he attracted the attention of Thomas Jefferson, who recommended him to Benjamin Henry Latrobe (see p. 123). For six years, Mills served as Latrobe's assistant at the U.S. Capitol and on other projects. During this period (1803–9), he became devoted to a spare, even austere, architectural classicism, preferring Greek simplicity. He also acquired from Latrobe a sense of professionalism that included a knowledge of engineering.

In 1815, Mills settled in Baltimore, where he became that burgeoning city's leading architect of houses, mercantile buildings, monuments, and churches. All of these were characterized by a spartan monumentality and classical love of reasoned geometry. One of Mills's Baltimore projects was the Washington monument (1814–42), a massive Greek Doric column set upon a block base and crowned by the colossal bronze figure of George Washington, by the immigrant sculptor Enrico Causici (whose figure of Liberty was discussed in chapter 12). Mills also designed the Monumental Church in Richmond, Virginia (1812–7), which reflects the pure, geometric classicism of Latrobe.

The style that evolved during Mills's formative years is seen in the County Records Building, or Fireproof Building as it was called, in Charleston, South Carolina, to which he had moved in 1820 (Fig. 13.1). The building, a simple block form—remarkable for its almost total lack of

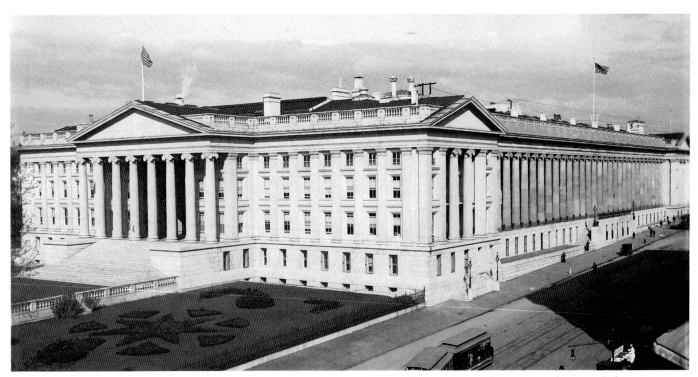

13.2 Robert Mills, United States Treasury Building (long colonnade façade at the side), 1836–42; Thomas U. Walter, Façade facing viewer, 1852, Washington, D.C.

ornamentation—has monumental porticoes on two sides, each composed of a massive Doric Order in which even the fluting on the columns is eliminated. A bold, continuous entablature unites all four sides. The plane of the wall is seldom violated, being interrupted only by windows or a slight recession. The entire edifice is dominated by precise forms, neat, sharp edges, and powerful masses. Classical motifs—arches, porticoes, entablatures—are reduced to abstract geometric forms. The design arises out of a comprehension of the spirit of classicism, rather than from an assemblage of classical details.

The Fireproof Building was constructed mainly of brick, the walls being covered with stucco. In an effort further to minimize the danger of fire, wood was replaced by cast iron wherever possible. The graceful arches of the windows are echoed in the interior by the gentle curves of the vaulted ceilings, constructed of brick. Mills's knowledge and command of vaulting here are noteworthy.

ROBERT MILLS IN WASHINGTON, D.C.

Attracted by the need for large governmental buildings, early in 1830 Mills moved to Washington, D.C. Probably more than anyone else, Mills established the architectural character of the great federal city. He designed, in monumental Doric style, the Patent Office Building (1836–40, 1849–51), which now houses the National Museum of American Art and the National Portrait Gallery. Then, in 1836, President Andrew Jackson assigned to Mills the design and construction of a Treasury Building. The result was a megalithic edifice of monumental classicism that set the style for federal architecture for over a century (Fig. 13.2). Mills also received the commission for the Post Office

Building (1839–42, now the International Trade Commission). It is a tribute to Mills's skill as an engineer, his knowledge of fireproofing, and his concept of enduring utility that these and other buildings survive to this day, and continue to be used.

In the Treasury Building, Mills proved himself a master of largescale design in the Greek Revival mode. The long façade is the work of Mills, while his rival, Thomas U. Walter, was responsible for the end section (Fig. 13.2). Mills's noble design is dominated by the vertical cadence of thirty monolithic Ionic columns. These are beautifully united by the strong horizontals of the full basement, and the powerful entablature and balustrade. The ends of the long façade are punctuated by pedimented pavilions. The sheer size of the structure presented a major problem in architectural design, but Mills's scheme is exquisitely, if deceptively, simple, allowing the bold beauty of classical forms to assert itself, and the rationalism of the classical aesthetic to prevail. The forms are sufficiently bold to permit decorative enrichment, as in the linear fluting of the columns and the reserved ornamentation of the capitals. Inside, **barrel-vaulted** corridors allow an efficient flow of traffic to the **groin-vaulted** offices.

Mills's penchant for simplicity is manifested in his design for the Washington Monument, which is based on the Egyptian **obelisk** form. The architect originally intended it to stand upon a circular base of a monumental Doric Order, but that was ultimately eliminated. Instead it was erected (1848–84) as a plain but elegantly simple form, towering to a height of 550 feet (168 m). Its graceful form, with a surface of beautiful white marble facing, punctuates one end of the Mall, a counterpoint to the Capitol at the opposite end.

GREEK TASTE

The Greek Revival in America spanned the years 1820 to 1845. It originated in Europe in the 1750s, with Stuart and Revett's famous trip to Greece, which culminated in the publication of the first volume of *Antiquities of Athens* in 1762. This spread the *gusto greco*—enthusiasm for things Greek—far and wide.

The little Doric temple that James Stuart (1715–88) designed for Hagley Park (1758, Worcestershire) is an early English example of Greek Revival architecture. Other landmarks of the style include the Brandenburg Gate (1789, Berlin) by Karl Gotthard Langhans (1781–1869), and the study for a monument to Frederick the Great (1796) by Friedrich Gilly (1772–1800).

From the design of chairs to the style of women's dresses, the Greek mode was enormously popular. In England, the connoisseur Thomas Hope published plates of items in the Greek fashion in his *Household Furniture and Interior Decoration* (London, 1807) and *Costume of the Ancients* (London, 1809). Americans identified strongly with the Greek cause when in the 1820s Greece fought to free itself from the Ottoman empire and Turkish despotism. The Greek War for Independence was associated with America's own valiant struggle of a few decades earlier. Americans also recognized in Greece the cradle of democracy and the fountainhead of learning, culture, and the arts. To design a chair or a building in the Greek mode was thus to pay allegiance to the democratic spirit, and to the timelessness of Western culture.

WILLIAM STRICKLAND AND THE SECOND BANK

William Strickland (1788–1854) contributed greatly to the rise of the Greek Revival style in America. The son of a carpenter who was employed in constructing the Bank of Pennsylvania in Philadelphia, young Strickland came to the attention of its designer, Benjamin Latrobe, who took the clever lad on as an assistant for three years.

In 1818, William Strickland's design won the competition for the Second Bank of the United States, in Philadelphia (Fig. 13.3). If Latrobe's Bank of Pennsylvania evoked Greek principles, Strickland's was the first American building to copy unabashedly Greek design.

No doubt Nicholas Biddle, wealthy president of the Second Bank, had much to do with the selection of a design in the Greek style. Educated in the classics, Biddle was one of few Americans to visit Greece, which he did in 1806. It was natural that he should favor a design for the Second Bank that was based on a Greek temple—just as he did for the design of his own home, Andalusia (Fig. 13.11).

For the façades, Strickland drew directly upon an engraved plate of the Parthenon in Stuart and Revett's *Antiquities of Athens*, employing the Doric Order to create **octastyle** porticoes. The colonnades along the sides of the Parthenon were replaced at the Second Bank by continuous, rather heavy walls. This was a Roman feature, but one which

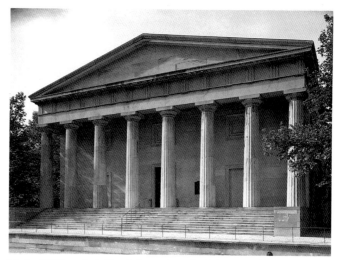

13.3 William Strickland, Second Bank of the United States, Philadelphia, Pennsylvania, 1818–24.

gave more space and allowed more light in the interior than the Greek model. An additional style, Roman, was introduced because it was expedient. Architects of the nineteenth century frequently sacrificed stylistic purity to create a hybrid of historic styles as a concession to contemporary and commercial requirements.

The success of the Second Bank brought Strickland a series of important commissions in the 1820s and 1830s for public buildings in Philadelphia. For the Merchants' Exchange, he again turned to the Greek mode (Fig. 13.4). Strickland believed a young architect need study nothing but the plates in *Antiquities of Athens*, which he himself constantly drew upon for inspiration. Among the plates he

13.4 William Strickland, Merchants' Exchange, Philadelphia, Pennsylvania, 1832–4. Wayne Andrews/Esto.

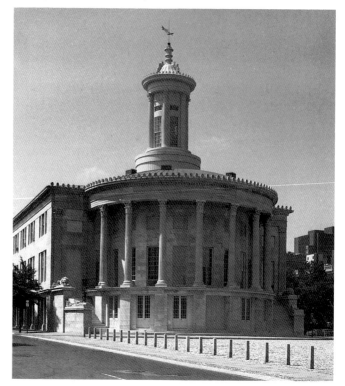

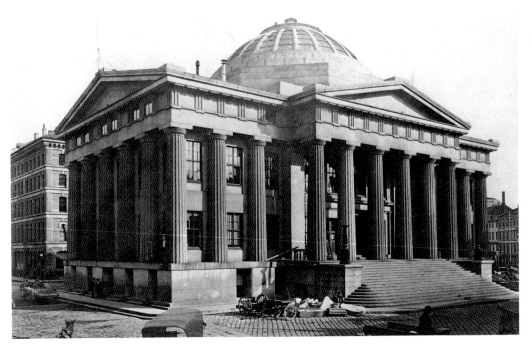

found a model for the elegant Corinthian columns that form a semicircular screen around the end of the Exchange, the entire structure sharing a continuous entablature. The cupola is based directly upon the plate illustrating the Choragic Monument of Lysicrates in Athens. Strickland so admired this ancient masterpiece that it served as his model for the cupola that crowned his Tennessee State Capitol (1845–59, Nashville).

SPREAD OF THE GREEK REVIVAL

The list of architects who gave breadth and depth to the Greek Revival is impressive, and many of the first generation of American-born professional architects worked in that style. Ammi Burnham Young (1798–1874), son of a New England carpenter, opened his office as an architect about 1830 in Burlington, Vermont, and established his reputation with several buildings on the Dartmouth College campus and the Vermont State House (1833–6) in Montpelier, the latter being in the Greek Doric style. Perhaps his most important building is the Customs House in Boston (1837–47), a ponderous example of the Doric Order (Fig. 13.5). Pediments at both ends and another over the portico of the main entrance are capped by a low Roman dome, and, except for those supporting the entablature of the portico, the massive columns are engaged in the Roman manner.

TOWN AND DAVIS

One of the most gifted exponents of the Greek Revival was Ithiel Town (1784–1844), who studied briefly under Asher Benjamin in Boston before opening his own office in New Haven, Connecticut, about 1813. For the next decade, he was often occupied with the designing and engineering of bridges, and in 1820 he received a patent for a bridge truss which soon made him wealthy. Town formed the finest private architectural library in the country, which eventually totaled over 11,000 volumes. He settled in New York City in 1825.

In 1829, Town was joined by Alexander Jackson Davis. The firm of Town and Davis was the first great and really successful architectural firm in America, although the partnership lasted only six years. In the early 1830s it produced some of the finest masterpieces of the Greek Revival. The North Carolina State Capitol (1833–42) at Raleigh has a beautiful Doric portico, but for utility's sake, Roman features are found in the mural (that is, wall rather than columnar) structural system and the dome over the central rotunda. The firm's reputation spread westward with the expanding nation—for example, Town and Davis designed the Indiana State Capitol (1831–5, destroyed) in Indianapolis, a long Doric temple with a central domed rotunda. With their Customs House (1833–42, now called Federal Hall) in New York, the influence of the Athenian Parthenon is seen once more, the design derived from a plate in *Antiquities of Athens* (Fig 13.6). Actually, the **peripteral** style of a single row of freestanding columns is found only on the two ends. Along the sides the columns are replaced by square piers, which do, however, maintain the rhythmic cadence of a row of columns. Within, there is a large rotunda with a low dome, but this inconsistency with Greek Doric design is not visible from the outside (Fig. 13.7).

Town and Davis designed residences as well as churches and commercial and governmental buildings. The Corinthian Order, with its handsome, richly ornate capitals, was adapted for use in La Grange Terrace, a series of nine

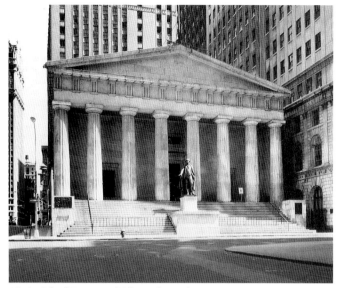

13.6 Ithiel Town and Alexander Jackson Davis, Customs House (later, Sub-Treasury Building, now Federal Hall National Memorial), New York City, 1833–42.

rowhouses in New York City, of which only four survive (Fig. **13.8**). A rusticated basement supports the grand colonnade above, with a vertical row of windows set in the **intercolumniations**; a superb vertical unity is thus achieved, while the bold cornice provides horizontal unity. La Grange Terrace is the domestic equivalent of the monumental scale of Mills's Treasury Building in Washington, D.C. (Fig. **13.2**).

Town and Davis provided Robert Gilmor, Jr. (Fig. **10.10**), with an asymmetrical Gothic design for his country home, Glen Ellen (1832–4) at Towson, Maryland. The firm created

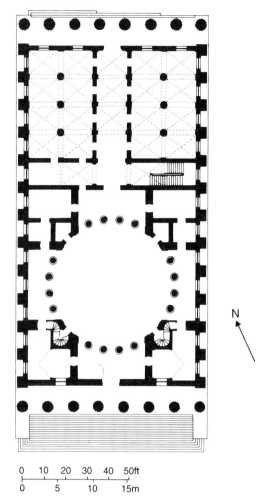

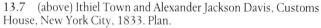

13.7 (above) Ithiel Town and Alexander Jackson Davis, Customs House, New York City, 1833. Plan.

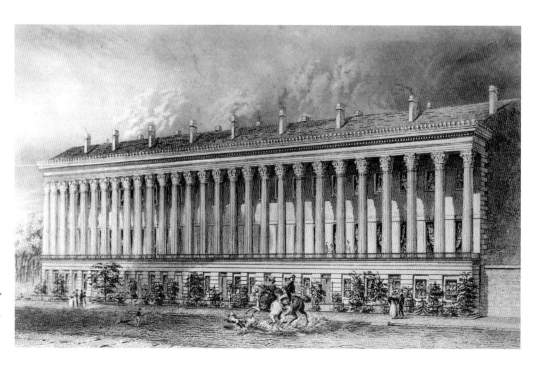

13.8 Ithiel Town, Alexander Jackson Davis, and James Dakin, La Grange Terrace, New York City, 1832. Engraving. Courtesy The New-York Historical Society, New York City.

another Gothic design for the New York University Building (1833–7), and it would be in the Gothic mode that A. J. Davis ultimately found his greatest fame.

GREEK REVIVAL IN THE SOUTH

The foremost characteristic of the southern antebellum mansion is the row of colossal two-story columns across the façade, or, more rarely, on all four sides. This same form had been used earlier, at Parlange (Fig. 8.24), for example, but there the slender columns suggest more a Caribbean origin than an association with ancient Greece. Auburn, built in Natchez, Mississippi, in 1812 after a design by Levi Weeks, is believed to be the first application of giant Greek columns to the façade of a southern mansion.

Oak Alley, in Vacherie, Louisiana, is an archetypal antebellum plantation house with a row of huge columns supporting a roof that shades the porches and galleries, on both the first and second floors (Fig. 13.9). An unknown architect designed the mansion about 1836 for the planter J. T. Roman, who had come from a distinguished Creole family. In the warm climate of the South, galleries and porches became important parts of the living space, and accordingly they became integral parts of the architectural form—that is, they are not just tacked on to the block of the house as an entrance portico might be in the North.

Henry Howard (1818–84), originally a carpenter and a native of County Cork, Ireland, arrived in New Orleans in 1837. The leading architects there at that time were James Dakin (1806–52) and James Gallier (1827–68), both of whom had earlier assisted Town and Davis. Howard studied briefly with Dakin. He was especially noted for his

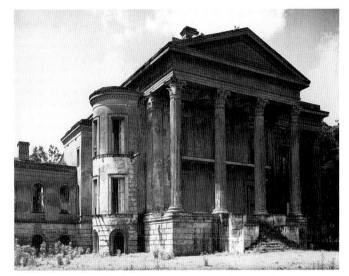

13.10 Henry Howard, Belle Grove, near White Castle, Louisiana, 1857 (burned 1952). Wayne Andrews/Esto.

handsome detailing, as seen at Belle Grove, which he designed in 1857 for the planter John Andrews (Fig. 13.10). Belle Grove, the ruins of which stand near White Castle, Louisiana, had an elegant entrance portico in the Corinthian Order. It stood amid beautifully planned gardens, and the interior was as resplendent as the exterior, the rooms filled with furnishings imported from Europe. Rooms in southern mansions tended to have high ceilings and tall windows so the heat of summer would rise well above the heads of those who lived in them, and for better circulation of air. Floor plans normally took such crossventilation into account.

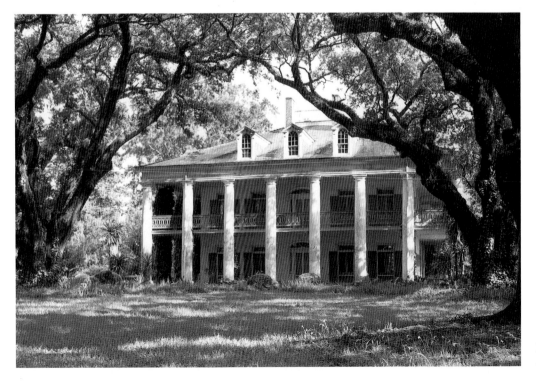

13.9 Oak Alley, Vacherie, Louisiana, c. 1936. Wayne Andrews/Esto.

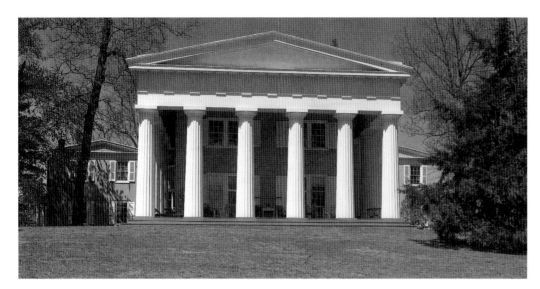

13.11 Thomas Ustick Walter, Andalusia, near Philadelphia, Pennsylvania, 1836. Wayne Andrews/Esto.

THOMAS USTICK WALTER AND THE GRECO-ROMAN REVIVAL

Returning north, one of the finest adaptations of the Greek style to domestic architecture is Andalusia, near Philadelphia (Fig. 13.11). The house was built in 1798 in the Federal style, but enlarged by Latrobe a few years later. When Nicholas Biddle acquired the house, his love of Greek culture led him to commission Thomas Ustick Walter (1804–87) to add a grand Doric portico to its façade. The design for Biddle's elegant home on the Delaware River, which became the center of the intellectual and social life of Philadelphia, was based on the six-columned Doric temple of Theseus at Athens. As president of the board of directors of Philadelphia's Girard College, and instrumental in the selection of Walter's design in the Greek mode for the institution's main building (Fig. 13.12), Biddle perhaps saw himself as a modernday Pericles.

Walter had been apprenticed to his father—a bricklayer and stonemason—during the time when his father worked on Strickland's Second Bank of the United States. Following a brief period in Strickland's office, Thomas attended the Franklin Institute, where he learned architectural design and engineering from John Haviland.

Walter began his career as an architect about 1830. His design for Girard College for Orphans was selected in a competition in 1833, and he achieved an immediate national reputation. Founders Hall, the main building,

13.12 Thomas Ustick Walter, Girard College, Philadelphia, Pennsylvania, 1834–6. Engraving by A. W. Graham. Free Library of Philadelphia.

13.13 United States Capitol, Washington, D.C., as enlarged by Thomas Ustick Walter, 1851–65.

unquestionably owes a debt to one of the finest statements of French Neoclassicism—La Madeleine, then being built in Paris. Its beautiful Corinthian Order is also derived from an engraved plate of the Choragic Monument in *Antiquities of Athens*.

With his design for the enlargement of the U.S. Capitol (1850), Walter demonstrated his ability to work in the monumental Roman style (Fig. 13.13). Bulfinch's old wooden dome over the rotunda of the Capitol (Fig. 17.6) was taken down and replaced with Walter's much larger one, to bring it into scale with the enormous House and Senate wings also being added in the mid-1850s.

The great dome was constructed of cast iron, after the manner used in Auguste Montferrand's St. Isaac's Cathedral (1818–58) in St. Petersburg. However, the new building material was forced into an old mold: Rather than allowing a new aesthetic and style to emerge from the new material, cast iron was given the shape of Roman architectural forms. Furthermore, it was painted gray in imitation of stone. While this was necessary to achieve continuity with the rest of the Capitol, elsewhere—in warehouses and commercial structures—cast iron was being allowed to dictate the design. It was those instances, not in the revival style such as the Capitol dome, that led the way to modern architecture. Nevertheless, with the addition of the House and Senate wings, and the dome's completion in 1865, the nation had a capitol that befitted its new role as a great power on the world stage—which the nation in part assumed, and in part had cast upon it in the decades following the Civil War.

GOTHIC REVIVAL

The Classical Revival served America well for the expression of certain ideologies, values, and ambitions. Other historic styles proved equally useful and expressive. The matter of appropriateness in the choice of one revival style over another was always a significant consideration. One of the most popular styles was the Gothic. The Gothic Revival began in England with Horace Walpole's Strawberry Hill (begun 1749, Twickenham), and William Beckford's Fonthill Abbey, designed by James Wyatt (1746–1813) in 1796.

The greatest example of the adaptation of Gothic Revival to governmental architecture is the Houses of Parliament (1840–60, London), designed by Sir Charles Barry (1795–1860). Gothic seemed appropriate, too, for college and university architecture. This was partly because many universities were founded in the late medieval period, and partly because of the precedent of such English institutions as the Oxford and Cambridge universities, where the Gothic style prevailed. In America, early expressions of this style appeared in Daniel Wadsworth's home, Montevideo (c. 1818, near Hartford, Connecticut). This was, however, little more than Gothic details applied to a clapboard house. More fully developed Gothic designs are found in Latrobe's alternate design for the Baltimore Cathedral (1804), in Maximilian Godefroy's (1765–1840?) Chapel (1807) for St. Mary's Seminary in Baltimore, and Strickland's Masonic Hall (1808–11, Philadelphia). The English influence was strong, and made its way into American Gothic Revival architecture through a number of publications. Among the most

important were three by A. W. N. Pugin: *Contrasts; Or, A Parallel Between the Noble Edifices of the Middle Ages and Similar Buildings of the Present Day* (1836), *The True Principles of Pointed or Christian Architecture...* (1841), and *Glossary of Ecclesiastical Ornament and Costume...* (1844), all published in London. Especially significant in providing a critical and theoretical foundation for the Gothic Revival were John Ruskin's *The Seven Lamps of Architecture* (1849) and *The Stones of Venice* (1851–3), published in London, but with early editions printed in America.

RICHARD UPJOHN AND TRINITY CHURCH

Richard Upjohn (1802–78) was an English-born cabinet-maker, who came to America in 1829. Within five years, he had established a modest practice as an architect in Boston. In the mid-1830s, Upjohn designed two Gothic Revival houses and a church (St. John's, Bangor, Maine). His first great opportunity came with Trinity Church in New York City (Fig. 13.14). In England, the Oxford movement and the Cambridge Camden Society were demanding religious reform. Upjohn firmly believed that Gothic was the true style for church architecture because it best expressed the religious sentiments of the time. In turning to a simplified

13.14 Richard Upjohn, Trinity Church, New York City, 1839–46.

version of the Gothic style, Upjohn was echoing the beliefs of reform. Clergy and laity alike were searching for an architecture that could be identified with the reform movement. Looking back upon the thirteenth century as a golden era of Christian piety, they adopted its architectural style—Gothic—as expressive of their own religious convictions.

Rather than referring to late medieval churches in England, Upjohn turned to contemporary books with illustrations of Gothic Revival forms. The tower, spire, and nave design of Trinity Church are derived directly from Pugin's *The True Principles of Pointed or Christian Architecture*, published in the year Upjohn drew his plans for Trinity.

Earlier attempts at the Gothic style in America had tended to be applications of Gothic decoration to the walls of box-shaped buildings. With Trinity Church, Upjohn sought the essence of the Gothic style, modifying it to suit nineteenth-century needs. Built in brownstone, it has a single great tower with spire at one end, and squared-off chancel at the other. These are both features typical of English—as opposed to Continental—Gothic churches of the thirteenth century. The pointed arch is used throughout, and the enormous windows of the side aisles and the **clerestory** above the nave are composed of tracery and stained glass. Wall buttresses between the windows end in **crocketed** finials, and **castellation** decorates the roofline. There is, however, more to Trinity than an accumulation of Gothic details, for Upjohn imposed an order and a simplicity upon the design that is typical of his version of the Gothic. For

13.15 Richard Upjohn, Trinity Church, Warsaw, New York, 1854.

example, each unit, or bay, of the nave is beautifully defined by pairs of wall buttresses and the window between.

Trinity was an excellent solution for a church in New York City, but it was too large, too expensive, and too pretentious for small, rural parishes, which wanted churches that expressed the same religious sentiments as Trinity. Upjohn's solution was the lovely edifice, also called Trinity Church, which he produced for the Episcopalian community in Warsaw, New York (Fig. **13.15**). The tower and spire placed to one side give it an asymmetrical, picturesque quality, while the pointed arch and the steep pitch of the roof lend essential Gothic character. The building is constructed of wood. That Upjohn created an enduring form is demonstrated by its appearance in the house in Grant Wood's famous painting of 1930, *American Gothic* (Fig. **29.20**).

JAMES RENWICK: CHURCHES AND MUSEUMS

Another architect who gave exquisite expression to the Gothic Revival style in America was James Renwick (1818–95). Renwick was trained as an engineer, but acquired a knowledge of architecture while still a young man. Well-connected socially, and extraordinarily gifted, his rise to success was swift: at the age of twenty-four, with hardly any previous architectural work to his credit, he was awarded the important commission for Grace Church in New York City. Adjoining the church he built the Rectory (1847), an ecclesiastical palace that demonstrates a thorough understanding of Gothic form and ornamentation.

One of the crowning achievements of the Gothic Revival in America is Renwick's St. Patrick's Cathedral in New York City (1853–8; Fig. **13.16**). As a Roman Catholic edifice,

13.16 James Renwick, St. Patrick's Cathedral, New York City, 1853–8.

13.17 James Renwick, The Smithsonian Institution, Washington, D.C., 1847–55.

it was appropriately based on famous French examples such as the cathedrals at Amiens and Reims. Renwick's St. Patrick's is thoroughly and consciously French, with three façade portals leading into the nave and side aisles, a great rose window above the central portal, and twin towers giving rise to elaborately decorated spires. Inside, however, the ceiling over the nave recalls the intricate patterns of the ribbed vaults of English churches like Exeter Cathedral or Westminster Abbey.

Renwick also designed the building to house the Smithsonian Institution in Washington, D.C. (Fig. **13.17**). This richly picturesque mass, which rises so darkly upon the great Mall in marked contrast to the white classicism of the Capitol, is more Romanesque Revival than Gothic. Both Upjohn and Renwick appreciated the bold, expressive powers of the Romanesque style, and used it frequently. Romanesque was the style which preceded the Gothic movement in Europe in the eleventh and twelfth centuries. The simplicity of its forms, its powerful masses, adaptability, and possibilities for picturesque interpretation made it appealing to the eclectic spirit. The brownstone form of the Smithsonian—which was carefully planned for use as an exhibition area, library, research center, and repository—rises like a latterday medieval castle that has grown over the ages in stages, with a tower appended here and a wing randomly attached there. The Romanesque style also lent itself beautifully to church architecture. Both Upjohn and Renwick used it, Upjohn in Bowdoin College Chapel (1845–55, Brunswick, Maine), and Renwick in St. Bartholomew's Church (1871–2, New York City).

ALEXANDER JACKSON DAVIS: RURAL RESIDENCES

Alexander Jackson Davis (1803–92) had an enormous influence on the development of the Gothic Revival, particularly in the popularization of the picturesque Gothic cottage. Davis began his career in New York City as an artist specializing in beautiful watercolor "portraits" of buildings. This led him into architectural design, and by 1829 he had joined Ithiel Town in partnership. The next six years saw the creation of several edifices in the Gothic Revival style, as mentioned earlier.

After the firm of Town and Davis broke up in 1835, Davis turned his attention to developing the picturesque suburban cottage. He is best remembered for quaint houses like the Henry Delamater Residence (1844; Fig. **13.18**), and the William Rotch House (1845, New Bedford, Massachusetts). Davis was strongly influenced by the English theory of the picturesque, which in architecture meant irregularity, roughness, natural materials, and the use of medieval decoration.

The Delamater Residence has the steeply pitched Gothic gable and vertical emphasis in the board-and-batten siding which suggests rustic simplicity, as opposed to urban sophistication. A large verandah and bay window contribute

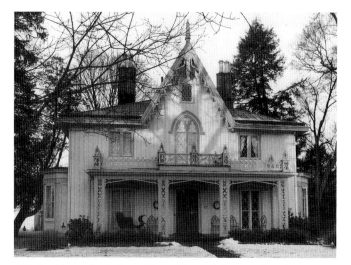

13.18 Alexander Jackson Davis, Henry Delamater Residence, Rhinebeck, New York, 1844.

to the irregularity of form, with ornate Gothic ornamentation on the vergeboard of the gable, and on the posts and balustrade of the porch. Even the tall chimneypots contribute to the picturesque, romantically medieval appearance, as does the pointed arch with tracery in the center window above the verandah. Davis supplied the designs for all parts of the house, including the elaborate Gothic details, and the house was then built by local carpenters. The invention of the scroll-saw permitted the intricate cutout pieces characteristic of Victorian Gothic gingerbread.

Davis claimed that the classical revival styles were inappropriate for countryhouses, as he explained in his influential book, *Rural Residences* (New York, 1837). This contained many illustrations of houses similar to the Delamater Residence, and also of rustic churches and schoolhouses. A few years later, when Andrew Jackson Downing published *A Treatise on...Landscape Gardening Adapted to North America...With Remarks on Rural Architecture* (New York, 1841), Davis provided illustrations of several countryhouses. These books popularized the country cottage, and the concept of the picturesque throughout America. Many of Davis's ideas were used in the 1850s on a large scale in one of the earliest suburban developments in the United States: Llewellyn Park in West Orange, New Jersey. This was a residential park that sought a unification of nature and architecture. Wealthy Americans at this time were taking to the country to escape the blight and social woes of the Industrial Revolution. For this, the architecture of Davis and the landscape design of Downing were the perfect antidote.

One of Davis's greatest houses is Lyndhurst, in Tarrytown, New York, begun in 1838 as a modest Gothic villa for General William Paulding. Lovely watercolor elevations of this early structure are preserved in the Metropolitan Museum of Art. In 1865–7 the cottage was greatly enlarged to the medieval-castle form we know today. A great, keeplike

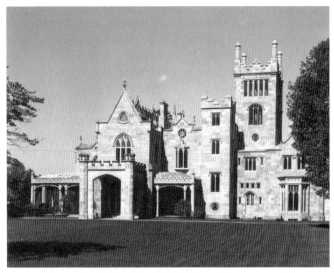

13.19 Alexander Jackson Davis, Lyndhurst, Tarrytown, New York, 1838 and 1865–7. A property of the National Trust for Historic Preservation.

tower is the main focal point (Fig. **13.19**). Davis may have been influenced by the English collegiate style, as the house resembles one illustrated in Davis's *Rural Residences* labeled "A Residence in the English Collegiate Style." Numerous colleges soon adopted this style which was based on Oxford and Cambridge models.

Inside Lyndhurst, many of the rooms are like medieval halls, and the stained glass windows further contribute to a Gothic ambience. In the dining room (Fig. **13.20**), Davis created a rich, Gothic décor that is augmented by Gothic Revival furniture, some of which Davis designed himself (Fig. **14.5**). Like a mid-nineteenth-century recreation of Walpole's library (Strawberry Hill, England), there is wood paneling wrought in designs of the pointed arch with tracery, as well as exposed rib-beams resting on corbels, Gothic niches, and a Gothic fireplace. Lyndhurst was eventually acquired in 1880 by railroad and financial tycoon Jay Gould. As one of the great speculators and capitalists of the Industrial Revolution, he perhaps found it to be the perfect escape from the realities of the world in which he moved.

13.20 Alexander Jackson Davis, Lyndhurst, Tarrytown, c. 1864. Interior, dining room.

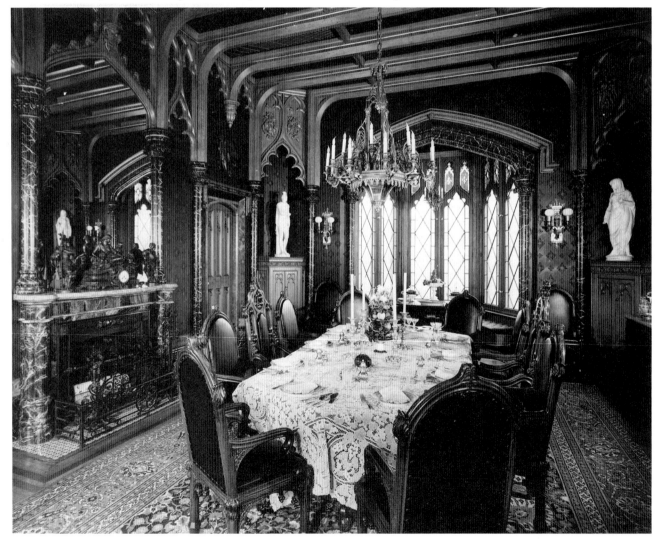

ANDREW JACKSON DOWNING: FIRST LANDSCAPE ARCHITECT

Andrew Jackson Downing (1815–52) was one of the most influential men of his day in changing urban and suburban environments. America's first professional landscape architect, Downing is the father of the park movement. His treatises touched upon projects from town planning to rural cemeteries, and from national parks to Central Park in New York City.

Downing published several books that helped to popularize the Gothic cottage and its picturesque landscape environment. Among the most important were *Cottage Residences* (1842) and *The Architecture of Country Houses* (1850). The plates of the books gave elevations, plans, and designs for Gothic details that could be copied by any carpenter. The result was what has come to be called "carpenter Gothic."

Sometimes, an older house was "modernized" in the Gothic vogue, as in the Wedding Cake House in Kennebunk, Maine (Fig. **13.21**). The original structure was a rather plain Federal-style brick house, built about 1800, and modernized around 1850 by a profuse application of Gothic ornamentation wrought of wood. Sunnyside, the residence of Washington Irving (Tarrytown, New York), displays the

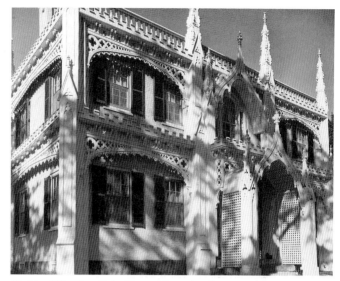

13.21 Wedding Cake House, Kennebunk, Maine, c. 1800. Wayne Andrews/Esto.

rustic and picturesque aesthetic advocated in Downing's publications (Fig. **13.22**). Irving bought the seventeenth-century Dutch farmhouse, originally called "Wolfert's Roost," in 1832, and hired Town and Davis to remodel it.

13.22 Sunnyside, Tarrytown, New York, 1832. Courtesy Historic Hudson Valley, Tarrytown, New York.

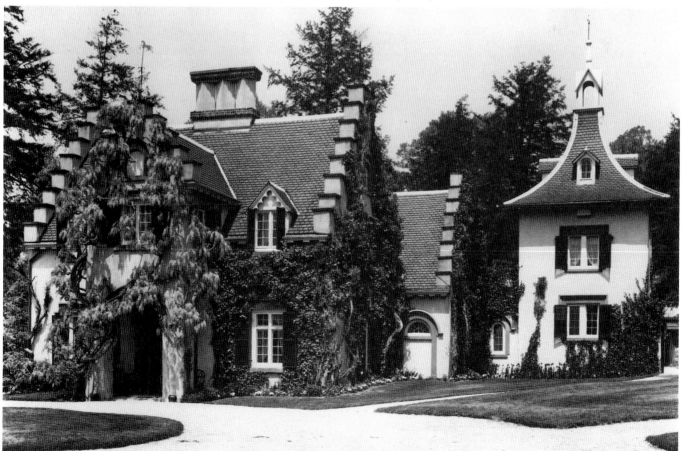

Irving had spent four days in Scotland with the novelist Sir Walter Scott, and was caught up in the passion for the Gothic mode. The steep gables, tall chimneypots, and Gothic ornamentation of Sunnyside were meant to evoke a Romantic vision of a time long past, which was thought to be simpler, and somehow better.

ITALIAN VILLAS, EGYPTIAN TEMPLES, MOORISH PALACES

Downing's *Cottage Residences* included views and plans for another type of house that became very popular—the Italian villa (Fig. **13.23**). In the 1840s and 1850s, the Italian villa style was probably used more than any other by America's

13.23 A Villa in the Italian Style, Bracketed. From Andrew Jackson Downing, *Cottage Residences* (1842), Figs. 48 and 49. Morris Library, University of Delaware, Newark, Delaware.

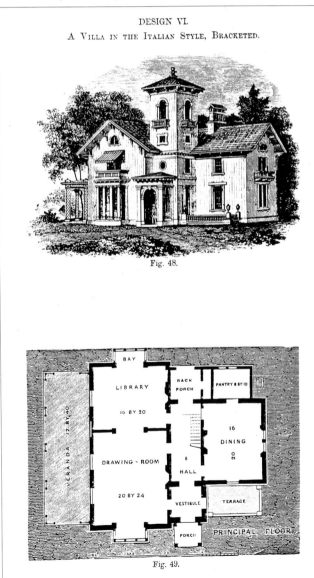

wealthiest citizens. As Downing said, it seemed to express a domestic dignity and an aura of culture, the latter because of its association with Renaissance Italy. As he noted: "The Italian mode is capable of displaying a rich domestic character in its balconies, verandahs, ornamental porches, terraces, etc. The square tower, or *campanile*, is a prominent feature in villas of this style.... The projecting roof and the round-arched window are also characteristic features."[1]

Victoria Mansion Downing's words describe perfectly one of the finest surviving examples of the Italian villa—Victoria Mansion (Fig. **13.24**). The tall, square tower, one of the distinguishing features of the house, was strictly for picturesque purposes, serving no real function except that, as Downing declared in his book, from its upper story, "an extensive prospect of the country for miles around is enjoyed." Downing's version was intended for the country and was to be built of wood, but Victoria Mansion is an urban example constructed of brownstone. The other features Downing described are also found here—great overhanging eaves supported by brackets, verandahs, round-headed windows, ornamental porches. In addition, the architect Henry Austin enriched the design with handsome moldings on the window pediments, decorative brackets, finely carved classical details of the Ionic columns, rich quoining, and balustrades on the verandah and steps.

Egyptian Temples Henry Austin (1804–91) began his career as a carpenter in Connecticut before working for Ithiel Town in the 1820s, and in 1837 establishing an office in New Haven. Like most architects of this era, Austin designed in a variety of historic styles: small houses in the Greek mode, a library (1842–5) for Yale College in the Gothic manner, and Victoria Mansion in the Italian-villa style. Austin also contributed to the emergence of exotic styles through his Egyptian Revival design for the entrance to Grove Street Cemetery (Fig. **13.25**). Its sloping walls and cavetto (hollowed out in a quarter-circle shape) cornice remind one of the great **pylons** that stand before Egyptian temples, and the columns are nineteenth-century interpretations of the type found in **hypostyle halls** at Luxor on the banks of the Nile. Austin may well have studied engraved plates of Egyptian antiquities, where he would have found motifs such as the symbol of Ra, the sun god, with its disk of the sun, hawk wings, and cobras, protectors of the pharaoh, seen in the cornice.

The Egyptian mode became popular immediately following Napoleon's campaign into Egypt in 1798, and Egyptian motifs were often used in the decorative arts during his reign as emperor (1804–14). From the initial expedition came Denon's *Voyage dans la Basse et la Haute Egypte* (Paris, 1802), which contained 142 engraved plates. The official document of the expedition, *Description de l'Egypte...* (1809–29), consisted of ten volumes of text and fourteen volumes of plates. These and other such books spread the Egyptian fashion throughout Europe and America. Thomas

13.24 Henry Austin, Victoria Mansion (Morse-Libby House), Portland, Maine, 1859.

U. Walter used the Egyptian Revival style for the entrance to Philadelphia's Debtors' Prison (1832), as did Thomas S. Stewart in his design for the Medical College Building (1844) in Richmond, Virginia. It soon appeared on American store-fronts, in fireplace mantels, and in many other places.

Cemeteries Because of the ancient Egyptian preoccupation with tombs and the next life, the Egyptian style was associated with death. It was therefore appropriate for entrances to cemeteries—in particular, rural ones, which were the result of the growth in population in cities, as more people were dying than could be buried within a church or its small burial ground. It was also discovered to be unhealthy to bury the dead close to the wells which supplied drinking water to the living.

The rural cemetery movement began in the late 1820s at Mount Auburn, a 72-acre (29-ha) site near Boston. By about 1845, an Egyptian Revival entrance had been erected there in granite, resembling the north and south portals of the great Temple of Karnak. There are numerous examples of the Egyptian mode in American burial grounds, ranging from the great granite sphinx (Mount Auburn Cemetery, Massachusetts) that Martin Milmore sculpted for the Bigelow Memorial in 1872, to the Woolworth Mausoleum (Woodlawn Cemetery, Bronx, New York)—which shows the style was still in vogue as late as 1919.

Mount Auburn began as a tract purchased by the Massachusetts Horticultural Society to be used as its experimental garden. The Society soon joined forces with the cemetery association because their goals were mutual. The concept of the cemetery was no longer of an urban churchyard filled with rows of perpendicular slabs, but of a rural garden, where winding paths offered to the living lovely vistas and

13.25 Henry Austin, Grove Street Cemetery entrance, New Haven, Connecticut, 1846.

tranquil nooks for contemplation. Handsome monuments and tombs in the Egyptian, classical, and Gothic styles united art, nature, and Christianity in a rural setting for the world-weary soul. As if it were a park rather than a cemetery, visitors were welcomed—families even brought picnic lunches, and spent the day. The parkland-like setting of Mount Auburn Cemetery can be seen in Thomas Chambers's contemporary view (Fig. 19.10). The rural cemetery movement spread rapidly—Greenwood Cemetery in Brooklyn, Laurel Hill in Philadelphia, Green Mount in Baltimore, Mount Hope in Rochester, New York, and the Albany Rural Cemetery are a few examples.

Churches and Prisons One author, writing in the *North American Review* (1836), referred to the Egyptian style as "the architecture of embalmed cats and deified crocodiles." Despite this opinion, the mode was deemed appropriate for several types of structures other than cemeteries—for example, churches and prisons. The major example of the latter is John Haviland's New York Halls of Justice (The Tombs) (Fig. 13.26). Haviland (1792–1852) was English-born, but by 1816 had settled in Philadelphia, which was the center of his activities for the rest of his career. His Franklin Institute (1826, Philadelphia; now the Atwater Kent Museum) was in the Greek Revival style. The building which established his reputation, however—Eastern State Penitentiary (1821–37, Philadelphia)—was castellated Gothic in design. The penitentiary was considered the last word in prison reform, as it provided each inmate with his own cell and exercise yard. Its radiating plan meant maximum surveillance with minimal guard force. Haviland's reputation brought him a number of commissions for prisons. For the New Jersey Penitentiary near Trenton (1833–6) he used the Egyptian style. His

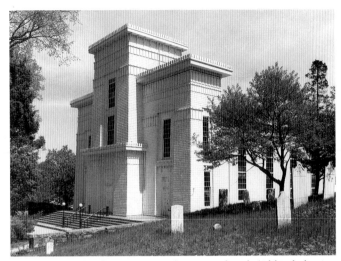

13.27 Minard Lafever, First Presbyterian Church (Old Whalers' Church), Sag Harbor, New York, 1844. Wayne Andrews/Esto.

bestknown example in that mode, however, is The Tombs. The façade has large windows trimmed in a decorative manner that recalls ancient Egyptian pylons, and the lotus columns of the entrance are reminiscent of the great hypostyle halls along the Nile.

The Egyptian style was also used for church architecture, as in the Old Whalers' Church (Fig. 13.27). Built of wood by ships' carpenters in 1843–4, the façade imitates the battered walls of Egyptian temple fronts in form and decoration. Its ornamentation has been Americanized, however, by the use of the blubberspade motif along the tops of cornices (appropriately, as Sag Harbor was a major whaling port). Old Whalers' was designed by Minard Lafever (1798–

13.26 John Haviland, New York Halls of Justice (The Tombs), New York City, 1835–6. Courtesy The New-York Historical Society, New York City.

1854), who usually worked in the classical or Gothic revival styles. For Old Whalers' Church he probably turned to the engraved plates in Denon's *Description de l'Egypte*. Lafever's design is pure eclecticism. While its façade is Egyptian, its interior is classical revival, and the tower that once rose above the central portion of the façade—destroyed by a hurricane in 1938—was English Baroque *à la* Wren, with a slight resemblance to the steeple of a Chinese pagoda.

A Moorish Mansion A superb example of exotica is found in Longwood, an Oriental villa near Natchez, Mississippi, which Samuel Sloan designed as an octagonal plantation mansion for a cotton planter just before the outbreak of the Civil War (Fig. 13.28). Sloan (1815–84), a Philadelphia architect, had published a fantasy design for an "Oriental Villa" in his book *The Model Architect* (Philadelphia, 1852), and in *Sloan's Homestead Architecture* (Philadelphia, 1861) he included illustrations of the plan and elevation of Longwood, with the comment that "Fancy dictated that the dome should be bulbiform—a remembrancer of Eastern

magnificence which few will judge misplaced as it looms up against the mellowed azure of a Southern sky." William Gilmore Simms, the contemporary southern novelist, once commented that the Moorish style was more appropriate for the South than the Greek or Gothic because of the similarity of climate. Alas, the outbreak of the Civil War halted work on Longwood itself, and when the cotton planter died in 1864 it was left uncompleted.

The passion for the exotic in architecture continued for a while after the Civil War—witness Frederic Church's Olana (Fig. 20.1). A. J. Downing observed that "with the passion for novelty, and the feeling of independence that belong to this country, our people seem determined to try everything."

The architecture of the mid-nineteenth century was Romantic, escapist, and as imaginative as it was eclectic and exotic. The people who fostered such edifices were as bold in their adventurous exploitation of historic styles as they were in inventing machines, building factories, or laying railways.

13.28 After a design by Samuel Sloan, Longwood, Natchez, Mississippi, 1860. Wayne Andrews/Esto.

CHAPTER FOURTEEN
DECORATIVE ARTS:
THE AGE OF ROMANTICISM
AND ECLECTICISM, 1800–70

The United States held a special fascination for European intellectuals. Many of them, who crossed the Atlantic to see its people, places, and institutions, were struck by what they judged to be a low level of culture. This became a national characteristic in their eyes, and they often wrote deprecating accounts of what they perceived to be American crudeness and coarseness. Frances Trollope, an English-woman who traveled about the United States between 1827 and 1831, mockingly described how, after the Revolution, the American government was formed and upon what principles:

> Their elders drew together and said, "Let us make a government that shall suit us all; let it be rude and rough, and noisy; let it not affect either dignity, glory, or splendour...; let every man have a hand in making the laws, and no man be troubled about keeping them...; if a man grow rich, let us take care that his grandson be poor, and then we shall all keep equal...."[1]

Trollope thoroughly berated Americans for what she claimed was their lack of culture, and gratuitously advised them that "individual sacrifices must be made, and national economy enlarged, before America can compete with the old world in taste, learning, and liberality."

Other visitors were similarly critical of the American way of life. Harriet Martineau, visiting from England, published *Society in America* in 1837, and the touring Frenchman Alexis de Tocqueville brought out *Democracy in America* in 1835. He observed how a democratic form of government that seeks equality also reduces culture to the commonplace, which has a profound impact on the arts: "The number of consumers increases, but the opulent and fastidious consumers become more scarce..., the productions of artists are more numerous, but the merit of each production is diminished."[2]

While Americans naturally bristled at all this criticism, and although they took enormous pride in the egalitarian form of government they had created, they also sensed a cultural inferiority. Some retaliated against the censure of visiting foreigners with great bluster. Others, such as the noted Unitarian minister and transcendentalist of Boston, William Ellery Channing, admitted the problem and began

to address it. In his *Self-Culture* of 1838 he urged that cultural improvement become a national priority, not for an élite few, but for the masses—and not so America could keep up with Europe, but because everyone needed culture.

America became a cultural experiment, just as it had been a political experiment. Could Americans create a culture of their own, which arose from the common people and spoke of the commonplace in life? Could an intellectual, creative, and artistic culture emerge from storekeepers, farmers, and tradespeople? Would creative talent find sufficient patronage among men who seemed to worship money more than culture?

If the masses were to be exposed to culture, the leaders of American society—who themselves might have only recently emerged from a humble stratum—were the ones to show the way. In the United States there was no aristocracy—only a group of moderately wealthy middle-class citizens, who occupied the upper level of a truncated social pyramid. In France, this level of society was referred to as the *haute bourgeoisie*, a successful and moderately prosperous upper-middleclass that developed its own social code, from morals to interior design. To the American equivalent, the domestic ambience became a statement of their culture, taste, and stylishness. Generally, they adopted the styles of the Old World, even as they sought to define their own national cultural identity.

NOUVEAU RICHE INTERIOR

In his essay "Philosophy of Furniture" (1840), Edgar Allan Poe noted that Americans have "no aristocracy of blood, and having therefore...fashioned for ourselves an aristocracy of dollars, the display of wealth has here to take the place...of the heraldic display in monarchical countries."[3] In the United States, Poe continued, "the populace...are insensibly led to confound the two entirely separate ideas of magnificence and beauty. In short, the cost of an article of furniture has at length come to be, with us, nearly the sole test of its merit...." The author of "The Raven" and "Murders in the Rue Morgue" then described what he considered a typical American parlor, in a way that suggests an opulent gaudiness:

[The room has] two windows, which . . . are large, reaching down to the floor—their panes are of a crimson-tinted glass, set in rosewood framings They are curtained within the recess, by a thick silver tissue Without the recess are curtains of an exceedingly rich crimson silk, fringed with a deep network of gold The folds of the whole fabric . . . issue from beneath a broad entablature of rich giltwork, which encircles the room at the juncture of the ceiling and walls The tints of crimson and gold appear everywhere in profusion.

The carpet is crimson with gold tassels, while the walls are a silver tint, "spotted with small Arabesque devices of a fainter hue." There are many paintings hanging on the walls, in broad gold frames, and two large, low sofas "of rosewood and crimson silk, goldflowered . . . [and] a pianoforte (rosewood, also)," plus an octagonal marbletopped table, and so on. In the extraordinary richness of Poe's room we have a forecast of interiors such as are seen in Figures 14.9 and 14.10.

If this era began with a reserve dominated by the classical restraint of the Greek Revival, it ended in a bombastic, opulent display of materialism that is expressive of the taste of the upper-middleclass *nouveaux riches* of the Industrial Revolution.

14.1 Harvey Lewis, Inkstand, 1815–25. Silver, height 3⅝in (9.2cm), diameter 3⁹⁄₁₆in (9cm) (top), 3¼in (8.3cm) (base). Yale University Art Gallery, New Haven, Connecticut.

EMPIRE, REGENCY, AND GREEK REVIVAL STYLES

Throughout this period, the interiors and the decorative arts that filled them generally reflected the major revivalist styles—Greek, Roman, Gothic, Egyptian, and Near Eastern. Seldom has the creative spirit been given such freedom to produce domestic furnishings of daily use. Between about 1840 and 1870 the first widespread impact of the Industrial Revolution in the United States was felt, which included a major transition from handcrafted to machinemade objects.

The Empire style in the decorative arts appeared in America soon after the turn of the century, following the fashions of the Empire style in France and the Regency in England. The style of almost everything at Napoleon's court was based on models from imperial Rome. It suited the emperor's political purposes to have the comparison drawn between his empire and the greatest empire of antiquity.

In Paris, Charles Percier and Pierre Fontaine were the leading designers. The French Empire style was spread internationally with the publication of their *Recueil de Décorations Intérieures* (1801). In London, the stylesetter was Thomas Hope, whose *Household Furniture and Interior Decoration* (1807), together with George Smith's *Cabinetmaker and Upholsterer's Guide* (1808), defined the Regency style. All of these men worked in a manner they believed to be more archeologically correct than that of their predecessor Robert Adam. A true sense of classical proportion was

sought in furniture, resulting in a heaviness of scale that was quite different from the slender forms of Adam, Sheraton, and Hepplewhite. The delicate inlay of the earlier style was replaced by bold sculptural carving, and there was a greater use of gilt and brass ornamentation in the capitals of pilasters or columns. Legs often end in great brass animal paws or dolphins, and marble—so closely associated with ancient classical art—was frequently used for tabletops and even columnar legs. The imperial eagle, the Greek anthemion, acanthus leaves, and the lyre became favorite decorative motifs.

The Empire style found expression in silver as well as furniture. An inkstand, for example, made about 1815–25 in Philadelphia by Harvey Lewis has some of the same characteristics seen in the Lannuier-like sidetable—for example, the winged sphinx-creature with animal feet (Fig. 14.1). In the inkstand, the head is that of a Native American woman, whose hair is decorated with feathers, an Americanization of a Greek or Egyptian form. The sphinx had been a popular motif ever since Napoleon's armies encountered the enigmatic Great Sphinx of Giza solemnly overlooking the banks of the Nile. The bowl and base of the inkstand are classical in their geometric forms, and the combination, within a single object, of Egyptian, Greco-Roman, and American forms is typical of the eclecticism of the nineteenth century.

GREEK REVIVAL

There was also a new craze for the Greek mode, although the latter did not make its way into American decorative arts until the 1820s, the era of the Greek war for independence.

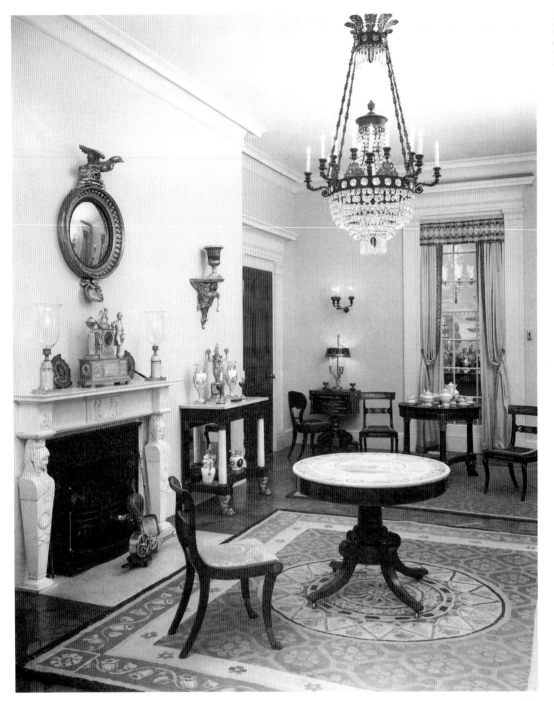

14.2 Empire parlor, from a house in Albany, New York, c. 1830, as installed in Winterthur Museum, Winterthur, Delaware.

The Empire style frequently included influences of the Greek Revival, and within the same room one might well find a mixture of the two, coexisting in perfect harmony.

The cabinetmaker Charles Honoré Lannuier (1779–1819) arrived in New York City from France in 1803, bringing with him the new Empire style of Napoleon's Paris. Duncan Phyfe was quick to offer furnishings in the popular new Greek style to his customers. Between Lannuier and Phyfe, New York City became the main center for Empire and Greek Revival furniture. Fashionable ladies, wearing high-waisted dresses inspired by the Greek *chiton*, sat in chairs wrought in the form of the Greek *klismos*, of a type seen in the foreground of Figure 14.2, an Empire parlor recreated at Winterthur Museum. Dating from about 1820, the chair has a curving back and curving saber legs, which are typical, as are the animal paw feet on the front legs. The circular, pillarbase table with its simulated marble top has the heavy proportions that characterize the Greek Revival style. The pier table against the wall beside the fireplace has a marble top, with marble columnar legs in front which terminate in richly carved and gilded animal feet. The circular, giltframe mirror with its crowning eagle is also typical of this period.

14.3 Grecian couch, 1825–35. Mahogany, pine,
80 × 13 × 25½in (203.2 × 33 × 64.8cm).
Courtesy Winterthur Museum, Winterthur, Delaware.

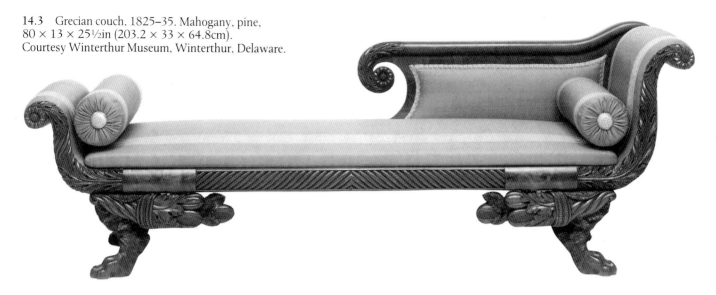

The heavy proportions of the Greek Revival style are seen in a couch that was made in New York in 1825–35 (Fig. **14.3**). Its S-scroll brackets bear lush acanthus leaves, and the legs are also richly carved with cornucopia and animal paw motifs. A classical balance exists between the straight lines and the bold curve of the scrolls. Greek Revival furniture was often decorated with gilt adornments, as in the pier table that has a marble top supported by carved eagles with lion bodies (Fig. **14.4**). The imperial form of the griffinlike supports is characteristic of the work of Charles Honoré Lannuier, although this piece is not attributed to him. Roman decorative motifs have been stenciled onto the side

14.4 Pier table in the style of Honoré Lannuier, c. 1815–25. Mahogany, pine, marble top, 33⅓ × 40¾ × 18⅞in (84.7 × 103.5 × 47.9cm). Museum of Fine Arts, Boston. Gift of W. N. Banks Foundation.

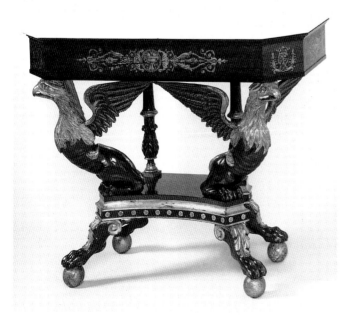

of the tabletop, in imitation of the more expensive cast and gilded ormolu mounts that had to be imported from France. The rich gilding of the eagles and the base is also typical.

GOTHIC REVIVAL

Just as it did in architecture, the Gothic Revival style rivaled the classical styles, and offered a special picturesque quality to interiors and furnishings. Many of the Gothic features found in the Gothic Revival interior in the dining room at Lyndhurst (Fig. **13.20**)—wooden beams, carved paneling, slender cluster columns, ogive arches, crockets—are also found in the furnishings of the room. The architect Alexander Jackson Davis designed a considerable amount of furniture for Lyndhurst, including the chair seen in Figure **14.5**. A free interpretation of the Gothic mode—no such piece of furniture existed in the twelfth or thirteenth centuries—it has the flavor of the Gothic style. The chair back resembles the rose window of a Gothic cathedral, and throughout, the irregular form and the decorative motifs are of a Gothic spirit.

Even more elaborately Gothic is the side chair seen in Figure **14.6**. The intricate, irregular form is the antithesis of the Greek Revival *klismos* chair seen in Figure **14.2**. The twisted turnings of the front legs and the stiles were machinemade, turned on a motorized lathe with special blades. The elaborately pierced trefoil, ogive, and other tracery of the back were first cut out with a powersaw before being finished by hand. Pendant ornaments on the skirt front and finials at the top of the back were produced totally by machines. The original needlepoint of the seat and back was similarly machinemade. This very Gothic-style chair was actually a product of the Industrial Revolution, while its design belongs to picturesque Romanticism.

Just as Americans of the 1820s and 1830s had a preference for the controlled, reserved lines of the Greek Revival, in the 1840s, 1850s, and 1860s a taste for intricate fancywork in furniture developed. Nowhere is this more obvious

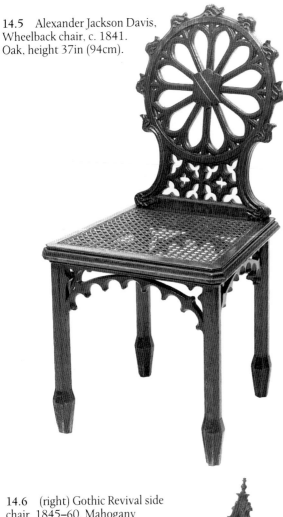

14.5 Alexander Jackson Davis, Wheelback chair, c. 1841. Oak, height 37in (94cm).

14.6 (right) Gothic Revival side chair, 1845–60. Mahogany with needlepoint upholstery, 42¾ × 18 × 17¾in (108.6 × 45.7 × 45.1cm). Museum of Fine Arts, Boston. Bequest of Barbara Boylston Bean.

14.7 Etagère, or whatnot shelf, c. 1860. Mahogany, marble, mirror, height 7ft 1in (2.16m). Henry Ford Museum, Dearborn, Michigan.

than in the **étagère**—a grand, standing whatnot shelf upon which trinkets and collectables were displayed—which seems to have been developed in response to mid-Victorian love of decorative carving and doodads (Fig. 14.7). The example shown is typical in its intricate and irregular outlines, and in the trefoil patterns and forms that resemble Gothic tracery. Such a piece would have been a standard component of any fashionable parlor.

By the 1840s, American silversmiths were producing objects in the Gothic style, which lent itself especially to church silver. While American silver in the Gothic mode was only rarely made for domestic use, it is beautifully demonstrated in the pitcher and goblet created by Zalmon Bostwick (active 1845–52) (Fig. 14.8). The shape of the goblet resembles its medieval counterpart, and the Gothic arches, trefoils, ribs, mullions, and other surface decorations on the pitcher complete the allusion. One can well imagine such

14.8 Zalmon Bostwick, Pitcher and goblet, c. 1845. Silver, 11 × 8½ × 5½in (27.9 × 21.6 × 14cm), goblet 8 × 3⅝ × 3⅞in (20.3 × 9.2 × 9.8cm). High Museum of Art, Atlanta, Georgia.

14.9 Victoria Mansion (Morse-Libby House), Portland, Maine, 1859. Interior, reception room.

pieces in a Gothic Revival dining room (Fig. 13.20), where there is a continuity of form in the décor, furniture, and silver vessels.

The making of silver objects was greatly affected by the Industrial Revolution, specifically by the appearance of large manufacturing firms which increasingly replaced the individual silversmith. The growing demand of a growing middleclass made the change inevitable, and new technologies such as electroplating made it economically possible. Certain areas of Rhode Island and Massachusetts led the way. The firm of Reed and Barton was established in Taunton, Massachusetts, in 1840, while the Gorham Company was founded in Providence, Rhode Island, in 1863. Retail outlets also arose, among the bestknown being Tiffany and Company in New York City and J. E. Caldwell and Company in Philadelphia.

VICTORIAN INTERIOR

The Victorian concept of interior décor becomes evident when rooms like those seen in Figures 14.9 and 14.10 are contrasted with the simplicity of Federal or Greek Revival rooms (Figs. 9.6 and 14.2). The interior of Henry Austin's Victoria Mansion of 1859 (Fig. 13.24) is a visual display of *nouveau riche* opulence. The painted ceiling decorations, by Giovanni Guidirini, depict allegorical and mythological subjects. Grandeur is evident in the high ceilings, elaborate multi-tiered cornices, and high windows of etched or colored glass, enframed by yard upon yard of lavish drapery. Floral-patterned carpeting covers the floor, while the room is illuminated by a great chandelier of wondrous form. The furniture is sufficiently ponderous to be impressive. There is a Second Empire richness to the ensemble that calls to mind

the interior of the Paris Opera House, and in fact the furniture frequently follows the fashion of the great French designer of the period, Alexandre Georges Fourdinios (active 1841–81). Appropriately enough, the room has something of the showiness of a hotel lobby—Ruggles Morse, for whom Victoria Mansion was built, made his fortune as a hotel owner.

ROCOCO REVIVAL

The Rococo Revival originated in France during the reign of Louis-Philippe (reigned 1830–48). The restored Bourbon family line wished to recapture the grandeur of its golden era of the eighteenth century. Rococo-inspired furniture attained its greatest popularity in America during the 1850s and 1860s. Much of the furniture seen in Figure 14.10 is original to the room, including the set of chairs made by Elijah Galusha (1804–71) of Troy, New York.

The parlor from the Robert Milligan House of Saratoga, New York, has elaborate plasterwork moldings on the ceiling, and its floral motifs are countered by equally rich floral patterns in the carpet. Windows reaching nearly the full height of the room are covered by great tasseled draperies and shutters. The style of the room, however, is actually set

14.10 Robert J. Milligan House, Saratoga Springs, New York, built 1853, furnished 1854–6. Parlor (now known as the library), as installed in Brooklyn Museum.

by the Rococo Revival furnishings. The gilt frame of the mirror above the marble fireplace, for example, is an extraordinary reinterpretation of eighteenth-century French design.

The most famous makers of Rococo Revival furniture were John Henry Belter (1804–63) and Alexander Roux (1813–81), who created ostentatious symbols of wealth to endow *nouveau riche* living rooms with a sense of high-style, Old World culture. Belter emigrated from Germany to New York City in 1833 and became a successful furniture craftsman. His method consisted of laminating seven or eight thin layers of rosewood—a favorite wood of the day—so they could be bent into the graceful curves of the Rococo style. Thus constituted, the wood could also be pierced and carved into the rich patterns of birds, flowers, vines, leaves, and so forth, seen in the sofa in Figure **14.11**. Much of the ornate carving on this type of furniture was done by German craftsmen who emigrated to America following the revolution of 1848. When he opened his factory in New York City in the early 1850s, Belter employed many of them. Nature is the primary subject in the carvings, reflecting a fascination

14.11 John Henry Belter, Sofa, 1840–60. Rosewood, brass, satin upholstery, 42 × 63 × 33½in (106.7 × 160 × 85.1cm). Courtesy Winterthur Museum, Winterthur, Delaware.

14.13 Alexander Roux, Etagère, c. 1855. Rosewood, chestnut, poplar, height 7ft 2in (2.18m). Metropolitan Museum of Art, New York City.

also seen in America's love of landscape and still life painting. The graceful Rococo S-curve predominates throughout. A marbletop rosewood table, similar to the one in the center of the Milligan parlor, has comparable features, with an especially handsome carving of a bouquet of flowers at the intersection of the leg braces (Fig. **14.12**).

While Belter's name is virtually synonymous with this type of furniture, others made exquisite pieces of an almost identical form—J. and J. W. Meeks (active 1836–59), for example, had a large factory and showroom in New York City, while George Croome (1807–79) was the foremost

14.12 John Henry Belter, Center table, c. 1855. Rosewood with marble top, 29 × 32 × 41in (73.7 × 81.3 × 104.1cm). Courtesy Winterthur Museum, Winterthur, Delaware.

manufacturer of Rococo Revival style furniture in Boston. Alexander Roux was Belter's greatest competitor. Roux was trained in his native France before coming to New York City about 1837. His factory employed 120 workers by the mid-1850s, making furniture in a variety of revival styles that included the Gothic, Elizabethan, Renaissance, and Rococo. A rosewood étagère he made about 1855 uses C-scrolls and S-curves, cabriole legs, and elaborate carving of nature motifs, particularly flowers (Fig. **14.13**), in a robust fashion. In the center of the apron is the delicately wrought head of a woman—possibly a portrait of the mistress of King Louis XV, Madame de Pompadour, one of the foremost patrons of the arts during the Rococo era in eighteenth-century France.

Intricate and naturalistic as the carving is in this étagère, much of it was done by machines that were designed and programmed for that purpose. The places where Roux, Belter, and others manufactured such pieces can truly be called factories, rather than shops. A fine étagère like this was too expensive for the average household, so we cannot say it was massproduced. Nevertheless, it was a product of the Industrial Revolution. In fact, its lush floral forms and its Rococo style were probably an attempt to escape from the mechanized crassness of the Industrial Revolution. But if the Industrial Revolution created dire social problems, it also allowed increasing numbers of Americans to enjoy fine things, for the high cost of handmade objects had previously meant that only a privileged few could possess them.

CHAPTER FIFTEEN
PAINTING:
LANDSCAPE, 1825–70

If American culture was still rooted in a European heritage, there was nevertheless a unique quality about the land, which was recognized and admired by Americans and Europeans alike. It was as responsible for the emerging national character of the Americans as the democratic sociopolitical system they had devised. Unlike Europe, the United States seemed to have unlimited land available to the common person. As new states or territories joined the Union, the federal government became the first proprietor of the land, but then sold parcels of it cheaply to anyone who would move in and homestead it.

A romance grew out of the land, out of Americans' relationship to it, and their accomplishments within it. The Erie Canal, for example, which allowed barges to travel from the Great Lakes to the seaport of New York City, was hailed upon its completion in 1825 as a mighty triumph of mankind over nature. That same year, the Ohio legislature authorized a canal that would connect Cleveland with the Ohio River, which led to the Mississippi and to the port of New Orleans. The Pennsylvania canal system was begun in 1825 as well. These canals—along with the railroads that came slightly later—made it possible to ship the produce from the developing Midwest to the markets and seaports of the East Coast.

There was romance, too, as Americans pushed further and further west. In 1821, the Santa Fe Trail was established between Missouri and New Mexico. Independence and St. Joseph were staging points for pioneers headed west, after they had traveled by steamboats up the Missouri River. From there on it was overland in covered wagons. The Oregon Trail, from Independence, Missouri, along the Platte, Snake, and Columbia Rivers, had been charted in 1832. Nine years later, the first emigrant train of forty-eight wagons set out upon it, crossing the Sierras on the California Trail on its way to Sacramento. The northern route of the Oregon Trail also carried settlers to the Northwest. In 1843, a thousand settlers departed from Independence for Oregon Territory, marking the beginning of the great homesteading movement.

The new lands were chronicled in Colonel John C. Fremont's *Report of the Exploring Expedition to the Rocky Mountains in the Year 1842 and to Oregon and Northern California in the Years 1843–1844*, and James Hall wrote about them in *Legends of the West* (1832). In a chapter titled "The Emigrants," Hall noted, "Accustomed to the contemplation of great mountains, long rivers, and boundless plains, the majestic features of their country swelled their ideas, and gave a tinge of romance to their conceptions . . . , while their long journeys over the boundless plains teeming with the products of nature, gave them exalted notions of the magnificence of their country."[1]

MANIFEST DESTINY OR PARADISE REGAINED?

Back east, Americans became nostalgic for a wilderness they knew they had lost to progress, as forests were cleared, factories rose, trestle bridges crossed rivers, and trains cut through the landscape. In the July 1845 issue of the *Democratic Review*, the term "manifest destiny" was coined. This advocated the white person's right and duty to make use of the land as God's intention, even if it meant the displacement of indigenous peoples. Progress must take place across the land if America's future were to be fulfilled, and in the nineteenth century, few who went west questioned the rightfulness of their mission.

Authors and artists began creating romantic reminiscences about how it used to be before the Industrial Revolution, when a woodsman or a pioneer family could live in harmony with the wilderness, and know God through nature. People living in civilization lamented the loss of the wilderness, and wanted stories about it and pictures of it. James Fenimore Cooper epitomized that spirit in his "Leatherstocking Tales"—*The Pioneers* (1823), *The Last of the Mohicans* (1826), and *The Prairie* (1827). Cooper wrote about nature and America in a way that appealed to a broad audience. In order to understand the rise of the American school of landscape painting in the second quarter of the century, at least one of Cooper's "Leatherstocking Tales" should be read. In each of these, the land of America itself is both the setting and to a large degree the subject of the story.

After about 1825, Americans wanted images of the land itself: Its mountains, forests, and prairies; the lives and customs of the Native Americans who dwelt on it; the adventurous men and women who moved into and settled it. To some, the landscape became a metaphor for moral, religious, and poetic sentiments, and so it must be preserved. To others, it represented the American Dream because of the opportunities it offered, and so it must be utilized. Some saw the interminable forests as a biblical Eden, awaiting a new Adam and Eve—in the form of the American pioneers, who had the·chance to regain grace in a land uncorrupted by the Industrial Revolution. Many more saw the land as there to be "improved" by the civilizing and Christianizing influences of the white settlers. Soon, Americans became interested in the world beyond their own borders—the ancient lands of the Near East, the magnificent Andes in South America, and the polar wastes of the frozen North.

The patrons were often prosperous merchants, bankers, or factory owners, desiring scenes of natural splendor as an antidote to the crass and coarse business world. Or rural scenes reminiscent of the days spent on the farm, when life was slower and easier—somehow better. Armchair travelers enjoyed paintings of the exotic West, which they might never see for themselves. To satisfy this demand, a large and talented corps of landscape artists arose to paint essentially naturalistic visions altered by Romantic sentiments. Landscape painting before 1825 had been sporadic, often quite good, but generally lacking a strong thematic focus. After 1825, it enjoyed a great flowering.

THOMAS COLE AND THE MORALIZING LANDSCAPE

While Thomas Cole (1801–48) has been called the founder of the American school of landscape painting, there were others who launched the movement before Cole appeared upon the scene. Alvan Fisher (1792–1863), for example, led the way in New England, painting landscapes soon after the end of the War of 1812. In Philadelphia, beginning in the early 1820s, Thomas Doughty (1793–1856) was the first to create romantic visions of landscape scenery. After early success, Doughty turned to painting fantasies like *Fanciful Landscape*, which proved too poetic for most of his patrons (Fig. **15.1**). To many of them, nature lost its reality as it dissolved into a lyrical idyll, and it lost its national identity with the inclusion of moldering medieval ruins of Old World castles and cathedrals. Such was not the type of landscape for which Americans yearned.

15.1 Thomas Doughty, *Fanciful Landscape*, 1834. Oil on canvas, 30⅛ × 39⅞in (76.5 × 101.5cm). National Gallery of Art, Washington, D.C.

The first artist whose scenes of wilderness and descriptive views of wellknown places struck a resounding chord among Americans was Thomas Cole. Cole's youth was spent in his native England amid milltowns of the Industrial Revolution. Many aspects of his life and art seem a reaction against that experience. He came to America with his parents in 1818, finding in the beautiful scenery around eastern Ohio and Pittsburgh a wonderful respite and inspiration bordering on religious devotion. By 1825, Cole had made his way back to New York City, and that autumn he journeyed up the Hudson River to the Catskill Mountains, where he encountered wildly exciting scenery. Cole was entirely selftaught, and for the most part he created his own new mode of vision for the representation of landscape.

What appealed to Americans in Cole's early pictures was the pristine, Edenlike wilderness that offered the world-weary soul a natural sanctuary in which to find God. Through a system called Associationism, established by several late eighteenth-century Scottish philosophers, a person could, while not knowing God directly, arrive at some knowledge of him through the contemplation of his natural works. One could perceive the glory of God in a splendid sunrise, his majesty in a great mountain range, his gentleness in a little wildflower, or his wrath in the violence of a thunderstorm. Moreover, the Romantic spirit thrilled at the awesome spectacle of interminable forests, high cliffs, and raging storms. An often-used symbol was the gnarled old treetrunk, representing one of America's great natural antiquities—which Cole's patrons contrasted to the ruins of the manmade antiquities of Europe. The stump of a sawed-off treetrunk, however, was a symbol of human intervention, and the beginning of the end of the holy wilderness. Such meanings invested Cole's art with a religious and moral content, and their didactic quality increased as his career evolved.

Last of the Mohicans Cole believed in the artistic theory of the Grand Manner (chapter 10), which held landscape painting to be a low form of art, and history painting to be the highest. Landscape painting therefore had to be

15.2 Thomas Cole, Scene from *The Last of the Mohicans*, "Cora Kneeling at the Feet of Tamenund," 1827. Oil on canvas, 25⅜ × 35¹/₁₆in (64.5 × 89.1cm). Wadsworth Atheneum, Hartford, Connecticut.

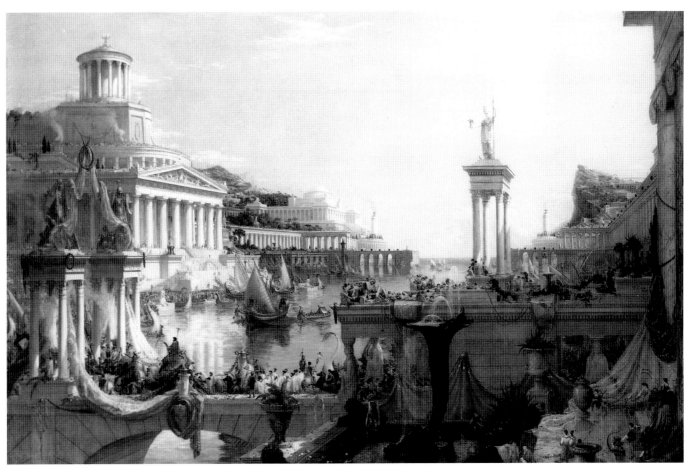

15.3 Thomas Cole, *The Consummation of the Empire*, from *The Course of Empire*, 1836. Oil on canvas, 4ft 3in × 6ft 4in (1.3 × 1.93m). Courtesy The New-York Historical Society, New York City.

ennobled, if not by the spirit of God, then by legend, historical event, or literary association. This can be seen in *Last of the Mohicans*, which Cole painted for Robert Gilmor of Baltimore, although it ended up in the hands of Daniel Wadsworth of Hartford (Fig. **15.2**). Cole's picture, based on James Fenimore Cooper's novel, represents the Mohawks gathered in council before their ancient chief, Tamenund, as the captured white woman, Cora, is told she must choose between the wigwam or the knife of the treacherous Mohawk warrior Le Subtil. The drama is set amid towering mountain peaks, plunging valleys, and virgin forests. These dwarf the tiny figures, creating in the viewer the awesome feeling of insignificance in the presence of all-powerful nature. The soul is excited vicariously by the action occurring so close to the edge of a great precipice, thus providing an experience of the sublime.

To improve his art, Cole embarked in 1829 on a three-year tour of Europe, spending the final year in Italy. There he was greatly moved by the crumbling ruins, which he saw as symbols of human folly, ambition, and pride—testimonies to the futility of material pleasures sought by great civilizations of the past, and of empire building, which time and corruption always brought to ruin.

The Course of Empire Cole returned to New York City in 1832, and began a series of five pictures called *The Course of Empire*, which told the history of a site through the following stages: Savage, Pastoral, Consummation of the Empire, Destruction of the Empire, and Desolation. While the Savage stage represents a way of life that is too wild and chaotic, in the Pastoral state men, women, and children coexist in peaceful harmony with nature, each person practicing the occupation of his or her calling. Gaudy hedonism triumphs in the Consummation stage, in which the works of man obliterate the works of God—that is, nature. A large priesthood—seen by the hundreds filing down the stairs of the huge temple at the left middleground—suggests elaborate religious ceremonies (Fig. **15.3**). The magnificent architecture before which the triumphal procession moves, however, is destroyed in a violent scene of burning, pillage, and slaughter in the Destruction stage. The great city's colossal architecture is the stuff of which lonely ruins are made, solemn and haunting in the moonlight of the final, Desolation stage. Here, nature reclaims the scene in a moralizing message of the triumph of God over those symbols of human vanity and wickedness. Cole undoubtedly felt that in following the siren songs of the

15.4 Thomas Cole, *The Oxbow (The Connecticut River near Northampton)*, 1836. Oil on canvas, 4ft 3½in × 6ft 4in (1.31 × 1.93m). Metropolitan Museum of Art, New York City.

15.5 (below) Thomas Cole, *The Voyage of Life: Youth*, 1842. Oil on canvas, 4ft 4⅞in × 6ft 4¾in (1.34 × 1.95m). National Gallery of Art, Washington, D.C.

Industrial Revolution and Manifest Destiny, America was on a similar course.

Cole had moved far from the images of the purely American wilderness that had made his art so popular, and few patrons would buy his historic tableaux. Instead, he was forced to paint scenes of specific sites and wellknown places, as in *The Oxbow*, which depicts a famous loop in the Connecticut River near Mount Holyoke in Massachusetts (Fig. 15.4). While one finds a blasted old tree and a passing storm at the left, the other section presents a scene of "improved" landscape, where fence rows mark off the geometric patterns of cultivated fields, wisps of smoke curl up from chimneys, a few boats ply the river, and tranquility pervades the scene. Unlike the fantasy of the Pastoral stage, the real America is presented. Cole's patrons far preferred this to allegory.

The Voyage of Life Nevertheless, Cole's interest in what he considered superior to simple landscape views continued unabated. His next major series was *The Voyage of Life*, four pictures representing Infancy, Youth (Fig. **15.5**), Manhood, and Old Age, in which the hero journeys along the river of life in a barge decorated with symbols of the fates and time. A guardian angel watches over him, first from the barge, then from the riverbank, having been put ashore as the eager young man insists on being captain of his own ship of fate, anxious to pursue his exotic castles in the sky—seen in the upper left. Here was a moral told in a visual vocabulary that Americans could understand, and the series became famous through engravings made of it by James Smillie. Smillie also engraved the Youth stage for distribution as an annual premium of the American Art Union, a popular art lottery of the 1840s and 1850s. Cole's *Voyage of Life* thus appeared on the walls of thousands of American homes. The image of Youth, when isolated from the other pictures in the series in Smillie's large engraving, was interpreted by many as a vision of America discovering its future, and fulfilling its Manifest Destiny.

The Art Union shows a much broader base of the American population turning its attention to art—it was a popular cultural institution, typical of the new type of institutions being fostered by an egalitarian nation. Art was no longer reserved for an aristocratic élite. Now the common citizen—if he or she could afford to do so—began to play the role of patron, and middleclass tastes began to have an influence.

The Architect's Dream This painting reveals Cole's indulgence in visual fantasy, and the love of his age for different historic architectural styles (chapter 13) (Fig. **15.6**).

15.6 Thomas Cole, *The Architect's Dream*, 1840. Oil on canvas, 4ft 5in × 7ft¹⁄₁₆in (1.35 × 2.14m). Toledo Museum of Art, Toledo, Ohio.

The picture was commissioned by the architect Ithiel Town, who is shown reclining atop a great capital, a few volumes from his celebrated architectural library scattered around him. The architect dreams of all the great building styles of the past assembled before his eyes—Egyptian, Greek, Roman, and Gothic. The artist indulged himself in his penchant for grand extravaganza. To the end of his life, Cole persevered in painting the moralizing landscape, even though he knew American patrons preferred specific views.

ASHER B. DURAND: KINDRED SPIRITS AND PROGRESS

Cole's successor as leader of the American school of landscape painting was Asher B. Durand (1796–1886). Durand's first career was as an engraver. In fact, by the early 1830s, he was the best engraver in America, executing not only banknotes and other types of commercial work, but also excellent fine-arts engravings. Two of his most successful prints were taken from John Trumbull's *Signing of the Declaration of Independence* (1822) and John Vanderlyn's *Ariadne* (1834). By 1834, Durand had begun to think of painting as a more challenging medium. His transition to painter was facilitated by Luman Reed's commission for a set of painted portraits of the first seven presidents of the United States. Reed, a successful grocery wholesaler, was one of the first of a new breed of merchant-patrons, who provided much-needed support for American painters as they began to form an American school independent of Europe. Ridding his collection of the spurious European Old Masters he had bought, Reed began buying only pictures by living American artists, especially Durand, William Sidney Mount, and Thomas Cole. It was Reed who tolerantly allowed Cole to paint *Course of Empire* for the art gallery Reed had incorporated into his fine new house—the first private art gallery in America.

Durand went to Europe in 1840–1 for the obligatory artist's pilgrimage. He generally disliked the experience, and came back unchanged by visions of ruins and moldering empires. Taking up landscape painting in a naturalistic style, but often with an engraver's linear precision, Durand rose quickly to the fore with works such as *The Beeches* (Fig. 15.7). Trees—often the noble heroes of Durand's pictures—enframe a path, along which a shepherd drives his flock of sheep into a golden diaphanous sunset that dissolves the gentle landscape beyond a river. A lovely scene that extolls the beauties of nature, it is an ode to the simple, rural life.

American merchants found such scenes therapeutic after a hard day at the office. Here was a scene that was recognizably American, transported them back to the days of their youth, and restored the soul. Pictures such as *The Beeches* made Durand wealthy, and brought prestige among his fellow-artists. In the year he painted that picture, they elected him president of the National Academy of Design.

When Durand's dear friend of many years, Thomas Cole,

15.7 Asher B. Durand, *The Beeches*, 1845. Oil on canvas, 5ft⅜in × 4ft⅛in (1.53 × 1.22m). Metropolitan Museum of Art, New York City.

died in 1848, Jonathan Sturges, the late Luman Reed's business partner and successor as leading patron of the New-York-based artists, asked Durand to paint a commemorative picture. The result was *Kindred Spirits*, which shows Cole (right) with his fellow nature-worshiper, the poet William Cullen Bryant, standing on a rocky ledge and discussing the beauty of the Catskill Mountains (Fig. 15.8). The trees, rocks, ferns, mosses, and lichens have been painted with a fidelity that reveals the artist's love for them. Although painted as a memorial to Cole, it includes no ruins of temples or reminders of fallen empires, for the picture was meant to signal the triumph of American natural scenery. This is not nature as the scientist analyzes it, but Nature viewed by a Romantic soul, who adores it, communicates with it, and becomes spiritually at one with it.

Glorification of nature and nationalistic pride were two key components of Durand's pictures, and when he painted a fantasy, he would base it on those ideologies. *Progress* (Fig. 15.9), just such a picture, is thematically and compositionally similar to Cole's *The Oxbow* (Fig. 15.4), but with heightened optimism and nationalistic fervor. At the left are magnificent old arboreal giants, rough rocky outcroppings, and Native Americans, all of which suggest an idea of the American wilderness as being in a primitive state before the coming of the white people. But in the lower right

15.8 Asher B. Durand, *Kindred Spirits*, 1849. Oil on canvas, 3ft 8in × 3ft (1.12 × 91.4m). New York Public Library.

15.9 Asher B. Durand, *Progress*, 1853. Oil on canvas, 4ft × 6ft (1.22 × 1.83m). Warner Collection of Gulf States Paper Corporation, Tuscaloosa, Alabama.

15.10 Jasper Francis Cropsey, *Autumn—On the Hudson River*, 1860. Oil on canvas, 5ft × 9ft (1.53 × 2.74m). National Gallery of Art, Washington, D.C.

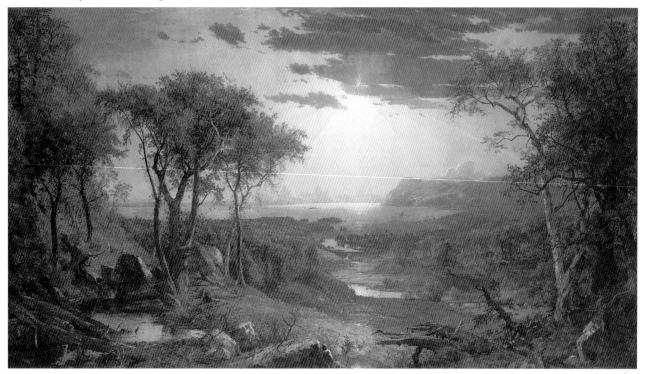

we see a drover taking his cattle down a country road—lined by tall poles carrying the telegraph wires into the interior. The road makes its way past travelers headed toward the inland settlements, past a schoolhouse—a symbol of learning and culture—while a spire in the middle distance indicates the presence of a church—symbol of Christianity's contribution to the refining of the savage land. Wandering visually along the edge of the bay we encounter factories, a train, steamboats, and, on the little peninsula in the middle distance, a prosperous city. But this is no Colean Consummation of the Empire that predicts the doom of civilization—quite the contrary. *Progress* is a visual hymn to Manifest Destiny. If Cole's *Empire* series carried a negative message meant as a warning, Durand's picture was a positive nationalistic anthem to the future greatness of the nation.

The magnificent requiem of landscapes of northeastern America was painted by Jasper Francis Cropsey (1823–1900) in *Autumn—On the Hudson River* (Fig. **15.10**). A panoramic, sweeping vista, with a glorious sunset and many-hued cloud formations, the scene depicts the American landscape clad in its unique autumnal colors—a phenomenon of nature that pleased American eyes and fascinated Europeans. Like Durand, Cropsey provided a wealth of naturalistic detail in the foreground, where the viewer is confronted with the wild tangle and chaos of nature, contrasted with the serenity of the village of the middleground.

FREDERIC EDWIN CHURCH: FROM THE CATSKILLS TO THE ANDES

Frederic Edwin Church (1826–1900), the only pupil Thomas Cole ever accepted for instruction, learned to study natural scenery from his master. Church, however, had more the observant eye of the scientist, and was less the moralizing fantasist than Cole. He began by painting American scenery in naturalistically rendered details. His facility in the detailed execution of natural forms is evident in *New England Scenery*, an early picture (Fig. 15.11). All of nature seems to have been examined microscopically before being painted into the larger scheme of the composition. The result is an apparent sharpness of focus in the rendering of all natural detail, but in fact each detail plays a subordinate role to the grand plan of the total composition. Church's picture left no doubt that it depicted a specific place and a thoroughly American scene.

The essence of Church's art was established early: A presentation of both the microcosm and the macrocosm of the natural world, all set within some grand natural scheme. Meticulous detail within a broad panorama characterizes his greatest pictures. *Niagara Falls* (1857, Corcoran Gallery of Art, Washington, D.C.), for instance, bears scrutiny with a magnifying glass, but also captures the expansive phenomena of that natural wonder if viewed from a distance. Such a technique parallels the writings of the German scientist-explorer Baron Alexander von Humboldt, author of the celebrated book *Kosmos* (1845–62), which was translated and read throughout Europe and America. Addressing landscape painters, the author advocated that artists should know their subject specifically but also see it as part of a global geographic and climatic zone.

Von Humboldt had explored South America as a naturalist in 1799–1804, and the publication of the first volumes of his book fired the imagination of many, including Frederic Church, who traveled to Ecuador and Colombia in 1853 and

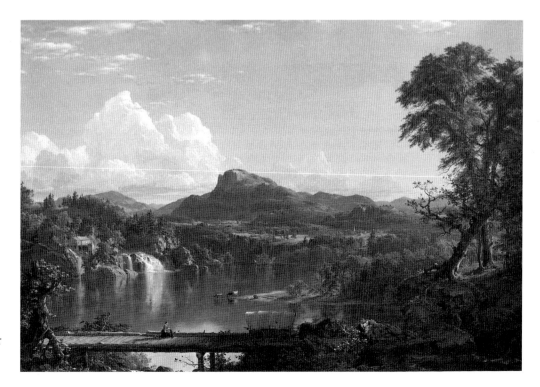

15.11 Frederic E. Church, *New England Scenery*, 1851. Oil on canvas, 3ft 4in × 4ft 9in (1.02 × 1.45m). George Walter Vincent Smith Art Museum, Springfield, Massachusetts.

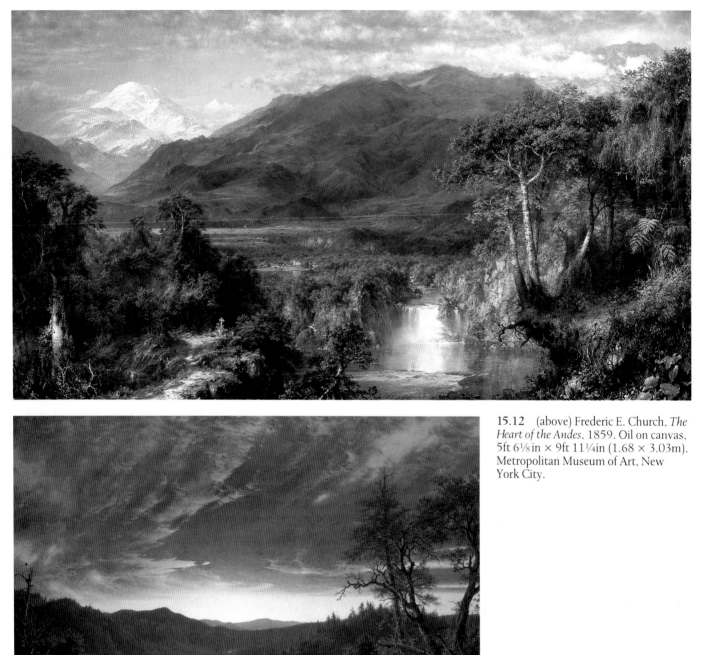

15.12 (above) Frederic E. Church, *The Heart of the Andes*, 1859. Oil on canvas, 5ft 6⅛in × 9ft 11¼in (1.68 × 3.03m). Metropolitan Museum of Art, New York City.

15.13 Frederic E. Church, *Twilight in the Wilderness*, 1860. Oil on canvas, 3ft 4in × 5ft 4in (1.02 × 1.63m). Cleveland Museum of Art, Cleveland, Ohio.

again in 1857. On each trip, Church made beautifully detailed, colorful sketches of the flora, the geological formations of the mountain ranges, and studies of cloud embankments. Once he was back in his New York City studio, he combined them into some of his most famous large paintings. The heroic *Heart of the Andes* established Church as the premier landscape painter in America (Fig. **15.12**). The viewer marvels at the wonders of nature and the detail in which they are represented—finding amid the foliage of the foreground such delightful surprises as butterflies, exotic birds, and birdnests. The British critic John Ruskin, author of *Modern Painters* (1843–60), advised artists to give close scrutiny to the details of nature in order to portray its essence, and saw art, nature, and morality as being unified spiritually. Painters such as Durand and Church read and were influenced by Ruskin's writings. The minute observations in *The Heart of the Andes* exemplify the famous critic's theory—they are played masterfully against the grand,

towering summits of the peaks of the distant mountain ranges. In the left foreground a few peasants pause before a cross, indicating that religion (Christianity) lives in peaceful coexistence within this land. Religious faith and scientific observation are blended with the artist's imagination, poetry, the romance of discovery, and a fascination with faraway, exotic places.

If *Heart of the Andes* represented the composite essence of landscape in the tropical zone, *Twilight in the Wilderness* (Fig. **15.13**) and *Icebergs* (1861, Dallas Museum of Fine Arts) were Church's consummate expressions of the North American and Arctic regions. In *Twilight* we see a sky saturated with brilliant vermilions and yellows, settling over the dramatic solitude of the interminable American wilderness, much of which is shrouded in mysterious shadow. For all of its naturalism, the picture remains enigmatic: Did the artist intend a celebration of the American wilderness, pure and simple? Is it a metaphor, predicting the end of Eden before the march of civilization? Does it allude to the impending end of a great era of American history (it was painted on the eve of the outbreak of the Civil War)?

In 1868–9, Church's wanderlust took him to the Near East, Greece, and Italy, where he made numerous studies, many of which would form the basis for later pictures such as *The Parthenon* (1871, Metropolitan Museum of Art). In the early 1870s he began to build his great Persian mansion, Olana (Fig. **20.1**), high on a bluff overlooking the Hudson River, and this required much of his attention. By the middle of the decade, Church had developed inflammatory rheumatism which made it difficult to hold a brush, so bringing his career to an end.

ROBERT SCOTT DUNCANSON

Robert Scott Duncanson (1817 or 1822–72), son of a black mother and a Scotch-Canadian father, painted specific views and idealized landscapes. Born in New York State but raised in Canada, Duncanson joined his mother near Cincinnati in 1842, beginning his career as a selftaught artist. A few years later, the wealthy patron of the arts Nicholas Longworth commissioned him to paint eight large landscape murals for his fine new home, Belmont, which is now the Taft Museum.

In 1853, Longworth made it possible for Duncanson to go to Italy in the company of the young painter's friend, the landscapist William Sonntag, from whom Duncanson learned much about the conventions of the Hudson River School of painting. Italy had a profound effect on Duncanson, for he had a natural inclination for painting poetic idylls strewn with classical ruins. Soon after he returned to Cincinnati in 1854, the sketches from his trip served as inspiration.

While he painted many scenes of specific, wellknown sites in the manner of Durand, Duncanson seems to have preferred idealized landscapes. The strong influence of his Italian trip is seen in *Pompeii* (Fig. **15.14**). Although small, it has the panoramic sweep typical of the Hudson River School, and the luxuriant flowers and foliage are reminiscent of the work of Thomas Cole. Ancient Roman ruins stand or lie majestically about, while Vesuvius smolders in the distance. Duncanson's art sold well and he prospered, but mental disease brought an untimely end to his career in Detroit.

15.14 Robert Scott Duncanson, *Pompeii*, 1855. Oil on canvas, 21 × 17in (53.3 × 43.2cm). National Museum of American Art, Smithsonian Institution, Washington, D.C.

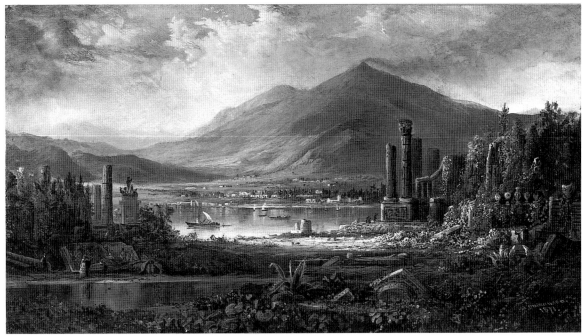

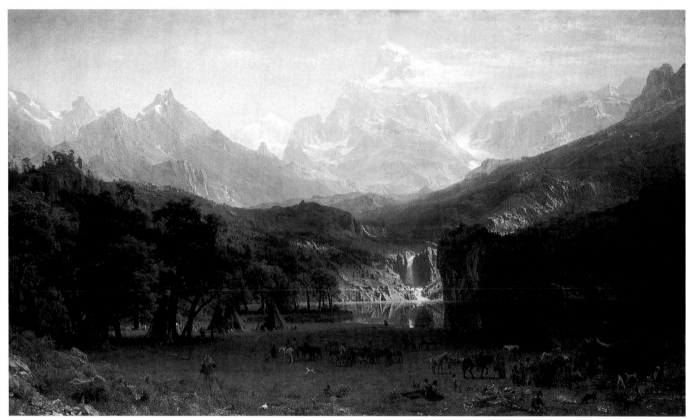

15.15 Albert Bierstadt, *The Rocky Mountains, Lander's Peak*, 1863. Oil on canvas, 6ft 1½in × 10ft¾in (1.87 × 3.07m). Metropolitan Museum of Art, New York City.

ALBERT BIERSTADT: WESTWARD TO THE ROCKIES AND YOSEMITE

Albert Bierstadt (1830–1902) was brought to America as an infant by his German parents, but returned to Düsseldorf as a young man to study at that famous Rhineland art center. After about a year in Italy, he established his studio in New York City. In 1859, Bierstadt made his first trip into the American West, traveling as far as the Rocky Mountains, most of the time with Colonel Frederick Lander's army exploration expedition. The trip was made on horseback, often under perilous circumstances, but all along the way Bierstadt made innumerable oil sketches of the prairies, rivers, valleys, mountains, native peoples, buffalo, and antelope. Such scenery—much of it unknown to white people—became the basis of Bierstadt's art and reputation.

In 1863, Bierstadt painted his most famous picture, which was a compilation of studies made on that first western sojourn—*The Rocky Mountains, Lander's Peak* (Fig. 15.15). Perhaps following the example of Church's large canvases, or because he felt the vastness of his subject demanded it, Bierstadt painted this scene of a Native American encampment on a huge scale—10 feet (3 m) across. This view of exotic aboriginals with all of their colorful costumes and customs seen amid a majestic mountain landscape thrilled Americans with its panoramic vision of a far-distant part of their land. Bierstadt was the first to bring them a visualization of its grandeur and romance. He was also praised for his anthropological description of the Native Americans.

Bierstadt's second western trip took place in 1863. This time, he went all the way to California and the Pacific Northwest. Many handsome canvases resulted from studies made along the way, particularly of Yosemite Valley and the Sierra Nevada Mountains. Never mind that he took artistic license in dramatizing the great peaks—Bierstadt painted with such naturalism that they seem as real as the blades of grass detailed in the foreground. *Among the Sierra Nevada Mountains, California* is typical of such pictures, which often established the enormous scale of great escarpments by the presence of a solitary Native American in a tiny canoe, by a bear or two, or, as here, by a herd of deer that has come to drink at the edge of the mirrorlike mountain lake (Fig. 15.16).

Since the days of the '49 Gold Rush, Americans had been keenly interested in the West. As the nation began to expand west following the Civil War, Manifest Destiny became a reality. Bierstadt's *Emigrants Crossing the Plains* is a pictorial epic of the wagontrains moving westward (Fig. 15.17). This is an ancient, pristine land, uninhabited by white people. Bleached bones (left foreground) suggest its inhospitable nature, but a golden sunset symbolizes hope and ultimate success. In the central middleground is a tribal encampment. On their westward trek, the settlers constantly passed through such Native American territory. Easterners, for whom the artists painted, saw the "red men" differently from the settlers—back east the interest was anthropological. Many artists went west to record the aboriginals while they were still unchanged by the white settlers' ways.

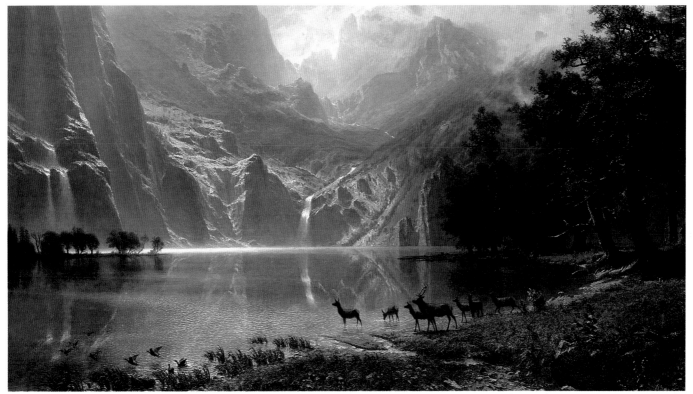

15.16 Albert Bierstadt, Detail of *Among the Sierra Nevada Mountains, California*, 1868. Oil on canvas, 6ft × 10ft (1.83 × 3.05m). National Museum of American Art, Smithsonian Institution, Washington, D.C.

15.17 Albert Bierstadt, *Emigrants Crossing the Plains*, 1867. Oil on canvas, 5ft × 8ft (1.52 × 2.44m). National Cowboy Hall of Fame and Western Heritage Center, Oklahoma City, Oklahoma.

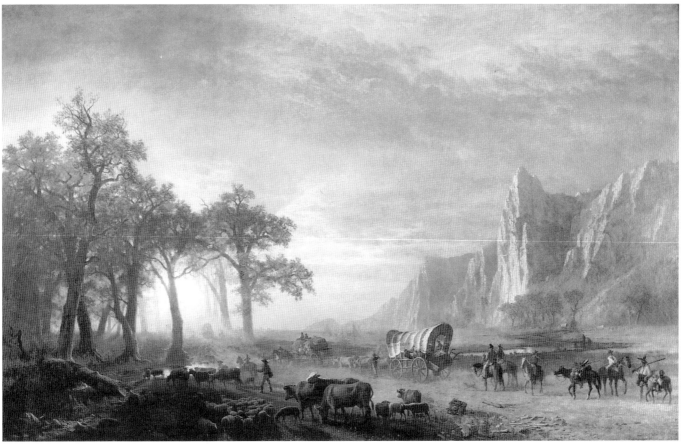

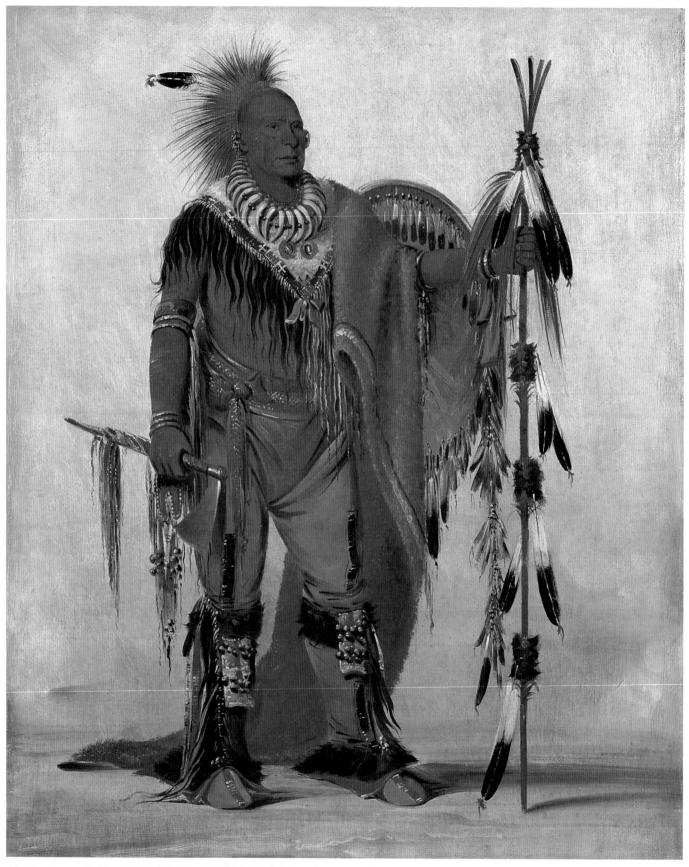

15.18 George Catlin, *Keokuk (The Watchful Fox), Chief of the Tribe*, 1832. Oil on canvas, 29 × 24in (73.7 × 60.9cm). National Museum of American Art, Smithsonian Institution, Washington, D.C.

NATIVE AMERICANS

George Catlin (1796–1872) was among the first to make Native Americans the subject of his art. A Pennsylvanian, Catlin was fascinated by the Native American artifacts at Peale's Museum in Philadelphia, and by a touring delegation of Native Americans visiting that city. Although trained as a lawyer, Catlin soon gave up that career for art. In 1830 he headed west, in order to document Native American life with his pencil and brush. From St. Louis he traveled up the Mississippi, Missouri, Platte, and Red Rivers, visiting various tribes, painting portraits of their leaders, and scenes descriptive of their customs.

Keokuk (The Watchful Fox), Chief of the Tribe is typical of the careful and accurate descriptive quality of Catlin's anthropological portraits (Fig. **15.18**). In 1832, General Winfield Scott acknowledged Keokuk as the greatest chief of the plains, proclaimed as such by his own people—all this just before Catlin painted him with his shield, staff, ax, and the other colorful paraphernalia of his native attire. Altogether, Catlin painted nearly 600 portraits and scenes of villages, tribal rituals, buffalo hunts, and the like. These formed the basis for the Indian Gallery he established in Washington, D.C. In 1841 he published *Letters and Notes on the Manners, Customs, and Condition of the North American Indian*, a valuable written document that augments his pictures.

There were many others who painted Native American subjects—among them John Mix Stanley, Arthur Jacob Miller, Karl Bodmer. Seth Eastman (1808–75), a native of Maine and a graduate of the Military Academy at West Point, spent all of his free time studying and sketching the Sioux and Chippewas while he was stationed among or near them at Fort Snelling, Minnesota, in the 1840s. He respected these people, spoke their languages fluently, and had many friends among them. Saddened by the thought that the race might be dying out, he recorded their everyday customs—as in *Lacrosse-Playing among the Sioux Indians* (Fig. 15.19).

The thousands of settlers who came pouring into the Native American territories often took a less-than-benevolent or anthropological view toward the inhabitants. By the 1860s, artists such as Bierstadt were declaring that now was the time to paint the "red men," for their way of life was rapidly changing.

15.19 Seth Eastman, *Lacrosse-Playing among the Sioux Indians*, 1851. Oil on canvas, 28 × 41in (71.1 × 104.1cm). Corcoran Gallery of Art, Washington, D.C.

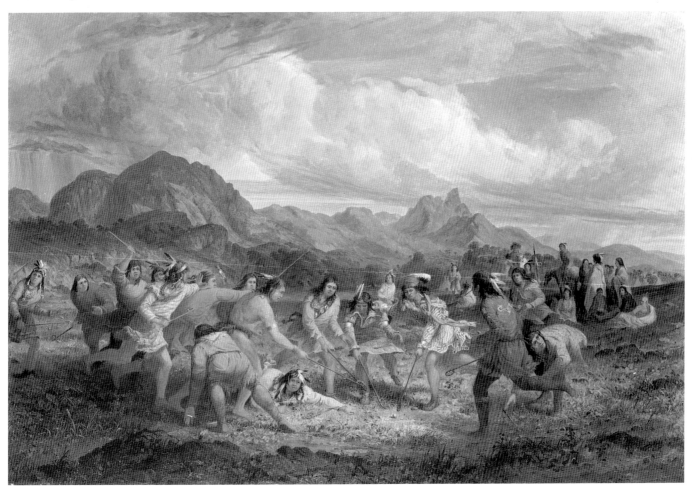

FARMYARDS, HARBORS, AND LUMINISM

Back east, the American school of landscape painting grew rapidly in the 1850s and 1860s, each new member contributing some special mode of vision. Just as some artists preferred mountains, others favored farms, harbors, coves, or lakes. While American artists seldom produced cityscapes, the farm scene in particular was frequently the subject of their pictures.

George Henry Durrie (1820–63) focused upon farmhouses, barns, outbuildings, livestock, haystacks, or farm folk at their chores. In *Winter Scene in New Haven, Connecticut*, a blanket of snow covers everything, and the trees are bare except for a few brownish leaves from the previous autumn (Fig. 15.20). Anecdotal details of rural life invite the viewer to tour the picture: Barking dogs announce the arrival of a neighbor in a horsedrawn sleigh; smoke curling from a chimney suggests coziness within; chickens peck about near an open barn door. Durrie lived in the New Haven area for about twenty years after 1840, and was familiar with the scenes he painted. His work was popularized after his death by Currier and Ives, the famous lithographic firm, which issued ten handsome, handcolored prints taken from Durrie's paintings.

Robert Salmon (1775–c. 1845) was one of America's foremost painters of shipfilled harbors. *Boston Harbor from Constitution Wharf* displays the characteristic linear precision with which he painted every form, from waves to rigging (Fig. 15.21). Devotion to detail was not exclusively

an American trait, for Salmon was already past fifty when he emigrated from Liverpool to Boston in 1828, with his style already fully formed. The quality of light in pictures like *Boston Harbor* suggests that before leaving England Salmon had studied the work of Claude Lorraine (1600–82) and J. M. W. Turner (1775–1851), which prefigures the luminist element in American painting.

LUMINISM

Luminism has sometimes been identified as the defining characteristic of American landscape painting of the third quarter of the nineteenth century. It is now generally understood to represent *a* characteristic rather than *the* characteristic. Luminism entails, first, an effect of light that some see as uniquely American, as distinct from European; second, an objectivity leading to precisely delineated forms; third, an absence of visible brushstrokes; and, fourth, a reduction of the number of compositional components, with a tendency to treat them as abstract forms, masses, and areas. Certain works by several painters conform to some or all of these criteria, and archetypal examples of luminism are found among the works of Fitz Hugh Lane, Martin Johnson Heade, John F. Kensett, Worthington Whittredge, and Sanford R. Gifford.

Fitz Hugh Lane (1804–65) painted the scenes around his native Gloucester, Massachusetts, and also in Boston Harbor and along the coast of Maine. The son of a Gloucester sailmaker, he was trained first as a lithographer, but turned to painting in the 1840s without benefit of formal instruction. Lane's *Boston Harbor* is one of the great marine

15.20 George Henry Durrie, *Winter Scene in New Haven, Connecticut*, c. 1858. Oil on canvas, 18 × 24in (45.6 × 60.9cm). National Museum of American Art, Smithsonian Institution, Washington, D.C.

15.21 Robert Salmon, *Boston Harbor from Constitution Wharf*, 1833. Oil on canvas, 26¾ × 40¾in (67.9 × 103.5cm). U.S. Naval Academy Museum, Annapolis, Maryland.

15.22 (below) Fitz Hugh Lane, *Boston Harbor*, 1850–5. Oil on canvas, 26¼ × 42in (66.8 × 106.7cm). Museum of Fine Arts, Boston. M. and M. Karolik Collection of American Painting, 1815–65, by exchange.

pictures of American art (Fig. **15.22**). A hushed calm pervades the scene, made golden by the glow of the setting sun. A crystal clarity is achieved by the linear definition of form, particularly in the painting of the ships. An exquisite pattern of linear design is a byproduct of this technique— especially noticeable in the masts, sails, and rigging. Salmon's influence can be seen if this picture is compared with *Boston Harbor from Constitution Wharf* (Fig. **15.21**).

Lane evoked a transcendental quality akin to the view of nature held by Ralph Waldo Emerson and Henry David Thoreau. His pictures possess a timeless stillness, a mood of tranquility in a wellordered world. Lane sought to capture the spiritual bond between the elements—land, water, air—and humankind.

Martin Johnson Heade (1819–1904) was similarly fascinated with problems posed by the effects of light upon a landscape. Born in Lumberville, Pennsylvania, he received brief instruction from Edward Hicks before departing for Europe in 1838. In his early years, Heade was mainly a portraitist in St. Louis, Chicago, Trenton, and Providence, before settling in New York City in 1859, where he formed a close friendship with Frederic Church.

In 1862, Heade began painting saltmarshes in the coastal regions around Newburyport, Massachusetts, in Rhode Island, and New Jersey. As Claude Monet (1840–1926) was to do a decade or so later, Heade took haystacks as a subject for study, analysis, and experimentation. This established a constant in the subject matter, enabling him to concentrate on the problems of light, color, and form. As in the work of Lane, nature was composed and simplified, almost to the point of abstraction. The artist's preoccupation with light is also found in his seascapes and pictures of storms, for example *Thunder Storm on Narragansett Bay*, in which the eerie light that often accompanies the arrival of a storm is the subject of the painting (Fig. **15.23**). Sails—compositional equivalents to haystacks—are carefully arranged white trapezoids seen against the darkness. Powerful horizontals establish an ordered calm in a composition broken by an erratic, vertical slash of lightning.

Perhaps influenced by the success his friend Church was having with his great pictures of the Andes and Ecuador, Heade made three trips to South America in 1864, 1867, and 1870. From these resulted numerous paintings of the lush jungle growth along riverbanks and pictures of orchids and hummingbirds. Late in his career, Heade painted blossoms—especially magnolias—lying on a rich velvet cloth, a veiled Victorian eroticism expressed through nature's forms and fecundity.

JOHN FREDERICK KENSETT'S LANDSCAPE OF ESSENCES

John Frederick Kensett (1816–72) began his career as an engraver, but turned to landscape painting while studying in England, France, and Italy, from 1840 to 1847. After his return to the United States, his early pictures included the wealth of details that typified Hudson River School landscapes in the early 1850s. Kensett's style then began to mature into a synthesis of natural form that has a remarkable simplicity and reductive abstract quality.

15.23 Martin Johnson Heade, *Thunder Storm on Narragansett Bay*, 1868. Oil on canvas, 32 × 54in (81.3 × 137.2cm). Amon Carter Museum, Fort Worth, Texas.

15.24 John Frederick Kensett, *Beacon Rock, Newport Harbor*, 1857. Oil on canvas, 22½ × 36in (57.2 × 91.4cm).
National Gallery of Art, Washington, D.C.

15.25 John Frederick Kensett, *Lake George*, 1869. Oil on canvas, 3ft 8in × 5ft 6¼in (1.12 × 1.68m).
Metropolitan Museum of Art, New York City.

In *Beacon Rock, Newport Harbor* the primary components have been reduced to sky, water, and the rock-mass at the right (Fig. **15.24**). Minor features—such as the narrow strip of land on the horizon, the tiny, red-shirted fisherman on the right, or the sailboat in the center—do not disrupt the simplicity of the composition. The rock-mass, especially, reveals the abstract synthesis of natural form that the artist sought. Kensett makes the viewer believe the eye sees every natural detail, but in truth he gave only the essential character of the boulders, abstracting away all unessential details.

Kensett enjoyed painting the coastal scenes around Newport, Narragansett Bay, and the New Jersey coast. In the serene blue sky and the placid plane of the surface of the blue-green water he found the basic components of his art, existing in broad, simplified areas of related coloration and tone. His exquisite tonal harmonies are apparent in a later work, *Lake George*, in which the viewer is again presented with the basic physical elements of earth, sky, and water, in a gentle symphony of muted hues and glowing light (Fig. **15.25**). If Kensett resorted to the Hudson River School technique of carefully painted details in the immediate foreground, the rest of the painting is devoted to essences, the grand purposes of which are the harmony and tranquility of nature. Lake George, in the Adirondack Mountains of New York, was a favorite haunt of mid-nineteenth-century landscape painters. In painting its scenery, however, Kensett departed from strict geographic description, taking liberties for the sake of his art. He omitted certain features and rearranged others. Several islands, for example, were left out, while others were moved to places where they became formally united with the larger land-masses—all in the name of compositional simplicity and harmony.

In Kensett's work, the effects of light and atmosphere, together with hue, are employed as unifying agents within the painting. His color range was purposefully limited and low-key, while a silvery, shimmering atmosphere softens contrasts of light and dark, imbuing the composition with a wonderful serenity. Kensett avoided dramatic effects, pursuing instead a poetic, subtle, and personal mode of vision.

PRECURSORS OF IMPRESSIONISM

Many other painters contributed to the breadth and depth of the American landscape school. Worthington Whittredge (1820–1910) left his native Ohio to spend ten years studying in Europe. At the German art center of Düsseldorf, he and other Americans found a compatible approach to nature in an aesthetic that emphasized the meticulous recording of naturalistic details. When Whittredge returned to America in 1859, he established his studio in New York City, and joined the other painters assembled there in making extended annual treks into the Catskills and the White Mountains. The American wilderness was sketched on the spot, in the open air where the effects of sunlight could be studied directly. *The Trout Pool* (Fig. **15.26**), which is typical

15.26 Worthington Whittredge, *The Trout Pool*, c. 1868. Oil on canvas, 36 × 27⅛in (91.4 × 68.7cm). Metropolitan Museum of Art, New York City.

of Whittredge's mature work, shows the influence of Asher B. Durand, whose landscapes he admired as "truly American." This study of tall trees darkly enframing a forest nook invites comparison with Durand's *The Beeches* (Fig. **15.7**). The loose brushwork, however, owes more to the technique of the Barbizon painters, such as Corot or Diaz, whose work Whittredge had seen in France, than to the tight draftsmanship of the Düsseldorf school. Sunlight filters through loosely sketched, leafy boughs in a delicate mixture of light, air, and color that anticipates the French Impressionists.

Such things were also of special concern to Sanford R. Gifford (1823–80), whose *Kauterskill Clove* is less concerned with the physical substance of nature than with the visual impression of form-dissolving light, atmosphere, and flickering color sensations (Fig. **15.27**). Nature is perceived and rendered very differently here than in Durand's *Kindred Spirits* (Fig. **15.8**), although both pictures represent scenes set in the Catskills. Gifford's painting is luminist, as it is concerned with light, retinal sensations, and quasi-impressionistic techniques.

Thomas Moran (1837–1926) is a fitting artist with whom to conclude this chapter. His art shows the shifting of interest within the landscape school from nature worship to

15.27 Sanford Robinson Gifford, *Kauterskill Clove*, 1862. Oil on canvas, 4ft × 3ft 3⅞in (1.22 × 1.01m). Metropolitan Museum of Art, New York City.

15.28 Thomas Moran, *The Grand Canyon of the Yellowstone*, 1872. Oil on canvas, 7ft × 12ft (2.13 × 3.66m). National Museum of American Art, Smithsonian Institution, Washington, D.C.

an understanding of the aesthetic qualities of pigment, light, color, air, and brushwork.

Born in England, raised in Philadelphia, and apprenticed to a wood-engraving firm, Moran had no formal training in art. He continued the tradition of the great panoramic landscapes of Church and Bierstadt, frequently painting on canvases that measured 12 feet (3.66 m) across. Like Bierstadt, Moran carries us into an American West of magnificent mountain ranges and sublime valleys and canyons. But in pictures such as *The Grand Canyon of the Yellowstone* (Fig. **15.28**), the effect is very different from, say, Bierstadt's *Among the Sierra Nevada Mountains* (Fig. **15.16**), although only four years separate the two works. Moran began his career as a watercolorist, and the fresh, quick strokes and

bright translucent color carried over into his work in oil. Moreover, while on a visit to England in 1862, he studied—in fact copied—the work of J. M. W. Turner, with its passionate preoccupation with the pure aesthetics of color, light, and air. His *Grand Canyon of the Yellowstone* resulted from studies made when he accompanied Ferdinand V. Hayden's U.S. Geological Expedition to Yellowstone in 1871. Moran's large picture was painted in 1872, the same year Congress established Yellowstone National Park. In it he demonstrated that the American school of landscape painting had matured to the point where the painter's concern was as much with the painterly effects of art as with the description of nature. Hence, about 1870, we detect a major change in American painting.

PAINTING:

GENRE, NARRATIVE, STILL LIFE, AND PORTRAITURE, 1825–70

American culture charted its own new course during the middle of the nineteenth century, at times drawing heavily upon Old World traditions, at other times arising out of America itself. Americans became aware they had a history—a storied past to feed the imagination of author, poet, and painter. It was in the commonplace aspects of life, which were often so severely criticized by European visitors, that they found something wholesome, and worthy of the pen and the brush.

An earlier generation had proved itself exceedingly capable in the drafting of political documents such as the Declaration of Independence and the Constitution of the United States. A later generation now proved itself equally able in philosophical and intellectual systems. These arose out of a spirit of independence that allowed Americans to think in creative and new ways, unencumbered by centuries of European intellectual thought.

Transcendentalism was the collective effort of a group of sages centered in Boston and Concord, Massachusetts. Nature, God, and social relationships were among their primary interests. Transcendentalists believed that formalized society tended to oppress the individual; formalized religion provided fewer spiritual truths than philosophical inquiry, which was often based on nature-study; and scientific, empirical knowledge, while necessary, was inferior to and transcended by insight and revelation. Although Transcendentalism was in some ways indebted to Old-World thought, it was essentially an American movement, and an expression of American intellectual independence.

The Transcendental Club was organized in Boston in 1836, with Ralph Waldo Emerson, A. Bronson Alcott, and George Ripley among the charter members. In 1840 they published their own magazine, *The Dial*, edited by Margaret Fuller. William Ellery Channing, the author of *Self-Culture*, joined their circle, as did Henry David Thoreau. Emerson's *Nature* (1836) declared that all persons were one with Nature, and that Nature was one with God. This spiritual unity and kindredness gave significance and dignity to the ordinary individual, a premise inherent in Channing's *Self-Culture*. Thoreau withdrew from society to live in the woods beside a pond near Concord for two years. He wrote about the experience in his bestknown book,

Walden (1854).

Twenty-four years before Charles Darwin's *Origin of Species* (1859), Benjamin Silliman, a Yale professor of geology, expressed doubts about the biblical account of Creation. In 1860, Asa Gray, a botany professor at Harvard, wrote several essays in support of Darwin in the newly founded magazine *Atlantic Monthly*. By 1869 John Fiske was lecturing at Harvard on the theory of evolution, and his lectures were published as *Outlines of Cosmic Philosophy, Based on the Doctrine of Evolution* (1874). Zoologist Louis Agassiz arrived from Switzerland in 1846 and began teaching at the Lowell Institute before moving to Harvard University, and in 1847 he brought out his *Introduction to Natural History*. The American Museum of Natural History was founded in New York City in 1869. By mid-century there were 120 colleges in the United States, testifying to the rapid spread of culture and intellectual life in the nation.

American literature blossomed as well during these mid-century decades, adding to the nation's literary wealth. Many authors turned to the country's past for inspiration, or to contemporary America. Nathaniel Hawthorne's *The Scarlet Letter* (1850) and *The House of Seven Gables* (1851) use seventeenth-century New England as subject and setting, while Henry Wadsworth Longfellow drew on America's past for his wellknown poems "The Courtship of Miles Standish" (1858) and "Paul Revere's Ride" (1860). Life at sea was another source of inspiration, as in Richard Henry Dana's *Two Years before the Mast* (1840), which describes his experiences aboard a clippership on its way to California, and the greatest American novel of the sea, *Moby Dick* (1851), by Herman Melville. American literary culture moved west with Mark Twain's tales set in Missouri, and his *Celebrated Jumping Frog of Calaveras County* (1867), which takes place in California.

Little Women appeared in 1868, written by Louisa May Alcott, daughter of the Transcendentalist Amos Bronson Alcott. The Transcendentalists were staunch advocates of women's suffrage, but the cause had risen even earlier with Charles Brockden Brown's *Alcuin: A Dialogue on the Rights of Women* (1797). Mary Lyon established Mount Holyoke Female Seminary in 1837 to pioneer higher education for women, and Elmira [New York] Female College was

founded in 1855, the first institution to award academic degrees to women. Vassar Female College was chartered in 1861. The first women's rights convention was held in 1848, and the National Women's Suffrage Association was organized in New York City in 1869 to lobby for a Constitutional amendment that would give women the vote. In the paintings and portraits of this era, little of this issue surfaces. Nevertheless, how women were represented—as wife, mother, and homemaker—remains a fascinating theme.

The founding of numerous cultural institutions during this period further testifies to the nation's cultural growth. The Smithsonian was established in Washington, D.C., in 1846, while the Astor Library (forerunner of the New York Public Library) and the Boston Public Library were founded in 1854. W. W. Corcoran of Washington, D.C., made his splendid art collection available to the public in 1869, hoping it would become the basis for a national gallery of the type in London. Evidence of culture moving westward can be seen with the establishment of the Cincinnati Art Museum in 1869.

AMERICAN GENRE PAINTING

It was not so much high culture that provided the themes to which genre painters and their patrons were drawn, but the simple, homey scene. These often were of rural subjects—if city life was depicted, it was almost always set within the home, not in the streets, for there were far fewer representations of the city than of the country or of rural folks. Undoubtedly, this was a reaction against the Industrial Revolution and what city life had become. While the greater portion of the population was rural rather than urban, which might explain the popularity of country genre scenes, the patrons were almost always citydwellers, who, it would appear, wanted rural genre pictures as an escape from urban existence. As antidotes to industrialization, genre and still life were as socially therapeutic as paintings of landscapes.

By the 1830s, ordinary men and women had made it clear that they preferred genre or still life subjects over the lofty themes of the Grand Manner. The term "genre" means ordinary people doing ordinary things. In American art it is an affirmation of Jefferson's faith in the common people, and the triumph of Jacksonian democracy. As a reflection of middleclass interests, it found its closest parallel in the middleclass, Protestant, mercantile society of seventeenth-century Holland, with the charming genre scenes of Pieter de Hooch (1629–83), David Teniers (1610–90), and Gerard Ter Borch (1617–81), and the still lifes by Willem Kalf (1619–93).

Like Holland two centuries earlier, the United States had no aristocracy, and virtually no Catholic church to patronize paintings of mythological or religious subjects. The finest American houses were modest in contrast to European palaces, country estates, and great cathedrals. An art of modest size accordingly developed. Federal and state governments were slow to assume the role of munificent patron. Moreover, although many Americans prospered during this period, this was not an era of enormous fortunes—that era came after 1870, with America's first millionaire society. This was also an era of nationalistic chauvinism, before the arrival of the international, cosmopolitan, often expatriate character of "millionaire" society in the closing decades of the century.

Genre subjects only occasionally appeared in the colonial period, as in a picture attributed to John Greenwood—*Sea Captains Carousing in Surinam* (1757, St. Louis Art Museum). Little genre vignettes occur in Francis Guy's cityscapes, as in his *Winter Scene in Brooklyn* (Fig. 11.7). The first artist in America to specialize in genre paintings was John Lewis Krimmel. The titles of his pictures express their genre nature: *Fourth of July in Center Square, Philadelphia* (Fig. 11.6), *Quilting Frolic* (1813, H. F. du Pont Winterthur Museum), *Interior of an American Inn* (1813, Toledo Museum of Art), and *Country Wedding* (1814, Pennsylvania Academy of the Fine Arts). But, although Krimmel established the genre subject as a viable theme in American art, he died young, in 1821.

HOMESPUN AND HUMOR

William Sidney Mount The leading figure in the establishment of a lasting tradition in genre painting is William Sidney Mount (1807–68). Leaving his home in Stony Brook, Long Island, to paint signs in New York City, Mount attended classes at the newly founded National Academy of Design in the mid-1820s. At first he subscribed to the theories of the Grand Manner, and attempted history painting with biblical subjects. Mount soon realized such work was unnatural to him, and that he did not like city life, so he went back to quiet, rural Stony Brook. There he found both subject matter and a way of life that were conducive to his work.

Mount's first success came with *Rustic Dance after a Sleigh Ride* (1830, Museum of Fine Arts, Boston), which was well received when it was shown at a trade fair in New York City that advocated a "buy American" policy, and encouraged the patronage of American art over European. With *Rustic Dance*, the rural subject and the theme of music became established as two of the most important elements of Mount's art. They are found again in *Dancing on the Barn Floor*, in which a jovial fiddler plays a lively tune, while a farm youth and country lass dance their merry jig (Fig. 16.1). The reference to music is probably due to the artist's love of it. He was an accomplished fiddler, and one of his brothers was a professional musician and composer. The barn setting is familiar in a number of later works, and its individuality is so pronounced that one can believe just such a barn existed at Stony Brook. A wholesome simplicity, even virtue, was associated with country life, and such scenes

16.1 William Sidney Mount, *Dancing on the Barn Floor*, 1831. Oil on canvas, 24⅝ × 29⅝in (62.3 × 75.2cm). Museums at Stony Brook, New York.

16.2 William Sidney Mount, *The Truant Gamblers*, 1835. Oil on canvas, 24 × 30in (61 × 76.2cm). Courtesy The New-York Historical Society, New York City.

as Mount painted were considered truly American. Thus pictures like this one became enormously popular because they extolled the good life of rural folk, uncorrupted by the evils and temptations that beset citydwellers. They seemed to be truly American, untouched by a dissipated European culture.

There is wonderful humor in Mount's *Truant Gamblers* (Fig. 16.2). Four young boys who should be in school are so absorbed in their pennypitching—which takes place in the now-familiar barn—that they are unaware of the approaching farmer, who, with a determined stride and an ominous set to his jaw, carries a switch he is about to put to use. In the next instant, pandemonium will erupt as small boys yelp and scatter in all directions. The humor is obvious, but the underlying moral is more subtle—loafing, gambling, and drinking (note the jug) are sure to be punished, and truancy will surely lead to ignorance. A patron looking at

such a picture would probably smile goodnaturedly, yet nod his head in approval of the moral it taught.

Luman Reed, sponsor of Thomas Cole and Asher B. Durand, was just that sort of patron, especially enjoying those paintings which transported him back to a life he remembered as being pleasant and virtuous. Reed had already bought Mount's *Bargaining for a Horse* (1835, New-York Historical Society), and *Truant Gamblers* soon joined it in his famous gallery. Reed was not alone in feeling as he did about the virtues of country life—such ideas had existed since the late eighteenth century, when Hector St. John de Crevecoeur had expressed the notion so clearly in his book, *Letters from an American Farmer*.

Eel Spearing at Setauket is similarly a reverie of Mount's blissful days in rural Long Island (Fig. 16.3). African-Americans appear quite often in Mount's pictures, and he is the first American painter to treat them extensively. Often

16.3 William Sidney Mount, *Eel Spearing at Setauket*, 1845. Oil on canvas, 29 × 45in (73.7 × 114.3cm). New York State Historical Association, Cooperstown.

16.4 Francis W. Edmonds, *The Image Peddler*, 1844. Oil on canvas, 33 × 42in (83.8 × 106.7cm). Courtesy The New-York Historical Society, New York City.

they are outsiders at festivities, as in *The Power of Music* (1847, Century Association, New York City), and *Dance of the Haymakers* (1845, Suffolk Museum and Carriage House, Stony Brook, Long Island), in which the black man stands outside the familiar barn, apart from the activities within. But Mount could also treat African-Americans heroically, as in two late pictures of 1856, *The Banjo Player* (Suffolk Museum and Carriage House, Stony Brook, Long Island) and *The Bones Player* (Museum of Fine Arts, Boston).

In the 1830s, Mount was the dominating figure in genre painting. In the 1840s, he was joined by a number of artists who also made it their specialty. Foremost among these were Francis William Edmonds (1806–63) and Richard Caton Woodville (1825–55).

Francis William Edmonds Edmonds's pictures, rich in charming anecdotal details, often suggest cozy warmth and

family affections, as in *The Image Peddler* (Fig. **16.4**). We see a familiar scene, for peddlers selling little plaster figurines and busts—generally massproduced and of modest quality—wandered the neighborhoods of American cities or traveled from hamlet to hamlet. Again one finds a didactic element: the grandfather (left) gestures toward a bust of George Washington, and tells his grandson about the great man's dedication to the national cause, his civic responsibility, and his renowned honesty. As in a seventeenth-century Dutch interior scene, which it resembles spatially, the picture is enriched with numerous passages that enchant the eye—the still life in the foreground, for example, just in front of the grandmother. Closer to his own time, and undoubtedly a strong influence on Edmonds, was the art of the Scottish painter Sir David Wilkie (1785–1841). The latter's *The Blind Fiddler* (1806, Tate Gallery, London) invites comparison with *The Image Peddler.*

Richard Caton Woodville The number of paintings by Woodville is not large because he died young, at age thirty, from an overdose of morphine. But his few pictures reveal an exceptional talent. Unlike Mount and Edmonds, Woodville spent much of his career abroad. From 1845 to 1851 he studied at Düsseldorf, where he learned to apply a high finish to the multitudinous details of his compositions, and to use everyday life as subject matter for his art. Woodville's pictures are usually small, and often have a timely, lively topic, as in *War News from Mexico* (National Academy of Design, New York) or *Politics in an Oyster House* (Walters Art Gallery, Baltimore). Both were painted in 1848 while he was in Düsseldorf, although they portray settings of his native Baltimore. In 1851, Woodville went to Paris to live. There, he painted his masterpiece, *The Sailor's Wedding*,

again set in a Baltimore interior (Fig. **16.5**). An old justice of the peace is noticeably perturbed at having his midday meal interrupted by the best man, who requests that he marry the cocky sailor and the demure young woman. The bride's parents and spinster sister complete the little wedding party, and a black serving girl at the left and two more jovial African-Americans at the doorway observe the event. Although there are twelve figures, Woodville maintains masterful control over the composition, with the central group stabilizing the arrangement, and secondary symmetrical groups at either side. He proved himself master of anecdotal details in objects such as the goat-hair trunk and the cluttered still life atop the chest at the left. For all the details, there is a monumental solidity in the figures that is typical of Woodville's style.

16.5 Richard Caton Woodville, *The Sailor's Wedding*, 1852. Oil on canvas, 18 × 22in (45.7 × 55.9cm). Walters Art Gallery, Baltimore, Maryland.

16.6 Lilly Martin Spencer, *Kiss Me and You'll Kiss the 'Lasses*, 1856. Oil on canvas, 30¹/₁₆ × 25¹/₁₆in (76.3 × 63.7cm). Brooklyn Museum.

Lilly Martin Spencer A playful flirtation is implied in Lilly Martin Spencer's *Kiss Me and You'll Kiss the 'Lasses* (Fig. 16.6). The scene is enriched by the still lifes upon a kitchen table, chair, and floor—an abundance of fruit and vegetables which, along with the molasses, offer a delectable sensory experience. Spencer (1822–1902), born in England to French parents who emigrated to the United States in 1830, was largely selftaught. After living for a while in Marietta, Ohio, she moved to New York City in 1847, when she married. Her pictures were popular in Victorian America, and many of them reaffirm the parallel with seventeenth-century Dutch interiors. One is reminded of Vermeer's pictures of women at their worktables surrounded by kitchen paraphernalia, while the still lifes suggest the work of Willem Kalf.

SATIRE AND BURLESQUE

So far, where there has been a moral in the genre pictures discussed, it has been presented with good humor, rather than biting satire. Most painters and patrons preferred it that way. But David Gilmour Blythe (1815–65) was exceptional in that he used the genre type to point up social injustices. This was unusual, for in both literature and art a positive and optimistic view of America generally prevailed.

Blythe was born in Ohio, but his career was spent in Pittsburgh, where he was a carpenter and a carver before he turned to painting. His own miserable, impoverished life probably accounted for his jaundiced view of society's institutions. *Art versus Law* is no doubt partly autobiographical, for it shows a poor artist returning to his loft studio only to find himself locked out, with notices on the door advertising the place for rent (Fig. 16.7). According to Blythe, society favored landlords over creative artists, and placed the law on the side of slumlords. The words of the central sign, "…Water Tax Paid (Provided the Tenant uses any water)," are insulting, in their implication that artists seldom bathe. Blythe regularly used distortion and caricature. His art has obvious affinities with that of the Englishman William Hogarth (1697–1764), the Frenchman Honoré Daumier (1808–79), and the American cartoonist Thomas Nast (1840–1902). His businessmen and judges are grotesque, fat, and greedy, his ragged street-urchins are young criminals, unsavory city types who are the antithesis of Mount's wholesome country boys.

Another genre was inspired by literature, of which the leading figure was John Quidor (1801–81). Loose brush-work and thin paint, as well as a tendency to caricaturize, give Quidor's pictures a distinctive style, and he turned almost every subject he undertook into a burlesque. These qualities are discernible in his madcap *Antony van Corlear*

16.7 David Gilmour Blythe, *Art versus Law*, 1859–60. Oil on canvas, 24 × 20in (61 × 50.8cm). Brooklyn Museum.

16.8 John Quidor, *Antony van Corlear Brought into the Presence of Peter Stuyvesant*, 1839. Oil on canvas, 27⅜ × 34⅟₁₆in (69.5 × 86.5cm). Munson-Williams-Proctor Institute, Museum of Art, Utica, New York.

Brought into the Presence of Peter Stuyvesant, in which the potbellied little trumpeter gives such a blast on his horn that everyone in the room is thrown into pandemonium (Fig. 16.8). The literary source is Washington Irving's *Diedrich Knickerbocker's A History of New York*. Quidor was born at Tappan, New York, not far from Washington Irving's home in Tarrytown, and many of his pictures were inspired by stories by Irving—*Ichabod Crane Pursued by the Headless Horseman* (1828, Yale University Art Gallery), *The Return of Rip van Winkle* (1829, National Gallery of Art, Washington, D.C.), and *The Money Diggers* (1832, Brooklyn Museum). While he often mixed the weird and the bizarre with comedy and buffoonery, Quidor could nevertheless develop psychological tensions among his characters. Although he lived and worked in New York City, he never became a part of the community of artists, and his art did not suit the taste of the emerging group of patrons there.

THE WESTERN FRONTIER: BINGHAM

As America expanded beyond the Allegheny Mountains into the Great Plains, the arts soon followed. There was considerable activity in both painting and sculpture in Cincinnati by the 1830s, due largely to enlightened patronage from men like Nicholas Longworth. By the next decade, the frontier had its own chronicler in George Caleb Bingham (1811–79), who took his inspiration from the spirited life along the Missouri and the Mississippi rivers, anticipating Mark Twain's tales of that region by about twenty years.

Although born in Virginia, Bingham grew up in Missouri, returning east briefly to study art in Philadelphia.

Bingham's work comes into historical focus with *Fur Traders Descending the Missouri* (Fig. 16.9). In the golden haze of a misty dawn—the atmospheric effect of the background is remarkable—a French trader and his half-breed son move along the mirror-placid waters of the great river in a dugout canoe. They wear the typical colorful costumes of their culture, and have a wild-animal pet tied to the bow. Bingham saw something exciting and exotic in the men who lived in the solitary wilderness of the upper Missouri, running their traps or trading with Native Americans, and he captured the romance surrounding them. Furs, traded for guns or blankets, were bartered to John Jacob Astor's American Fur Company in St. Louis, and from there shipped by steamboat to world markets. Bingham's picture depicts not the company-owned steamboat portion of this saga, but a wary trader and his son, making their annual descent to the fringe of "civilization."

Pictures like this depicted a new type of folk hero, created by the land itself. Europe had no counterpart, and so here again was a subject that was uniquely American. Another evocative subject used by Bingham was the bargemen who plied the waters of the great Mississippi River. The classic example is *The Jolly Flatboatmen*, which was actually painted in Düsseldorf, Germany, where the artist had gone to study (Fig. 16.10). Here, all the color and spirit of life on the great river are captured in rich detail.

Always interested in politics, Bingham was himself

16.9 George Caleb Bingham, *Fur Traders Descending the Missouri*, c. 1845.
Oil on canvas, 29 × 36½in (73.7 × 92.7cm). Metropolitan Museum of Art, New York City.

16.10 George Caleb Bingham, *The Jolly Flatboatmen in Port*, 1857. Oil on canvas, 3ft 11¹⁄₁₆in × 5ft 9⅝in (1.2 × 1.77m).
Saint Louis Art Museum.

16.11 George Caleb Bingham, *The County Election*, 1851–2. Oil on canvas, 35⁷⁄₁₆ × 48¾in (90 × 123.8cm). Saint Louis Art Museum.

elected to political office. A keen observer of American democracy, his scrutiny resulted in several pictures of that system at work on the frontier. *The County Election* (Fig. 16.11) is an assemblage of election-day vignettes by an artist who had firsthand knowledge of such events: lively debates, drunkards, last-minute campaigning with the tip of the hat, and swearing-in as the vote is cast. There is a festival-like atmosphere that has brought the farmers into town from miles around, but note the absence of women (who did not have the vote). A black man pours another glass of beer or hard cider as he tends the concession at the left—a wealth of anecdotal detail is recorded. Bingham recognized that within the commonplace there was greatness. Despite inebriates and bumpkins, Bingham's presentation of the scene is positive. The message is that even here, on the frontier, the system of selfgovernance works.

CURRIER AND IVES

Easterners who were caught up in the romance of Manifest Destiny and of the western territories wanted images of such things. At one level, there is Asher B. Durand's *Progress* (Fig. 15.9). At another, more popular level, the fascination with the expansion in the West is seen in Currier and Ives's print, *Across the Continent: "Westward the Course of Empire Takes its Way"* (Fig. 16.12). In the lower right two Native Americans observe what is happening to their plains as white communities begin to develop houses, stores,

churches, and schools. Railroad tracks and telegraph lines imply that the whites intend to penetrate even further into the continent. On the side of the train are the words "Through Line, New York to San Francisco." The print was made in 1868 in anticipation of the railroad's coast-to-coast connection at Promontory Point, Utah, in the following year (Fig. 25.1). At the left a wagontrain heads off into the open landscape, while another is being organized amid the crude log buildings of the settlement. *Across the Continent* (1866)

16.12 Frances F. Palmer, *Across the Continent: "Westward the Course of Empire Takes its Way,"* 1868. Currier and Ives lithograph, 20 × 27in (50.8 × 68.6cm). Library of Congress.

by Samuel Bowles was a popular book about a trip from the East Coast overland to California, through country much like that seen in the lithograph. "Westward the course of empire takes its way" is a line from a poem written in 1726 by the English philosopher Dean George Berkeley (Fig. 5.6). By the mid-nineteenth century, the words had become a slogan emblazoned upon the banner of Manifest Destiny.

Currier and Ives catered to the interests and tastes of the common people of America, supplying them with inexpensive images of familiar scenes. Their lithographic prints were produced in their shop in New York City in great number, handcolored in an assemblyline system, and sold on street corners and in general stores across the country. The firm of Currier and Ives was started in 1835 by Nathaniel Currier (1813–88), who took James Ives (1824–95) into the firm in 1852 as a bookkeeper. Five years later, the famous partnership was formed. Their lithographs sold for as little as twenty-five cents, and although the quality of the prints varied enormously, it put art within the reach of ordinary people. Currier and Ives remained active in the firm until the 1880s, and their sons kept the business going until 1907. The designs were produced by staff artists, like Frances Palmer, and often they bought paintings by artists such as Eastman Johnson, George Durrie, and Arthur Fitzwilliam Tait, and had them copied on stone.

THE HEROIC NARRATIVE

The heroic narrative was not a major feature in American art in the mid-nineteenth century. This was largely for practical reasons: there were few places for it in a land that had no great manorhouses, where churches did not display large-scale religious pictures, and where local, state, or federal government seldom assumed the role of patron.

One of the few artists to make a reputation for himself as a history painter was Emanuel Leutze (1816–68), who is best remembered today for *Washington Crossing the Delaware* (Fig. 16.13). Born in Germany but brought to America as a child, Leutze returned to Düsseldorf to study in 1840. He remained abroad for nearly twenty years before returning to America in 1859. *Washington Crossing the Delaware*, painted in Düsseldorf in 1851, shows Washington making his daring and strategically brilliant crossing of the Delaware River on Christmas Eve 1776 in a surprise attack upon Trenton, where he routed the British and the Hessians. The general assumes a determined stance as his motley troops push through the ice of the river. The picture was an immediate success, and gained the artist a commission to paint a mural for the United States Capitol—*Westward the Course of Empire Takes its Way* (1860). It was, however, uncommon for artists to obtain such grand commissions.

16.13 Emanuel Leutze, *Washington Crossing the Delaware*, 1851. Oil on canvas, 12ft 5in × 21ft 3in (3.78 × 6.48m). Metropolitan Museum of Art, New York City.

16.14 John F. Francis, *Luncheon Still Life*, c. 1860. Oil on canvas, 25½ × 30⅜in (64.6 × 77.2cm). National Museum of American Art, Smithsonian Institution, Washington, D.C.

STILL LIFE AND THE JOY OF ABUNDANCE

In the eighteenth century, flowers and fruits were the province of the botanical artist, and were treated almost as scientific illustrations. Early in the nineteenth century, however, the Peale family of Philadelphia established the still life as a valuable subject in the artist's repertoire. The fruit pieces by James and Sarah Miriam Peale are simple arrangements of a few objects, handsomely colored but infused with a soft, subtle tonality, small in size, and representing little more than what they are (Figs. 11.1 and 11.4). In contrast were the highly symbolic, complex compositions by Charles Bird King, with their biting satire and critical social commentary (Fig. 11.5). Each of these strains continued into and well past mid-century.

John F. Francis (1808–86) was a part of the Pennsylvania still life tradition that arose, at least in part, from the work of the Peales. Francis was born and worked in Philadelphia, where he would have known the still lifes painted by the Peales. He was also active in central Pennsylvania,

16.15 Severin Roesen, *Still Life with Fruit and Champagne*, 1853. Oil on canvas, 30 × 44in (76.2 × 111.8cm). Munson-Williams-Proctor Institute, Museum of Art, Utica, New York.

Washington, D.C., and elsewhere, often as an itinerant portraitist. Most of his still lifes date from around 1850 to 1875. *Luncheon Still Life* looks like one of the Peales' pieces on a larger scale, its greater complexity resulting from the number of objects (Fig. 16.14). It is also indebted to the luncheon type of still life found in seventeenth-century Dutch painting. The opened bottles of wine and the glasses partially consumed suggest a number of unseen guests. The appeal of the fruit and nuts to our sense of taste is heightened by the juicy orange, which has already been sliced. The arrangement is additive, that is, made up of many different parts, not always compositionally integrated, with all objects of essentially equal importance.

About 1848, Severin Roesen (active 1845–72) came to the United States from Germany, where he had painted decorative, probably floral, designs on porcelain. His work is closest to that of the Danish still life painter Johan Laurentz Jensen, who in the 1820s and 1830s painted floral compositions on porcelain pieces in the Sèvres factory near Paris.

Roesen settled in New York City, where he began to paint large, lush, still lifes of flowers, fruit, or both, often measuring over 4 feet (1.2 m) across. *Still Life with Fruit and Champagne* is typical in its brilliance of color, meticulous rendering of detail, compact, crowded composition, and unabashed abundance (Fig. 16.15). Here is a tradition quite different from that formed by the Peales, for Roesen's style is greatly indebted to European traditions, from seventeenth-century Dutch still lifes to the Düsseldorf painter Johann Wilhelm Preyer (1803–89), or the French master of a generation earlier Jean Louis Prévost the younger (1760–1810). Rich in symbolic overtones, the beautifully painted objects carry additional meanings—butterflies or fallen buds suggest the impermanence of life, a bird's nest with eggs means fertility, a pineapple is a standard symbol of welcome, and so on. Above all, Roesen's art expresses the abundance that America symbolized to many of its citizens.

Still Life is typically arranged on a shelf or tabletop. The immediacy is apparent from the many tiny bubbles seen rising in the recently poured glass of champagne. Raspberries are heaped in a compote, while peaches and other fruit fill a wicker basket. A slice of melon excites the viewer's taste buds, and a partially peeled lemon makes the mouth pucker. These diverse specimens are united into a compact composition by the numerous bunches of grapes, vines, and tendrils. Never mind that these luscious fruits never became ripe at the same time of the year—the purpose was to convey the idea of abundance and mouth-watering delectability.

Roesen worked in New York City until about 1858, when he is believed to have gone to Pennsylvania, where the rest of his life was spent in Williamsport. His art was well known in New York, where it had a great influence on younger still life painters such as Paul Lacroix (active 1858–d. 1864), Charles Baum (1812–77), and George Henry Hall (1825–1913).

PORTRAITURE: A BLATANT REALISM

If Americans of the mid-nineteenth century cherished naturalism in still life, landscape, and genre, they also demanded it in portraits of themselves. In general, it was not a period of excellence in portraiture. For the style of the era was dominated by a kind of blatant realism—in competition with the realism offered by the newly arrived photographic image—or a romantic sentimentality. The art of portraiture had to await a later generation to be restored to respectability by painters such as Thomas Eakins and John Singer Sargent. Still, portraits remained the most popular form of painting, and it is therefore important to note the manner in which mid-century Americans wished to be portrayed.

Charles Cromwell Ingham (1796–1863) was a competent professional portrait painter who came to New York City from his native Ireland in 1816. He developed a special finish through a glazing technique and meticulous execution, which gave his fleshtones an enamel-like quality. This is seen in *The Flower Girl*, which shows Ingham catering to Victorian tastes for the sweet innocence of maidenhood, a melodramatic sadness within the soul, and a love of flowers (Fig. 16.16). This is probably a portrait of a real person, but

16.16 Charles Cromwell Ingham, *The Flower Girl*, 1846. Oil on canvas, 36 × 28⅞in (91.4 × 73.3cm). Metropolitan Museum of Art, New York City.

it has been converted into a saccharine idealization of the Victorian woman.

Henry Inman (1801–46) studied under the New York portrait painter John Wesley Jarvis and established his own studio in 1824. Within a decade, he had become the leading portraitist in New York. Many of his paintings have a fluid brushstroke, and even a lingering trace of Romantic idealization. A forthright plainness, however, may at times be detected in his likenesses, as the real, materialistic world of the Industrial Revolution begins to assert itself. A good example of his work is *Georgianna Buckham and her Mother* (Fig. 16.17). Inman made a trip to England in 1844–5 but died about a year after he returned to America.

Portraits of men frequently took on something of the crassness of the real world. Chester Harding (1792–1866) was Stuart's successor in Boston, and Thomas Sully's almost exact contemporary. If we compare Sully's *Thomas Handasyd Perkins* (Fig. 10.12) with Harding's *Amos Lawrence* (Fig. 16.18), we observe a loss of refinement and elegance and a harsh truthfulness that refuses flattery. Lawrence's face, rendered without idealization, is a strong characterization and is well painted. There is something of a love of material stuffs that runs deep among a middleclass *nouveau*

16.18 Chester Harding, *Amos Lawrence*, c. 1845. Oil on canvas, 7ft⅝in × 4ft 6in (2.15 × 1.37m). National Gallery of Art, Washington, D.C.

16.17 Henry Inman, *Georgianna Buckham and her Mother*, 1839. Oil on canvas, 34¼ × 27¼in (87 × 69.2cm). Museum of Fine Arts, Boston. Bequest of Georgianna Buckham Wright.

riche, satisfied here by the expensive paisley robe and the colorful and expensive carpet. Amos Lawrence and his brother Abbott had one of the most successful mercantile establishments of the early nineteenth century, and Abbott was one of the entrepreneurs who founded the textile town of Lawrence, named in his honor. Amos, too, was involved in the textile industry. These things may explain the extraordinary emphasis placed on the handsome textile of Lawrence's robe, and the fact that he wears a robe and slippers in an otherwise formal portrait. The painter also tried to associate his full-length portrait with the Grand Manner through the inclusion of the monumental column with its base—a reference to noble architecture of large scale—and the great swag of drapery, following a type of composition that had been employed by Gilbert Stuart.

There can be no question that painters, especially portrait

16.19 Charles Loring Elliott, *Mrs. Thomas Goulding*, 1858. Oil on canvas, 34 × 27in (86.4 × 68.6cm). National Academy of Design, New York City.

painters, felt the competition of the recently arrived daguerreotype, an early form of the photograph, which virtually drove the miniaturist portrait painter out of existence. The daguerreotype was so popular, so inexpensive, and so accurate in every detail that portraitists working in full scale felt a need to compete with it.

This is apparent in Charles Loring Elliott's portrait of *Mrs. Thomas Goulding* (Fig. 16.19). Elliott (1812–68) maintained a successful New York portrait studio, which catered to the materialistic tastes of an upper-middleclass clientele by developing a style of daguerreotype-like exactitude in detail and truthfulness. After several years as an itinerant portrait painter in New York State, he established himself in New York City in 1839, the same year that Samuel F. B. Morse returned from France with the daguerreotype process. Elliott's style permitted no intrusion of a Romantic ideal. His *Mrs. Thomas Goulding* is the antithesis of Sully's sweet idealizations of earlier times (see Fig. 10.11). Every line of Mrs. Goulding's face is as carefully delineated as every detail of her fancy bonnet, and every wrinkle of her aged hand is as truthfully drawn as those of her dress. Her image has the same excruciating realism seen in the daguerreotype of old Lewis Cass (Fig. 17.3). In portraits of young women of this

period, such as those by Ingham (Fig. 16.16), the painter and patron might seek a romanticized ideal of feminine beauty and sensitivity—in images of older women, such flattery and falsehood were evidently considered nonsense, and accordingly disposed of.

Another area where idealization was tolerated, even desired, was in portraits of children, as in Lilly Martin Spencer's *Four Children of Marcus L. Ward* (Fig. 16.20). These are handsome, wholesome, and lively children with intelligent faces, every one exuding the joy of childhood and the hope and promise of the future. They are depicted in a fashionable interior, where a love of the exotic is shown by the large, brightly colored parrot. Spencer had also established a reputation as a portraitist in addition to her genre paintings. Her picture of the Ward children is, in fact, almost a genre picture, and at the right the artist included a lovely little still life. The wonderfully carved Gothic Revival chair reflects the popularity of that historic style in fashionable furnishings, and the luxurious, richly patterned carpet is exemplary of the pleasure this age took in material stuffs. Here are the princes and princesses of the Industrial Revolution in America as the future leaders of their society. In fact, Marcus Ward was active in political, social, and cultural

16.20 Lilly Martin Spencer, *Four Children of Marcus L. Ward*, 1858–60. Oil on canvas, 7ft 8in × 5ft 8½in (2.34 × 1.74m). Collection, Newark Museum, Newark, New Jersey.

16.21 William Page, *Mrs. William Page*, c. 1860. Oil on canvas, 5 × 3ft (152.4 × 91.4cm). Detroit Institute of Arts.

affairs, and in 1860 was a delegate to the national convention that nominated Abraham Lincoln for president. A few years later he became governor of New Jersey.

The expatriate style showed strong influences from the European Old Masters, and from the artists' long years of living and studying abroad. George Peter Alexander Healy (1813–94) lived a major portion of his life in Paris, and evolved a realistic portrait style that was greatly indebted to the art of Rembrandt. William Page (1811–85) spent the 1850s in Rome as part of the large American colony there. His portrait of his wife, standing in front of the Colosseum, reveals Page's study of the work of the famous Renaissance painter Titian in its coloration and its tonalities (Fig. 16.21). The attraction of Italy remained powerful throughout the middle part of the century, even as a purely American art was sought back home. Both Healy and Page represent the cosmopolitan type of artist, far more than, say, Harding or Elliott, whose forthright naturalism was a response to American culture itself.

CHAPTER SEVENTEEN

PHOTOGRAPHY:

THE EARLY YEARS, 1839–70

Living in the late twentieth century, a world with few or no images is difficult for us to imagine. We are constantly exposed to pictures in books, magazines, and newspapers, on television and billboards, and on the walls of our homes and workplaces. At the beginning of the nineteenth century, however, the ordinary person encountered visual images infrequently. The first revolution in this matter came with lithography, introduced into America around 1810–20, which made cheap, massproduced pictures available to a wide range of the public. The next revolution came with the introduction of the photographic process in 1839. As a new medium that was unrestricted by the restraints of tradition, it provided the public with graphic images of burning issues, great events, and humble lives. Cameramen innovatively turned their lenses upon innumerable new themes from the American panorama that painters had not deigned to consider. When the camera did vie with painting in subjects such as portraiture or landscape, it forced a reconsideration of the aesthetics of those artforms.

From its first appearance, photography began to document the unfolding saga of nineteenth-century America, sometimes heroic, sometimes tragic. Slavery and the Civil War, for example, were issues generally ignored by painters, but which were chronicled by the photographer. During this era, the nation was divided within itself over the matter of states' rights, particularly the right of each state to decide on the legality of slavery. This was especially crucial as territories joined the Union—Missouri, Texas, Kansas, Nebraska, and California, for example—and the question was hotly debated whether these new states should decide for themselves, or whether it was to be determined by the United States Congress.

New England had long been a center for the anti-slavery movement, and activities increased in the 1830s with the formation of the New England Anti-Slavery Society, in which William Lloyd Garrison and John Greenleaf Whittier (Fig. 18.10) were active. Tempers flared over the issue in Boston, where in 1835 a pro-slavery mob dragged Garrison through the streets. By 1836, there were over 500 abolitionist societies in the northern states. In 1838, the Underground Railroad was organized to help escaped slaves make their way to northern states and freedom. John Quincy Adams (Fig. 17.1) was a fiery abolitionist orator in the House of Representatives when his picture was taken in 1843. In the Senate, a Compromise Bill was worked out in 1850 by Henry Clay and Daniel Webster, but it postponed the Civil War for only a decade.

Harriet Beecher Stowe's *Uncle Tom's Cabin* (1852) fanned the flames of anti-slavery sentiments. Frederick Douglass, a former slave who escaped to the North in 1838, published *My Bondage and My Freedom* in 1854. Two years later, the fanatical and militant abolitionist John Brown led an attack on Lawrence, Kansas, which had been established by the

17.1　Philip Haas, *John Quincy Adams*, 1843. Daguerreotype. Metropolitan Museum of Art, New York City.

New England Emigrant Aid Society to promote the free-state movement in "bleeding Kansas," as it was called. When pro-slavery forces moved in, Brown began his raids. He was caught and hanged in 1859. Julia Ward Howe's "Battle Hymn of the Republic" appeared in 1861 in the *Atlantic Monthly*. Two months later, General P. T. Beauregard fired his cannon on a federal fort in the harbor at Charleston, South Carolina. The Civil War had begun.

For four long, bloody years the Blue and the Gray fought at places such as Manassas or Bull Run, Shilo, Vicksburg, and Antietam (Fig. 17.10). From the first to the third of July, 1863, a battle raged at Gettysburg—when it was over, the war turned in favor of the Union. More than 7000 men lay dead upon the rockstrewn fields, and another 34,000 were wounded. President Abraham Lincoln (Fig. 17.9) issued the Emancipation Proclamation on 1 January 1863, freeing all slaves (Fig. 18.12). On 19 November he dedicated the battlefield at Gettysburg as a national shrine with the immortal words of his Gettysburg Address. On 9 April 1865, General Robert E. Lee met General Ulysses S. Grant at Appomattox Courthouse, Virginia, and surrendered. Within a week, John Wilkes Booth had assassinated President Lincoln at Ford's Theater in Washington.

The Union had lost its spiritual as well as its political leader—the South had lost everything, and was devastated. The period of Reconstruction, a decade of anguish, followed, but it was a long time before recovery really came to the southern states. A profound pall hung over a nation that was severely scarred by the war, by the assassination of Lincoln, and by the corruption of the postwar era. Prewar optimism and the American Dream were crushed. In order to escape and start anew in yet another Eden, Americans turned west.

If the South was devastated, the North emerged from the Civil War stronger than ever in industrial might and financial power. The foundations for the great fortunes of late-nineteenth-century America were laid solidly in place.

ORIGINS OF PHOTOGRAPHY: THE DAGUERREOTYPE

Americans loved mechanical gadgets, and once the camera was introduced, within three decades—from 1839 to 1870—the popularity of the photographic image was immense. Soon every town and hamlet across the land was familiar with the new picturemaking process.

The story of photography begins in Europe. Early experiments in light-sensitive images had been conducted in France by the chemist Joseph Nicéphore Niépce. When he died in 1833, Niépce's process was taken up and perfected by his fellow-countryman Louis Jacques Mandé Daguerre (1789–1851).

Daguerre's procedure involved coating a copper plate with a light-sensitive emulsion, which, when exposed to light, produced an image on the plate. As there was no negative, the image was unique and could not be duplicated. Daguerre's work marks the beginning of photography. In August 1839 he made his process public knowledge, and word of it spread far and wide.

Meanwhile, an Englishman named William Henry Fox Talbot had developed a method that employed a negative, from which any number of positive prints could be made on light-sensitive paper. Talbot, however, was fiercely protective of his process, patenting it, and only releasing it through franchises which he sold. Pictures made using Daguerre's procedure are known as daguerreotypes, those produced from Talbot's method are **talbotypes** or **calotypes**.

A few months before Daguerre announced his process publicly, accounts of it appeared in a number of American newspapers. By October of that year a Philadelphian, Joseph Saxon, produced what is believed to be the first daguerreotype in America. Robert Cornelius (1809–93), a manufacturer of metal lamps in the Quaker City, was also one of the first to produce daguerreotypes, operating a studio from 1839 to 1842. His partner, Dr. Paul Beck Goddard, a chemistry professor at the University of Pennsylvania, discovered bromine, which speeded up the exposure time sufficiently to make posing for a portrait possible. Philadelphia's credentials as an early center of photography were further established by the exhibitions of daguerreotypes held at the Franklin Institute and the American Philosophical Society in late 1839 and 1840.

PERSONALIZED PICTURES FOR ALL

In New York City, the former painter Samuel F. B. Morse was influential in the introduction and dissemination of the daguerreotype process. Morse had been in Paris in 1839 and knew Daguerre. When he returned to America that year, he began advocating the use of the camera by artists—as president of the National Academy of Design, he was in a good position to do so.

The necessary equipment was at first bulky, but it was uncomplicated. The original camera was an unsophisticated affair, little more than a wooden box with a lens at one end and a sensitized plate at the other. The process required some mechanical aptitude and a little knowledge of chemistry, but no artistic talent whatsoever. This in itself effected a revolution in picturemaking. Suddenly anyone could produce images. By 1853, there were reportedly 2000 daguerreotypists practicing in America, most of whom were in the business to make money, not art. Although the early daguerreotypes had a relatively low aesthetic threshhold, there were many powerful images among them showing perceptive observation and great exactitude in every detail.

The daguerreotype was the most democratic form of imagemaking ever known, bringing personalized pictures within the reach of the common person. It was estimated

that by 1853, three million Americans, out of a total population of about twenty-five million, were having their portraits taken annually with the new invention. The daguerreotype was inexpensive and affordable to the masses. While ordinary people might be able to purchase an engraving, previously they could not afford to commission something so personal as a portrait. Now they could, and every city and town soon had its own photographer and studio. Itinerant daguerreotypists carried their darkrooms with them in their horsedrawn buggies. There were even some who had their studios on flatboats so they could do business at all the river towns.

VISUAL REALISM

The early daguerreotypists came into contact with and recorded images of people and their lifestyles that had seldom attracted the attention of painters—again, the democratization of picturemaking is evident. The camera produced a visual realism such as had never been known. For this reason, Europeans disliked the photographic image as a substitute for art—but Americans loved it, both for the mechanical wizardry it involved, and for the factual character of the image.

Because the process offered less opportunity for the intrusion of the artist, the daguerreotype became synonymous with truthfulness. Nothing could be added, changed, or left out, and this was admired greatly as the ultimate truth in imagery. The fascination with truthfulness soon outweighed a concern for aesthetic refinement. As one man remarked upon seeing a daguerreotype portrait of himself: "An ugly little thing, and a capital likeness." Edgar Allan Poe admired the daguerreotype because it was infinitely more accurate than anything painted by hand. In Nathaniel Hawthorne's *The House of Seven Gables* (1851), Holgrave the daguerreotypist delves into the psyche of others, with the declaration that the camera reveals the inner, often darker conditions of the soul: The daguerreotype "brings out the secret character with a truth that no painter would venture upon, even could he detect it."

PORTRAITURE: REALISM AT EVERY LEVEL

In this early period, the portrait was the most popular of photographic images, although genre subjects, city views, and landscapes were photographed as well. Attempts at allegory, moral tableaux, and religious subjects were not successful because the photograph was too blatantly realistic for their idealizing content. The forthright realism of the daguerreotype was acceptable for portraiture at all levels of American society. John Quincy Adams, for example, although mystified by the process, posed frequently. The full-length portrait of him by Philip Haas (Fig. 17.1) is very

different from Thomas Sully's elegant and idealized portrait of the wealthy Bostonian Thomas Handasyd Perkins (Fig. 10.12)—yet only a decade separates the two. Haas (active 1840–60), one of the early daguerreotypists, operated a studio in Washington, D.C. Adams posed for him there on at least one occasion on behalf of an artist, James Reid Lambdin, who wished to use the picture as an aid when he painted Adams's portrait. While Adams appreciated the realism with which his features were preserved by the daguerreotype, he lamented to his diary, on 2 August 1843, that the images were "too true to the original."

THE UNERRING EYE

Of all the forms of painting, portraiture was the most affected by the daguerreotype. The unerring eye of the camera gave the ordinary American, who was unsophisticated in matters of aesthetics and the fine arts, that truthfulness which he or she respected in an image. The *Country Couple* (Fig. 17.2), for example, has a naturalness and almost painful plainness of face, an absence of expression or gesture, that are not in any way associated with pretension or the artistic traditions of traditional painted portraits. The people are viewed straight-on, and every detail is magically captured. It was these qualities Grant Wood incorporated

17.2 Anonymous, *Country Couple*, c. 1844. Daguerreotype. Ohio State University Library for Communication and Graphic Arts, Columbus, Ohio. Floyd and Marion Rinhart Collection.

17.3 Anonymous, *Lewis Cass*, c. 1855. Daguerreotype. Chicago Historical Society, Chicago, Illinois.

17.4 Anonymous, *The Toleware Maker*, c. 1850. Daguerreotype. International Museum of Photography, George Eastman House, Rochester, New York.

17.5 Samuel F. B. Morse, *Mrs. Samuel F. B. Morse and Daughter Playing Chess*, c. 1848. Daguerreotype. Courtesy The New-York Historical Society, New York City.

into his famous picture of another country couple in *American Gothic* (Fig. 29.20) nearly one hundred years later.

The camera was unprejudiced. It made no distinction between the common person and one who was famous, rich, or powerful. The observing lens captured the warts, bags under the eyes, and puffy, sagging flesh of the face of Lewis Cass, who in 1848—shortly before his daguerreotype was taken—was the unsuccessful democratic candidate for the presidency (Fig. 17.3). The portrait painter Rembrandt Peale observed in 1857 that "...it has become necessary for the portrait painter to make his portraits *as true* but expressly *more true* than daguerreotypes."[1] That mid-century America was already inclined to accept such forthright representation is apparent in Hiram Powers's bust of Andrew Jackson (Fig. 18.3), done two years before the daguerreotype was known in the United States.

The variety that existed within daguerreotype portraiture can be seen in *The Toleware Maker* (Fig. 17.4), a latterday companion to Copley's *Paul Revere* (Fig. 7.9). The subject wished to be represented at his trade with an assortment of the tools of his craft and several fine specimens of his britannia metalware (an alloy of tin, copper, and antimony). A workingman's pride and the American work ethic are revealed here: Britannia was the metal of the common people's tableware, just as the daguerreotype had become the natural medium for their portraits. Genre scenes of people at their work or resting from it had been painted by

William Sidney Mount in the 1830s and 1840s, but Mount's world seems idyllic, like amusing pastoral poetry in contrast to the realities of life that are apparent in this daguerreotype.

FINE ART PORTRAITS

It is natural that an artist such as Samuel F. B. Morse, a painter for over thirty years, should be concerned with the pictorial fine-art qualities of the daguerreotype. In the portrait of his wife and daughter playing chess in an outdoor setting, with a soft sunlight filtering through the airy boughs of the trees, Morse achieved delicate tonal qualities, and feathery, painterly, impressionistic effects (Fig. 17.5). Morse's daguerreotype looks ahead to Thomas Eakins, one of America's greatest artists, who used the photographic image in genre or portrait studies.

In the 1840s and 1850s, painters often tried to give their work something of the character of a daguerreotype—and daguerreotypists frequently attempted to imbue their pictures with painterly qualities. Neither knew precisely what the aesthetic dimensions of the new type of image were. For the average daguerreotypist, the best results were achieved when utilizing the bold strength of the medium, rather than trying to achieve subtle, aesthetic finesse.

DOCUMENTARY PHOTOGRAPHY

Picturesque views of famous natural landmarks, important buildings, and urban scenes quickly became popular. John Plumbe, Jr. (1809–57), operated studios and galleries in New York City, Washington, Boston, Philadelphia, and nearly every other major American city, even as far west as Dubuque, Iowa, in the 1840s. His view of the U.S. Capitol, which is seen essentially as Charles Bulfinch completed it, is the earliest photographic record of the building (Fig. 17.6). Luigi Persico's recently installed pedimental sculptures and his Discovery Group on the blocking beside the stairs can be seen. We also see that there was once a pool in front of the steps, to provide water in case of fire. Such photography is valuable as a documentary record of bygone America. John Plumbe did as much as anyone prior to the time of George Eastman to promote photography, in part through periodic publications such as *The National Plumbeotype Gallery* and the *Plumbeian*.

In Philadelphia, the foremost practitioners of the new medium were William Langenheim (1807–74) and his brother Frederick (1809–79), who had emigrated from Germany in the 1820s. By 1840, they were salesmen of

17.6 John Plumbe, Jr., *United States Capitol,* 1846. Daguerreotype.

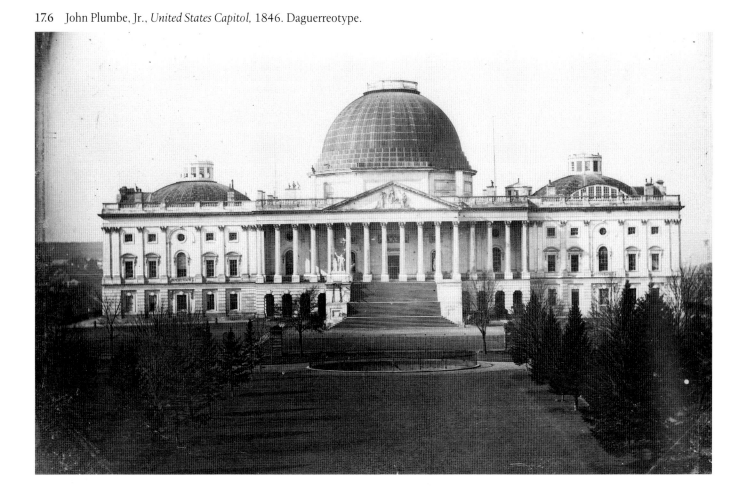

17.7 Langenheim Brothers, *Northeast Corner of Third and Dock Streets, Philadelphia*, 1844. Daguerreotype. Library Company, Philadelphia.

European cameras, lenses, and other equipment, but within two years, they had opened their own studio in the Merchants' Exchange (Fig. 13.4). International acclaim came with a series of views of Niagara Falls, taken in 1845. While the brothers used the daguerreotype at first, they purchased exclusive American rights to the Talbot process in 1846. In the following decade they were the first in the United States to popularize **stereoscopic** views, establishing the American Stereoscopic Company. Before long, thousands of homes across the nation had equipment for showing slides or viewing the familiar double image through a handheld stereoscope or stereopticon. The insatiable demand for this form of home entertainment broadened photography's range of subject matter immensely.

An early daguerreotype by the Langenheim brothers is the view of Girard Bank (formerly First Bank of the United States, see Fig. 8.15) (Fig. 17.7). This shot is of special interest because it records one of the so-called Native American Riots, when American-born citizens were demanding that foreigners, particularly Irish immigrants, should have to live in America for twenty-one years before they were allowed to vote. It is the earliest known use of the camera as a journalistic instrument.

In the early 1850s, photography underwent important technical changes. The **wet plate**, or **collodion-coated plate**, replaced the daguerreotype. This simplified and less

expensive process led to ambrotypes on glass, tin types on tin, or some other thin sheet of metal, and, finally, to pictures printed on paper. The negative meant it was possible to duplicate the image *ad infinitum*. Other technical advancements made it possible for photographers to move outside their studios, and turn their lenses upon the city and the landscape.

MR. LINCOLN'S CAMERAMAN

Probably the bestknown photographer of this period was Mathew B. Brady (c. 1823–96). Born in Upstate New York, Brady studied art with William Page, and then attended the National Academy of Design. When he was about twenty, he learned the daguerreotype process from Samuel F. B. Morse. By 1844 Brady had opened a studio on lower Broadway. During the next two decades, he was among the most successful photographers in America, with fashionable Manhattan society as clientele. By 1849 he had a branch studio in Washington, D.C.

Brady had a flair for the dramatic, a sensitivity to the personality of his sitter, and a feeling for mood—he made his camera work toward the desired image. *Samuel F. B. Morse*, for example, is a daguerreotype portrait of an elder

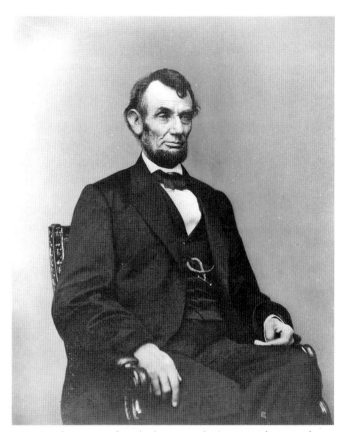

17.9 Mathew B. Brady, *Abraham Lincoln*, c. 1863. Photograph. Library of Congress.

17.8 Mathew B. Brady, *Samuel F. B. Morse*, c. 1845. Daguerreotype. Library of Congress.

statesman of the fine arts, a distinguished professor, and a celebrated inventor (Fig. 17.8). He is shown three-quarter length, as if giving a lecture-demonstration about his telegraph (lower right). On 24 May 1844, Morse successfully sent the first message over his telegraph wire from Washington, D.C., to Baltimore. Brady made his portrait soon after that momentous event.

Brady is often referred to as Mr. Lincoln's Cameraman. While he photographed Lincoln many times, he never caught the essence of his subject as splendidly as in the portrait shown in Figure 17.9. Lincoln's gravity, his craggy, lined, tired face, his solemn pensiveness, and rumpled attire—all are given with the visual realism for which the photograph had become so famous. Brady, however, had achieved something more than a dull, factual, blatant realism, for here, surely, is Lincoln as subsequent generations remembered him. Lincoln's son Robert called this the best likeness of his father ever made. When an image of the great man was needed for the five-dollar bill—still in use today— this was the image that was chosen.

Brady on the Battlefield Over 300 cameramen were issued passes to enter the battle zones of the Civil War. Thus Mathew Brady was by no means the only one to photograph the conflict, although he is certainly now the bestknown. Brady employed a number of photographers to

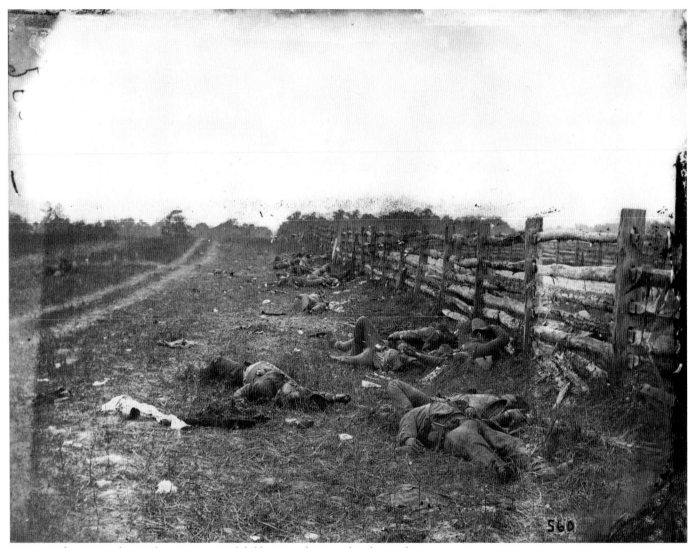

17.10 Mathew B. Brady, *On the Antietam Battlefield*, 1862. Photograph. Library of Congress.

cover the regions in which the war was being waged. Some of these men later became wellknown in their own right—for example, Alexander Gardner, who published *Gardner's Sketch-Book of the War* (1865–6), and Timothy O'Sullivan. Brady and his teams traveled with the Union armies in their own specially outfitted, horsedrawn buggies—cumbersome vehicles loaded with glass plates, chemicals, tanks, storage boxes, and camera equipment, and a diminutive darkroom.

Because the exposure time was still so long—many seconds—it was not possible to photograph the actual battles, which, of course, were in constant motion. The record of the Civil War is therefore of the aftermath of battle. Americans had never before seen war shown so graphically. Brady himself photographed the carnage following the battle at Antietam, Maryland, on 17 September 1862, when nearly 5000 were killed and 18,000 wounded. In pictures like *On the Antietam Battlefield*, the stark, bloody, reality of war is shown in a way that painters such as Winslow Homer never captured (Fig. 17.10). The

camera's lens presents the horror of war with an uncompromising realism that overwhelms any romantic or sentimental notions about its glory. As Oliver Wendell Holmes said of Brady's pictures of Antietam:

> Let him who wishes to know what war is, look at this series of illustrations.... It was so nearly like visiting the battlefield to look over these views, that all the emotions excited by the actual sight of the stained and sordid scene, strewed with rags and wrecks, came back to us, and we buried them in the recesses of our cabinet as we would have buried the mutilated remains of the dead they too vividly represented.[2]

Early attempts at photographic war journalism seared the soul of America. The nation, though ultimately emerging with the Union intact, would never be the same—the sense of innocence and optimism that it had enjoyed before the war was gone.

After the war, Brady operated his studio in Washington, D.C., turning his camera upon the American scene, and

17.11 Mathew B. Brady, *Broadway Looking North from Spring Street, New York City,* 1867. Stereograph. Courtesy The New-York Historical Society, New York City.

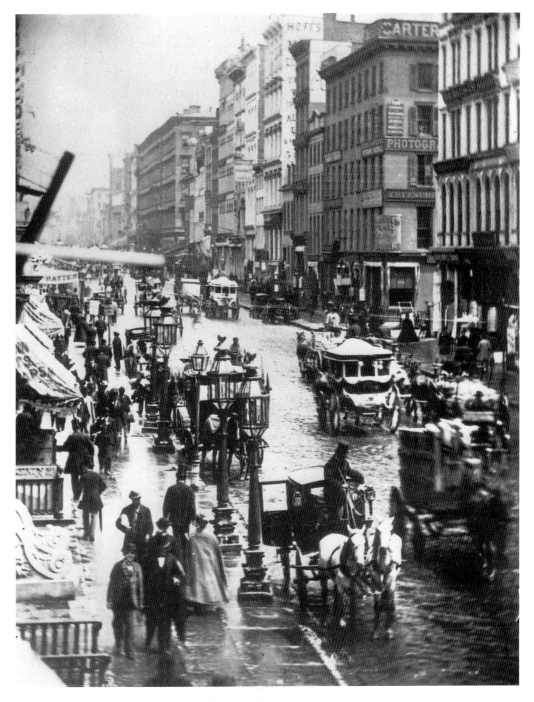

making portraits of the leading figures of the day. His view of New York City, *Broadway Looking North from Spring Street* is typical of the photographer's interest in city life (Fig. 17.11). Not until the rise of the Ashcan school early in the next century did painters take up these subjects. Here is an instance of a cameraman pioneering new pictorial themes in advance of the painters. The final years of Brady's career were far from happy. Bankrupt, he lost his studio, worked for a long time for other photographers, died in a charity ward in New York City, and was buried in an unmarked grave in Washington, D.C.

TO EUROPE—AND YOSEMITE

After the Civil War, wherever Americans went, the camera went along to record their activities and the sights they saw. Some went to Europe in search of culture; others went west to see the vast new territories there. In Rome, Henry Wadsworth Longfellow and his daughter Edith were photographed in the studio of the portraitist George P. A. Healy, in 1868–9 (Fig. 17.12). The print is scored for scaling to facilitate transferring the image to canvas, which Healy did in *The Arch of Titus* (1871; The Newmark Museum). The

painting shows the poet and his daughter passing under the famous Roman arch, while a group of American artists in the foreground includes Frederic Church sketching as Healy and Jervis McEntee look on.

With the end of the war, many Americans sought an escape from its horrible memories in the natural beauty of the West. They sought their fortunes in the goldfields, silvermines, or, more modestly, the fertile fields of the vast prairies—in the new territories that the government opened up after Congress had finally passed a Homestead Act in 1862.

The history of photographing the West began before the war. As early as 1851 a San Francisco photographer named Robert Vance (d. 1876) offered some 300 views of California for sale. That same year, Carlton E. Watkins (1829–1916) arrived in the city by the Bay, from Oneonta, New York, and worked for Vance for a while before opening a studio and gallery in 1857. Watkins made an adventurous trip into Yosemite Valley in 1861, taking a series of large plates of its extraordinary loveliness (Fig. 17.13). The photographer signed his prints just as an artist would sign his painting. His twenty-five or so views of Yosemite, which were avidly collected by naturalists, prepared the way for the passage of a bill in Congress which was signed by President Lincoln, establishing Yosemite as a national preserve.

17.12 Anonymous, *Henry Wadsworth Longfellow and his Daughter, Edith, in G. P. A. Healy's Studio in Rome*, c. 1868–9. Photograph. Archives of American Art, Smithsonian Institution, Washington, D.C.

17.13 Carlton E. Watkins, *The Three Brothers—4480 Feet—Yosemite*, 1861. Photograph. Library of Congress.

17.14 Timothy O'Sullivan, *Ancient Ruins in the Canyon de Chelle, New Mexico*, 1873. Collodion print, 10⅞ × 8in (27.6 × 20.3cm). Collection, The Museum of Modern Art, New York. Gift of Ansel Adams in memory of Albert M. Bender.

Watkins's *Yosemite Valley* anticipates Albert Bierstadt's paintings of that and other areas in California, such as *Among the Sierra Nevada Mountains, California* (Fig. **15.16**) of 1868. Bierstadt was a skilled photographer, and took hundreds of views of the mountains and valleys of the Rockies and the California ranges in 1859 and the early 1860s. He also took photographs of Native Americans who lived in these regions, some of which were later used in his paintings (Fig. **25.3**).

Timothy O'Sullivan (1840–82) began his career as an assistant to Mathew Brady. He preserved some of the most memorable scenes of death and carnage on Civil War battlefields, especially of the aftermath of Gettysburg. Many of his pictures appeared in Alexander Gardner's *Sketch-Book of the War*. After the war, O'Sullivan went west in 1867 with the U.S. Geological Explorations West of the 40th Parallel, an expedition led by Clarence King. O'Sullivan left an invaluable documentation of this entire survey. In 1870 he similarly recorded the activities of the Darien Expedition through the jungles of Panama, in search of the best location for a great canal connecting the Atlantic and Pacific oceans. Next, O'Sullivan crossed the scorching sands of Death Valley, then made a tortuous trip by boat up the Colorado River.

Perhaps his most impressive work came from the Wheeler Expedition of 1873–5, which explored and charted Arizona and New Mexico. O'Sullivan had an eye for vivid contrasts, enormous scale, and the extraordinary features of the West, seen in his remarkable *Ancient Ruins in the Canyon de Chelle*, with its Cyclopean rock formations, scarred and scored by eons of dynamic geological violence, that totally dwarf the abandoned Pueblo dwellings (Fig. **17.14**). The sheer face of the wall rises about 700 feet (213 m) above the canyon floor, filling the Romantic soul with awe in the presence of nature's grandeur.

By 1870, photography in America had become a proven medium for documentation, with capabilities for powerful expressiveness. In the first decades of its existence, there appeared more photographers than painters in America. The best American photographers obtained results that were technically and aesthetically the equal of anything being done in Europe. Photography brought portraiture within the grasp of the common man and woman, it turned its eye upon levels of society that had seldom before been depicted, it recorded the facts dispassionately, but often most perceptively, and with a realism that fascinated. It made graphic illustration an integral part of journalism. Photographers traveled to wherever the action was, be it the battlefield of Antietam or the lonely beauty and solitude of Yosemite. Some artists learned to use it as a tool, while others, particularly portrait painters, tried to compete with it. In these first few decades, photographers began to discover the artistic potential of their new medium.

CHAPTER EIGHTEEN

SCULPTURE:

NEOCLASSICISM AND NATURALISM, 1825–70

Americans were polarized by divergent loyalties in the second quarter of the nineteenth century, in political and economic matters, and in social and cultural issues. This split in the collective national personality is evident in the new artform that rose to prominence—sculpture—with one tract following a nationalistic-naturalistic line, and another choosing the European-neoclassical avenue.

This sociocultural schism manifested itself in the election of Andrew Jackson as president in 1828, marking the beginning of a new wave of democracy, and a vigorous assertion of the power and importance of the common person. Jackson was the choice of the masses, who turned out to vote for their rough-and-ready general, Indian fighter, and hero of the Tennessee frontier. Before Jackson, each of America's six presidents had been of a patrician family from either Virginia or Massachusetts. Each had been put into office more by political organization than by a popular vote of the ordinary people. All of that changed in the election of 1828, which was a victory for the common person and, to those opposed to the "leveling" of society, for the common-place. The élite of the nation—the old-established families and the intellectuals—tended to oppose all that Jackson represented, and to deplore the low culture they perceived him to stand for.

Americans who championed the cause of democracy as the will of the common person found Jackson to be a kindred spirit. They were convinced that American democracy could produce—and was producing—a valid culture. Others, seeking a higher culture, frequently turned to Europe and its rich traditions. They even went abroad, often to live for years in France, England, and especially Italy. These people became expatriates, as they are called. The problem facing the creative American was stated in the preface to Nathaniel Hawthorne's *The Marble Faun*: "No author, without a trial, can conceive of the difficulty of writing a romance about a country where there is no shadow, no antiquity, no mystery, no picturesque and gloomy wrong, nor anything but a commonplace prosperity, in broad and simple daylight..."[1] Hawthorne found his inspiration for *The Marble Faun* while living in Rome in 1858–9. Henry James, upon his arrival in Rome, wrote to his brother William on 30 October 1869, "At last—for the first time—I live!"

The procession of these expatriate Americans to what many considered the fountainhead of culture had begun much earlier, when Benjamin West arrived in Italy in 1760. Soon after the turn of the century Washington Irving, John Vanderlyn, and Washington Allston went to Rome, where they became a part of the brilliant international set that had gathered there. To retrace their experiences one should read Madame de Staël's *Corinne* (1807)—especially the chapter "Statues and Paintings"—and Lord Byron's *Childe Harold* (1812–18). These were the fictional and poetic guidebooks with which touring Americans viewed the wonders of Italy and absorbed its culture as the fascination with Italy intensified, evolving as a kind of counter-culture to that which was arising in Jacksonian America.

In 1838, James Fenimore Cooper wrote to his young sculptor-friend Horatio Greenough, "I could wish to die in Italy." Following the extraordinary success of his early novels—*The Pioneers, Last of the Mohicans*, and *The Prairie*—Cooper left the United States to spend four years in France and in Italy. In Florence he came to know the painters Thomas Cole and Samuel F. B. Morse, and he became an early patron of Horatio Greenough. Under the spell of the onetime home of Ghiberti, Donatello, Michelangelo, and Cellini, Cooper did something he had not done when he lived in America: He became a patron of a sculptor. Greenough produced a marble bust of Cooper and a pair of singing cherubs to Cooper's commission.

Something happened to Americans while in Italy that seldom occurred at home. This was noted by William Cullen Bryant in Rome, 21 May 1858: "It is remarkable that they [American artists] find Rome a better place for obtaining orders from their countrymen than any of the American cities. Men who would never have thought of buying a picture or a statue at home, are infected by the contagion of the place the moment they arrive."[2] Bryant then related how conversation, too, was different in Rome: "No talk of the money market here; no discussion of any public measure; no conversation of the ebb and flow of trade; no price current, except of marble and canvas; all the talk is of art and artists. The rich man who, at home, is contented with mirrors and rosewood, is here initiated into a new set of ideas, gets a taste, and orders a bust, a little statue of Eve, a Ruth, or a Rebecca ... for his luxurious rooms in the United States."

In the same letter Bryant observed, "There is certainly an increase in the number of artists residing here.... When I first came to this place, in 1835, there was not an American artist in Rome...; now the painters and sculptors from our country are numerous enough to form a little community; they amount... to thirty or more." In Rome, Bryant lived at the Hôtel d'Europe. Nathaniel Hawthorne, who called on him there, had a seven-room apartment in a villa near the Trevi Fountain. The sculptor Thomas Crawford and his wife Louisa, sister of Julia Ward Howe, had their lodgings in the Villa Negroni, near the Baths of the Emperor Diocletian, where they frequently entertained Roman society. Another popular gathering-place was the apartment of the sculptor William Wetmore Story in the seventeenth-century Palazzo Barberini. On Sunday morning, 23 May 1858, Nathaniel Hawthorne had breakfast at the Storys', where they were joined by William Cullen Bryant and a sprightly young American sculptor named Harriet Hosmer, who was shocking Rome with her unorthodox dress and manner. Hawthorne also visited William Wetmore Story in his studio, where he found the sculptor working on an heroic figure of Cleopatra, which the author described as a sullen tigress. Visiting sculptors' studios was a regular activity in Rome and Florence, and Hawthorne often made the rounds.

Visiting ruins and the great collections of art was also a standard pastime. Hawthorne recorded a trip to the Capitol museum on 22 April 1858: "We afterwards went into the Sculpture Gallery, where I looked at the faun by [the fourth-century-B.C. Greek sculptor] Praxiteles.... It seems to me that a story... might be contrived on the idea of their species having become intermingled with the human race."[3] The result was *The Marble Faun*, begun in Italy, finished in England, and published in 1860.

If antique marble statuary could have such an influence on and prove such an inspiration for an American author, it would surely do the same for American sculptors once in Italy. Florence and Rome changed the Americans who went there, made them different from their fellow-citizens who remained insulated from the rich culture that Italy offered. It was not a question of one tradition being good and one being bad: Each went its own way and each had its own strengths, its own weaknesses. As sculpture began to emerge as an artform in and for America, the two distinct traditions existed contemporaneously.

THE FIRST SCHOOL OF AMERICAN SCULPTURE

Before 1825, three-dimensional art in America had been in the hands of artisan woodcarvers and stonecutters, or foreign sculptors who had immigrated or sent their work to America. But in the late 1820s and 1830s, a number of gifted young men decided to make sculpture their career. The results were impressive. When they went to Florence or Rome, they very quickly established their credentials among the international community of sculptors, making significant contributions to the neoclassical movement there.

Sculpture at this time was dominated by the memory of Antonio Canova (1757–1822), whose elegant portrait of *Pauline Bonaparte Borghese* (1808, Borghese Gallery, Rome) is an archetypal expression of the new classicism, and by the presence of the great Danish sculptor Bertel Thorvaldsen (1770–1844). Works such as *Jason with the Golden Fleece* (1803–28, Thorvaldsen Museum, Copenhagen) seem to be marble reincarnations of the classical ideal established by Phidias and Polycleitos in Greece in the fifth century B.C.

Marble was the medium. Pure and white, or slightly offwhite, it came from the ancient, inexhaustible quarries at Carrara in central Italy. Characters from classical mythology and ancient history, and portraits of contemporary men and women, were about the only suitable subjects within the neoclassical aesthetic. The nude posed the greatest challenge to the sculptor, and, if successful, brought the highest praise. In portraiture, no higher accolade could be bestowed upon a subject than to associate him or her with those most noble virtues of antiquity by adorning the shoulders with a togalike drapery, or some other device connected with ancient Greek and Roman culture. The versatility of Neoclassicism is seen in its ability to express either republican or imperialist sentiments. It offered an ideal or a naturalistic model, whichever was appropriate for the work at hand.

Italy was able to provide what was not then available in America: Great collections of ancient statues to study and upon which to base one's own works; established masters of sculpture from whom to learn and whose busy studios provided gathering-places for artists and patrons; nude models; professional workmen who assisted in the routine procedures of the studio; marblecarvers who sensitively translated the sculptor's models from plaster into marble. Finally, there was an ambience in which sculpture was recognized as a major artform—in America it was barely known to exist. It was into this world that the first group of young American sculptors plunged themselves, beginning with Horatio Greenough, who first went to Italy in 1825, Thomas Crawford, who arrived in Rome in 1835, and Hiram Powers, who left for Florence in 1837.

HORATIO GREENOUGH

Horatio Greenough (1805–52) came from a prominent Boston family. While attending Harvard, his interest in sculpture was first aroused. Washington Allston, whose studio was in nearby Cambridgeport, may have advised the young man that he should go to Italy if he wanted to be a sculptor. That trip to Rome in 1825 was exciting, but was cut short by illness, which forced Greenough to return home. In 1828, he was again aboard ship, having been given free passage aboard a merchant vessel of Thomas Handasyd Perkins (Fig. 10.12), this time heading for Florence, where he would spend most of the next twenty-three years.

James Fenimore Cooper gave Greenough his first important commission—for an ideal subject, as such things were called to distinguish them from portraits. It was for the marble group called *Chanting Cherubs* of 1830 which has since disappeared. The *Cherubs* group, based on two little angels in a painting by Raphael in the Pitti Palace in Florence, was modeled in clay, translated into marble, and then sent to America. Both patron and artist were shocked at the reception it received. The Americans—generally so unfamiliar with sculpture that they did not know how to react to it—criticized its nudity. Moreover, reflecting their fascination with gadgetry, viewers actually expected the group to sing, and felt cheated when it did not. The reaction Greenough received for *Cherubs* should have prepared him for America's expectations of sculpture when the great work of his life came along—*George Washington*. It did not.

18.1 Horatio Greenough, *George Washington*, 1840. Marble, 11ft 4in × 8ft 6in × 6ft 10½in (3.45 × 2.59 × 2.1m). National Museum of American Art, Smithsonian Institution, Washington, D.C.

In 1832, Greenough received what no other American had ever received, a commission from his own government for a large, important piece of sculpture—the marble statue of George Washington that was intended to adorn the center of the rotunda of the United States Capitol (Fig. 18.1). In creating his image of the Father of his Country, the sculptor used Houdon's bust of Washington as the model for the head, basing the figure on the most famous statue of antiquity, Phidias's fifth-century-B.C. colossal ivory-and-gold *Zeus*, which once sat in the god's Doric temple at Olympia in Greece. Greenough wanted to endow Washington with all of the nobility, virtue, and grandeur of the greatest of the ancients. Whereas Houdon had represented Washington in the uniform he actually wore (Fig. 12.4), Greenough showed him bare to the waist in a garment unknown to Americans, wearing Greek sandals, sitting in a Greek chair, giving up a Greek sword with his left hand, and pointing heavenward with his right. The result is noble and impressive, a splendidly sculptural and superbly finished piece when judged by the neoclassical criteria of its day. But when it was sent to the United States, few Americans could understand the masquerade—they felt their beloved George Washington did not need to be represented as anything or anybody other than himself. They were not familiar with the neoclassical criteria of sculpture. The sculpture was ridiculed unceasingly, and was finally removed from the rotunda and placed out in the Capitol grounds, where for decades it was subjected to the elements.

The beauty of American neoclassical sculpture in its purest form is seen in Greenough's *Castor and Pollux* (Fig. 18.2). This marble **bas-relief** reminds one of both the horsemen section of the exquisite Ionic relief from the Parthenon and the elegant line drawings of the *Odyssey* and the *Iliad* by the English artist John Flaxman (1755–1826),

18.2 Horatio Greenough, *Castor and Pollux*, 1847–51. Marble, 34⅝ × 45³⁄₁₆ × 1¾in (88 × 114.8 × 4.5cm). Museum of Fine Arts, Boston. Bequest of Mrs. Horatio Greenough.

which were published in the late eighteenth century. Even sculpture as handsome as this, however, never became generally popular in America. Among Greenough's countrymen, only a few intellectuals shared his devotion to Neoclassicism. Greenough did much to establish sculpture of a high standard in America, but it would be for others to create works that struck a responsive chord in popular taste.

HIRAM POWERS

Hiram Powers (1805–73) accomplished that very thing in both his portraits and his ideal pieces. This Vermont-born mechanic and gadgeteer was working in Cincinnati when he first tried his hand at modeling in the late 1820s. He was so successful at it that Nicholas Longworth, a prominent local patron, offered to send him to Italy to study.

Before going abroad, Powers spent three years in Washington, D.C., taking busts of the eminent men on the political scene there. It was at that time that Powers modeled his extraordinary portrait of President Andrew Jackson (Fig. 18.3). "Old Hickory" posed several times for the artist in a room of the White House, reportedly instructing the sculptor: "Make me as I am, Mr. Powers, and be true to nature always I have no desire to look young when I feel old." Jackson's charge disclosed a pragmatic American's respect for realism and straightforward truth, expressing more of the aesthetic preferences of his countrymen than he probably realized. Powers was fully capable of capturing every line and wrinkle in the leathery old face, and for justification of such a naturalistic style there was always the

18.3 Hiram Powers, *Andrew Jackson*, 1835. Marble, height 34in (86.4cm). Metropolitan Museum of Art, New York City.

18.4 Hiram Powers, *The Greek Slave*, 1843. Marble, height 5ft 5in (1.65m). Yale University Art Gallery, New Haven, Connecticut.

example of ancient Roman portraiture. The classical allusion was completed by terminating the bust in a togalike drapery about the shoulders. The bust was modeled in clay and then cast in plaster, but soon after Powers got to Italy he began translating it into marble.

In 1837, Powers settled in Florence, where he spent the rest of his life. Before long, his studio was on the list of places visited by tourists from many countries. The naturalism of Powers's portraits brought him a steady flow of commissions, and a couple of his early ideal busts—the *Ginevra* and *Proserpine*, both of about 1840—were among the most popular pieces of their kind, with frequent requests for replicas of each. It was, however, an ideal statue of a nude female figure that brought Powers international fame—the much-celebrated *Greek Slave* (Fig. 18.4).

In the 1820s, the struggle of the Greeks to obtain their freedom from the empire of the Ottoman Turks had won the hearts of Europeans and Americans. Playing to these sympathies, Powers chose as his subject the story of a beautiful young Greek maiden who has been captured by the Turks and put on the slave block. She is represented at this moment, stripped of her clothing and forced to endure the lascivious stares of lewd men. Her wrists chained, she modestly turns her head to avoid their lustful gaze. She is a Christian, however, as indicated by the cross that hangs on the post beside her, and her faith protects her, giving her strength in this hour of woe. To make sure that all of this was understood Powers described her sorrowful story in a brochure to be read while viewing his statue. In the Victorian era there had to be some justification for nudity, and this way the sculptor convinced his public that his was a demonstration of Christian virtue over heathen lust. Even ministers advised their flocks to go see the *Greek Slave*, and learn from the lesson of moral strength and faith that it offered.

Viewers recognized a dim association with the *Venus de' Medici*—the fourth-century-B.C. Greek masterpiece by Praxiteles which was on display not far from Powers's studio—and the profile is of the Greek classical ideal. Viewers also marveled at the virtuosity of the marble links of the chain, and the details of the tassels on the robe. Seven lifesize replicas were ordered by patrons from several nations, and the *Greek Slave* was sent on a tour of the United States, where it won the hearts of the Americans.

THOMAS CRAWFORD

Thomas Crawford (1813–57) was employed in a stonecutting firm when his interest in sculpture was first aroused. He went to Italy in 1835, settling in Rome rather than Florence. There, he came under the tutelage of the renowned Thorvaldsen, working for a while in a corner of the great master's busy studio. By May 1839, Crawford was already at work on his first major piece—the *Orpheus and Cerberus*, which became the season's sensation among the Roman studios, and further established the reputation of the American

18.5 Thomas Crawford, *Orpheus and Cerberus*, 1843. Marble, 67½ × 36 × 54in (171.5 × 91.4 × 137.2cm). Museum of Fine Arts, Boston. Gift of Mr. and Mrs. Cornelius Vermeule, III.

school (Fig. 18.5). *Orpheus* was praised for its subject matter, for this moment in the Greek myth—when Orpheus descends into Hades, past the three-headed guardian dog, Cerberus, in search of his beloved Eurydice—had never before been illustrated in art. The figure of the ancient musician bore a similarity to the ancient Hellenistic statue the *Apollo Belvedere*, so its classical pedigree was impeccable. There was a romantic quality as well—the mystery of the dark infernal regions, the search for a lost love. *Orpheus* was put into marble in 1843, and shipped back to America for exhibition in Boston the next year. Crawford's star began to ascend at home as it had in Italy.

By the early 1850s, Crawford's studio was one of the most active in Rome. For the city of Richmond, Virginia, he was working on a complex, multifigured monument to George Washington to be erected near the State Capitol, marking the beginning of the outdoor commemorative monument movement in America. At the same time, congressmen back home had decided the art on the U.S. Capitol

18.6 Thomas Crawford, *The Progress of Civilization*, 1851–63. Senate pediment, United States Capitol, Washington, D.C.

ought to be done by American artists, not foreign immigrants, and the federal government was putting more work into his hands than he could cope with.

These were the years of the expansion of the Capitol (see Fig. 13.13), calling for much sculptural adornment. Crawford modeled a colossal image of America as Armed Freedom, which was cast in bronze and placed atop Thomas U. Walter's great dome. He began work on historiated panels (with images that tell a story) for huge bronze doors for the two new wings of the Capitol, and developed the iconographic program and the plaster models for the pediment of the Senate wing (Fig. 18.6).

The pediment sculptures represent the ascendency of American civilization. In the center a female figure attended by an eagle personifies America. She gestures to her left, blessing the American pioneer, who swings his ax as he clears the forest that had been the bountiful hunting grounds of the Native Americans. A despondent chief sits, contemplating his people's demise, while behind him a Native American mother mourns beside an open grave. On the other side, a soldier stands ready to defend freedom and the rights of the common person. A merchant sits on bales of goods, instructing two boys in the arts of commerce, an anchor at his feet symbolizing both hope and America's maritime prowess. A teacher instructs a youth. The program ends with a figure of a mechanic and a cogwheel, symbol of American industry. Here was nationalistic imagery suitable to the proud, classical, templelike architecture it was to grace.

Crawford died suddenly, before any of these projects could be brought to completion. He had, however, advanced them to a point where their execution could be supervised by other American artists. By the time Crawford left Rome early in 1857, he had established American art there through his efforts and success. Many a fellow-American followed him there over the next two decades.

NATURALISM: THE APPROPRIATE NATIONAL STYLE

A number of sculptors decided it was time for the art of sculpture to arise on American soil, and not just in far-off Italy. Although he spent four years studying in Florence and Rome in the mid-1840s, Henry Kirke Brown (1814–86) advocated this view. Some of his early works bear the influence of antiquity and Neoclassicism, but once back in America he espoused naturalism as the national style.

EQUESTRIAN STATUES

This is seen in Brown's equestrian statue of George Washington, modeled in his Brooklyn studio and cast in bronze at the Ames Foundry in Chicopee, Massachusetts (Fig. 18.7). It was therefore wholly made and produced in America, by Americans. Rather than turning to idealized classical prototypes, as Greenough had done, Brown looked to naturalistic models such as the two magnificent equestrians of the Florentine Renaissance, Donatello's *Gattamelata* (1445–50, Padua) and Verrocchio's *Colleoni* (1483–8, Venice). For the head of Washington, Brown followed Houdon's model—it and Stuart's portrait were the images Americans had accepted and knew well. Brown followed Houdon's—and not Greenough's—example by showing Washington attired in the uniform he wore when he led the fight for independence. When the statue was unveiled on Union Square in New York City, it was hailed as a great success.

The equestrian statue has always been one of the greatest challenges to the sculptor. The problem of representing the horse in action, rearing on its hind legs, had confounded no

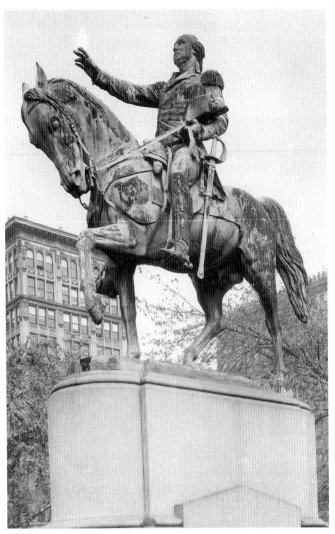

18.7 Henry Kirke Brown, *George Washington*, 1853–5. Bronze, height 14ft (4.27m). Union Square, New York.

18.8 Clark Mills, *Andrew Jackson*, 1853. Bronze. Lafayette Park, Washington, D.C.

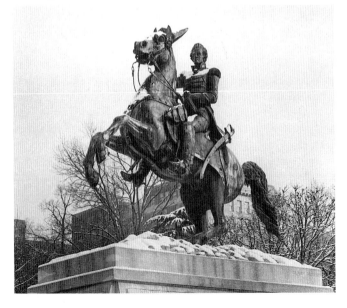

less an artist than Leonardo da Vinci. The accomplishment of Clark Mills (1810–83) is therefore all the more remarkable, even if his *Andrew Jackson* is more an example of Yankee ingenuity than of artistic genius (Fig. **18.8**). Mills, who was born in Onondaga County, New York, worked as a carpenter and mechanical jack-of-all-trades in New Orleans and Charleston, South Carolina, before turning to ornamental plasterwork. From that he moved on to sculpture, without any instruction in art. Mills had never attempted anything more ambitious than a portrait bust when he undertook the daring feat of modeling and casting the *Jackson* equestrian statue in his own homemade studio and bronze foundry outside Washington, D.C.

As Jackson was known as a man of action, an image different from Brown's *Washington* was called for. The sculptor thus represented him in military uniform—such as he wore at the Battle of New Orleans—and had him doffing his hat in salute to his troops as his lively steed rears. After much trial-and-error, and numerous recastings, the many pieces were assembled in 1853 in Lafayette Park, across from the White House. Americans took great pride in Mills's technical accomplishment, and they appreciated the bold naturalism of the style.

ERASTUS DOW PALMER AND *THE WHITE CAPTIVE*

Erastus Dow Palmer (1817–1904), another carpenter from Onondaga County, New York, became even more famous as a sculptor, and possessed even greater innate talent. Like Mills, Palmer had no formal training in art, but he was good at using tools and had the daring to try to make sculpture. His sculpting career began about 1845 when he started carving little cameo portraits in Utica and Albany, but he began exhibiting lifesize works in marble in New York City in the early and mid-1850s.

As if in response to Powers's *Greek Slave*, Palmer created *The White Captive* (Fig. **18.9**). Here, however, the nude young woman is an American who has been captured by Native Americans and tied to a treetrunk, while her captors debate her future—hence the worried expression of her face, which is in marked contrast to the calm resignation of the *Greek Slave*. Although wrought in pure white marble, any indebtedness to Italian Neoclassicism ends there, for this is an image of a real American girl that carries no connotation of an ancient Venus.

The White Captive was a remarkable accomplishment for someone with no training in sculptural form or techniques, and who had no collections of ancient statuary from which to learn about such things as anatomy, proportions, pose, and surface treatment. The style is naturalistic, which increasingly came to be thought of as appropriate for American sculpture. It was a style the sculptor could develop independently, when he had had no training in some other mode.

18.9 Erastus Dow Palmer, *The White Captive*, 1857. Marble, height 5ft 6in (1.68m). Metropolitan Museum of Art, New York City.

GENRE THEMES: JOHN ROGERS

Many felt that if naturalism were to be the national style, American genre themes should make up the subject matter. That in part explains the popularity of the work of John Rogers (1829–1904). Rogers was of a prominent family of Boston and Salem, but the decline of his family's fortunes forced him into an apprenticeship as a mechanic rather than the pursuit of his first love, art. In his leisure hours Rogers made little figures taken from the everyday life around him,

or from literature. In 1858, he quit his job to go to Paris and Rome to study art. The great collections he saw and the work of the great studios did not convert him to the Grand Manner nor to Neoclassicism. Rogers returned to America after about a year abroad. Soon after, one of his groups—the *Slave Auction*—attracted much attention when exhibited at a bazaar in September of 1859. Rogers's career was launched. His key development occurred when he decided to copyright his groups and produce them in large number for a mass market.

For the next several years, before and during the Civil War, many of Rogers's plaster groups, which averaged about 24 inches (61 cm) in height, were of themes inspired by the abolitionist movement or by the war itself. The sculptor's own abolitionist sympathies bordered on zealotry. Even after the war, Rogers continued to draw on themes such as *The Fugitive's Story*, in which art became social commentary (Fig. 18.10).

The group shows three prominent leaders of the abolitionist movement—John Greenleaf Whittier, Henry Ward Beecher, and William Lloyd Garrison. They are listening attentively to a tale told by a young black mother, possibly

18.10 John Rogers, *The Fugitive's Story*, 1869. Plaster, height 22in (55.9cm). Courtesy The New-York Historical Society, New York City.

of her escape to the North along the Underground Railroad. Each man is shown in contemporary attire, with details carefully noted. The mother is represented with sensitivity, especially in the modeling of the face, while her destitute situation is suggested by the small tear in her shawl, and by the bundle at her feet, which contains all her earthly belongings. The storytelling element is a strong feature of Rogers's style, which is naturalistic, with many anecdotal details to enrich the story.

Rogers's success was phenomenal in the 1860s and 1870s. To meet popular demand, a large factory in New York massproduced his models, sometimes turning out as many as 10,000 of a particular favorite. Rogers issued catalogues with illustrations of each group, and the four or five new groups created each year were eagerly awaited. His groups were sold throughout the country for about ten or fifteen dollars each, and the middleclass American parlor was considered incomplete without at least one of Rogers's groups. Here was sculpture for the masses—and another example of the democratization of art in America.

Rogers is best remembered for amusing, homey genre scenes that extoll the wholesomeness of American life, such as *Checkers up at the Farm* (Fig. **18.11**). That and other

18.11 John Rogers, *Checkers up at the Farm*, 1875. Bronze, height 20in (50.8cm). Courtesy The New-York Historical Society, New York City.

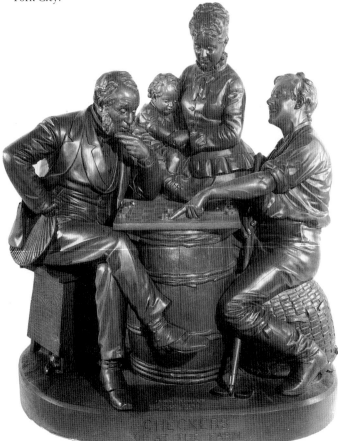

pieces like it celebrate the triumph of the middleclass—happy, healthy, and prospering—and praise the simple and virtuous American way of life, here in its rural setting. The mother holding her child in the *Checkers* group represents something very different from the mother in *The Fugitive's Story*. The scene is rich in anecdotal details that expand the narrative. The hoe between the jubilant young man's legs suggests he is taking a short break from his work in the garden; the fan held by his opponent indicates the heat of summer; the mother holds her infant's right hand to keep it from grasping the checkers on the board. The barrel, overturned basket, and stool show that the game occurs in the barn, and not in a stylish parlor, while the attire of the two men implies that the one on the left is a "city slicker" visitor who is about to be vanquished by his country friend. Here was an art with which middle America could identify in a way it never could with a Zeus-like image of George Washington.

THOMAS BALL AND PUBLIC SCULPTURE

The Civil War created far more work for sculptors than it did for painters because of the rise of the outdoor public monument. If antebellum America had its Washington and Jackson to celebrate, this era had its Lincoln, as we see in Thomas Ball's *Emancipation Group*, in which Lincoln holds the Emancipation Proclamation in one hand, and with the other bids the young African-American, his wristchains now broken, to rise a free man (Fig. **18.12**). Ball (1819–1911), who left Boston to study and work in Florence, had been

18.12 Thomas Ball, *The Emancipation Group*, 1874. Bronze. Washington, D.C.

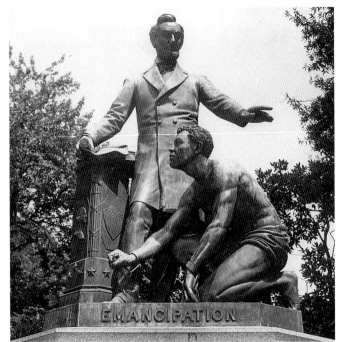

trained in the aesthetics of marble, which he merely applied to bronze when he worked in that medium. The broad, smooth planes, which were attractive in the glistening, crystalline marble, seem uninteresting and dull in bronze. Marble was the medium of Neoclassicism, and its aesthetic was not automatically transferable to bronze. It would be for the next generation of French-trained American sculptors to understand and exploit the potential of bronze. Still, Ball's *Emancipation Group* is a solemn, moving image, appropriately wrought in a naturalistic style.

THE SECOND GENERATION IN ITALY

The momentum of the first generation of expatriate American neoclassical sculptors working in Italy passed to a second generation. The best of these gave wonderful expression to romantic Victorian sensibilities.

18.13　Harriet Hosmer, *Puck*, 1856. Marble, 30½ × 16⅝ × 19¾in (77.5 × 42.1 × 49.9cm). National Museum of American Art, Smithsonian Institution, Washington, D.C.

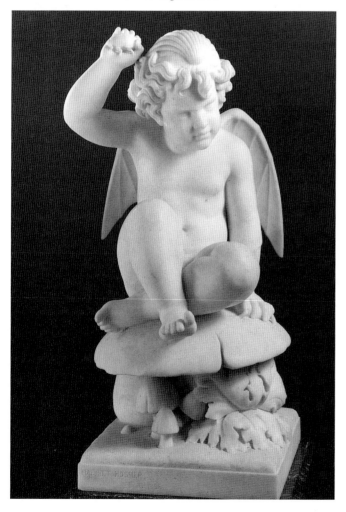

HARRIET HOSMER

Harriet Hosmer (1830–1908) created images of monumental heroines of the ancient Near East, as in her *Zenobia* (1858). Hawthorne found her modeling in clay when he visited her studio, and referred to the piece as "a high, heroic ode." He also saw Hosmer's image of a pathetic, imprisoned maiden, the *Beatrice Cenci* (c. 1855). The sculptor also made pieces like *Will-o'-the-Wisp* (c. 1860) and *Puck* (Fig. 18.13), which were so popular that commissions for marble replicas of them virtually supported her in Rome. *Puck*, representing Shakespeare's mischievous but friendly little elf, was popular not only among wealthy Americans visiting Rome, but with the English aristocracy, too. As sculpture was now judged by how well it related a literary narrative, the piece possesses a strong literary quality. *Puck* and other ideal works by the American contingent in Rome represented culture rather than a concern for social issues.

Hosmer was often at the center of controversy, for she had chosen a profession generally considered unsuitable for a woman because of the physical labor involved and the necessity of studying the nude—male as well as female. A free spirit who was raised in Massachusetts by a liberal, indulgent father, she shocked many of her contemporaries when she attended an all-male medical college in St. Louis so she could study anatomy. In 1852, Hosmer went to Rome, where she studied with the famous English sculptor John Gibson. Henry James referred to her as the leading figure among "the white marmorean [marble] flock," that group of four or five American women sculptors active in Rome at the time.

EDMONIA LEWIS

Edmonia Lewis (1845–?), a member of that flock, was the daughter of an African-American father and a Chippewa mother. She attended Oberlin College, after which she went to Boston, where the Abolitionist William Lloyd Garrison introduced her to the sculptor Edward Brackett, who taught her to model in clay. Among her earliest works are a medallion of John Brown and a posthumous bust of Colonel Robert Gould Shaw, leader of a troop of black soldiers in the Civil War. The bust sold so well that Lewis was able to travel to Rome in 1865. There she joined Hosmer's circle, and received instruction from the English sculptor John Gibson.

Lewis's works often reflected her own experiences, or depicted heroines with whom she identified. Her first major piece was of Hagar, shown in her despair in the wilderness. To nineteenth-century eyes, Hagar, an Egyptian woman, would have symbolized Africa, and therefore was representative of the plight of the black race. From the sculptor also came subjects such as *Hiawatha* (lost) and the *Old Indian Arrow Maker and his Daughter* (private collection). *Forever Free* shows a black man who has broken the chains of slavery, and a black woman who kneels at his side in

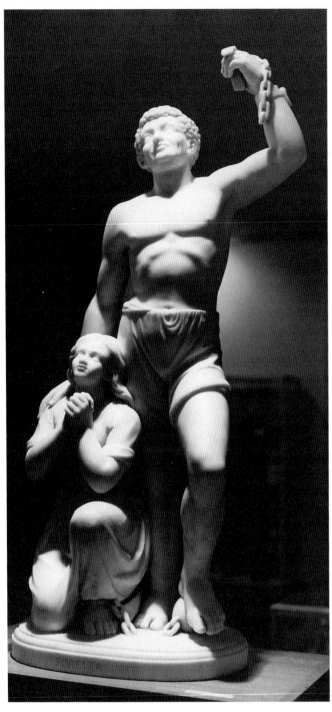

18.14 Edmonia Lewis, *Forever Free*, 1867. Marble, height 3ft 4½in (1.03m). Howard University, Washington, D.C.

prayerful gratitude for the freedom that has come at last (Fig. 18.14).

Visitors to Rome flocked to Lewis's studio, for she was considered exotic. She remained in Rome, except for brief visits to the United States, having found in Rome an acceptance not attainable in America. In spite of her fame, she virtually disappeared from the records around 1880.

RANDOLPH ROGERS

Randolph Rogers (1825–92) was famous among the studios of Rome for literature-inspired ideal works such as *Nydia, the Blind Girl of Pompeii*, and the biblical *Ruth Gleaning in Fields of Boaz*. *Nydia*, of which over one hundred marble replicas were ordered, illustrates a scene from Bulwer-Lytton's famous novel *The Last Days of Pompeii* (1834). It depicts the blind girl trying to make her way amid the rubble and chaos caused by the eruption of Mount Vesuvius in A.D. 79 (Fig. 18.15). Victorians reveled in the pathos expressed in the face of the helpless and abandoned girl. Her closed eyes, with hand to her ear, and walking stick, together with her unsteady step, indicate her blindness, while the classical capital overturned beside her right foot suggests the city in

18.15 Randolph Rogers, *Nydia, the Blind Girl of Pompeii*, 1853. Marble, height 4ft 7in (1.4m). Metropolitan Museum of Art, New York City.

the process of its destruction. An allusion to classical antiquity was achieved by basing the figure on a wellknown Hellenistic statue, the *Old Market Woman* (second century B.C., Metropolitan Museum of Art).

WILLIAM WETMORE STORY

Melodrama of a more brooding sort underlies the marble sculptures of William Wetmore Story (1819–95). The Boston-born son of U.S. Supreme Court Justice Joseph Story, a Harvard graduate, and a successful lawyer, Story developed a fascination for sculpture that led him to Rome and the cultured, cosmopolitan life of an expatriate. His pensive, moody heroines from antiquity, such as *Cleopatra* (Metropolitan Museum of Art) or *Libyan Sibyl* (National Museum of American Art, Washington, D.C.), are exemplary monuments of their time, around 1860. *Medea*, in glistening white marble, shows this tragic woman in a moment of total withdrawal as she plots her revenge upon the unfaithful Jason, whom she helped to gain the Golden Fleece (Fig. **18.16**). Her face has a villainy about it, and the knife in her hand signals that she already plots the murder of Jason's children. At that time, the celebrated actress Adelaide Ristori was performing the role of Medea on the Roman stage, and the Storys frequently entertained her among the other guests—including their friends the poets Robert and Elizabeth Barrett Browning—who attended the weekly salons held in the drawing room of their apartments in the Palazzo Barberini. The literary-theatrical element was therefore understandably strong in the conception of the piece. A number of details expand upon the narrative, by telling a fuller story about ancient clothing, jewelry, hairstyle, and weaponry.

WILLIAM RINEHART

Another prominent member of the American expatriate colony in Rome was William Rinehart (1825–74). Rinehart left Baltimore in 1855 to study in Italy, where his art became totally committed to the late phase of Neoclassicism. He is perhaps best remembered for his chaste, nude image of *Clytie*, a nymph from Greek mythology who falls in love with the sun god, Apollo, who rewards her with immortality by turning her into a sunflower, symbol of unwavering love and devotion (Fig. **18.17**). The graceful nude figure was judged an artistic success by wealthy American patrons, such as W. T. Walters of Baltimore and W. W. Corcoran of Washington, D.C., both of whom left their collections to the public as museums. Rinehart's Neoclassicism had an appealing purity. In the decade before his death in 1874 his work may be seen as the swansong of American neoclassical sculpture.

18.16 William Wetmore Story, *Medea*, 1868, after the original of 1864. Marble, height 6ft 4in (1.93m). Metropolitan Museum of Art, New York City.

18.17 William Rinehart, *Clytie*, 1872. Marble, height 5ft 2in (1.57m). Metropolitan Museum of Art, New York City.

18.18 William Rimmer, *Dying Centaur*, c. 1871. Bronze, height 21in (53.3cm). Metropolitan Museum of Art, New York City.

WILLIAM RIMMER: ROMANTIC ENIGMA

The work of one man does not easily fit into any of the other movements discussed in this chapter. This is the eccentric William Rimmer (1816–79), whose highly charged and richly modeled Romantic pieces anticipated the art of Auguste Rodin (1840–1917) by several decades. As early as 1830, Rimmer had modeled a small nude figure titled *Despair*, an essay in the expression of psychological torment. But Rimmer then became a physician, in East Milton, Massachusetts, and his next major effort in sculpture did not occur until 1861. In the *Falling Gladiator*, the rippling surfaces and dynamic tensions suggest the anguished death throes of a powerful, muscular figure. Rimmer then turned his energies to teaching art, especially drawing and anatomy, at the art school of the Cooper Union in New York City. By 1870, he was back in Boston, where he created two of his most famous works, the *Fighting Lions* and the *Dying Centaur* (Fig. 18.18). Death and violence are the continuing themes in these pieces, wrought in an emotion-filled Romantic style that is the antithesis of the cerebral purity of Neoclassicism.

American sculpture was born and matured between 1825 and the 1870s, with an impressive number of gifted artists establishing a school that won high praise both at home and in the international arenas of art in Europe. With heroic marble maidens populating the salons of the wealthy, and little plaster genre groups placed in many a middleclass parlor, by the 1870s sculpture was firmly established as an artform in America.

CHAPTER NINETEEN

FOLK ART:

A SPECIAL MODE OF VISION

During the course of the nineteenth century, the corps of trained professional artists grew continually in all branches of the arts. These men and women produced buildings, furniture, paintings, and sculpture in the contemporary high style. There was, however, another group of painters, sculptors, and craftsmen who worked in a naïve, primitive, folk, or vernacular manner. While such artists and artisans were usually familiar with the current high style, their means of expression and technical execution produced a distinctive vision.

In the pictorial arts, abstraction of form results from a special sensitivity to design—for example, the patterns of a quilt, or the linear rhythm of the outline of a weathervane. Visual realism is less important than the idea or the expressiveness of the image. Scale may be altered for the sake of

emphasis, and space may be compressed or eliminated. The figure may be anatomically incorrect, and forms may be simplified or made more elaborate. The folk artist is not restricted to representing the natural world as the eye sees it, or as the established academic traditions dictate. Materials, techniques, and personal mannerisms may all influence the folk interpretation of high-style design. The resulting aesthetic is nevertheless both artistically valid and culturally expressive. The maker of folk art may be either a professional or an amateur artist or artisan.

The colonial era had a folk art. A case could be made for placing a seventeenth-century gravestone, an eighteenth-century carved shopsign, or a portrait by a Hudson Valley Patroon painter within the folk tradition. The folk style often paralleled a high-style tradition.

An example of folk art sculpture from the late eighteenth century is *George Washington on Horseback*, carved in wood and polychromed (Fig. 19.1). When compared with Henry Kirke Brown's equestrian *Washington* (Fig. 18.7), its salient characteristics emerge. Naturalism and anatomical accuracy were unnecessary, yet the sculptural form and graceful flow of contours are admirable, and there is a naïve charm that is so often present in folk art. Folk art characteristically expresses the very essence of its subject, as in the military erectness of the general and the "equineness" of the horse.

RUFUS HATHAWAY

Within a few years of Rufus Hathaway's (1770–1822) painting *Lady with her Pets* (Fig. 19.2), Gilbert Stuart was painting portraits in the most sophisticated style of the eighteenth-century English school. A comparison with Stuart's *Mrs. Richard Yates* (Fig. 10.7) reveals that while Hathaway knew the high style generally, his own version of it was quite different.

In *Lady with her Pets*, form is flattened and defined by outline, space is compressed, light and shade are not important, and decorative features are emphasized. The face and arm have no more the appearance of flesh than the folds of the dress have the structure of fabric. These characteristics, however, were not considered inadequacies by either painter or patron. Hathaway typically seized upon one charming

19.1 Anonymous, *George Washington on Horseback*, c. 1780. Polychromed wood, height 21in (53.3cm). Shelburne Museum, Shelburne, Vermont.

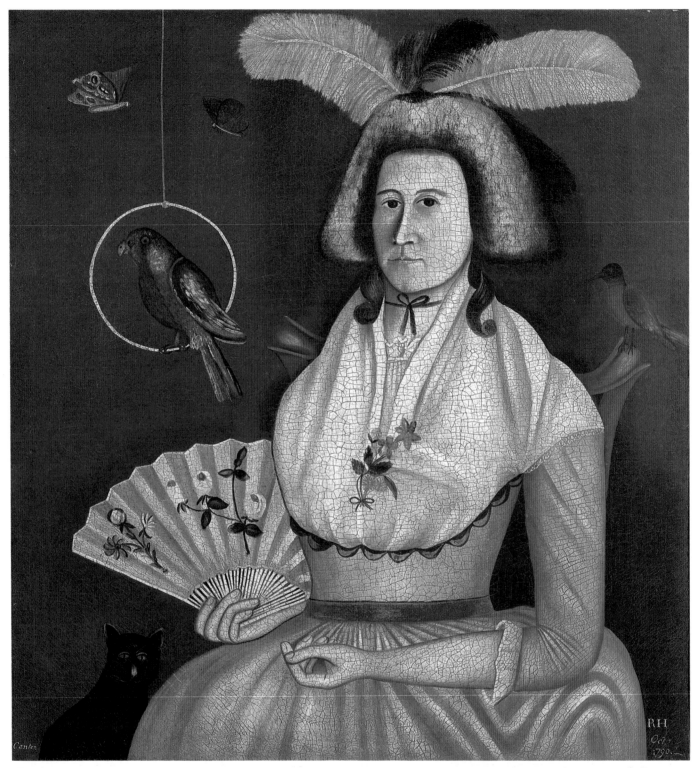

19.2 Rufus Hathaway, *Lady with her Pets*, 1790. Oil on canvas, 34¼ × 32in (87 × 81.3cm). Metropolitan Museum of Art, New York City.

detail after another, each of which was undoubtedly associated with his subject—the parrot in a hoop, the little bird on the chairback, the two butterflies, and the cat, which is identified by the inscription as "Canter."

Hathaway probably never had formal instruction, and most of his two dozen or so portraits are of relatives. After about 1800, when he became a physician in Duxbury, Massachusetts, his painting activity was an avocation.

JOSHUA JOHNSTON

Joshua Johnston (active 1796–1824) was the first African-American to become a professional painter and make his living as an artist. Johnston claimed he was "a self-taught genius, deriving from nature and industry his knowledge of art."[1] Of West Indian ancestry, he probably began life as a slave, but by the time he began painting portraits in Baltimore in the 1790s he was a free man.

Early in his career Johnston was influenced by the styles of Charles Willson Peale and the latter's nephew, the Baltimore portraitist Charles Peale Polk (1767–1822), and he may in fact have been an assistant to the elder Peale. In Baltimore, Johnston's portrait subjects included the leading white families, and he enjoyed professional success there. *The Westwood Children* is typical in the naïve charm of the faces, the rather stiff figures simplistically arranged in a line across the picture space, and the decorative details that receive extraordinary attention—coatbuttons, crenellated collars, the basket of flowers, and the delightful little dog (Fig. 19.3). While neither pictorial space nor anatomical form is used in the traditional academic manner, an enjoyable, consistent style exists nevertheless. By about 1820, Johnston's career was in decline.

19.3 Joshua Johnston, *The Westwood Children*, c. 1807. Oil on canvas, 3ft 5⅛in × 3ft 10in (1.05 × 1.17m). National Gallery of Art, Washington, D.C.

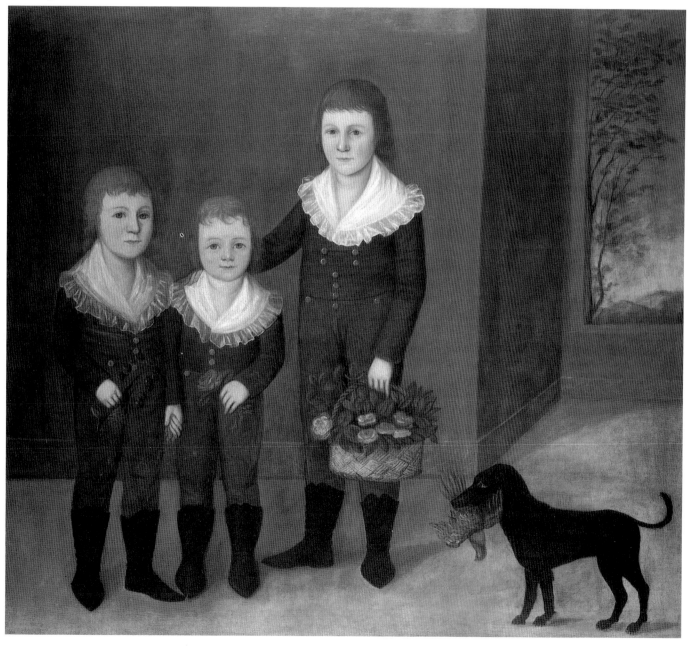

EUNICE GRISWOLD PINNEY

Eunice Griswold Pinney (1770–1849) was born to prominent, wealthy parents in Simsbury, Connecticut. Well-educated, and taught to put idle moments to good use, she found an outlet for creative talent in the numerous watercolors made between 1809 and 1826. These were done in Simsbury or nearby Windsor, just north of Hartford, small towns that were remote from the emerging metropolitan art centers. Watercolor was then a medium used mainly by amateurs. Mrs. Pinney's range of subject matter was broad, including portraits, interiors, genre and literary scenes, and masonic emblems.

Mourning pictures were very popular, and Figure 19.4 is a typical example of Pinney's art. Usually the name of the deceased is given on the pedestal or urn, but for some reason no inscription was included. The dead person's family grieve

19.4 Eunice Pinney, *Undedicated Memorial*, c. 1815. Watercolor, 18½ × 15¾in (47 × 40cm). New York State Historical Association, Cooperstown.

19.5 Joseph H. Davis, *James and Sarah Tuttle*, 1836. Watercolor on paper, 9½ × 14½in (24.1 × 36.8cm). Courtesy The New-York Historical Society, New York City.

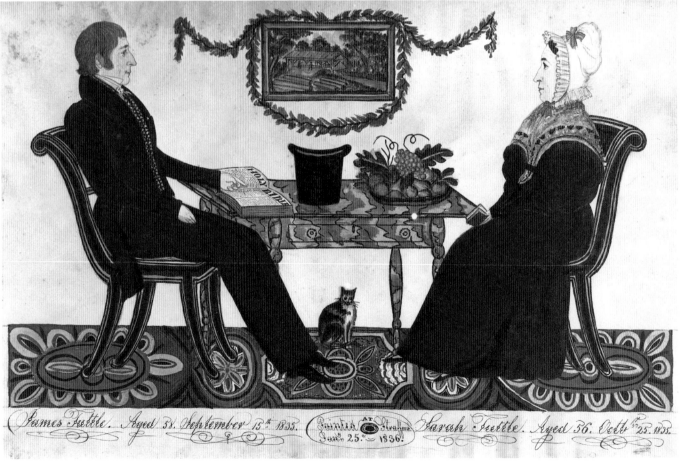

at the funerary marker—which is of a standard Federal period form, the urn—and the Federal style of their clothing is carefully noted. Another standard motif of such scenes is the weeping, or mourning, willow at the left, presented in a decorative, linear pattern. The weeping willow indicates that nature joins in the grief of the passing of the deceased. The landscape background includes boaters on a pond and several schematized buildings. The "realness" of their appearance is immaterial—it is sufficient that they are understandable symbols, decoratively presented.

JOSEPH H. DAVIS

Of a similar but distinctive style is the work of Joseph H. Davis, an itinerant watercolor portrait painter who worked the back roads and small towns of Maine and New Hampshire between about 1832 and 1838. Beyond this, practically nothing is known of the man, but he was probably selftaught. Davis had a set formula for representing families: Husband and wife sit full-length in profile, facing each other at a painted, country Sheraton table, on Greek Revival *klismos*-type chairs. A highly decorative floor covering unites the group.

Variations within this scheme allowed the artist to personalize his scenes of middleclass respectability. In the portrait of James and Sarah Tuttle, for example, the family cat sits beneath the table, the woman holds a small book (to indicate her ability to read), the gentleman (his status shown by his suit, vest, and top hat) points to the open Bible, indicating the piety of the family, while a picture on the wall shows a lumber mill, probably a reference to the man's source of wealth (Fig. 19.5). Further personalization is seen in the beautiful calligraphic inscription that reports the sitters' names, ages, and birthdates, and records that the picture was painted on 25 January 1836. The scene is viewed from several vantage points—the floor from one, the sitters from another, and the tabletop from a third—but such visual inconsistencies did not trouble the folk artist.

PORTRAIT PAINTERS ON THE BACK ROADS

One of the most prolific of the rural portrait painters of the nineteenth century was Ammi Phillips (1788–1865), who worked in western Massachusetts and Connecticut, and along the Hudson Valley from Albany to Rhinebeck. His career began about 1810, spanned over half a century, and was devoted almost entirely to the portraiture of unpretentious country and hamlet gentry.

One of Phillips's earliest and most charming portraits is that of Harriet Leavens (Fig. 19.6). The anatomy is not well articulated, and the hands seem large and awkward, but the simplified forms and delicate hues of the clothing— pale pinks and soft greens—have an elegance nevertheless. The simplicity of form, palette, and background permitted

Phillips to focus on the face, always the strongest part of a portrait by the artist. Phillips reportedly had no formal training in art, but he probably was familiar with the current high style, such as Thomas Sully's portraits represent (Fig. 10.11). Also, in 1817 Phillips lived in Troy, New York, and he may have been familiar with the art of a popular portraitist of Albany, Ezra Ames.

Erastus Salisbury Field (1805–1900) was an itinerant

19.6 Ammi Phillips, *Harriet Leavens*, c. 1815. Oil on canvas, 58 × 28in (147.3 × 71.1cm). Fogg Art Museum, Harvard University, Cambridge, Massachusetts.

portrait painter working the rural areas of western Massachusetts and Connecticut. Field was selftaught, except for a brief period of study with Samuel F. B. Morse in New York City. His group portrait, *Joseph B. Moore and his Family*, depicts smalltown aristocracy dressed up in their finery and surrounded by symbols of wealth (Fig. 19.7). Joseph Moore was a hatmaker in the winter and an itinerant dentist in the summer. In hierarchical arrangement, the husband and wife dominate the scene, with their two children at the right and the two children of Mrs. Moore's deceased sister on the left. All look straight out at the viewer. The black-and-white attire unifies the figural group, and is in marked contrast to the warm colors and rich patterns of the background and carpet, respectively.

A SIGNPAINTER'S PEACEABLE KINGDOM

Edward Hicks (1780–1849), a Quaker minister and signpainter in Bucks County, Pennsylvania, created some of the period's most charming specimens of folk painting. The scope of his subject matter was limited, mainly to themes of natural wonders of America, portraits of local farms, and religious pictures. *Falls of Niagara* shows the great cataract, with the wildness of the area indicated by the rattlesnake, beaver, and moose. A small figure (lower right) raises his arms, seemingly in prayerful worship before the grandeur of nature (Fig. 19.8). Hicks's experience as a signpainter can be seen in the inscription surrounding this scene, lines from *The*

19.7 Erastus Salisbury Field, *Joseph B. Moore and his Family*, 1839. Oil on canvas, 6ft 10¾in × 7ft 9¼in (2.1 × 2.36m). Museum of Fine Arts, Boston. Gift of Maxim Karolik for the M. and M. Karolik Collection of American Paintings, 1815–65.

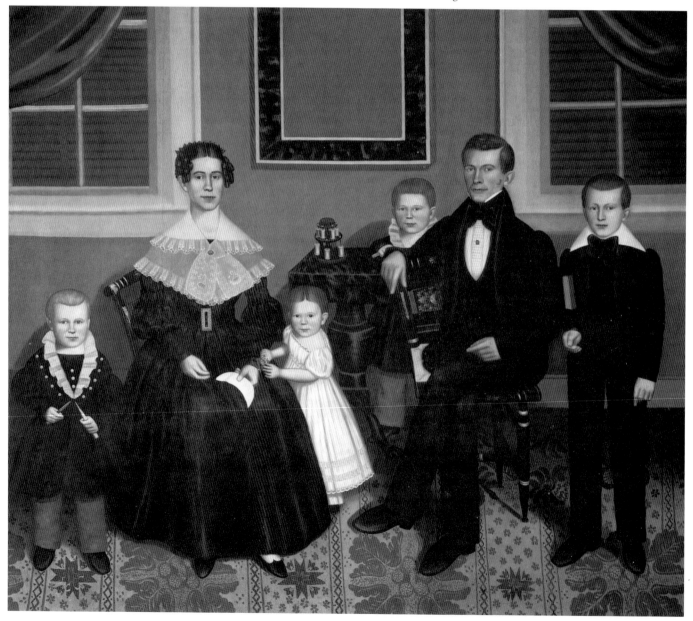

19.8 Edward Hicks, *The Falls of Niagara*, 1825. Oil on canvas, 31½ × 38in (80 × 96.5cm). Metropolitan Museum of Art, New York City.

The Falls

Above, below, where 'er the astonished eye
Turns to behold, new opening wonders lie,

of Niagara

With uproar hideous first the *Falls* appear,
The stunning tumult thundering on the ear.

This great overwhelming work of awful Time
In all its dread magnificence sublime,

Rises on our view, amid a crashing roar
That bids us kneel, and Time's great God adore.

18 25

19.9 Edward Hicks, *Peaceable Kingdom*, c. 1834. Oil on canvas, 30 × 35½in (76.2 × 90.2cm). National Gallery of Art, Washington, D.C.

Foresters: A Poem, Descriptive of a Pedestrian Journey to the Falls of Niagara (1818) by the ornithologist-artist Alexander Wilson. It ends with the lines:

This great o'erwhelming work of awful Time
In all its dread magnificence sublime,
Rises on our view, amid a crashing roar
That bids us kneel, and Time's great God adore.

Hicks is best remembered for *Peaceable Kingdom*, of which he painted numerous variants (about sixty survive). Almost all included two main groups—the assortment of wild animals that seem to be mystically under the control of a child, and the central group taken from Benjamin West's *Penn's Treaty with the Indians*, all set within a landscape that resembles the Delaware River Valley (Fig. 19.9). The animal section was based on an engraving after the painting *The Peaceable Kingdom of the Branch* by the English artist Richard Westall (1765–1836), but Hicks's interpretation was painted with the fantasy that often inspires such primitive painters. The scene is based on Isaiah 11:6, which foretells the coming of peace on earth: "The wolf also shall dwell with the lamb, and the leopard shall lie down with the kid; and the young lion and the fatling together; and a little child shall lead them." Hicks was an admirer of William Penn, whom he saw as one who tried to bring about the fulfillment of Isaiah's prophecy of peaceful coexistence.

FOLK LANDSCAPE

Landscape or scenery was often painted with a naïve charm and directness that was characteristic of folk art. While landscapes by Thomas Chambers (1808–after 1866) may lack the visual reality of, say, Asher B. Durand's *The Beeches* (Fig. 15.7), they nevertheless capture the spirit of nature, as in his *Mount Auburn Cemetery* (Fig. 19.10). Chambers came to America from his native England in 1832.

19.10 Thomas Chambers, *Mount Auburn Cemetery*, c. 1850. Oil on canvas, 14 × 18⅛ in (35.6 × 46cm). National Gallery of Art, Washington, D.C.

19.11 Linton Park, *Flax Scutching Bee*, 1885. Oil on bed ticking, 31¼ × 50¼in (79.4 × 127.6cm). National Gallery of Art, Washington, D.C.

He worked in the Boston, Albany, and New York City areas, painting marine subjects and landscapes, many of which were based on engravings rather than on direct observation. His picture of the famous cemetery outside Cambridge, Massachusetts, for example, is taken from an engraving by William H. Bartlett.

SCUTCHING BEES AND QUILTING BEES

Linton Park (1826–1906), who was raised in western Pennsylvania, was trained as a cabinetmaker. But in 1863 he was in Washington, D.C., where he was one of the workmen who literally painted the Capitol. Five years later, Park returned to his hometown of Marion, where he operated a sawmill for many years and tinkered with inventions. Park does not appear to have had any formal training in art, or any association with societies of professional painters. He just seems to have enjoyed making pictures of scenes familiar to him—such as *Flax Scutching Bee* (Fig. **19.11**)—which he exhibited at county fairs, rather than at the annual salons of the academies. Here, the rural locale is established by the loghouse, barn, and outbuilding. Its joy, however, is in the group of more than two dozen farm folk who participate in the flax-beating bee. At the left a man operates a flax-brake, while beside him stands a woman smoking a pipe. Other figures chat with one another, or mischievously wave their paddles at each other, or tease the barking dog, or occasionally beat the flax on boards standing upright before them.

Portraits of farms had been popular since the mid-eighteenth century, as seen in overmantel paintings. In the 1790s, Ralph Earl represented them as seen through windows beside his sitters. Nineteenth-century folk artists had their own special way of depicting a farm or rural community. One of the finest folk renditions of this theme is *Mahantango Valley Farm*, which shows so well the wonderful command of those abstract fundamentals of art—line, pattern, color, rhythm—that exist as innate sensibilities in the folk artist (Fig. 19.12).

It is not an accurate visual representation, but one in which the mind has grasped the essence of the scene and presented it simplistically and schematically—and with exceptional sophistication in matters of design. The anonymous, untrained folk artist clearly understood the basics of art. The linear rhythms of the fences are superbly ordered, either paralleling the angular axis of the road or running horizontally across the picture plane at fairly regular intervals from bottom to top. The geometric parallelograms of

19.12 Anonymous, *Mahantango Valley Farm*, late 19th century. Oil on fabric window shade, 28 × 36⅛in (71.1 × 91.7cm). National Gallery of Art, Washington, D.C.

the red roofs have an axial order imposed upon them that instills harmony within the composition, and several of the fields beyond repeat these same geometric shapes, thereby extending the unity throughout the foreground and middleground. The lines of the clapboards on the buildings repeat those of the fences, and the shapes of the shingles on the roofs echo the shapes of the roofs themselves. Then, too, there are all the marvelous vignettes of farm life—the livestock so beautifully stylized; the pigeons on the roof and the chickens in the barnyard; the hunters at the left who shoot game in the copse of trees, and the hunter returning home with his two dogs in the foreground.

This Pennsylvania farmscene, which must be counted among the masterpieces of nineteenth-century American folk art, was painted on a window shade. Folk artists used whatever materials were at hand, for they often worked far removed from art-supply stores that catered to the professional academic painter.

Of a similar style but painted with less precision is *Manchester Valley* by Joseph Pickett (1848–1918), a carpenter of New Hope, Pennsylvania (Fig. 19.13). Pickett regularly ran off with the carnival to operate concessions and shooting galleries. When his rifle range prospered, and after his marriage in about 1893, he settled down in New Hope, where he ran a grocery and general store until his death. Late in life Pickett began to paint pictures, only four of which are known to survive.

Manchester Valley suggests Pickett never studied art as it was taught in the academies, for there is an original, intuitive vision and execution here. The scene depicts mills beside a river with a waterfall, alongside which runs the Philadelphia & Reading Railroad. Beyond the tracks are a few houses and a large building, possibly a courthouse, with a bell cupola and an American flag.

19.13 Joseph Pickett, *Manchester Valley*, 1914–18. Oil with sand on canvas, 3ft 9½in × 5ft⅝in (1.16 × 1.54m). Collection, The Museum of Modern Art, New York. Gift of Abby Aldrich Rockefeller.

Around the turn of the century, the modern art movement recognized the validity of many aspects of primitive and folk art. It is interesting to note that this picture, by a carnival concessionaire, jack-of-all-trades, and proprietor of a general store, is now in the collection of The Museum of Modern Art in New York City.

Often the folk artist seized an opportunity to produce art in a form that the conventional, academic artist never had access to—quilts, for example. Quilts were made in virtually all areas, and they were a natural and utilitarian outlet for creativity. Quilts were especially an outlet for creative talent among women, who made them as useful and decorative objects for the home. A particularly handsome example is one which has in its central panel a scene of the village green of Greenfield Hill, Connecticut, the home of its maker, Sarah Furman Warner (Fig. 19.14). A church spire is flanked by two Federal-style houses and trees, while citizens of the

village, no doubt friends of the artist, parade about the green. The central section is surrounded by a band of entwined vines from which leaves and flowers sprout, and upon which birds perch. This abstract floral-and-leaf design makes a lively and attractive border.

The quilt shown in Figure 19.15 is called a Baltimore Album quilt. It was made by several women, each of whom made one or more of the seventeen blocks, which were then assembled at a quilting bee. The separate designs were fairly standardized and included vases of flowers, wreaths, cornucopias, bowls of fruit, birds, and patriotic images, with variations from quilt to quilt. At the top is a design of the U.S. Capitol, recently completed by Charles Bulfinch (see Fig. 17.6). Next to it is a war memorial with American flags and rows of rifles. Both motifs are found on other quilts. Album quilts such as this were made in or near Baltimore between 1820 and 1860.

19.14 Sarah Furman Warner, *Quilt with Scene of New England Village Green*, c. 1800. Appliqué, 8ft 9in × 7ft (2.67 × 2.13m). Henry Ford Museum, Dearborn, Michigan.

19.15 Sarah Anne Whittington Lankford, probably Mary Evans, and possibly others, *Baltimore Album Quilt*, c. 1850. Appliqué, 7ft × 8ft 3in (2.13 × 2.51m). Abby Aldrich Rockefeller Folk Art Center, Williamsburg, Virginia.

19.16　Shaker Dwelling Room, c. 1830, as installed in Winterthur Museum, Winterthur, Delaware.

SHAKER SIMPLICITY

In their spiritual mysticism and in their beliefs about how secular life should be conducted, the Shakers offer a good example of how the convictions of a society can affect the form of its art. Shakerism came to America from England in 1774 in the person of Ann Lee, the founder of the United Society of Believers in Christ's Second Appearance. The members were called Shakers because they reportedly trembled during their mystical religious experiences. Their numbers were never large, about 6000 at their peak in the mid-nineteenth century, divided among about twenty Shaker communities in New England, New York, Ohio, Indiana, and Kentucky.

Believers withdrew from the world to live celibate lives in their own communities. Marriage being forbidden, the men slept in one dormitory, the women in another. They were as selfsufficient as possible, building their own communal houses and barns, raising their own food, and making their own clothing, furniture, baskets, and wagons. Within such isolation, a distinctive style that was expressive of the community's basic beliefs evolved.

In a sect such as Shakerism, the line between religious and secular virtues was blurred, for secular values such as orderliness, simplicity, and cleanliness were considered a part of godliness. These mores are reflected in the Shaker interior and its furnishings (Fig. 19.16). Undecorated walls are spotlessly white; uncovered plank floors are scrubbed clean; an end wall is devoted to cabinets and drawers so that everything could be put away when not in use. When chairs were not in use, they were hung up on pegs, out of the way—for neatness' and orderliness' sake, and so as not to be a temptation to loafing. In furniture design, functionalism was the primary concern. Anything decorative was forbidden, as it was deemed superfluous or even decadent. In the late eighteenth and early nineteenth centuries Shaker craftsmen began making chairs and tables that were consistent in design with their religious and secular principles. Consciously eschewing the current vogue for Adamesque, Sheraton, and Hepplewhite styles, with their fine carvings and decorative motifs, a separate aesthetic emerged that was a direct result of the Shaker way of life. The lines of the stove, table, and chair in Figure 19.16 are dominated by a sparseness and a commitment to utilitarianism. Yet in the simplicity of their design, and in the beauty of the wood, there is a valid functionalist aesthetic. Proportion, line, simplicity, beauty of material, and superb craftsmanship are the fundamentals of Shaker objects.

FOLK SCULPTURE

The craft of carving had been raised to a high level in the work of William Rush. But the arrival of foreign sculptors working in the neoclassical style, and the rise of the American school of sculptors about 1825, sent the high-style tradition off in one direction and the craft of carving in another. After about 1830, the carvers' tradition, which had come down through the Skillins, Rush, and hundreds of other gifted artisans, was channeled into such areas as cigarstore figures, ships' figureheads, circus-wagon ornamentations, and merry-go-round animals. Apart from the academic styles of Rome, Paris, and New York, throughout the nineteenth century it enjoyed a very lively existence.

19.17 Anonymous, *The Preacher*, c. 1870. Wood, height 21in (53.3cm). Abby Aldrich Rockefeller Folk Art Center, Williamsburg, Virginia.

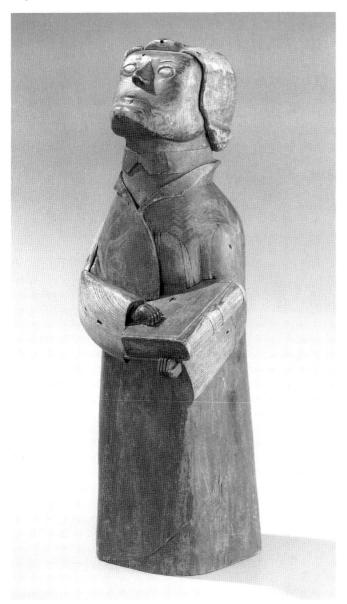

The little wooden figure of a preacher is an excellent example of the folk carvers' tradition (Fig. 19.17). The piece may represent the Rev. Henry Ward Beecher, one of the most famous American ministers of the nineteenth century. It may also be related to a statue of the religious reformer Martin Luther that was erected in Worms, Germany, in 1868—if the carver were a German immigrant, he might well have recalled the original statue in making his own naïve version of it. In any case, the carver seized upon the evangelical zeal of the man as the characteristic he most wanted to capture. The form of the body is greatly simplified, and the hands are inordinately small so that emphasis may be placed on the large head—turned heavenward, the mouth opened in zealous prayer—and the large Bible.

Child with Bucket is believed to have been carved by an African-American, about the time of the Civil War or possibly a little earlier (Fig. 19.18). Not only do the facial features suggest a young black person, but their form is similar to that of carved wooden masks from Africa. Indeed, the whole figure resembles African figurines, and this piece may be an example of the survival of African arts in America which were brought over years earlier by slaves. Tribal customs survived transplantation in other arts, such as music, so it is possible that sculptural forms did as well.

19.18 Anonymous, *Child with Bucket*, c. 1860. Wood, height 8in (20.3cm). Abby Aldrich Rockefeller Folk Art Center, Williamsburg, Virginia.

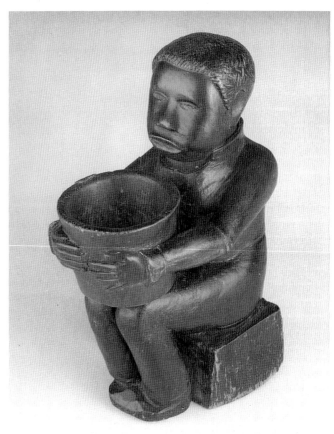

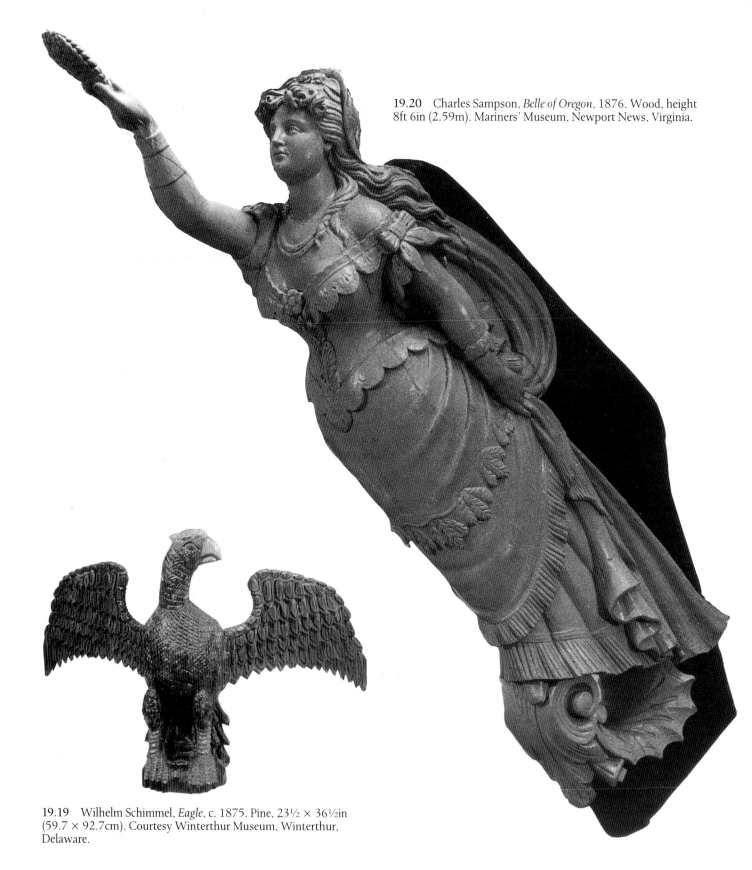

19.20 Charles Sampson, *Belle of Oregon*, 1876. Wood, height 8ft 6in (2.59m). Mariners' Museum, Newport News, Virginia.

19.19 Wilhelm Schimmel, *Eagle*, c. 1875. Pine, 23½ × 36½in (59.7 × 92.7cm). Courtesy Winterthur Museum, Winterthur, Delaware.

Wilhelm Schimmel (1817–90), a big, burly, surly, German-speaking man, was an itinerant, doing odd jobs in western Pennsylvania. Reportedly, he never used any tool other than a pocketknife to carve the eagles for which he is today famous (Fig. 19.19). After his pieces were carved, they were usually coated with **gesso** and then painted. Schimmel would travel from community to community, selling his carved toys, animals, eagles, and other birds in baskets for ten to twenty-five cents each. His eagles are strongly stylized, and are exemplary of the folk artist's penchant for abstract form.

Schimmel was a country whittler, but there were other carvers who worked in large cities. Ships' figureheads or other ornamental work offered opportunities for the artisan-

carver, at least until the great wooden sailing vessels were replaced by steampowered ships with metal hulls in the 1870s.

One of the last figureheads to be carved was for the *Belle of Oregon* (Fig. **19.20**). This is the work of Colonel Charles A. L. Sampson (1825–81), who, during a period of great prosperity for the shipbuilding industry in Bath, Maine, produced nearly thirty figureheads. *Belle of Oregon* has bold sculptural form that is nicely enlivened by concentric linear patterns at the bodice and waist and along the skirt. The Belle, who wears an elegant gown of current fashion, holds a shaft of wheat in her right hand, and tufts of wheat form some of the patterns that decorate her gown—appropriate symbols for a ship that was in the grain trade.

Charles J. Dodge (1806–86) was a New York carver who learned his craft in the shop of his father Jeremiah, with whom he was in partnership from around 1830 to 1842, when he opened his own establishment. Dodge, too, produced much ornamental work for ships, but he also carved shopsigns. *Seated Indian*, which stood until 1930 outside a tobacco shop in Brooklyn, is an extraordinary example of the carver's art, and demonstrates the vitality of the vernacular, nonacademic tradition (Fig. **19.21**). There is a monumental nobility about the sculpture, for Dodge represented his subject with the natural dignity and gravity appropriate to a grand chief. The lifesize figure, holding a bundle of cigars and smoking a long pipe, belongs to a tradition that began in England in the seventeenth century of using images of Native Americans to promote the New World commodity of tobacco.

19.21 Attributed to
Charles J. Dodge, *Seated Indian*, c. 1862.
Painted wood, height 5ft 6in (1.68m).
Brooklyn Historical Society.

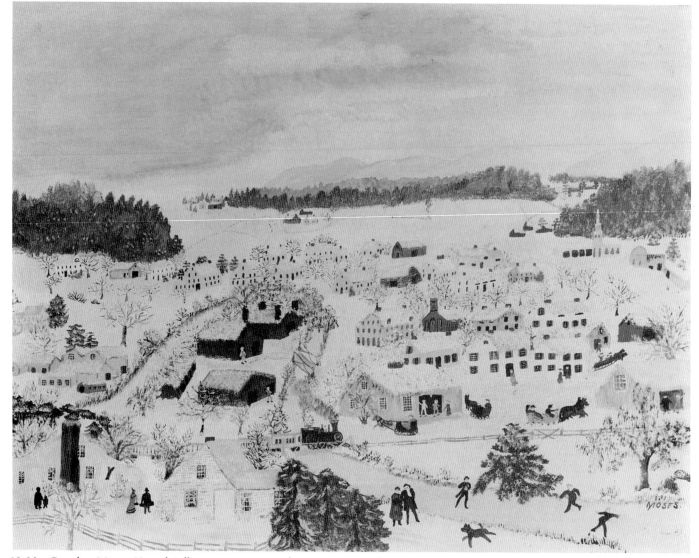

19.22 Grandma Moses, *Hoosick Falls in Winter*, 1944. Oil on masonite panel, 19½ × 24¾in (49.5 × 62.9cm). Copyright and photograph courtesy Grandma Moses Properties Co. Painting in the Collection of the Abby Aldrich Rockefeller Folk Art Center, Williamsburg, Virginia.

GRANDMA MOSES

One example demonstrates the continuation of folk-art traditions well into the twentieth century—the painter Anna Mary Robertson Moses. Better known as Grandma Moses (1860–1961), she lived in upstate New York, where she embroidered pictures with worsted yarn, until neuritis forced her to give up the needle for the brush when she was in her early seventies. She exhibited her work at county fairs, along with her canned preserves, until she was discovered by collectors in the late 1930s.

Her charming scenes of rural life—*Hoosick Falls in Winter* (Fig. 19.22), for example—have an obvious affinity with nineteenth-century pictures such as *Mahantango Valley Farm* (Fig. 19.12), with Joseph Pickett's *Manchester Valley* of about 1915 (Fig. 19.13), and with the view of the village green in the center of the quilt in Figure 19.14. Moses's scenes were often reminiscences of bygone days, when

people traveled across the snow in horsedrawn sleighs, before industrialization and mechanization greatly altered the tenor of country life. Isidor Wiener (1886–1970), an immigrant from eastern Europe, came to be called "Grandpa Wiener" after he started painting naïve biblical scenes in a manner similar to that of Moses.

Folk art is not a term that applies to a particular time-period of long ago. It is, rather, almost always present, paralleling academic or high styles, sometimes related to them—but most often charmingly independent of them. There is usually an originality and expressiveness present because the folk artist makes images in a direct expression, or from a mode of vision that has not been regimented by disciplined training in a school that promotes one style or another. Works such as *Hoosick Falls in Winter* demonstrate that artistic talent is innate, and can be carried to a high aesthetic level, even without formal instruction.

PART 4

The American Renaissance

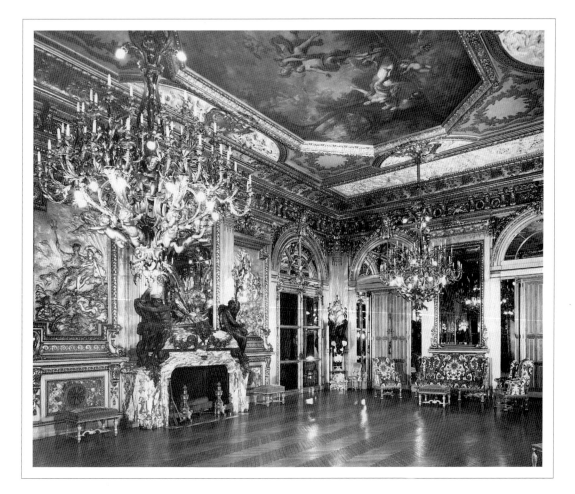

CHAPTER TWENTY

ARCHITECTURE:

THE AGE OF CAPITALISM, IMPERIALISM, AND HIGH SOCIETY, 1870–1900

The United States was different after the Civil War. The bloody violence of the upheaval destroyed the innocence and optimism of the antebellum era, and the assassination of President Lincoln contributed to a mood of depression. Governmental scandals followed: President Andrew Johnson was accused of "high crimes and misdemeanors in office," the Grant Administration was riddled with corruption, and the Tweed Ring in New York was exposed in *Harper's Weekly* through satirical cartoons by Thomas Nast. Carpetbaggers were the scourge of the South. The failure of the banking house of Jay Cooke and Company in 1873 precipitated a panic that led to long years of economic depression, even as the captains of capitalism began their wars among themselves and with the laboring classes. As early as 1868 came the classic struggle of Cornelius Vanderbilt against Daniel Drew, Jay Gould, and Jim Fisk for control of the Erie Railroad. The next three decades saw an unparalleled expansion of railroads crisscrossing the nation, contributing to the rise of great Midwestern market towns like Chicago, St. Louis, and Kansas City.

Fabulous fortunes, such as America had never known, were made. When John Jacob Astor died in 1848, reportedly the richest man in the United States, he left an estate of twenty million dollars. But in 1902, Andrew Carnegie could give away half that amount to establish the Carnegie Institution in Washington, D.C., and in 1901, J. Pierpont Morgan organized the United States Steel Company, the first billion-dollar corporation. Fortunes were lost, too, for economic depressions occurred with sickening frequency. In 1884 and 1893 the banks, railroads, stockmarkets, and industries failed with devastating results. Despite such calamities, capitalism raced ahead, often failing to establish safeguards against abuses. Trusts were formed to obtain monopolies as with the original Standard Oil Company, the American Sugar Refining Company, and the United Fruit Company. The result was governmental intervention through antitrust legislation.

This was a period of social as well as economic unrest. The population of the country doubled in the thirty years between 1870 and 1900. The Ku Klux Klan was formed in the South in 1868, the Society for the Prevention of Cruelty to Children in 1875, and the social worker Jane Addams founded Hull House in Chicago in 1889. There were savage race riots in Vicksburg, Mississippi, and bloody anti-Chinese riots in California.

Labor rose to confront capitalism through such organizations as the Social Democratic Workingmen's Party and the Socialist Labor Party, and through unions such as Samuel Gompers's American Federation of Labor and the United Mine Workers. These groups fought for the eight-hour workday, the end of the "company store" system, and better wages and working conditions. Their efforts often brought them into bitter conflict with employers—for example, the coalmine, factory, and railroad strikes that began in the 1870s increased and intensified in the next two decades. In 1886, a bomb exploded amid an angry throng of police, anarchists, and labor demonstrators, igniting the Haymarket Square Riots in Chicago. Further violence occurred during the Homestead, Pennsylvania, steelmill strike of 1892, when Pinkerton Agency guards were hired by the company to contend with strikers. During the confrontation, Henry Clay Frick was shot and stabbed, but survived to form a great art collection.

At the same time, America, with its industrial, financial, and agrarian might, asserted its place among the great powers, accruing, by military means if necessary, territories around the world. In *Our Country* (1885), Josiah Strong theorized that it was America's duty to become imperialistic. He was countered by Rudyard Kipling's "The White Man's Burden," which attacked American imperialism after the Spanish-American War of 1898. It was in that war that America raised a new breed of hero—for example, Colonel Teddy Roosevelt, who led a cavalry charge of Rough Riders up San Juan Hill in Cuba to vanquish the Spanish forces, and Admiral George Dewey, who destroyed the Spanish fleet in Manila Bay. America was soon in possession of the Philippines, Guam, Wake Island, and Samoa; Hawaii and Puerto Rico were then annexed, and American presence was felt in

Cuba after Spain gave it up as well. By 1904 the United States had acquired a 10-mile(16-km)-wide strip through Panama in which to dig a canal, so that its merchant and naval fleets could pass directly from one ocean to another.

It is in the context of this vast panorama of growth and unrest, extraordinary wealth and depressing poverty, of railroads, factories, building, and inventing that the art and architecture of the era should be observed.

PERSIAN PALACES AND THE SECOND EMPIRE STYLE

The exoticism of mid-century continued, reaching its climax in the Islamic-Persian palace built for the landscape painter Frederic Edwin Church high on a bluff above the Hudson River (Fig. 20.1). In 1867, Church and his wife embarked on an extensive tour abroad, which carried them not only to Europe but to Egypt and the Near East. Upon their return, they began planning their estate, which they called Olana— a name taken from an Arabic word which means "our place on high." In 1870, Calvert Vaux (1824–95), the English-born architect and former partner of the late Andrew Jackson Downing, was called upon to produce the design, which combined Near-Eastern exoticism and picturesque irregularity in a grand expression of nineteenth-century Romanticism. Decorative patterns of multicolored tile and glazed brick, together with Islamic-style pointed arches, recreate the richness of a mosque. In the late 1880s, Church designed the studio wing, seen at the left of the illustration. He was also responsible for much of the decorative detail— mostly Persian and Syrian—as well as the wealth of the interior exotic furnishings.

20.1 Calvert Vaux and Frederic E. Church, Olana, Hudson, New York, 1870–2 and 1888–9.

SECOND EMPIRE STYLE

Eclecticism and the revival of historic styles dominated the architecture of this period. Such styles emerged from a number of European sources, most of which were French. Many young Americans received their architectural training at the famed Ecole des Beaux-Arts in Paris, the fountainhead of tasteful design in the second half of the nineteenth century. They carried the teachings of the Ecole home with them, along with visions of Emperor Napoleon III's additions to the ancient palace of the Louvre, which defined the Second Empire style. They also returned with recollections of the French Renaissance and the Baroque era, such as the palaces at Fontainebleau and Versailles, and the beautiful châteaux of the Loire Valley. These same architects created the architecture of the American Renaissance—Fifth Avenue mansions, Newport "cottages," and palaces for libraries, art museums, railroad stations, and, finally, a grand exposition in Chicago that summed up America at the end of the century.

The Second Empire style originated in Paris. It was an expression of the spirit of Napoleon III's reign, and the new wealth of the bourgeoisie. The new architectural style found its fullest statement in the new Louvre of the 1850s, designed by Hector Martin Lefuel, and in that greatest display of nineteenth-century ostentatiousness, the Opéra (1861–74) by Charles Garnier. The style, based on French Renaissance and Baroque models, was characterized by the **mansard roof**, pavilions, and a richness of architectural and sculptural ornamentation.

In 1855, the financier and art collector William Wilson Corcoran visited Paris in the company of the man he had selected to design his gallery in Washington, D.C.—James Renwick, the architect of St. Patrick's Cathedral and the Smithsonian Institution (Figs. **13.16** and **13.17**). Corcoran and Renwick wanted to familiarize themselves with the Second Empire style. Returning to Washington, D.C., Renwick designed the Corcoran Gallery (now the Renwick Gallery) in the mode of the new Louvre (Fig. **20.2**). The central and corner pavilions are capped by low triangular or arched pediments and mansard roofs, and the entire façade is enriched with ornamentation and given a colorful aspect by the use of red brick and brownstone. To Corcoran, it seemed perfectly appropriate to build his gallery in the style of the French palace that held the greatest collection of art in the world. But it must have been a shock to Washingtonians. Here was the first real challenge to the classical style of architecture, which was the official mode of federalism. Virtually every edifice in the national capital was descended from ancient Rome. Corcoran's new gallery was clearly of a different spirit, and it set the fashion for the 1870s.

The Second Empire style was used for a number of important commercial, cultural, domestic, and governmental buildings in the 1860s and 1870s. Boston City Hall of 1861–5, designed by Arthur Gilman (1821–82) and Gridley Bryant (1816–99), was one of the earliest. The State, War,

20.2 James Renwick, The Corcoran Gallery (now The Renwick Gallery), Washington, D.C., 1859–61 and 1871.

and Navy Building (now the Old Executive Office Building) in Washington, D.C., was in its day considered one of the most beautiful and impressive buildings in America (Fig. **20.3**). It has the characteristic pavilion system, mansard roof, and richness of surface which is derived exclusively from architectural decoration, not from sculptural ornamentation. The building was designed in 1871 by Alfred B. Mullett (1834–90), who designed about forty buildings in Washington, D.C., and was responsible for the postwar character of the capital city.

City Hall in Philadelphia is a gigantic structure, encompassing over 4 acres (1½ ha), with a central tower that rises to a height of 548 feet (167 m), making it on completion the tallest public building in America (Fig. **20.4**). Its four Second Empire façades rivaled the architectural lavishness of the new Louvre. The lofty tower, however, is inconsistent with the French style, suggesting the soaring ambitiousness of America in 1869, when City Hall was designed by John McArthur, Jr. (1823–90).

Unlike Mullett's State, War, and Navy Building, nearly every part of City Hall has not only architectural decoration, but also a profusion of sculptural reliefs. These were the work of Alexander Milne Calder (1846–1923), father of the sculptor Alexander Stirling Calder (1870–1945), and grandfather of the mobilist Alexander "Sandy" Calder (1898–1976). Both McArthur and Calder were born in Scotland. McArthur was brought to America when he was ten and learned about architecture while still a carpenter, attending Thomas U. Walter's lectures at Philadelphia's Franklin Institute. Calder, however, had studied in Paris and London—where he had worked on the Albert Memorial—before coming to Philadelphia in 1868. Five years later, McArthur hired Calder to do the sculptures for City Hall, which occupied him for two decades. It culminated in Calder's 37-foot (11.3-m), 26-ton (26.4-tonne) bronze statue of William Penn, which was placed atop the central tower in 1894. The American quest for splendor, however, turned in other directions long before City Hall was completed, and by 1880 the Second Empire style had become passé.

20.3 (above) Alfred B. Mullett, State, War, and Navy Building (now the Old Executive Office Building), Washington, D.C., 1871–5.

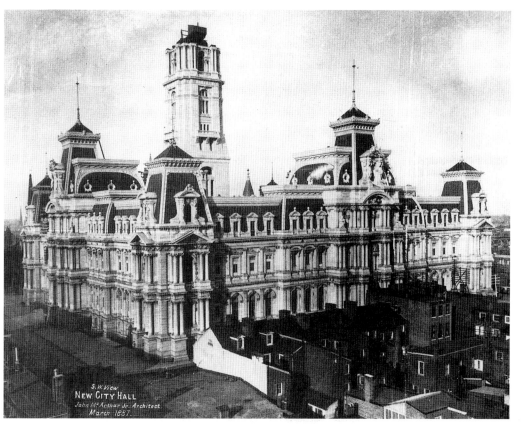

20.4 John McArthur, Jr., City Hall, Philadelphia, 1869–81. Sculpture by Alexander Milne Calder.

HIGH VICTORIAN GOTHIC

An alternative style during the postwar decades was High Victorian Gothic. This was advocated by the English critic John Ruskin, whose two treatises on architecture—*The Seven Lamps of Architecture* (1849) and *The Stones of Venice* (1851–3)—were printed in American editions. Ruskin's message was that the essential purpose of great building lay in the decorative effect applied to the surface of structure, and that architecture should give pleasure to the senses. To Ruskin's mind, the colorful Italian Gothic style offered the best model for inspiration, and the Doge's Palace (1345–1438) in Venice represented perfection itself. When the National Academy of Design decided to erect its own building in New York City, the design employed revealed a debt to both the Doge's Palace and to Ruskin as the acknowledged arbiter of taste (Fig. **20.5**). Regrettably the building no longer exists, but photographs show its use of the pointed, banded arch, a profusion of Gothic ornamental details, and **polychroming** achieved by the use of stones of different colors. Peter B. Wight (1838–1925), the architect, was in fact rather obvious in his borrowing from the Venetian prototype.

English and Irish buildings—such as All Saints' Church (1849–59, London) by William Butterfield, Trinity College Museum (1852–7, Dublin) and Oxford University Museum (1855–61, Oxford) by the Irish firm of Thomas Deane and Benjamin Woodward, and St. James-the-Less (1858–65, Westminster) by George Edmund Street—established the High Victorian Gothic style according to the gospel of John Ruskin. Within a remarkably brief period, the style had appeared in New York City at All Souls' Unitarian Church (1853–5), designed by a recently arrived Englishman named Jacob Wrey Mould. It was mainly after the Civil War that the style flourished in America. John H. Sturgis (1834–88), with his partner Charles Brigham (1841–1925), provided a bold statement of the style in his design for the Museum of Fine Arts, Boston (1870–6, destroyed).

In neighboring Cambridge, the firm of William R. Ware and Henry van Brunt created Memorial Hall (1870–8) for the campus of Harvard University, giving an ecclesiastical aspect to a building that was actually a theater and dining hall (Fig. **20.6**). Memorial Hall seems to have a nave, choir, transept façades, and central crossing tower as well as Gothic **lancets** with pointed arches and rose windows, wall buttresses, crockets, and other Gothic paraphernalia. The

20.5 Peter B. Wight, National Academy of Design, New York City, 1863–5.

20.6 Ware and van Brunt, Memorial Hall, Harvard University, Cambridge, Massachusetts, 1870–8. Courtesy Harvard University Archive.

basic form, however, is not medieval. It is too blocklike, and the mansardic roof on the tower displays the architects' willingness to combine styles into a mutant form. Both Ware (1848–1917) and Van Brunt (1832–1903) had been trained in the New York City office of Richard Morris Hunt, and in 1863 they formed a partnership, which for twenty years was the preeminent architectural firm in Boston.

20.7 Frank Furness and George W. Hewitt, Pennsylvania Academy of the Fine Arts, Philadelphia, Pennsylvania, 1872–6.

Frank Furness (1839–1912) also learned architecture in the offices of Richard Morris Hunt just before and after the Civil War. He then returned to Philadelphia, where he spent the rest of his career as a disciple of Ruskin. Furness's masterpiece is the Pennsylvania Academy of the Fine Arts, his first important commission, in which he combined Ruskin's love of the Gothic and polychromed effect with the French pavilion system and mansard roof, plus sculptured reliefs in the Renaissance mode (Fig. 20.7).

The three-part façade has a central pavilion with a pointed arch encasing a rose window, with lancets reminiscent of the façade of a Gothic cathedral. Squat, truncated columns with ornate capitals give relief to the surrounding massiveness. The picturesque eclecticism and combination of several architectural styles were enriched by the effects of color and texture: Rustication was played against smoothcut stone, which was set in contrast to the gleaming polished surfaces of granite columns. Mauve-hued brownstone, pale-gray sandstone, red brick, and sometimes black brick contributed to the brilliant polychromy.

The variety of styles, colors, and textures in rich ornamentation characterizes the High Victorian mode, and distinguishes it from the unity of stylistic purity (where a single historic style prevails) that is found in the work of Richard Morris Hunt and the firm of McKim, Mead, and White. The interior of the Academy is especially rich in its coloration and the splendor of its surfaces—a true art-palace for the gilded age. Furness maintained a successful practice in Philadelphia, where most of the nearly 400 buildings he designed were erected.

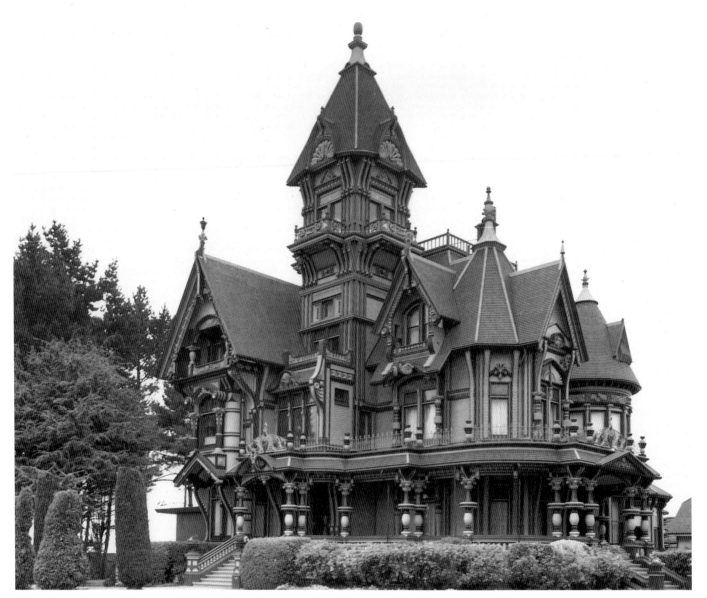

20.8 Samuel and J. C. Newsom, William Carson House, Eureka, California, 1885. Wayne Andrews/Esto.

DOMESTIC ARCHITECTURE

The High Victorian Gothic style was popular in the 1870s and 1880s for domestic architecture as well as cultural institutions and commercial structures. This was especially so for homes of newly wealthy Americans. The style carried the banner of beauty and taste, and also lent itself to the display of affluence.

William Carson House That the style had spread to the West Coast is demonstrated by the William Carson House of 1885, in Eureka, California (Fig. 20.8), arguably the archetypal example of the High Victorian style. All the Ruskinian characteristics are displayed in lavish profusion. The relative restraint of the Pennsylvania Academy and Harvard's Memorial Hall is here unleashed to achieve an appearance that can only be described as flamboyant. The Carson House was designed by two brothers, Samuel and Joseph Cather Newsom, who were born in Ontario, Canada, but established their architectural practice in the San Francisco area in the 1870s. Eventually, Joseph (1858–1930) went to Los Angeles to reap the rewards of the boom in southern California, while Samuel (1854–1908) remained in the Bay region. It is estimated that they designed some 600 houses and numerous churches and commercial buildings, mostly on the West Coast. Their designs were made known through the eleven pattern books they published between 1884 and 1900. Two additional masterpieces by the Newsoms are the Baldwin House in San Francisco and the Bradbury House in Los Angeles, both of 1887, where the spirit of the exciting, roaring boom years of California is manifested.

THE AMERICAN RENAISSANCE

The American Renaissance in art and architecture refers to the era from about 1885 to around 1920. It was a spirit that was less nationalistic, and more associated with European culture, particularly that of the Renaissance and Baroque periods. American millionaires saw themselves as the modernday counterparts of European aristocracy, and wished to live in homes that resembled sixteenth-century palaces of Italian princes or seventeenth-century châteaux of French nobility. They wanted their clubs, libraries, train stations, and art museums to express a rebirth of the grandeur of European golden ages past. J. P. Morgan and Henry Clay Frick built a library and a mansion in New York City in the neo-Renaissance style. They filled them not with works by American artists but with Old World masterpieces from the Middle Ages to the Baroque.

The fullest expression of the American Renaissance was at the World's Columbian Exposition in Chicago in 1893, but it found more permanent form in such projects as the Library of Congress, the Metropolitan Museum of Art, and the Boston Public Library. Setting aside nationalistic preferences, the artists and patrons of the American Renaissance became cosmopolitan in their taste, employing the Beaux-Arts style to assert America's new internationalism. The American Renaissance was the mantle of culture that cloaked American materialism, industrialism, capitalism, and even imperialism.

RICHARD MORRIS HUNT

If the Carson House typifies the homes built for the wealthy upper-middleclass in this era, the architecture of Richard Morris Hunt and the partnership of McKim, Mead, and White exemplify the domestic, corporate, and cultural architecture erected for America's new millionaire society. Fabulously rich, the members of this fortunate set joyously flaunted their wealth, and lived in a manner that both emulated and rivaled the European aristocracy. Whether in their Fifth Avenue châteaux, their summer "cottages" at Newport, their temples of finance, or the cultural institutions they patronized, they used architecture as a symbol of their place in society, as well as their cosmopolitan sophistication.

No architect better understood the taste and social ambitions of America's millionaire society than Richard Morris Hunt (1827–95), who was considered the dean of American architects in the 1880s and early 1890s. When he was sixteen, Hunt's widowed mother took him and his older brother William (the future painter discussed below) to Italy, before settling into expatriate life in Paris. There, in 1845, Richard was taken into the atelier of Hector Martin Lefuel, and the next year was admitted to the Ecole des Beaux-Arts—the first American to study architecture there.

In 1854, when Lefuel was made architect in charge of the new Louvre, Hunt was employed in the design of the Pavillon de la Bibliothèque. The next year the young architect returned to America to begin his practice in New York City. Hunt was kept busy designing grand homes for the wealthy of Manhattan, Boston, Newport, and Chicago. By the late 1870s, he had become the darling of America's Gilded Age society.

William K. Vanderbilt House In 1879, Richard Morris Hunt designed the first of his great houses, and the first of more than a dozen Fifth Avenue mansions—the William K. Vanderbilt House at 660 Fifth Avenue (Fig. 20.9). Until then, New York City streets were a dreary repetition of row upon row of brownstone houses, but the Vanderbilt mansion set a new standard of elegance, splendor, and stylishness—and it established Hunt's reputation. The pace quickened noticeably as the wealthy began to vie with one another in the grandeur of their townhouses and retreats. After drawing upon a number of historic styles for previous buildings, Hunt turned, for the first time in America, to the French Renaissance style of Francis I (reigned 1515–47). This style possessed enough lingering medievalism to provide a touch of the picturesque, and was known to American society through the splendid edifices of the great royal palace at Fontainebleau, and the noble châteaux of the Loire Valley, where there were also French Baroque mansions of aristocratic dignity—such as Blois, Chambord, Chenonceaux, Chinon, and Amboise.

The main feature of the Vanderbilt House was its uniform color and material, a gray limestone. This placed it in sharp contrast to the colorful High Victorian and Second Empire

20.9 Richard Morris Hunt, William Kissam Vanderbilt House, New York City, 1879–81. Courtesy The New-York Historical Society, New York City.

styles. Its decoration did not conceal the whole surface and structure, but rather was used as discreet adornment to architectural mass, wall, door, and window. The exquisitely wrought ornamentation is late Gothic, and the charming **tourelle** adds a delightful picturesque element. The roof is steeply pitched and irregular, also characteristics of the French Renaissance style. Inside, the house was lavishly outfitted in a variety of historical modes. The library was French Renaissance, but the billiard room was Moorish, the Salon was in the style of Louis XV, and the dining hall recalled the era of Henry II.

The impact of Hunt's French château—so expressive of Old World aristocracy, elegance, taste, and culture—is seen in a wide range of buildings in New York City, from the elegant Isaac Fletcher House (1899) by Charles P. H. Gilbert (1863–1952) to Napoleon LeBrun's (1821–1901) Engine Company 31 Firehouse (1896), to the noble Plaza Hotel (1907), designed by Henry J. Hardenberg (1847–1918). By the turn of the century, there were no fewer than six grand Vanderbilt mansions on Fifth Avenue between Fifty-first and Fifty-eighth streets, with John D. Rockefeller's fine residence just off the Avenue, on Fifty-fourth Street, and William Waldorf Astor's mansion standing at the corner of

Fifty-sixth and Fifth. Unfortunately, most of these splendid Fifth Avenue mansions—including the William K. Vanderbilt House—were destroyed when maintenance became too expensive and the property too valuable for domestic purposes. The Vanderbilt House was razed in 1925, a victim of the encroachment of commercial establishments along Fifth Avenue.

Biltmore Richard Morris Hunt's fullest expression of the château style is the magnificent mansion called Biltmore, commissioned by George W. Vanderbilt and erected on a vast estate of 125,000 acres (50,586 ha) near Ashville, North Carolina (Fig. 20.10). Although the original source of inspiration was unquestionably the palace of Francis I at Fontainebleau, both patron and architect may also have known the English countryhouse Waddesdon Manor (1877–89), designed by Gabriel Hippolyte Destailleur for Baron Ferdinand de Rothschild, the English scion of the great international banking house. At Biltmore, late-Gothic detailing of the French Renaissance style adorns a generally symmetrical, but irregular, building. Like its prototypes, Biltmore has a monumental staircase to one side of the main entrance. It is monochromatic, built of limestone, and its

20.10 Richard Morris Hunt, Biltmore, Ashville, North Carolina, 1895.

20.11 Richard Morris Hunt, Banquet Hall, Biltmore, Ashville. 72 × 42 × 70ft (22 × 12.8 × 21.3m).

steeply pitched roof is covered with slate. The celebrated landscape architect Frederick Law Olmsted (1822–1903), who laid out New York's Central Park, was called in to design the grounds.

Inside, the scale and lavishness led one critic to christen Biltmore the grandest house in America. There are 255 rooms. The ceiling of the banquet hall rises 70 feet (21.3 m) above the parquet floor, and is given the appearance of a sixteenth-century European *grande halle* with the

embellishments of flags and mooseheads, tapestries and animalskin rugs (Fig. 20.11). To suit the scale of the room, the fireplace was made in three parts, over which runs a great marble bas-relief. George W. Vanderbilt, grandson of Commodore Cornelius Vanderbilt, was himself a student of architecture and a collector, and he filled Biltmore with the treasures he had gathered on several expeditions to Europe. The library, though smaller than the great hall, has handsome carvings and a ceiling painting by the seventeenth-

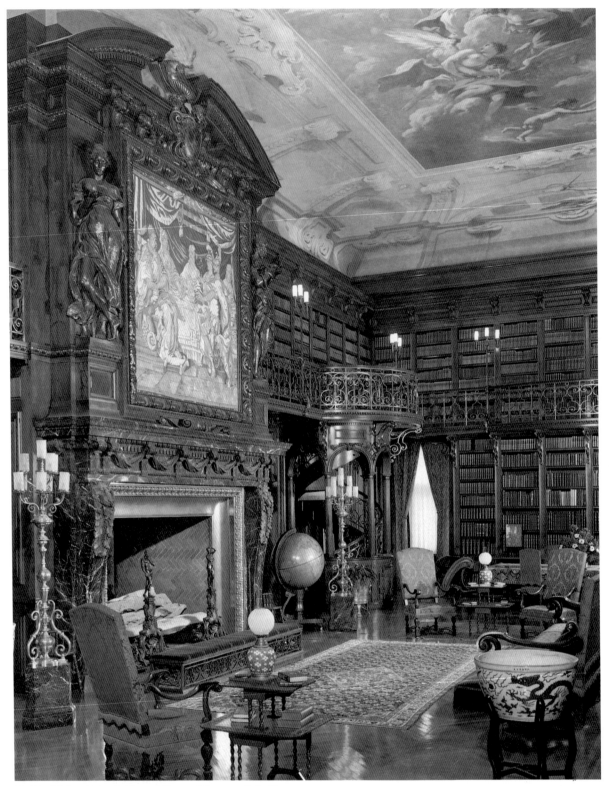

20.12 Richard Morris Hunt, Library, Biltmore, Ashville.

century decorative muralist Giovanni Antonio Pellegrini (Fig. 20.12). Vanderbilt, a welltraveled, studious young man of twenty-three, filled his handsomely outfitted library with over 20,000 volumes.

George Vanderbilt had inherited only ten million dollars when his father, William H. Vanderbilt, died in 1885, while George's brothers William K. and Cornelius II were bequeathed about sixty-five million dollars each.

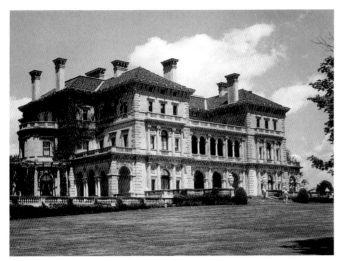

20.13 Richard Morris Hunt, The Breakers, Newport, Rhode Island, 1892–5.

The Breakers George's brothers William and Cornelius commissioned Hunt to create mansions for them at that most fashionable of summer resorts, Newport, Rhode Island. The Breakers, residence of Cornelius II, was erected in 1892–5. In design it is a departure from the French château style, for it is based on northern Italian Renaissance models, especially palazzi of the Genoa area (Fig. 20.13). Hunt displayed his versatility by designing in the classical idiom with equal brilliance. The handling of mass, wall, and proportion, the sense of containment, the feeling for geometric form, and the elegant interpretation of classical details—such as columns, capitals, pilasters, round-headed arches, cornices, and balustrades—reveal the hand of a Beaux-Arts master at his best.

Within the Breakers, rooms such as the dining room rivaled the lavishness of European palaces of any era (Fig. 20.14). Yet homage was paid to the artistic traditions of

20.14 Richard Morris Hunt, Dining Room, The Breakers, Newport, c. 1895.

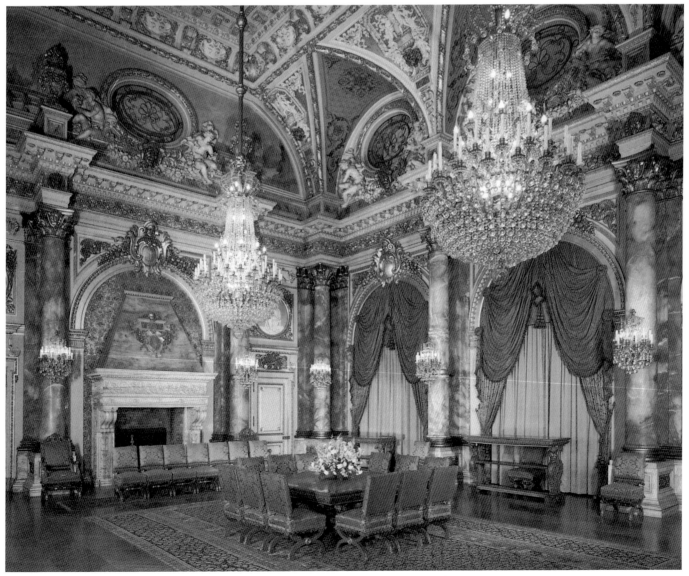

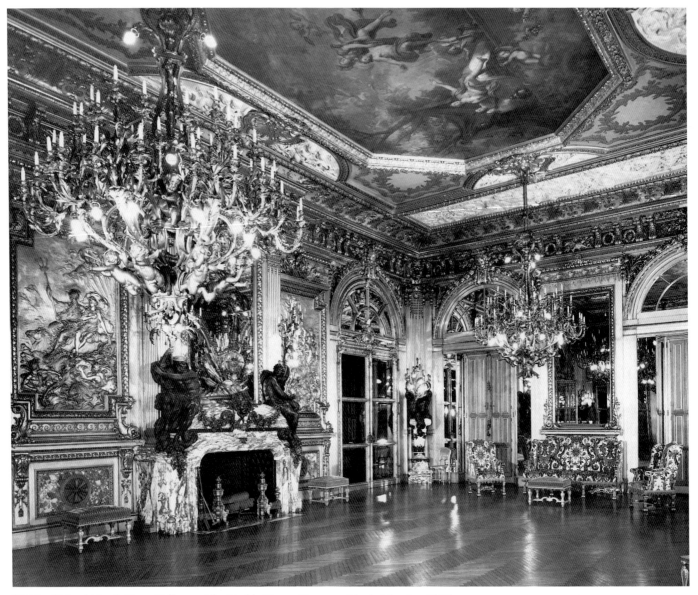

20.15 Richard Morris Hunt, Ballroom, The Marble House, Newport, Rhode Island, c. 1895.

Europe, for the dining room in the Breakers, and the ballroom (Fig. 20.15) in another of Hunt's Newport cottages, the Marble House (1888–92), reveal that Hunt looked entirely to historic European prototypes for the styles he used. It never occurred to Hunt to try to create a purely American style, totally free of any European associations.

Marble House Ballroom A recreation of the grandeur of Versailles in the ballroom of the Marble House, the Newport residence of an American railroad baron, seemed entirely appropriate. Here, ornate splendor is the keynote. Carved gilt bas-relief panels depict mythological scenes of gods and goddesses. Lifesize bronze figures, personifications of Youth and Old Age, perch upon an elaborate marble fireplace and hold candelabra, above which rises a great mirror. Enormous chandeliers are adorned with gilded cherubs. Door

enframements and cornices are similarly gilded, while mirrors above the doors reflect the light, glitter, and gilt of the ensemble. A new spirit of interior décor on a truly lavish scale had descended upon America—at least, on the homes of the privileged few who could afford such things.

Richard Morris Hunt was chosen chairman of the board of architects for the great 1893 World's Columbian Exposition in Chicago. His own Administration Building anchored one end of the main axis. Hunt died in 1895. To honor him, nearly every fine arts organization and club in New York City joined together to commission the Hunt Memorial (1898), with sculptures by Daniel Chester French. It was originally to be placed near the façade of the Metropolitan Museum of Art, which Hunt had designed, but its ultimate location was at Seventieth Street on Fifth Avenue, across from the Henry Clay Frick mansion.

McKIM, MEAD, AND WHITE

The firm of McKim, Mead, and White rose to the challenge of creating urban dignity and grandeur through a classical style that equaled the emerging American megalopolis in scale, organization, and expressiveness. In the age of iron and steel, the firm lent suave urbanity to a great municipal library or to an enormous railroad station. They did this by adapting the architectural theories of the Ecole des Beaux-Arts to the social, cultural, and commercial demands of the American metropolis as if it were the Rome of the Caesars. At a time when cities were beset with social problems and with random sprawl lurching out of control, McKim, Mead, and White infused into them a sense of order, humane sophistication, and exquisite aesthetic taste.

Charles Follen McKim (1847–1909) studied at the Ecole des Beaux-Arts in Paris, where he learned about the integration of the arts—architecture, sculpture, murals, mosaics, stained glass—into a unified aesthetic scheme. He also learned about the organic organization of architectural spaces, especially as applied to structures or complexes of vast scale. After three years in Paris, McKim returned to New York City in 1870 to work in the office of H. H. Richardson. Three years later, he formed a loose partnership with William Rutherford Mead (1846–1928), who had just returned from Italy where his brother, Larkin Mead, was a sculptor. Mead, like McKim, had earlier spent a brief period in the architectural office of Russell Sturgis. New Yorker Stanford White (1853–1906) worked for H. H. Richardson, primarily designing interiors for such major projects as Trinity Church, Boston (Fig. **20.27**), before he joined McKim and Mead to form what would become the most successful architectural firm of the American Renaissance.

McKim brought to the firm a capacity for organizing vast projects, and the patience of the consummate perfectionist. White was an energetic and brilliant designer, with a special sensitivity to the integration of several arts in spectacular interiors. Mead, also a gifted architect, was the manager of the firm's many projects, and of the staff, which by the early 1890s numbered over one hundred.

Shingle Style The early success of McKim, Mead, and White came at Newport, with houses designed in the Shingle style, such as the one for Isaac Bell of 1882–3 (Fig. **20.16**). The Shingle style emerged out of the so-called Queen Anne style, a revival developed in England by Norman Shaw (1831–1912) and introduced to America through houses erected by the English contingent at the Philadelphia Centennial. More Elizabethan than anything else, the Shingle style had been used by H. H. Richardson for the Watts Sherman House (Fig. **20.24**), on which Stanford White had worked. The Queen Anne and Shingle styles offered an informality for country or resort living that appealed to Americans.

20.16 McKim, Mead, and White, Isaac Bell House, Newport, Rhode Island, 1882–3. Wayne Andrews/Esto.

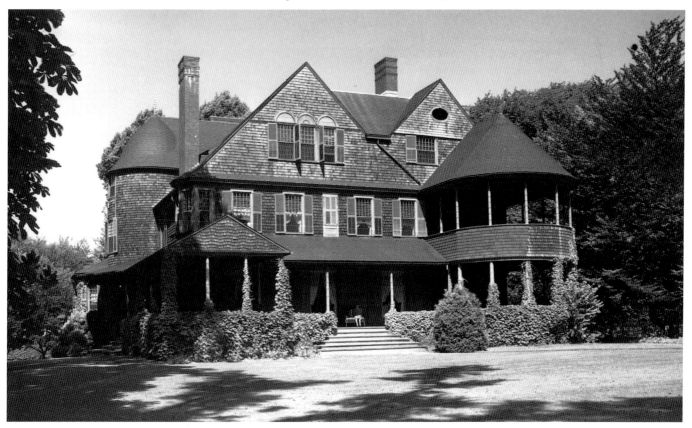

Houses like the one for Isaac Bell were sheathed with wood shingle, giving rise to the style's name and to a fine unity of walls and roof. All three members of the firm were interested in colonial New England architecture, including seventeenth-century houses, which were frequently covered with shingles. The shingle facing was in its own way the revival of an historic style, but now it was American rather than European or Near Eastern. Grand porches or verandahs, bay windows, and semicircular **tourettes** (derived from French farmhouses) completed the repertoire of forms and sources for typical Shingle-style houses. They were normally irregular and asymmetrical, but they could also be simple and monumental, as in the firm's house for William G. Low in Bristol, Rhode Island, in 1886–7.

Urban Architecture It was in urban architecture that McKim, Mead, and White made their reputation and had their most profound effect. Their first great success, and the building that established the classical Renaissance palace as the source of their design for the next two decades, was the Henry Villard Houses (Figs. **20.17** and **20.18**). Villard, president of the Northern Pacific, was a railroad magnate who wanted a great mansion as a symbol of his success. Three houses were united in a U-plan around an open court. The exterior design was based on the Chancelleria Palace in Rome. It had a boldly rusticated lower level and smooth surfaces for the two upper floors, and exquisitely framed classical windows. Stringcourse moldings and a handsome

20.17 McKim, Mead, and White, Villard Houses, New York City, 1885. Courtesy The New-York Historical Society, New York City.

crowning cornice gave horizontal definition to the design. The building is indeed a modernday American palazzo, with the details executed by the firm's most talented draftsman, Joseph Morrill Wells (1853–90). Within, the building demonstrated the Beaux-Arts concept of the integration of the arts, with White in charge of the design, sculptures by Augustus Saint-Gaudens, and murals by John La Farge.

20.18 McKim, Mead, and White, Villard Houses, New York, 1885. Plan.

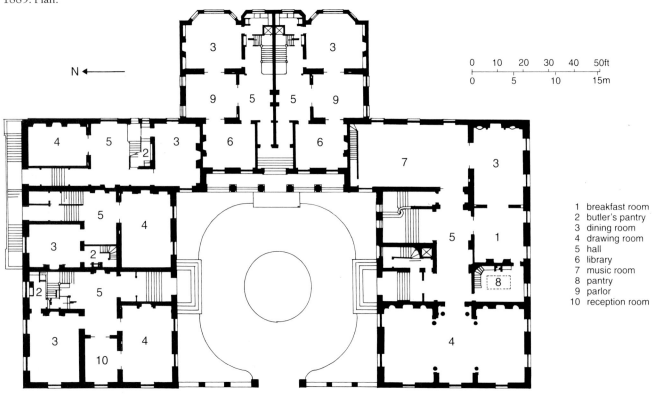

1 breakfast room
2 butler's pantry
3 dining room
4 drawing room
5 hall
6 library
7 music room
8 pantry
9 parlor
10 reception room

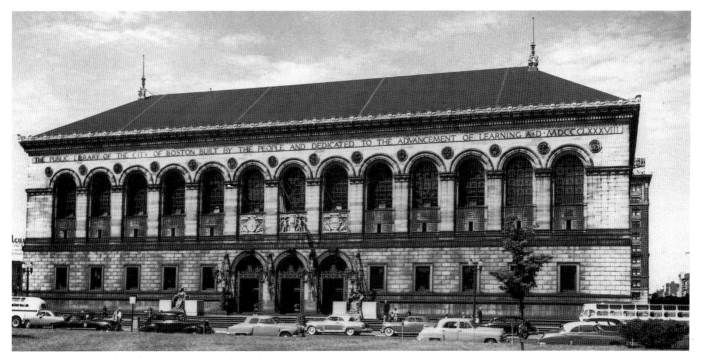

20.19 McKim, Mead, and White, Boston Public Library, Boston, Massachusetts, 1888.

20.20 McKim, Mead, and White, Boston Public Library. Plan, as published in *American Architect and Building News*, 26 May 1888.

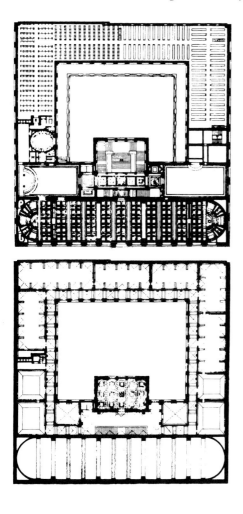

Public Buildings The Villard Houses was a prelude to one of the firm's largest and most successful projects—the Boston Public Library (Figs. 20.19 and 20.20). This imposing edifice was erected on Copley Square, opposite Trinity Church (Fig. 20.25). The archetypal High Victorian Museum of Fine Arts (destroyed) dominated another side of the plaza. There had never been a public lending library as large as this, and the firm seized the opportunity to create a palace of culture in white granite.

In plan, the building is a square with a large, open central court, like the *cortile* of the Medici Palace in Florence. The trustees of the library had in fact initially referred to it as a "palace of the people." The elevation of the main façade, however, is indebted to Henri Labrouste's Bibliothèque Sainte-Geneviève (1850) in Paris. The design is united across the breadth of the façade by the continuous rustication of the lower floor and the procession of monumental, arched windows of the upper level, with the tripartite entrance echoing the arcade above it. The splendid detailing is again the work of Joseph M. Wells. The equally palatial interior has murals by Pierre Puvis de Chavannes (1824–98), John Singer Sargent, and Edwin Austin Abbey (Fig. 24.13), while Augustus Saint-Gaudens and Daniel Chester French made sculptures for it.

The Boston Public Library possesses a Renaissance-like geometry, simplicity, and monumentality. Well before it was finished, McKim, Mead, and White—as well as innumerable potential clients—realized that in drawing upon the Italian Renaissance the firm had discovered the very mode to express cultural dignity in the turn-of-the-century American metropolis.

Italian Renaissance architecture and its ancient Roman antecedents proved to be adaptable to a wide range of projects of greatly varying scale—whether for the Agriculture Building, one of the primary buildings at the World's Columbian Exposition of 1893 in Chicago (Fig. 20.23), or the J. Pierpont Morgan Library in New York of 1902–7. The latter was built to house the extraordinary private collection of rare manuscripts owned by the financier J. P. Morgan, adjoining his mansion on East Thirty-sixth Street. This superb little white-marble structure was modeled on Ammanati's Villa Giulia in Rome, and its entrance reminds one of an ancient Roman triumphal arch.

Farther uptown, McKim, Mead, and White designed a new campus for Columbia University on a very formal, classical plan. Most of the buildings were erected at street-side, so a large, open, and spacious campus of lawns and walks is enclosed within. The buildings placed on the periphery of Columbia's great quadrangle were modeled after Roman palaces, while the mall is dominated by the magnificent neoclassical dignity of Low Library.

Perhaps the most demanding challenge that McKim, Mead, and White faced was the commission for Pennsylvania Station (Fig. 20.21). The Pennsylvania system, which previously had its terminal in Jersey City, had recently acquired the Long Island Railroad. Its president, Alexander J. Cassatt—brother of the American Impressionist Mary Cassatt—wanted a Manhattan terminal to service and link both lines. The result was a paradigm of logic and careful planning. One long axis allowed a freeflow of travelers moving through the station, while a lesser cross-axis accommodated huge numbers of people as a waiting room—the latter enclosed by enormous, high, coffered crossvaults resting on massive piers and colossal Corinthian columns.

The whole plan was based on the Baths of Caracalla (Rome, third century B.C.), and the vaulted area of the waiting room, which towered over the rest of the complex and was illuminated by eight large lunette windows, corresponded to the *frigidarium* (cold bath area) of the ancient structure. The four broad façades were unified by grand colonnades and long rows of pilasters, with temple-portico pavilions at the corners, and central entrances that resembled triumphal arches. McKim—probably the primary figure in the plan, scale, and design—conceived a building that would be an appropriate gateway to the great metropolis, express the importance of the railroad, and be able to hold its own against the skyscrapers that began to overshadow it. This station and its counterpart, Grand Central Station (by Whitney Warren, 1907–13), were proud emblems of their time. Pennsylvania Station survived until 1964, when it gave way to its modern replacement, surmounted by Madison Square Garden Center.

By 1910 the partnership of McKim, Mead, and White had executed nearly 800 commissions. It must be considered one of the greatest success stories in American architecture, yet it did not survive the first decade of the twentieth century intact. On 25 June 1906, while dining at a restaurant in the original Madison Square Garden (1887–98) which he himself had designed, Stanford White was shot by Harry K. Thaw, the jealous husband of White's paramour, Evelyn Nesbit. White's death and the ensuing scandal, exploited by the yellow press, took its toll on McKim, who died in 1909. Mead turned to traveling abroad, and retired in 1919.

Richard Morris Hunt and the firm of McKim, Mead, and White so dominated the architecture of their era that many other excellent architects tend to be overshadowed by them. Many worked generally in the same vein. George Browne

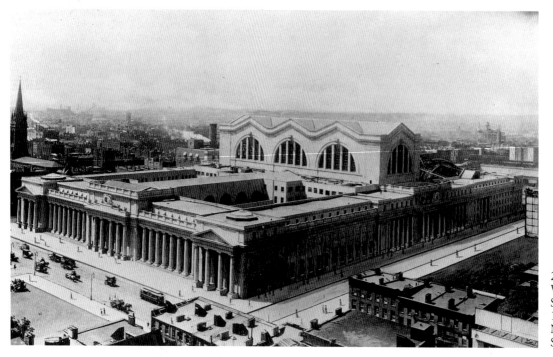

20.21 McKim, Mead, and White, Pennsylvania Station, New York City, 1910. Courtesy The New-York Historical Society, New York City.

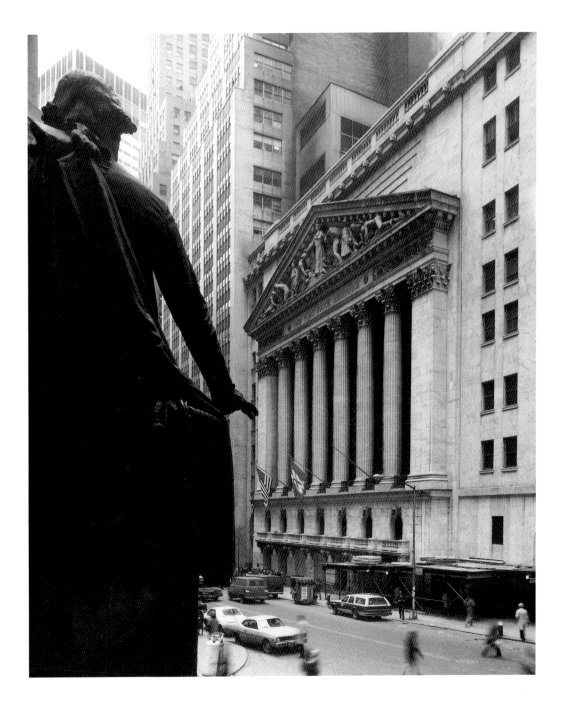

20.22 George B. Post, New York Stock Exchange, New York City, 1901–4. Paul Warchol/Esto.

Post (1837–1913), for example, had a long and distinguished career. For about two years he worked in the offices of Hunt before setting off on his own in 1860. He could design equally well in the French Renaissance style—as in his Fifth Avenue mansion for Cornelius Vanderbilt II of 1882–93—or in the Roman classicism of his New York Stock Exchange, with its pedimental sculptures by John Quincy Adams Ward (Fig. 20.22). The façade of the Stock Exchange was designed in the mode of a great imperial temple, and the marble figures in the pediment represent the theme of "Integrity Protecting the Works of Man," which seemed perfectly appropriate for one of the great financial centers of the world.

THE WORLD'S COLUMBIAN EXPOSITION, 1893

The grandeur that was Rome, so romantically envisioned half a century earlier in Thomas Cole's *Consummation of the Empire* (Fig. 15.3), found its reincarnation at the World's Columbian Exposition, held in Chicago in 1893 to celebrate the four-hundredth anniversary of the discovery of America. (The fair was held a year late because planning was not begun in time to get it organized and the buildings erected for 1892.) Many of the great names of architecture were associated with this titanic project, located on the shores of Lake Michigan. It heralded the rise of the Midwest as one of

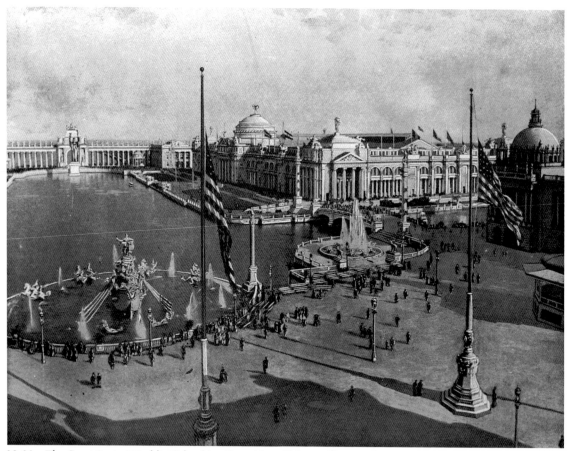

20.23 The Great Basin, World's Columbian Exposition, Chicago, Illinois, 1893.

the mercantile and cultural centers of the nation. Daniel Burnham, a Chicago architect, was the primary consultant, and he invited Frederick Law Olmsted to assist in devising the master plan. This called for a Court of Honor on the main axis with a large lagoon at its center, enframed by buildings of classical Roman style (Fig. 20.23).

The architectural mode that prevailed throughout was considered a triumph for "eastern establishment" designers such as Hunt, McKim, Mead, and White, and Post. The Chicago School, led by Burnham, Jenney, Adler, and Sullivan, was evolving a very different style—one strongly influenced by the new technologies and materials. This was, in fact, one of the finest hours for the Beaux-Arts style in America, but it unfortunately did not last. Almost all the sculptures and buildings were constructed of staff, a mixture of plaster and straw or some other binding agent, and have not survived.

The far end of the Court of Honor terminated in a great **peristyle** crowned with a **quadriga** group by the sculptor John Quincy Adams Ward. Before it, on a pedestal in the lagoon, stood Daniel Chester French's colossal gilded statue of the *Republic*. The near end of the lagoon had the large fountain containing Frederick MacMonnies's *Barge of State* (Fig. 26.13). At the right stood McKim, Mead, and White's Agriculture Building, with Augustus Saint-Gaudens's *Diana*

perched atop the low saucer dome. Sculptures appeared throughout—at bridges, atop buildings, along promenades—but most of it disappeared within a year, exposed to the elements of a harsh winter.

An exposition such as this gave architects a unique opportunity to plan, dream, and carry out grandiloquent schemes. Sometimes the magic of their schemes found permanent expression in far-distant places long after the fair had closed. The World's Columbian Exposition was so impressive in terms of its planning, organization, and potential for urban renewal that it sparked the City Beautiful movement, the fruits of which many Americans enjoy to this day. Cass Gilbert, Daniel Burnham, and Charles F. McKim, for example, were all involved in retrieving L'Enfant's plan (Fig. 8.16) for Washington, D.C., at the turn of the century. The result is the present noble Mall, lined with buildings reminiscent of those at the Chicago Fair of 1893. San Francisco, rebuilding after the disastrous earthquake of 1906, benefited from the concept. So did Philadelphia, with its handsome treelined Benjamin Franklin Parkway extending from MacArthur's City Hall to the golden marble temple of the Philadelphia Museum of Art (1919–28), designed by Horace Trumbauer (1869–1938) with the museum's director, Fiske Kimball, as consultant.

HENRY HOBSON RICHARDSON

Henry Hobson Richardson (1838–86) represents the transition from the eclectic, revival-style architecture of the nineteenth century to the new manner created by architects such as Louis Sullivan and Frank Lloyd Wright. This meant a change from an essentially Beaux-Arts mode to an anticipation of Sullivan's form-follows-function theory, and Wright's organic Prairie House. Richardson, who was born in Louisiana, went to Harvard, where his interests turned to architecture during his senior year. After graduation, he went to the Ecole des Beaux-Arts in Paris. He also worked in the architectural office of Theodore Labrouste, brother of Henri Labrouste, architect of the Bibliothèque Sainte-Geneviève. After this rigorous training in Beaux-Arts theory and practice, Richardson returned in 1865 to America, and settled in New York City.

Picturesque eclecticism dominated Richardson's early work. His Watts Sherman House (Fig. 20.24) is the first articulate example in America of the Queen Anne style which, as we have seen, originated in England, primarily in the work of Norman Shaw. The English architectural journal *Building News* published designs by Shaw in 1871, and soon after the Queen Anne style became popular in America. The main appeal of this house was in its picturesqueness and informality. The exterior is characterized by irregularity of shape and texture, with huge chimney stacks breaking the ridgeline of the steep, Gothic roof, and a large, projecting main entrance. Rough-surfaced, irregular, ashlar masonry gives way to shingle and brick above, while Old English halftimber designs dominate the entrance area. Historical associations with Old England made the style most appealing to America's new wealthy class of the 1870s. Within, the design was based on a new concept of open, freeflowing space, which broke with the idea of boxlike rooms lined up in a row. This concept had major significance for later domestic architecture, particularly that of Frank Lloyd Wright.

20.24 Henry Hobson Richardson, Watts Sherman House, Newport, Rhode Island, 1875. Wayne Andrews/Esto.

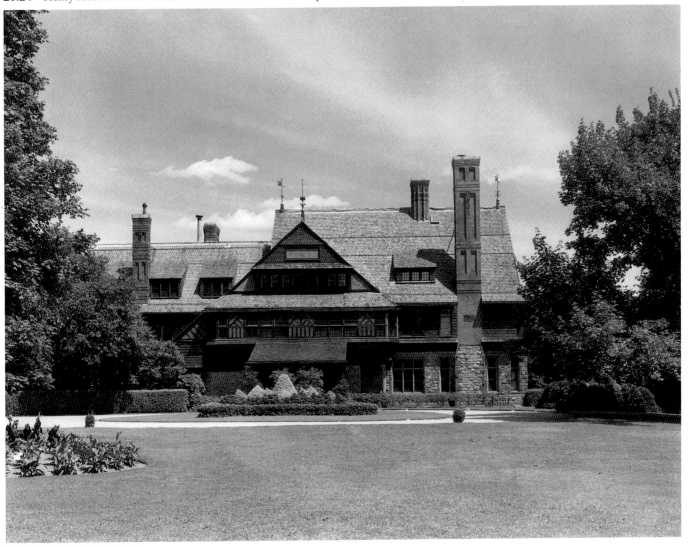

Trinity Church, Boston The supreme test of Richardson's creative powers in picturesque eclecticism came with the commission awarded in 1872 for Trinity Church (Figs. 20.25 and 20.26), erected on one side of Boston's Copley Square. Trinity's design is drawn from twelfth-century Romanesque churches of southern France and Spain. The tripartite entrances are indebted to Saint-Gilles-du-Garde at Arles, France, while the towering form of the central crossing is reminiscent of the cathedral at Salamanca in Spain.

The Romanesque Revival style had been known and used in the United States before this, but in Trinity Church Richardson gave it its most monumental expression, perhaps because of his love for bold, massive masonry, both as to structure and aesthetics. The reddish-brown granite has a somber presence, which is enlivened by sculptures and architectural detailing in the Romanesque manner. The round-headed arch is the unifying leitmotif, and irregularity of form is achieved by turrets, spires, crockets, gargoyles, and finials.

The interior of Trinity exceeds the exterior in richness of decoration (Fig. 20.27). Indeed, such decoration was unprecedented in American architecture. Most of the decoration was executed by the gifted John La Farge and his assistants, who provided not only the figurative and geometric paintings for the walls, but the designs for the brilliant stained glass as well. Through the broad but truncated nave, into the transept crossing—which soars 130 feet (40 m) to the ceiling of the tower—one is led to the semicircular apse, with its beautiful stained glass windows. There is a masterly manipulation of architectural space, with rectangular and hemispherical voids flowing into and interacting with each other splendidly.

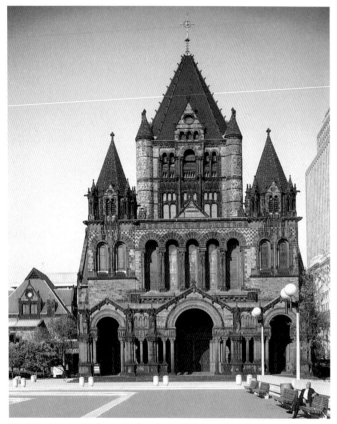

20.25 Henry Hobson Richardson, Trinity Church, Boston, Massachusetts, 1872–7.

20.26 Henry Hobson Richardson, Trinity Church, Boston. Plan.

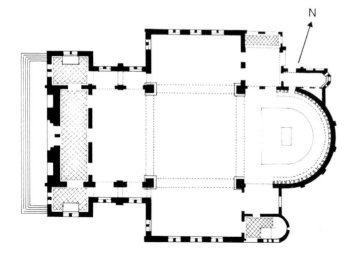

20.27 Henry Hobson Richardson and John La Farge, Trinity Church, Boston. Interior.

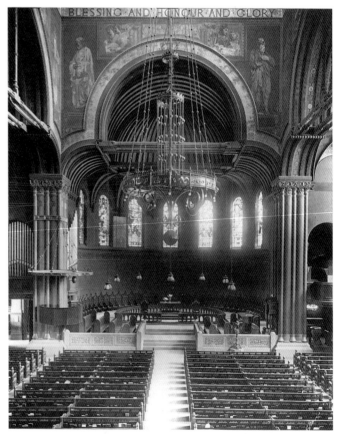

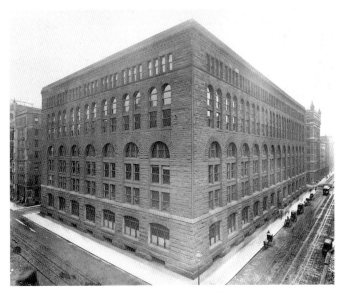

20.28 Henry Hobson Richardson, Marshall Field Wholesale Store, Chicago, Illinois, 1885–7.

Marshall Field Store Richardson continued to use the massive, mural style of Romanesque masonry and detailing in smaller structures, such as local railroad stations and libraries. He became increasingly aware, however, of the abstract potential of ashlar masonry. His opportunity to explore this came with the commission for the Marshall Field Wholesale Store (Fig. 20.28). While Richardson may not have recognized the potential of new building materials and technologies as fully as he might, the Marshall Field Wholesale Store was nevertheless one of the most masterly solutions to the problem of largescale commercial architecture to date. There are still vague and general reminiscences of historic styles: The heavy masonry and round-headed arches are suggestive of Richardson's favored Romanesque style, while the total block of the building reminds us of a Florentine Renaissance palace, for example the Rucellai or the Medici. Overpowering these historical associations, however, is a new concept of design. This is based on abstract principles inherent in structure, and on a simplification of form that eliminates most decorative detailing. The demands placed on him by his patron may well have brought Richardson to this austere economy of means, for Marshall Field was a hardnosed, no-nonsense businessman, with an enduring concern for profit, and a merchant's anxiety over costs. Such concerns of the marketplace had a profound impact on the development of an architectural style that offered an economic alternative to the expensive revival styles.

Simplicity of form and a superb organization of structural parts and openings characterize the design of the Marshall Field Store. This takes the form of a box, the pure geometry of which is not disrupted by elaborate details or protuberances, such as a heavy cornice or projecting pavilions. The sheer flatness of the walls is relieved by the rustication, which becomes lighter in the upper portions. Richardson's favored medium of rough-surfaced ashlar masonry is used, but with a new concept in architectural design.

If the mural planes are devoutly respected, it is only with the greatest care that they are penetrated with fenestration and doorways. Richardson placed enormous, bold piers at the corners, which helped to establish both the simple box-form and the plane of the wall. Lesser, but still bold, piers between the windows extend the full height of the building. Piers and windows form a vertical alignment, and their vertical accent is in perfect balance with the horizontal forces in the design.

Each bay is identical to its neighbor, except where an entrance replaces a groundfloor window in the center of the long wall—but the doorway is unobtrusive and does not disrupt the unity of the plane. Each seven-story bay has one large opening on the ground level, then a stringcourse, above which comes a taller opening that encompasses three floors, capped by a great round-headed arch. This zone is one opening wide by three high. In the next unit above, the pattern becomes two windows wide and two stories high—decreasing in vertical modules but increasing in horizontal parts. This scheme proceeds logically to the top floor, which is only one story high, but four openings wide. Therefore, above the stringcourse the design is, vertically, three stories, two stories, then one story, while horizontally its transformation is from one opening, to two, and finally to four. The logic and simplicity of each bay are combined with the unity of the total façade planes to create an architecture that is based primarily on abstract principles, rather than revived historic styles.

There was something new here, born perhaps of the sparseness demanded by the economic laws of the world of commerce. Louis Sullivan later admitted the influence this new concept had on him. Richardson did not live to see the Marshall Field Wholesale Store completed, for he died in 1886, a year before it was finished. One cannot but wonder what he might have brought to his next venture. For all it accomplished, however, the Marshall Field Wholesale Store did not make full use of the new technologies that were already known or then developing—cast-iron **skeletal systems**, Bessemer steel, reinforced concrete, curtain walls of glass, and so on. Richardson was so strongly wedded to Beaux-Arts practices and stone masonry that he did not probe these exciting new areas, which in fact involved engineering as much as Beaux-Arts training in architectural design.

The new technologies and engineering practices produced a new breed of architect and architectural design that laid the foundation for modern architecture, leading the way out of the historic revival styles that had dominated nineteenth-century design.

CHAPTER TWENTY-ONE

TOWARD MODERN ARCHITECTURE:
NEW TECHNOLOGIES AND THE ADVENT OF THE SKYSCRAPER, 1850–1900

While commercial and industrial building was not the sole agent active in the rise of modern architectural styles, it undoubtedly played a major role. The world of American business was sufficiently free and adventurous to try new things without being restricted to historical styles. Business, too, had its own demands—such as cost-effectiveness, expediency, and utilitarianism—with which it challenged architects and engineers. Yankee ingenuity in engineering and technology was often more important than a cultural élitism founded on Beaux-Arts theory and revived historic styles. Factories and railroad bridges demanded new solutions, and a new breed of engineer-builders arose to meet the need.

From 1870 to 1900, the American industrial-commercial-financial complex grew mighty, outdistancing the rest of the world. It is not surprising that this new force asserted itself in nearly every aspect of American culture, including architecture.

This was the period of the founding of Rockefeller's Standard Oil Company in 1870. Two years later, the mailorder house of Montgomery Ward published its first catalogue, and F. W. Woolworth opened his first dimestore in 1879. For railroads, this exciting era was inaugurated in 1870 with the arrival in New York City of the first through car from California. Meanwhile, Cornelius Vanderbilt, Jay Gould, and Daniel Drew fought for control of the New York Central and other expanding lines. Andrew Carnegie's steelmills were straining under capacity production, and in 1893 Henry Ford made his first automobile.

Examples of the new requirements imposed upon builders are James Buchanan Eads's steel arch bridge, the first of its kind, which spanned the Mississippi River at St. Louis in 1874; and the Brooklyn Bridge, which, completed in 1883, demonstrated the principle of the steel-cable suspension bridge. Then there was the rise of America's first skyscraper—the Home Insurance Company Building in Chicago in 1884—which towered to a height of ten stories, constructed of a steel frame instead of masonry; and

thousands of other examples of railroad trestles and terminals, factories and mills, office buildings, department stores, and warehouses.

Other factors contributed to the building boom. The Great Fire of 1871 destroyed huge portions of Chicago. Combined with that city's emergence as a major financial and trade center, this created a need for an enormous number of commercial buildings. There were many indications of Chicago's growth. Culturally, the Art Institute was founded in 1879, the Symphony Orchestra was established in 1891, the University of Chicago dates from 1892, and the Field Museum of Natural History two years after that. Also in 1892, Chicago inaugurated an elevated railroad system for moving masses of people through the city with minimal interference to road traffic. This innovative engineering response to urban growth in size, population, and commercial activity further established Chicago as a center for exciting engineering projects.

American engineers were organized into professional societies during this period, following the lead of Great Britain's Institution of Civil Engineers, founded in 1818 for the dissemination of knowledge and maintenance of standards. The American Society of Civil Engineers was established in 1852, the American Society of Mechanical Engineers in 1880, and the Institute of Electrical and Electronics Engineers in 1884. College curricula began to reflect the need for specialized training. Some schools oriented their programs toward engineering, such as Purdue University in Lafayette, Indiana (opened 1874), and Lehigh University in Bethlehem, Pennsylvania (chartered 1866), where the great Bethlehem Steel Works were erected in 1873. The Massachusetts Institute of Technology was chartered in 1861, Georgia Institute of Technology opened in 1888, and California Institute of Technology was founded in 1891. The Cooper Union, established as an art and engineering school in New York City in 1859, was founded by Peter Cooper, the inventor and industrialist who built the Tom Thumb, the first successful railway locomotive in

America. In Chicago, the Armour Institute of Technology and the Lewis Institute of Technology were founded in 1892 and 1896 respectively (later to be merged in 1940 to form the Illinois Institute of Technology).

IRON FRAMES AND ELEVATORS

Technological advances such as the steel skeletal frame and the elevator now made it possible to build ever upward in the cities, where the square-footage costs of land ran high, and cost-effectiveness demanded the maximum number of floors to a given site. Necessity, financial considerations, and technology gave birth to the skyscraper. The industrial-commercial-financial complex set about with the engineer-builders to define a new set of aesthetics that grew directly out of the demands of the age.

A new architectural style was born in response to the modern world. The style had begun in industrialized England in the last quarter of the eighteenth century with cast-iron bridges. By the early nineteenth century, large, multistoried factories were being erected with cast-iron

components in a skeletal system, and by the 1840s cast iron was being used for storefronts. In the mid-nineteenth century, however, many felt that iron used in a building disqualified it as architecture in the noblest sense. For example, John Ruskin's sensibilities were offended by the crassness of iron. In *Seven Lamps of Architecture* (1849) he declared that "architecture" does not admit iron, even as a hidden, constructive material. Although mid-century America tended to genuflect to Ruskin's theories, there were many who saw the practical possibilities of building with cast iron—even if they were as a group inventors, gadget-makers, mechanics, blacksmiths, foundrymen, and engineers, rather than architects.

The new way of building, dating from around 1850, was both faster and less expensive. It offered options that were not possible with either masonry (such as spanning great distances) or wood (which was combustible). Cast-iron trusses for factory roofs were probably used in American milltowns like Lowell, Massachusetts, in the first half of the nineteenth century. It was not until mid-century, however, that prefabricated cast-iron parts were employed

21.1 James Bogardus, The Bogardus Factory, *The First Cast Iron House Erected*, Lithograph, c. 1850. Museum of the City of New York.

throughout to construct an entire building, with wall areas increasingly freed of supporting responsibilities and given over to glass. James Bogardus began to put into practice in America what had culminated in England with the Crystal Palace (London, 1851), which housed Prince Albert's great international trade exhibition.

ARCHITECT IN IRON

James Bogardus (1800–74), a selftaught engineer and founder who referred to himself as "an architect in iron," was a manufacturer of milling machines for lead and grain. In 1848, he established a foundry in New York City for the production of cast-iron structural and decorative architectural parts. The next year, Bogardus was awarded a patent for the first cast-iron-constructed building. About that time, he erected his own factory, employing the principle of prefabricated, interchangeable, modular cast-iron parts (Fig. 21.1). This was the first all-iron building in America, and its advantages were immediately apparent to the commercial sector. Bogardus executed several buildings using his new cast-iron skeletal system, among them the Laing Stores (c. 1849) and Harper and Brothers (1854), after the design of John B. Corlies. Both were in New York City.

When it was decided to hold a great trade fair in New York City, the requirements of the huge exhibition hall presented a great opportunity to show off the new method of construction. A competition was held, there being other individuals and firms in the cast-iron architecture business by 1852 besides Bogardus.

Bogardus's design called for a cast-iron frame enclosed with glass exterior walls. This was of absolutely astounding dimensions, possible only with the new technology: 1200 feet (366 m) in diameter, with a 300-foot (91.4-m) tall tower (Fig. 21.2). Bogardus claimed that after the fair was over, the structure could be disassembled and the parts reused in another building. But he did not win the competition: The prize instead went to the team of Georg Carstensen (1812–57) and Charles Gildemeister (1820–69) for their Greek-cross greenhouse design, with its great dome. They claimed, in a display of bravado, that this was second in size only to the dome of St. Peter's in Rome. The cast-iron exterior was painted olive green, with touches of gilding. The glass sheathing enclosed an enormous, virtually unobstructed interior space for the international exhibition, which contained everything from Hiram Powers's *Greek Slave* (Fig. 18.4) to a newly devised threshing machine. Here was proof to America of the enormous potential of cast-iron architecture. Inside, the cast iron was brilliantly polychromed, with grand staircases, broad galleries, and ornate cast-iron ornamental work (Fig. 21.3).

Although a new material and a new technology were at hand, no form had suggested itself to establish its shape and style. Therefore, architects such as Bogardus and Carstensen and Gildemeister turned to historic styles—such as Roman, Gothic, or Renaissance—especially in the decorative parts of their structures. In their final report Carstensen and Gildemeister explained that they turned to the Venetian Gothic style for the mode of cast-iron decoration, for it was "the most favorable for lightness and elegance." In time, the new materials and technologies would suggest an aesthetic of their own, as seen in, say, the Seagram Building in New York (Fig. 33.11).

21.2 James Bogardus, Project for the New York World's Fair of 1853. From Benjamin Silliman and C. R. Goodrich, *The World of Science, Art, and Industry* (New York, 1853). Morris Library, University of Delaware, Newark, Delaware.

21.3 New York Crystal Palace, 1853. Interior.

Finally, the New York Crystal Palace exposition (1853) saw an event of great importance for the evolution of the tall building: E. G. Otis's safety elevator was introduced to the world there. Heretofore, the human capacity to climb stairs had limited the height of buildings to about five stories. The sky was now, indeed, the limit.

By the mid-1850s, several firms were producing cast-iron parts according to specification. Foremost among these was Daniel Badger's Architectural Iron Works of New York City. Badger (1806–84), a blacksmith from Boston, settled in New York City in 1846 and began producing cast-iron storefronts. His big opportunity came when he was given the contract for the façade of A. T. Stewart's huge new department store. Probably Badger's most famous effort, however, was the E. V. Haughwout Store, with its bold, handsome grid of cast-iron columns, capitals, and cornices that in the design of the bay unit is reminiscent of the Colosseum in Rome (Fig. **21.4**). John P. Gaynor (c. 1826–89), an engineer-architect from Ireland who arrived in New York in 1849, is credited with the design of this five-story

building. A special feature is that one of the first safety elevators produced by Elisha Graves Otis, founder of the Otis Elevator Company, was installed.

The new technology spread rapidly. Bogardus reportedly shipped a storefront by boat to Havana, where it was assembled, while Badger sent one to Chicago by rail. All along the riverfront in St. Louis rose cast-iron storefronts, creations of selftaught foundrymen who styled themselves architects. The next important step came in the 1870s, when the cast-iron components were encased in terracotta. They had initially been praised for being incombustible but were then discovered to be susceptible to heat. The technique was first developed in Chicago, where people were especially conscious of the necessity for fireproofing after the disastrous conflagrations of 1871 and 1874.

By 1875, most of the basic essentials for the modern, highrise commercial building were in practice, thanks mainly to blacksmiths, founders, and engineers. The next stage was for trained architects to recognize the new technology, and to explore the design aesthetic inherent within it.

21.4 John P. Gaynor and Daniel Badger, Haughwout Store, New York, c. 1857. From *Badger's Illustrated Catalogue of Cast Iron Architecture* (New York, 1865). Morris Library, University of Delaware, Newark, Delaware.

JOHN ROEBLING AND THE BROOKLYN BRIDGE

An example of the adventurousness of the men who pioneered the new course for architecture can be seen in the Brooklyn Bridge (1869–83), designed by John A. Roebling (Fig. **21.5**). After training at the Royal Polytechnic Institute, Berlin, in his native Germany, Roebling (1806–69) emigrated to the United States in 1831. He became State Engineer in Pennsylvania, in charge of canal construction. By 1841 he had invented the twisted-wire cable, which he soon began to manufacture. Its chief advantage was its strength, for it proved much stronger than the iron chains that had been used previously for suspension bridges.

Roebling soon was acknowledged as the authority on this type of construction. His wire cable made possible such remarkable accomplishments as the bridges across the Ohio River at Wheeling, West Virginia (1854), across the Niagara River at Buffalo, New York (1851–5), and across the Allegheny River at Pittsburgh (1857–60).

Iron bridges had been known since the erection of the Coalbrookdale Bridge across England's Severn River in 1777. Thomas Telford had introduced the suspension bridge with his Menai Bridge of 1819–26, in North Wales. Now, great distances could be spanned without the need to construct intermediate supports—often difficult to do in the middle of a river or over a great gorge. Chains or cables support the platform of the bridge, which is suspended from

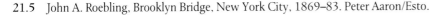

21.5 John A. Roebling, Brooklyn Bridge, New York City, 1869–83. Peter Aaron/Esto.

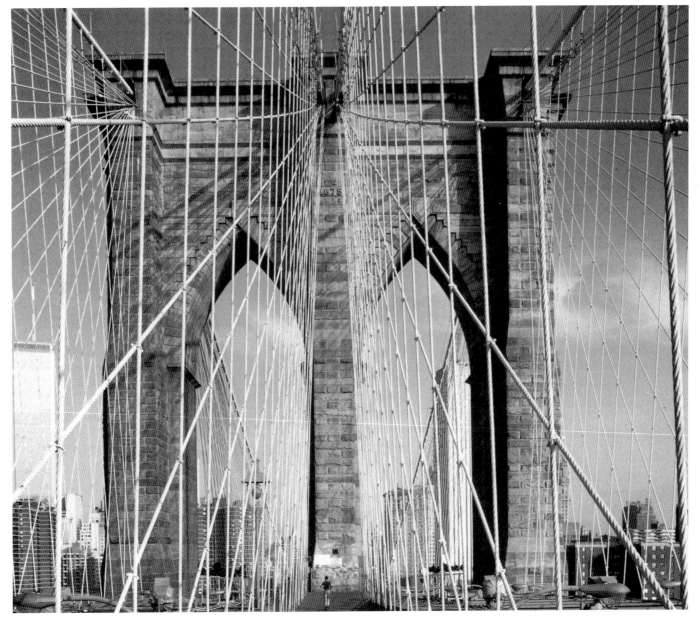

massive towers, rather than held up from below. Roebling's twisted-wire cable allowed the construction of suspension bridges able to carry railroads, where previously such enormous weight had been a problem.

In 1867, Roebling was appointed chief engineer of the project to build the bridge across the East River, connecting Manhattan with Brooklyn. While the design was his, he saw only the beginning of the work, for he died in 1869. His plan was carried out by his son, Washington Augustus Roebling (1837–1926), an engineer and a graduate of Rensselaer Polytechnic Institute in Troy, New York. The main span of the Brooklyn Bridge reached nearly 1600 feet (488 m) across open space and water. At that time, this was the greatest suspension span ever created, a technological breakthrough that deservedly attracted the admiration of the world. Interestingly, the form of the two great masonry towers reveals a lingering influence of historic styles, for the openings are in the shape of Gothic lancet windows. Otherwise, the Roeblings's bridge looks to the future as much as the Eiffel Tower in Paris did when completed in 1889—six years after the Brooklyn Bridge. Today, the Verrazano-Narrows and the George Washington bridges in New York span 4260 and 3500 feet (1298 and 1067 m) respectively, while the Golden Gate Bridge in San Francisco reaches 4200 feet (1280 m) under suspension. But such figures in no way diminish Roebling's triumph.

CHICAGO AND THE RISE OF THE SKYSCRAPER

Once trained architects began to take the potential of the new materials and technologies seriously, the story of the skyscraper begins to unfold. It occurred mainly in Chicago and New York City in the 1880s. In the latter, George B. Post, designer of the New York Stock Exchange (Fig. 20.22), was one of the first to design buildings that would reach heavenward—for example, his Mills Building (1881–3) and Produce Exchange (1881–4). But Post, a Beaux-Arts architect, was strongly tied to the old Renaissance-Baroque Revival style, which he tended to apply to his highrise structures.

It was in Chicago that the early skyscraper was most fully developed. Indeed, the early tall building is one vision conjured up by the term "the Chicago school of architecture." The Great Fire in 1871 had left much of Chicago in ashes, creating a need for rebuilding that was unprecedented in America. Moreover, Chicago was entering a boom period, as it rose to preeminence as the agricultural, financial, merchandising, and industrial hub of the Midwest.

WILLIAM LE BARON JENNEY

The leading figure in the emergence of the Chicago school was William Le Baron Jenney (1832–1907). A native of

Massachusetts, he entered the Harvard University engineering program in 1850. Dissatisfied, he left to go to Paris, where he attended the Ecole Centrale des Arts et Manufactures. During Jenney's years in France, he learned much about the engineering possibilities of cast iron, and also about architectural theory. He served briefly as an engineer on a project building a railroad across southern Mexico. After the Civil War he settled in Chicago, where he opened an architectural office.

The structural grid of the cast-iron skeletal system is clearly reflected in the Leitner Building (Chicago, 1879), the geometric logic of its design being of greater importance to Jenney than decoration derived from one of the historic revival styles. A more mature statement of this came a few years later in his bestknown work—the Home Insurance Building (Fig. 21.6). Originally nine stories high, with two more added in 1891, the structural system consisted of cast- and wrought-iron columns with cast-iron girders in the first six floors, but steel girders in the upper stories—the first use of steel girders in a building.

Part of the supporting work is in the form of masonry piers, so it is not actually the first instance of a skyscraper erected entirely on a cast-iron or steel support system.

21.6 William Le Baron Jenney, Home Insurance Building (destroyed), Chicago, Illinois, 1884–5.

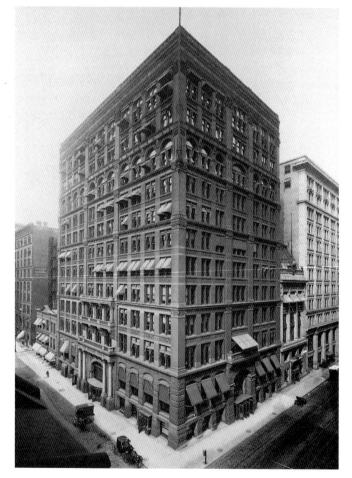

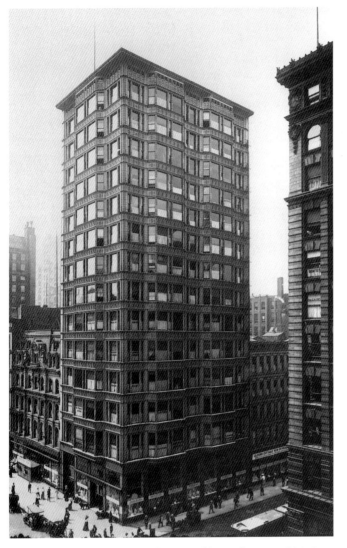

21.7 Daniel H. Burnham, Reliance Building, Chicago, 1894–5.

Root (1850–91) to form one of the most successful architectural firms of the period. Root died just as the commission for the Reliance Building was received, and in Burnham's design, developed in collaboration with his new partner Charles B. Atwood (1849–95), yet another step is taken in the development of the modern commercial building (Fig. 21.7). It rises fourteen stories on a steel, not iron, skeletal system, and reportedly the top ten floors were erected in fifteen days—a phenomenal achievement for that time. The design freely admits that the exterior wall is not loadbearing, and is only a thin veneer, mostly of glass. The metal cage is lithe and elegant: Richardson's Marshall Field Wholesale Store (Fig. 20.28), of masonry, seems heavy, ponderous, and of another era by comparison—yet only eight years separate their completion dates. The Reliance Building is a milestone on the road to modern architecture and the development of the skyscraper.

Daniel Burnham was a man of diverse talents, ranging from architectural designer to organizer of vast projects. His ability as a designer ranged from the tall, lean Flatiron Building (New York, 1903; see Fig. 31.5) to the thoroughly Beaux-Arts, neo-Roman giant, Union Station (1907) in Washington, D.C. Burnham was also the coordinating consultant for the World's Columbian Exposition in Chicago in 1893. This was far more a triumph of East Coast preference for Beaux-Arts classicism than the inauguration of the Chicago school's new architectural style as presented by Burnham and Atwood in the Reliance Building. Many—among them Louis Sullivan—saw the neoclassical White City that rose on the shore of Lake Michigan as a setback in the progress of modern architecture.

Moreover, the metal frame is concealed on the exterior by a stone veneer, probably because monumental buildings were traditionally of stone. Iron and steel were then considered base metals, too inelegant for exposure. Nevertheless, Jenney's design is a handsome grid, with vertical sections reflecting the underlying structure and emphasizing height as they extend from ground level to the top floor.

DANIEL BURNHAM

Jenney was influential, not only through his buildings but also through his work with younger men who passed through his office, such as Daniel Burnham, William Holabird, Martin Roche, and Louis Sullivan. When Holabird (1854–1923) and Roche (1855–1927) formed a partnership, one of their first commissions was an architectural masterpiece of the era—the Tacoma Building, erected in Chicago in 1886. Daniel H. Burnham (1846–1912) had worked in Jenney's office in 1867–8, and teamed up with John Wellborn

LOUIS SULLIVAN: FIRST MODERN ARCHITECT

The man credited with giving form to the tall building and establishing a theoretical foundation for modern architecture in the United States is Louis Sullivan (1856–1924). One of Sullivan's avowed purposes was to break with those who in his opinion were still imposing historic styles on architecture, instead of letting the new materials, technologies, and the spirit of the age evolve a new style of their own. Insofar as he was successful, Sullivan deserves to be called the first modern architect in America.

Born in Boston, Sullivan briefly attended the Massachusetts Institute of Technology (MIT), but soon left to work in the architectural office of Frank Furness in Philadelphia. By the fall of 1873, he had moved to Chicago and entered the office of William Le Baron Jenney. The next summer he went to Paris and to the Ecole des Beaux-Arts. Restless and dissatisfied, Sullivan found that his career did not really take off until after he returned to Chicago, when in 1879 he became an architectural draftsman for Dankmar Adler (1844–1900). By 1883, he had become a partner in the firm

of Adler and Sullivan, the older man concentrating on business affairs and engineering while Sullivan devoted himself mainly to architectural design.

Auditorium Building Probably the most important commission the firm of Adler and Sullivan received during its early years was for the Auditorium Building of 1886–9—an office building, hotel, and theater for grand opera for an increasingly culture-conscious Chicago. Sullivan was impressed by H. H. Richardson's Marshall Field Wholesale Store, then being constructed in Chicago, and the debt to that building is obvious. Sullivan's search for a new mode of expression, however, is demonstrated in the interior, especially in the theater (Fig. 21.8). When finished, the 4237-seat theater was acclaimed for its splendid acoustics—moreover, it was the first theater in America to be airconditioned. But it is the striking decoration that is

perhaps most impressive of all. In it, Sullivan sought an architectural enrichment that was independent of classical, medieval, and Renaissance motifs, and turned instead to nature and to geometric patterns.

Richness of decoration became one of the trademarks of Sullivan's architecture, and its extensive use, as seen here, puts Sullivan's famous phrase—"form follows function"—into perspective. Sullivan did not mean by this that architecture should be reduced to a barren, utilitarian machine—rather, that the functions of any edifice should be expressed in its form. Once this form was achieved, there was no reason to leave it unadorned.

Wainwright Building These principles reached a mature expression in the Wainwright Building, a huge step toward the twentieth-century skyscraper (Fig. 21.9). Here, Sullivan established a tripartite division of the façade: a bold lower

21.8 Adler and Sullivan, The Auditorium Building, Chicago, 1889. Interior.

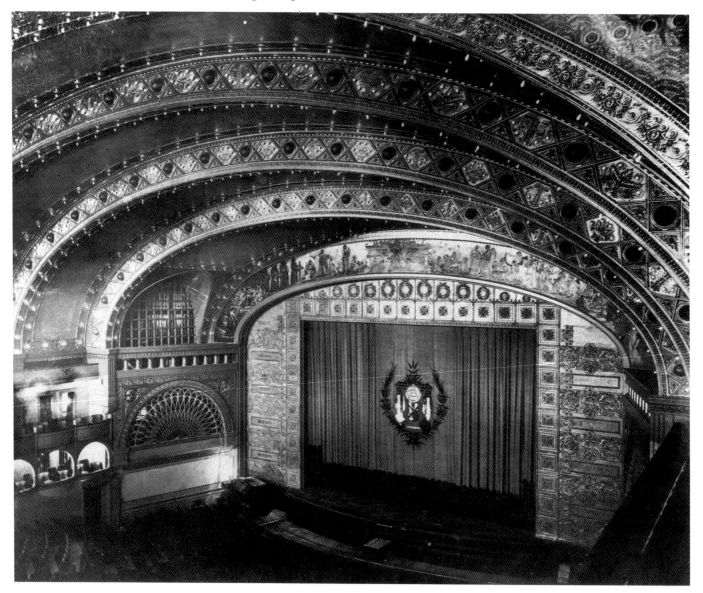

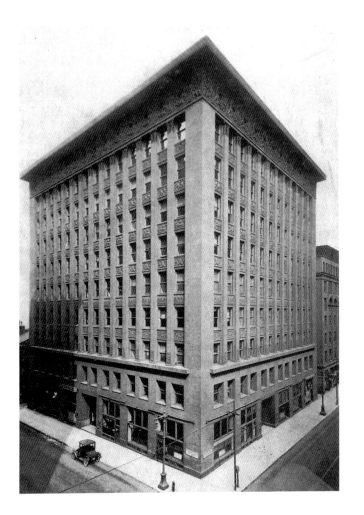

section, then a vertically oriented middle section, and, finally, the grand, projecting cornice, richly ornamented with **foliate** motifs. Although the exterior of the building is of masonry construction, the stone clearly takes on the form of the skeletal system within. Unity of design is achieved in part by eliminating the usual rustication of the lower floors and using a smooth facing throughout. The strength of the corner piers carries from ground level to cornice, uniting the three sections. The intermediate piers contribute to this unity while stressing the vertical rise of the building. It was this that Sullivan declared as being the formal hallmark of the new type of building known as the skyscraper. Horizontals—such as the **spandrels**, with their foliate motifs that echo the floral design of the cornice—are relegated to minor chords in an otherwise vertical symphony.

World's Columbian Exposition Nowhere was Sullivan's pioneering effort to break the grip of the historic styles and establish a fresh, modern mode of architectural expression more apparent than at the World's Columbian Exposition of 1893 (Fig. 20.23). When given the task of designing the Transportation Building for the great fair, Sullivan's response was predictable (Fig. 21.10). As the site of the building was remote from the grand concourses, its style would not disrupt the homogeneous classicism of the buildings surrounding the Lagoon of Honor. Sullivan therefore sought total independence, in both architectural form and decoration. The entrance was a *tour de force*, an elaboration upon the proscenium area of the theater in the Auditorium Building (Fig. 21.8). The forms and the decorative motifs were

21.9 (above) Louis Sullivan, Wainwright Building, St. Louis, Missouri, 1890–1.

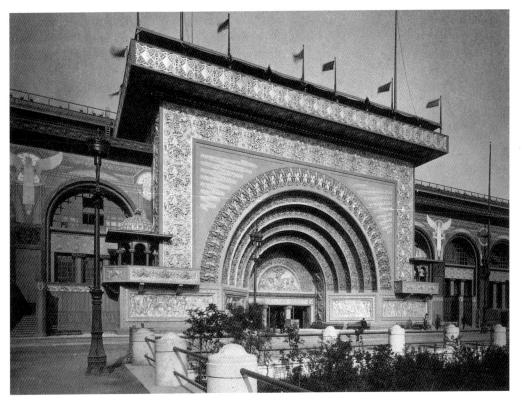

21.10 Louis Sullivan, Transportation Building (destroyed), World's Columbian Exposition, Chicago, Illinois, 1893.

deliberately nonclassical, and, in contrast to the other buildings of the Great White City, Sullivan's structure was defiantly polychromed in red, orange, blue, yellow, and green. A more willful challenge to the architectural traditions of the past could hardly be imagined.

Guaranty Building Adler and Sullivan dissolved their partnership in 1895. One of their last joint efforts was the Guaranty Building (Fig. 21.11). A reworking of the design that had evolved in the Wainwright Building, this has a two-story foundation level, a ten-story middle section that emphasizes verticality, and a most unusual cornice. The latter—unlike any classical cornice, yet serving the same purpose—has a row of large oculi, or round windows, which form a transition from the arches below it to the flaring ridge above. It is an imaginative new design for an old architectural form. Refinement is the key principle, for the cornice has become slight in comparison with that of the Wainwright Building. The piers—at the corners and separating the bays—are more svelte and attenuated, and the bold, smooth surfaces of the earlier work have given way to delicate decoration. The Wainwright Building represents the powerful classic stage in this early evolution of the tall building, while the Guaranty Building becomes a display of virtuosity,

21.11 Adler and Sullivan, Guaranty Building, Buffalo, New York, 1895.

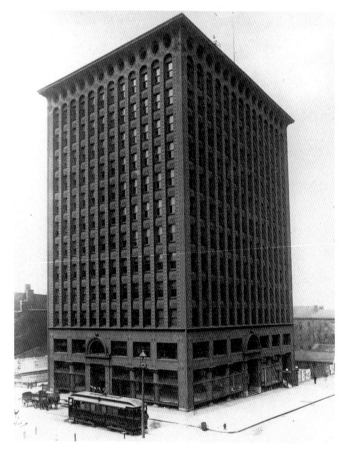

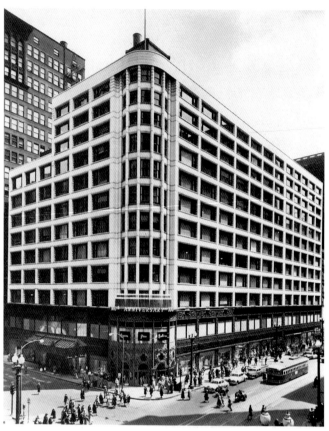

21.12 Louis Sullivan, Schlesinger and Mayer Department Store (now Carson, Pirie, Scott and Company), Chicago, Illinois, 1899.

a variation upon a theme that had been worked out in the St. Louis building.

Sullivan's Grid In his design for the Schlesinger and Mayer Department Store (now Carson, Pirie, Scott) in Chicago (1899), Sullivan presented a new and forthright architectural statement that emphasizes the verticals and horizontals of the building's structural system (Fig. 21.12). A simple, honest grid emphasizes the materials employed in its construction. Most of the wall is given over to glass wherever structure is not involved, and ornamentation is confined to restricted areas.

By limiting the exceedingly rich ornamentation to a couple of horizontal bands and the area around the doorway, Sullivan allowed the vertical and horizontal elements to assert themselves as the sources of functionalism as well as of architectural aesthetics. This dynamic, innovative development was seized upon by architects of the next generation. To counterbalance any sterility that might arise, Sullivan provided a lush floral design to surround and give emphasis to the entrance of the building (Fig. 21.13). Nature-based, curvilinear decorations such as this have been described as an American version of the Art Nouveau style that was in vogue in Europe in the

21.13 Louis Sullivan, Schlesinger and Mayer Department Store, Chicago. Detail of entrance.

1890s. Neither Art Nouveau nor Sullivan's art were the ultimate aesthetic solution for modern architecture, but both were indispensable in effecting the break with the Beaux-Arts past.

By 1900, the major portion of Sullivan's career was behind him. There were no more tall buildings, only cubic blocks—a series of small Midwestern banks—delicately ornamented with his special brand of decoration. Sullivan's influence, however, was considerable, especially on younger architects. Frank Lloyd Wright, for example, spent nearly six years with the firm of Adler and Sullivan from 1888 to 1893, during which time Sullivan was designing or completing the Auditorium Building, the Wainwright Building, and the Transportation Building, among other commissions. Sullivan spread his ideas through the printed word as well in a number of important articles. "The Tall Office Building Artistically Considered" is one example, in which he denounced the revival styles and advocated an aesthetic that grew out of the functions, materials, and technologies of the buildings that were then beginning to dot the urban skyline in America.[1] There would be a timelag of a few years, during which the revival styles enjoyed their last hurrah—but before long the originality and potential of Sullivan's contribution was recognized.

CHAPTER TWENTY-TWO

THE ARTFUL INTERIOR:

COSMOPOLITANISM, THE AESTHETIC MOVEMENT, AND THE AMERICAN HOME, 1870–1900

In the decades following the Civil War, many members of America's new millionaire society found their native land to be provincial, but with an upper-middleclass vision of life. They therefore tended to turn to Europe to find the rich, elegant cultural model they wished to follow. Some even left the United States—William Waldorf Astor, for example, who established permanent residence in England in 1890, eventually to become the first Viscount Astor. Others formed attachments to European aristocracy when their daughters, endowed with dowries freshly provided by the Industrial Revolution, were married off to sons of noble but impoverished Old World houses.

Several authors have described this millionaire society, but none with more perceptive insights than Henry James and Edith Wharton. The life of each was woven into the fabric of the new American aristocracy. Both lived and enjoyed the expatriate life in England, Italy, or France, and, especially interesting for our purposes, each took a keen interest in houses and their interiors as poignant symbols of the society which they observed, and about which they wrote.

Henry James's father had inherited modest resources that enabled him to pursue a leisurely, cosmopolitan life. At the age of twelve, Henry was taken to Europe to live for three years. On their return, the family entered into the society of Boston, Cambridge, and Newport. James dropped out of Harvard Law School to follow a career in letters, and spent several years traveling about Europe, imbibing a culture he came to adore. Bored in America, he wrote to a friend in 1868 that "Paris, vulgarized as it has become, haunts my imagination."[1] When he got to Paris he was exhilarated, finding the Louvre's galleries "wondrous," and attending the Théâtre Français, where he saw plays by Molière. In England, James met Charles Darwin, visited the studio of the famed Pre-Raphaelite painter Dante Gabriel Rossetti (1828–82), and dined at the home of John Ruskin, where he admired the critic's collection of paintings by Old Masters of the Venetian School. He wrote to his parents, "My own desire to remain abroad has by this time taken very definite shape. In fact, I feel as if my salvation, intellectually and literarily, depended on it."[2]

James did return temporarily to America, and tried to settle down to a literary career in New York. His letters betray his unhappiness. He yearned for the cosmopolitan life that could not be found in his native land, and in 1876 he moved to England, which became his home.

James also loved Italy, and believed the Italian Renaissance to be the supreme period in painting. He was determined to overcome the provincial ignorance that he found in no less an intellect than Ralph Waldo Emerson. One day in Paris he and Emerson visited the Louvre together, and James observed: "His perception of art is not . . . naturally keen; and Concord can't have done much to quicken it He's not one of your golden Venetians, whose society I decidedly envy you now."[3] James's friend Isabella Stewart Gardner, however, was very different. About 1899 she built herself a Venetian palace in Boston in order to house her collection of European Old Masters. These had been gathered with the advice of Charles Eliot Norton, an eminent scholar of art at Harvard, and her protégé Bernard Berenson, who became a kind of American Ruskin as arbiter of taste in the fine arts, and an advocate of Italian Renaissance art. It was just this coalition of the wealthy with the tastemakers of the era that created the new cosmopolitan interior setting as a cultural backdrop. The importance of the interior ambience to such people is demonstrated by the fact that Henry James made the contest for the possession of the contents of an English countryhouse the theme of one of his finest novels, *The Spoils of Poynton* (1897).

Wealthy Americans wanted interiors that spoke of a culture elevated well above middleclass comfort. Because to them America had not yet created a mode equal to the grand style of Europe, a rage arose for Italian villas—such as Henry Clay Frick built on Fifth Avenue—for Louis XV furniture, paintings by Titian, Rembrandt, and Rubens, Gothic manuscripts and ivory carvings—such as filled J. P. Morgan's library—Romanesque bronzes, and so on. Practically none of it was American, except the money that paid for it.

Edith Wharton not only sought out Old World modes of décor, but found it unthinkable that a new style could

emerge from America—much less from the new materials and technologies of the Industrial Revolution:

> Strive as we may for originality, we are hampered at every turn by an artistic tradition of over two thousand years. Does any but the most inexperienced architect really think that he can rid himself of such an inheritance? He may mutilate or misapply the component parts of his design, but he cannot originate a whole new architectural alphabet.[4]

Wharton goes on to identify the periods to be emulated: "The styles especially suited to modern life [are] those prevailing in Italy since 1500, in France from the time of Louis XIV, and in England since the introduction of the Italian manner by Inigo Jones." The Vanderbilt banquet hall at Biltmore (Fig. 20.11), the dining room at the Breakers (Fig. 20.14), and the ballroom at the Marble House (Fig. 20.15) express the sociocultural and aesthetic convictions of Mrs. Wharton's society.

Wharton, though born in New York City, had lived abroad as a girl, and moved in a society that spent summers at Newport or at Lenox, Massachusetts, and the winter "season" in New York, traveling about France, England, and Italy in between. The home was often an important theme in her novels about the Fifth Avenue society that frequented Europe. *House of Mirth* (1905) contains some poignant—and critical—passages about the houses of the wealthy, some newly so. The author describes one of the main characters, Lawrence Selden: "All he asked was that the very rich should live up to their calling as stagemanagers, and not spend their money in a dull way."[5] The heroine of the story is the young but suddenly impoverished socialite, Lily Bart, who receives a proposal of marriage from Rosedale, a person who is newly rich and anxious to rise in society. Wharton describes him thus:

> ...he was [slowly] making his way through the dense mass of social antagonism. Already his wealth and his masterly use of it were giving him an enviable prominence in the world of affairs, and placing Wall Street under obligations which only Fifth Avenue could repay. In response to these claims, his name began to figure on municipal committees and charitable boards..., and his candidacy at one of the fashionable clubs was discussed with diminishing opposition.[6]

Rosedale, according to Wharton, recognized the necessity of a proper house and furnishings.

In the social order of the world of Henry James and Edith Wharton there was clearly an iconography of houses and interiors that asserted a cosmopolitan preference for Old World culture. Together with this came a rejection of American modes as provincial, and a separation of the truly wealthy from the middleclass. In terms of interior design it was a complex age. Within it there was also room for the brilliant creations of Louis Comfort Tiffany, the rather plain aesthetic of the Craftsman movement, and the exotic luster of Oriental objects.

AESTHETICS AND THE AMERICAN INTERIOR

In the last three decades of the nineteenth century, the interior of the American home changed significantly from what it had been before the Civil War. There was a marvelous spirit of reinterpretation of Old World styles, and a remarkable wave of aestheticism. Individual objects, even entire rooms, were calculated to display a tasteful awareness of the beautiful and superbly crafted *objet d'art*. Eventually, all of this filtered from the homes of the very wealthy to a large portion of the middleclass. The change was as much a reaction against the crassness and ugliness perpetrated by the Industrial Revolution as it was a discovery that the machines of that very revolution could produce objects of high artistic quality, at prices affordable to an enormous segment of society. New professions were called into existence—the industrial designer, for example, and the interior decorator—for patrons now eagerly sought the guidance of a new group of tastemakers.

22.1 Easel in the Eastlake style, c. 1870. Walnut with gilded and painted detail, 82 × 28in (208.3 × 71.1cm). Brooklyn Museum.

22.2 Renaissance Revival sofa, c. 1870. Rosewood, gilt, upholstery, length 6ft 4¾in (1.95m). Metropolitan Museum of Art, New York City.

THE EASTLAKE MODE

One of the first of the new tastemakers was the English artist and writer Charles Locke Eastlake (1836–1906). His impact was so great that a whole classification of furniture and interior design—in fact, a subsection of the Victorian style—bears his name. Eastlake was trained in architecture, although he never really practiced it. In the book that launched a new period in interior design—*Hints on Household Taste in Furniture, Upholstery, and Other Details* (1868)—Eastlake attacked the Rococo Revival furniture of the sort Belter and Roux made (see Figs. **14.11–14.13**). Instead, he demanded straightedged, flatsurfaced, rectilinear furniture, with turned spindles and delicately incised ornamentation, all in a vaguely late-medieval, neo-Gothic, or Renaissance Revival style. Among Eastlake's most important contributions were a concept of the total interior, the tastefulness of décor, and a new respect for finely crafted "art objects."

The easel seen in Figure **22.1** is a good example of the kind of "art object" Eastlake's tasteful interior called for. Designed to store and display fine-art prints in a parlor or library, the easel should not be confused with a "working" easel upon which an artist paints a picture, for it was expressly designed for the refined interior, not for the studio. It shows the characteristics Eastlake advocated—straight lines, rectilinear form, flat surfaces, lathe-turned spindles, and incised decoration, all loosely inspired by the Gothic mode.

The sofa seen in Figure **22.2** has similar features, although it is of the Renaissance Revival style rather than the Gothic—but still in the Eastlake mode. This example is upholstered in a patterned damask, with a frame of rosewood with gilt incising. An example of the adaptation of Eastlake's general theories of design for a broad American market, it was manufactured in a factory, as opposed to being a one-of-a-kind piece.

The Eastlake mode also exerted its influence on the handcrafted piece, as seen in the cabinet in Figure **22.3**. It is believed to have been designed by the architect Frank Furness and made in Philadelphia by the German-born cabinetmaker Daniel Pabst (1826–1910). Furness frequently supplied Pabst with designs for furniture, and Pabst was reportedly the finest furnituremaker in Philadelphia in

MASSPRODUCTION FOR THE MIDDLECLASSES

Manufacturers of furniture were proud of their work and felt they had proved that the Industrial Revolution could participate in the aesthetic movement and the rage for the artful interior. At the great Philadelphia Centennial Exposition of 1876, their work was seen by thousands of visitors. This important international trade fair introduced the typewriter, the telephone, and also aesthetic objects, such as Oriental porcelains and Japanese interiors, to Americans. These things were to have a profound impact on American design in the decades that followed. Furnituremaking became a major contributor to the economy, because of the vast array of machines that were invented—for everything from rosette carving to dovetailing—and because of an ever-increasing demand. The brash industrial establishment had finally found its partnership with cultured arbiters of taste such as Eastlake. The marriage was indeed a happy one from the manufacturers' viewpoint, if not from Eastlake's.

Never before did so many middleclass homeowners have access to both the advice of the tastemakers, and to the manufactured *objet d'art* at affordable prices. The most current taste, as defined by Clarence Cook—the foremost American counterpart to Charles Eastlake—was available to all in *The House Beautiful* (New York, 1877) and Harriet Prescott Spofford's *Art Decoration applied to Furniture* (New York, 1878). The furnishings themselves were readily available from factory showrooms or from illustrated catalogues. Montgomery Ward published its first mailorder catalogue in 1872, and by 1888 Sears, Roebuck was ready to do mail-order business on a scale never before known.

THE HIGH-STYLE ARTFUL INTERIOR

The ensemble—the complete interior—became a concept in the late nineteenth century. A number of illustrated books on the artful interior appeared, one of the most important of which was *Artistic Houses, Being a Series of Interior Views of a Number of the Most Beautiful and Celebrated Homes in America* (Figs. **22.4–22.6**). It is evident from the plates that more was considered better: The more artistic furniture and furnishings one could cram into the artful interior, the better the total effect. The eclecticism, exoticism, and variety of the objects are wonderful to behold. In a single interior, for example, one might find peacock feathers, Japanese fans, a colonial American sideboard, Persian carpets, Chinese ceramic urns, neoclassical marble sculptures, English patterned wallpapers, Italian tiles, Moorish brass vessels, stained glass windows, tooled leather, gilded ceilings, painted folding screens, mother-of-pearl inlaid furniture, Renaissance paintings, East Indian ivory carvings, and Tiffany lamps. This was a rich, overwhelming visual and tactile mixture, carefully

22.3 Attributed to Frank Furness, Cabinet, 1874. Manufactured by Daniel Pabst. Walnut, maple, glass, brass, height 8ft (2.44m). Metropolitan Museum of Art, New York City.

the 1860s and 1870s. Wrought in the Modern Gothic style—as one version of the Eastlake style was called—the flat surfaces are enlivened with inventive floral and geometric patterns. Curvilinear motifs prevail in the two-dimensional surface decorations, but the total piece is planar and rectilinear. The elaborate floral designs suggest the later decorative reliefs of Louis Sullivan (see Fig. **21.10**), and in fact Sullivan worked in Furness's architectural office as a draftsman at about the time this cabinet was made. Furness's furniture designs invite comparison with his architecture, as may be seen by comparing the cabinet with his façade of the Pennsylvania Academy of the Fine Arts (Fig. **20.7**).

22.4 "Mr. Louis C. Tiffany's Library," plate from *Artistic Houses* (New York, 1883–4).
Morris Library, University of Delaware, Newark, Delaware.

22.5 "The Hon. Hamilton Fish's Drawing-Room," plate from *Artistic Houses* (New York, 1883–4).
Morris Library, University of Delaware, Newark, Delaware.

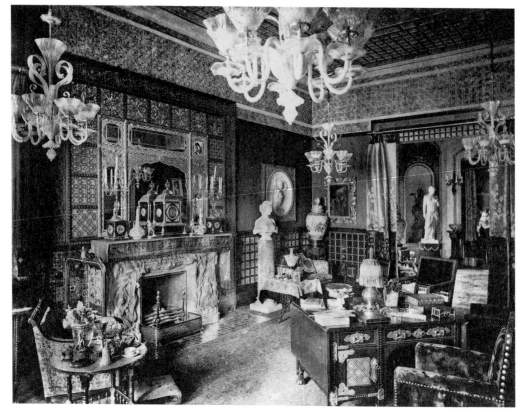

assembled to please the tasteful eye and express the owner's cultivation. America's new millionaire society shed all lingering Puritanism in its rush to indulge itself in the creation of lavish interiors—in the home, public buildings, hotels, gentlemen's clubs, theaters, and restaurants.

LOUIS COMFORT TIFFANY

The professional interior decorator was needed to advise on the creation of the artful domestic environment. Probably the bestknown of these was Louis Comfort Tiffany. His purpose was to create the aesthetic interior of the type seen in Tiffany's own library in his New York apartment on East Twenty-sixth Street. In the corner, peacock feathers are placed against a wallcovering of Japanese inspiration, while Moorish and East Indian features also appear in tasteful variety. A furry animalskin rug is laid before the tiled fireplace, and shelves above the mantel display brass and porcelain curios and collectibles (Fig. 22.4).

Even greater eclecticism is found in the drawing room of Hamilton Fish (Fig. 22.5), in which one sees the marble bust of *Proserpine* by Hiram Powers and Erastus Dow Palmer's full-length marble statue *The Dawn of Christianity*, which is now in the Metropolitan Museum of Art. Fish also owned Palmer's *White Captive* (Fig. 18.9), which he gave to the Metropolitan as well. For Fish's drawing room, Tiffany chose a colorscheme dominated by blue and ivory, with peacock blue plush **wainscoting** and curtains. The Persian-style overmantel mirror is framed in carved teak wood, and a Moorish frieze runs around the upper portion of the walls.

HERTER BROTHERS

Another firm which was as celebrated as Tiffany's was Herter Brothers of New York City. Its finest achievement was the interior decoration of the William H. Vanderbilt

22.6 "Mr. W. H. Vanderbilt's Library," plate from *Artistic Houses* (New York, 1883–4). Morris Library, University of Delaware, Newark, Delaware.

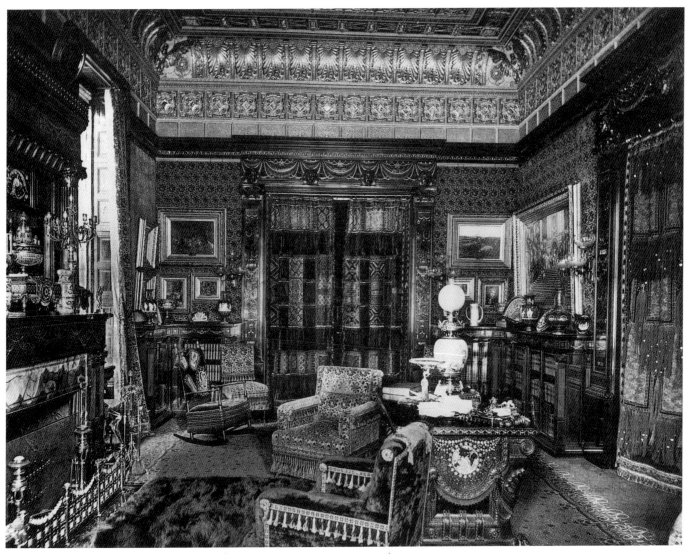

House at the corner of Fifty-first Street and Fifth Avenue. Herter Brothers's reputation extended from coast to coast— the firm's commissions included the J. Pierpont Morgan house in New York, Potter Palmer's grand residence in Chicago, and the Mark Hopkins and Collis P. Huntington mansions in California. Gustave Herter (1830–98), the son of a cabinetmaker, emigrated to New York from Germany in 1848, and for a few years he worked for Tiffany, Young, and Ellis (predecessor of Tiffany and Company) before establishing his own furnituremaking firm. He was joined by his younger brother Christian (1840–83), who emigrated in 1860 after studying at the Ecole des Beaux-Arts in Paris. Christian bought out Gustave's interests about 1870, and thereafter headed the firm during its heyday, gaining for it the reputation of being one of the foremost design houses of the Aesthetic Movement. Herter Brothers designed and made furniture, and imported wallpapers, carpets, tiles, porcelains, and collectible items from around the world. It also maintained an art gallery renowned particularly for the French Barbizon pictures it offered clients, and assembled a corps of designers, architects, and decorators to assist its patrons in the creation of the artful interior.

Herter began work on the William H. Vanderbilt House in 1879. His client spared no expense in creating what must have been one of the great showplaces of the Aesthetic Movement. Everything in the wonderfully lavish library was the very best of its kind (Fig. 22.6). Floor, walls, draperies, ceiling, and upholstery present a riot of patterning, and the room is enriched with lush woodcarving and plaster reliefs. Upon the beautifully detailed built-in bookcase (right) are collectibles ranging from a Japanese fan to a Wedgwood-type urn and an ornate Persian waterbottle, above which hangs, in a massive gilt frame, a French academic painting. An especially exquisite piece is the library table (Fig. 22.7). An example of the high standard of Herter Brothers's design and exquisite workmanship, it is made of rosewood, finely carved, with inlay of brass and mother-of-pearl. A globe of the two hemispheres is worked into the ends.

About the time it began work on the Vanderbilt interiors, the firm produced the exotic cabinet seen in Figure 22.8, which is made of ebonized cherrywood with inlays and gilded ornament. The creative design and craftsmanship, at their very best, exemplify the spirit of the Aesthetic Movement. Inspiration came from the art of Japan, then only recently discovered by Western artists and artisans. The Englishman Edward W. Godwin's *Art Furniture* (London, 1877) had a great influence on Japanese-inspired design in America. The woods are a dramatic contrast of colors and light and dark, and the elegant saber legs remind one of Godwin's adaptation of Japanese swords for the legs on contemporary art furniture. The Herter Brothers's cabinet has handsomely carved griffin heads which serve as finials. The central panel, the brilliant focal point of the piece, was created by delicate inlay, and represents an urn surrounded by cranes, snakes, butterflies, and flowers, also derived from Japanese sources.

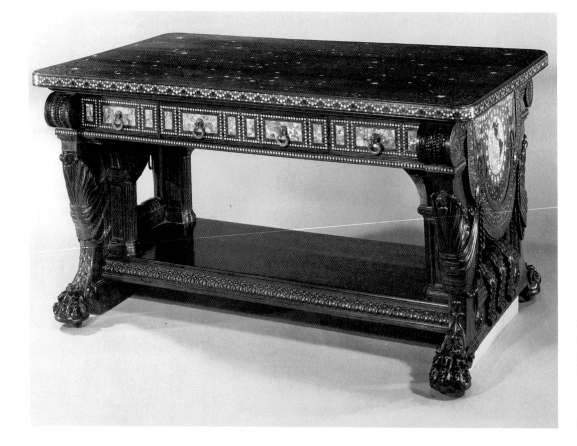

22.7 Herter Brothers, Library table for the William H. Vanderbilt House, 1882. Rosewood, brass, mother-of-pearl, 31¼ × 60 × 35¾in (79.4 × 152.4 × 90.8cm). Metropolitan Museum of Art, New York City.

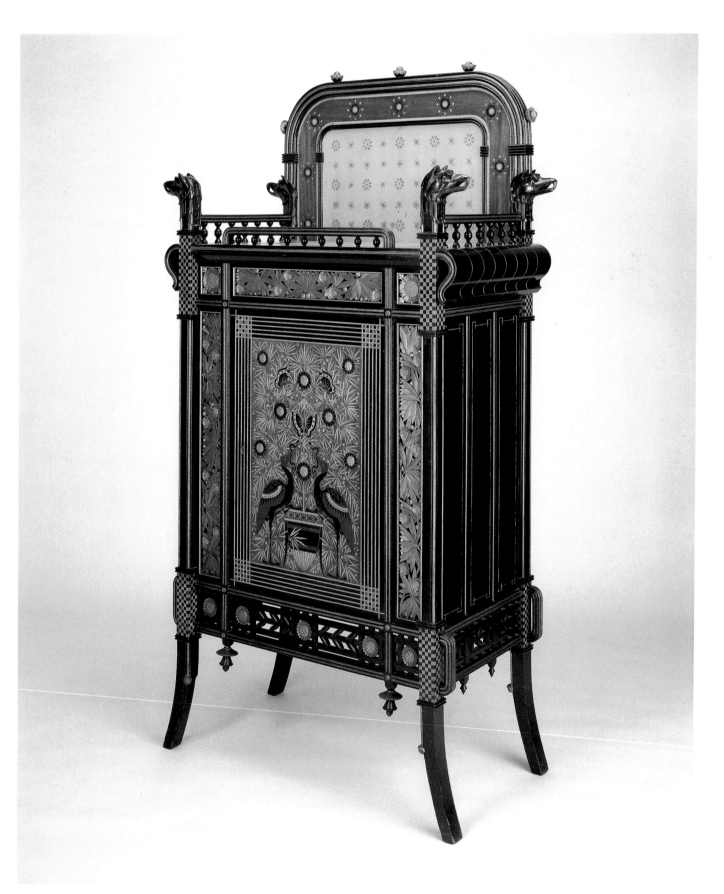

22.8 Herter Brothers, Cabinet, c. 1880. Ebonized cherry, inlaid and gilded woods, height 5ft (1.52m). High Museum of Art, Atlanta, Georgia.

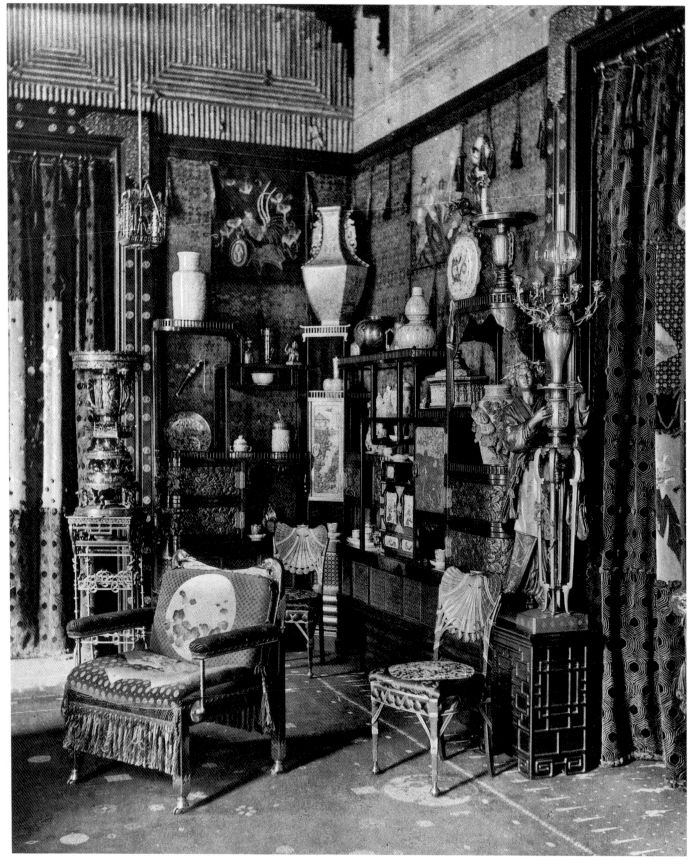

22.9 The Japanese Room, from a plate in Edward Strahan (Earl Shinn), *Mr. Vanderbilt's House and Collection* (New York, 1883–4). Morris Library, University of Delaware, Newark, Delaware.

JAPONISME

Christian Herter played a significant role in introducing the Japanese style into American interior design. He probably became aware of Japanese art while he was a student in Paris in the 1860s, and he no doubt noticed the popularity of the Japanese exhibits at the Philadelphia Centennial fair of 1876. The firm of Herter Brothers imported *objets d'art* from Japan even before undertaking the decoration of the William H. Vanderbilt House, which had a Japanese Room in which the owner proudly displayed his many exquisite objects from the East (Fig. 22.9). The ebonized wood cabinets and the woven bamboo ceiling were produced within a few miles of the Vanderbilt House, so thoroughly did American designers and craftsmen understand the aesthetic principles of Japanese art. The room itself must have been brilliant, with its red-lacquered beams, gold brocade wall-hangings, and stained glass windows by John La Farge.

Prior to the Civil War very few Americans were aware of Japanese art. But those who visited the international exposition of 1867 in Paris brought back reports of its beauty. Ernest Francisco Fenollosa went to Tokyo in 1878 to become a professor of philosophy at the Imperial University. Fenollosa was fascinated by Japanese and Chinese art, and in 1890 he returned to Boston to be the curator of Oriental art at the Museum of Fine Arts. William Sturgis Bigelow, a Boston physician who went to Japan in 1882, spent seven years there forming an extraordinary collection, which became the basis for the Museum of Fine Art's collection of Japanese art, reportedly the best outside Japan. The prominent decorator Samuel Bing collected a number of essays into the three-volume *Artistic Japan* (1891), which helped to popularize the Japanese mode, and Henry Adams and John La Farge went to Japan in 1886. In this way American scholars, critics, collectors, curators, decorators, and artists became aware of the newfound beauties of Japanese art. Through them, Japonisme became an exotic style for interior décor.

The English, too, had become interested in Japanese art, as evidenced by Godwin's book and James Abbott McNeill Whistler's Peacock Room (Fig. 22.10) for the London home of Frederick Richards Leyland (installed in 1919 in the Freer Gallery, Washington, D.C.). Whistler's brilliant Peacock Room—the actual title was *Harmony in Blue and Gold*—was

22.10 James McNeill Whistler, The Peacock Room, 1876–7, now installed in the Freer Gallery of Art, Washington, D.C. Oil color and gold on leather and wood, 13ft 11⅞in × 33ft 2in × 19ft 11½in (4.26 × 10.11 × 6.08m).

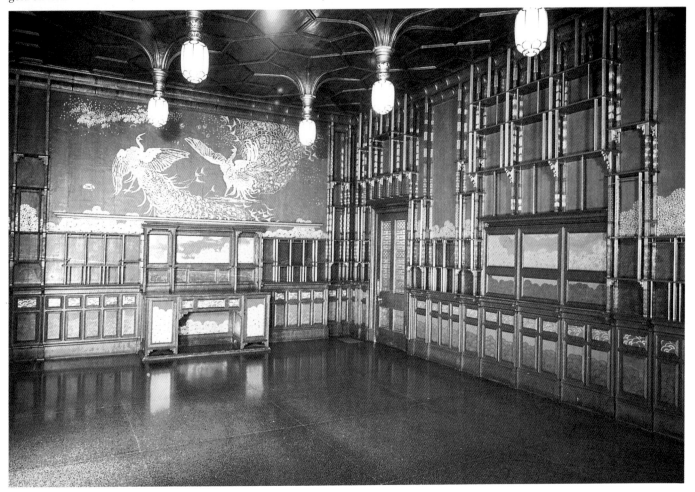

an attempt to make the room environment into a total work of art. The leatherlined walls were painted peacock blue-green, and the gilded bamboo-like ribbing simulated the walls of a Japanese house or shrine. Gilded built-in shelves were meant to display Leyland's extensive collection of Oriental blue-and-white porcelain. In a form resembling a Japanese screen, Whistler created the beautiful goldleaf peacock mural on blue leather as the centerpiece of the room. The peacock became a favourite motif of the Aesthetic Movement, not as the traditional symbol of vanity, but because of its exotic nature and its spectacular, iridescent colors. Everything in the room contributed to a lavish but aesthetically coordinated unity.

ART IN GLASS: LA FARGE AND TIFFANY

The new interest in the use of stained glass arose when the Modern Gothic movement introduced late-medieval influences into the fashionable interior. Among the best windows of this period were those designed by John La Farge. An excellent example of his work is the *Peonies* window (Fig. 22.11). La Farge perhaps felt a kinship with the medieval artisan who labored to produce handcrafted objects of beauty—a feeling very much in the spirit of the Arts and Crafts Movement of La Farge's day.

During his career, La Farge produced several thousand windows. His first *Peonies* type was created for the Newport residence of William Watts Sherman which had been designed by H. H. Richardson (Fig. 20.24). Innovative experiments included the development of an opalesque luster in the glass. The *Peonies* window suggests La Farge's interest in both the art of the English Pre-Raphaelite painters and of Japanese prints and enamelwork. He had collected Japanese art since about 1856, and was in fact one of the first Americans to do so.

Louis Comfort Tiffany, too, became famous for stained glass work. The name of Tiffany was already internationally known and respected long before Louis Comfort turned his attention to the artful interior. In 1837, his father, Charles Louis Tiffany (1812–1902), had joined with a man named John B. Young to open a shop in Broadway, near New York City Hall, to deal in "fancy articles and curiosities." By 1870, Tiffany and Company was internationally acclaimed for its jewelry and silver creations—the house of Tiffany was awarded a silver medal for the work it displayed at the great Universal Exposition in Paris in 1867, the first American firm to receive such recognition. By the 1870s, the firm had begun importing exotic objects from Japan, China, India, and North Africa, as well as from Europe. As early as 1850 Tiffany and Company had opened a branch in Paris, and by 1868 there was another in London. The firm continues to this day, a world-renowned house specializing in beautiful objects, artfully created out of precious materials.

Louis Comfort Tiffany (1848–1933) showed little interest in his father's business, and chose instead to study painting, departing in 1868 for Paris to do so. The following year he

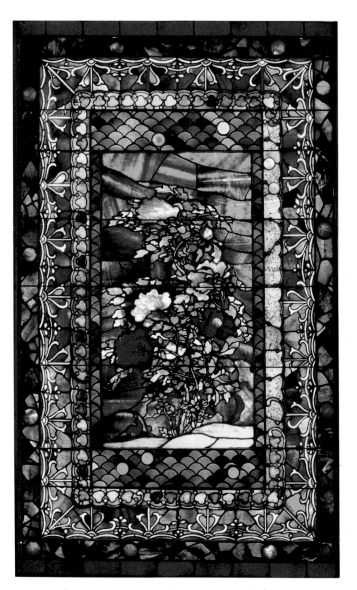

22.11　John La Farge, *Peonies Blown in the Wind*, 1878–9. Window made for the Henry G. Marquand House, Newport, Rhode Island. Leaded glass, 6ft 3in × 3ft 9in (1.91 × 1.14m). Metropolitan Museum of Art, New York City.

joined another American painter, Samuel Colman (who would also soon turn to interior designing), on a sketching trip to North Africa, where he became familiar with Moorish styles of architecture and decorative arts. Throughout the 1870s, Tiffany enjoyed moderate success as a painter, but by the end of the decade he had already decided to become an interior decorator. In 1879 he joined Samuel Colman (1832–1920), Lockwood de Forest (1850–1932), and Candace Wheeler (1828–1923) to form Associated Artists.

When Associated Artists was dissolved in 1883, Tiffany struck out on his own as Louis C. Tiffany and Company, turning his attention increasingly to the making of art glass. He soon operated a large factory in New York, producing a wide range of glass objects, from stained glass windows to

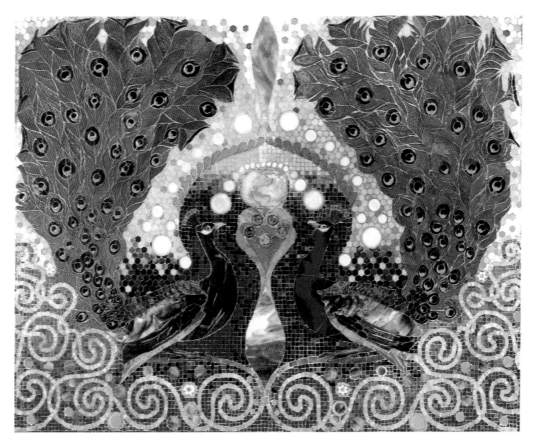

22.12 Louis Comfort Tiffany, *Peacock Mosaic*, 1890–1, for the entrance hall of the Henry O. Havemeyer House, New York. Iridescent cabochon glass, pottery, plaster, 52 × 64 × 4in (132.1 × 162.6 × 10.2cm). University of Michigan Museum of Art, Ann Arbor, Michigan.

22.13 (below) Louis Comfort Tiffany, Vases and bottle, 1890–1910. Blown Favrile glass. Metropolitan Museum of Art, New York City.

luminous glass mosaics of stylized peacocks. For the entrance hall of Henry O. Havemeyer's splendid house in New York, Tiffany created a brilliant peacock mosaic out of **Favrile glass**, the opalescent quality of which gave a vibrant luster to the rich colors (Fig. 22.12). Mosaics such as this were often an integral part of the elegant décor in great houses of the Aesthetic Movement. Tiffany and Samuel Colman collaborated on several rooms of the Havemeyer house, creating coordinated interiors with their patrons' collections of ancient glass, Oriental porcelain, and Impressionist paintings.

Favrile Glass Favrile, the new type of glass developed by Tiffany, has a satiny surface and rich, iridescent colors. Tiffany established glass-furnaces in Corona, New York, where he produced beautifully designed and exquisitely crafted Favrile glass vases and bowls.

The resurgence of art glass and art pottery in the 1880s and 1890s was due in large part to his artistic genius and entrepreneurship. For his patrons, Tiffany provided a whole array of precious *objets d'art* with which to fill the interiors of homes done in the new taste—objects such as those illustrated in Figure 22.13. The forms and decorative motifs of Tiffany glass are often abstractions of flowers or vines, and frequently have the undulating, curvilinear sensuousness that characterizes the Art Nouveau style.

In 1892, the firm became the Tiffany Glass and Decorating Company, and seven years later its name was shortened

22.14 Louis Comfort Tiffany, Wisteria table lamp, c. 1900. Glass, lead, bronze. Private collection.

to Tiffany Studios. Within the house of Tiffany there were decorators, designers, and craftsmen, working not only in glass but also in metal, ceramics, and wood. It was the archetypal Aesthetic Movement establishment.

Tiffany Lamp The object for which Louis Comfort Tiffany is most famous is the Tiffany lamp, with its beautiful stained glass shade, illuminated by the incandescent light within. The Wisteria table lamp seen in Figure 22.14 is typical, with its domed shade and irregular bottom edge set upon a brownish-green bronze base. The organic form of the base is suggestive of a treetrunk, the roots of which are wrought in the soft, undulating manner of Art Nouveau. The small pieces of green and purple glass are leaded together, as in a stained glass window. Tiffany began making this kind of lamp well before the turn of the century. With Thomas Alva Edison's invention of the incandescent lightbulb in 1879, designers had to rethink the lamp form. Edison's new light-source had the power of twenty or more oilburning lamps, and Tiffany took advantage of its extra-

ordinary brilliance to illuminate the bright, jewel-like colors of his glass. By 1883, Edison had set up a factory in New York to produce his revolutionary new type of lighting, and Tiffany led the way in devising beautiful new forms for this latest technological wonder of the Industrial Revolution.

The Gorham Manufacturing Company, founded in Providence, Rhode Island, in 1863, is an excellent example of the factory-type organization of the Industrial Revolution turning to the production of fine-art products. The Gorham firm had been established before mid-century by Jabez Gorham (1792–1869), a jewelrymaker, and his son John (1820–98) took over in 1848. It was John who modernized the machinery and introduced steam power into the factory so production could be greatly increased. He brought in other new procedures, such as electroplating silver. The design of the objects was not neglected. The silver punch-bowl of 1885, with its **repoussé** images of a seadragon writhing amid broiling waves, crustaceans, fish, and ocean plants, was wrought in a wonderfully composite style that is both Oriental and Art Nouveau (Fig. **22.15**).

22.15 Punchbowl and ladle, by Gorham Manufacturing Company, Providence, Rhode Island, 1885. Silver, 10½ × ¹⁄₁₀in (26.7 × 0.3cm). Museum of Fine Arts, Boston. Edwin L. Jack Fund.

22.16 Curio cabinet, by George C. Flint and Company, New York, c. 1910. Mahogany, glass, 58¾ × 36 × 16in (149.2 × 91.4 × 40.6cm). Metropolitan Museum of Art, New York City.

ART NOUVEAU

Art Nouveau never found broad acceptance in America, but its forms occurred often in turn-of-the-century decorative arts and jewelry. The style originated in Europe in the 1880s as an alternative to historic revival styles, and was one of the avenues explored in the search for a modern mode of expression. Its limply curving, sensuous lines—frequently softly modeled abstractions of tendril, floral, or other natural forms—were used in a variety of objects from cast-iron subway entrances in Paris to lovely, delicate jewelry and glass pieces by René Lalique, to furniture design. Parisian critics and the professors at the Ecole des Beaux-Arts detested it, considering it a vulgar challenge to the honored traditions upon which their aesthetic was founded.

Art Nouveau arrived in the United States in the 1890s, and the architectural ornament designed by Louis Sullivan is often cited as the American version (Fig. 21.13). More in keeping with the European brand, however, is the type of furniture represented by the curio cabinet illustrated in Figure 22.16. In fact, this piece follows almost exactly the lines and design of a pair of cabinets made in Nancy, France, by Louis Majorelle. Attenuated, linear motifs and soft, impressionistic renditions of flowers, foliage, ivy, and vines are typical, as is the preference for sinuous curves rather than angles. Art Nouveau proved to be a dead end, and the search for a non-revival, modern style went in other directions in the early twentieth century.

Before the advent of the Industrial Revolution, only the wealthy, usually the aristocratic minority in a society, possessed finely crafted *objets d'art*. The arrival of the Industrial Age brought massproduced objects into the price range of the broader public, but at first those objects were crass, misproportioned, and overly cluttered with what their makers hoped would pass as decoration. As a reaction, the last decades of the nineteenth century saw a return to careful craftsmanship of unique handmade objects in the Arts and Crafts and the Aesthetic movements, while artistically talented designers turned to the problem of providing high-quality designs for the machines and factories to produce. With all of these forces in action, the several strata of society could seek whatever level of artistic environment they could afford.

CHAPTER TWENTY-THREE

PAINTING:

THE NATURALISTIC TRADITION AND COSMOPOLITANISM, 1870–1900

In the United States in the final decades of the nineteenth century, the continuing cultural tug-of-war between the powerful allure of Europe and a fierce American chauvinism is evident in both literature and painting. Contradictory as it may seem, to many American authors and painters going to the Old World to find training, inspiration, and even subject matter was a perfectly American thing to do—at least those inclined toward a cosmopolitan lifestyle and cultivation of the arts felt so. One need only read *The Letters of Bernard Berenson and Isabella Stewart Gardner* (1987), a correspondence mostly between Florence or Venice and Boston in the 1880s and 1890s, to get a glimpse of two Americans who, with wonderfully urbane wit, indulged themselves and each other in cosmopolitan values and aesthetics. Henry James subscribed to it to the fullest, and painters such as John Singer Sargent and Mary Cassatt did so in equal measure.

Not all Americans, however, were so totally committed to the cosmopolitan form of art, for a pro-American sentiment was actually very strong. It is useful to look at this more closely, especially in its literary manifestations, in order to understand the subject matter of the artist Winslow Homer and the realism of Thomas Eakins.

Some Americans chose to mock European art and ways of life rather than to admire and follow them. Mark Twain accompanied a group of Americans who visited Europe and several Mediterranean countries in 1867, and two years later published *Innocents Abroad*, an account of their experiences. It was Twain's—and most of the other Americans'—first trip abroad. In his book, Twain seldom takes seriously the sights meant to impress him, and frequently draws humorous comparisons between the New and Old Worlds—the American example usually being found superior. He did not like Florence at all, and saw the revered Medici princes as despots rather than great patrons. He found the Catholic church equally tyrannical and wallowing in luxury, and pronounced the inept governance of Italy grossly inferior to the American system. Città Vecchia, the port near Rome, he described thus:

The finest nest of dirt, vermin and ignorance we have found yet, except that African perdition they call Tangiers.... The people live in alleys two yards wide, which have a smell about them which is...not entertaining.... These alleys are ...carpeted with deceased cats, and decayed rags, and decomposed vegetable tops, and remnants of old boots, all soaked with dish-water, and the people sit around on stools and enjoy it. They are indolent, as a general thing....[1]

In Rome, anything Italian was always inferior to anything American: "St. Peter's did not look nearly so large as the [U.S.] capitol, and certainly not a twentieth part as beautiful"[2] Inside St. Peter's he observed Bernini's *baldacchino* (an elaborate canopy over a tomb or an altar), describing it as a "frame-work like that which upholds a mosquito bar. It only looked like a considerably magnified bedstead— nothing more."[3] At the end of the journey, he noted:

We had cared nothing much about Europe. We galloped through the Louvre, the Pitti, the Uffizi, the Vatican—all the galleries—and through the pictured and frescoed churches of Venice, Naples, and the cathedrals of Spain; some of us said that certain of the great works of the old masters were glorious creations of genius..., and the others said they were disgraceful old daubs. We examined ancient and modern statuary with a critical eye in Florence, Rome, or any where we found it, and praised it if we saw fit, and if we didn't we said we preferred the wooden Indians in front of the cigar stores of America.[4]

Innocents Abroad enjoyed great popularity in the United States as a long-awaited rebuttal to Frances Trollope's criticisms, and it established Twain as a pro-American critic whose opinions were based on realistic appraisal and common sense.

Realism became a potent force in American literature. Also, a preference for purely American subjects in literature is found in Twain's enormously popular novels—*Tom Sawyer* (1876), *Life on the Mississippi* (1883), and *Huckleberry Finn* (1884). Colloquial dialect and unpretentiousness blend with realistic style and nationalistic subject matter to create something wholly American, and totally independent of European traditions.

Perhaps it was because Henry James was of the cosmopolitan, expatriate, Old World tradition that he recorded an exquisite perception of the American tradition in a review of

a New York art exhibition, in which he singled out a work by Winslow Homer, *Milking Time* (Delaware Art Museum):

> Mr. Homer goes in . . . for perfect realism, and cares not a jot for such fantastic hair-splitting as the distinction between beauty and ugliness. He is a genuine painter; that is, to see, and to reproduce what he sees, is his only care; to think, to imagine, to select, to refine, to compose . . . , all this Mr. Homer triumphantly avoids. He not only has no imagination, but he contrives to elevate this rather blighting negative into a blooming and honorable positive. He is almost barbarously simple, and, to our eye, he is horribly ugly; but there is nevertheless something one likes about him. What is it? For ourselves, it is not his subjects. We frankly confess that we detest his subjects—his barren plank fences, his glaring, bold, blue skies, his big, dreary, vacant lots of meadows, his freckled, straighthaired Yankee urchins, his flatbreasted maidens, suggestive of a dish of rural doughnuts and pie, his calico sunbonnets, his flannel shirts, his cowhide boots. He has chosen the least pictorial features of the least pictorial range of scenery and civilization; he has resolutely treated them as if they *were* pictorial, as if they were every inch as good as Capri or Tangiers; and to reward his audacity, he has incontestably succeeded.[5]

Walt Whitman (Fig. 25.6), the close friend of Thomas Eakins, had earlier sounded the call to rejoice in those things that were America with his collected poems, *Leaves of Grass* (1855). Whitman's poetry unabashedly celebrates the greatness of the nation, of the land, and of the common people—the great successors of an exhausted European culture. One senses this joy in "I Hear America Singing:"

> I hear America singing, the varied carols I hear,
> Those of mechanics, each one singing his as it should be blithe and strong,
> The carpenter singing his as he measures his plank or beam,
> The mason singing his as he makes ready for work, or leaves off work,
> The boatman singing what belongs to him in his boat, the deck-hand singing on the steamboat deck,
> The shoemaker singing as he sits on his bench, the hatter singing as he stands,
> The wood-cutter's song, the ploughboy's on his way in the morning, or at noon intermission or at sundown,
> The delicious singing of the mother, or of the young wife at work, or of the girl sewing or washing,
> Each singing what belongs to him or her and to none else. . . .

Whitman is America itself in "Starting from Paumanok" (Paumanok is in New Jersey, across the Delaware River from Philadelphia); after reviewing the greatness of ancient and European civilizations, he concludes: "Regarding it all intently a long while, then dismissing it, I stand in my place with my own day here." America's time has come. As an heir to European culture, having learned from it, it is time to dismiss it. America must rise to its own glorious place in the sun, on the strength of its own culture.

The majority of the painters discussed in the next two chapters were of the cosmopolitan, European-oriented tradition. But to understand the art of Eastman Johnson, Winslow Homer, and Thomas Eakins one must acknowledge the strength of sentiment for the homegrown American tradition. There was, of course, considerable crossover. An artist such as George Inness began painting in an American mode and later was converted to a European style. Even the most thoroughly American painters—Eakins, for instance—went abroad, and were alert to past and present European artistic traditions.

MORE CONCERNED WITH ART THAN NATURE . . .

Whereas mid-century painters saw their primary obligation to be a faithful if romanticized representation of nature, later artists were more concerned with art than nature. In the late nineteenth century, subject matter broadened beyond an empirical experience of the American scene to include subjective themes. These often arose out of the ancient iconographic imagery of the Western world—from antiquity, the Middle Ages, and the Renaissance. The French Academy in particular played a very important role. The nude figure was the foundation of most French academic art. It had never previously been accepted into American art, but now painters as different as Thomas Eakins and Kenyon Cox found the nude to be essential to their art.

As a new comprehension of the beauty of art in the abstract—of art as light, color, tonal harmonies, brushstrokes, patterns, and rhythms—dawned upon American painters, their art changed significantly. The compulsion to paint landscapes with botanical and geological exactitude, as seen in Frederic Church's *Heart of the Andes* (Fig. 15.12), gave way to suggestive forms, subjective moods, and shimmering hues. To American cosmopolitan painters, styles that had been or were being developed in Europe—from Renaissance art to French academicism, to Barbizon realism and Impressionism—were unselfconsciously accepted as the cultural fountainhead out of which America's own culture should emerge. Even those painters who retained a commitment to the American tradition and to nature and naturalism began to experiment with abstract elements. To this group belong Eastman Johnson, George Inness, Winslow Homer, and Thomas Eakins.

EASTMAN JOHNSON

Eastman Johnson (1824–1906) was born in Lowell, Maine, but his career began in Washington, D.C., with a series of charcoal portraits of prominent people. In 1849, he went to Europe for several years of study, first to Düsseldorf, where

instruction at the Academy reinforced the American's penchant for detailed representation of nature. After two years there, Johnson went to Holland, where he was moved by the rich colors, exciting brushwork, extraordinary play of lights and shadows, and the psychological studies of mood and introspection in the portraits by Rembrandt and Frans Hals. Johnson returned home in 1855 by way of Paris, where he worked briefly with the leading academician of that day, Thomas Couture.

Although Johnson settled in Washington, his début was at the National Academy of Design in New York in 1859. There he exhibited *Life in the South*, or *Old Kentucky Home* as it has come to be called (Fig. **23.1**). The picture, which reportedly represents a scene behind Johnson's father's house in Washington, won him instant recognition. The masterful, detailed execution of the painting reflects his

Düsseldorf training, and it was praised for its accuracy and truthfulness. This was no abolitionist attack upon the issue of slavery, but a genre scene rich in homey vignettes of courting lovers, dancing children, and the melodious strumming of the banjo player.

Throughout the 1860s, Johnson worked in this highly detailed, anecdotal, genre manner, often portraying American rural scenes, as in *Corn Husking* (1860, Everson Museum of Art, Syracuse University). In the 1870s, his palette and technique underwent a profound change. Gone are the bright colors of Düsseldorf derivation, to be replaced by the somber tones of Rembrandt. Johnson continually explored the abstract components of his art—light, shadow, and color—and, rejecting detailed objectivity, he delved into the subjective mood. The art of painting—rather than that of depicting nature—and the portrayal of the innermost

23.1 Eastman Johnson, *Old Kentucky Home,* or, *Life in the South,* 1859. Oil on canvas, 36 × 45in (91.4 × 114.3cm). Courtesy The New-York Historical Society, New York City.

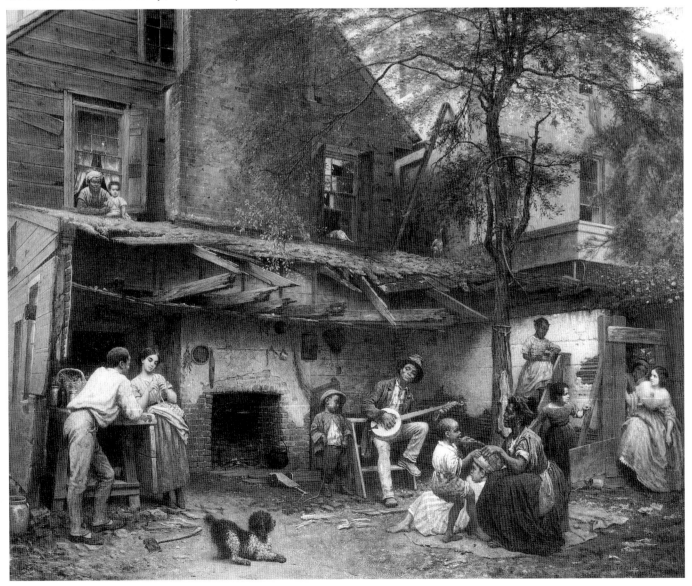

23.2 Eastman Johnson, *In the Fields*, 1875–80. Oil on academy board, 17¾ × 27½in (45.1 × 69.9cm). Detroit Institute of Arts, Detroit, Michigan.

thoughts of the soul became his goal.

The change is evident if we contrast *Old Kentucky Home* with *In the Fields* (Fig. **23.2**). This is a study for *The Cranberry Harvest, Nantucket Island* (1880, Timken Art Gallery, San Diego, California). The larger, finished picture is certainly more detailed. But *In the Fields* is concerned mainly with patterns created by the intense, raking light of a setting sun and the resultant shadows; with the effect upon color of the presence or absence of light; with abstract treatment of the cranberry bog in which the figures stand, rather than objective, detailed descriptions; and with the silence of the scene, and the introspection of the figures. In a study such as this, Johnson discovered avenues of painting that were unknown to his mid-century predecessors.

GEORGE INNESS

George Inness (1825–94) also began his career working in the tight, detailed style of the Hudson River School, as is evident in one of his early masterpieces, *Lackawana Valley* (1855, National Gallery of Art, Washington, D.C.). Born at Newburgh, New York, and raised in Newark, New Jersey, Inness first studied in New York with Regis Gignoux (1816–82) of the Hudson River School. Inness's first trip to Europe in 1850 was spent mostly in Italy. On the second visit in 1853, he went to France where he, like William Morris Hunt a little earlier, was greatly influenced by the painters of the artists' community of Barbizon, located southeast of Paris near Fontainebleau.

Some of the most prominent features of the Barbizon school—its tonal qualities, color, loose brushwork, and softness of form as seen in landscapes by Théodore Rousseau—soon began to appear in Inness's pictures. They

can, in fact, be seen in *Delaware Water Gap*, which is of the *plein air* tradition (painting out in the open air, away from the studio, under natural light) (Fig. **23.3**). Instead of concentrating on a precise depiction of nature, Inness softened the details to explore coloristic and tonal harmonies. Anecdotal passages—so important to the landscape painters of the Hudson River School—have already given way to exploration of formal qualities. The large trees at the left, for example, are not treated as botanical specimens or symbols of innocent American wilderness, but simply as a bold patch of green pigment, counterbalancing a band of similar harmonies stretching across the right side of the picture.

In 1863, Inness left the hustle and bustle of New York to move to an artists' colony at Eagleswood, New Jersey. There he met the painter William Page (1811–85), who introduced him to the spiritualism of the eighteenth-century Swedish philosopher Emanuel Swedenborg, who had stressed that the spiritual world was as much a reality as the material world. Inness's great painting of 1865, *Peace and Plenty* (Metropolitan Museum of Art), may be an early manifestation of his concerns with spiritual harmonies in nature. Hereafter, Inness's landscapes begin to be personal visions of the natural world, often imbued with a mood of wellbeing. The evolution within his style continued, as landscapes became less dependent on the physical, natural world. Throughout the 1870s and 1880s, Inness's style became increasingly painterly, until physical form almost dissolved into vaporous arrangements and harmonies of color, air, light, and pigment. These characteristics are apparent in *Early Autumn, Montclair* (Fig. **23.4**). The poetic, spiritualistic vision of nature becomes all the more obvious if this picture is compared with Frederic Church's *Heart of the Andes* (Fig. **15.12**).

23.3 George Inness, *Delaware Water Gap*, 1861. Oil on canvas, 36 × 50⅛in (91.4 × 127.2cm). Metropolitan Museum of Art, New York City.

23.4 George Inness, *Early Autumn, Montclair*, 1891. Oil on canvas, 30 × 45in (76.2 × 114.3cm). Delaware Art Museum, Wilmington, Delaware.

IN THE BARBIZON MOOD

William Morris Hunt (1824–79), brother of the architect Richard Morris Hunt, was instrumental in introducing French art—particularly of the Barbizon school—into the mainstream of American painting and to American collectors. In the late 1850s and early 1860s this offered to patron and painter an alternative to the entrenched Hudson River School. Hunt's artistic ability revealed itself while he was a student at Harvard College. When a respiratory ailment necessitated the mandatory ocean voyage, his mother took him to Europe in 1843, where he first studied sculpture in Rome, then spent several months at Düsseldorf before settling in Paris. In the French capital, Hunt's interest shifted from sculpture to painting under the influence of Thomas Couture, with whom he worked for five years.

Of even greater impact was the art of Jean-François Millet (1814–75), leader of the little colony of painters—renegades from the official academic art establishment in Paris—at Barbizon, a rural community near the forests of Fontainebleau, about 40 miles (64 km) southeast of Paris. These painters—Millet, Jean-Baptiste Camille Corot (1796–1875), and Théodore Rousseau (1812–67), among others—rejected what they felt was the aesthetically depleted academic tradition. They preferred instead to paint directly from nature, preferably out in the open rather than in the studio, and to find their subject matter in real life. Leaving the studios of Paris and the Ecole des Beaux-Arts, they found a kind of noble dignity in the humble lives of peasant folk, captured beautifully in Millet's famous pictures *The Sower* (1850, Museum of Fine Arts, Boston), *The Gleaners* (1857, Musée d'Orsay, Paris), and *The Angelus* (1859, Musée d'Orsay, Paris). There is a monumentality to Millet's figures which results from a largeness and simplification of form, a reduction of detail, and a grave seriousness arising from the low-hued palette of browns, umbers, and other earth tones. These features, plus the unmelodramatic treatment of a rural subject, are seen in *The Belated Kid*, painted in America two years after Hunt returned from Europe (Fig. 23.5).

In Boston, Hunt persuaded patrons such as Martin Brimmer to collect paintings of the Barbizon school, and he was influential in sending a whole group of younger American painters to study at Barbizon instead of Paris, Rome, or Düsseldorf. When these artists returned, they enlarged the ranks of devotees of this special brand of French art. Men such as J. Foxcroft Cole (1837–92), Winckworth Allan Gay (1821–1910), and Robert Loftin Newman (1827–1912) worked in an essentially Barbizon style all their lives.

WINSLOW HOMER

The realist Winslow Homer (1836–1910) also underwent a major change in his painting style between the early and late periods of his career. In his native city of Boston, Homer was apprenticed to a lithographer named Buford. After only two years he moved to New York City, in 1859, to become a freelance illustrator. His formal education in art amounted to little more than a few evening classes at the National Academy of Design. He owned and presumably read a translation of Eugène Chevreul's *The Laws of Contrast of Color* (1859). Otherwise, Homer learned mainly from his own acute observation and an intense study of nature. He was a brilliant recorder, capturing the essence but eliminating the unessential, and avoiding any hint of sentimentality. Perhaps Homer's experience as a freelance illustrator—a reporter detached from his subject—contributed to his realistic style. Some of his contemporaries found his subjects ugly and his realism unrefined. In any case, with Homer, the American tradition of realism powerfully asserts itself.

Soon after his arrival in New York, Homer began making illustrations for popular periodicals such as the newspaper *Harper's Weekly*, with which he was associated until 1875. He provided the drawn or painted illustration from which someone else would produce the wood-engravings. When the Civil War broke out, Homer was sent to the army encampments to record events. He selected the quiet moments of camp life, rather than the heated pitch of battle or

23.5 William Morris Hunt, *The Belated Kid*, 1857. Oil on canvas, 54 × 38½in (137.2 × 97.8cm). Museum of Fine Arts, Boston. Bequest of Elizabeth Howes.

23.6 Winslow Homer, *Long Branch, New Jersey*, 1869.
Oil on canvas, 16 × 21¾in (40.6 × 55.2cm). Museum of Fine Arts, Boston. The Hayden Collection.

the brutal views of corpses strewn about a battlefield such as Mathew Brady had photographed. During these war years, Homer began to paint in oils. His masterpiece of the Civil War is *Prisoners from the Front* (1866, Metropolitan Museum of Art).

In 1866, the war over, Homer went to France, where he spent nearly a year, mostly in Paris. There he undoubtedly became acquainted with the work of Gustave Courbet (1819–77) and Edouard Manet (1832–83), whose realism and brushwork he would have appreciated. Their art, too, was based on direct observation of nature, with a special interest in the effects of light on form. Homer's early style is seen in a picture that illustrates these points very well—*Long Branch, New Jersey*, of 1869 (Fig. 23.6). Long Branch was one of the most popular beach resorts of the mid-Atlantic region during the President Grant era. Homer was drawn to subjects of young women engaged in casual social activities, such as playing croquet, or strolling along bluffs overlooking the ocean. In *Long Branch*, his style is realistic yet painterly, informal in its composition, and skillful in the handling of the effects of light upon color and form. Homer remained a realist throughout his career, and his ability to suggest reality with the stroke of a brush, rather than through an assemblage of detail, is already evident.

In the 1870s one of Homer's favorite themes was the life of boys at play, at work, or idly musing, sometimes on a farm, other times around a harbor. *Snap the Whip* is a splendid example of such work, which reached a wide popular audience when it was engraved as an illustration for *Harper's Weekly* (Fig. 23.7). A group of nine boys are playing their game during recess from the one-room school building

23.7 Winslow Homer, *Snap the Whip*, 1872. Oil on canvas, 22 × 36in (55.9 × 91.4cm).
Butler Institute of American Art, Youngstown, Ohio.

behind them. The scene is set on the floor of a valley, probably somewhere in the Adirondack Mountains, which Homer had been visiting since 1870. In the middle distance, at the left, two girls observe the frolicking boys. Feminist art-historical theory might interpret this motif as females— even in the games of youth—already being shut out from or sidelined at a male-dominated event, in preparation for adult life. To be sure, American society in the 1870s was controlled by men. *Snap the Whip* focuses on an undramatic, unheroic, but thoroughly American subject. Here are the rural urchins, as common as a board fence, of whom Henry James complained.

Homer and High Drama

Prior to 1881, Homer had seldom explored drama in his art. But in that year he went to England and settled in a fishing village near Tynemouth, where he began to paint the folk who daily struggled with the North Sea for their survival. Without indulging in sentimental melodrama, Homer began to paint their stoic confrontation with the forces of nature. In solemn, leaden tones, deprived of the sunlight and bright color of earlier pictures, his art now rose to heroic high drama.

The Life Line shows an unconscious woman being transported from an unseen foundering ship to another vessel, she and her rescuer tenuously supported by a tautly stretched line (Fig. 23.8). The monumental figures, swinging precariously amid violent swells that crash upon treacherous rocks, are suspended between the unseen wreck (flapping sails are visible in the upper corner) at the left and the safety of the rescue ship at the right, also out of view. In such pictures Homer began to explore psychological drama, with undertones of death and masked sexual themes. The tenor of Homer's art deepened significantly in the 1880s. The artist continually developed tense drama in his art,

particularly in scenes of the sea, such as *The Fog Warning* (1885, Museum of Fine Arts, Boston), but also in animal pictures such as *The Fox Hunt* (1893, Pennsylvania Academy of the Fine Arts, Philadelphia).

Homer's regular trips to the Adirondack Mountains provided him with innumerable subjects. Some of his best watercolors resulted from those excursions. He loved the woods, the crafty huntsmen, and the oldtime fisherman who would drift in his rowboat until he sensed the presence of some great bass darting in the cool blue water of the mountain stream (Fig. 23.9). No one at the time surpassed Homer in his command of watercolor painting, which is a very difficult medium since mistakes cannot be painted over the way they can be with oil paints, so perfect execution is required with each brushstroke. Homer's fresh, sparkling, colorful images represent one of the aesthetic pinnacles of late-nineteenth-century American painting.

Beginning in the mid-1880s, Homer frequently escaped the New England winters by going to Bermuda or the Caribbean area, to Cuba, Nassau, or Florida. The landscape, seascape, and genre scenes of the local people inspired in him some of the most brilliant watercolors he ever executed. The bright sunlight, the blue-green waters, and the colorful clothing of the people with their black skin caught his eye. The luminous coloristic effects of watercolors were sometimes transferred to his works in oil, as in *The Gulf Stream* (Fig. 23.10). Here, the drama of a man's struggle for survival against the sea and awesome powers in nature is again the underlying theme. A black man rests, exhausted and helpless, on the deck of his small boat, which has lost both mast and rudder—that is, all means of controlling the movement of the boat, which drifts at the whim of the waves and the current of the Gulf Stream. He looks with concern at the swirling funnel of the waterspout on the horizon at the

23.8 Winslow Homer, *The Life Line*, 1884. Oil on canvas, 28¾ × 44⅝in (73 × 113.4cm). Philadelphia Museum of Art.

23.9 Winslow Homer, *The Adirondack Guide*, 1894. Watercolor on cream wove paper, 15⅛ × 21½in (38.5 × 54.7cm). Museum of Fine Arts, Boston. Bequest of Nathaniel T. Kidder.

23.10 Winslow Homer, *The Gulf Stream*, 1899. Oil on canvas, 28⅛ × 49⅛in (71.3 × 124.6 cm). Metropolitan Museum of Art, New York City.

right, and a triangular tension is set up between the raging wrath of the storm, the possible rescue by the ship seen on the distant horizon at the left, and the huge, foreboding sharks that have already begun to circle the vulnerable little craft. Which will get to him first—sharks, storm, or rescue ship? But, as usual with Homer, there is no saccharine melodrama, which is part of the power of the picture.

Homer moved out of New York in 1884, and settled permanently in Prout's Neck on the rocky, sea-bashed coast of Maine. The basic elements of nature fascinated him, and he painted a splendid series of pictures of the eternal confrontation of sea and rock—the unending pounding, crashing, and roaring, the silent resistance, the everpresent drenching spray—which seemed to him an heroic struggle of primeval forces of nature. Human presence was not needed, or was dwarfed and overwhelmed if included. Homer did not dissolve matter into vaporous light and color, as was the solution of J. M. W. Turner (1775–1851). Instead, water, air, and rock remain tangible, physical substances—as one would expect of Homer.

THOMAS EAKINS

Realism is the bond between the work of Winslow Homer and that of Thomas Eakins (1844–1916). In fact, Eakins once described Homer as America's greatest painter. Born in Philadelphia, Eakins lived there all his life except for a few years spent in Europe. His study of art began in 1862 at the Pennsylvania Academy, where he first drew from antique casts, but then worked from a live model. Mastery of the nude figure was fundamental to Eakins's art. It was so important that he enrolled in the anatomy course at the Jefferson Medical College.

By 1866, Eakins was in Paris, where he was accepted into the Ecole des Beaux-Arts to study in the studio of one of the leading academic painters and draftsmen of the day, Jean-Léon Gérôme. In 1869, he went to Spain, where he was impressed by the brushwork and realism of the great Baroque painters Diego de Velázquez (1599–1660) and Jusepe de Ribera (1591–1656). Back in Paris he worked under the guidance of Léon Bonnat (1833–1922), whose fluid

23.11 Thomas Eakins, *Max Schmitt in a Single Scull*, 1871. Oil on canvas, 32¼ × 46¼in (81.9 × 117.5cm). Metropolitan Museum of Art, New York City.

brushwork appealed to him, and he briefly studied modeling in clay. On this trip, Eakins also discovered the deep, rich tones and suggestiveness of form in Rembrandt's art, which were among the major influences he carried home to Philadelphia in 1870.

From the very first pictures he painted after his return, Eakins brought a new mode of vision to American art, and a preference for themes which the academic establishment would have found unconventional. An avid outdoorsman, Eakins often painted the activities he loved—rowing and sailing—even though such themes were unsanctioned by the academicians. Other subjects included hunters, baseball players, and prizefighters.

Realism is the foundation for *Max Schmitt in a Single Scull*, and the entire scene is envisioned with a cameralike clarity and objectivity (Fig. 23.11). However, Eakins was actually highly selective, giving only the essentials and eliminating the unessentials, but causing the viewer to believe that all of nature was there in his picture. The landscape is immediately recognizable as an area along the Schuylkill River in Philadelphia. The details of landscape, however, for all their appearance of realism, are merely suggested, and are not in the same sharp focus as the figure of Schmitt. The informality of the composition is equally deceptive. Eakins took great pains to work out details of perspective and of light and color in a whole series of preparatory studies. The brilliant light and color reveal that he had already begun the practice of working out of doors, at least in his studies and sketches, for these are not the artificial light and color of the studio.

It was customary at this time for nude female models to wear masks to conceal their identity, for propriety's sake, while posing in life drawing classes (Fig. 23.12). Many of Eakins's contemporaries found his brutally truthful drawings objectionable and offensive to aesthetic sensibilities that had long been conditioned by academic idealizations of the nude. But being true to nature was fundamental to Eakins's credo as an artist, and he saw beauty in truthfulness such as this. The monumental massing of form and the powerful manipulation of light and shadow also signal pivotal features of his style.

The Gross Clinic *The Gross Clinic* is a brilliantly staged composition. Focusing the viewer's eye precisely where the artist wished, it dramatizes a commonplace event in the life of the famous Philadelphia physician and teacher of surgery, Samuel David Gross (Fig 23.13). Although a commissioned portrait, it was intended to express the full range of Eakins's talents. The scene is set in the surgical amphitheater of Jefferson Medical College, with young medical students seen dimly in the stepped background, including Eakins himself at the right. Dr. Gross holds center-stage, like an actor delivering his grand soliloquy. The light from the unseen skylight is theatrically and masterfully controlled by the artist, drawing attention at once to the surgeon's head and his bloody hand. To one side of him, the attention of his assistants is riveted on the incision in the leg of the

23.12 Thomas Eakins, *Nude Woman Seated, Wearing a Mask*, c. 1875. Charcoal on paper, 24¼ × 18⅝in (61.6 × 47.3cm). Philadelphia Museum of Art.

anesthetized patient, while at the left, a relative of the charity patient, whose attendance during the operation was required by law, withdraws from the bloody sight, shielding her eyes. The picture has its precedents, not only in subject matter but in style, in Rembrandt's *Anatomy Lesson of Dr. Tulp* (1632, Mauritshuis, The Hague, Holland). Much of the canvas area is given over to a low-keyed tonality, allowing the artist to focus attention where he wished by means of the theatrical, spotlight technique for which Rembrandt is famous.

Reaction to *The Gross Clinic* was generally unfavorable, many finding its uncompromising realism objectionable. At the Philadelphia Centennial of 1876 it was refused exhibition space in the art gallery, and was consigned to obscurity in the U.S. Army Post Hospital exhibit.

In general, Eakins's art did not sell well, and he supported himself mainly by teaching at the Pennsylvania Academy and elsewhere. He was appointed to the faculty of the Academy in 1879, and was made director of the school three years later. In 1886, he was dismissed after removing the loincloth from a male model, in order to demonstrate a certain tendon or muscle, in a mixed class of men and women students.

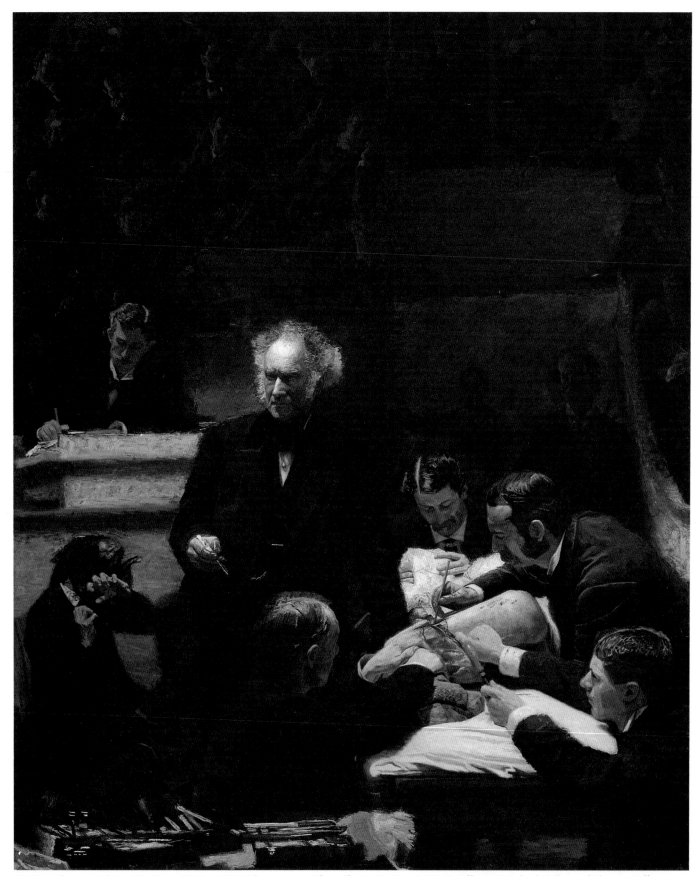

23.13 Thomas Eakins, *The Gross Clinic*, 1875. Oil on canvas, 8ft × 6ft 6in (2.44 × 1.98m). Jefferson Medical College of Thomas Jefferson University, Philadelphia.

During the 1880s and 1890s, Eakins concentrated on portraiture, not of the commercial potboiler type, but the kind that would allow him to explore and depict the depths of the human soul in introspection—subjects totally absorbed in their own worlds of music, science, literature or some other pastime. Such portraits were seldom commissioned, so the artist was free to experiment as he wished. Examples of these moody, often melancholy portraits are found in *The Pathetic Song* and *Miss Amelia van Buren* (Figs. **23.14** and **23.15**). In *The Pathetic Song*, Eakins was painting people he knew well—for example, the pianist is Susan Hannah Macdowell, one of Eakins's students, who in 1884 would become his wife. The somber mood of the picture, the withdrawal of the people into their own little concert, the intense concentration of each person on his or her performance were the things upon which Eakins focused. Amelia van Buren, conversely, sits alone, totally absorbed in her own thoughts. An overwhelming quiet—a characteristic of many of Eakins's portraits—pervades the canvas, permitting no distraction from the subject's deep, somber reverie. Eakins felt compelled to plumb the depths of human emotional and psychological experience. At about

23.15 Thomas Eakins, *Miss Amelia van Buren*, 1886–90. Oil on canvas, 45 × 32in (114.3 × 81.3cm). © The Phillips Collection, Washington, D.C.

23.14 Thomas Eakins, *The Pathetic Song*, 1881. Oil on canvas, 45 × 32in (114.3 × 81.3cm). Corcoran Gallery of Art, Washington, D.C.

the same time that he was painting Miss van Buren's portrait, he made a series of photographs of her which are related in form and mood to the painting.

By the mid-1880s, Eakins was using photographs as aids in developing his paintings. While use of the photograph never decreased the painterliness of Eakins's style, it unquestionably intensified its realism. The informality of the camera's image also appealed to him.

If the general public and most critics did not care for the vitalized realism of Eakins's art, his students recognized its greatness, and his influence appears in their work. Thomas Anshutz (1851–1912), for example, studied with Eakins at the Pennsylvania Academy, then taught with him there, and became his successor as director of the school after Eakins's dismissal in 1886. Anshutz's *Steelworkers—Noontime* (Fig. **23.16**) is as unconventional in subject matter, according to the academic establishment's hierarchy of themes, as Eakins's prizefighters or baseball players. No theme inspired by the art of antiquity or the Renaissance, or by great literature here—this is a slice of real life, with anonymous, unimportant, uncultured men aimlessly milling about.

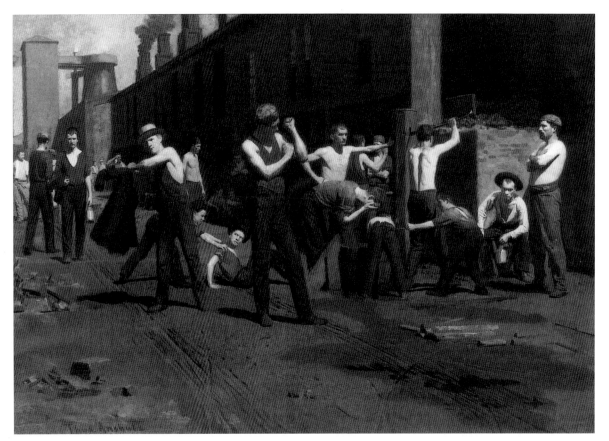

23.16 Thomas Anshutz, *Steelworkers—Noontime*, 1880. Oil on canvas, 17⅛ × 24in (43.3 × 61.2cm). Fine Arts Museums of San Francisco.

Anshutz was probably drawn to this subject by its vitality, and because of the opportunity to work with the human figure, sometimes partially nude, in a variety of poses. It is not a great step from *Steelworkers—Noontime* to the art of the Ashcan school, several members of which—including Robert Henri and John Sloan—passed through Philadelphia, where they were influenced by the art of Eakins and Anshutz.

EXPATRIATES AND COSMOPOLITANISM

Realism was not the only potent force in American painting in the late nineteenth century, for there were many artists who associated themselves with a variety of international, cosmopolitan art movements. Numerous foreign styles were introduced to the mainstream of American painting, mainly by American expatriate painters studying abroad. American artists contributed significantly to the international movements, and artists such as Whistler and Sargent were as well-known as any painter of their day. In their work—as well as that of the American Impressionists, the Tonalists, the Symbolists, and so forth—realism is of little concern.

JAMES ABBOTT McNEILL WHISTLER

Although born in America, James Abbott McNeill Whistler (1834–1903) was actually an international figure. By the age of nine, he was taken by his family to Russia, where his father worked as a railroad engineer. Except for about six years spent in the United States, from 1849 to 1855, he lived abroad. Whistler settled first in Paris, where he took up a Bohemian lifestyle and became an artist. His early work was greatly influenced by the French realists Gustave Courbet and Edouard Manet, both of whom he knew. He also painted landscapes along the Normandy coast with Charles Daubigny (1817–78). After one of his pictures was rejected at the Salon of 1859, Whistler moved to London, where he came into contact with Dante Gabriel Rossetti and the Pre-Raphaelite Brotherhood. He and Rossetti shared an interest in Japanese prints and porcelain, the patterning and spatial features of which had a profound impact on Whistler's art.

After returning to Paris, Whistler painted *The White Girl* (Fig. 23.17), which was rejected at the Salon of 1863. When he showed it at the now-historic Salon des Refusés that same year, it caused greater notoriety than even Manet's *Déjeuner sur l'herbe* (1863, Musée d'Orsay, Paris). *The White Girl* is an early experiment in white on white: the model—Whistler's mistress Joanna Heffernan—wears a white dress and stands against a white background. It is a portent of

things to come, as ten years later the artist added the subtitle *Symphony in White, No. 1*, stressing the importance of the abstract elements over subject matter. The picture is not merely a formalist exercise, for there are enigmatic, expressive, and even erotic undercurrents wrought into the image which reveal the influence of the Pre-Raphaelites. Critics have seen both an innocence and a loss of innocence, alluding to the white lily—symbol of virginity—held in the left hand and the bestial and threatening stare of the bear's head on the rug.

23.17 James McNeill Whistler, *The White Girl (Symphony in White, No. 1)*, 1862. Oil on canvas, 7ft½in × 3ft 6½in (2.15 × 1.08m). National Gallery of Art, Washington D.C.

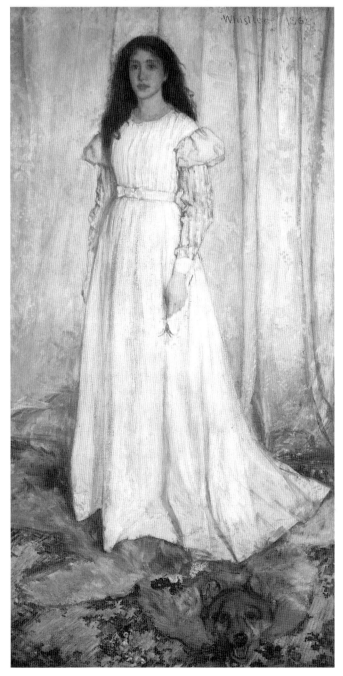

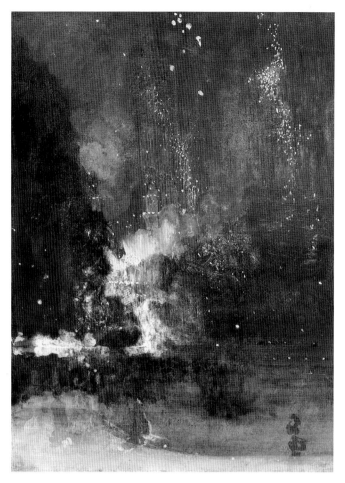

23.18 James McNeill Whistler, *Nocturne in Black and Gold: The Falling Rocket*, c. 1874. Oil on oak panel, 23¾ × 18⅜in (60.3 × 46.7cm). Detroit Institute of Arts, Detroit, Michigan.

Whistler's fascination with abstract qualities found outlet in a number of "symphonies" and "nocturnes" in the years that followed *The White Girl*, as, for instance, in *Nocturne in Black and Gold: The Falling Rocket* (Fig. **23.18**). In this representation of a rocket display over the River Thames, physical reality gives way to light, color, and air—those qualities that had so fascinated Turner many decades earlier—and to an adventurous use of pigment upon the surface of the canvas. This was the painting that drew the hostile comment from John Ruskin—to whom naturalism was all-important—that Whistler had flung "a pot of paint in the public's face." The artist sued for libel, won the case after a much-publicized trial, but was awarded only one farthing in damages.

Whistler's concern with formal painterly problems—one can almost say abstraction—is further demonstrated in the picture popularly known as *Whistler's Mother*. Its actual title, however, is *Arrangement in Gray and Black, No. 1* (1871, Musée d'Orsay, Paris). It is less a work of familial devotion than a formal exercise in tonalities and patterns. The influence of Oriental art can be seen; Whistler painted several pictures that were inspired by Japanese themes.

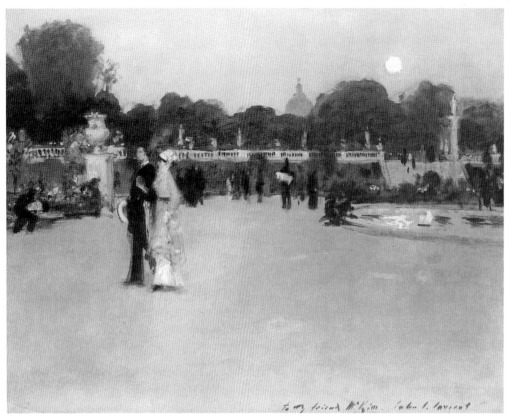

23.19 John Singer Sargent, *Luxembourg Gardens at Twilight*, 1879. Oil on canvas, 29 × 36½in (73.7 × 92.7cm). Minneapolis Institute of Arts.

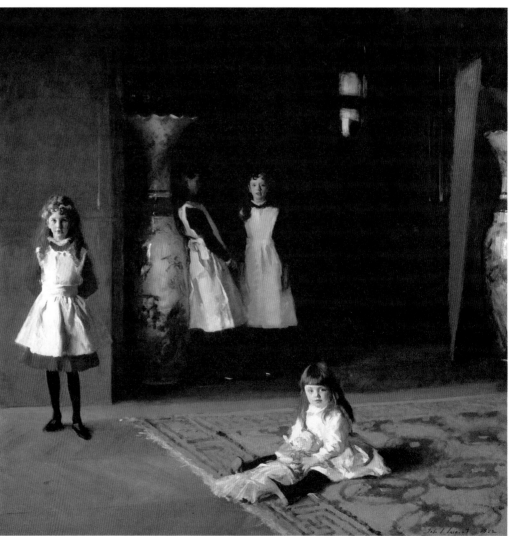

23.20 John Singer Sargent, *The Daughters of Edward Darley Boit*, 1882. Oil on canvas, 7ft 3in × 7ft 3in (2.21 × 2.21m). Museum of Fine Arts, Boston. Gift of Mary Louisa Boit, Florence D. Boit, Jane Hubbard Boit, and Julia Overing Boit, in memory of their father, Edward Darley Boit.

JOHN SINGER SARGENT

John Singer Sargent (1856–1925) was born in Florence, Italy, while his wealthy and cultured parents were living abroad. He was educated mainly in Italy and France, and traveled to many other countries of Europe before he first visited the United States when he was twenty. By then Sargent had already begun to study art, in the Parisian atelier of the noted portraitist Emile Auguste Carolus-Duran, who had his students paint directly on canvas from observation, without preparatory studies. This led to the fluid, painterly brushstroke that would characterize Sargent's style all his life.

One of the early works that demonstrates the freedom and looseness of the technique is the *Luxembourg Gardens at Twilight*—an informal composition with figures, urns, trees, and balustrades, all rendered in broad, suggestive brushstrokes (Fig. 23.19). Coloristically, it is a symphony in cool gray tones. Compositionally, the two strolling figures at the left, who are about to walk out of the picture, are balanced by the red-orange orb of the sun seen through a haze. The fleeting moment, informality, and everyday quality of the scene suggest Sargent's familiarity with the early work of the Impressionists.

Another formative influence on Sargent was a trip to Spain in 1879, when he discovered the seventeenth-century master Velázquez, whose naturalism and brushwork appealed to him. The Spanish experience led to one of his bestknown works, *El Jaleo* (1882, Isabella Stewart Gardner Museum, Boston). Sargent traveled to Holland in 1880, where the art of another seventeenth-century painter, Frans Hals, impressed him greatly. In Paris, Sargent had most probably seen the contemporary work of Edouard Manet as well.

All of these influences blended into his own personal style, which received its first real test with the commission to paint a portrait of the daughters of his friend and fellow-artist Edward Darley Boit (Fig. 23.20). Sargent's swashbuckling brushwork and the asymmetrical composition, with empty areas surrounding the figures and the dark void behind them, were too unconventional for most critics. Their reaction to it when it was exhibited at the Paris Salon of 1883, however, focused attention on the young American for the first time. Sargent's superb understanding of the use of color is seen in the balancing of the red-orange gash of the standing screen at the right (virtually reduced to an abstract color-patch) with the red of the little girl's dress at the left. The craze for Oriental art that had swept Paris is indicated by the furnishings of the Boit apartment, in the huge blue-and-white Japanese porcelain vases, and the Chinese carpet.

It was not long before Sargent again found himself at the center of controversy, this time brought on by the manner in which he had painted the image of one of Paris's beauties, Madame Gautreau (1884, Metropolitan Museum of Art). The portrait, known as *Madame X*, is the quintessence of late-nineteenth-century feminine elegance and refinement.

The profile is so striking that it belongs to the rarefied category of the ancient Egyptian queen Nefertiti. But the bare shoulders and plunging neckline of the black gown which the artist created in the portrait were too daring, and when the picture was exhibited at the Salon of 1884, even Parisian society was shocked—Judith Gautreau and her husband most of all.

Response to *Madame X* was so unfavorable that Sargent moved to London that same year. There, he became the darling of society, most of whom wanted their likenesses painted by the gifted genius who had hit upon a portrait formula that reminded them of those golden eras of English painting when Van Dyck, Reynolds, Gainsborough, and Lawrence captured the very essence of British aristocracy. His fashionable style can be seen in *The Wyndham Sisters*, painted at the height of his fame (Fig. 23.21). It is a huge picture, worthy of the English countryhouse tradition of portraiture in scale as well as quality. Elegance and refinement are the very foundation of such art.

After receiving the commission in 1890 for a set of murals for the new Boston Public Library (Fig. 24.13), Sargent crossed the Atlantic frequently in connection with that

23.21 John Singer Sargent, *The Wyndham Sisters: Lady Elcho, Mrs. Adeane, and Mrs. Tennant*, 1899. Oil on canvas, 9ft 7in × 7ft⅛in (2.92 × 2.14m). Metropolitan Museum of Art, New York City.

23.22 John Singer Sargent, *Mr. and Mrs. Isaac Newton Phelps Stokes*, 1897. Oil on canvas, 7ft¼in × 3ft¾in (2.14 × 1.01m). Metropolitan Museum of Art, New York City.

project, and commissions for portraits of America's leading families awaited his arrival. Sometimes his turn-of-the-century equivalent of the jetset clientele would find him in Venice or in London, as in *Mr. and Mrs. Isaac Newton Phelps Stokes* (Fig. **23.22**). The artist had originally painted only a single portrait of Edith Minturn Stokes wearing a blue satin evening gown, but one day when she arrived at his London studio he was so struck by her attire—that seen in the picture—that he scrapped the first attempt. The next stage was to have her accompanied by a Great Dane, but this, too, was painted out to arrive at the ultimate form we now see, with Mr. Stokes as a rather shadowy vision behind his wife. Sargent was wellskilled in capturing the energetic vivaciousness of Edith Stokes, who seems totally animated and informally fashionable.

By 1900, Sargent had grown tired of society portraiture, and he began to seek new avenues of artistic expression, largely for his own personal satisfaction. He took up watercolors and excelled in them. At their best they rival those painted by Winslow Homer.

HENRY OSSAWA TANNER

Henry Ossawa Tanner (1859–1937) was an African-American artist who found acceptance and a nonprejudiced environment in Paris that were not available in America. The son of a minister of the African Methodist Episcopal Church, Tanner grew up in Philadelphia where, in 1879, he enrolled at the Pennsylvania Academy to study with Thomas Eakins. While Eakins encouraged him, not all of his fellow students accepted him. In 1891, Tanner left for Paris, and thereafter the French capital would be more a home to him than Philadelphia. At the Académie Julian, his teacher was Benjamin Constant, whose broad, loose brushwork is often apparent in Tanner's work. Although he frequently painted genre scenes, his deep religious convictions soon surfaced in

23.23 Henry Ossawa Tanner, *The Seine*, 1902. Oil on canvas, 9 × 13in (23 × 32.9cm). National Gallery of Art, Washington, D.C.

paintings of scriptural subjects. His richly painted *Resurrection of Lazarus* was exhibited at the Paris Salon of 1897, and thereafter it was purchased by the French government for the Luxembourg Museum.

In that same year, Tanner made his first trip to the Near East, financed by the wealthy businessman and patron of Philadelphia, Rodman Wanamaker, who was then living in Paris. For many years after, the barren landscapes and exotic costumes and cultures of that region provided subject matter for his paintings, which sometimes reveal an affinity for the mysterious imagery of the contemporary Symbolist movement. The richness of Tanner's brushwork and his attachment to his beloved Paris are seen in *The Seine*, a scene looking from a quay across the river, turned golden in the twilight, toward the Pont Royal with its wide, graceful arches, with the lavender silhouette of the Louvre in the distance (Fig 23.23). The painting is a study in harmonies of hue in the traditions of Whistler and Monet. Further success and recognition came to Tanner. In 1909 he was elected an associate member of the National Academy of Design in New York, the same year as Mary Cassatt.

MARY CASSATT

Mary Cassatt (1844–1926), who was born near Pittsburgh, was taken to Europe by her parents when she was still a child. Returning to Philadelphia, she enrolled at the Pennsylvania Academy in 1861, where she studied for four years. Dissatisfied with drawing from casts, she left in 1866 for Paris, which would be her home for most of the rest of her life. There she studied with Jean-Léon Gérôme, copied works by Old Masters—especially Velázquez and Hals—and admired the work of Gustave Courbet, Edouard Manet, and especially Edgar Degas (1834–1917). The latter invited Cassatt in 1877 to join the painters who became known as the Impressionists. She was the only American actually to be a member of that group. Several times Cassatt sent her work to their Salon des Indépendants in the late 1870s and early 1880s.

Cassatt was closest to Degas, both in her friendship and in the style of her work. Like the Impressionists generally, she chose subjects that were casual, informal vignettes of daily life—scenes at the theater or opera, a boating party, a carriage ride through the Bois de Boulogne, or the intimate relationship of a mother and child. The latter became a favored theme: *The Bath* is a splendid example of her treatment of the subject (Fig. 23.24). Impressionist, too, is the use of bright colors and the absence of dark shadows. Another influence of great importance is seen here as well. In 1890 Cassatt saw the large exhibition of Japanese prints held at the Ecole des Beaux-Arts, and the bold patterning seen in *The Bath* reflects the powerful impact the experience had on her. Here it is seen in the union of diverse patterns in the carpet, the woman's gown, the wallpaper, and the decorated chest, and even the design on the waterpitcher has an Oriental flavor. Cassatt is known to have had a

23.24 Mary Cassatt, *The Bath*, 1891–2. Oil on canvas, 39½ × 26in (100.3 × 66cm). Art Institute of Chicago.

collection of prints by Hokusai, Hiroshige, Utamaro, and other celebrated Japanese printmakers—she was also a gifted graphic artist.

Cassatt enjoyed open-air scenes where the natural sunlight flooded the canvas, which became saturated with bright colors, as in *The Boating Party* (Fig. 23.25), a picture reminiscent of Edouard Manet's *Boating* (1874, Metropolitan Museum of Art). The man wears dark blue and purple attire, and sits in a yellow-green boat set against the brilliant blue of the water. The woman's dress is a soft blue, the child's is pink. This bold patterning of color areas is primarily for decorative effect, and in that respect differs from the expressive experiments then being carried out by Paul Gauguin (1848–1903).

After about 1900, Cassatt was instrumental in the formation of the collections of several wealthy Americans who visited Paris—the H.O. Havemeyers, for example. She induced many such people to include works by Courbet,

23.25 Mary Cassatt, *The Boating Party*, 1893–4. Oil on canvas, 35½ × 46⅛in (90.2 × 117.1 cm). National Gallery of Art, Washington, D.C.

Manet, Monet, and Degas in their collections. Late in life, she developed cataracts and had to stop painting. She died at her country home outside Paris.

Cassatt is a good example of the American painter who chose to live the expatriate life abroad and partake of the exciting new influences bursting upon the art world as it made its way toward modernism. Rejection of historic styles, a fascination with light and color for their own decorative values, participation in new experiments, the discovery of new aesthetic heroes such as Hiroshige or Hokusai—all of these signal the spirit of change that characterized her time. Other American artists chose to return to their native land, bringing the new styles with them.

CHAPTER TWENTY-FOUR

PAINTING:

AMERICAN IMPRESSIONISM, AMERICAN RENAISSANCE, AND *TROMPE L'OEIL* REALISM

Unlike the way in which romantic naturalism had served nearly all aspects of mid-century painting, throughout the last three decades of the nineteenth century American painting ceased to be governed by one all-encompassing spirit. Now, a great diversity existed, usually related to the European art centers. After 1870, young American artists increasingly went to Paris instead of Rome, to Munich instead of Düsseldorf. They also studied new masters, such as Velázquez in Spain and Hals in Holland. American taste ran the gamut from French Impressionism to academic revivalism, from Tonalism to the mysticism and abstraction of Elihu Vedder, Ralph Blakelock, and Albert Pinkham Ryder, and to the traditional realism that appears in the new form of the *trompe l'oeil*.

Impressionism came late to America, but, once here, it became enormously popular among vast numbers of paint-ters and collectors. It had been established in Paris in the 1870s as an alternative to the French academic manner. Its artists preferred sunlight to shadows; light, air, and color as experienced out of doors; the fleeting daily scene as opposed to mythological gods or religious icons; the image as registered in an instant on the retina of the eye rather than the studied composition of the academic painters, and a technique consisting of a multicolored patchwork of tiny brushstrokes. Among the leading Americans who adopted Impressionism and brought it back to the United States were William Merritt Chase, J. Alden Weir, Theodore Robinson, Cecilia Beaux, and Childe Hassam.

IMPRESSIONISM IN AMERICA

WILLIAM MERRITT CHASE

William Merritt Chase (1849–1916) was one of the leading figures of his day, as a painter, teacher, and participant in artists' organizations. A native of Indiana, he studied briefly in Indianapolis before he went to New York in 1869. Three years later, Chase left for Munich, where at the Royal Academy he acquired the dark palette, the loose, fluid brushstroke, and the heavy **impasto** typical of the Munich school. Throughout his life—even after he had turned to Impressionism—he would return to this dark palette and rich, painterly technique. Chase painted still lifes which reveal the influence of works by the seventeenth-century masters Velázquez and Hals, who were held in highest esteem in Munich.

Back in New York in 1878, Chase took quarters in the Studio Building, where many of the leading painters worked, and began a series of pictures of interiors of artists' studios—environments of cultivated, cosmopolitan taste. *In the Studio* (Fig. 24.2) shows a fashionably dressed young woman seated on a bench beside a richly carved Renaissance-Baroque-style **credenza** (small table used in churches). An Oriental carpet is on the floor and exquisite Japanese fabrics hang on the wall, while shiny brass basins

24.1 William Merritt Chase, *Idle Hours*, c. 1894. Oil on canvas, 25 × 35in (63.5 × 88.9cm). Amon Carter Museum, Fort Worth, Texas.

24.2 William Merritt Chase, *In the Studio*, c. 1880. Oil on canvas, 28⅛ × 40⅟₁₆in (71.4 × 101.8cm). Brooklyn Museum.

and pictures in massive gilt frames abound. A print of Hals's *Malle Babbe, the Witch of Haarlem* (c. 1630, Kaiser Friedrich Museum, Berlin) hangs just to the viewer's left of the credenza. Chase undoubtedly knew and admired that picture, with its slashing brushstrokes, dark palette, shiny metal container, and exotic bird—all of which appear in many of his own works. Here, the method of application of paint is as important as the objects painted.

Chase is perhaps bestknown for his Impressionist canvases of outdoor scenes in Central Park and Brooklyn's Prospect Park, particularly of the area around Shinnecock on eastern Long Island. In *Idle Hours* one finds the Impressionists' palette of bright-blue sky and water, vibrant green grasses, spots of brilliant color—as in the red hat worn by one of the women—and a crisp, sparkling use of white (Fig. 24.1). The whole scene is bathed in fresh air and sunlight. Technical execution consists of myriad strokes of pure color, loosely and freely applied. This is an American version of the coastal scenes that Claude Monet (1840–1926) loved to paint. Impressionist pictures such as this date mainly from the 1890s, lagging behind French Impressionism by a decade or two.

JULIAN ALDEN WEIR

Like Chase, Julian Alden Weir (1852–1919) also turned to Impressionism midway through his career, in the 1890s. Born at West Point, where his father, Robert W. Weir, taught drawing at the Military Academy, he and his brother, J. Ferguson Weir (who also became a painter), had their first lessons at home. After three years of study at the National Academy of Design, J. Alden Weir left for Paris in 1873, where he became a student of Jean-Léon Gérôme at the Ecole des Beaux-Arts, and later discovered the work of Jules Bastien-Lepage. Weir followed the common practice of young painters, the pilgrimage to Holland and Spain to see the work of Frans Hals and Diego Velázquez, whose realism, brushwork, and low-keyed palette he admired.

Soon after returning to New York in 1877, Weir joined Chase as a member of the newly formed Society of American Artists, and began teaching at Cooper Union Women's Art School and at the Art Students League. He returned to Europe frequently in the 1880s, where he overcame an earlier aversion to what he had considered the formlessness of Impressionist pictures. Weir discovered the palette and

brushwork of Manet and the technique and airiness of Monet, and by the early 1890s was himself working in the Impressionist style.

Typical of Weir's work in the mid-1890s is *The Red Bridge*, which depicts a scene on the Shetucket River near Windham, Connecticut, which the artist visited frequently (Fig. **24.3**). Reportedly, Weir had been fond of an old wooden covered bridge that spanned the Shetucket, and on one visit was dismayed to find that it was being replaced by a cast-iron structure. The bright-red paint on the frame appealed to him, however, perhaps because of its contrast with its lush green surroundings. Just as Monet had taken a cast-iron trainshed for one of his most famous subjects, Weir set about painting the bridge. The flickering color and light of a fleeting vision are present, and the surface of the canvas reveals passing sensations of color more than construction of form, space, and matter.

By 1897, Weir was considered one of the leading American painters working in the Impressionist style. In that year he was one of the founders of the Ten American Painters, most of whom were also painting in the French mode.

EARLY AMERICAN IMPRESSIONISTS

One of the first Americans to work in the Impressionist style was Theodore Robinson (1852–96). He, too, arrived at it only after first pursuing other means of expression. Born in Vermont, Robinson grew up in Wisconsin, and first sought formal training in Chicago before settling in New York in 1874, where he studied at the National Academy and the newly founded Art Students League. Two years later, he was in Paris working in the studio of Carolus-Duran, and then with Jean-Léon Gérôme. A few years after that, Robinson was painting in the rural village (but by then famous art center) of Barbizon. He next visited Giverny in the valley of the River Seine, where in 1888 he met Claude Monet. His art soon turned in the direction of that great Impressionist.

Robinson's *Bird's-Eye View of Giverny* is a cluster of simple houses set against the green fields and hedgerows of the French countryside (Fig. **24.4**). Although not exactly Impressionist in technique—he did not build up the visual image through innumerable tiny brushstrokes—the canvas is nevertheless more a visual sensation created in pigment

24.3 Julian Alden Weir, *The Red Bridge*, 1895. Oil on canvas, 24⅛ × 33¾in (61.1 × 85.7cm). Metropolitan Museum of Art, New York City.

24.4 Theodore Robinson, *Bird's-Eye View of Giverny*, 1889. Oil on canvas, 25¾ × 32in (65.4 × 81.3cm). Metropolitan Museum of Art, New York City.

24.5 John Twachtman, *Arques-la-Bataille*, 1885. Oil on canvas, 5ft × 6ft 6⅞in (1.52 × 2m). Metropolitan Museum of Art, New York City.

than a reconstruction of physical matter in an illusionistic space—which is essentially what painting had been since the arrival of the Renaissance. Back in the United States, Robinson applied his essentially Impressionist style to American rural scenes, especially in Vermont.

John Twachtman (1853–1902) was similarly the product of a number of European experiences. Born to German immigrant parents who had settled in Cincinnati, he had his first lessons in art in that city when he entered the studio of Munich-trained Frank Duveneck (1848–1919), who had returned temporarily to the Ohio River town. When Duveneck went again to Munich in 1875, he took Twachtman with him. There, the young American was exposed to the favored dark palette, the broad, fluid brushstroke, the thick application of paint, and the admiration of the work of Velázquez and Hals. In 1881, he toured Holland on a sketching trip with the brothers J. Ferguson and Julian Alden Weir, and in Paris he studied at the Académie Julian. By the mid-1880s, Twachtman had rejected the dark coloration and vigorous brushwork of the Munich school for exercises in subtle tonal harmonies such as *Arques-la-Bataille* (Fig. 24.5). A river scene near Dieppe in Normandy, its

subject and natural form are less important than the opportunity to experiment in monumental and nearly abstract arrangements of soft grays, greens, and blues. Land, river, and sky are reduced to flat tonal patterns that anticipate abstract painting in the next century. Twachtman must have been aware of Whistler's harmonies and nocturnes of the 1870s, for this work has much in common with them. The Japanese influence is felt in the calligraphic treatment of the river-plants in the foreground. Twachtman also seems to have understood the Oriental search for essence in the representation of natural form.

Even after he turned to a more impressionistic way of working in the 1890s, a concern for subtle tonal harmonies remained in Twachtman's art. One of his closest friends in New York, where he was a founding member of the Ten American Painters group, was Theodore Robinson, through whom he may have learned the Impressionist style. Twachtman never received the critical acclaim he hoped for, and he died at age forty-nine.

CHILDE HASSAM

By the time Childe Hassam (1859–1935) painted *Union Square in Spring* in 1896, Impressionism had become one of the thoroughly accepted styles in American art (Fig. **24.6**). Born in Dorchester, Massachusetts, Hassam began his career drawing and cutting commercial woodblock illustrations, and attending classes at the Boston Art Club and the Lowell Institute. By the early 1880s, he had his own studio, where he began to paint scenes of Boston in the rain or snow, employing a dark, somber palette to depict anecdotal vignettes of city life, rendered in careful detail. *Boston Common at Twilight* (1885–6, Museum of Fine Arts, Boston) is a good example of his work of that type.

In 1883, Hassam went to Europe, touring Holland, Spain, and Italy. He returned in 1886, for a three-year period spent mostly in Paris. Back in New York, he worked in an Impressionist manner, with tiny brushstrokes breaking up form into bright flickers of color and light, in momentary

24.6 Childe Hassam, *Union Square in Spring*, 1896. Oil on canvas, 21½ × 21in (54.5 × 53.3cm). Smith College Museum of Art, Northampton, Massachusetts.

glimpses of pleasant city life. Hassam painted New York City the way the French Impressionist Camille Pissarro (1831–1903), for example, portrayed Paris—a place full of gaiety in everyday life, as in Hassam's view of Union Square.

In the early twentieth century, Hassam's work took on a more expressionistic quality, probably as a result of exposure to the work of the Post-Impressionists Vincent van Gogh (1853–90) and Gauguin. His flag series, executed about the time of World War I, is an expressionistic evocation of flag-draped Fifth Avenue, depicted as a fluttering vision of the Avenue of the Allies in active red, white, and blue brushstrokes. Hassam also painted many landscapes outside New York City, such as Old Lyme, Connecticut, and East Hampton, Long Island.

24.7 Cecilia Beaux, *Mr. and Mrs. Anson Phelps Stokes*, 1898. Oil on canvas, 6ft¹⁄₁₆in × 3ft 3⁷⁄₈in (1.83 × 1.01m). Metropolitan Museum of Art, New York City.

CECILIA BEAUX

The early work of Cecilia Beaux (1855–1942) of Philadelphia first reflected the influence of Thomas Eakins, with whom she studied at the Pennsylvania Academy. While spending several years in France in the 1880s, however, she turned to Impressionism. In Philadelphia and New York, Beaux painted portraits in the popular new French style, such as *Mr. and Mrs. Anson Phelps Stokes* (Fig. 24.7). This was painted the year after Sargent painted the portrait of the Stokes's son, Isaac Newton Phelps Stokes, with his wife Edith Minturn (Fig. 23.22), and Beaux's style reflects something of Sargent's manner. Other American Impressionists of this period were Willard Leroy Metcalf (1853–1925), Walter Launt Palmer (1854–1932), Robert Vonnoh (1858–1933), Frank Benson (1862–1951), Edmund Tarbell (1862–1938), and Robert Reid (1862–1929).

MUNICH AS AN ART CENTER: REALISM

A number of American painters chose to go to Munich to study in the 1870s and 1880s. The Bavarian capital was enjoying a boom period following the German victory in the Franco-Prussian War of 1870, and King Ludwig, who emerged the leader of the unified German states, was a munificent patron of the arts. Munich replaced Düsseldorf as an art center, and quickly became a rival to Paris itself. The celebrated picture collection displayed at the Alte Pinakothek contained the usual Italian Renaissance painters, but of even greater importance, as far as the Bavarian Royal Academy was concerned, it had an excellent selection of works by the greatest of the seventeenth-century masters—Rembrandt and Hals, Velázquez and Murillo—which students were encouraged to copy. Karl von Piloty became director of the Academy in 1874, and thereafter put his realism stamp on the curriculum. Wilhelm Leibl was the leading teacher, and he, like Wilhelm von Diez, advocated an undramatic realism.

These men and their students admired the work of Edouard Manet and, especially, Gustave Courbet. Courbet's visit to Munich in 1869 gave sanction to the unsentimental realistic style that prevailed there. By 1872, there were reportedly forty students from the United States in the Bavarian city, and they had even organized their own American Art Club.

Frank Duveneck (1848–1919) was one of the first students from America to arrive in Munich in 1870. Born in Covington, Kentucky, he had first been a signpainter. His yearning for formal artistic training led him to Bavaria, where his style was formed—a dark palette, ordinary subject matter, and unsentimental realism, with a rich, fluid brushwork that found its model in the art of Hals and Rembrandt, Manet and Courbet. Duveneck enrolled in the studio of

Wilhelm Leibl, and also studied with Wilhelm von Diez. All of these compatible influences resulted in *Whistling Boy* (Fig. 24.8). A local youth served as model in this virtuoso display of painterly brushwork and fluid impasto, yet the subject remains unsentimentalized. Another of Duveneck's early works is the wellknown *Turkish Page* (1876, Metropolitan Museum of Art), which was painted in the Munich studio of his friend William Merritt Chase, a studio which abounded in exotic objects, as seen in the picture.

In America, Duveneck gained a reputation as a teacher, chiefly in Cincinnati, but also in Chicago and New York. Through his teaching he introduced innumerable young students who had not yet studied abroad to the bold, lush style that had originated in Munich. Duveneck became famous in his own time for his portraits and figure studies.

MYSTICISM, EXOTICISM, AND MURALS

Elihu Vedder (1836–1923) was a visionary with a penchant for mysticism. A native of New York City who would spend most of his life as an expatriate in Europe, Vedder went first to Paris to study in 1856, but soon discovered he preferred the life and the art world of Italy, and so settled in Florence. Italian Renaissance painting was a powerful influence on

24.8 (above) Frank Duveneck, *Whistling Boy*, 1872. Oil on canvas, 27⅞ × 21⅛in (70.8 × 53.7cm). Cincinnati Art Museum.

24.9 Elihu Vedder, *The Questioner of the Sphinx*, 1863. Oil on canvas, 34 × 41¾in (91.5 × 106cm). Museum of Fine Arts, Boston. Bequest of Mrs. Martin Brimmer.

24.10 Elihu Vedder, *Rome, Representative of the Arts*, 1894. Oil on canvas, 29½ × 55⅛in (75 × 140cm). Brooklyn Museum.

him, but it was only one of several that would shape his art. When he returned to New York in the 1860s, Vedder met several of the leading literary figures of the city—among them, Fitz Hugh Ludlow (author of *The Hasheesh Eater*, 1857—and he became familiar with their writings about the exotic and supernatural. During this period, Vedder produced the *Fisherman and the Genie* and *The Roc's Egg*, both of 1863, and the *Lair of the Sea Serpent*, 1864, all of which are now in the Museum of Fine Arts, Boston. Each of these was inspired by *Arabian Nights*, of which an unexpurgated English edition was published in 1840. *Questioner of the Sphinx* of 1863 is set against the vast wastes of the Egyptian desert, haunted by the spirits of the long-fallen temples (Fig. 24.9). Time has nearly buried the Great Sphinx, celebrated for its knowledge of the future, but also for its enigmatic silence. An Arab, hoping to learn of the future, bends forward to place his ear upon the enormous lips. Through such works, Vedder became recognized as America's leading exponent of the supernatural in painting.

Returning to Europe, Vedder settled in Rome, where he made his home for most of the rest of his life. In the mid-1880s, he again turned to the exotic literature of the Near East in an excellent series of illustrations for a translation of the *Rubaiyat of Omar Khayyam*. In the 1890s, this versatile genius devoted his attention to murals. Reproduced here is a small version of *Rome, Representative of the Arts*, which he created on a large scale for the Walker Art Gallery at Bowdoin College in Brunswick, Maine (Fig. 24.10). For the

same hall, John La Farge was to paint a mural depicting Athens (Fig. 24.11), Abbott Thayer was to do one representing Florence, and Kenyon Cox set to work on one of Venice—thereby honoring the four great art centers of antiquity and the Renaissance. Vedder's interest in classical Italian art is evident in his mural, with the seated female at the left reminiscent of Michelangelo's Sibyls from the Sistine Ceiling. There are other influences as well, for on a visit to England in 1876 Vedder had become interested in the art of William Blake (1757–1827), the Pre-Raphaelites, and in several contemporary English painters, among them Lawrence Alma-Tadema (1836–1912) and Frederic, Lord Leighton (1830–96).

JOHN LA FARGE

John La Farge (1835–1910) was a leader in many different aspects of American art in the late nineteenth century, including mural paintings, stained glass, *plein air* landscapes, color theory, and the introduction of Oriental art and influences. He was born in New York City to French émigré parents from Santo Domingo, and as a young man studied law. His interest in art then manifested itself, and in 1856 he took a trip to France to see the work of the Barbizon painters, which he admired very much. He met the authors Victor Hugo and Charles Baudelaire, discovered the art of Eugène Delacroix (1798–1863), copied works by Old Masters in the Louvre, and studied briefly in the studio of

24.11 John La Farge, *Athens*, 1894. Oil on canvas, 9ft × 20ft (2.77 × 6.15m). Bowdoin College Museum of Art, Brunswick, Maine.

Thomas Couture. On his way home the next year he stopped off in England, where he was greatly taken by the paintings of the Pre-Raphaelites. Although La Farge tried to resume his law practice, he soon found himself studying painting with William Morris Hunt in Newport, and by the early 1860s he had committed himself to art. His work of this period consists mainly of brilliant *plein air* landscapes, and highly colorful floral still lifes in the loose, painterly style of Henri Fantin-Latour (1833–1904).

In the mid-1870s La Farge began work as a muralist and as coordinating artist for large, architectural interior projects. La Farge was the leader in the rise of mural art in America, charting the course followed later by artists such as Edwin Austin Abbey, H. Siddons Mowbray, and Edwin Howland Blashfield. La Farge's first great opportunity came in 1876, when H. H. Richardson placed him in charge of the interior decoration of Trinity Church in Boston (Fig. **20.27**). This was the first totally integrated decorative program on a monumental scale in America, for the United States Capitol interior had been executed in a piecemeal fashion. The architect had indicated that he wanted a "rich effect of color," and that is what La Farge and his assistants provided in the colossal biblical figures set against a red background, surrounded by lavishly painted architectural ornamentation.

Trinity was but the first of many such projects on which La Farge collaborated. For example, he executed the murals for St. Thomas's Church (1877), for the Church of the Incarnation (1885), and for the Church of the Ascension (1886–8), all in New York City. La Farge also provided decorations for the architectural interiors of secular buildings, for example, the Union League Club in New York,

1881–2. For the Art Gallery at Bowdoin College, he created the large lunette of "Athens" as one of the four great cultural and artistic centers of the world. It was rendered with reminiscences of the splendid era of Renaissance mural painting of the sixteenth century (Fig. **24.11**). Athena—goddess of wisdom, protector of Athens, patron of the arts—stands at the left, drawing the partially nude model, whose torso is very like the statue known as Venus de Milo. At the right, the personification of the city of Athens sits on a stone that has a sculpted relief depicting Athena's owl, emblem of wisdom. Mount Parnassus, home of the muses of the several arts, rises behind Athena, and part of a Doric column makes reference to the city's beautiful architecture.

In 1880, La Farge formed an interior decorating company, which lasted only about five years. During that period, he was involved in some of the major domestic projects of the day. For example, he contributed significantly to the Japanese Room in William H. Vanderbilt's house (Fig. **22.9**). La Farge had begun collecting Japanese art as early as 1856, and was one of the first Americans to do so. In the late 1880s, he went to Japan in the company of the author Henry Adams, and in the early 1890s he traveled about the islands of the South Seas, making many watercolor and oil sketches as he went. These bright and fresh studies, of which *Maua, our Boatman* (Fig. **24.12**) is an example, were later used as illustrations for his books about his travels—*An Artist's Letters from Japan* (New York, 1897), and *Reminiscences of the South Seas* (New York, 1912). *Maua, our Boatman* depicts a paddler from the ten-oar boat which Chief Seumanu had assigned to La Farge for his use in trips to nearby islands. The picture invites comparison with the

24.12 John La Farge, *Sketch of Maua, Apia. One of our Boat Crew (Maua, our Boatman)*, 1891. Oil on canvas, 47¼ × 38¼in (120 × 97.2cm). Addison Gallery of American Art, Phillips Academy, Andover, Massachusetts.

South Seas paintings by Paul Gauguin, who had gone to live in that part of the world at about the same time La Farge visited it. Both men responded to the brilliant colors of the indigenous flora and native costumes.

MURAL PAINTING

The late 1880s and 1890s were a golden age for mural painting in America, because it became an integral part of largescale architectural projects. Two men whose reputations were established through their murals were Edwin Austin Abbey (1852–1911) and Edwin Howland Blashfield (1848–1936). After studying at the Pennsylvania Academy in his native Philadelphia, Abbey began his career as an illustrator for *Harper's Weekly* in the 1870s, studied briefly in Paris and London, and then moved to England. While there, he became an admirer of paintings by Rossetti, John Everett Millais (1829–96), and other members of the Pre-Raphaelite Brotherhood. He is best remembered in America for his murals representing the *Quest for the Holy Grail* for the Boston Public Library (Fig. 24.13). The legends of King Arthur represented the epitome of the Victorian literature of Alfred, Lord Tennyson, whose Arthurian poems were

acclaimed in the decades just before Abbey painted these murals.

Edwin H. Blashfield was born in Brooklyn and studied drawing at the Boston Institute of Technology. In Paris in 1867, he became a student of Léon Bonnat and received criticism from Jean-Léon Gérôme. Blashfield, like Abbey, developed a preference for medieval themes of chivalry and knighthood, rich in historical trappings. His murals often appear to be academic illustrations, of high and lofty purpose, as in his wall decorations for the Senate Chamber of the Minnesota State Capitol in St. Paul; the dome of the State Capitol in Madison, Wisconsin; the State Capitol in Des Moines, Iowa; the Court House in Baltimore; and the Federal Court House and the Cleveland Trust Company in Cleveland. His most notable work is the *Progress of Civilization*, painted on the dome of the Library of Congress (Fig. 24.14). Illustrated here is a study for this, depicting the Middle Ages in the personification of crusade warrior and church builder. Italy, as mother of the fine arts, holds a painter's palette, with a violin, a small image of Michelangelo's *David*, and a Corinthian capital at her side. Germany is represented by Johann Gutenberg, whose printing press refers to the revolution in learning and knowledge brought about by the invention of movable type. These figures and their attributes are archetypally Beaux-Arts, the very perfection of the academic artistic language of the American Renaissance.

ACADEMIC CLASSICISM, THE AMERICAN RENAISSANCE, AND TONALISM

KENYON COX

Kenyon Cox (1856–1919) was one of the most famous painters and art critics of his era. He was the personification of academic classicism in the American Renaissance mold, and, in later years, a voice of reaction against the impellent march of modernism. From his native Warren, Ohio, Cox first went to the Art Academy of Cincinnati, then to the Pennsylvania Academy in Philadelphia, before going to Paris in 1877, where he studied with Carolus-Duran, Alexandre Cabanel, and Gérôme. Returning to America in 1882, Cox settled in New York and painted landscapes and nudes in landscapes, a typical example of the latter being *An Eclogue* (Fig. 24.15). An eclogue is an idyllic pastoral poem, usually in the form of a dialogue. The classical subject, probably inspired by the Roman poet Virgil's *Eclogues*, or *Bucolics* (37 B.C.), shows four nude or partially nude female figures, rendered in a style that is both realistic and idealized. It is a perfect specimen of the studio nude transformed into a

24.13 McKim, Mead, and White, Delivery Room, Boston Public Library. Mural of *The Quest for the Holy Grail* by Edwin Austin Abbey, 1895–1901.

24.14 Edwin Howland Blashfield, *Study for "The Progress of Civilization: Middle Ages, Italy, Germany,"* 1895. Oil on canvas, 3ft 8⅝in × 7ft 9⅞in (1.13 × 2.38m). Collection, Williams College Museum of Art, Williamstown, Massachusetts.

24.15 Kenyon Cox, *An Eclogue*, 1890. Oil on canvas, 4ft × 5ft½in (1.23 × 1.54m). National Museum of American Art, Smithsonian Institution, Washington, D.C.

classical paraphrase. The central standing figure is based on an ancient image of Venus, yet there is a reality about her that is equally evident in the two seated women. The landscape is generally impressionistic, and the full moon adds an elegiac mood to the scene, while the sickle and bundle of wheat provide a bucolic note.

Cox was in great demand, and among his many mural commissions were those for the Manufacturers and Liberal Arts Building at the World's Columbian Exposition in Chicago in 1893, and the lunette representing Venice under the dome of the Walker Art Gallery at Bowdoin College in Brunswick, Maine. He provided two murals for the spectacular new Library of Congress, and another for the Appellate Court Building in New York City.

THOMAS WILMER DEWING

In the 1880s, Thomas Wilmer Dewing (1851–1938) worked in an American Renaissance style, as seen in *The Days* (Fig. 24.16). Dewing grew up in Boston, where he may have had a few lessons in drawing. It was not until he arrived in Paris in 1876, however, that he found the training he yearned for, at the Académie Julian, under the instruction of Jules-Joseph Lefebvre and Gustave Boulanger. He returned briefly to Boston, but by 1880 had moved to New York, where he became one of many young European-trained artists who were challenging the conservative old guard at the National Academy of Design. Dewing's work

during these years, as in *The Days*, was greatly influenced by French academicism and the English Pre-Raphaelites. The painting recalls the work of painters of the Brotherhood such as Dante Gabriel Rossetti and other English artists, especially Frederic, Lord Leighton. Dreamy idealizations of womanhood, clad in quasi-Renaissance attire that elevates them above the crass, contemporary world, symbolize an array of noble virtues, all treated in a decorative manner.

The influence of Whistler's harmonies and nocturnes led to the development of a style known as Tonalism. Dewing produced subtle tonal symphonies of soft blue and pale green hues throughout the 1890s, as in *Summer* (Fig. 24.17). Elegantly and fashionably clad women dissolve in a vaporous landscape, viewed through a mist, with vague but poetic suggestions of lawn, flowers, bushes, and trees. In the dissolution of physical form and matter, and in the fleetingness of the moment represented, such art finds parallels with Impressionism. After 1898, Dewing exhibited with the group known as Ten American Painters.

Through Stanford White, Dewing's art was brought to the attention of one of the most important collectors of the period, the wealthy Detroit industrialist and capitalist Charles Lang Freer, whose collection is now preserved as the Freer Gallery in Washington, D.C., part of the Smithsonian Institution. It is especially rich in objects of Oriental art, works by Whistler and Dewing, and also in paintings by Abbott Handerson Thayer (1849–1921), a contemporary of Dewing.

24.16 (above) Thomas Wilmer Dewing, *The Days*, 1887. Oil on canvas, 3ft 7³⁄₁₆in × 6ft (1.1 × 1.83m). Wadsworth Atheneum, Hartford, Connecticut.

24.17 Thomas Wilmer Dewing, *Summer*, c. 1890. Oil on canvas, 3ft 6⅛in × 4ft 6¼in (1.07 × 1.38m). National Museum of American Art, Smithsonian Institution, Washington, D.C.

24.18 Abbott Handerson Thayer, *The Virgin*, 1893. Oil on canvas, 7ft 6⅜in × 5ft 10⅞in (2.3 × 1.83m). Freer Gallery of Art, Smithsonian Institution, Washington, D.C.

ABBOTT HANDERSON THAYER

Thayer, who was born in Boston, attended classes at the Brooklyn Art School and at the National Academy of Design before going to Paris in 1875 to study at the Ecole des Beaux-Arts under Jean-Léon Gérôme. Four years later, he established a studio in New York.

Working in a style that was colorful, fluid in its brushwork, and flickering in the effects of light and shade, Thayer's manner was impressionistic without being Impressionist. He also drew inspiration from the Italian painters Botticelli, Raphael, and Tintoretto, and saw himself as a part of the American Renaissance. Thayer sought to create an ideal of womanhood for the Gilded Age, seeking a visual representation of such virtues as charity, civic-mindedness, piety, and so on—but always one recognizable as an American woman. She was usually clothed in garments resembling a Greek *chiton* or a Renaissance gown, but in facial type and figural form she was intended to be the ideal American woman. Sometimes she appears with great angelic wings, as in *Angel* (c. 1889, National Museum of American Art, Washington, D.C.), sometimes reminiscent of a classical statue, as in *Charity* (1894–5, Museum of Fine Arts, Boston). *The Virgin* shows a proud, resolute, boldly striding,

and serious-minded young American girl (Fig. **24.18**). The model was probably the artist's daughter Mary. She exudes innocence, and the blossoms above her suggest freshness and purity. Pictures of this type brought their creator much critical acclaim.

INNER VISIONS: BLAKELOCK AND RYDER

Most of the artists discussed so far arrived at their mature styles as a direct result of European training or exposure to Oriental art. Painters as diverse in style as Childe Hassam and Elihu Vedder are united in their art by the common thread of European artistic traditions—ancient, Renaissance, and contemporary. There were some American artists of this period, however, whose work stems primarily from their own inner visions. Ralph Blakelock and Albert Pinkham Ryder are two, who, in their introspection, expressiveness, and abstraction, forecast the Modern movement in art.

Blakelock (1849–1919), the son of a New York physician, had no formal training in painting and never felt the need to study in Europe. Being selftaught explains in part the unique, very personal character of his style. Blakelock had already begun exhibiting his work at the National Academy of Design when he set off on a trip in 1869, but instead of crossing the Atlantic he went west, visiting Colorado, Wyoming, Utah, Nevada, and California. Long after his return to New York City, he continued to draw upon his experiences in the West. His *Moonlight, Indian Encampment* (Fig. **24.19**) is in marked contrast to Bierstadt's *The Rocky Mountains* (Fig. **15.15**). A mysterious mood characteristically permeates Blakelock's images, which are frequently night scenes illuminated by moonlight. He used pigments containing bitumen, or coal tar, which darkens with age, for the dark tone of his pictures. The trees, silhouetted against a luminous sky, are built up in a thick impasto, and there is a nervousness in their forms that suggests the mental problems the artist was to experience.

A large family to support, lack of patronage, and mounting debts all contributed to the first of Blakelock's mental breakdowns in 1891. Before the turn of the century, the problem became so severe that he was confined to a mental hospital, from which he was not released until 1916. Even while in the asylum Blakelock continued to paint, but supplies were scarce, and his pictures were often painted on bits of cardboard or fragments of windowshades, even wallpaper. Ironically, his work began to attract a following soon after he was institutionalized, which brought an increase in prices, but also a flood of forgeries—it has been estimated there are more forgeries than original Blakelocks.

Albert Pinkham Ryder (1847–1917) was raised in New Bedford, Massachusetts, where he had a few lessons from an amateur painter. After his family moved to New York City in 1870, he was eventually admitted to classes at the National Academy. Unlike Blakelock, he made several trips to Europe, though each was of short duration, allowing time only to

24.19 Ralph Albert Blakelock, *Moonlight, Indian Encampment*, 1885–9. Oil on canvas, 27⅛ × 34⅛in (68.8 × 86.8cm). National Museum of American Art, Smithsonian Institution, Washington, D.C.

look but never really to study. While there are some similarities between his early work—small landscapes and farm scenes—and the art of Barbizon painters such as Corot, or of Monticelli, Ryder's personal style was so original, and his visionary imagination so powerful, that external influences had little impact on him.

By the early 1880s, Ryder had arrived at a type of composition and technical execution that typifies his mature work, as seen in *Toilers of the Sea* (Fig. 24.20). This small picture is probably in some way related to Victor Hugo's novel (1866) of the same name, which deals with man's combat against the powerful and awesome forces of the sea, with major scenes set at night. Ryder had begun to impose a grand simplification on natural form that led naturally to abstraction. The straight line of the horizon, the circle of the moon, the triangular shape of the sail, all suggest a

24.20 Albert Pinkham Ryder, *Toilers of the Sea*, c. 1882. Oil on wood panel, 11½ × 12in (29.2 × 30.5cm). Metropolitan Museum of Art, New York City.

24.21 Albert Pinkham Ryder, *Siegfried and the Rhine Maidens*, 1888–91. Oil on canvas, 19⅞ × 20½in (50.5 × 52cm). National Gallery of Art, Washington, D.C.

consideration of abstract elements. Ryder's art, however, is far more than an arrangement of geometric forms. Pictures such as this are romantic evocations of a world seen in a dream and filled with mystery. The shadowy characters contribute greatly to this, as does the somber, low-keyed palette. There is often a heaviness to the pigment in Ryder's paintings which is a result of constant reworking and the building up of numerous layers of glazes. The degree to which Ryder carried his abstraction is remarkable in pictures such as *Moonlight Marine* (1880s, Metropolitan Museum of Art), which seems to anticipate the work of Franz Kline or Robert Motherwell by about eighty years.

For all of his natural inclination toward simplification and abstraction, literary content remained important to Ryder. He himself wrote poetry, and he enjoyed opera. These interests surface in pictures like *Siegfried and the Rhine Maidens* (Fig. 24.21), the source for which was the libretto of Richard Wagner's *Ring of the Nibelung*, first performed in 1876. Although a small work, measuring just under 20 inches (50.8 cm) in height, the painting has the impact of a grand operatic vision, filled with the drama of a Wagnerian production. Natural forms, especially the clouds and trees, participate in the dynamic moment, and suggest the howling, swirling forces of nature. The scene is once again viewed by moonlight, and the world is filled with shadowy, mysterious forms.

As the years passed, Ryder became increasingly reclusive and eccentric, caring little about social relationships or income, living in chaotic clutter, totally absorbed in his art. Ironically, his art began to sell well, and, as with Blakelock, this led to many forgeries.

SYMBOLISM

There were also artists in Europe in the 1880s and 1890s who were concerned more with the painting of visions than with the depiction of the objective world, and were more interested in the expressive power of color and form than the accurate portrayal of physical matter. The Symbolists, although never united as a group, represent an increased emphasis on subjective and emotional qualities. Paul Gauguin was one, and his friend Vincent van Gogh another; Whistler's work also sometimes had the requisite mystical quality; and in the art of Gustave Moreau (1826–98), Odilon Redon (1840–1916), and James Ensor (1860–1949) inspiration usually came from within. As counterparts in the other arts there were the poets Stéphane Mallarmé and Paul Valéry, critics Albert Aurier and Maurice Denis, and the musician Claude Debussy.

The American contingent, which developed independently, was represented by Albert Pinkham Ryder and Ralph Blakelock, among others. Their work was recognized by American avant-garde artists and patrons as possessing modernist characteristics even before there was a modern art in America. Many American artists of this period worked in the Symbolist mode, for the mysteries of the inner world were explored from time to time by George Inness, Elihu Vedder, Thomas Dewing, John La Farge, Arthur B. Davies, Robert Loftin Newman (1827–1912), and Pamela Colman Smith (c. 1877–c. 1950).

TROMPE L'OEIL

Consideration of another wholly different mode of vision and execution can be found in the *trompe l'oeil* still lifes of Harnett, Peto, Haberle, Chalfant, Cope, and others. *Trompe l'oeil* means a trick played on the eye: On a two-dimensional surface, the artist paints a series of objects with such fidelity that the viewer is fooled into accepting the ruse as the real thing. As a tradition, *trompe l'oeil* dates back to the fifteenth century, and was especially popular in seventeenth-century Dutch painting. Amid all the other styles being explored in the late nineteenth century in America, it represented the survival of the realist strain which had long been dear to the nation, since the days of Copley and Peale. Charles Willson Peale had experimented with the idea as early as 1795 in *Staircase Group* (Philadelphia Museum of Art), and so had his son Raphaelle in his wellknown *trompe l'oeil* picture *After the Bath* (Fig. 11.2). In late-nineteenth-century examples there was usually a narrative, and often a moral lesson that unfolded when the meticulously detailed objects were scrutinized carefully. This, too, appealed to many American patrons.

In their own lifetimes, *trompe l'oeil* painters found their greatest following among lay people rather than art critics. Their works were as likely to be seen hanging above a bar in a saloon as at the salon of the annual exhibition of the

National Academy or the Pennsylvania Academy. Critics and established artists often dismissed such pictures as a deception—therefore a lie and lacking truth, and little more than technical proficiency. Lay people, however, admired them as curiosities, and for their cleverness, craft, and novelty.

WILLIAM MICHAEL HARNETT

William Michael Harnett (1848–92) was brought to Phila-delphia from Ireland when he was an infant. After learning the skills of the engraver, he attended the Pennsylvania Academy and then, moving to New York in 1869, studied at the National Academy. Harnett went to Europe in 1880, first to London, then Frankfurt, and finally to Munich, where he spent four years, painting still lifes—in part because he could not afford models. Perhaps because of his early training as an engraver, he took on none of the fluid, painterly brushwork associated with the Munich school. Instead, his still lifes have been compared with the large photographic still lifes produced about 1860 by Adolphe

24.23 William Michael Harnett, *New York Daily News*, 1888. Oil on wood panel, 5½ × 7½in (14 × 19.1cm). Metropolitan Museum of Art, New York City.

24.22 William Michael Harnett, *After the Hunt*, 1885. Oil on canvas, 5ft 11½in × 4ft½in (1.91 × 1.23m). Fine Arts Museums of San Francisco.

Braun, an Alsatian, in which a variety of game and hunting paraphernalia is hung in a cluster upon a board wall—clearly anticipating Harnett's *After the Hunt* (Fig. 24.22).

Considered by many to be the masterpiece of American *trompe l'oeil* work, *After the Hunt* was painted in four versions, the first in 1883, and the one illustrated here in 1885 in Paris. In precise detail, the artist delineated the various objects, which are carefully arranged in a highly ordered composition of verticals, horizontals, diagonals, straight and curved lines, and circles. The geometric order, balance, and harmony are extraordinary. The trophies of the hunt consist of four birds and a rabbit. Reference is made to an earlier hunt by the antlers. The rifle is of Old World craftsmanship, and the alpenstock (which floats rather than hangs, since there is no cord) is a walkingstick of the type used by European mountain climbers, thereby establishing the hunt as taking place somewhere in central Europe. The old hat suggests the presence of the hunter, while an antique pistol and rust on the horseshoe and decorative hinges interject the passage of time. Harnett exhibited the picture in Paris, but it did not sell. In 1886 he brought it with him when he returned to New York, where it was purchased by a man who owned a tavern near City Hall. There, hung above the bar, it was seen by many who admired it, which led to a number of commissions for *trompe l'oeil* still lifes.

Harnett often worked on a smaller scale, of more modest arrangements in the tabletop or shelftop type, with a grouping of only a few objects. *New York Daily News*, which measures less than 8 inches (20 cm) across, is typical of this sort (Fig. 24.23). The gray beer mug and the meerschaum pipe indicate a quiet corner of a man's world, which in some pictures like this is given immediacy by glowing embers or a curling wisp of smoke, suggesting the smoker's presence. The newspaper is a further reference to the ordinary world of popular culture.

24.24 John Peto, *Old Souvenirs*, 1881–1900. Oil on canvas, 26¾ × 22in (67.9 × 55.9cm). Metropolitan Museum of Art, New York City.

JOHN FREDERICK PETO

John Frederick Peto (1854–1907) was another master of the deception piece. Born and raised in Philadelphia, he probably knew Harnett when they were fellow-students at the Pennsylvania Academy in 1878. It was the example of Harnett's work that set Peto on his course as a *trompe l'oeil* still life painter. One category of deception painting at which Peto excelled is the rack type—a vertical panel with ribbons tightly stretched and tacked, into which are tucked various memorabilia such as newspaper clippings, addressed

envelopes, photographs, theater tickets, pamphlets, and so on. The rack type had been used in seventeenth- and eighteenth-century Dutch still life painting, as in the work of Wallerant Vaillant (1623–77) and Evert (or Edwaert) Collier (or Colyer) (b. 1673). In the early nineteenth century it was known in America, for Raphaelle Peale had painted just such a deception piece in 1802. A particularly fine example by Peto is *Old Souvenirs*. Within the ribbons, an issue of the *Philadelphia Evening Bulletin* of 10 October 1881, a postcard addressed to the artist, a greetings card with a lily on it, a photograph of the painter's daughter Helen, and a green pamphlet titled simply "Report" can be seen (Fig. 24.24). Below is an envelope inscribed "Important Information Inside," a phrase Peto included on a number of similar still lifes. Rack-type arrangements sometimes, as here, dealt with personal memorabilia related to the life of the painter. Other examples may concern some national issue, such as the assassination of Abraham Lincoln.

A number of other artists painted *trompe l'oeil* pictures in the late nineteenth century, and their work displays even further variety in subject matter. The musical instrument theme, for example, can be seen in *The Old Violin* (1888, Delaware Art Museum, Wilmington) by Jefferson Davis Chalfant (1856–1931). Chalfant gave up his cabinetmaking business, moved to Wilmington, Delaware, in 1879, and throughout the next decade painted charming deception pieces that frequently included violins and sheet music. John Haberle (1856–1933) made a specialty of dollar bills and banknotes, drawn and painted with remarkable exactitude. Alexander Pope (1849–1924) and George Cope (1855–1929) also deserve mention, for both produced very fine *trompe l'oeil* still lifes in the manner of Harnett.

At the opposite pole from the *trompe l'oeil* pieces were paintings that pointed ahead to abstraction and a concern for art rather than reality. Both traditions continued into the twentieth century. But, having reached the years around 1900, American painting became very different, moving on from the unified style seen before the Civil War. Pre-Civil War American painting seems isolationist, whereas after the war, American painting was often fused with European artistic traditions.

CHAPTER TWENTY-FIVE

PHOTOGRAPHY:

1870–1900

After the Civil War, the West came to represent a land where life could begin anew. To soldiers returning north to find no jobs, to Southerners who saw only devastation and corruption around them, the West was a place of hope—both economically and psychologically. It was wild, unsettled, and difficult to get to, much of it either desert or mountains. The country now was divided not into North and South, but East from West Coast with a vast landscape separating the two—roughly between St. Joseph, Missouri, and Sacramento, California. The first order of business was to connect the two parts of the nation with a transcontinental railroad, which would also service the great intervening expanse. Congress appropriated funds to pay for the track. The Union Pacific moved westward out of Omaha, and the Central Pacific started eastward from Sacramento; the two companies met near Salt Lake City in 1869 (Fig. 25.1). The country was united. Soon spurs from this line and additional transcontinental systems carried settlers and supplies into the land, and the harvest out of it.

The next project for the government was to conduct a survey of that vast, largely unknown land to see what natural resources it held. A group of extraordinary men were involved with this project. In 1863, at age twenty-one, Clarence King and a friend set out across the continent, traveling on horseback to Nevada, on foot from there, over the Sierras, to San Francisco. King then explored unknown regions of California before returning east. Back in Washington, he convinced Congress of the necessity of a survey of the land between Colorado and California, which he conducted between 1866 and 1877. Published in fifty-seven volumes, King's report provided a wealth of theretofore unknown geological knowledge about the area. King's expeditions were so successful that Congress established a permanent agency—the United States Geological Survey—in 1878.

Ferdinand V. Hayden conducted a similar survey of the Wyoming Territory. Along the way, he picked up a gifted young photographer, William Henry Jackson, to document the expedition's discoveries. After the Civil War, Jackson had gone westward to seek his fortune in the silver mines of Montana, heading out of St. Joseph with a wagontrain. He ended up in California instead. Jackson next moved to Omaha, where he set up a photography studio. From there he made trips, traveling in a horsedrawn wagon-studio, to photograph Native Americans, settlers, homesteads, and the trans-continental railroad construction. About 1870 he received a commission for 10,000 stereographic views of the West, and while on that trip, he met Ferdinand Hayden. Jackson spent the next eight summers, until 1879, as Hayden's survey photographer. Later in his career Jackson worked out of Denver, photographing the western landscape, often on commission from the railroads, which wanted his pictures for publicity purposes in order to entice settlers to the lands now served by the Iron Horse.

John Wesley Powell returned home to Illinois after the Civil War to become a professor of geology. In 1869, sponsored by Congress and the Smithsonian Institution, he embarked on a three-month expedition to explore a 900-mile (1450-km) length of the Colorado River, through the Grand Canyon. He conducted other scientific expeditions into the western territories and the Rocky Mountains, and in 1880 succeeded King as director of the U.S. Geological Survey. Powell had a special interest in the Native Americans of these territories, and for many years he was director of the Bureau of Ethnology, a division of the Smithsonian.

Scottish-born John Muir's interests were geology and botany. As a young man he walked from Indiana to the Gulf of Mexico, keeping a journal about the flora and the terrain through which he traveled. By 1868 he was in California, where he spent part of the next six years exploring Yosemite Valley and studying glaciers and the great sequoia forests. Through a series of articles in *Scribner's* and *Century* magazines, Muir brought the magnificent beauty of the West to the attention of a broad audience. Muir is recognized as one of the early leaders of the conservation movement. He spearheaded the crusade to have Yosemite Valley declared a national park, which Congress did in 1890.

At the same time, fortunes were being made by men like Leland Stanford, William Henry Vanderbilt, and J. Pierpont Morgan. Stanford became president of the Central Pacific, and along with his colleagues Collis P. Huntington, Mark Hopkins, and Charles Crocker made millions in the railroad business. In 1885, he founded and endowed Stanford College in Palo Alto. Also at Palo Alto, Stanford maintained a

large farm for the breeding of thoroughbred horses; the riding and training of horses became one of the passionate interests of his life, which had significance in the history of photography.

William Henry Vanderbilt was the son of Cornelius the "Commodore," the founder of the family's fortunes. Upon the death of the Commodore in 1877, William inherited a vast sum of money, as well as control of huge railroad interests, which he deftly began pulling together. The Vanderbilt system soon connected New York, Cleveland, Detroit, Chicago, Cincinnati, and St. Louis. William Henry Vanderbilt doubled the size of the estate that had been left to him and used part of the money to build a grand Fifth Avenue mansion, which included an art gallery and what was reportedly the largest private art collection of its day.

In 1879, Vanderbilt chose a young financial genius named J. Pierpont Morgan (Fig. 25.9) to handle the sale of Vanderbilt railroad stock in England. Morgan did this expeditiously, marking the beginning of his rise to fortune and power in the world's financial circles. Morgan was an extraordinary entrepreneur, who bought out Andrew Carnegie in 1901, and put together the world's largest corporation, United States Steel. He was as aggressive in collecting art as he was in finance, and he formed one of the finest collections of Gothic and Renaissance art and Oriental porcelains of his day. He was also one of the major benefactors of the newly founded Metropolitan Museum of Art, of which he was president for many years.

The population of the United States leaped from thirty-eight million in 1870 to seventy-six million in 1900. Most of this was due to immigration. Irishmen provided much of the labor for the building of the Union Pacific Railroad, as Chinese did for the Central Pacific. In 1892, Ellis Island, in New York Harbor, became an immigration station. Through its portals over the next several decades passed millions of immigrants (Fig. 31.7). Although they became a part of the rich pageant of American life, few had fortune smile on them the way Andrew Carnegie did after he immigrated in 1848. Most lived wretched lives, huddled in the tenements that now began to sprawl throughout the cities. While painters took little note of their plight, photographers did (Figs. 25.10 and 25.11). In fact, very little of the American scene escaped the eye of the camera in the closing decades of the nineteenth century.

During this period, the photograph was used to document places and events, as a tool of the painter, and as a form of imagemaking in its own right. Painters such as Thomas Eakins became absorbed with and adept at making photographs. Others, like Jacob Riis, who in no way thought of themselves as artists, began to show America the expressive power of the photographic image. Important technical developments improved the equipment and the processes, for example, the discovery of the **dry plate**. With the introduction of flexible film and the portable, inexpensive Kodak camera, photomaking came within the reach of the general population.

PHOTOGRAPHY AND THE WEST

With the end of the Civil War, the nation turned to developing its enormous potential. Photographers, professional and otherwise, documented the enormous energy and accomplishments of this time. Captain Andrew J. Russell (1830–1902), who had been a member of Mathew Brady's Photographic Corps during the Civil War, was on hand when the two tracklaying parties of the Union Pacific met on 10 May 1869, at Promontory Point, Utah (Fig. 25.1). In the middle of the photograph, shaking hands, are Samuel Montague (left), chief engineer of the Central Pacific, and his counterpart for the Union Pacific, Grenville Dodge. The whole nation celebrated the event, and the popular illustrated newspapers of the day carried engravings of scenes similar to Russell's picture. American engineering genius, capitalism, and entrepreneurship are praised in the central figures, but American labor and the common man—the rowdy, rough-and-tumble unknown worker whose muscle accomplished this remarkable feat—are also lauded. The picture was posed, but not composed in the manner of Renaissance-Baroque compositional theory as practiced in the studios of academic painters. The seeming naturalness of the arrangement lends verity and immediacy to the image, and coordinates perfectly with the naturalism of the photographic medium. It is a picture of capitalism and labor caught in an heroic moment, while expressing the spirit of a new kind of Manifest Destiny. This was documentary photography that used the camera in its own natural way to record the memorable moment.

EARLY PHOTOGRAPHERS

The expansive, wild reaches of the nation fascinated Americans, who learned about them bit by bit as the railroads cut into them. People wanted pictures of the new lands, and it was to the advantage of the railroad owners—to whom Congress had given enormous tracts paralleling the rail lines—if interest was fanned through images of these lands. Bierstadt, Moran, and others provided paintings of such subjects for the wealthy—but it was the photographers who brought their relatively inexpensive images into the hands of many.

Two of the earliest photographers who went west, in the 1860s and early 1870s, were Carleton E. Watkins and Timothy O'Sullivan. Others followed, and among the best was William Henry Jackson (1843–1942). When Ferdinand Hayden saw Jackson's photographs he invited him to join his expedition. The resulting series of images—towering mountains, sweeping valleys, spouting geysers, and steaming hot springs—so completely captured the imagination of the nation that they were instrumental in causing Congress to create the first national park—Yellowstone—which President Grant signed into law on 1 March 1872.

25.1 Andrew J. Russell, *Meeting of the Rails*, Promontory Point, Utah, 1869. Photograph. Union Pacific Railroad Collection, Historical Museum, Omaha, Nebraska.

25.2 William Henry Jackson, *The Grand Canyon of the Yellowstone*, 1871. Photograph. Library of Congress.

Jackson carried his equipment—several cameras, hundreds of glass plates, processing materials, tents, and everything else he needed—on pack mules, into some of the most rugged mountainous areas in the United States. The results were pictures such as *The Grand Canyon of the Yellowstone* (Fig. 25.2). To do justice to the scale and sublime grandeur of his subject matter while photographing the Rocky Mountains, Jackson used a largesize glass plate that measured 20 by 24 inches (50.8 × 61 cm). This was unheard of in that day, and the fact that the extremely fragile plates had to be transported about in such regions did not fail to impress Americans generally. Pictures like that shown in Figure 25.2 remind us of paintings by Jackson's good friend and occasional companion Thomas Moran, who painted similar subjects, as a comparison with Figure 15.28 demonstrates. Jackson's image gave a sense of the reality of the place—it truly did exist, as seen in the photograph, which everyone knew could not be exaggerated or romanticized the way artists' paintings could be.

Photographers like Jackson encountered Native Americans as they traveled about the West, and they recorded them with their cameras as George Catlin (Fig. 15.18) had done thirty years earlier with his paintbrush—sometimes in portraits, sometimes in general views of village life. Eadweard Muybridge (1830–1904) took an interesting shot of the painter Albert Bierstadt seated before his easel, painting a group of Native Americans at Mariposa, California, the gateway to Yosemite Valley (Fig. 25.3). Within twenty-four hours of seeing Muybridge's photograph, Bierstadt reportedly had incorporated much of it into the painting *Indians in Council, California* (New York art market, 1972). In a newspaper review of an exhibition of the Yosemite photographers then being shown in San Francisco, the *Alta California* reported on 7 April 1873 that "Muybridge has produced ... a series of eight hundred of the most perfect photographs ever offered for public inspection.... The view of Temple Peak ... should be taken as a subject for a great painting, and probably will be by Mr. Bierstadt." Muybridge published the photo of Bierstadt as one of his many stereographs—double images that were viewed through a stereoscope, which was found in nearly every parlor at this time. Photography had become an important form of amusement and learning at home.

Muybridge had emigrated to America from his native England in 1852, settled in San Francisco three years later, and sometime in the 1860s had learned the photographic processes. He had already roamed about in the enchanted valley of the Yosemite in 1860, and he returned a second time in 1867, this time with a camera. His large (16 × 20 in; 40.6 × 50.8 cm) pictures, printed from glass-plate negatives, were so impressive when they were exhibited in America and Europe that he enjoyed immediate international acclaim. By 1868, Muybridge had joined a government survey expedition in Alaska as its photographer, and in 1875–6 he was in Central America taking views. Although these wanderings all produced extraordinary images of landscapes, native peoples, and men building railroads, Muybridge is best remembered for another kind of documentation—humans and animals in motion.

In 1872, Leland Stanford, former governor of California, wagered a friend $25,000 that a running horse had all four feet off the ground when at full gait. To prove his point, Stanford commissioned Muybridge to photograph one of his favorite horses in motion. Along a racetrack at Stanford's Palo Alto ranch, Muybridge set up a series of cameras, which were tripped by wires strung across the track as the horse ran the course. For the first time, it was possible to see the actual stages of an animal's movement. Stanford won the bet. Muybridge's fame soared. The University of Pennsylvania became interested, and in 1883 invited the photographer to pursue his work in documenting locomotion under its auspices. Figure 25.4 is but one of innumerable series Muybridge made. At this time the painter Thomas Eakins and Muybridge worked closely together on the project. Eakins also made similar photographs showing the movement of a jumping boy in eight positions within a single frame. Eakins is known to have applied the "truth" learned from his motion studies of horses to his painting *The Fairman Rogers Four-in-Hand* (1879, Philadelphia Museum of Art). It should be noted that at that time in France, Professor Etienne Jules Marey was conducting similar experiments, as was Ottomar Anschutz in Leszno, Poland.

25.3 Eadweard Muybridge, *Albert Bierstadt's Studio*, 1872. Stereograph. Collection of Leonard A. Walle, Novato, California.

25.4 Eadweard Muybridge, *Female Figure Hopping*, 1887. Sequence photography, plate 185 from *Animal Locomotion* (Philadelphia, 1887). National Museum of Design, Cooper-Hewitt Museum, New York City.

25.5 (below) Thomas Eakins, *Mrs. William H. Macdowell*, c. 1882. Photograph. Metropolitan Museum of Art, New York City.

THE AESTHETICS OF PHOTOGRAPHY

Thomas Eakins had known, or at least corresponded with, Muybridge several years before the photographer arrived in Philadelphia. He also had owned a set of the action photos of horses, and had begun making photographs before their meeting. In the years before Alfred Stieglitz determined to make photography an art, Eakins became one of the most adept manipulators of the medium.

Eakins used the camera to record many of the effects he had begun to achieve in his painted portraits, as in *Mrs. William H. Macdowell*, a photograph of his mother-in-law (Fig. 25.5). The careful control of light, introduced from one side, against a dark background, rendered his subject in a deeply pensive mood amid a great stillness, lost in her own thoughts. About a decade later, this same crossover of influences is found in his portraits of his longtime and aging friend, the poet Walt Whitman. The photograph of Whitman (Fig. 25.6) possesses certain qualities also found in the painted portrait by Eakins, one version of which is at the Pennsylvania Academy. A series of photographic studies exists of Amelia van Buren, of whom Eakins also painted a portrait (Fig. 23.15). These, like the painting, are marvelous

25.6 Thomas Eakins, *Walt Whitman, Seated in a Chair*, c. 1890. Photograph. Philadelphia Museum of Art.

25.7 William B. Post, *Summer Days*, 1895. Photograph. International Museum of Photography, George Eastman House, Rochester, New York.

studies of mood and personality. But while there are innumerable photographs of his which are directly related to his paintings, there is evidence that Eakins saw the camera as an instrument capable of producing aesthetic imagery in its own right.

There were a number of amateurs exploring the aesthetic possibilities of the photographic image during these years. William B. Post (1857–1925), although an amateur, was also a member of the Photo-Secessionist movement (see chapter 31). Retiring from his position as a New York financier in his mid-fifties, Post moved to Freyburg, Maine, where he had spent his summers for many years. His great joy was in photographing ladies with parasols strolling or in hammocks, or drifting about in a small rowboat on a lily pond, as in *Summer Days* (Fig. 25.7). The Englishman Peter Henry Emerson was one of the earliest to theorize on photography as art, and Post undoubtedly knew Emerson's writings and examples of his pictures. Post's *Summer Days*, for example, is a paraphrase of Emerson's *Gathering Water Lilies* of 1886.

Pictures such as these—Post's and Emerson's alike—were known to a wide, international audience, thanks to the new process called **photogravure** which allowed the printing of photographs in popular graphic media, particularly newspapers. One cannot help but think, when looking at Post's *Summer Days*, of pictures by contemporary American Impressionists—for example, Cassatt's *The Boating Party* (Fig. 23.25) or Chase's *Idle Hours* (Fig. 24.1). A scene in the open air, bathed in light and filled with shimmering reflections; a casual, middleclass subject, seemingly uncomposed; a passing moment—all these reveal that the cameraman was attempting to replicate what the Impressionist painter had done.

PORTRAITS AND SOCIAL COMMENTARY

Portraiture remained one of the primary areas of photography. Napoleon Sarony (1821–96), the leading portraitist in New York after Mathew Brady moved to Washington, D.C., in the mid-1870s, had begun his career as a lithographer in 1846, but learned photography while visiting his brother in England. By 1864, he had established his studio in New York City, where he made a fortune taking portraits of the leading actors and literary figures of the period. In many ways, Sarony followed the example of Disdéri, the Parisian photographer who made the carte de visite so popular after 1854. Cartes de visite, which measured only about 4 by 2½ inches (10 × 6.4 cm), usually represented famous persons, and it was popular to collect them. Sarony's studio was filled with props—everything from stuffed birds to an Egyptian mummycase—which he incorporated into his portraits.

Typical of Sarony's work is the melodramatic portrait of Sarah Bernhardt (Fig. 25.8). The celebrated French actress was at the height of her fame when she arrived in the United

25.8 Napoleon Sarony, *Sarah Bernhardt*, c. 1880. Photograph. International Museum of Photography, George Eastman House, Rochester, New York.

States in the fall of 1880, following spectacular successes in Paris and London. Her portrayal of Camille in Alexandre Dumas *fils's La Dame aux Camélias* had captivated American audiences (reportedly, Cornelius Vanderbilt attended every performance and wept openly as the Divine Sarah expired in the closing scene). Sarony photographed Bernhardt as Camille in her dying swoon, capturing the theatricality of this highly emotional moment.

If Sarony's reputation rested on his theatrical photographs, another kind was developed for the mighty tycoons of American finance and industry. As in the painted portraits of this same group, the massive form and imposing demeanor of the subject were usually presented in a dark tonality with light falling primarily on the face. The photograph of J. Pierpont Morgan is a typical example (Fig. 25.9). The camera was manipulated to capture the sense of presence, the dynamic vigor, the bold assertiveness of the sitter. The London *Times* referred to Morgan as a man of genius and taste, and compared him to Lorenzo the Magnificent, that greatest of princely Florentine patrons of the fifteenth century.

A very different picture of America was presented in a remarkable book, *How the Other Half Lives* (1892), by Jacob Riis. Riis (1849–1914) came to America in 1870 from his native Denmark. As a police reporter for the *New York Tribune*, his work carried him into the tenement slums and unsavory hideouts of the teeming city, where people lived without daylight, ventilation, or sanitation, where filth,

25.9 (above) Edward J. Steichen, *J. Pierpont Morgan, Esq.*, 1903. Photogravure, from *Camera Work*, c. 1906. Morris Library, University of Delaware, Newark, Delaware.

25.10 Jacob Riis, *In Poverty Gap: An English Coal-Heaver's Home*, c. 1889. Photograph. Museum of the City of New York.

25.11 Jacob Riis, *Bandits' Roost, Mulberry Street, New York*, c. 1888. Photograph. Museum of the City of New York.

disease, and hopelessness completed the human degradation. Here was what the Englishman James Bryce described in his book *American Commonwealth* (1888) as "the conspicuous failure of the city."[1] The people of the slums were no longer viewed as colorful, charming, or picturesque subjects for painters who romanticized their plight. The camera's objective eye now presented such scenes with brutal realism.

Riis took up the camera along with his pen, as he began his crusade against social and economic injustices. Pictures such as *In Poverty Gap: An English Coal-Heaver's Home* (Fig. 25.10) documented the wretched conditions of the working poor with such realism that when they were seen in the pages of *How the Other Half Lives*, a reform movement followed.

Riis considered that to be the sole purpose of his photography, and never thought of it as being related to art. Sometimes Riis took pictures at his peril, as with *Bandits' Roost*, in which one clearly senses the suspicion and the hostility directed at the intruder with his camera (Fig. 25.11). Here was a back alley known for its gangs and the murders that occurred there regularly. The picture—which was used as evidence in a murder trial—so moved the then police commissioner of New York City, Theodore Roosevelt, that he began a crackdown to eradicate such festering sores. As a direct result of the books and photographs Riis published, the public social conscience was awakened to the urgent necessity for reform. When a large section of the tenements was torn down and a new housing project erected, the latter was named after Jacob A. Riis.

25.12 Fred Church, *George Eastman on Board Ship*, 1890. Photograph. International Museum of Photography, George Eastman House, Rochester, New York.

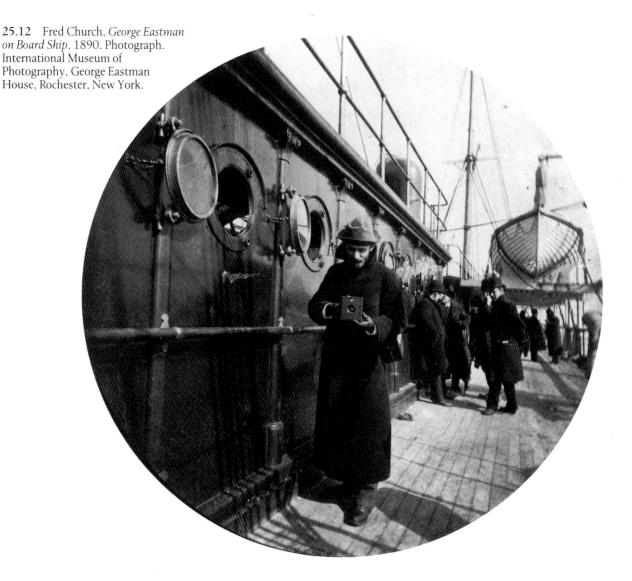

CAMERAS FOR EVERYONE

Riis has been credited with the introduction of the flash in American photography—a necessity for him when he worked in the dim light or darkness of back alleys and windowless tenement rooms. There were many improvements in the photographic process between 1870 and 1900. In mid-century photography, the negative was made on a chemically sensitized glass plate—that is, a sheet of glass was coated with collodion solution (guncotton, ether, and alcohol), mixed with silver iodide and iodide iron. The glass plate was slipped into the camera while the solution was still wet, and exposed. As soon as it was dry, a contact print, which was the same size as the plate, could be made. These were laborious to prepare, messy, difficult to transport, and limited picture-taking to the professional photographer. The next step came with the English invention of the dry plate, which was coated with light-sensitive gelatin-bromide. Now, readymade plates could be produced.

George Eastman, a bank employee by day, spent his evenings developing a superior form of dry plate which made him famous as a producer of photographic supplies. Eastman first developed sensitized paper, then film that could be put on a roll in a small, handheld camera. By 1888, his factory was producing the famous Kodak model. This made Eastman one of America's richest men, for amateur "shutterbugs" bought it by the tens of thousands. Figure 25.12 shows Eastman holding one of his magic black boxes.

By 1890, the negative had been reduced in size, so that nearly fifty would fit on a roll in the Kodak. That necessitated the invention of the enlarger for the printing process, and George Eastman assured all amateurs that he would take care of enlarging and printing as well—his motto was, "You press the button, we do the rest." When the roll of film was totally exposed, camera and film were sent to the Eastman Company in Rochester, New York. The prints were made, and returned to the owner along with the reloaded camera. While it was the amateurs who made Eastman rich, his compact Kodak, with its interchangeable parts, prepared the way for more convenient professional cameras as well. A revolution in imagemaking had been launched.

CHAPTER TWENTY-SIX

SCULPTURE:

FROM THE AMERICAN RENAISSANCE TO
THE WESTERN FRONTIER, 1870–1900

Amid the agony and success in the social, economic, political, and international arenas, Americans proved that they knew how to celebrate and to don the mantle of culture. The latter was particularly the prerogative of the new millionaire high society. About 1892, Ward McCallister drew up the list of New York's "true" society, as the "400" he designated to be invited to Mrs. William Astor's grand ball. The era of the fancydress ball was inaugurated on 26 March 1883, when William Kissam Vanderbilt and his wife Alva had a housewarming for their new Fifth Avenue mansion, designed for them by Richard Morris Hunt. It was a gala celebration, and it was the Vanderbilt family's *entrée* into society, somewhat begrudgingly agreed to by Mrs. Astor. Tennis, imported from England, was played on Newport mansion lawns, and by 1876 polo had been introduced to Newport by James Gordon Bennett, Jr., publisher of the *New York Herald*. The wealthy also congregated at Saratoga Springs, north of Albany, New York, for the waters, the races, and simply to be seen. But Long Branch, the resort on the New Jersey coast, as seen in Winslow Homer's painting (Fig. 23.6), was strictly for the middleclass, as the gulf widened between the well-to-do *bourgeoisie* and the fabulously rich members of the millionaires' club.

Cultivation of the arts became a passion and an accepted *noblesse oblige* of American high society. The new millionaires built symphony halls and opera houses. American music came of age. New York had had a symphony orchestra since the 1840s, which was revitalized in the 1890s. The Metropolitan Opera opened in its new house in 1883, and Carnegie Hall dates from 1892. The rise of Midwestern cities as centers of the arts began with the founding of the St. Louis Symphony Orchestra in 1880, a year before the Boston Symphony was organized. The Chicago Symphony was founded in 1891, with the backing of Marshall Field, Cyrus McCormick, George M. Pullman, Martin Ryerson, and Philip D. Armour. Cincinnati had a symphony orchestra from 1895, and the following year saw the Pittsburgh Symphony's first performance. In 1900, the Philadelphia Symphony Orchestra was established with Mrs. Alexander Cassatt, the sister-in-law of Mary Cassatt, as one of its principal patrons.

Chicago blossomed during this era, rising like a phoenix from the ashes of the great fire of 1871. Potter Palmer, who had earlier sold his department-store business to a young man named Marshall Field, turned his attention to real estate and building speculation. He is remembered today for his grand Palmer House Hotel. His wife Bertha gave an endless string of galas and charity balls, for which she was internationally famous. Mrs. Palmer was chosen as president of the Board of Lady Managers for the World's Columbian Exposition of 1893, and made the women's department both a large and an important sector of that great fair. The Palmers were tastemakers in the best sense, and numerous Chicagoans particularly looked to Mrs. Palmer for advice in forming their art collections. She was one of the first Americans to recognize the beauty of French Impressionist pictures, which she—and others, on her advice—began collecting. Today, Chicago is especially rich in Impressionist art, thanks to Mrs. Palmer.

In New York, the Vanderbilts realized instinctively that art patronage was *de rigueur* for the emerging American aristocracy. As we know, William Henry Vanderbilt formed a large collection for his Fifth Avenue mansion. His taste in paintings ran almost exclusively to nineteenth-century French pictures of Turkish harems, Moorish interiors, seventeenth- and eighteenth-century costume/genre pieces, and peasant and cattle scenes, by artists such as Bonheur, Corot, Gérôme, Couture, Meissonier, and Millet. One would not know that American painters, past or present, existed. At one doorway off the main entrance, Vanderbilt had installed a bronze replica of the "Gates of Paradise," Lorenzo Ghiberti's fifteenth-century masterpiece created for the Florentine Baptistry.

The sons of William Henry Vanderbilt were also interested in collecting and patronage. When the collection of the great New York department-store magnate A. T. Stewart came on the auction block in 1887, Cornelius II paid a vast sum for Rosa Bonheur's *Horse Fair*, the sensation of the Paris Salon of 1853—and promptly presented it to the Metropolitan Museum of Art. Upon his death in 1899, Cornelius II bequeathed to that same institution J. M. W. Turner's *Grand Canal, Venice*. His brother, William Kissam, left a number of

Old Masters to the Metropolitan when he died in 1920, including Rembrandt's *Noble Slav* and Boucher's *Toilet of Venus*.

SCULPTURE FOR MANSIONS

Many Americans felt that placing European Old Masters or nineteenth-century French academic pieces upon the walls of one's mansion lent a grander aura of culture and sophistication than did American paintings. American sculptures fared better, largely because they were permanent fixtures of the décor.

In the vestibule of the New York mansion that Richard Morris Hunt designed for Cornelius Vanderbilt II was a large fireplace with two caryatid female figures representing Love and Peace, by Augustus Saint-Gaudens; La Farge designed the mosaic overmantel just above them. These handsome figures were rescued before the house was demolished in 1926, and were installed at the Metropolitan Museum of Art. Saint-Gaudens also created sculptural decorations for the Villard Houses on New York's Madison Avenue (Fig. 20.17).

Karl Bitter (1867–1915) was one of society's favorite sculptors for the Beaux-Arts decoration of mansion interiors, and he worked especially closely with Hunt and his son, Richard Howland Hunt, on several Vanderbilt houses. For the elaborate ballroom of Alva and William Kissam Vanderbilt's Marble House at Newport, Bitter carved several figurative panels (Fig. 20.15). To stress the house's association with seventeenth- and eighteenth-century France, he modeled profile medallions of Jules Hardouin-Mansart, architect of Versailles, and Hunt. They face each other, with a replica of Bernini's bust of Louis XIV on a bracket between them. He also created a *Diana at the Chase* for William and Alva's house at Oakdale, Long Island, and several figures for the Fifth Avenue mansion (Fig. 20.9), which were integrated with murals by Edwin Howland Blashfield. He made carvings for Cornelius II's house at Fifty-seventh Street and Fifth Avenue, and for his Newport "cottage." All that sculpture around the house may have inspired one of Cornelius's daughters, Gloria Vanderbilt Whitney, to become a sculptor, and eventually to found the Whitney Museum of American Art in New York.

For George Vanderbilt's Biltmore, Bitter made the spirited, large *Return from the Chase*, a marble relief which spans the triple opening of the great fireplace of the banquet hall (Fig. 20.11). For the organ loft at the opposite end of the hall, he made five additional reliefs representing the entrance of the minstrels from Wagner's opera *Tannhäuser*. In the richly ornate library of Biltmore, Bitter's lifesize personifications of Hestia, goddess of the hearth, and Demeter, goddess of the earth, decorate the fireplace overmantel (Fig. 20.12).

The new millionaire society incorporated the work of American sculptors into the decorations of the mansions they built. They also turned to sculptors to memorialize their heroes and to provide ornamentation for the churches they attended, or for their palaces of commerce and finance, as John Quincy Adams Ward did in the pedimental group he created for George Post's New York Stock Exchange (Fig. 20.22).

CELEBRATIONS, FESTIVITIES, AND CEREMONIES

This was an era of exciting celebrations, which frequently involved sculpture on a grand scale. American triumphs and other causes for festivities came in many forms, such as the unveiling of Bartholdi's Statue of Liberty in New York Harbor in 1886, or the jubilant ceremony arranged in 1899 to welcome home Admiral George Dewey after his victory at Manila Bay the year before (Fig. 26.15). President Ulysses S. Grant, Henry Wadsworth Longfellow, James Russell Lowell, and Ralph Waldo Emerson were among the crowd that assembled just outside Concord, Massachusetts, for the dedication of young Daniel Chester French's bronze statue of the *Minute Man* (Fig. 26.7), launching a celebration of the nation's one-hundredth birthday that would culminate in the great international exhibition of the Philadelphia Centennial of 1876. In Chicago in 1887, Augustus Saint-Gaudens's statue of a standing, lanky Abraham Lincoln was dedicated at the south end of Lincoln Park. Not far away, half a dozen years later, the Great White City would rise up on the muddy banks of Lake Michigan as the World's Columbian Exposition. No fuller use of sculpture was ever made in America, before or after (Figs. 20.23 and 26.13). In the final three decades of the nineteenth century, sculpture had become an integral part of American living, celebration, and commemoration.

About 1870, the procession of American sculptors to Europe began to shift away from Italy to Paris. The favored medium ceased to be the gleaming white marble of Neoclassicism, but rather dark bronze with textured surfaces. A new generation felt that Neoclassicism had exhausted itself. Emerging out of an aesthetic of American naturalism, the sculptors discovered the rich modeling, active surfaces, and spontaneity of figurative form that characterized the Parisian ateliers. The new style became apparent in the French capital with the work of Jean-Baptiste Carpeaux in the 1850s and 1860s, seen in the sprightly figures of the group of the Dance for the Paris Opéra.

Paris quickly became the foremost art center for the study of sculpture, just as it had been for painting. The precisely controlled form, surface, and contour of Neoclassicism gave way to a flickering surface and form that suggested the fleeting moment, instead of the eternal pose. This new style was applied to the portrait of a national hero, or to an intimate group of a mother and child, to a cowboy on a bucking bronco, or to a prancing nymph. America's beloved naturalism—so strongly expressed in painting by men like Eakins and Homer—was almost always the starting point, to which the new Parisian style was added.

HEROES CAST IN BRONZE

The work of John Quincy Adams Ward (1830–1910) continues the naturalistic tradition, established by an earlier generation of American sculptors led by Henry Kirke Brown. Born near the farming community of Urbana, Ohio, Ward had little opportunity to learn about the techniques of sculpture until he went to New York City. There, he showed such talent that he was hired immediately as an assistant to Brown, who taught him the rudiments of the art and that naturalism was the appropriate style for America.

Ward worked with Brown on the major project of the bronze equestrian *George Washington* (Fig. **18.7**), erected in Union Square in 1856. Soon after, Ward struck out on his own, and during the next twenty years made a living as a sculptor of busts and portrait statues. One of his earliest pieces is the *Indian Hunter*. To Ward, the Native American subject demanded a naturalistic style (Fig. **26.1**). Completed and cast in bronze in 1860, the work was praised by contemporaries, who admired its anthropological accuracy and the tense drama of the hunt. A few years later, in 1869, Ward was commissioned to make a lifesize version, which was set up in New York's Central Park. Critics appreciated the choice of a truly American theme, and they praised the way the hunter was portrayed so convincingly, totally

26.1 John Quincy Adams Ward, *Indian Hunter*, 1860. Bronze, height 16in (40.6cm). Courtesy The New-York Historical Society, New York City.

26.2 John Quincy Adams Ward, The James A. Garfield Memorial, Washington, D.C., 1887. Bronze and stone.

intent upon his quarry—quieting his absorbed hunting companion merely by placing a practiced hand lightly on the dog's throat. An expandable narrative was evoked, and the critics liked that, too.

Ward did not feel it was necessary to go to Europe to study, declaring that "an American sculptor will serve himself and his age best by working at home."[1] Nevertheless, by the 1880s he had become aware of the exciting, richly modeled surface of French sculpture, and he began to incorporate this into his own art, although he never emphasized this as much as did younger sculptors who actually studied in France. A strong naturalism blended with an enlivened surface characterizes Ward's mature style, as seen in his figures for the James A. Garfield Memorial (Fig. **26.2**). Ward used a bold naturalism for the romantic allegorical figures on the base of the Garfield monument, figures which refer to Garfield's life as student, warrior, and statesman. In the hands of lesser sculptors, portrait sculpture had become pedantic, and the representation of contemporary attire downright boring. Ward infused his realism with animated vitality, and made the clothing work as part of the robust sculptural form.

AUGUSTUS SAINT-GAUDENS

The art of Augustus Saint-Gaudens (1848–1907) is also based in naturalism, but this is augmented and modified by the sculptor's European experience, not the straightforward naturalism which Ward felt rose from the American soul, directly and innately. Born in Dublin, Ireland, and brought to the United States as an infant, Saint-Gaudens grew up in New York City, where he was apprenticed to a cameo carver. In 1867, he went to Paris, where he spent three years, part of that time in the studio of the renowned François Jouffroy at the Ecole des Beaux-Arts. The masters of the French ateliers had turned to bronze as the preferred medium, but its dark surface needed enlivening, which they accomplished by creating a modeled texture, across which lights and shadows rippled. Greater life was given to statues by choosing animated poses, rather than the more static postures preferred by neoclassical sculptors.

Saint-Gaudens left Paris in 1870 for Italy, where he spent several years. He was less interested in the ancient sculptures there than in the work of several fifteenth-century Florentine sculptors, particularly Lorenzo Ghiberti and Donatello, whose work possessed a naturalism that revealed to the young American how he might invigorate his own work.

In 1875, Saint-Gaudens returned to New York City, where he received his first important commission—the Farragut Memorial (Fig. 26.3). The figure of Farragut is based on Donatello's *St. George* at Or San Michele in Florence. The admiral's feet are placed apart, as if to steady himself on the rolling deck of a ship. He scans the distant horizon, binoculars in hand, and the skirt of his coat blows

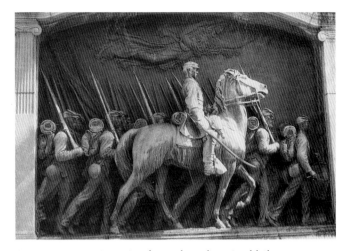

26.4 Augustus Saint-Gaudens, The Robert Gould Shaw Memorial, Boston, Massachusetts, 1884–96. Plaster cast, 11 × 14ft (3.35 × 4.27m).

to suggest a brisk sea breeze. This detail was a stroke of genius, for it expands upon the narrative of the portrait by placing the subject at sea, upon his bridge. It also adds a liveliness to the figure, as does the slight *contrapposto*. The beautifully modeled head is a splendid study of stalwart determination in the face of battle.

The figure is structurally sound, the style clearly naturalistic, and the surface has a texture that reveals a constant interplay of light and shadow. The base, an innovative departure from earlier Victorian and neo-Gothic forms, has personifications of Courage and Loyalty as ocean maidens seated amid fishes and watery currents. This was the first of many bases designed collaboratively by Saint-Gaudens and the architect Stanford White. The Farragut Memorial was unveiled in 1881, an early example of the Civil War memorials that would soon populate American cities. Saint-Gaudens executed a number of these, and none was finer than his equestrian memorial, in Boston, to Robert Gould Shaw (1884–96), with its marching procession of African-American soldiers, rendered in a high relief. There are perhaps no more moving images of black men in nineteenth-century American art (Fig. 26.4).

Each commission posed a unique sculptural challenge to Saint-Gaudens, but none quite as much as the Adams Memorial, which was finally finished and erected after the sculptor had struggled with the problem for five years (Fig. 26.5). Marian, the invalid wife of the author Henry Adams, had ended her life in suicide, and the grieving widower asked Saint-Gaudens to create a monument to mark her grave, set within a holly grove. There were many unfruitful starts, for Adams did not want the figure to be a portrait of his wife, nor did he want the usual personification of grief, quasi-classical variants of which abounded in American cemeteries. Adams's fondess for Oriental philosophies provided the key. The figure—a female—was to represent that tranquility of mind that comes from a meditative withdrawal

26.3 Augustus Saint-Gaudens, The Admiral David Farragut Memorial, New York City, 1881 (base designed by Stanford White). Bronze and stone.

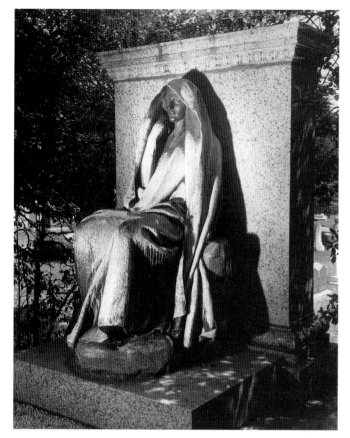

26.5 Augustus Saint-Gaudens, The Adams Memorial, 1886–91. Bronze. Rock Creek Cemetery, Washington, D.C.

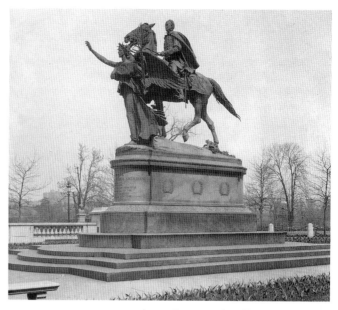

26.6 Augustus Saint-Gaudens, The General William Tecumseh Sherman Memorial, Grand Army Plaza, Central Park, New York City, 1892–1903. Bronze, granite pedestal, over-lifesize.

Saint-Gaudens created a goddess who seems truly American, even in her idealized form, and she is the perfect foil for the figure of Sherman, which has a vital naturalism.

DANIEL CHESTER FRENCH

Daniel Chester French (1850–1931) began modeling little animals and genre subjects in clay in Concord, Massachusetts, in his late teens. Abigail May Alcott, a neighbor and friend of the family, gave him his first lessons, and he had a few more, in drawing, from William Rimmer and William Morris Hunt. Then, an untried novitiate, he had a test of fire thrust upon him. The townspeople of Concord wished to celebrate the centennial of the famous Revolutionary War battle. They presented the twenty-three-year-old sculptor with the commission which resulted in the *Minute Man* (Fig. 26.7).

French rented a studio in Boston where he set up a cast, borrowed from the Athenaeum, of the Apollo Belvedere, which served as the model for the figure. He also had several Concord men pose for him so he could achieve the realism that the classical statue could not provide. He set a plow beside the man, to remind the viewer that here was a farmer who left his fields to defend his liberty. The clothing was rendered as authentically as possible. The face expresses defiance, and the right hand holds the rifle tensely but resolutely. The modeling of both form and surface is vigorous. One can only marvel at the success of what was essentially a first effort. *Minute Man* was cast in bronze at the Ames Foundry in Chicopee, Massachusetts, from melted-down cannon. By the time it was unveiled in 1875, the young sculptor was on his way to Italy.

from the world. Boston Brahmins like Henry Adams understood the Nirvana of Buddhism—that final escape from existence into blissful nonexistence. And so Saint-Gaudens represented the woman in a spiritual trance at the moment that ultimate peace is attained. He gave her a noble, monumental form of unprecedented simplicity, and wrapped her in an unspecific, timeless garment. Stanford White provided the design for the classical base and wall against which the figure sits in total repose. The abstract element is remarkable, but the sculptor did not pursue its possibilities further.

Saint-Gaudens was a perfectionist in his art and its technical aspects. His attention to the larger organization of a composition or the smallest detail gives his work an excellence seldom achieved by other sculptors. One of his last major works demonstrates this point—the General William Tecumseh Sherman Memorial in New York's Central Park (Fig. 26.6). In what many would call the supreme example of equestrian statuary in American art, here is an American descendant of Donatello's *Gattamelata* at Padua and Verrocchio's *Colleoni* in Venice. Saint-Gaudens's mastery of sculptural form and the bold manipulation of light and shadow—created by the interplay of projecting mass accentuated by cavernous recession, particularly in the folds of drapery and the Victory's wings—are splendidly revealed.

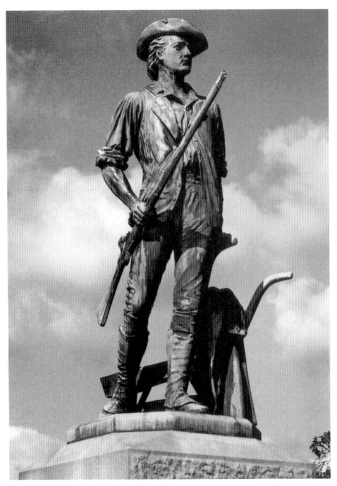

26.7 Daniel Chester French, *The Minute Man*, Concord, Massachusetts, 1874. Bronze and stone.

26.8 Daniel Chester French, *The Angel of Death and the Sculptor* (The Martin Milmore Memorial). Marble copy (1926) of the bronze original (1891–2). Metropolitan Museum of Art, New York City.

26.9 Daniel Chester French, *Abraham Lincoln*, The Lincoln Memorial, Washington, D.C., 1922. Marble.

In the Florentine studio of Thomas Ball, French learned professional practices and studied the nude. He returned home to begin his career, but he soon sensed that he should go to Paris for further study, which he did in 1886. He was only in Paris two years, but that was long enough for him to grasp the essentials of the new style, which stressed lively surfaces and de-emphasized associations with classical statuary.

The Angel of Death and the Sculptor possesses bold form and faceted surfaces (Fig. 26.8). French's skill in the inter-action of form, space, light, and shade is especially notice-able in the way the angel's hood thrusts forward to create a dark cavern, beautifully defining the profile of the head. The figure of the young sculptor is lively, and anything but static. The scene represents the gentle Angel of Death coming to take a sculptor—Martin Milmore—in his prime of life as he works on one of his monuments, the Sphinx-like Bigelow Memorial (Mount Auburn Cemetery, Cambridge, Massachusetts). She carries poppies in her right hand, symbols of endless sleep, while with her left she softly stays the hand of the young artist. The bronze original was set up in Boston's Forest Hills Cemetery in 1892 as the Milmore

Memorial, and the marble version illustrated here was carved many years later, in 1926.

French's career was a long one, extending well beyond the advent of modernism in the early twentieth century. One of his bestknown sculptures in America is the colossal marble image (Fig. 26.9) enshrined in Henry Bacon's classical temple, the Lincoln Memorial (Fig. 27.3), which was dedicated in 1922. Nearly a decade had lapsed since the Armory Show and the appearance of Marcel Duchamp's *Nude Descending a Staircase*. By comparison, French's *Lincoln* seems academic, entrenched against the avant garde. Judged on its own terms, however, it is a beautiful work, showing the Great Emancipator burdened by his troubled times, grave and pensive, and dignified in his own raw, unsophisticated way. By 1922, French had long been declared Saint-Gaudens's successor as dean of American sculptors, a title bestowed by the conservative group centered around the National Sculpture Society in New York.

AMERICANS IN PARIS

Olin Levi Warner (1844–96) arrived in Paris in 1869, and joined Augustus Saint-Gaudens, who was also studying in the Jouffroy atelier at the Ecole des Beaux-Arts. Among the many celebrated Parisian sculptors active then were J. A. J. Falguière and M. J. A. Mercie, and Jean-Baptiste Carpeaux, who had recently completed his decorations for the Pavilion of Flora at the new Louvre.

Warner worked briefly in Carpeaux's large studio, but when the civil and political unheavals of the Franco-Prussian War rocked Paris in 1870, he returned to the United States. In New York he took a studio in the same building as the painter Julian Alden Weir, who had recently returned from study at the Ecole in Paris. About 1880, Warner modeled a bust of Weir. This possesses the lively, flickering surfaces and the impressionistic attitude toward form that characterized the Parisian studios (Fig. 26.10). Warner was one of the many sculptors connected with the World's Columbian Exposition at Chicago in 1893. He designed the commemorative silver dollar, which thousands of visitors took home as souvenirs. Three years later he died, at the age of fifty-two.

Paul Wayland Bartlett (1865–1925) was the son of a minor sculptor but an important art critic, Truman Bartlett, who sent his son, at age nine, to Paris to be educated. By 1880, when he was only fifteen, Paul was already taking drawing and modeling classes at the Ecole. He soon began to study under the noted animal sculptor Emmanuel Frémiet. He was still in his early twenties when he created the work that brought him immediate critical acclaim—*The Bear Tamer* (Fig. 26.11). The Western world had suddenly become fascinated with "primitive" peoples, in part because of the controversy raging over Charles Darwin's *Origin of Species* (1859). Such subjects were startlingly new to art, and we have already seen how popular Ward's *Indian Hunter* was (Fig. 26.1). A comparison of these two pieces shows how Bartlett's style was truly a product of his French

26.10 Olin Levi Warner, *Julian Alden Weir*, 1880. Bronze, height 22in (55.9cm). Corcoran Gallery of Art, Washington, D.C.

training. There is a boldness in the modeling that leaves the viewer with a sense of spontaneity, the artist's fingerprints and toolmarks still visible, giving the sculpture the appearance of having been freshly done.

Bartlett became one of the most successful American sculptors in the late nineteenth century. For the rotunda of the new Library of Congress, he created bronze figures of Columbus and Michelangelo. Just before 1900, he began work on an equestrian statue of Lafayette, which was erected in the courtyard of the Louvre in Paris, a gift in

26.11 Paul Wayland Bartlett, *The Bear Tamer*, 1887. Bronze, height 27in (68.6cm). Corcoran Gallery of Art, Washington, D.C.

exchange for the Statue of Liberty. For the long-empty pediment of the House of Representatives wing of the U.S. Capitol, he sculpted *Peaceful Democracy*, executed in the fluid French style which stands in marked contrast to Thomas Crawford's earlier Senate pediment in the neoclassical mode.

Brooklyn-born Frederick MacMonnies (1863–1937) was a sculptor in the New York studio of Augustus Saint-Gaudens,

26.12 Frederick William MacMonnies, *Bacchante and Infant Faun*, small replica of the original of 1893. Bronze, height 16¼in (41.3cm). Cincinnati Art Museum.

where he became expert in modeling. In 1884, he went to Paris to work under the tutelage of Jean Alexandre Joseph Falguière, whose studio assistant he became. His statue of *Nathan Hale* (1890) for New York City and his impish *Pan of Rohallion* (early 1890s) brought him much acclaim. Then came the work that scandalized Boston—the *Bacchante* (Fig. 26.12), commissioned by Charles Follen McKim for the courtyard of Boston's new Public Library (Fig. 20.19). MacMonnies created a sprightly, gleeful, romping nude young female carrying the infant Dionysus in one hand and tantalizing him with a bunch of grapes in the other. She danced merrily with all the abandon of Carpeaux's circle of nymphs from the Opera House group. Bostonians found her wanton—so debased as not even to realize the sin of her nudity. She was chased out of town, but found a home in the Metropolitan Museum of Art. The *Bacchante* is a reflection of the actual studio model, a real-life late-nineteenth-century young French woman, whose smiling merriment is the antithesis of classical restraint and decorum.

MacMonnies often seemed to indulge in excesses, and sometimes his work rose to a grand neo-Baroque crescendo—as in the *Barge of State*, which he created for the World's Columbian Exposition at Chicago (Fig. 26.13). In a ship vaguely resembling one of Columbus's three, Columbia sits perched on her high throne, while Time steers the rudder and winged Fame leads the way on the bow. At the oars are personifications of the Arts and Industries. This extravaganza, made of staff material (a mixture of plaster and straw), was placed in the middle of cascading waters at one end of the Great Basin. It was a wonderful amalgamation of Beaux-Arts, neo-Baroque, and American Renaissance features, and it worked beautifully with the architecture of the Great White City around it (Fig. 20.23). Like all the other staff sculptures, however, it did not long survive exposure to the elements.

26.13 Frederick William MacMonnies, *The Triumph of Columbia*, or *The Barge of State*, World's Columbian Exposition, Chicago, Illinois, 1893. Staff material (destroyed).

LATE-NINETEENTH-CENTURY FRENCH INFLUENCES

Late-nineteenth-century French influences also dominated the art of George Grey Barnard (1863–1938), bestknown for his enigmatic group *Struggle of the Two Natures in Man* (Fig. 26.14). Barnard's boyhood was spent in the Midwest, and his first formal instruction was at the Art Institute of Chicago. In 1883 he set off for Paris to study at the Ecole des Beaux-Arts. He learned the modeling techniques and the special surface effects of the French ateliers. The muscular, monumental figures of Michelangelo were also a powerful influence on him, as can be seen in *The Two Natures in Man*.

It was this heroic work that brought the young American sculptor to the attention of the art world when it was exhibited at the Paris Salon in 1894. The title may be derived from Victor Hugo's "Je sens deux hommes en moi" ("I am aware two men exist within me"), suggesting the eternal struggle of two forces, one active, the other passive. When it was finished, he had it carved from a block of Carrara marble rather than cast in bronze, possibly as a result of his admiration not only for Michelangelo's work, but also for that of his contemporary, the celebrated arch-Romanticist Auguste Rodin (1840–1917), who often worked in marble and whose sculptures Barnard knew well. This influence is especially noticeable in one of Barnard's later commissions, for the new Pennsylvania State Capitol at Harrisburg (1902–10), representing *The Broken Law* and *The Unbroken Law*. The groups remind us very much of Rodin's *Gates of Hell*.

26.15 Charles R. Lamb, The Dewey Arch, New York City, 1899. Sculpture by Frederic Ruckstull and others. Staff material (destroyed).

26.14 George Grey Barnard, *Struggle of the Two Natures in Man*, 1889–94. Marble, height 8ft 5in (2.57m). Metropolitan Museum of Art, New York City.

In 1893, American sculptors formed their own organization—the National Sculpture Society—to promote the cause of sculpture, to sponsor annual exhibitions, and to maintain high quality in art. A few years later, when New York City honored Admiral George Dewey, the naval hero of the Spanish-American War, the National Sculpture Society coordinated the erection of a great triumphal arch at the spot where Fifth Avenue joined Madison Square (Fig. 26.15). Nearly every prominent sculptor of the day contributed a group or a figure to the rich imagery, which was, like the sculptures made for the World's Columbian Exposition in Chicago, wrought in the temporary and perishable staff material.

Atop the arch a triumphant Victory rides the bow of a ship pulled by powerful horses of the sea. Naval heroes from the nation's past adorn the arch, as do groups of sailors and officers in action on the decks of ships. Victories salute the conqueror from the bases of columns, the foremost of which display the trophies of war. If sculpture was an unknown art a century earlier, sculptors demonstrated here that they could create just the sort of festive, nationalistic, imperialistic, chest-thumping imagery that caught the mood of the United States around 1900.

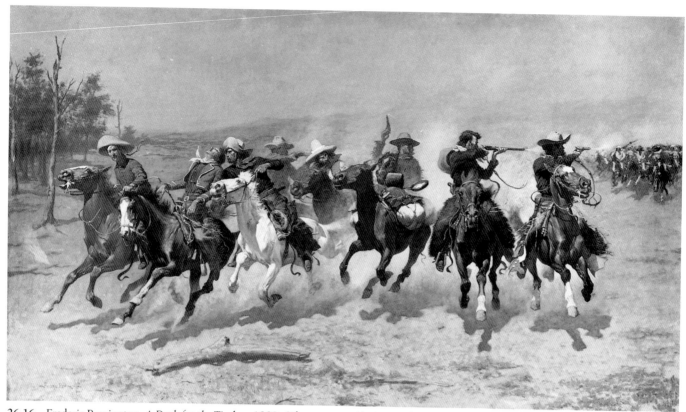

26.16 Frederic Remington, *A Dash for the Timber*, 1889. Oil on canvas, 4ft¼in × 7ft⅛in (1.23 × 2.14m). Amon Carter Museum, Fort Worth, Texas.

SCULPTURE AND THE AMERICAN WEST

If Americans were suddenly conscious of their new power among the nations of the world, they were also fascinated with their own land, now romanticized along with a rugged new popular hero—the Westerner, whether pioneer, cowpoke, cavalryman, mountain trapper, or goldminer. Brett Harte had made the West popular among Easterners with tales like "The Luck of Roaring Camp" (1868) and "Outcasts of Poker Flats" (1869). No one captured the image and spirit of the cowboy and the mounted trooper of the plains, however, the way Frederic Remington did.

Remington (1861–1909), who had a natural talent for art but little formal training, set out from his native Upstate New York to see the West when he was nineteen. Before long, in the late 1880s, he was supplying popular periodicals with sketches. He was also writing his own stories about life among the "cowboys and Indians," which were illustrated with his own pen-and-ink drawings and, later, oil paintings, such as *A Dash for the Timber* (Fig. **26.16**). An action scene set in Arizona, it depicts eight hardriding cowboys pursued by a band of Apaches in a life-and-death drama.

Remington did not attempt his first sculpture until 1895. That initial effort was a remarkable success—*Bronco Buster* (Fig. **26.17**). *Bronco Buster* has the reality and the spirit of life born of Remington's experience rather than of academic training. The subject was raw, wild, and untamed, and the artist had the good sense not to try to portray this

26.17 Frederic Remington, *Bronco Buster*, 1895. Bronze, height 23in (58.4cm). Courtesy The New-York Historical Society, New York City.

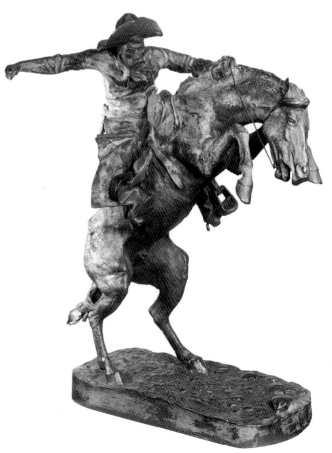

rough-and-tumble cowboy in the guise of an Apollo riding his steed across the heavens. The modeling technique is as vigorous, rough, and bold as the subject itself, and, in Remington's hands, subject and style were perfectly matched. In response to popular demand, over 200 replicas were cast.

One of Remington's finest and most expressive sculptures is the *Trooper of the Plains, 1868*. It was created in 1905 as a nostalgia piece, for by then the Indian Wars and the flight-to-escape while firing over one's shoulder were only memories (Fig. 26.18). Remington was as careful to portray the horse accurately—the type used on the frontier rather than one of thoroughbred Arabian stock—as he was to capture the likeness of a leatherskinned, lean, tough, mustachioed old pony-soldier who carries with him everything he owns. Every detail was attended to meticulously, for accuracy was at the very center of Remington's art.

There were now a number of sculptors—men who either came from the West or had lived there long enough to know it well—who took the Native American as their subject. The "Indian threat" had ceased to exist, removed by defeat, disease, annihilation, or to lands no one else wanted, so the time had come to romanticize the Native American. Several sculptors produced especially sympathetic images—Cyrus Dallin (1861–1944), for instance, in his four heroic equestrian statues. Perhaps the bestknown of these are *Medicine Man* (Fig. 26.19) and *Appeal to the Great Spirit* (1908, Museum of Fine Arts, Boston). In *Medicine Man*, the

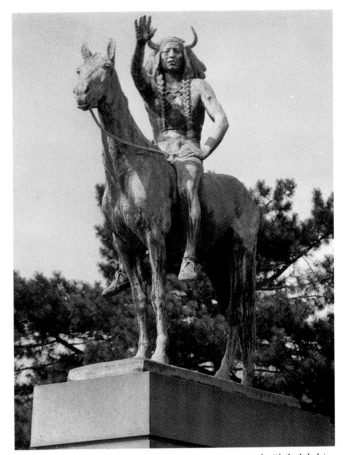

26.19 Cyrus Dallin, *Medicine Man*, Fairmount Park, Philadelphia, 1899. Bronze.

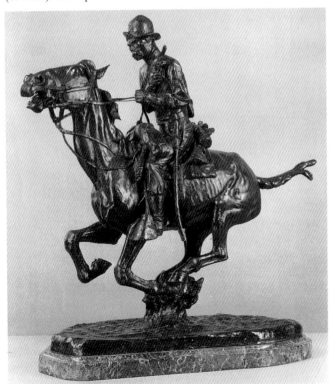

26.18 Frederic Remington, *Charging Trooper (Trooper of the Plains, 1868)*, 1905. Bronze with marble base, height 25in (63.5cm). Metropolitan Museum of Art, New York City.

mounted warrior seems to be watching from his pinnacle as a never-ending line in the distance brings more and more white settlers deeper and deeper into his tribe's lands. He raises his outstretched arm and murmurs some incantation to halt the invasion that will end his way of life. Contemporaries marveled at the naturalism of the piece, but also at the noble dignity with which Dallin imbued his Native American rider. Dallin, who had been born and raised in Utah Territory, had studied in Paris at the Académie Julian under Henri Michel Chapu, but it was the subject itself, in his western sculptures, that dictated the style.

Solon Hannibal Borglum (1868–1922) grew up in Nebraska Territory, where he and his brother Gutzon (also a sculptor, bestknown for his presidential portraits on Mount Rushmore in South Dakota) would daily play with the Native American boys of a nearby tribe. Borglum studied in Paris, but fascination with cowboys, Native Americans, horses, and the animals of the western plains made him anxious to return home. The great Louisiana Purchase Exposition, celebrating the centennial of the acquisition of that vast tract of land in the middle of the nation, was then in the planning stages and scheduled to open in St. Louis in 1904. Borglum was commissioned to create four large groups depicting western subjects for it. Made of staff, these

26.20 Solon Hannibal Borglum, *Sioux Indian Buffalo Dance*, small replica of the group made for the Louisiana Purchase Exposition, St. Louis, 1904. Bronze, 38 × 46in (96.5 × 116.8cm).

26.21 (below) Herman Atkins MacNeil, *Sun Vow*, 1898. Bronze, height 6ft 1in (1.85m). Metropolitan Museum of Art, New York City.

groups soon deteriorated, but a small bronze replica of *Sioux Indian Buffalo Dance* gives an idea of what the larger work was like (Fig. **26.20**). The sculptor captured all the color and excitement of the ceremony, in which the participants implored the Great Spirit to send them huge herds of the life-sustaining buffalo. One can almost hear the beat of the drummer at the rear of the group and the incantations of the central figure, and feel the energy and urgency of the foremost figure, clad in his buffalo hide, with a string of bear claws around his neck.

Another sculptor who took Native American life as a favorite theme was Hermon Atkins MacNeil (1866–1947), a New Englander by birth who studied in Paris with Chapu and Falguière. Returning to the United States, he went to Chicago to find employment making the sculptures for the World's Columbian Exposition. One of the main attractions of that fair was Buffalo Bill's Wild West Show, the finale of which had a great number of Native Americans stage a mock attack on a wagontrain that had drawn up into a circle. MacNeil was so enthralled with the Native Americans and their ways that he spent much of the next ten years traveling among them, especially the Moquis and the Zunis. The result was works such as *Sun Vow*, a lifesize bronze group that shows an older man instructing his adolescent charge in the ceremony of shooting an arrow toward the sun and making a vow, as part of the rites of passage from youth to manhood (Fig. **26.21**). The piece has the rich, flickering surface of the Parisian manner, but there is also accuracy in the way the hair is worn, the cut of the moccasins, and the type of bow and feathered headdress. There is a vigorous naturalism which all sculptors of the western theme adopted.

26.22 Bessie Potter Vonnoh, *The Young Mother*, 1896. Bronze, height 14½in (36.8cm). Metropolitan Museum of Art, New York City.

GENRE SCULPTURE

American genre sculpture, too, had undergone significant changes since mid-century, when it was dominated by John Rogers and his popular little plaster groups (Figs. **18.10** and **18.11**). With the advent of a more cosmopolitan awareness of international art movements, interest in Rogers's groups subsided dramatically in the late 1870s. Genre instead took on the form found in Bessie Potter Vonnoh's *The Young Mother*, a small bronze group that reminds us of a theme made popular by Mary Cassatt (Fig. **23.24**) and wrought in a loose, fluid, spontaneously modeled, impressionistic manner (Fig. **26.22**). Also, in the sweeping, undulating curves one finds a trace of the popular contemporary Art Nouveau. Bessie's father, Edward Potter, was a successful sculptor, and she learned the rudiments of her art from Lorado Taft in Chicago. Bessie Potter (1872–1955) married the painter Robert Vonnoh in 1899. Vonnoh worked in the Impressionist style.

About the time she rose to the height of her career, modernism arrived upon the American art scene, eclipsing her work—just as it did that of so many other fine sculptors of her generation who preferred the more traditional manner. Americans felt they had to choose between the traditional and the modern, that both could not exist simultaneously. The conservative group that rallied around the National Sculpture Society was for many decades ignored, while nearly all attention was focused on the dazzling experiments of modern art. More recently, a feeling that it is possible to enjoy both traditions in art has emerged, that the conservative, figurative tradition is deeply rooted in American culture—from John Singleton Copley to Andrew Wyeth in painting, and from colonial gravestone carvings to Duane Hanson in sculpture.

PART 5

The Early Modern Period

CHAPTER TWENTY-SEVEN

ARCHITECTURE:

THE FIRST GENERATION OF MODERNISM, 1900–40

As the new century opened, the United States claimed a prominent position on the stage of world affairs. It became involved in the Boxer Rebellion in 1900, and mediated in the Russo-Japanese War. In 1900, Walter Reed discovered that yellow fever was carried by mosquitoes. Three years later, William Gorgas was sent to Panama to eliminate the mosquito and the disease so work could begin on a canal connecting the Atlantic and Pacific oceans. On 15 August 1914, under American protection and management, the Panama Canal was officially opened.

This was the era of Teddy Roosevelt's (president 1901–9) "speak softly, but carry a big stick" philosophy of foreign affairs. In 1907–9 he sent the great white fleet of American naval vessels on a tour around the world, just to remind the world of America's military might. American interests were no longer isolationist and selfcontained, but assertively international and global.

In domestic affairs, President Roosevelt attacked the mammoth industrial monopolies and financial combines in an effort to impose regulation upon a capitalism that had been running rampant. Herbert Croly became the spokesman for the Roosevelt assault when he published *The Promise of American Life* (1909), in which he declared that " . . . the prevailing abuses and sins, which have made reform necessary, are all of them associated with prodigious concentration of wealth, and of the power exercised by wealth, in the hands of a few men."[1] And Croly struck true to the mark in forecasting the direction in which American government would generally move in the ensuing century when he continued, "The American state will in effect be making itself responsible for a morally and socially desirable distribution of wealth." Armed with the Sherman Anti-Trust Act of 1890, both Roosevelt and his successor William Howard Taft (president 1909–13) took on J. P. Morgan, John D. Rockefeller's Standard Oil Trust, and the American Tobacco Company. Here was a federal government as ready to intrude into the world of business as it was into world affairs.

Political tensions had been mounting on the Continent well before 28 June 1914, when Archduke Ferdinand was assassinated at Sarajevo. Germany and Austria-Hungary immediately declared war on France, England, Russia, and Belgium. Warfare itself was now changed by the use of submarines, airplanes, and poison gas, all producing devastating results. The Russian Revolution erupted on 15 March 1917, Tsar Nicholas abdicated, and Russia was essentially out of the war. By early November, the Bolsheviks had overthrown the provisional government, placing Lenin and Trotsky in power.

Although the main concern of President Woodrow Wilson (president 1913–21) was to avoid being drawn into the conflict, the United States was angered by the repeated sinking of American ships by German U-boats, and so was inexorably drawn into the vortex of war. In April 1917, President Wilson asked Congress for a declaration of war against Germany and Austria. It was given at once.

By June, the first American expeditionary troops had landed in France, singing "It's a long way to Tipperary" as they disembarked. By October they were in the trenches of the Western Front, and the dreadful slaughter had begun. The high-spirited singing had stopped by then, and even with the signing of the armistice on 11 November 1918, a state of profound revulsion swept the world as total casualties were tabulated: An estimated ten million dead—of whom 130,000 were Americans—and twenty million wounded. John McCrea, a Canadian poet, wrote his famous poem while under fire on the front lines, and the opening words have a haunting melancholy about them, even to this day: "In Flanders fields the poppies blow/Between the crosses row on row"

Insight into the scarred souls and nihilistic psychosis of those who were in the war and survived is expressed by authors such as Erich Maria Remarque in *All Quiet on the Western Front* (1929) and Ernest Hemingway in *The Sun Also Rises* (1926) and *A Farewell to Arms* (1929). In Remarque's novel, Paul Baumer is little more than a boy in a German uniform, huddled with others like him in the trenches of the Western Front. He is no hero, and war is not romantic. In place of valor he knows only fear, hunger, and pain; he hears men crying in the night and sees his friends killed or dismembered by exploding shells. Amid the rats, dysentery, typhus, and influenza of the trenches—where he is slightly gassed—a profound disillusionment sets in, a conclusion that life is meaningless. On an October day in

1918 (only a couple of weeks before an armistice would be reached), despite a communiqué reporting that all is quiet on the Western Front, a stray bullet hits Baumer and kills him. The story ends there, on a note of utter futility.

Similarly, Hemingway's *The Sun Also Rises* involves a group of spiritually war-wounded American and British expatriates living in Paris about three years after the Great War. Jake Barnes, more a nonhero than hero or antihero, has been wounded in the war and is physically incapable of making love, which is frustrating for both him and Lady Brett, who seeks escape in alcohol and consolation in meaningless affairs. Jake and his friends drink constantly and heavily, move from place to place, from party to party, and all but Jake make love easily but rather emptily with prostitutes, bullfighters, or whoever. It, too, is a story of despair, disillusionment, and aimlessness in the wake of unprecedented horror. Hemingway himself had been in Paris soon after the war. Once, when he visited Gertrude Stein's apartment, she reportedly told him that his was a "lost generation."

In the United States, the decade following the war became known as the Roaring Twenties—a time of seemingly endless bibulous gaiety. In 1919, Congress passed the Eighteenth Amendment, and from January 1920 Prohibition was the law—or the lawlessness—of the land. In response, gangs fought for control of the bootleg booze business, while flappers frenetically danced the Charleston in "speakeasies." It was a time of hipflasks, raccoon coats, and sleek Bugatti automobiles speeding along the highways. On 4 December 1927, twenty-eight-year-old Duke Ellington opened a five-year run at the Cotton Club in Harlem, a high point of society's Harlemania.

The supreme chronicler of the Roaring Twenties—supreme because he lived it so fully himself—was F. Scott Fitzgerald. His trilogy—*This Side of Paradise* (1920), *The Great Gatsby* (1925), and *Tender is the Night* (1934)—chronicles the frivolity and abandon of the Jazz Age. *The Great Gatsby* was Fitzgerald's masterpiece. Like other novels written by the "lost generation," it has main characters who find life empty, fraudulent, or illusory.

Despite an underlying mood of depression, it was an exciting, productive era in commerce and industry, as well as in the arts. Business became a foremost patron of architecture, and the skyscraper came of age with the designing and construction of such milestones as the Flatiron Building and the Woolworth Building in New York City. The latter, called "The Cathedral of Commerce," was in 1913 the world's tallest building, reaching to a height of nearly 800 feet (244 m).

A dynamic style of architecture rose above the skylines of the major cities—the Philadelphia Savings Fund Society, the Empire State Building, the Chrysler Building, and the vast complex of Rockefeller Center in New York City. It was a time when the established Beaux-Arts Revival styles were challenged by the new, clean lines of modernism.

BEAUX-ARTS ARCHITECTURE: A LAST HURRAH

The old historic styles, however, died hard. As late as 1922, when a competition was held for the design of a major skyscraper, an entry in the Gothic mode won. That same year, a Greek Doric temple was erected at one end of the Mall in Washington, D.C.—a gleaming white marble shrine to Abraham Lincoln. Indeed, the Ecole des Beaux-Arts style was yet to have a number of triumphs. Foremost among these was Carrère and Hastings's New York Public Library. The use of a Renaissance-Baroque Revival style for such an important commission clearly demonstrated that the influence of the Ecole was alive and well. Carrère and Hastings used a similar French classicism in 1912 for the Henry Clay Frick residence, now the home of the Frick Collection, New York City.

John Merven Carrère (1858–1911) and Thomas Hastings

27.1 Carrère and Hastings, New York Public Library, New York City, 1897–1911.

(1860–1929) had been students together at the Ecole in Paris in the early 1880s, and after returning to the United States they both worked for the firm of McKim, Mead, and White before forming their own partnership in 1887. They won the competition to design the library in 1897, only a few years after the World's Columbian Exposition at Chicago, itself a Beaux-Arts extravaganza (Fig. 27.1).

The influence of the Beaux-Arts style was also felt at the Panama-Pacific Exposition, held in San Francisco in 1915 (Fig. 27.2). The City by the Bay was anxious to show the world it had survived the disastrous earthquake of 1906,

which had leveled two-thirds of the town, and the Beaux-Arts style was a conscious choice for the architecture of the fair. The Palace of Fine Arts was designed by Bernard R. Maybeck (1862–1957), who graduated from the Ecole des Beaux-Arts, and worked for a while in the firm of Carrère and Hastings in New York City before going to the San Francisco area in 1899.

Further evidence of the Beaux-Arts style is found in the Lincoln Memorial, designed in the Greek Doric Order by Henry Bacon (1866–1924) (Fig. 27.3). Within the temple sits the colossal marble image of Abraham Lincoln by Daniel

27.2 Bernard R. Maybeck,
Palace of Fine Arts,
Panama-Pacific Exposition,
San Francisco, California, 1915.
Wayne Andrews/Esto.

27.3 Henry Bacon,
The Lincoln Memorial,
Washington, D.C., 1922.

Chester French (Fig. 26.9). Bacon did not attend the Ecole, but adopted the Beaux-Arts style while working in the offices of McKim, Mead, and White in the 1880s and 1890s.

The Beaux-Arts style remained viable throughout the next decade, being used especially in federal, state, and municipal buildings. One of its leading practitioners was John Russell Pope (1874–1937), who left his imprint on such buildings as the Jefferson Memorial (1936) and the National Gallery of Art (1937–41). Through buildings like these, nineteenth-century French Beaux-Arts classicism was transformed into what is loosely referred to as the Federal style of the 1930s.

Paul Cret (1876–1945), a native of France and trained at the Ecole des Beaux-Arts, came to the United States in 1903 and established a successful practice in Philadelphia. His success was due in part to his ability to transform Beaux-Arts classicism into a quasi-modern idiom, as in his designs for the Indianapolis Public Library (1914), the Detroit Institute of Arts (1919–27), the Rodin Museum in Philadelphia (1926–30), and the Folger Shakespeare Library (1930–7) in Washington, D.C.

THE SKYSCRAPER: HIGHER AND HIGHER

The path of modern architecture was, of course, developing contemporaneously. Soon after the new century opened, buildings began to soar high above the five- and six-storied urban skyline. The skyscraper posed the greatest challenge to the progressive architects of the day. Passing first through a Beaux-Arts stage, the design grew into a towering glass box. Stripped almost totally of decoration, it relied purely on proportion and the character of the building materials for aesthetic content. The economic expediency of eliminating carved and other costly decoration was not lost on corporate executives, who often viewed architecture as a commercial, rather than a fine-art, venture.

A FORM FOR THE TALL BUILDING

When it was completed in 1903, Daniel Burnham's Flatiron Building towered above everything else in New York City (Fig. 31.5). It was soon challenged, however, by Ernest Flagg's Singer Tower of 1908, which rose to a height of forty-seven stories, and was, for a few years, the tallest building in the world. Flagg (1857–1947) had been trained at the Ecole in the early 1890s. To cap his towering giant, he devised a variant of the French Baroque style, thus terminating his achievement in a grand stroke of historicism.

If the Singer Tower was a rather heavy-handed solution to skyscraper design, the Woolworth Building by Cass Gilbert (1859–1934) was a much more elegant answer to the problem, although it, too, employed an historic style (Fig. 27.4).

27.4 Cass Gilbert, Woolworth Building, New York City, 1911–13. Courtesy The New-York Historical Society, New York City.

Gilbert had been trained at the Massachusetts Institute of Technology (MIT) before going to Europe, where he studied Gothic and Renaissance buildings as he traveled about. He worked briefly for McKim, Mead, and White around 1880, but then settled in St. Paul, where his neoclassical design for the Minnesota State Capitol (1895–1903) brought him national recognition. Soon after, Gilbert received the important commission to design the Woolworth corporate headquarters. Frank W. Woolworth, with a successful and growing chain of five-and-ten-cent stores, set out to displace the Singer (of sewing machine fame) Tower in setting a new world record for height. Woolworth was reportedly impressed by a photograph of the Victoria Tower of the nineteenth-century Houses of Parliament in London, executed in the Gothic mode.

Rising from a lower block, the Woolworth Building reached a height of fifty-five floors (760 ft, 232 m) to become the world's tallest inhabited structure. Its exterior is a glistening white terracotta veneer, applied to the steel frame of the structure. Each vertical member culminates in a Gothic canopy or finial of exquisite detailing. With the refined vertical reach of the Woolworth Building, the tall building had at last achieved a form consistent with its towering mass. The solution, however, was still as dependent as ever upon an historical style.

CITY VERSUS CITY

In those early decades of the twentieth century, New York City and Chicago competed with each other in the development of the skyscraper. While the Midwestern city developed out of the school of William Le Baron Jenney, Louis Sullivan, Daniel Burnham, and the like, the eastern metropolis asserted its claim through the designs of Ernest Flagg, Cass Gilbert, and others. Each city evolved its own form. For example, many Chicago skyscrapers consisted of a single blocklike structure capped with a great cornice, while in New York City, the preferred design was a tall, slender tower—with more of a finial than a cornice—rising out of a lower block, as in the Woolworth Building.

The skyscraper, however, created problems from the beginning. When façades rose to twenty and more stories, the streets below became dark canyons that the sun seldom reached. Skyscrapers also created congestion and traffic problems, as well as fire hazards. Legislation addressing such problems came in 1916, with New York City's setback laws, which required that buildings literally be set back from the edges of their lots and that they be designed in the stairstep form if taller than a given height.

If the Woolworth Building was New York City's first thoroughly successful solution to the problem of skyscraper design, Chicago's first full realization of the form came with the Wrigley Building, the creation of the firm of Graham, Anderson, Probst, and White (Fig. 27.5, left). Here again,

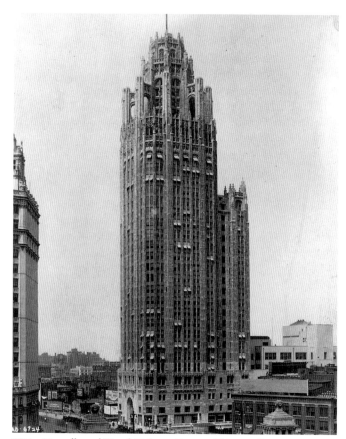

27.6 Howells and Hood, Tribune Tower, Chicago, Illinois, 1922–5.

the pier form was used to stress the vertical axis of the tall building, with stronger piers defining the corners and running the full height of the tower section. The ornamentation—wrought in glazed white terracotta—in the friezes, cornices, and finials is Palladian and French Baroque. The tripartite design of a multifloored base section, followed by the towering midsection, and capped by a crown, reveals the influence of the Woolworth Building. The portion of the Wrigley Building to the right of the original block was added in 1924.

Just across North Michigan Avenue from the Wrigley Building stands the Tribune Tower (Fig. 27.6). The 1922 competition for the building created great interest throughout Europe and America, attracting over 200 entries from an international array of architects. The competition was of great importance because of the variety of solutions proposed. The only stipulation the competition committee set forth was that the Tribune Tower should be the "world's most beautiful office building." The design that was selected was by John Mead Howells and Raymond Hood, who produced a skyscraper in the Gothic mode, with slender, vertical piers accentuating its height and culminating in a flamboyant display of Gothic tracery, finials, and flying buttresses.

The Tribune Tower was one of the most eclectic skyscrapers ever made, for it looked backward to Beaux-Arts historicism, as one might expect from Howells and Hood at this stage of their careers. Howells (1868–1959) had studied at the Ecole des Beaux-Arts before joining the New York City firm of I. N. Phelps Stokes. Hood (1881–1934) also had

27.5 Graham, Anderson, Probst, and White, Wrigley Building, Chicago, Illinois, 1921–5.

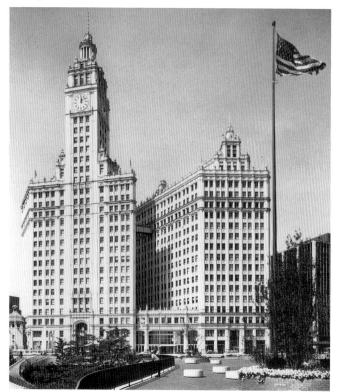

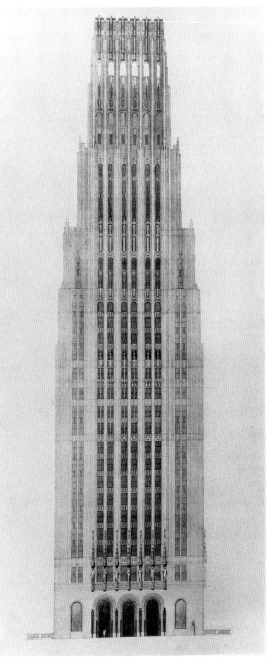

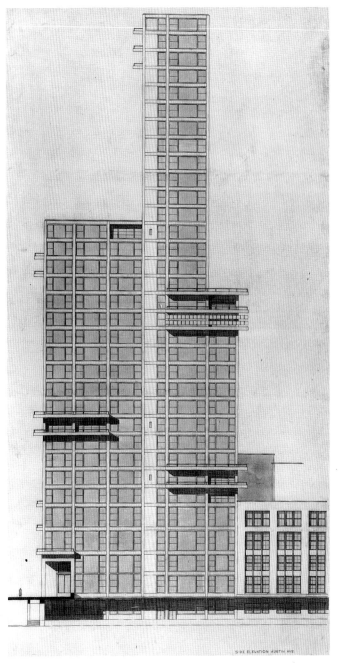

27.7 Eliel Saarinen, Competition drawing for the Chicago Tribune
Tower, 1922. Plate 14 from *The International Competition for a
New Administration Building for the Chicago Tribune* (Chicago,
1923). Morris Library, University of Delaware, Newark, Delaware.

27.8 Walter Gropius (with Adolph Meyer), Competition drawing
for the Chicago Tribune Tower, 1922. Elevation. Ink and gray
wash, 60 × 30in (152 × 76.2cm). Busch-Reisinger Museum,
Harvard University, Cambridge, Massachusetts.

studied at the Ecole and had observed the sensitive use of
Gothic style when he worked for the successful Boston
architect Bertram Goodhue.

Howells and Hood may have won the competition for the
Tribune Tower, but the design submitted by Eliel Saarinen
(1873–1950) of Helsinki attracted greater critical attention
and had a greater influence on the development of modern
architecture. Saarinen's entry (Fig. 27.7), which won second
prize, also had Gothic features, but the series of gradual
setbacks as it rose to its full height was entirely new and
would influence the design of buildings such as the Empire
State Building, the Chrysler Building, Rockefeller Center,
and the Daily News Building. The reception accorded his

design caused Saarinen to leave Finland in 1923 to settle in
the United States.

Other strains of modernism turned up in the Tribune
Tower competition. From Holland came an entry submitted
by Knud Lonberg-Holm (b. 1895), executed in the De Stijl
manner, with flat planes and primary colors, and devoid
of any historicism. Walter Gropius (1883–1969), of Bau-
haus fame (see pp. 419 and 504), submitted a design that
derived its aesthetics largely from the steel frame itself
(Fig. 27.8). Such designs, however, were too progressive
for American taste in 1922, and it would be nearly a decade
before such work made a serious inroad into architectural
design.

FRANK LLOYD WRIGHT: THE EARLY CAREER

As a boy on the family farm near Spring Green, Wisconsin, Frank Lloyd Wright (1867–1959) learned about the organic interrelatedness of nature's systems. Later, he would see that architecture, too, was subject to similar organic laws.

In 1887 Wright went to Chicago, where he became a draftsman with the firm of Adler and Sullivan. In this way he was exposed to the most advanced architectural thought of the period, and he learned much from Sullivan. Another important influence on Wright was Oriental art, which he began to collect—especially Japanese prints. At the World's Columbian Exposition, held in Chicago in 1893, he saw the Japanese house that was a part of Japan's exhibition. Its intimate scale and the use of natural materials, open, free-flowing spaces, and screen walls made a strong impression on Wright. In 1905 he made his first visit to Japan.

LARKIN BUILDING AND UNITY TEMPLE

By then Wright had opened his own office and designed two of his most important early works—the Larkin Building (1903) in Buffalo and Unity Church (1904–6) in Oak Park, Illinois. The Larkin Building was an innovative departure from standard office-building architecture. Its bold, block-like, simplified masses reveal the influence of Louis Sullivan (see p. 309), but carried a step beyond (Fig. 27.9). Because of the surrounding unpleasant urban area, Wright turned the building in upon itself—it had few windows in the exterior walls, and a large, central, open court permitted light to reach all portions of the building. Historicism was purged from the design, the form of the building evolving from its use and structure. The large blocks at the corners, for example, housed stairwells, while the buttresslike forms contained ventilation shafts.

In Unity Church (1904–6) Wright experimented further with abstract geometric form and building materials (Fig. 27.10). The larger block houses the sanctuary, while the smaller is a social hall. Again, the exterior is an arrangement of bold masses, beautifully interrelated. Eaves are reduced to horizontal planes, which are cantilevered over the windows. There is a Cubist quality, an appreciation for form in the abstract.

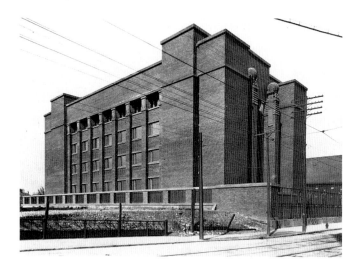

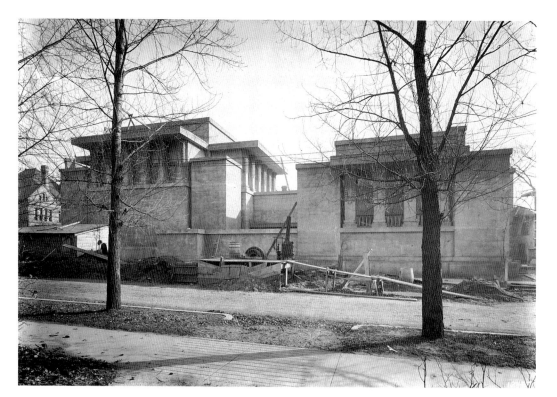

27.9 (above) Frank Lloyd Wright, Larkin Company Administration Building, Buffalo, New York, 1903 (destroyed).

27.10 Frank Lloyd Wright, Unity Church, Oak Park, Illinois, 1904–6.

To control costs, he used poured concrete for the walls: Forms were built, concrete was poured into them, and then the forms were removed. Pebbles provided texture and a natural quality to the surface. The use of poured concrete for aesthetic purposes would become an essential feature of Wright's work.

The interior of Unity Church is a symphony of abstract geometric forms, planes, and lines wrought in masterly restraint. At the time, the total absence of details associated with historical styles must have been startling, and Wright's work at that moment was as inventive and original as anything being done in Europe or America.

THE PRAIRIE HOUSES

Early in his career, Wright arrived at a new form of domestic architecture. The Prairie House was so called because most of the early examples were erected in prairie states, and because they seemed to grow organically out of the land itself. That a structure should be an integral part of its environment was essential in Wright's theory of design. The importance of that quality in architecture was articulated by Wright some years later in a book called *An Organic Architecture* (1939).

The Prairie Houses evolved in early residences such as the Willitts House (1900–2, Highland Park, Illinois) and the Cheney House (1904, Oak Park, Illinois). But it was in the Frederick Robie House in Chicago, completed in 1909, that all of the essential features coalesced.

The exterior of the Robie House is dominated by powerful horizontals that mirror the horizon of the prairie, thus uniting the building with its natural environment and achieving the desired organic quality (Fig. 27.11). Even the large, central chimney does not create a vertical strong enough to interfere with the prevailing horizontality. The horizontal axis is emphasized by the cantilevered forms and the extremely low pitch of the roof. These became cardinal components of Wright's work, as did the projecting eave, which contributes to the feeling of shelter, a quality Wright believed a house should possess.

Wright frequently eliminated basements because he found them dark, damp, and unpleasant. Buildings such as

27.11 Frank Lloyd Wright, Frederick Robie House, Chicago, Illinois, 1908–9.

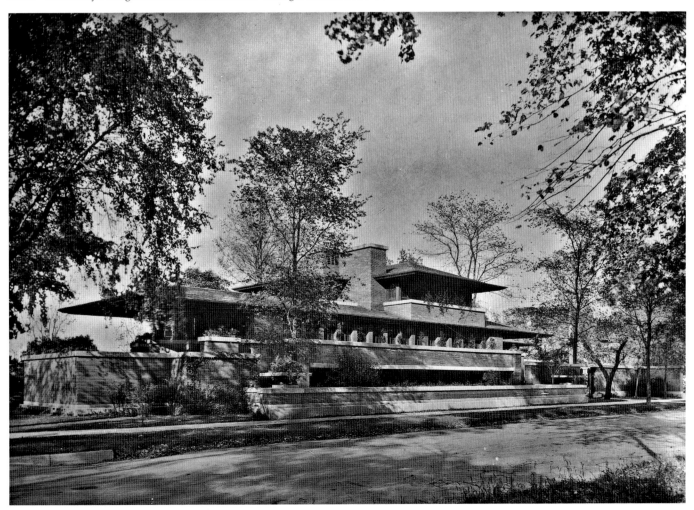

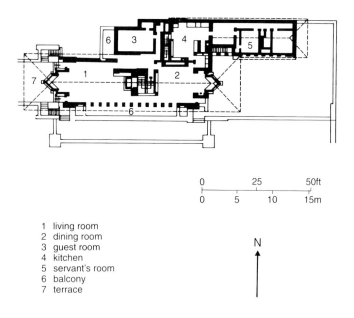

0 25 50ft

0 5 10 15m

1 living room
2 dining room
3 guest room
4 kitchen
5 servant's room
6 balcony
7 terrace

N

27.12 Frank Lloyd Wright, Frederick Robie House, Chicago. Plan.

27.13 Frank Lloyd Wright, Dining Room, Frederick Robie House.

the Robie House were placed upon a concrete platform and raised slightly above ground level.

The interior of the Robie House is equally innovative, with the elimination of the "box" form—the rejection of the concept of interior space as a cluster of boxes (Fig. 27.12). Instead, in Wright's plan, internal space is organized around the central core of the large fireplace, and flows freely from the living room into the dining room—a quality that arose from Wright's interest in Japanese domestic architecture.

For Wright, each architectural project was a totality that included the surrounding landscape externally, and the furniture and furnishings internally: All must come under one dominating mind. For his interiors he designed built-in bookcases, seating units, and storage drawers and shelving, and, as we see in the dining room, even tables and chairs, their rectilinear forms coordinating with the rectilinear character of the architecture (Fig. 27.13). Even the design of windows fell under Wright's purview, and he gave them, too, a thoroughly modern and original character, as seen in a window from the Coonley Playhouse, Riverside, Illinois (Fig. 27.14).

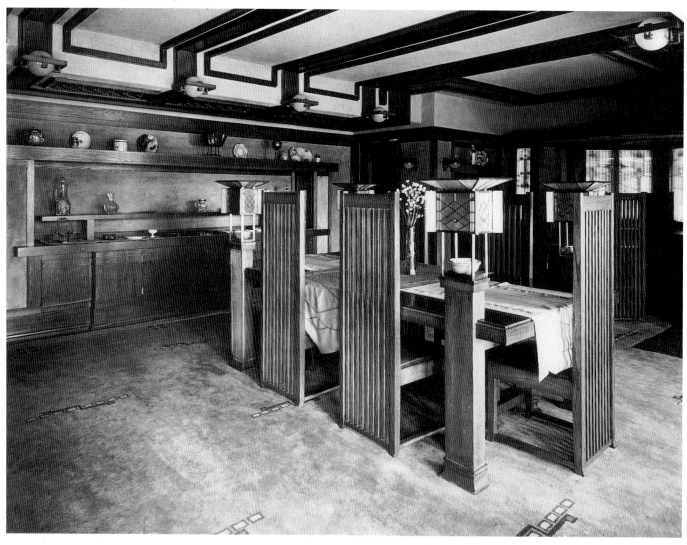

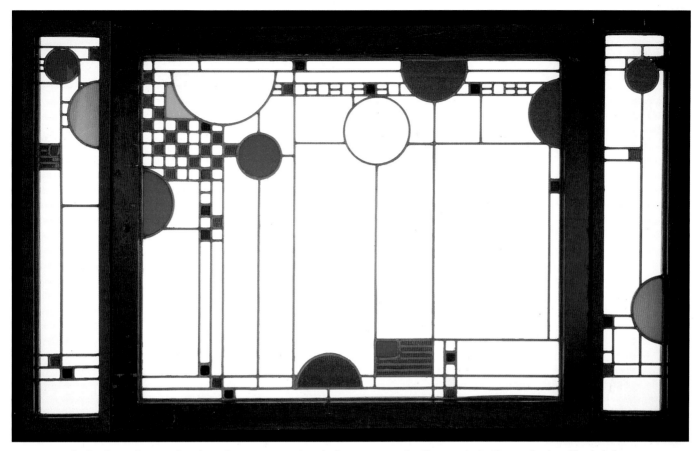

27.14 Frank Lloyd Wright, Window from the Avery Coonley Playhouse, Riverside, Illinois, 1912. Clear and colored leaded glass in wooden frame, 35 × 43in (88.9 × 109.2cm). Art Institute of Chicago.

ARTISTIC INFLUENCES

Wright was influenced by the contemporary Arts and Crafts Movement. About 1901 he had met Charles Ashbee (1863–1942), a leading figure in the English movement, when the Englishman had visited the United States. Wright had also long been interested in the work of William Morris (1834–96), the founder of the movement in England. Morris's American counterpart was Gustav Stickley (1848–1942), who championed the cause of finely crafted handmade objects for use in daily life. Between 1901 and 1916 Stickley published *The Craftsman*, which promoted the ideology of the movement. Its issues regularly contained articles on artistic styles that had a profound effect on design—articles on mission architecture (early Spanish-influenced architecture in the American Southwest), for instance, or on Oriental art, or bungalow design. An example of the kind of illustrations *The Craftsman* carried is seen in Figure 27.15, which bears many similarities to the interiors by Wright.

Wright's treatment has much in common stylistically with the De Stijl movement in Holland. In the vertical and horizontal linear patterns and in the use of geometric patches of primary colors, one is reminded of the paintings of Piet Mondrian (1872–1944), but also of the work of other Dutchmen, such as H. P. Berlage (1856–1934) or Theo van Doesburg (1883–1931). Indeed, Wright's innovative work was widely respected among the most advanced of the European art community. He was wellknown partly because of *Ausgeführte Bauten*, a handsome portfolio of his designs, published in Berlin in 1911. Walter Gropius and

27.15 Dining Room, from *The Craftsman*, vol. 6, April 1904. Morris Library, University of Delaware, Newark, Delaware.

Mies van der Rohe (1886–1969), for example, were quite taken by the fresh new architectural ideas they found illustrated in the book.

FRUITFUL YEARS

Wright settled on the family farm, near Spring Green, Wisconsin, and in 1911 began to build his often-remodeled home and studio, Taliesin. In Chicago he erected Midway Gardens (1913), a kind of pleasure arcade, and a few years later he was occupied with designing the earthquake-resistant Imperial Hotel for Tokyo. In the 1920s, Wright produced a number of homes in California, working there as he stopped off on his return trips from Japan. The Millard House (1923) in Pasadena, with its walls treated as decorative screens, is perhaps the bestknown of these. In the mid-1930s, Wright was concerned with the development of what he called his Usonian homes—modest and relatively

inexpensive residences in which parts were often prefabricated and assembly was a do-it-yourself project. The first Herbert Jacobs House (1936) in Madison, Wisconsin, is a good example.

FALLINGWATER

In spite of the generally stultifying effect of the Great Depression of the 1930s, the career of Frank Lloyd Wright experienced a resurgence in 1937 with the creation of Fallingwater—or the Kaufmann House—one of his masterpieces.

Rising beside Bear Run Creek, an outcropping of natural bedrock emerges in front of the fireplace in the living room, emphasizing the organic quality of the house (Fig. 27.16). Around a huge, central fireplace made of local stones, open spaces sweep freely. Texturally, the natural stone of the fireplace offers an interesting contrast to the concrete forms.

27.16 Frank Lloyd Wright, Fallingwater, or the Kaufmann House, Mill Run, Pennsylvania, 1937.

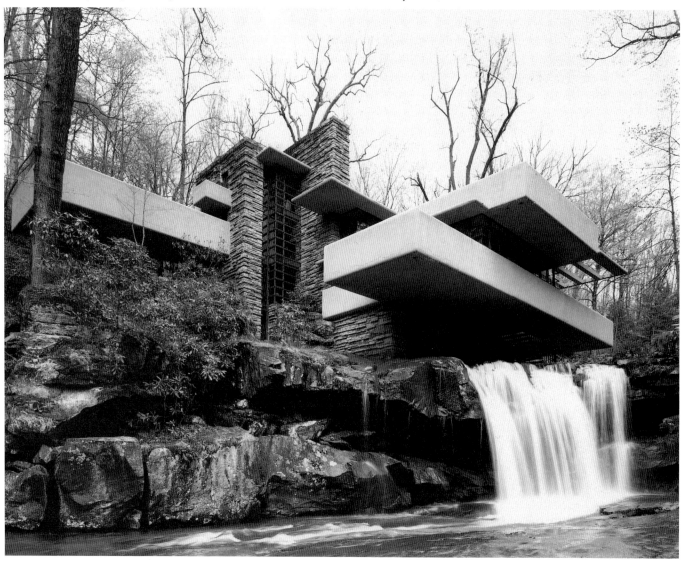

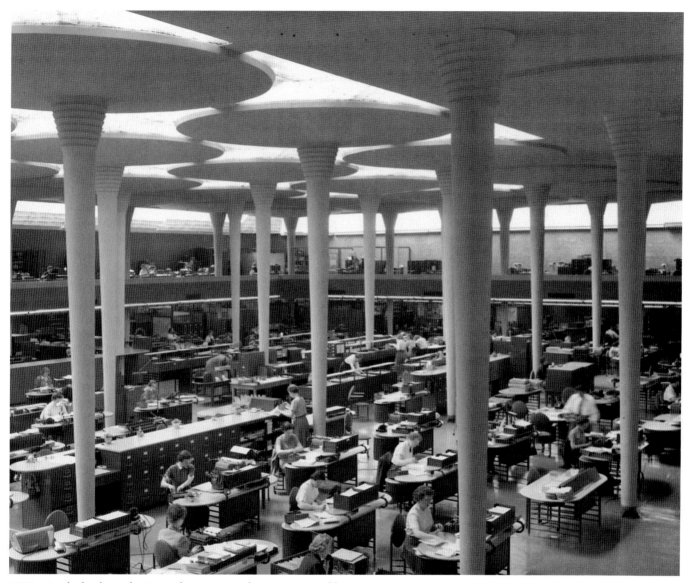

27.17 Frank Lloyd Wright, S. C. Johnson Wax Administration Building, Racine, Wisconsin, 1936–9. Interior

Walls of glass give a feeling of oneness between the interior of the house and its wooded environment. While a decided horizontality of lines, geometric planes, and concrete forms anchors the building to its site, a rich interplay of architectural form and space is created through cross-axes and cantilevering. Cantilevered balconies jut out into the wooded space so that one feels as if one were standing in the woods or above the little waterfall, while still within the structure of the house.

There were few other houses in America that departed so radically from traditional house designs, and seldom had such a mature form of the modern house been achieved. The warm, humanistic quality of Wright's work becomes evident if, for example, Fallingwater is compared to a Bauhaus design of the 1930s, or with Le Corbusier's "machine for living" in the Villa Savoye (1929) at Poissy-sur-Seine in France.

COMMERCIAL INNOVATION

In commercial architecture, Wright's triumph of these years was the S. C. Johnson Wax Administration Building in Racine, Wisconsin, erected in 1936–9. As in the Larkin Building and Unity Church, the outside world is ignored and the building is turned in upon itself. The most distinctive feature of the interior is the large, open secretarial section with its unique, tapering "toadstool" columns (Fig. 27.17). The geometric shape of the circle became the leitmotif of the design, as seen in the flaring disks that crown each column. Indirect lighting from skylights positioned between the great disks fills the room. Wright designed the steel furniture as well, and to achieve his desired unity of building and furnishings he made desks with rounded ends, echoing the rounded corners of the exterior of the building (Fig. **33.2**).

By the late 1930s, Frank Lloyd Wright was recognized

internationally as one of the primary luminaries of modern architecture, and he began to have a considerable following. By 1940, architecture was significantly changed from when Wright had started his career nearly sixty years earlier, and he had played a major role in effecting this change.

THE CALIFORNIA SCHOOL

RESIDENTIAL ARCHITECTURE

Just as a school of American architecture arose in and around Chicago, another appeared in California, the early leaders of which were Bernard Maybeck and the brothers Charles and Henry Greene. While there was no single master to act as a unifying catalyst, a distinctive style evolved in response to the lifestyle, climate, and local building materials of California.

Maybeck—whose work for the Panama-Pacific Exposition at San Francisco in 1915 we have already seen (Fig. 27.2)—worked mainly in the San Francisco Bay area from about 1890. While studying in Paris he had learned much from theories on the use of new materials, structural systems, and technologies propounded by the nineteenth-century French architect Viollet-le-Duc.

Maybeck's residential architecture is a curious combination of Beaux-Arts historicism and progressive design, while his use of materials ranged from exposed native redwood columns to reinforced concrete. His houses appear to be a combination of "medieval-hall" design and California

materials, such as redwood timbers and mission-type roofing tiles. There is also an innovative, informal openness about the houses that makes them particularly suitable for California life.

Two brothers—Charles Sumner Greene (1868–1957) and Henry Mather Greene (1870–1954)—formed the firm of Greene and Greene, which created the epitome of the California house in this early phase.

In a manual training school in St. Louis, the brothers had gained the skills of woodworking, and were also introduced to the theories of William Morris and the Arts and Crafts Movement. At MIT they had been exposed to the tradition of the Ecole des Beaux-Arts, and, while in the Boston area, to the Shingle style of H. H. Richardson. On their way to California in 1893 to join their parents, the brothers visited the World's Columbian Exposition in Chicago. There, like Frank Lloyd Wright, they were struck more by the Japanese house than by the grandeur of the Beaux-Arts buildings.

By the first decade of the new century, the Greene brothers were designing a type of residence seen in the David B. Gamble House (Fig. 27.18). Critics agreed that they had perfected the bungalow type. This was a one-floor, rambling, lowroofed house, with projecting eaves and jutting porches. The exterior environment and interior space were commingled and built of beautiful woods that were exquisitely finished and joined. The Californian climate invited the incorporation of terraces, pools, porches, gardens, and patios into the design, to permit living out of doors nearly as much as indoors. A house such as the one designed for the Gambles stands in marked contrast to the

27.18 Greene and Greene, David B. Gamble House, Pasadena, California, 1909. Wayne Andrews/Esto.

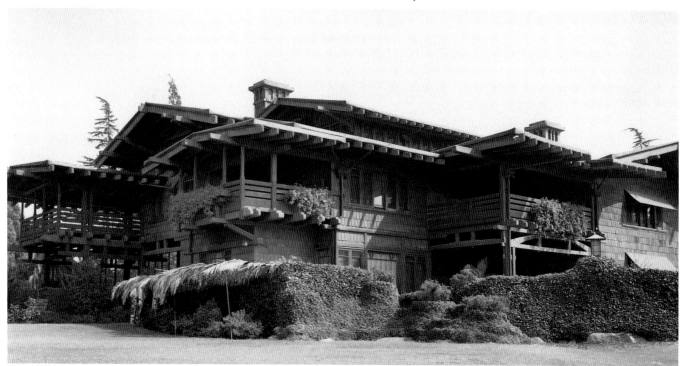

27.19 Irving Gill, Walter L. Dodge House, Los Angeles, California, 1914–16.

earlier fine houses built in California, like the William Carson House in Eureka (Fig. 20.8). Here, the influences are ·no longer French Beaux-Arts, Victorian, or Italianate, but rather Japanese, the Arts and Crafts Movement, Spanish mission—and the southern California region itself.

THE NEXT GENERATION

With the next generation of California architects came a noticeable change in style. The leading figures in this severe, hardedged, machine-age style were Irving Gill (1870–1936), Rudolph Michael Schindler (1887–1953), and Richard Neutra (1892–1970). The new style is already obvious in Gill's Walter L. Dodge House in Los Angeles (Fig. 27.19). Gill, son of a Quaker carpenter, found early employment in the Chicago offices of Adler and Sullivan when that firm was working on the Transportation Building for the Columbian Exposition of 1893. Later in 1893 he moved to San Diego, where he became interested in yet another of the non-Beaux-Arts styles that so affected his generation of California architects: The mud-walled mission architecture.

Using concrete to replace the mud, Gill became one of the leading experimenters in the application of poured concrete for residential architecture. In allowing the material to dictate a form of its own, he achieved a result that was an arrangement of cubic forms with sheer walls, precise edges, no moldings or decoration, and a flat roofline. In the severity of the design, the utter simplification of all form, and its rectilinearity, there is a pronounced austerity. This is relieved by careful attention to landscaping and by making outdoor patios and porches integral extensions of the interior spaces.

R. M. Schindler and Richard Neutra were both Viennese, and while they were young men they both came under the influence of the progressive architects Otto Wagner (1841–1918) and Adolf Loos (1870–1933). Each heard Loos lecture in praise of machinemade, prefabricated components, attack the use of ornament, and extoll life in America. Both were also greatly affected by the German publication in 1911 of Frank Lloyd Wright's work.

Schindler left for Chicago in 1914, and four years later he was working in Wright's office. In 1919, Wright sent him to Los Angeles to supervise construction of the Aline Barnsdall

27.20 R. M. Schindler, Philip Lovell Beach House, Newport Beach, California, 1926. Wayne Andrews/Esto.

House, a poured-concrete structure. Schindler was already familiar with the material from buildings erected in Austria by Adolf Loos. After the Barnsdall House was completed, he remained in California, where he established his own office.

During the 1920s, concrete became Schindler's primary building material. His exploitation of its possibilities is seen, for example, in the Philip Lovell Beach House (Fig. 27.20). Five rows of concrete piers raise the house well above the beach, and, with the vertical piers, the horizontal balconies create a form suggestive of the machine age in their precision. In many areas, broad membranes of glass replace external weightbearing walls, for the structural system is now largely internal. If the Lovell House lends itself to comparison with anything, it would be with some of the contemporary experiments in design being conducted at the Bauhaus (see pp. 419 and 504).

Richard Neutra came to America from Vienna in 1923 and, like Schindler, worked for Wright briefly. By 1925, he had settled in Los Angeles, where he and his fellow Viennese friend had an informal partnership for a while. In Neutra's work, too, one sees the influences of both Loos and Wright. His Jardinette Apartment Building (1927) in Los Angeles is one of the earliest examples of the International style of architecture (see chapter 33) in the United States.

27.21 Richard J. Neutra, Philip Lovell House, Los Angeles, California, 1928.

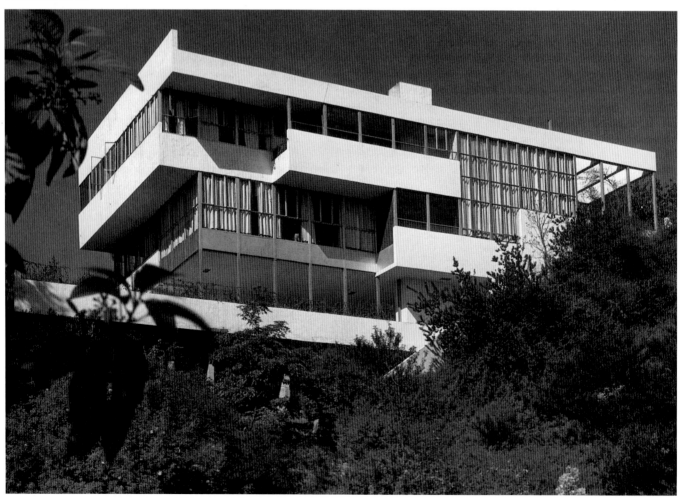

Constructed of reinforced concrete, it has long rows of prefabricated, metal-frame ribbon windows, cantilevered balconies, and a flat roof.

For Dr. Philip Lovell, Neutra designed a Los Angeles house (Fig. 27.21) which has an even more severe, machine-age quality to it than Schindler's Lovell Beach House. Neutra's house has a steel frame that is enclosed with poured concrete and glass. The aesthetics of a structure such as this arise from the clean, sharpedged lines and forms, the precision, careful proportioning, and the open flow of spaces. Many of the components of the building were ordered from a manufacturer's catalogue. This, too, was a part of the revolution that had occurred, for now machinemade, prefabricated parts replaced the earlier hand-crafted, custommade work that had been produced by artisans on the building site. When completed, the Lovell House was as advanced in design as anything then being done in Europe by Gropius, Le Corbusier, or Jacobus Oud (1890–1963), and at that moment Neutra had reached parity with Frank Lloyd Wright.

Soon after, Neutra embarked on a trip around the world that included a visit to Japan and a period in Germany, where he was a guest lecturer at the Bauhaus. Back in Los Angeles, in the 1930s he designed a number of private residences and a school that became the model for many others in the area. Neutra remained active after 1940, especially in the designing of houses in southern California.

THE SKYSCRAPER: ART DECO AND THE INTERNATIONAL STYLE

Having left off in the early 1920s with the Tribune Tower— that skyscraper in the Gothic mode—we return now to the challenge posed by the tall office building.

The march of modernism was relentless, and its advocates were determined to purge architecture of all traces of historicism. Around 1930, two attempts were made to find some solution other than historicism for the skyscraper, which now rose to unprecedented heights.

THE CHRYSLER BUILDING AND THE EMPIRE STATE BUILDING

Both the Chrysler Building (Fig. 27.22), designed by William van Alen (1883–1954), and the Empire State Building (Fig. 27.24), by the firm of Shreve, Lamb, and Harmon, were designed in three sections: A base, a shaft that is set in from the base, and an elegant, spirelike top. In each building, slender ribs extend heavenward from the street level to the spire, creating the pronounced vertical axis that is appropriate to the form, while at the same time suggesting the structure of the reinforced steel frame.

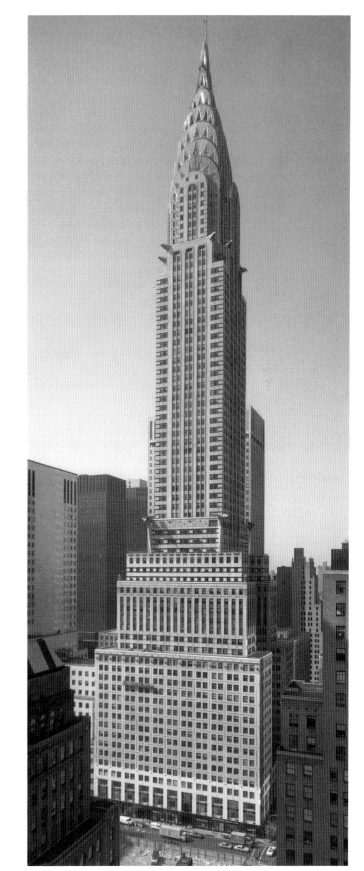

27.22 William van Alen, Chrysler Building, New York City, 1928–30. Peter Mauss/Esto.

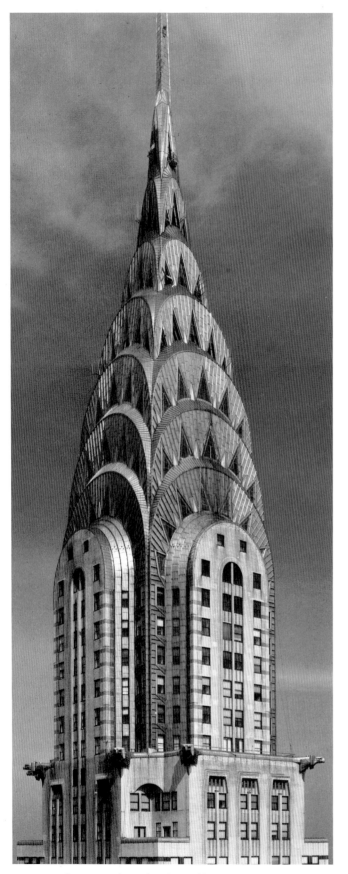

The crowning glory of the Chrysler tower is its Art Deco spire, the result of a conscious effort to create some form other than Beaux-Arts historicism (Fig. 27.23). The lovely, innovative composition of decreasing, wheel-like motifs with radiating triangles is encased in aluminum, a metal that suggested sleekness and the streamlined forms of the machine age.

Art Deco had only a temporary life in the late 1920s and the 1930s. The designs tended to be geometric, in keeping with the severe geometry of the new architecture, which in turn seemed to many to need some kind of decorative relief. Art Deco could also be based on natural form. Whether floral, animal, or human, this usually was simplified and stylized until it worked agreeably with the surrounding architecture. In the end, however, it was decided that no decoration was best of all, which stripped architecture of one of its richest artistic heritages.

The Chrysler Building rose to a height of just over 1000 feet (305 m). For a brief moment it was the tallest building in the world—until the Empire State Building topped out at 1250 feet (381 m) one year later (Fig. 27.24).

The Empire State Building is an archetypal but successful example of the commercialism that beset corporate architecture at the time. William F. Lamb (1883–1952), one of the designers, freely admitted that all handwork was eliminated

27.24 Shreve, Lamb, and Harmon, Empire State Building, New York City, 1929–31.

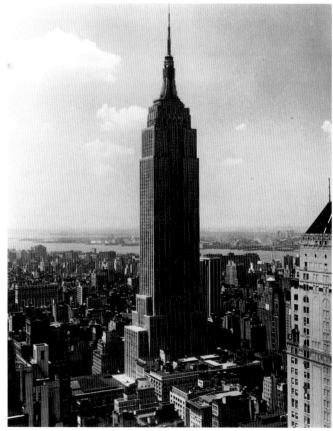

27.23 William van Alen, Chrysler Building, New York City, 1928–30. Detail of top. Peter Mauss/Esto.

because it was cost-effective to do so. Nevertheless, the building proved that the skyscraper did not need decoration such as that found on the Tribune Tower to be successful. In fact, it showed that the beauty of a building can reside in its design, exquisite craftsmanship, and materials, rather than in applied decoration.

The Empire State Building, constructed of stone and steel, is of a simpler, bolder, more massive form than the Chrysler Building. From its base, a tasteful setback scheme allows a fine transition into the shaft of the tower. At the very top, the spire is itself an extension of the architectural form. The vertical accent is carried the full height of the eighty-five-story building by the rib system used on all four sides.

THE TRIUMPH OF MODERNISM

Raymond Hood, co-winner of the competition for the Tribune Tower (Fig. 27.6), soon realized that the Gothic style was not the key to the future in skyscraper design. Accordingly, in his Daily News Building in New York City, he imposed an excruciating simplicity upon a slablike, vertical-ribbed tower with squared-off top (Fig. 27.25). This abrupt termination of the roofline set a pattern that was to be followed in subsequent skyscraper design. There is not even a lingering trace of a cornice to remind us of a Renaissance heritage, or a grand arched doorway to suggest the triumphal arch of the Romans. Instead, an aesthetic emerges from

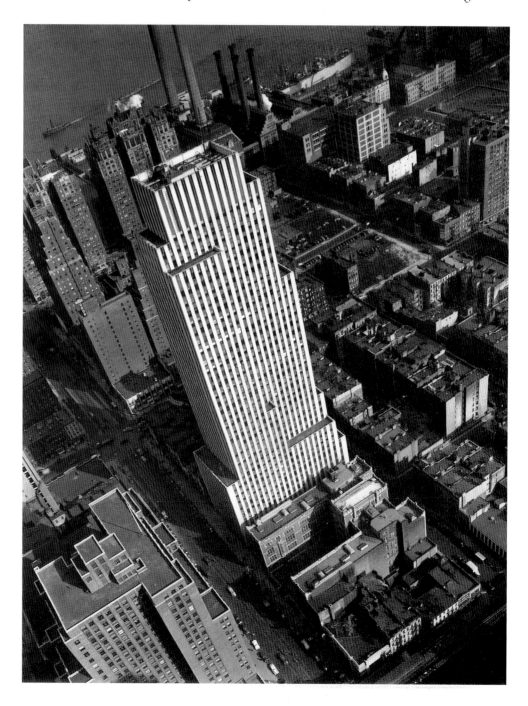

27.25 Raymond Hood, Daily News Building, New York City, 1929–30. Ezra Stoller/Esto.

the technology of the structural system in the clean lines of the vertical ribs, the grid system formed by the horizontals, and the bold simplicity of the masses.

Although new in form, the Chrysler Building and the Empire State Building were still connected to the past by their stone exteriors. In Hood's next important skyscraper—the McGraw-Hill Building—stone is eliminated. Here, the exterior walls become horizontal bands of glass hung upon a steel frame, separated by bands of terracotta, which, like the glass, are tinted blue-green, asserting that this twentieth-century **ziggurat** is definitely not made of stone.

THE INTERNATIONAL STYLE

The next step in the evolution of the skyscraper came with the Philadelphia Savings Fund Society (PSFS) Building (Fig.

27.26 Howe and Lescaze, Philadelphia Savings Fund Society (PSFS) Building, Philadelphia, Pennsylvania 1929–32.

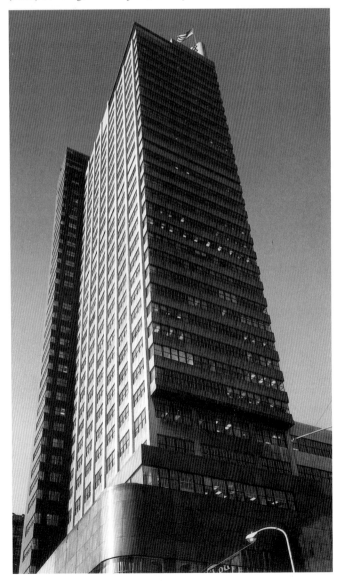

27.26). Here one finds evidence of those powerful influences from European modernism that led to the International Style, namely, a steel skeletal frame for a slablike tower; a glass-sheathed exterior; and a rejection of all historical decorations and traditions. Severe in its simplicity, precise in form, and expressive of the machine age, the building is distinguished by the exquisite refinement of its details and materials.

It is called the International Style because it transcended national boundaries, even oceans. Its leaders were also international: Walter Gropius and Mies van der Rohe in Germany; Le Corbusier (or Charles Edouard Jeanneret, 1887–1965) in France; and, in the United States, men such as Gill, Schindler, Neutra, Hood, and Howe and Lescaze. Some scholars have seen the PSFS as a counterpart to Gropius's Bauhaus building in Dessau, Germany.

George Howe (1886–1955) had lived a cosmopolitan life abroad before he attended Harvard College and then the Ecole des Beaux-Arts. After settling in Philadelphia, his eclectic, historical-style houses brought him a very successful practice. Then, about 1928, Howe made a remarkable conversion to the International Style. The PSFS was the result of his first effort in that vein.

Just as work began on the PSFS design, Howe joined in partnership with the Swiss modernist architect William Lescaze (1896–1969), who was influential in introducing the International Style not only to Howe, but to the United States generally. Upon completion of his training in Zürich, Lescaze worked briefly in Cleveland, and in 1923 started his practice in New York City. His partnership with Howe lasted until 1933, and the PSFS—which came as a startling revelation of the new modernism to most Americans—was their greatest triumph.

ROCKEFELLER CENTER

The most ambitious project of this era was Rockefeller Center in New York City (Fig. 27.27). Occupying several city blocks and consisting of a complex of fourteen buildings, its focal point is the seventy-story RCA Building, approached by way of a handsome pedestrian mall. At the foot of this central structure is a sunken outdoor café, which in winter becomes an iceskating rink. In this way the Center created something amenable to the public in the midst of corporate slab-towers.

Not since the World's Columbian Exposition of 1893, the redesigning of the Mall in Washington, D.C., and the plan for the campus of Columbia University around the turn of the century had an architectural complex such as this been undertaken. With the financial backing of John D. Rockefeller, Jr., the first plans for Rockefeller Center were made in 1927. A small army of architects, designers, engineers of all types, and consultants was involved. The firm of Reinhard and Hofmeister was in charge, with assistance from Raymond Hood and Harvey W. Corbett. Rockefeller Center was truly an expression of corporate America, for Rockefeller

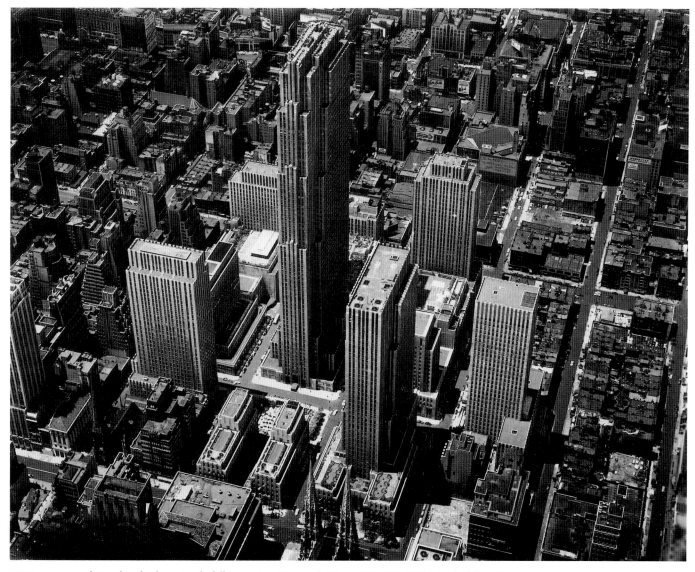

27.27 Raymond Hood and others, Rockefeller Center, New York City, 1927–39. © The Rockefeller Group.

and a host of other businessmen and lawyers sat on the design committee.

The basic design of the several buildings of Rockefeller Center was the work of Hood. Their relationship to his Daily News Building is evident. Here was an effort to organize urban commercial life in a vast complex of buildings; below ground all buildings are connected through a system of shoplined passages, and the Center has its own subway entrance at that level. A lower level allows for deliveries by trucks.

Each building is a slab type, sheathed in light-gray limestone, with subtle setbacks and squared-off tops. There is a visually pleasing unity in the overall design.

Work on the initial phase of Rockefeller Center ended with the close of the 1930s. Two more buildings were later added—the Time-Life Building in 1961, and the Sperry-Rand Building five years later. These were designed to harmonize with the existing complex, although postwar architecture had already developed a new brand of modernism.

Architecturally, the period from 1900 to 1940 had been an extremely important one: A new type of house had been created in response to twentieth-century life, and a successful solution had been found for the commercial skyscraper.

CHAPTER TWENTY-EIGHT

DECORATIVE ARTS AND INTERIORS:

THE AGE OF THE MACHINE AND
STREAMLINING, 1900–40

Henry Adams stood awestruck in the huge Gallery of Machines at the Paris Exposition of 1900, perceiving— almost mystically—a new kind of god or religion, a techno-theology, so to speak. In his autobiography, the author related his experience as he entered the great hall of the colossal electric generators:

> . . . to Adams the dynamo became a symbol of infinity. As he grew accustomed to the great gallery of machines, he began to feel the 40-foot [12-m] dynamos as a moral force, much as the early Christians felt the Cross[1]

For those of us who have lived for so long with the machine and artificially generated energy, it is difficult to imagine the feelings of the transitional generations of the nineteenth century who witnessed the rise of those awesomely powerful forces. Although initially it was debated whether the machine was a blessing or a curse, by the year 1900 it was a part of the modern spirit and was accepted with the devotion of a religious conversion.

Francis Picabia (1879–1953), a French Dadaist-Surrealist painter (see p. 461), translated this force into aesthetic terms, noting on the occasion of a visit to the United States, "Almost immediately upon coming to America it flashed on me that the genius of the modern world is in machinery, and that through machinery art ought to find a most vivid expression."[2] Picabia further observed that, "The machine has become more than a mere adjunct of life. It is really a part of human life—perhaps the very soul." In that same year Paul Haviland, a friend of Picabia and of the photographer Alfred Stieglitz (1864–1946), coined the term "machinomorphic," which unites machine and humanity into a single being.

But if adulation of the machine was one of the essential characteristics of the modernist spirit, for some the machine was a cause for alarm. Sherwood Anderson, one of the most popular American authors of the 1920s and 1930s, frequently introduced the machine into his stories and novels. Anderson, a good friend of Stieglitz and of Gertrude Stein, was close to the center of modernism in both art and literature. In *A Story Teller's Story* (1924) he voiced the concern that dreamers, artists, creators generally are constantly stultified by the moneymakers and by "standardization." By the latter he meant that individual creativity had been subordinated in a process in which men and women become mechanistic parts of an assembly line, and he refers specifically to the assembly line devised by Henry Ford. In bitter irony, Anderson foresaw all aspects of life becoming standardized products of the great machine. But in the end, even he came to accept the machine.

In 1900, there were an estimated 8000 automobiles in the United States, or one car for every 9500 people. In order to reduce that ratio by making an auto that was even more affordable to the American population, the Ford Motor Company was organized in 1903. Within five years it was producing the famed Model T, which was priced at $850.50. By 1913 Ford had instituted the assembly-line system in his factory near Detroit. Theretofore, automobiles had been largely custommade, that is, handmade; Ford produced a standardized vehicle in an assembly-line process that revolutionized industry. Visitors to the Ford factory in those days found it one of the most exciting places on earth, throbbing with power, the workmen apparently becoming automatons, or integral extensions of the vast complex of machinery.

The General Motors Company was founded in 1908, and the Maxwell Motor Company, founded in 1913, became the Chrysler Corporation in 1925. Both followed Ford's example in the assembly-line process. By the late 1920s, automobile production was America's largest single industry, rivaled only by the steel industry—it was one of the main forces in the booming economy of the Roaring Twenties.

Another form of travel and transportation, the airplane, ignited the imagination of America, indeed, of the world, even more than the automobile. The airplane became the very symbol of the machine age, in streamlined form. On 17 December 1903 at Kitty Hawk, North Carolina, Wilbur Wright made the first successful powered flight when he flew 852 feet (260 m) in fifty-nine seconds, and his brother Orville was airborne for 120 feet (37 m) and twelve seconds. In 1911 the first transcontinental flight, from New York to Pasadena, California, was made in three-and-a-half days of actual flying time. To people living in that year whose

grandparents or even parents had taken three months to cross the continent by covered wagon, that feat must have seemed astonishing indeed.

People all over listened to their radios in excitement and wonder on 20 and 21 May 1927 as Charles A. Lindbergh winged his way across the Atlantic Ocean in thirty-three hours in the "Spirit of St. Louis." Lindbergh was the first person to fly solo across the ocean. In 1932 Amelia Earhart became the first woman to make the transatlantic flight solo. By 1938 it was possible for Howard Hughes to fly around the world in ninety-one hours. How very much the world had shrunk since Jules Verne's Phileas Fogg made it *Around the World in Eighty Days* in 1873! By 1935, planes were flying across the Pacific from California, and in 1939 a regular transatlantic passenger service was established between New York and Lisbon.

There was something exciting and romantic, daring and adventurous about all this, as time and space became the new frontiers. Frank Lloyd Wright recognized it when he wrote, "A new space-concept is needed A definite phase of this new ideal comes in what we call organic architecture—the *natural* architecture of the democratic spirit in this age of the machine."[3] The machine age, glass and steel skyscrapers, automobiles and airplanes, dynamos, factories and assembly lines—such things determined the pulse of much of the world in the first four decades of the twentieth century. It is only to be expected that such things should also have their influence on all of the fine arts and, as we shall soon see, on the decorative arts and interior decoration.

28.1 Graham, Anderson, Probst, and White, Continental Illinois National Bank Building, Chicago, Illinois, 1924. Interior.

BEAUX-ARTS AND ARTS AND CRAFTS

In architecture, the Beaux-Arts style was in use well into the twentieth century, in buildings such as the New York Public Library and the Lincoln Memorial (Figs. 27.1 and 27.3). Such buildings called for interiors of similar mode, and the persistence of the historic styles is well demonstrated, for example, by the neo-Roman classical interior of the Continental Illinois National Bank in Chicago (Fig. 28.1).

The huge space of the main banking room is dominated by two rows of colossal Ionic columns, which support an appropriately scaled classical entablature. The classical scheme is carried through in the Roman-style lampstands at the base of each column.

While the Bank represented a Beaux-Arts scheme that penetrated deeply into the modern era, into the age of the automobile, the speeding locomotive, and the sleek, aluminum-skinned airplane—that is, into the age of modern design—for many Americans the Beaux-Arts tradition was not expressive of the twentieth century, nor could its features be adapted to the modern era.

THE ARTS AND CRAFTS MOVEMENT

The search for a way out of the grip of the Beaux-Arts mode began even before the turn of the century. While Art Nouveau was a break with the historic styles in order to start afresh, the movement was shortlived, even in France where it originated, and it never had much of a flowering in the United States. The Arts and Crafts Movement, on the other hand, had an important, if rather brief, flourish around the turn of the century.

The movement began in England in the mid-nineteenth century, with William Morris's reaction against the Industrial Revolution and the inferior aesthetic value of machine-made furnishings. Morris stressed the virtue of handmade objects for the home, in everything from pottery to embroidery, stained glass windows to tiles, furniture to wallpapers. He also insisted upon excellence in design, craftsmanship, and materials.

Morris's bestknown American counterpart was Gustav Stickley, who, with other members of the Arts and Crafts Movement, was not opposed to historicism. In fact, they admired handcrafted work from past ages, especially of the medieval period. Nevertheless, Stickley offered an alternative to the usual Beaux-Arts modes, for example with his

28.2 Gustav Stickley, Settle, 1909. Made by Craftsman Workshops. Oak, back 38 × 71¹⁄₁₆ × 22in (96.5 × 180.5 × 55.9cm), seat 19 × 62in (48.3 × 157.5cm). Art Institute of Chicago.

28.3 (below) Frank Lloyd Wright, Side chair, 1904. Oak, leather, 35¾ × 15 × 18½in (90.8 × 38.1 × 47cm). Collection, The Museum of Modern Art, New York. Gift of the designer.

mission-style furniture (Fig. 28.2). Solid, simple, well-crafted pieces such as this were produced in Stickley's Craftsman Workshops in Eastwood and Syracuse, New York, between 1898 and 1915. The pieces carried the Craftsman label and Stickley's signature, and they were promoted in his *Craftsman* magazine, and displayed in his New York City showroom. Oak—plain but sturdy, un-painted and ungilded—was favored, and for the cushions, leather or canvas was preferred over the velvet and tapestry fabrics of late Victorian furniture. Pieces could be ordered from a catalogue, but because they were handmade they tended to be relatively expensive.

The architect Frank Lloyd Wright openly acknowledged his admiration for William Morris and the Arts and Crafts Movement. The similarity between Stickley's settle and the furniture Frank Lloyd Wright designed for the Robie House (Fig. 27.13) is apparent—simplicity prevails, the form is rectilinear, and the beauty of the material—wood—is stressed, as is the craftsmanship. The dining room table and chairs harmonize with the rectilinear shapes, patterns, and decorations of the room, which is precisely what Wright had in mind—total unity.

Wright often built-in as much of the furniture as he could, in part to assure it would stay as he designed it. He seemed to be deaf to the complaints of critics and his patrons that his furniture was uncomfortable.

Wright also designed the interiors and furnishings for his commercial structures. The side chair (Fig. 28.3) he designed for the Larkin Building (Fig. 27.9) was as new and radical as

28.4 Frank Lloyd Wright, Living Room, the Hollyhock House (Aline Barnsdall House), Los Angeles, California, 1917–20. Ezra Stoller/Esto.

the building itself. While it is reminiscent of the lines of Stickley's furniture, there is one important difference: Wright was one of the first to accept the machine, whereas artisans of the Arts and Crafts Movement did not. Wright designed pieces which could be made by machines. In this way, in their forms and materials, they were expressive of the machine age. The Larkin Company swivel armchair looks as if the machine had played a role in its production. The innovative design did not escape the notice of Europeans who were also searching for a suitable machine-age aesthetic.

Wright applied the type of form he had evolved in furniture to ornamental reliefs for interiors, as in the composition he designed for the fireplace of the Aline Barnsdall House (Fig. 28.4). Representing no identifiable natural form, it looks as if it was designed entirely with the straightedge, compass, and triangle—the normal instruments of the architect. Its patterns are geometric and harmonize with Wright's interior and the total building design. The design anticipates

Art Deco, the style which swept America like a storm in the late 1920s and throughout the 1930s.

ART DECO

The term "Art Deco" is derived from the spectacular *Exposition Internationale des Arts Décoratifs et Industriels Modernes* held in Paris in 1925. In the 1920s and 1930s, art of that style was referred to as "modernistic" or *moderne*.

It was the *Exposition* that brought together for the first time the decorative arts of the new style, announcing to the world that the modern style had arrived in utilitarian objects, just as it had in painting, sculpture, and architecture many years earlier. The *Exposition* also made it clear that the machine was both a partner in the production of, and a determinant factor in, the design of decorative arts.

It did not take long for the aesthetic ramifications to reach the United States. The next year, 1926, the show left Paris

to tour eight American cities, starting with Boston and New York City. In 1929, the Metropolitan Museum of Art held a similar exhibition, "The Architect and the Industrial Arts," extending its mantle of approval over the brilliant array of objects wrought in the new *style moderne*.

28.5 (below) Kem Weber, Sketch for a Public Dining Room for Barker Brothers of Los Angeles, c. 1926. Watercolor. Architectural Drawing Collection, University Art Museum, University of California, Santa Barbara.

28.6 (below, right) Walter von Nessen, Standing floor lamp, c. 1928. Brushed chromium-plated brass, cast iron, height 5ft 7in (1.7m). Yale University Art Gallery, New Haven, Connecticut.

ART DECO DESIGNERS

The new style was in fact being introduced even before the Metropolitan's exhibition of 1929 by designers such as Paul Frankl (1887–1958) and Joseph Urban (1872–1933), who had emigrated from Vienna, one of the main centers of advanced design, and by others who returned from Paris fired with an enthusiasm for the new mode, such as Karl Emanuel Martin (Kem) Weber (1889–1963).

Weber had been apprenticed to a cabinetmaker in his native Germany and studied under Bruno Paul in Berlin before going to San Francisco in 1914 to design the German Pavilion at the Panama-Pacific Exposition. He remained in California, finding employment with the design studio of

Barker Brothers. While he was traveling in Europe in 1925–6, Weber attended the *Exposition*, after which he returned to Los Angeles where he opened his own studio, from which the influence of modernistic design spread throughout southern California. The way had been prepared by the architecture, interiors, and furnishings created by his friends Wright and Schindler in that region.

We may gain an idea of Weber's work during these years from a sketch for a public dining room (Fig. **28.5**). Geometric, rectilinear patterns prevail, and in the stepped treatment of the wallcorner at the right, as well as in the motif on the ceiling, there are forms reminiscent of the setback of the skyscrapers then arising. Design had become thoroughly independent of historicism. Its new partnership was with modern architecture, the machine, and the aesthetics of streamlining.

For the furnishing of the modern house or apartment, the new style is seen in the floor lamp designed by Walter von Nessen (1889–1943), made of chromium-plated brass with a cast-iron base (Fig. **28.6**). Chromium was at the time an expensive, almost exotic, substance, and its bright, metallic quality delighted designers and patrons alike, contributing as it did to the "machinemade" character of the piece.

28.8 Paul Feher, Screen, 1930, designed for the Rose Iron Works, Cleveland, Ohio. Silver-plated iron, aluminum appliqué, gold-plated bronze, height 5ft 2½in (1.59m). Severance Hall, Cleveland, Ohio.

28.7 Jules Bouy, Mantelpiece, 1925–8, designed for Ferrobrandt, Inc., New York City. Wrought iron, 77¾ × 62 × 9in (197.5 × 157.5 × 22.9cm). Metropolitan Museum of Art, New York City.

The wrought-iron fireplace mantel (Fig. **28.7**) designed by Jules Bouy (1872–1937) is reminiscent of the shapes, lines, and patterns found in the spire of the Chrysler Building of 1928–30 (Fig. **27.23**). The fireplace was produced for Ferrobrandt, Inc., the United States outlet for the French designer Edgar Brandt, who became famous for his Art Deco metal screens, skyscraper entrances, and elevator doorways.

A screen designed by Hungarian-born and Paris-trained Paul Feher (b. 1898) is quintessential Art Deco in style (Fig. **28.8**). Rectilinear and curvilinear patterning is integrated with highly stylized and abstracted natural forms. This piece, made of iron and bronze with silver and gold plating, was shown at the International Exhibition of Contemporary Industrial Art, held at the Metropolitan Museum of Art in 1930.

ROOM INSTALLATIONS

The preceding year, the Met's show—"The Architect and the Industrial Arts"—had architecturally designed room installations of the type seen in Saarinen's dining room (Fig. **28.9**)—a complete ensemble of interior setting and furnishings, and all in the new Art Deco mode.

In 1926, Saarinen designed the buildings for the newly founded Cranbrook Academy of Art in Bloomfield Hills, Michigan, and six years later he became its director. Saarinen came to the United States in 1923 after winning second place in the Chicago Tribune Tower competition, bringing

28.9 Eliel Saarinen, Dining Room, 1929, for the Eleventh Annual Manufacturers' and Designers' Exhibition of Contemporary Industrial Art.

from his native Finland a knowledge of Scandinavian design and respect for the innate beauty of materials. Under his guidance, Cranbrook became one of the leading centers for training in modern design.

Following the lead of Paris's Galeries Lafayette, which organized a room installation at the *Exposition* of 1925, commercial department stores began presenting room ensembles that popularized the modernistic mode. In the spring of 1928, Lord & Taylor's presented New Yorkers with five rooms of furniture *à l'art moderne*, direct from Paris. A little earlier, R. H. Macy's had begun displaying modern furnishings in roomtype settings.

On a coffeetable of modernistic design, one might find an Art Deco tea and coffee service of the type shown in Figure 28.10. This silver and ivory set was designed by Peter Müller-Munk (1904–67), who had been trained in his native Germany before coming to New York in 1926. After working for Tiffany and Company briefly, Müller-Munk set up his own silvercrafting studio, but during the Depression he turned to industrial design.

28.10 Peter Müller-Munk, Tea and coffee service, 1931. Silver, ivory, height of kettle 10in (25.4cm). Metropolitan Museum of Art, New York City.

BAUHAUS DESIGN COMES TO AMERICA

Influences in the new design came not only from France. They came also from Germany, especially from the Bauhaus, a new kind of art school that had been founded in 1919 in Weimar with Walter Gropius as its director. The Bauhaus advocated progressive, modernistic design in its training of architects, painters, sculptors, and industrial designers. It praised the machine as a servant of mankind which only awaited excellence in the design for the objects it was asked to massproduce. It championed and exploited the new materials and technologies, from chromeplating to plastics to neon lighting. The term "Bauhaus" became the counterpart in Germany to the French *l'art moderne*.

The school moved to Dessau in 1925 and to Berlin in 1932, but closed soon after under the Nazi regime. The school's distinguished faculty included Walter Gropius, Mies van der Rohe, Paul Klee, Vassily Kandinsky, Josef Albers, Marcel Breuer, Lionel Feininger, and Làszló Moholy-Nagy. Many of these men left Nazi Germany in the 1930s to come to the United States, where they had a profound impact on architecture, art, and design.

MODERN CLASSICS

Although Mies van der Rohe did not come to America until 1938, his influence was felt well before that. Philip Johnson, who had just recently been appointed head of the architecture division of the newly founded Museum of Modern Art, met Mies in Berlin in 1930 and persuaded him to design his Manhattan apartment for him.

28.11 Philip Johnson, The Philip Johnson Apartment, 216 East 49 Street, New York, 1930. Photograph courtesy The Museum of Modern Art, New York.

Mies had just completed two of his early masterpieces—the German Pavilion (usually referred to as the Barcelona Pavilion) at the International Exposition in Barcelona, Spain (1929), and the Tugendhat House in Brno, in what was then Czechoslovakia (1930). These were manifestoes of the new spirit of architecture and interior décor, with their glass walls, tubular metal furniture, machine-milled components, polished marble surfaces, precision-sharp edges, and almost total elimination of decoration *per se*. These are also the prevailing qualities in Johnson's New York City apartment (Fig. **28.11**), where exquisite materials, carefully worked to display their special beauty, replace applied decoration in room and furniture.

One of the classic examples of twentieth-century design was present in the room—the "Barcelona" Chair (Fig. **28.12**). Mies had created the chair for the German Pavilion the year before. Its lithe, chromeplated, crossing legs are the ultimate in elegance. Any coldness from the metal is relieved by the warm richness of the tufted leather cushions. Although expressive of the machine age, the "Barcelona" Chair required much handwork before the desired finish was achieved. It is one of the great classics of modern design.

Marcel Breuer, too, created a classic chair design. Breuer (b. 1902) was still in Germany in 1928, teaching at the Bauhaus, when he designed the chair. Here, chromeplated steel tubing was used, with canvas for the seat and back

28.13 Marcel Breuer, Armchair, designed 1928, manufactured 1933. Chromium-plated tubular steel, painted wood, canvas, 33½ × 21⅞ × 24in (85.1 × 55.6 × 61cm). Wadsworth Atheneum, Hartford, Connecticut.

28.12 Ludwig Mies van der Rohe, "Barcelona" Chair, 1929. Chromeplated flat steel bars with pigskin cushions, 29⅞ × 29½ × 29⅝in (75.9 × 74.9 × 75.2cm). Collection, The Museum of Modern Art, New York. Gift of Knoll International.

(Fig. **28.13**). A cantilevered frame eliminated the necessity of back legs. It, too, looks like a product of the machine age, but also required a lot of handwork. Such pieces, produced under the direction of the designer himself, were quite expensive, and they were not wellknown in America until the early 1930s.

Donald Deskey (1894–1988), perhaps the most gifted American interior designer of the late 1920s and 1930s, had been a student of painting and had twice traveled to France before he settled in New York City in 1926. At first he created window displays in the modernistic mode for Saks Fifth Avenue and Franklin Simons department stores, and he designed fashionable Manhattan apartments.

Deskey's greatest effort, however, came when he was placed in charge of the interior decoration of the vast and diverse complex of spaces in Radio City Music Hall. For its foyer he created a sophisticated elegance on a grand scale, tempered by a touch of gaudiness that had become traditional in theater décor (Fig. **28.14**). Here there is ample use of the favorite materials of Art Deco—shining, highly polished metal surfaces, colossal mirrors, and tubular fixtures, with somewhat garish colors in the huge draperies and plush carpeting.

An enormous mural, *The Fountain of Youth* by Ezra Winter, dominates the wall of the grand stairway. Deskey brought a number of artists of the Modern movement in to the project; for example, Georgia O'Keeffe (see p. 457), Stuart Davis (see p. 465), Louis Bouche, and Yasuo Kuniyoshi all painted murals for one room or another, and sculptures were commissioned from Robert Laurent, Gwen Lux, and William Zorach.

The art projects planned for Rockefeller Center sometimes became the center of great controversy. For example, S. L. "Roxy" Rothafel, the manager of Radio City Music Hall, was scandalized by the nudity of the statues Zorach, Laurent, and Lux created. He refused to allow them to be placed on display, until Nelson Rockefeller and several newspaper art critics applied sufficient pressure that he gave in. The talented Mexican muralist and avowed Communist Diego Rivera (1886–1957) had placed a portrait of Lenin prominently in his *Man at the Crossroads*, a complex composition suggestive of a people's revolution. He was asked to remove the Lenin portrait, but refused. Nelson Rockefeller, who had become interested in modern art as a collector and patron, suggested it be installed in the new Museum of Modern Art, but that institution declined. Rivera was given the ultimatum of removing the portrait or else. When he again refused, the mural was destroyed.

The change in artistic décor between 1900 and 1940 was great, as we may see by comparing the interior of Chicago's Continental Illinois National Bank (Fig. 28.1) with Deskey's design for the foyer of Radio City Music Hall. Clearly, a change had come about in the environment—in the home, in the workplace, and in the place of entertainment. The changes were reflective of a new age—an age of machines and technology—that arose in the first four decades of the twentieth century.

28.14 Donald Deskey, Foyer, Radio City Music Hall, Rockefeller Center, New York City, c. 1930. Mural by Ezra Winter. Ezra Stoller/Esto.

CHAPTER TWENTY-NINE

PAINTING:

REALISM AND REGIONALISM, 1900–40

As the new century opened, America was a nation in transition, and ripe for many kinds of revolutions—in politics, social systems, and certainly in literature and painting. The latter, in particular, must be seen against the backdrop of social revolt and shifting values and forces that were occurring within American society at large.

Capitalism, a virtually unbridled power in the last quarter of the nineteenth century, was challenged by the rise of socialism and the growing strength of the labor movements. "Society" came to mean the people, as well as the wealthy. Treatises such as Thorstein Veblen's *The Theory of the Leisure Class* (1899) made an attack on capitalism, and Monsignor John A. Ryan's *A Living Wage* (1906) called for a sharing of wealth. In 1901, Andrew Carnegie, formerly a penniless immigrant, published his side of the story in *The Gospel of Wealth*.

To counterbalance the great corporations, the power of labor was increasingly asserted across the country. By 1905, the American Federation of Labor's membership had reached 1,500,000, and other unions increased as well. Socialism and the labor movement were frequently drawn together in a common cause. There were frequent strikes, often involving considerable violence between workers and management, at factories and mills. Violence appealed to anarchists, who believed that the old order must be destroyed before a new order could arise. It was an anarchist who assassinated President McKinley in 1901 at the Pan-American Exposition in Buffalo.

The workingclasses discovered they had supporters among the intelligentsia, writers, and artists. Jack London, today better-known for his stories of the West and of the sea, was an avowed Marxist. The liberal, progressive point of view found an outlet in the magazine *The New Republic*, founded in 1914 by Herbert D. Croly, and the journal *The Masses*, founded in 1911, called for the downfall of the old society so that a new society of the workingclass might replace it.

The old, ordered society of upper-middleclass Victorian America was assailed by younger authors with a new means of expression—realism. The style and subject shifted, beginning with William Dean Howells's *The Rise of Silas Lapham* (1885) and *A Hazard of New Fortunes* (1890). Meanwhile younger men introduced new themes that had previously been considered unacceptable—even vulgar—such as poverty, social injustice, drunkenness, prostitution, and life in a skid-row flophouse. Stephen Crane, a young journalist, wrote *Maggie, A Girl of the Streets* (1893), the first American novel to deal realistically with the sordid life of the slums. Upton Sinclair's *The Jungle* (1906) is an angry social-protest novel that calls attention to the exploitation of immigrants, while Theodore Dreiser's *The Financier* (1912) and *The Titan* (1914) are tensely drawn psychological studies—some might say indictments—of capitalists and of capitalism for their failure to provide, in their pursuit of greed, even the bare essentials of life for the people. By 1920, for the first time the urban population of the United States surpassed the number of rural Americans, and the plight of the misgoverned became the focus of books such as *The Shame of the Cities* (1904) by Lincoln Steffens.

As early as the 1890s, the critic Hamlin Garland began calling for a means of expression that was American in subject matter and style and not based on European traditions. He also called for a rejection of the tradition of elegant and refined gentility in favor of themes from real life—even from the seamier side of life.

A new kind of painting in America also emerged, one that was not genteel, but drew its vitality from the life of the streets. It was truly American and largely free of European influences. Like the new literature, it was based in a vigorous new realism. The paintings meshed perfectly with the newfound interest in ordinary people, especially those of the workingclass, and often paralleled the new novels about the daily streetlife of urban America. With this social and literary background, the emergence of the Ashcan school was perhaps inevitable.

REALISM VERSUS MODERNISM VERSUS TRADITION

Realism, or the appearance of reality in the painted image, had long been the main tradition in American art, from Copley and Peale to Eakins and Homer, and so on into the

twentieth century with artists such as John Sloan and Andrew Wyeth.

In their own form of rebellion against the Beaux-Arts style of painting of the late nineteenth century, the artists of the so-called Ashcan school revitalized the realist tradition in the decade or so before World War I. Their response to the modern world was to choose common street scenes and the bawdy life instead of lofty, rarefied themes from the mythology and literature of bygone times. Somewhat later, painters of the Regionalist schools, such as Thomas Hart Benton, John Steuart Curry, and Grant Wood, painted scenes of Midwestern life, again with new styles that broke with tradition.

The preference for naturalism in art in America, however, was challenged with the invasion of modernism in the second decade of the new century. No longer was the artist obligated to recreate the physical world—suddenly, the concept of abstraction of form, color, and light was taken up, at first among only a few artists, patrons, and critics, but then, in the 1920s and 1930s, with an outburst of the enthusiasm that characterizes spiritual conversion.

The history of American painting during the first four decades of the century therefore consists of two parallel traditions—realism and **abstraction**. The former seemed to arise naturally out of America itself, while the latter followed the lead of the dynamic European experiments in visual imagery.

Whichever tradition a painter belonged to, this was a period of new ways of seeing, new ways of painting, of fresh, new attitudes about art for art's sake. The group known as The Eight, most of whom were of the new realism, caused as much of an uproar when they held their first exhibition in 1908 as the modernists did when they had their exhibition at the Armory Show five years later. Both traditions, each in its own way, challenged an art establishment that had long been committed to a genteel art in the Beaux-Arts manner. Critics decried the vulgarization of art on the one hand, and the insanity and anarchy of modern art on the other.

ROBERT HENRI AND THE EIGHT

The story of the realist tradition of this period begins with Robert Henri (1865–1929). Henri was raised in the Midwest, and studied art at the Pennsylvania Academy in Philadelphia, being instructed in the curriculum established by Thomas Eakins and perpetuated by Thomas Anshutz (see pp. 338 and 341). A trip to Paris introduced Henri to the academic style of the Ecole des Beaux-Arts, but he soon turned to Impressionism as a preferred way of painting. However, Impressionism, too, soon seemed inadequate, and at that point Henri discovered the work of the great seventeenth-century realists Velázquez and Hals, as well as the more contemporary work of Manet and Whistler.

29.1 Robert Henri, *West Fifty-seventh Street, New York*, 1902. Oil on canvas, 26 × 32in (66 × 81.3cm), Yale University Art Gallery, New Haven, Connecticut.

Returning to Philadelphia, Henri began to acquire a reputation as a painter and a teacher, especially among a group of young newspaper illustrators who gathered around him. This group included future members of The Eight—John Sloan, Everett Shinn, William Glackens, and George Luks. No small part of Henri's attraction was his defiance of the art establishments—his rebellion against what had become, he contended, a vapid Impressionism, and against the moribund academic approach of the Pennsylvania Academy and the National Academy.

In 1900, Robert Henri settled in New York City. His change of style is seen in *West Fifty-seventh Street, New York* in which the light, pastel-hued palette of Impressionism has been replaced by the darker tones of Hals, Rembrandt, and Velázquez. The impressionist technique, too, has given way to a loose, painterly application in broad, rapid strokes (Fig. 29.1).

Henri accepted city life for what it was—often drab and grimy, but always throbbing with vitality. For all its clutter, seediness, and filth, *West Fifty-seventh Street* is exemplary of the artistic legacy he would pass on to a generation of younger painters, for pictures such as this established the legitimacy of a subject matter they were drawn to naturally.

The realism and informality of Henri's style are seen in his portrait of his artist-friend George Luks (Fig. 29.2). Henri's representation of Luks attacked the traditional academic insistence on the gentility of art and its separation from real life. Its brusque, forthright reality appealed greatly to young men such as Sloan, Luks, Shinn, and Glackens, all of whom—as illustrators for newspapers—were more accustomed to depicting real life than romantic fantasy. In the portrait, a careless informality new to portraiture is created by Luks's cigarette, the disheveled old brown robe, and his rumpled hair. Henri's technique suggests the robust, slovenly character of his subject, making this portrait quite different from, say, Sargent's *Mr. and Mrs. Isaac Newton Phelps Stokes* (Fig. 23.22).

Henri continued to be the mentor and rallying force around which younger, but equally rebellious, artists gathered. Sloan, Luks, Glackens, and Shinn followed him to New York from Philadelphia, and others such as Arthur B. Davies and Maurice Prendergast soon joined the group.

Henri advocated an artistic freedom, a search for one's personal means of expression and for truth in art. The Academy, on the other hand, sought beauty, but beauty that seemed unrelated to real life and therefore deprived of its vigor. Henri defended vulgarity and ugliness in art—because they are present in life, they are therefore legitimate in art. He opened his own school, where he instituted his innovative teaching methods. These included a pseudo-scientific color system that had been devised by Hardesty Maratta in the late nineteenth century.

When some of his young friends had their work rejected for the annual National Academy show in 1904, Henri, in a bold stroke, immediately organized a show of their own. It was, however, the 1908 exhibition at the Macbeth Gallery in New York City that brought about the group known as The Eight. The group comprised Henri, Sloan, Glackens, Lawson, Luks, Shinn, Davies, and Prendergast.

These men never coalesced into a unified school and never again exhibited together as The Eight—they practiced, in fact, widely divergent styles. But they were, at that moment, united in their angry defiance of the National Academy. Because of the subject matter in some of their pictures,

29.2 Robert Henri, *Portrait of George Luks*, 1904. Oil on canvas, 76½ × 38¼in (194.3 × 97.2cm). National Gallery of Canada, Ottawa.

representing the cluttered, shabby street scenes of the city, some members were later dubbed the Ashcan school. However, the terms "The Eight" and the "Ashcan school" cannot be used synonymously.

Critical reviews of the exhibition recognized the rebellious spirit and the new modes of painting that challenged the old guard of the National Academy. There was such interest in the show that it was sent on tour to Philadelphia and eight other cities.

Henri's organizational efforts continued with another show, the Exhibition of Independent Artists in 1910, which brought additional pressure on the National Academy to liberalize its policies toward the younger artists and their work.

Henri's immediate followers were now free to paint the street people of the sidewalks of New York in an unromanticized realism that suited the subject matter. Tenement backyards were as acceptable as grand boulevards, and the neighborhood saloon was more interesting than the fashionable salon. Painting was free of academic restraints—free to respond to the urban environment in a way it never had before, in a manner that novelists such as Stephen Crane, Upton Sinclair, and Frank Norris had already done for a decade or more.

JOHN SLOAN AND THE ASHCAN SCHOOL

Henri urged John Sloan (1871–1951) to paint the life of Philadelphia, the city he knew so intimately. Sloan began his career as a staff artist for a newspaper and was familiar with the realities of the urban scene. His illustrations for *The Inquirer* and *The Press* bore the sensuous line of Art Nouveau and the decorative patterning of Japanese woodcuts that characterized the poster style of the 1890s. For a year Sloan studied at the Pennsylvania Academy under Thomas Anshutz, while he and his illustrator-friends met regularly at Henri's Philadelphia studio.

About the time he moved to New York City, following Henri there in 1904, Sloan was very interested in the technique of etching. One of his bestknown works is *Fifth Avenue Critics*, a satirical indictment of a snobbish wealthy class (Fig. 29.3). One is here reminded of a scene from Jacob Riis's *How the Other Half Lives*:

> A man stood at the corner of Fifth Avenue and Fourteenth Street the other day, looking gloomily at the carriages that rolled by, carrying the wealth and fashion of the avenue to and from the big stores down town. He was poor, and hungry, and ragged. This thought was in his mind: "They behind their well-fed teams . . . know hunger only by name, and ride down to spend in an hour's shopping what would keep me and my little ones from want a whole year." There rose up before him the picture of those little ones crying for bread around the cold and cheerless hearth—then he sprang into the throng and slashed about him with a knife, blindly seeking to kill, to revenge. The man was arrested, of course, and locked up. Today he is 'probably in a mad-house, forgotten. And the carriages roll by to and from the big stores with their gay throng of shoppers.[1]

Graphic works such as this belong in the social satire tradition of Honoré Daumier (1808–79).

29.3 John Sloan, *Fifth Avenue Critics*, 1905. Etching, 5 × 7in (12.7 × 17.8cm). Delaware Art Museum, Wilmington, Delaware. Gift of Helen Farr Sloan.

29.4 John Sloan,
The Wake of the Ferry II,
1907. Oil on canvas,
26 × 32in (66 × 81.3cm).
© The Phillips Collection,
Washington, D.C.

29.5 John Sloan,
McSorley's Bar, 1912.
Oil on canvas, 26 × 32in
(66 × 81.3cm). Detroit
Institute of Arts.

Sloan also did a series of etchings depicting New York City's infamous tenderloin district. But when he sent them to the American Watercolor Society for exhibition in 1906, nearly half were rejected because they were considered "too vulgar."

Unlike his etchings, most of Sloan's paintings avoided satire to concentrate on an uncritical representation of some passing moment of everyday urban experience, as in *The Wake of the Ferry II* (Fig. 29.4). One cold, misty March day in 1907, Sloan had taken the ferry across the Hudson River, returning from Jersey City to Manhattan. He began painting his reminiscence at once. The low-keyed tonality contributes to the all-pervading cheerlessness of the scene. In the shadowy figure at the right, one senses a disturbing isolation and loneliness within an overpopulated city. There is a freedom in the brushstrokes that suggests the spontaneity with which Sloan worked. The underpinning for this technique lay in the art of Henri.

Sloan sought out the very subjects that would have been anathema to the National Academy of Design—McSorley's Bar, for example, which Sloan painted several times. Located on East Eleventh Street near the Cooper Union School, its front window was covered with dust, sawdust was strewn about on the floor, its dark walls were covered with prints and programs of long-past sporting and theatrical events (Fig. 29.5). If the picture seems uncomposed by academic standards, it is because Sloan was applying journalistic principles—observing a passing scene, reporting on the pastimes of humanity—without making humanity conform to the "rules" of art.

Sloan's ideological inclinations were socialistic, and he was far more concerned with the masses than with the élite. This shows up in paintings such as *The Haymarket* (1907, Brooklyn Museum), which depicts several young women entering an infamous dancehall on Sixth Avenue, and the *Pigeons* (1910, Museum of Fine Arts, Boston), a view of tenement rooftops, which was rejected by the National Academy when Sloan submitted it for exhibition in 1910.

Sloan's art, like that of many of the Ashcan school, was slowly and begrudgingly accorded critical acceptance. He did not, however, sell a painting until 1913, when Dr. Albert C. Barnes bought one. His first oneperson show was held in 1916 at the Whitney Studio, and the next year he joined in the exhibition of the Society of Independent Artists. The newly formed Society proclaimed "no jury, no prizes," in imitation of the earlier French independents. While Sloan's work gradually gained favor and recognition, in the early years of his career he faced the outrage and denunciations encountered by any rebel who threatens the establishment.

GEORGE LUKS

Other members of the Ashcan school similarly sought their subject matter in the pageantry of daily city streetlife. George Luks (1867–1933), for example, found the crowded New York City sidewalks, the shops, the various languages, accents, and customs an exciting theme for his picture *Hester Street* (Fig. 29.6). After studying at the Pennsylvania Academy, Luks traveled about in Europe, briefly attending several art schools. He returned to Philadelphia in 1893,

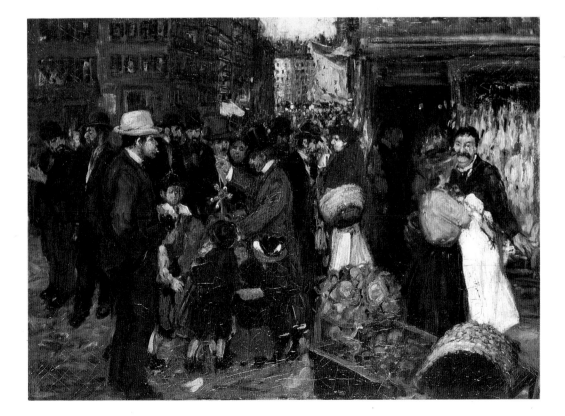

29.6 George Luks, *Hester Street*, 1905. Oil on canvas, 26⅛ × 36⅛in (66.3 × 91.8cm). Brooklyn Museum.

where he soon found employment as an illustrator. After serving as a war illustrator in Cuba during the Spanish-American War in 1898, he settled in New York City as a comicstrip cartoonist. His friends—Glackens, Shinn, and Henri—encouraged him to begin to paint seriously, which he did, in dark tones and with a loose, flowing, almost brutal brushwork that in its unrefinement suited the street-life subjects he chose to depict.

The art of Henri, and of the great seventeenth-century Dutch realist Hals—whose work he had studied in Europe—were the two most powerful influences on Luks's style: "Guts! Guts! Life! Life! That's my technique," he declared. In 1905, when he painted *Hester Street*, he produced a number of his most important pictures, including *The Spielers* (Addison Gallery, North Andover, Massachusetts) and *The Wrestlers* (Museum of Fine Arts, Boston). Luks's work found only disfavor among the art establishment, but it was very much at home in exhibitions such as that of The Eight in 1908. Pictures like *Hester Street* reveal the new vitality and life that was infused into art in the opening decade of the twentieth century. Looking at them, one thinks of similar scenes described in Abraham Cahan's classic novel of the life of an immigrant Jew in New York City, *The Rise of David Levinsky* (1917).

EVERETT SHINN

Everett Shinn (1876–1953) also began his career as an illustrator for a Philadelphia newspaper while studying at the Pennsylvania Academy. He then took up painting grim street scenes of New York City after he settled there in the late 1890s. During a trip to Paris Shinn became fascinated with theatrical life, which thereafter was frequently the subject of his canvases—as in *London Hippodrome* (1902, Art Institute of Chicago). Shinn painted with the fluid brushstrokes of Henri, whose circle he joined. Streetlife pictures such as *Early Morning, Paris* caused critics to refer to Shinn and his friends as the Ashcan school (Fig. 29.7).

Although he participated in the exhibition of The Eight at Macbeth's, Shinn's interest in the theater slowly drew him away from the art world. He painted the decorations for New York City's Belasco Theater, and even tried his hand at writing plays.

WILLIAM GLACKENS

Philadelphia-born William Glackens (1870–1938) worked as a newspaper illustrator, falling in with John Sloan, Everett Shinn, and George Luks. Like them, he studied with Anshutz at the Pennsylvania Academy. In 1895, Robert Henri encouraged the younger man to accompany him to France. Although he never enrolled in any art school while abroad, Glackens sketched the joyous life of the Parisian boulevards, and became acquainted with the art of the Impressionists.

Returning to America, he settled in New York City, where he shared a studio with Luks. Glackens took a job as a newspaper illustrator, but turned increasingly to painting as his career. His early masterpiece is *Chez Mouquin* (Fig. 29.8). Mouquin's was a popular café frequented by artists, writers, and young men-about-town. Members of The Eight dined there frequently. In coloration, technique, and

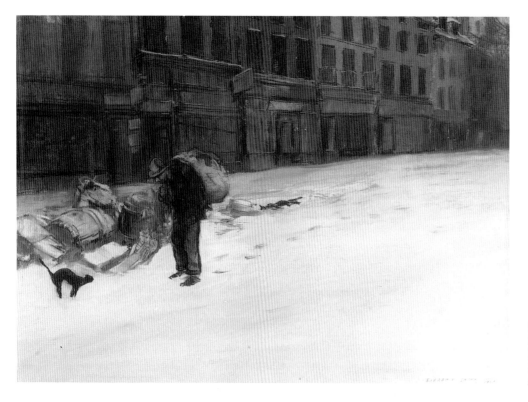

29.7 Everett Shinn,
Early Morning, Paris, 1901.
Pastel on paper,
21 × 29⅛in (53.5 × 74cm).
Art Institute of Chicago.

29.8 William Glackens,
Chez Mouquin, 1905.
Oil on canvas, 48 × 39in
(121.9 × 99.1cm).
Art Institute of Chicago.

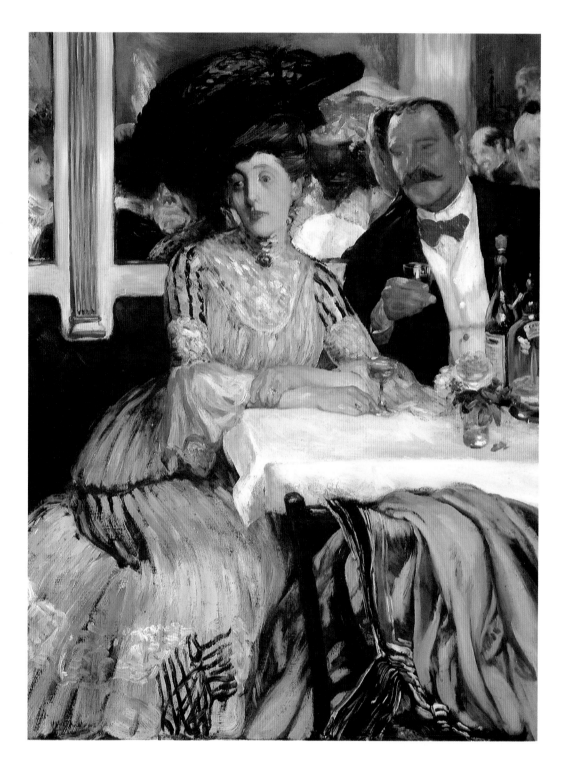

subject matter, the picture recalls impressionist paintings set in popular Parisian nightspots, and depicts life among the *demi-monde* society. Glackens represents it in a manner reminiscent of Edouard Manet's *A Bar at the Folies-Bergère* (1882, Courtauld Institute, London), showing a wonderful still life on the table and reflections of the glittering room in the mirror behind the figures.

Like the French Impressionists, Glackens also depicted the pleasant side of life—strollers in parks and along boulevards,

or people enjoying a carriage ride on a sunny afternoon. He exhibited his work with The Eight in 1908, and two years later sent pictures to the exhibition of the Independent Artists. When the Society of Independent Artists was organized in 1917, Glackens was elected its first president. About this time, too, he was assisting his longtime friend, Dr. Albert C. Barnes, in the formation of his collection of paintings by Degas, Manet, Renoir, and others of the modern French school. As time passed, Glackens's work

increasingly took on the lighthearted character of the Impressionists, rather than the grim hues and bleak scenes of streetlife as portrayed by his friends Sloan and Luks.

ERNEST LAWSON

Ernest Lawson (1873–1939), another member of The Eight, arrived in New York City in 1891, and began studying at the Art Students League. The school had been founded in the late 1870s by students who were dissatisfied with the rigid curriculum offered by the National Academy. Lawson also studied with two American Impressionists, J. Alden Weir and John Twachtman, at their art school in Cos Cob, Connecticut. His attachment to the French style intensified after he went to Paris in 1893, especially after he became friends with Alfred Sisley. While in Paris, he shared a studio with the English writer Somerset Maugham, who later used Lawson as the inspiration for the artist Frederick Lawson in his novel *Of Human Bondage* (1915).

Returning to the United States, Lawson settled in New York City, where he met Glackens and, through him, Sloan, Luks, Shinn, and Henri. Although the impressionist flavor of his style was very different from the darktoned work of Henri, Sloan, and Luks, he also took the city scene as his subject matter, as we see in *Winter Landscape: Washington Bridge* (Fig. 29.9). When Lawson first returned from Paris, he lived in Washington Heights, an area overlooking the Harlem River flowing through a region of the city that had not yet become urbanized. He painted many landscapes of this part of the city between 1905 and 1915, often in the unifying whites and grays of winter snows, in an impressionist manner reminiscent of the subtle tonal harmonies of John Twachtman.

MAURICE PRENDERGAST

Not all members of The Eight were Ashcan painters, the most notable exceptions being Maurice Prendergast and Arthur B. Davies.

29.9 Ernest Lawson, *Winter Landscape: Washington Bridge*, 1905–15. Oil on canvas, 18¼ × 24⅜in (46.3 × 62cm). Brooklyn Museum.

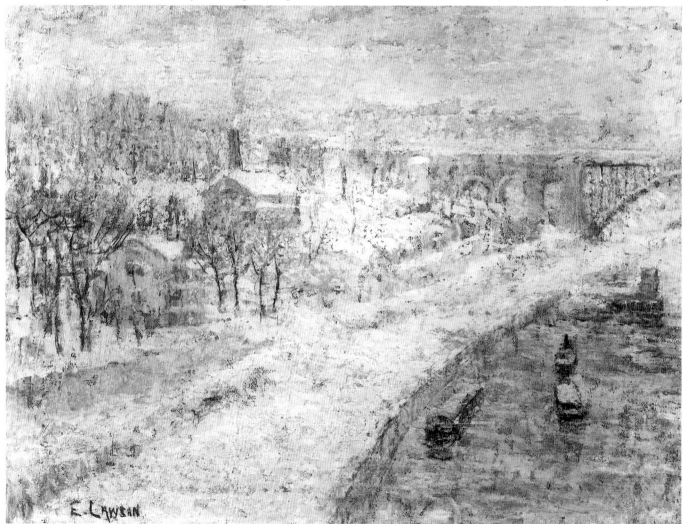

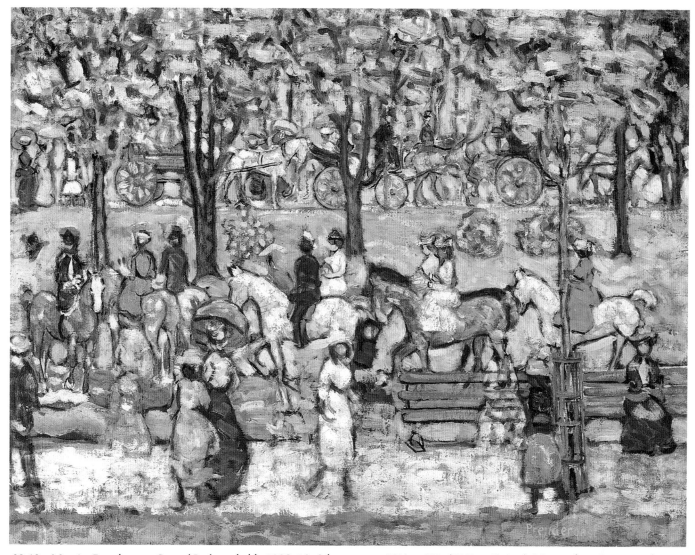

29.10 Maurice Prendergast, *Central Park*, probably 1908–10. Oil on canvas, 20¾ × 27in (52.7 × 68.6cm). Metropolitan Museum of Art, New York City.

Maurice Prendergast (1859–1924) grew up in Boston before going to Paris in 1891, arriving at a time when the Impressionists had established themselves and new movements were appearing on the scene, such as seen in the work of the Post-Impressionists and the Nabis. Prendergast was particularly struck by the decorative treatment of color used in patches to define naturalistic forms. The works by Pierre Bonnard (1867–1947) especially appealed to his decorative inclinations. During his three years in Paris, Prendergast spent much time making watercolor sketches of parks, boulevards, and café scenes.

At the turn of the century, Prendergast settled in New York City, where he met William Glackens. The two men were drawn together by a preference for similar subjects and for the modern French styles of painting. Soon Prendergast was introduced to other members of the Henri group and began to exhibit with them—at the National Arts Club show of 1904 and at Macbeth's in 1908.

The East River (1901, Museum of Modern Art), a watercolor, is an early example of the personal style Prendergast was evolving in which park, river, the far shore, clouds, and sky are all reduced to flickering patches of brilliant color that are only suggestive of natural forms.

This style developed rapidly. By the time he painted *Central Park* (Fig. 29.10), Prendergast's vision had become a tapestry of pattern and color, and space had become condensed. As in Impressionism and Post-Impressionism, the stroke of the brush, often dragged dry over another color, becomes an important component of the aesthetics of the work. In areas such as the top of the picture, naturalistic form dissolves into sensations of color.

This was, however, as far as Prendergast carried his experiments in color. He did not disassemble the physical world and then reassemble it, the way the Cubists would a few years later, or the way another American watercolorist—John Marin—would soon do (see p. 455).

29.11 Arthur B. Davies, *Unicorns*, 1906. Oil on canvas, 18¼ × 40¼in (46.4 × 102.2cm). Metropolitan Museum of Art, New York City.

ARTHUR B. DAVIES

One of the main figures in the New York City art world of this era was Arthur B. Davies (1862–1928). Although he exhibited in The Eight show of 1908, his work was very different from that of the realist members of the group.

After studying at the Chicago Art Institute, Davies moved to New York City in 1896, where he earned a living as a magazine illustrator. In that same year, William Macbeth offered him his first oneperson show at his gallery. Davies's propensity to paint dreamlike visions was already present in his early works, and critics linked them to the visionary imagery of Ryder and Blakelock. The critics also used such words as "innocent," "childlike," and "naïve" to describe his work.

The department store magnate Benjamin Altman took an interest in Davies, and subsidized a trip to Europe in order for him to study. There, Davies discovered a rich variety of inspiration, ranging from the great Venetian Renaissance painter Giorgione to the nineteenth-century French artist Puvis de Chavannes, and from the color used by Delacroix to the Romantic mysticism of Arnold Böcklin. Davies's work has been associated with the fantasy imagery of the Symbolist movement, especially in its dreamlike aspects, and some of his early pictures bear a similarity to the dream-visions of Odilon Redon.

Although none of these influences has any connection with the seamy street scenes of the Henri-Sloan-Luks group, soon after his return to New York, Davies joined with these men and their friends in their rebellion against the National Academy.

Davies's work during the opening years of the new century is exemplified in *Unicorns*—a gentle idyll set amid a floating dream-world that praises the innocence of maidenhood (Fig. **29.11**). Davies's work characteristically dealt with similar themes of poetic visions, far removed from the realities of urban life.

When Robert Henri began to mobilize his forces in rebellion against the National Academy, Davies entered the fray and was instrumental in getting Macbeth's gallery for the 1908 exhibition of The Eight. John Sloan recalled that most dealers would not touch such controversial art. Davies also showed his work with the Henri group and other artists in the 1910 Exhibition of Independent Artists, which was scheduled at the same time as the National Academy's annual show. Gallerygoers turned out in great numbers to visit the Independents and stayed away by the hundreds from the Academy. The insurgents had won a decisive victory. The stodgy old Academy had to come around to admitting some of them, and to showing their work.

The term "Ashcan school" was not actually coined until 1934, by which time the progeny of the first generation of painters had broadened the scope of New York City realist painting. Like their predecessors, many of the younger artists had socialist, if not Marxist, sympathies that were reflected in their art. The group included George Bellows, Edward Hopper, and Reginald Marsh, to name three of the most important. There were in fact dozens of painters who were making urban realism the foundation of their art.

GEORGE BELLOWS

George Wesley Bellows (1882–1925) was born in Columbus, Ohio, where he attended Ohio State University

before going to New York City in 1904 to study art. For two years Bellows worked under Henri at Chase's New York School of Art. Here, Bellows mastered the broad, slashing brushstroke and fluid flow of paint upon canvas, as heir to the Hals-Munich tradition via his American teacher and the indirect influence of Chase. His subject matter followed the urban realist party line—children swimming along the docks, gang fights, and the like—but he also painted high society, elegantly dressed, playing tennis or watching a polo match. There was a puzzling duality about Bellows's career, for he eventually became a leader of the realist group, but he was also welcomed into the orbit of the National Academy.

Success came early to Bellows, with pictures such as *River Rats* (1906, private collection) and *Forty-two Kids* (1907, Corcoran Gallery). The zestful nature of his art was demonstrated in his pictures of prizefighters, for example, *Stag at Sharkey's* (1907, Cleveland Museum of Art) and *Both Members of This Club* (Fig. 29.12).

Prizefights were at the time illegal in New York City, but nevertheless were held at private clubs like Sharkey's, which

Bellows frequented regularly. The title *Both Members of This Club* was derived from the practice of making the two pugilists temporary members of the club, which gave the fight legal status. As in *Stag at Sharkey's*, there are no women present, for such places were open only to men.

Bellows, who was quite athletic himself, moved in close to the ring in order to capture the scene—to observe and transfer the smell and sweat of the combatants onto his canvas. The bloodiness of the white man's face contributes to the unsavoriness of the scene—from the viewpoint of Academicians—and the two nearly nude figures are anything but Apollo-like. The viewer is drawn in to mingle with the shouting, boisterous, intoxicated crowd. Bellows's brushwork is intentionally brusque and rough, and is used to convey the dynamic energy the artist sensed in his unrefined subject.

Although he came from a conservative Midwestern background, Bellows's sympathies for the poor of the city's slums led him increasingly toward a socialistic outlook. In May 1913 he contributed a drawing to *The Masses*, one of

29.12 George Bellows, *Both Members of This Club*, 1909. Oil on canvas, 3ft 9¼in × 5ft 3⅛in (1.15 × 1.61m). National Gallery of Art, Washington, D.C.

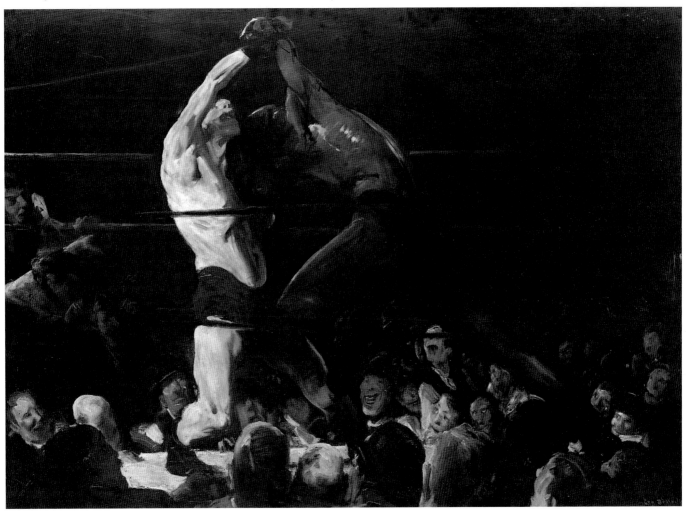

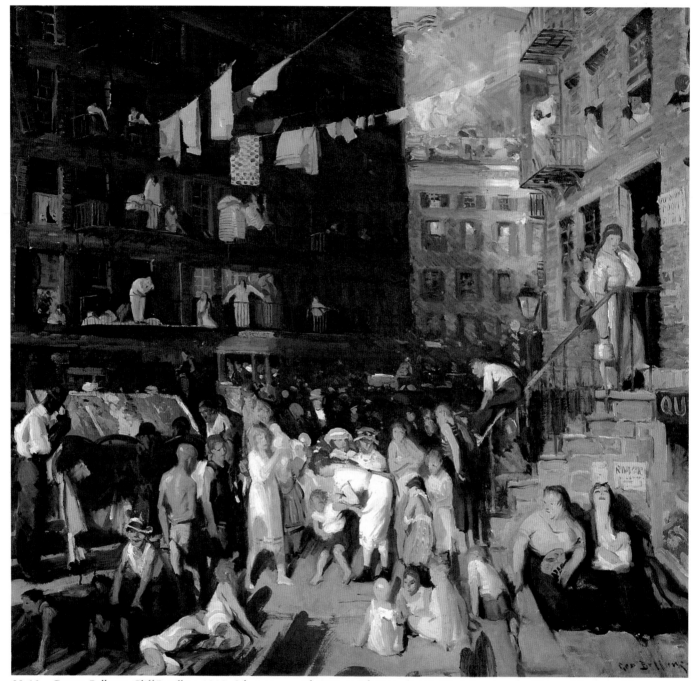

29.13 George Bellows, *Cliff Dwellers*, 1913. Oil on canvas, 3ft 3½in × 3ft 5½in (1 × 1.05m). Los Angeles County Museum of Art.

the leading socialist periodicals of the day. That same year Bellows painted *Cliff Dwellers*, which depicts the huddled masses of the Lower East Side (Fig. 29.13). The scene is filled with people who cannot escape the summer heat of the city. A satirical title was given to the preparatory drawing, which was published in *The Masses*. The words supposedly were spoken by a wealthy Fifth Avenue socialite—"Why Don't They All Go to the Country for Vacation?"

Pictures such as this attacked the belief that the poor were happy with their lot in life. Bellows saw a rich, vital pageantry in such scenes, with noisy, shouting children, a cacophony of languages and noises, sweltering souls on the fire-escapes, and sidewalk vegetable stalls. Escape to the country or to a better life is walled off by the ghetto itself.

The duality of Bellows's career persisted: He was not only one of the participants in the 1913 Armory Show, but also the same year was elected by the National Academy to full membership. Little more than a decade remained of Bellows's life. Two of his finest portraits from his later years are his *Portrait of My Mother* (1921, Columbus Gallery of Fine Arts), and the one of his daughter, *Lady Jean* (1924, Yale University Art Gallery).

EDWARD HOPPER

Edward Hopper (1882–1967) also studied under Robert Henri at the New York School of Art, between 1900 and 1906, thereby acquiring a fascination with the urban scene. Even in Paris before World War I, Hopper drew and painted city life, and in the years 1915–18 he made many etchings that reveal the influence of John Sloan. Hopper relied on commercial art to support himself, and the imagery of signs and advertising art later appeared in many of his pictures.

In Hopper's many scenes of windows looking out on to the city, there is a sense of loneliness and isolation. *Eleven A.M.* is typical of a Hopper interior, with a window looking out on an urbanscape, the view closed off by tall buildings (Fig. **29.14**). The viewer in the picture is an unidealized nude woman, who represents the darkly erotic element often present in Hopper's paintings. Her face is hidden from us, but we can nevertheless tell that she is lost in the loneliness

of her own thoughts. Silence fills the scene. The room is lacking in personal objects, suggesting the austerity of a hotel room. Hopper's low-keyed palette also contributes to an atmosphere of depression.

Hopper would often escape from the city to the New England coast, especially to Cape Cod, which provided him with innumerable subjects. Such paintings are monumental landscapes, in which details would only become unnecessary intrusions. They usually combine strong, raking sunlight with bold blue shadows, giving the forms a powerful solidity. Also typical is the image of an old house—usually painted white with blue shadows—which is viewed from a low vantage point. Because such pictures are often without people, there is the same haunting loneliness that pervades Hopper's cityscapes.

The loneliness of the city and the unrequited relationships of its people were enduring themes in Hopper's work, as in *Early Sunday Morning* (1930, Whitney Museum of

29.14 Edward Hopper, *Eleven A.M.*, 1926. Oil on canvas, 28⅛ × 36⅛in (71.3 × 91.6cm). Hirshhorn Museum and Sculpture Garden, Washington, D.C.

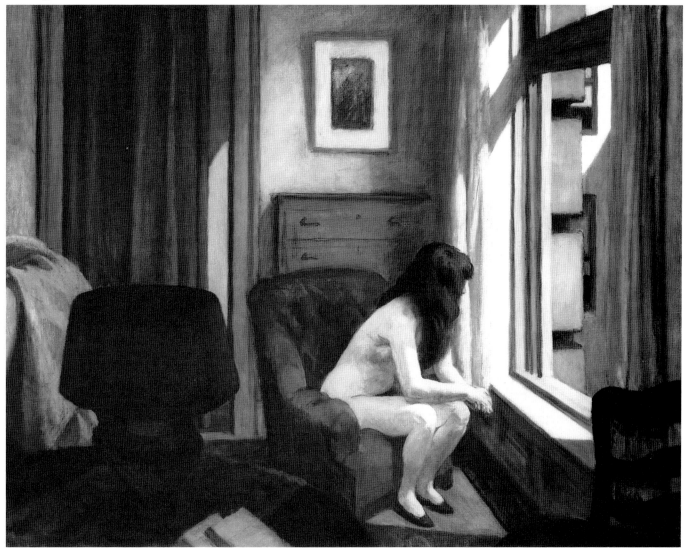

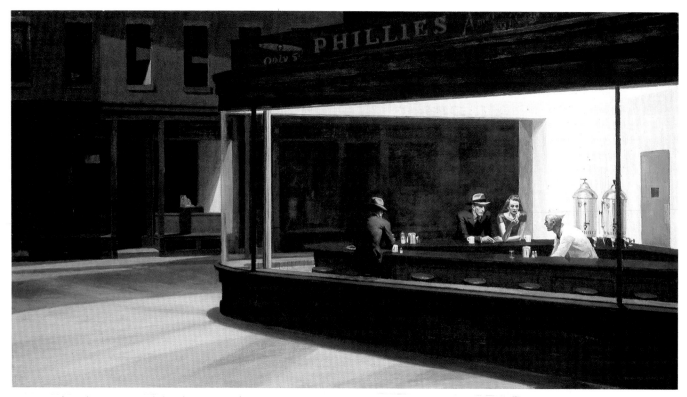

29.15 Edward Hopper, *Nighthawks*, 1942. Oil on canvas, 33 × 60in (83.8 × 152.4cm). Art Institute of Chicago.

American Art), which shows a typically deserted street and a row of shops in an old two-story building. *Nighthawks* exhibits the characteristics that made Hopper's art unique (Fig. **29.15**). In contrast to the gloominess of the redbrick storefronts across the street, a café filled with garish, stark fluorescent lighting clearly exposes the isolation of three people at the counter. Even the man and woman sitting together seem uninterested in each other. Again, Hopper reduced the picture's details to the bare essentials in order to force our concentration upon the stark loneliness of the scene.

Hopper was elected a member of the National Academy of Design in 1932. He declined because the Academy had rejected his work too many times.

REGINALD MARSH

Like Hopper, Reginald Marsh (1898–1954) carried the tradition of using city streetlife as subject matter into the early 1950s. Unlike Hopper, his is a honkytonk world portrayed in an unrefined burlesque fashion. And more blatantly than Hopper, Marsh confronts the undercurrents of unwholesome sexuality and the potential danger that lurks amid the compacted crowds on sidewalks and in the subways.

Marsh was the son of well-to-do parents who were painters. While attending art school at Yale University, he was the illustrator for the *Record*. After graduation, he moved to New York City, where he illustrated magazines and newspapers such as *The New Yorker* and the *Daily News*, doing satirical quick-sketch illustrations. It was out of this milieu that Marsh's art emerged in about 1930. By then he had been to Europe and had studied at the Art Students League with John Sloan and George Luks, both of whom encouraged him in the social commentaries he drew and painted.

Marsh's *Tattoo and Haircut* is set in the cavernous bowels of a subway station, where sunlight never penetrates (Fig. **29.16**). Grimfaced figures mill aimlessly about—the poor and unemployed, the homeless, the urban castaways. They are all men, except for one lone woman who passes uneasily through their shuffling throng. Marsh often focused on the dehumanizing aspects of city life, such as the cheerless gray iron-and-steel atmosphere of the subway, and especially the gaudy and mutilative electric tattooing of the body. More than any artist discussed so far, Marsh incorporated signs into his pictures, which he used to amplify his visual commentary. One, hanging beneath the glare of a bare lightbulb, assures "A clean towel to every customer."

Marsh worked in **tempera** much of the time, combining a sketchy technique with a wash of color that sometimes seems hastily scrubbed in. This is noticeable in *Coney Island Beach* (1935, private collection), in which people are so crammed together that both beach and ocean are all but invisible. Amidst all of this merriment, the headline on a discarded newspaper reads, "U.S. threatens Soviet Russia." For the moment at least, this frolicking crowd has little care for the tensions that threaten the world.

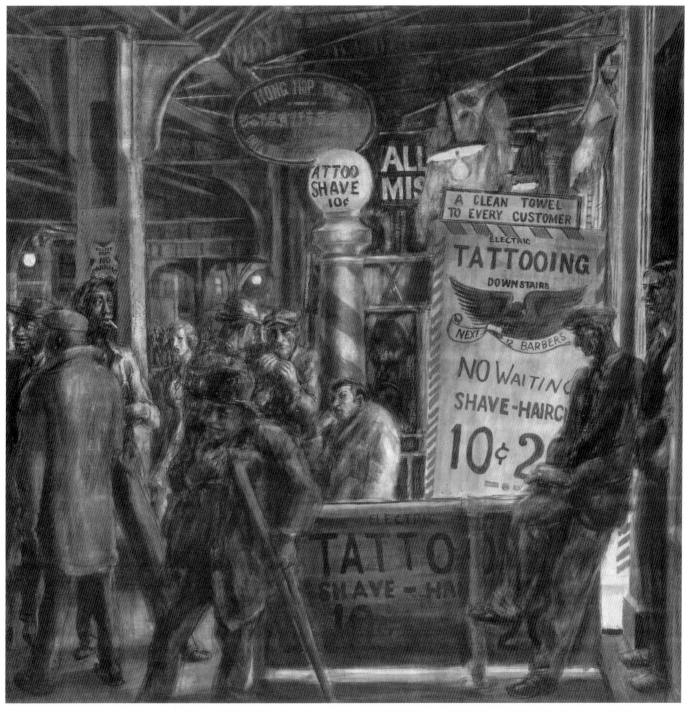

29.16 Reginald Marsh, *Tattoo and Haircut*, 1932. Egg tempera on masonite, 3ft 10½in × 4ft (1.18 × 1.22m). Art Institute of Chicago.

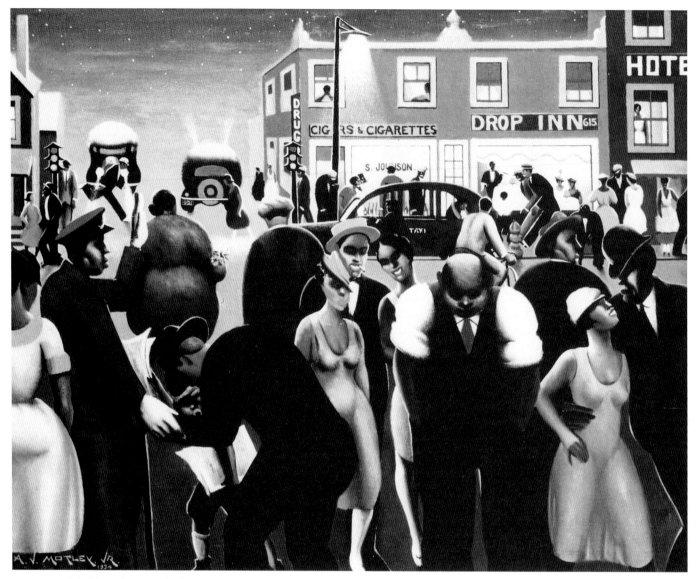

29.17 Archibald Motley, Jr., *Black Belt*, 1934. Oil on canvas, 31⅞ × 37¼in (81 × 94.6cm). Hampton University Museum, Hampton, Virginia.

ARCHIBALD MOTLEY, Jr.

An African-American, Archibald Motley, Jr. (1891–1981), found his urban subjects in the black community. Born in New Orleans but raised in Chicago, he attended the School of the Art Institute of Chicago from 1914 to 1918. Unable to find work as an artist because he was black, Motley resorted to menial jobs. Then, in 1920, one of his paintings was shown in the annual exhibition of the Art Institute.

Thereafter, Motley's scenes of life in black communities appeared regularly in group shows. In 1928 he had a oneperson show at The New Gallery in New York City, the first time an African-American painter was given a solo exhibition in a commercial gallery. That same year, his work received a gold medal from the Harmon Foundation (see p. 544), and in 1929 he was awarded a Guggenheim Fellowship, which allowed him to study in Paris for a year.

During that important year, Motley began to blend his fascination with jazz with his discovery of abstract painting. Returning to the United States, he synthesized a style that pulsated with the rhythms of the Jazz Age, with subjects taken from the urban black experience, as seen in his *Black Belt* (Fig. 29.17). It was in the area of Chicago known as Bronzeville that Motley found the rich pageant of the black community in nightclubs, dancers and hornplayers, speakeasies, and Saturday-night street scenes.

As these were the Depression years, Motley found employment with several government-sponsored arts programs, for example, painting murals under the Works Progress Administration. Although he did not want to be typed as a black artist, Motley's work reveals an indebtedness to black culture, from which it gained the extraordinary power of its imagery.

THE RISE OF REGIONALISM

The years before World War I were filled with artistic experimentation and rebellion—the forging of powerful new means of expression ranging from realism to abstraction. By the eve of the Great War, the realists were reeling from the charge of the modernists. After the war, however, the modern movement quieted down in America and, while remaining impellent, became less aggressive.

There was a pronounced revival of interest in purely American themes and patronage of a truly American style—realism. The country became isolationist, seeking inspiration from within its own borders. Many reasons have been given for this. Shocked by the horrors of the war—which many held to be a European affair the United States should never have been drawn into—there was an antipathy toward things European. Following the financial crash of 1929 and the Great Depression of the 1930s, the nation became absorbed with its own problems, causing it to turn even more inward as it coped with poverty, unemployment, and the plight of the Dust Bowl farmers.

During the Depression, the government offered assistance to many artists through such agencies as the Works Progress Administration and the Federal Arts Project. Here too, however, a chauvinistic nationalism was fostered through the stipulation that murals for government buildings—and there were hundreds of such commissions—had to depict American themes of the present day or from history. In this way American realism maintained its strength and vigor, spreading across the nation to art centers far removed from the East Coast.

There was a group of painters, working mainly in the naturalistic tradition but increasingly sensitive to the allure of abstraction, who did not adopt East Coast city life as their subject. Because they often disassociated themselves from the art centers of the Eastern Seaboard, they are referred to as regionalists.

New York City may have been the cultural center of these decades, but new centers in the interior of the nation fostered forms of expression that were distinct from those of the East. Because this phenomenon occurred earlier in literature than in painting, a glance at some Midwestern writers provides a background for the art that arose in the region.

During the decades before and after the turn of the century, there arose a type of literature in the Midwest that addressed the tragic plight and hardships of farmers and life in small towns, often with powerful psychological undercurrents. Hamlin Garland used the realist style in *Main-Travelled Roads* (1891) and *Prairie Folks* (1893). Early in her life, Willa Cather wrote about Nebraska. The tragic heroes of her novels *O, Pioneers!* (1913) and *My Antonia* (1918) are the rural counterparts to Upton Sinclair's immigrants in urban and industrial settings, as in *The Jungle*. Booth Tarkington wrote about the rise and fall of an upper-middleclass Midwestern family in *The Magnificent Ambersons* (1918), while smalltown America became the focus of novels by Sinclair Lewis in *Main Street* (1920) and Sherwood Anderson in *Winesburg, Ohio* (1919). The era closed with *The Grapes of Wrath* (1939), a powerful novel by John Steinbeck which confronts the difficult lives of farmers in the Dust Bowl, a story in which common people become epic heroes.

During the 1920s and 1930s, regionalist schools of painting developed in the Midwest, although there was no one style that bound the artists—who lived and painted in places like Chicago, Indianapolis, Kansas City, Iowa City, and Madison, Wisconsin—together. Foremost among these artists were Thomas Hart Benton, John Steuart Curry, and Grant Wood. Taking Midwestern wheat harvests, Kansas cyclones, and sober, flinty farmfolk as their subject matter, they rebelled against the élitism of an academic style, just as the urban-scene painters did. As they were far removed from art centers with dominant, influential figures such as Robert Henri, they tended to evolve very personal styles. While critics often branded them as being reactionary, chauvinistic, and provincial, their unique ways of rendering rural Midwestern subjects—even creating an heroic vision of them—proved popular with their own people, and gradually they gained national recognition.

THOMAS HART BENTON

Namesake and grandson of the United States senator from Missouri, Thomas Hart Benton (1889–1975) was born and raised in that state before going to Chicago to study briefly at the Art Institute. In 1908, Benton went to Paris, where he was influenced by Cubism and Synchromism (see p. 450). The more lasting impressions he carried back to America, however, were of the energetic, elongated figures found in the late works of Michelangelo and in those of El Greco and Tintoretto. Although Benton settled in New York City, he was perhaps happiest painting scenes of Midwestern history, legend, and daily life, which evolved into a monumental representation of the commonplace.

Mural painting in the United States had been given a great boost by the example of several Mexican artists who excelled at it, and who provided a precedent in depicting nationalistic themes. Diego Rivera, José Orozco, and David Alfaro Siqueiros were foremost among these. Their works were admired by Americans, and they were invited to come to the United States to execute murals. The mural movement was also encouraged through government patronage across the country, appearing in post offices and similar federal buildings.

The mural seemed uniquely suited to the scope and complexity of Benton's mode of vision. Beginning with the *America Today* series (1930–1), executed for the New School for Social Research in New York City, there was a completely new treatment of the mural as an artform. Here we see an approach to form, color, style, composition, and subject matter that is totally different from the quasiclassical

Beaux-Arts murals of the preceding generation.

As soon as the New School project was completed, Benton was commissioned by Indiana to paint a mural for that state's building at the 1933 Chicago World's Fair. The next major undertaking was a set of murals executed for the new Capitol building of Benton's native state of Missouri (Fig. 29.18), where we see the artist's style fully matured.

The theme of the mural is the history of the state, beginning with the buckskin-clad hunter in the lower left, through steamboat traffic on the Mississippi, the coming of the railroad, plowing, harvesting, and community dinner socials in the righthand portion of the mural. The left half is devoted to the growth of towns and to smalltown democracy at work.

The figures and other objects in the mural are boldly modeled, with dark shadows creating a sculptural effect. Benton made a practice of using plastilene (a manmade clay) to model his figure groups, and even his landscapes, in relief—something he claimed to have learned from the practices of Tintoretto and El Greco. Also typical of Benton's style is the dynamic, undulating composition that writhes restlessly across the canvas, carrying the eye on to the next episode of the state's history. Yet order is maintained throughout the composition, even though space and action seem oriented in several directions at once.

Benton continued to paint in the 1940s and 1950s, intensifying his color and developing a richer tactile quality, as in pictures such as *July Hay* (1942–3, Metropolitan Museum of Art).

JOHN STEUART CURRY

Born in Kansas, John Steuart Curry (1897–1946) studied at the Kansas City Art Institute and the Chicago Art Institute. Even after a year in Paris, on his return to New York City in 1927 he chose to paint familiar Midwestern scenes. *Baptism in Kansas* (1928, Whitney Museum of American Art) established him as one of the leading three artists of the regionalist group, even though Curry was living and painting in New York City, where he would soon begin teaching at the Art Students League.

Curry's bestknown picture is *Tornado Over Kansas* (Fig. 29.19). Here we see a Kansas farm family scurrying into a subterranean storm cellar as the ominous "twister" strikes nearby. The woman, concerned but unfearful, carries an infant in her arms, while her husband—a strong, lean, broad-shouldered ideal of the American farmer—urges on children and pets before devastation reaches them. The rough, loose brushstrokes and the dynamic accentuation of angles are characteristic of Curry's work.

29.18 Thomas Hart Benton, *Missouri Mural*, section, 1936. Oil on canvas. Missouri State Capitol, Jefferson City, Missouri.

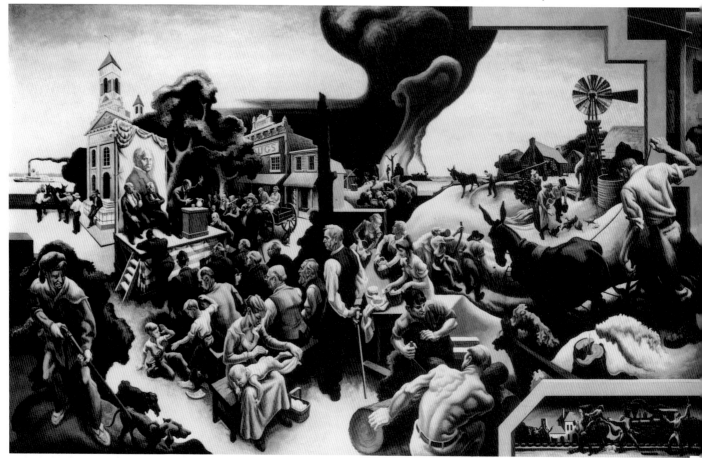

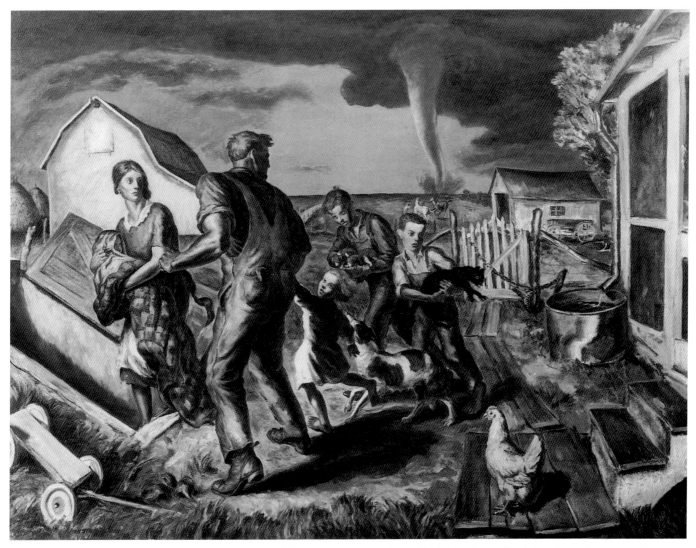

29.19 John Steuart Curry, *Tornado Over Kansas*, 1929. Oil on canvas, 3ft 10¼in × 5ft⅜in (1.18 × 1.53m). Muskegon Museum of Art, Muskegon, Michigan.

Returning to the Midwest in 1936, Curry was appointed artist-in-residence at the College of Agriculture, University of Wisconsin. He painted a set of murals for the College. This was followed by another series for the Justice Building (1936–7) in Washington, D.C. Perhaps his most famous mural, however, is that in the Kansas State Capitol—*The Tragic Prelude*—in which Curry depicted the fiery-eyed abolitionist John Brown as an heroic, Moses-like visionary, exhorting his followers to rise in rebellion against slavery. The image conjures up the bloody slavery dispute that racked Kansas in the years just preceding the Civil War.

GRANT WOOD

Another Midwestern regionalist was Grant Wood (1892–1941), who was born and raised in Iowa. After studying at the School of the Chicago Art Institute, Wood made a number of trips to Europe. There he was exposed to the various modern movements of the 1920s, but for the most part the exposure did not influence his art. Although because of his socialist views Wood was considered a radical in his native state, his art caused critics to label him a rightwing conservative. Other critics, opposed to the influence of European modern art, found Wood's work praiseworthy because it was purely American, and free of what they considered to be the "insanity" of Cubist and Fauvist art.

In fact, neither of the two greatest influences on Wood's very personal style was American. As a boy, he had been fascinated by the images on his mother's blue willow-ware, the inexpensive China dinnerware that typically has scenes of temples, hills, and trees all rounded off and mounded in a manner that reappears in Wood's *Midnight Ride of Paul Revere* (1931, Metropolitan Museum of Art). In *Daughters of the Revolution* (1932, Cincinnati Art Museum), one of the three elderly women holds a willow-ware teacup. The other

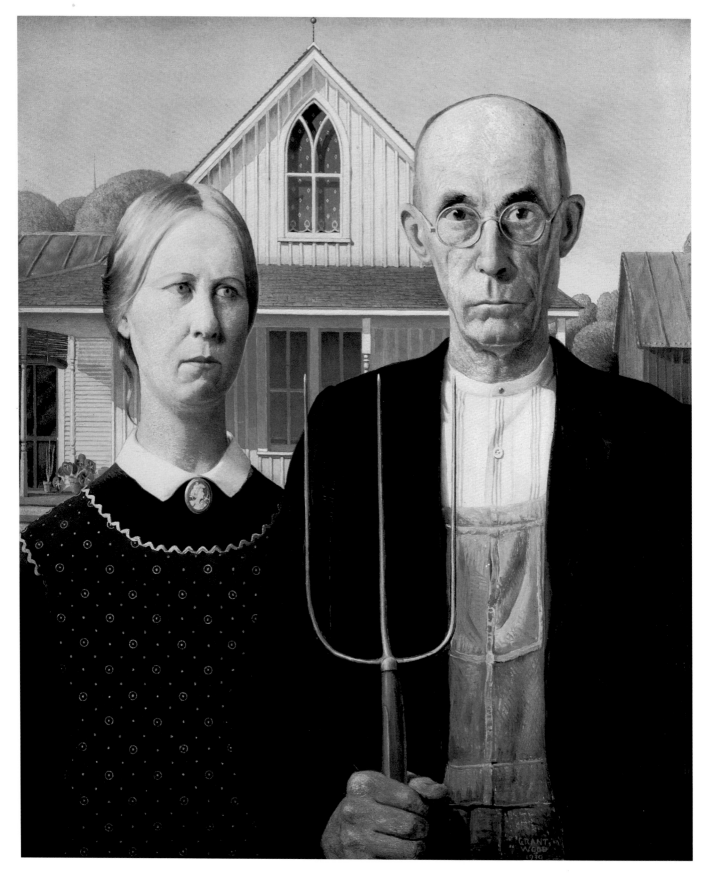

29.20 Grant Wood, *American Gothic*, 1930. Oil on beaver board, 29⅞ × 24⅞in (75.9 × 63.2cm). Art Institute of Chicago.

influence came from such fifteenth-century Flemish masters as Jan van Eyck and Rogier van der Weyden, especially their meticulous rendering of detail.

Wood's bestknown work is of course *American Gothic* (Fig. 29.20). Using his sister and his dentist as models, Wood sought to portray a type that he perceived to be the backbone of rural Midwestern America. He posed them against a farmhouse of the carpenter Gothic style to imply both the powerful religious element in their lives and the constancy of their unchanging ways.

It is an heroic image, yet one with humor. These folk are plain of feature and dressed in ordinary, everyday clothing—the woman wears an apron and the man wears overalls and carries a pitchfork, suggesting neither is far from their daily chores. The picture might be thought of as a kind of homage to plain folk, for Midwestern people like this would have felt no more necessity for idealization than did John Singleton Copley's colonial merchants and their wives (see p. 99). This naturalistic strain in American art had persisted throughout the centuries, and would continue in a later generation of regionalism through the work of Andrew Wyeth (see p. 581).

But if the naturalistic strain in American painting was strong enough to survive into the 1930s and beyond, it did not go unchallenged, for America had her followers of the exciting new modern tradition as well. Indeed, the American art scene frequently came close to open warfare as adherents of naturalism and modernism were forced to coexist.

CHAPTER THIRTY

PAINTING:

THE MODERN MODE, 1900–40

The period 1900 to 1940 was a time of radical change. It was an era when socialism, communism, and anarchism challenged capitalism and the values of the upper-middleclass. It was the era of world war, prohibition, prosperity, and the Great Depression. In a small town in Tennessee, the Scopes Trial decided the issue of teaching Darwin's theory of evolution, which was understood as challenging the biblical account of creation. It was the time of the Jazz Age—of Blues singer Billie Holiday, of exotic dancer Josephine Baker, of Duke Ellington. Of Nazi Germany, of Babe Ruth and Will Rogers, of Al Jolson in a talking movie called *The Jazz Singer*, of gangsters and machineguns. It was an age of speeding motor cars, sleek, silver locomotives of awesome power, of streamlined airplanes. It was roaring, wild, and gay. It was sad, cruel, and grim. It was exceedingly volatile and unstable—sure signs that monumental social, political, economic, and cultural changes were in progress. An old order was being overturted. Old forms had to be destroyed, many believed, if a new order was to have a chance at creating a better world. Revolution was global and omnipresent.

The arts, too, came under the assault of revolution—as seen, for example, in the tonal dissonance of Igor Stravinsky's *The Rite of Spring*, which caused riots when first performed in 1913, or in Diaghilev's attack on classical ballet.

New forms of literature appeared in the writings of James Joyce, André Breton, Jean Cocteau, Gertrude Stein, T. S. Eliot, Wallace Stevens, William Carlos Williams, and e. e. cummings. American literature in particular flowered during this period. It was the era of Ernest Hemingway, Eugene O'Neill, John Dos Passos, Archibald MacLeish, H. L. Mencken, Sherwood Anderson, Sinclair Lewis, John Steinbeck, Ring Lardner, Edna St. Vincent Millay, Thornton Wilder, Theodore Dreiser, and a host of others. F. Scott Fitzgerald and his wife Zelda regularly scandalized even the America of the Roaring Twenties with their extremely unconventional behavior. Zelda was, in fact, the embodiment of a new spirit, for she put originality and creativity above conformity, and she exploited the value of shock effect. She refused to live by the rules that had come down from another age. These are some of the traits that characterize modernism.

THE PARISIAN INFLUENCE

Even more than writers, painters and sculptors were influenced by the revolutionary spirit. For the young American artist, Paris was the place to be in the early years of the twentieth century. It was in Paris that Fauvism and Cubism were born, with Dadaism and Surrealism soon to follow. The Ecole des Beaux-Arts and the Académie Julian were as stultifying to young Parisian painters as the National Academy was to those in New York City. An all-out attack upon the art establishment was led by Henri Matisse and his followers, who were called *fauves*, or "wild beasts." Pablo Picasso (1881–1973) and Georges Braque (1882–1963) soon evolved Cubism as an option to a lifeless academic naturalism. New gods of art were proclaimed in the Post-Impressionists Paul Gauguin, Vincent van Gogh, and, especially, Paul Cézanne (1839–1906).

In 1903, those who were refused representation at the Paris Salon, that bastion of the art establishment, organized their own annual exhibition in the Salon d'Automne. Events of enormous importance occurred with exhilarating rapidity during those years. By 1905, the Salon d'Automne included works by Matisse, Braque, Cézanne, Georges Rouault (1871–1958), and Odilon Redon (1840–1916), and also by the Americans Max Weber, Patrick Henry Bruce, and John Marin. That same year, the rebellious Salon des Indépendants presented a grand exhibition of the art of Gauguin and Van Gogh.

From 1906, the Parisian apartment of Gertrude Stein and her brother Leo, expatriates from San Francisco, became the gathering place of a European and American avant garde consisting of writers, painters, and sculptors. Here, many a young American artist first saw paintings by Matisse and Picasso, or met those leaders of the great revolution. Leo and Gertrude's brother Michael Stein was also a collector of the newest art, and his wife Sarah was a student, along with her American friend Patrick Henry Bruce, in the art school that Matisse opened in 1908. There the Fauvist freedom of color was fully encouraged.

In 1907, Picasso painted his epoch-making *Demoiselles d'Avignon*, preparing the way for Cubism. African art became a new source of inspiration. The following year, the

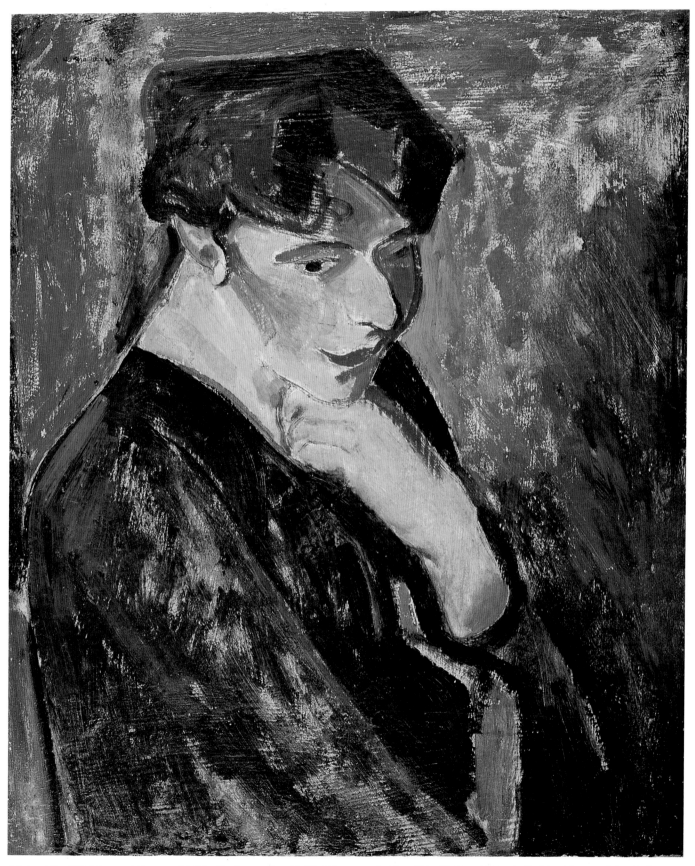

30.1 Alfred H. Maurer, *Woman with Blue Background*, c. 1907. Oil on panel, 22 × 18in (55.9 × 45.7cm). Sheldon Memorial Art Gallery, University of Nebraska-Lincoln, Nebraska.

young American insurgents organized the New Society of American Artists in Paris, in reaction to the restraints imposed by the old society. The New Society first met in the studio of Edward Steichen, an American painter and photographer, who became instrumental in arranging shows of avant-garde art to be sent from Paris to Alfred Stieglitz's revolutionary 291 gallery in New York City.

Three main thrusts came from Paris: Fauvism, Cubism, and, slightly later, Dadaism-Surrealism. Even Futurism, which originated in Italy, became known to Americans primarily in Paris. Germany gave birth to a new movement called Expressionism, but its harsh use of color and image repelled many Americans. The Expressionist Ernst Kirchner freed color from reality, giving it extraordinary expressive power. Abstraction, on the other hand, was pushed to **non-objectivity** by the Russian group, most notably Vassily Kandinsky.

Within a few short years, the artistic traditions of several centuries were shaken to their very foundations, and the new "modern" art of the twentieth century burst forth, triumphant and irrepressible.

AMERICANS IN PARIS: THE RISE OF THE AVANT GARDE

American avant-garde painting was frankly derived from French art, but in the hands of a sizeable number of talented artists it established a brilliant life of its own, here and there even making an original contribution.

The Armory Show, held in New York City in 1913, is sometimes cited as having launched modern art in the United States (see p. 459). However, many American

30.2 Arthur B. Carles, *L'Eglise (The Church)*, c. 1910. Oil on canvas, 31 × 39in (78.7 × 99.1cm). Metropolitan Museum of Art, New York City.

painters and several sculptors were living and working in Europe, particularly in Paris, well before the Armory Show. They were not only intimately aware of the revolutionary new movements taking place, but participated in them. Many of these artists returned to New York City well before the Armory Show, bringing the styles of the avant garde with them.

THE AMERICAN GROUP

The father of Alfred H. Maurer (1868–1932) had been an artist employed by the lithographers Currier and Ives. Alfred himself was trained in the academic tradition at the National Academy before sailing for Europe in 1897. In 1904, Maurer was introduced into the circle of Leo and Gertrude Stein, who had settled in Paris the previous year. At their brilliant salon, held at 27 rue de Fleurus, Maurer met Henri Matisse, who was evolving his earliest landscapes and figure studies in the Fauve manner.

The American's style was instantly transformed. Maurer comprehended completely the art of Matisse, as his *Woman with Blue Background* reveals (Fig. 30.1). Here, Maurer abandoned any obligation to realistic depiction, casting aside allegiance to an academic ideal in favor of a newfound freedom of color and design. The artist asserts the aesthetic validity of the work of art, independent of the natural world, even though that may have been the source of inspiration. When looking at *Woman with Blue Background*, one is reminded of similar works by Matisse, such as *Woman with Green Stripe* (Statens Museum for Kunst, Copenhagen) and *Woman with Flowered Hat* (private collection), both of 1905. A selection of Maurer's work was shown at Alfred Stieglitz's 291 gallery in 1909, along with pictures by John Marin. It was one of the first introductions to modern art for American gallerygoers.

Another American who joined the Fauves in Paris was Arthur B. Carles (1882–1952), a Philadelphia-born painter who studied at the Pennsylvania Academy before going to Paris in 1905 and again in 1907. It was probably through his friend Maurer that he met Leo and Gertrude Stein, and also soon came under the influence of Matisse, with whom he reportedly studied. Carles's picture *L'Eglise* is in the manner of a Matisse early Fauve landscape (Fig. 30.2). For example, the blue tree with magenta shadows cast upon a purple wall reveals the liberation of color from reality that characterized Matisse's work of a few years earlier.

By 1910, Carles's pictures were being shown at Stieglitz's 291 gallery. A large oneperson show of his work was presented there two years later. Although Carles did not remain a leader of the avant garde after returning to the United States about the time of World War I, as a teacher at the Pennsylvania Academy and as a painter he was fundamental to the introduction of modern art to Philadelphia.

Arriving in Paris in 1903, Patrick Henry Bruce (1881–1936) was one of the earliest to participate in the exciting revolution that was about to unfold. Bruce left his native

30.3 Patrick Henry Bruce, *Still Life (Flower Pot and Bananas)*, c. 1911. Oil and charcoal on canvas, 18 × 21¼in (45.7 × 54cm). Collection of The Montclair Art Museum, Montclair, New Jersey.

Virginia to study with Robert Henri in New York City before going to Paris, where he became a student of Matisse. His early work parallels the experiments in color abstraction of Synchromism, a movement being forged by two of his fellow-countrymen. Bruce was looking at the art of Cézanne and Robert Delaunay as well. In fact, he exhibited with Delaunay and the Orphists in 1913.

In the first years in Paris, however, the major influence on Bruce was Matisse, which is obvious in the brilliant color and decorative treatment of nature found in *Still Life (Flower Pot and Bananas)* (Fig. 30.3). In typical Fauve fashion, the eye is provided with a brilliant feast of pure color, but there is also something of Cézanne's careful construction in the composition.

After World War I, Bruce's paintings became arrangements of geometric, flat patterns. They lost the freshness of his earlier work, and they never found critical or popular acceptance. Bruce himself became increasingly bitter and morose, and shortly before he returned to America in 1936 he destroyed much of his work. In November of that year he committed suicide.

Henry Lyman Saÿen (1875–1918) studied at the Pennsylvania Academy before going to Paris in 1906. He, too, became a member of the group that assembled at the Steins' apartment, and through Leo Stein met Henri Matisse, whose painting classes he began to attend in 1908. Saÿen's academic style underwent an instantaneous transformation, and by the following year he was exhibiting with other avant-garde painters at the Salon d'Automne.

With the outbreak of war in 1914, Saÿen returned to Philadelphia. He continued to experiment and to carry his art into new directions, as in *The Thundershower* (Fig. 30.4). A familiarity with Cubism is apparent, and one of the most

30.4 H. Lyman Saÿen, *The Thundershower*, 1917–18. Tempera and pencil on plywood, 36 × 46in (91.4 × 116.8cm). National Museum of American Art, Smithsonian Institution, Washington, D.C.

innovative features is the use of **collage**—the incorporation of everyday materials, such as newspaper or wallpaper, into the composition. While Saÿen used actual wallpaper in the study for this picture, in the finished version he painted certain areas to simulate wallpaper. The result is an interesting juxtaposition of abstraction, color, and pattern on the one hand, and realism and craftsmanship on the other. In the last four years of his life, Saÿen was instrumental in establishing modern art in the Quaker City.

Marguerite Thompson (1887–1968) arrived in Paris in 1908, prepared to study in the academic tradition at the Ecole des Beaux-Arts. The hometown of Thompson's youth—Fresno, California—had little prepared her for the exciting new experiments in art taking place in Paris. A visit to the Salon d'Automne, where she saw the work of Matisse and other avant-garde painters, redirected her line of study into the modernist camp. Her earliest works reveal the primary influence to be the Fauve landscapes that Matisse had been painting for the last two years or so. Thompson met Picasso, who was first defining Cubism. She became a frequent visitor to the Steins', where the glittering array of intellectuals and creative people from the arts supported her commitment.

Returning to California in 1912, Thompson began to paint the natural beauty she found in the landscapes of her native state. *Man Among the Redwoods* is an example of California scenery rendered in the bold new methods of French Fauve modernism (Fig. 30.5). Pure color applied with a rich impasto brushwork, with decorative rather than descriptive intent, and freedom to alter the reality of nature for aesthetic reasons, characterize Thompson's art of this period.

30.5 Marguerite Thompson Zorach, *Man Among the Redwoods*, 1912. Oil on canvas, 25¾ × 20¼in (65.4 × 51.4cm). Private collection, Hockessin, Delaware.

That same year she established herself in New York City, where she married William Zorach, then a painter but soon to become one of the leading figures in American modernist sculpture (see p. 494).

SYNCHROMISM

Probably the most original contribution made by Americans in Paris in the years just before World War I was called Synchromism. In its most simplistic translation, this means "with color," but it also carries a connotation of symphonic color harmonies. Its founders were Morgan Russell (1886–1953) and Stanton Macdonald-Wright (1890–1973). Russell first studied sculpture at the Pennsylvania Academy before going to Paris in 1909. Two years later, under the influence of the Fauves, he gave up sculpture for painting. In 1911, Russell met Macdonald-Wright, who had been in Paris since 1907. Macdonald-Wright had studied at the Art Students League of Los Angeles, working in a conservative academic style. Once in Paris, however, seeing Cézanne's work sent him in a new direction—ultimately into the mainstream of the avant garde.

30.6 Stanton Macdonald-Wright, *Abstraction on Spectrum (Organization, 5)*, 1914–17. Oil on canvas, 30⅛ × 24³⁄₁₆in (76.5 × 61.4cm). Des Moines Art Center, Des Moines, Iowa.

30.7 Morgan Russell, *Synchromie Cosmique*, 1915. Oil on canvas, 17 × 13in (43.2 × 33cm). Munson-Williams-Proctor Institute, Museum of Art, Utica, New York.

The light of the Impressionists, the color of the Post-Impressionists, the scientific approach of Seurat and the color theorists such as the chemist Michel Eugène Chevreul and the physicist Herman von Helmholtz interested the two men. Russell was particularly fascinated by the relationship between painting and music, color and tone. The Parisian painter Robert Delaunay also had been experimenting with color in a movement that the French poet Guillaume Apollinaire had labeled Orphism. The two Americans, however, believed their own experiments to be more original in the search for pure form and more adventurous in liberating color from subject matter and natural objects.

Macdonald-Wright and Russell showed their work together only a few times within the space of only a couple of years. Their first joint exhibition, at which they issued the Synchromist manifesto, was in June 1913 in Munich. There, they displayed paintings similar to Macdonald-Wright's *Abstraction on Spectrum (Organization, 5)* (Fig. 30.6) and Russell's *Synchromie Cosmique* (Fig. 30.7). The titles suggest the new directions in which their explorations of color were leading them. By this time, Americans in Europe were painting totally nonobjective pictures. Here, too, there is no reference to natural form, but a superbly controlled organization of color and pigment on the plane of the canvas surface.

In the year following the Armory Show, Russell and Macdonald-Wright held a Synchromist exhibition in New York City, introducing Americans to this new art. Thereafter, the two men went their different ways. As brilliant a colorflash as their movement made upon the progressive art scene, it had largely disappeared by 1920.

Andrew Dasburg (1887–1979) was briefly drawn into the orbit of the Synchromists. Born in Paris, but taken to New York City as a child, he studied for a short time with Kenyon Cox (see p. 358), whom he found dull. He soon switched to Robert Henri. By 1907, Dasburg was again in Paris, in time to see the Salon d'Automne. He discovered the art of Cézanne that year, and he renewed his friendship with Morgan Russell.

When he returned to New York City, Dasburg was totally dedicated to the avant-garde experiments in color and form. In 1912 he wrote that a painting "could exist as a thing in itself without reference to a subject beyond its general color and configuration of movement...."[1] Indeed, *Floral Still Life* shows strong affinities with Synchromism (Fig. 30.8). Thereafter, Dasburg's art went through a Cubist phase, with still life remaining his favored theme. In the 1920s, he began visiting a colony of avant-garde artists working in Taos, New Mexico. He settled there permanently in 1930, and his work became inspired by the scenery and life in the Southwest.

30.8 Andrew Dasburg, *Floral Still Life*, 1914. Oil on canvas, 20 × 16in (50.8 × 40.6cm). Regis Collection, Minneapolis, Minnesota.

30.9 William B. Mullins, *Alfred Stieglitz at 291*, 1910–15. Photograph, 6½ × 4½in (16.5 × 11.4cm). Philadelphia Museum of Art.

THE 291 GALLERY

Among the earliest Americans to embrace modernism were several painters who were in one way or another connected with Alfred Stieglitz and his 291 gallery in New York City (Fig. 30.9). Stieglitz's life and career as a photographer are discussed later (see p. 469). Here we will take brief note of his important role as the first gallery owner to promote the avant garde in America, and as editor of *Camera Work*, a journal devoted to the cause of modernism, which ran from 1903 to 1917. The Little Galleries of the Photo-Secession, better known as 291 because of its Fifth Avenue address, was founded by Stieglitz in 1905. It soon became the central gathering place for the New York City modernists. Some of the most important names of the American avant garde looked upon 291 as a home port in a hostile sea of anti-modernism. Max Weber, Arthur Dove, John Marin, Marsden Hartley, and Georgia O'Keeffe were among the artists who were in some way assisted or encouraged by Stieglitz. As a group, they had no common manifesto, only a commitment to modernism.

By the time 291 closed in 1917 it had held nearly eighty exhibitions, introducing Americans to the new art in painting, sculpture, and photography. In addition to showing the work of avant-garde American artists, Stieglitz also exhibited the work of European artists such as Rodin, Cézanne, Matisse, and Rousseau. Picasso's first oneperson American show was held at 291 in 1911. By 1914, Stieglitz had also shown the art of Brancusi and Braque. Many of these shows were organized in Paris by Stieglitz's partner, Edward Steichen (see p. 472).

The American modernists were first presented to the New York art world in 1909 with an exhibition at 291 of the work of Marin and Maurer. The next year, Stieglitz staged an important show entitled "Younger American Painters," which displayed the paintings of Carles, Steichen, Dove, Marin, Weber, Hartley, and Maurer. It attracted much attention, huge crowds, and the censure of many critics, who raged that insanity and anarchy had beset American art. The show was successful in acquainting many people with the work of the avant garde. Stieglitz also reached an audience well beyond New York City through his handsome publication *Camera Work*, which reported on current exhibitions and the latest developments in modern art.

MAX WEBER

Among the several avant-garde American artists associated with the Stieglitz circle, Max Weber (1881–1961) was one of the most talented. Born in Bialystok, Russia, to Jewish parents, he was brought to America when he was ten. He grew up in an impoverished section of Brooklyn. When Weber attended the Pratt Institute, he came under the influence of Arthur Wesley Dow, who had worked with Gauguin. Weber never forgot Dow's emphasis on structure and pattern in design.

From 1905 to 1908 Weber was in Paris, participating in the early experiments of the Cubists and the Fauves. The work of Cézanne, too, greatly appealed to him. He studied in a class taught by Matisse; his friends included Picasso and Robert Delaunay, and he exhibited at the Salons d'Automne of 1907 and 1908.

Weber returned to New York City in 1910. In the years that followed, his work took on an increasingly Cubist character, sometimes with a powerful primitive element introduced as well, as in *Composition with Three Figures* (Fig. 30.10). Here, the picture area is reduced to a compositional study in structure while the figures are transformed into a sequence of welldefined planes. It is not difficult to see a relationship between the head of the foremost figure and an African mask. Picasso had similarly drawn on African art in his *Demoiselles d'Avignon* of 1907, which Weber would have seen in Paris. The New York art world was made aware of Weber's work through an exhibition in 1911 at the 291 gallery. When some of his pictures were refused at the Armory Show two years later, Weber withdrew them all, so he was not represented in that important exhibition.

30.10 Max Weber, *Composition with Three Figures*, 1910. Gouache with some
watercolor, over underdrawing in black crayon or black chalk on corrugated
cardboard, 47 × 23in (119.4 × 58.4cm). Ackland Art Museum, University
of North Carolina at Chapel Hill.

30.11 Max Weber, *Rush Hour, New York*, 1915. Oil on canvas, 36¼ × 30¼in (92 × 76.9cm). National Gallery of Art, Washington, D.C.

Thereafter, Weber experimented with a number of modern styles, ranging from Synthetic Cubism, as seen in *Chinese Restaurant* (1915, Whitney Museum of American Art), to Futurism, as demonstrated in *Rush Hour, New York* (Fig. 30.11). In *Rush Hour*, Weber sought to capture the enormous energy of the New York City street scene in abstract forms and rhythms. Such art was too progressive for American critics, however, most of whom attacked it in the local press with great vehemence. Weber turned increasingly to representational images of the figure, and by the early 1920s his greatest period of originality was largely past.

JOHN MARIN

After studying briefly at the Pennsylvania Academy and the Art Students League, John Marin (1870–1953) spent 1905 to 1911 in Europe, mostly in Paris, where he became aware of the current revolution in art. Marin exhibited his work at the Salon des Indépendants and the Salon d'Automne. He was particularly alert to the Cubist reorganization of forms, planes, and space. Marin was perhaps directly influenced by Robert Delaunay, whose pictures around 1908–10 included a disassembling of structures—such as the Eiffel Tower—

30.13 John Marin, *Marin's Island, Maine*, 1915. Watercolor, 15¾ × 19in (40 × 48.3cm). Philadelphia Museum of Art.

30.12 John Marin, *St. Paul's, Lower Manhattan*, 1912. Watercolor, 18¼ × 14¾in (46.4 × 37.5cm). Delaware Art Museum, Wilmington, Delaware.

which were then reassembled, along with the space surrounding them, according to the artist's sense of dynamic rhythms, lines, and planes of color.

In Paris, Marin met Edward Steichen, through whom he met Alfred Stieglitz. The latter then introduced him to America through exhibitions at 291 and supported him financially when his pictures did not sell. Back in New York City, Marin began to paint the city the way Delaunay had painted Paris, but in a style that emerged as very personal. *St. Paul's, Lower Manhattan* shows the defractive vision that would characterize Marin's work for the rest of his life (Fig. 30.12). Working in watercolor, Marin's color notations capture the dynamic energy of the city, its skyscrapers and swarming crowds. Yet the color, patterns, and rhythms also possess a life of their own, independent of the scene that inspired them. Similarly, Marin's views of the Woolworth Building and of Brooklyn Bridge (Metropolitan Museum of Art) suggest a familiarity with Futurism as well as Cubism.

Marin often spent his summers along the New England coast, particularly in Maine, where he painted landscapes and seascapes that captured the essence of sun, sky, sea, and land without pedantic description of naturalistic details. In works such as *Marin's Island, Maine*, although nature remains the stimulus, the rendition of sensations and impressions is the basis of the painter's technique (Fig. 30.13). For all the disassemblage of nature, there remains a sense of structure and order, sometimes even a powerful geometry. Later in his career, Marin turned to the landscape around Taos, New Mexico, for subject matter.

30.14 Arthur Dove, *The Lobster*, 1908. Oil on canvas, 25¾ × 32in (65.4 × 81.3cm). Amon Carter Museum, Fort Worth, Texas.

ARTHUR DOVE

30.15 Arthur Dove, *Sunrise, No. 3*, 1937. Wax emulsion on canvas, 24⅞ × 35⅛in (63.2 × 89.2cm). Yale University Art Gallery, New Haven, Connecticut.

Arthur Dove (1880–1946) was another member of the Stieglitz group. After graduating from Cornell University and working in New York City as an illustrator, he went to Paris where, in 1908, he saw the work of the Fauves. His closest friend at this time was Alfred Maurer, with whom he left Paris to work in the rural area of Cagnes. There, he painted *The Lobster*, which he exhibited at the Salon d'Automne (Fig. **30.14**). Dove's study of Cézanne's work is apparent. Even more obvious, however, is the influence of Matisse in the decorative use of brilliant color.

Dove returned to New York City in 1910 and began to exhibit his work at 291. By 1912 he was creating pictures that were independent of natural subject matter, thereby placing him, along with the Russian modernist Vassily Kandinsky, as one of the innovators of nonobjective art.

Dove exhibited at the important Forum Gallery show of 1916, and the next year he sent his work to the Society of Independent Artists, which staged an equally impressive exhibition. During the 1920s and 1930s Dove's work underwent a process of simplification in which paint and color became the essence of his imagery, as in *Sunrise, No. 3* (Fig. **30.15**). The radiance of the sun and the power that emanates from it, above an undulating strip of earth, are reduced to total abstraction. By the late 1920s, Duncan Phillips—critic, collector, and founder of the Phillips Gallery in Washington, D.C.—had become Dove's friend and patron. Phillips proclaimed that, in the exploration of color and form, Dove was "the boldest American pioneer."

MARSDEN HARTLEY

Marsden Hartley (1877–1943) brought a different dimension to the modernist group clustered around Stieglitz and 291. Hartley was born in Maine, the mountainous landscape of which inspired his earliest paintings. These were executed in an impressionist mode, but imbued with a mysticism that persisted throughout his life and work.

When his family moved to Cleveland, Hartley studied at the art school there. He then went to New York City, where an early acquaintance with Albert Pinkham Ryder (see p. 362) may explain the mystical quality of his early work. Through his introduction to the 291 circle a great change occurred in his art even before he went to Europe—proof of the impact that Stieglitz's gallery had on rising artistic talent in America.

Hartley left for Europe in 1912. In Paris, he studied the work of Cézanne, the Cubists, and the Fauves. Then, in 1913, he went to Germany where he met the members of Der Blaue Reiter group in Munich, and an Expressionist element entered his work.

German art established a form of modernism that was highly charged emotionally, filled with subjective feeling, always passionate, sometimes brutal, and often disturbing in form, color, and subject matter. In their imagery, the German artists attacked materialism, militarism, and exploitation of the masses. For these reasons the movement is known as German Expressionism. One center was in Dresden, where the group called Die Brücke ("The Bridge"), founded in 1905, had Ernst Ludwig Kirchner and Karl Schmidt-Rottluff as its leaders. In Munich, Der Blaue Reiter ("The Blue Rider") was founded in 1911, taking its name from a painting by Vassily Kandinsky, one of the foremost explorers of nonobjective painting before the war. In Berlin, there was Max Beckmann. Although modern German painting was never as influential on avant-garde American art as French painting, it did have an impact on a few artists, as the work of Marsden Hartley demonstrates.

During the years just before World War I, Hartley painted, in Berlin, one of his most important series of pictures, in which he sought to capture the militarism and nationalism that had seized Germany. *Portrait of a German*

30.16 Marsden Hartley, *Portrait of a German Officer*, 1914. Oil on canvas, 5ft 8¼in × 3ft 5⅜in (1.73 × 1.05m). Metropolitan Museum of Art, New York City.

Officer is an abstraction and amalgamation of military decorations and insignia that proclaim a brash, bold dedication to militarism (Fig. **30.16**). Also to be considered, however, is the intimate friendship that had developed between Hartley and a German officer who was killed in 1914, the very year the picture was painted.

Returning to New York City in 1916, Hartley frequently exhibited his work at 291. In the 1920s he, too, went to Taos, New Mexico. There followed a series of abstract landscapes in bold colors, often with heavy black outlines defining the simplified but monumental forms of nature.

GEORGIA O'KEEFFE

The final artist of the Stieglitz circle to be discussed here is Georgia O'Keeffe (1887–1986). After studying at the Art Institute of Chicago in 1904–5 and at the Art Students

League in New York City in 1908, she attended classes taught at Columbia University by Arthur Wesley Dow, who opened her eyes to the abstract beauty of form and color. Thereafter, O'Keeffe became an art teacher in Texas. It was not until 1915, when Alfred Stieglitz (see p. 469) chanced upon a series of her drawings and watercolors and exhibited them at 291, that she was drawn into the orbit of the New York avant garde. In 1917 Stieglitz organized her first oneperson show. In 1924 he and O'Keeffe were married.

While O'Keeffe was not directly influenced by European modernism, the avant-garde paintings she saw at 291 and elsewhere reinforced her inclinations toward abstraction. During 1916–17 she produced a remarkable series of watercolors inspired by nature that also treat color and form as separate entities. Few American painters of that day ventured as close to nonobjective art as O'Keeffe did in her "Blue" series of 1916.

Nature remained forever essential to O'Keeffe. In *Evening Star, III* she reduced the hilly countryside and the firmament above to a few strokes of color (Fig. **30.17**). In the 1920s, she evolved the genre for which she is best remembered— the closeup studies of flowers that are evocative abstractions of great spirituality and sensuality, with connotations of sexuality and even eroticism (Fig. **30.18**). In 1929 O'Keeffe went for the first time to Taos, and in the decade that followed she painted **reductive** landscapes of the adobe buildings and rolling hills of New Mexico.

LEO AND GERTRUDE STEIN

There were other American painters centered around Alfred Stieglitz and his 291 gallery. There were also other focal points in the rise of the American avant garde. In Paris, for example, the importance of Leo and Gertrude Stein can hardly be overestimated.

Gertrude and her older brother Leo were born in Allegheny, Pennsylvania, but led nomadic early lives that carried them to Vienna, Paris, California, and Cambridge,

30.17 Georgia O'Keeffe, *Evening Star, III*, 1917. Watercolor on paper, 9 × 11⅞in (22.7 × 30.2cm). Collection, The Museum of Modern Art, New York. Mr. and Mrs. Donald B. Straus Fund.

30.18 Georgia O'Keeffe, *Black Iris*, 1926. Oil on canvas, 33 × 24in (83.8 × 60.9cm). Metropolitan Museum of Art, New York City.

Massachusetts, where both attended Harvard University. Wishing to pursue a career as an artist, Leo went to Italy where he studied with the celebrated art historian Bernard Berenson. He moved to Paris to become a painter, and in 1903 Gertrude joined him there.

Gertrude and Leo began to collect paintings by Cézanne, thereby meeting the famous art dealer Ambroise Vollard. The Steins' fascination with the cultural revolution they recognized was taking place led them to collect the work of Matisse, Braque, Rousseau, Daumier, Manet, Gauguin, Derain, and, especially, Picasso. Gertrude's ambitions as a writer also attracted the literary avant garde to the informal salons held in the Steins' apartment in those exciting years in Paris between about 1904 and 1914. Authors, painters, musicians, art collectors and dealers, dancers, intellectuals, and socialites attended regularly, reinforcing each other's commitment to revolution in the arts. Many a young American painter saw there for the first time works by Matisse and Picasso—and even met those artists and discussed the newest experiments in painting.

After World War I Leo lived in Italy, having taken much of the fabulous collection with him. Gertrude returned to Paris to pursue a literary career. Her salons now attracted such figures as Ernest Hemingway, Ezra Pound, F. Scott Fitzgerald, and Sherwood Anderson. Her bestknown literary effort was her *Autobiography of Alice B. Toklas* (1933).

MABEL DODGE

What the Steins' apartment was in Paris, Mabel Dodge's Fifth Avenue house was in New York City—a social gathering place for the avant garde. Mrs. Dodge, a prominent socialite from Boston, had lived the expatriate life in grand elegance for ten years in Florence, Italy. While in Europe, she came to know Gertrude Stein. She became fascinated with Stein's willingness to collect the work of modern painters, no matter how much the critics denounced their work. In this way, Mrs. Dodge was drawn into the world of modern art in its formative years even before she returned to America in 1912, when she became a frequent visitor to Stieglitz's 291 gallery.

Through her friendship with the sculptor Jo Davidson, Mrs. Dodge became involved with the planning of the Armory Show. For a special issue of the magazine *Arts and Decoration* which was devoted to the show, she wrote an article about Gertrude Stein.

An array of celebrities and anarchists, poets and painters came to her salons, ready to discuss any topic from Cubism to birth control. There, one might encounter the free-spirited dancer Isadora Duncan chatting with the columnist Walter Lippman and the "muckraker" Lincoln Steffens, or the sociologist Frances Perkins in conversation with the painter Marsden Hartley—or maybe Mrs. Dodge herself, planning the Armory Show with Arthur B. Davies and Jo Davidson. Among other artists who frequently attended were John Marin, Andrew Dasburg, Maurice Sterne, and the Dada painter Francis Picabia. In 1917, Mabel Dodge left New York City with her then husband Maurice Sterne to move to Taos, New Mexico, where she spent most of the next quarter-century.

THE ARMORY SHOW OF 1913

The great cultural event of 1913 was without question the International Exhibition of Modern Art—otherwise known as the Armory Show because it was held in New York City's Sixty-ninth Regiment Armory. In 1912, several painters began planning a large exhibition that would acquaint the general public with the exciting new movements in modern art that were taking place. Because critics and academicians had been largely hostile to the new art, there was no hope of the conservative National Academy of Design holding such a show. Among the artists who were involved with the organization of the show were Walt Kuhn—probably its staunchest advocate—Arthur B. Davies, William Glackens, Ernest Lawson, Robert Henri, George Bellows, John Sloan, and Maurice Prendergast, and the sculptors Jo Davidson, Gutzon Borglum, and Mahonri Young. Davies was elected president of the group, which called itself the Association of American Painters and Sculptors. Davies and Kuhn spent

30.19 Walter Pach, International view of the "Armory Show": International Exhibition of Modern Art, held at the Sixty-ninth Regiment, New York, 17 February through 15 March 1913. Photograph by Walter Pach, courtesy of The Museum of Modern Art, New York.

the summer of 1912 in Europe, aided by Alfred Maurer and the critic Walter Pach in making a selection of works to represent all of the modern movements.

When the Armory Show opened on 17 February 1913, some 1300 works of art were displayed before an audience that seemed more stunned and scandalized than anything else (Fig. 30.19). Over 70,000 people saw the show in New York City before a smaller version traveled to Chicago.

Of the 300 artists represented, about one hundred were Europeans. Here were pictures by Cézanne, Gauguin, Van Gogh, Matisse, Picasso, Braque, Delaunay, Picabia, Kandinsky, and Derain, among others. One could see Brancusi's *Madame Pogany* and Marcel Duchamp's *Nude Descending a Staircase.* The American contingent included several members of The Eight, Alfred Maurer, Albert Pinkham Ryder, Patrick Henry Bruce, Arthur B. Carles, Stuart Davis, Marsden Hartley, Edward Hopper, John Marin, Joseph Stella, Morgan Russell, Morton Schamberg, and many more. In the aftermath of the Armory Show, modern art in America could not be ignored, even if it was not always appreciated.

AFTER THE ARMORY

Another exhibition of special importance in advancing the cause of modern art in America was the Forum Exhibition of 1916, held at the Anderson Galleries in New York City. In the aftermath of the Armory Show, commercial art galleries had focused attention on European modernism. The purpose of the Forum show was to redirect interest toward the American avant garde. Its prime mover was Willard Huntington Wright, critic for *Forum* magazine and brother of Stanton Macdonald-Wright.

Wright called upon Henri and Stieglitz, among others, to help him choose seventeen American painters and select 200 of their works for display. Europeans were excluded. The exhibitors represented a wide spectrum of modernism, including Maurer, Dove, Hartley, Dasburg, Benton, Marin, Russell, Macdonald-Wright, William and Marguerite Zorach, Man Ray, Charles Sheeler, Oscar Bluemner, Ben Benn, Henry McFee, and George Of. The show was a success in that it brought, often through controversy, much attention to the American avant garde.

The forces of the avant garde were expanded still further by the appearance on the scene of Walter Arensberg and his wife, Louise. Walter, a Harvard graduate who had studied in Italy and written poetry while working as a newspaper reporter, just happened to take in the Armory Show the day before it closed. With the zeal of spiritual converts, the Arensbergs began to collect the new art, filling the walls of their West Sixty-seventh Street apartment with works by Duchamp, Picasso, and many more of the most progressive artists of the day (Fig. 30.20). The Arensberg collection eventually contained some 400 works of contemporary art, with more than a dozen paintings by Picasso, nineteen sculptures by Brancusi, several works by Braque, Gris, and Miró, and a large representation of the art of Duchamp.

By 1915, poets were joining painters for regular gatherings at the Arensbergs' salon. The Society of Independent Artists, founded in 1917, was the outgrowth of several discussions held there the previous year, with Duchamp, Man Ray, William Glackens, Walter Pach, Katherine Dreier, and George Bellows among the participants.

30.20 Charles Sheeler, The Arensberg Apartment, c. 1918. Photograph. Philadelphia Museum of Art.

THE DADAISTS

Dada had been founded in Europe at about the beginning of World War I. It was at first mainly a literary movement, and Paris and Zürich were its main centers. Among its founders, however, were Jean Arp, Max Ernst, and Kurt Schwitters, and many more painters and sculptors soon joined its ranks.

Strongly nihilistic from the start, Dada paralleled the political activities of the anarchists of that era, opposing everything in the way of rules and traditions—its manifesto even opposed manifestoes! It stressed spontaneity and the "discovery" of art in ordinary objects. For example, taking great pleasure in debunking the sacred cows of the art world, it declared a bicycle wheel and bottlerack to be pieces of sculpture, and, in a willful act of irreverence, painted a copy of Leonardo da Vinci's *Mona Lisa* with a mustache.

When World War I erupted in Europe, many artists there fled to America. When Marcel Duchamp—one of the founders of the Dada movement—arrived in New York City, he stayed with the Arensbergs until he found his own accommodation. This lent a decided Dada orientation to what had by then become known as the Arensberg circle. Other Frenchmen of Dadaist inclinations, including Francis Picabia and Jean Crotti, were frequent visitors to the Arensberg soirées. There they mingled with American painters such as Man Ray, Charles Sheeler, Charles Demuth, and Joseph Stella. The author William Carlos Williams, the editor Max Eastman, and the dancer Isadora Duncan might also drop by from time to time.

With the exhibitions at Stieglitz's 291, the great Armory Show of 1913, the salons of the Steins in Paris and of Mabel Dodge and the Arensbergs in New York, the American avant garde could sense a movement forming which had momentum and an ever-increasing following.

In America, Dada appeared with the arrival of Marcel Duchamp, but Americans—such as Man Ray and Morton Schamberg—immediately became a part of the movement. In 1912, while still in Paris, Duchamp had painted *Nude Descending a Staircase* (Philadelphia Museum of Art), which was exhibited at the Armory Show the next year. Soon afterward the Arensbergs purchased the painting, and it became a centerpiece of their growing collection. It was probably the most famous—or infamous—picture of that era of modernism in America.

Duchamp caused a sensation when he took a commonplace, manufactured object, placed it in a new context, and called it "art," implying there is no distinction between the everyday object and the work of art. In 1917, he proclaimed a urinal to be a "readymade" work of art, titled it *The Fountain*, and sent it to the exhibition of the newly formed Society of Independent Artists. It immediately became the center of controversy and scandal, which thoroughly pleased the Dadaists, although the piece was ultimately excluded from the show.

By the mid-1920s Dada had lost much of its force, and many of the artists of the group moved toward Surrealism.

By then, too, the Arensbergs had moved to California. The Dada manifesto was perhaps the most powerful denial of artistic tradition of all the modern movements, forcing as it did consideration of the aesthetic value of everyday objects. We must remember, too, that European Dadaists knew all too well the horrors of World War I and the social conditions that preceded it. Their intention to destroy everything, in order to get rid of the old order so society could have a fresh start, is perhaps understandable.

MAN RAY

Man Ray (1890–1976) was the foremost of the American Dada group. Born in Philadelphia, he moved to New York City as a young man and began studying art at the National Academy and the Art Students League. Frequent visits to Stieglitz's 291 gallery acquainted him with the newest modes of modernism, and his own work became basically Cubist.

Ray met Marcel Duchamp soon after the Frenchman arrived in New York City. *The Rope Dancer Accompanies Herself with Her Shadows* reflects the art and theory of Duchamp (Fig. 30.21). For example, the dancer at the top is depicted with her costume and legs seen in different views simultaneously, just as is Duchamp's figure in *Nude Descending a Staircase*.

Ray showed his art regularly at the Daniel Gallery. Several New York City gallery owners were now willing to incur the wrath of the conservative critics and the old guard establishment to display the radical new work of the modernists. One piece by Man Ray that was very much in the Dadaist manner was his *Cadeau* of 1921, in which he took an everyday, manufactured flatiron and glued a row of nails to its flat surface. The year before, Man Ray had joined Duchamp and Katherine Dreier, an amateur painter, as one of the founders

30.21 Man Ray, *The Rope Dancer Accompanies Herself with Her Shadows*, 1916. Oil on canvas, 5ft 2in × 6ft 1⅜in (1.32 × 1.85m). Collection, The Museum of Modern Art, New York. Gift of G. David Thompson.

of the Société Anonyme, which offered an annual exhibition that was sympathetic to the most progressive experiments of the modernists. The Société arranged exhibition opportunities around the country for avant-garde artists and encouraged the purchase of their works. The Société itself bought numerous paintings, sponsored lectures on modernism, and helped to introduce to the public such artists as Vassily Kandinsky, Kurt Schwitters, Paul Klee, Joan Miró, Kasimir Malevich, and Francis Picabia, among the Europeans, and many American painters. Influential though the Société was, it remained active for only a few years, and its place was eventually taken by The Museum of Modern Art (MOMA), founded in 1929.

Man Ray moved to Paris in 1921, joining the Dada circle there until it had evolved into the Surrealist movement in the mid-1920s. He also made several Surrealist motion pictures. He remained an active member of the international avant garde in Paris until he returned to New York City in 1940.

FUTURISM AND PRECISIONISM

Another of the founders of the Société Anonyme was Joseph Stella (1877–1946), also a member of the Arensberg circle. Born in Italy, Stella came to America when he was nineteen and soon began to study, first at the Art Students League and then with William Merritt Chase. He spent the years 1909–12 in Italy and then in Paris, where his work was greatly influenced by the art of his fellow-countrymen Umberto Boccioni, Gino Severini, and Carlo Carra, the leading figures of the Futurist movement. Stella was present when the Futurists held their first exhibition in Paris in February of 1912.

Futurism had been launched in Italy in 1909 with a manifesto by the poet Filippo Tommaso Marinetti, which called for the elimination of all traditional forums of art, such as museums and libraries. The manifesto was revised

30.22 Joseph Stella, *Battle of Lights, Coney Island*, 1913. Oil on canvas, 6ft 4in × 7ft (1.93 × 2.13m). Yale University Art Gallery, New Haven, Connecticut.

30.23 Joseph Stella, *The Brooklyn Bridge: Variation on an Old Theme*, 1939. Oil on canvas, 5ft 10in × 3ft 6in (1.78 × 1.07m). Collection, Whitney Museum of American Art, New York.

the following year by a group of Milanese painters and sculptors, who denounced traditional art and its academic or bourgeois themes in favor of the dynamic new forces of the twentieth century—machines from automobiles to machine-guns, the energetic movement of subways and airplanes, skyscrapers, and brightly colored neon lights. All of this was abstracted into dynamic patterns of brilliant color which suggested the pulsating real world.

An example of Stella's early Futurist work is his *Battle of Lights, Coney Island*, painted the year after he returned to New York (Fig. **30.22**). The honkytonk world of glaring neon lights and amusement-park glitter, of swirling forms and undulating rollercoaster structures, is expressed in brilliant color and abstracted forms. According to the Futurist vision, even forms that are normally inert take on a lively existence, as we see in Stella's *The Brooklyn Bridge* (Fig.

30.23). Sweeping "force lines" of the suspension cables dominate the composition. Through the Gothic-like openings of the great pylons we see abstractions of skyscrapers, revealing the Futurists' fascination with the great city of New York as a work of art in itself—the dynamic, archetypal city-scene of the twentieth century. Here, Stella captured the spirit he found in the bridge and the two New York boroughs, rather than the actual reality of the scene.

Charles Demuth (1883–1935) also frequented the Arensbergs' salons between visits to Paris and his native Lancaster, Pennsylvania. As a youth Demuth had gravitated to nearby Philadelphia to study art at the Pennsylvania Academy. His early career was consequently in the conservative mode, even after a trip to Paris in 1907 when he visited the Salon d'Automne and met several of the leaders of the modernist movement, including Matisse and Braque. His discovery of the art of Cézanne—with its exquisite compositional order and the reduction of forms to a series of planes—had a more immediate impact.

Back in New York City, Demuth began to paint still lifes of flowers as well as scenes of vaudeville performers and

30.24 Charles Demuth, *Sailboats and Roofs*, c. 1918. Pencil and watercolor, 13¹⁵⁄₁₆ × 9¹⁵⁄₁₆in (35.4 × 25.2cm). Museum of Fine Arts, Boston. Anonymous gift.

circus acrobats. These were all executed in watercolor, a medium he preferred over oils. Not until about 1917 did Demuth bring together the several artistic components that made up his mature style.

In the work that followed, he arrived at what most scholars agree was the origin of the Precisionist movement. Precisionism had its roots in Cézanne's analytical approach to form and in Cubism's precise definition of planes. It often included as well a mechanistic element arising from the artist's fascination with machines, industrialization, and large constructions within the landscape.

Demuth's pictures of sailboats and seascapes, however, are also considered to be Precisionist. In works such as *Sailboats and Roofs*—probably painted at Provincetown, Cape Cod, one of his favorite summertime retreats and then an active colony of artists and writers—Demuth synthesized the art of Cézanne and the Cubists into a personal mode of expression (Fig. 30.24). The world has been restructured according to the artist's sense of order in shapes, planes, and lines, the whole assuming a geometric precision from which the movement takes its name. By comparison, the landscapes and seascapes of John Marin seem loose and free (Fig. 30.13). Also characteristic of Demuth's work of this time was the very delicate, nearly pastel palette, applied as a translucent wash.

In the late 1920s, Demuth experimented with yet another

form of expression, taking common streetsigns or commercial posters as its point of departure. An example of such work is *I Saw the Figure 5 in Gold*, which was inspired by a poem by his friend William Carlos Williams (Fig. 30.25). The image is presented in carefully organized planes and lines that evoke an experience of ordinary contemporary life, the dynamic spirit of which is expressed in the lines from Williams's poem "The Great Figure:"

> Among the rain
> and lights
> I saw the figure 5
> in gold
> on a red
> firetruck
> moving
> tense
> unheeded
> to gong clangs
> siren howls
> and wheels rumbling
> through the dark city.

Charles Sheeler (1883–1965), also a member of the Arensberg circle, is considered the archetypal Precisionist. In his native Philadelphia, Sheeler first attended the School of Industrial Art and then the Pennsylvania Academy, where he acquired a style strongly influenced by his teacher, William Merritt Chase. On a trip to Italy and France in 1909, he discovered an underlying structural harmony in the work of the Old Masters and in the modern art of Cézanne.

Back in Philadelphia, Sheeler experimented briefly with Fauvism but found it too uncontrolled for him. He began to search for a basic structure in art that led him to the very personal style seen in *Barn Abstraction* (Fig. 30.26). The Precisionists often retained something of a typically American environment, but presented the subject in the modern

30.25 Charles Demuth, *I Saw the Figure 5 in Gold*, 1928. Oil on composition board, 36 × 29¾in (91.4 × 75.6cm). Metropolitan Museum of Art, New York City.

30.26 Charles Sheeler, *Barn Abstraction*, 1917. Conté crayon on paper, 14 × 19in (35.6 × 48.3cm). Philadelphia Museum of Art.

30.27 Charles Sheeler, *American Landscape*, 1930. Oil on canvas, 24 × 31in (61 × 78.7cm). Collection, The Museum of Modern Art, New York. Gift of Abby Aldrich Rockefeller.

idiom. In *Barn Abstraction* (which was once owned by the Arensbergs) Sheeler may well have intended to remind us of a Bucks County, Pennsylvania, barn complex, although we are not presented with the actual view that inspired him. Instead, this typical American scene has been reduced to an essential structure of line and plane. Its beauty lies in its rectilinear simplicity.

About 1912 Sheeler had taken up photography in order to earn money. His increasing interest in the medium eventually brought about yet another profound change in his art. If *Barn Abstraction* is seen as Cubism reduced to a single plane, then photographs such as *Wheels* (Fig. **31.10**) reveal a temperament that responds to abstract geometric forms in modern machines.

His work with the photographic image also led Sheeler back to a more naturalistic vision in his paintings, as in *American Landscape* (Fig. **30.27**). Machines, trains, and huge grainstorage complexes are treated as a rural counterpart to the city filled with skyscrapers and all the paraphernalia of the urban scene. Again, Sheeler reduced a typically American scene to a splendid harmony that is dominated by powerful horizontal and vertical lines. While all of the forms are presented with an absolute precision, now, unlike in *Barn Abstraction*, there is space and a naturalistic vision.

Precisionism consisted of a looseknit group of painters who never exhibited as a group and never issued a manifesto. This permitted a range in styles that ran from, for example, Georgia O'Keeffe to Stuart Davis.

STUART DAVIS

Stuart Davis (1894–1964) was proud of his American heritage. Like many of the early modernists, he rejected only the academic traditions of America, not its culture. Davis was born in Philadelphia, where his father was art director of *The Press*—the newspaper that employed the illustrators Sloan, Luks, Shinn, and Glackens. In 1910, at the age of sixteen, he entered Robert Henri's school. There he was taught to seek his subject matter in the real life he saw in the city around him.

The Armory Show of 1913, in which young Davis exhibited five watercolors, made a tremendous impact, acquainting him with European modernists such as Van Gogh, Gauguin, and Matisse. Davis began immediately to experiment with abstraction, rejecting the illusionary quality of all painting since the Renaissance. In an important series of 1927–8 called the *Eggbeater* series, he worked on a sequence of canvases. He painted the still life before him, which contained an eggbeater, over and over again, until space was reduced to the two-dimensional plane of the canvas and visual reality had been eliminated, leaving only an arrangement of color, pattern, and line. In Davis's mind, this freed art from nature and gave absolute integrity to the canvas surface; the latter no longer represented something else—an illusion—but was a thing of aesthetic value in and of itself. This was a major principle of post-1945 modern art.

Nevertheless, Davis remembered well the lessons learned

30.28 Stuart Davis, *Landscape with Garage Lights*, 1932. Oil on canvas, 32 × 47⅞in (81.3 × 121cm). Memorial Art Gallery of the University of Rochester, Rochester, New York.

30.29 Stuart Davis, *Visa*, 1951. Oil on canvas, 3ft 4in × 4ft 4in (1.02 × 1.32m). Collection, The Museum of Modern Art, New York. Gift of Gertrude A. Mellon.

from Henri that he should paint what he saw around him, and he accordingly responded to the contemporary American scene, as in *Landscape with Garage Lights* (Fig. 30.28). Here, the landscape is reduced to a composition of flat patterns, lines, and bright colors—a scene of urban energy, with messages appearing in several signs. Still, Davis continued to think of himself as a realist, for he painted the real America as a result of experiences that were real to him. Now, however, his "realism" was one of abstraction rather than of illusion.

While there is something typically American about Davis's work, it must be seen in relation to the events in modern European art. For example, the cutout, decorative, and highly colorful forms of Henri Matisse's art find a parallel in Davis's *Visa* (Fig. 30.29). Inspiration again came from the commonplace—a matchbox advertising a brand of batteries called "Little Giant." Words such as "champion" became the leitmotif in Davis's work of this period, while the integrity of the picture plane is respected and all illusion has been purged. These words may or may not have symbolic connotations, but pictures such as *Visa* have an undeniable attachment to the real world of American commercialism, industrialization, and massproduction—a world filled with signs.

CHARLES BURCHFIELD

From time to time in the history of American painting an artist comes along whose mode of vision or vocabulary of forms is so personal that he does not fit easily into any one movement. So it is with Charles Burchfield (1893– 1967). Born in Ohio, Burchfield studied first at the Cleveland Institute of Art and then briefly at the National Academy in New York City before returning to work in a factory in Salem, Ohio.

When time permitted, he began making watercolors inspired by nature—perhaps as a reaction against his work in the mill—but a nature that was possessed of strange, often macabre spirits. Personal psychological problems caused him to see menaces lurking in the blossom of a flower or a grove of trees, and these evil forces made themselves known through the expressionistic forms of nature. One finds this in a sketchbook of symbols Burchfield drew in 1917 in which abstracted natural forms are labeled "fear," "evil," "morbidness," "melancholy," "brooding," "insanity," and so on. In that same year he painted *The First Hepaticas*, a scene of an enchanted forest filled with evil and hostility, in which a powerful expressionism informs nature (Fig. 30.30).

30.30 Charles Burchfield, *The First Hepaticas*, 1917–18. Watercolor, 21½ × 27½in (54.6 × 69.8cm). Collection, The Museum of Modern Art, New York. Gift of Abby Aldrich Rockefeller.

The next major theme to arise in Burchfield's work, occupying him throughout the 1920s, was life in a small town, typically rendered in depressing imagery. In 1919 Burchfield read Sherwood Anderson's book *Winesburg, Ohio*, and it made a profound impression on him, for behind the scenes smalltown life took on a menacing, secretive existence. There are obvious parallels between Burchfield's bleak, harsh, brooding watercolors of houses and lines such as the following from Anderson's book *Hello Towns!*[2] of 1929:

> The houses have faces. The windows are eyes. Some houses smile at you; others frown. There are some houses that are always dark.... You hear no laughter from such houses; no one sings.... I know houses that always seem to be whispering to me. There are secrets in such houses.

The haunting fantasy of nature, filled with the potential for evil, was an enduring theme throughout Burchfield's life.

While the mainstream of modern American art should never be separated from the evolution of modernism in Europe, American painters added both originality and breadth to the movement. Between 1900 and 1940, American artists established the aesthetic validity of modern painting in the United States, preparing the way for the exciting innovations that placed American painters in a position of leadership after 1945.

CHAPTER THIRTY-ONE
PHOTOGRAPHY:
AESTHETIC MATURITY,
1900–40

If the bywords of the Roaring Twenties had been "Let the good times roll!" by 1932 the tune had changed to "Brother, can you spare a dime?" The zest of the 1920s came to a crashing halt on 29 October 1929, when the stockmarket utterly collapsed. Rich people found themselves suddenly penniless, as thirty billion dollars in assets vanished within two weeks. Working people found themselves without work. Prices fell, wages plummeted, factories closed, and unemployment skyrocketed. The Great Depression had struck deeply and would maintain its grip upon the nation throughout the coming decade.

As if the Depression were not enough, whole areas of the Midwest were turned into a dust bowl through drought and from over-plowing. The crisis period, 1935 to 1939, hit Oklahoma and Arkansas the hardest. Sharecroppers and small farmers were forced to abandon the land. Most headed west, to California, where they hoped to begin a new life in the fertile valleys they had heard about. They were derisively and hatefully called "Oakies" and "Arkies." It has been calculated that in the late 1930s, some 350,000 people from Oklahoma and Arkansas left their homes for California.

John Steinbeck told of the plight of one such family in his novel *The Grapes of Wrath*. Published in 1939, it is one of the great classics of the Depression era. Steinbeck's novel raised important issues, such as the social responsibility of the state—for the author was sympathetic to the socialist movement and to the rights of the people to have protection against a police system. Tom Joad, the hero of Steinbeck's story, is released from an Oklahoma prison where he has served time for killing a man in self-defense. When he reaches home he finds his family has left for California in a dilapidated old truck. They live in shanty towns and Hoovervilles, as the settlements of jobless and migratory workers were then called. Tom and his friend Jim Casey, a labor agitator or organizer, are constantly victims of an unjust social and judicial system, until finally Jim is slain by a policeman and Tom has to go on the run for killing a deputy. It is a story of the downtrodden who, from Stein-beck's perspective, are exploited in this era of Depression, drought, and wandering homelessness. Steinbeck's other great novel is *Of Mice and Men* (1937), which similarly treats the plight of the migrant worker in California.

The Great Depression forced the American government to review—and do something about—the social issues and economic imbalances that had created a gulf between the wealthy and the middleclasses and the poor and the under-privileged. So many were now disenfranchised by the eco-nomic collapse that they had enormous clout through their sheer numbers at the voting booth.

Because the Crash came during the administration of Herbert Hoover (president 1929–33), the latter bore the brunt of the blame for the calamity. It was Franklin Delano Roosevelt, who was elected in 1932 to the first of four terms and served until his death in 1945, who proposed a "New Deal" that would purportedly carry the nation out of the Depression and institute social equality. Within "the first hundred days" Roosevelt initiated and Congress enacted a prodigious legislation program in which the federal govern-ment became the main agent in stimulating the economy and assisting the poor and the nearly fifteen million un-employed. One of the rare havens encountered by Tom Joad in *The Grapes of Wrath* was a government-run camp for transient farmworkers—the otherwise homeless of their day. Numerous government bureaux and agencies were created in an attempt to provide the social welfare that capitalism had not. On 26 July 1935, the Works Progress Administration (WPA) established divisions for the funding of authors, artists, and musicians, bringing the government into the business of arts subsidy. That same year, the Farm Security Administration (FSA) set up a project for photo-graphers to document the tragic plight of the American farmer (see p. 476).

Socialism was spreading through Europe at the same time that a form of it was being instituted in the United States. The Soviet Union—under Lenin and then under Josef Stalin—spent the 1920s and 1930s trying to create a communist people's government. In America, the labor unions pressed Roosevelt's government to enact social re-form. The country began to divide between those who favored government intervention in social reform and those who did not. The clash appeared everywhere, touching the arts as well. Photography proved to be a forceful weapon in the furthering of reform ideology, as well as a powerful form of art in itself.

PHOTOGRAPHY AS ART

As the new century opened, photography had already been known in America for sixty years. For all its popularity, however, it was still not considered to be an artform. It made images by use of a machine, and at the academies and the salons everyone of taste knew that true art was something created by hand. In the period under discussion, however, this attitude changed. Indeed, a group of determined photographers set about forcing the change, and photography at last took its place as a creative medium.

Technical advances—mechanical, chemical, and optical— of the preceding years had prepared the way for this change. Cameras were now small enough to be held in the hand and could be taken almost anywhere. A picture could be snapped quickly, without a loss of spontaneity. The medium kept what was good and increased the "artistic" component, lifting photography to new heights of aesthetic expression.

ALFRED STIEGLITZ

One of the prime movers behind all of this was Alfred Stieglitz (1864–1946), whom we met earlier as an entrepreneur of modernism through his influential gallery, 291 (see p. 452).

Born to wealthy immigrant parents in Hoboken, New Jersey, Stieglitz was afforded all the comfort and culture of the upper-middleclass, including a college education and study abroad, where, at the University of Berlin, he met a world authority on photoscience, Dr. Herman Vogel.

Stieglitz took his first photographs in Germany in 1883. After returning to New York City in 1890, he quickly made an international reputation for himself through his impressionistic views of the city. Another of his interests surfaced at this time—the promotion of innovative photographic processes through publication. Between 1897 and 1902, for example, he was the editor of *Camera Notes*. Throughout much of his career he would use such publications to call attention to the best photography had to offer.

In 1902, Stieglitz joined several other photographers who were also devoted to elevating the art of photography. The group was called the Photo-Secession, and among its members were Edward Steichen, Gertrude Käsebier, Clarence White, and Alvin Langdon Coburn.

Käsebier's portrait of Stieglitz (Fig. 31.1) reveals her extraordinary genius as an artist, as well as a new sensitivity in interpreting personality in photographic portraiture. Käsebier (1852–1934) had studied painting in France before taking up photography about 1894. In both the manner of composing the portrait and the retouching of the negative in special ways, she tried to make her photographic portraits vie, aesthetically, with painted portraits. In time, many photographers and critics decided this was a mistake: Photographers ought to exploit the medium's special qualities, rather than try to make their prints look like paintings.

31.1 Gertrude Käsebier, *Portrait of Alfred Stieglitz*, 1902. Gum bichromate platinum print on tissue, 11¾ × 9⅛in (29.8 × 23.2cm). Collection, The Museum of Modern Art, New York. Gift of Miss Mina Turner.

The Photo-Secession group formed after a very successful exhibition that was organized in New York City, called "An Exhibition of American Pictorial Photography Arranged by the Photo-Secession." Its headquarters were established in 1905 in the Little Galleries of the Photo-Secession at 291 Fifth Avenue. Although there were only three small rooms, enormous events unfolded.

The gallery became the gathering place for an ever-increasing number of serious and talented photographers and critics who were sympathetic to the medium, and the home of the organization's new publication, *Camera Work*. Art photography now had a permanent display-place of its own. Stieglitz, as director of the gallery and editor of the publication, insisted that photography be taken seriously as an artform. *Camera Work*—published in fifty issues between 1903 and 1917—spread the fame of the group to distant places, so that people who could not visit 291 could still see examples of the new creative photography.

Many would agree that Stieglitz's own masterpiece of these years was a photograph entitled *The Steerage* (Fig.

31.2 Alfred Stieglitz, *The Steerage*, 1907. Photograph. Library of Congress.

31.2). The picture seems to represent the huddled masses of immigrants about to arrive in their new homeland, America. In actuality, the shot was taken on one of Stieglitz's eastbound ocean crossings—he himself was traveling firstclass—so the ship was going from America to Europe, rather than the other way around.

The title Stieglitz gave the picture suggests a kindred interest in the lives of the lower classes shared with Robert Henri, John Sloan, and other Ashcan painters of the same time. Stieglitz later recalled the circumstances of his making this picture:

> A round hat; the funnel leaning left, the stairway leaning right, the white drawbridge with its railings made of circular chains—white suspenders crossing on the back of a man in the steerage below, round shapes of iron machinery, a mast cutting into the sky, making a triangular shape I saw a picture of shapes and underlying that the feeling I had about life.[1]

When Stieglitz first saw the view that struck him so, he did not have his camera with him. He dashed to his stateroom, got the camera, returned, and snapped the shot. There was a spontaneity about the taking of the picture that he liked, and it demonstrates Stieglitz's aesthetic sensibilities about the abstract qualities of art. He printed the full picture, without cropping, retouching, or blurring to make it look like a painting. This was an honest—"straight," he and others called it—use of the camera, as it should be used.

When Stieglitz got to Paris he showed the photograph to Picasso, who admired it greatly. Stieglitz met many of the avant-garde artists on that trip. After he returned to New York City, he began showing modern painting and sculpture as well as photographs at 291. Stieglitz's intimate involvement with avant-garde painters and sculptors reinforced his sensitivity to abstraction in imagery and probably helped him to clarify the potential of his chosen medium. The gallery remained a major focal point in modern art until the building was torn down in 1917.

In 1924, Stieglitz married the painter Georgia O'Keeffe (see p. 457), who became one of his primary subjects in a series of extraordinary portrait studies that spanned two decades. *Georgia O'Keeffe: A Portrait-Head* is a good example of the straightforward exploitation of the medium, capturing both the intense character of the subject and a fascinating juxtaposition of textures, as seen in the soft, human form against the grain of the weathered wood (Fig. 31.3).

In the 1920s, Stieglitz also began a series of remarkable photographs of clouds which are at times lyrical studies, at times powerful and expressive, and curiously abstract in their realism. By this time it was no longer necessary for Stieglitz to be the spearheading force in the introduction of modernism that he had been before World War I, although he did continue to operate galleries—the Intimate Gallery (1925–9) and An American Place (1929–46).

31.3 Alfred Stieglitz, *Georgia O'Keeffe: A Portrait-Head*, 1922. Photograph. National Gallery of Art, Washington, D.C.

31.4 Edward J. Steichen, *Rodin with His Sculptures "Victor Hugo" and "The Thinker,"* 1902. Photogravure, from *Camera Work*, 1905. Morris Library, University of Delaware, Newark, Delaware.

31.5 (below) Edward J. Steichen, *The Flatiron*, from a negative of 1904. Photogravure, from *Camera Work*, 1906. Morris Library, University of Delaware, Newark, Delaware.

EDWARD STEICHEN

Another of the founding members of the Photo-Secession group was Edward J. Steichen (1879–1973). Born in Luxembourg, he was brought to America as an infant by immigrant parents who settled in Milwaukee, Wisconsin. By 1895, when only sixteen, Steichen had taken up photography seriously. Four years later his exceptional talent was discovered by Alfred Stieglitz and Clarence White.

In 1900 Steichen went to Paris for further study. At this time he was a painter as well as a photographer, and he attempted to work the painterly effects of his canvases into his photographs, as seen in *Rodin with His Sculptures* (Fig. 31.4). One is reminded of the dramatic play of light and the loose, suggestive brushwork of Rembrandt. Steichen achieved these effects by using the **gum bichromate process**, which allowed him to manipulate the printing process. This is quite unlike the approach of Stieglitz, who preferred "straight" photography.

Steichen became a member of the inner circle of the avant garde in Paris. As Stieglitz's counterpart in France, he was instrumental in the selection of works to be shown at 291. Steichen's influence on Stieglitz in introducing him to the art and artists of the avant garde was considerable.

In New York City, Steichen found his subject matter in the city itself, as in *The Flatiron*, which shows the famous skyscraper on a misty day, with hackney carriages and their drivers silhouetted in the foreground (Fig 31.5). Again, one

31.6 Clarence White and Alfred Stieglitz, *Nude Figure*, 1910. Photogravure, from *Camera Work*, 1910. Morris Library, University of Delaware, Newark, Delaware.

is inclined to compare it with a painting, perhaps with an impressionist work or possibly with some of Whistler's subtle tonal nocturnes. As the brother-in-law of Carl Sandburg, Steichen shared a poetic vision. When the Lumière brothers made a great breakthrough in color photography in Paris in 1907, Steichen saw it as bringing photography one step closer to painting.

When the United States entered the war, Steichen was sent to France to set up aviation photography. The demands of this task completely changed his way of working and the effects he sought. He became so fascinated with the techniques of photography that, when the war was over, he burned all of his paintings. Henceforth, there would be no confusion of the two media in his mind.

Steichen settled in New York City in 1923, opened a studio, and began a long period as a fashion photographer for *Vanity Fair* and *Vogue* magazines. He also became an exceptionally fine portraitist, taking photographs of many of the world's most famous men and women of the 1920s and 1930s. After World War II, Steichen was head of the Photography Department at MOMA, where he initiated the huge Family of Man show in 1955.

CLARENCE WHITE

Clarence H. White (1871–1925) also attempted to compete with the aesthetic effects of painting. Born and raised in Ohio, White first became interested in photography when he saw an exhibition at the World's Columbian Exposition in Chicago in 1893. For several years he continued with his work as a bookkeeper, practicing photography on the side.

In 1906 White moved to New York City. His *Nude Figure* is characteristic of the artistic effects he sought (Fig. 31.6). In 1910 these effects were not considered to be radical, for they arose from influences in painting that had been known for several decades—Impressionism and Whistler's tonal harmonies, for example. But whereas previously the nude had scarcely been proper subject matter in legitimate photography, with this new generation it gained acceptance.

White also played an important role as a teacher of photography, beginning at Columbia University in 1907 and at a summer school he ran in collaboration with Max Weber at Georgetown Island, Maine. In 1914 he opened his own school in New York City, and his pupils included Dorothea Lange and Margaret Bourke-White (see pp. 476 and 623). White's work was known for its soft lighting and for lyrical, poetic visions of young women.

SOCIAL DOCUMENTARY PHOTOGRAPHY

There was another branch of photography that achieved a profoundly expressive imagery—social documentary photography. The purpose here was more the exposure of social inequities than aesthetic excellence. In chapter 25 it was noted that at the turn of the century Jacob Riis had used his camera to force recognition of the wretchedness of life in New York City's slums.

LEWIS HINE

Riis's successor was Lewis Wickes Hine (1874–1940), who carried his camera well beyond New York City to document such social problems as exploitation of child labor, from South Carolina cotton mills to Pennsylvania coalmines. Hine—himself active in many causes throughout his life—arrived in New York City from his native Wisconsin in 1901, taking up photography two years later. From the beginning his use of photography was "straight"—that is, he sought a truthful reality in his images and did not manipulate them for artistic effect.

Hine's first important series of photographs resulted from regular visits to Ellis Island to photograph immigrants as they arrived from Europe. *Italian Family Seeking Lost Baggage, Ellis Island* precedes Stieglitz's *The Steerage* by two years (Fig. 31.7). Hine's purpose and end result were quite different. He did not seek out the abstract, artistic values of

such a shot, but rather the human story it related: The uncertainty, fear, and confusion, the estrangement from all that had been familiar. The photographic narrative is richly and movingly told.

The Ellis Island pictures brought Hine to the attention of the National Child Labor Committee, which sent him traveling about the country to document in photographs the abuses of child labor in factories, mines, and mills. *Child in Carolina Cotton Mill* is an early example (Fig. 31.8). One is reminded of the industrialist who observed that children made good laborers because their small hands were well suited to reaching into the machines—the only problem was that when they got tired they became careless, and sometimes those little hands got caught in the machines.

Hine also took a memorable photograph called *Breaker Boys in Coal Chute, South Pittston, Pennsylvania*. This was a new kind of group portrait which began to strike deep into America's conscience. The photograph told the story of young boys who were in the mines instead of in school, who breathed coal dust all day, with little opportunity to play in the sunshine or to breathe fresh air.

The Library of Congress has a collection of about 5000 photographs that Hine took for the National Child Labor Committee. He also did a remarkable series on the construction of the Empire State Building in 1930. By the late 1930s Hine's work began to be recognized by the art world through several retrospective exhibitions.

31.7 (above) Lewis W. Hine, *Italian Family Seeking Lost Baggage, Ellis Island*, 1905. Modern print made by the Photo League, 1942. Gelatin-silver print, 5½ × 4¼in (14 ×10.8cm). Collection, The Museum of Modern Art, New York. Purchase.

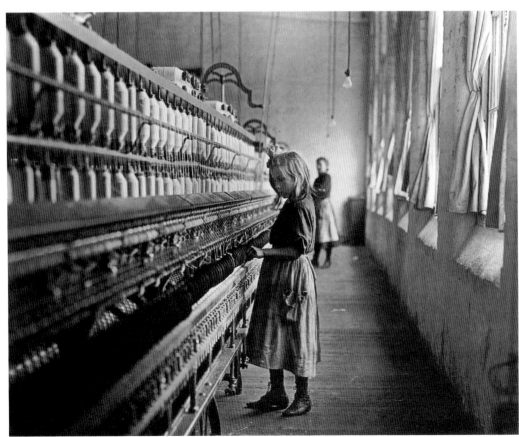

31.8 Lewis W. Hine, *Child in Carolina Cotton Mill*, 1908. Gelatin-silver print on masonite, 10½ × 13½in (26.7 × 34.3cm). Print made by Hine Foundation of Photo League. Collection, The Museum of Modern Art, New York. Purchase.

31.9 Charles Yessel, *Mrs. Dorothy Henderson, Machine Operator*, c. 1915. Photograph. Hagley Museum and Library, Wilmington, Delaware.

YESSEL AND SHEELER

If the machine in Hine's photographs often carried an ominous connotation, it was seen in very different ways by other photographers of that era. Charles Yessel (d. 1953), for example, probably took the picture *Mrs. Dorothy Henderson, Machine Operator* during World War I, when women were called in to work in factories (Fig. 31.9). Her uniform clearly identifies Mrs. Henderson as the worker she is, right hand laid confidently on the part of the machine she operated. Here is "straight" photography, yet the picture-taker was clearly as fascinated with the machine as with its operator. We are reminded of the passionate interest the machine evoked in many of the leading avant-garde artists, from Dadaists to Futurists, and Surrealists to Constructivists.

Charles Sheeler brought his camera's lens to focus on machinery and industrial sites out of a different aesthetic motivation, namely the relation between a sharply focused photograph, the technique involved, and the machine being photographed. As a painter, Sheeler was a Precisionist (see p. 464), and the term applies equally well to his photographic work, as is evidenced in one of his most famous prints, *Wheels* (Fig. 31.10).

31.10 Charles Sheeler, *Wheels*, 1939. Gelatin-silver print, 6⅝ × 9⅝in (16.8 × 24.4cm). Collection, The Museum of Modern Art, New York. Given anonymously.

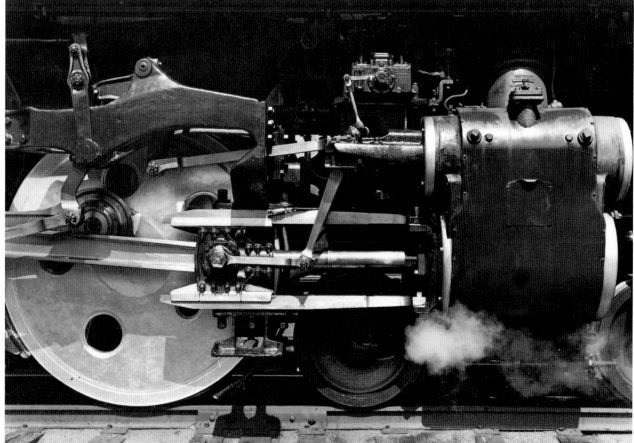

The abstract shapes and patterns of the powerful locomotive appealed to the artist as a readymade composition and as an object that was one of the primary agents of the culture of its era. The artistry is in the recognition of the object as an important symbol, in Sheeler's technical ability, and in happy, unexpected accidents like the puff of steam in the lower right corner. There is a monumentality about the image that belies the actual size of the print, which is only slightly over 6 inches (15 cm) in height.

One of Sheeler's most famous series was of the vast industrial complex of the Ford Motor Company's River Rouge plant. Thus we see photographers finding their subject matter in the construction of the Empire State Building, in machines in a Westinghouse factory, in a Ford assembly plant, and in a powerful steamdriven locomotive.

PAUL STRAND

Paul Strand (1890–1976) attended the Ethical Culture School in his native New York City where one of his teachers was Lewis Hine. Hine recognized the extraordinary quality of some of Strand's early photographs and took him to meet Alfred Stieglitz in 1907. Through Stieglitz, Strand met other members of the Photo-Secession group, and in the galleries of 291 he became acquainted with the principles of abstract art. This was an important point, for no matter how sharply reality is focused in his pictures, there was throughout his life's work a sensitivity to the abstract and formal components of art. In 1916 Stieglitz arranged Strand's début with a oneperson exhibition at 291. In 1917 the last two issues of *Camera Work* were devoted to his photographs.

Strand's eye ceaselessly roved in search of a wide variety of themes. In the early 1920s, for example, he made an exceptional series of studies of machines, parts of automobiles or lathes, and the inner mechanisms of cameras, that were abstract yet Precisionist. Strand also did closeup shots of plant forms, in which he forces us to look so closely at the plants that we, too, perceive the abstract quality that he always found in nature. The plant studies are similar to the closeup, abstract vision of plant forms seen in the art of Georgia O'Keeffe (see p. 457).

Strand also worked with the moving picture medium, collaborating with Charles Sheeler in 1921 in the making of *Mannahatta*, a cinematic ode to New York City. In the 1930s Strand was one of the cameramen who shot the documentary *The Plow That Broke the Plains*.

While visiting the artists' colony in Taos, New Mexico, in 1931, Strand took *Church, Ranchos de Taos*. It demonstrates his sensitivity to abstract forms, patterns, and planes, and to surfaces, as well as to the emotional content inherent in an ancient building (Fig. 31.11). The solemn monumentality, the simplicity of planes, the spiritual silence of the massive adobe walls all caught the cameraman's eye because of their expressive abstract forms. In 1945 MOMA organized a show of Strand's work—the first oneperson exhibition of photography it had ever presented.

PHOTOGRAPHY AND THE FSA

In the 1930s, the federal government established a number of agencies to deal with the economic and social conditions that beset the nation during the Great Depression. Painters, sculptors, and architects were employed by one or another of these, such as the Federal Art Project under the Works Progress Administration, in designing and decorating post offices, courthouses, and other federal buildings throughout the country.

Photography found an unexpected source of patronage in the Farm Security Administration (FSA), set up in 1935 under the direction of Roy Stryker, a New Deal economist and sociologist. The FSA, a branch of the Resettlement Administration within the Department of Agriculture, undertook to inform the American people about the wretched living and working conditions of migratory laborers, the dire necessity of resettling farmers who faced economic disaster brought on by the Depression, and the displacement of laborers by mechanization.

Stryker, recognizing the power of photography in the cause of reform, hired six photographers. Foremost among these were Dorothea Lange, Ben Shahn, and Walker Evans. The result was about 270,000 negatives which form a "straight" photographic record of the life of a vast number of Americans during those difficult times.

DOROTHEA LANGE

Dorothea Lange (1895–1965) had polio as a child and attended grade school in Manhattan's Lower East Side.

31.11 Paul Strand, *Church, Ranchos de Taos, New Mexico*, 1931. Photograph. Paul Strand Archive, Millerton, New York.

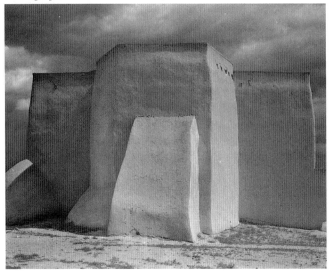

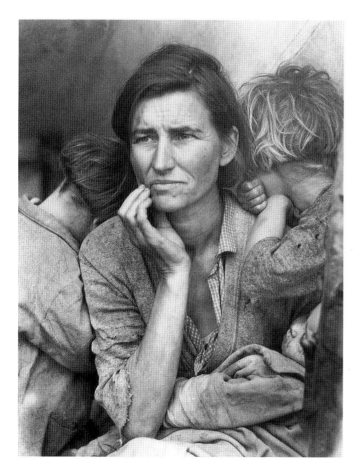

Lange always felt this gave her an affinity with people who suffered and endured poverty, and her photographs reveal a compassionate soul behind the camera's eye.

Lange acquired her first camera in 1914 and a few years later studied photography with Clarence White at Columbia University. In 1919 she set up a studio in San Francisco as a freelance photographer and portraitist, but in the early 1930s she began to take pictures of city street scenes. Her husband was a sociologist with whom she began to collaborate in the study of impoverished farmworkers in southern California.

One of Lange's masterpieces is *Migrant Mother*, taken in 1936 in Nipomo, California (Fig. **31.12**). The woman in the picture, Florence Thompson, the mother of ten children, looks much older than thirty-two, her actual age. It is an image that tends to haunt one's memory, one of those rare visualizations that captures the suffering of an entire era and a whole sociological group, transcending the individual to reach the universal. We see a tired, destitute mother, surrounded by her children, two of whom turn their heads away, seeking refuge from a harsh world. The care and concern expressed in the mother's face, the fatigue expressed by the hand that supports the chin are remarkable features.

Lange traveled to many parts of the country, taking pictures under the auspices of the FSA that were intended as documentation, but are art as well. *Tractored Out* (Fig. **31.13**)—a title that refers to both the overworked land and to the people who have been displaced by the machine—

31.12 (above) Dorothea Lange, *Migrant Mother, Nipomo, California,* 1936. Photograph. Farm Security Administration photo, Library of Congress.

31.13 Dorothea Lange, *Tractored Out, Childress County, Texas,* 1938. Photograph. Farm Security Administration photo, Library of Congress.

demonstrates Lange's ability to recognize a scene devoid of human beings that tells a story of human tragedy. It shows, with an economy of means, how the tractor plowed its furrows to the very doorway of the now-derelict farmhouse that once belonged to the fieldhands, whom the machine has long since displaced. This is not one of nature's poetic solitudes, such as a mid-nineteenth-century landscape painter might have found in a farm scene; this image tells of loneliness, failure, and dislocation.

BEN SHAHN

Ben Shahn (1898–1969), better known as a painter than a photographer (see p. 544), was also a member of Stryker's team between 1935 and 1938. *Rehabilitation Clients* (Fig. 31.14) depicts the sort of people who might have once lived in the deserted house in Lange's *Tractored Out*. The simple farm folk, and others like them in the FSA series, are the visual counterparts to the characters found in Steinbeck's *The Grapes of Wrath* (1939)—it is very likely that the author was influenced by the FSA photographs he had seen.

Shahn's *Rehabilitation Clients* invites contrast with Grant Wood's *American Gothic* (Fig. 29.20) of only five years earlier. Wood's picture conveys a solid confidence and selfreliance, an optimistic statement that wholesome, hardworking American farmers do find the fulfillment of their dreams. In Shahn's image, both the confidence and the dream have been shattered by the realities of life, and the stoicism and faith found in Wood's painting have begun to waver.

WALKER EVANS

Another FSA photographer was Walker Evans (1903–75) who, after graduation from Williams College, went to Paris to live, to read Baudelaire, and to become a writer. The realism of Baudelaire's writing undoubtedly influenced the style of Evans's photography, which he took up after his return to New York City in 1927. Literary interests kept him in close contact with writers, editors, and publishers, all of which had an effect on the storytelling quality of his pictures.

In 1936, Evans took a leave of absence from the FSA project to go with the author James Agee to Alabama, where they lived with a sharecropper and his family. This was originally to be a collaborative effort sponsored by *Fortune* magazine, but when the magazine rejected their work they published it under the title *Let Us Now Praise Famous Men* (1941), with Agee's story illustrated by Evans's photographs.

Washroom and Dining Area of Floyd Burroughs's Home is one of the pictures from this series (Fig. 31.15). Aside from the story it tells about the starkness of the sharecropper's life, it is a beautiful arrangement of formal—that is, aesthetic—elements. The board of the doorjamb is a powerful vertical, just offcenter, with a simplified grid of horizontals to the right. There is a rich texturing, not only in the grain of the weathered wood but also in the counter-directional arcs of the saw marks. The elliptical shape of the bowl relieves the strict rectilinearity of this half of the picture. In the other half, diagonal lines of floorboards, table

31.14 Ben Shahn, *Rehabilitation Clients, Boone County, Arkansas*, 1935. Photograph. Farm Security Administration photo, Library of Congress.

31.15 Walker Evans, *Washroom and Dining Area of Floyd Burroughs's Home, Hale County, Alabama,*
1936. Photograph. Farm Security Administration photo, Library of Congress.

edges, and corner cabinet are juxtaposed to the perfect horizontal/vertical linear scheme of the right side. Every important detail is in sharp focus, giving the scene an undeniable reality. Evans always advocated that such realism was the natural style of the photographic medium.

To call the work of Lange and Evans "straight" photography needs some qualification: As with every artist, they, too, imposed their will upon their subject matter, altering it for the sake of poignancy. This was perfectly compatible within the realism they wished to achieve. For example, concerning Lange's *Migrant Mother*, there were actually six photos in the series, but only one was singled out, and even that one was cropped, thereby selectively altering the image. Florence Thompson had ten children, but Lange was concerned that showing more than three would stir current resentment about over-population among the poor. Walker Evans, too, manipulated his scenes by removing, adding, or rearranging objects in order to heighten the desired effect.

THE WESTERN SCHOOL

The Western school of photographers included Edward Weston, Ansel Adams, and Imogen Cunningham, among others. As a group they were nature-oriented, nature encompassing everything from a desert landscape to closeup floral forms to the nude figure.

EDWARD WESTON

Weston (1886–1958), the spiritual leader of the group, was born in Highland Park, Illinois, and raised in Chicago. He got his first camera when he was sixteen. By 1906 he had moved to California where he set up a studio as a portrait photographer, making creative softfocus pictures in his free time. The exhibition of modern art at the Panama-Pacific Exposition in San Francisco in 1915 gave Weston an awareness of the abstract qualities inherent in nature, and his own art began to show increasing concern with those qualities. In 1922, on a visit to New York City, Weston met Stieglitz, Strand, and Sheeler, who reinforced his interest in the abstract beauty found in nature. After Weston returned to California he abandoned the softfocus effect in favor of sharply focused detail in nature studies.

Weston was one of the founding members of the f64 Group in 1932. This was a small group of photographers who took their name from the smallest f stop on the camera, which gave them the deepest focal range so necessary for landscape photography in which the details on a distant horizon are as sharply focused as foreground details. It was essential to Weston, for example, that the delicate, curvilinear rhythms on a sand dune in the middle distance be recorded as distinctly as those of the immediate foreground, as seen in *Oceano* (Fig. 31.16). To lose the linear patterns of the middle dune would have been a great loss to the unity of the picture. In *Oceano*, nature is adoringly

31.16 Edward Weston, *Oceano, California*, 1936 (negative), 1941 (positive). Gelatin-silver print, 7 × 9⅝in (17.8 × 24.4cm). Collection, The Museum of Modern Art, New York. Given anonymously.

31.17 Ansel Adams, *Monolith, the Face of Half Dome, Yosemite National Park*, 1927. Photograph.

recorded, but the photographer's eye was obviously sensitive to the abstract masses and delicate surface rhythms as well.

ANSEL ADAMS

Ansel Adams (1902–84) was a member of the Western school who brought together an unsurpassed technical mastery of the photographic medium, a keen eye for natural beauty, and the passionate concerns of a conservationist.

After taking pictures of Yosemite Valley when he was only fourteen, Adams knew he had found what he wanted to do with his life. In 1920 he worked with the Sierra Club, a conservation organization, and by 1928 he had become its official photographer. The preceding year he took one of his most famous studies, *Monolith, the Face of Half Dome*, in which the rhythmic, linear striations on the surface of the colossal geological formation build to a majestic climax at the mountain's crest (Fig. 31.17). The photographer was careful to establish a scale of grandeur by including the pine

31.18 Imogen Cunningham, *Magnolia Blossom*, 1925. Photograph.

trees at the lower left, which are dwarfed by the giant that towers over them. Adams also took advantage of the snow on the high crest, which forms a thin white line that gives definition to the rounded top of the monolith.

IMOGEN CUNNINGHAM

If Weston and Adams usually viewed nature from a distance in their landscapes, Imogen Cunningham (1883–1976) moved her camera in close, sometimes to the point where the specific botanical identity of the plant form is lost, even though the verdant quality is retained.

Born in Oregon and raised in Seattle, Cunningham was first inspired to try photography after seeing a photographic series by Gertrude Käsebier in a magazine in 1901. She studied photographic chemistry in Dresden, Germany, and on her return trip met Alfred Stieglitz and Käsebier as she passed through New York City in 1910. Five years later she married, and her family responsibilities kept her close to home in San Francisco. Thus restricted, she began to photograph the plants in her garden. An example is *Magnolia*

Blossom, with its abstract conception and perception of nature. Here is nature that is both delicate and fecund, seen in the lyrical spread of the petals and the jutting stamen (Fig. 31.18). Works such as the *Magnolia* possess an affinity with the equally sensuous floral paintings by Georgia O'Keeffe (Fig. 30.18).

By 1940 the richness and variety, the technical diversity and mastery of the medium in the hands of the men and women discussed in this chapter had earned photography a place among its sister arts. Its practitioners had learned that photography has special qualities that are of high aesthetic value, and that, to achieve equality, photography did not have to be like painting. They learned how to exploit their medium's natural capacity for realism, but they also recognized the power of abstraction. In fact, it was the avant garde who welcomed the photographers into the sisterhood of the arts, while the academicians remained aloof. The old cry, "If it's made by a machine it can't be art," began to lose its following in an age that loved airplanes, streamlined trains, and racing motorcars.

CHAPTER THIRTY-TWO

SCULPTURE:

TRADITION, DIVERSITY, AND
ANARCHY, 1900–40

Two phenomena of the 1930s had a profound effect upon American life and the subsequent history of the nation. One was the Great Depression, which was a domestic problem, although it had worldwide shockwaves. The other was the rise of the Nazi Party in Germany, which eventually led to World War II.

America was being drawn into the swirling vortex of international affairs even before World War I. Because of the role it played in the war and its economic strength in the aftermath, it emerged inseparably bound into the affairs of Europe. What happened there now directly affected the fate of the United States, whether it was the Russian Revolution and the spread of Communism or the events that brought Adolf Hitler to power.

Following the armistice that ended World War I, the victorious allied powers enforced a peace treaty upon Germany that bore the seeds of World War II by emasculating the German economy and industry. The country was racked by unemployment and riotous inflation, and communist and anarchist agitators screamed for revolution.

Stripped of its pride and its resources, the way was prepared for one who would promise to purify Germany, restore her pride, and rebuild her economy and industry. Adolf Hitler, head of the National Socialist—or Nazi—Party, was swept into power in 1933. Hitler quickly acquired dictatorial authority and crushed all opposition. A few immediately saw the rise of the Nazis as horrifying and, particularly among intellectuals and Jews, the exodus began. The noted physicist Albert Einstein left in 1933 to take up permanent residence in Princeton, New Jersey. In that same year the playwright Bertolt Brecht also fled, first to Scandinavia, and then in 1941 to America.

Hitler announced that Germany would rearm, and he began to retrieve territories lost through the Peace Treaty of Versailles. At the Munich Conference of 1938, the British Prime Minister Chamberlain and French Prime Minister Daladier failed to stand up to Hitler, preferring "peace in our time." America, along with the rest of Europe, only looked on.

Events moved rapidly. On 1 September 1939, the German war machine invaded Poland, and World War II had begun. There was much opposition to allowing the United States to be drawn into a second European conflict, particularly from the labor unions. Then, suddenly and unexpectedly, the blow came—not from across the Atlantic, but in the Pacific. On the morning of 7 December 1941, the Japanese airforce struck the American fleet in Pearl Harbor. On 8 December, Congress declared war on Japan and, three days later, on Germany and Italy. The whole world was at war, yet again.

All of this may seem to have little direct bearing on American sculpture. The watershed created by World War II, however, has enormous importance for postwar America. One's understanding of America in the 1930s is incomplete if the events that transpired in Europe are isolated from it.

NATURE AND CLASSICISM ABSTRACTED

At the turn of the century, Americans were still remembering the great World's Columbian Exposition at Chicago in 1893—a veritable extravaganza of Beaux-Arts architecture and sculpture. By 1900, John Quincy Adams Ward, Augustus Saint-Gaudens, and Daniel Chester French were still active, representing the academic tradition, which seemed firmly entrenched with such institutions as the National Sculpture Society and the National Academy of Design. Almost all other sculptors worked in a similar academic, Beaux-Arts-inspired manner, which did not begin to suggest the diversity and controversy—even what some would call anarchy and insanity—that beset American sculpture in the four decades preceding World War II.

That unity, however, was soon split asunder into a diversity of artistic expression. The major movements included: The continuation of the Beaux-Arts style; a new academic tradition led by Paul Manship; a brief affiliation with the romantic style of Auguste Rodin; a realist counterpart to the art of The Eight (see p. 423); Art Deco (see p. 415); experimentation with form as inspired by Cubism, Expressionism, Futurism, Dada, and other "isms" from European modern art (see chapter 30); direct carving; the early wire constructions of Alexander Calder; the work of sculptors whose art defies categorization—Gaston Lachaise and Hugo Robus, for example; and African-American sculpture.

MANSHIP AND THE OLD GUARD

Early in the twentieth century, the sculptors who continued to work in the academic tradition produced a number of excellent pieces. However, they soon took the stance of a defensive old guard as their way of working came under assault from all sides.

The most brilliant member of the younger generation to arise out of the academic tradition was Paul H. Manship (1885–1966), whose work offered a compromise between the traditional historicism and the new tendencies toward abstraction.

Manship spent his youth in St. Paul, Minnesota, where he first studied art. He made rapid progress, and in 1909 he won the highly coveted Prix de Rome, which allowed him to study at the American Academy in Rome (founded 1894) for three years.

From Italy Manship traveled to Greece where he discovered Greek sculpture of the preclassical era, that is, before about 450 B.C. The stylization of human forms and fabrics in Archaic and Severe style Greek art had an immediate impact on his art, as he began to concentrate on the abstract qualities of form. Manship also discovered the art of the ancient Middle East—Persian, for example—and India.

After his return to New York City in 1913, early small bronzes such as *Centaur and Dryad* (1913, Smith College Museum of Art) won Manship immediate acclaim. The subjects of such pieces came from classical mythology, and they had stylistic associations with ancient Greek art. Other bronzes, *Salome* (1915, Minnesota Museum of Art, St. Paul), for example, were clearly inspired by the decorative patterns and rhythmic stylizations of ancient Middle Eastern art.

One of Manship's most popular and widely acclaimed sculptures of this early period was *Dancer and Gazelles* (1916, Corcoran Gallery of Art, Washington, D.C.). The flowing rhythms of drapery and the sensuous undulation of the dancer reveal the artist's fascination with Indian art.

Manship's simplification and stylization of natural form are evident in *Indian Hunter with Dog* (Fig. 32.1), especially when it is compared with the naturalism of Ward's statuette of the same theme (Fig. 26.1). In Manship's version, the dog recalls the leaping bulls of Minoan murals (c. 1500 B.C.), while the treatment of the hair around the neck reminds us of the famous Assyrian lionhunt reliefs from ancient Nineveh (c. 650 B.C., British Museum, London), or the celebrated bronze *She-Wolf of the Capitol* (c. 500 B.C., Capitoline Museum, Rome).

The academicians therefore praised Manship's work for its historical associations and for its perpetuation of their beloved artistic traditions. Others found the abstraction of form and decorative details appealing, and his bronzes were commended for the exceptional beauty of their craftsmanship and their exquisite surfaces and patina.

Manship's major work of the 1930s was the heroic gilded bronze *Prometheus*, created as the focal point of Rockefeller Plaza in New York City. A spectacular floating image of the Greek god who brought the gift of fire to mankind, it remains a much-loved image of the era of Art Deco. As exquisite as it was, however, Manship's work was finally judged to belong more to the academic tradition than to the new realism or to the avant garde.

32.1 Paul H. Manship, *Indian Hunter with Dog*, 1926. Bronze, mounted on green marble base, height 23in (58.4cm). Metropolitan Museum of Art, New York City.

ART DECO

In the 1920s and 1930s, Art Deco was a style that used a simplification and stylization of natural form to achieve abstraction (see p. 415). Art Deco sculpture is often associated with architecture, and consequently it may also have geometric patterns that reflect its architectonic purpose. It was also often seen in furniture that utilized shiny metallic surfaces, brightly colored plastics, and forms best characterized as modernistic.

The dean of Art Deco architectural sculpture was Lee Lawrie (1877–1963) who was German-born but raised in Chicago and trained under Augustus Saint-Gaudens and other sculptors of the academic tradition. Early in his career Lawrie began to create work for the architect Bertram Goodhue, and in the sculptures for the Nebraska State Capitol (1922) the Art Deco style of architectural ornamentation began to take form. Lawrie also did the sculptural decorations for the Los Angeles Public Library (1922–6), designed by Goodhue.

Lawrie is probably bestknown, however, for his sculptures for Rockefeller Center in New York City. In 1933, his multicolored stone and glass decorations for the main

32.2 Lee Lawrie, *Genius, Which Interprets to the Human Race the Laws and Cycles of the Cosmic Forces of the Universe*, c. 1930. RCA Building, Rockefeller Center, New York City. © The Rockefeller Group.

entrance to the RCA Building were set in place (Fig. **32.2**). The main motif is a modern-day Michelangelesque figure, thundering down from the clouded heavens. The stylization of such forms as the beard and clouds gives a regularity that achieves a unity with architecture. The use of glass in a decorative fashion—rather than bronze, marble, or wood—announces a commitment to the modern age. The entrance is on an axis with Manship's gilded *Prometheus*, which is set just below street level in the Plaza's garden/ice-rink area.

If Art Deco was the style used for skyscrapers and nightclubs, it was also found in federal architectural projects erected during the years of the Great Depression of the 1930s, although the glitter and optimistic imagery were often replaced by more sober themes of social concern. On buildings erected in Washington, D.C., in the 1930s we see innumerable sculptures that transformed the Art Deco style into a modern-day Federal style.

Foremost among the sculptors who fulfilled these governmental commissions were Leo Friedlander (1889–1966), who had also worked on Rockefeller Center decorations; John Gregory (1879–1958), whose work of 1937 adorns the Federal Reserve Board Building; and Hermon Atkins Mac-Neil (1866–1947), represented by the pediment of 1935 for the Supreme Court Building. Carl Paul Jennewein's (1890–1978) reliefs were placed on the Justice Department Building in 1934–5, and James Earle Fraser (1876–1953) created the pedimental group for the Department of Commerce in 1934.

Meanwhile, other avenues of expression were being explored. Around the turn of the century, several Americans came under the spell of the great French Romantic-Realist Auguste Rodin. A few, such as Malvina Hoffman (1887–1966), actually studied in Rodin's studio, with a noticeable influence on their work. However, no permanent Rodinesque movement was ever established in the United States: If Americans wanted realism in their sculpture, they did not want it romanticized. The Realist movement, on the other hand, paralleled the urban and social commentary so often found in the paintings by the Ashcan school.

SOCIAL REALISM

While the social-realist sculptors never really came together as a school, their work had certain characteristics in common. They tended to work on a small scale in bronze; their surfaces were often rough, lacking finish and refinement; and they took their themes from the real, everyday streetlife they observed around them, just as Robert Henri had advised his painting students to do. The two best representatives of this group are Mahonri Young and Abastenia St. Leger Eberle.

Mahonri Young (1877–1957), grandson of the Mormon leader Brigham Young, started modeling little figures in clay while still a child in Utah. After studying briefly in New York City, he went to Paris. The Beaux-Arts style held little appeal for Young. He was drawn more to Barbizon paintings

of peasants, or to the sculptures by the Belgian Constantin Emile Meunier, who was among the earliest to treat the oppressed masses as legitimate subject matter, in a realistic style. Young was probably also aware of the social and labor-related works by Jules Dalou.

Young achieved early success with similar works, such as *The Stevedore* (Fig. 32.3). A laborer is bearing a burden so heavy that his whole body bends as he trudges up the gangplank. He is faceless, for he is meant to represent all who toil. The modeling, surface, and finish are intentionally coarse to achieve the effect of bold strength. When *The Stevedore* was exhibited at the National Academy of Design in 1911 it was awarded a medal—although it clearly broke with the rarefied and often élitist themes that the Academy usually preferred. Other small statuettes by Young reveal a persistent theme—*The Shoveler, Man Tired, Man with a Pick,* and *Man with a Wheelbarrow,* for example. After a trip

32.4 Abastenia St. Leger Eberle, *You Dare Touch My Child,* c. 1915. Bronze, height 11½in (29.2cm). Corcoran Gallery of Art, Washington, D.C.

32.3 Mahonri Young, *The Stevedore,* 1904. Bronze, height 16in (40.6cm). Metropolitan Museum of Art, New York City.

through the American West, Young took up the Native American as his subject matter. In the 1920s and 1930s he produced several pugilistic figures, such as *Groggy* and *The Knockdown,* which parallel George Bellows's paintings of fighters (see p. 432).

The genre pieces of Abastenia St. Leger Eberle (1878–1942) are in marked contrast to the wholesome, innocent group by Bessie Potter Vonnoh, seen in Figure 26.22. The social realism and the scathing criticism of social evils that beset America are what make the difference.

Eberle was born in Iowa, grew up in Ohio, and in 1899 moved to New York City to study at the Art Students League. She traveled to Italy in 1907 and visited Paris in 1913. Upon her return to New York City, she established her studio in the Lower East Side.

The tenor of Eberle's art was set forth in the piece she exhibited at the Armory Show in 1913. *White Slave* (un-located) represents a nude young girl, barely past puberty, being auctioned off by a callous older man who is indifferent to the shame and fear expressed in her cowering figure. But who was there to collect such work as *White Slave,* or the wrathful mother ferociously shaking her fist in *You Dare Touch My Child* (Fig. 32.4)? Rich in modeling and highly expressive of a deep social consciousness, the latter piece is today judged a success—but in 1915 there was no market for art that was also a social indictment.

Eberle turned a room of her Bowery studio into a play-room for the children of the neighborhood so she could observe them as subjects. Some of her best work resulted from this, but by 1919 she had developed a serious illness, and her creative career was over.

Jo Davidson (1883–1952) was raised in Manhattan's Lower East Side but sought his subject matter elsewhere, becoming known primarily as a portraitist. By chance, young Davidson's youthful drawings were seen by the director of the Yale University Art School, and he was invited to attend classes free of charge. There he discovered a natural penchant for modeling. In 1907 he went to Paris to study, but lasted only three weeks at the Ecole des Beaux-Arts. He met Gertrude Vanderbilt Whitney, a wealthy patron who was herself a sculptor. Whitney became Davidson's patron, allowing him to seek his own naturalistic style, independent of the classical mode taught at the Ecole.

As a portraitist of celebrities, success came quickly to Davidson. His subjects included the diplomats who concluded the Treaty of Versailles after World War I, President Woodrow Wilson, and Davidson's close friend in Paris, Gertrude Stein (Fig. **32.5**). Here, Davidson captured the characteristic mass of his subject in a familiar posture, but his naturalism, as in other portraits, is blended with a bold, sculptural form and a lively surface. These abstract qualities made Davidson's work appealing to modernists, despite the basically naturalistic style in which he worked.

32.5 Jo Davidson, *Gertrude Stein*, 1920. Bronze, 31¼ × 24¼ × 24¼in (79.4 × 61.6 × 61.6cm). Collection, Whitney Museum of American Art, New York City.

THE RISE OF MODERNISM

Many young Americans went to France to study sculpture in the years before World War I—and many of them were soon caught up in the excitement of the artistic experiments of the avant garde.

Picasso and Matisse were experimenting with abstraction in sculpture as well as in painting. Startling innovations were being created by Constantin Brancusi (1876–1957), who had arrived in Paris in 1904 from his native Romania. By 1915, he had created and exhibited such milestones of modern sculpture as *The Kiss*, *Mlle. Pogany*, *The Newborn*, and *Sleeping Muse*. Brancusi had five sculptures in the Armory Show in 1913. The next year, a oneperson exhibition of his work was arranged by Edward Steichen at the 291 gallery. By 1913, Marcel Duchamp, who was still in Paris, had already collected the first of his "readymade" works of art (see p. 461).

Many a young American who went to Paris to study at the Ecole des Beaux-Arts was drawn away by the avant-garde impulse. But as with painting, modernism in sculpture was also introduced into America through Europeans fleeing the devastations of war.

EUROPEAN INFLUENCES

Elie Nadelman (1882–1946) was born in Warsaw, at the time a part of Russian Poland. By 1904 he was in Paris, and when the Cubist revolution burst upon the scene a few years later he was already a part of the avant garde. Nadelman independently began experimenting with three-dimensional form in abstractions of the human head and body, in drawings that can best be described as proto-Cubist. In fact, Nadelman claimed that it was when Leo Stein brought Picasso to his studio in 1908 that Picasso first perceived the implications of Cubism for sculpture.

Although Picasso had by then painted *Les Demoiselles d'Avignon* (1907), the story demonstrates Nadelman's position near the forefront of modernism. His *Standing Female Nude* reveals his interest in the reshaping of natural forms and the counterplay of the convexities and concavities of sculptural forms (Fig. **32.6**). Here, the creation of rhythmic masses and contours assumes greater importance than naturalism.

With the outbreak of world war, Nadelman left Europe for America where, in 1915, he held a oneperson exhibition of his work at Stieglitz's 291 gallery. Quickly becoming a part of the avant-garde scene, he attracted the patronage of Helena Rubenstein, who began placing his art in her beauty salons around the country. His earlier Cubist tendencies were replaced by a fascination with the simplicity, gentle humor, and abstract form of folk art, and his own sculptures—representing dancers, circus figures, socialites—clearly drew their inspiration from that source.

Russian-born Alexander Archipenko (1887–1964) arrived in Paris from Kiev in 1908. He joined the newly born Cubist movement and began to exhibit with the avant garde at the

32.6 Elie Nadelman, *Standing Female Nude*, c. 1909. Bronze, 21¾ × 8⅝ × 7¼in (55.2 × 21.9 × 18.4cm) including base. Collection, The Museum of Modern Art, New York. Aristide Maillol Fund.

32.7 Alexander Archipenko, *Woman Combing her Hair*, 1915. Bronze, 13¾ × 3¼ × 3⅛in (34.9 × 8.3 ×7.9cm) including base. Collection, The Museum of Modern Art, New York. Acquired through the Lillie P. Bliss Bequest.

Salon des Artistes Indépendants and the Salon d'Automne. In the abstracting and reordering of natural form as planes and masses, *Woman Combing her Hair* (Fig. 32.7) is typical of Archipenko's Cubist treatment of the human figure. In opening up the mass of sculptural form with a void in the place of the head, Archipenko was acclaimed as offering a new concept in terms of mass-space relationships.

Although Archipenko's art had been known in the United States since the Armory Show in 1913, he did not arrive until 1923. He opened a successful art school in New York City, taught in the art departments of a number of American universities, and held many oneperson shows from coast to coast, all of which contributed greatly to the growth of modernism.

As we have seen in our discussion of him as a painter (see p. 452), Max Weber was also foreign-born. He was brought to America from his native Russia at age ten, and he became a member of the avant garde only after returning to Europe in 1905.

Weber began making sculptures around 1910, some of which show a familiarity with African and other types of primitive art, which were then being discovered by the Parisian art world. His *Spiral Rhythm* of 1915—one of the earliest pieces by an American to treat form nonobjectively—reveals aspects of both Cubism and Futurism. *Spiral Rhythm* is pure form, taking an important step beyond the abstraction of natural form (Fig. 32.8).

Many of Weber's sculptures were also based on the human figure, albeit with great distortion. Weber declared he found distortion both poetic and thrilling. Such pronouncements, of course, drew the fire of the old guard academicians, who saw only anarchy in such an aesthetic credo. To declare an African figurine to be as inspirational as a classical Greek figure or to present a nonobjective form—

representing nothing more than form itself—for exhibition was too much for the patrons of traditional taste to bear, and a bitter war of words ensued.

In the years before the war, the ranks of the avant garde in Paris were enlarged by a number of native-born American sculptors. John Storrs (1885–1956) grew up in Chicago but spent much of his adult life in Europe. By 1913 he was a favored pupil in Rodin's studio, but soon after he rejected the romantic realism of Rodin's art, turning instead to Cubism. Before 1920 he was creating works whose titles indicate his concern with abstract, even nonobjective, three-dimensional form, for example, *Abstract Forms No. 2* (University of North Carolina, Greensboro) and *[Stone] Panel with Black Marble Inlay* (MOMA, New York). Storrs's Cubist work is seen in a piece titled *Gendarme Seated* of 1925. Of even greater innovation is the carved stone pillar called *Forms in Space No. 1* (Fig. 32.9). This has an architectonic quality about it, and Storrs in fact is credited with developing a geometric nonobjective form of the Art Deco style in sculpture. In similar pieces he would frequently work other materials—glass, colored metal, stainless steel—into the geometric patterns of the sculpture's surface.

32.8 Max Weber, *Spiral Rhythm*, 1915. Bronze, 24⅛ × 14¼ × 14⅞in (61.1 × 36.1 × 37.6cm). Hirshhorn Museum and Sculpture Garden, Smithsonian Institution, Washington, D.C.

32.9 John Storrs, *Forms in Space No. 1*, c. 1924. Marble, 76¾ × 12⅝ × 8⅝in (194.9 × 32.1 × 21.9cm). Collection, Whitney Museum of American Art, New York City.

DADA AND SURREALISM

Dadaism, just like Cubism, had its adherents among the vanguard of American sculptors. Marcel Duchamp, the pivotal figure in Dada art, had sent shock waves throughout the art world when in 1917 he took an industrially produced urinal, labeled it *Fountain*, and sent it to the jury-free exhibition of the Society of Independent Artists (see p. 461). Duchamp's intentions in doing this were to mock the grand traditions of "high art" and to demonstrate that expressive, meaningful form may be found in the commonplace objects of daily life. Man Ray was probably his closest American follower.

Duchamp's influence may be seen in Ray's *New York, 17*, which has a common clamp holding together several strips that make oblique reference to a skyscraper form, but, typically Dada, tilted at a most unarchitectural angle (Fig. 32.10). The world of popular culture (the clamp) has been merged with the modernist's fascination with shiny, streamlined, metallic things and the dynamics of skyscrapers, in a topsyturvy, mocking, Dada manner.

32.11 Morton Schamberg, *God*, c. 1918. Miter box and plumbing trap, height 10½in (26.7cm). Philadelphia Museum of Art.

32.10 Man Ray, *New York, 17*, 1966, after the original of 1917. Chromeplated bronze and brass painted, 17⅜ × 9¼ × 9¼in (44.1 × 23.5 × 23.4cm). Hirshhorn Museum and Sculpture Garden, Smithsonian Institution, Washington, D.C.

Philadelphia-born Morton Schamberg (1881–1918) seemed headed for a traditional sort of career, attending the University of Pennsylvania, where he received his degree in architecture, before studying painting at the Pennsylvania Academy. In Paris in 1906, however, he discovered the forces that were on the threshhold of modernism. In the company of his good friend Charles Sheeler, Schamberg was converted to the avant garde. Back in New York City, he was a frequent visitor to the Arensbergs' apartment (see p. 460) where he met Duchamp and Picabia.

Like Sheeler, Schamberg was at the time painting Precisionist pictures that reflected the machine age. These elements come together in one of the few sculptures he made—an arrangement of lead pipe in the form of the plumbing trap found under every sink, which, in deliberate heresy, he called *God* (Fig. 32.11). Its base, or "pedestal," is a common wooden miter box. Schamberg's *God* was acquired by the Arensbergs. It must have been an amusing conversation piece at their perpetual salon, admired for its Dadaist irreverence to both artistic and religious traditions. Tragically, Schamberg died soon after its creation.

In the 1920s and 1930s, Dada underwent a metamorphosis and emerged as Surrealism. The French poet André Breton (1896–1966) issued a Freudian-influenced surrealist manifesto in 1924, declaring the movement to be "based on the belief in the superior reality of certain forms of association . . . , in the omnipotence of the dream, and in the disinterested play of thought."[1] This led to a kind of free-association sculpture that was often suggestive of anthropomorphic form, and needed no further justification than its creation as a result of a freeflowing stream of consciousness. To its followers, this seemed more real than reality, hence the name "surrealism," or "beyond reality."

32.12 David Smith, *Interior*, 1937. Wrought steel with cast-iron spheres, 15½ × 26 × 6in (39.5 × 66 ×15cm). Weatherspoon Gallery, Greensboro, North Carolina.

In the 1930s, a few American sculptors were influenced by European Surrealists such as Alberto Giacometti, Max Ernst, and Francis Picabia. David Smith (see p. 591), for example, worked for a while in the surrealist style, creating works such as *Interior* (Fig. 32.12). The influence of Ernst and Giacometti is evident here, especially in the anthropomorphic character of the forms. The viewer need not understand the imagery—the sculptor merely allowed the forms to flow as it were subconsciously, without necessarily comprehending the meaning himself.

The seeds of Surrealism that were sewn in the 1930s were to bear a rich harvest in the postwar era of the late 1940s and the 1950s, as we shall see.

CALDER'S WIRE CONSTRUCTIONS

Alexander Calder (1898–1976) provided yet another dimension to modernism, and one of the most original and enduring contributions made by an American to the avantgarde movement. The son of a successful academic sculptor, Alexander Stirling Calder, and the grandson of Alexander Milne Calder, who did the sculptures for Philadelphia City Hall, Calder had his first training in mechanical engineering at the Stevens Institute of Technology in Hoboken, New Jersey. His desire to become an artist led him to the Art Students League and then to Paris in 1926, where he began to create little images of circus figures and animals out of wire and other materials, mostly for his own amusement. The result was the famous Calder Circus (Whitney Museum of American Art, New York City). Amusing as these miniature acrobats, clowns, and elephants were, they were also instrumental in setting Calder upon a course that led directly to a new and highly significant artform.

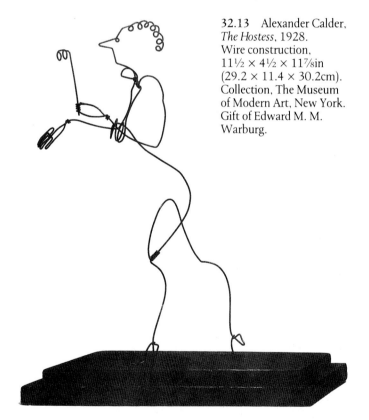

32.13 Alexander Calder, *The Hostess*, 1928. Wire construction, 11½ × 4½ × 11⅞in (29.2 × 11.4 × 30.2cm). Collection, The Museum of Modern Art, New York. Gift of Edward M. M. Warburg.

By the late 1920s, Calder had begun to make sculptures by means of wire lines traveling through space, as in *The Hostess*, which typically incorporates Calder's wit and ability as a caricaturist (Fig. 32.13). Since the days when Egyptian pharaohs had their portraits carved in eternal stone, sculpture had been conceived as three-dimensional mass. Five

32.14 Alexander Calder, *Construction*, 1932. Wood and metal, height 30in (76.2cm). Philadelphia Museum of Art.

thousand years later, Calder broke with that tradition when he made sculpture by tracing a line through space. Moreover, Calder's *Hostess* was not created with the sculptor's traditional tools—mallet, chisel, modeling instrument, and so on—but with tools from a machineshop—wirecutters, welding iron, and pliers.

The use of wire was fundamental to the development of that highly original form of sculpture which comes to mind at the very mention of Calder's name—the **mobile**. In the 1930s, planes of color were added to the wire lines, and the sculpture underwent a transformation from abstract to nonobjective form. Calder was in France much of that decade and was clearly affected by the art of avant-garde European artists. His preference for planes of primary colors was influenced by paintings by Piet Mondrian (1872–1944), while his forms suggest a familiarity with the freeform shapes used by Jean Arp (1887–1966) and Joan Miró (1893–1983), Surrealist painters. He was also well aware of sculptures by the Russian Constructivists Naum Gabo (1890–1977) and Antoine Pevsner (1886–1962).

Calder, however, copied none of these, but created out of that milieu and his own innate genius a very personal style. As early as 1932 he was making pieces such as *Construction*, with brightly colored circular motifs—two planes and one ball—suspended in space by wire, with a large circle painted on the background support (Fig. 32.14). In this work, Calder was still thinking in terms of a framed picture, but by the end of the 1930s his wire-and-plane

constructions had left the pictureframe to stand or hang in their own space. Calder liked the idea of the movement that resulted from the limberness of wire: even the term "mobile" implies motion.

In its search for responses to real life in the early twentieth century, American sculpture, like architecture, took note of the machine age and, particularly in the 1930s, tried to assimilate some of its qualities into sculptural form. Streamlined trains and airplanes with sleek, glistening metallic surfaces, machinemade objects, the fascination with spaceships and rayguns, the use of new materials like plastics, or the new treatment of old materials such as glass—all were noticed by sculptors. A good example is *Airport Structure* by Theodore Roszak, which many felt was more a homage to machinery than to art (Fig. 32.15). In its own way it proclaims the presence of a machine age. Its ancestry lies more in turbines, manifolds, and rockerarms than in the sculpture of Michelangelo, Bernini, or Rodin.

32.15 Theodore Roszak, *Airport Structure*, 1932. Copper, aluminum, steel, brass, height 23in (58.4cm). Newark Museum, Newark, New Jersey.

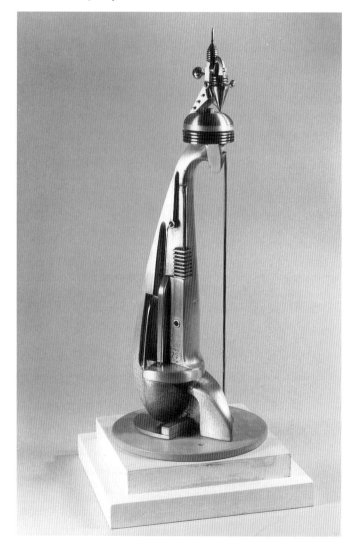

LACHAISE AND ROBUS

As it unfolded between the two world wars the modern movement took many forms in America. Most Americans preferred abstraction to nonobjectivity. For the sculptors discussed below, nature was the inspiration, even though naturalism was not their style. The diversity of experiments with abstract sculptural form is particularly well demonstrated in the art of Gaston Lachaise and Hugo Robus.

Lachaise (1882–1935) had one all-consuming passion to express in sculptural form—woman, both in the universal sense and as a portrait of the great love of his life, Isabel. Born in France, Lachaise entered the Ecole des Beaux-Arts in 1898. His early work was quite conventional. About that time he met and fell in love with Mrs. Isabel Dutaud Nagle of Boston. When she returned to America, Lachaise soon followed, arriving in Boston in 1906. To earn his living he moved to New York City, where he became a studio assistant to Paul Manship and a portrait sculptor.

As early as 1910 Lachaise was absorbed with modeling the female form. This he did on a small scale but with great monumentality. Over the next couple of decades a voluptuous, Amazonian form evolved, inspired by his beloved Isabel. The female figure became abstracted by the emphasizing of enormous breasts, hips, and buttocks, accentuated by a narrow waist, but with a grand, even regal, carriage throughout the figure.

This form reached its maturity by 1927 and may be seen in Figure 32.16. Cast in bronze and towering well over 7 feet (2.2 m) in height, the image is Venus, the Great Earth Mother, and Isabel, all rolled into one archetypal Lachaise vision of woman. In later years, he became increasingly absorbed with female breasts and the vulvar area, abstracting them to the point of startling exaggeration.

Hugo Robus (1885–1964) also took the female figure as his primary subject, but with less emphasis on anatomical exaggeration and a greater tendency toward simplification and streamlining of forms into flowing, often serpentine volumes and contours. Born and raised in Cleveland, Robus was first trained as a jewelry craftsman before studying at the Cleveland School of Art. Moving to New York City, he attended the painting classes of the National Academy of Design, but spent the years 1912–14 in Paris. While there, he joined a sculpture course given by Antoine Bourdelle, a follower of Rodin, in order to learn about form. In 1915, following the outbreak of war, Robus returned to New York City and continued to paint in a modern idiom that was influenced by both Cubism and Futurism.

In 1920 Robus turned to sculpture, but worked in isolation from the quickening mainstream of avant-garde American artists. *Woman Combing her Hair* (Fig. 32.17) is typical in its smooth surfaces and refinement of detail, which alert us to the fact that the sculptor was a jewelry craftsman at the time of its creation—he supported his family by working precious metals, making everything from jewelry to table settings. In Figure 32.17 the treatment

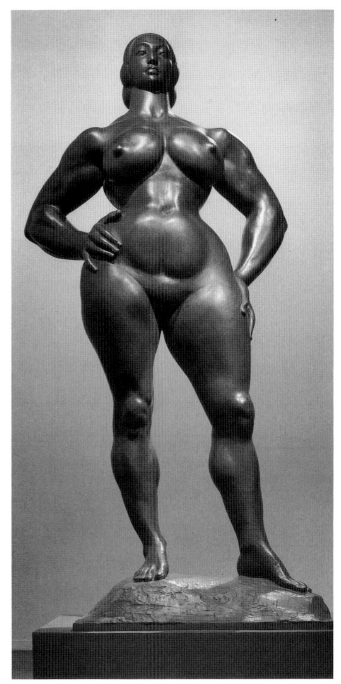

32.16 Gaston Lachaise, *Standing Woman*, 1932. Bronze (cast 1932), 88 × 41⅛ × 19⅛in (223.5 × 104.5 ×48.6cm). Collection, The Museum of Modern Art, New York. Mrs. Simon Guggenheim Fund.

32.17 Hugo Robus, *Woman Combing her Hair*, modeled 1927, cast c. 1958. Bronze, height 16in (40.6cm). Corcoran Gallery of Art, Washington, D.C.

of form as volume is independent of anatomical correctness. The curving contours and simplification of natural form indicate a true comprehension of the theory of abstraction.

By the mid-1930s, Robus had struck his mature style with such pieces as *Girl Washing her Hair*, created in 1933 and acquired by MOMA in 1939. But his work was virtually unknown until the late 1930s, and most of it remained in plaster until after his "discovery" around 1940.

DIRECT CARVING

With Robert Laurent and William Zorach, **direct carving** enters into the story of modern American sculpture. Direct carving—in which the sculptors themselves carve stone or wood with mallet and chisel—must be recognized as something more than just a technique. Implicit in it is an aesthetic principle as well: That the medium has certain qualities of beauty and expressiveness with which the sculptor must bring his or her own aesthetic sensibility into harmony. For example, sometimes the shape or veining in a piece of stone or wood suggest, perhaps even dictate, not only the ultimate form, but even the subject matter. A kind of spiritual unity occurs between the artist and the material being worked.

The technique of direct carving was a break with the nineteenth-century tradition in which the making of the clay model was considered the creative act, and the work was then turned over to studio assistants to be cast in plaster or bronze or carved in marble. Neoclassical sculptors seldom held a mallet or chisel in their own hands, readily conceding that the Italian artisans they employed were far better than they were at carving the finished marble.

With the turn-of-the-century Craftsman movement and the discovery of nontraditional sources of inspiration, such as wooden African figures and masks, there arose a new urge for hands-on, personal execution of art and an interaction with the medium. Even as early as the 1880s and 1890s, a nonconformist European artist such as Paul Gauguin, inspired by the primitive carvings of the South Pacific, was attempting direct carving. By the second decade of the twentieth century, Americans—Laurent and Zorach most notably—had adopted it as their primary means of working.

Born in Concarneau, France, Robert Laurent (1890–1970) was a prodigy whose talents were recognized by an American painter, Hamilton Easter Field, who took the boy to the United States where he received his education. In 1905 Laurent was sent to Paris as an apprentice to an art dealer, and in the years that followed he came to know Picasso, witnessed the birth of Cubism, and discovered primitive art and the carvings of Gauguin. During a brief period in Rome, Laurent learned the techniques of woodcarving from an Italian framemaker.

Back in New York City by 1910, Laurent began carving pieces such as *Negress* (or *Priestess*), which reveals his fascination with primitive art (Fig. 32.18). African, Pre-Columbian, and South Pacific art had only recently been discovered as "art," and Laurent's sculpture is among the first to show its influence.

Taking a walnut plank, the sculptor carved the expressive, stylized design. It is one of the earliest examples of direct carving in American sculpture. The plank's form dictated the rigidly frontal view and the low relief. Even its irregular shape must have appealed to Laurent as a break with a longstanding tradition that required a sculptor or painter to work within a perfect rectangle or square.

Laurent went daily to the Armory Show, which was held the same year he created *Negress*. His own work came to the attention of the art world in 1915 when an exhibition of his woodcarvings was held in New York City. Although he frequently came close to nonobjectivity, he was never inclined to pursue it, preferring instead the abstraction of natural form.

In the 1920s and 1930s, Laurent worked also in stone. His *Seated Nude* (Pennsylvania Academy of the Fine Arts) of 1940 is of alabaster. In its compactness and largeness of forms, one recognizes the sculptor's respect for his material. There is a similar feeling about Egyptian and Inuit sculpture. Again we find a modernist more closely related to some new source of inspiration than to the academic tradition.

William Zorach (1889–1966) was brought to America from his native Lithuania when he was three years old and grew up in Ohio. After attending the Cleveland School of Art, he studied painting briefly in New York City. It was after Zorach arrived in France in 1910 that the future of his art was determined. In Paris he met his future wife,

32.18 Robert Laurent, *The Negress* or *The Priestess*, 1913. Walnut, height 3ft 4in (1.02m). Private collection.

Marguerite Thompson, who introduced him to the exciting new experiments of the avant garde and to the artists who were forging its several movements. Zorach was still at that time a painter, and his canvases of those years reveal his discovery of the Post-Impressionists, Cubists, and Fauves.

The break with the academic tradition was made well before Zorach ever thought of becoming a sculptor. That did not happen, in fact, until about 1917, when he carved a relief titled *Waterfall* (private collection) as a pendant to a piece carved by his wife. An example of direct carving, there were virtually no preparatory sketches or studies to interfere with the spontaneous act of creation. The piece is highly primitivistic, yet shows a familiarity with Cubist concerns with planes and fragmented forms.

That Zorach had a genuine interest in primitive art is demonstrated by the fact that he bought a portfolio of photographs, taken by Charles Sheeler, of Marius de Zayas's collection of African sculptures. There is a direct relationship between African wooden figurines and works by Zorach, such as that titled *Tessim* (1921, private collection).

During the 1920s Zorach turned increasingly to sculpture. His respect for his material is seen in *Child with Cat*, which is compact and stony. Zorach was obviously reluctant to cut holes in the block (Fig. **32.19**). Here is a marvelous abstraction and simplification of natural form, but there is

32.19 William Zorach, *Child with Cat*, 1926. Tennessee marble, 21¾ × 11¼ × 7½in (55.2 × 28.6 × 19.1cm) including base. Collection, The Museum of Modern Art, New York. Gift of Mr. and Mrs. Sam A. Lewisohn.

also the sculptor's regard for subject matter, which remained strong in Zorach's art. Zorach continued to be active through a long career into the 1960s, and his two books, *Zorach Explains Sculpture* (1947) and *Art is My Life* (1967), are most informative sources.

Other direct carvers contributed significantly to the breadth and depth of the movement. José de Creeft (1884–1982) began his study of sculpture in his native Spain but moved to Paris by 1905. Because he wanted to learn how to execute his clay and plaster models in stone himself, he worked for a French stonecutter for three years. Then, in 1915, he began carving his works directly in wood, and in stone the next year. He settled in New York City in 1929, already an established artist.

Typical of De Creeft's direct carving is *Cloud*, which has the compactness, monumental volumes (even though it is only about 14 inches—36 cm—high), stylization of natural form, unperforated mass, and interest in texture that we have come to associate with the movement (Fig. 32.20).

John B. Flannagan (1895–1942) had a special eye for recognizing natural forms in stones just as he found them—in fields, in riverbeds—and as a result tended to modify them as little as possible. The basic shape of a whale, for example, was already in his mind's eye when he found the stone that became *Jonah and the Whale* (Fig. 32.21). Flannagan altered the basic shape very little: With a few carved lines he gave further definition to the whale form and incised

32.20 José de Creeft, *The Cloud*, 1939. Greenstone, 16¾ × 12⅜ × 10in (42.5 × 31.4 × 25.4cm), base 3¾ × 10 × 10in (9.5 × 25.4 × 25.4cm). Collection, Whitney Museum of American Art, New York City.

32.21 John B. Flannagan, *Jonah and the Whale*, 1937. Cast stone, 30 × 11 × 5in (76.2 × 27.9 × 12.7cm). Virginia Museum of Fine Arts, Richmond. Gift of Curt Valentin.

32.22 Chaim Gross, *Handlebar Riders*, 1935. Lignum vitae, height 3ft 5¼in (1.05m), at base 10½ × 11½in (26.7 × 29.2cm). Collection, The Museum of Modern Art, New York. Gift of A. Conger Goodyear.

the image of Jonah in its belly. Flannagan began direct carving in wood around 1922 but switched to stone as his primary medium about five years later. There is often a touch of humor in his carvings.

Austrian-born Chaim Gross (1904–91) had settled in New York City by 1921 and he began studying at the Beaux-Arts Institute of Design, where Elie Nadelman was one of his teachers. Here we see how a first wave of European modernists influenced a second.

Gross had a natural attraction for wood, for in his childhood his father had worked for a lumber company in the Carpathian Mountains. He began carving directly in wood around 1926, and the next year he studied briefly with Robert Laurent to learn the techniques of that method.

Gross was particularly fond of acrobatic themes, as in *Handlebar Riders* (Fig. **32.22**). *Handlebar Riders* has the blockiness that characterized his early work—a kind of personalized Cubism in his treatment of planes and masses. The compactness of form already noted in pieces by other direct carvers is present here too.

Gross was always careful to bring out the grain of favored woods. As in an African figurine one can still "see" the original shape of the log from which the piece was carved, reflecting a respect for the inherent shape and qualities of the medium.

AFRICAN-AMERICAN SCULPTORS

Many African-American sculptors came into prominence between the two world wars. Sargent Claude Johnson (1887–1967) was born in Boston, but grew up in San Francisco where he would live the rest of his life. There he attended the avant-garde A. W. Best School of Art. At an early age, Johnson began exhibiting at the shows sponsored by the Harmon Foundation, where his sculpture won prizes in the late 1920s and early 1930s. In 1935, his work, along with that of Barthé and Malvin Gray Johnson, was exhibited at the Delphic Gallery in New York City, under the sponsorship of the Harmon Foundation. Johnson's work was frequently praised for its craftsmanship, but the sculptor was equally interested in African-American subject matter and in African art as a wellspring for his own creations. All of this is apparent in *Mask* (Fig. **32.23**), which calls to mind a statement by Johnson himself:

Very few artists have gone into the history of the negro in America, cutting back to the sources and origins of the life of the race in this country. It is the pure American negro I am concerned with, aiming to show the natural beauty and dignity in that characteristic lip and that characteristic hair, bearing and manner; and I wish to show that beauty not so much to the white man as to the negro himself. Unless I can interest my race, I am sunk[2]

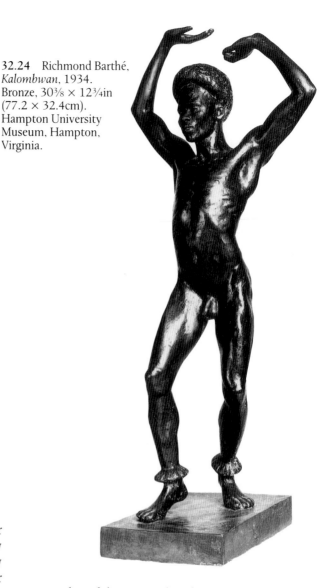

32.24 Richmond Barthé, *Kalombwan*, 1934. Bronze, 30⅜ × 12¾in (77.2 × 32.4cm). Hampton University Museum, Hampton, Virginia.

32.23 Sargent Claude Johnson, *Mask*, c. 1930–5. Copper on wood base, 15½ × 13½ × 6in (39.4 × 34.3 ×15.3cm). National Museum of American Art, Smithsonian Institution, Washington, D.C.

The poet of Harlem, Langston Hughes, voiced similar concerns when he lamented, "...we who have so few memorials to our own racial heroes in this country, so few monuments to Sojourner Truth, or Frederick Douglass, or Booker Washington or any other of the great figures in our own perilous history. Is it that we have no artists—or no pride?"[3]

Johnson's *Mask* reveals an interest in African tribal masks and wooden totem figures, which he translated into a form that became African-American. He was one of the first Americans to introduce the cultural traditions of equatorial Africa into his own art, thereby making his people aware of their own great heritage.

Richmond Barthé (1901–89), like many black Americans of his era, left the South for the North. He moved from his native Bay St. Louis, Mississippi, in 1924 to go to Chicago, where he attended the school of the Art Institute. Barthé's work twice earned him the prestigious Rosenwald Prize. This allowed him to go to New York City where his sculptures were exhibited regularly at the Harmon Foundation, the Delphic Studios, and the Metropolitan Museum of Art. They were also shown at the Pennsylvania Academy in Philadelphia. Barthé's work was the first by an African-American to be acquired for the permanent collection of the Whitney Museum. His success continued when he was awarded a Guggenheim Fellowship in 1940. Five years later, sponsored by the sculptor Malvina Hoffman, he was elected a member of the National Sculpture Society.

Barthé disliked abstraction. As he himself said, he sought God in every subject he modeled, and he could not find God in squares and triangles. His genre figures usually treated the African-American experience, and he became especially wellknown for his bronze dancers, such as *Kalombwan* (Fig. **32.24**). This piece evokes the movements of both African tribal rhythms and modern dance of the 1930s. The figure is beautifully and vigorously modeled. Barthé usually used himself as model, posing before a full-length mirror.

There were a number of other black sculptors of this period—for example, Nancy Elizabeth Prophet (1890–1960), Leslie Garland Bolling (1898–1955), William Ellisworth Artis (1914–77), Elizabeth Catlett (b. 1919), and Augusta Savage (1892–1926).

By the time war broke out in Europe in 1939, modernism had a sufficient membership in America among artists, collectors, curators, critics, and gallery dealers to declare that victory over the academic tradition had been won—although by no means did that tradition fade away. That year marks a watershed. A new chapter in the story of modern art began after peace was achieved in 1945.

PART 6

Postwar Modern, Postmodern Art

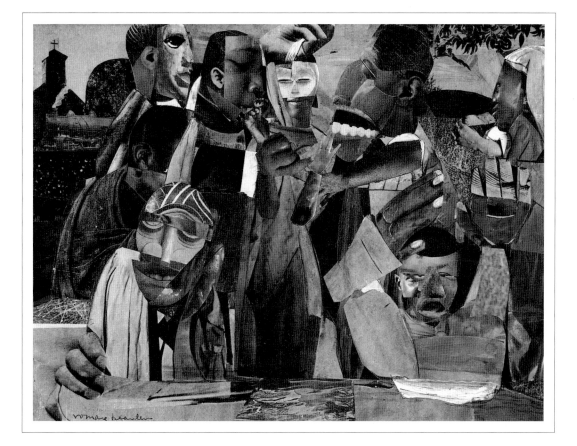

ARCHITECTURE:

THE INTERNATIONAL STYLE
AND THE "GLASS BOX,"
1940 TO THE PRESENT

The first half of the 1940s was devoured by World War II, which ended with the explosion of atomic bombs at Hiroshima and Nagasaki. The threat of nuclear holocaust became a part of life for in the aftermath of the world war of the 1940s came the Cold War of the 1950s. This was also a period of unbridled consumerism when Americans released a previously contained passion for material goods and the things they could not afford during the Depression and could not get during the war years. That consumerism had its impact on the arts is nowhere more apparent than in the rise of popular culture in the 1960s.

The 1960s were especially troubled years. The whole nation was affected by the assassinations of President John Kennedy and his brother Robert, the murders of civil rights leader Reverend Martin Luther King and the black Nationalist leader Malcolm X. There was the Cuban Missile Crisis of 1962, then the Vietnam War.

Social unrest was expressed by the burning of the Watts section of Los Angeles. Nationally, dissent centered around the issues of desegregation and the bussing of school children. There were the Youth Revolution, the Drug Culture, and the Sexual Revolution, expressed through the first great rock festival at Woodstock. On the nightly news, viewers saw the burning of the American flag, draft cards, and bras. And the 1960s rock 'n' roll of Elvis Presley and the Beatles turned to acid rock in the 1970s. Artists, of course, were witness to all of this—indeed, they were frequently participants.

The 1970s were a reaction to the turmoil of the preceding decade, which seemed to have drained the nation's energy. But the country was soon jolted by Watergate, and the first-ever resignation of a president of the United States, Richard M. Nixon. There was also the growth of the women's movement, which demanded a rethinking of the relationship between men and women on all levels.

The 1980s opened with the election of Ronald Reagan as president, promising a strengthening of the nation's military prowess and a return to what a "silent majority" held to be the fundamentals of American society. Reagan aroused a deep feeling for patriotism that had long been dormant. The thaw in East-West relations finally came after Mikhail Gorbachev became premier of the Soviet Union, and the world watched as the Berlin Wall was torn down.

The increase in corporate power and the assertiveness of popular culture were bound to be reflected in art and architecture. In popular culture the antihero had long since replaced the American hero, and America in general heaped greater rewards on rock stars—such as Mick Jagger and the Rolling Stones and Michael Jackson—and sports figures than on purveyors of high culture. There again were the artists, observing, participating, and expressing in their art what America had become. We now return to the beginning of the era and to the story of postwar American architecture.

THE POSTWAR BOOM AND THE AMERICAN DREAM

When we left off in the late 1930s, the federal government was sponsoring much of the building that was going on, and a kind of "Federal Depression" style had emerged (see chapter 27). Under government patronage, few adventurous forays were made into modernism. The corporations were not in a fiscal position to expand, so no new buildings were required, and most Americans did not have the money to buy new houses. With the war, architects were employed to design factories for the war effort, not beautiful houses or imposing commercial structures. The war was therefore a break in the cultural pattern which set the stage for new beginnings.

Suddenly, the war was over and the boom began. America entered an era of consumerism such as it had never known. Commerce and industry exploded into a period of frantic conversion to peacetime needs and corporate expansion to meet those needs.

Veterans came back from the war by the millions, eager to get on with their lives. It was time to start a family, buy a house, a car, and a refrigerator. Nearly all appliances were

either worn out or outdated, and hence the great consumer boom that created the jobs needed to pay for all the stuff, which sent industry into a whirlwind of action. The great American Dream was coming true at last—and architecture became one of its foremost symbols.

THE BIRTH OF SUBURBIA

The response to the need came early in the form of affordable, single-unit housing. Levittown, in Nausau County, Long Island, emerged as one of the cultural phenomena of the postwar era. Between 1946 and 1951, what had been potato fields 10 miles (16 km) east of New York City were now filled with row upon row of small houses on small plots of ground, eventually numbering over 17,000 units. Suburbia was born. Here was a total community, developed by the firm of Levitt and Sons, with its own paved streets, shopping centers, schools, playgrounds, and swimming pools. Levittown was the forerunner of hundreds of other large developments across the country. If the Levittown house was small, it was also a marvel of practicality, economy, and space utilization. On one floor, it had a kitchen, living room, two bedrooms, and one bathroom, put up in assembly-line fashion. The Levittown house was the predecessor of the larger splitlevel and ranch types that came with the even greater prosperity of the late 1950s and 1960s. The curious thing is that all of these types of houses have no definable style. Some may claim a passing relationship to Colonial American, but the resemblance is remote indeed. So, we simply refer to them as "development houses," a term which conjures up an image of a type of house that is still being built today.

America fell in love with this efficient, rather nondescript dwelling, and, interestingly enough, it was preferred to the more modern designs proposed by progressive architects as affordable housing. The average American wanted the descendant of the Cape Cod cottage—perhaps because it was still associated with the fulfillment of the American Dream. Frank Lloyd Wright attempted several times to design a standardized house for moderate-income Americans, often experimenting with prefabricated structures—but even Wright's designs did not catch on, and the development house prevailed.

As admired as it was, the Levittown house also served as the nucleus around which some of the problems of postwar American society unfolded. This darker side of the Dream was illustrated in Sloan Wilson's *The Man in the Gray Flannel Suit* (1955). The novel exposes the values and ambitions of many postwar Americans, and it identifies a new class of American *bourgeoisie*. These were people who were not devoted to high culture, but to the enjoyment of a popular culture—which would be glorified in the 1960s by the Pop Art movement.

FRANK LLOYD WRIGHT

After World War II, architectural design in America was influenced by one of two main currents—either the Wright tradition, which was resumed with renewed vigor, or the International Style, brought from Europe by Walter Gropius, Marcel Breuer, Mies van der Rohe, and others of the Bauhaus group. Fundamentally different philosophies of design were involved: Wright detested the "glass boxes" of

33.1 Frank Lloyd Wright, Taliesin West, near Scottsdale, Arizona, 1938–59. Ezra Stoller/Esto.

his competitors, while one American practitioner of the Bauhaus approach mockingly referred to Wright as America's finest nineteenth-century architect.

Wright designed a great many homes in the postwar period, each continuing the tradition of his earlier "Prairie Houses"—such as the Robie House (Fig. 27.11). These made sensible use of natural, local materials and had a structure which fit organically into its environment, as in the Kaufmann House of 1937 (Fig. 27.16).

One of the most interesting is Taliesin West, which was begun in 1938 as Wright's own winter home near Scottsdale, Arizona (Fig. 33.1). Eventually it became the quarters of his architectural school. Taliesin is a Welsh word meaning "shining brow," a reference to the placement of the house on a high rise within the 700-acre (283-ha) desert site, which was intentionally selected because it was isolated from the distractions of the outside world.

Typical of Wright houses, Taliesin seems to grow out of its desert habitat. Local stones were used, generally just as they were gathered—that is, they were not reshaped—and set in rough concrete. The effect was meant to reflect the natural coarseness of the local terrain. For the roof, rough timber beams were set at an angle that suggested the slope of nearby mountains, and canvas was stretched between the beams. The result was something like a desert camp, which it was originally.

As Wright took on additional assistants and student apprentices, the site expanded into a complex of structures. After Wright's death, in an effort to make the shrine more permanent, his followers who operated the school replaced the wooden beams with steel and the canvas with plexiglass. Within, the spaces are open and flowing in typical Wrightian pattern, and built-in furnishings are in the rectilinear design that the master preferred.

Wright received commissions for a variety of buildings, ranging from churches and synagogues to art museums to corporate structures. Soon after the war, for the S.C. Johnson Wax Company he designed the Research Tower (Fig. 33.2) adjoining the Administration Building he had designed fifteen years earlier. Simplicity characterizes the fourteen-story Research Tower. Each floor is cantilevered out from a central hollow core, which houses all stairways, elevators, and utilities. The outer portions of each floor are thus left free of these necessities, and the characteristically Wrightian flow of open space is achieved. The exterior is finished in brick and glass tubing—the latter admits light but prevents viewing through it. The starkness of the Tower's geometric form is relieved by the rounding of the corners, echoing the treatment Wright had used on the Administration Building. The Tower dominates the horizon, as if to proclaim the importance of the company for this community.

THE GUGGENHEIM MUSEUM

Wright often found his inspiration in natural objects. He claimed, for example, that the decreasing spiral of the Solomon R. Guggenheim Museum was suggested by a snail's shell (Fig. 33.3). While the first studies were made as early as 1943, the building was not completed until the late 1950s.

Like the Kaufmann House, the building is sculptural in its conception, inside and out, with bold plastic forms playing against each other. This sculptural quality is one of the characteristics that distinguishes Wright's style from the International Style, with its single planes of rectangular glass walls.

The complexity of Wright's Guggenheim Museum becomes apparent if it is compared with what came to be called the "glass box" type of structure, in Mies van der Rohe's Seagram Building or Skidmore, Owings, and Merrill's Lever House (Figs. 33.11 and 33.13).

The interior of the Guggenheim is exciting, innovative, and revolutionary in its solutions to the requirements of museum design (Fig. 33.4). Critical of the traditional square-box type of rooms in earlier museums, Wright established a long, continuous, spiraling ramp that allowed the visitor to follow without interruption the continuity of an exhibition. The center of the spiral is a large, skylit court, open from the domed top to the ground floor. It offers interesting spatial relationships when looked into, or across to the opposite side of the spiral.

The form of the building was achieved by pouring cement

33.2 Frank Lloyd Wright, S. C. Johnson Wax Research Tower, Racine, Wisconsin, 1950.

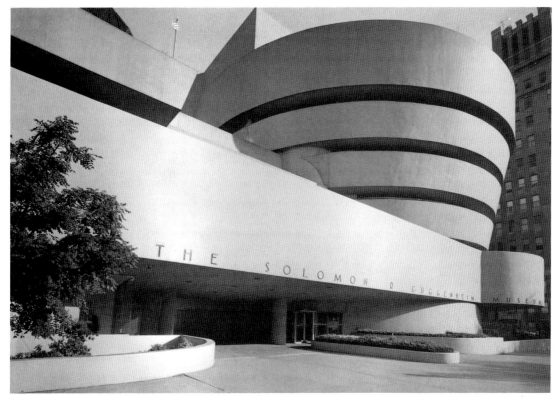

33.3 Frank Lloyd Wright, Solomon R. Guggenheim Museum, New York City, 1956–9.

33.4 Frank Lloyd Wright, Solomon R. Guggenheim Museum, New York City, 1956–9. Interior.

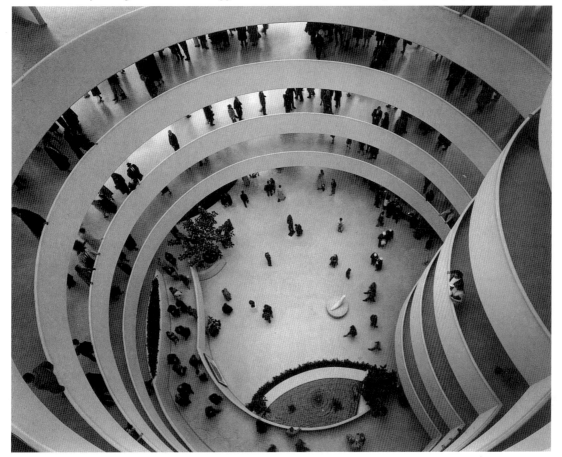

into specially constructed forms. Although Wright frequently indulged in decorative detailing in his interiors, here he did not, purposely keeping the interior free from anything that might distract from the works of art on display.

The Guggenheim is the crowning achievement of Wright's later career. There are other large and handsome projects, such as the Marin County, California, municipal complex (1957) and the Gammage Auditorium on the campus of Arizona State University in Tempe. The Guggenheim, however, was Wright's big splash in New York City. Although he disliked the city, he recognized that he should be represented there by a major monument.

Although architects of the next generation may not have followed Wright's style, many were indebted to his way of thinking through an architectural problem. He wanted his structures to be humane, not thought of as "a machine for living." At a time when much architectural design had been imported to the United States from European centers of modern art, Wright was a product of America, and so was his work.

WALTER GROPIUS: BAUHAUS DESIGN COMES TO AMERICA

The foremost conduit of Bauhaus theory and the International Style was Walter Gropius (1883–1969). While studying architecture at the technical school in his native Berlin, Gropius grew restless. He was much happier as an assistant to Peter Behrens (1868–1940), one of the pioneers of modern design in Germany. By the time Gropius set up his own practice in the years shortly before World War I, he had already begun to form ideas about massproduced housing for workers and increased production through better-designed factory environments.

His first opportunity to put these into effect came with the commission for the Fagus Factory in Alfeld, Germany, in 1911–12. This remarkable building set a new pattern for factory design and established Gropius's reputation as a leader in dealing with industry, technology, new ideas in building materials, and related social problems. Its most extraordinary feature was the introduction of the internal steel skeletal frame encapsulated by an exterior glass curtain-wall. The Fagus Factory would cast a long shadow indeed—one which eventually spanned the Atlantic.

After World War I, Gropius became increasingly active in promoting a new aesthetic that would meet the demands of the machine age. The opportunity to put his theories into practice came in 1919 when he was appointed director of the Bauhaus in Weimar—which was the capital of Germany from 1919 until the rise of Hitler in 1933.

The Bauhaus looked not to the historic past and historic

styles for inspiration, but to the future—one that included a union of art and technology and an integration of creative artistic genius with industrialized society. In this new kind of school, not only design was taught, but also industrial methods and the use of new materials, or, as in the case of glass, the use of longknown materials in new ways. Among the faculty Gropius assembled were the modern painters Paul Klee and Vassily Kandinsky, designer Làszló Moholy-Nagy, color theorist Josef Albers, and a brilliant young architect, Marcel Breuer.

The architectural style Gropius advocated at this time is seen in his competition design of 1922 for the Chicago Tribune Building. There, Gropius rejected all historicism and turned instead to technology and industrial products as the wellspring of his aesthetic theory (Fig. 27.8). Dutch modernists—the painters of the De Stijl movement and the leading architect J. J. P. Oud—were working within a similar concept of design.

The students of the Bauhaus were given problems in design that came from industry on a contract basis. Thus there arose a corps of industrial designers—gifted artists who accepted industry as an ally, not an enemy. Clean, new design was demanded, in order to break with the old, bourgeois-controlled world that the architects of the Bauhaus claimed was an exhausted social failure.

When the Bauhaus moved to Dessau in 1925, Gropius designed the studios, workshops, and dormitories. All decorative ornamentation and historical references were eliminated as the art school took on the appearance of a factory. This was indeed revolutionary and it was a milestone in the history of modern design. Gropius received a flood of commissions over the next few years. But then came the rise to power of the Nazi Party. The Nazis closed the Bauhaus, and Germany became a hostile place for modern artists and architects. Gropius left for England in 1934. Three years later he accepted the invitation to become chairman of the department of architecture at Harvard University in Cambridge, Massachusetts, which previously had been a bastion of Beaux-Arts architectural design.

33.5 Walter Gropius and Marcel Breuer, Walter Gropius House, Lincoln, Massachusetts, 1937. Photo, Damie Stillman.

Gropius quickly set about reorganizing the curriculum along the lines of the Bauhaus program. He also opened his own practice and brought Marcel Breuer over from Germany to be his partner.

Although in those Depression years there were few commissions, one landmark was the house that Gropius, with Breuer's help, designed for himself in Lincoln, Massachusetts (Fig. 33.5). Here was a new type of house, and one for which most Americans would have little liking. Its flat roof (ill-considered in view of the region's snowfalls), its stark rectilinear geometry, the use of industrial materials or parts such as **glass brick** or prefabricated wrought-iron stairway, standard metal enframements of the ribbon windows, and the steel **Lally posts** for support were all unrelated to the New England building tradition. While a few such houses were built in the area, these tended to be for a wealthy élite who already had been converted to modernism. The Gropius house, however, was too much like "a machine for living"—as the contemporary Swiss/French architect Le Corbusier would describe such a building—to be the warm, traditional place most Americans wanted to call "home." It would not be in domestic architecture that Gropius made his name in the United States.

THE ARCHITECTS' COLLABORATIVE (TAC)

In 1946 Gropius and seven colleagues formed a firm called the Architects' Collaborative (TAC) which was instrumental in establishing the International Style in America. One of the early, important commissions for the firm was the Harvard University Graduate Center of 1949–50, which offered Gropius the opportunity to work once more with the problem of mass housing (Fig. 33.6).

When TAC's design was approved, Gropius and his followers hailed the university's decision as a victory for modern architecture. Located near Harvard Yard, the plan for the graduate students' dormitories and lounges was similarly developed around open courtyards, and the use of red brick also established continuity with the older buildings of the Yard. What is different is that the roofline is flat, industrially produced parts were used, the design has a pronounced geometry, and there is virtually no decoration beyond the inherent beauty of the wood, brick, or stone. Supporting columns, made of concrete poured into a cylindrical mold, have no bases, no flutes, no capitals—in brief, there is no reference whatsoever to the classical-type column that had for so long been dominant.

The design of the Graduate Center has an appealing, clean crispness. Its use of standard industrial parts, its low cost because of the elimination of handwrought decoration, and its low maintenance costs also made its style appealing to cost-conscious boards of directors, who had final approval for corporate headquarters buildings.

The result of this was the great glass and steelframe skyscrapers that soon began to rise in New York City and elsewhere. A new look was soon to appear upon the horizon of the American city. Everything from churches and schools to municipal buildings, shopping centers, and gasoline stations was affected by the architectural concepts introduced by Gropius and his followers.

Gropius remained active within the Architects' Collaborative. He was consultant on numerous major projects, such as Emery Roth's Pan-Am Building (1963) in New York City.

33.6 The Architects' Collaborative, Harvard University Graduate Center, Cambridge, Massachusetts, 1949–50. Courtesy Harvard University Archives.

BREUER, MIES, AND THE INTERNATIONAL STYLE

Several of Gropius's European associates who followed him to the United States contributed to the breadth and variety of the International Style.

Marcel Breuer (1902–81) was born in Hungary and attended school at the Bauhaus in the early 1920s. When it moved to Dessau in 1925 he joined the Bauhaus faculty, his specialty at that time being furniture design. With the rise of the Nazis, he followed Gropius to England in 1935 and then to the United States two years later, where he joined his friend in the department of architecture at Harvard University and in a private partnership. Breuer designed a house for himself, near his mentor's home, in Lincoln, Massachusetts, in 1938–9. An extension of the Bauhaus concept of design, it clearly expresses its relationship to industry and modern technology.

Breuer's architectural style is seen in another house he built for himself in New Canaan, Connecticut (Fig. 33.7). Flat-roofed, it is a long, low, rectangular block, cantilevered over a concrete basement/foundation and sheathed in handsome natural wood, with a long, virtually uninterrupted window. A porch, repeating the rectangular pattern of the main block, is suspended from one end, supported by tension cables. In addition to the natural quality of the wood, Breuer incorporated natural stone in a low wall at one end. The interior is open and airy and commands beautiful views through the long wall of glass.

Breuer's partnership with Gropius was dissolved in 1941, and from about 1950 he received several important commissions—a dormitory for Vassar College (1950) and an Arts Center for Sarah Lawrence College (1952), for example. The most significant of all, however, which brought him international acclaim, was the United Nations Educational, Scientific, and Cultural Organization (UNESCO) headquarters in Paris, completed in 1958.

33.7 Marcel Breuer, Marcel Breuer House, New Canaan, Connecticut, 1947. Wayne Andrews/Esto.

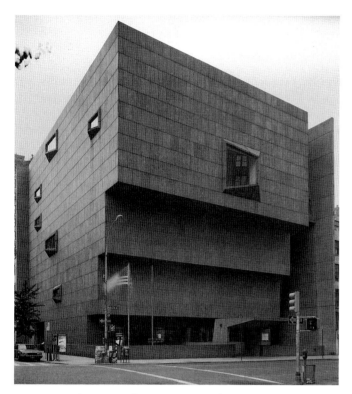

33.8 Marcel Breuer, Whitney Museum of American Art, New York City, 1964–6.

THE WHITNEY MUSEUM

During the mid-1960s Breuer was occupied with designing the Whitney Museum of American Art in New York City (Fig. 33.8). The building is stark in its massiveness, the boldness of its planes, and the sharpness of its corners. Only a rare genius such as Breuer could have given such a building the elegance the Whitney possesses. Upon the small lot— 100 by 125 feet (30 × 38 m)—the architect created an inverted ziggurat with three stories cantilevered over the one below. A covered entrance-walk carries visitors across an open moatlike sculpture court sunken below street level. The building is sheathed in standardized slabs of gray granite, the warmth and subtle modulation of their hue giving a special quality to the exterior. Broad panes of glass are used across the ground floor. The few windows for the upper levels are truncated, projecting pyramids, which relieve the starkness of the wall at just the right points. Inside, the second, third, and fourth floors are almost totally open spaces, designed to accommodate changing exhibitions rather than a large permanent collection.

Wright's Guggenheim Museum, a few blocks away, and Breuer's Whitney Museum proclaim the opening of an exciting new era in museum design. As small as the Whitney is, its boldness asserts itself among the skyscrapers surrounding it. Moreover, amid the hustle and bustle of Madison Avenue, Breuer was able to create a quiet moment of architectural dignity.

MIES VAN DER ROHE

More than any other single architect, Ludwig Mies van der Rohe (1886–1969) created the classic, archetypal International Style building in both the skyscraper and the low building.

Born in Aachen, Germany, the son of a stonemason, Mies made his way to Berlin in 1905. Two years later, he became an assistant to the noted pioneer of modern architecture and industrial design Peter Behrens. This was at a time when Behrens was designing the buildings for the Allgemeine Elektricitäts Gesellschaft (AEG), and when the structural system of the steelframe factory building was recognized as a valid basis for architectural aesthetics. The steel frame, with glass or brick infill, had been known for many decades in both Europe and America, but it had been used in structures in which aesthetics had a low priority. Now, however, architects such as Behrens, Gropius, and soon Mies were taking the structural system as a point of departure for the aesthetic foundation of modern architecture.

Mies left Behrens's office about 1912 to set up on his own. Following service in World War I he had few commissions, but his projects on paper during the 1920s were among the most progressive of their day, clearly anticipating the birth of the International Style. Through these, his mature style began to emerge: A marriage of architecture and technology, truthfulness in materials and structure, a monumental simplicity united with a classical restraint, a credo of "less is more," and a theory based in thinking about a building as "skin and bone," that is, as a skeletal frame (steel and/or concrete) with membranes of glass or brick filling between the structural parts, or encapsulating them totally. Aesthetically, Mies's ideas were very close to the geometric, rectilinear designs of the Dutch De Stijl group, and Theo van Doesburg was his closest friend.

Mies attracted much attention with his design for the German Pavilion at the International Exhibition of 1929 at Barcelona, Spain. This established the potential for a classic grace, elegance, and luxury within the aesthetics of the new architecture. The building's walls and floors of **travertine** stone, onyx, and glass, its steel supports, either highly polished or painted in bright colors, and its reflecting pools proved that the new architecture could be beautiful as well as functional.

Mies was appointed director of the Bauhaus in 1930, but then came the economic depression and the rise of Nazism, which ideologically detested the new architecture—of which Mies had become one of the recognized standard-bearers. He left Germany in 1938 to become head of the department of architecture at the Illinois Institute of Technology (IIT).

Between 1939 and 1941 Mies had developed a masterplan for the IIT campus, laid out on a modular grid system. Following World War II, he designed several buildings for the school, all of which were related by their position on the grid and by a philosophy that echoed industrial architecture, with steelframe construction and membrane walls of brick

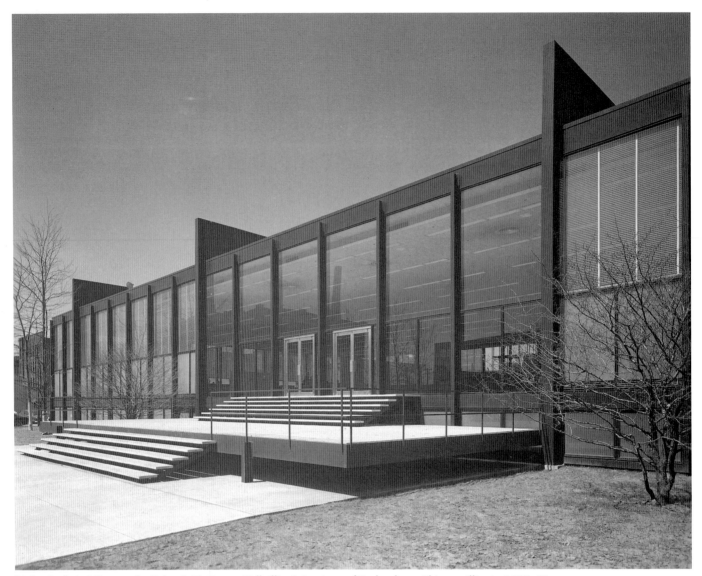

33.9 Ludwig Mies van der Rohe, S. H. Crown Hall, Illinois Institute of Technology, Chicago, Illinois, 1939–41.

or glass (Fig. 33.9). The remarkable unity, simplicity, and continuity are characteristic of Mies's work.

In Chicago, Mies felt a natural affinity with long-deceased architects who had pioneered the development of the skyscraper—men such as William Le Baron Jenney, Daniel Burnham, and Louis Sullivan. By the late 1940s, Chicago could already boast a skyline dominated by skyscrapers, although they were often embellished with historical or Art Deco decorations and belonged to the prewar era.

In the late 1940s and early 1950s, Mies created a new form of skyscraper with his design for Lake Shore Drive Apartments (Fig. 33.10). These buildings established the general form of most highrise apartment and office buildings, in Chicago especially, for the quarter-century that followed.

The Lake Shore Drive Apartments are twin towers, twenty-six stories high, in the form of rectangular blocks, with three bays on one side and five on the other. Typical of a Mies design, there is a central core for elevators, stairs, utilities, and so on, leaving the outer spaces unencumbered. The structural system is perfectly evident in the steel

skeletal frame, with glass curtain-walls in between. The ground floor, except for the central core of the entrance and elevators, is open, accentuating the piers that define the bays, and the top is absolutely flat. There is no applied decoration: Such decorative quality as exists is in the grid design of each façade and in the choice of materials—steel and glass. The modular scheme is evident throughout, each four-window bay on each floor being one module, with logical reference to interior spaces. The steel skeleton allows great flexibility in the placement of interior walls, permitting open, flowing spaces or enclosures as desired. The lobby interior recalls the elegance of the Barcelona Pavilion.

The range of Mies van der Rohe's work during the 1950s and 1960s included everything from the prototype glass house he designed for Edith Farnsworth (1945–50, Plano, Illinois), to the ultimate triumph of the "glass box" skyscraper, the Seagram Building of 1954–8 in New York City (Fig. 33.11).

Here we see a great steel skeletal slab set within its own plaza, making it freestanding and visually separate from the other buildings on Park Avenue. The pronounced modular

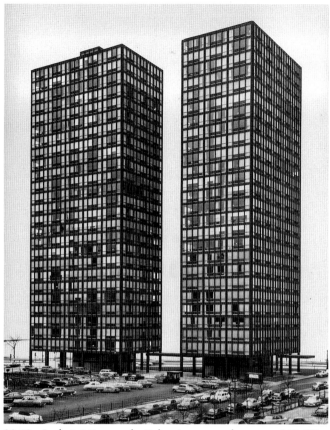

33.10 Ludwig Mies van der Rohe, Apartment houses at 860–80 North Lake Shore Drive, Chicago, Illinois, 1951.

33.11 Ludwig Mies van der Rohe, Seagram Building, New York City, 1954–8. Ezra Stoller/Esto.

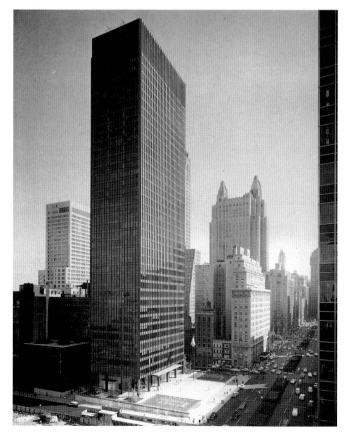

system, so evident in the Lake Shore Drive Apartments, has evolved into a delicate linearity, with a superb unity throughout the precisely defined rectangular mass. Rectangular reflecting pools are at either side of the foreplaza, and a cantilevered, rectangular plane marks the entrance. At the lower level, the piers are freestanding, giving the structure an appearance of lightness. The coloration and materials add greatly to the building: The metal surface is a bronze sheathing and the glass is tinted a dark amber hue, thus achieving an extraordinary unity of color throughout. It stands like a beautiful dark shadow among its lighter neighbors.

AMERICAN ARCHITECTS OF THE INTERNATIONAL STYLE

Mies van der Rohe, probably the most influential of all of the Europeans who brought the International Style to America, had many followers. Among the gifted American architects who took Mies's art as their point of departure and created excellent works in the same vogue were Philip Johnson and the firms of Skidmore, Owings, and Merrill and Harrison and Abramovitz.

PHILIP JOHNSON

Mies's associate in the Seagram Building project was Philip Johnson (b. 1906), one of the most successful American interpreters of the International Style, both as an architect and as an architectural critic. Johnson, who was born in Cleveland and graduated from Harvard University, became interested in the new architecture he saw as he traveled around Europe in the late 1920s. Returning to New York City and to his position as head of the architecture department at the newly established Museum of Modern Art, he, along with the architectural historian Henry Russell Hitchcock, organized a blockbuster exhibition in 1932 called "The International Style: Architecture since 1922."

The exhibition acquainted Americans with the new architecture of the International Style even before many of its best European practitioners came to the United States. Not only did Johnson and Hitchcock thereby coin the name of the movement, but they declared that there was but one style of modern architecture, that it was a cohesive movement, that it was universal in its application, that it originated with men such as Gropius, Mies, Oud, and Le Corbusier, and, finally, that the trend in American architecture represented by Frank Lloyd Wright was not a part of the modern movement. The latter point understandably created tension between Wright and Johnson.

Philip Johnson returned to Harvard to obtain a degree in architecture, which he received in 1943. His indebtedness to

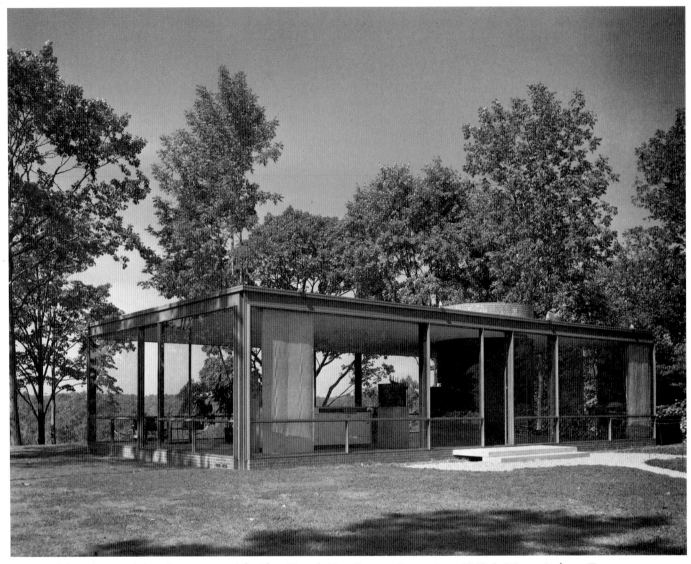

33.12 Philip Johnson, Philip Johnson House (The Glass House), New Canaan, Connecticut, 1948–9. Wayne Andrews/Esto.

Mies, who was by then in the United States, is seen in the exquisite house—the Glass House—that Johnson designed for himself (Fig. 33.12).

The concept is based on Mies's Farnsworth House of 1945–50 in Plano, Illinois. It is the earliest building by an American architect working in the International Style. Set upon a brick plinth, the steel frame—painted black—supports a flat roof which echoes perfectly the plane of the floor, while the entire wall area is of glass, with symmetrically placed doors.

Within, a brick cylinder contains the bathroom and the fireplace, but otherwise the space is open, flowing, and filled with light. The glass walls bring nature virtually within the living area. Johnson furnished the house in a style compatible with the architecture—with Mies's "Barcelona" Chairs and other furniture made of tubular steel and glass, in the elegant machinemade mode (Fig. 35.5).

In 1953 Johnson designed the sculpture garden for MOMA and eleven years later added an annex to the museum. During the 1960s he created a number of exceptionally fine art museums, among the best being the Munson-Williams-Proctor Institute (1960, Utica, New York), the Amon Carter Museum (1961) in Fort Worth, Texas, and the Sheldon Memorial Art Gallery (1963, University of Nebraska, Lincoln).

The change that was evolving in Johnson's style is already noticeable in these museums and in the New York State Theater (1964) he designed for the Lincoln Center complex (Fig. 33.16, left). Although there is still an underlying geometry controlling the design and the flat roofline prevails, there is a greater use of sculptured forms in handsome stone—as in the eight pairs of colossal columns on the travertine stone façade, or in the almost classical use of stone for the side walls. Johnson's "glass box" phase of the Glass House and the Seagram Building—as exquisite as they are—seems cold and industrial in character compared with

the richness of the sculptured stone façades of his buildings of the 1960s.

As devoted as Johnson was to the International Style, he did not feel obliged to maintain the commitment forever. His extraordinary versatility is seen in his designs for the Moses Institute, Montefiore Hospital, in New York City, and the Kline Science Center at Yale University, both of 1965. Both foreshadow the postmodern architectural style of the 1980s.

SKIDMORE, OWINGS, AND MERRILL

Very much as McKim, Mead, and White did half a century earlier, Skidmore, Owings, and Merrill presented the team approach to architectural design. The firm was organized in

33.13 Skidmore, Owings, and Merrill, Lever House, New York City, 1952. Esto.

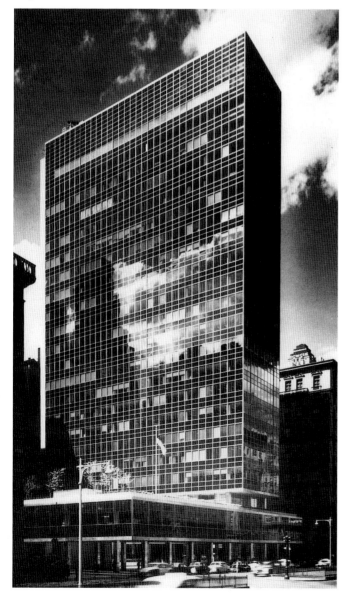

1939 when the partnership of Louis Skidmore (1897–1962) and Nathaniel Owings (1903–84) was joined by John O. Merrill (1896–1975).

In the decades following World War II, its extraordinary success allowed the firm to expand, with offices in San Francisco, Portland, Oregon, Washington, D.C., Boston, and Denver, in addition to the original prewar offices in Chicago and New York City. Following the war, the firm set its course with the International Style as the basis of its designs.

The firm first gained recognition as one of the American leaders in that style with its design for Lever House on Park Avenue in Manhattan, completed in 1952 (Fig. 33.13). Erected shortly after Mies's Lake Shore Drive Apartments, but several years before his Seagram Building, Lever House occupies a special place in the early history of the "glass box" type of structure. Only Wallace K. Harrison's United Nations Secretariat Building (1950, Fig. 33.15) predates Lever House in effecting a change in the Manhattan skyline in the new style. Gordon Bunshaft (1909–90) was the member of the firm in charge of the design. Among his other distinguished credits are the Chase Manhattan Bank (1961, New York City), Beineke Library (1963, Yale University), and the Hirshhorn Museum and Sculpture Garden (1974, Washington, D.C.).

Small as modern skyscrapers go, being only twenty-four stories high, Lever House is a rectangular glass block of steelframe construction, with green-tinted glass curtain-walls hovering above a horizontal slab placed over an open plaza. Its revolutionary design broke with tradition in a number of ways, one of the most important of which was that it was "anti-urban" in concept. That is, for well over a century, traditional architecture along Manhattan's avenues had abutted buildings to their neighbors, forming continuous rows of façades and solid blocks of buildings that were interrupted only by the grid of streets and sidewalks. In an effort to create an open, airy environment, as well as to establish the independent identity of the building, Bunshaft designed his glass tower to occupy only a portion of the total lot size. This broke the continuity of façades along Park Avenue, just as the use of the new International Style interrupted the homogeneity of the Avenue's essentially Beaux-Arts appearance. Other skyscrapers followed this precedent.

In Chicago, Skidmore, Owings, and Merrill's John Hancock Building (1966–8) rises like a truncated black obelisk to a towering height of one hundred stories. For a while it held the honor of being the tallest building in the world (Fig. 33.14). A multi-use structure, it contains 700 apartment units and 800,000 square feet (74,320 m²) of office space, as well as restaurants, health clubs, shops, swimming pool, and ice rink. The grid design is marked by diagonal exterior trusses, which carry the principal stresses in this giant of the Windy City.

Not far away stands another darktoned colossus designed by the same firm—the Sears Tower of 1974, rising to a

The list of buildings designed and erected by the firm of Skidmore, Owings, and Merrill is indeed impressive, for it includes Manufacturers Hanover Trust on New York City's Fifth Avenue (1954), Inland Steel Corporate Headquarters (1958, Chicago), and the Library and Museum of the Performing Arts, Lincoln Center, New York City (1965).

In the 1960s and 1970s the firm's philosophy of design began to ease away from the exposed metal frame with glass skin, and, as we have seen with Philip Johnson's career, moved toward sculptured stone forms, as at One Shell Plaza (1971) in Houston.

HARRISON AND ABRAMOVITZ

Another leading firm in the introduction of the new style was Harrison and Abramovitz of New York City.

Wallace K. Harrison (1895–1981), born in Worcester, Massachusetts, arrived in New York City in 1916 where he was employed by McKim, Mead, and White. In Paris, Harrison was admitted to the Ecole des Beaux-Arts, but he soon returned to McKim, Mead, and White. In the late 1920s and early 1930s he worked as a draftsman under Raymond Hood on the Rockefeller Center project.

Max Abramovitz (b. 1908) left Chicago to study for two years (1932–4) at the Ecole des Beaux-Arts in Paris before returning to New York City, where he joined in a partnership with Harrison in 1941. After the war, the firm was associated with several of the largest and most important projects of its era.

Although Beaux-Arts-trained, both men looked to a philosophy of design that was expressive of the modern age. Between 1939 and 1942 they taught at Yale University's School of Architecture, completely revamping its program from Beaux-Arts to modern. In 1939 their design for the perisphere and trylon at the World of Tomorrow Fair in New York City gave them celebrity status as avant-garde architects.

When the United Nations headquarters was established in New York City soon after World War II, Harrison, with Abramovitz as his associate and Louis Skidmore as a design consultant, was given the commission to design its permanent home (Fig. 33.15). The concept owes much to Le Corbusier. The first "glass box" to rise on the Manhattan skyline, with green glass and marble sheathing, the building was completed in 1950. The tower provides office space for the international delegations while the lower structure houses the assembly hall and meeting rooms. Although today the building hardly seems innovative or controversial, in 1950 it was new and startling, and it announced a new modern style of architecture was on the horizon.

In the 1960s Harrison and Abramovitz were very much involved in the large project of the Lincoln Center for the Performing Arts (Fig. 33.16). Robert Moses, the civic entrepreneur, had cleared eighteen square city blocks to make room for the Center. Wallace K. Harrison was named the coordinator.

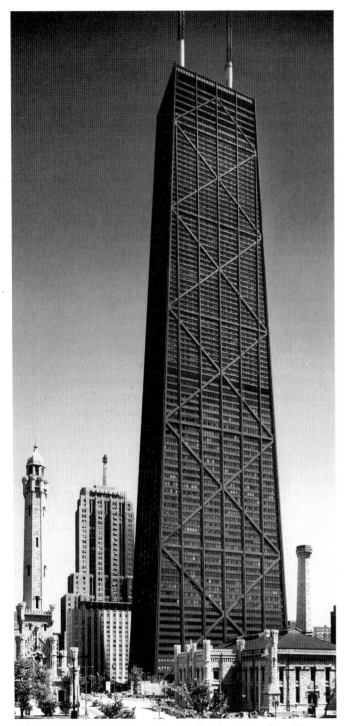

33.14 Skidmore, Owings, and Merrill, John Hancock Building, Chicago, Illinois, 1966–8. Ezra Stoller/Esto.

height of 110 stories. At 1450 feet (442 m) it is the tallest building in the world. In a city where high winds must be contended with, for necessary strength the Sears Tower is a cluster of nine interconnected sections of staggered heights. Bruce Graham (b. 1925) was the partner in charge of the design for both the Hancock and Sears buildings.

33.15 Wallace K. Harrison and Associates, United Nations Secretariat Building, New York City, 1950.

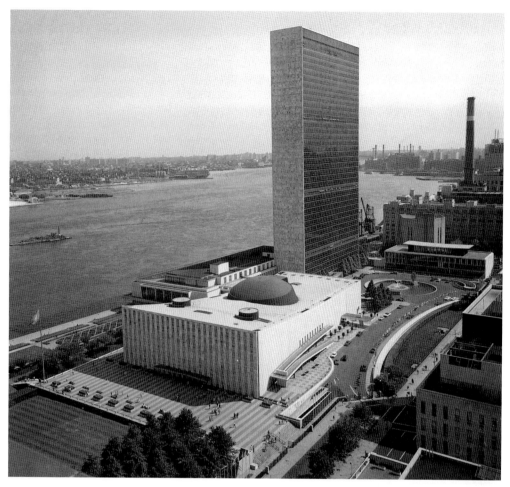

33.16 (below) Lincoln Center for the Performing Arts, New York City (left to right): Philip Johnson, New York State Theater, 1964; Wallace K. Harrison, Metropolitan Opera House, 1966; Eero Saarinen, Vivian Beaumont Theater, 1965; and Max Abramowitz, Philharmonic Hall (now Avery Fisher Hall), 1962.

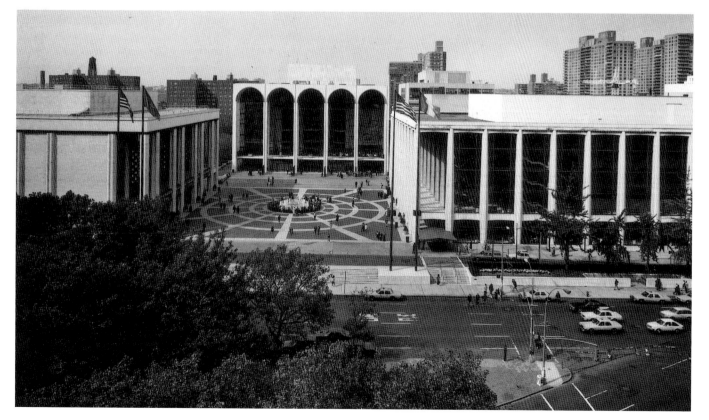

Philip Johnson designed the New York State Theater (1964), and Skidmore, Owings, and Merrill created the Library and Museum; Eero Saarinen produced the Vivian Beaumont Theater (1965); Harrison himself did the Metropolitan Opera House (1966) as the centerpiece of the complex, and Max Abramovitz designed Philharmonic Hall (1962), later renamed Avery Fisher Hall. While each of the buildings is of an independent design, they work well together, with continuity created by the use of a warm, offwhite travertine stone that is handsome and elegant.

Harrison's Opera House has a row of impressive columns along the façade, supporting arches across five large bays. Inside, there is a plush-and-gilt richness that recalls the great opera houses of Paris, Vienna, and Milan. It has a Baroque grandeur, executed in the modern mode. Just inside the Opera House, but visible from the exterior, are huge murals by Marc Chagall (1887–1985), contributing greatly to the brilliance of the building's entrance area. Abramovitz's splendid hall for the New York Philharmonic Orchestra is, like the other structures, flatroofed and rectangular, with an arrangement of colossal columns in regular cadence around the exterior.

Harrison and Abramovitz were associated with an even larger complex—the Empire State Plaza in Albany, New York. Governor Nelson A. Rockefeller's vision of a grand governmental mall (1965–79), this two-billion-dollar mall has been sharply assailed by numerous critics. One critic said its futuristic appearance looked more like something from the planet Krypton than Albany, New York, and concluded by declaring that Harrison's total design:

> ...is not so much a vision of the future as of the past. The ideas here were dead before they left the drawing board, and every design decision...emerges from an outdated notion of what modern architecture, not to mention modern government, should stand for.[1]

Clearly, the "glass box" and the International Style in general were no longer the darlings of modern art that they once were. As early as 1966, in his book *Complexity and Contradiction in Architecture*, Robert Venturi—whose work is considered in chapter 34—denounced what he saw as a sterility and austerity in the "glass box" style. Ada Louise Huxtable, long the dean of architectural critics, lashed out at Manhattan's new World Trade Center—by Minoru Yamasaki and Emery Roth and Sons (1970–7)—and the adjacent Customs House, saying that with them, "Public architecture declined and fell:"

> The new [Customs House], like the whole Trade Center group including the giant twin towers, is an exercise in design by reduction. This is partly the fault of the times, when soaring construction costs have led to cheapness by choice and necessity, and partly because of current building

systems, which substitute the technology of the neutral grid for solid, stylish stonework. But it is more the fault of the architect, who has trivialized the inherent drama of modern engineering and nullified the legitimate and powerful aesthetic that is its true effect. He has succeeded in making some of the biggest buildings in the world ordinary and inconsequential.[2]

In 1981, the popular author Tom Wolfe wrote a scathing denunciation of the International Style, devoting a whole book—*From Bauhaus to Our House*—to the subject. Wolfe places the blame for the bankrupt architectural aesthetic squarely upon the heads of Walter Gropius and his Bauhaus followers, and upon their devoted chroniclers such as Sigfried Giedion, author of *Space, Time, and Architecture* (1949), which championed the new style.

In writing about some summer homes executed in the new mode, Wolfe said that each one:

> ...has so many pipe railings, ramps, hob-tread metal spiral stairways, sheets of industrial plate glass, banks of tungsten-halogen lamps, and white cylindrical shapes, it looks like an insecticide refinery. I once saw the owners of such a place driven to the edge of sensory deprivation by the whiteness & lightness & leanness & cleanness & bareness & spareness of it all. They became desperate for...coziness & color.[3]

We will conclude with Wolfe's assurance that these are not just his feelings:

> ...one has only to go to conferences, symposia, and jury panels where the architects gather today to discuss the state of the art. They profess to be appalled with themselves. Without a blush they will tell you that modern architecture is exhausted, finished. They themselves joke about *the glass boxes*. They use the term with a snigger. Philip Johnson, who built himself a glass box house in Connecticut in 1949, utters the phrase with an antiquarian's amusement, the way someone else might talk about an old brass bedstead discovered in the attic.[4]

All of this criticism, severe as it is, does not mean that the International Style was worthless. From the postwar period to the 1970s a great many architectural masterpieces were created in that mode. More than any other trend in modern architecture, the International Style effected a complete break with the past, so that the modern era might find an architectural expression of its own. It had, and still has, many admirers.

Other avenues of architectural expression were explored contemporaneously with the International Style, and they were often related to it. We will turn to these alternatives in the following chapter, and to the reaction of the postmodern style.

ARCHITECTURE:

DIVERSITY AND REACTION, 1940 TO THE PRESENT

Between the many programs and agencies it set up to cope with the Great Depression of the 1930s and the controls it assumed during World War II, by 1945 the federal government had entered into nearly every aspect of American life. The arts, too, had been touched, for example in the Federal Arts Project, set up to assist painters, musicians, and writers. In 1963 Senator Hubert H. Humphrey referred to the arts as the soul and spirit of the nation and observed that "the Federal Government has a responsibility, particularly a Government of the people. I do not know why the arts need to have . . . a king or an emperor or a duke to be the patron of the arts"[1] At about the same time, President Kennedy was hosting a luncheon at the White House to which he had invited prominent businessmen whose aid he hoped to enlist in his project of a National Culture Center. Although Kennedy was not destined to see the results of this alliance of government, business, and private funding, his dream became a reality in the Kennedy Center for the Performing Arts (1971), designed by Edward Durell Stone (1902–78), on the banks of the Potomac River.

What many senators and President Kennedy wanted, on an even larger scale, was a National Foundation for the Arts, through which an enormous federal subsidy for art and culture could be channeled annually. Congressional hearings were held in 1963, legislation was passed, and the next year President Johnson signed the bill. By 1965 the Foundation's two main divisions—the National Endowment for the Arts, and the National Endowment for the Humanities—had their appropriation, with "a specific mandate to encourage the development and growth of the arts throughout the Nation."

At state level, the way had been led when Governor Nelson Rockefeller established the New York State Council on the Arts in 1960. From the very beginning it enjoyed extraordinary success. Support of the arts was now being undertaken at national level, usually with federal agencies providing half the funds for a given project, while expecting the community or the private sector to raise matching money.

All across the nation, whether in small towns or cities, a kind of cultural explosion occurred as American democracy began to patronize the arts through this partnership of governments (soon all states had State Arts Councils), the people, corporations and business executives, and artists, performers, curators, and scholars.

As early as 1961 Arthur Goldberg, Secretary of Labor under Presidents Kennedy and Johnson, had addressed this very point—support for the arts in a democracy: " . . . as we become more and more a cultural democracy, it becomes less and less appropriate for our major cultural institutions to depend on the generosity of a very few of the very wealthy. That is a time that has passed We must come to accept the arts as a new community responsibility. The arts must assume their place alongside the already accepted responsibilities for health, education, and welfare."[2]

The example of the federal and state governments, plus the tax incentives they created, encouraged corporate America to get into the game—which it often did, on a large scale. The increasing amounts awarded by the Ford Foundation, for example, reflect the corporate world's growing enthusiasm for the arts. The Rockefeller family and the Rockefeller Foundation were similarly active. The Kennedy Center in Washington raised six million dollars from corporate sources, and American businesses came up with over ten million dollars to help pay for the buildings at New York's Lincoln Center.

There were those, however, who had grave concerns about the government becoming involved in the arts. At the Senate hearings, one witness voiced the fear that there was the possibility that art funded by the government might be forced to promote a particular political ideology. Senator Strom Thurmond of South Carolina, from the floor of the Senate, reminded his colleagues that "the Federal Government has the power to control that which it subsidizes, and experience proves that when the Federal Government has the power, that power is eventually exercised"[3] Thurmond concluded his remarks by introducing a constitutional issue, saying " . . . it is not a proper function of the U.S.

Government to supervise and finance the arts."

The conservative voice in the matter was expressed by Jane Blumenthal in an article, "Art for Power's Sake," in Ayn Rand's journal *The Objectivist*, when she wrote, "With the force of the government behind them, [the 'authorities'] . . . can ultimately intimidate artists and public alike. Then a work will be accepted as art by the decree of the government's 'culture commissars,' who will compel the public to 'appreciate' it."[4] Since the founding of the Endowments there have been a few occasions, in fact, where some member of Congress has attempted to manipulate or censor art, using the threat of withdrawal of government funds as a weapon. A case in point came up in the late 1980s when Senator Jesse Helms of North Carolina objected to some of the photographs of nudes by Robert Mapplethorpe—calling them obscene, erotic, and masochistic. But on balance, the National Endowments have done enormous good and have only rarely supported projects that anyone found offensive.

Having introduced the name of the philosopher and novelist Ayn Rand, a few words should be said here about the issues she raised relative to some of the matters we have just been discussing.

Rand's first success came with *The Fountainhead* (1943), followed by *Atlas Shrugged* (1957). In the 1960s, a cult began to develop around her "objectivist" philosophy. In *The Fountainhead* she pits the productive, creative genius against the parasitical but scheming drones who surround him. Her hero is an architect, who, some have claimed, was based on Frank Lloyd Wright. He is a hardworking, brilliant creator of original designs whose integrity and independence are unbearable to the villain of the story, whose mission is to thwart creativity, reduce genius to something average, and destroy integrity. The novel attempts to expose those who have a special advantage when working in a democratic society, because of the leveling factor—that is, the tendency of a democratic system to pace initiative and talent to the national average, instead of encouraging genius and excellence.

Rand's novels raise interesting questions about the role of a creative person in a democratic society that all too often is content with mediocrity and is hostile to those who demand quality and originality of themselves and of others.

ALTERNATIVES TO THE INTERNATIONAL STYLE

While the towering figure of Frank Lloyd Wright and the practitioners of the International Style represent two of the mainstreams of American post-World War II architecture, there were also other avenues that were explored.

The work of the architects included in this chapter adds a richness and variety to the story of American architecture, which collectively is marked by diversity and innovation. For example, in the aesthetics of architectural design,

expression of purpose at times becomes more important than expression of structure. Or treatment of surface—with much greater emphasis on decorative qualities—may replace the clarity and logic expressed in the grid scheme of a skyscraper executed in the International Style. In postmodern architectural design, there may even be a new interpretation of historicism, as that old bugaboo of the International Style—the Beaux-Arts style—is resurrected.

EERO SAARINEN

Eero Saarinen (1910–61) is an example of a onetime advocate of the International Style who branched off in order to assert a personal flair. Eero was the son of Eliel Saarinen, a successful Finnish architect who came to the United States in 1923 and became director of Cranbrook Academy. Eero was born in Finland but came to America with the rest of the Saarinen family shortly after Eliel arrived. In 1930 he returned to Europe to study sculpture in Paris. This early interest in sculpture is significant in connection with some of his later architectural designs.

After studying architecture at Yale University, Eero joined his father in 1937 in a successful practice. After World War II, Eero showed every sign of departing from his father's concept of design and turning to the International Style. Eero's design for the General Motors Technical Center (1945–55) in Warren, Michigan, for example, is party-line International Style and invites comparison with Mies van der Rohe's Illinois Institute of Technology.

But it was not with work in the mode of Gropius and Mies that Saarinen most distinguished himself. In 1948 Saarinen won the competition for the Jefferson National Expansion Memorial in St. Louis—the great arch that was finally completed in 1964. Here was a romantic expression on a colossal scale of the city that had been the gateway to the West a century before. Its aesthetic is based in the expression of an idea, a romantic dream, far more than in the logic of structure. Therein lies the shift away from the International Style.

Sweeping curves and a broad convex roof dominate Saarinen's design for Kresge Auditorium (1953–6) for MIT in Cambridge, Massachusetts, while one of his loveliest creations is the diminutive chapel he designed for the MIT campus (Fig. 34.1). The circular form, faced with red brick, is surrounded by a little moat. The arched openings around the base permit the reflections of light off the water to play about the interior. On the roof, an abstract sculpture by Theodore Roszak (see p. 587) suggests the yearning of a spirit to rise aloft. Within, a golden construction by Harry Bertoia (see p. 533) floats above the simple form of the marble altar like a spiritual presence (Fig. 35.4). There is a spirituality about the interior that is interdenominational.

Saarinen continued to explore the expressive potential of architecture in each new commission. His Ingalls Hockey Rink (1958) for Yale University conveys the excitement of

34.1 Eero Saarinen, Chapel at Massachusetts Institute of Technology, Cambridge, Massachusetts, 1953–7.

the sport. It also seems Scandinavian, with wonderful curves that recall the lines of a Viking ship—expressive curves that are the antithesis of the rigid, rectilinear International Style.

Saarinen's greatest triumph was the TWA Terminal at New York's Kennedy Airport (1956–62) (Fig. **34.2**). The four vaults of the roof, beautifully sculptural, express a yearning to fly. The reinforced concrete vaults are supported by four huge Y-shaped piers that are themselves sculptural—indeed, it seems as if the architect molded concrete forms with the ease of shaping forms in clay or plaster. Inside, one is even more keenly aware of Saarinen's manipulation of plastic form, with spaces like voids within some great piece of modern sculpture (Fig. **35.3**). If Saarinen was indebted to anyone, it was to Pier Luigi Nervi (1891–1979), the Italian architect who pioneered new forms wrought from reinforced concrete.

The TWA Terminal reminds us that as a youth Saarinen had studied sculpture. It is also worth noting that another Scandinavian, Jorn Utson (b. 1918) of Denmark, was at the same time designing and erecting the dramatic Opera House in Sydney, Australia. There, too, the sculptural qualities of soaring ridged vaults, interacting with each other as expressive plastic shapes, prevail over structural clarity.

34.2 Eero Saarinen, Trans World Airlines Terminal, Kennedy Airport, New York, 1956–62.

34.3 I. M. Pei and Partners, East Building, National Gallery of Art, Washington, D.C., 1983.

I. M. PEI

Ieoh Ming Pei (b. 1917), usually known as I. M. Pei, took a still different approach to architectural design, although he emerged from the fountainhead of the International Style.

Born in Canton, China, Pei came to the United States, entering MIT in 1938 and later attending Harvard University for his master's degree in architecture. Gropius was then the spearheading force at Harvard's School of Design, and Pei worked under his instruction.

In 1948 Pei was hired by the urban developer William Zeckendorf as head of his architectural office. In 1960 Pei opened his own firm. His plan for Boston's new Government Center (1963) was followed by Society Hill Apartments (1965) in Philadelphia, as well as a number of beautifully conceived and detailed small art museums—the Des Moines Art Center (1968), the Everson Museum of Art (1968) at Syracuse University, and the Herbert F. Johnson Museum of Art (1973) at Cornell University. The building that brought him the most attention was the John Hancock Building (1973) which dominates Boston's skyline as a lovely green-glass tower, very much in the mode of the International Style.

Pei's work with small art museums was followed by commissions for larger institutions, as in the addition to the Museum of Fine Arts (1981) in Boston and the East Building of the National Gallery of Art in Washington, D.C. (Fig. 34.3). The original National Gallery building (1941), a gift to the nation from financier and industrialist Andrew

Mellon, was designed by John Russell Pope (1874–1937) in a classical Beaux-Arts style.

Pei's addition, separated from Pope's West Building by John Marshall Park but connected by a pedestrians' tunnel, is of a completely different style. Trapezoidal in plan to suit the building site, the East Building is a bold arrangement of planes of pinkish-cream marble veneer. An Oriental respect for simplicity pervades the lines, planes, angles, and overall form. There is no cornice other than the top row of stones set at a vertical axis, and the corners and angles are crisp and sharp, with all structural members concealed for the sake of monumental simplicity. Within, large and small irregular-shaped spaces accommodate the flow of visitors, the mounting of large or small exhibitions, and the Center for Advanced Study in the Visual Arts. The building's simplicity and serenity allow its monumental works of art to take front stage—such as the huge mobile by Calder that drifts about in the open spaces of the interior court.

LOUIS KAHN

Louis I. Kahn (1901–74), who was brought to America from his native Russia at age four, received his degree in architecture from the University of Pennsylvania in 1924. During the following decades he was associated with leading Philadelphia architects, such as Paul Cret and George Howe. Only in the 1950s did he begin to emerge as a major figure in architectural design.

The art museum as an architectural form played a major

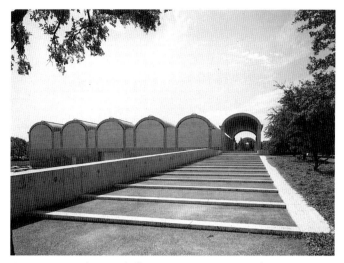

34.4 Louis Kahn, Kimbell Art Museum, Fort Worth, Texas, 1967–72.

illustrated here, shows how the vaults and walls of the galleries are articulated by the use of a darker coloration in a linear, rhythmic sequence. The building is constructed of reinforced concrete, which is left exposed. The vaults have skylights at their crests, which provide natural light for the galleries. Kahn's design for the Salk Institute of Biological Research (1959–65) at La Jolla, California, also utilized concrete wall construction, but in a very bold and forceful arrangement of planes and forms.

By the time of his death, Louis Kahn had become an internationally acclaimed architect and was further influential through a group of devoted students.

PAUL RUDOLPH

Paul Rudolph (b. 1918) used exposed, massive concrete walls in his designs. The complex concrete masses of his buildings represent a distinctive architectural aesthetic.

Rudolph grew up in the South and attended the Alabama Polytechnic Institute before going to Harvard's Graduate School of Design in 1941, where he studied with Walter Gropius. Among his fellow students were Philip Johnson and I. M. Pei. In the early years of his career he designed a number of houses, many in Florida and Alabama, which were in the cellular, glass box mold of the International Style. He served as chairperson of the department of architecture at Yale University from 1958 to 1965.

Rudolph's Art and Architecture Building at Yale is massive, bold, and complex. Geometrically sculptural, of roughened concrete surface, it has few windows, which appear more as holes in the heavy walls than glass membranes stretched across a skeletal frame (Fig. **34.5**). These characteristics have earned the epithet "brutalist" for a number of

role in Kahn's career. He first came into national prominence with his design for the Yale University Art Gallery (1951–3) in New Haven. A quarter-century later he created the building that houses the Center for British Art and Studies for Yale, another project backed by the Mellon family. Kahn's masterpiece, many would agree, is the Kimbell Art Museum (1967–72) in Fort Worth, Texas (Fig. **34.4**).

The museum has five long, parallel galleries that are covered by vaults, revealing Kahn's longstanding interest in Roman architecture. The primary internal spaces are indicated in the exterior design. Roman, too, is the importance given to the wall, for its solid and continuous form is the antithesis of the steel, skeletal frame with a glass skin that was so favored in the International Style. The end view,

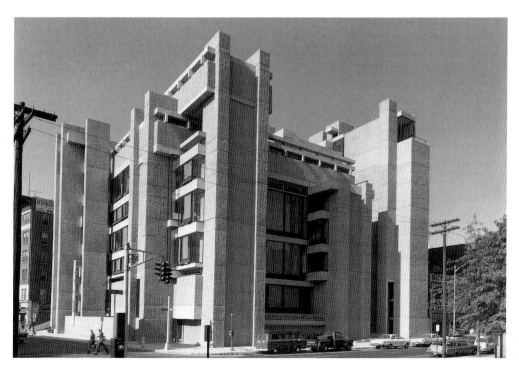

34.5 Paul Rudolph,
Art and Architecture Building,
Yale University, New Haven,
Connecticut, 1958–64.
Ezra Stoller/Esto.

Rudolph's buildings. The term is not used in the sense of barbaric or crude, but rather as expressive of massiveness, strength, and the bold, forthright use of materials, especially concrete. Many of these features are found in those portions of Boston's Government Center for which Rudolph was the coordinator.

WESTERN AND MIDWESTERN ARCHITECTURE

The diversity, breadth, and richness of American architecture mentioned at the beginning of this chapter found additional avenues of expression on the West Coast. One of the leading figures is Charles W. Moore (b. 1925), who received his architectural training at the University of Michigan and served as Rudolph's successor as chairperson of the department of architecture at Yale from 1966 to 1975. Moore's interest in the history of architecture led him to a PhD. in that subject from Princeton University in 1957—

another hint at the return of historicism that blossomed in the postmodern era.

Practicing in San Francisco, Moore was the principal figure in a partnership with Donlyn Lyndon, William Turnbull, and Richard Whitaker, known as MLTW. The firm's design for Sea Ranch, a condominium complex north of San Francisco, brought it national attention (Fig. 34.6).

Ordinary vernacular architecture—such as summer cottages, barns, or other farm buildings—was the source of inspiration. The exterior is covered with boarding that is allowed to weather naturally. The complex achieves an organic unity with the natural terrain, which, if landscaped at all, utilizes grasses and shrubs indigenous to the area. Here is a case of architects seeing in vernacular structures an innate geometry of the sort that appealed to Charles Sheeler in works such as *Barn Abstraction* (Fig. 30.26).

One of Charles Moore's most fascinating projects is the Piazza d'Italia (1975–8) in New Orleans. This is a reinterpretation of Roman and Italian Renaissance architecture with

34.6 Moore, Lyndon, Turnbull, and Whitaker, Condominium No. 1, Sea Ranch, California, 1965. Wayne Andrews/Esto.

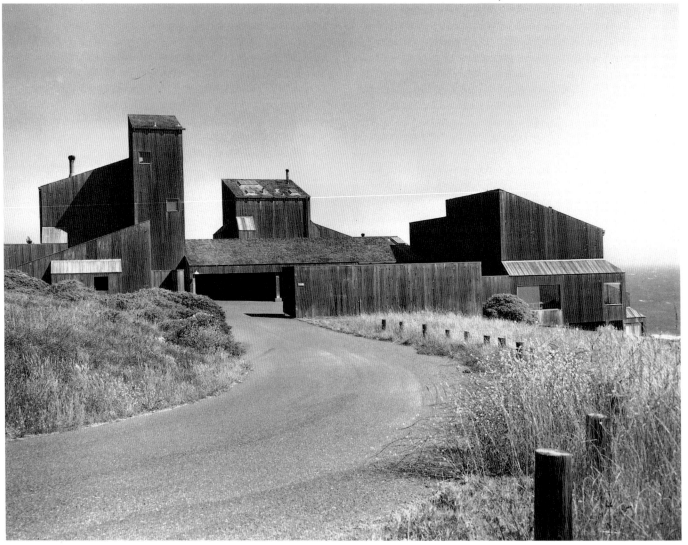

evocations of triumphal arches, bell towers, and fountains arranged as a backdrop to a circular plaza, into which extends a huge relief map of Italy. Picturesque, eclectic, and colorful, the Piazza d'Italia, erected to honor the Italian population of the city, is an early and delightful example of the new spirit in architecture that rebelled against the austerity of structuralism and functionalism.

John C. Portman (b. 1924) delights in large complexes of buildings that involve not only the talents of the architect but also the acumen of the entrepreneur. The two best-known examples of this are his Peachtree Center in Atlanta and Detroit's Renaissance Center. Peachtree Center (1961), a redevelopment of a large area of downtown Atlanta, includes numerous shops and restaurants, office space, and a seventy-story hotel. The latter—cylindrical in form and wrapped in bright bronzed reflective glass—has a large **atrium** running the full height of the building as a central well. Although enclosed by glass at the top, it has the feeling of an open space. Trees and other potted plants on the atrium floor further create an area that was designed to be pleasing to the people who use it.

Even larger than Peachtree Center was the project for the Renaissance Center, a 32-acre (13-ha) site set beside the Detroit River that reclaimed a derelict and forgotten section of the inner city. The idea was first proposed in 1971 by Henry Ford II, who persuaded about fifty other corporations

34.7 John Portman, Atrium, Renaissance Center, Detroit, Michigan, 1971–5.

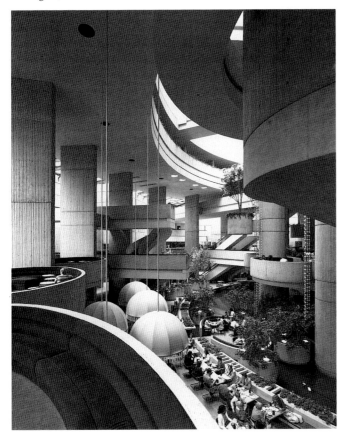

to join Ford Motor Company in sponsoring a revitalization of Detroit, then still scarred from the race riots of 1967. Portman's design called for five towers, set upon a four-story base. The central structure, a glass-sheathed cylinder that rises to a height of seventy-three stories, is a hotel with a central atrium that is eight floors high. The other four buildings, one each at the four corners of the site, are office buildings. All five buildings are connected at the atrium level. There is a sleek city-of-the-future quality to the complex.

Portman has a special skill in creating humanistic interior spaces—interiors that people find a joy to be in. He has done just that with the atrium area of the hotel in Renaissance Center (Fig. 34.7). Natural lighting and a profusion of plants, shrubs, and even trees are combined with dramatic and exciting architectural forms and spaces.

The architecture of Robert Meier (b. 1934) also has a futuristic character about it. One senses this in the building that first brought him international acclaim, the Bronx Development Center (1976), a school, residence, and out-patient clinic for the mentally handicapped. After Meier received his bachelor's degree in architecture at Cornell University, he worked from 1960 to 1963 for Marcel Breuer and Associates before establishing his own practice in the latter year. One of Meier's finest works is the High Art Museum in Atlanta, Georgia (1980–3), the exterior of which recalls the art of Le Corbusier. Meier also designed a number of houses that extend the tradition of Le Corbusier, J. J. P. Oud, and the Bauhaus group—a house of 1971 in Old Westbury, Long Island, for example.

One of Meier's finest works is the Atheneum (1975–9) in New Harmony, Indiana. That town is an interesting, if rare, phenomenon—the occasional small community, far removed from the great cities, that has somehow gotten swept up in the spirit of modern architecture. New Harmony also has a lovely little shrine designed by Philip Johnson in 1960.

Columbus, Indiana, has an even more extraordinary collection of structures by many of the leading architects of the modern movement. There, for example, one may find schools designed by Walter Gropius's group, the Architects' Collaborative, and by Eliot Noyes, Gunnar Bickerts, and Edward Larrabee Barnes; a county library by I. M. Pei with a colossal sculpture by Henry Moore (1898–1986) in its plaza; a post office and an engine factory from the firm of Kevin Roche and John Dinkeloo; a fire station by Robert Venturi; a bank and a church designed by Eero Saarinen; and a newspaper plant by Skidmore, Owings, and Merrill, to name but a few of its buildings. Columbus has a population of about 30,000, and it is surprising to find such a commitment to modern architecture so far removed from New York, Chicago, Los Angeles, or other large metropolitan centers. Although the guiding spirit was J. Irwin Miller of the local Cummins Engine Company and Foundation, the community generally has become involved. This veritable museum of modern architecture has been a source of justifiable pride to the citizens of Columbus.

Seven generations of J. Irwin Miller's forebears had lived in Columbus, Indiana. After studying at Yale and Oxford he returned there, eventually to run the family enterprises. In 1941, when the First Christian Church decided to erect a new building, he persuaded the congregation to commission Eliel and Eero Saarinen to design it. That was just the beginning. Miller then asked the younger Saarinen to do the new building for the Irwin Union Bank and Trust (1954) and to design a house for him. Irwin Miller was a member of the Business Committee for the Arts, which David Rockefeller had founded in 1967, and he was on the board of trustees of the Ford Foundation when that organization determined to erect a new headquarters in New York City. It selected Roche and Dinkeloo, successors to Eero Saarinen, to create the design.

34.8 Kevin Roche, John Dinkeloo and Associates, Knights of Columbus Building, New Haven, Connecticut, 1965–9. Wayne Andrews/Esto.

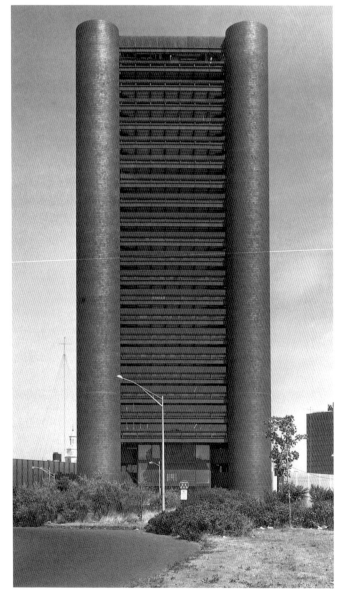

Kevin Roche (b. 1922) studied architecture in his native Ireland before coming to America in 1948. He was briefly a student of Mies van der Rohe at the Illinois Institute of Technology before he joined the firm of Eero Saarinen in 1950. That same year, John Dinkeloo (1918–81) became a member of Saarinen's office, after being trained at the University of Michigan and working for a while for Skidmore, Owings, and Merrill. Roche became a partner in 1954, and Dinkeloo two years later. It was they who saw Saarinen's designs to completion after his death in 1961. Two years later they formed their own partnership, with Roche primarily concerned with design while Dinkeloo looked after technology, engineering, and construction.

They began with the Ford Foundation Building (1963–8) in New York City, but one of their most striking efforts was the Knights of Columbus Building in New Haven, Connecticut (Fig. 34.8). The design of the twenty-three-story tower is simple and comprehensible to the eye and mind, with cylindrical forms at the four corners and powerful horizontals in the steel girders that define each floor. The corner towers, which house the stairways and utility rooms, are faced with a purplish-brown tile, while the dark glass and dark girders give a somber yet dignified character to the structure. As we advance toward the postmodern style, color plays an increasingly expressive and/or decorative role in architectural design. Roche and Dinkeloo's willingness to experiment with colorful treatments and innovative shapes is also seen in their College Life Insurance Buildings (1967–71) in Indianapolis, Indiana.

POSTMODERN ARCHITECTURE

The foundation for the postmodern revolution against modernism, a reaction that arose in the late 1960s and early 1970s, is the celebration of Pop culture, commercialism, historicism, and decorative qualities. Modernism itself had rebelled against artistic tradition, which included Beaux-Arts historicism and middleclass values. Postmodernism reacted against what was felt to be a sterile formularization that was unrelated to the real world—the real world meaning the everyday, commonplace environment of Mc-Donald's restaurants, Las Vegas-type neon signs, roadside billboards, Marlborough Man cigarette ads, the war of the taste-test waged by Pepsi and Coca-Cola, rock 'n' roll music, and television images.

No matter how tacky, that was the real world of the mid-to-late twentieth century, and painters such as Andy Warhol extolled it (Fig. 37.9), while Claes Oldenburg in his sculptures created parodies of vacuum sweepers, hamburgers (Fig. 39.6), clothes-pins, and baseball bats.

If modernism had separated itself from the mainstream of real life, postmodernism was determined to bring art and popular culture together again. Moreover, postmodernists

frequently did not like the disassociation from the past, from longstanding cultural traditions that modernism had insisted upon in order to forge its brave new world. A younger generation of artists and architects yearned for the inspiration of historic styles that had been taken away from them. And so they returned to them, not in the same spirit of turn-of-the-century Beaux-Arts historicism, but in inventive evocations of cultural heritage, as preserved in historic styles.

It was no longer sufficient that beauty be expressed through a super-rational, machinemade, industrial structure—the glass box. Beauty in architecture came to depend on color, decoration, and even whimsy—for a kind of fun and joyousness now pervaded architectural design.

ROBERT VENTURI

With the publication of his book *Complexity and Contradiction in Architecture* (1966) Robert Venturi (b. 1925) was among the first to question the authority of the International Style. Not only did Venturi challenge the old order, but he

proposed a course that led to postmodern architectural design. While recognizing the genius of Le Corbusier, he also praised popular culture as a source of inspiration for high culture. This led to the theory that high art should arise from vernacular sources, rather than from earlier high art.

Venturi, who was born in Philadelphia, studied architecture at Princeton University. In the 1950s he worked in the offices of Eero Saarinen and Louis Kahn before establishing his own practice in the Quaker City. One of his earliest efforts, the house he designed for his mother, is a manifesto of many of his beliefs regarding form and symbolism in architecture (Fig. 34.9). Both historicism and vernacular prototypes are involved here, for the shape of the house strongly recalls Shingle-style houses by H. H. Richardson and McKim, Mead, and White. The arc above the doorway suggests the arch form that Richardson so often worked into his designs, yet it may also be seen as an Art Deco motif. There is also something reminiscent of ordinary middle-class housing. Thus popular culture became a source of inspiration.

Decorative historicism is even more obvious in Venturi's

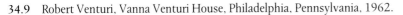

34.9 Robert Venturi, Vanna Venturi House, Philadelphia, Pennsylvania, 1962.

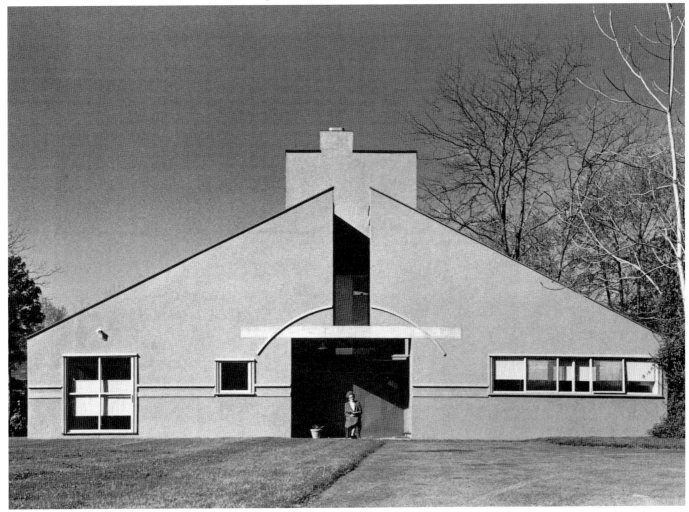

Wyning's Park Condominiums (1981) in Houston, where a Federal-style fanlight is seen above a row of Ionic pilasters wrought in relief on an end wall. Above the fanlight is a swag motif, also a reinterpretation of a late-eighteenth-century Federal-style decorative feature.

Another of Venturi's interests found expression in the building he designed for the Institute of Scientific Information (1978) in Philadelphia. Here, he worked into its colorful checkerboard façade something of the glitz and glitter of the everyday commercial environment, including lettering and a billboard-like sign that identifies the building.

Venturi's theories advocating that artists and architects should take inspiration from Pop culture were presented in his book *Learning from Las Vegas* (1972). Indeed, the Institute for Scientific Information Building is a perfect architectural counterpart to Pop Art painting.

JOHNSON IN TRANSITION

It is greatly to Philip Johnson's credit that although he had been one of the discoverers of the International Style, and since then one of its leading practitioners, he recognized in about 1970 that it had run its course and that it was time for a change. That change began to appear in his own work in his Pennzoil Place in Houston, designed in collaboration with his new partner, John Burgee (b. 1933) (Fig. 34.10).

While it is true that some of the characteristics of the International Style "glass box" of the 1950s and 1960s remain, there are important if subtle changes that suggest a transition. First of all, there is in the dark coloration of these somber forms something expressive and dramatic. Such qualities are antithetical to the rationalism and structuralism of previous corporate office towers. Secondly, the rectangular form found in the Seagram Building and Lever House (Figs. 33.11 and 33.13) has been altered to allow the architect to explore the decorative effect of various angles introduced into the design—most noticeable in the slant of the roofline, but echoed in the slope of the glass-sheathed angular section at the base of the two towers. The perfectly horizontal roofline had virtually become an inviolable condition of modern architecture, but the time had come to see what else could be done with the top of a building besides making it flat.

There was much critical debate about Johnson and Burgee's American Telephone and Telegraph (AT&T) Building (1978–82) in New York City. One thing is certain—it marked in a monumental way that could not be ignored the return of historicism to architectural design (Fig. 34.11). From bottom to top, this building proclaims a new direction in architectural design. The round-headed arch of the main entrance—placed symmetrically in the façade—reminds one of a Roman triumphal arch or a Renaissance façade, while the roofline is crowned with a great Chippendale-style pediment.

These are two obvious examples of historicism. But equally important is a departure from the steel skeleton and

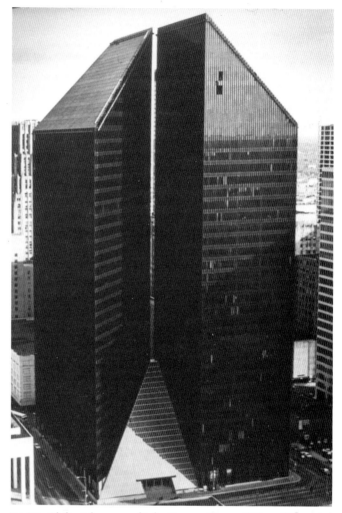

34.10 Philip Johnson and John Burgee, Pennzoil Place, Houston, Texas, 1972–6.

glass-skin type of highrise, for here is a return to masonry, at least for effect if not for actual construction.

The AT&T Building, with its powerful vertical mullions of pink granite reaching from a masonry base to a dramatically corniced top, re-establishes the skyscraper's links with such edifices as Louis Sullivan's Wainwright Building and Guaranty Building (Figs. 21.9 and 21.11). There is something purely decorative in the circular holes on the sides of the base—that they should inspire a critic to refer to the building as "lollipop modern" does not seem to cause offense. There is something equally amusing in the Chippendale-style pediment. This new style boldly asserts that it is perfectly acceptable for architecture to make people smile.

34.11 (opposite) Philip Johnson and John Burgee, with Simmons Architects, American Telephone and Telegraph Building, New York City, 1978. Peter Mauss/Esto.

34.12 Michael Graves, The Portland Building, Portland, Oregon, 1980.

MICHAEL GRAVES

Among the more adventurous architects of postmodernist design is Michael Graves (b. 1934). After graduating from the University of Cincinnati, Graves received his master's degree in architecture at Harvard University in 1959. Then, interestingly enough, he spent two years at the American Academy in Rome—something few young architects had done since the 1930s. In the late 1970s Graves burst upon the scene as the leading figure in innovative postmodernist design, mainly through two buildings, neither of which is in a traditional center of avant-garde architecture—the Portland Building in Portland, Oregon, and the Humana Hospital Building in Louisville, Kentucky.

The Portland Building houses a host of civic offices as well as an auditorium and a restaurant (Fig. **34.12**). The members of the city council knew they would bring dispute upon their heads when they selected Graves's design, even though it was soundly endorsed by their consultant, Philip Johnson. In form, the building is a square box, resting on a foundation sheathed in green tile. The basic form, however, is nearly overwhelmed by the decorative treatment of the four façades. Upon a creamcolored wall are applied richly colored motifs derived from ancient classical architecture. On one side are abstracted versions of two pilasters with projecting capitals, equally abstracted, which support an oversized **keystone**. On the other side, four pilaster forms set against reflecting glass are united at their top by a garland design.

Graves has been as interested in Cubist art as in classical architecture, and he has in fact made murals in the Cubist mode. If one could ask Picasso or Braque to redesign classical pilasters and garlands in the Cubist fashion, their efforts might well turn out similar to the red, brown, and blue decorations Graves has applied to the surfaces of his Portland Building.

The critics—from the citizens of Portland to professional East Coast architectural commentators—were divided on a structure that threatened to lead modernism off in a new direction. It was called "dangerous," a "marzipan monstrosity," and was compared to a jukebox. Someone declared it anti-contextual—that is, it did not fit in with the surrounding, rather sedate cityscape of downtown Portland. It would have been better, that critic stated, if it had been built in Las Vegas or Atlantic City. But anything so new and startling is apt to elicit such concerns, and no less authorities than the architect Philip Johnson and the architecture critics for the *New York Times*, Ada Louise Huxtable and Paul Goldberger, came out in favor of it.

Graves again stirred up a great controversy over his designs of 1985 and 1987 for the expansion of the Whitney Museum in New York City. Once more, he demanded a new mode of vision for the metropolitan cityscape. Like the great French forerunners of modern architecture, Ledoux and Boullée, he dared to place his personal vision out in the open, where it came under the scrutiny of anyone from taxi drivers to fellow-members of the American Institute of Architects.

We must await the judgment of time to see if the sort of design that Graves proposes establishes a following. The architect Charles Moore as early as 1976 expressed concern that the "glass box" type of architecture had so restricted the things that buildings were capable of expressing that people no longer found architecture interesting. One thing is certain: Michael Graves and other postmodern designers have, if nothing else, revived interest in the art of architecture.

THOMAS BEEBY

Thomas Beeby (b. 1941) has designed numerous houses in Illinois and Wisconsin which reveal his interest in nineteenth-century vernacular architecture of the type found in Midwestern rural areas and small towns. This inspiration from commonplace structures—a form of historicism in its own way—is, as we have seen in our discussion of Robert Venturi, consistent with postmodernism.

Beeby, who in his youth came under the spell of Mies van der Rohe and at Yale studied with Paul Rudolph, is a member of the Chicago firm of Hammond, Beeby, and Babka, whose design won the competition in 1988 for Chicago's new Harold Washington Library (Fig. **34.13**).

Controversy has similarly surrounded the selection of this design for public architecture. If it does not conform to the mold of Skidmore, Owings, and Merrill modernism as expressed in the nearby Hancock Building and Sears Tower, it nevertheless draws its inspiration from a most appropriate local precedent, which also involves historicism. The new library is manifestly related to the grand old Beaux-Arts Chicago Public Library of 1891–7, designed by Peter B. Wight. Above the foundation, the salient feature is a sequence of huge round-headed arches, a scheme clearly

34.13 Hammond, Beeby, and Babka, Harold Washington Library Center, Chicago, Illinois, 1991.

inspired by Wight's neo-Roman design. Decorative paraphrases of garlands and pilasters, in a color that contrasts with the reddish wall, grace the surfaces between the arches. All of this is crowned by a grand cornice and an even grander entablature that evoke ancient Greco-Roman temple rooflines, and also the forms of Wight's earlier structure.

Architecture, it would seem, is once more to be associated with historic styles, but in an abstract way. Moreover, it is to be decorative and enjoyable to look at—one can be sure that the city council of Chicago must have thought seriously about the expense of large amounts of decorative architectural detail. The purist, "glass box" type of architecture had long ago purged decorative detail of this type, and the economics of that purge made the style appealing.

But again, we are reminded of Charles Moore's comment that modern architecture of the "glass box" sort no longer seemed to interest people. The solution was to find a decorative or historically based style that would again appeal to the eye. The city fathers were evidently convinced that things such as tradition and cultural heritage count for something, too, and so they were willing to bear the added expense. In fact, when the design won a prize awarded in 1988 by *Progressive Architecture*, a member of the jury defended the selection by saying "a lot of people would think that this was a contemporary expression of their cultural values."

Postmodernism as a movement has not yet had time to explore all of the possible new avenues of design it has opened up, nor to evolve and refine itself through a significant number of important commissions. But it has an exciting potential that bears watching. Many people—from the person on the street to the architectural historian and critic—may have assumed that architecture was destined to evolve toward a kind of futuristic cityscape, all sleek and purist in form, with few humanistic qualities permitted to intrude. Postmodern architects such as Michael Graves, Thomas Beeby, and Philip Johnson have challenged that assumption, for works such as the Portland Building, the new library in Chicago, and the AT&T Building may well indicate that some architects have heard the message that further pursuit of the "glass box" style is unacceptable— that architecture must once more consider humanistic qualities as well as corporate, industrial, economic, and structural concerns.

DESIGN IN AMERICA:

MODERN AND POSTMODERN, 1940 TO THE PRESENT

By the end of the 1930s there were signs that the economic depression was loosening its grip, and manufacturers, designers, curators, and consumers began to look with cautious optimism to the future. One of the most important indicators of this new mood was the New York World's Fair of 1939–40, the theme of which was "Building the World of Tomorrow." It was planned as the fair of the future, intended to show off the technological wonders that were on the horizon for "the World of Tomorrow." New products—such as television—and new designs made their pitch to the exposition's forty-five million visitors. The fair's futuristic tone was set by its logo, the trylon and perisphere.

Many of the foremost decorators and designers of the day were involved: Donald Deskey, Wharton Esherick, Russel Wright, Raymond Loewy, Norman Bel Geddes. Getting into the spirit of things, *Vogue* magazine commissioned some of these men to design "clothes of the future," to give their conceptions of what clothing in the year 2000 would be like. *Vogue* staged an ultrafuturistic fashion show, which was illustrated in the magazine's issue of February 1939.

At that moment in time, the expectation was clearly that the world was headed for a futuristic Star-Trek-type environment and lifestyle. Yet the New York World's Fair showcased objects and designs that would eventually become realities in the daily life of Americans. In this the manufacturers were aided by the art museums: The Museum of Modern Art, for example, mounted exhibitions of well-designed furniture and furnishings, bestowing the imprimatur of the art world upon machinemade objects.

MODERN DESIGN AT THE MODERN

As director of the department of industrial design at The Museum of Modern Art (MOMA), Eliot Noyes (1910–77) was a pioneer in promoting good design for the home and workplace. In 1940–1, he put together an important show called "Organic Design." To see what modern design was like at that moment, in its embryonic form, one should look through the illustrations of the exhibition catalogue. The course is clearly set for clean lines, simplified form, and appropriate use of materials in a more or less industrial context. Especially evident is the influence of Scandinavian

design, entering the American scene by way of the Saarinens, as well as others.

Noyes was influential in a number of other ways. In 1947 he left MOMA to establish his own design office in New York City. He also became a teacher of design at Yale University, which had launched a course of study in that field. Of special importance, Noyes was design consultant in the late 1940s and early 1950s to *Consumer Reports*, the ultimate union of consumer and designer. The magazine was particularly concerned with the efficiency rating of a given product, while Noyes's interest lay in aesthetic quality. Both, however, were acting on behalf of the consumer.

Noyes wrote several essays for *Consumer Reports* in which he urged manufacturers to improve the aesthetic quality of their products, pointing out that proper design would enhance their efficiency and increase sales appeal. Implicit in his essays was the message that consumers should demand good design in the objects they bought, just as they would expect them to be wellmade.

The hope and optimism for the future exuded by the New York World's Fair was dashed by the outbreak of World War II. While the war years were a dormant period for the arts generally, at the same time there was a tremendous pressure building up for the good life that was anticipated once the war was over.

With the coming of peace, the enthusiasm which had characterized the World's Fair and Noyes's "Organic Design" exhibition fairly erupted upon the American scene. Museums all across the country hopped on the bandwagon by mounting exhibitions of welldesigned, industrially produced furnishings for the home. Corporations began to recognize the prestige that came with having their products regularly selected as the epitome of excellence in design. Hardly had the war ended when, in the autumn of 1945, MOMA renewed its series of exhibitions praising the aesthetics of manufactured objects. The next year, the Walker Art Center in Minneapolis organized a similar show, and so did the Akron Art Center and the Albright Gallery in Buffalo, New York—and so on across the country.

In 1946 MOMA hosted a "Conference on Industrial Design, a New Profession." The next year, the newly organized Society of Industrial Designers put together

an exhibition called "Industrial Design—The Creative Link between Business and Consumer," which toured the country. A broadbased partnership was quickly forming between manufacturers, designers, department stores, and curators—all working from their own perspective, with an eye towards the consumer. The welldesigned industrial products of the machine age came flooding into the marketplace.

A NEW KIND OF INTERIOR

America had entered an era that was significantly different from prewar times, and so American interiors presented new challenges. There were, for example, new interior spaces—shopping malls, hotel atria, airline terminals, domestic spaces enclosed only by glass, and subway stations. There were new materials, too—plastics, plywood, fiberglass, Naugahide, Teflon, and Lucite, which, if not entirely new to the period, came into prominent use. There were new objects to design—television sets, personal computers, and Cuisinarts. The individual craftsperson making furniture by hand—such as George Nakashima or Wharton Esherick—was rare indeed. Most fine furnishings now were designed by people like Russel Wright, Paul McCobb, or George Nelson, at the commission of large decorator or furniture companies like Knoll or Herman Miller.

Trade among nations escalated worldwide. Whether or not an object was designed and crafted in the United States became immaterial, because so much was imported. The furniture in a house might come mostly from American factories, but the carpeting might come from, say, Belgium, the drapery fabric from Finland, the lighting fixtures from Italy, and the stereo sound equipment from Japan, while the automobile in the garage might come from South Korea and the lawn furniture from Taiwan. Americans bought objects from foreign countries with the same ease as they did domestic products—for example, the beautiful wooden objects of Scandinavian design from Dansk or Georg Jensen.

Traditional favorites of the American people, however, were not discarded: Colonial or quasicolonial styles remained popular, and the comfort of an overstuffed easychair was seldom sacrificed for the sophistication of modern design in molded plastic and tubular steel. But modern

35.1 Skidmore, Owings, and Merrill with Raymond Loewy, Lever House, New York City, 1952. Interior. Ezra Stoller/Esto.

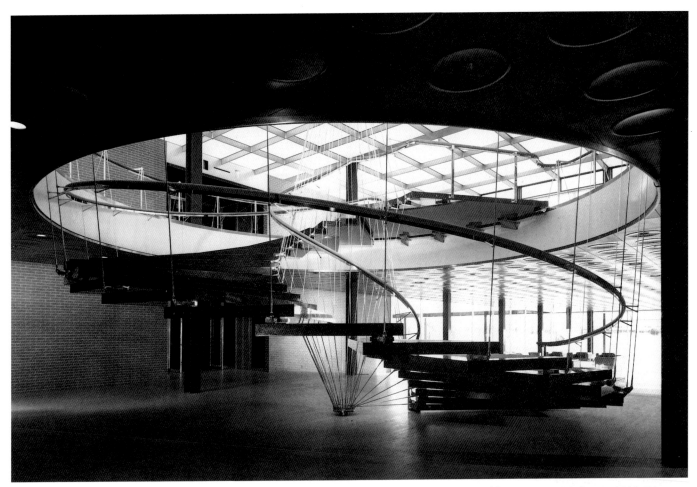

35.2 Eero Saarinen and Associates, General Motors Technical Center, Research Administration Building, Warren, Michigan, 1945–56. Ezra Stoller/Esto.

design did become popular with a significant number of Americans, and interest in it ran high.

In response to consumer and manufacturer demand, the corps of industrial designers swelled. Established architects were frequently involved in the design of furniture or other objects. These included Gropius, Wright, Mies, Breuer, Johnson, the Saarinens, Venturi, and Graves, among others. Art schools began to specialize in design as well as painting and sculpture, following the lead of Eliel Saarinen's Cranbrook Academy. There were also the Rhode Island School of Design in Providence and the Parson School of Design and the Pratt Institute in New York City. MIT, Harvard, Yale, and Illinois universities developed strong design programs, too.

CORPORATE INTERIORS

The American extension of the Bauhaus theory of design (see pp. 419 and 504) was resumed following the war. As might be expected, certain architect/designers of that tradition became leaders in the new design movement—Mies, Breuer, Philip Johnson, and so on.

Corporate America expressed itself within its fine new buildings in the same aesthetic spirit that governed the exteriors, as may be seen in Raymond Loewy's design for the lobby of Lever House (Fig. **35.1**). With its walls of glass, industrially produced metal window enframements, veneer of beautiful and highly polished stone, and tubular-frame furniture, it is a celebration of the International Style. Structure remains evident in spite of veneering, and nothing unessential is permitted to intrude. A splendid agreement has been attained between architectural design, engineering, industrial products, and the machine age.

Many of these same characteristics are found in Eero Saarinen's lobby of the Research Administration Building of the General Motors Technical Center (1945–56) in Warren, Michigan (Fig. **35.2**). Lovely, ivory-hued marble slabbing on the floor, warm, rustcolored brick on the walls, darktoned steel supports, and recessed lighting in the ceiling create an impressive space. The stairway becomes a grand constructivist sculpture in the manner of José de Rivera and Richard Lippold (Figs. **38.6** and **38.7**). The whole is an affirmation of the International Style.

But Eero Saarinen was by no means limited to the

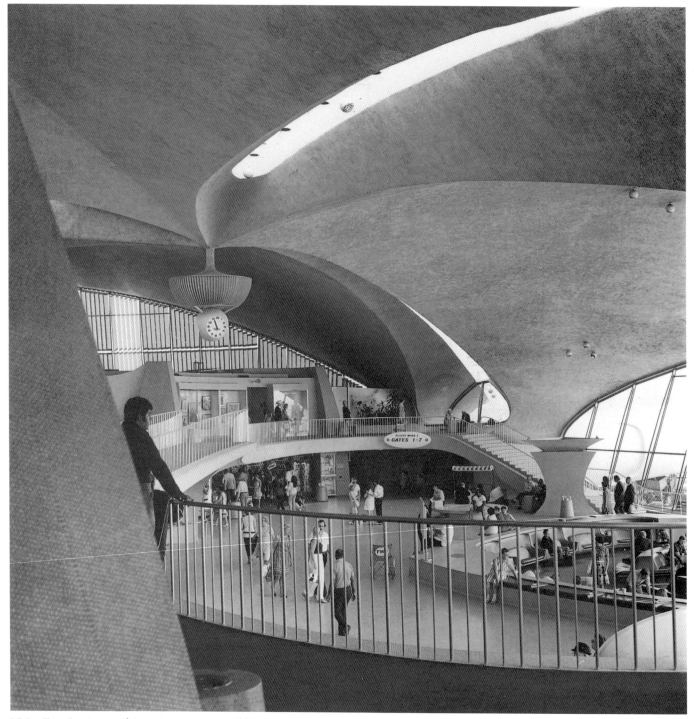

35.3 Eero Saarinen and Associates, Trans World Airlines Terminal, Kennedy Airport, New York, 1956–62. Interior.

International Style, and he used it only when it was appropriate. His TWA Terminal (1956–62) for Kennedy Airport was of a totally different design, as we have seen (Fig. 34.2). Its external forms and means of construction lead us to expect something quite different, within, from the rectilinearity of the General Motors building. The result is startling (Fig. 35.3). It is as if the viewer is suddenly within a gigantic piece of sculpture—surrounded by sculptured forms and sculptured spaces. Working with concrete cast in specially erected molds, Saarinen shaped his forms freely, as if he were a sculptor working with clay. If the furnishings of the lobbies of Lever House and the General Motors Technical Center stand in perfect agreement with the design of their exteriors, so do the furnishings here. The freeform shapes of the information desk in the center, for example, are in total harmony with the exterior and the interior.

35.4 Eero Saarinen, Chapel at Massachusetts Institute of Technology, Cambridge, Massachusetts, 1957. Interior. Ezra Stoller/Esto.

SPIRITUAL MODERN

Even traditions as conservative and enduring as those associated with the church experienced fundamental change in the name of modernism. While the old forms were out, what remained was a basic spirituality that was expressed by architectural and interior design.

In the chapel that Eero Saarinen designed for MIT, the interior (Fig. **35.4**) echoes the cylindrical form of the exterior (Fig. **34.1**). It is lighted by an oculus in the roof and light reflected from the moat under the arches. The altar—a simple, rectangular block of beautiful marble—is the focal point of the chapel. It rests on three plinths which are circular, and it is thereby related to the shape of the room.

The only ornamentation is a sculpture by Harry Bertoia (1915–1978), a decorative sculptor and furniture designer who had studied at the Cranbrook Academy and in the late 1930s taught metalcrafting there. Bertoia's sculpture is made of small golden bars. As the light from above plays on them, they look like filtered rays of sunlight, perhaps expressing the spirit of deity descending to earth over an altar. As the chapel is nonsectarian, symbols of specific religions were intentionally excluded. It is a lovely place, conducive to meditation.

DOMESTIC INTERIORS

The revolution that began at the Bauhaus and at Mies van der Rohe's Barcelona Pavilion was resumed in postwar America in domestic architecture. Examples of the International Style include Mies's Farnsworth House (1946–51) in Plano, Illinois, Philip Johnson's Glass House (1948–9) (Fig. **35.5**), and Richard Neutra's Kaufmann House (1946) in Palm Springs, California. The steel frame, exposed and handsome in itself, means that walls can be almost totally of glass. This gives maximum lighting to the interior and makes the surrounding environment visually a part of the living space. In Johnson's Glass House the enduring quality of the International Style in furnishings is seen in Mies's "Barcelona" Chairs. With their luxurious leather cushions, they contribute to the clean sparseness of the design of this interior.

EERO SAARINEN

An alternative to the style of furniture designed by the Bauhaus group working in America—including Mies, Gropius, and Breuer—was provided by Eero Saarinen and his friend Charles Eames.

The two men collaborated on a design for a chair which won first prize in the competition held by MOMA in conjunction with the exhibition "Organic Design in Home Furnishings" in 1940–1. While the chair was never manufactured, it set both men working with new concepts in furniture design. Saarinen began experimenting with a molded form, using plywood, to make a single unit of seat, back, and arms. In 1948, he produced the so-called "Womb" Chair. Further experimentation led him to the use of fiberglass, plastics, and aluminum, which in turn led to the creation of the celebrated "Tulip," or pedestal, table and chairs (Fig. **35.6**). In these graceful forms, cast in fiberglass and aluminum, we see the first really new concept in tables and chairs since the late 1920s. As well, the designer made use of new industrial materials and technology in their production.

KNOLL INTERNATIONAL

Interior design after World War II was fostered by the great decorator houses such as Knoll International. This was founded in 1938 by Hans Knoll (1914–55) to produce modern furniture from designs by the leading designers of the day. One could, for example, purchase Mies's "Barcelona" Chairs and accompanying pieces from Knoll. Florence Schust (b. 1917), an architect and designer who was trained at Cranbrook Academy and the Illinois Institute of Technology before being employed by the firm of Harrison and Abramovitz, began working for Hans Knoll in 1943, and three years later they were married. After Hans's untimely death in 1955, she carried on the firm's work and saw it rise to preeminence among American houses of interior design.

35.5 Philip Johnson and Mies van der Rohe, Philip Johnson House (The Glass House),
New Canaan, Connecticut, 1948–9. Wayne Andrews/Esto.

35.6 Eero Saarinen, Dining table and chairs, manufactured by Knoll International, Inc., 1956.
Harry Bertoia, *Standing Sunburst Sculpture*.

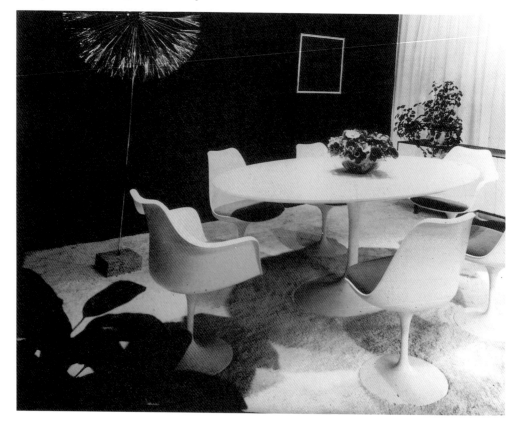

35.7 Raymond Loewy and Richard Latham, Coffee service 2000, 1954. Porcelain, height of coffee pot 9¼in (23.5cm).

The designers who provided models for Knoll International over the years make an impressive list indeed—Eero Saarinen, Mies van der Rohe, Harry Bertoia, Isamu Noguchi, George Nakashima, and Marcel Breuer among them. All aspects of interior design, from fabrics to plastics, and from office units to home furnishings, were provided by Knoll.

RAYMOND LOEWY

Upon the "Tulip" dining room table, one might place a white porcelain coffee service (Fig. **35.7**) designed in 1954 by Richard Latham (b. 1920) and Raymond Loewy (1893–1986). The graceful, curving lines and the exquisite simplicity of the forms have a symbiotic relationship with Saarinen's table and chairs.

Loewy was born in Paris and was trained as an electrical engineer before coming to the United States in 1919. Ten years later he became art director of the Westinghouse Electric Company. In 1930 he set up his own design firm, establishing his reputation in 1934 when he designed the revolutionary "Cold Spot" refrigerator for Sears Roebuck. Other classic designs to his credit include railroad locomotives, the Coca-Cola bottle, and the Lucky Strike cigarette package—all before World War II. After the war, Loewy's design for the 1947 Studebaker revolutionized the look of automobiles. In 1961 Loewy Associates became Loewy International, with offices in New York City, Chicago, Los Angeles, London, Brussels, and São Paulo. Loewy or members of his staff designed everything from lipsticks to Greyhound buses to the interior of Gimbel's department store in New York City. And, as we have seen, it was Loewy who was in charge of the interior design of Lever House.

CHARLES EAMES

Another major designer of the postwar period was Charles Eames (1907–78) who, while studying and later teaching at

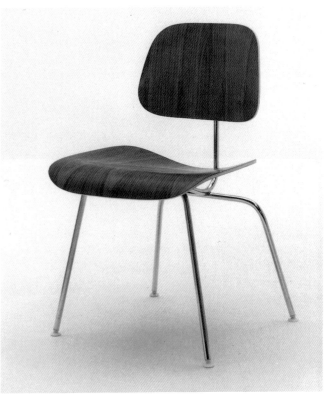

35.8 Charles and Ray Eames, Chair, 1945. Molded plywood, tubular steel. Manufactured by Herman Miller Furniture Company, Zeeland, Michigan.

Cranbrook Academy, came to know Florence Schust-Knoll, Harry Bertoia, and Eero Saarinen. During World War II, on commission from the Navy Department, Eames and his wife Ray Kaiser experimented with molded plywood, creating the classic little Eames Chair (Fig. **35.8**). It is composed of two curving planes of plywood, molded to provide comfort, which are supported by slender steel tubing. The chair was praised by critics when it was exhibited at MOMA in 1946. As in the architecture of the International Style, form is integrated with structure, materials, and technology in neat, clean lines and simplicity of shapes, expressive of the industrial age and an informal lifestyle.

Eames continued to experiment with molded furniture, and in 1948 he was the first to put fiberglass to commercial use in a molded chair. He also began working with plastics. Another classic, again a collaborative effort with his wife, is the lounge chair with ottoman (Fig. **35.9**) that is modern art's answer to the old, overstuffed chair with footstool. It was made of molded rosewood plywood, with pedestal supports and splayed legs of aluminum painted black, and with black leather upholstery. The sofa designed by the couple (Fig. **35.10**) has an oiled teak or walnut frame, cast aluminum supports, and leather upholstery over foam rubber. As with the architecture and interior into which such a piece would be placed, all irrelevant decoration has been eliminated in order to express an aesthetic compatible with the machine age and modern lifestyles.

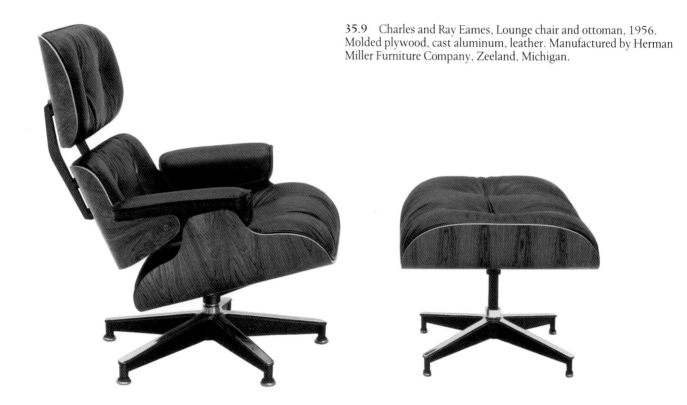

35.9 Charles and Ray Eames, Lounge chair and ottoman, 1956. Molded plywood, cast aluminum, leather. Manufactured by Herman Miller Furniture Company, Zeeland, Michigan.

35.10 (below) Charles and Ray Eames, Sofa, 1984. Teak, cast aluminum, leather. Manufactured by Herman Miller Furniture Company, Zeeland, Michigan.

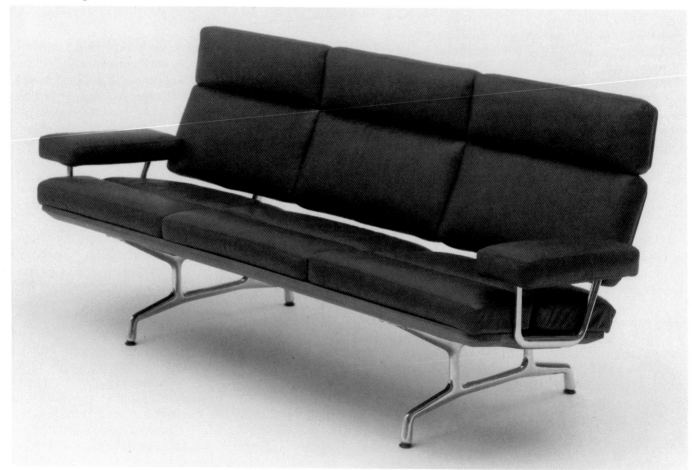

HANDCRAFTED VERSUS MACHINE-AGE FURNITURE

GEORGE NAKASHIMA

There were, of course, aesthetic points of view quite different from the International Style. George Nakashima (1905–90), for example, was a craftsman who preferred to work in wood, making each object a unique, handmade piece in the tradition, but not in the style, of the Arts and Crafts Movement—and of centuries of Western and Oriental craftsmen before that.

American-born Nakashima was trained at the University of Washington, Seattle, in forestry and architecture—an interesting combination considering his later work. He also earned a master's degree in architecture at MIT. Nakashima settled in New Hope, Pennsylvania, in 1943, where he opened his furniture-crafting studio.

Although he used power tools, they remained tools and did not, like machines, become the aesthetic determinant. Rather, Nakashima sought the spirit within his medium, creating forms that were in harmony with each piece of wood. He expressed something of his Oriental heritage when he wrote: "We work with wood, in a sense an eternal material, for without a tree there would be no human life. And we work with solid wood, not veneer, the better to search for its soul."[1]

These beliefs are expressed in the archetypal table and chair in Figure 35.11. In the table, Nakashima has preserved something of the rough edge and breech of the broad plank of the tabletop in order to allow us to sense the "soul" of the tree. The design of the chair encompasses a wide variety of sources of inspiration—from an early American Windsor chair to Shaker simplicity, and from a Japanese appreciation for abstractions to contemporary concepts of form. Subtle

35.11 George Nakashima, Conoid table and conoid chair, designed 1962, produced 1971. English walnut, height of table 28in (71.1cm).

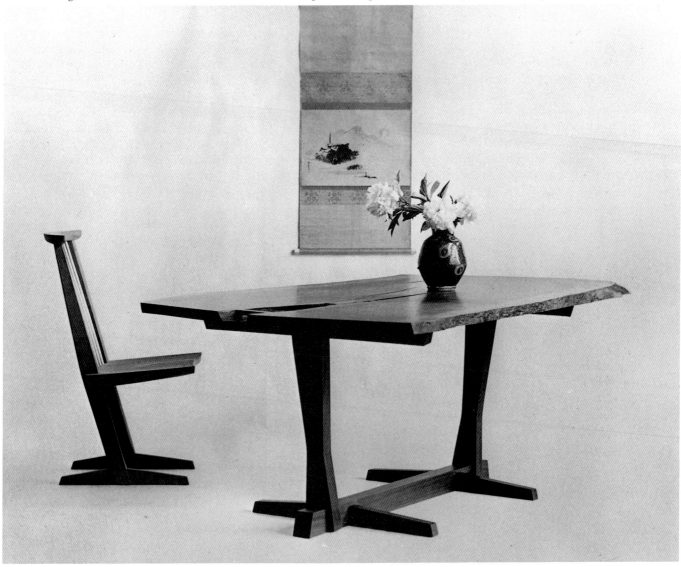

details, such as the spindles that bear the marks of hand-shaving, remind us that this is a handmade object—that its creator not only designed it, but also crafted it with his own hands.

WHARTON ESHERICK

Wharton Esherick (1887–1970) produced sculptured wooden furniture that was influenced by the Danish modern style, particularly by the Danish designer Finn Juhl of Copenhagen. At the request of Edgar Kaufmann, Jr., Juhl had organized the "Good Design" exhibition of 1951 at MOMA, and he designed the interior of Georg Jensen's store on Fifth Avenue. Juhl was therefore a major conduit for the introduction of Scandinavian design into the United States. Esherick, who was born in Philadelphia, attended the School of Industrial Art in his native city and also the Pennsylvania Academy. Although he began as a painter, he soon switched to sculpture. That accounts for the sculptural forms that are often found in his furniture, which he began making in the late 1920s.

WENDELL CASTLE

Wendell Castle (b. 1932) also was affected by the powerful influence of Danish modern, in the use of fine woods and the exploitation of their inherent beauties. After receiving his bachelor's degree in industrial design at the University of Kansas and his master's degree of fine arts in sculpture from the same institution, Castle began making sculpturesque furniture about 1960. In this he freely expressed his admiration for the organic quality of Art Nouveau and the

craftsmanship of early American furniture. He derives a special joy from sculpting wood by hand into innovative and unique furniture designs.

Many believed that craftspeople could not possibly satisfy the demand for objects that twentieth-century consumerism had created. Edgar Kaufmann, Jr. (1910–89), son of the Edgar Kaufmann for whom Frank Lloyd Wright created Fallingwater (Fig. 27.16), believed that one great advantage of the machine age was that it could put tastefully designed and wellmade objects into the hands of the masses instead of just the few. As head of the industrial arts department at MOMA, he was in a position to promote that belief, which he did in the 1940s and 1950s through a series of exhibitions titled "Useful Objects" and "Good Design." Kaufmann presented his techno-aesthetic ideology in a book called *What is Modern Design?* (1950), illustrated with a compendium of what the author considered the very best in design as of that year.

OFFICE EQUIPMENT

Office equipment frequently led the way in the development of well-designed, efficient, and easily cared-for furniture. A case in point is the desk designed by Charles Gwathmey and Robert Siegel and produced by Knoll International (Fig. 35.12).

The top and base are constructed of hardwoods with either a mahogany or **techgrain** veneer. Techgrain—a vinyl substance that can be manufactured to look very much like natural grained wood—is laminated to coarse but sturdy woods. It is extremely serviceable because it is less vulnerable to scarring and staining than real wood; moreover, it is

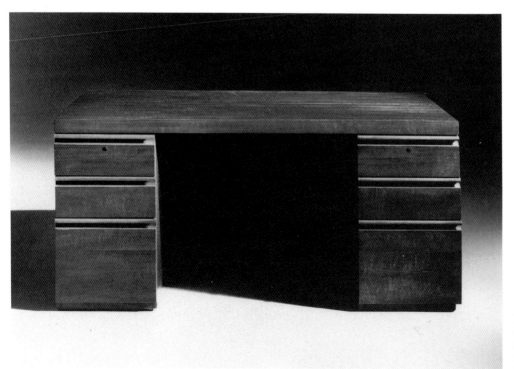

35.12 Charles Gwathmey and Robert Siegel, Desk, 1979. Mahogany, techgrain veneer. Manufactured by Knoll International.

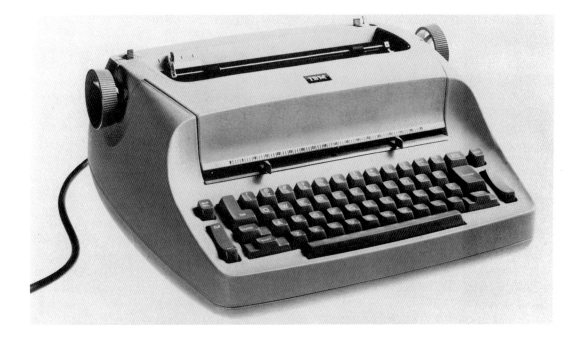

35.13 Eliot Noyes, I–30 Selectric typewriter, 1961. Manufactured by the IBM Corporation.

less expensive than solid walnut, mahogany, teak, or indeed any of the quality woods. The whole desk is modular, so one could order it with different-shaped tops, with a variety of drawer sizes, and even with a central section to fill in the kneehole if a credenza was desired instead of a desk. Appreciation of the natural beauty of wood (or the appearance of its vinyl imitation) was promoted by the strong influence exerted by Scandinavian design.

Upon a desk like the one designed by Gwathmey and Siegel, one might find an International Business Machines Selectric typewriter, designed by Eliot Noyes, who from 1956 until his death was the chief design consultant for IBM (Fig. 35.13). In that capacity he created a look for the whole line of the corporation's office equipment, characterized by a clean design expressive of function.

These ideas were instilled in Noyes as a student at Walter Gropius's graduate school of design at Harvard University and in the architectural firm of Gropius and Marcel Breuer. Noyes established his own office in New York City after World War II. He was a major designer for such corporate clients as Westinghouse, Pan-Am, Xerox, and Mobil.

The computer has become an indispensable part of office equipment, and the small personal computer is used in the office, at home, and, in its portable form, anywhere it can be carried. The "Compass" model of 1982, designed by Bill Moggridge for I. D. Two of Palo Alto, California, was one of the first portable computers to come on the market (Fig. 35.14). Its case is made of magnesium, so it is lightweight, and it is about the size of a slender briefcase. Its precisionlike appearance expresses the age of electronic technology.

35.14 Bill Moggridge, "Compass" computer, 1982. Manufactured by I. D. Two.

35.15 Charles W. Moore Associates, Rudolph House, Captiva Island, Florida, 1970–1.

35.16 Robert Venturi, Queen Anne table and chairs, 1984. Manufactured by Knoll International.

POSTMODERN DESIGN

As with the "glass box" house and skyscraper of the International Style, in the late 1960s and 1970s some designers and critics began to tire of the machine age and to turn to other types of décor which they felt were more humanistic.

If the living room of Philip Johnson's Glass House of 1948–9 (Fig. 35.5) is compared with the interior of the Rudolph House on Captiva Island, Florida, designed by Charles W. Moore, a world of difference is seen (Fig. 35.15).

The curving, cutout forms against the distant wall of the dining room are nonstructural. Instead, they are decorative, as are the checkerboard tiles of the floor, which enliven the area with color and pattern. The angular arch above the opening at the left is a curious construction, never intended to be a rational structure.

The furnishings reveal a taste for mixing: A Federal-style mirror with eagle above a country-style washstand, a nineteenth-century-style bentwood rocker on the porch, and contemporary furniture in the living room. Selection is arbitrary, based primarily on the owners of the house enjoying the objects, rather than adherence to a credo such as the International Style demands of its followers.

35.17 Charles W. Moore Associates, Wonderwall, 1982. World's Fair at New Orleans, Louisiana.

This reaction against a perceived severity and coldness was carried much further in Robert Venturi's "Queen Anne" table and chairs, in what he calls the "Grandmother Pattern" (Fig. 35.16). Produced by Knoll International in 1984, the suite is made of laminated wood and painted in bright, sometimes purposely garish, colors. That it makes one smile to look at it is consistent with the whimsical element frequently found in postmodern art and architecture, and its historical reference to the Queen Anne style is a decorative arts counterpart to the historicism of Philip

Johnson and John Burgee's Chippendale pediment on the AT&T Building (Fig. 34.11).

Venturi's set of sprightly colored table and chairs has less in common with machine age aesthetics than with the Las Vegas Strip or with the wonderful fantasy of Charles W. Moore's extravaganza for the New Orleans World's Fair of 1982 (Fig. 35.17). Commonplace, vernacular objects in incredible associations with one another fill the scene: A jukebox is juxtaposed with a giant alligator, and a flock of enormous, abstracted pelicans fly above an oversized faucet,

showerhead, and checkerboard-tiled wall. In the midst of all this garishness stands a little circular classical temple—a nod to historicism—rising above terraces of Romanlike arcades. It is a brilliant, wonderful joke, recalling in the most strident popular culture manner the great expositions of the past, at Chicago in 1893 (Fig. 20.23), Buffalo in 1901, St. Louis in 1904, and San Francisco in 1915.

Just as Moore's Wonderwall (destroyed) at New Orleans takes its inspiration from, and at the same time spoofs, American popular culture, all under the mantle of postmodernism, so do Michael Graves's furniture designs, as seen in Figure 35.18. His dressing table, which he calls Plaza, has been described as a "Hollywood revival fantasy."

"Fantasy" seems to be a word that pops up frequently in connection with postmodern works—it implies the antithesis of the structure and rationalism of the International Style. Graves's Plaza is architectural and recalls the color and decorative treatment he applied to the Portland Building (Fig. 34.12).

Michael Graves's teakettle was extremely popular, selling over 40,000 in the first year (Fig. 35.19). It is made of highly polished stainless steel, with a blue polyamide handle and a saucy little red bird on the spout that whistles when the water is hot. The colors carry associations with the American flag, and when one thinks of teapots one soon thinks of those made by Paul Revere (Figs. 7.9 and 9.7), with a touch of Art Deco thrown in. It is a happy, joyful little object that nonetheless is welldesigned and functional. With it, we end our discussion of contemporary decorative arts, in a state of anticipation as to what comes next.

35.18 Michael Graves, Plaza Dressing Table, 1981. Wood and mirror glass. Manufactured by Memphis.

35.19 Michael Graves, Teakettle, creamer, and sugar, 1985. Stainless steel with polyamide handle. Manufactured by Alessi, Italy.

CHAPTER THIRTY-SIX

PAINTING:

THE AFRICAN-AMERICAN EXPERIENCE, SOCIAL REALISM, AND ABSTRACTION, 1940 TO THE PRESENT

Although dominated by white, Anglo-Saxon sociocultural patterns, American culture is in fact a tapestry woven of diverse threads that include Native American, Hispanic, Asian, and African traditions, as well as those of European origin. The African-American contribution, for example, adds breadth and richness to the literature, music, and art of the United States. Before looking into it, this chapter will review some introductory material regarding the history of African-Americans.

The first slave ship, which sailed under a Dutch flag, arrived at Jamestown, Virginia, in 1619. The slaves who survived the horrors of the crossing came ashore with virtually no physical possessions—that is, no objects from their homeland cultures. They did have, however, memories of the songs, dances, and rituals of their native lands, and those things tended to survive within the black community. But the form and style of objects did not—these would have to be rediscovered in the early twentieth century.

The men and women born into slavery yearned to be free and to express themselves, although opportunities to do so were scarce indeed. The first novel by a black person was *Clotel* (1853) by William Wells Brown, a former slave who was the first black man to make his living as a writer—he was also the first to publish a play, *The Escape* (1858). Earlier, he had told his own story—*The Narrative of William Wells Brown, a Fugitive Slave* (1847)—which was one of the main sources for Harriet Beecher Stowe's *Uncle Tom's Cabin* (1851). *Clotel* traced the lives of three generations of African-American women and was written in the vernacular tongue of the author's own people.

Brown was probably encouraged to publish his autobiography by the example of *The Narrative of the Life of Frederick Douglass* (1845). Douglass had been born a slave in Maryland but escaped and found a haven in New Bedford, Massachusetts, although there remained a price on his head. Moving to Rochester, New York, in 1847 he began publishing an abolitionist newspaper, the *North Star*, which also advocated women's rights. His book *My Freedom and My Bondage* (1855) was immensely popular in the North.

Harriet Tubman was similarly involved with the abolitionist movement. Born a slave about 1821 in Maryland, she was put to work as a field laborer when still a child and never learned to read or write. Forced by her master to marry another slave, she escaped to the North in 1849. She became a successful agent of the underground railroad, making numerous trips into the South to organize groups of slaves, whom she led to freedom. During the Civil War, she served as a cook for the Union Army in South Carolina—and also as a spy.

The Reconstruction period had its chronicler in Frances Ellen Watkins Harper, author of *Iola Leroy*, probably the first novel by a black woman. Harper stressed the need for African-Americans to "uplift" or "elevate" themselves if, free at last, they were to take their place in American civilization.

As advocate for the education of blacks, the foremost voice was that of Booker T. Washington, who attended and then taught at the Hampton Institute until 1881 when he became president of the Tuskegee Institute.

In the years following the Civil War, a number of educational institutions were founded which offered instruction to African-Americans. Barely was the war over when Atlanta College was established in 1865, followed by the founding of Fisk University in Nashville, Tennessee, the next year, Howard University in Washington, D.C., in 1867, and the Hampton Institute in Hampton, Virginia, the year after that; the Tuskegee Institute in Alabama opened in 1881.

If African-Americans in those days were unsure of where they belonged in the social order, they were similarly uncertain of who they were culturally, for so much of their heritage had been left behind and lost over the centuries.

Heritage was something that had to be consciously regained. Between 1893 and 1910, Dr. William H. Sheppard, a black missionary returned from Africa, toured the United States telling blacks about African tribal culture. During his years abroad, Dr. Sheppard had formed a large collection of African artifacts, which he left to the Hampton Institute.

Meanwhile, in Paris avant-garde modernists were discovering African art as an inspirational alternative to the classical academic tradition. In America, Dr. Albert C. Barnes began to acquire African art, along with his extraordinary collection of works by Cézanne, Matisse, and others.

The cause was taken up by an African-American named Alain Locke, a philosophy professor at Howard University, who formed an extensive collection of African art. He used his collection to demonstrate to black people that they had a rich cultural heritage, one that existed before the era of slavery. African art achieved "legitimacy" when it was shown in the large exhibition *African Negro Art*, at MOMA in 1935.

As early as 1914, Meta Warrick Fuller, a black sculptor, had created the famous bronze image *Ethiopia Awakening* (Schomburg Center, New York Public Library), which launched African-American themes in art made by African-American artists. Such work declared a new awareness of the artists as heirs to an African culture. Countee Cullen's poem "Heritage" was published in 1925 in *Survey Graphic*, which was devoted to the life and culture of Harlem; the verse begins with the famous line "What is Africa to me?", which caused African-Americans to ask themselves about their heritage. All of this affected the art made by black men and women—we have already seen its influence in Sargent Claude Johnson's *Mask* of 1930–5 (Fig. 32.23).

Black artists continued to struggle against prejudice and the lack of opportunities for study, exhibition, patronage, and critical recognition. Many left America in the 1920s and 1930s to go to Paris, where they found a freedom and acceptance unavailable to them at home. It was in part to remedy such situations that William E. Harmon, a wealthy real-estate developer, established the Harmon Foundation in 1922. The Foundation created Awards for Distinguished Achievement Among Negroes, and it established cash prizes for black artists whose work was judged exceptional at the exhibitions that the Foundation sponsored between 1928 and 1935. In 1927, Alain Locke tried to organize a Museum of African Art in Harlem with funds from the Harmon Foundation, and African-American culture became the focus of the archival project of the Schomburg Center at the New York Public Library.

Literature by African-Americans continued to grow with the efforts of Langston Hughes, the "Poet Laureate of Harlem," with his collection of poems *A New Song* (1938), and a novel, *Not Without Laughter* (1945), which tells the story of a black youth's passage into manhood. Richard Wright's *Native Son* (1942) was one of the most controversial novels of that year and was followed three years later by *Black Boy*.

The flowering of black literature continued with James Baldwin's *Go Tell it on the Mountain* (1953) and *Nobody Knows my Name* (1961). Ralph Ellison's *The Invisible Man* appeared in 1952. Maya Angelou published *I Know Why the Caged Bird Sings* in 1970 and, more recently, Toni Morrison's *Song of Solomon* (1977) and *Beloved* (1987) quickly

became bestsellers. With such works, and many others, African-American writers have clearly established their place in the literary tradition of the United States.

Although some art schools, such as that at the Art Institute of Chicago, opened their doors to African-Americans, the students frequently turned to the art departments of black colleges for their training. Beginning in 1921, James Porter was an influential teacher at Howard University, where the sculptor Elizabeth Catlett and the painter and art historian David Driskell were among his students. Aaron Douglass, celebrated muralist of the Harlem Renaissance—a flowering of artistic and creative talent in Harlem in the 1920s and 1930s—established the art department at Fisk University in Nashville. Hale Woodruff, who had studied with Henry O. Tanner in Paris and with the Mexican muralist Diego Rivera, taught at Atlanta University, where he painted an impressive series of murals for the college library. John Biggers studied at the Hampton Institute and was for thirty-six years chairperson of the art department at Texas Southern University. Each of these influential teachers worked in a manner that combined modernist and African components, and their art tended to tell the story of black people, often making social commentaries on the black experience in America in the mid-twentieth century.

SOCIAL REALISM

In art, the term "social commentary" refers to a type of imagery that takes note of events or practices in society and comments on them—usually on their negative aspects. Sometimes individuals come under attack, but often the artist forces us to focus upon institutions or society as a whole.

Beginning in the early twentieth century, this style was called "social realism." It fed upon the social injustices of the 1920s and the economic conditions of the 1930s. It continued to be used into the 1940s, as America increasingly scrutinized its treatment of the poor, the elderly, ethnic minorities, and women.

BEN SHAHN

Such matters are at the very core of the art of Ben Shahn (1898–1969), whom we encountered previously as a photographer (see p. 478). Shahn was born in Lithuania and brought to America by immigrant parents when he was eight. He witnessed firsthand the plight of those who were victims of social injustice merely because they were poor or belonged to an ethnic minority.

After studying at the National Academy of Design and at the Art Students League, Shahn gained prominence through his paintings inspired by the famous trial and execution of Nicole Sacco and Bartolomeo Vanzetti, who were tried for murder but judged because they were radicals. Shahn's

36.1 Ben Shahn, *Miners' Wives*, 1948. Egg tempera on board, 48 × 36in (121.9 × 91.4cm). Philadelphia Museum of Art.

biting visual commentary—showing the two men in their coffins—pricked the national conscience, as did Upton Sinclair's novel *Boston* (1928), which also was based on the Sacco-Vanzetti case. The power of Shahn's social realism was intensified through his acquaintance with the Mexican socialist Diego Rivera, who was in New York City in 1933 in connection with the large mural he painted for Rockefeller Center (see p. 421). Shahn is called a social realist because his art usually deals with searing social issues and the harsh realities of life.

The tenor of Shahn's art in the 1940s is seen in several pictures he painted following a coalmine disaster in Centralia, Illinois, in 1947 in which 111 miners died. The haunting *Death of a Miner* (1949) is at the Metropolitan Museum of Art. We illustrate here Shahn's moving *Miners' Wives* (Fig. 36.1). Shahn had drawn illustrations for an article in *Harper's* magazine earlier in 1948 in which John Bartlow Martin had exposed the negligence and callous lack of concern that had led to the disaster. Shahn knew the look of anguish and bewilderment on the faces of the wives who

36.2 Jack Levine, *Gangster Funeral*, 1952–3. Oil on canvas, 5ft 3in × 6ft (1.6 × 1.83m). Collection, Whitney Museum of American Art, New York City.

rushed to the entrances when the alarm sounded to announce the disaster. He wanted to capture their grief, despair, and anxiety. The woman in the foreground is a grim image of such fear, expressed by the stark, staring eyes, the tense set of her mouth, and the nervous clasping of her hands—to which Shahn calls attention by making them oversized. The seated wife at the left is also a memorable image. The shawl connotes Old World immigrant customs, and she has a pathetic look of resignation on her face as she realizes that she and her child are now left alone and destitute. The jagged nervousness of Shahn's line became a trademark of his style. He perhaps acquired it from looking at the work of Paul Klee (1879–1940), but Shahn used it to his own expressionistic purpose.

OTHER SOCIAL REALISTS

Many painters took up the plight of those who were not sharing fully in the American Dream. Robert Gwathmey (1903–88), for example, often painted pictures of the social injustices meted out to blacks. Phillip Evergood (1901–73) painted heartwrenching scenes of the poor.

The work of Jack Levine (b. 1915), a social satirist as well as realist, forcefully calls our attention to the evils within our society. To forge his own very personal, expressive style, Levine draws inspiration from the painterliness of a wide range of artists, from Titian and Rembrandt to Goya, Daumier, and Rouault.

His *Gangster Funeral* shows such influences in the

brushwork, the texture of the pigment, and the flickering effects of light and color (Fig. 36.2). Typical is the caricaturing of corrupt and hypocritical elements in society, suggested by the presence of a police chief among the mourners as well as the man who ordered the dead man's execution.

Although there are abstract qualities in the styles of both Shahn and Levine, the realist factor connotes an attachment to the longstanding tradition of naturalism in American painting.

AFRICAN-AMERICAN ARTISTS

During the 1940s and 1950s, a number of African-American artists began to gain recognition. Those we will discuss here include William Johnson, Horace Pippin, Jacob Lawrence, Malvin Gray Johnson, Lois Mailou Jones, and Romare Bearden, who represent a cross-section of African-American painting.

WILLIAM JOHNSON

As a boy in his hometown of Florence, South Carolina, William Johnson (1901–70) used to copy newspaper cartoons. Moving to New York City in 1918, he studied at the National Academy of Design for several years. In 1926 he left for Paris, where, from his studio in Montparnasse, he would walk to the museums or visit Henry O. Tanner. At the exhibitions he familiarized himself with the new experiments taking place in modern art. In 1919, Johnson returned to New York City where he established a studio in Harlem.

Johnson lived in Denmark from 1930 to 1938 but returned to New York City in 1939. By then his personal style had coalesced as he turned to themes of religious spiritualism and of the life of black people.

The Breakdown (Fig. 36.3) dates from this time and represents a poor African-American family, each member of which is barefoot, standing beside their old wreck of a car while the father changes a flat tire. Stylized mountains in the background indicate the family is traveling across country, possibly from the South to the North in the hope of finding

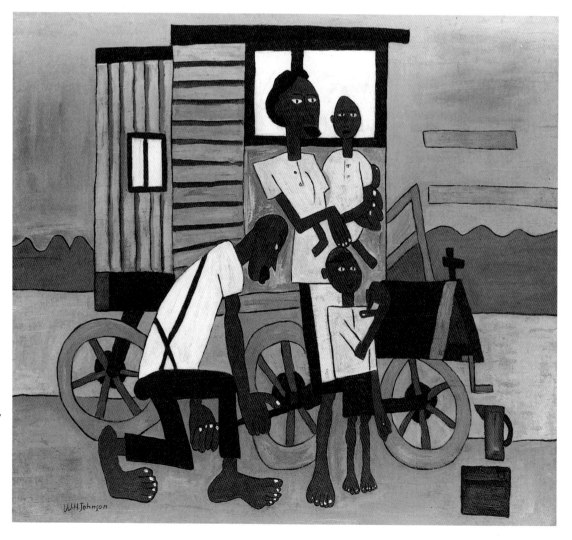

36.3 William Henry Johnson, *The Breakdown*, 1940–1. Gouache and pen and ink on paper, 34⅛ × 37½in (86.7 × 95.3cm). National Museum of American Art, Smithsonian Institution, Washington, D.C.

work and a life that is better. The painting reveals that Johnson had come to understand well the power of abstraction, which is especially noticeable in the linear patterns and flat planes of the composition. In the face of the mother we also notice that Johnson perhaps had been observing African masks. The cross mounted on the hood of the car tells us of the faith that sustains people throughout such hardships.

Johnson's art found few patrons, and after he became mentally disoriented in 1956 the Harmon Foundation acquired all of the pictures in his studio. Eleven years later, the Foundation presented them—all 1154—to the National Museum of American Art in Washington, D.C.

HORACE PIPPIN

A black man whose grandparents had been slaves, Horace Pippin (1888–1946) was born in West Chester, Pennsylvania, but grew up in upstate New York. Wounded severely in his right arm during World War I, Pippin was unable thereafter to do manual labor. Instead, he assisted his wife, who was a laundress in West Chester, where he spent the rest of his life.

Entirely selftaught, Pippin was discovered by several pioneers of the folk art revival in the 1930s. *Victorian Interior* (Fig. 36.4) shows a mode of vision that is independent of both academic naturalism and the modernist movements of the twentieth century, although Pippin was familiar with modernism through his frequent visits to the Barnes Collection in nearby Marion, Pennsylvania, and to the art galleries of Philadelphia.

In *Victorian Interior*, Pippin found his own brand of abstraction in the stylization of natural form into flat patterns and delicate, linear rhythms. The color, too, is bright and decorative, and it is abstract in that it is largely independent of the actual color of the objects painted. Selftaught artists such as Pippin often felt free to intensify color for the sake of decorative or expressive purposes.

Pippin's concern with the story of his own people was often expressed in his art, as in *John Brown Going to His Hanging* (1942, Pennsylvania Academy of the Fine Arts)—Pippin's grandmother, a freed slave, had witnessed John Brown's hanging—and the *Cabin in the Cotton* (1944, private collection). Pippin also painted a wide range of themes, from rural Pennsylvania genre scenes to biblical pictures.

JACOB LAWRENCE

Jacob Lawrence (b. 1917) also took the life of black people in America as his subject matter. After attending Frederick Douglass Junior High School in New York City, he took classes at the Harlem Art Workshop in the 135th Street branch of the New York Public Library. In 1937, when only twenty, Lawrence started the first of several series of paintings, this one on the theme of Toussaint L'Ouverture, the hero of the Haitian slave rebellion.

This was followed by two of his most important series,

36.4 Horace Pippin, *Victorian Interior*, 1946. Oil on canvas, 25¼ × 30in (64.1 × 76.2cm). Metropolitan Museum of Art, New York City.

36.5 Jacob Lawrence, *Harriet Tubman worked as a water girl to cotton pickers; she also worked at plowing, carting, and hauling logs,* 1939–40. Harriet Tubman series No. 7. Tempera on hardboard, 18 × 12in (45.7 × 30.5cm). Hampton University Museum, Hampton, Virginia.

the Frederick Douglass series (1938–9) of thirty-two panels, and that devoted to Harriet Tubman (1939–40) of thirty-one panels. The seventh panel in the Tubman cycle shows the power of Lawrence's imagery. Tubman is represented, one knee on the log she is sawing, as a massive physical form that nearly fills the picture area. This suggests that in her strength lies her ability to survive, to fight, and to gain her freedom (Fig. 36.5).

The painting also shows that Lawrence was familiar with abstractionist techniques, particularly Cubism. He was, however, forging his own personal brand of abstraction in images of a raw expressionistic power.

In 1940, Lawrence received a Rosenwald Foundation Fellowship, which allowed him to paint his next series, *The Migration of the Negro North.* He was surrounded by powerful influences that encouraged him in his art, ranging from the social realist pictures by Ben Shahn to the great wall paintings by the Mexican muralists Rivera and Orozco,

whose works were wellknown in New York City in the 1930s. *The Migration* series, which was circulated nationally by MOMA, was followed by another series devoted to the saga of John Brown (1945), which was sent on national tour under the auspices of the American Federation of Arts.

In 1948 Lawrence made a set of six black-and-white expressive woodcut-like illustrations for a book of poetry by Langston Hughes, *One-Way Ticket.* A few lines from the book read:

I am fed up I pick up my life
With Jim Crow laws, And take it away
People who are cruel On a one-way ticket –
And afraid, Gone up North,
Who lynch and run, Gone out West,
Who are scared of me Gone!
And me of them.

In chapter 32 we noted the rise of interest in African tribal art and its impact on sculptors—Sargent Claude Johnson, for example (Fig. **32.23**). Many African-American painters also responded to the rediscovery of the artifacts of their heritage, as we see in the work of Malvin Gray Johnson and Lois Mailou Jones.

MALVIN GRAY JOHNSON

Johnson (1896–1934) was born in Greensboro, North Carolina, but migrated to New York City where he lived most his

36.6 Malvin Gray Johnson, *Negro Masks,* 1932. Oil on canvas, 28¼ × 19⅛in (71.8 × 48.4cm). Hampton University Museum, Hampton, Virginia.

life. He came into prominence in 1928 when his painting *Swing Low, Sweet Chariot* was awarded the Otto Kahn Prize at the annual exhibition sponsored by the Harmon Foundation.

Although Johnson painted the streetlife of Harlem and subjects taken from black spirituals, paintings such as *Negro Masks* are clearly inspired by the tribal arts of Africa (Fig. 36.6). The African elements, however, have been blended with Western abstractionist experiments—their compatibility is as evident here as in the mask-like faces in Picasso's *Les Demoiselles d'Avignon* (1907, MOMA).

LOIS MAILOU JONES

Soon after Lois Mailou Jones (b. 1906) began teaching at Howard University in 1930, Alain Locke suggested that she draw upon her African heritage as inspiration for her painting, using the tribal art collection at the university. This set the pattern for much of Jones's work for the rest of her career. An early, wellknown example is *Les Fétiches* (1937, collection of the artist), which has African masks as its motif.

Although born in Boston, Jones spent most of her career in Washington, D.C., and in Haiti, where her Haitian husband was a nationally recognized painter. Along with African themes, Haitian subjects make up an important part

36.7 Lois Mailou Jones, *Petite Ballerina*, 1982. Acrylic on canvas, 37 × 32in (94 × 81.3cm). Collection of the artist.

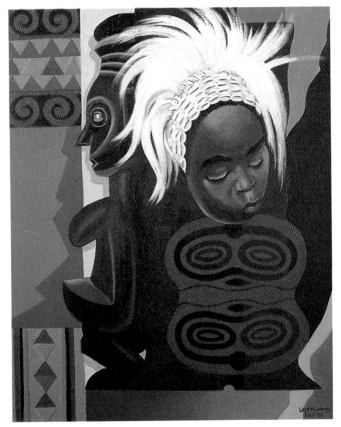

of her work. To get to know the heritage of her people better, Jones visited African countries, particularly identifying with the life of young black females.

These two concerns are united in pictures such as *Petite Ballerina*, which shows the head of a girl wearing a ceremonial headdress. She flounces it as she does the tribal dance of the ritual of passage from adolescence to womanhood (Fig. 36.7). The painting also contains references to tribal fabric patterns and, in the figurine, to the spirit of ancestors—the woman's lifecycle will be completed when she ultimately joins her ancestors. Jones's paintings often have a brilliant coloration.

ROMARE BEARDEN

Romare Bearden (b. 1912) studied with George Grosz (1893–1959) at the Art Students League in the mid-1930s. He then took up philosophy and art history at the Sorbonne in Paris in 1951, before setting up his studio in New York City in 1956. The time he spent in Paris well acquainted Bearden with the Synthetic Cubism of Picasso, and other early influences include Mondrian, Miró, and Stuart Davis.

In 1934, in an article in *Opportunity: Journal of Negro Life*, Bearden had voiced a warning that the black artist should not try to imitate white people's art to the extent that nothing of the black experience was expressed:

> The Negro in his various environments in America holds a great variety of rich experiences.... One can imagine what men like Daumier, Grosz, and Cruickshanks [*sic*] might have done with a locale like Harlem, with all its vitality and tempo.
>
> Modern art has borrowed heavily from Negro sculpture. This form of African art had been done hundreds of years ago by primitive people. It was unearthed by archaeologists and brought to the continent. During the past twenty-five years it has enjoyed a deserved recognition among art lovers. Artists have been amazed at the fine surface qualities of the sculpture, the vitality of the work, and the unsurpassed ability of the artist to create such significant forms. Of great importance has been the fact that the African would distort his figures, if by so doing he could achieve a more expressive form. This is one of the cardinal principles of the modern artist.[1]

In the late 1950s Bearden began working in collage, the technique of creating an image by pasting various pieces of paper on to a support of paper or board. But the African element remained strong in spite of his adoption of a basically Cubist use of form. This is apparent in Figure 36.8. Here, in images of black people which recall the forms of tribal art, we see the story of the importance of the church and Christian ritual to African-Americans, and also the lingering—or rediscovered—heritage of their ancestors in remote African villages. To Bearden, an essential continuum stretching from ancient ancestry to the present day was thereby established in his art.

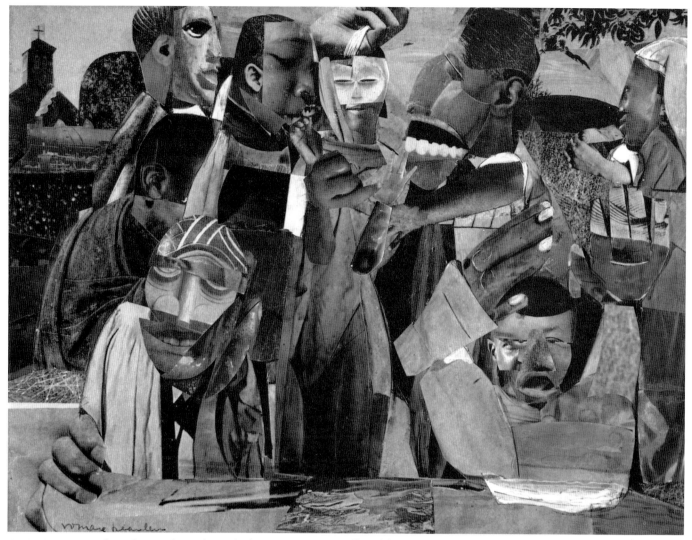

36.8 Romare Bearden, *The Prevalence of Ritual: The Baptism*, 1964. Collage (photomechanical reproduction, synthetic polymer, pencil) on paperboard, 9⅛ × 12in (23 × 30.5cm). Hirshhorn Museum and Sculpture Garden, Smithsonian Institution, Washington, D.C.

FOUNDATIONS OF ABSTRACT EXPRESSIONISM: SURREALISM

In order to understand the movement in modern art known as Abstract Expressionism, which emerged in the United States during and after World War II, it is necessary to understand the philosophy and literature of the movement known as Surrealism. Surrealism had its beginnings in Europe, mainly in Paris in the 1920s, and flowered in the 1930s. American artists did not take to it with much enthusiasm at that time. During and after the war, however, the latent force of Surrealism became the wellspring for the most important movement of the 1940s and 1950s, Abstract Expressionism.

The term "surrealism"—or *surréalisme*—was first coined around 1917 by Guillaume Apollinaire (1880–1918), a brilliant leader of the young intellectuals in Paris, a gifted poet, and a perceptive critic of early modernism. Apollinaire died in World War I, and it was for another young poet, André Breton, to become the guiding spirit of the movement.

In those early years, before Surrealism had actually coalesced as a movement, its embryonic ideas were inter-related with those of the Dadaist movement (see p. 461). Dada sought to destroy and ridicule almost everything, but particularly the art of the establishment, in order to wipe the slate clean and rebuild a better world. Probably because Dada was too negative and had no positive program to offer, it faded in the 1920s. As it did, Surrealism rose from its foundation, offering more avenues for creative exploration.

In the early twentieth century, there were some who felt that objective rationalism—which had long dominated the

process of reasoning in the Western world—had failed mankind. Since the Age of Enlightenment in the eighteenth century, reason and empirical knowledge had provided a foundation for Western civilization. The horror of World War I, however, had convinced many that the rationalism of the old order was far from perfect—indeed, was bankrupt. They began looking for some other way for arriving at an understanding of reality by turning inward, instead of outward. Distrusting the appearance of things, in intellectual and creative matters, they chose intuition and subjective experience over empirical knowledge and rationalism.

A SURREALIST MANIFESTO

For convenience, we may say that Surrealism was launched in 1924 with the appearance of the *Surrealist Manifesto*, written by André Breton.

A medical student before the war, Breton was drafted in 1915 and served in a psychiatric unit of the French army. During that period, he became interested in psychoanalysis and the theories of Sigmund Freud. He also admired the hallucinatory, dream-world poetry of Arthur Rimbaud (1854–91) who, in "Sun and Flesh," had declared human reason to be inadequate in understanding the real world. Breton, too, began to see the supposed logic and reason of the external world as an illusion, and he turned instead to the subconscious, to the irrational, and to the technique of free association. He proclaimed that insanity was as valid as sanity, and that dreams were the occasions when the conscious and the subconscious were reconciled. Creativity flowed forth from the artist in a stream of images, which the artist him- or herself might or might not understand.

In one of the most important passages in the *Manifesto* of 1924, Breton gives his definition of Surrealism:

> Psychic automatism in its pure state, by which one proposes to express—verbally, by means of the written word, or in any other manner—the actual functioning of thought. Dictated by thought, in the absence of any control exercised by reason, exempt from any aesthetic or moral concern.[2]

A later passage, in which Breton quotes the poet and critic Charles Baudelaire, declares that,

> It is true of Surrealist images as it is of opium images that man does not evoke them; rather, they "come to him spontaneously, despotically. He cannot chase them away; for the will is powerless now and no longer controls the faculties."

Under Surrealism, fantasy and even absurdity enjoyed a higher standing than rationalism. Indeed, the absurd developed a genre of its own in both literature and pictorial imagery.

A NEW WAY OF SEEING

When World War II erupted, André Breton came to the United States where he joined his refugee friends Marcel Duchamp, Yves Tanguy (1900–55), André Masson (b. 1896), and Max Ernst (1891–1976). They constituted a brilliant band of surrealist painters and theorists in America. This was an important factor in the rise of Abstract Expressionism during and immediately after the war, for several aspects of Surrealism were fundamental to that new school of painting, especially the ideas of automatic writing and the involuntary flow of the subconscious.

In his definition of Surrealism, Breton had spoken of "psychic automatism." This simply means that all rational control over the mind is released, and so the mind delivers a free flow of words or images automatically. Whatever comes forth comes from the depths of the subconscious, as Freud theorized, has truth and significance, and is even a superior form of reality. Dreams offer a close parallel. When an artist allows his subconscious to take over, the result has validity, even if it is difficult or impossible to interpret—therefore, creation must be largely automatic and spontaneous.

In the *Surrealist Manifesto* Breton had declared that abstract, nonobjective forms can have greater potential for self-expression than images that are consciously rendered in a naturalistic manner. The Russian painter Marc Chagall often seemed to paint images from his dreams, while in the work of the Italian artist Giorgio de Chirico (1888–1978), the viewer travels visually through a dreamscape. The Spaniard Salvador Dali (1904–89) is probably the best-known of the dream painters. Another Spaniard, Joan Miró, and the Frenchman Jean Arp expressed their subconscious through the **biomorphic** (living) forms of their art.

The first surrealist exhibition in the United States was held at the Hartford Atheneum in 1931, followed the next year by the "Surrealist Group Show" at the Julien Levy Gallery in New York City. In the announcement of another Surrealism show at the Levy Gallery in 1936, where paintings by Salvador Dali were shown for the first time, the essence of the movement was explained:

> [Surrealist] painters attempt to depict a world of the subconscious imagination more real than conventional reality—not abstract, but fantastic in so far that it is opposed to the logic of our everyday life.... The Surréalistes of 1924 adopted the Freudian psychology as a key to the subconscious world they wished to represent, [and] the Surréalistes often deliberately propose to shock and surprise, so that you may be deprived of all preconceived standards, open to new impressions, and able to recognize this world that lies behind barriers of the conscious mind. The dream world, of which one-third of our life consists, may be found to have a continuity which our memory has been used to neglect....[3]

In 1936 Levy published an early study of the movement in his book *Surrealism*, and MOMA mounted a large exhibition, "Fantastic Art, Dada, Surrealism," which focused the

attention of the New York art world on Surrealism as a major movement. All of this created a fertile base for the flowering of American surrealist painting, which followed the end of the war.

SURREALIST PAINTING

Through an extension of the Surrealism of the 1930s and the creation of a new technique called "action painting," or Abstract Expressionism, in the late 1940s the American art scene became the most exciting and innovative place in the world of art. Mark Tobey (1890–1976) and Arshile Gorky extended the perimeters of Surrealism, while Jackson Pollock (1912–56), Willem de Kooning (b. 1904), and Franz Kline (1910–62) created Abstract Expressionism. Robert Motherwell (b. 1915), Mark Rothko (1903–70), and Adolph Gottlieb (b. 1903) were leaders of a related movement. All of these artists had gone through the training phases of their careers by or in the 1930s. The restoration of peace in 1945 permitted the redirecting of creative energies, bringing to fruition their several modes of artistic expression.

One thing became clear: For the first time, the power center in contemporary art had shifted from Europe to America, particularly to New York City. For 300 years, American painters had borrowed from and contributed to artistic movements that had been born and refined in Europe. Now, Americans were leading the way in the establishment of the most daring and progressive postwar art movements.

ARSHILE GORKY

The man whose work first indicated the rise of a new school of modernism in America was Arshile Gorky (1904–48). Gorky was born in Armenia but came to the United States when he was sixteen. During the late 1920s and 1930s he retraced the evolution of modern painting in his art, the better to understand its principles. About 1941, however, Gorky developed a very personal form of expression which was related to the Surrealism of the European painters Miró, Arp, and Masson. He was also influenced by the Chilean Surrealist Roberto Matta (b. 1912), who arrived in the United States in 1939.

The essential features of Surrealism that redirected Gorky's art were biomorphism and automatism (an unconscious, uncensored means of expression in which forms flow automatically onto the canvas). All of this is present in *Garden in Sochi*, in which abstract shapes suggest biomorphic forms, anxiety, and psychological disturbance (Fig. 36.9). Gorky himself could not explain precisely what the forms meant or represented, since his images flowed freely from his subconscious and were executed without conscious effort by the swift action of his hand. What has come to be called the "happy accident" is sometimes present in his art: If paint that accidently dripped onto the canvas worked well as an integral part of the composition, the artist accepted it and left it. Gorky's art and method had an enormous impact on the rising group of young painters who created Abstract Expressionism.

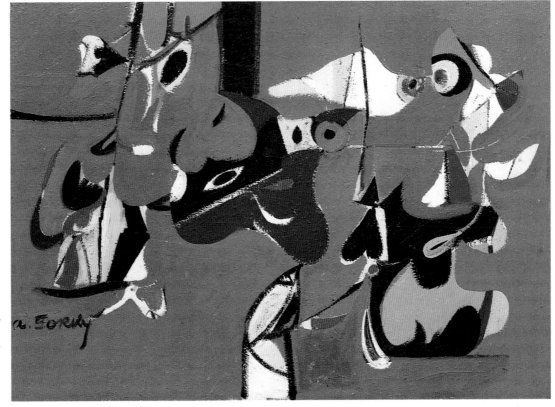

36.9 Arshile Gorky, *Garden in Sochi*, 1941. Oil on canvas, 3ft 8¼ × 5ft 2¼in (1.12 × 1.58m). Collection, The Museum of Modern Art, New York. Purchase Fund and gift of Mr. and Mrs. Wolfgang S. Schwabacher (by exchange).

MARK TOBEY AND BRADLEY TOMLIN

Mark Tobey (1890–1976) was born in Centerville, Wisconsin, and studied briefly at the Chicago Art Institute and in New York City before settling in Seattle in 1922. By then he had become a follower of Bahaism, a religion founded in Persia in 1863 which advocates the unity of all things and all faiths, world peace, and the equality of men and women. Around 1923, an Oriental student introduced Tobey to the art of Chinese calligraphy. In 1934 Tobey traveled to Japan where he entered a Zen Buddhist monastery. There, between periods of meditation, he again took up calligraphy.

All of these events began to coalesce in Tobey's art in the late 1930s in pictures which were made up of white writing, as it was called—a pattern that spread over most of the canvas surface, composed of calligraphy-like symbols in white paint. By the time of his first oneperson exhibition in New York City in 1944, Tobey's style had reached its mature phase.

36.10 Mark Tobey, *Universal City*, 1951. Watercolor and gouache on paper, 37³⁄₁₆ × 24⁷⁄₈in (94.5 × 63.2cm). Seattle Art Museum.

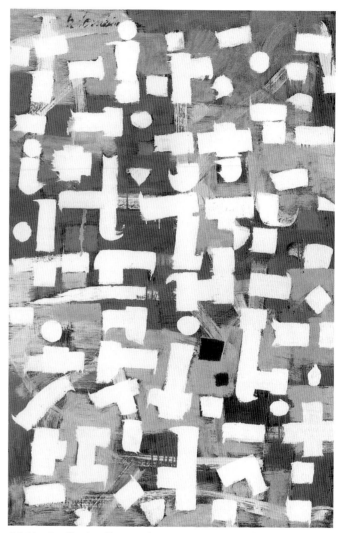

36.11 Bradley Walker Tomlin, *No. II*, c. 1949. Oil on canvas, 44¹⁄₈ × 29in (112.1 × 73.7cm). Munson-Williams-Proctor Institute, Museum of Art, Utica, New York.

In *Universal City* (Fig. 36.10), the unity and equality of Tobey's faith are expressed in myriad calligraphic symbols, which float like particles of meditative thought upon the plane of the canvas. These symbols represent no specific objects and establish no one focal point—they declare the integrity of the canvas surface and its independence of the objective world. A spaceless, soft, gray-green ground suggests infinity, while the overall pattern of symbols indicates the interrelatedness of all things—a fundamental tenet of Tobey's beliefs. The field of symbols is built up by a kind of automatic writing which is traced unconsciously upon the canvas, in a script that even the artist need not understand.

The paintings of Bradley Walker Tomlin (1899–1953) possess many of the characteristics found in Tobey's art. Here, too, one finds calligraphic symbols on the surface of the canvas, without reference to objects of the natural world or to the illusion of three-dimensional space. Tomlin, however, did not arrive at his style through the study of

religion and calligraphy. His canvases are usually larger than Tobey's, and his symbols are bolder, as we see in *No. II* (Fig. 36.11).

Tomlin's symbols are white bars, dots, crosses, and other forms that rest upon a plane of patches of varying shades of muted blues and greens. The brushwork is loose and active, and there are places where paint has run down the canvas in dribbles, which was accepted as an integral part of the work. In Tomlin's mature work there is a delicate but disciplined balance between spontaneity—a desirable feature in much postwar American painting—and structure. Note, too, the title of the painting, which carries no reference to the objective world. Artists will frequently use this device to assert the independence of the canvas from the world of objective reality.

WILLIAM BAZIOTES

William Baziotes (1912–63) painted surrealist pictures of a very different kind. Born in Pittsburgh, Baziotes was trained in the academic manner at the National Academy of Design in New York City. Discovery of the surrealist work of Miró, Masson, and Gorky, however, converted him to abstraction by the mid-1940s. *Scepter* is exemplary of his very personal style (Fig. 36.12). Upon a mottled ground of muted blues and gray-greens, a pale symbol stands erect, dominating the imagery like a monarch, while an ameba-like darker form drifts beneath the spiderlike line at the upper right. Biomorphic forms appear, apparently from the subconscious —unfathomable, perhaps, but elegant and sophisticated in form and hue.

36.12 William Baziotes, *Scepter*, c. 1960–1. Oil on canvas, 5ft 6in × 6ft 6⅛in (1.68 × 1.98m). National Museum of American Art, Smithsonian Institution, Washington, D.C.

ABSTRACT EXPRESSIONISM

The most dynamic movement of the postwar period was Abstract Expressionism, sometimes also called action painting. Its foremost painters included Jackson Pollock, Willem de Kooning, Franz Kline, and Hans Hofmann (1880–1966), but there were many others whose work was tangential.

Abstract Expressionism arose in part out of Surrealism, but it soon became a movement in its own right. It is called Abstract Expressionism because the imagery is abstract or even nonobjective, and the way in which the paint is put on to the canvas expresses the action with which the work was made. Naturalistic representation of objects is of less importance than the artist's feelings about them or the aesthetic experience of the act of painting itself. In Abstract Expressionism, explosive energy is a part of the method of creating—an emotional drama builds through the technique itself. Accidents inevitably occur in the frenetic execution of a work, and are often retained as evidence of spontaneity. The scale of such paintings soon increased to heroic dimensions, mainly because broad areas were required for the freeswinging movements of the artist's arm and hand.

The integrity of the canvas surface should again be emphasized. The Abstract Expressionist work is a thing unto itself, and it should not be judged by how well or how badly it represents something else. It does not have to be a still life, a portrait, or a landscape. It is aesthetically sufficient for it to be simply pigment, color, canvas, and brushwork—the result of spontaneous, energetic creation.

JACKSON POLLOCK

Jackson Pollock (1912–56) created one of the most original forms of expression in the history of American painting. Born in Cody, Wyoming, as a youth he made his way first to Los Angeles and then to New York City. Pollock studied at the Art Students League with Thomas Hart Benton, whose mannered expressionism influenced him. Discovery of the work of Albert Pinkham Ryder (Figs. 24.20 and 24.21), however, particularly the thick pigments and rich impasto blended into the overall design, had an even greater impact. Pollock also became familiar with the automatic writing of Surrealists such as Gorky and Tobey. This became the foundation of his unique style, which emerged in the late 1940s.

In *Autumn Rhythm*, the paint is dribbled and flung upon the canvas, which, as Pollock worked on it, was placed flat on the floor rather than upright on an easel (Fig. 36.13). The end result is unpremeditated, and the "happy accident" is an integral part of the imagery and a reference to its spontaneity. On an offwhite ground, the primary color is black, with a secondary color of rust-orange and touches of numerous other hues.

The painting exists as an exciting aesthetic experience—an experience the viewer can share because the painting itself explains in an instant the process of its making. Typically of Pollock's work, the overall effect is without depth of space or focal center. While the action glides across the surface, easily if frenetically, a structure, a unity, and even an order eventually evolve in the multitude of complexities.

36.13 Jackson Pollock, *Autumn Rhythm: No. 30, 1950*, 1950. Oil on canvas, 8ft 9in × 17ft 3in (2.67 × 5.26m). Metropolitan Museum of Art, New York City.

In an interview with Pollock, it was noted that he and other Abstract Expressionists:

> ...are not concerned with representing a preconceived idea, but rather with being involved with an experience of paint and canvas, without interference from the suggested forms and colors of existing objects.... [Pollock] does not know beforehand how a particular work of his will end. He is impelled to work by the urge to create and this urge and what it produces are forever unknowable.... We can experience the unknowable, but not understand it intellectually....[4]

WILLEM DE KOONING

Much the same can be said of the art of Willem de Kooning (b. 1904) except that his imagery retains some reference to the human figure. Trained in his native Rotterdam in a crafts school and then at a traditional art academy, De Kooning developed an interest in the modern movement which was quickened when he first saw the work of the Dutch De Stijl painters Piet Mondrian and Theo van Doesburg. When De Kooning emigrated to the United States in 1926, he was still a figure painter. By the late 1930s, under the influence of Cubism, his figures became fragmented and reassembled. Meanwhile, through his friendship with Gorky, De Kooning discovered the surrealist technique of automatic painting. Whereas the automatism of, say, Tobey is delicate, diminutive, and conducive to quiet meditation, De Kooning's developed into a slashing attack upon the canvas surface, with a large brush loaded with pigment.

De Kooning's distinctive style is evident in *Woman, I*, which is over 6 feet (1.8 m) in height (Fig. 36.14). The gesture of the brush—often appearing to be wild and uncontrolled—and the amount of pigment that seems to be scrubbed in are important features of his style. As with the work of Pollock, the process of making the picture is perfectly evident, for that is one of the primary requirements of Abstract Expressionism.

Spontaneity notwithstanding, the picture took two full years to bring to completion. De Kooning did not work on it constantly, and it is important to understand that *Woman, I* was an ongoing process with constant revisions. For example, at one point, after devoting over a year to reworking the picture, De Kooning discarded it. Some weeks later it was rescued, reworked slightly, and sent off for exhibition. Perhaps the artist had sensed the infinite number of possibilities existing in the image, and their exploration was as important as the finished picture.

For De Kooning—as for the many younger painters he influenced—painting became an existentialist experience: The act itself was as important as the thing created. Two of the tenets of the philosophy of Existentialism are the identification of anguish as an emotion that is common to all men and women and a demand for participation. When a viewer stands before a huge De Kooning canvas, a vicarious

36.14 Willem de Kooning, *Woman, I*, 1950–2. Oil on canvas, 6ft 3⅞in × 4ft 10in (1.93 × 1.47m). Collection, The Museum of Modern Art, New York. Purchase.

participation in reexperiencing the act and process of its creation is inevitable, and one certainly senses an anguish inherent in both the image and the gesture. The Existentialism of philosophers such as Jean-Paul Sartre and Albert Camus had great appeal to many of the avant garde for the freedom it offered, for its aversion to conformity, its recognition of the absurdities of life. It denied materialism, and it placed greater emphasis on being and doing than on knowing and understanding.

FRANZ KLINE

Franz Kline (1910–62) also burst upon the New York City art scene in about 1950 with a startling new style. Born in Wilkes-Barre, Pennsylvania, he studied in Philadelphia, Boston, and London before going to New York City in 1938, at the time working in a figurative manner.

In the mid-1940s Kline began to experiment with the abstract quality of his figure drawings, done in black on white paper, ever simplifying the form. By the time of his first oneperson show at the Egan Gallery in New York City in 1950, Kline's work was totally abstract, and his characteristic black-on-white palette was already present, as in

36.15 Franz Kline, *Mahoning*, 1956. Oil and paper collage on canvas, 6ft 6in × 8ft 4in (2.03 × 2.54m). Collection, Whitney Museum of American Art, New York City.

Mahoning (1956), a painting of a few years later. By then the canvas had grown to accommodate the freeswinging brushstrokes slashing a black image upon a white ground in Kline's personal calligraphic manner (Fig. 36.15). There is a boldness to Kline's work and frequently a powerful tension in the lines and patterns. The technique is automatic and spontaneous, and the image represents nothing except itself—pigment upon canvas.

Perhaps under the influence of De Kooning, to whom Kline was particularly close in the early 1950s, color—bold and bright—entered his abstractions. It, too, was treated in essentially the same nonobjective, calligraphic manner as his powerful black forms.

Kline would begin a painting by making many quick sketches in black on newsprint or newspaper until a motif unconsciously presented itself. He would then tack a huge sheet of canvas onto an upright board and begin to slash in the main areas in black and white oil paints. His brushes were the ones used by housepainters, and his black paint was a commercial brand used for tinting house-paints. Working rapidly, Kline would paint white over black, black over white, until the dynamic arrangement he sought evolved. One senses the energy of creation in the very brushstrokes.

A MIXED RESPONSE

Critics, curators, collectors, and the public did not entirely know how to cope with the new art that forced itself upon them between 1948 and 1951. After MOMA's show of 1951, "Abstract Painting and Sculpture in America," it could certainly not be ignored. In the catalogue to that show, curator Andrew Carduff Ritchie used such terms as "Expressionist Geometric" to categorize the work of Tomlin, Mother-

well, Reinhardt, and Hofmann, and "Expressionist Biomorphic" for the art of Gorky, De Kooning, Pollock, Baziotes, and Rothko. "Abstract Expressionism" appears for the first time as a subject heading in the *Art Index*, a reference guide to literature on art, in the volume for 1955–7. Sympathetic critics were by then coming forth to help interpret the newly born brand of American abstraction—Clement Greenberg, Harold Rosenberg, and Thomas Hess foremost among them.

The new art was nothing if not controversial. But by the end of the 1950s, Abstract Expressionism had won both acceptance and acclaim, and the artists' works were in great demand from the major museums and collectors in the United States and abroad.

COLORFIELD PAINTING

Under the rubric of Abstract Expressionism, Pollock, De Kooning, and Kline belong to the gestural group, while others belong to what might be called the **colorfield** camp. The latter share many characteristics with the former. The most prominent of the group are Robert Motherwell, Adolph Gottlieb, Mark Rothko, Hans Hofmann, Clyfford Still, and Philip Guston.

ROBERT MOTHERWELL

Robert Motherwell (1915–91) was born in Aberdeen, Washington, and attended the California School of Fine Arts in San Francisco before earning a degree at Stanford

University. At Harvard he studied philosophy and aesthetics and then went to Columbia University in New York City to do graduate work in art history. It was in the early 1940s that Motherwell came to know the large group of European modernists who had sought refuge from the war. These friendships redirected his interests toward painting, of which the automatism of Surrealism was probably the single most important influence.

Motherwell's concept of pigment on canvas matured rapidly: *The Voyage* reveals how quickly his style gained its essential character and monumentality (Fig. **36.16**). A measured cadence of vertical bars establishes the order of the composition, which is rendered in a reserved colorscheme dominated by black on white, with areas of ocher. The forms are loosely painted without suggestion of precision. Variety is offered by the black ameba shape to the left and by a starlike form near the center. The flattened forms resemble a collage, and in fact Motherwell was working in collage at that time, arranging compositions out of torn strips of colored paper and pasting them onto a support.

Motherwell's style developed a monumentality in the 1950s and 1960s in a series called *Elegies to the Spanish Republic*, composed of massive, bold black vertical bars connected by black ovoid forms on a white ground.

ADOLF GOTTLIEB

Adolph Gottlieb (1903–74) began studying art in his native New York City at the Art Students League, where his teachers included Robert Henri and John Sloan. A trip to

36.16 Robert Motherwell, *The Voyage*, 1949. Oil and tempera on paper mounted on composition board, 4ft × 7ft 10in (1.22 × 2.39m). Collection, The Museum of Modern Art, New York. Gift of Mrs. John D. Rockefeller 3rd.

36.17 Adolph Gottlieb, *The Frozen Sounds, No. 1*, 1951. Oil on canvas, 36 × 48in (91.4 × 121.9cm). Collection, Whitney Museum of American Art, New York City.

Europe in the early 1920s introduced him to avant-garde painting. His early pictures reveal a range of influences from Picasso to Paul Klee. During a visit to Arizona, Gottlieb became interested in **pictographs**, his personal version of which soon began to form the basis of his paintings. These were influenced by the automatism of Surrealism, and traces of the styles of Joan Miró and Bradley Walker Tomlin are found.

The Frozen Sounds, No. 1 demonstrates the process of simplification that has reduced myriad characters and pictographs of Gottlieb's earlier work to a few bold motifs (Fig. **36.17**). The action painting that is especially noticeable in the lower half of the composition permits the viewer to share the spontaneous moment of creation, while the large red and black forms set against a white ground in the upper portion assert the integrity of the picture plane. While pictographs reappear from time to time in his work, Gottlieb's tendency was reductive and increasingly monumental—a single disk of color above one large, bold splash of another color, on a neutral ground.

MARK ROTHKO

Just as painting was now liberated from any obligation to mirror the physical world, space was freed from the centuries-old tradition of three-dimensional illusion and reduced almost entirely to one dimension: The surface of the canvas. Meanwhile, color became an independent entity in itself.

The art of Mark Rothko (1903–70) demonstrates these features very well. Rothko was brought to America in 1913 from his native Russia. His formal training in art was brief—at Yale University (1921–3) and then at the Art Students League with Max Weber. His pictures of the 1930s were naturalistic in style, but also expressionistic in treating aspects of city life, such as the loneliness of people in a crowd.

By the early 1940s Rothko had discovered Surrealism and Freud, and his imagery turned to biomorphic forms and calligraphic symbols. His canvases became larger and larger as he simplified the motifs. Soon, Rothko's pictures were reduced to a single colorfield above another on a neutral ground, all unified within a single plane. This synthesis may be seen in *Orange and Tan*, in which a red-orange field above a pale yellow, slightly larger field lies upon a tan ground (Fig. **36.18**). The colors are loosely brushed in, usually rather thinly, with fuzzy edges, suggestive of the action with which the work was created.

36.18 (opposite) Mark Rothko, *Orange and Tan*, 1954. Oil on canvas, 6ft 9¼in × 5ft 3¼in (2.06 × 1.61m). National Gallery of Art, Washington, D.C.

36.23 Helen Frankenthaler, *Small's Paradise*, 1964. Acrylic on canvas, 8ft 4in × 7ft 9⅝in (2.54 × 2.38m). National Museum of American Art, Smithsonian Institution, Washington, D.C.

36.24 Morris Louis, *Faces*, 1959. Acrylic on canvas, 7ft 7¼in × 11ft 4in (2.32 × 3.46m). National Museum of American Art, Smithsonian Institution, Washington, D.C.

echoes of the red-orange below to left and right. Absolute unity of plane and color has been attained to the extent that the illusion of space is eliminated.

Morris Louis (1912–62), who was born in Baltimore and spent most of his early career as a painter there and in Washington, D.C., rather than in New York City, was committed to abstraction. It was not until he saw Frankenthaler's stained canvases in 1954, however, that he found the means of expression that satisfied him. Also using unprimed canvas, Louis, too, poured, dribbled, or flooded the diluted acrylic hues over the surface (Fig. **36.24**). As in most abstract expressionist painting, the viewer's experience of the technique is important, and uneven edges along the colorfield suggest a certain amount of action in the process of making the work, while accidents—dribbles or runs—indicate the spontaneous creative process. To realize the breadth and variety of Abstract Expressionism one need only contrast the savage attack of De Kooning's *Woman, 1* with the gentle, lyrical loveliness of Louis's *Faces*.

Abstract Expressionism was, however, but one of several avenues explored by American artists in the postwar period, and to these other approaches we now turn.

PAINTING:

HARDEDGE COLORFIELD, POP ART, AND
REALISM, 1940 TO THE PRESENT

The United States in the 1960s was a troubled country, divided against itself economically, socially, culturally, and ideologically, and with a widening generation-gap. The decade was beset by assassinations, a bloody war, civil rights problems, an escalation of crime and violence in the streets, a sharp rise in drug abuse, and social revolutions such as the rise of the counterculture. On an autumn day in 1963, the young president, John F. Kennedy, was killed in Dallas. His brother Robert was gunned down in a Los Angeles hotel on 5 June 1968. Two months earlier, the Reverend Martin Luther King had been murdered as he stood on the balcony of a Memphis motel. The anger and frustration felt by many black people were strongly expressed by Malcolm X—until he, too, was shot dead in New York City on 21 February 1965.

The Civil Rights movement began on 1 December 1955 when Rosa Parks, an elderly black woman, refused to give up her seat in the front of a bus in Montgomery, Alabama. She was arrested, but the next year the Supreme Court declared "Jim Crow" laws to be illegal. That was only the beginning. In August 1963, 200,000 people—black and white—turned out in Washington, D.C., to demand equal opportunities for all Americans. Congress passed the Civil Rights Act (1964), which outlawed discrimination, but this did not immediately guarantee rights.

On 21 March 1965, Martin Luther King led a march from Selma, Alabama, to the state capital to demand civil rights for black people. The march that began with 3200 people swelled to over 25,000. Although their manner had dignity born of a Gandhi-like patience and resolve, sometimes frustration erupted into violence, as in the Watts district of Los Angeles during five days in August 1965, which left that part of the city burned out and devastated.

All of these events left scars on the troubled soul of America in the 1960s, but none racked the nation as painfully and caused such internal conflict as the Vietnam War, which began under President Kennedy and reached its darkest hours during the Johnson administration. In response, antiwar demonstrations broke out, and young men burned their draft cards. Democracy itself seemed to be in jeopardy, as violence erupted at the 1968 Democratic National Convention in Chicago. Demonstrators, journalists,

and bystanders alike were set upon by riot-control police and the National Guard.

The youth of America rebelled—against the war, against the values of their parents, against consumerism and commercialism. At a time when the nation was entrenched in a horrible war, many Americans turned to peace and love—the Flower Children, who dropped out of a society they disliked.

Rock music had been the anthem of the younger generation since the mid-1950s with Bill Haley and the Comets and Elvis Presley, whose recordings of 1956—"Heartbreak Hotel," "Love me Tender," "Hound Dog," and "Don't Be Cruel"—firmly implanted a new sound in American popular music. There were others: Chuck Berry, Buddy Holly, and Ricky Nelson. In 1964, a mop-haired group called the Beatles arrived from Liverpool. Their music touched a responsive chord. One of their greatest successes, an album titled *Sergeant Pepper's Lonely Hearts Club Band* (1967), addressed the generation-gap, the drug culture, middleclass culture, and life in a modern-day industrialized and commercialized society.

At the same time, the strength of popular culture increased to the point where it became a dominant force in both society and the arts. Amid the affluence and consumerism that America was enjoying, music companies catered to the taste for popular music, and publishers did the same with the popular novel. Movie-makers produced scores of films that were mindless at best, violent at worst, and television—in both its programs and its commercials—often made its appeal to a rather low taste. In the same decade the omnipresent chains of fastfood restaurants were born. Although seldom concerned with the elevation of taste or the stimulation of the intellect, this culture throbbed with a vibrant, neon life of its own, clearly separating itself from "high" or classical culture.

A war of the two cultures began (which continues to this day). A glorification of the tastes and desires of the person in the street made popular culture legitimate. The success of this mass culture was an outgrowth of an affluent democratic society, whereas earlier high culture tended to be élitist. Visually, Americans were bombarded by colorful images from popular culture—cartoons, comicstrips, billboards, and

dazzling neon lights. Places like Disneyland—opened in 1955—the Las Vegas Strip, and hundreds of carnival-like theme and amusement parks across the nation established a glitzy, visual extravaganza in praise of popular culture.

The merging of the commercial world of popular culture and art became commonplace. For example, when the Houston National Bank commissioned local artists to paint pictures that were enlarged upon billboards along the city's major highways, it was estimated that some 650,000 people saw them daily. Art was thus viewed not in the sacred precincts of an art museum, but from a speeding car, racing along a freeway with the radio blaring—or was contemplated while one sat in a traffic-jam. Creative people—ranging from public school students to talented commercial artists—began to paint images on the sides of urban buildings. Some expressed the African-American experience in the inner city, others were scenic or architectural. Popular culture was forcing a partnership with the visual arts—and doing so on its own terms. It was inevitable that a new breed of artist would arise to respond to the craze for bottled cola drinks, canned foods, and an endless variety of brands of beer. The effect that popular culture had on the emergence of Pop Art will be discussed shortly. First, however, we will continue where we left off with Abstract Expressionism.

HARDEDGE COLORFIELD PAINTING

A number of American modernists found the methods of Pollock and De Kooning extreme, yet their commitment to abstract and nonobjective art was just as great. This group included Barnett Newman, Ad Reinhardt, Ellsworth Kelly, Kenneth Noland, and Frank Stella, among others. A more controlled means of working, even to the extent of a reasoned precision, was more to their liking. Because they rejected the painterly techniques and gestural brushstrokes of the Abstract Expressionists, such artists are sometimes referred to as hardedge colorfield painters.

The things this group held in common with the Abstract Expressionists were the absolute independence of the work—it represents nothing other than itself—a respect for the single plane of the canvas, color as a thing in its own right, and a tendency to work on a large, sometimes monumental, scale.

BARNETT NEWMAN

Throughout his career, Barnett Newman (1905–70) was quite close to the Abstract Expressionists, frequently exhibiting his work with theirs. Newman attended the Art Students League but then entered his father's clothing business. With his friend Adolph Gottlieb, however, he went regularly to galleries. About 1944 he started a series of calligraphic surrealist drawings which evolved into biomorphic paintings. Next came experiments with circular motifs.

The problem Newman faced was what could be done in geometric painting that had not already been done by the Russian early modernist Kasimir Malevich (1878–1935), bestknown for his painting *White on White* (1913, MOMA), or the Dutch De Stijl artist Piet Mondrian. Eventually, a single vertical line evolved, which separated portions of the canvas into precise colorfields. *Vir Heroicus Sublimis* (Fig. 37.1) is an early example of Newman's mature style carried to an heroic scale. Here, a huge field of red is divided

37.1 Barnett Newman, *Vir Heroicus Sublimis*, 1950–1. Oil on canvas, 7ft 11⅜in × 17ft 9¼in (2.44 × 5.42m). Collection, The Museum of Modern Art, New York. Gift of Mr. and Mrs. Ben Heller.

by thin vertical "zips," as Newman called them. There is no sense of foreground or background, and no representation of a natural object—only gorgeous color and an all-pervading feeling of harmony.

In reducing his art to such basic geometric shapes, Newman parallels the work of the minimalist sculptors. The interaction of the color of his "zips" with the main color of the plane and the care with which they are placed are important aspects of Newman's art, which became cerebral and controlled in contrast to the emotive action paintings of many of his fellow artists.

JOSEF ALBERS

Several painters were absorbed with the idea of color as a pure optical experience. Josef Albers (1888–1976) taught the introductory design course at the Bauhaus in his native Germany from 1923 to 1933, when he came to the United States. The course was concerned with the students' understanding of color—color in relation to light and to other colors, or variations of the same color. It also involved principles of basic design. In his own work of the 1920s, Albers began a series of paintings composed of geometric bars and patterns on a white or brightly colored ground. In the late 1930s, series of studies of large, precise, geometric planes of one or two colors placed against a field of another color indicated a continuing fascination with the relationships of pure color in two-dimensional planes and rectilinear shapes.

By 1950 Albers had evolved the format for which he is

remembered, an example of which is *Homage to the Square: "Saturated"* (Fig. 37.2). Here, a magenta square has been positioned within a dark-red square, which is within a bright-red square. The inner squares of each have been placed a little below center. Albers made painting after painting like this one, only changing the color combinations. The constancy of this format permitted him to concentrate on his primary interest—color. He did not seek emotional responses but rather an analytical comprehension of color in endless variations and relationships.

AD REINHARDT

Born in Buffalo, New York, Ad Reinhardt (1913–67) studied the history of art at Columbia University in New York City before turning to painting in the mid-1930s. An early influence was the art of Stuart Davis, but after he discovered the work of the Russian modernist Malevich his art took a different direction. Reinhardt was also an admirer of the art of Piet Mondrian.

By the 1950s Reinhardt was absorbed with red and blue canvases in which the overall color was divided into squares or rectangles of tonal variants of those colors; there was but a single plane—the surface of the canvas—on which geometric shapes formed perfectly symmetrical compositions. Like other artists, Reinhardt often spoke of the purity of painting—the integrity of the canvas plane and color.

Around 1960 Reinhardt began his *Black Paintings*. These were large canvases divided into a grid of, say, three squares across and three down, each square being a slightly different

37.2 Josef Albers, *Homage to the Square: "Saturated,"* 1951. Oil on masonite, 23⅜in × 23¼in (59.4 × 59.2cm). Yale University Art Gallery, New Haven, Connecticut.

37.3 Ad Reinhardt, *Black Painting No. 34*, 1964. Oil on canvas, 5ft¼in × 5ft⅛in (1.53 × 1.53m). National Gallery of Art, Washington, D.C.

37.4 Ellsworth Kelly,
Blue, Red, Green, 1962–3.
Oil on canvas, 7ft 7in × 6ft 10in
(2.31 × 2.08m). Metropolitan
Museum of Art, New York City.

shade of black by the addition of one color or another, as in *Black Painting No. 34* (Fig. 37.3). This Reinhardt considered the logical extension of Malevich's white square on a white canvas. As it was felt to be virtually impossible to reduce pigment and form to anything more basic, Reinhardt's art had great appeal for the group of younger artists who founded Minimalism.

MINIMALISM: KELLY, NOLAND, AND STELLA

About 1960 several younger artists rebelled against what was perceived to be the emotionalism and sensualism of Abstract Expressionism. Instead, they sought a depersonalized art in which the hand of the artist and arbitrary aesthetic judgments were eliminated or minimalized. Their forms, whether in painting or sculpture, were reduced to an ultimate simplicity, and their works usually had a precision that was purged of all individual mannerisms.

An archetypal example is Ellsworth Kelly's *Blue, Red, Green* (Fig. 37.4). A precisely defined blue form crosses a green field, with a red rectangle anchoring the bottom of the composition. Neither illusionistic space nor recognizable object was intended in this perfectly flat image, which represents nothing other than what its title declares—blue, red, and green. Kelly (b. 1923) was careful to leave no traces of brushwork, and hence no reminder of his presence—which is very unlike the work of the Abstract Expressionists. In its minimal form, it is color and shape on a plane, and, characteristic of Minimalism, it lacks a focal point and any kind of dramatic incident.

Kenneth Noland (b. 1924) was born in Ashville, North Carolina, and studied art at Black Mountain College in that state before going to Paris in 1948, where the sculptor Ossip

37.5 Kenneth Noland, *Bend Sinister*, 1964. Synthetic polymer on canvas, 7ft 8½in × 13ft 6½in (2.35 × 4.12m). Hirshhorn Museum and Sculpture Garden, Smithsonian Institution, Washington, D.C.

Zadkine (1890–1967) was his teacher. By 1949 Nolan had settled in Washington, D.C., where, with Morris Louis, he established the Washington school of color.

Like Louis, Noland was at the time strongly influenced by the soak-stain paintings of Helen Frankenthaler. Shortly before 1960 he began painting a "target" series in which the concentric bands of color were scrubbed in with the gestural technique, the rough edges, and the drippings and smears that characterized Abstract Expressionism in those years.

The next stage was to make the edges of the circular bands neat and precise, and of pure, flat color without evidence of brushwork. Noland's interest in color, laid down in bands, was then transferred from a circular pattern to a rectangular format. He had arrived at the formula for which he is bestknown, as in *Bend Sinister* (Fig. 37.5). Starting with the central inverted triangle at the top, which is dark green, the composition progresses in succeeding sharpedged bands that are orange, bright-blue, blue-violet, and yellow—the tip of the latter touching the bottom frame line—all on a white field that accentuates the beautiful, pure colors. This series of chevron or "V" paintings was begun after Noland moved to New York City in 1961. Like Josef Albers, Noland tended to stay with a given compositional pattern—target or chevron—so that he could concentrate on color relationships.

Similar concerns with color and shapes are found in the work of Frank Stella (b. 1936), who began to paint while at Princeton University. Stella, too, rejected the emotional gesturing of the Abstract Expressionists in favor of an analytical approach to color, with brilliant, rainbowlike results. His multicolored pinwheels and chevrons are as flat as the canvas itself. As early as 1960 Stella had become dissatisfied with the standard square or rectangle of the stretched canvas, and he began to make irregularly shaped paintings, of which *Agbatana III* is an example. Here, a wide band of black rims the form and establishes compartments, in which strips of color work with or react against the created shape (Fig. 37.6). To explore the multiple possibilities of color, Stella often created several canvases of the same irregular shape, varying the color combinations within them.

ART AND POPULAR CULTURE

During this period, painting, sculpture, music, poetry, dance, and literature were greatly affected by the rise of popular culture and by the challenging of established traditions. The composer John Cage (1912–92) emerged as a central figure. A friend or acquaintance of many of the most progressive painters of the third quarter of the century, Cage

37.6 Frank Stella, *Agbatana III*, 1968. Acrylic on canvas, 10 × 15ft (3.05 × 4.57m). Allen Memorial Art Museum, Oberlin College, Oberlin, Ohio.

dispensed with traditional melody and harmony. Instead, he worked with discordant sound, particularly percussion, introducing everyday noises such as the banging of doors, the closing of windows, the clatter of tin cans, and the trickle of running water. In a surrealist mode, he used the sounds of cigarette ashes dropping into an ashtray or the putting on and taking off of eyeglasses. Sounds of the street were introduced into his music, too, further incorporating the vernacular of popular culture into an artform that had previously been kept apart from everyday life. Another composer of the 1950s, Gunther Schuller (b. 1925), joined atonal jazz sounds with the classical tradition.

This unification of popular and high culture in art is also found in the paintings of a number of artists, including Robert Rauschenberg, Jasper Johns, Andy Warhol, Roy Lichtenstein, James Rosenquist, Robert Indiana, and Tom Wesselmann. It is too simplistic to label them "Pop artists." There are other factors which influence their work, such as Surrealism and Abstract Expressionism. The common denominator, however, is the powerful component that is introduced from vernacular or popular culture.

ROBERT RAUSCHENBERG

Robert Rauschenberg (b. 1925) came under the influence of John Cage when he was an art student at Black Mountain

College in North Carolina in the late 1940s. Rauschenberg attended the school to study with Josef Albers, but if Albers imposed a discipline on his art, it was Cage and the modern dance choreographer Merce Cunningham who provided the stimulus for a new freedom. Willem de Kooning was also on the faculty at Black Mountain, and action painting is often found in Rauschenberg's art. He also studied photography at Black Mountain, and the photographic image later became an important and integral part of his paintings.

Rauschenberg's mature style began to emerge in the early 1950s when he first started working in the collage technique. The introduction of found objects, pieces of paper, or other materials onto the canvas had been practiced in European art since early in the twentieth century, but American artists had seldom employed that technique. By 1955 Rauschenberg had created *Bed* (private collection). This is made up of an actual pillow and a quilt, with various colors of paint splashed on them, and much running of pigments in action-painting manner.

In *Estate*, Rauschenberg used popular photographic imagery which was applied to the canvas by **silkscreen**. The use of action painting adds color-notes and fuses the various images (Fig. 37.7). The latter range from the Statue of Liberty to the interior of the Vatican's Sistine Chapel, from various architectural details to street signs that say "Stop,"

37.7 Robert Rauschenberg, *Estate*, 1963. Oil and printer's ink on canvas, 8ft × 5ft 10in (2.44 × 1.78m). Philadelphia Museum of Art.

"One Way," and "Public Shelter." The **montage** is made up of images taken mainly from the world of popular culture— that is, pictures such as appear in ordinary magazines and images that are generally experienced through popular media. As heir to the surrealist tradition, Rauschenberg did not need to understand why he put certain images into his work.

JASPER JOHNS

A friend of Robert Rauschenberg, John Cage, and Merce Cunningham, Jasper Johns (b. 1930) was an important agent in redirecting the course of American painting away from Abstract Expressionism into Pop Art.

Born in South Carolina, Johns first studied at the University of South Carolina before serving in the army and then settling in New York City in 1952. Soon after, he began painting familiar objects, but presented them in fresh visions—the flag of the United States, for example, or an archery target. The former (Fig. **37.8**) lent itself to a flat, planar treatment of bands of red and white or stars on a blue field, while the latter was composed of concentric bands of

color on a single plane. Both the image of something and the thing itself became one and the same. In answer to queries about the meaning of the flag paintings, the artist has stated that he had a dream one night that he was painting a flag, and so did so. This interplay between dream experience and reality is, of course, entirely consistent with surrealist theory. Johns claimed that there was no symbolic reference in his work. He also worked with motifs such as numbers, letters of the alphabet, and maps, increasingly with a richer quality of brushwork and pigment, and always with respect for the plane. By 1960 action painting was very much a part of his technique.

Johns's fascination with the ordinary, commonplace object of everyday culture is also found in a number of sculptures he made, which include such items (or replicas) as a flashlight, a pair of glasses, paintbrushes stuck into a coffee can, and beer cans (Fig. **39.5**). In this, he (like Rauschenberg, who also made sculptures out of everyday found objects) was extending the tradition established by Marcel Duchamp, who was one of the first to break down the barrier between the world of high art and that of everyday objects and experience (see p. 461).

37.8 Jasper Johns, *Three Flags*, 1958. Encaustic on canvas, 30⅞in × 45½in × 5in (78 × 115.6 × 12.7cm). Collection, Whitney Museum of American Art, New York City.

37.9 Andy Warhol, *Green Coca-Cola Bottles*, 1962. Oil on canvas, 6ft 10½in × 5ft 7in (2.1 × 1.45m). Collection, Whitney Museum of American Art, New York City.

ANDY WARHOL

The 1960s saw the widespread exploration of themes from popular culture, further blurring distinctions between high and Pop cultures. The guru of Pop Art in the early 1960s was unquestionably Andy Warhol (1930–87), who took the most ordinary objects and the most popular personalities of American culture, gave them heroic scale, and turned them into art. Warhol once commented that department stores were like art museums, and, indeed, his use of multiple images of Coca-Cola bottles or Campbell's Soup cans are but parodies of a supermarket.

Warhol, who attended the Carnegie Institute in his native Pittsburgh before moving to New York City in 1952, began his career as a commercial artist. Among his early works were huge enlargements of comicstrip pictures, which were used in the display windows at Bonwit Teller's, the department store. Warhol himself once declared that Pop artists painted pictures of things that anyone walking along Broadway "...could recognize in a split second—comics, picnic tables, men's trousers, celebrities, shower curtains, refrigerators, Coke bottles—all the great modern things that the Abstract Expressionists tried so hard not to notice at all."[1]

Green Coca-Cola Bottles forces our attention upon a subject from popular culture as skillfully as if orchestrated by a Madison Avenue advertising agency (Fig. 37.9). We see visions like this every day on television in the living room, on roadside billboards, in magazine ads, or while riding on the subway. The argument could be made that the national drink of the United States is Coke or Pepsi. Warhol gives us

37.10 Andy Warhol, *Turquoise Marilyn*, 1962. Silkscreen ink on synthetic polymer paint on canvas, 36 × 36in (91.4 × 91.4cm). Collection Stefan T. Edlis, Chicago, Illinois.

37.11 Roy Lichtenstein, *Oh, Jeff... I love you, too... but...*, 1964. Oil and magna on canvas, 4 × 4ft (1.22 × 1.22m). Collection Harry N. Abrams family, New York.

a picture of this segment of Amerian life, presented very much as it would be in the advertising media.

Warhol's list of subjects often reads like a shopping list. It is impossible to talk about his art without using brandnames. When asked why he painted Campbell's Soup cans, Warhol replied that he used to have Campbell's soup every day for lunch—it was as much a part of his life as of the average American's.

What Warhol created was a new kind of still life in a twentieth-century massmedia, popular-culture mode, rather than in the illusionary manner of the nineteenth century. In sculpture, counterparts to the Campbell's Soup paintings would be Jasper Johns's *Beer Cans* and Claes Oldenburg's *Giant Hamburger* (Figs. 39.5 and 39.6).

Andy Warhol took his heroes and heroines from popular culture or from the famous of their day. He made silkscreen portraits of movie actresses Elizabeth Taylor and Marilyn Monroe simply because, he said, they were beautiful and they were "popular." Even the use of silkscreen for *Marilyn* suggests the reproduction effects of posters or commercial advertisements (Fig. 37.10). A photograph was transferred to canvas and tinted by a silkscreen process in broad, flat, hardedged areas of color. The artist liked the "mechanical," that is, impersonal, effect the technique gave. Monroe was at the height of her career, an internationally popular symbol of a voluptuous love-goddess, when Warhol created her portrait in 1962.

The artist painted other popular figures from the silver screen—James Dean, the very symbol of youthful rebellion in the 1950s, and Elvis Presley, the folk-hero of rock 'n' roll, around whom a fanatical cult-devotion has developed. Here was the new form of portraiture of the 1960s—heir to the tradition of Copley, Stuart, Eakins, and Sargent.

ROY LICHTENSTEIN

Roy Lichtenstein (b. 1923) is bestknown for his comicstrip images. After studying at Ohio State University and then moving to New York City, Lichtenstein began his career by working in **assemblage**. By the late 1950s he was working in the Abstract Expressionist style, but like Rauschenberg, Johns, and Warhol, he found that style too concerned with formal matters and technique and lacking in opportunity to explore symbols, cultural values, and the treatment of the human figure.

From the beginning, Lichtenstein had been interested in purely American imagery—cowboys, a ten-dollar bill, Mickey Mouse, and Donald Duck. By 1960 he had begun doing paintings of Disney-style characters and of commonplace objects such as a wedding ring, an electrical cord, a hotdog with mustard, or a telephone—all in the comicstrip manner (Fig. 37.11). Comics were an American invention, so he was satisfied on that count, and if the face of the woman looked like that of the "Draw Me" women on matchbook covers, that seemed all the more appropriate. After a decade of searching for a style that would allow him to depict the American lifestyle, he had found it in something that was itself a product and expression of popular culture.

After completing a sketch on a small scale, Lichtenstein enlarged it by using an opaque projector to cast the image onto the canvas, upon which he traced the drawing in the bold, black outline characteristic of the comicstrip style. Areas were then filled with flat colors and stenciled with innumerable tiny dots, replicating the Ben-Day process used in commercial printing, to create shaded effects.

37.12 James Rosenquist, *Silver Skies*, 1962. Oil on canvas, 6ft 6in × 16ft 7in (1.98 × 5.06m). Chrysler Museum, Norfolk, Virginia.

JAMES ROSENQUIST

James Rosenquist (b. 1933) did not discover his ultimate style in popular culture—rather, it evolved out of it. After attending the Minnesota School of Art and the University of Minnesota in the early 1950s, Rosenquist took a job painting roadside billboards. By 1955 he had moved to New York City where he earned his living by signpainting, working on those enormous billboards that have become an integral part of the popular culture of New York City's Times Square. The imagery on the billboards included everything from beautiful women to cigarette advertisements, and from automobiles to soft-drinks.

These are the very images that reappear in Rosenquist's huge canvases. He was quite at home working on a very large scale; his *F–111* (1965, private collection), for example, measures 10 feet (3 m) high by 86 feet (26 m) in length. We see the parody of American civilization—its values, its blatant consumerism, but also its dynamic energy —in works such as *Silver Skies*, which has the scale and symbols of a billboard (Fig. 37.12). To make sure we do not miss the satirical jab at America's love affair with the banal, Rosenquist made the automobile tires especially prominent—and, in a touch of irony, placed an enormous rose next to them.

ROBERT INDIANA

In New York City in the mid-1960s, Rosenquist moved in the circle of Robert Rauschenberg, Jasper Johns, and Robert Indiana (b. 1928). The latter was born Robert Clark in New Castle, Indiana, and later adopted the name of his native state. As a selfstyled "American painter of signs," Indiana borrowed the bold commercial letters and numbers and bright, garish colors found in signs and billboards because of their power to communicate boldly and directly. In these he

found a common language, made visual, that all America could understand. His famous paintings, graphics, and sculptures of "LOVE," "EAT," and "DIE" have become familiar symbols.

In *The Figure 5*, however, Indiana demonstrates how the imagery of Pop Art, even though rising out of popular

37.13 Robert Indiana, *The Figure 5*, 1963. Oil on canvas, 5ft × 4ft 2⅛in (1.52 × 1.27m). National Museum of American Art, Smithsonian Institution, Washington, D.C.

culture, can maintain strong and direct ties with artistic heritage and tradition (Fig. 37.13). The painting is an evocation of Charles Demuth's *I Saw the Figure 5 in Gold* (Fig. 30.25), which was inspired by William Carlos Williams's short poem "The Great Figure." Indiana's image contains three diminishing fives, in gold outlined in silver, on a red star set against a black and gray background that contains the stencil-like words "EAT," "HOG," "DIE," "ERR," and "USA." The words have a sharp impact, and they are as hardedged and terse as the painting style itself, bringing together meaning and style. As do many modern painters, Indiana leaves the viewer to puzzle over the precise meaning of both the number and the words.

Indiana's enthusiasm for popular culture and its influence on art was expressed in an interview in 1963. "Stifled" by Abstract Expressionism, he declared that:

> ...some young painters turn back to some less exalted things like Coca-Cola, ice-cream sodas, big hamburgers, supermarkets and "EAT" signs.... Pure Pop culls its techniques from all the present-day communicative processes: it is [Tom] Wesselmann's TV set and food ad, Warhol's newspaper and silkscreen, Lichtenstein's comics and Ben-Day, it is my road signs.

TOM WESSELMANN

Tom Wesselmann (b. 1931) arrived in New York City in the mid-1950s, in time to see the early Pop Art works of Rauschenberg, Johns, and Warhol. He had studied art in his native city at the University of Cincinnati and the Art Academy of Cincinnati. In his pictures of the early 1960s, all imagery came directly from the world of popular culture— Wesselmann has stated that billboard and advertising art provide the stimulus for his paintings.

By 1960 Wesselmann had begun to paint images of the female nude, sometimes as part of a room assemblage which contained a real bathtub, window, and clothes hamper, and sometimes as a sensuous study on canvas of the nude reclining in a bedroom setting. Figure 37.14 is an example of the latter, verging on the erotic but not yet venturing into that sphere the way some of his later works do. The nude reclines on a leopardskin-like fabric, adding a touch of the exotic. In the boldness of her intimate and confrontational pose, she becomes a restatement of Edouard Manet's *Olympia* (1863, Musée d'Orsay, Paris). Wesselmann's intent to make his nude sexually provocative is evident in his treatment of the parted lips, the nipples, and the seductive narcissus blossoms, all of which are related in form and size

37.14 Tom Wesselmann, *Great American Nude, No. 57*, 1964. Synthetic polymer on composition board, 4ft × 5ft 5in (1.22 × 1.65m). Collection, Whitney Museum of American Art, New York City.

and establish the focal pattern of the picture. For Wesselmann and others, the nude female figure—traditionally one of the primary vehicles for the artist's expression of his ideal—had returned to the mainstream of art.

THE NEW REALISM

Realism and naturalism are probably the most enduring traditions in American painting, capable of being traced back to the seventeenth century. Some of America's most celebrated painters have worked in that tradition—Copley, Church, Remington, Homer, Eakins, and Hopper, to name but a few. After World War II, the nude was seldom found in the paintings of the Abstract Expressionists, and when it did—say, in the work of Willem de Kooning—its form was sacrificed to the painter's technique.

The return of the nude and of realism as a style, strongly influenced by the photographic image, was a further example of the rebellion of the 1960s against Abstract Expressionism. With artists such as Philip Pearlstein (b. 1924) and Richard Estes (b. 1936) we have the leaders of movements known as New Realism and Photorealism. In Andrew Wyeth, on the other hand, we have a continuation of that enduring naturalist tradition that has extended throughout more than 300 years of American painting.

PHILIP PEARLSTEIN

Critics had become so accustomed to seeing, thinking, and verbalizing in the modern idiom that they were uncertain what to do with Philip Pearlstein's nudes when they appeared upon the scene in the early 1960s. His work had no references to Dadaism, Cubism, Fauvism, Abstract Expressionism, or any of the other modern styles—it was clearly outside the mainstream movements of modern art. The term "realism," moreover, had already been used in the Pop Art sense of the word. Pearlstein's technique was also conventional—oil paint applied to canvas with a brush, just as the Old Masters had done—and his subject matter, the nude, was as traditional as one could get. In forging a return to realism, however, Pearlstein had not made the error of retreating to historical styles or academic clichés.

With the realism of Pearlstein, the polemic between illusion and the sanctity of the canvas surface returned: Pearlstein's nudes are representations of the physical world in the Renaissance tradition. Pearlstein never seeks to assert an ideal form in his nudes, nor are they expressionistic. They are just there—powerful in their presence.

The artist, who studied at the Carnegie Institute in his native Pittsburgh and at New York University, found action painting less than satisfying. Perhaps through his friendship with Andy Warhol, he was led away from the Abstract

37.15 Philip Pearlstein, *Two Female Nudes with Red Drape*, 1970. Oil on canvas, 5 × 6ft (1.52 × 1.83m). Collection, Williams College Museum of Art, Williamstown, Massachusetts.

37.16 Chuck Close, *Big Self-Portrait*, 1968. Acrylic on canvas, 8ft 11½in × 6ft 11½in (2.73 × 2.12m). Collection, Walker Art Center, Minneapolis, Minnesota. Art Center Acquisition Fund, 1969.

Expressionists. A trip to Italy in the late 1950s may have awakened an interest in the nude in painting. By 1961, the nude had become his primary subject, often in groups of two figures, as in *Two Female Nudes with Red Drape* (Fig. 37.15).

Pearlstein works from live models posed before him in his studio. A realistic recreation of the physical figure is his primary goal. The figures are unidealized, deadpan, often appearing to be bored or lethargic, but they are painted without commentary. They are not erotic—just very, very nude. There is kinship with photographic images, indicated by the lighting and by the cropping of the figures. However, Pearlstein does not see his art as imitating the photographic image, for he feels that as an artist he sees "more than a camera does."

CHUCK CLOSE

Chuck Close (b. 1940) has taken the portrait image as his subject and, in the spirit of the New Realism, renders it with incredible fidelity.

A native of Monroe, Washington, Close studied at the University of Washington, then earned a bachelor's degree of fine arts at Yale University in 1963 before taking the master's program at the Academy in Vienna, Austria. A Photorealist, Close has made the photograph a working part of his technique in order to produce highly detailed portraits, an example of which is *Big Self-Portrait* (Fig. 37.16).

Taking an 8 by 10 inch (20 × 25 cm) photograph of himself or someone else, Close enlarges it onto a canvas that

may reach a height of 8 feet (2.4 m) or more. Working with airbrush and minute amounts of paint, he achieves an image that truly rivals that of the photograph, but is alarmingly confrontational and overwhelming in its scale. There is no idealization, but neither is there social criticism—only an astounding presence.

RICHARD ESTES

The potential variations that have opened up within New Realism and Photorealism are proving to be numerous indeed. For example, the storefronts and urban street scenes by Richard Estes are the very antithesis of Abstract Expressionism's respect for the canvas plane, for they are among the most completely illusionistic images ever produced.

Estes was born in Kewanee, Illinois, and studied at the Art Institute of Chicago in the mid-1950s before moving to New York City just as Pop Art burst upon the scene as an alternative to Abstract Expressionism. At first, Estes

painted pictures of automobiles, achieving remarkable effects, with the aid of a camera, in the rendering of windshield reflections.

In 1968 Estes turned his camera toward storefronts and began painting his own brand of Pop Art kaleidoscopes of consumer delights, as seen in *Candy Store* (Fig. 37.17). The neon signs, the fluorescent lights, the famous brandnames, the handpainted signs, and the glut of it all are rendered in a *tour de force* of realism. The dividing lines between illusion and reality and between art and popular culture are the only things no longer in sharp focus.

Estes's *View of Thirty-fourth Street from Eighth Avenue* (1979, collection of the artist) is a recreation of a reality, of an environment and a lifestyle known to millions of Americans. It uses a visual language that rises from their own experience, and the format is that used by the mass media to bombard their consciousness every day. As in all true art, no matter how real it may look at first glance, the painter has still exercised a selection and rejection of details to arrive at an essence of reality.

37.17 Richard Estes, *Candy Store*, 1969. Oil and synthetic polymer on canvas, 3ft 11¾in × 5ft 8¾in (1.21 × 1.75m). Collection, Whitney Museum of American Art, New York City.

NATURALISM: A DEEPROOTED TRADITION

If Photorealism represents a rebirth of naturalism, after what some would call the purging, purifying experience of Abstract Expressionism, there is another strain of naturalism that belongs to a continuous tradition. This is a tradition that rejected most of the principles of modernism and went quietly on its way, clinging to a form of art that seemed true, natural, and based on centuries of tradition.

If galleries and museums such as MOMA, the Guggenheim, and the Whitney were the focal points of modernism, this other tradition had its centers in places like the National Academy of Design and the National Sculpture Society. During the long decades when modernism played to packed galleries, the deeprooted tradition of naturalism maintained a devoted following of those who wished their art to resemble the world they knew. Beginning in the late 1950s, Americans began to rediscover the roots of this powerful cultural heritage of naturalism in the paintings of Copley, Homer, Eakins, Sloan, Hopper, Grant Wood, and so on—and they soon discovered a contemporary exponent of that tradition in Andrew Wyeth.

ANDREW WYETH

Wyeth (b. 1917) was born in Chadds Ford, Pennsylvania. Although he was the son of the famous illustrator N. C. Wyeth, he maintains he was largely selftaught.

Wyeth found his subjects among the old stone farmhouses and mills of the Brandywine River valley; in the ancient, weathered clapboard structures along the Maine coast; in the quiet passages of nature—a clump of wild mayflowers, a berry patch, a sycamore tree—and in the people around him, who became the objects of intense psychological scrutiny.

Wyeth's first oneperson show in New York City in 1937, all watercolors of Maine, was an instant sellout, a testimony that Wyeth's naturalistic style struck a responsive chord in

37.18 Andrew Wyeth, *Christina's World*, 1948. Tempera on gessoed panel, 32¼ × 47¾in (81.9 × 121.3cm). Collection, The Museum of Modern Art, New York. Purchase.

America's taste in art. The appeal of his work gained national attention with *Christina's World*, which was purchased in 1948 by MOMA (Fig. 37.18).

The painting depicts a woman, Christina Olson, crippled since youth by infantile paralysis, turned from the viewer to look toward the bleak building on the coast of Maine where she lived and kept house for her brother Alvaro, a fisherman. Wyeth had arranged to set up a studio in one room of the house. One day he saw Christina—who moved by dragging herself about—picking berries near the family graves, and that sight became the basis for the painting. Wyeth had trouble with the figure, not only with its awkward movement and emaciated musculature, but also with the psychological drama that had impressed him so. He later revealed that he wanted to show both the joy and the tragedy of the scene. Christina could go no further than she could drag herself, so what we see in the picture is, quite literally, Christina's world.

The picture is painted in tempera, a quickdrying pigment which allows almost instant overpainting. It is Wyeth's favorite medium, for it permits the artist to build up one layer over another, while letting the colors underneath show through. It also lends itself to the exact detailing that Wyeth desires.

Wyeth's execution of details, however, should not obscure the strong abstract element in his work. No small part of the greatness of his art is due to his extraordinary powers of selection and rejection—that is, of selecting only that which is quintessential to his scene and his story, and rejecting all other detail as extraneous. Closeup inspection of a painting by Wyeth is frequently surprising, for there is usually much less detail than expected. The *essential* details, however, are there.

In the broadest sense, the abstract qualities are perceived in his reduction of the scene to basic components: The invalid, the field, the silhouetted structures, and the sky. This reduction to the point of starkness is, of course, an essential means for the drama he wished to evoke. While we feel the raspiness of the dry grasses of the field, those grasses are rendered in a most abstract way, with the entire expanse of the field treated as a mass rather than as studies of individual blades. Only by treating that broad area as an abstract mass could Wyeth concentrate our attention on the dynamic tension that is sensed between the girl and the distant house. The viewer thinks he or she sees a field of grass painted with great fidelity—but in fact an illusion of fidelity is created by the abstract use of paint and line and color and brushstrokes.

In the work of Andrew Wyeth we have a confluence of the two mainstreams of American art—the longstanding, one can almost say indigenous, naturalism of American art, and the more recently developed aesthetic appreciation for abstract art.

POSTMODERNISM

Sometime between 1970 and 1990 the modern movement seemed to exhaust itself, or so it seemed to some who began a reaction against many of its tenets. But postmodernism, in literature as well as the visual arts, has not yet formed a clear definition of itself. Moreover, one of its pivotal features is pluralism—acceptance of a wide diversity of styles—and so there is little that unifies postmodernism into a movement. It accepts mass culture such as television, graffiti, and fashion photography, and seems uninterested in the concept of high culture. The latter was an art of an élite minority, whereas postmodernism identifies with the visual language of the mass majority. It dislikes modernism's dogmatic attitude, which purged historical-style references and eclecticism from art, and manifests a desire to embrace such things once again.

Dissatisfied with the rules as laid down by modernism, postmodernism seems to want no rules at all. Painted images within a single frame may have neither relationship to each other, nor to the real world. If capable of being "realized" at all, the real world would be witnessed as in a stream of several hours of continuous television, where one would see bits of a program interspersed with commercials that are totally unrelated to the storyline, which is in turn disconnected from all the other programs and commercials that follow. The result is an evening of unrelated visual images and themes, not unlike the unrelated juxtaposed images found in a painting by David Salle.

Similarly, in postmodern literature, a work of fiction becomes a stream of unrelated, often meaningless events that unfold without the structure imposed by the classical construct of beginning, middle, and end, and without moral judgments being intended or even proposed. Historicism may reappear in art, as in the adaptation of the famous seventeenth-century painting *Syndics of the Cloth Guild* by Rembrandt, although the inspiration would more likely come from the lid of a Dutch Masters cigarbox than from the Old Master painting itself.

To interpret postmodern imagery one may need to engage in the business of semiotics—the analysis of signs and symbols, for both are important aspects of the new art.

Barbara Kruger (b. 1945), for example, literally works in a billboard mode, consisting of a social message clearly stated. Her art is most at home in a raw urbanscape, where it is surrounded by other signs. *Untitled*, which is nearly 18 feet (5.5 m) long, or close to billboard size, sends a feminist message that male domination and female subjugation start at a very early age (Fig. 37.19).

Similarly, Jenny Holzer (b. 1950) has withdrawn from visual imagery and turned to the use of language in her paintings of the late 1980s and early 1990s. Her pictures are like graffiti found scrawled or stenciled on public spaces in urban America, eschewing the refinements of an élite culture for a burning social message blazoned in a mass-culture vocabulary. Holzer's words are often filled with a wrath

37.19 Barbara Kruger, *Untitled (We don't need another hero)*, 1987. Photographic silkscreen, vinyl, 9ft 1in × 17ft 6in (2.77 × 5.33m). Mary Boone Gallery, New York City.

rising from feminist convictions as well.

Keith Haring (1958–90) used a graffiti style, sometimes combined with comicbook technique, that grew out of his childhood experiences in New York City, when he created graffiti images and messages on subway trains and the sides of buildings on the way home from school.

Julian Schnabel (b. 1951) and David Salle (b. 1952) were two of the leading figures in the rebellion against modernism in the 1980s. Schnabel often painted on red velvet—that in itself was an association with low rather than élite culture —in a nervously neo-expressionistic mode, in a style that was an attack upon refinement and craftsmanship in art. Schnabel, too, would sometimes incorporate language into

his paintings, and, indeed, the words could be the main vehicle for the expression of the intended message—as in his *Fox Farm* series of around 1989–90. There, the inscription declared a message supporting the animal rights movement: That there was no place worse on this planet to be, at pelting time, than on a fox farm.

David Salle's complex canvases are often made up of three, four, or more images which are seemingly unrelated to each other in either form or subject matter. He may introduce historicism, as in *Ugolino's Room* (Fig. 37.20), a large canvas that invokes images of Renaissance and Baroque portraits and genre pictures juxtaposed with African masks, a sketch of a Chippendale chair (upper right), and

37.20 David Salle, *Ugolino's Room*, 1990–1. Oil and acrylic on canvas, 7ft 3in × 9ft 6in (2.21 × 2.9m). Collection private foundation.

37.21 Jean-Michel Basquiat, *Untitled*, 1982. Oilstick on paper, 22¼ × 16¾in (54.5 × 42.5cm). Courtesy Robert Miller Gallery, New York City. © Estate of J.-M. Basquiat. All rights reserved.

wordless cartoon speech-balloons. The historical reference is underscored by the title, which is taken from Dante's fourteenth-century literary masterpiece, *The Divine Comedy*.

Jean-Michel Basquiat (1960–88), an African-American artist who died young, filled his canvases and sketchpads with images that spoke of violence, the absurdity of life, anguished emotions, and oppression in a highly expressionistic style. Many of these qualities are seen in his figure of a seated man, a portrait that connotes the rage and insane violence that are too often unleashed (Fig. 37.21).

Another African-American artist, Sam Gilliam (b. 1933), has taken a more lyrical departure from modernist art. His early work consisted of long unstretched canvases that were stained in the manner of Morris Louis and then draped in a three-dimensional freeform rather than stretched into a plane. Later works, beautifully colored, are planar constructions in the tradition of Frank Stella.

Peter Halley (b. 1953) has carried the postmodern movement in yet another direction, one that emerges out of the rectilinear color patterns of Josef Albers and Ellsworth Kelly. Working in Day-Glo acrylics, Halley's large squares become brilliant colorfields surrounded by startling contrasts and harmonies in meandering stripes. The control exercised in such paintings as *Double Elvis* of 1990 (Sonnabend Gallery, New York City) is the antithesis of the work of, say, Schnabel, and confirms the commitment to a pluralism of styles that characterizes postmodern art.

At times, postmodern painting seems unsure of itself, selfconscious. Critics and scholars have yet to write a clear definition of its goals and purposes. The one thing that seems clear is that it is a conscious break with modernism. Where it goes from here remains to be seen.

CHAPTER THIRTY-EIGHT

SCULPTURE:

OLD TRADITIONS AND NEW DIRECTIONS, 1940 TO THE PRESENT

World War II ended with the explosion of the atomic bomb in August 1945. Thereafter, the world had to live with the haunting threat of nuclear war, a possibility that was omnipresent in the 1950s and 1960s—the decades of the Cold War. In 1962, two novels addressed the horrifying potential for atomic war—Eugene Burdick's *Fail-Safe* and Fletcher Knebel's *Seven Days in May*. These and other works of fiction paralleled one of the most chilling moments in the history of the Cold War, when the world seemed to teeter on the brink of a nuclear holocaust—the Cuban Missile Crisis of October 1962, when President Kennedy demanded that Premier Khrushchev remove the Soviet missiles that had been secretly installed in Castro's Cuba, only 90 miles (145 km) off the coast of Florida.

Other manifestations of the Cold War include the building of the Berlin Wall in 1961 and the Korean War of 1950–3, in which over 25,000 Americans died and more than 100,000 were wounded. It was through the new forms of cultural expression, the motion picture and television, that the Korean conflict was memorialized—first in the movie *M*A*S*H* (1970), directed by Robert Altman, and then in the long-running TV series (1972–83) derived from it. Both questioned the romantic view of the glory and honor of war and proclaimed its utter insanity and destructiveness.

The hovering shadow of nuclear devastation and the horror of three major wars within thirty-two years—between 1941 and 1973—contributed to a mindset in America that challenged old values, political systems, and social orders. Such challenges prepared the way for something new, and the new forms of art, literature, music, and dance are both a result and a manifestation of them.

There were many signs that after the three great ages of antiquity, the Middle Ages, and the Renaissance-to-modern era, humanity was embarking on a fourth major period. For example, it became apparent that humanity now possessed an awesome source of energy such as the world had never known. Another sign of a major change from one era to another is that we are no longer confined to a terrestrial existence, as humanity has been since the beginning of time.

In the autumn of 1957, America was stunned by the report that the Soviet Union had fired a satellite into orbit. Suddenly, it seemed as if the United States had become a secondclass power. The space race was on. Within four months, an American satellite was circling the Earth. On 12 April 1961, a young Russian named Yuri Gagarin became the first man to go into orbit. By mid-year, two Americans—Alan Shepherd and Virgil Grissom—had taken suborbital rocket flights and, in February 1962, John Glenn became the first American to orbit this planet. In 1965 came the spacewalks, both Russian and American. The first woman in outer space was a Russian in 1963; the first American woman in space was Sally Ride in 1983, while Kathryn Sullivan was the first woman to walk in space the following year. After Armstrong and Aldrin made their lunar landing in the summer of 1966, people found themselves gazing at the moon and thinking, "We've been there, and back." One no longer felt anchored to Earth. One's perception of the universe, and one's own relationship to it, had changed significantly.

In the space race that followed, an enormous emphasis was placed on math, physics, and engineering in American education. The nation became science-conscious, which in turn affected art. For example, one cannot look at Walter de Maria's *Lightning Field* (Fig. 39.16) of the 1970s without thinking of meteorology and space age experiments. José de Rivera's *Construction No. 100* (Fig. 38.6) seems related to a model in physics, of energy become matter, of atoms circling in space. Even the name of Ibram Lassaw's *Galactic Cluster No. 1* (Fig. 38.5) reflects a fascination with the mysteries of the universe. The emphasis on math and the concept of all matter as consisting of molecules and atoms may well have contributed to a mindset that was receptive to abstractions, in painting and sculpture as well as in science. Sol LeWitt's *Open Modular Cube* (Fig. 39.10), for example, would seem to share certain features with a kind of mathematical formula.

REDEFINING SCULPTURE

Sculpture after World War II presents one of the most complex phenomena in the history of American art. The traditional techniques and forms of three-dimensional art are questioned, and the basic conception of the medium is

reformulated. Its vitality is suggested by the sheer number of movements: Cubism, Abstract Expressionism, Surrealism, Constructivism, Assemblage (found object), Pop Art, Minimalism, Site/Environment, Process Art, Concept Art, and a revival of realism.

Significantly different techniques are employed, and media range from traditional bronze to neon lights, from discarded toys to industrial products, from gold wire to vinyl and plastic. The scale runs the gamut from a small box to landscape manipulations involving vast spaces. The studio and the gallery are inadequate to accommodate the scale and concepts, so sculpture moves outdoors to dominate the urban plaza, or to harmonize in monumentality with the desert, mountain range, or lake.

There was a revolution in form after the war. For centuries sculpture had been conceived in terms of mass. Now, for several artists, sculpture changed from an art concerned with mass and volume to one involved mainly with light and space, with little or no need for mass. If there was revolution, however, there was also reaction. As this period opened, there were numerous sculptors working in the styles, techniques, and media from earlier in the century.

ISAMU NOGUCHI

Isamu Noguchi (1904–88) made a full commitment to abstraction, although his forms were often anthropomorphic or biomorphic and his style is based as much on Oriental principles as on Western modernism. Born in Los Angeles, Noguchi was taken as an infant to Japan, and he returned to the United States only in 1918. Four years later, he became an apprentice to the sculptor Gutzon Borglum (1867–1941). Of far greater importance, however, was a visit to an exhibition of Brancusi's sculpture at the Brummer Gallery, New York City, in 1926. Noguchi was so moved by what he saw that he soon left for Paris to study with Brancusi. While in Europe he was also exposed to the surrealist forms of Arp and Miró. The next major influence in his career came when he returned to Japan in 1931—he studied pottery at Kyoto, and the shapes of ancient Japanese ceramics are frequently discernible in his art thereafter.

Humpty Dumpty reveals a sophisticated understanding of abstraction found in the sculpture of Brancusi, of biomorphic Surrealism, and of ancient Japanese pottery (Fig. 38.1). For all its modernity, however, it has strong links to sculpture of the past: It is carved in stone, Noguchi's favorite medium; it is anthropomorphic, standing near the height of an average person, on leglike forms; and it consists of plane and mass interacting with light and space in the traditional sense.

Noguchi's special brand of abstraction remained popular throughout the 1950s, 1960s, and 1970s. His noble forms worked well as monumental adornments to corporate office structures and as abstract objects in handsome sculpture gardens, in which one finds an Oriental interest in solitude and meditation.

38.1 Isamu Noguchi, *Humpty Dumpty*, 1946. Ribbon slate, height 5ft 10¾in (1.49m). Collection, Whitney Museum of American Art, New York City.

ABSTRACT EXPRESSIONIST SCULPTURE

With the rise of Abstract Expressionism around 1945–50, America asserted its independence of European artistic traditions and established its preeminent position as leader in the contemporary visual arts. Several sculptors made significant contributions to that movement.

THEODORE ROSZAK

Theodore Roszak (1907–81) began his career in the 1930s, when Constructivism, a European movement of around 1915–25 led by Naum Gabo (1891–1973), was rising as a potent influence in American art. We have already noted the machinelike precision and polish of his early work, as in *Airport Structure* (Fig. **32.15**). In the early 1940s, Roszak's art underwent a profound change from the mechanistic to the surrealistic. Technology suddenly seemed less important than deeply felt human emotions. After World War II, his work incorporated the dramatic, violent gesture and movement of Abstract Expressionism and the bony, spiky, biomorphic forms that are consistent with Surrealism, as seen in *Specter of Kitty Hawk* (Fig. **38.2**).

After studying at the Art Institute of Chicago and the National Academy of Design in the 1920s, in 1929 Roszak traveled in Europe, where he was exposed to Surrealism. He was then still a painter, and the art of De Chirico had a great impact on his work. The *Specter of Kitty Hawk* also has a suggestion of the surrealist forms of Miró, but the richness and roughness of texture are typical of Abstract Expressionism. While the form suggests something primeval and darkly threatening, the title connotes the possible use of the airplane as an engine of destruction. We must remember that this piece was created less than a year after U.S. Air Force bombers dropped two atomic bombs on heavily populated Japanese cities.

Abstract forms of a very different expressive content are found in the sculpture Roszak created for the top of Saarinen's Chapel at MIT (Fig. **34.1**).

38.3 Herbert Ferber, *The Flame*, 1949. Brass, lead, soft solder, 5ft 5½in (1.66m). Collection, Whitney Museum of American Art, New York City.

38.2 Theodore Roszak, *Specter of Kitty Hawk*, 1946–7. Welded and hammered steel brazed with bronze and brass, 40¼ × 18 × 15in (102.2 × 45.7 × 38.1cm). Collection, The Museum of Modern Art, New York. Purchase.

HERBERT FERBER

At the same time that he was earning a degree in dentistry at Columbia University, Herbert Ferber (b. 1906) studied sculpture at night at the Beaux-Arts Institute in New York City, working in the direct carving manner of William Zorach. An expressive quality also evolved in his art, which was probably derived from his interest in the sculpture of Ernst Barlach (1870–1938).

Immediately after the war, just as Abstract Expressionism came upon the scene, Ferber began working with soldered and welded metal. His work soon revealed a concern with biomorphism and a surrealist fascination with the totem-fetish image, as seen in *Flame* (Fig. 38.3). Ferber's art frequently expresses a psychic energy that he perceived locked within a human form, including strong animalistic undercurrents. The sculpture is less a representation of the figure than a metaphor for something spiritual within.

SEYMOUR LIPTON

Like Ferber, Seymour Lipton (1903–86) was trained as a dentist, but he began making sculpture in the 1930s. After the war, he started working with metal, cutting forms out of sheet metal and welding them together.

Lipton tended more toward biomorphic than anthropomorphic images. *Sanctuary*, for example, reminds one of a great pod that protects within it some menacing seed (Fig. 38.4).

While *Sanctuary* has something of a floral quality—as in, say, the unfolding petals of a rosebud—there is inherent in it, as in most of Lipton's sculpture, a powerful suggestion of demonic potential. While the title implies a safe haven, *Sanctuary* may remind one of some organism that traps and encapsulates unsuspecting victims and then devours them. The aggressive quality, hinting at impending evil, is characteristic of much of abstract expressionist sculpture and is

38.4 Seymour Lipton, *Sanctuary*, 1953. Nickel-silver over steel, 29¼ × 25 × 18¾in (74.3 × 63.5 × 47.6cm). Collection, The Museum of Modern Art, New York. Blanchette Rockefeller Fund.

38.5 Ibram Lassaw, *Galactic Cluster No. 1*, 1958. Bronze, silver, 33 × 38½ × 16in (83.8 × 97.8 × 40.6cm). Collection, Newark Museum, Newark, New Jersey.

aligned with surrealist interest in the darker side of the psychic world.

IBRAM LASSAW

Ibram Lassaw (b. 1913) has a personal abstract expressionist style that consists of a textured, agitated line moving through space, seemingly randomly and erratically. His sculptured line—as in *Galactic Cluster No. 1* (Fig. 38.5)—took a course of its own in much the same way as did the stroke of the brush or the dribble in the action painting of Willem de Kooning or Jackson Pollock.

Lassaw, who was born in Alexandria, Egypt, but was brought to the United States when he was eight, studied at the Beaux-Arts Institute in New York City and by 1933 had already begun to make open metal sculptures. During

World War II, while serving in the army, he learned direct welding, a skill that would later permit him to arrive at the style seen in *Galactic Cluster No. 1*.

JOSÉ DE RIVERA

Sculpture of a very different line is found in the work of José de Rivera (1904–85), who first learned to work with metals from his father, an engineer in a New Orleans sugar mill, and then from employment in foundries and machine shops. After studying art briefly in Chicago, De Rivera turned to sculpture about 1930. Early works exhibit an interest in the polished metal surfaces of Brancusi's abstractions.

The special form for which De Rivera is bestknown—the continuous curving line, flowing smoothly and gracefully through space—is the antithesis of Lassaw's staccato, erratic

38.6 José de Rivera, *Construction No. 100*, 1967. Bronze, 9½ × 10¾ × 9in (24.1 × 27.3 × 22.9cm). Collection of Dr. and Mrs. Arnold D. Kerr.

line. De Rivera does not, in fact, belong to the Abstract Expressionist group but rather to the Constructivist camp. There is a precision of technique and an elegantly finished and polished surface in his work. The element of chance is eliminated, and the whole is the result of a preconceived concept of design. In the gleaming, metallic surface of *Construction No. 100* there is an affinity with the machine age. More than that, there is a rejection of the notion that sculpture is limited to static mass (Fig. 38.6). Usually wrought of tubular aluminum or stainless steel, such pieces are often set in motion on a slowly revolving stand, which constantly changes the appearance of the curvilinear form. Like a fluid ray of light moving through and defining space, this sculpture elicits a mystical aesthetic experience of twentieth-century physics and alchemy, of atoms and materialized energy in the nuclear age.

RICHARD LIPPOLD

There is also a Constructivist order and precision to Richard Lippold's *Variation No. 7: Full Moon*, but the line here is rectilinear instead of curvilinear, and in place of the simplicity of De Rivera's *Construction No. 100* we find a great complexity (Fig. 38.7).

Once again, it is necessary to redefine sculpture, for there is no mass here, only thin lines in space. Light does not define volume, but rather creates the brilliant gleam of the golden wire.

Lippold (b. 1915), who was trained as an industrial designer at the school of the Art Institute of Chicago and the University of Chicago, began making wire constructions in the mid-1940s when he moved to New York City. His fascination with such things as suspension bridges, space probes, and nuclear fission, as phenomena resulting from new technologies, is paralleled in his art.

The art critic for *Time* magazine referred to work such as *Full Moon* as having the "polished beauty and coldness of a mathematical equation," and quoted Lippold as saying "Our faith is in space, energy and communication, not in pyramids and cathedrals."[1] Another critic, writing specifically about *Full Moon*, commented that the artist " . . . interprets it as a symbol of the tenseness of the world today. If one of the taut key-wires were to snap, the whole structure would collapse."[2]

38.7 Richard Lippold, *Variation No. 7: Full Moon*, 1949–50. Brass rods, nickel-chromium and stainless steel wire, 10 × 6 × 6in (25.4 × 15.2 × 15.2cm). Collection, The Museum of Modern Art, New York. Mrs. Simon Guggenheim Fund.

In 1956, the Metropolitan Museum of Art commissioned *Variation within a Sphere, No. 10: The Sun*, a celestial counterpart to *Full Moon*. As preparation, Lippold studied the sun's nuclear explosions through solar films at Harvard University's high-altitude observatory.

ALEXANDER CALDER AND DAVID SMITH

Alexander Calder, whose early constructivist sculptures we have studied previously (see p. 491), continued to explore and refine the mobile in the years following World War II.

Calder's training as a mechanical engineer should be recalled, as well as his involvement with the modern movement in Paris in the 1920s and his desire to see the colors of Mondrian and the shapes of Miró set in motion. By the beginning of the postwar period, his very personal form of expression—irregular sheets of metal, painted either black, white, or bright colors, dancing on the ends of meticulously balanced wires—needed only to be perfected.

In works such as *International Mobile*, the order and logic, the perfect understanding of weight and counterweight, the potential for movement of the delicately hung parts, and the combination of wire line and painted planes are all present (Fig. 38.8). The work's movement is natural, being caused by air currents, which are erratic and unpredictable, and therefore offer the viewer a constantly changing chance relationship of parts.

38.9 Alexander Calder, *Model for Teodelapio*, 1962. Standing stabile: painted sheet aluminum, 23¾ × 15¼ × 15¾in (60.3 × 38.7 × 40cm). Collection, The Museum of Modern Art, New York. Gift of the artist.

38.8 Alexander Calder, *International Mobile*, 1949. Sheet aluminum, rods, wire, 20 × 20ft (6.1 × 6.1m). Museum of Fine Arts, Houston, Texas.

Calder successfully enlarged the scale of his mobiles for the vast interiors of the new postwar architecture, as seen in his huge constructions for the Philadelphia Museum of Art, New York's Kennedy Airport, and I. M. Pei's new wing for the National Gallery of Art.

Whereas Calder's mobiles are suspended from above by a single wire, giving them maximum buoyancy, his **stabiles** are set firmly and directly on the floor or ground. They assume an even greater monumentality than the mobiles and often reach truly colossal scale.

Illustrated here is the model for his *Teodelapio* (Fig. 38.9), the finished version of which, erected as a city gate in Spoleto, Italy, towers to a height of 58 feet (17.7 m), with an open space underneath large enough to allow traffic to pass through. The huge pieces of freeform sheet metal, which are bolted together, carry reminiscences of the surrealist forms of Joan Miró. The monumental quality is enhanced by its being painted entirely in a matt black. If there is something amusing, even playful in Calder's early mobiles, there is often a brooding, somber character, sometimes even slightly menacing, in his stabiles, as in the *Black Widow* (MOMA, New York) of 1959.

David Smith (1906–65), one of the greatest masters of modern American sculpture, combined Constructivist principles with the metal-working skills he learned in the machine shop. He incorporated elements of Cubism, Surrealism, and Abstract Expressionism into the style he developed following World War II. We have already seen the convergence of many of these features in his art in the 1920s and 1930s (see p. 491), and need only recall here that as the postwar period opened, Smith was already a skillful welder and metalworker. He was also a pioneer in introducing the industrial technology of the machine shop into the making of sculpture, and he had already begun working found industrial objects into his compositions. Smith believed that

38.10 David Smith, *Tanktotem V*, 1955–6. Steel, height 8ft 1in (2.46m). Private collection.

38.11 David Smith, *Cubi XVIII*, 1964. Stainless steel, height 9ft 7¾in (2.94m). Dallas Museum of the Fine Arts, Dallas, Texas.

metal was the quintessential expressive medium of the twentieth century.

As the postwar period opened, the Surrealist element was still a powerful presence in Smith's art. By the mid-1950s, he was working on his *Tanktotem* series. *Tanktotem V* (Fig. 38.10), which incorporates several standard industrial parts, reveals a surrealist element in the anthropomorphic suggestion of human form and in the attenuated quality paralleling the sculptures of the contemporary Italian Surrealist Alberto Giacometti (1901–66).

Smith read the works of Sigmund Freud extensively, especially *Totem and Taboo*. This was an important influence on many Surrealists, because it dealt with repressed desires and the subconscious, and because it linked primitivism and modern society, and therefore primitive and modern art. *Tanktotem V* has a primitive, totem- or fetish-like quality.

With *Tanktotem*, Smith began to enlarge his work to monumental proportions. In the early 1960s his sculpture became less anthropomorphic and more geometric, and still more massive and monumental, while simplicity and refinement replaced the roughness and brutality of earlier works, as seen in three extraordinary series: *Zig*, *Voltri*, and *Cubi*.

His *Voltri* series, named after the Italian city and begun in Italy for the Spoleto Festival in 1962, consists of fewer but larger components, working toward a monumental simplicity in abstract form, now largely free of expressive, surrealist connotations. By this time Smith, who had commenced his career as a painter, had begun to paint his sculptures in bright, bold colors.

With the *Cubi* series, Smith's work reached a grandeur in monumental, geometric, nonobjective form. *Cubi XVIII* (Fig. 38.11) reveals that his sculpture had changed from an affinity with Abstract Expressionism to something paralleling postpainterly, hardedge painting, similar to the work of his close friend Kenneth Noland (see Fig. 37.5). Smith's art began to move in the direction of Minimalism. He abraded the surfaces of his assembled stainless-steel cubes to a high polish, reflecting the light of the outdoor setting that he preferred for his work. The *Cubi* series was created at his farm at Bolton Landing, in upstate New York, where he had since 1929 operated his own machineshop type of studio. Work on the series ended with his death in 1965 in an automobile accident.

Smith's early use of the tools and materials of the machine shop and his incorporation of standard industrial found objects into the work of art opened many new paths of exploration, which were followed, each in their own way, by a number of younger sculptors.

RICHARD STANKIEWICZ

Richard Stankiewicz (1922–83) was one of the first of these. After studying engineering, he worked in the tool industry in Detroit. Following the war, Stankiewicz attended Hans Hofmann's school in New York City before going to Paris to study painting. Back in New York City by 1953, he began exhibiting constructions made of assorted pieces of industrial scrap metal welded together.

Although the form was new and controversial, Stankiewicz's early sculptures were influenced by Duchamp's ideas about readymade works of art. Again, the sustained impact of Dada is noted. *Instruction* is a bold yet carefully ordered composition of readymade parts of pipes, cylinders, nuts, bolts, and so on (Fig. 38.12). Stankiewicz's sculpture has a rough, unpolished character. The beautiful, rich, and lustrous patinas of nineteenth-century academic bronzes are replaced with corrosion, accidental acid-staining, or rusting, or whatever is natural to industrial metals.

38.12 Richard Stankiewicz, *Instruction*, 1957. Welded scrap iron and steel, 12½ × 13¼ × 8⅝in (31.8 × 33.7 × 21.9cm). Collection, The Museum of Modern Art, New York. Philip Johnson Fund.

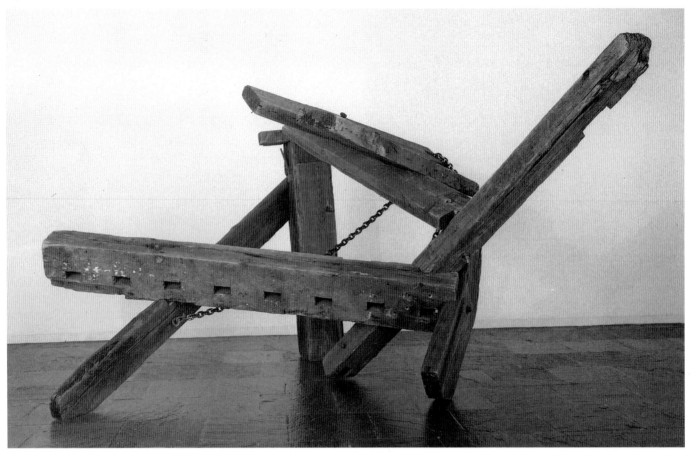

38.13 Mark di Suvero, *Hankchampion*, 1960. Wood, chains (nine wooden pieces overall), 6ft 5½in × 12ft 5in × 8ft 9in (1.97 × 3.79 × 2.67m). Collection, Whitney Museum of American Art, New York City.

MARK DI SUVERO

If Stankiewicz was the pioneer in so-called "junk sculpture," others soon conducted similar experiments. Mark di Suvero (b. 1933) carried this artform to a monumental scale.

Born in Shanghai, Di Suvero had Italian parents who brought him to San Francisco in 1941, where his father worked in a shipyard. Mark attended the University of California, Berkeley, where he received his degree in philosophy. He had begun to study art before moving to New York City in 1957, where he came under the influence of the action painters Franz Kline and Willem de Kooning.

Di Suvero supported himself as a carpenter while he began making his first constructions — works composed of found objects and discarded items that had once had a former life and usefulness. Such pieces possessed a vernacular quality and an attachment to real life that Di Suvero found desirable.

Di Suvero's art came before the New York City art scene in 1960 with an exhibition that included *Hankchampion*, which is made of old beams and chains from the refuse heap (Fig. 38.13). In the dynamic, centrifugal surge one already finds a characteristic that would persist in his later art. This may be compared to the energetic force of gesture painting seen in the work of Kline, De Kooning, and others. Typical, too, is a biomorphic quality, which suggests some great, lumbering beast.

By the mid-1960s Di Suvero's sculptures had grown in scale, and he increasingly used metal, especially I-beams, in addition to old tires and large chains. Such works continued to have the roughness of junk sculpture. By 1967, however, the "junk" quality was replaced with elegance, even in huge constructions composed entirely of I-beams. While the forceful thrust and industrial affiliation of earlier works remain, there is now a simplicity and refinement. This proved to be the future direction of Di Suvero's art, as demonstrated in the beautiful but powerful I-beam construction *Isis* (1978), commissioned by the Institute of Scrap Iron and Steel and presented to the Hirshhorn Museum and Sculpture Garden in Washington, D.C.

In these later works, Di Suvero's art achieved a svelteness that drew it near the colossal stabiles of Alexander Calder. His sculptures are distinguished from Calder's, however, by the industrial character of the material—which makes them as much akin to bridge and skyscraper construction as to other forms of art.

CHAPTER THIRTY-NINE

SCULPTURE:

FEMINISM, FOUND OBJECTS, POP, MINIMALISM, AND REALISM, 1940 TO THE PRESENT

In every period of American history women have made a contribution to the arts, and in view of the feminist movement that has evolved since about 1960 a discussion of the matter is relevant here. The women's movement in the United States began well before the period now under consideration. In 1848, the first Women's Rights Convention in America, organized by Elizabeth Cady Stanton and Lucretia C. Mott, was held at Seneca Falls, New York. It called for better education for women, improved job opportunities, and the right to vote. Stanton was largely responsible for the Declaration of Sentiments that issued from the meeting, which paraphrased the Declaration of Independence, but with important changes of wording. For example, where the document of 1776 read "all men are created equal," Stanton's read "all men and women are created equal."

In 1869 Stanton joined Susan B. Anthony to found the National Women's Suffrage Association, organized to lobby for a constitutional amendment. Ten years later, the amendment was introduced. It took forty years, however, before action was finally taken. Lucretia Mott, a Quaker and one of the founders of Swathmore College in 1864, had earlier written a book, *Discourse on Women* (1850), which discusses the restrictions on women in education, politics, and careers in business.

In the second decade of the twentieth century, there were signs that things might at last be changing. In 1916 Jeanette Rankin became the first woman to be elected to the House of Representatives, and the next year over 20,000 women marched in a suffrage parade in New York City. In 1920 the Nineteenth Amendment was finally passed, giving women the right to vote in national elections, and the League of Women Voters was organized. In 1924 Miriam Amanda Ferguson of Texas became the first woman to be elected governor in America.

A feminist perspective began to be asserted in literature with the publication of books such as Virginia Woolf's *A Room of One's Own* (1924), Gertrude Stein's *Autobiography of Alice B. Toklas* (1933), and Simone de Beauvoir's *The Second Sex* (1949). The Women's Rights movement accelerated in the 1960s with the publication of Betty Friedan's *The Feminine Mystique* (1963), which challenged women's belief that their only chance at happiness was through housewifery, childbearing, and motherhood. It pointed out that many women gave up their own identity to live through their husbands and their children. In 1966 Friedan founded and became president of the National Organization for Women (NOW), which asserted that women were not secondclass citizens and declared that professional careers should be open to women as well as men. Crucial issues were taken up. NOW began speaking out on behalf of battered wives and against rape. In 1970 Friedan resigned as president of NOW in order to organize the nationwide Women's Strike for Equality. Thereafter, the women's movement accelerated as a political-action movement.

Many women felt that the government's Equal Employment Opportunities Commission had not adequately addressed the problem of sex discrimination. Even if men and women held the same jobs, women were often paid less, and so the feminist movement advocated the equal-pay-for-equal-work concept. In 1972 Congress passed the Equal Rights Amendment (ERA), which had been stalled in committees for over fifty years, but it became a controversial issue and failed to be ratified. Meanwhile, NOW was joined by a number of other organizations. Women's Studies courses were instituted in schools. Women were increasingly elected to town councils, as mayors, as state representatives, governors, senators and congresswomen. In 1984, Geraldine Ferraro was the Democratic nominee for the vice-presidency.

In the 1970s and 1980s, women increasingly began to move into management and entrepreneurial positions. A major spokesperson for the feminist movement in the 1970s was Gloria Steinem, an articulate journalist and a gifted organizer. She became editor of *Ms.* magazine, a publication devoted entirely to women's causes, which was edited and operated by women.

WOMEN AND ART

In 1981 the National Museum of Women in the Arts was founded in Washington, D.C. By then, the College Art Association, the professional organization for artists, art historians, curators, and gallery people, had established a women's caucus within that society.

Women have long been active in the fine arts in America. Rebecca Rawson, of seventeenth-century Massachusetts, practiced in England rather than the Bay Colony, but Henrietta Johnston was making pastel portraits (Fig. 5.9) in South Carolina by about 1708. Several daughters and other female relatives of Charles Willson Peale became painters in the nineteenth century, and Gilbert Stuart's daughter Jane became so proficient in her father's style that experts frequently had difficulty distinguishing their work.

The Victorian era had few professional women painters because that period tended to think ill of women taking an active role in the arts, except in an amateurish way. We have seen, for instance, that Harriet Hosmer raised many a Victorian eyebrow because of her work as a sculptor in mid-nineteenth-century Rome. Also, women of that period were not given the same opportunities as men in American art schools—in drawing from the nude figure, for example. Except in a few women's colleges, the profession of teaching art was not open to them, and membership in the professional academies was made up mainly of men. The situation improved in the twentieth century, and we have already noted the examples of Marguerite Zorach (Fig. 30.5), Georgia O'Keeffe (Figs. 30.17 and 30.18), and Helen Frankenthaler (Fig. 36.23).

Because of the physical labor and the mess, sculpture was long considered unsuitable for women. Nevertheless, as early as the end of the eighteenth century, Patience Wright (1725–86) was carving cameo portraits in New York City. By the middle of the nineteenth century, there was a whole contingent of American women sculptors active in Italy—Harriet Hosmer (Fig. 18.13), Emma Stebbins (1815–82), Margaret Foley (c. 1820–77), Louisa Lander (1826–1923), Anne Whitney (1821–1915), and Edmonia Lewis (Fig. 18.14).

Representatives from the turn of the century and the era before World War II include Bessie Potter Vonnoh (Fig. 26.22), Janet Scudder (1873–1940), Abastenia St. Leger Eberle (Fig. 32.4), Anna Hyatt Huntington (1876–1973), Ethel Myers (1881–1960), Malvina Hoffman (1887–1966), and Gertrude Vanderbilt Whitney (1875–1942). Among the more renowned of the contemporary sculptors are Louise Bourgeois (Fig. 39.18), Anne Truitt (b. 1921), Sylvia Stone (b. 1928), Louise Nevelson (Fig. 39.2), Marisol Escobar (Fig. 39.7), Varda Chryssa (Fig. 39.13), Eva Hesse (1936–1970), Nancy Holt (b. 1938), Judy Chicago (Fig. 39.19), and Nancy Graves (Fig. 39.20). In the present study women artists have not been isolated from the history of their own time to be studied as a group, but anyone wishing to pursue the subject will find a special section in the Bibliography devoted to women artists in America.

FOUND OBJECTS AND ASSEMBLAGES

The use of the *objet trouvé*, or found object, was advocated by the early Dadaists, in one way to debunk high art, in another to bring art and real life together. Even earlier, several Cubists, led by Picasso, worked in a technique called assemblage, in which parts of newspapers, wine labels, strips of colored paper or whatever were pasted into the composition.

JOSEPH CORNELL

The American progenitor of found-object art was Joseph Cornell (1903–72), who created a very personal form of expression—the shallow wooden box, glass-enclosed, containing items that were reclaimed from real life for use and new life as sculpture.

Cornell was selftaught. Beginning in 1921, he worked for a decade as a textile salesman in New York City, where his favorite avocation was to scour about the secondhand shops on Third Avenue in search of ephemeral memorabilia that triggered a romantic nostalgia, most often associated with the theater, the cinema, opera, music, and historical epochs such as the Renaissance. When the Depression ended Cornell's employment, he began to create his wistful little assemblages. From the beginning Surrealism played a significant role in his art.

Cornell happened to be in the Julien Levy Gallery—a major center for avant-garde art in New York City in the 1930s and 1940s—when a surrealist exhibition was being unpacked. Excited by what he saw, he began to make little bell assemblages, several of which were shown at the Levy Gallery's "Surréalisme" exhibition in 1932.

Soon afterward, the first of his shadowboxes—wooden or cardboard boxes lined with old maps or engravings and containing an assortment of found objects—appeared. Toys, photographs, glasses, prints, cutouts of movie stars, all things which had some appeal to Cornell, were worked into his enclosed constructions.

The surrealist element is found in that Cornell himself did not always understand the symbolic content or the associations of some objects to others. Still, his shadowbox arrangements often had coherent iconographic programs, as in one that honors Lauren Bacall, one of his favorite movie idols, and in *The Medici Slot Machine* (1942), with its color reproduction of Maroni's portrait of a Renaissance prince as its main theme. While surrealist art frequently presents the viewer with an emotional shock, Cornell's work is more often a trip down memory lane.

The *Suite de la Longitude* is a shadowbox lined with pages from an old encyclopedia or geography book, with a row of six little wineglasses, each of which has a marble in it; a ball rests on the base of the box, while two loops are hung from the top (Fig. 39.1). Although viewers may have difficulty

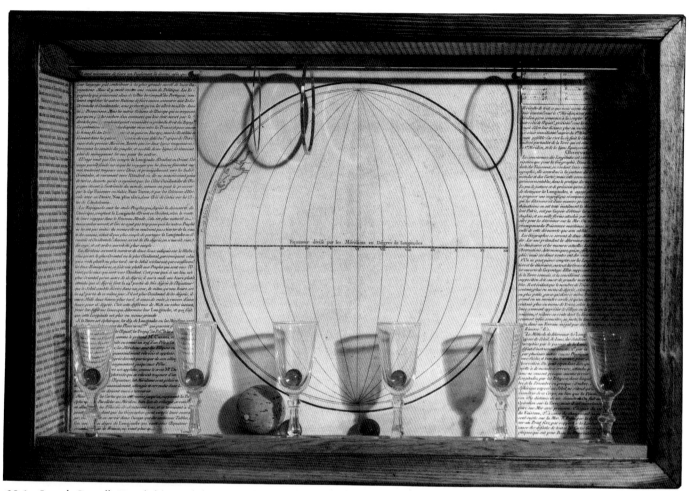

39.1 Joseph Cornell, *Untitled (Suite de la Longitude)*, 1955–7. Box construction of painted wood, printed papers, glasses, marbles, cork, metal rings, ink wash, pencil, 13¼ × 19¾ × 4⅜in (33.8 × 50.2 × 11.2cm). Hirshhorn Museum and Sculpture Garden, Smithsonian Institution, Washington, D.C.

comprehending the meaning of the assembled objects, they usually find pieces like this intriguing and enjoyable.

In the 1930s, Cornell was ahead of his time in America when he made art out of ordinary household objects or commonplace things from popular culture. By the 1950s his method of relating art to the real world by the use of familiar objects was widely acclaimed. A whole host of mid-century artists began to use ordinary found objects in their individual ways, including Robert Rauschenberg, Jasper Johns, George Segal, Edward Kienholz, and Louise Nevelson.

LOUISE NEVELSON

It took Louise Nevelson (1900–88) a while to decide to be a sculptor, for her interests in the arts were broad and varied. In addition to painting, she studied operatic voice, acting, modern dance, and poetry. Nevelson was at the Art Students League in 1929, but two years later she went abroad. In Munich she worked with Hans Hofmann and in her travels became familiar with European modernism. Back in New York City, she assisted Diego Rivera in the painting of

the great Rockefeller Center mural. It was not until about 1940 that Nevelson turned seriously to sculpture, making abstractions, mostly in the Cubist mode, in various media. Not before about 1954–5 did she arrive at the style most often associated with her—the compartmentalized wall-assemblage as seen in *Sky Cathedral* (Fig. **39.2**).

Nevelson's wallpieces were built by stacking wooden wine crates or vegetable boxes to establish vertical and horizontal unity. Within these were placed scraps of wood of unusual and varying shapes and found objects such as balusters, chairbacks, newel posts, table legs, or shelf moldings, which Nevelson might find at a demolition site or in a junkshop.

The wall, which could rise to a height of 8 feet (2.4 m), became an allover bas-relief of fascinating patterns, its great complexity given unity by the loose grid of the vertical and horizontal edges of the boxes and by being painted with a matt black.

Although totally abstract, sculptures by Nevelson almost always have a powerful spiritual or poetic presence, as is evident, for example, in *Homage to Six Million*, a wallpiece of

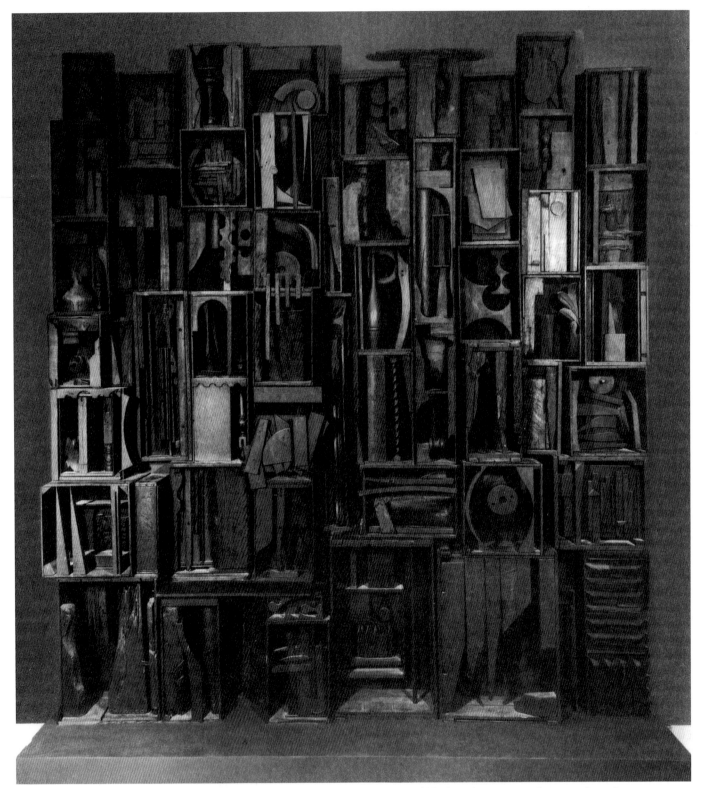

39.2 Louise Nevelson, *Sky Cathedral*, 1958. Assemblage: wood construction painted black, 11ft 3½in × 10ft¼in × 1ft 6in (3.44 × 3.05 × 0.46m). Collection, The Museum of Modern Art, New York. Gift of Mr. and Mrs. Ben Mildwoff.

39.3 Edward Kienholz, *The Wait*, 1964–5. Tableau: Epoxy, glass, wood, found objects, 6ft 8in × 12ft 4in × 6ft 6in (2.03 × 3.76 × 1.98m). Collection, Whitney Museum of American Art, New York City.

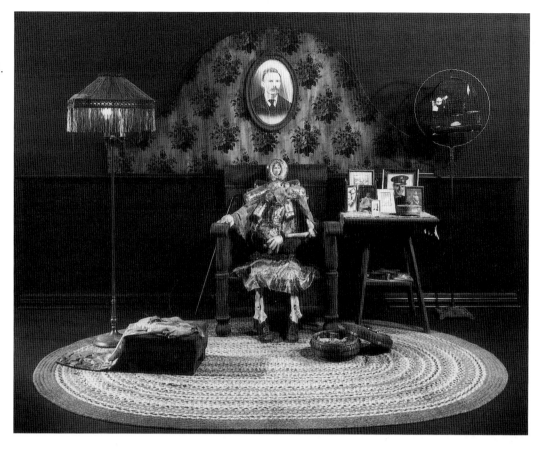

the early 1960s, which honors the Jews who were killed by the Nazis.

In Nevelson's constructions, neither the incorporation of objects into the mass of the wall nor their being painted uniformly black completely conceals the relationship they once held with the real world. The found object has undergone a metamorphosis, but has been allowed to retain lingering references to its earlier existence. About 1965, Nevelson departed from the black-shadow effect and began painting her wall-assemblages gold. Late in her career, she expanded beyond the wallrelief type to create monumental steel sculptures meant to be seen in the round. These were generally in the Constructivist mode, as in *Dawn Shadows*, erected in one of Chicago's corporate plazas in 1983.

EDWARD KIENHOLZ

Assemblage of a very different sort and expressive content, but still utilizing the found object, is seen in the tableaux of Edward Kienholz (b. 1927). In works such as *The Wait*, virtually the entire piece consists of found objects, judiciously selected for their expressive, metaphorical capabilities (Fig. 39.3).

Educated in his native state of Washington, Kienholz held a number of jobs after college, ranging from an orderly in a mental institution to car salesman and window-display arranger. He was selftaught as an artist, working first as a painter, then making bas-reliefs from assorted scraps in his transformation to sculptor.

Kienholz's first environmental tableaux came about 1960, and he gained international notoriety with *Roxy's* (1961). This is a recreation of a room from a Las Vegas brothel, in which the girls are battered mannequins, and wallpaper, a jukebox, and other items from the real world complete the tawdry setting. At about the same time he began work on *Barney's Beanery* (Stedelijk Museum, Amsterdam), a 22-foot (6.7-m) walkthrough simulation of a Los Angeles bar, created out of signs, lights, beer bottles and glasses, all the accouterments of a neighborhood bar, where the mannequin-customers with clocks for heads "kill time" in their loneliness.

Kienholz's work treated such social themes as illness, madness, sexual patterns, and neglect of the aged, in a manner that often brought harsh criticism. *Back Seat Dodge '38* of 1964, which depicts a copulating couple in the back seat of an old car, while intended to raise the issues of adolescent sex and Victorian mores, was denounced by Los Angeles city officials as pornographic.

The reality of Kienholz's images makes them disturbing. *The Wait*, for example, is a satire on the way the aged are left to their loneliness and memories amid dustgathering mementos of an earlier life. A figure of an old woman in a real dress, her emaciation indicated by the use of cow bones for her shriveled legs, sits amid a tableau of found objects.

These are not used for their formal abstract shapes, but rather for their expressiveness.

The woman's head is a bottle which contains a photograph of a young girl of around 1910—a recollection of her appearance in youth—while the jars of her necklace encapsulate other objects that evoke the events of her life. An oldfashioned fringed lamp, an end table filled with photographs, a birdcage, a sewingbasket, and a large photo of a handsome young man, also of about 1910, tell more of the pitiful story. The title refers to the patient wait for death. Through the use of the found object, the barrier between real life and art has been decisively shattered. Many people find Kienholz's work too troubling to endure.

GEORGE SEGAL

George Segal (b. 1924) also creates environments composed in their settings of real objects from everyday life—Coca-Cola machines, rubber tires, doorways or windows, furniture, and oilcans. Segal's tableaux are populated with pasty-white human figures that have a zombie-like existence.

Segal, a native New Yorker, had observed the rise of Abstract Expressionism while a student at New York University. For him, the human figure was essential in the expression of the human condition. At this stage, Segal was influenced more by Allan Kaprow's total-environment theatrical "happenings," or art-events that were staged only once.

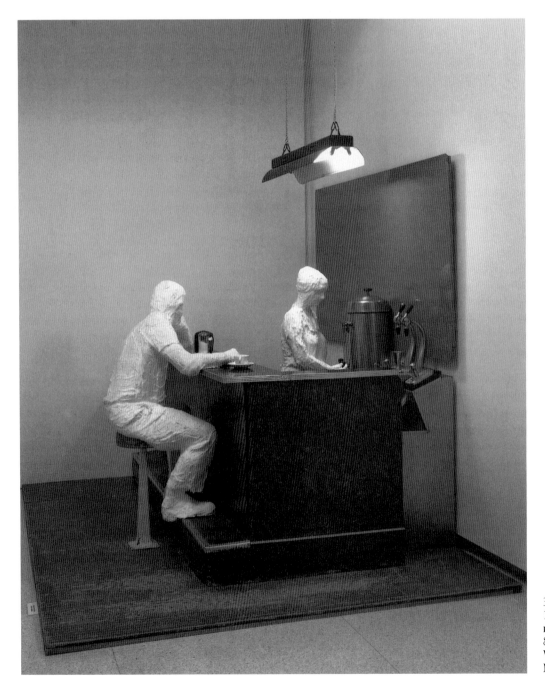

39.4 George Segal, *The Diner*, 1964–6. Plaster and various media, 7ft 9¾in × 12ft¼in × 8ft (2.38 × 3.66 × 2.44m). Walker Art Center, Minneapolis, Minnesota.

39.5 Jasper Johns, *Untitled, Painted Bronze (Beer Cans)*, 1960. Painted bronze, height 5½in (14cm). Private collection.

Segal's interest lay in men and women in their daily lives, causing him to seek the real environment. Because he wanted a universal quality in his figures, they became plaster abstractions, as we see in *The Diner* (Fig. 39.4). A real counter, real stools, actual sodafountain equipment and a real coffeemaker are used, but the two figures are, for all their semblance to reality, typological abstractions. The viewer is reminded of the lonely people in Edward Hopper's scenes of New York City cafés (Fig. 29.15).

Segal had originally worked in plaster applied to an armature, but about 1960 he began to make body casts. He wrapped real people, who had assumed the poses he desired, in strips of cloth, and then applied plaster. After the plaster had set, the encasing form was cut to allow the figure to ease out. The hollow form was then repaired and worked over for the desired expressive effect.

What Segal wished to create was the reality of experiences he had known—the personal experience, for example, of entering a roadside café after midnight, of sensing, as he said, that the waitress was avoiding eye-contact because she was wondering if she might be raped or robbed by this latenight stranger. The viewer senses the psychological distance that separates the figures.

JOHNS AND RAUSCHENBERG

After Joseph Cornell, Jasper Johns and Robert Rauschenberg were among the earliest of the younger generation to utilize objects and images from popular culture in their art.

In *Monogram* (1959, National Museum, Stockholm) and *Trophy IV (For John Cage)* (1961, collection of the artist), Rauschenberg used discarded objects or worn and battered junk from the real world to make sculptures that are at one and the same time realistic—in that they are composed of real objects—and abstract, in that their meaning is metaphorical.

Johns, in works such as *Untitled, Painted Bronze (Beer Cans)*, used a different method, for his sculptures are cast in bronze and then painted. His intention was to take a commonplace subject from real life—two Ballantine Ale cans—and make it a part of the rarefied realm of art (Fig. 39.5). The viewer may well become confused when looking at this piece, wondering "Am I looking at art, or am I looking at reality?" The answer is, at least to artists who receive their inspiration from popular culture, that it does not really matter.

POP ART SCULPTURE

CLAES OLDENBURG

Many sculptors rushed to join the popular culture revolution because of the liberation and the vitalizing force it offered. Foremost among these was Claes Oldenburg (b. 1929), sometimes referred to as "the pope of Pop."

Born in Stockholm, Sweden, Oldenburg was brought to Chicago in 1937. Later, at Yale University, he majored in

literature, taking art courses only in his senior year. His studies continued with night classes at the Art Institute of Chicago while working as art editor and cartoonist for *Chicago Magazine*—a job that integrated his art interests with the world of commercial advertising and mass media.

By 1956 Oldenburg moved to New York City, where he became fascinated with the displays he saw in neighborhood shop windows, in which the objects perhaps seemed like a grand realization of Marcel Duchamp's readymades. This fascination led to the establishment of *The Store* (1960–1), an environment piece in which Oldenburg filled a rented vacant shop with sculptured (usually painted plaster) parodies of consumer goods. In his book *Store Days* he revealed the inspiration that ordinary objects excited in him:

> I am for Kool-art, 7-Up art, Pepsi-art, Sunshine art, 39 cents art, 15 cents art, Vatronol art, Dro-bomb art, Vam art, Menthol art, L&M art, Ex-Lax art, Heaven Hill art, Pamryl art, San-o-med art, Rx art, 9.99 art, Now art, New art, How art, Fire sale art, Last chance art, Only art, Diamond art, Tomorrow art, Franks' art, Ducks' art, Meat-o-rama art.[1]

After *The Store* closed, the shop became his studio, which, as the site of several theatrical happenings, was renamed the Ray Gun Manufacturing Company.

The next step in Oldenburg's career came in 1962 with the first of his large soft sculptures, an example of which is *Giant Hamburger* (Fig. 39.6). Other sculptures—also greatly oversized and made of cloth, foam rubber, kapok, plastic, and vinyl—included an icecream cone, frenchfried potatoes, and a piece of chocolate cake—objects that parallel Andy Warhol's bottles of Coca-Cola (Fig. 37.9) and Wayne Thiebaud's paintings of slices of cream pies. There were also washbasins, eggbeaters, and, later, carpetsweepers, toilet seats, electrical plugs, and cigarette butts.

39.6 Claes Oldenburg, *Giant Hamburger*, 1962. Painted sailcloth stuffed with foam, 4ft 4in × 6ft 11⅞in (1.32 × 2.13m). Art Gallery of Ontario, Toronto.

In addition to the wit that Oldenburg infused into these trivia from everyday life, there is a strong surrealist strain in the incongruity between the subject, the grossly distorted scale, and the materials used. Surrealistic, too, is the shock effect they produce.

Oldenburg enlarged his sculptures to colossal proportions in such urban monuments as *Giant Lipstick* (1969, Yale University), *Clothes-pin* (1974, Philadelphia), and the multistory-high *Baseball Bat* (1977, Chicago).

Oldenburg was also involved with Concept Art, in which the concept is a valid thing in itself and as important as a finished piece. Through drawings he envisioned enormous monuments which he knew would never be realized—an ironingboard over New York City, a huge banana for Times Square, a giant windshield wiper for Chicago.

MARISOL ESCOBAR

Pop Art followed as diverse avenues in sculpture as in painting. Marisol Escobar (b. 1930), for example, combines the traditional technique of woodcarving with assemblage of things from real life to create her satirical observations on everyday life, as in *Women and Dog* (Fig. 39.7).

Born in Paris to Venezuelan parents, Marisol attended the Ecole des Beaux-Arts before coming to New York City in 1950, where she studied at Hans Hofmann's school. In the early 1960s, she began making multimedia sculptures that included plaster casts, drawings on blocks of wood, painted details, applied photographs, and found objects. Her portrait subjects include representations of Andy Warhol, John Wayne, and the John F. Kennedy family, as well as numerous parodies, such as the ideal bride and groom. In *Women and Dog* (which has a dog's head that is stuffed), her interests in the simplified forms of folk sculpture and in Pre-Columbian art from South America are apparent.

MINIMALISM

The decade of the 1960s was one of the most protean periods in twentieth-century American art. There were many movements and numerous individual artists whose careers either started or came to fruition then. Sculptors contributed greatly to the exploration of innovative, socially relevant aesthetic concepts, and often certain forms—such as **earthworks**—could be realized in sculpture, whereas they could not in painting.

If Pop Art was one fundamentally new movement, Minimalism was another. Minimal sculpture had its counterparts in architecture—say, in I. M. Pei's East Building of the National Gallery in Washington, D.C. (Fig. 34.3), and in painting in the canvases of Ellsworth Kelly and Kenneth Noland (Figs. 37.4 and 37.5).

In sculpture, the Minimalists reduced form to its most basic shapes, eliminated all evidence of the artist's hand,

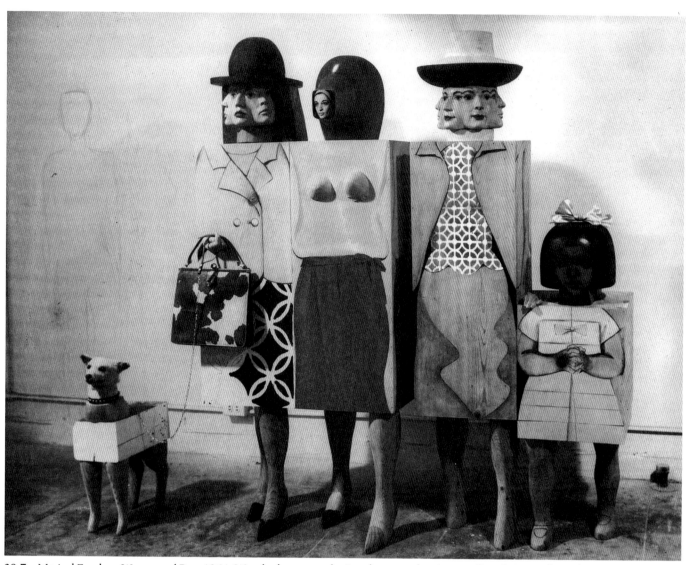

39.7 Marisol Escobar, *Women and Dog*, 1964. Wood, plaster, synthetic polymer, and various media, 6ft 5in × 7ft 7in (1.96 × 2.31m). Collection, Whitney Museum of American Art, New York City.

reduced the number of arbitrary decisions to be made by the artist, eliminated compositional hierarchy, and tried to purge such things as beauty, emotion, and subject matter. What remained was something like Tony Smith's simple, black steel cube called *Die* (1962, National Gallery of Canada, Ottawa) or Donald Judd's stack of identical steel and plexiglass rectangles (Fig. **39.9**). These sculptors sought purified, primary forms that de-emphasized the artist's ego and technical capabilities in order to focus attention on form itself.

TONY SMITH

Tony Smith (1912–80) attended the Art Students League in the mid-1930s, supporting himself by working as a toolmaker. He then studied architecture at the New Bauhaus in Chicago, and for two years he assisted Frank Lloyd Wright

before establishing his own architectural practice in New York City. In 1960 he turned to sculpture. From the beginning Smith was interested in the problem of reductive form and artistic anonymity, features which dominated his *Black Box* of 1962.

Inspired by the simplicity of a small black index-card filebox, Smith telephoned the Industrial Welding Company in Newark, New Jersey, giving the enlarged dimensions over the phone. *Black Box*, his first work in steel, was thus conceived in his mind but executed in a totally impersonal way, with no trace of his hand or ego. Like the 6-foot (1.8-m) square *Die*, *Black Box* represented nothing, but was merely a fact in itself. It was pure form, a primary structure, with no symbolic meaning. Pieces like *Black Box* and *Die* are set directly on the ground or floor, without pedestals.

Smith enlarged the dimensions of his work to monumental proportions and set the form to meandering through

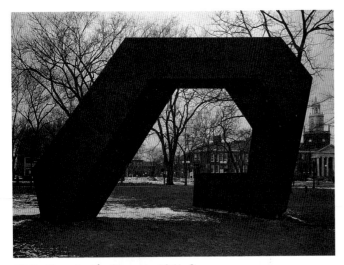

39.8 Tony Smith, *Cigarette*, 1961–8.
Corten steel, 15 × 18 × 26ft (4.57 × 5.49 × 7.93m).
Albright-Knox Art Gallery, Buffalo, New York.

space in *Cigarette* (Fig. **39.8**). The latter—large, somber, ponderous—is captivating by its dominating presence. Indeed, Smith often thought of his creations as "presences," a term he preferred to "sculptures." Other variations in minimal form took the shape of pyramids and other geometric shapes, arranged in groups like rocks in a Japanese garden.

DONALD JUDD

Donald Judd (b. 1928) has been an articulate theorist for, and a consummate designer of, minimalist sculpture. His art has nothing to do with the integration of popular culture, mass media, and art—it is concerned solely with art in its purest form, as a reality complete in itself, without illusionistic representation of, or symbolic references to, anything else.

Judd's goal in the 1960s was to make sculpture that was nothing more than shape, volume, color, light, and material in a rational, ordered arrangement. We see this in Figure **39.9**, a series of identical cubic rectangles stacked vertically with the intervening voids of precisely the same measurements. The piece, like most other works by Judd, is titled *Untitled*. To give it any kind of name would be to give it associations which the artist wished to avoid. Even calling it by a number would give it a place in a sequence, thus establishing historical references to others of his works.

Repetition is often a part of Judd's art, as a way of establishing order in a given locality. All parts are fabricated with precision into hardedged, basic, geometric forms, with no trace of the artist's hand.

SOL LeWITT

A similar order, reduction, and repetition are found in the grid structures of Sol LeWitt (b. 1928). A typical example is

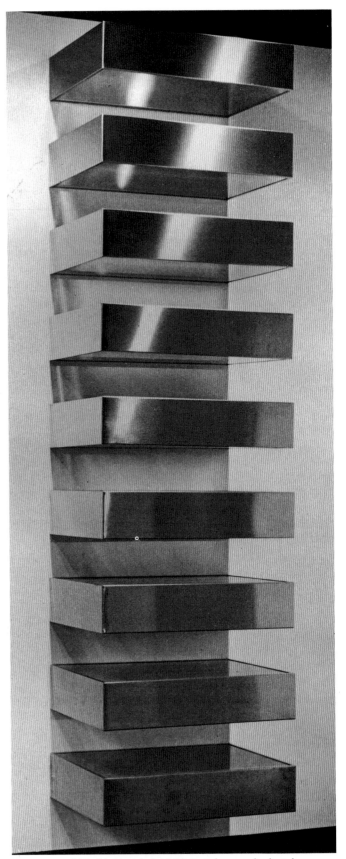

39.9 Donald Judd, *Untitled*, 1967. Stainless steel, plexiglass, each unit 9¹/₁₆ × 40¹/₁₆ × 3¹⁵/₁₆in (23 × 101.8 × 10cm). Modern Art Museum of Fort Worth, Texas.

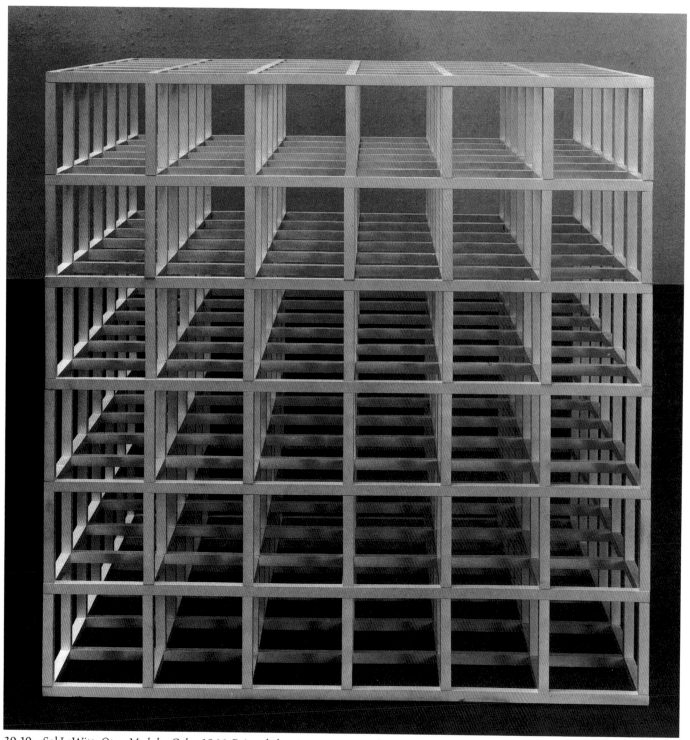

39.10 Sol LeWitt, *Open Modular Cube*, 1966. Painted aluminum, 5 × 5 × 5ft (1.52 × 1.52 × 1.52m). Art Gallery of Ontario, Toronto.

Open Modular Cube, constructed with the hardedged precision of painted aluminum (Fig. 39.10). Such works, often referred to as serial compositions, are a search for purity of form through a construction that approximates a three-dimensional mathematical equation. They are a definition of space by cubic multiples, created by the white rectilinear grid. Minimalists like LeWitt rejected composition of the traditional sort and made their compositions regular and repetitious so the viewer could concentrate on the form.

By the end of the 1960s, however, LeWitt had abandoned constructions of this type, and he began concentrating on the conceptual ramifications of his art, becoming fascinated with drawings that explored the innumerable permutations of his grid.

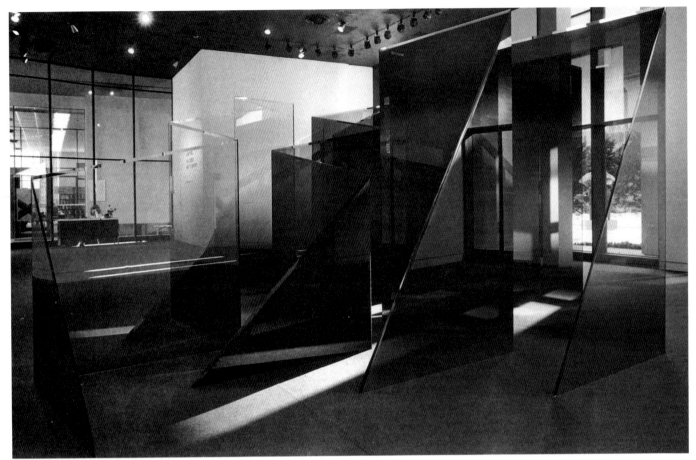

39.11 Larry Bell, *The Iceberg and its Shadow*, 1975. Inconel and silicon dioxide on plate glass, varying heights × 60 × ⅜in (× 152.4 × 1cm). Massachusetts Institute of Technology, Cambridge, Massachusetts.

39.12 Dan Flavin, *Three Sets of Tangented Arcs in Daylight and Cool White (To Jenny and Ira Licht)*, as installed at the National Gallery of Canada, Ottawa, in 1969. Fluorescent lights, room size 9ft 6in × 24ft 8in (2.9 × 7.52m).

LARRY BELL AND DAN FLAVIN

Minimal artists experimented with new materials and media as they sought freedom from the longstanding traditions of sculpture. Larry Bell (b. 1939) began working with panes and sheets of glass, while Dan Flavin took fluorescent light as his medium. Both materials—glass and light—are non-traditional, in the sense that while they may define space, they are not themselves mass.

In *The Iceberg and its Shadow* of 1975, Bell created an environment of translucent planes set at right angles, with a dynamic element introduced in the diagonals, altering the space, but nowhere obscuring it with solid masses (Fig. 39.11). As the glass is reflective, myriad visual impressions—sometimes including the spectator's own image—present themselves. In spite of the title, the work represents nothing but sheets of glass in a space, wrought of hardedged planes cut to precision. In this it is minimalist.

Working in Los Angeles, Bell began by making simple glass cubes in the early 1960s which were supremely reductive. He uses industrial techniques in cutting the glass and applying special coatings such as silicon dioxide to it to achieve the desired effect.

Dan Flavin (b. 1933), too, used readymade, industrially produced materials in the fluorescent tubes and fixtures with which he created his light-sculptures, beginning in the early 1960s. His rows or lines of soft lights arranged about a room changed the space, or even defined certain portions of it, and that made it sculpture. For thousands of years light had been an auxiliary to mass, used by sculptors to clarify form, surface, and detail. Now, Flavin began making sculpture out of light itself, as in *Three Sets of Tangented Arcs in Daylight and Cool White* (Fig. 39.12).

Flavin arranged his strings of lights with great care and precision, usually in gallery rooms that were otherwise unoccupied. That few such arrangements were permanent was a part of a new aesthetic of the 1960s—that art was temporary and not permanent, that it had a brief existence, when it was to be experienced and documented, but then it should give way to other, newer works. In 1964 Marcel Duchamp was one of the first to recognize the potential of Flavin's light sculptures.

CHRYSSA

Others made sculpture from light and glass as well, including Chryssa (b. 1933), an American born in Athens who attended the California School of Fine Arts in San Francisco. In contrast to Flavin's cool and reserved white light, Chryssa took neon lighting as her special medium, utilizing its garish color. She bent it into forms resembling the commercial signs where we normally expect to find neon lights. In fact, for *Gates to Times Square* (Fig. 39.13), her original inspiration came from commercial neon signs, and in this we find a unification of popular culture and art. In pieces such as *Chicago Cityscape*, in painted aluminum and neon, Chryssa

39.13 Chryssa, Fragment for *Gates to Times Square*, 1966. Neon, plexiglass, 43 × 34$\frac{1}{16}$ × 27$\frac{1}{16}$in (109.2 × 86.5 × 68.7cm). Whitney Museum of American Art, New York City.

continues her work into the 1990s, but it has now shed its references to signs.

LUCAS SAMARAS AND OTHERS

In the mid-1960s, Lucas Samaras (b. 1936) made room environments in which all of the walls, the ceiling, and the floor were lined with mirrors, creating a kaleidoscope of fragmented reflections of the viewer as he or she walked through the room. One of these brilliant, glittering

environments—*Corridor* of 1967—is owned by the Los Angeles Museum of Art. Samaras, who was born in Greece but came to America at age twelve, studied under Allan Kaprow, a leader in the "happenings" of the 1960s. Samaras experimented with sculptural creations that were charged with psychological undercurrents, as in a small box to which he applied knives, razor blades, and thousands of pins pointing outward.

Meanwhile, Carl André (b. 1935) declared an end to art produced in the studio, and he proceeded to make art by laying strips of bricks in a line on the floor of an otherwise empty gallery.

Robert Morris (b. 1931) created Dada-Surrealist pieces such as *Box with the Sound of its own Making*, in which the noises of sawing and hammering during construction were recorded and then replayed as an integral part of the finished work. Morris also explored the environment mode, as well as Process Art and Concept Art, and, through dance and photography, Body Art.

By the early 1970s, Robert Irwin (b. 1928), who had earlier made sculptures with light, plexiglass, aluminum, and other materials, had decided that the actual making of the work of art was unnecessary—that the idea or concept was the important, really creative experience.

SITE SCULPTURES AND EARTHWORKS

Because some sculptors felt the size of the studio or gallery limited the scale of their work, they moved outdoors. Some moved to urban plazas, others to areas of the vast, remote American landscape—to deserts, lakes, and mountains. The leading figures were Richard Serra, Robert Smithson, Walter de Maria, and Christo. When working in their studios they tended to content themselves with Process Art or Concept Art, occasionally producing an actual sculpture that could be shown in a gallery. The fulfillment of their art, however, normally came outside in works that were integrated, in both form and scale, with the landscape itself.

RICHARD SERRA

Richard Serra (b. 1939), who was born and raised in California, received a master's degree in fine arts at Yale University in 1964, before establishing his studio in New York City just at the time Minimalism was beginning to emerge. Although at first influenced by that movement, his art often rebels at its precision and permanence.

Serra has been one of the primary figures in Process Art, which is less rational, less craftsmanlike, even less visually attractive than Minimalist art. In Process Art, emphasis is placed on procedure. Chance relationship and indeterminacy of parts are accepted, and mutability is taken for granted as a parallel to the transitory aspects of life itself. Art becomes a temporary happening in which disorder and chaos are accepted because they exist also in real life.

In Process Art, an odd assortment of objects may be scattered about on the floor, and experienced thus until they are gathered up to make room for something else. Then, that specific work of art is no more. Even if the same pieces are again scattered around on the same floor at a later time, the result is a different work, which is equally mutable. Serra has done this with long strips of felt, which each time fall randomly into different patterns, chance being a primary determinant.

Moving outside the studio and gallery, Serra has worked with large steel plates—industrial products of no aesthetic uniqueness—erecting walls which divide or somehow alter the urbanscape or landscape. *Tilted Arc*, composed of several pieces of Corten steel embedded in the Federal Plaza in New York City, was 12 feet (3.7 m) high by 120 feet (36.6 m) long and bisected the plaza's space (Fig. **39.14**). But people who used the area found it so offensive that their complaints caused it to be removed—in their own way enforcing the mutability theory. Serra intends that his work should be intrusive in this sense, but also that it should be

39.14 Richard Serra, *Tilted Arc* (dismantled), Federal Plaza, New York City, 1981. Corten steel, 12 × 120ft (3.66 × 36.58m).

compatible with the environment. The latter—the "site"—is taken into account during the conceptual planning stages and throughout the execution process on the location.

ROBERT SMITHSON

Robert Smithson's site sculptures are of a different sort. In place of great planes of industrial steel—so obviously a manmade product—he sculpted with natural components such as rocks and earth. As a boy, Smithson (1938–73) had preferred New York City's Museum of Natural History to the Metropolitan Museum of Art. He collected shells, rocks, and insects, and he loved family vacations at the Grand Canyon and the Mojave Desert. Later, Smithson studied painting at the Art Students League, but he found greater stimulation in his friendships with the literary and intellectual leaders of the Beat Generation, for example, Jack Kerouac and Allen Ginsberg, and he read Freud and Jung. Smithson's fascination with primal sources eventually appeared in his art.

Smithson did not begin making sculptures until about 1965, only eight years before his death. The idea of withdrawing art from the realm of the precious and from the sanctuary of the museum may first have come to him when he was asked to be a consultant for the Dallas-Fort Worth Airport, then in the planning stage. He proposed moundlike forms—of colossal scale, like the primitive burial mounds in Ohio—around the periphery, which could only be seen to advantage from the air. Although his proposal was rejected, one can see in it the concept of his earthworks, which date from only a few years later.

At Kent State University in Ohio in 1970 Smithson created *Partially Buried Woodshed*, in which he dumped load after load of earth on an old shed until it buckled from the weight, creating a ruin mingled with earth such as he had admired in Rome and the Mexican jungle. The tools of the sculptor now were no longer the mallet and chisel, but rather the bulldozer and the wheelbarrow.

His love of the open vastness and natural beauty of the American West took Smithson to Utah's Great Salt Lake in 1970 to create his most famous earthwork. *Spiral Jetty* was a geometric spiral that extended into the lake in ramplike form. It was constructed of a boulder foundation, with a dirt road on top that ran for 1500 feet (457 m) in total length (Fig. **39.15**). Smithson saw in this construction affinities with primeval geological forces and ancient mythologies.

39.15 Robert Smithson, *Spiral Jetty*, 1969–70. Black rock, earth, length 1500ft by width 15ft (457.2 × 4.57m). Great Salt Lake, Utah.

Although the natural materials allowed it to blend with the surrounding landscape, the geometry of its perfect spiral betrays the hand of a human creator. The sculptor probably would not be disturbed by the fact that the lake has since risen and *Spiral Jetty* is no longer visible. Such is the mutability of the new art.

Several other sculptors, including Smithson's widow, Nancy Holt, turned to the earth as the medium of their art. Michael Heizer (b. 1944) has worked in the vast expanses of Nevada, cutting voids into the desert floor. Another artist who has used the American landscape is the British sculptor Richard Long (b. 1945), who has extended Smithson's concept of earthworks within the gallery into the 1990s by arranging assortments of rocks in regularized compositions upon the gallery floor. Walter de Maria (b. 1935) filled a New York City gallery with dirt in order to bring Earth Art indoors and to an urban audience. His most important work, however, is *The Lightning Field*, a grid of 400 stainless steel poles, each about 20 feet (6 m) high, spread out across the desert in a remote area near Quemado, New Mexico (Fig. 39.16). Here, again, the human hand creates on a vast scale in keeping with the expansiveness of the landscape, and even achieves an easy unity with it. There is a harmony, too, with the elemental force of lightning which flashes about the rim of the scene, occasionally making contact with one pole or another. Throughout the deserts of the American Southwest, thousands of giant saguaro cactuses stand tall and linear against the sky. De Maria's metallic poles are but paraphrases of those natural forms. But in the poles themselves and the precise geometric regularity of their placement, the creation of the sculptor remains distinct from its natural environment.

39.16 Walter de Maria, *The Lightning Field*, 1971–7. Near Quemado, New Mexico. 400 stainless steel poles, average height 20ft 7in (6.27m).

39.17 Christo, *Running Fence, Sonoma and Marin Counties, California*, 1972–6. 24-mile (39-km) fence erected in northern California. Photo, Wolfgang Volz. © Christo 1993.

CHRISTO

Yet another form of Earth Art is found in the work of Christo (b. 1935), a Bulgarian who came to the United States in 1964. From his earliest efforts, Christo was committed to certain principles of Surrealism, most importantly the use of readymades and found objects, which he transformed and gave new meaning as works of art.

The means of transformation for Christo was packaging—wrapping anything from bottles to bicycles in plastic, paper, cord, and so on. By the late 1960s, Christo was wrapping constructed storefronts within a gallery, creating eerie surrealistic cityscapes like something out of a De Chirico painting. The next logical step was to wrap actual buildings, and in 1968 he proposed, unsuccessfully, to wrap The Museum of Modern Art. Undaunted, Christo went on to wrap a mile-long (1.6-km) section of the coast of Australia, strung a gigantic orange curtain across a broad valley at Rifle Gap, Colorado, and surrounded eleven small islands in Miami's Biscayne Bay with floating pink plastic, at a cost of three-and-a-half million dollars. Perhaps his bestknown

effort is *Running Fence*, an 18-foot (5.5-m) high white nylon band that ran for over 24 miles (39 km) across a portion of northern California, before terminating in the Pacific Ocean (Fig. 39.17). Marcel Duchamp would have loved the incongruity, selfassertivenes, and audacity of it.

THE FEMINIST ART MOVEMENT

Beginning about 1970, a new sensibility arose which addressed the interests, concerns, and opportunities of women in art. It was felt that since time immemorial art had been dominated by men while women's efforts were often confined to crafts such as weaving and quilting. Furthermore, critics and art historians tended to be men. But now women—as art critics and in other fields—began declaring that men did not always take up the issues that were of greatest importance to women, and that while the woman's experience may be less dramatic or heroic it is nevertheless

of great importance. Women were too often closed out of the mainstream of art by male-dominated politics, for gallery owners, curators, and those who generally made the decisions about whose work was to be shown were mostly male. Women vociferously demanded an art that might employ shock effect to make its statement, that reflected their experiences, accomplishments, creative equality, and concerns. Demanded, too, were more channels for women's art to be shown, more critical response to it, and more recognition of its validity.

LOUISE BOURGEOIS

The sculptor Louise Bourgeois (b. 1911) was one of the earliest to call attention to the plight of the woman artist, well before the modern American feminist movement.

Born in Paris, Bourgeois studied at the Sorbonne and the Ecole du Louvre before coming to the United States in 1938. In New York City, she worked briefly with Marcel Duchamp. Her sculpture in the 1940s was abstractionist and constructivist in technique. A feminist perspective, however, was already asserting itself in drawings like *Femme Maison*—not to be translated as "woman of the house," but rather "housewoman" (Fig. 39.18).

In this powerful image, the woman has lost her identity and personality, overwhelmed by being confined to the house and its care, while professional and intellectual challenges are unavailable to her. The lower portion of the figure makes reference to her role as a sex-object. Only two years separate the date of this drawing and the publication in 1949 of Simone de Beauvoir's *The Second Sex*, which encouraged women to seek their own identities and destinies.

JUDY CHICAGO

The women's movement of the 1970s first arose against the condition of not having a choice beyond homemaking. One of the leading figures to use art to express feminist sentiments was Judy Chicago (b. 1939) who highlighted this theme in her art. After several false starts in her art in which she sought male acceptance and approval, Chicago assumed, in the late 1960s, a militant feminist perspective. While teaching at the University of California at Fresno, she began the first women's art program, and then, moving to Los Angeles, she became a co-founder, along with Miriam Schapiro, of "Womanhouse," a derelict house that was renovated by women. Each room became a shrine to some portion of a woman's experience, with themes that ranged from a child's dollhouse to menstruation.

One of Judy Chicago's most important projects was a large piece called *The Dinner Party* of 1973–9, which celebrates the accomplishments of famous women from early history to the present—an ancient goddess, the Greek poet Sappho, the English Queen Eleanor of Aquitaine, the American dancer Isadora Duncan, the movie-actress Katharine Hepburn, and so on (Fig. **39.19**). Altogether, 999

39.18 Louise Bourgeois, *Femme Maison*, 1947. Ink on paper, 9⅛ × 3⅝in (23.3 × 9.19cm). Courtesy Robert Miller Gallery, New York City.

39.19 Judy Chicago, *The Dinner Party*, 1973–9. Mixed media, 48 × 48 × 48ft (14.63 × 14.63 × 14.63m).

women are honored by the inscription of their names. The piece is a table, triangular in shape, each side 48 feet (14.6 m) long. There are thirty-nine place settings, each of which visualizes some aspect of women's experience, and which call attention to women's contributions throughout history. The sexual element is sometimes strongly expressed through images suggestive of vaginal forms. This feminist icon is a mixedmedia production which utilizes traditional women's crafts, such as handwoven placemats.

Chicago thus expresses her conviction that women's art, especially when it takes the form of handicrafts, had been kept at the periphery of the "real" art world through male domination. This process is countered here in a work that refuses to be marginalized, denied, or ignored. The *Dinner Party* was followed by other largescale works—*Birth Project* (1985) and *Holocaust Project* (1988).

NANCY GRAVES

Not all women sculptors made works that were derived from women's themes. In the 1950s and 1960s, sculpture became an artform open to women to an extent that it never had been before. Nancy Graves (b. 1940) has been one of the most innovative creators in three-dimensional media. After studying at Vassar College and at Yale University, she established her studio in New York City. There she gained critical attention in 1969 with her lifesize and lifelike *Camels*, constructed of bones, hides, and a wooden armature.

Graves explored numerous other avenues in the 1970s, although nature and the human environment remained at the core of her art. In the 1980s she developed a form of sculpture, made of found objects that are cast or welded together and then brightly polychromed, that extends

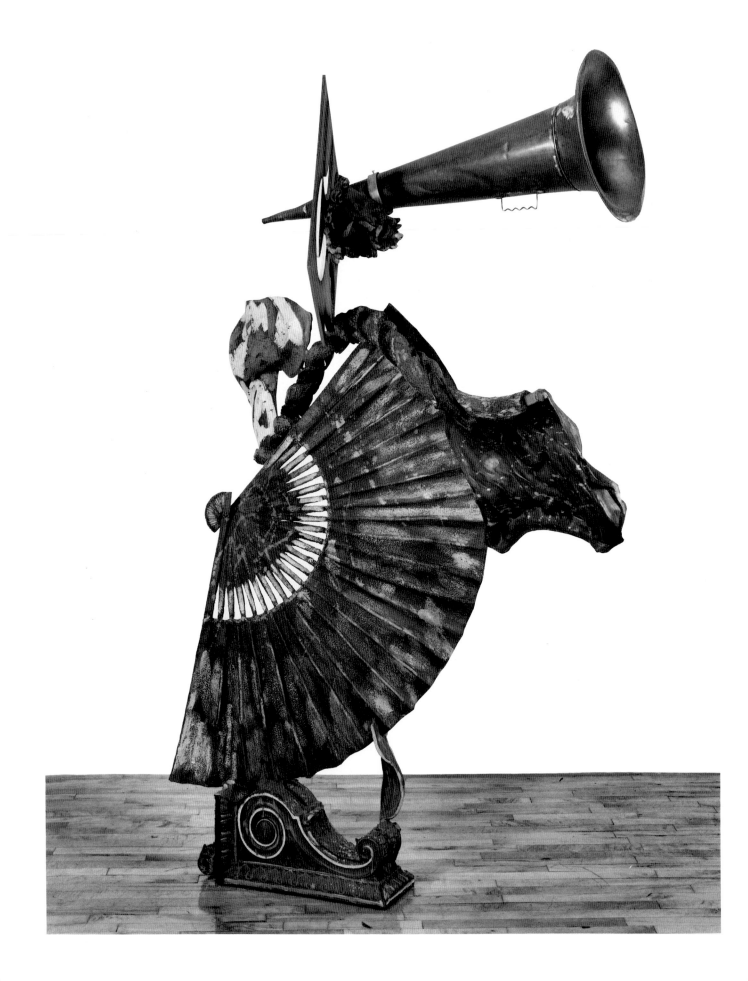

39.21 Judy Pfaff, *NYC/BOE*, 1987. Installation: painted steel. Holly Solomon Gallery, New York City.

Surrealism into the final decade of the century. *Synonymous with Ceremony* is just such a piece (Fig. **39.20**).

Graves searches out a wide assortment of found objects which are arrayed on the floor and then selected to be worked into a freestanding sculpture on a random, trial-and-error basis. Working without premeditation, without preconceived notions of the "meaning" that her totemlike image will convey, she further identifies her art with surrealist theory.

There is, however, also a strong element of historicism, a factor often associated with postmodern art. In *Synonymous with Ceremony*, an oldtimey phonograph horn seems to speak from atop an equally oldfashioned crenelated fan, while the "foot" of the piece is taken from an architectural bracket. If an object be fragile—the paper fan, for example—it is cast in bronze and made a sturdy counterpart to the other objects. Then the whole is painted in brilliant colors that cover the full range of the spectrum, and sometimes especially remarkable coloristic effects are achieved by baking enamel colors on to the piece.

39.20 (opposite) Nancy Graves, *Synonymous with Ceremony*, 1989. Mixed media, 81 × 53 × 31in (205.7 × 134.6 × 78.7cm). Private collection.

JUDY PFAFF

Judy Pfaff (b. 1946) similarly makes assemblages out of found objects and industrial products. In the early 1980s, these were freeform environments that were uniquely created in specific roomspaces for temporary display and so defied permanence. The viewer was invited to walk into their inner spaces and commingle with the parts. There is a sense of free play in their creation, as seen in *NYC/BOE*, a painted steel construction (Fig. **39.21**). A riot of bright colors prevails throughout, in a brilliant entanglement of cavorting linear rhythms which flaunts any attempt to impose upon it the rules of order of modern art.

AFRICAN-AMERICANS AND THE FOUND-OBJECT IMAGE

JAMES HAMPTON

In one major work, to which he devoted the last fourteen years of his life, James Hampton (1909–64) represents the naïve genius of folk art asserting itself in the middle of the twentieth century. Born in Elloree, South Carolina, the son

39.22 James Hampton, *The Throne of the Third Heaven of the Nation's Millennium General Assembly*, c. 1950–64. Gold and silver tinfoil, Kraft paper, plastic over furniture, and paperboard, 177 pieces, overall 10ft 6in × 27ft × 14ft 6in (3.2 × 8.23 × 4.42m). National Museum of American Art, Smithsonian Institution, Washington, D.C.

of a Baptist minister, Hampton moved to Washington, D.C., where he became a night custodian at the General Services Building.

Hampton possessed deep religious convictions and in fact had mystical experiences, possibly induced by reading his favorite text, the *Book of Revelation*. Through conversations with God, he became convinced of a Second Coming of Christ—the motivating force behind his creation of the *Throne of the Third Heaven of the Nation's Millennium General Assembly* (Fig. **39.22**).

It was to be the throne upon which Christ would sit, surrounded by altars, pulpits, and symbols of the Old and New Testaments. Discarded furniture was wrapped in silver and gold foil, and found objects such as lightbulbs and cola bottles were worked into the design. One inscription reads "Fear not," while another reveals the visionary experience: "Where there is no vision, the people perish." Individual parts are remarkable, but it is the orchestration of the whole that is most impressive, for the several pieces are superbly ordered and relate to each other exquisitely. In its presence, we feel as if we are confronting a magnificent throne room from some ancient civilization, from some other world.

Many other African-Americans worked intuitively in a folk-art tradition that extends to the present day, using mainly discarded objects which they find in the streets, alleys, or trashbins. David Butler (b. 1898), for example, filled his whole lawn in Patterson, Louisiana, with whirligigs and wonderfully gaudy images of flowers, animals, birds, and just abstract shapes. Derek Butler (b. 1934) did much the same thing in Chicago. Similarly, Mr. Imagination (b. 1948), also of Chicago, creates images from found objects, images that call up visions of past civilizations, particularly ancient Egypt. He claims imagination is something everybody uses every day, and in that it has much in common with the ordinary everyday objects, rescued from the trashheap, with which Mr. Imagination makes his sculptures.

THE RETURN OF REALISM

If many American sculptors since 1960 have sought to rid their art of any illusionistic representation of the natural world, if some have turned to total nonobjectivity and to working with blowtorches and bulldozers, others have found their strength and stimulation in the tradition of naturalism that began in the seventeenth century. This tradition is alive and well, and will probably thrive, no matter how unpopular it might be among the avant garde, simply because it continues to produce good art that is appreciated by a vast number, perhaps even a majority, of Americans.

DUANE HANSON

The sculpture of Duane Hanson (b. 1925) is a counterpart to Richard Estes's pictures of consumer goods in a store window (Fig. 37.17). Hanson's *Supermarket Shopper* of 1970 is also related to Pop Art through the incorporation of actual consumer objects that fill a real shopping cart to overflowing (Fig. 39.23). Frozen TV dinners, Coca-Cola, canned goods, chocolate chip cookies, dogfood, teabags, aluminum foil, and toilet tissue suggest a modernday cornucopia of convenience foods and household items. All add greatly to the realism of the piece because they are real

39.23 Duane Hanson, *Supermarket Shopper*, 1970. Polyester resin figure and various media, lifesize. Ludwig Collection, Aachen, Germany.

things. The woman, overweight from overconsumption, wears real clothes and has real curlers in her hair. The realism gives the piece its vitality—but it takes the artist's eye to identify and isolate a vignette of contemporary life such as we see here. There is often in Hanson's work a subtle commentary on American life that brings a smile to one's face, but also gives one something to ponder.

Hanson's first step in making one of his sculptures was to spot an archetypal example of some aspect of American life. Usually he did not use professional models, but turned instead to friends or people he encountered on the streets, in stores, or at parties.

In order to achieve the realism he desired, Hanson had to develop special techniques. For his figures he made body-molds, from which casts were made in fiberglass reinforced with polyester resin, a method and a material which allowed him to capture and reproduce every wrinkle, mole, and bulge of the model. His casts are handtinted to flesh-color, then wigs are set in place, and hair on arms and legs meticulously inserted. He might actually buy the model's own clothing if it seems to be the perfect example he is looking for, and then dress his statue in it.

Hanson's range of subjects and themes is wide and varied, beginning with early pieces that depict the violence of the Vietnam War or street-gangs. These mellowed, about 1970, to detached observations of American life—a group of outrageously clad tourists, no doubt visiting Miami for the first time; a construction worker wearing his hardhat, sitting, holding a can of beer; an elderly woman who sits and waits. There is an uncanniness in the realism of these pieces. Here, indeed, is what has been aptly termed "verist sculpture."

THE TRADITION CONTINUES

The naturalistic tradition, in the manner of Andrew Wyeth and in the line of academic sculpture, survives, even thrives, although it is not so much noticed amid the din of more radical art. This tradition survives from the days of great Beaux-Arts projects at the end of the nineteenth century, and its practitioners, who gather around the National Sculpture Society in New York City, see themselves as continuing the principles and craftsmanship of sculptors such as Augustus Saint-Gaudens (1848–1907) and Daniel Chester French (1850–1931).

As representative of this tradition, we cite the work of Charles Parks (b. 1922), who served for several years as president of the National Sculpture Society. His art is based on the form, surface, and naturalism of sculptors like John Quincy Adams Ward (1830–1910), whose work he does in fact admire. Parks's charming bronze portrait of little Margaret Babbott (Fig. 39.24) has even earlier antecedents, for it reminds one of the vital naturalism found in fifteenth-century Renaissance portraits—in works of Luca della Robbia or Desiderio da Settignano, for example. Naturalism of this sort seems to have an indigenous strength within the tradition of American art which will not wither, even when

39.24 Charles Parks, *Margaret Babbott*, 1964. Bronze, lifesize. Collection of Mr. and Mrs. Edward Babbott, Summit, New Jersey.

neglected by critics and curators.

If there be any doubt regarding the deeprootedness of that naturalistic tradition, consider the matter of the National Vietnam War Memorial, located at the western end of the Mall in Washington, D.C., near the Lincoln Memorial.

The original design, by Maya Lin (b. 1960), an under-

graduate architecture student at Yale, called for two walls of polished black granite that met in a "V," each wall 246 feet (75 m) long. On the wall were inscribed the names of the 57,692 Americans who were killed in Vietnam between 1959 and 1973 (Fig. **39.25**). Lin's design, Minimalist in its simplicity, is dignified and eloquent, one of the most

39.25 Maya Lin, Vietnam War Memorial, The Mall, Washington, D.C., 1981–4. Black polished granite wall. Two wings, length of each 246ft (75m). Peter Aaron/Esto.

exquisite structures erected in official Washington since the Washington Memorial. It focuses quietly on the sense of loss the nation rightly feels for those who died in that distant land, totally avoiding the turbulent questions regarding the righteousness of American action there and the moral issues that war now raises.

Although Lin's design was selected and approved by the American Institute of Architects, the Fine Arts Commission, and the Department of the Interior, a great outrage arose against the design, led mainly by Vietnam veterans who found it too abstract to convey the emotions they still carried, too lacking in patriotism, with no reference to the heroism that American men and women had shown there. What the veterans and many other Americans wanted was not a symbolic abstraction, but a realistic image of heroism and patriotism, comparable to the statue of U.S. Marines

raising the American flag on Iwo Jima (see p. 622). This was just across the Potomac River in Arlington National Cemetery and commemorated one of the heroic triumphs of World War II. So great was the pressure they brought to bear that the committee in charge gave in, agreeing to add a lifesize bronze group of three heavily armed, battle-tried and toughened soldiers—two white, one black—in a super-realistic style. This group, by Frederick Hart, was placed in a grove to one side of the two inscribed walls.

In terms of aesthetics, it is a reminder that while America has come far since World War II insofar as abstraction in art is concerned, there are many for whom naturalism is the more meaningful form of expression. There is no reason to assume that America must have only one official mode of artistic expression, that we must choose between abstraction and naturalism—there is clearly a place for each.

PHOTOGRAPHY:

1940 TO THE PRESENT

In the decades since World War II, America has become increasingly aware that there are large groups of its citizens who have been disenfranchised from the American Dream. These are men, women, and children who are "outsiders" insofar as the mainstream of American society is concerned. Many postwar photographers have been drawn to these "outsiders" as their subjects, although others have continued the tradition of formal experimentation with their medium. The illustrations reproduced in this chapter contain several themes from a long list of causes: The urban poor, the elderly, Hispanic and black minorities, the disabled, the homeless, homosexuals, the mentally handicapped; and issues such as medical care, AIDS, crime in the streets, and equality of law-enforcement.

In the past, the federal government responded to the escalating national awareness of these social problems in a number of ways. In 1953 the Department of Health, Education, and Welfare was created. Significantly, its first secretary was a woman, Oveta Culp Hobby. The Department of Housing and Urban Development followed in 1965, with Robert C. Weaver as secretary. He was the first African-American to hold a cabinet-level appointment. President Johnson signed an anti-poverty bill in 1964 creating the Economic Opportunity Act, intended to help the poor through job training, a Youth Corps, and assistance to chronically impoverished rural areas like Appalachia. The Medicare program came in the following year, under which the umbrella of social security broadened to cover more Americans.

The burning social issues of the day were often called to the nation's attention through literature. Such literary themes were often the subjects that attracted photographers. The plight of the mentally ill, for instance, was stressed in bestsellers such as Mary Jane Ward's *The Snake Pit* (1946) and Ken Kesey's *One Flew over the Cuckoo's Nest* (1962). Several plays by Tennessee Williams explored the themes of loneliness and isolation among the psychologically disturbed, as in *The Glass Menagerie* (1944), *A Streetcar Named Desire* (1947), and *Cat on a Hot Tin Roof* (1955). Arthur Miller's Pulitzer-Prize-winning play of 1949, *Death of a Salesman*, called attention to the inhumane treatment of pathetic Willy Loman, who at age sixty-three is dumped as

useless on a social trashheap by a company which he has served many years.

The ostracization of ethnic minorities was brought to national attention through the example of Mexican-American farm laborers. By 1965 Cesar Chavez had organized his people into the National Farm Workers' Union, and after a long strike that organization gained recognition as the workers' bargaining representative.

The nation became aware, too, of life in the Barrio, the Mexican-American section of east Los Angeles. Two million Chicanos live in the Barrio, many of them employed as agricultural laborers in the fertile valleys nearby. In the 1970s, the old Barrio—part of which was a slum ghetto—was broken up to make way for a baseball stadium and the expansion of the freeway. Organizing to oppose displacement contributed to the rise of an ethnic movement, and the Chicano community began to promote pride in its traditions and to call attention to double standards in the judicial and law-enforcement systems.

In the Barrio, in Watts, in south central Los Angeles, there are gang problems, drive-by random shootings, stolen-car chases, drug buys, all seen against the screaming sirens and flashing red lights of police cars, and graffiti that rage with hate. Five hundred street-gangs in Los Angeles have some 80,000 teenage members, and there are about 450 gang-related murders annually. On the one hand, the "I Have a Dream Foundation" tries to identify bright children in the city's ghettos who will be sent to college if they agree to finish high school. On the other, the U.S. Army has been sending its doctors to the Martin Luther King, Jr., General Hospital for training, because there they can get experience treating gunshot wounds that would normally be found only on the battlefield.

In 1965 the Los Angeles County Museum of Art opened its new building on Wilshire Boulevard, the largest structure devoted to art west of the Mississippi. That was also the year of the Watts riot, which started on the evening of 11 August when a white patrolman arrested a young black man for speeding. A crowd gathered around, more police arrived, and it seemed to some of the crowd that excessive force was used in subduing the youth. Five days and nights of looting and burning followed, and when it was over thirty-five

people had been killed, hundreds wounded or injured, and dozens of square blocks of Watts totally devastated. A detailed account of it may be read in *Burn, Baby, Burn* (1966) by Jerry Cohen and William S. Murphy. The West Side of Chicago was similarly hit by riots in July of 1966 when police turned off the water of fire hydrants that had been opened in the black section so that children could cool themselves. The "long, hot summer" of 1967 saw riots in over one hundred cities in the United States. Detroit and Newark, New Jersey, were among the hardest hit. These were reactions rising out of frustrations among people who found themselves to be "outsiders" insofar as participation in the American Dream was concerned. Photographers were there to record the events, and their pictures often pricked the national conscience to the point of admitting that social inequities existed.

At the other pole of the social order were those who rebelled against the middleclass economic and moral system in which they had been raised. They saw life as an absurdity without either purpose or any guiding, protecting, caring deity. These were the Existentialists. Rejecting virtually all else, they believed that the only purpose in life was to exist and somehow to cope with its absurdities. They read the works of the French Existentialists Albert Camus—such as *The Myth of Sisyphus* (1942) and *Caligula* (1948)—and Jean-Paul Sartre, especially *Being and Nothingness* (1943). American theater-goers were exposed to the "theater of the absurd," with Samuel Beckett's *Waiting for Godot* (1952) and Eugene Ionesco's play *Rhinoceros* (1960), both of which dealt with irrationality in a real world.

Following World War II, there were those who felt themselves to be members of a "lost generation" similar to the one Gertrude Stein and Ernest Hemingway had identified after World War I (see p. 393). This time, however, they called themselves the Beat Generation, which meant "hip," libertine, in rebellion against most current social mores concerning sex, homosexuality, drugs, and so on. In their poems, songs, novels, even in their photography, there was often the cry of the lost wanderer, who constantly, but with futility, sought fulfillment on some other horizon.

This counterculture found its leaders in the mid-1950s in artists such as Jack Kerouac and Allen Ginsberg. Some claim the movement was launched in San Francisco on 13 October 1955, when a group met at the Six Gallery for a poetry reading. The piece that caused the greatest sensation was Ginsberg's *Howl*, a sexually explicit poem that defined the Beat Generation's attitude toward free love and homosexuality and its anti-establishment spirit. Jack Kerouac was present at that poetry reading; his novel *On the Road* (1957) tells of four aimless crisscrossings of the country in stolen cars, defying the establishment at every opportunity, listening to jazz, drinking heavily, constantly indulging in casual sex, smoking marijuana, with no goals, no ambition—only to find that that life is exceedingly empty and each trip ends in disappointment and disillusion.

American Existentialism was an attempt to escape reality and responsibility through indulgence in pleasure. It failed because it was essentially nihilistic and did not provide any acceptable spiritual foundation. Nevertheless, from about 1955 to 1965 it seemed to some to offer an alternative to a society from which members of the Beat Generation had exiled themselves. As outsiders, they contemptuously vented their wrath upon Middle America. After about a decade, however, they faded from the scene, and Middle America endured. Some of them, in fact, shaved off their beards, put on dark three-piece suits, and rejoined the affluent American establishment whence they came.

PHOTOJOURNALISM

By 1940 photographers in America were heirs to a special bequest from photographers of the preceding generation: A confidence in the power and artistry of their medium. Their task was to continue several wellestablished traditions and to expand the potential of the photographic image.

Some would take up documentary photography where Dorothea Lange and Walker Evans (see pp. 476 and 478)

40.1 Joe Rosenthal, *Marines Raising the American Flag on Iwo Jima*, 1945. Photograph. Library of Congress.

had left off. Now, however, they called themselves "photojournalists," and worked for popular magazines such as *LIFE* and *Look*, reporting pictorially events from around the world. Others, turning their talents to the pure artistry of their medium, created fascinating parallels to the Surrealist and Abstract Expressionist movements in painting. Still others turned their lenses on the people and institutions of America, exposing the nation to an awesome scrutiny of its moral conscience. Many others preferred to seek instead the pristine, mystical beauty of nature, from the expansiveness of the Grand Canyon to the veining on a leaf.

LIFE magazine, founded in 1936, was the foremost popular outlet for photojournalism during the years of World War II and the quarter-century that followed. One of the most memorable still photographs to come from the war was that of six U.S. Marines raising the American flag atop Mount Suribachi after a hardfought victory on Iwo Jima (Fig. 40.1). Taken in February 1945 by Joe Rosenthal of the Associated Press, this memorable image won a Pulitzer Prize (1945) and was later the model for a huge bronze commemorative statue erected in Arlington National Cemetery, Washington, D.C.

This photograph is an example of on-the-spot reportage—filled with natural drama, reporting an event of consequence, and compositionally perfect, although apparently unstaged. But while there were many photographers from the news agencies and in the military service who documented the devastation, victory, or defeat of World War II, none established higher reputations than W. Eugene Smith and Margaret Bourke-White.

W. EUGENE SMITH

W. Eugene Smith (1918–78) became interested in photography while he was in highschool in Wichita, Kansas, and entered the University of Notre Dame on a photography scholarship. Leaving school to go to New York City, he became a staff photographer for *Newsweek*, resigned to do freelance work, and in 1939 joined the staff of *LIFE*. He quit two years later after refusing to use the large and unwieldy press camera—he preferred the smaller 35mm one that gave him the maneuverability he felt was essential to the kind of picture he sought.

Smith covered the closing years of the war in the Pacific for *LIFE* and remained on its staff in the years that followed peace, producing several excellent photographic essays in the late 1940s and early 1950s. Most notable among these were "Country Doctor" (20 September 1948), "Spanish Village" (9 April 1951), and "Nurse Midwife" (3 December 1951).

For the "Country Doctor" series, Smith visited Kremmling, Colorado, and made the rounds with, and attended the office calls of, a rural doctor. His technique was to become a constant witness to the physician's activities, but

40.2 W. Eugene Smith, from "Country Doctor" essay, for *LIFE*, 20 September 1948. Photograph.

personally to "fade into the wallpaper" in order to capture the events as they happened naturally. This approach to photojournalism—at that time innovative—allowed him to catch the moving, real-life dramas of the doctor's office like the one seen in Figure **40.2**, where an unconscious little girl with a serious head injury has just been brought in. While the doctor and nurses work intensely over her (unseen to the viewer in this shot) the father holds and tries to console the frantic mother. The natural drama in the two figures at the left and the dynamic tension that is set up between them and the infant on the table make this photojournalism of the highest order. The immediacy and spontaneity of such photography established new aesthetic and expressive criteria for the photographer. These qualities were continued in Smith's other peacetime essays.

Smith left *LIFE* again in 1954 in order to be free to choose his own themes for photojournalistic essays. Perhaps the best of these was the one on Pittsburgh, taken in 1955–6, which appeared in *Photography Annual* for 1959. By then he was, along with Bourke-White, recognized as the best of the photojournalists.

MARGARET BOURKE-WHITE

Margaret Bourke-White (1904–71) began her professional career as a photographer for *Fortune* magazine in 1929 and also worked freelance for advertising agencies in New York City in the early 1930s. From 1939 to 1942 she was married to the author Erskine Caldwell, with whom she collaborated on three books, the bestknown of which is *You Have Seen Their Faces* (1937), which ranks with Archibald MacLeish's *Land of the Free* (1938), Dorothea Lange's *An American Exodus* (1939), and Walker Evans and James Agee's *Let Us Now Praise Famous Men* (1941) as a documentary on poverty among America's "outsiders." She joined the staff of *LIFE* in 1936, but during the war she served as an official U.S. Air Force photographer in England, North Africa, Italy, and Germany. After World War II, Bourke-White again became a staff photographer for *LIFE* and remained with the magazine until her retirement in 1957.

Bourke-White's perceptive eye enabled her to strike deep to the heart of fact. In December 1949, she departed on an assignment from *LIFE* to make a photographic essay on South Africa. Her series was among the earliest warnings to the world of the civil strife that would come to that nation if black people continued to be denied the social and economic privileges that whites enjoyed. She made powerful, beautiful images which speak eloquently on such subjects, as in *Gold Miners*, a photo of two young black men taken deep in a mine, the flash of her camera reflecting brilliantly off the sweat of their faces and bodies (Fig. **40.3**). For all the injustice of the exploitation of their labor, she could still perceive the stalwart pride and natural dignity these men possessed, even under the most humbling of circumstances. This photograph is prophetic of the phrase that became popular more than a decade later: "Black is Beautiful."

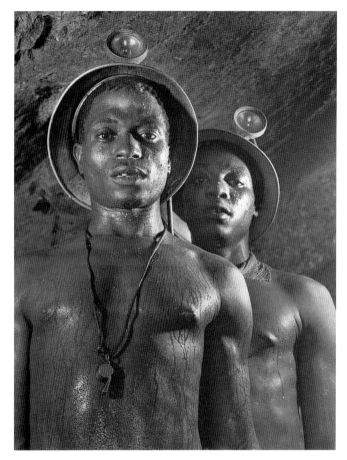

40.3 Margaret Bourke-White, *Gold Miners, South Africa*, 1950. Photograph.

In 1952 Bourke-White covered the Korean War for *LIFE*, but the next year the first symptoms of Parkinson's Disease appeared, and the end of her career soon followed.

THE END OF *LIFE*

By the late 1950s, the death-knell had also begun to sound for that greatest of photojournalistic publications—*LIFE* magazine. At its peak circulation, it carried the real-life documentary images by W. Eugene Smith, Margaret Bourke-White, Alfred Eisenstaedt, and other excellent photojournalists to more than twenty-four million readers.

Then came television. Those who are old enough to remember the assassination of President John F. Kennedy in 1963 will probably recall the vision in the form of a television image rather than as a photograph. And although the Vietnam War was graphically photographed for *LIFE*, most of us recall its imagery through the magic eye of television rather than from Larry Burrows's still shots.

LIFE ceased publication in 1972, depriving the photojournalist of his or her best outlet. To be sure, newspapers have continued to publish photos of current events, but with the demise of *LIFE* and *Look* (1971), a special era of photojournalism came to an end.

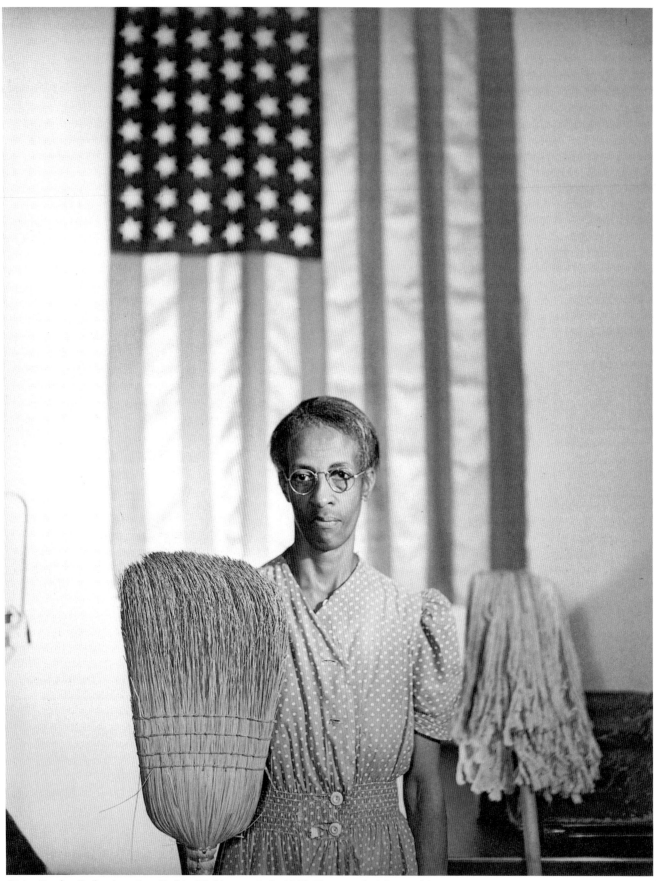

40.4 Gordon Parks, *American Gothic, Washington, D.C.*, 1942. Photograph. Library of Congress.

GORDON PARKS

Gordon Parks (b. 1912) is a documentary photographer in the tradition of Walker Evans and Dorothea Lange. An African-American, he succeeded in breaking the color barrier that had almost totally excluded blacks from professional photography. Born in Fort Scott, Kansas, Parks attended schools in St. Paul, Minnesota, and worked as a busboy, piano-player, and diningcar attendant, but by age fifteen he had already discovered his natural affinity for the camera. His big opportunity came in 1942 when he was awarded the Julius Rosenwald Fellowship in Photography, which allowed him to go to Washington, D.C., to work with Roy Stryker at the Farm Security Administration. Stryker taught him how to achieve the most from his chosen medium.

Parks recalled that he had never encountered such racial prejudice as in the national capital in the 1940s. Stryker set him to making a photographic essay on the subject. When it was not working out, Stryker advised him to interview a black charwoman employed by the government. Parks found one at work and learned that she was educated and capable, but that sweeping and mopping was the only job available to her in the so-called capital of democracy. On the spot, he posed the woman in front of a great American flag, placed a broom in one hand and a mop in the other, and caught the look of total resignation in her wan face. Parks created one of his most famous images, which he titled, in irony, *American Gothic, Washington, D.C.* (Fig. 40.4), as a parody on the picture by Grant Wood (Fig. 29.20).

Parks's career thereafter became remarkably successful—although Hearst Publications refused to hire him because he was black, and Standard Oil of New Jersey employed him only because Stryker threatened to resign from the photographic project he had agreed to do for the company if he was not allowed the assistant of his choice.

From 1948 to 1961 Parks was on the staff of *LIFE* magazine, and during that period he produced some of his best photographic essays on a wide range of subjects, from Harlem street-gangs to Paris fashions, from civil rights marches to Ingrid Bergman. There were also photo-essays on Malcolm X, Duke Ellington, and Muhammad Ali—all taken with that power and directness that characterize Parks's work. A poet and writer, he published his autobiography *To Smile in Autumn, A Memoir* in 1979.

Other African-Americans have made significant contributions to the aesthetic and cultural artistry of America through their photographic work. Even earlier than Gordon Parks, James van der Zee (1886–1983) worked as a photographer in Harlem for several decades during the period of the Harlem Renaissance, making sensitive portraits of his people in images that show a natural dignity, pride, and selfrespect.

Roy DeCarava (b. 1919) escaped from the ghetto to aim his camera at the commonplace scene of American streetlife, capturing poignant images that call our attention to material and spiritual deprivation among African-Americans and whites alike. The recipient of a Guggenheim Photography Fellowship in 1952 and chairman, in the mid-1960s, of the Committee to End Discrimination Against Black Photographers, DeCarava has been a professor of photography at Hunter College since 1975.

Van der Zee, Parks, DeCarava, and younger black photographers such as Adrian Piper (b. 1948) have found in the African-American experience a rich source of inspiration, and in the camera a means to express that experience in powerful imagery that encompasses truth, poetry, rage, and pride.

PHOTOGRAPHY AND ABSTRACTION

Exploration of the more purely aesthetic potential of photography, continuing along the lines of Stieglitz, Steichen, Weston, and Adams, was carried on by Minor White, Henry Holmes Smith, Gyorgy Kepes, and Clarence John Laughlin, among others.

MINOR WHITE

Minor White (1908–76) became a photographer for the Works Progress Administration (WPA) in 1938, and after World War II settled in New York City. There he met Alfred Stieglitz and, working at MOMA as a photographer, came to know the historians of photography Nancy and Beaumont Newhall. Moving to San Francisco in 1946, White entered the circle of Ansel Adams and Edward Weston, whose nature photography was of great influence on him. An able organizer, White was one of the founders and the first editor of *Aperture*, a quarterly magazine established in 1951 to promote and improve the artistry of the camera. Not since Stieglitz's *Camera Work* did photography have such an important avenue for creative experimentation.

Meanwhile, White was drawn into the study of Zen Buddhism, and his comprehension of Oriental mysticism began to invade his photographic images. He also began to experiment with technical effects, manipulating his lovely, lonely, poetic visions of nature, for example, through the use of infrared film. It was in that manner that he produced the dreamlike quality of *Road with Poplar Trees*, part of the series known as *Sequence 10/Rural Cathedrals* (Fig. 40.5). The effect is achieved by the film's special sensitivity to light, which makes the leaves and grasses, which reflect light, appear to be charged with light from within.

White's intention was to lead one's thoughts, while contemplating his scene or detail of nature, beyond the subject itself to some loftier realm. This he called the concept of equivalence. White provides no narrative story in his pictures, but seeks to create visions that will induce meditative excursions beyond the detail of driftwood, the formation of clouds, or the treelined road.

40.5 Minor White, *Road with Poplar Trees*, from *Sequence 10/Rural Cathedrals*, 1955. Photograph. Minor White Archive, Princeton University.

LÀSZLÓ MOHOLY-NAGY AND GYORGY KEPES

Other avenues of expression were explored in the postwar years—for example, working with abstract designs instead of nature.

Hungarian-born Làszló Moholy-Nagy (1895–1946) had taught at the Bauhaus in Germany in the 1920s, was influenced by the Russian Constructivists, and was a designer in Amsterdam, where he was acquainted with the modern Dutch movement of De Stijl—all before coming to the United States in 1937.

He had commenced making "photograms" in 1922—photographs produced without a camera by placing objects on sensitized paper which was then exposed to light, similar in technique to the "Rayographs" created by Man Ray a few years earlier. Moholy-Nagy encouraged techniques of this sort at his shortlived New Bauhaus School in Chicago in 1937 and at the Illinois Institute of Technology, where he taught until his death.

Gyorgy Kepes (b. 1906), also Hungarian by birth, had similarly arrived in America in 1937 after teaching at the Bauhaus in Germany, and he joined Moholy-Nagy on the faculty of the New Bauhaus. In 1943 he went to MIT, where he spent the remainder of his career.

In his photography Kepes—a painter and architectural designer as well as filmmaker—created abstractions organized around a Constructivist's perspective, with design patterns that were compatible with machine imagery. Using

essentially the same technique as Moholy-Nagy, he, too, called his works "photograms" (Fig. **40.6**).

With the experiments performed by Man Ray even before 1920 and the ideas about abstraction and the photogram techniques brought over by Moholy-Nagy and Kepes, something of a tradition in that sort of imagery was established in America before World War II.

HENRY HOLMES SMITH

Henry Holmes Smith (1909–86) attended college in his native Bloomington, Illinois, before going to Chicago where in 1937 he, too, joined the faculty of the New Bauhaus. The influence of Moholy-Nagy and Kepes on Smith was substantial.

After serving in the army during the war, he became a member of the faculty at Indiana University in Bloomington, where his distinguished career as a teacher spanned three decades. Smith's *Light Study*, made immediately after the war, reveals his interest in geometric abstract patterns (Fig. **40.7**). By placing objects and textures such as loose-weave fabrics, screen wire, and so on, on light-sensitive paper and exposing them, Smith obtained patterns like those seen in *Light Study*. His technique was one of manipulation of the negative, of the film itself, or of light-sensitive paper. Frequently his images were made without the use of a camera.

40.6 Gyorgy Kepes, *Photogram*, 1939. Photogram on silver-gelatin paper, 15⅞ × 19⅞in (40.4 × 50.5cm). Art Institute of Chicago.

40.7 Henry Holmes Smith, *Light Study*, c. 1946. Dye transfer print. Henry Holmes Smith Photo Archive, Indiana University Art Museum, Bloomington, Indiana.

THE SURREALISTIC IMAGE

Parallels to Surrealism exist in photography, for the medium, through manipulation or choice of subject, lent itself wonderfully to such imagery. In *A Vision of Dead Desire*, for example, Clarence John Laughlin (1905–85) created a dream vision by superimposing several negatives upon one another (Fig. 40.8). Born in Louisiana and working all his life in New Orleans, Laughlin probably discovered the sculptures seen in this picture while roaming the extraordinary cemeteries of the Delta City.

To him, the camera and lens existed as a release for the imagination, which he insisted must have full freedom if the poetry and imagery he desired were to be attained. Objectivity and documentation, which to many are the salient features of the photograph, gave way in Laughlin's work to fantasy, mystery, an evocation of the past and of the dark secrets of the mind—and of New Orleans itself.

Wynn Bullock (1902–75) created a haunting, even frightening surrealist image in *Child in the Forest* (Fig. 40.9). Its objective realism has a definite Freudian element, introduced in the figure of the naked child, and the viewer is left to speculate as to whether she is asleep, under a spell in this enchanted forest, or dead. The manifestly unnatural, presented in a sharply naturalistic vision, is characteristic of Surrealism. To achieve a surrealist effect such as this, Bullock, unlike Laughlin, did not manipulate his medium, but rather controlled and altered his subject matter.

40.8 (opposite) Clarence John Laughlin, *A Vision of Dead Desire*, 1954. Photograph. Historic New Orleans Collection.

40.9 Wynn Bullock, *Child in the Forest*, 1951. Photograph.

40.10 Jerry Uelsmann, *Poet's House*, 1965. Photograph.

40.11 Harry Callahan, *Environs of Chicago*, c. 1953. Photograph. © Harry Callahan, Pace/MacGill Gallery, New York City.

JERRY UELSMANN

Of the younger generation of photographers who seek a surrealist vision of nature through manipulated effects, Jerry Uelsmann (b. 1934) is the leading figure. Born in Detroit, Uelsmann studied with Minor White at the Rochester Institute of Technology and with Henry Holmes Smith at Indiana University.

Poet's House demonstrates the brilliant technical inventiveness and skill that are typical of his work, but also the lyrical, delicate, romantic moodiness (Fig. 40.10). It is the image that concerns Uelsmann—in its formal composition, its sharp, crisp focus, and, here, its fading effect, its linearity set against mass, all working to create a haunting vision. It is not necessary that he himself understands the symbolism—it is sufficient that his imagery evokes in the mind of the viewer a search for the meaning of the symbols.

HARRY CALLAHAN

Harry Callahan (b. 1912) similarly takes nature as his subject, but without the surrealist overtones. He also works in a straight manner, concentrating on formal arrangements. A native of Detroit and selftaught as a photographer, he began teaching at the Chicago Institute of Design in 1946 and fifteen years later moved to the Rhode Island School of Design. From Ansel Adams, he learned about tone and texture in photographs, but there is an appreciation of abstract qualities in Callahan's work that sets it apart.

Environs of Chicago (Fig. 40.11) has the rigid discipline of a composition by Piet Mondrian. The world has been reduced to three formal compositional parts and textures: The cylindrical pole that divides the sky into two unequal rectangles and the cornfield. The absolute verticality of the pole is countered by the perfect horizontality of the horizon

line, the geometric precision of which is ever so subtly disturbed by balancing interruptions at the far left and the far right. Yet for all of this preoccupation with formal arrangement, Callahan was intimately attuned to the subject itself. His parents were farmers, so a scene such as this is equally associated with a love of farmland, a healthy crop, and the raspy, rustling sounds of leaves on cornstalks blowing in the breeze.

PAUL CAPONIGRO

Beauty and abstraction in nature, seen so close up as to become isolated from the whole, in ultrasharp focus that captures every texture, soft or brittle—these are the hallmarks of the work of Paul Caponigro (b. 1932).

He, too, studied with Minor White at the Rochester Institute of Technology, in 1957–8, and has been a freelance photographer since 1955. In a picture such as *Rock Wall, No. 2*, Caponigro focused upon the linear and planar patterns and the tonal harmonies of a small portion of nature (Fig. 40.12). These were considered of no consequence other than the artist discovering them as a microcosm of some larger entity. Real understanding of the Grand Canyon, Caponigro might say, begins with the scrutiny of a minuscule detail of a piece of rock, just as a knowledge of the ocean begins with an examination of a drop of water. There is as much beauty in the detail as in the whole. In the delicate, linear rhythms of the underside of a fungus, Caponigro perhaps finds some secret mystery of the universe.

THE OBSERVING EYE

If Caponigro, Minor White, and Jerry Uelsmann seek a timeless, poetic quality in their work, there is another group of photographers who search out the specific and often the darker side of American life. Robert Frank, Diane Arbus, Garry Winogrand, and Weegee are foremost among them. Their search is not so much for beauty as for truth as they experience or perceive it in American society. They can be absolute masters of subtle satire and irony, of detached observation, or they can be devastatingly blunt.

ROBERT FRANK

The publication in 1958—one year after Kerouac's *On the Road*—of a book of photographs by Robert Frank (b. 1924) signaled that something new had occurred in American photography.

Frank was born in Zürich, Switzerland. He came to the United States in 1947, age twenty-three, and left for Canada in 1969 as a protest against the Vietnam War.

Frank had been trained as a photographer before he arrived in America, and at first he worked in New York City as a freelancer for *LIFE*, *Look*, *Harper's Bazaar*, and *Fortune*. In 1955 he received a Guggenheim Fellowship and went on the road, much like Kerouac's character, crisscrossing the country, observing and recording with his camera a vision of America that it perhaps took an outsider to see. The dryly unemotional images—of jukeboxes and funerals,

40.12 Paul Caponigro, *Rock Wall, No. 2*, 1959. Gelatin-silver print, 10⅜ × 13⁵⁄₁₆in (26.4 × 33.8cm). Collection, The Museum of Modern Art, New York. Purchase.

40.13 Robert Frank, *U.S. 285, New Mexico*, from *The Americans*, 1958.
Silver-gelatin print, 11½ × 7½in (29.1 × 19.2cm). Art Institute of Chicago.

motorcycles and roadside cafés, rodeo cowboys on the filth-littered streets of New York and Detroit—were the result of culture-shock in the move from Switzerland to America.

The impulse behind the pictures is less social criticism than a cynicism that penetrated deeply. The impression of the road and the interminable expansiveness of the country are seen in *U.S. 285, New Mexico* (Fig. 40.13). Through Frank's observant eyes, America had been stripped of an innocence it had long believed in. The American Dream of

hope, success, suburban comforts and amusements had turned sour.

The series, published as *The Americans*, is an Existentialist stream of images. Jack Kerouac wrote the introduction, and Frank later made films with Allen Ginsberg. Through his photographs, Frank made Americans see themselves in a new way. Much resentment was voiced against the series, while many who saw the photographs admitted he captured a vision of things that were true, but had been repressed.

40.14 Diane Arbus, *Pro-War Parade*, 1967. Gelatin-silver print, 14¾ × 14½in (37.5 × 36.8cm). Collection, The Museum of Modern Art, New York. Ben Schultz Memorial Collection. Gift of the artist.

DIANE ARBUS

Diane Arbus (1923–71) also aimed her camera at subjects that had largely been avoided by serious photographers. For her, the subject was the all-important element in her art, more so, for example, than beautiful printing effects. Arbus approached life in a straight manner, seizing directly on film and without manipulation the less-than-normal or overly normal aspects of American culture and lifestyle that caught

her eye. States of being—in the full human spectrum—were the things she singled out to make us think about. The total corpus of her work is remarkably extensive, considering that it was created in only about a decade, before her suicide in 1971.

Born Diane Nemerov in New York City, she married a fashion photographer in 1941, and for nearly two decades was his partner. When Arbus struck off on her own in the late 1950s, she asserted her independence with a conscious

40.15 Diane Arbus, *A Young Man in Curlers at Home on West Twentieth Street, New York City*, 1966. Gelatin-silver print, 14¾ × 14in (37.5 × 35.6cm). Collection, The Museum of Modern Art, New York. Purchase.

choice of subject matter diametrically opposed to the world of fashion. She photographed people almost exclusively, with what can only be described as a psychological curiosity—not necessarily being critical.

Arbus was fascinated by the question of who ordinary—or not-so-ordinary—people are, or who they think they are. She was always interested in the individual as a unique being, but also as a representative of a group or class of people.

That Arbus's observing eye extended from one pole of human behavior to the other is obvious in the two photographs illustrated here—*Pro-War Parade* and *A Young Man in Curlers at Home on West Twentieth Street, New York City* (Figs. **40.14** and **40.15**).

The nude continued to be a favorite subject of photographers in shots of the partial figure, or seen poetically as if through a veil or in a Surrealistic fantasy. Sexual themes also appeared: Eroticism, transvestitism, and homosexuality.

ROBERT MAPPLETHORPE

As the gay community came out of its closet, so did open disclosure of its lifestyle. One of the most talented photographers in this area was Robert Mapplethorpe (1946–89), whose nudes were sometimes blatantly erotic and often sadomasochistic. Some viewers found both the subject and the extremely graphic style objectionable, but to Mapplethorpe and to others it was a legitimate area for exploration.

There is an inescapable physicality and power about Mapplethorpe's nudes, explicit in the musculature and implicit in the chains and other kinds of binding. But if sensuality is an integral component of his nudes, so is formal arrangement, as we see in *Nude*, in which he treats the partial figure as an object to be composed by the artist (Fig. **40.16**). In this same photo, too, the model is clearly flexing the muscle of her arm in the manner of a bodybuilder, another reference to physical power. Mapplethorpe's nudes

40.16 Robert Mapplethorpe, *Nude*, 1981. Gelatin-silver print, 20 × 16in (51 × 41cm). Robert Miller Gallery, New York City.

40.17 Weegee (Arthur Fellig), *Untitled (Woman Being Pulled Away from Dying Man by Policeman)*, 1938. Gelatin-silver print, 13⅕ × 10½in (33.5 × 26.8cm). Art Institute of Chicago.

have attracted so much attention that two other areas in which he was absolutely brilliant are frequently overlooked—portraiture and a style of still life in the tradition of seventeenth-century Dutch painters.

WEEGEE

Scenes of the city and its people did not escape the notice of photographers, and one who was drawn into the brutal reality of human tragedies was Weegee (1899–1968).

Born Usher H. Fellig in Zloczew, Poland, he was brought to the United States in 1910. He changed Usher to Arthur, but then took the name Weegee, from the ouija board. Selftaught in the use of the camera and the processes of the darkroom, Weegee became a freelance street photographer in New York City by age fifteen, then worked for United

Press International, and then as a freelance photographer for several New York newspapers, operating out of Manhattan Police Headquarters in the 1940s and 1950s.

His role as cameraman was to capture the tragedies of the streets in a straightforward, powerful, and selfexplanatory manner, in the tradition of documentary photography that reached back to Jacob Riis—who was also a police photographer working the poorer districts of the city. *Woman Being Pulled Away from Dying Man by Policeman* is an example of the sort of picture Weegee took, catching the tearful anxiety of the distraught woman and the fear of dying in the eyes of the man whom she lovingly tries to console (Fig. 40.17). Such pictures might appear on the front page of the *New York Daily News* or *Sun*. Their artistry is in the force and power of directly expressed human drama.

40.18 Garry Winogrand, *Los Angeles*, 1964. Gelatin-silver print, 9 × 13½in (22.9 × 34.3cm). Collection, The Museum of Modern Art, New York. Purchased with funds provided by The International Council.

GARRY WINOGRAND

Garry Winogrand (1928–84) first majored in painting in college before studying photography with Alexey Brodovitch at the New School for Social Research in New York. Although he began his career as a commercial photographer, his interest in the affairs of the urban street scene became the real focus of his work, whether it be of a hardhat rally in New York or of a bandaged young black man speeding along in a flashy convertible at a Los Angeles intersection (Fig. 40.18).

Winogrand's pictures are not so much photojournalism as narratives of life on the city streets—single still shots that evoke a broader story. With all the immediacy that the small 35mm camera allows, photographs such as *Los Angeles* offer the viewer the experience of a spontaneous, fleeting moment, uncomposed and natural, and unaltered by any manipulation in the darkroom. As one looks at *Los Angeles* one experiences a little slice of this young man's world—a world of a sullen, beaten, and bandaged face, of a goodlooking woman in the seat beside him, and of a fancy speeding automobile, racing through the noise and the lights of the inner city. Where he is going seems unimportant.

LEE FRIEDLANDER

In *New York City*, Lee Friedlander (b. 1934) gives us a very different experience of the inner city—one of loneliness, even despair, as viewed through, or in the reflections of, broad plateglass windows in a seedy section of town (Fig. 40.19).

Compositionally, the picture is rational in the strong vertical of the pier, the broad planes of white to left and right of the pier, and the staccato, curvilinear architectural detail in the lower left, carefully balanced by the rectilinear architectural patterns of the upper right. The image of the man with his head on his arms, however, is surrealistic and enigmatic: Is it a picture on the glass? A scene of a real person we witness through the glass? Is it an image of despair? Or merely temporary exhaustion? Pictures such as this invite one to speculate, to make up one's own narrative out of the raw material for a story which the photographer furnishes.

40.19 Lee Friedlander, *New York City*, 1964. Photograph.

POSTMODERNISM AND THE CAMERA

Only a few years after graduating from the State University of New York, Buffalo, in 1976, Cindy Sherman (b. 1954) began to attract critical attention in the New York press for her series of black-and-white film stills which remind the viewer of shots from some 1950s-style *film noir*.

Using herself as model, Sherman creates images that evoke stereotypes of Hollywood heroines in shallow, melodramatic moments, often with sexual undercurrents, or that suggest the darker side of the psyche. The woman in the pictures, always alone, experiences the malaise of a romance gone wrong.

From the beginning, Sherman's work concerned semiology, for she calls our attention to the signs, symbols, and media usage of feminine stereotyping as much as to the stereotyping itself. About 1980, Sherman switched to color photography and satires of middleclass women—unsure of themselves, seeking approval from men—recalling the cultural conditioning of teenage girls and young women through the reading of comicbook romances and love stories. Also in

the 1980s came a commission for a series of fashion illustrations for a chain of women's wear stores.

In the latter part of the 1980s Sherman experimented with largescale portraits that parodied famous historical portraits by Ingres, David, Holbein, and others—her contribution to postmodernism's revival and reuse of historical styles.

Sherman then shifted from the figure as subject to enormous still lifes of horrifying reality, and often of considerable repugnance, in a view of the world as waste, litter, and filth. All of her photographs are untitled, so they speak for themselves, and certainly *Untitled No. 175* does just that (Fig. **40.20**). It is a nightmarish assemblage of rotting chocolate cupcakes, vomit, and other refuse scattered about the sand of a beach. The human factor is made present by the image of the small head reflected in the lens of the plastic sunglasses. Even the scale is disturbing, for this photograph measures 6 feet 1 inch (1.85 m) across.

Reminding the viewer that even something so delightful as a day at the beach has a darker side, Sherman's work becomes possessed by this negative aspect of humanity, as in her images of fatty buttocks covered with pustules, which seem calculated to achieve a shock effect as an end in itself.

40.20 Cindy Sherman, *Untitled No. 175*, 1987. Color photograph, 4ft 1in × 6ft 1in (1.24 × 1.85m).

The total rejection of the refinement of high art, the denial of the separation of art from life, the drawing of stimulation from the objects of popular culture, the creation of images in which the signs or symbols are as important as their content—all of these are characteristic of postmodern picturemaking.

Whether nature or human nature, urbanscape or landscape, the specific or the universal, realism or abstraction or Surrealism, "straight" photography or manipulated—an extraordinary richness of texture, tone, content, and innovation characterizes American camerawork in the postwar period. As a body, it asserts its own aesthetic and expressive validity, built upon the traditions of Stieglitz and Adams, Lange and Evans, Strand and Man Ray, and a host of others.

But it has charted its own new paths as well, utilizing the flexibility offered by the small 35mm camera, developing sophisticated new methods of manipulation, and probing new depths of the American conscience. In doing all this, it has reaffirmed its position as one of the fine arts of the twentieth century. There is one thing that photographic prints always seem to do—they make us see things we have not seen before, or perhaps cause us to see things as we had not seen them before.

GLOSSARY

ABSTRACTION The essence of natural forms reshaped or redesigned according to a given aesthetic or ideal; this may involve the simplification or geometrization of forms or their transformation into symbols. Greater emphasis is frequently placed on the line, shape, color, pattern, and rhythms of natural forms than on their visual appearance of reality.

ACTION PAINTING A painting technique of the late 1940s and 1950s employed by Abstract Expressionists. One of its primary aesthetic qualities derives from the fact that the brush is wielded with great energy and exuberance; alternatively, paint may be dribbled onto the canvas directly from the can in a semi-controlled manner.

ADOBE A mud mixture of dirt and water, used in building in the American Southwest. Adobe may be built up in layers, according to a method known as puddling employed by Native Americans, or formed into bricks, according to European practice, and then dried in the sun.

APRON A decorative appendage applied to a structural **rail** on the front of a piece of furniture.

APSE A semicircular part of a building, usually extending beyond the **nave** of a church to form the area where the altar, pulpit, and/or choir are located.

AQUATINT A graphic process by which a copper plate is etched with acid, usually to obtain tonal rather than linear effects.

ASHLAR MASONRY In construction, the use of stone that has been squared off into flat vertical and horizontal planes with right angles at all corners and edges.

ASSEMBLAGE In sculpture, the creation of a three-dimensional composition, sometimes set against a flat plane, out of an assortment of components or **found objects**.

ATRIUM The enclosed entrance courtyard of a house or other type of building.

BALUSTER The short columnar posts, usually repeated at regular intervals, that support a railing.

BARREL VAULT A continuous semicircular or semi-elliptical arched roof, usually constructed of stone.

BAS-RELIEF Sculpture that is developed from a back plane through low-relief carving or modeling.

BIOMORPHISM Shapes or designs in painting or sculpture that suggest biological forms.

BREWSTER CHAIR A type of seventeenth-century chair made in New England and named after the elder William Brewster of Plymouth Plantation.

BUNGALOW A type of twentieth-century house that is usually of one floor and is modest in size and design.

BUTTRESS A stone or brick structure built against a wall to reinforce it or to help support vaulting.

CABRIOLE LEG The leg of a piece of furniture, shaped in an S-curve, found especially in Queen Anne and Chippendale styles.

CALOTYPE An early form of photography developed in the mid-nineteenth century. William Henry Fox Talbot, an Englishman, was the first to develop the process, which involved a light-sensitive negative from which a positive print could be made.

CANTILEVER In architecture, a joist or beam that projects beyond its support, as in a balcony or an overhang.

CAPITAL The uppermost part of a column, forming the transition between the vertical **post** and the horizontal lintel or beam. The most common, found in the classical **Orders**, are of the **Doric**, **Ionic**, **Corinthian**, and **Composite** types.

CASTELLATION Either the crenelated top wall of the battlements of a castle, or a type of building with turrets and battlements, usually similar to a medieval castle.

CHAMFERED A wall or edge of a block of **ashlar masonry** that is beveled (set or cut at a slight angle in relation to the primary plane of the wall or block).

CHANCEL The part of a church where the altar is placed, or the area reserved for the choir.

CHIAROSCURO The use of light and shadow in the drawn or painted representation of an object to suggest a three-dimensional quality on a two-dimensional plane.

CHINOISERIE The vogue for Chinese objects and architecture in European and American culture, especially in the eighteenth century.

CLAPBOARD A thin board with the lower edge thicker than the upper, used to cover the exterior of buildings.

CLERESTORY The upper level of the walls of a church where windows are located.

COLLAGE A composition created by pasting various pieces of paper or other two-dimensional materials onto a flat surface.

COLLODION-COATED PLATE A photographic plate to which a quick-drying, light-sensitive coating of nitrate cellulose and alcohol has been applied.

COLORFIELD The area of a painting occupied by a given color, or a nonobjective style of painting in which large areas of the plane are devoted to a single color.

COMPOSITE One of the classical **Orders** created by the combination of the **Ionic** and **Corinthian** Orders.

CONTRAPPOSTO The twisting of the human figure on its own axis, often used to suggest inner torment or dynamic action.

CORINTHIAN The classical **Order** characterized by a fluted shaft and a capital enriched by carved acanthus leaves.

CORNICE A decorative horizontal band that projects from a wall, as in the uppermost part of the **entablature** on the exterior of a building or, in the interior, along the area where the wall joins the ceiling.

CREDENZA In furniture, a buffet or sideboard.

CRENELLATION The irregular upper line of a battlement on a castle.

CREST RAIL The upper **rail** located across the back of a chair or sofa.

CROCKET A small vertical decoration, usually carved with leaves or flame motifs, applied to the **cornices** of medieval buildings.

CROMWELLIAN CHAIR A common seventeenth-century chair with leather covering on the seat and back, named after the Englishman Oliver Cromwell.

CROSSING The area in a church where the **nave** and the **transepts** cross, often topped by a dome or tower.

CRUCIFORM In the form of a cross.

CUPOLA A small dome often crowning a tower on the roof of a building.

CURTAIN WALL A wall that is nonstructural—that is, a wall that does not bear weight but is used to enclose or partition architectural spaces.

DAGUERREOTYPE An early photographic process, perfected in France by Louis Daguerre in the 1830s, in which an image is registered on a metal plate that has been coated with a light-sensitive solution. As no negative is involved, the image is unique.

DORIC One of the primary classical **Orders**, characterized by its boldness and heavy proportions.

DOUBLE-PILE In domestic houses, a plan that is two rooms deep.

DRY PLATE A photographic plate on which the light-sensitive emulsion is allowed to dry before use; a dry plate can therefore be prepared ahead of time, whereas a **wet plate** must be prepared on the spot and used at once.

ELEVATION The vertical design of a building, either exterior or interior.

ENTABLATURE In architecture, everything above the supporting columns or walls, including the architrave, **cornice**, frieze, **pediment**, and roof.

ETAGERE A piece of furniture used for the display of curios and collectibles.

ETCHING A graphic medium in which lines are scratched into a layer of emulsion on a copper plate; the plate is then bathed in acid, which bites into the plate where the lines have been drawn. A print is then taken from the inked plate.

FAVRILE GLASS A type of glass developed by Louis C. Tiffany in the late nineteenth and early twentieth century. It possesses a lustrous opalescence and rich, iridescent colors.

FIELDSTONE Stone used in the construction of buildings just as it is found in the field or riverbed—that is, stone that is not worked into geometric planes in the manner of **ashlar masonry**.

FINIAL A decorative vertical feature that crowns a **cornice** in architecture or a **crest rail** in furniture.

FLYING BUTTRESS The arcing segment that springs from an external **buttress** to the wall of a building to support the weight and thrust of **vaulting**.

FOLIATE Consisting of leaf designs, but sometimes including floral motifs.

FOUND OBJECTS Objects, usually of a commonplace sort from the everyday world, that are given new formal and symbolic meaning when they become the materials from which a work of art is created.

GABLE The triangular area at the end of a roof, established by the two sloping planes of the roof.

GAMBREL ROOF A roof that has a double pitch on each of the two sides of the **ridge beam**.

GATELEG TABLE A table in which two of the six legs are hinged and may be folded back, allowing the leaves to drop to the side; its chief convenience is that it takes up little space when the leaves are dropped, yet makes a fullsize table when the leaves are supported by the gatelegs.

GENRE PAINTING Painting in which the subject is of ordinary people doing ordinary things.

GESSO A mixture of plaster and glue that is applied to the surface of sculpture or wooden panels and sometimes used on canvas as a primer coating before those surfaces are painted.

GLASS BRICK Hollow glass cubes about 10 inches (25cm) across by 6 inches (15cm) deep that are used to make translucent walls in twentieth-century buildings.

GRISAILLE A figure, scene, or still life painted in monotone (often gray, black, and white) to imitate relief sculpture on a two-dimensional surface, usually on furniture or architecture.

GROIN VAULTING Vaulting in which two **barrel vaults** intersect each other; the resulting ridge lines are the groins of the vaults.

HADLEY CHEST A type of chest produced in the seventeenth century. It is rectangular in shape with a hinged lid that opens to form a large storage area, below which are one or two shallow drawers. At one time it was believed that such chests were made only in Hadley, Massachusetts, but in fact the type was known throughout New England.

HIPPED ROOF The roof of a square or rectangular building in which all four planes incline toward the center.

HISTORY PAINTING A type of painting that takes its subject matter from history or literature, usually treating great events or dramatic scenes.

HYPHEN In architecture, a lesser section (often little more than a hallway or a small room) that connects two larger parts of a building.

HYPOSTYLE HALL A great columnar hall found in ancient Egyptian temples.

ICON An image, most often of a revered person such as a religious personality or ancestor.

IMPASTO The heavy build-up of pigment (paint) upon a canvas or panel.

INTERCOLUMNIATION The spaces between the columns in a colonnade.

IONIC One of the three primary classical **Orders**, characterized by spiral-shaped volutes in the capital; the shaft is slenderer than that of the **Doric** Order and has a base.

JAPANNING In furniture, the treatment of a wooden surface that produces a glossy, lacquered effect; the technique was perfected in Japan and introduced into the Western world when globe-circling sea captains brought specimens of it back to Europe and America in the seventeenth and eighteenth centuries.

KEYSTONE The topmost wedge-shaped stone in an arch, and the one that, when set, holds all of the other stones (**voussoirs**) in place.

LALLY POST A tubular metal post with an adjustable inner tube used for supports in architecture.

LANCET A narrow window with a pointed arch at the top, most often associated with the Gothic style.

LIMNER The sixteenth- and seventeenth-century word used for a painter, particularly a portraitist.

LITHOGRAPH A type of graphic art in which an image is drawn on a flat stone and printed from it.

LUMINISM A quality of light, found in certain mid-nineteenth-century American landscape paintings, that causes objects to be seen with great clarity and rendered in meticulous detail. The special lighting of a sunrise or sunset is often one of the main themes in such pictures.

LUNETTE A semicircular form in architecture, often serving as the terminal wall of a **barrel vault**.

MANSARD ROOF A roof that has two slopes on each of the four sides, the lower slope being steeper than the upper. Its name is taken from the seventeenth-century French architect François Mansart.

MEGALITH An architectural construction consisting of huge stones.

MEZZOTINT In the graphic arts, a type of engraving that allows subtle gradations of tone ranging from black to gray to white.

MONTAGE A pictorial composition created by uniting a variety of pictures or images into a single arrangement.

MORTISE-AND-TENON JOINT In furniture, the interlocking construction that unites two parts, often found in the drawers of pieces made in the seventeenth to the nineteenth centuries.

MULLIONS Vertical and horizontal dividing bars in windows which help to hold the glass panes in place.

MURAL PAINTING Painting on walls, usually those that have been plastered.

NATURALISM A style of painting and sculpture in which fidelity to nature is one of the artist's primary goals.

NAVE The long central hall in a church that runs from the entrance to the **crossing** or to the **apse**. It is the part occupied by the congregation.

OBELISK Originally, an Egyptian funerary marker in the form of a tapering vertical stone with a pyramidal top. A wellknown example in America is the Washington Monument in Washington, D.C.

OCTASTYLE A type of classical temple that has eight columns across the front.

OCULUS A circular opening (usually a window) in a building.

OGIVE (OGEE) An arch, the curve of which reverses itself, forming a gentle S-curve on each side of the opening.

ORDER One of the primary structural and design schemes of the ancient Greek and Roman worlds; the foremost Orders are the **Doric**, the **Ionic**, the **Corinthian**, and the **Composite**, although there are several other variations as well.

PALLADIAN WINDOW A form of window, named after the sixteenth-century Italian architect Andrea Palladio, which has a large arched window in the middle with a smaller rectangular window on each side of it.

PASTELS Colored chalks used in making pictures.

PATTERN BOOK A book containing numerous engraved plates of architectural and furniture designs.

PEDIMENT The triangular **gable** end of a roof created by the sloping lines of the roof and the horizontal **cornice**.

PENDANT In architecture, something that hangs, suspended from above—as in the decorative pendants (or pendills) that are suspended from the overhang of a seventeenth-century New England house.

PERIPTERAL A type of building that is surrounded by columns on all four sides, usually found in temple forms of architecture.

PERISTYLE In a temple form, any enclosure surrounded by a row of columns.

PEWTER An alloy of tin with lead, brass, or copper that was used to make common plates and drinking utensils in the seventeenth and eighteenth centuries.

PHOTOGRAVURE A process of photo-engraving in which a photograph is transferred to a plate so it may be reproduced, usually in large numbers for a magazine or newspaper.

PICTOGRAPH A picture or symbol used in writing, as in Egyptian hieroglyphics.

PICTURE PLANE The plane established by the surface of the canvas, panel, wall, or other support on which an image is painted or drawn.

PILASTER A column or half-column that is applied to a wall for decorative purposes; it plays virtually no structural role.

PLEIN-AIR PAINTING The practice of painting out in the open under direct lighting conditions, as opposed to painting in the studio under artificial or controlled lighting.

POLYCHROMING The painting of sculpture or other objects in a variety of colors, usually with a very bright effect.

PORTAL The entrance to a building, especially a church.

PORTICO A porch resembling a temple front, with a pedimented roof supported by columns.

POST AND BEAM See post and lintel.

POST AND LINTEL In architecture, the simplest form of construction in which vertical supports (columns, piers, posts) support a horizontal member (beam) for the enclosure of space.

PROPORTION The relationship of parts to the whole, as in the human figure or in architecture. The theory of proportions which defines the aesthetic judgment for good proportional relationships may differ between one culture and period and another.

PUTTI Little winged cherubs or angelic creatures found in paintings and sculptures depicting religious or mythological subject matter; they usually accompany a god or goddess.

PYLON A high-walled entrance preceding a building, often found in Egyptian temple architecture. The walls frequently slope slightly and are capped by a cornice.

QUADRIGA A chariot drawn by four horses.

QUOINING The large rectangular blocks of stone set at the corners of a building to give emphasis to the corners. The effect of quoining is sometimes achieved by the use of bricks.

RAIL In furniture, any horizontal structural part.

REPOUSSE The technique of hammering a metal plate to create a design in relief. The design is ultimately raised from the surface of the plane.

REREDOS A decorative screen behind the altar in a church.

REVIVAL STYLES A variety of styles— Egyptian, Greek, Roman, Gothic, Renaissance, Baroque, Rococo, and Moorish are the most prominent—that are brought back into use in architecture and the decorative arts because they serve some new expressive or symbolic purpose for a later age.

RIDGE OR RIDGE BEAM The topmost beam in the roof of a building; the timber that forms the peak of a roof.

RUSTICATION Derived from the Latin word for country, this architectural term refers to heavy, bold masonry with a rough or irregular surface that is intended to appear unfinished.

SALTBOX FORM In seventeenth-century New England architecture, the form of a house that results from a lean-to section being added to the back of a structure.

SETBACK A space or area of a plot that cannot be built on because of zoning laws, which were devised to prevent the creation of dark canyons in streets as skyscrapers arose along them. In skyscrapers, a receding of the design at intervals.

SILKSCREEN A graphic process in which a design is transferred to a piece of silk stretched across a frame; an impression may be obtained by forcing paint through the screen. Innumerable copies may be produced by repeating the process.

SKELETAL SYSTEM A system in architecture in which the supporting work is done by slender vertical, horizontal, and arching members, rather than the walls. In stone, Gothic architecture is a good example, while in modern building methods, the steel-frame architecture of a skyscraper is typical.

SPANDREL The generally triangular area between the curve of an arch and the vertical and horizontal members around it.

SPLAT The vertical centerpiece in the back of a chair.

STABILE A sculpture of the sort developed by Alexander Calder which is set directly upon the ground or a base, as opposed to a mobile, which is suspended from above. Movement is usually a part of its design.

STEPPED GABLE A gable or end of a roof that has the form of descending steps along its diagonal sides.

STEREOSCOPE An instrument used for viewing photographs which gives a three-dimensional effect to photographic views.

STILE Any vertical structural member in a piece of furniture.

STRAPWORK A straplike design that was popular in architectural and furniture decoration in the sixteenth and seventeenth centuries.

STRETCHER In furniture, a system for connecting the legs of a chair, table, or chest for the purpose of giving strength and support.

STRINGCOURSE A raised row or rows of bricks or stones on the exterior of a building that define the level of the various stories.

STUCCO A plaster or cement used for coating walls, usually exterior surfaces. It is sometimes developed into ornate patterns on the ceilings of interiors.

TALBOTYPE An early form of photography developed in the 1830s and 1840s by the Englishman William Henry Fox Talbot.

TOURELLE Towerlike in form, or a small tower or turret in a building.

TRANSEPT The arms of a church that cross the nave at right angles. The transepts divide the nave from the apse.

TRAVERTINE A porous stone of soft yellow coloration.

TROMPE L'OEIL In painting, a "trick of the eye" in which the artist has attempted to give such visual reality to the image that the viewer is fooled into thinking that he or she is looking at actual objects.

TURKEYWORK CHAIR A type of seventeenth-century chair that uses a colorful upholstery fabric made in England in imitation of the more expensive product woven in Turkey.

VAULT An arched roof or ceiling, usually constructed of stone but occasionally of brick.

VELLUM A parchment, made from lambskin or calfskin, with a finely prepared surface used for writing or picture-making.

VENEERING The covering of a surface, usually of a coarser substance, with a thin layer of another material, most often of a finer substance. In furniture, a base wood (such as pine) might be veneered with a more elegant wood such as mahogany or walnut.

VOUSSOIRS All of the wedge-shaped stones that make up an arch except the topmost stone, which is called a **keystone**.

WAINSCOTING The wood panel surfacing that is applied to a wall or to the lower portion of a wall.

WATERCOLOR A medium for painting in which the pigments are water-soluble. Watercolor painting is usually done on paper.

WET PLATE A process in photography in which a plate is coated with a light-sensitive solution and the photograph is taken while the emulsion is still wet.

WOODCUT A graphic process in which an image is carved from a piece of wood cut along the grain; the remaining surface is inked and an impression is taken on paper.

ZIGGURAT A stepped pyramidal form in architecture.

BIBLIOGRAPHY

Because of the large amount of research published on American art, especially in recent years, mainly books, rather than articles, are listed in this bibliography. In selecting titles for inclusion, more recent scholarship has been given precedence over older studies. Extensive bibliographies are available in many of the books cited. An article has been listed only when it is the primary source for a topic or artist, or when it has special importance for the study of American art. The reader is referred to the *Art Index* as a guide to periodical literature. Among the foremost journals are the *American Art Journal*, *American Art* (formerly *Smithsonian Studies in American Art*), *Antiques*, *Art Forum*, *Art News*, and the *Winterthur Portfolio*.

SOURCES AND SURVEYS

Baigell, Matthew. *A Concise History of American Painting and Sculpture*. New York: Harper & Row, 1984.
—— *Dictionary of American Art*. New York: Harper & Row, 1982.
Brown, Milton, Sam Hunter, John Jacobus, Naomi Rosenblum, and David Sokol. *American Art: Painting, Sculpture, Architecture, Decorative Arts, Photography*. New York: Abrams, 1988.
Gerdts, William H., and James Yarnall. *The National Museum of American Art's Index to American Art Exhibition Catalogues: From the Beginning through the 1876 Centennial Year*. 6 vols. Boston: G. K. Hall, 1986.
Harris, Neil. *The Artist in American Society; The Formative Years, 1790–1860*. New York: G. Braziller, 1966.
Hills, Patricia, and Roberta K. Tarbell, *The Figurative Tradition and the Whitney Museum of American Art: Painting and Sculpture from the Permanent Collection*. Newark, Del.: University of Delaware Press, 1980.
Howat, John K., John Wilmerding, and Natalie Spassky. *19th-Century America: Paintings and Sculpture*. New York: New York Graphic Society for the Metropolitan Museum of Art, 1970.
Karpel, Bernard, ed. *Arts in America: A Bibliography*. 4 vols. Washington, D.C.: Smithsonian Institution Press for the Archives of American Art, 1979.
McCoubrey, John W., ed. *American Art, 1700–1960: Sources and Documents*. Englewood Cliffs, N.J.: Prentice-Hall, 1965.
McLanathan, Richard B. K. *The American Tradition in the Arts*. New York: Harcourt, Brace & World, 1968.
—— *Art in America: A Brief History*. London: Thames and Hudson, 1973.
Mendelowitz, Daniel M. *A History of American Art*. New York: Holt, Rinehart and Winston, 1970.
Poesch, Jessie J. *The Art of the Old South: Painting, Sculpture, Architecture & the Products of Craftsmen, 1560–1860*. New York: Knopf, 1983.
Prown, Jules David. "Style as Evidence." *Winterthur Portfolio* 15 (1980): 197–210.
Stein, Roger B. *Seascape and the American Imagination*. New York: C. N. Potter, 1975.
Taylor, Joshua C. *The Fine Arts in America*. Chicago: University of Chicago Press, 1979.
Wilmerding, John. *American Art*. New York: Penguin Books, 1976.
—— *American Marine Painting*. New York: Abrams, 1987.

ARCHITECTURE
General

Andrews, Wayne. *Architecture, Ambition, and Americans: A Social History of American Architecture*. New York: Free Press, 1978.
—— *Pride of the South: A Social History of Southern Architecture*. New York: Atheneum, 1979.
Burchard, John Ely, and Albert Bush-Brown. *The Architecture of America*. Boston: Little, Brown, 1966.
Condit, Carl W. *American Building: Materials and Techniques from the First Colonial Settlements to the Present*. Chicago: University of Chicago Press, 1982.
—— *The Chicago School of Architecture: A History of Commercial and Public Building in the Chicago Area, 1875–1925*. Chicago: University of Chicago Press, 1964.
Fitch, James Marston. *American Building*. 2 vols. Boston: Houghton Mifflin Co., 1966–1972.
Forman, Henry Chandlee. *Maryland Architecture; A Short History from 1634 through the Civil War*. Cambridge, Md.: Tidewater Publishers, 1968.
Gowans, Alan. *Images of American Living; Four Centuries of Architecture and Furniture as Cultural Expression*. Philadelphia: Lippincott, 1964.
Hitchcock, Henry Russell. *Rhode Island Architecture*. Providence, R.I.: Rhode Island Museum Press, 1939.
——, and Edgar Kaufmann, Jr., et al. *The Rise of an American Architecture*. New York: Praeger, for the Metropolitan Museum of Art, 1970.
Huxtable, Ada Louise. *The Tall Building Artistically Reconsidered: The Search for a Skyscraper Style*. New York: Pantheon Books, 1984.
Lancaster, Clay. *The Japanese Influence in America*. New York: Abbeville Press, 1983.
Lane, Mills. *Architecture of the Old South: Georgia*. New York: Abbeville Press, 1990.
—— *Architecture of the Old South: North Carolina*. New York: Abbeville Press, 1990.
—— *Architecture of the Old South: South Carolina*. New York: Abbeville Press, 1989.
—— *Architecture of the Old South: Virginia*. Savannah, Ga.: Beehive Press, 1989.
Morrison, Hugh S. *Early American Architecture, from the First Colonial Settlements to the National Period*. New York: Oxford University Press, 1952.
Mumford, Lewis. *Sticks and Stones; A Study of American Architecture and Civilization*. New York: Dover Publications, 1955.
Nochlin, Linda, and Henry A. Millon, eds. *Art and Architecture in the Service of Politics*. Cambridge, Mass.: MIT Press, 1978.
Pierson, William H., Jr. *American Buildings and their Architects:*

The Colonial and Neo-Classical Styles. Garden City, N.Y.: Doubleday & Co., 1970.

—— *American Buildings and their Architects: The Corporate and Early Gothic Styles.* Garden City, N.Y.: Doubleday & Co., 1978.

Placzek, Adolf K., ed. *Macmillan Encyclopedia of Architects.* 4 vols. New York: Macmillan Co., 1982.

Scully, Vincent J. *American Architecture and Urbanism.* New York: H. Holt, 1988.

—— *Modern Architecture; The Architecture of Democracy.* New York: G. Braziller, 1974.

Smith, G. E. Kidder. *A Pictorial History of Architecture in America.* 2 vols. New York: American Heritage Publishing Co., 1976.

Tatum, George B. *Penn's Great Town: 250 Years of Philadelphia Architecture Illustrated in Prints and Drawings.* Philadelphia: University of Pennsylvania Press, 1961.

Whiffen, Marcus, and Frederick Koeper. *American Architecture, 1607–1976.* Cambridge, Mass.: MIT Press, 1981.

Wischnitzer, Rachael. *Synagogue Architecture in the United States: History and Interpretation.* Philadelphia: Jewish Publication Society of America, 1955.

Colonial and Federal

Cummings, Abbott Lowell. *The Framed Houses of Massachusetts Bay, 1625–1725.* Cambridge, Mass.: Harvard University Press, Belknap Press, 1979.

Donnelly, Marian Card. *The New England Meeting Houses of the Seventeenth Century.* Middletown, Conn.: Wesleyan University Press, 1968.

Park, Helen. *A List of Architectural Books Available in America before the Revolution.* Foreword by Adolf K. Placzek. Los Angeles: Hennessey & Ingalls, 1973.

Tatum, George B. *Philadelphia Georgian: The City House of Samuel Powel and some of its Eighteenth-Century Neighbors.* Middletown, Conn.: Wesleyan University Press, 1976.

Whiffen, Marcus. *The Eighteenth-Century Houses of Williamsburg: A Study of Architecture and Building in the Colonial Capital of Virginia.* Williamsburg, Va.: Colonial Williamsburg Foundation, 1984.

—— *The Public Buildings of Williamsburg, Colonial Capital of Virginia; An Architectural History.* Williamsburg, Va.: Colonial Williamsburg, 1958.

Romanticism and Eclecticism, 1830–70

Andrews, Wayne. *American Gothic: Its Origins, its Trials, its Triumphs.* New York: Random House, 1975.

Carrott, Richard G. *The Egyptian Revival: Its Sources, Monuments, and Meaning, 1808–1858.* Berkeley: University of California Press, 1978.

Gayle, Margot. *Cast-Iron Architecture in New York: A Photographic Survey.* New York: Dover Publications, 1974.

Gilchrist, Agnes. *Romanticism and the Gothic Revival* (1938). New York: Gordian Press, 1967.

Hitchcock, Henry Russell. *The Crystal Palace: The Structure, its Antecedents, and its Immediate Progeny.* Northampton, Mass.: Smith College, 1951.

Kennedy, Roger G. *Greek Revival America.* New York: Stewart, Tabori, & Chang, 1989.

Loth, Calder, and Julius T. Sadler, Jr. *The Only Proper Style: Gothic Architecture in America.* Boston: New York Graphic Society, 1975.

Maass, John. *The Victorian Home in America.* New York: Hawthorne Books, 1972.

Stanton, Phoebe B. *The Gothic Revival & American Church Architecture; An Episode in Taste, 1840–1856.* Baltimore: Johns Hopkins University Press, 1968.

Wiebensen, Dora. *Sources of Greek Revival Architecture.* University Park: Pennsylvania State University Press, 1969.

Beaux-Arts Architecture and Skyscrapers, 1870–1900

Condit, Carl W. *The Rise of the Skyscraper: The Genius of Chicago Architecture from the Great Fire to Louis Sullivan.* Chicago: University of Chicago Press, 1952.

Drexler, Arthur, Richard Chafee, et al. *The Architecture of the Ecole des Beaux-Arts.* New York: The Museum of Modern Art, and Cambridge, Mass.: MIT Press, 1977.

Jordy, William H. *American Buildings and their Architects: Progressive and Academic Ideals at the Turn of the Century.* Garden City, N.Y.: Doubleday & Co., 1976.

Scully, Vincent J. *The Architecture of the American Summer: The Flowering of the Shingle Style.* New York: Rizzoli, 1989.

—— *The Shingle Style and the Stick Style; Architectural Theory and Design from Richardson to the Origins of Wright.* New Haven, Conn.: Yale University Press, 1971.

Stillman, Damie, ed. *Architecture & Ornament in Late 19th-Century America.* Newark, Del.: University of Delaware, 1981.

Wilson, Richard Guy, Dianne Pilgrim, and Richard Murray. *The American Renaissance, 1876–1917.* New York: Brooklyn Museum, 1979.

The Modern Period, 1900–40

Hitchcock, Henry Russell, and Philip Johnson. *The International Style: Architecture since 1922.* New York: W. W. Norton, 1932.

Krinsky, Carol Herselle. *Rockefeller Center.* New York: Oxford University Press, 1978.

Lancaster, Clay. *The American Bungalow, 1880–1930.* New York: Abbeville Press, 1985.

Modern Architecture: International Exhibition (The Museum of Modern Art, 1932). New York: Arno Press, 1969.

Robinson, Cervin, and Rosemarie Haag Bletter. *Skyscraper Style: Art Deco New York.* New York: Oxford University Press, 1975.

Modern and Postmodern, 1940 to the Present

Blake, Peter. *Form Follows Fiasco: Why Modern Architecture Hasn't Worked.* Boston: Little, Brown, 1977.

Giedion, Sigfried. *Space, Time, and Architecture; The Growth of a New Tradition.* Cambridge, Mass.: Harvard University Press, 1962.

Hitchcock, Henry Russell, and Arthur Drexler, eds. *Built in the USA: Post-War Architecture.* New York: The Museum of Modern Art, 1952.

Jacobus, John. *Twentieth-Century Architecture: The Middle Years, 1940–1965.* New York: Praeger, 1966.

Jencks, Charles. *The Language of Post-Modern Architecture*. New York: Rizzoli, 1987.

Jordy, William H. *American Buildings and their Architects: The Impact of European Modernism in the Mid-Twentieth Century*. Garden City, N.Y.: Doubleday & Co., 1976.

Klotz, Heinrich, and Douglas Davis, et al. *New York Architecture, 1970–1990*. New York: Rizzoli, 1989.

Marder, Tod A. *The Critical Edge: Controversy in Recent American Architecture*. Cambridge, Mass.: MIT Press, 1985.

Stern, Robert A. M., with Raymond W. Gastil. *Modern Classicism*. New York: Rizzoli, 1988.

ARCHITECTS

Before 1900

AUSTIN, HENRY: Meeks, Carroll L. V. "Henry Austin and the Italian Villa." *Art Bulletin* 30 (June 1948): 145–9.

BADGER, DANIEL: *Badger's Illustrated Catalogue of Cast Iron Architecture* (1865). Introduction by Margo Gayle. New York: Dover Publications, 1981.

BENJAMIN, ASHER: Benjamin, Asher. *The American Builder's Companion* (1806). Introduction by William Morgan. New York: Da Capo Press, 1972.

BOGARDUS, JAMES: Bogardus, James. *Cast Iron Buildings: Their Construction and Advantages*. New York: J. W. Harrison, 1858.

BUCKLAND, WILLIAM: Berine, Rosamond Randall, and John Henry Scarff. *William Buckland, 1734–1774: Architect of Virginia and Maryland*. Baltimore: Maryland Historical Society, 1958.

BULFINCH, CHARLES: Kirker, Harold. *The Architecture of Charles Bulfinch*. Cambridge, Mass.: Harvard University Press, 1969.

BURNHAM, DANIEL: Hines, Thomas S. *Burnham of Chicago, Architect and Planner*. New York: Oxford University Press, 1974.

DAVIS, ALEXANDER JACKSON: Newton, Roger Hale. *Town & Davis, Architects: Pioneers in American Revivalist Architecture, 1812–1870*. New York: Columbia University Press, 1942.

DOWNING, ANDREW JACKSON: Downing, Andrew Jackson. *The Architecture of Country Houses* (1850). Introduction by George B. Tatum. New York: Da Capo Press, 1968. Tatum, George B., and Elisabeth Blair MacDougall, eds. *Prophet with Honor: The Career of Andrew Jackson Downing, 1815–1852*. Philadelphia: Atheneum of Philadelphia, and Washington, D.C.: Dumbarton Oaks Research Library and Collection, 1989.

FURNESS, FRANK: O'Gorman, James F. *The Architecture of Frank Furness*. Philadelphia: University of Pennsylvania, 1987.

GODEFROY, MAXIMILIAN: Alexander, Robert L. *The Architecture of Maximilian Godefroy*. Baltimore: Johns Hopkins University Press, 1974.

HARRISON, PETER: Bridenbaugh, Carl. *Peter Harrison, First American Architect*. Chapel Hill: University of North Carolina Press, 1949.

HAVILAND, JOHN: Baigell, Matthew E. "John Haviland in Philadelphia, 1818–1826." *Journal of the Society of Architectural Historians* 25 (1966): 197–208.

HOBAN, JAMES: Ryan, William, and Desmond Guinness. *The White House: An Architectural History*. New York: McGraw-Hill, 1980.

HOLABIRD & ROCHE: *Holabird & Roche and Holabird & Root: An Illustrated Catalogue of Works, 1800–1940*. Edited by Robert Bruegmann and the Chicago Historical Society. 3 vols. New York: Garland Publishing, 1991.

HUNT, RICHARD MORRIS: Baker, Paul. *Richard Morris Hunt*. Cambridge, Mass.: MIT Press, 1980. Stein, Susan R., ed. *The Architecture of Richard Morris Hunt*. Chicago: University of Chicago Press, 1986.

JEFFERSON, THOMAS: Adams, William Howard. *Jefferson and the Arts: An Extended View*. Washington, D.C.: National Gallery of Art, 1976. Adams, William Howard. *Jefferson's Monticello*. New York: Abbeville Press, 1983.

JENNEY, WILLIAM LE BARON: Turak, Theodore. *William Le Baron Jenney: A Pioneer of Modern Architecture*. Ann Arbor, Mich.: UMI Research Press, 1986.

LAFEVER, MINARD: Landy, Jacob. *The Architecture of Minard Lafever*. New York: Columbia University Press, 1970.

LATROBE, BENJAMIN HENRY: Carter, Edward C., II, ed. *The Papers of Benjamin Henry Latrobe*. Clifton, N.J.: Published for the Maryland Historical Society, 1976+. Hamlin, Talbot F. *Benjamin Henry Latrobe*. New York: Oxford University Press, 1955. Norton, Paul F. *Latrobe, Jefferson, and the National Capitol*. New York: Garland Publishing, 1977.

L'ENFANT, PIERRE-CHARLES: Caemmerer, Paul H. *The Life of Pierre-Charles L'Enfant, Planner of the City of Washington*. Washington, D.C.: National Republic Publishing Co., 1950.

McCOMB, JOHN JR.: Stillman, Damie. "New York City Hall: Competition and Execution." *Journal of the Society of Architectural Historians* 23 (1964): 129–42.

McINTIRE, SAMUEL: Kimball, Fiske. *Mr. Samuel McIntire, Carver: The Architect of Salem* (1940). Gloucester, Mass.: Peter Smith, 1966. Ward, Gerald W. R. *The Gardner-Pingree House*. Salem, Mass.: Essex Institute, 1976. Ward, Gerald W. R. *The Peirce-Nichols House*. Salem, Mass.: Essex Institute, 1976.

McKIM, MEAD, & WHITE: Roth, Leland. *McKim, Mead, & White, Architects*. New York: Harper & Row, 1983. Wilson, Richard Guy. *McKim, Mead, & White, Architects*. 4 vols. New York: Dover Publications, 1990. Wodehouse, Lawrence. *White of McKim, Mead, & White*. New York: Garland Publishing, 1988.

MILLS, ROBERT: Bryan, John Morrill. *Robert Mills, Architect*. Washington, D.C.: American Institute of Architects Press, 1989. Bryan, John Morrill. *Robert Mills, Architect, 1781–1855*. Columbia, S.C.: Columbia Museum of Art, 1976.

OLMSTED, FREDERICK LAW: Kalfus, Melvin. *Frederick Law Olmsted: The Passion of a Public Artist*. New York: New York University Press, 1990. Roper, Laura Wood. *FLO: A Biography of Frederick Law Olmsted*. Baltimore: Johns Hopkins University Press, 1973.

RICHARDSON, HENRY HOBSON: Hitchcock, Henry Russell. *Richardson as a Victorian Architect*. Baltimore: Barton-Gillet, 1966. O'Gorman, James F. *H. H. Richardson: Architectural Forms for an American Society*. Chicago: University of Chicago Press, 1987. Stebbins, Theodore. "Richardson and Trinity Church: The Evolution of a Building." *Journal of the Society of Architectural Historians* 27 (1968): 281–98.

ROEBLING, JOHN AUGUSTUS: Trachtenberg, Alan. *Brooklyn Bridge: Fact and Symbol*. Chicago: University of Chicago Press, 1979.

ROOT, JOHN WELLBORN: Hoffmann, Donald. *The Architecture of John Wellborn Root*. Baltimore: Johns Hopkins University Press, 1973.

SLOAN, SAMUEL: Cooledge, Harold N. *Samuel Sloan, Architect of Philadelphia, 1815–1884*. Philadelphia: University of Pennsylvania Press, 1986.

STRICKLAND, WILLIAM: Gilchrist, Agnes Eleanor Addison. *William Strickland, Architect and Engineer, 1788–1854*. Philadelphia: University of Pennsylvania Press, 1950; New York: Da Capo Press, 1969.

SULLIVAN, LOUIS: Andrew, David S. *Louis Sullivan and the Polemics of Modern Architecture: The Present against the Past*. Urbana: University of Illinois Press, 1985. Sullivan, Louis. *The Autobiography of an Idea* (1924). New York: Dover Publications, 1956. Sullivan, Louis. *Kindergarten Chats and Other Writings* (1934). New York: Dover Publications, 1980. Twombly, Robert C. *Louis Sullivan: His Life and Work*. New York: Viking, 1986.

THORNTON, WILLIAM: Stearns, Elinor, and David N. Yerkes. *William Thornton: A Renaissance Man in the Federal City*. Washington, D.C.: AIA Foundation, 1976.

TOWN, ITHIEL: Newton, Roger Hale. *Town & Davis, Architects: Pioneers in American Revivalist Architecture, 1812–1870*. New York: Columbia University Press, 1942.

UPJOHN, RICHARD: Upjohn, Everard Miller. *Richard Upjohn, Architect and Churchman*. New York: Columbia University Press, 1939.

VAN BRUNT, HENRY: Coles, William A., ed. *Architecture and Society; Selected Essays of Henry van Brunt*. Cambridge, Mass.: Harvard University Press, Belknap Press, 1969.

VAUGHAN, HENRY: Morgan, William. *The Almighty Wall: The Architecture of Henry Vaughan*. New York: Architectural History Foundation, and Cambridge, Mass.: MIT Press, 1983.

VAUX, CALVERT: Vaux, Calvert. *Villas and Cottages* (1857). New York: Dover Publications, 1970.

WALTER, THOMAS USTICK: Gilchrist, Agnes Addison. "Girard College: An Example of the Layman's Influence on Architecture." *Journal of the Society of Architectural Historians* 16, no. 2 (1957): 22–5.

WIGHT, PETER B.: Landau, Sarah Bradford. *P. B. Wight— Architect, Contractor, and Critic, 1838–1925*. Chicago: Art Institute of Chicago, 1981.

After 1900

THE ARCHITECTS' COLLABORATIVE: Gropius, Walter, and Sarah Harkness, eds. *The Architects' Collaborative, 1945–1964*. New York: Architectural Book Publishing Co., 1966.

BREUER, MARCEL: Papachristou, Tician. *Marcel Breuer: New Buildings and Projects*. New York: Praeger, 1970.

BUNSHAFT, GORDON: Krinsky, Carol Herselle. *Gordon Bunshaft of Skidmore, Owings & Merrill*. New York: Architectural History Foundation, and Cambridge, Mass.: MIT Press, 1988.

CRAM, RALPH ADAMS: Tucci, Douglass S. *Ralph Adams Cram, American Medievalist*. Boston: Boston Public Library, 1975.

CRET, PAUL: White, Theophilus Ballou. *Paul Philippe Cret, Architect and Teacher*. Philadelphia: Art Alliance Press, 1973.

GILL, IRVING: Kamerling, Bruce. *Irving Gill: The Artist as Architect*. San Diego, Calif.: San Diego Historical Society, 1979.

GRAVES, MICHAEL: Jencks, Charles. *Kings of Infinite Space: Frank Lloyd Wright and Michael Graves*. New York: St. Martin's Press, 1983. *Michael Graves, Buildings and Projects, 1982–1988*. Edited by Karen Vogel, et al. New York: Princeton Architectural Press, 1989.

GREENE & GREENE: Makinson, Randell L. *Greene & Greene*. 2 vols. Salt Lake City: Peregrine Smith, 1977–9.

GROPIUS, WALTER: Giedion, Sigfried. *Walter Gropius: Work and Teamwork*. New York: Reinhold Publishing Corp., 1954. Gropius, Walter. *Scope of Total Architecture*. New York: Harper & Row, 1955. Herdeg, Klaus. *The Decorated Diagram: Harvard Architecture and the Failure of the Bauhaus Legacy*. Cambridge, Mass.: MIT Press, 1983.

HARRISON, WALLACE K.: Newhouse, Victoria. *Wallace K. Harrison, Architect*. New York: Rizzoli, 1989.

HOOD, RAYMOND: Kilham, Walter H. *Raymond Hood, Architect: Form through Function in the American Skyscraper*. New York: Architectural Book Publishing Co., 1974. Stern, Robert A. M. *Raymond Hood*. New York: Rizzoli International Publications, 1982.

HOWE, GEORGE: Stern, Robert A. M. *George Howe: Toward a Modern American Architecture*. New Haven, Conn.: Yale University Press, 1975.

JOHNSON, PHILIP: Johnson, Philip. *Writings*. New York: Oxford University Press, 1979. *Philip Johnson, Processes: The Glass House, 1949, and the AT&T Corporate Headquarters, 1978*. New York: Institute for Architecture and Urban Studies, 1978.

KAHN, LOUIS I.: Latour, Alexandra, ed. *Louis I. Kahn, Writings, Lectures, Interviews*. New York: Rizzoli International Publications, 1991. Ronner, Heinz, et al. *Louis I. Kahn: Complete Works, 1935–74*. Boulder, Colo.: Westview Press, 1977. Tyng, Alexandra. *Beginnings: Louis I. Kahn's Philosophy of Architecture*. New York: Wiley, 1984.

LESCAZE, WILLIAM: Lanmon, Lorraine Welling. *William Lescaze, Architect*. Philadelphia: Art Alliance Press, 1987.

MAYBECK, BERNARD R.: Cardwell, Kenneth H. *Bernard Maybeck: Artisan, Architect, Artist*. Santa Barbara, Calif.: Peregrine Smith, 1977.

MEIER, RICHARD: Frampton, Kenneth. *Richard Meier, Architect: Buildings and Projects, 1966–1976*. New York: Oxford University Press, 1976.

MIES VAN DER ROHE, LUDWIG: Carter, Peter. *Mies van der Rohe at Work*. New York: Praeger, 1974. Johnson, Philip. *Mies van der Rohe* (1947). New York: The Museum of Modern Art, 1978. Schulze, Franz. *Mies van der Rohe: A Critical Biography*. Chicago: University of Chicago Press, 1985.

MOORE, CHARLES W.: Bloomer, Kent, and Charles Moore. *Body, Memory, and Architecture*. New Haven, Conn.: Yale University Press, 1977.

NEUTRA, RICHARD: Hines, Thomas S. *Richard Neutra and the Search for Modern Architecture: A Biography and History*. New York: Oxford University Press, 1982. Neutra, Richard. *Survival through Design*. New York: Oxford University Press, 1954.

ROCHE, KEVIN, and DINKELOO, JOHN: Dal Co, Francesco, ed. *Kevin Roche*. New York: Rizzoli, 1985. *Kevin Roche, John Dinkeloo and Associates, 1962–1975*. Introduction by Henry

Russell Hitchcock. New York: Architectural Book Publishing Co., 1977.
RUDOLPH, PAUL: Spade, Rupert. *Paul Rudolph*. New York: Simon & Schuster, 1971.
SAARINEN, EERO: Saarinen, Aline, ed. *Eero Saarinen on his Work*. New Haven, Conn.: Yale University Press, 1962. Spade, Rupert. *Eero Saarinen*. New York: Simon & Schuster, 1968.
SAARINEN, ELIEL: Christ-Janer, Albert. *Eliel Saarinen: Finnish-American Architect and Educator*. Foreword by Alvar Aalto. Chicago: University of Chicago Press, 1979.
SCHINDLER, RUDOLF: Gebhard, David. *Schindler* (1971). Santa Barbara, Calif.: Peregrine Press, 1980.
SKIDMORE, OWINGS & MERRILL: Bush-Brown, Albert. *Skidmore, Owings & Merrill: Architecture and Urbanism, 1973–1983*. New York: Van Nostrand Reinhold, 1983. Drexler, Arthur, and Axel Menges. *The Architecture of Skidmore, Owings & Merrill: 1963–1973*. New York: Architectural Book Publishing Co., 1974.
STERN, ROBERT A. M.: *Robert Stern*. Introduction by Vincent J. Scully. London: Architectural Design, 1981.
VENTURI, ROBERT: Scully, Vincent J., et al. *The Architecture of Robert Venturi*. Albuquerque: University of New Mexico Press, 1989. Venturi, Robert. *Complexity and Contradiction in Architecture*. New York: The Museum of Modern Art, and Boston: New York Graphic Society, 1977. Venturi, Robert, Denise Scott Brown, and Steven Izenour. *Learning from Las Vegas*. Cambridge, Mass.: MIT Press, 1977.
WRIGHT, FRANK LLOYD: Storrer, William Allin. *The Architecture of Frank Lloyd Wright: A Complete Catalogue*. Cambridge, Mass.: MIT Press, 1978. Twombly, Robert C. *Frank Lloyd Wright: An Interpretive Biography*. New York: Harper & Row, 1973. Wright, Frank Lloyd. *An Autobiography* (1932). New York: Duell, Sloan and Pearce, 1943; New York: Horizon Press, 1977. Wright, Frank Lloyd. *An Organic Architecture: The Architecture of Democracy*. London: Lund, Humphries & Co., 1939. Wright, Frank Lloyd. *Genius and Mobocracy* (1949). New York: Horizon Press, 1971.

DECORATIVE ARTS
General

Buhler, Kathryn C., and Graham Hood. *American Silver, Garvan and Other Collections in the Yale University Art Gallery*. New Haven, Conn.: Yale University Press, 1970.
Cooper, Wendy A. *In Praise of America: American Decorative Arts, 1650–1830*. New York: Knopf, 1980.
Davidson, Marshall B., and Elizabeth Stillinger. *The American Wing in the Metropolitan Museum of Art*. New York: Metropolitan Museum of Art, 1985.
Denker, Ellen. *After the Chinese Taste: China's Influence in America, 1730–1930*. Salem, Mass.: Peabody Museum of Salem, 1985.
Fairbanks, Jonathan, and Elizabeth Bidwell Bates. *American Furniture, 1620 to the Present*. New York: R. Marek, 1981.
Fales, Martha Gandy. *American Silver in the Henry Francis du Pont Winterthur Museum*. Winterthur, Del.: The Henry Francis du Pont Winterthur Museum, 1958.
Heckscher, Morrison H. *American Furniture in the Metropolitan Museum of Art*. New York: Metropolitan Museum of Art and Random House, 1985.
Naeve, Milo M. *Identifying American Furniture: A Pictorial Guide to Styles and Terms, Colonial to Contemporary*. Nashville, Tenn.: American Association for State and Local History, 1981.
Poesch, Jessie Jean. *Early Furniture of Louisiana*. New Orleans: Louisiana State Museum, 1972.

Colonial

Fairbanks, Jonathan, Robert Trent, et al. *New England Begins: The Seventeenth Century*. 3 vols. Boston: Museum of Fine Arts, 1982.
Kane, Patricia E. *Furniture of the New Haven Colony: The Seventeenth-Century Style*. New Haven, Conn.: New Haven Colony Historical Society, 1973.
Philadelphia Silver, 1682–1800, at the Philadelphia Museum of Art. Philadelphia: Philadelphia Museum of Art, 1956.
Quimby, Ian M. G., ed. *Arts of the Anglo-American Community in the Seventeenth Century*. Charlottesville, Va.: University Press of Virginia, for The Henry Francis du Pont Winterthur Museum, 1975.
———, ed. *The Craftsman in Early America*. New York: W. W. Norton, 1984.
Trent, Robert, ed. *Pilgrim Century Furniture: An Historical Survey*. New York: Main Street/Universe Books, 1976.
Whitehill, Walter Muir, Brock Jobe, and Jonathan Fairbanks, eds. *Boston Eighteenth-Century Furniture*. Boston: Colonial Society of Massachusetts, 1974.

Federal

Bordes, Marilyn Johnson. *Baltimore Federal Furniture in the American Wing*. New York: Metropolitan Museum of Art, 1972.
Garvan, Beatrice B. *Federal Philadelphia, 1785–1825: The Athens of the Western World*. Philadelphia: Philadelphia Museum of Art, 1987.
Gerdts, William H., and Berry Tracy. *Classical America, 1815–1845*. Newark, N.J.: Newark Museum, 1963.
Montgomery, Charles F. *American Furniture, the Federal Period, in the Henry Francis du Pont Winterthur Museum*. New York: Viking, 1966.
———, and Patricia E. Kane, eds. *American Art, 1750–1800: Towards Independence*. Boston: New York Graphic Society, for Yale University Art Gallery, 1976.
Mudge, Jean McClure. *Chinese Export Porcelain in North America*. New York: C. N. Potter, 1986.
Neoclassicism in the Decorative Arts: France, England, and America. Wilmington, Del.: The Henry Francis du Pont Winterthur Museum, 1971.

Romanticism and Eclecticism, 1830–70

Davidson, Marshall B. *The American Heritage History of American Antiques from the Revolution to the Civil War*. New York: American Heritage Publishing Co., 1968.
The Greek Revival in the United States. New York: Metropolitan Museum of Art, 1943.
Howe, Katherine S., and David B. Warren. *The Gothic Revival*

Style in America, 1830–1870. Houston, Tex.: Museum of Fine Arts, 1976.

Victorian Silverplated Holloware. Princeton, N.J.: Pyne Press, 1972.

Beaux-Arts Style and the Aesthetic Movement, 1870–1900

Burke, Doreen Bolger, et al. *In Pursuit of Beauty: Americans and the Aesthetic Movement.* New York: Rizzoli, for the Metropolitan Museum of Art, 1986.

Madigan, Mary Jean Smith. *Eastlake-Influenced American Furniture, 1870–1890.* Yonkers, N.Y.: Hudson River Museum, 1973.

Selz, Peter. *Art Nouveau; Art and Design at the Turn of the Century.* New York: The Museum of Modern Art, 1975.

Spencer, Robin, et al. *The Aesthetic Movement and the Cult of Japan.* London: Fine Arts Society, 1972.

Arts and Crafts, Art Deco, and the Machine, 1900–40

Clark, Robert Judson. *The Arts and Crafts Movement in America, 1876–1916.* Princeton, N.J.: Princeton University Press, 1972.

———, et al. *Design in America: The Cranbrook Vision, 1925–1950.* New York: Abrams, 1983.

Giedion, Sigfried. *Mechanization takes Command; A Contribution to Anonymous History.* New York: Oxford University Press, 1948.

Hillier, Bevis. *Art Deco of the '20s and '30s.* New York: Schocken Books, 1985.

Kaplan, Wendy. *"The Art that is Life": The Arts and Crafts Movement in America, 1875–1920.* Boston: Little, Brown, 1987.

Scheidig, Walter. *Crafts of the Bauhaus, 1919–1924.* New York: Reinhold Publishers, 1967.

Volpe, Todd, Beth Cathers, and Alastair Duncan. *Treasures of the American Arts and Crafts Movement, 1890–1920.* New York: H. N. Abrams, 1988.

Wingler, Hans Maria. *The Bauhaus: Weimar, Dessau, Berlin, Chicago* (1962). Cambridge, Mass.: MIT Press, 1979.

Modern and Postmodern, 1940 to the Present

Drexler, Arthur, and Greta Daniel. *Introduction to Twentieth-Century Design, from the Collection of The Museum of Modern Art.* Garden City, N.Y.: Doubleday & Co., for The Museum of Modern Art, 1959.

Kaufmann, Edgar, Jr. *Introductions to Modern Design: What is Modern Design? What is Modern Interior Design?* (1950). New York: Da Capo Press, 1969.

———. *Prize Designs for Modern Furniture from the International Competition for Low Cost Furniture Design.* New York: The Museum of Modern Art, 1950.

Miller, Craig. *Modern Design, 1890–1990, in the Metropolitan Museum of Art.* New York: Metropolitan Museum of Art, 1991.

Noyes, Eliot F. *Organic Design in Home Furnishings.* New York: The Museum of Modern Art, 1941.

ARTISANS AND DESIGNERS

BELTER, JOHN HENRY: Schwartz, Marvin D., Edward J. Stanek, and Douglas K. True. *The Furniture of John Henry Belter and the Rococo Revival: An Inquiry into Nineteenth-Century Furniture Design through a Study of the Gloria and Richard Manney Collection.* New York: E. P. Dutton, 1981.

BREUER, MARCEL: Wilk, Christopher. *Marcel Breuer, Furniture and Interiors.* New York: The Museum of Modern Art, 1981.

DESKEY, DONALD: Hanks, David A., with Jennifer Toher. *Donald Deskey: Decorative Designs and Interiors.* New York: E. P. Hutton, 1987.

EAMES, CHARLES: Drexler, Arthur. *Furniture from the Design Collection.* New York: The Museum of Modern Art, 1973.

KNOLL INTERNATIONAL: Larrabee, Eric, and Massimo Vignelli. *Knoll Design.* New York: H. N. Abrams, 1981.

LA FARGE, JOHN: Weinberg, Helene Barbara. *The Decorative Work of John La Farge.* New York: Garland Publishing Co., 1977.

MIES VAN DER ROHE, LUDWIG: Glaeser, Ludwig. *Ludwig Mies van der Rohe: Furniture and Furniture Design.* New York: The Museum of Modern Art, 1977.

NAKASHIMA, GEORGE: Ostergard, Derek E. *George Nakashima: Full Circle.* New York: Weidenfeld & Nicolson, 1989.

PHYFE, DUNCAN: McClelland, Nancy V. *Duncan Phyfe and the English Regency, 1795–1830.* New York: W. R. Scott, 1939.

REVERE, PAUL: Buhler, Kathryn C. *Paul Revere, Goldsmith, 1735–1818.* Boston: Museum of Fine Arts, 1956. Fairbanks, Jonathan, Walter Muir Whitehill, et al. *Paul Revere's Boston, 1735–1818.* Boston: Museum of Fine Arts, 1975.

RICHARDSON, JOSEPH: Fales, Martha Gandy. *Joseph Richardson and Family, Philadelphia Silversmiths.* Middletown, Conn.: Wesleyan University Press, for the Historical Society of Pennsylvania, 1974.

STICKLEY, GUSTAV: Freeman, John C. *Gustav Stickley and his Craftsman Mission Furniture.* Watkins Glen, N.Y.: Century House, 1966. Stickley, Gustav. *Craftsman Homes.* New York: The Craftsman Publishing Co., 1909.

TIFFANY, LOUIS COMFORT: Duncan, Alastair, Martin Eidelberg, and Neil Harris. *Masterworks of Louis Comfort Tiffany.* Washington, D.C.: Renwick Gallery, 1989. Koch, Robert. *Louis C. Tiffany's Art Glass.* New York: Crown Publishers, 1977. Potter, Norman, and Douglas Jackson. *Tiffany Glassware.* New York: Crown Publishers, 1988.

PAINTING

General

Baigell, Matthew. *A History of American Painting.* New York: Praeger, 1971.

Gerdts, William H. *The Great American Nude; A History in Art.* New York: Praeger, 1974.

———, and Russel Burke. *American Still-Life Painting.* New York: Praeger, 1971.

———, and Mark Thistlethwaite. *Grand Illusions: History Painting in America.* Fort Worth, Tex.: Amon Carter Museum, 1988.

Johns, Elizabeth. *American Genre Painting, The Politics of Everyday Life.* New Haven and London: Yale University

Press, 1991.

Nochlin, Linda, *Realism*. Harmondsworth, Middlesex, UK: Penguin Books, 1971.

———. *Realism and Tradition in Art, 1848–1900; Sources and Documents*. Englewood Cliffs, N.J.: Prentice-Hall, 1966.

Novak, Barbara, Elizabeth Garrity Ellis, et al. *Nineteenth-Century American Painting*. New York: Vendome Press, 1986.

Prown, Jules David, and Barbara Rose. *American Painting: From the Colonial Period to the Present*. New York: Rizzoli, 1980.

Quick, Michael, Marvin Sadik, and William H. Gerdts. *American Portraiture in the Grand Manner, 1720–1920*. Los Angeles: Los Angeles County Museum of Art, 1981.

Rose, Barbara. *American Painting: The Twentieth Century*. New York: Rizzoli, 1986.

Stebbins, Theodore E. *American Master Drawings and Watercolors: A History of Works on Paper from Colonial Times to the Present*. New York: Harper & Row, 1976.

Williams, Hermann Warner. *Mirror to the American Past; A Survey of American Genre Painting, 1750–1900*. Greenwich, Conn.: New York Graphic Society, 1973.

Wilmerding, John, et al. *The Genius of American Painting*. New York: Morrow, 1973.

Colonial and Federal

Craven, Wayne. *Colonial American Portraiture: The Economic, Religious, Social, Cultural, Philosophical, Scientific, and Aesthetic Foundations*. New York: Cambridge University Press, 1986.

Dickson, Harold E. *Arts of the Young Republic; The Age of William Dunlap*. Chapel Hill, N.C.: University of North Carolina Press, 1968.

Dresser, Louisa. *XVIIth-Century Painting in New England*. Worcester, Mass.: Worcester Art Museum, 1935.

Miles, Ellen, and Richard Saunders. *American Colonial Portraits, 1700–1776*. Washington, D.C.: Smithsonian Institution Press, for the National Portrait Gallery, 1987.

Nygren, Edward, and Bruce Robertson. *Views and Visions: American Landscape before 1830*. Washington, D.C.: Corcoran Gallery of Art, 1986.

Quimby, Ian M. G., ed. *American Painting to 1776: A Reappraisal*. Charlottesville, Va.: University Press of Virginia, for The Henry Francis du Pont Winterthur Museum, 1971.

Romanticism, 1830–70

Callow, James T. *Kindred Spirits; Knickerbocker Writers and American Artists, 1807–1855*. Chapel Hill, N.C.: University of North Carolina, 1967.

Ferber, Linda S., and William H. Gerdts. *The New Path; Ruskin and the American Pre-Raphaelites*. Brooklyn, N.Y.: Brooklyn Museum, 1985.

Foshay, Ella M. *Luman Reed's Picture Gallery: A Pioneer Collection of American Art*. Introduction by Wayne Craven. New York: H. N. Abrams, 1990.

Gerdts, William H. *Revealed Masters: 19th-Century American Art*. New York: American Federation of Arts, 1974.

Hills, Patricia. *The Painters' America: Rural and Urban Life, 1810–1910*. New York: Praeger, 1974.

Howat, John K. *American Paradise: The World of the Hudson River School*. New York: Metropolitan Museum of Art and

H. N. Abrams, 1987.

Huntington, David C. *Art and the Excited Spirit: America in the Romantic Period*. Ann Arbor, Mich.: University of Michigan Museum of Art, 1972.

Jaffe, Irma B., ed. *The Italian Presence in American Art, 1760–1860*. New York: Fordham University Press, 1989.

McShine, Kynaston, Barbara Novak, Robert Rosenblum, and John Wilmerding. *The Natural Paradise: Painting in America, 1800–1950*. New York: The Museum of Modern Art, 1976.

Novak, Barbara. *American Painting in the Nineteenth Century: Realism, Idealism, and the American Experience*. New York: Harper & Row, 1979.

———. *Nature and Culture: American Landscape and Painting, 1825–1875*. New York: Oxford University Press, 1980.

Stein, Roger B. *John Ruskin and Aesthetic Thought in America, 1840–1900*. Cambridge, Mass.: Harvard University Press, 1967.

Wilmerding, John, et al. *American Light: The Luminist Movement, 1850–1875, Paintings, Drawings, Photographs*. New York: Harper & Row, for the National Gallery of Art, 1980.

Wolf, Bryan Jay. *Romantic Revision: Culture and Consciousness in Nineteenth-Century American Painting and Literature*. Chicago: University of Chicago Press, 1982.

The Gilded Age, 1870–1900

Bermingham, Peter. *American Art in the Barbizon Mood*. Washington, D.C.: Smithsonian Institution Press, for the National Collection of Fine Arts, 1975.

Boyle, Richard J. *American Impressionism*. Boston: New York Graphic Society, 1974.

Fink, Lois Marie. *American Art at the Nineteenth-Century Paris Salons*. New York: Cambridge University Press, and Washington, D.C.: Smithsonian Institution Press, for the National Museum of American Art, 1990.

Frankenstein, Alfred. *The Reality of Appearance; The Trompe l'Oeil Tradition in American Painting*. Greenwich, Conn.: New York Graphic Society, in association with the National Gallery of Art, 1970.

Gerdts, William H. *American Impressionism*. New York: Abbeville Press, 1984.

Hills, Patricia. *Turn-of-the-Century America: Paintings, Graphics, Photographs, 1890–1910*. New York: Whitney Museum of American Art, 1977.

Marling, Karal Ann. *George Washington Slept Here: Colonial Revivals and American Culture*. Cambridge, Mass.: Harvard University Press, 1988.

Quick, Michael, Eberhard Ruhmer, and Richard V. West. *Munich & American Realism in the 19th Century*. Sacramento, Calif.: E. B. Crocker Art Gallery, 1978.

Weisberg, Gabriel P., and Yvonne M. L. Weisberg. *Japonisme, An Annotated Bibliography*. New York: Garland Publishing, 1989.

1900 to 1940

Agee, William C. *The 1930s: Painting & Sculpture in America*. New York: Whitney Museum of American Art, 1968.

———. *Synchromism and Color Principles in American Painting, 1910–1930*. New York: Knoedler Galleries, 1965.

Baigell, Matthew. *The American Scene: American Painting of the 1930s*. New York: Praeger, 1974.

Brown, Milton Wolf. *American Painting: From the Armory Show to the Depression*. Princeton, N.J.: Princeton University Press, 1955.

———. *The Story of the Armory Show*. Greenwich, Conn.: New York Graphic Society, 1963.

Dreier, Katherine. *Collection of the Société Anonyme: Museum of Modern Art, 1920*. New Haven, Conn.: Yale University Press, 1950.

Hills, Patricia. *Social Concern and Urban Realism: American Painting of the 1930s*. Boston: Boston University Art Gallery, 1983.

Homer, William Innes. *Alfred Stieglitz and the American Avant-Garde*. Boston: New York Graphic Society, 1977.

———, et al. *Avant-Garde Painting & Sculpture in America, 1910–1925*. Wilmington, Del.: Delaware Art Museum, 1975.

Kingsbury, Martha. *Art of the Thirties: The Pacific Northwest*. Seattle: University of Washington Press, for the Henry Art Gallery, 1972.

Levin, Gail. *Synchromism and American Color Abstraction, 1910–1925*. New York: G. Braziller, 1978.

Lippard, Lucy, ed. *Dadas on Art*. Englewood Cliffs, N.J.: Prentice-Hall, 1971.

Marling, Karal Ann. *Wall-to-Wall America: A Cultural History of Post Office Murals in the Great Depression*. Minneapolis: University of Minneapolis Press, 1982.

Martin, Marianne Winter, ed. *The Louise and Walter Arensberg Collection*. Philadelphia: N.p., 1954.

Mellow, James R. *Charmed Circle: Gertrude Stein & Company*. New York: Praeger, 1974.

Mumford, Lewis. *The Myth of the Machine*. New York: Harcourt, Brace & World, 1967.

O'Connor, Francis V. *Federal Support for the Visual Arts: The New Deal and Now*. Greenwich, Conn.: New York Graphic Society, 1969.

———, ed. *The New Deal Art Projects; An Anthology of Memoirs*. Washington, D.C.: Smithsonian Institution Press, 1972.

Rubin, William S. *Dada and Surrealist Art*. New York: H. N. Abrams, 1968.

Wilson, Richard Guy, Dianne H. Pilgrim, and Dickran Tashjian. *The Machine Age in America, 1918–1941*. New York: Brooklyn Museum, 1986.

Young, Mahonri Sharp. *American Realists, Homer to Hopper*. New York: Watson-Guptill, 1977.

———. *The Eight; The Realist Revolt in American Painting*. New York: Watson-Guptill, 1973.

Modern to Post-Painterly Modern, 1940 to the Present

Arnason, H. H. *American Abstract Expressionists and Imagists*. New York: Solomon R. Guggenheim Museum, 1961.

Beardsley, John, and Jane Livingston. *Hispanic Art in the United States: Thirty Contemporary Painters and Sculptors*. Houston: Museum of Fine Arts, and New York: Abbeville Press, 1987.

Compton, Michael. *Pop Art*. New York: Hamlyn, 1970.

Cowart, Jack. *New/Photo Realism: Painting and Sculpture of the 1970s*. Hartford, Conn.: Wadsworth Atheneum, 1974.

Finch, Christopher. *Pop Art: Object and Image*. London: Studio Vista, 1968.

Hess, Thomas B. *Abstract Painting; Background and American Phase*. New York: Viking Press, 1951.

Hobbs, Robert Carleton, and Gail Levin. *Abstract Expressionism, the Formative Years*. Ithaca, N.Y.: Herbert F. Johnson Museum of Art, Cornell University, 1978.

Levy, Julien. *Surrealism* (1936). New York: Arno Press, 1968.

Lippard, Lucy. *Pop Art*. London: Thames and Hudson, 1966.

Lucie-Smith, Edward. *Art Now: From Abstract Expressionism to Superrealism*. New York: Morrow, 1981.

Meyer, Ursula. *Conceptual Art*. New York: E. P. Dutton, 1972.

Motherwell, Robert, ed. *The Dada Painters and Poets: An Anthology*. Boston: G. K. Hall, 1981.

"Photo Realism." *Art in America* 60 (Nov.–Dec. 1972): 58–107.

Pincus-Witten, Robert. *Against Order: Chance and Art*. Philadelphia: University of Pennsylvania Press, 1970.

———. *Postminimalism into Maximalism: American Art, 1966–1986*. Ann Arbor, Mich.: UMI Research Press, 1986.

Rose, Barbara. *Autocritique: Essays on Art and Anti-Art, 1963–1987*. New York: Weidenfeld & Nicolson, 1988.

Rosenberg, Harold. *The De-Definition of Art; Action Art to Pop to Earthworks*. New York: Horizon Press, 1972.

Rosenblum, Robert. *Modern Painting and the Northern Romantic Tradition: Friedrich to Rothko*. New York: Harper & Row, 1975.

Russell, John, and Suzi Gablik. *Pop Art Redefined*. New York: Praeger, 1969.

Sandler, Irving. *Abstract Expressionism: The Triumph of American Painting*. London: Pall Mall, 1970.

———. *American Art of the 1960s*. New York: Harper & Row, 1988.

Shapiro, David, and Cecile Shapiro. *Abstract Expressionism: A Critical Record*. New York: Cambridge University Press, 1990.

Ward, John L. *American Realist Painting, 1945–1980*. Ann Arbor, Mich.: UMI Research Press, 1988.

PAINTERS

Before 1900

ALLSTON, WASHINGTON: Bjelajac, David. *Millennial Desire and the Apocalyptic Vision of Washington Allston*. Washington, D.C.: Smithsonian Institution Press, 1988. Gerdts, William H., and Theodore E. Stebbins, Jr. *"A Man of Genius," The Art of Washington Allston*. Boston: Museum of Fine Arts, 1979.

AUDUBON, JOHN JAMES: Ford, Alice. *John James Audubon: A Biography*. New York: Abbeville Press, 1988. Fries, Waldemar H. *The Double Elephant Folio: The Story of Audubon's Birds of America*. New York: Abbeville Press, 1985.

BEAUX, CECILIA: *Cecilia Beaux: Portrait of an Artist*. Philadelphia: Pennsylvania Academy of the Fine Arts, 1974.

BIERSTADT, ALBERT: Anderson, Nancy K., and Linda S. Ferber. *Albert Bierstadt: Art and Enterprise*. New York: Hudson Hills Press, in connection with the Brooklyn Museum, 1990. Baigell, Matthew. *Albert Bierstadt*. New York: Watson-Guptill, 1981. Hendricks, Gordon. *Albert Bierstadt: Painter of the American West*. New York: Abrams, 1975.

BINGHAM, GEORGE CALEB: Block, Maurice. *The Paintings of George Caleb Bingham: A Catalogue Raisonné*. Columbia: University of Missouri Press, 1986. Shapiro, Michael, ed. *George Caleb Bingham*. St. Louis: Saint Louis Art Museum, with H. N. Abrams, 1990.

BLAKELOCK, RALPH A.: Gebhard, David, and Phyllis Stuurman. *The Enigma of Ralph A. Blakelock*. Santa Barbara: University of California, 1969. Geske, Norman. *Ralph Albert Blakelock, 1847–1919*. Lincoln: University of Nebraska Press for the Sheldon Memorial Art Gallery, 1975.

BLYTHE, DAVID GILMOUR: Chambers, Bruce W. *The World of David Gilmour Blythe (1815–1865)*. Washington, D.C.: Smithsonian Institution Press for the National Collection of Fine Arts, 1980.

BRIDGES, CHARLES: Hood, Graham. *Charles Bridges and William Dering: Two Virginia Painters, 1735–1750*. Williamsburg, Va.: Colonial Williamsburg Foundation, 1978.

CASSATT, MARY: Breeskin, Adelyn. *Mary Cassatt: A Catalogue Raisonné of the Oils, Pastels, Watercolors, and Drawings*. Washington, D.C.: Smithsonian Institution Press, 1970. Getlein, Franklin. *Mary Cassatt, Paintings and Prints*. New York: Abbeville Press, 1980. Pollock, Griselda. *Mary Cassatt*. New York: Harper & Row, 1980.

CATLIN, GEORGE: Truettner, William H. *The Natural Man Observed: A Study of Catlin's Indian Gallery*. Washington, D.C.: Smithsonian Institution Press, 1979.

CHASE, WILLIAM MERRITT: Atkinson, D. Scott, and Nicolai Cikovsky, Jr. *William Merritt Chase: Summers at Shinnecock, 1891–1902*. Washington, D.C.: National Gallery of Art, 1987.

CHURCH, FREDERIC EDWIN: Kelly, Franklin. *Frederic Edwin Church and the National Landscape*. Washington, D.C.: Smithsonian Institution Press, 1988. Kelly, Franklin, et al. *Frederic Edwin Church*. Washington, D.C.: National Gallery of Art, 1989. Stebbins, Theodore E., Jr. *Close Observation: Selected Oil Sketches from the Collections of the Cooper-Hewitt Museum*. Washington, D.C: Smithsonian Institution Press, 1978.

COLE, THOMAS: Noble, Louis L. *The Life and Works of Thomas Cole (1853)*. Edited by Elliot S. Vesell. Cambridge, Mass.: Harvard University Press, Belknap Press, 1964. Parry, Ellwood C., III. *The Art of Thomas Cole: Ambition and Imagination*. Newark, Del.: University of Delaware Press, 1988. Powell, Earl A. *Thomas Cole*. New York: H. N. Abrams, 1990.

COPLEY, JOHN SINGLETON: Prown, Jules David. *John Singleton Copley*. 2 vols. Cambridge, Mass.: Harvard University Press, for the National Gallery of Art, 1966. Prown, Jules David. *John Singleton Copley, 1738–1815*. Washington, D.C.: National Gallery of Art, 1965.

CROPSEY, JASPER F.: Brennecke, Mishoe. *Jasper F. Cropsey, Artist and Architect*. Essays by Ella M. Foshay and Barbara Finney. New York: New-York Historical Society, 1987.

CURRIER AND IVES: Conningham, Frederic A. *Currier & Ives Prints, An Illustrated Check List*. New York: Crown Publishers, 1970. *Currier & Ives: A Catalogue Raisonné*. Introduction by Bernard F. Reilly. 2 vols. Detroit: Gale Research Company, 1983.

DURAND, ASHER BROWN: Durand, John. *The Life and Times of A. B. Durand (1894)*. New York: Kennedy Graphics, 1970. Lawall, David B. *Asher B. Durand: A Documentary Catalogue of the Narrative and Landscape Paintings*. New York: Garland Publishing Co., 1978.

DURRIE, GEORGE HENRY: Hutson, Martha Young. *George Henry Durrie, 1820–1863: American Winter Landscapist, Renowned through Currier & Ives*. Santa Barbara, Calif.: Santa Barbara Museum of Art, 1977.

DUVENECK, FRANK: Quick, Michael. *An American Painter Abroad: Frank Duveneck's European Years*. Cincinnati: Cincinnati Art Museum, 1987.

EAKINS, THOMAS: Fried, Michael. *Realism, Writing, Disfiguration: On Thomas Eakins and Stephen Crane*. Chicago: University of Chicago Press, 1987. Goodrich, Lloyd. *Thomas Eakins*. 2 vols. Cambridge, Mass.: Harvard University Press, for the National Gallery of Art, 1982. Homer, William. *Thomas Eakins: His Life and Art*. New York: Abbeville Press, 1992. Johns, Elizabeth. *Thomas Eakins, The Heroism of Modern Life*. Princeton, N.J.: Princeton University Press, 1983. Lubin, David M. *Act of Portrayal: Eakins, Sargent, James*. New Haven: Yale University Press, 1985.

EARL, RALPH: Kornhauser, Elizabeth. *Ralph Earl: The Face of the Young Republic*. New Haven, Conn.: Yale University Press, and Hartford: Wadsworth Atheneum, 1991.

EDMONDS, FRANCIS: Clark, H. Nichols B. *Francis W. Edmonds, American Master in the Dutch Tradition*. Washington, D.C: Smithsonian Institution Press, for the Amon Carter Museum, 1988. Mann, Maybelle. *Francis William Edmonds, Mammon and Art*. New York: Garland Publishing Co., 1977.

FEKE, ROBERT: Foote, Henry Wilder. *Robert Feke, Colonial Portrait Painter*. Cambridge, Mass.: Harvard University Press, 1930.

GIFFORD, SANFORD R.: Weiss, Ila. *Poetic Landscape: The Art and Experience of Sanford R. Gifford*. Newark, Del.: University of Delaware Press, 1987.

HARNETT, WILLIAM: Frankenstein, Alfred. *After the Hunt; William Harnett and Other American Still Life Painters, 1870–1900* (revised edition). Berkeley: University of California Press, 1969.

HASSAM, CHILDE: Hoopes, Donelson F. *Childe Hassam*. New York: Watson-Guptill, 1979.

HEADE, MARTIN JOHNSON: Stebbins, Theodore E., Jr. *The Life and Works of Martin Johnson Heade*. New Haven: Yale University Press, 1975.

HESSELIUS, GUSTAVUS: Fleischer, Roland. "Gustavus Hesselius," in *American Painting to 1776: A Reappraisal*. Charlottesville: University Press of Virginia, 1971, pp. 127–58.

HESSELIUS, JOHN: Doud, Richard. "John Hesselius: Maryland Limner." *Winterthur Portfolio* 5 (1969): 129–53.

HICKS, EDWARD: Ford, Alice. *Edward Hicks: His Life and Art*. New York: Abbeville Press, 1985. Mather, Eleanore Price, and Dorothy Canning Miller. *Edward Hicks: His Peaceable Kingdoms and Other Paintings*. Newark, Del.: University of Delaware Press, 1983.

HOMER, WINSLOW: Cikovsky, Nickolai. *Winslow Homer*. New York: Abrams, 1990. Cooper, Helen A. *Winslow Homer Watercolors*. Washington, D.C.: National Gallery of Art, 1986. Tatham, David. *Winslow Homer and the New England Poets*. Worcester, Mass.: American Antiquarian Society,

1980. Wilmerding, John. *Winslow Homer*. New York: Praeger, 1972. Wood, Peter H., and Karen C. C. Dalton. *Winslow Homer's Images of Blacks: The Civil War and Reconstruction Years*. Austin: University of Texas, 1988.

HUNT, WILLIAM MORRIS: Hoppin, Martha J., and Henry Adams. *William Morris Hunt: A Memorial Exhibition*. Boston: Museum of Fine Arts, 1979.

INMAN, HENRY: Gerdts, William H. *The Art of Henry Inman*. Catalogue by Carrie Rebora. Washington, D.C.: National Portrait Gallery, 1987.

INNESS, GEORGE: Cikovsky, Nicolai, and Michael Quick. *George Inness*. Los Angeles: Los Angeles County Museum of Art, and New York: Harper & Row, 1985. Ireland, LeRoy. *The Works of George Inness; An Illustrated Catalogue Raisonné*. Austin: University of Texas Press, 1965.

JOHNSON, EASTMAN: Hills, Patricia. *Eastman Johnson*. New York: Potter, in association with the Whitney Museum of American Art, 1972. Hills, Patricia. *The Genre Painting of Eastman Johnson: The Sources and Development of his Style and Themes*. New York: Garland Publishing, 1977.

JOHNSTON, JOSHUA: Weelkey, Carolyn J. *Joshua Johnston: Freeman and Early American Portrait Painter*. Williamsburg, Va.: Abby Aldrich Rockefeller Folk Art Center, and Baltimore: Maryland Historical Society, 1987.

KENSETT, JOHN FREDERICK: Driscoll, John Paul, and John K. Howat. *John Frederick Kensett, An American Master*. New York: Worcester Art Museum in association with Norton, 1985. Howat, John K. *John Frederick Kensett, 1816–1872*. New York: Whitney Museum of American Art, 1968.

KRIMMEL, JOHN LEWIS: Naeve, Milo M. *John Lewis Krimmel, An Artist in Federal America*. Newark, Del.: University of Delaware Press, 1987.

LA FARGE, JOHN: Adams, Henry, et al. *John La Farge: Essays*. New York: Abbeville Press, 1987. Weinberg, Helene Barbara. "John La Farge and the Decoration of Trinity Church." *Journal of the Society of Architectural Historians* 33 (1974): 323–53.

LANE, FITZ HUGH: Wilmerding, John. *Fitz Hugh Lane*. New York: Praeger, 1971. Wilmerding, John. *Paintings by Fitz Hugh Lane*. Washington, D.C.: National Gallery of Art, and New York: Abrams, 1988.

LEUTZE, EMANUEL: Groseclose, Barbara S. *Emanuel Leutze, 1816–1868: Freedom is the Only King*. Washington, D.C.: Smithsonian Institution for the National Collection of Fine Arts, 1975.

MORAN, THOMAS: Gerdts, William H. *Thomas Moran, 1837–1926*. Riverside: University of California Press, 1963. Truettner, William. "Scenes of Majesty and Enduring Interest: Thomas Moran goes West." *Art Bulletin* 58 (June 1976): 241–59.

MORSE, SAMUEL F. B.: Kloss, William. *Samuel F. B. Morse*. New York: H. N. Abrams and the National Museum of American Art, 1988. Staiti, Paul J. *Samuel F. B. Morse*. New York: Cambridge University Press, 1989.

MOUNT, WILLIAM SIDNEY: Cassedy, David. *William Sidney Mount: Works in the Collection of the Museums at Stony Brook*. Stony Brook, N.Y.: Museums at Stony Brook, 1983. Frankenstein, Alfred. *William Sidney Mount*. New York: Abrams, 1975.

PAGE, WILLIAM: Taylor, Joshua. *William Page, The American Titian*. Chicago: University of Chicago Press, 1957.

PEALE, CHARLES WILLSON: Miller, Lillian B., ed. *The Selected Papers of Charles Willson Peale and his Family*. New Haven: Yale University Press for the National Portrait Gallery, Smithsonian Institution, 1983+. Richardson, Edgar P., Brooke Hindle, and Lillian B. Miller. *Charles Willson Peale and his World*. New York: H. N. Abrams, 1983. Sellers, Charles Coleman. *Charles Willson Peale*. New York: Scribner, 1969.

PEALE, RAPHAELLE: Cikovsky, Nicolai, with Linda Bantel and John Wilmerding. *Raphaelle Peale, Still Lifes*. Washington, D.C.: National Gallery of Art, 1989.

PEALE, REMBRANDT: Hevner, Carol Eaton. *Rembrandt Peale, 1778–1860, A Life in the Arts*. With an essay by Lillian B. Miller. Philadelphia: Historical Society of Pennsylvania, 1985.

PETO, JOHN F.: Wilmerding, John. *Important Information Inside: The Art of John F. Peto and the Idea of Still-Life Painting in Nineteenth-Century America*. Washington, D.C.: National Gallery of Art, 1983.

QUIDOR, JOHN: *John Quidor*. Introduction by John I. H. Baur. Utica, N.Y.: Munson-Williams-Proctor Institute, 1965.

REMINGTON, FREDERIC: Ballinger, James K. *Frederic Remington*. New York: Abrams, 1989. Hassrick, Peter H. *Frederic Remington: Paintings, Drawings, and Sculpture in the Amon Carter Museum and the Sid W. Richardson Foundation Collections*. New York: Abrams, 1973.

RUSSELL, CHARLES M.: Hassrick, Peter H. *Charles M. Russell*. New York: Abrams, 1989.

RYDER, ALBERT PINKHAM: Broun, Elizabeth. *Albert Pinkham Ryder*. Catalogue by Eleanor L. Jones. Washington, D.C.: Smithsonian Institution Press, for the National Museum of American Art, 1989. Homer, William Innes, and Lloyd Goodrich. *Albert Pinkham Ryder, Painter of Dreams*. New York: H. N. Abrams, 1989.

SALMON, ROBERT: Wilmerding, John. *Robert Salmon, Painter of Ship & Shore*. Salem, Mass.: Peabody Museum of Salem, 1971.

SARGENT, JOHN SINGER: Fairbrother, Trevor J. *John Singer Sargent and America*. New York: Garland Publishing, 1986. Hills, Patricia. *John Singer Sargent*. With essays by Linda Ayres, et al. New York: Whitney Museum of American Art, 1986.

SMIBERT, JOHN: Foote, Henry Wilder. *John Smibert, Painter, with a Descriptive Catalogue of Portraits and Notes on the work of Nathaniel Smibert* (1950). New York: Kennedy Galleries, 1969. *The Notebook of John Smibert*. With essays by Sir David Evans, John Kerslake, and Andrew Oliver. Boston: Massachusetts Historical Society, 1969.

SPENCER, LILLY MARTIN: Bolton-Smith, Robin. *Lilly Martin Spencer, 1822–1902; The Joys and Sentiment*. Washington, D.C.: National Collection of Fine Arts, 1973.

STUART, GILBERT: McLanathan, Richard. *Gilbert Stuart*. New York: Abrams, 1986. Mount, Charles M. *Gilbert Stuart, A Biography*. New York: W. W. Norton, 1964.

SULLY, THOMAS: Biddle, Edward, and Mantle Fielding. *The Life and Works of Thomas Sully (1783–1872)*. Philadelphia: N.p., 1921. Fabian, Monroe H. *Mr. Sully, Portrait Painter*. Washington, D.C.: National Portrait Gallery, 1983.

TRUMBULL, JOHN: Cooper, Helen A. *John Trumbull: The*

Hand and Spirit of a Painter. New Haven: Yale University Art Gallery, 1982. Jaffe, Irma B. *John Trumbull, Patriot-Artist of the American Revolution.* Boston: New York Graphic Society, 1975.

TWACHTMAN, JOHN HENRY: Boyle, Richard J. *John Twachtman.* New York: Watson-Guptill, 1979. Chotner, Deborah, Lisa N. Peters, and Kathleen A. Pyne. *John Twachtman: Connecticut Landscapes.* Washington, D.C.: National Gallery of Art, 1989.

VANDERLYN, JOHN: Mondello, Salvatore. *The Private Papers of John Vanderlyn (1775–1852), American Portrait Painter.* Lewiston, N.Y.: Edwin Mellen Press, 1990.

VEDDER, ELIHU: Soria, Regina. *Elihu Vedder; American Visionary Artist in Rome (1836–1923).* Rutherford, N.J.: Fairleigh Dickinson University Press, 1970. Taylor, Joshua C., Jane Dillenberger, Richard Murray, and Regina Soria. *Perceptions and Evocations: The Art of Elihu Vedder.* Washington, D.C.: Smithsonian Institution Press, for the National Collection of Fine Arts, 1979.

WEIR, J. ALDEN: Burke, Doreen Bolger. *J. Alden Weir, An American Impressionist.* Newark, Del.: University of Delaware Press, 1983.

WEIR, J. FERGUSON: Fahlman, Betsy. "John Ferguson Weir: Painter of Romantic and Industrial Icons." *Archives of American Art Journal* 20 (1980): 2–9.

WEST, BENJAMIN: Abrams, Ann Uhry. *The Valiant Hero: Benjamin West and Grand-Style History Painting.* Washington, D.C.: Smithsonian Institution Press, 1985. *Benjamin West, American Painter at the English Court.* With an essay by Allen Staley. Baltimore: Baltimore Museum of Art, 1989. Erffa, Helmut von, and Allen Staley. *The Paintings of Benjamin West.* New Haven: Yale University Press, 1986.

WHISTLER, JAMES ABBOTT McNEILL: Spencer, Robin, ed. *Whistler: A Retrospective.* New York: Hugh Lautner Levin Associates, 1989. Young, Andrew M., Margaret MacDonald, and Robin Spencer. *The Paintings of James McNeill Whistler.* New Haven: Yale University Press, for the Paul Mellon Centre for Studies in British Art, 1980.

WHITTREDGE, WORTHINGTON: Janson, Anthony F. *Worthington Whittredge.* New York: Cambridge University Press, 1989.

After 1900

ALBERS, JOSEF: Weber, Nicholas Fox, et al. *Josef Albers: A Retrospective.* New York: Solomon R. Guggenheim Museum, 1988.

BAZIOTES, WILLIAM: Alloway, Lawrence. *Baziotes.* New York: Solomon R. Guggenheim Museum, 1965.

BEARDEN, ROMARE: *Memory and Metaphor: Romare Bearden, 1940–1987.* Introduction by Kinshasha Holman Conwill, with an essay by Mary Schmidt Campbell. New York: Studio Museum in Harlem: Oxford University Press, 1991. Washington, M. Bunch. *The Art of Romare Bearden; The Prevalence of Ritual.* New York: Abrams, 1973.

BELLOWS, GEORGE: *George Bellows: A Retrospective Exhibition.* Washington, D.C.: National Gallery of Art, 1957. Myers, Jane, and Linda Ayres. *George Bellows: The Artist and his Lithographs, 1916–1924.* Fort Worth, Tex.: Amon Carter Museum, 1988.

BENTON, THOMAS HART: Adams, Henry. *Thomas Hart Benton: An American Original.* New York: Knopf, 1989. Adams, Henry. *Thomas Hart Benton: Drawing from Life.* New York: Abbeville Press, 1990. Baigell, Matthew. *Thomas Hart Benton.* New York: Abrams, 1974. Marling, Karal Ann. *Thomas Hart Benton and his Drawings: A Biographical Essay and a Collection of his Sketches, Studies and Mural Cartoons.* Columbia: University of Missouri Press, 1985.

BRUCE, PATRICK HENRY: Agee, William C., and Barbara Rose. *Patrick Henry Bruce, American Modernist: A Catalogue Raisonné.* New York: The Museum of Modern Art, 1979.

BURCHFIELD, CHARLES: Baur, John I. H. *The Inlander: Life and Work of Charles Burchfield, 1893–1967.* Newark, Del.: University of Delaware Press, 1982. *Charles Burchfield: A Concentration of Works from the Permanent Collection of the Whitney Museum of American Art.* New York: Whitney Museum of American Art, 1980.

CARLES, ARTHUR B.: Wolanin, Barbara. *Arthur B. Carles (1882–1952), Painting with Color.* Philadelphia: Pennsylvania Academy of the Fine Arts, 1983.

CURRY, JOHN STEUART: Kendall, M. Sue. *Rethinking Regionalism: John Steuart Curry and the Kansas Mural Controversy.* Washington, D.C.: Smithsonian Institution Press, 1986.

DAVIES, ARTHUR B.: Czestochowski, Joseph S. *Arthur B. Davies.* With a foreword by Mahonri Sharp Young. Chicago: University of Chicago Press, 1979. Czestochowski, Joseph S. *Arthur B. Davies: A Catalogue Raisonné of the Prints.* Newark, Del.: University of Delaware Press, 1987.

DAVIS, STUART: Agee, William, et al. *Stuart Davis, American Painter.* New York: Metropolitan Museum of Art, 1991. Sims, Patterson. *Stuart Davis.* New York: Whitney Museum of American Art, 1980. Wilkin, Karen. *Stuart Davis.* New York: Abbeville Press, 1987.

DE KOONING, WILLEM: Gaugh, Harry F. *Willem de Kooning.* New York: Abbeville Press, 1983. Waldman, Diane. *Willem de Kooning.* New York: Abrams, 1987.

DEMUTH, CHARLES: Fahlman, Betsy. *Pennsylvania Modern: Charles Demuth of Lancaster.* Philadelphia: Philadelphia Museum of Art, 1983. Haskell, Barbara. *Charles Demuth.* New York: H. N. Abrams and the Whitney Museum of American Art, 1987.

DOVE, ARTHUR: Haskell, Barbara. *Arthur Dove.* San Francisco: San Francisco Museum of Art, 1974. Morgan, Ann Lee. *Arthur Dove: Life and Work, with a Catalogue Raisonné.* Newark, Del.: University of Delaware Press, 1984.

FRANKENTHALER, HELEN: Carmean, E. A. *Helen Frankenthaler: A Paintings Retrospective.* New York: Abrams, 1989. Rose, Barbara. *Helen Frankenthaler.* New York: Abrams, 1971.

GLACKENS, WILLIAM: Glackens, Ira. *William Glackens and the Eight: The Artists who Freed American Art.* New York: Horizon Press, 1984.

GORKY, ARSHILE: Jordan, Jim M. *The Paintings of Arshile Gorky: A Critical Catalogue.* New York: New York University Press, 1982. Lader, Melvin P. *Arshile Gorky.* New York: Abbeville Press, 1985. Waldman, Diane. *Arshile Gorky, 1904–1948: A Retrospective.* New York: H. N. Abrams, Solomon R. Guggenheim Museum, 1981.

GOTTLIEB, ADOLF: Doty, Robert, and Diane Waldman. *Adolf Gottlieb.* New York: Whitney Museum of American Art and Solomon R. Guggenheim Museum, 1968.

GUSTON, PHILIP: Storr, Robert. *Philip Guston.* New York: Abbeville Press, 1986.

HARTLEY, MARSDEN: Haskell, Barbara. *Marsden Hartley.* New York: Whitney Museum of American Art in association with New York University Press, 1980. Scott, Gail R. *Marsden Hartley.* New York: Abbeville Press, 1988.

HENRI, ROBERT: Henri, Robert. *The Art Spirit.* Compiled by Margery Ryerson. Philadelphia: Lippincott, 1960. Homer, William Innes. *Robert Henri and his Circle.* Ithaca: Cornell University Press, 1969; rev. ed., New York: Hacker Art Books, 1988.

HOFMANN, HANS: Goodman, Cynthia. *Hans Hofmann.* New York: Abbeville Press, 1986.

HOPPER, EDWARD: Hobbs, Robert C. *Edward Hopper.* New York: Abrams, in association with the National Museum of American Art, 1987. Levin, Gail. *Edward Hopper: The Art and the Artist.* New York: Norton and the Whitney Museum of American Art, 1980.

INDIANA, ROBERT: McCoubrey, John. *Robert Indiana.* Philadelphia: Institute of Contemporary Art, 1968.

JOHNS, JASPER: Crichton, Michael. *Jasper Johns.* New York: Abrams, in association with the Whitney Museum of American Art, 1977. Francis, Richard. *Jasper Johns.* New York: Abbeville Press, 1984.

JOHNSON, WILLIAM: Powell, Richard J. *Homecoming: The Art and Life of William H. Johnson.* Washington, D.C.: National Museum of American Art, 1991.

KELLY, ELLSWORTH: Coplans, John. *Ellsworth Kelly.* New York: Abrams, 1972. Upright, Diane. *Ellsworth Kelly: Works on Paper.* New York: H. N. Abrams and the Fort Worth Art Museum, 1987.

KLINE, FRANZ: Gaugh, Harry F. *The Vital Gesture: Franz Kline.* New York: Abbeville Press, 1985.

LAWRENCE, JACOB: Wheat, Ellen Harkins. *Jacob Lawrence, American Painter.* With an essay by Patricia Hills. Seattle: University of Washington Press and the Seattle Art Museum, 1986.

LEVINE, JACK: Brown, Milton, and Stephen Robert Frankel. *Jack Levine.* New York: Rizzoli, 1989.

LICHTENSTEIN, ROY: Alloway, Lawrence. *Roy Lichtenstein.* New York: Abbeville Press, 1983.

LOUIS, MORRIS: Elderfield, John. *Morris Louis.* New York: The Museum of Modern Art, and Boston: Little, Brown, 1986.

LUKS, GEORGE: Cary, Elisabeth L. *George Luks.* New York: Whitney Museum of American Art, 1931.

MACDONALD-WRIGHT, STANTON "MacDonald-Wright: Special Issue." *American Art Review* 1 (Jan.–Feb. 1974). MacDonald-Wright, Stanton. *A Treatise on Color.* Los Angeles: Privately printed, 1934.

MARIN, JOHN: Fine, Ruth. *John Marin.* Washington, D.C.: National Gallery of Art, and New York: Abbeville Press, 1990. Reich, Sheldon. *John Marin: A Stylistic Analysis and Catalogue Raisonné.* 2 vols. Tucson: University of Arizona Press, 1970.

MARSH, REGINALD: Goodrich, Lloyd. *Reginald Marsh.* New York: Abrams, 1972. Sasowsky, Norman. *The Prints of Reginald Marsh: An Essay and Definitive Catalogue.* New York: C. N. Potter, 1976.

MAURER, ALFRED HENRY: Reich, Sheldon. *Alfred H. Maurer: 1868–1932.* Washington, D.C.: National Collection of Fine Arts, 1973.

MOSES, GRANDMA: Kallir, Jane. *Grandma Moses, The Artist behind the Myth.* New York: C. N. Potter, 1982. Kallir, Otto. *Grandma Moses.* New York: Abrams, 1973.

MOTHERWELL, ROBERT: Arnason, H. Harvard. *Robert Motherwell.* New York: Abrams, 1982. Ashton, Dore, and Jack D. Flam. *Robert Motherwell.* New York: Abbeville Press, 1983.

NEWMAN, BARNETT: Hess, Thomas B. *Barnett Newman.* New York: The Museum of Modern Art, 1971. Rosenberg, Harold. *Barnett Newman.* New York: Abrams, 1978.

NOLAND, KENNETH: Waldman, Diane. *Kenneth Noland: A Retrospective.* New York: Solomon R. Guggenheim Museum, 1977.

O'KEEFFE, GEORGIA: Cowart, Jack, et al. *Georgia O'Keeffe, Art and Letters.* Washington, D.C.: National Gallery of Art, 1987. Lisle, Laurie. *Portrait of an Artist: A Biography of Georgia O'Keeffe.* Albuquerque: University of New Mexico, 1986. Stieglitz, Alfred. *Georgia O'Keeffe, A Portrait.* New York: Metropolitan Museum of Art, 1978.

PIPPIN, HORACE: *Horace Pippin.* With an essay by Romare Bearden. Washington, D.C.: Phillips Collection, 1976.

POLLOCK, JACKSON: Frank, Elizabeth. *Jackson Pollock.* Abbeville Press, 1983. Landau, Ellen G. *Jackson Pollock.* New York: Abrams, 1989. O'Connor, Francis V., and Eugene V. Thaw, eds. *Jackson Pollock: A Catalogue Raisonné of Paintings, Drawings, and Other Works.* 4 vols. New Haven: Yale University Press, 1978.

PRENDERGAST, MAURICE: Clark, Carol, Nancy Mowll Mathews, and Gwendolyn Owens. *Maurice Brazil Prendergast, Charles Prendergast: A Catalogue Raisonné.* Williamstown, Mass.: Williams College Museum of Art, 1990.

RAUSCHENBERG, ROBERT: Rose, Barbara. *Rauschenberg: An Interview with Robert Rauschenberg.* New York: Vintage Books, 1987. Tomkins, Calvin. *Off the Wall: Robert Rauschenberg and the Art World of Our Time.* Garden City, N.Y.: Doubleday, 1980.

RAY, MAN: Foresta, Merry. *Perpetual Motif: The Art of Man Ray.* Washington, D.C.: National Museum of American Art and Abbeville Press, 1988. Man Ray. *Self Portrait/Man Ray.* Boston: Little, Brown, 1988.

REINHARDT, AD: Lippard, Lucy. *Ad Reinhardt.* New York: Abrams, 1981.

RIVERS, LARRY: Hunter, Sam. *Larry Rivers.* New York: Rizzoli, 1989.

ROSENQUIST, JAMES: Goldman, Judith. *James Rosenquist.* New York: Viking, 1985.

ROTHKO, MARK: Ashton, Dore. *About Rothko.* New York: Oxford University Press, 1983. Cleve, Anna. *Mark Rothko: Subjects in Abstraction.* New Haven: Yale University Press, 1989.

SHAHN, BEN: Pohl, Frances K. *Ben Shahn: New Deal Artist in a Cold War Climate, 1947–1954.* Austin: University of Texas Press, 1989.

SHEELER, CHARLES: Troyen, Carol, and Erica E. Hirshler. *Charles Sheeler, Paintings and Drawings.* Boston: Little, Brown, 1987.

SHINN, EVERETT: DeShazo, Edith. *Everett Shinn, 1876–1953, A Figure in his Time.* New York: C. N. Potter, 1974.

SLOAN, JOHN: Elzea, Roland. *John Sloan's Oil Paintings: A Catalogue Raisonné.* 2 vols. Newark, Del.: University of

Delaware Press, 1991. Elzea, Roland, and Elizabeth Hawkes. *John Sloan: Spectator of Life.* Wilmington, Del.: Delaware Art Museum, 1988. Morse, Peter. *John Sloan's Prints: A Catalogue Raisonné of the Etchings, Lithographs, and Posters.* New Haven: Yale University Press, 1969. Sloan, John, with the assistance of Helen Farr Sloan. *The Gist of Art.* New York: American Artists Group, 1939.

STELLA, FRANK: Rubin, Lawrence. *Frank Stella: Paintings, 1958 to 1965: A Catalogue Raisonné.* New York: Stewart, Tabori & Chang, 1986.

STELLA, JOSEPH: Jaffe, Irma. *Joseph Stella.* New York: Fordham University Press, 1988. Zilczer, Judith. *Joseph Stella, the Hirshhorn Museum and Sculpture Garden Collection.* Washington, D.C.: Smithsonian Institution Press for the Hirshhorn Museum and Sculpture Garden, 1893.

STILL, CLYFFORD: O'Neill, John P. *Clyfford Still.* New York: H. N. Abrams, 1979.

TOBEY, MARK: Breeskin, Adelyn. *Tribute to Mark Tobey.* Washington, D.C.: Smithsonian Institution Press for the National Collection of Fine Arts, 1974. Dahl, Arthur. *Mark Tobey, Art and Belief.* Oxford: G. Roland, 1984.

TOMLIN, BRADLEY WALKER: Sandler, Irving, and Jeanne Chenault. *Bradley Walker Tomlin: A Retrospective View.* Garden City, N.Y.: Whaler Press, 1975.

WARHOL, ANDY: Borudon, David. *Warhol.* New York: H. N. Abrams, 1989. Feldman, Frayda, and Jorg Schellmann. *Andy Warhol Prints: A Catalogue Raisonné.* New York: R. Feldman Fine Arts and Abbeville Press, 1989. McShine, Kynaston, ed. *Andy Warhol: A Retrospective.* New York: The Museum of Modern Art, 1989.

WEBER, MAX: Rubenstein, Daryl R. *Max Weber: A Catalogue Raisonné of his Graphic Work.* Chicago: University of Chicago Press, 1980. Werner, Alfred. *Max Weber.* New York: Abrams, 1975.

WESSELMANN, TOM: Stealingworth, Slim. *Tom Wesselmann.* New York: Abbeville Press, 1980.

WOOD, GRANT: Corn, Wanda M. *Grant Wood, The Regionalist Vision.* New Haven, Conn.: Yale University Press, for the Minneapolis Institute of Arts, 1983.

WYETH, ANDREW: Corn, Wanda M., et al. *The Art of Andrew Wyeth.* Greenwich, Conn.: New York Graphic Society, for the Fine Arts Museums of San Francisco, 1973. Wilmerding, John. *Andrew Wyeth: The Helga Pictures.* New York: H. N. Abrams, 1987. Wyeth, Betsy James. *"Christina's World": Paintings and Pre-Studies of Andrew Wyeth.* Boston: Houghton Mifflin Co., 1982.

ZORACH, MARGUERITE: Tarbell, Roberta K. *Marguerite Zorach: The Early Years, 1900–1920.* Washington, D.C.: National Collection of Fine Arts, Smithsonian Institution, 1973. Tarbell, Roberta K. *William and Marguerite Zorach: The Maine Years.* Rockland, Maine: William A. Farnsworth Library and Art Museum, 1981.

SCULPTURE

General

Armstrong, Tom, et al. *200 Years of American Sculpture.* Boston: D. R. Godine, for the Whitney Museum of American Art, 1976.

Craven, Wayne. *Sculpture in America.* Newark, Del.: University of Delaware Press, and New York: Cornwall Books, 1984.

Ekdahl, Janis. *American Sculpture, A Guide to Informational Sources.* Detroit: Gale Research Co., 1977.

Greenthal, Kathryn, Paula M. Kozol, Jan Seidler Ramirez, and Jonathan Fairbanks. *American Figurative Sculpture in the Museum of Fine Arts, Boston.* Boston: Museum of Fine Arts, 1986.

Philadelphia's Treasures in Bronze and Stone. New York: Walker Publishing Co., 1976.

Shapiro, Michael. *Bronze Casting and American Sculpture, 1850–1900.* Newark, Del.: University of Delaware Press, 1985.

Taft, Lorado. *The History of American Sculpture.* New York: Macmillan Co., 1924.

Colonial and Federal

Craven, Wayne. "The Origins of Sculpture in America: Philadelphia, 1785–1830." *The American Art Journal 9* (Nov. 1977): 4–33.

Ludwig, Allan I. *Graven Images: New England Stonecarving and its Symbols, 1650–1815.* Middletown, Conn.: Wesleyan University Press, 1966.

Romanticism, Neoclassicism, and Naturalism, 1830–70

Crane, Sylvia E. *White Silence: Greenough, Powers, and Crawford, American Sculptors in Nineteenth-Century Italy.* Coral Gables, Fla.: University of Miami Press, 1972.

Gerdts, William H. *American Neo-Classical Sculpture; The Marble Resurrection.* New York: Viking Press, 1973.

Thorp, Margaret Farrand. *The Literary Sculptors.* Durham, N.C.: Duke University Press, 1965.

Beaux-Arts Sculpture, 1870–1900

Fusco, Peter, and Horst W. Janson. *The Romantics to Rodin: French Nineteenth-Century Sculpture from North American Collections.* Los Angeles: Los Angeles County Museum of Art, and New York: G. Braziller, 1980.

Sharp, Lewis I., with David W. Kiehl. *New York City Public Sculpture by 19th-Century American Artists.* New York: Metropolitan Museum of Art, 1974.

Wasserman, Jeanne L., and Arthur Beale, eds. *Metamorphoses in Nineteenth-Century Sculpture.* Cambridge, Mass.: Harvard University Press, for the Fogg Art Museum, 1975.

Early Modern, 1900–40

Marter, Joan M., Roberta K. Tarbell, and Jeffrey Wechsler. *Vanguard American Sculpture, 1913–1939.* New Brunswick, N.J.: Rutgers University Art Gallery, 1979.

Proske, Beatrice Gilman. *Brookgreen Gardens: Sculpture.* Brookgreen, S.C.: Brookgreen Gardens, 1943.

Rawls, Walton, ed. *A Century of American Sculpture: Treasures from the Brookgreen Gardens.* New York: Abbeville Press, 1988.

1940 to the Present

Battcock, Gregory. *Minimal Art; A Critical Anthology.* New

York: E. P. Dutton, 1968.

Beardsley, John. *Earthworks and Beyond: Contemporary Art in the Landscape*. New York: Abbeville Press, 1984.

——. *Probing the Earth: Contemporary Land Projects*. Washington, D.C.: Smithsonian Institution Press, for the Hirshhorn Museum and Sculpture Garden, 1977.

Doty, Robert M. *Light: Object and Image*. New York: Whitney Museum of American Art, 1968.

Hulten, Karl Gunnar. *The Machine, as Seen at the End of the Mechanical Age*. New York: The Museum of Modern Art, 1968.

Kaprow, Allan. *Assemblage, Environments & Happenings*. New York: H. N. Abrams, 1966.

Karshan, Donald H. *Conceptual Art and Conceptual Aspects*. New York: New York Cultural Center, 1970.

Kepes, Gyorge. *Arts of the Environment*. New York: G. Braziller, 1972.

Krauss, Rosalind E. *Passages in Modern Sculpture*. New York: Viking Press, 1977.

McShine, Kynaston. *Primary Structures: Younger American and British Sculptors*. New York: The Jewish Museum, 1966.

Phillips, Lisa. *The Third Dimension: Sculpture of the New York School*. New York: Whitney Museum of American Art, 1986.

Tuchman, Maurice. *American Sculpture of the Sixties*. Los Angeles: Los Angeles County Museum of Art, 1967.

Waldman, Diane. *Transformations in Sculpture: Four Decades of American and European Art*. New York: Solomon R. Guggenheim Museum, 1985.

SCULPTORS

Before 1900

BALL, THOMAS: Ball, Thomas. *My Three Score Years and Ten*. Boston: Roberts Brothers, 1891; reprinted, New York: Garland Publishing, 1976.

BARNARD, GEORGE GREY: Dickson, Harold. "Log of a Masterpiece, Barnard's 'Struggle of the Two Natures of Man.'" *College Art Journal* 20 (1961): 139–43.

BORGLUM, GUTZON: Smith, Rex Alan. *The Carving of Mount Rushmore*. New York: Abbeville Press, 1985.

BORGLUM, SOLON H.: Davies, A. Mervyn. *Solon H. Borglum, A Man Who Stands Alone*. Chester, Conn.: Pequot Press, 1974.

BROWN, HENRY KIRKE: Craven, Wayne. "Henry Kirke Brown: His Search for an American Art in the 1840s." *American Art Journal* 4 (Nov. 1972): 44–58.

CRAWFORD, THOMAS: Gale, Robert L. *Thomas Crawford, American Sculptor*. Pittsburgh: University of Pittsburgh, 1964.

DALLIN, CYRUS E.: Francis, Rell G. *Cyrus E. Dallin: Let Justice Be Done*. Springville, Utah: Springville Museum of Art, 1976.

EAKINS, THOMAS: Domit, Moussa M. *The Sculpture of Thomas Eakins*. Washington, D.C.: Corcoran Gallery of Art, 1969.

FRENCH, DANIEL CHESTER: Cresson, Margaret. *Journey into Fame: The Life of Daniel Chester French*. Cambridge, Mass.: Harvard University Press, 1947. Richman, Michael T. *Daniel Chester French: An American Sculptor*. New York: Metropolitan Museum of Art, 1976.

GREENOUGH, HORATIO: Wright, Nathalia. *Horatio Greenough, The First American Sculptor*. Philadelphia: University of Pennsylvania Press, 1963. Wright, Nathalia, ed. *Letters of Horatio Greenough, American Sculptor*. Madison: University of Wisconsin Press, 1972.

HOSMER, HARRIET: Carr, Cornelia. *Harriet Hosmer, Letters and Memories*. New York: Moffat, Yard and Co., 1912. Sherwood, Dolly. *Harriet Hosmer, American Sculptor, 1830–1908*. Columbia: University of Missouri Press, 1991.

McINTIRE, SAMUEL: Cummings, Abbott L., et al. *Samuel McIntire, A Bicentennial Symposium*. Salem Mass.: Essex Institute, 1957.

PALMER, ERASTUS DOW: Webster, James Carson. *Erastus Dow Palmer: Sculpture—Ideas*. Newark, Del.: University of Delaware Press, 1983.

POWERS, HIRAM: Reynolds, Donald. *Hiram Powers and his Ideal Sculpture*. New York: Garland Publications, 1977. Wunder, Richard P. *Hiram Powers, Vermont Sculptor, 1805–1873*. 2 vols. Newark, Del.: University of Delaware Press, 1991.

REMINGTON, FREDERIC: Shapiro, Michael. *Cast and Recast: The Sculpture of Frederic Remington*. Washington, D.C.: National Museum of American Art, 1981. Shapiro, Michael, et al. *Frederic Remington: The Masterworks*. New York: Abrams, 1988.

RIMMER, WILLIAM: *William Rimmer, A Yankee Michelangelo*. With essays by Jeffrey Weidman, Neil Harris, and Philip Cash. Hanover, N.H.: Brockton Art Museum and University Presses of New England, 1985.

RINEHART, WILLIAM: Ross, Marvin C., and Anna W. Rutledge. *William Henry Rinehart, Maryland Sculptor*. Baltimore: Walters Art Gallery, 1948.

ROGERS, JOHN: Wallace, David. *John Rogers, the People's Sculptor*. Middletown, Conn.: Wesleyan University Press, 1967.

ROGERS, RANDOLPH: Rogers, Millard F. *Randolph Rogers: American Sculptor in Rome*. Amherst: University of Massachusetts Press, 1971.

RUSH, WILLIAM: *William Rush, American Sculptor*. Philadelphia: Pennsylvania Academy of the Fine Arts, 1982.

SAINT-GAUDENS, AUGUSTUS: Dryfhout, John. *The Work of Augustus Saint-Gaudens*. Hanover, N.H.: University Presses of New England, 1982. Greenthal, Kathryn. *Augustus Saint-Gaudens, Master Sculptor*. New York: Metropolitan Museum of Art, 1985.

STORY, WILLIAM WETMORE: Gerdts, William H. "William Wetmore Story." *The American Art Journal* 4 (1972): 16–33. James, Henry. *William Wetmore Story and his Friends*. Boston: Houghton Mifflin Co., 1903.

WARD, JOHN QUINCY ADAMS: Sharp, Lewis. *John Quincy Adams Ward, Dean of American Sculpture, with a Catalogue Raisonné*. Newark, Del.: University of Delaware Press, 1985.

After 1900

ARCHIPENKO, ALEXANDER: Karshan, Donald, ed. *Archipenko, International Visionary*. Washington, D.C.: Smithsonian Institution Press, 1969. Michaelsen, Katherine Janszky. *Alexander Archipenko, A Centennial Tribute*. Washington, D.C.: National Gallery of Art, 1986.

CALDER, ALEXANDER: Arnason, H. Harvard. *Calder*.

Princeton, N.J.: Princeton University Press, 1966. Marter, Joan. *Alexander Calder*. New York: Cambridge University Press, 1991.

CHRYSSA: Hunter, Sam. *Chryssa*. New York: H. N. Abrams, 1974.

CORNELL, JOSEPH: McShine, Kynaston. *Joseph Cornell*. New York: The Museum of Modern Art, 1980. Waldman, Diane. *Joseph Cornell*. New York: G. Braziller, 1977.

DE CREEFT, JOSE: Breeskin, Adelyn D. *José de Creeft, Sculpture and Drawings*. Washington, D.C.: National Museum of American Art, 1983.

DE MARIA, WALTER: Wortz, Melinda. "Walter De Maria's 'Lightning Field.'" *Arts Magazine* 54 (1980): 170–3.

DE RIVERA, JOSÉ: Marter, Joan, and Dore Ashton. *José de Rivera, Constructions*. Madrid: Taller Ediciones, 1980.

DI SUVERO, MARK: Monte, James. *Mark di Suvero*. New York: Whitney Museum of American Art, 1975.

FERBER, HERBERT: Agee, William C. *Herbert Ferber: Sculpture, Painting, Drawing, 1945–1980*. Houston: Museum of Fine Arts, 1983. Goossen, E. C. *Herbert Ferber*. New York: Abbeville Press, 1981.

FLANNAGAN, JOHN B.: Miller, Dorothy C. *The Sculpture of John B. Flannagan*. New York: The Museum of Modern Art, 1942.

FLAVIN, DAN: Flavin, Dan, and Brydon Smith. *Dan Flavin, Fluorescent Light, Etc*. Ottawa: National Gallery of Canada, 1969.

GROSS, CHAIM: Flint, Janet. *Chaim Gross: Sculpture and Drawings*. Washington, D.C.: National Collection of Fine Arts, 1974. Tarbell, Roberta K. *Chaim Gross*. New York: The Jewish Museum, 1977.

HANSON, DUANE: Bush, Martin. *Duane Hanson*. Wichita, Kans.: Wichita State University, 1978. Varnadoe, Kirk. *Duane Hanson*. New York: Abrams, 1985.

INDIANA, ROBERT: Mecklenburg, Virginia M. *Wood Works: Constructions by Robert Indiana*. Washington, D.C.: Smithsonian Institution Press, for the National Museum of American Art, 1984.

JUDD, DONALD: Haskell, Barbara. *Donald Judd*. New York: Whitney Museum of American Art, 1988. Judd, Donald. *Complete Writings, 1959–1975*. New York: New York University Press, 1975.

KELLY, ELLSWORTH: Sims, Patterson, and Emily Pulitzer. *Ellsworth Kelly, Sculpture*. New York: Whitney Museum of American Art, 1982.

KIENHOLZ, EDWARD: Tuchman, Maurice. *Edward Kienholz*. Los Angeles: Los Angeles County Museum of Art, 1966.

LACHAISE, GASTON: Nordland, Gerald. *Gaston Lachaise: The Man and his Work*. New York: G. Braziller, 1974.

LASSAW, IBRAM: Goossen, E. C., and Irving Sandler. *Three American Sculptors: Ferber, Hare, Lassaw*. New York: Grove Press, 1959.

LAURENT, ROBERT: Moak, Peter. *The Robert Laurent Memorial Exhibition*. Durham, N.H.: University of New Hampshire, 1972.

LeWITT, SOL: Lippard, Lucy R., Bernice Rose, and Robert Rosenblum. *Sol LeWitt*. New York: The Museum of Modern Art, 1978.

LIPPOLD, RICHARD: Campbell, Lawrence. "Lippold Makes a Sculpture." *Art News* 55 (1956): 31 ff.

LIPTON, SEYMOUR: Elsen, Albert E. *Seymour Lipton*. New York: H. N. Abrams, 1970. Rand, Harry. *Seymour Lipton, Aspects of Sculpture*. Washington, D.C.: Smithsonian Institution Press, 1979.

MANSHIP, PAUL: Manship, John. *Paul Manship*. New York: Abbeville Press, 1989. Rand, Harry. *Paul Manship*. Washington, D.C.: National Museum of American Art, 1989.

MARISOL: Creeley, Robert. *Presences*. New York: Scribner's, 1976. *Marisol*. Worcester: Worcester Art Museum, 1971.

NADELMAN, ELIE: Baur, John I. H. *The Sculpture and Drawings of Elie Nadelman*. New York: Whitney Museum of American Art, 1975. Kirstein, Lincoln. *Elie Nadelman*. New York: Eakins Press, 1973.

NEVELSON, LOUISE: Lipman, Jean. *Nevelson's World*. New York: Hudson Hills Press, in association with the Whitney Museum of American Art, 1983. Lisle, Laurie. *Louise Nevelson: A Passionate Life*. New York: Summit Books, 1990.

NOGUCHI, ISAMU: Hunter, Sam. *Isamu Noguchi*. New York: Abbeville Press, 1978. *Isamu Noguchi: The Sculpture of Spaces*. New York: Whitney Museum of American Art, 1980.

OLDENBURG, CLAES: Fuchs, Rudolf H. *Claes Oldenburg: Large-Scale Projects, 1977–1980*. New York: Rizzoli International Publications, 1980. Rose, Barbara. *Claes Oldenburg*. New York: The Museum of Modern Art, 1970.

ROBUS, HUGO: Tarbell, Roberta K. *Hugo Robus (1885–1964)*. Washington, D.C.: Smithsonian Institution Press, 1980.

ROSZAK, THEODORE: Arnason, H. Harvard. *Theodore Roszak*. Minneapolis: Walker Art Center, 1956.

SAMARAS, LUCAS: Levin, Kim. *Lucas Samaras*. New York: H. N. Abrams, 1975.

SEGAL, GEORGE: Hunter, Sam. *George Segal*. New York: Rizzoli, 1989. Van der Marck, Jan. *George Segal*. New York: H. N. Abrams, 1979.

SERRA, RICHARD: Krauss, Rosalind E. *Richard Serra/Sculpture*. New York: The Museum of Modern Art, 1986.

SMITH, DAVID: Fry, Edward F. *David Smith*. New York: Solomon R. Guggenheim Museum, 1969. Krauss, Rosalind. *Terminal Iron Works: The Sculpture of David Smith*. Cambridge, Mass.: MIT Press, 1971. Marcus, Stanley E. *David Smith, the Sculptor and his Work*. Ithaca, N.Y.: Cornell University Press, 1983. Wilkin, Karen. *David Smith*. New York: Abbeville Press, 1984.

SMITH, TONY: Lippard, Lucy *Tony Smith*. London: Thames and Hudson, 1972.

SMITHSON, ROBERT: Hobbs, Robert. *Robert Smithson: Sculpture*. With contributions by Lawrence Alloway, John Coplans, and Lucy Lippard. Ithaca, N.Y.: Cornell University Press, 1981.

STANKIEWICZ, RICHARD: *The Sculpture of Richard Stankiewicz*. Albany, N.Y.: University Art Gallery, State University of New York, 1979.

STORRS, JOHN: Kirshner, Judith Russi. *John Storrs (1885–1956): A Retrospective*. Chicago: Museum of Contemporary Art, 1976.

ZORACH, WILLIAM: Baur, John I. H. *William Zorach*. New York: Praeger, for the Whitney Museum of American Art, 1959. Zorach, William. *Art is my Life: The Autobiography of William Zorach*. Cleveland, World Publishing Co., 1967.

PHOTOGRAPHY

Adams, Ansel, and Rober Baker. *The Camera*. Boston: New York Graphic Society, 1980.

Bunnell, Peter. *A Photographic Vision: Pictorial Photography, 1889–1923*. Santa Barbara, Calif.: P. Smith, 1980.

Coke, van Deren. *The Painter and the Photograph, from Delacroix to Warhol*. Albuquerque: University of New Mexico Press, 1972.

Curtis, James. *Mind's Eye, Mind's Truth: FSA Photography Reconsidered*. Philadelphia: Temple University Press, 1989.

Doty, Robert M. *Photography in America*. Introduction by Minor White. New York: Random House, for the Whitney Museum of American Art, 1974.

———. *Photo Secession; Photography as a Fine Art*. Foreword by Beaumont Newhall. New York: George Eastman House, 1960.

Greenough, Sarah, et al. *On the Art of Fixing a Shadow: One Hundred and Fifty Years of Photography*. Washington, D.C.: National Gallery of Art, 1989.

Hurley, F. Jack. *Portrait of a Decade: Roy Stryker and the Development of Documentary Photography in the Thirties*. Baton Rouge, La.: Louisiana State University Press, 1972.

Jones, John. *Wonders of the Stereoscope*. New York: Knopf, 1976.

Marling, Karal Ann. *Iwo Jima: Monuments, Memories, and the American Hero*. Cambridge, Mass.: Harvard University Press, 1991.

Naef, Weston. *Era of Exploration: The Rise of Landscape Photography in the American West, 1860–1885*. Buffalo, N.Y.: Albright Knox Art Gallery, and New York: Metropolitan Museum of Art, 1975.

Newhall, Beaumont. *The Daguerreotype in America*. New York: Dover Publications, 1976.

———. *The History of Photography: From 1839 to the Present*. New York: The Museum of Modern Art, 1982.

Szarkowski, John. *American Landscapes: Photographs from the Collection of The Museum of Modern Art*. New York: The Museum of Modern Art, 1981.

———. *Mirrors and Windows: American Photography since 1960*. New York: The Museum of Modern Art, 1978.

———. *Photography until Now*. New York: The Museum of Modern Art, 1989.

Trachtenberg, Alan. *Reading American Photographs: Images as History: Mathew Brady to Walker Evans*. New York: Hill and Wang, 1989.

———, Peter Neill, and Peter Bunnell. *The City: American Experience*. New York: Oxford University Press, 1971.

Willis-Thomas, Deborah. *An Illustrated Bio-Bibliography of Black Photographers, 1940–1988*. New York: Garland Publishing, 1989.

Wood, John, ed. *America and the Daguerreotype*. Iowa City: University of Iowa Press, 1991.

PHOTOGRAPHERS

ADAMS, ANSEL: Adams, Ansel, with Mary Street Alinder. *Ansel Adams, An Autobiography*. Boston: Little, Brown, 1985. Alinder, James, and John Szarkowski. *Ansel Adams: Classic Images*. Boston: New York Graphic Society/Little,

Brown, 1985.

ARBUS, DIANE: Arbus, Doon, and Marvin Israel, eds. *Diane Arbus, Magazine Work*. Lawrence, Kans.: Spencer Museum of Art/Aperture, 1984. Bosworth, Patricia. *Diane Arbus: A Biography*. New York: Knopf, 1984.

BOURKE-WHITE, MARGARET: Goldberg, Vicki. *Margaret Bourke-White*. New York: Harper & Row, 1986. Silverman, Jonathan. *For the World to See: The Life of Margaret Bourke-White*. New York: Viking Press, 1983.

BRADY, MATHEW: Meredith, Roy. *Mathew Brady's Portrait of an Era*. New York: Norton, 1982. Meredith, Roy. *Mr. Lincoln's Camera Man: Mathew B. Brady*. New York: Dover Publications, 1974.

CALLAHAN, HARRY: Bunnell, Peter. *Harry Callahan*. New York: American Federation of the Arts, 1978. Szarkowski, John, ed. *Callahan*. Millerton, N.Y.: Aperture, 1976.

CAPONIGRO, PAUL: Caponigro, Paul. *Seasons*. Boston: New York Graphic Society, 1988.

CUNNINGHAM, IMOGEN: Dater, Judy. *Imogen Cunningham: A Portrait*. Boston: New York Graphic Society, 1979.

EAKINS, THOMAS: Hendricks, Gordon. *The Photographs of Thomas Eakins*. New York: Grossman Publishers, 1972. Parry, Ellwood C., III. *Photographer Thomas Eakins*. Philadelphia: Olympia Galleries, 1981.

EVANS, WALKER: Agee, James, and Walker Evans. *Let Us Now Praise Famous Men*. Boston: Houghton, Mifflin Co. 1969. *Walker Evans: Photographs from the Farm Security Administration, 1935–1938*. Introduction by Jerald C. Maddox. New York: Da Capo Press, 1975. Ward, Joseph A. *American Silences: The Realism of James Agee, Walker Evans, and Edward Hopper*. Baton Rouge, La.: Louisiana State University Press, 1985.

FRANK, ROBERT: Frank, Robert. *The Americans*. Introduction by Jack Kerouac. Millerton, N.Y.: Aperture, 1969. Frank, Robert. *The Lines of my Hand* (1972). New York: Pantheon Books, 1989.

FRIEDLANDER, LEE: *Lee Friedlander*. Introduction by Loic Malle. New York: Pantheon Books, 1988. *Lee Friedlander, Portraits*. Boston: Little, Brown, 1985.

HINE, LEWIS: Curtis, Verna Posever. *Photography and Reform: Lewis Hine & the National Child Labor Committee*. Milwaukee: Milwaukee Art Museum, 1984. Doherty, Jonathan L., ed. *Women at Work: 153 Photographs by Lewis Hine*. Rochester, N.Y.: George Eastman House, and New York: Dover Publications, 1981. Trachtenberg, Alan, and Naomi Rosenblum. *America & Lewis Hine: Photographs, 1904–1940*. New York: Aperture, 1977.

JACKSON, WILLIAM HENRY: Hales, Peter B. *William Henry Jackson and the Transformation of the American Landscape*. Philadelphia: Temple University Press, 1988. Jackson, William Henry. *Time Exposure: The Autobiography of William Henry Jackson*. Albuquerque: University of New Mexico Press, 1986.

KÄSEBIER, GERTRUDE: Homer, William Innes. *A Pictorial Heritage: The Photographs of Gertrude Käsebier*. Wilmington, Del.: Delaware Art Museum, 1979.

KEPES, GYORGY: *Gyorgy Kepes, Light Graphics*. New York: International Center of Photography, 1984.

LANGE, DOROTHEA: Ohrn, Karin Becker. *Dorothea Lange and the Documentary Tradition*. Baton Rouge, La.: Louisiana State University, 1980. *Photographs of a Lifetime: Dorothea Lange*.

Millerton, N.Y.: Aperture, 1982.

LAUGHLIN, CLARENCE JOHN: *Clarence John Laughlin: The Personal Eye*. Millerton, N.Y.: Aperture, 1973.

MAPPLETHORPE, ROBERT: Mapplethorpe, Robert. *Some Women*. Boston: Bulfinch Press, 1989. Marshall, Richard, et al. *Robert Mapplethorpe*. New York: Whitney Museum of American Art, 1988.

MOHOLY-NAGY, LÀSZLÓ: Hight, Eleanor M. *Moholy-Nagy: Photography and Film in Weimar Germany*. Wellesley, Mass.: Wellesley College Museum, 1985. Passuth, Krisztina. *Moholy-Nagy*. New York: Thames and Hudson, 1985.

MUYBRIDGE, EADWEARD: Hass, Robert B. *Muybridge, Man in Motion*. Berkeley: University of California Press, 1976. Hendricks, Gordon. *Eadweard Muybridge, The Father of Motion Pictures*. New York: Grossman Publishers, 1975.

O'SULLIVAN, TIMOTHY: Dingus, Rick. *The Photographic Artifacts of Timothy O'Sullivan*. Albuquerque: University of New Mexico Press, 1982. Snyder, Joel. *American Frontier: The Photographs of Timothy H. O'Sullivan, 1867–1874*. Millerton, N.Y.: Aperture, 1981.

RAY, MAN: Foresta, Merry. *Man Ray*. New York: Pantheon Books, 1989. Martin, Jean-Hubert, and Man Ray. *Man Ray Photographs*. New York: Thames and Hudson, 1982.

RIIS, JACOB A.: Alland, Alexander, Sr. *Jacob A. Riis, Photographer & Citizen*. Preface by Ansel Adams. Millerton, N.Y.: Aperture, 1974. Doherty, Robert J. *The Complete Photographic Work of Jacob A. Riis*. New York: Macmillan Co., 1981.

SHAHN, BEN: Pratt, Davis, ed. *The Photographic Eye of Ben Shahn*. Cambridge, Mass.: Harvard University Press, 1975.

SHEELER, CHARLES: Stebbins, Theodore E., and Norman Keyes, Jr. *Charles Sheeler, The Photographs*. Boston: Little, Brown, 1987.

SMITH, HENRY HOLMES: Bossen, Howard. *Henry Holmes Smith, Man of Light*. Ann Arbor, Mich.: UMI Research Press, 1983.

SMITH, W. EUGENE: Hughes, Jim. *W. Eugene Smith: Shadow & Substance: The Life and Work of an American Photographer*. New York: McGraw-Hill, 1989. Maddow, Ben. *Let Truth Be the Prejudice: W. Eugene Smith, his Life and Photographs*. New York: Aperture, 1985.

STEICHEN, EDWARD: Longwell, Dennis. *Steichen: The Master Prints, 1895–1914*. New York: The Museum of Modern Art, 1978. Steichen, Edward. *A Life in Photography*. Garden City, N.Y.: Doubleday & Co., 1981.

STIEGLITZ, ALFRED: Greenough, Sarah, and Juan Hamilton. *Alfred Stieglitz, Photographs & Writings*. Washington, D.C.: National Gallery of Art, 1983. Homer, William Innes. *Alfred Stieglitz and the Photo-Secession*. New York: New York Graphic Society, and Boston: Little, Brown, 1983.

STRAND, PAUL: Denton, Sharon, ed. *Paul Strand Archive*. Tucson, Ariz.: Center for Creative Photography, University of Arizona, 1980. *Paul Strand*. New York: Aperture, 1987.

UELSMANN, JERRY: Enyeart, James L. *Jerry N. Uelsmann, Twenty-Five Years: A Retrospective*. Boston: Little, Brown, 1982.

WATKINS, CARLETON: Palmquist, Peter. *Carleton E. Watkins, Photographer of the American West*. Albuquerque: University of New Mexico Press, for the Amon Carter Museum, 1983.

WEEGEE: Stettner, Louis. *Weegee*. New York: Knopf, 1977. *Weegee's New York; 335 Photographs, 1935–1960*. Introduction by John Coplans. New York: Grove Press, 1982.

WESTON, EDWARD: Maddow, Ben. *Edward Weston, his Life and Photographs*. Millerton, N.Y.: Aperture, 1979. Newhall, Beaumont. *Supreme Instants: The Photography of Edward Weston*. Boston: Little, Brown, 1986. Stebbins, Theodore E., Jr. *Weston's Westons: Portraits and Nudes*. Boston: Museum of Fine Arts, 1989.

WHITE, CLARENCE: Bunnell, Peter C. *Clarence H. White: The Reverence for Beauty*. Athens, Ohio: Ohio University Gallery of Fine Art, 1986. Homer, William Innes, ed. *Symbolism of Light: The Photographs of Clarence H. White*. Wilmington, Del.: Delaware Art Museum, 1977.

WHITE, MINOR: Bunnell, Peter C. *Minor White: The Eye that Shapes*. Princeton, N.J.: Art Museum, Princeton University, 1989. White, Minor. *Mirrors, Messages, Manifestations*. Millerton, N.Y.: Aperture, 1982.

WINOGRAND, GARRY: Szarkowski, John, ed. *Winogrand: Figments from the Real World*. New York: The Museum of Modern Art, 1988. Winogrand, Garry, and Ron Tyler. *Stock Photographs: The Fort Worth Fat Stock Show and Rodeo*. Austin: University of Texas Press, 1980.

THE NEW WORLD, NEW SPAIN, AND NEW FRANCE

Baer, Kurt. *Architecture of the California Missions*. Berkeley: University of California Press, 1958.

Bunting, Bainbridge. *Taos Adobes: Spanish Colonial and Territorial Architecture of the Taos Valley*. Sante Fe: Museum of New Mexico, 1964.

Hulton, Paul. *America, 1585: The Complete Drawings of John White*. Chapel Hill, N.C.: University of North Carolina Press, 1984.

———, and David Beers Quinn. *The American Drawings of John White, 1577–1590: With Drawings of European and Oriental Subjects*. Chapel Hill, N.C.: University of North Carolina Press, 1964.

———, et al. *The Work of Jacques Le Moyne De Morgues, A Huguenot Artist in France, Florida, and England*. 2 vols. London: British Museum Publications, 1977.

Kessell, John L. *The Missions of New Mexico since 1776*. Albuquerque: University of New Mexico Press, 1980.

Kubler, George. *The Religious Architecture of New Mexico; In the Colonial Period and Since the American Occupation*. Albuquerque: University of New Mexico Press, 1973.

Wilder, Mitchell A., with Edgar Breitenbach. *Santos: The Religious Folk Art of New Mexico*. New York: Hacker Art Books, 1976.

WOMEN ARTISTS

Anderson, Janet A. *Women in the Fine Arts: A Bibliography and Illustration Guide.* Jefferson, N.C.: McFarland, 1991.

Banta, Martha. *Imaging American Women: Idea and Ideals in Cultural History.* New York: Columbia University Press, 1987.

Beckett, Wendy. *Contemporary Women Artists.* New York: Universe Books, 1988.

Chadwick, Whitney. *Women, Art, and Society.* New York: Thames and Hudson, 1990.

Chiarmonte, Paula, ed. *Women Artists in the U.S.: A Selective Bibliography and Resource Guide on the Fine and Decorative Arts, 1750–1986.* Boston: G. K. Hall, 1990.

Cikovsky, Nicolai, William H. Gerdts, Marie H. Morrison, and Carol Ockman. *Nineteenth-Century American Women Neoclassical Sculptors.* Poughkeepsie, N.Y.: Vassar College Art Gallery, 1972.

Harris, Ann Sutherland, and Linda Nochlin. *Women Artists, 1550–1950.* Los Angeles: Los Angeles County Museum of Art, 1976.

Harrison, Helen A., and Lucy Lippard. *Women Artists of the New Deal Era: A Selection of Prints and Drawings.* Washington, D.C.: National Museum of Women in the Arts, 1988.

Heller, Nancy. *Women Artists: An Illustrated History.* New York: Abbeville Press, 1987.

Hoppin, Martha J. "Women Artists in Boston, 1870–1900: The Pupils of William Morris Hunt." *The American Art Journal* 13 (Winter 1981): 17–46.

Kaiser, Elizabeth. *From Pedestal to Pavement: The Image of Women in American Art, 1875–1975.* South Hadley, Mass.: Mount Holyoke College, 1976.

Kasson, Joy. *Marble Queens and Captives: Women in Nineteenth-Century American Sculpture.* New Haven, Conn.: Yale University Press, 1990.

Lippard, Lucy *From the Center: Feminist Essays on Women's Art.* New York: E. P. Dutton, 1976.

Nochlin, Linda. *Women, Art, and Power; And Other Essays.* New York: Harper & Row, 1988.

The Pennsylvania Academy of the Fine Arts and its Women, 1850–1920. Philadelphia: Pennsylvania Academy of the Fine Arts, 1974.

Petteys, Chris, ed., with Hazel Gustow, Ferris Olin, and Verna Ritchie. *Dictionary of Women Artists: An International Dictionary of Women Artists Born before 1900.* Boston: G. K. Hall, 1985.

Raven, Arlene, Cassandra Langer, and Joanna Ellen Frueh, eds. *Feminist Art Criticism: An Anthology.* Ann Arbor, Mich.: UMI Research Press, 1988.

Rubinstein, Charlotte Streifer. *American Women Sculptors: A History of Women Working in Three Dimensions.* Boston: G. K. Hall, 1990.

Thorp, Margaret. "The White Marmorean Flock." *New England Quarterly* 32 (1959): 147–69.

Tucker, Anne, ed. *The Woman's Eye.* New York: Knopf, 1973.

Tufts, Eleanor. *American Women Artists, Past and Present, A Bibliographical Guide.* New York: Garland Publishing, 1984.

Watson-Jones, Virginia. *Contemporary American Women Sculptors.* Phoenix, Ariz.: Oryx, 1986.

Women of Photography: An Historical Survey. San Francisco: San Francisco Museum of Art, 1975.

AFRICAN-AMERICAN ARTISTS

Adams, Karen M. "The Black Image in the Paintings of William Sidney Mount." *American Art Journal* 7 (Nov. 1975): 42–59.

Bearden, Romare, and Harry Henderson. *Six Black Masters of American Art.* New York: Zenith Books, 1972.

Cederholm, Theresa Dickason, ed. *Afro-American Artists, A Bio-Bibliographical Directory.* Boston: Boston Public Library, 1973.

Doty, Robert M. *Contemporary Black Artists in America.* New York: Whitney Museum of American Art, 1971.

Dover, Cedric. *American Negro Art.* Greenwich, Conn.: New York Graphic Society, 1960.

Driskell, David C. *Hidden Heritage: Afro-American Art, 1800–1950.* San Francisco: Bellevue Art Museum and the Art Museum Association of America, 1985.

———. *Two Centuries of Black American Art.* Los Angeles: Los Angeles County Museum of Art, 1976.

———, David Levering Lewis, and Deborah Willis Ryan. *Harlem Renaissance: Art of Black America.* New York: Studio Museum in Harlem and H. N. Abrams, 1987.

Greene, Carroll, Jr. *The Evolution of Afro-American Artists: 1800–1950.* New York: University of New York, 1967.

Holmes, Oakley N., Jr. *The Complete Annotated Resource Guide to Black American Art.* Spring Valley, N.Y.: Black Artists in America/Macgowan Enterprises, 1978.

Igoe, Lynn Moody, with James Igoe. *250 Years of Afro-American Art, An Annotated Bibliography.* New York: R. R. Bowker Co., 1981.

Livingston, Jane, John Beardsley, and Regina Perry. *Black Folk Art in America, 1930–1980.* Jackson, Miss.: Center for the Study of Southern Culture, 1982.

Parry, Ellwood C., III. *The Image of the Indian and the Black Man in American Art, 1590–1900.* New York: G. Braziller, 1974.

Rozelle, Robert V., Alvia Wardlaw, and Maureen McKenna, eds. *Black Art: Ancestral Legacy: The African Impulse in African-American Art.* Dallas, Tex.: Dallas Museum of Art, and New York: Distributed by H. N. Abrams, 1989.

FOLK ART

An American Sampler: Folk Art from the Shelburne Museum. Washington, D.C.: National Gallery of Art, 1987.

Andrews, Edward Demings, and Faith Andrews. *Visions of the Heavenly Sphere; a Study in Shaker Religious Art.* Charlottesville, Va.: University Press of Virginia, for The Henry Francis du Pont Winterthur Museum, 1969.

Bishop, Robert C. *American Folk Sculpture.* New York: E. P. Dutton, 1974.

Black, Mary C. *American Folk Painting.* New York: C. N. Potter, 1966.

Brewington, Marion V. *Shipcarvers of North America.* Barre, Mass.: Barre Publishing Co., 1962.

Glassie, Henry. *The Spirit of Folk Art. The Girard Collection at the Museum of International Folk Art.* New York: H. N. Abrams, in association with the Museum of New Mexico, Santa Fe, 1989.

Grant, Jerry V., and Douglas R. Allen. *Shaker Furniture Makers.* Hanover, N.H.: University Press of New England, for Hancock Shaker Village, 1989.

Ketchum, William C. *All-American Folk Arts and Crafts.* New York: Rizzoli, 1986.

Lipman, Jean, and Tom Armstrong, eds. *American Folk Painters of Three Centuries.* New York: Hudson Hills Press, 1980.

———, Elizabeth Warren, and Robert Bishop. *Young America: A Folk-Art History.* New York: Hudson Hills Press, in association with the Museum of American Folk Art, 1986.

Little, Nina Fletcher. *American Decorative Wall Painting, 1700–1850.* New York: E. P. Dutton, 1972.

Peck, Amelia. *American Quilts and Coverlets in the Metropolitan Museum of Art.* New York: Metropolitan Museum of Art, 1991.

Quimby, Ian M. G., and Scott T. Swank, eds. *Perspectives on American Folk Art.* New York: W. W. Norton, for The Henry Francis du Pont Winterthur Museum, 1980.

Ricco, Roger, Frank Maresca, and Julia Weissman. *American Primitive: Discoveries in Folk Sculpture.* New York: Knopf, 1988.

Rumford, Beatrix. *Treasures of American Folk Art from the Abby Aldrich Rockefeller Folk Art Center.* Boston: Little, Brown, in association with the Colonial Williamsburg Foundation, 1989.

Sprigg, June. *By Shaker Hands.* New York: Knopf, 1975.

———. *Shaker Design.* New York: Whitney Museum of American Art, 1986.

NOTES

Chapter 1

1 For the original text see Thomas Hariot, *A Brief and True Report of the New Found Land of Virginia . . .* (London, 1588), pl. xx. The modernized transcription quoted here is from Stefan Lorant, *The New World, The First Pictures of America, Made by John White and Jacques Le Moyne and Engraved by Théodore de Bry* (New York: Duell, Sloan and Pearce, 1965), 264.

2 Lorant, *The New World*, 246.

Chapter 2

1 See J. A. Leo Lemay, *The American Dream of Captain John Smith* (Charlottesville: University Press of Virginia, 1991).

2 Examples of these design books are Jacques Androuet de Cerceau's *Livre de Grotesques* (Paris, 1566) and Jan Vriederman's *Grottesco* (Amsterdam, 1555–60).

Chapter 3

1 Quoted from William W. Hening, *The Statutes at Large, Being a Collection of all the Laws of Virginia*, 13 vols. (New York, 1819–23), 2:511.

Chapter 7

1 On 30 April 1773, Susanna Wheatley of Boston wrote to the Countess of Huntington in London that Phillis "is grateful that the countess has permitted Phillis to dedicate her volume to her ladyship, grateful also that the countess insists that an engraved likeness of Phillis preface the forthcoming volume of poems." Quoted from William H. Robinson, *Phillis Wheatley: A Bio-Bibliography* (Boston: G. K. Hall, 1981), 18. The engraved portrait seen in Figure 7.1 was probably made in London at the time of Wheatley's visit there in 1773.

2 Quoted from Allan Cunningham, *The Lives of the Most Eminent Painters and Sculptors*, 4 vols. (New York, 1834), 4:140.

3 Letter, Charles Willson Peale to John Beale Bordley, Philadelphia, November 1772. Peale Papers, American Philosophical Society, Philadelphia, Pa.

4 J. A. Leo Lemay and P. M. Zall, eds., *Benjamin Franklin's Autobiography, An Authoritative Text, Backgrounds, Criticism* (New York: W. W. Norton, 1986), 54.

Chapter 10

1 Fred Lewis Pattee, ed., *The Poems of Philip Freneau*, 2 vols. (Princeton, N.J.: University Library, 1903), 2:261–2.

2 *The Works of Joel Barlow*, facsimile reproductions with an introduction by William K. Hottorff and Arthur Lord (Gainesville, Fla.: Scholars' Facsimiles & Reprints, 1970), 217–20.

3 L. H. Butterfield et al., eds., *Adams Family Correspondence*, 4 vols. (Cambridge, Mass.: Harvard University Press, Belknap Press, 1963–73), 3:342.

4 The Vaughan type got that name because an Englishman, Samuel Vaughan, owned one of the replicas. He took it to London, where it was engraved by Thomas Holloway for Johann Caspar Lavater's *Essays on Physiognomy* (1789–98). Vaughan's name appeared on the plate, which was widely circulated because of the popularity of Lavater's writings. This image of Washington thus became known as the Vaughan type.

Chapter 11

1 Gulian C. Verplanck Papers, New-York Historical Society, New York City.

2 *American Ornithology* (1813), 3:29.

Chapter 12

1 John Bigelow, ed., *The Works of Benjamin Franklin*, 11 vols. (New York: G. P. Putnam's Sons, 1904), 10:118.

Chapter 13

1 A. J. Downing, *Cottage Residences, Rural Architecture, & Landscape Gardening* (New York, 1842), 115.

Chapter 14

1 Frances Trollope, *Domestic Manners of the Americans* (New York: Knopf, 1949), 406.

2 Alexis de Tocqueville, *Democracy in America* (New York: Knopf, 1963), 2:51.

3 Thomas O. Mabbott, ed., *Collected Works of Edgar Allan Poe*, 3 vols. (Cambridge, Mass.: Harvard University Press, Belknap Press, 1978), 2:496.

Chapter 15
1 James Hall, *Legends of the West* (Philadelphia, 1832), 171.

Chapter 17
1 Rembrandt Peale, *The Crayon* 4 (1857), 44.
2 *Atlantic Monthly* 12 (1863), 11.

Chapter 18
1 Nathaniel Hawthorne, *The Marble Faun, or, the Romance of Monte Beni* (1860). Quoted from the Textual Studies Series edition (Columbus: Ohio State University Press, 1968), 3.
2 William Cullen Bryant, *Letters of a Traveller* (New York, 1859), 259.
3 Nathaniel Hawthorne, *Notes of Travel*, 4 vols. (Boston: Houghton Mifflin Co., 1900), 3:334.

Chapter 19
1 *Baltimore Intelligencer*, 19 Dec. 1798.

Chapter 21
1 Louis Sullivan, "The Tall Office Building Artistically Considered," *Lippincott's Magazine* 57 (March 1896): 403–9.

Chapter 22
1 Leon Edel, ed., *Letters, Henry James*, 4 vols. (Cambridge, Mass.: Harvard University Press, 1974–84), 1:81.
2 *Letters, Henry James*, 1:297.
3 *Letters, Henry James*, 1:310, to Charles Eliot Norton, 19 Nov. 1872.
4 Edith Wharton, *The Decoration of Houses* (New York: W. W. Norton, 1978), 13.
5 Edith Wharton, *House of Mirth* (New York: Charles Scribner's Sons, 1951), 131.
6 Wharton, *House of Mirth*, 240–1.

Chapter 23
1 Mark Twain, *Innocents Abroad* (New York: Library of America, 1984), 213.
2 Twain, *Innocents Abroad*, 213.
3 Twain, *Innocents Abroad*, 214.
4 Twain, *Innocents Abroad*, 517–18.
5 *Galaxy*, July 1875.

Chapter 25
1 Even earlier, John Thomson had turned his camera on the insidious condition of the urban poor in his *Street Life in London* (London, 1877).

Chapter 26
1 G. W. Sheldon, "An American Sculptor," *Harper's Magazine* 57 (June 1878): 64.

Chapter 27
1 Herbert Croly, *The Promise of American Life* (New York: Macmillan Co., 1912 ed.), 23.

Chapter 28
1 Henry Adams, *The Education of Henry Adams* (Boston: Houghton Mifflin Co., 1918), 380.
2 Francis Picabia, *New York Tribune*, 24 Oct. 1915.
3 Frank Lloyd Wright, *The Living City* (New York: Horizon Press, 1958), 23.

Chapter 29
1 Jacob Riis, *How the Other Half Lives* (New York: Charles Scribner's Sons, 1904 ed.), 262.

Chapter 30
1 Quoted from Douglas Hyland, "Andrew Dasburg," in *Avant-Garde Painting and Sculpture in America, 1910–1925* (Boston: New York Graphic Society, 1977), 48.
2 Sherwood Anderson, *Hello Towns!* (New York: Horace Liveright, 1929), 111.

Chapter 31
1 Quoted from William I. Homer, *Alfred Stieglitz and the American Avant-Garde* (Boston: New York Graphic Society, 1979), 70.

Chapter 32
1 Quoted from *Manifestoes of Surrealism*, transl. by Richard Seaver and Helen Lane (Ann Arbor: University of Michigan, 1972), 26.
2 Quoted from *Black Art, Ancestral Legacy* (New York: H. N. Abrams, 1989), 272.
3 *Opportunity: Journal of Negro Life* 8 (Nov. 1930): 334.

Chapter 33
1 *New York Times*, 2 July 1976.
2 *New York Times*, 4 Oct. 1973.
3 Tom Wolfe, *From Bauhaus to our House* (New York: Farrar Straus Giroux, 1981), 4.
4 Wolfe, *From Bauhaus to our House*, 5–6.

Chapter 34
1 *National Arts Legislation*, Hearings (Washington, D.C.: U.S. Government Printing Office, 1963), 46.
2 *New York Times*, 15 Dec. 1961.
3 Senator Strom Thurman, *Congressional Record*, 20 Dec. 1963.
4 *The Objectivist* 7 (Dec. 1968): 10.

Chapter 35
1 George Nakashima, *The Soul of a Tree, A Woodworker's Reflections* (Tokyo: Kodansha International, 1981), 121.

Chapter 36
1 Romare Bearden, "The Negro Artist and Modern Art," *Opportunity: Journal of Negro Life* 13 (Dec. 1934): 371.
2 *Manifestoes of Surrealism*, 26.
3 *Art Digest* 6 (15 Jan. 1936): 32.
4 Robert Goodnough, "Jackson Pollock Paints a Picture," *Art News* 50 (May 1951): 60.

Chapter 37
1 Quoted from Andy Warhol and Pat Hackett, *POPism: The Warhol '60s* (New York: Harcourt Brace Jovanovich, 1980), 3.

Chapter 38
1 *Time* 56 (15 Aug. 1955): 55.
2 *LIFE* 28 (12 June 1950): 59.

Chapter 39
1 Claes Oldenburg, *Store Days* (New York: Something Else Press, 1967), 39–41.

PICTURE CREDITS

1.1 Bequest of James Hazen Hyde. Print Collection. Miriam and Ira D. Wallach Division of Art, Prints, and Photographs. New York Public Library, Astor, Lenox and Tilden Foundations.
1.2 British Museum, London.
1.3 Library of Congress, Washington, D.C.
1.4 Tyler Dingee/Museum of New Mexico, Santa Fe (Negative no. 91967).
1.5 Arthur Taylor/Museum of New Mexico, Santa Fe (Negative no. 91794).
1.6 Leon Cantrell/Museum of New Mexico, Santa Fe (Negative no. 55491).
1.7 © 1981 by the Massachusetts Institute of Technology. Reproduced from Marcus Whiffen and Frederick Koeper, *American Architecture 1607–1976*. London and Henley: Routledge and Kegan Paul.
1.8 Museum of New Mexico, Santa Fe (Negative no. 2873).
1.9 Museum of New Mexico, Santa Fe (Negative no. 2871).
1.10 G. E. Kidder Smith, New York City.
1.11 Arizona Historical Society, Tucson.

2.1, 2.4 Wayne Craven, Newark, Del.
2.2 Virginia State Library and Archives.
2.3 © 1981 by the Massachusetts Institute of Technology. Reproduced from Marcus Whiffen and Frederick Koeper, *American Architecture 1607–1976*. London and Henley: Routledge and Kegan Paul.
2.5 J. Jan Jansen, Topsfield, Mass.
2.7 Essex Institute, Salem, Mass.
2.8 Imants Ansbergs, Cohasset, Mass.
2.9 Gilbert Ask Photography/Winterthur Museum, Winterthur, Del.
2.10 Pilgrim Society, Plymouth, Mass.
2.11 Bowdoin College Museum of Art, Brunswick, Maine (Gift of Ephraim Wilder Farley, Newcastle, Maine).
2.12 Mark Sexton/Essex Institute, Salem, Mass.
2.13, 2.14, 2.16 Winterthur Museum, Winterthur, Del.
2.15 Yale University Art Gallery, New Haven, Conn. (Mabel Brady Garvan Collection, Gift of Francis P. Garvan).
2.17 New-York Historical Society, New York.
2.18 Staten Island Historical Society, New York.
2.19 Winterthur Museum, Winterthur, Del. (Gift of Henry Francis du Pont).

3.1, 3.2, 3.8 Worcester Art Museum, Worcester, Mass.
3.3 Wadsworth Atheneum, Hartford, Conn. (Gift of Mrs. Walter H. Clark).
3.4 Pilgrim Society, Plymouth, Mass.
3.5 Stephen J. Kovacik/Massachusetts Historical Society, Boston.
3.6 Museum of Fine Arts, Boston/Boston Medical Library in the Francis A. Countway Library of Medicine.
3.7 Massachusetts Historical Society, Boston.
3.9 American Antiquarian Society, Worcester, Mass.
3.10 New-York Historical Society, New York.
3.11 Virginia Historical Society, Richmond, Va.
3.12 Wayne Craven, Newark, Del.
3.13 Daniel Farber, Worcester, Mass.

4.1, 4.5 Virginia State Library and Archives, Richmond, Va.
4.2, 4.4 Colonial Williamsburg Foundation, Williamsburg, Va.
4.3 Abby Aldrich Rockefeller Folk Art Center, Williamsburg, Va.
4.6, 4.11 © 1981 by the Massachusetts Institute of Technology. Reproduced from Marcus Whiffen and Frederick Koeper, *American Architecture 1607–1976*. London and Henley: Routledge and Kegan Paul.
4.7 Library of Congress, Washington, D.C.
4.9, 4.14, 4.15, 4.16, 4.17, 4.18, 4.20, 4.21 Winterthur Museum, Winterthur, Del.
4.10 National Trust for Historic Preservation, Philadelphia, Pa.
4.12 Warner House Association, Portsmouth, N.H.
4.13 Royall House Association, Medford, Mass.
4.19 Metropolitan Museum of Art, New York (25.115.1).
4.22 Revd. Robert W. Golledge, Old North Church, Boston, Mass.
4.23 Wayne Andrews/Esto, New York.
4.24 Cortlandt van Dyke Hubbard, Philadelphia, Pa.
4.25 Thomas L. Davies/National Parks Service, Philadelphia, Pa.

5.1 Joseph Szaszfai/Yale University Art Gallery, New Haven, Conn. (Bequest of Allen Evarts Foster).
5.2 Brooklyn Museum, New York (Dick S. Ramsay Fund).
5.3 Winterthur Museum, Winterthur, Del.
5.4 Metropolitan Museum of Art, New York (Bequest of Charles Allen Munn—24.90.14).
5.5 Toledo Museum of Art (Purchased with funds from the Florence Scott Libbey Bequest in memory of her father, Maurice A. Scott).
5.6 Yale University Art Gallery, New Haven, Conn.
5.7 Harvard Law Art Collection, Cambridge, Mass. (Gift of Dr. George Stevens Jones).
5.8 Bowdoin College Museum of Art, Brunswick, Maine (Bequest of Mrs. Lucy Flucker Knox Thatcher).
5.9 Museum of Early Southern Decorative Arts, Winston Salem, N.C.
5.10 Maryland Historical Society, Baltimore, Md.
5.11 Historical Society of Pennsylvania.
5.12 Virginia Museum of Fine Arts, Richmond, Va. (Lent by the Ambler Family).
5.13, 5.14 Colonial Williamsburg Foundation, Williamsburg, Va.
5.15 Wayne Craven, Newark, Del.
5.16 Bostonian Society, Old State House, Boston, Mass.

6.1 Redwood Library and Atheneum, Newport, R.I.
6.2 Printed Book and Periodical Collection, Winterthur Museum, Winterthur, Del.
6.3 Arthur Haskell/Society for the Preservation of New England Antiquities, Boston, Mass.
6.4 © John T. Hopf, Newport, R.I.
6.5 John T. Hopf/Preservation Society of Newport County, Newport, R.I.
6.6 Norman S. Watson/First Baptist Church in America, Providence, R.I.
6.7, 6.9, 6.18 Wayne Andrews/Esto, New York.
6.8 Historic Hudson Valley, Tarrytown, N.Y.
6.10 Philadelphia Museum of Art, Philadelphia, Pa.
6.11 Jack E. Boucher/Cliveden, a co-stewardship property of the National Trust for Historic Preservation, Philadelphia, Pa.
6.12 © 1981 by the Massachusetts Institute of Technology. Reproduced from Marcus Whiffen and Frederick Koeper, *American Architecture 1607–1976*. London and Henley: Routledge and Kegan Paul.
6.13 Cortlandt van Dyke Hubbard, Philadelphia, Pa.
6.14 Metropolitan Museum of Art, New York (18.87.1–4).
6.15, 6.16, 6.23 Winterthur Museum, Winterthur, Del.
6.17 Yale University Art Gallery, New Haven, Conn. (Mabel Brady Garvan Collection).
6.19 Wayne Craven, Newark, Del.
6.20, 6.21 Colonial Williamsburg Foundation, Williamsburg, Va.
6.22 Charleston Museum, Charleston, S.C.
6.24 Maryland State Archives, Annapolis, Md. (Marion E. Warren Collection).
6.25 Freehand drawing by H. Lee Hirsche from William H. Pierson, Jr., *American Buildings and their Architects: The Colonial and Neo-Classical Styles*. Oxford University Press, 1970.
6.26 Marion E. Warren, Annapolis, Md.

7.2 Herbert P. Vose/Mead Art Museum, Amherst College (Gift of Herbert L. Pratt, class of 1895).
7.3 Metropolitan Museum of Art, New York (Rogers Fund—29.85).
7.4 Toledo Museum of Art (Purchased with funds from the Florence Scott Libbey Bequest in memory of her father, Maurice A. Scott).
7.5 Museum of Fine Arts, Boston (Abraham Shuman Fund).
7.6, 7.8 Museum of Fine Arts, Boston (Gift of the artist's great-grand-daughter).
7.7 Rick Stafford/Harvard University Art Museums, Cambridge, Mass. (Bequest of Ward Nicholas Boylston to Harvard University, 1828).
7.9 Museum of Fine Arts, Boston (Gift of Joseph W., William B., and Edward H. R. Revere).
7.10 Museum of Fine Arts, Boston (Gift of Mr. and Mrs. Maxim Karolik for the M. and M. Karolik Collection of Eighteenth-Century American Arts).
7.11, 7.15 New-York Historical Society, New York.
7.12 Charleston Museum, Charleston, S.C.
7.13, 7.16 Winterthur Museum, Winterthur, Del.
7.14 Baltimore Museum of Art (Gift of Alfred R. and Henry G. Riggs, in memory of General Lawrason Riggs).
7.17 Philadelphia Museum of Art (Cadwalader Collection. Purchased with funds contributed by the Pew Memorial Trust and gift of an anonymous donor).
7.18 Pennsylvania Academy of the Fine Arts, Philadelphia (Gift of Maria McKean Allen and Phebe Warren Downes through the bequest of their mother, Elizabeth Wharton Downes).
7.19 Joseph Szaszfai/Yale University Art Gallery, New Haven, Conn. (Gift of Roger Sherman White, B.A. 1859, M.A., LL.B. 1862).

8.1, 8.4 Virginia State Library and Archives, Richmond.
8.2 Karen Osborne, London.
8.3 Balthazar Korab, Troy, Mich.
8.5, 8.6, 8.7, 8.8 Essex Institute, Salem, Mass.
8.9 Boscobel Restoration, Inc., Garrison-on-Hudson, N.Y.
8.10 J. David Bohl/Society for the Preservation of

24.15 National Museum of American Art, Smithsonian Institution, Washington, D.C. (Gift of Allyn Cox).
24.16 Wadsworth Atheneum, Hartford, Conn. (Gift from the estates of Louise Cheney and Anne W. Cheney).
24.17 Art Resource, New York/National Museum of American Art, Smithsonian Institution, Washington, D.C.
24.18 Freer Gallery of Art, Smithsonian Institution, Washington, D.C. (93.11).
24.19 National Museum of American Art, Smithsonian Institution, Washington, D.C. (Gift of John Gellatly).
24.20 Metropolitan Museum of Art, New York (George A. Hearn Fund—15.32).
24.21 National Gallery of Art, Washington, D.C. (Andrew W. Mellon Collection).
24.22 Fine Arts Museum of San Francisco (Mildred Anna Williams Collection—1940.93).
24.23 Metropolitan Museum of Art, New York (Gift of Mr. and Mrs. William L. McKim—1973.166.1).
24.24 Metropolitan Museum of Art, New York (Bequest of Oliver Burr Jennings—68.205.3).

25.1 Union Pacific Railroad Company, Omaha, Nebr. (H1–23).
25.2 Library of Congress, Washington, D.C. (United States Geological Survey).
25.3 Leonard A. Walle. Novato, Calif.
25.4 Art Resource, New York/Cooper-Hewitt Museum, Smithsonian Institution, Washington, D.C.
25.5 Metropolitan Museum of Art, New York (Gift of Charles Bregler—41.142.1).
25.6 Philadelphia Museum of Art, Philadelphia, Pa. (Bequest of Mark Lutz).
25.7, 25.8, 25.12 George Eastman House, Rochester, N.Y.
25.10, 25.11 Museum of the City of New York (Jacob A. Riis Collection).

26.1, 26.17 New-York Historical Society, New York.
26.2 Abbie Rowe/National Park Service, Washington, D.C.
26.3 Collection of the City of New York (Madison Square, Manhattan).
26.4 Collection of Saint-Gaudens National Historic Site, Cornish, N.H. (Photograph courtesy of the U.S. Department of Interior, National Park Service, Saint-Gaudens National Historic Site).
26.5 Del Ankers Photographers, Washington, D.C./Rock Creek Cemetery, Washington, D.C.
26.6 Courtesy of the Art Commission of the City of New York (Grand Army Plaza, Manhattan).
26.7 Keith Martin, Concord, Mass.
26.8 Metropolitan Museum of Art, New York (Gift of a group of Trustees—26.120).
26.9 Abbie Rowe/National Park Service, Washington, D.C.
26.10 Corcoran Gallery of Art, Washington, D.C. (Gift of Ferargil Galleries—25.3).
26.11 Corcoran Gallery of Art, Washington, D.C. (Gift of Mrs. Paul Wayland Bartlett—44.8).
26.12 Cincinnati Art Museum (Gift of Mrs. Henry Matson Waite—1959.165).
26.14 Metropolitan Museum of Art, New York (Gift of Alfred Corning Clark—96.11).
26.16 Amon Carter Museum, Fort Worth.
26.18 Metropolitan Museum of Art, New York (Bequest of Jacob Rupert—39.65.47).
26.19 City Archives of Philadelphia.
26.20 Brenwasser, New York/Kennedy Galleries, New York.
26.21 Metropolitan Museum of Art, New York (Rogers Fund—19.126).
26.22 Metropolitan Museum of Art, New York (Rogers Fund—06.306).

27.1 Photography Collection, Miriam and Ira D. Wallach Division of Art, Prints, and Photographs. New York Public Library, Astor, Lenox and Tilden Foundations.
27.2, 27.18, 27.20 Wayne Andrews/Esto, New York.
27.3 Library of Congress, Washington, D.C.
27.4 New-York Historical Society, New York.
27.5 Sigmund J. Osty/Chicago Historical Society, Chicago, Ill.
27.6 Kaufman & Fabry/Chicago Historical Society, Chicago, Ill.
27.8 The Busch-Reisinger Museum/Harvard University, Cambridge, Mass. (Gift of Walter Gropius).
27.9 Buffalo and Erie County Historical Society, New York.
27.10, 27.11, 27.13 Domino's Center for Architecture and Design, Ann Arbor, Mich.
27.14 Art Institute of Chicago, Chicago, Ill.
27.16 Ralph Liebermann, North Adams, Mass./Calmann & King Ltd., London, U.K.
27.17 S.C. Johnson Wax, Racine, Wis.
27.19 Library of Congress, Washington, D.C.
27.21 Julius Shulman, Los Angeles, Calif.
27.22, 27.23 Peter Mauss/Esto, New York.
27.24 Helmsley-Spear, Inc., Empire State Building, New York.
27.25 Ezra Stoller/Esto, New York.
27.26 G. E. Kidder Smith, New York.
27.27 Rockefeller Center/© The Rockefeller Group, New York.

28.1 Art Institute of Chicago, Chicago, Ill.
28.2 Art Institute of Chicago, Chicago, Ill. (Gift of Mr. and Mrs. John J. Evans, Jr.)
28.3 The Museum of Modern Art, New York (Gift of the designer).
28.4, 28.14 Ezra Stoller/Esto, New York.
28.5 Architectural Drawing Collection, University of California, Santa Barbara, Calif. Art Museum.
28.6 Joseph Szaszfai/Yale University Art Gallery, New Haven, Conn. (Enoch Vine Stoddard B.A. 1905 and Marie-Antoinette Slade Funds).
28.7 Metropolitan Museum of Art, New York (Gift of Juliette B. Castle and Mrs. Paul Dahlstrom —68.70.2).
28.8 Rose Metal Industries, Inc.
28.9 Metropolitan Museum of Art, New York.
28.10 Metropolitan Museum of Art, New York (Gift of Mr. and Mrs. Herbert J. Isenburger—1978.439.1–5).
28.11 The Museum of Modern Art, New York.
28.12 The Museum of Modern Art, New York (Gift of Knoll International).
28.13 Joseph Szaszfai, Bradford, Conn./Wadsworth Atheneum, Hartford, Conn.

29.1 Joseph Szaszfai/Yale University Art Gallery, New Haven, Conn. (Mabel Brady Garvan Collection).
29.2 National Gallery of Canada, Ottawa.
29.3 Delaware Art Museum, Wilmington, Del. (Special Purchase Fund, 1965).
29.4 Phillips Collection, Washington, D.C.
29.5 Detroit Institute of Arts, Detroit, Mich.
29.6 Brooklyn Museum, New York (Dick S. Ramsay Fund).
29.7 Art Institute of Chicago, Chicago, Ill. (Watson F. Blair Purchase Fund, 1939.181).
29.8 Art Institute of Chicago, Chicago, Ill. (Friends of American Art—1925.295).
29.9 Brooklyn Museum, New York (Bequest of Laura L. Barnes).
29.10 Metropolitan Museum of Art, New York (George A. Hearn Fund—50.25).
29.11 Metropolitan Museum of Art, New York (Bequest of Lillie P. Bliss—31.67.12).
29.12 National Gallery of Art, Washington, D.C. (Chester Dale Collection).
29.13 Los Angeles County Museum of Art.
29.14 Hirshhorn Museum and Sculpture Garden,

Smithsonian Institution, Washington, D.C. (Gift of the Joseph H. Hirshhorn Foundation).
29.15 Art Institute of Chicago, Chicago, Ill. (Friends of American Art).
29.16 Art Institute of Chicago, Chicago, Ill. (Gift of Mr. and Mrs. Earle Ludgin).
29.17 Hampton University Museum, Hampton, Va.
29.18 Missouri Department of Natural Resources, Jefferson City, Mo. © Thomas Hart Benton and R. P. Benton Testamentary Trusts/VAGA, New York 1993.
29.19 Muskegon Museum of Art, Muskegon, Mich. (Hackley Picture Fund).
29.20 Art Institute of Chicago, Chicago, Ill. (Friends of American Art). © Estate of Grant Wood/VAGA, New York 1993.

30.1 Sheldon Memorial Art Gallery, University of Nebraska-Lincoln (Bequest of Bertha Schaefer, 1971).
30.2 Metropolitan Museum of Art, New York (Arthur H. Hearn Fund—62.203).
30.3 Montclair Art Museum (Gift of Mr. and Mrs. Henry M. Reed).
30.4 National Museum of American Art, Smithsonian Institution, Washington, D.C. (Gift of the artist).
30.5 Private Collection, Hockessin, Del.
30.6 Mark Tade, Iowa City/Des Moines Art Center (Nathan Emory Coffin Collection, purchased with funds from the Coffin Fine Arts Trust—1962.21).
30.7 Munson-Williams-Proctor Institute, Museum of Art, Utica, N.Y.
30.8 Regis Collection, Minneapolis, Minn.
30.9, 30.13, 30.20, 30.26 Philadelphia Museum of Art, Philadelphia, Pa.
30.10 Ackland Art Museum, University of North Carolina at Chapel Hill.
30.11 National Gallery of Art, Washington, D.C. (Gift of the Avalon Foundation).
30.12 Delaware Art Museum, Wilmington, Del. (Gift of John L. McHugh).
30.14 Amon Carter Museum, Fort Worth (Acquisition in memory of Anne Burnett Tandy, Trustee, Amon Carter Museum, 1968–72).
30.15 Yale University Art Gallery, New Haven, Conn. (Gift of the Société Anonyme).
30.16 Metropolitan Museum of Art, New York (Alfred Stieglitz Collection—49.70.42).
30.17 The Museum of Modern Art, New York (Mr. and Mrs. Donald B. Straus Fund). © 1992 The Georgia O'Keeffe Foundation/ARS, New York.
30.18 Metropolitan Museum of Art, New York (Alfred Stieglitz Collection). © 1992 The Georgia O'Keeffe Foundation/ARS, New York.
30.19 Walter Pach/The Museum of Modern Art, New York.
30.21 The Museum of Modern Art, New York (Gift of G. David Thompson). © 1992 ARS, New York/ADAGP, Paris.
30.22 Joseph Szaszfai/Yale University Art Gallery, New Haven, Conn. (Gift of the Société Anonyme).
30.23 Whitney Museum of American Art, New York (Purchase 42.15).
30.24 Museum of Fine Arts, Boston (Anonymous Gift).
30.25 Metropolitan Museum of Art, New York (Alfred Stieglitz Collection—49.59.1).
30.27, 30.30 The Museum of Modern Art, New York (Gift of Abby Aldrich Rockefeller).
30.28 Memorial Art Gallery of the University of Rochester, New York (Marion Stratton Gould Fund). © Estate of Stuart Davis/VAGA, New York 1993.
30.29 The Museum of Modern Art, New York (Gift of Gertrude A. Mellon). © Estate of Stuart Davis/VAGA, New York 1993.

37.19 Zindman/Fremont, New York/Mary Boone Gallery, New York.
37.20 Gagosian Gallery, New York. © David Salle/VAGA, New York 1993.
37.21 © The Estate of Jean-Michel Basquiat. All Rights Reserved. Robert Miller Gallery, New York.

38.1 Whitney Museum of American Art, New York (Purchase 47.7).
38.2 Soichi Sunami/The Museum of Modern Art, New York.
38.3 Whitney Museum of American Art, New York (Purchase 51.30).
38.4 The Museum of Modern Art, New York (Blanchette Rockefeller Fund).
38.5 Witt/Newark Museum, Newark, N.J. (Purchase 1960 Sophronia Anderson Bequest Fund).
38.6 Walter Rosenblum, Long Island City/Grace Borgenicht Gallery, New York (Collection Dr. and Mrs. Arnold Kerr).
38.7 Soichi Sunami/The Museum of Modern Art, New York (Mrs. Simon Guggenheim Fund).
38.8 Museum of Fine Arts, Houston. © 1992 ARS, New York/ADAGP, Paris.
38.9 The Museum of Modern Art, New York (Gift of the Artist). © 1992 ARS, New York/ADAGP, Paris.
38.10 Visual Artists and Galleries Association, New York. © Estate of David Smith/VAGA, New York 1993.
38.11 Marlborough-Gerson Gallery, New York/Dallas Museum of the Fine Arts, Dallas, Tex. © Estate of David Smith/VAGA, New York 1993.
38.12 The Museum of Modern Art, New York (Philip Johnson Fund).
38.13 Whitney Museum of American Art, New York (Gift of Mr. and Mrs. Robert C. Scull—73.85).

39.1 Lee Stalsworth/Hirshhorn Museum and Sculpture Garden, Smithsonian Institution, Washington, D.C. (Gift of Joseph H. Hirshhorn, 1966).
39.2 The Museum of Modern Art, New York (Gift of Mr. and Mrs. Ben Mildwoff).
39.3 Geoffrey Clements, Staten Island, New York/Whitney Museum of American Art, New York (Gift of the Howard and Jean Lipman Foundation, Inc.—66.49).
39.4 Walker Art Center, Minneapolis. © George Segal/VAGA, New York 1993.
39.5 Visual Artists and Galleries Association, New York. © Jasper Johns/VAGA, New York 1993.
39.6 Art Gallery of Ontario, Toronto.
39.7 Eric Pollitzer, New York/Whitney Museum of American Art, New York (Purchased with funds from the Friends of the Whitney Museum of American Art—64.17). © Marisol Escobar/VAGA, New York 1993.
39.8 Albright-Knox Art Gallery, Buffalo, N.Y. (Gift of the Seymour H. Knox Foundation, Inc., 1968).
39.9 Modern Art Museum of Fort Worth (Museum purchase, the Benjamin C. Tillar Trust).
39.10 Art Gallery of Ontario, Toronto (Purchase, 1969). © 1992 Sol LeWitt/ARS, New York.
39.11 Massachusetts Institute of Technology, List Visual Arts Center, Cambridge, Mass.
39.12 © 1992 Dan Flavin/ARS, New York.
39.13 Geoffrey Clements, Staten Island, New York.
39.14 © 1992 Richard Serra/ARS, New York.
39.15 Gianfranco Gorgoni/Dawn Gallery, New York.
39.16 John Cliett/© Dia Art Foundation 1980.
39.17 Mrs. Jeanne-Claude Christo, New York.
39.18 Robert Miller Gallery, New York. © Louise Bourgeois/VAGA, New York 1993.
39.19 Donald Woodman/© Judy Chicago 1979, Santa Fe, N.Mex.
39.20 George Mintz & Company, Inc., Morristown, N.J. © Nancy Graves/VAGA, New York 1993.
39.21 Holly Solomon Gallery, New York.
39.22 National Museum of American Art, Smithsonian Institution, Washington, D.C.
39.23 Eric Pollitzer for O. K. Harris, New York.
39.24 Bungarz Foto, Ltd., Wilmington, Del.
39.25 Peter Aaron/Esto, New York.

40.1, 40.4 Library of Congress, Washington, D.C.
40.2 W. Eugene Smith, *LIFE* Magazine © 1948 Time Warner, Inc.
40.3 Margaret Bourke-White, *LIFE* Magazine © Time Warner, Inc.
40.5 Minor White Archive, Princeton University, N.J. Copyright © 1982 by the Trustees of Princeton University. All Rights Reserved.
40.6 Art Institute of Chicago—(Gift of Katherine Kuh, Chicago, Ill. 1954.1340).
40.7 Michael Cavanagh/Indiana University Art Museum, Bloomington.
40.8 Clarence John Laughlin/© 1992 The Historic New Orleans Collection.
40.9 Wynn Bullock, Monterey, Calif./Wynn and Edna Bullock Trust.
40.10 Jerry N. Uelsmann, Gainsville, Fla.
40.11 Pace/MacGill Gallery, New York.
40.12 Paul Caponigro, Santa Fe, N.Mex.
40.13 Art Institute of Chicago—(Restricted gift of the Photography Gallery, Chicago, Ill. 1961.925).
40.14 The Museum of Modern Art, New York. (Ben Schultz Memorial Collection. Gift of the Artist).
40.15 The Museum of Modern Art, New York (Purchase).
40.16 © The Estate of Robert Mapplethorpe. Robert Miller Gallery, New York.
40.17 Art Institute of Chicago—(Gift of Mrs. Stuyvesant Peabody, Chicago, Ill. 1952.477).
40.18 The Museum of Modern Art, New York (Purchased with funds provided by the International Council).
40.19 Lee Friedlander, New City, N.Y.
40.20 Metro Pictures, New York.

INDEX